nutritional support
of medical practice

Editors

HOWARD A. SCHNEIDER, Ph.D. Editor-in-Chief

Director, Institute of Nutrition, University of North Carolina, Chapel Hill, North Carolina

CARL E. ANDERSON, Ph.D.

Professor, Department of Biochemistry and Nutrition, School of Medicine, University of North Carolina, at Chapel Hill, Chapel Hill, North Carolina

DAVID B. COURSIN, M.D.

Director of Research, Research Institute, St. Joseph's Hospital, Lancaster, Pennsylvania

WITH 45 CONTRIBUTORS

nutritional support
of medical practice

Medical Department
Harper & Row, Publishers
Hagerstown, Maryland
New York, San Francisco, London

DRUG DOSAGE

The authors and publisher have exerted every effort to ensure that drug selection and dosage set forth in this text are in accord with current recommendations and practice at the time of publication. However, in view of ongoing research, changes in government regulations, and the constant flow of information relating to drug therapy and drug reactions, the reader is urged to check the package insert for each drug for any change in indications and dosage and for added warnings and precautions. This is particularly important when the recommended agent is a new and/or infrequently employed drug.

79 80 81 82 10 9 8 7 6 5 4 3

Library of Congress Cataloging in Publication Data

Main entry under title:

Nutritional support of medical practice.

Includes bibliographies and index.
1. Nutrition disorders. 2. Nutrition. 3. Diet in disease. 4. Diet therapy. I. Schneider, Howard A., 1912– II. Anderson, Carl E. III. Coursin, David Baird. [DNLM: 1. Diet therapy. 2. Nutrition. WB400 N977] RC620.N87 616.3′9 76–30307 ISBN 0–06–140259–1

*To John L. Dusseau,
leader and wise counselor in
American medical publishing*

CONTENTS

CONTRIBUTORS

Lilla Aftergood, Ph.D.

Chapter 9

Associate Research Biochemist, School of Public Health, University of California, Los Angeles, California

Roslyn B. Alfin-Slater, Ph.D.

Chapter 9

Professor of Nutrition, Division of Environmental and Nutritional Sciences, School of Public Health, University of California; Professor of Biological Chemistry, Department of Biochemistry, School of Medicine, University of California, Los Angeles, California

Carl E. Anderson, Ph.D.

Preface, Chapters 2, 3, 4

Professor, Department of Biochemistry and Nutrition, School of Medicine, University of North Carolina at Chapel Hill, Chapel Hill, North Carolina

Lewis A. Barness, M.D.

Chapter 29

Professor and Chairman, Department of Pediatrics, University of South Florida College of Medicine, Tampa, Florida

William R. Beisel, M.D., F.A.C.P.

Chapter 22

Scientific Advisor, United States Army Medical Research Institute of Infectious Diseases, Frederick, Maryland

René Bine, Jr., M.D.

Chapter 15

Associate Chief, Department of Medicine, Mount Zion Hospital and Medical Center, San Francisco, California

Bruce R. Bistrian, M.D., Ph.D.

Chapters 6, 10

Assistant Director, Nutritional Support Service, New England Deaconess Hospital, Boston; Research Associate, Department of Nutrition and Food Science, Massachusetts Institute of Technology, Cambridge, Massachusetts

George L. Blackburn, M.D., Ph.D.
Chapters 6, 10

Assistant Professor, Department of Surgery, Harvard Medical School; Director, Nutritional Support Service, New England Deaconess Hospital, Boston, Massachusetts

George A. Bray, M.D.
Chapter 19

Professor, Department of Medicine, UCLA School of Medicine, Los Angeles; Director, Clinical Study Center, Department of Medicine; Associate Chief of Metabolism, Division of Endocrinology, Department of Medicine, Harbor General Hospital, Torrance, California

Robert A. Briggaman, M.D.
Chapter 16

Professor, Departments of Dermatology and Medicine, School of Medicine, University of North Carolina at Chapel Hill, Chapel Hill, North Carolina

Edward M. Copeland, III, M.D.
Chapter 32

Professor, Department of Surgery, University of Texas Medical School at Houston, Houston, Texas

David B. Coursin, M.D.
Preface

Director of Research, Research Institute, St. Joseph's Hospital, Lancaster, Pennsylvania

Robert G. Crounse, M.D.
Chapter 16

Associate Dean and Chairman, Department of Medical Allied Health Professions, School of Medicine, University of North Carolina at Chapel Hill, Chapel Hill, North Carolina

William T. Dahms, M.D.
Chapter 19

Assistant Research Pediatrician, Department of Pediatrics, Harbor General Hospital, UCLA School of Medicine, Torrance, California

Pierre M. Dreyfus, M.D.
Chapter 24

Professor and Chairman, Department of Neurology, School of Medicine, University of California, Davis; Chief of Service, Department of Neurology, Sacramento Medical Center, Sacramento, California

Stanley J. Dudrick, M.D.
Chapter 32

Professor and Chairman, Department of Surgery, University of Texas Medical School at Houston; Chief of Surgical Services, Hermann Hospital, The Teaching Hospital, University of Texas Medical School at Houston, Houston, Texas

Steven J. Faigenbaum, M.D.
Chapter 27

Instructor, Department of Ophthalmology, Mount Sinai Hospital and Medical Center, New York, New York; Associate Staff Ophthalmologist, Somerset Hospital, Somerville, New Jersey

W. Page Faulk, M.D., M.R.C.Path.

Chapter 21

Professor of Immunology and Pediatrics, Department of Immunology and Microbiology, Medical University of South Carolina, Charleston, South Carolina

Frances E. Fischer, M.S., R.D.

Chapter 8

Professor, Department of Nutrition, Case Western Reserve University, Cleveland, Ohio

Grace A. Goldsmith, M.D. (deceased)

Chapter 7

Professor, School of Public Health and Tropical Medicine, Tulane University, New Orleans, Louisiana

William C. Heird, M.D.

Chapter 12

Assistant Professor, Department of Pediatrics, College of Physicians and Surgeons of Columbia University, New York, New York

Todd S. Ing, M.D.

Chapter 23

Professor, Department of Medicine, Loyola University Stritch School of Medicine, Maywood; Director, Section of Nephrology, Veterans Administration Hospital, Hines, Illinois

Francis J. Kane, Jr., M.D.

Chapter 30

Professor, Department of Psychiatry, Baylor College of Medicine, Houston, Texas

Robert M. Kark, M.D., F.R.C.P. (London), F.A.C.P.

Chapter 23

Professor and Associate Chairman, Department of Medicine, Rush Medical College; Senior Attending Physician, Presbyterian-St. Luke's Hospital, Chicago, Illinois

Irving H. Leopold, M.D., D.Sc. (Medicine)

Chapter 27

Professor and Chairman, Department of Opthalmology, California College of Medicine, University of California, Irvine, California

Charles S. Lieber, M.D.

Chapter 13

Professor of Medicine, Mount Sinai School of Medicine of the City University of New York; Chief, Section and Laboratory of Liver Disease and Nutrition, Bronx Veterans Administration Hospital, Bronx, New York

Morris A. Lipton, M.D., Ph.D.

Chapter 30

Sarah Graham Kenan Professor, Department of Psychiatry; Director, Biological Sciences Research Center of the Child Development Research Insitute, School of Medicine, University of North Carolina at Chapel Hill, Chapel Hill, North Carolina

Bruce V. MacFadyen, Jr., M.D.

Chapter 32

Assistant Professor, Department of Surgery, University of Texas Medical School at Houston, Houston, Texas

H.C. Meng, M.D., Ph.D.

Chapter 11

Professor, Departments of Physiology and Surgery, Vanderbilt University School of Medicine, Nashville, Tennessee

Daniel B. Menzel, Ph.D.

Chapter 31

Associate Professor, Departments of Physiology, Pharmacology and Medicine, Duke University Medical Center, Durham, North Carolina

Marcia A. Mills, M.A., R.D.

Chapter 5

Consulting Nutritionist, Director, Community Diet Counseling Service, Inc., Chapel Hill, North Carolina

Mark E. Molitch, M.D.

Chapter 19

Director, Metabolism Clinic, New England Medical Center; Assistant Professor, Department of Medicine, Tufts University, Boston, Massachusetts

Abraham E. Nizel, D.M.D., M.S.D

Chapter 28

Professor of Nutrition and Preventive Dentistry, Oral Health Service, Tufts University School of Dental Medicine, Boston; Visiting Professor of Nutrition and Metabolism, Department of Oral Science, Massachusetts Institute of Technology, Cambridge, Massachusetts

Elinor Pearson, M.S., R.D.

Chapter 14

Sioux Falls, South Dakota

Roy M. Pitkin, M.D.

Chapter 26

Professor, Department of Obstetrics and Gynecology, University of Iowa College of Medicine, Iowa City, Iowa

Howard A. Schneider, Ph.D.

Foreword, Preface, Chapter 1

Director, Institute of Nutrition, University of North Carolina, Chapel Hill, North Carolina

Spencer Shaw, M.D.

Chapter 13

Instructor, Department of Medicine, Mount Sinai School of Medicine of the City University of New York; Staff Physician, Bronx Veterans Administration Hospital, Bronx, New York

Harry S. Soroff, M.D.

Chapter 14

Professor and Chairman, Department of Surgery, State University of New York at Stony Brook, Stony Brook, New York

Keith B. Taylor, M.D.

Chapter 20

Barnett Professor and Vice-Chairman, Department of Medicine, Stanford University; Chief, Medical Service, Palo Alto Veterans Administration Hospital, Stanford, California

Richard C. Theuer, Ph.D.

Chapter 18

Director, Nutritional Research, Bristol–Myers Company, International Division, New York, New York

I. Frank Tullis, M.D.

Chapter 25

Clinical Professor, Department of Medicine, University of Tennessee College of Medicine; Medical Staff, The Sanders Clinic, Memphis, Tennessee

Kenneth F. Tullis, M.D.

Chapter 25

Clinical Assistant Professor, Department of Psychiatry, University of Tennessee College of Medicine, Memphis, Tennessee

Joseph J. Vitale, Sc.D., M.D.

Chapters 18, 21

Professor, Department of Pathology, Boston University School of Medicine, Boston, Massachusetts

Kelly M. West, M.D.

Chapter 17

Professor, Department of Medicine, University of Oklahoma Health Sciences Center, Oklahoma City, Oklahoma

Robert W. Winters, M.D.

Chapter 12

Professor, Department of Pediatrics, College of Physicians and Surgeons of Columbia University, New York, New York

FOREWORD

Interest in human nutrition as one of the new health sciences of the last half-century has both waxed and waned among practitioners of medicine in the Western world. Indeed we are now at what must be a rather low point in medical interest in the subject, if one is to judge from the short shrift given to identifiable teaching of nutrition in the crowded curricula of the medical schools of the United States. Committees of professional nutrition societies, for their part, wring their hands over their low estate; conferences on nutrition education in medicine are convened; nutrition professors cry havoc before Senate Committees; and harassed curriculum committees in medical schools frown on the importunings of nutrition "enthusiasts."

It was not always thus. Time was when nutritional discoveries brought crowded rooms at medical meetings and pellagra and rickets were not the rare curiosities of today.

The basic thesis of this book is that the waxing and waning of interest in human nutrition in the practice of medicine in the developed world is an inevitable and understandable phenomenon that has its historic–cultural roots in the continuing development both of the health sciences on which medical practice now rests and of the changing societies in which Western medicine is embedded. If this thesis is correct, nutritional science itself can be seen not as a monolithic but ineffectual competitor among the therapeutic modalities of modern medicine, but more appropriately as providing a wide spectrum of usefulness to medicine, ranging from directly curative intervention to aspects of prevention, and further, and most important, to means of supporting therapeutic choices with their own prior claims on the attention of medical practitioners.

This analysis has been confined to Western medicine and especially to the medicine of the developed countries. This view was taken not in a spirit of chauvinism but because of a conviction, generally shared, that modern medicine is led by the West, and by such others who are Western themselves in medical thought and training. This medical tradition is heavily dominated by a preoccupation with curing, and medical interest is indeed first stirred by the presentation of the patient's disease or trauma. The economic base of medicine itself rests on delivery of a healing service that is operationally identifiable with, in one way or another, the hand and thought of the physician or surgeon.

These presuppositions are, of course, reflected in medical education. In a broad sense, all of medical education is directed toward this first concern of

how to cure the patient who presses to claim the attention of the medical practitioner.

About a half-century ago a class of diseases of significant proportions in human populations, which could be clearly distinguished through research, became understandable as nutritional deficiency diseases. This set of deficiency diseases was the well-known group of scurvy, rickets, pellagra, and beriberi. Medical practitioners and medical educators showed a high degree of interest when nutritional research revealed the chemical identity of the *curative* vitamins involved and placed them in the practitioner's hand. As long as these clearly identifiable nutritional diseases presented themselves for cure, curative Western medicine was fully interested and busied itself learning to use the newly available vitamins.

But, in these very instances, nutritional knowledge also showed that the same vitamins, if regularly supplied, would *prevent* these diseases. On this knowledge, several events followed which lowered the interest of curative medicine and thereby that of its practitioners. Nutrition education proceeded to inform the general population, and attentive public health authorities, that the almost magic vitamins were available not only on prescription, but also, by proper choice of foods, at the grocery. Two further events ensured that the human dietary in the developed countries came to include preventive levels of the missing nutrients: 1) food fortification and enrichment programs improved supplies of the preventive nutrient and 2) with rising affluence, an expanding food technology and a distribution-marketing system brought a more varied diet within reach of all who could enter the marketplace. And the deficiency diseases went away.

With the monovalent deficiency diseases no longer pressing for attention in medical practice, it is small wonder that nutrition began to fade from the attention of medical educators to its present low visibility.

Nutrition research, of course, has not been idle but, apparently in the very biologic nature of things, has been lead inevitably to recognize the multiple causality of the intractable medical problems that remain to claim attention. As in ischemic heart disease, for example, nutritional parameters are several and of uncertain standing in the hierarchy of multiple causation which includes other nonnutritional parameters. Most importantly, even as they are being elucidated the identifiable nutritional factors are recognized as features of prevention strategies in terms of life styles, income levels, and cultural influences. The medical practitioner, although he is aware of these, no longer identifies them as medical problems amenable to his skills in practice. To the extent that all these matters are preventive, there is the strong inclination to leave them to others and concentrate on those modalities that can be employed in the office, at the bedside, or in the hospital.

If we are not completely wrong in this synopsis, then it is understandable that medical interest was highest when the vitamins cured diseases occurring frequently enough to be seen in practice, that it declined when the diseases disappeared for the socioeconomic reasons just discussed, and that it was relegated to the public health arena to which the responsibility has been assigned for the continuing dynamics of a varied and adequate, but increasingly sophisticated, food supply. Western curative medicine has only modest room for preventive medicine. As we have noted, it has no broadly accepted economic base in this domain, aside from the public health sector. Solutions to this particular problem must be left to the future.

Returning to the medical practitioner, however, we believe that the foregoing discussion does not exhaust the possible relationships of nutritional knowledge to medical practice. This book asserts there is at least one more important but hitherto unarticulated relationship. If medical practice in the West today no longer holds nutrition to be important in its original *curative* sense, and if in a *preventive* sense, nutrition has become the proper concern of other professionals, then nutrition can still be seen as an important claimant to the attention of the practitioner and his educators in a *supportive* sense. What do we mean by this?

We believe that the use of nutritional knowledge in medical practice is not mutually exclusive with the present modalities of therapy that are the proper preoccupation of medical thought and practice. Let the physician and surgeon, in all of the medical specialties, elect their therapies as their special knowledge dictates. And, then, to improve the outcome, to shorten convalescence, to extend the time frame for therapies, and to increase the patient's capability of favorable response, let the practitioner nutritionally support his patient as the hours lengthen into days, weeks, months, and years—as healing is truly achieved.

Nutrition, on its own, can still clearly be curative of certain, now rather rare, diseases. Further, nutrition, as part of the underlying multiple causality, can be an important factor in the prevention of some other and more-common diseases. But in the widest perspective, nutrition can be used *to support* the finest efforts of medical practice to cope with disease in all of its aspects.

H.A.S.

PREFACE

NUTRITIONAL SUPPORT OF MEDICAL PRACTICE has many authors, but a single idea: to assemble for the medical practitioner in the developed countries those features of nutritional science which are clearly useful and clinically applicable in day-to-day medical practice. We have elected to focus on medical practice in the developed countries because the similarities of their infrastructure of national systems of food supply, transportation, resource use, and industrialization make a unified treatment meaningful, and their historic roles of leadership in medicine recommends our attention. We are not blind to the nutritional problems of the rest of the globe, but these are set in other societal frameworks which seemingly demand systems of medical care delivery adapted to cultures with presuppositions different from those in the West. Further, we are not engaged in probing the tantalizing regions lying beyond the horizons of research, nor are we proposing to revolutionize medicine by some sweeping new paradigms derived from the nutritional sciences. Rather, given the necessarily pragmatic aim of today's medical schools to train practitioners to cope with the preponderance of medical problems they are most likely to encounter, we have come to ask, "How can knowledge of human nutrition help?"

To answer that question the editors sought the expert assistance of their colleagues assembled here. These authorities responded to our appeal to set forward in terms of their own clinical specialty just those aspects of applied nutrition that they had found useful. A broad spectrum emerges in terms of these specific applications, ranging from modalities of a clear and directly curative role, to aspects of prevention, to the more-numerous roles supportive of other modalities which the practitioner may elect as his prime means of intervention. This adds up to an increased effectiveness of the physician–surgeon in practice.

The book itself is structured into three main parts. After a brief description from the viewpoint of human biology, the setting of modern nutritional science, the first main section sets forward a concise review of the basics of the nutritional sciences, *i.e.,* energetics, physiology, and the biochemistry and metabolism of the nutrients. Then the various modes of applied human nutrition available to the physician in a variety of settings are described. The largest section of the book is comprised of 20 chapters reporting in detail the application of human nutritional science to the practice of the clinical specialties. This particularization of the relationship of human nutrition to the clinical specialties, one by one, is the heart of this book. The scientific advance of medicine inevitably generated the specialties, a process of speciation, if you will,

in the evolution of medical practice, and any useful analysis of the role of nutrition in modern medicine, it seems to us, must accommodate this process and this reality.

An appendix provides in tabular form some of the basic reference materials for which the authors of the clinical sections have had general need and which may be of ready use to the reader.

H.A.S.
C.E.A.
D.B.C.

ACKNOWLEDGMENTS

Like the proverbial soup spoiled by the ministrations of too many cooks, there is a similar hazard in assembling a sizable company of busy scientists and clinicians to produce a book such as this. If the book you now hold in your hands is at all palatable it is due to the unselfish help we have received from the patient and understanding staff at Harper & Row, and the editors acknowledge this sustaining help with gratitude.

It is particularly pleasant to acknowledge the gracious and supportive response of medical and scientific publishing organizations who, on our petition, immediately responded with permission to use tabular materials from their own publications. Such tables, reproduced in the present book as the Appendix, are separately acknowledged there. Let it be said here that the present editors are gratified to have been admitted to this select earlier company, and if we have borrowed from them, it is to signal our debt to scholarly predecessors.

Along the way we were helped by many others. A very important assistance came from either our colleagues or those of our contributors. These colleagues are too numerous to list here and some, indeed, are known only to the contributors themselves, who tested their own ideas in the give and take of professional judgments on campuses, in medical schools, in hospitals and clinics, at meetings of professional societies—all across the country and sometimes overseas. To all these colleagues we here record our thanks.

Last, and surely not least, we thank Mrs. Sue Johnson, Mrs. Sonya Best and Ms. Ellen English, the secretaries of the Institute of Nutrition, who kept the files and compiled the ever-shifting lists of manuscripts, reviewers' reports, revisions, names, addresses, telephone numbers, etc., so that order prevailed and we all eventually emerged into the broad daylight with our honor and our good will intact.

The Editors

nutritional support
of medical practice

1 Biologic setting of modern nutritional sciences

Howard A. Schneider

THE NATURAL HISTORY OF THE PLANET AND *HOMO SAPIENS*

What a piece of work is a man! how noble in reason! how infinite in faculties! in form and moving how express and admirable! in action how like an angel! in apprehension how like a god! the beauty of the world, the paragon of animals. ("The Tragedy of Hamlet, Prince of Denmark" Act II, Scene 2, pp 307–312)

"The paragon of animals!" So wrote the famous playwright and, as in so many things, so precisely touched the heart of the matter. For although modern biology, studiously eschewing anthropocentricity, still places *Homo sapiens* in a very special place at the terminus of the evolutionary progression, the fact remains that when viewed in an environmental perspective man's nature is incomprehensible if we neglect his animal origins and his animal needs. The unique possession of a mind may set him apart from all other species, but our concern here is with human nutrition, and we must reckon with man as an *eating* animal—as are indeed all the animals. This concern with eating is central to all that will follow, but before we deal with it further it seems profitable to step back in time and view very briefly the whole enterprise of life on the planet Earth and how we came to where we are.

THE PHYSICAL ENVIRONMENT AND CHEMICAL CONSEQUENCES

Modern estimates of the age of our solar system are now hovering around 4.7 billion years. Our planet, Earth, the third innermost of a group of nine, is orbiting 93,000,000 miles from the sun, a star named Sol, with all ostensibly having "begun" from some grand cosmic explosion. The cardinal feature of this relationship of our planet to the sun as concerns the support of life, is that the sun bathes the Earth in a flood of energy in the form of electromag-

netic waves, some of it invisible as ultraviolet and infrared radiation, but most of it visible light. The 93,000,000 miles of empty space between Sol and Earth is traversed in about 8 minutes, but of all the sun's energy thus sent out in all directions, the Earth intercepts less than one-billionth.

As the Sun's radiation enters the Earth's film of atmosphere much of the ultraviolet radiation is absorbed by the ozone layer. This simple fact provides a shield for living things on the earth's surface which protects them from what would otherwise be damaging effects, such as skin cancer in man. Further in, on the path through the atmosphere, water and carbon dioxide absorb infrared radiation. This absorption raises their temperature and thereby that of the total atmosphere. Some solar radiation never does reach the Earth but is reflected back into space by dust particles or by the condensed moisture of clouds. Since these processes are selective for ultraviolet and infrared radiation, most of the solar radiation reaching the Earth's surface is in the visible part of the light spectrum. The absorption of this visible light is, of course, a function of color. Black is almost totally absorbing, for example, as white is almost totally reflecting. It turns out that for life as we know it on our planet, the color green is all important. The absorption of red and blue light and the reflection of green is the important feature of chlorophyll, the green substance of plants, that signals the terrestrial trapping of the sun's energy. The physical-chemical consequence of the absorption of energy by a molecule is an increase in chemical reactivity. In a crude way this can be done by merely heating a mixture of the chemical substances one wishes to react with one another, but in a more-subtle way the consequences of the absorption of red and blue light by chlorophyll results in a series of chemical reactions, all driven by the push of light, with the end result being a production of organic chemical sub-

1

stances that contain the trapped energy. It is worth pondering that, on earth, the only significant chemical reaction that can trap the energy of the sun is photosynthesis, wherein the green leaf converts some of the absorbed energy into the potential energy of organic end products. We will not be concerned here with the consequences of such organic products as wood or cotton, which serve man in many ways, but with the central fact that all foods, the metabolizable sources of energy for all life (see Ch. 2), have this common origin in photosynthesis.

THE EVOLUTION OF THE HUMAN SPECIES

The origin of man and the necessarily antecedent origin of life are problems of great philosophic import, both worthy of volumes in themselves. It is not impertinence, therefore, but sheer necessity that restricts us to a statement, regrettably brief and sketchy, concerning these two great issues. For if we are to place human nutrition in an understandable and logical relationship to the planet and ourselves, we shall need to provide the framework of the origin and elaboration of the life processes and the origin, by evolution, of the species we know as man.

Earlier we have alluded to the sheer necessity of remaining sensitive to the animal component of the human species if we are to understand the relationships connecting the species and the nutritional environment. Our emphasis on man as an eating animal may seem brutish to some, but at this cross-section in time of our understanding, incomplete though that be, it is the best stance we can assume. The evolution of those aspects that, in the minds of some, draw a gulf between us and the animals, remains for the future to clarify.

The birth of the solar system about 4.7 billion years ago was in itself followed by a cosmic evolution and a settling down, so to speak, into a system of a sun and nine orbiting planets and their satellites. Then, as Dobzhansky has characterized it, cosmic evolution transcended itself when it produced life. In Dobzhansky's words (2),

Life on earth is reckoned to be two billion or more years old. It first arose under environmental conditions quite different from those which exist today; these conditions can be reconstructed only with difficulty. As the earth cooled sufficiently for the water vapor to condense and to form the oceans, the atmosphere consisted of such gases as hydrogen, methane, ammonia, carbon dioxide, and lesser quantities of nitrogen and little free oxygen. Chemical reactions that can take place in such mixtures have been extensively studied in laboratories. Formaldehyde, acetic acid, succinic acid, and as many as ten different amino acids can all be formed. These, and other even more complex substances, now made chiefly or only in living bodies, could arise and accumulate in solution in the then lifeless oceans, making the latter a kind of dilute "soup" of organic compounds.

And further:

Much ingenuity has been used to construct models of processes that might conceivably have led to combining the smaller molecular constituents into large molecules, such as DNA, which can facilitate the synthesis of their copies. The best that one can say about these models is that some of the processes which they postulate might conceivably have happened, but not that they did actually happen in the real history of the earth. It is also not quite generally agreed that self-reproduction is both the necessary and sufficient condition for regarding a chemical system as living, though it is agreed that it is at least a necessary condition. The reason for this is as follows: Self-replication means not only that a system engulfs suitable materials from its environment (food) and transforms them into its own likeness (reproduction), but also that any changes that may occur in the self-replicating process (mutation) may be reflected in the relative frequencies of the changed and unchanged systems in the course of time (natural selection). In other words, the origin of self-replication opens up the possibility of biological evolution. This evolution may, although it need not necessarily, be progressive. The evolution of a self-replicating system may be cut short by exhaustion of the environment or by changes in the system which make it less efficient (extinction). It is possible that, if self-replicating systems arose repeatedly, most of them were lost without issue. The point, is, however, that at least one system was preserved and "inherited the earth," by becoming the starting point of biological evolution.*

In sheer fact, then, we really do not know how life originated on the planet and transcended the inorganic world. But it surely has not escaped the reader interested in nutrition that Dobzhansky, in discussing self-reproduction as a necessary condition for regarding a system as living, identified the fundamental nature of those "suitable materials from its environment" as "food" when they were capable of being transformed into the very substance of the entity deemed as "living."

This is not the place to discuss the adaptive

*From THE BIOLOGY OF ULTIMATE CONCERN by Theodisius Dobzhansky. Copyright © 1967 by Theodosius Dobzhansky. By arrangement with The New American Library Inc., New York, N.Y.

radiation through evolution into a myriad living forms, first in the seas and then on land and into the very air. But, remembering our ultimate focus on the human species we must consider that other fateful transcendence, the appearance of man among living things. Once again we can do no better than repeat Dobzhansky's (2) skillful synopsis:

While the origin of life on earth is an event of a very remote past, man is a relative newcomer (even though the estimates of his antiquity have been almost doubled by recent discoveries). The record is still fragmentary, but the general outlines of at least the outward aspects of man's emergence are recognizable. During the early part of the Pleistocene age (the Villafranchian time, perhaps two million to one million years ago), there lived in the east-central and in the southern parts of the African continent at least two species of *Australopithecus,* a genus of Hominidae, the family of man. One of these, larger in body size *(Australopithecus robustus,* and its race *boisei),* apparently represented an evolutionary blind alley, and eventually died out. The other species, of a more supple build *(Australopithecus africanus),* may have been one of our ancestors.

There is good evidence in the structure of their pelvic bones that both species walked erect; their teeth were, if anything, more like ours than like those of the now-living anthropoid apes. The brain case capacity, though large in relation to the body size, was well within the ape range. Perhaps both species of *Australopithecus,* or at any rate one of them, made and used primitive stone tools. The remains of a most interesting creature have recently been found in the Villafranchian deposits in east-central Africa, and given the name *Homo habilis.* The name connotes the opinion of its discoverers that this creature had already passed from the genus *Australopithecus* to the genus *Homo,* to which we also belong. On the other hand, it is closely related to *Australopithecus africanus,* and may even have been only a race of that species. Regardless of the name by which it is classified, this is rather clearly one of the "missing links," which are no longer missing.

Later, during the mid-Pleistocene, there lived several races of the species *Homo erectus,* clearly ancestral to the modern *Homo sapiens.* Remains of *Homo erectus* have been found in Java, in China, in Africa, and probably also in Europe. Roughly 100,000 years ago, during the last, Würm–Wisconsin, glaciation, the territory extending from western Europe to Turkestan and to Iraq and Palestine was inhabited by variants of the Neanderthal race of *Homo sapiens.*

Rough stone tools have been found in association with australopithecine remains both in east-central and South Africa. *Homo erectus* in China is the oldest known user of fire. The Neanderthalians buried their dead. These are evidences of humanization. All animals die, but man alone knows that he will die. . . . A burial is a sign of a death awareness, and probably of the existence of ultimate concern. The ancestors of man had begun to transcend their animality perhaps as long as 1,700,000 years ago. The process is under way in ourselves.*

Several speculations of interest to a science of human nutrition can be drawn from the evolutionary relationships of the Hominoides, which includes apes and man. From the human viewpoint, for example, considerable interest attaches to the determinants that account for our ancestors' divergence from the rest of the primates. In discussing this issue, Jolly (5) advances certain proposals that rest on features recognized in *Ramapithecus,* the earliest fossil hominoid. These features, which are anatomic, are adaptive for "small object feeding": dental adaptations and the adaptations for feeding while sitting on the ground. The dental evolution, then, of small front teeth and large molars in a small-brained primate could have taken place long before the invention of tools or weapons. The grinding action of molars seems appropriate for the eating of small, hard seeds, and perhaps grass seeds of various kinds. This, in turn, would explain the terrestriality of *Ramapithecus* and the finding of these early hominoid fossils in deposits on the forest fringe and in treeless areas within forests. The functional connection between seed eating and our early ancestors' nutritional and adaptive dependencies is, of course, obvious.

The hominoid adaptation to seed eating resulted in some divergence from the primates in the habits of eating fruit, leaves, insects, and—rarely—meat. Indeed, even among the tool-using and hunting *Australopithecines* the huge grinding molars became the climax of this adaptation to seed eating. From such pathways, came eventually our own species, *Homo,* and it seems reasonable that modern man's reliance on starchy grains had its beginnings in the grassy areas of the forest's edge and the search for seeds.

To return, for the moment, to the diet of primates as observed in the wild, three major categories can be distinguished: 1) leaf eating, 2) fruit eating, and 3) insect eating. Intestinal anatomy and stomach contents of specimens give general indications of the predilections of a species. Man is classified as omnivorous, but he is

*From THE BIOLOGY OF ULTIMATE CONCERN by Theodisius Dobzhansky. Copyright © 1967 by Theodosius Dobzhansky. By arrangement with The New American Library Inc., New York, N.Y.

ill-adapted to leaf eating, an accomplishment of certain specialized folivores. Insect and fruit eating are common, however, throughout the order of primates. In general, man has dropped insects from his diet (quantitatively surely, although there are various exceptions noted in some cultures even today) and taken up meat eating. No other primate except the chimpanzee has so exerted himself, or been so inventive, in the hunt for meat as has been *Homo.* This generalization in turn has led to the error that, aside from man, the primates are vegetarians. The crucial ommission in this erroneous judgment is the neglect of the dietary role of insects among the primates. All primates are in need of vitamin B_{12} (see Ch. 3), which is obtainable only from animal sources. Insects are, of course, invertebrate animals, and as such a source of vitamin B_{12}, as is meat, milk, and other animal products. This dependency on vitamin B_{12} sources, coupled with the erroneous notion that primates are pure vegetarians, has resulted in some captive primates in zoos being deprived of the vitamin and suffering, as a consequence, the nerve degeneration that is a feature of the deficiency. It should be remarked further that capturing the smallish insect as an important item in the dietary probably favored, through natural selection among the primates, the attributes of manipulative skills and manual dexterity which from our vantage point in time we can identify as necessary conditions for the tool-inventing and weapon-wielding *Homo* who was to come.

In this brief sketch of the evolution of man we have emphasized the relationships to food, to its qualitative distinctions and to its ingathering from the environment. In this complex interplay of evolving organisms and their environment the focus on food has many consequences. One of the most astonishing—another transcendent leap—which that astonishing species *Homo sapiens* now essayed, was to master the very nature of his food supply and embark on a new evolution of a faster pace, his cultural evolution.

MAN'S MASTERY OF FOOD—THE AGRICULTURAL REVOLUTION

In dealing with those aspects of the evolution of our species which reflect the necessary adaptations to the securing and utilization of food we have had occasion to comment on the interactions which led to more and more success in the perpetuation of the species. Tool-making from stone was probably widespread throughout the Eurasion and African land mass by ancient types

of *Homo* 250,000 years ago. Bladed tools and modern physical man appear in the archaeological record about 50,000 years ago. This modern form of man, the supreme adapter, successfully sought and found food in environmental niches ranging from the frozen tundra to tropical jungles. By about 25,000 years ago a previously man-empty New World was colonized from the Old via the entry at Alaska and diffusion southward and eastward. Man was slowly increasing in numbers and, the archaeological evidence suggests, was penetrating his environment—living into his niche—to a high degree and learning the nature of "the fine structure" of the environment. This was especially true of the processes of food-collection. The archaeological record of the era (European Mesolithic, North American Archaic) gives testimony to the vigor and intensity of this preoccupation. Fish, snails, mussels, water birds, and even small, swift animals have left their remains. And in recent years, with the development of the field of paleoethnobotany, it is apparent that plants and seeds were also being brought into familiarity.

And then, about 10,000 years ago, the agricultural revolution was born, not once, but probably three times, in separate, widely separated sites. The first achievement of a food-producing technology occurred in the Near East, on the hills of the fertile crescent, running north along the eastern Mediterranean shore and arching eastward through Turkey down along the eastern banks of the Tigris river to the Persian Gulf. The question naturally arises, Why there? and Why then? The answer, from the archaeological record, is that the agricultural revolution did not take place only there and only then. The same events occurred at slightly later times in Central America (perhaps in the Andes, too) and in southeastern Asia and in China. From all this we can be persuaded (1) that the food-producing revolution came as a cultural climax to an historic process in which, as a consequence of that heightened "living into the environment," there had been accumulated an array of experiences necessary for agriculture, so that, in total, it became a sufficient experience. As Braidwood (1) reminds us, "Here in a climate that provided generous winter and spring rainfall, the intensified food-collectors had been accumulating a rich lore of experience with wild wheat, barley and other food plants, as well as with wild dogs, goats, sheep, pits, cattle and horses. It was here that man first began to control the production of his food."

The process of domestication of wild species

has been defined as one which results in reproductive processes under control by man. A detailed analysis of the various means of husbandry and cultivation is beyond our province here, but in view of the continuing interest in man in earlier "states of nature" it may be of use to view the agricultural revolution in its stages as revealed by the archaeological excavations at Jarmo in Iraq. Approximately 150 people lived in Jarmo about 7000 to 6500 B.C., a permanent year-round settlement. Among the foods identified here were primitive barley, two forms of domesticated wheat, domesticated goats and dogs, and possibly domesticated sheep. Bones of wild animals and the remains of sea foods, acorns and pistachio nuts indicate that hunting and collection of food had not been abandoned. This total array indicates that the people of Jarmo had a varied, well-balanced diet that was probably an adequate one. The teeth of the Jarmo people showed even wear, the happy outcome of the use of stone mortars and pestles and rubbing stones in food preparation. Food production and food technology had now assumed dimensions and features which make us feel a kinship to the people of Jarmo and others like them. The agricultural revolution was now irrevocably on its way. Man had domesticated his food supply and was himself the servant of his agriculture, with his life settling into the rhythms of the seasons, the planting and the reaping. The dog was the first domesticated animal and was seen on the paths of Jarmo as on the concrete and asphalt of our cities. Certain patterns of life were now set, certain foods becoming favored choices. These choices had consequences which needed to be understood, and the road to this understanding is our next logical concern.

THE EMERGENCE OF THE NUTRITIONAL SCIENCES

THE NATURALISTIC ERA (400 B.C. TO 1750 A.D.) (9)

Thus far, in sketching the biologic origins of man, his food supply, and the increasingly intricate and elaborate nature of the interrelationships of these domains, we have made no mention of medicine and the healing art. This is not to say that efforts by man to cope with disease did not exist or were not attempted. Our problem stems from the fact that we have been dealing with events in prehistory and only the archaeological and paleontological evidence has made our speculations possible. Speculation on the actual intervention by man with the idea of coping with illness is almost profitless until the birth of writing, about 3300 B.C. by the Sumerians of the Fertile Crescent. The art of the scribes diffused from Mesopotamia, and the Babylonians became the inheritors of greatness as the first disciples of the Sumerians; the peoples of the Mediterranean, in turn, learned from the Babylonians. The secret of Mesopotamian cultural dominance lay in the cuneiform script, for now there were records of matters (for our interest here) such as drugs and their corresponding ailments, and medical instructions systematized according to parts of the body or the location of symptoms. Medicine, magic, and the priesthood were, however, all intertwined, as was the case as well in the Egyptian civilization, which, it so happens, in its isolation on the Nile invented its own writing system of hieroglyphics only a bit later than the Sumerians.

It was in Ionia, on the island of Cos in the fourth century B.C., that what we can now discern as scientific medicine began. It was Hippocrates who advanced the idea that sickness could be understood only if one considered the whole patient and his environment. Successful treatment could be expected only if one used the beneficial experience of similar cases. Clearly, all this has a modern ring across almost 25 centuries, but aside from some lip-service to "the Father of Medicine," and in spite of the well-known fact that Hippocrates was very much concerned with the diet of his patients, there has been little attention paid by nutrition writers to this remarkable connection. One must except from this stricture, however, E.V. McCollum. In his "A History of Nutrition" (8) one will find a digest from the Hippocratic writings of the early Greek's views of special properties and uses of food in medical treatment. The compilation has historic interest, and there is an astonishing prescience of Hippocrates' recommendation that pulses should be eaten along with cereals. But set alongside this, for example, his listing of "remedial foods," *i.e.,* myrtle, apples, dates, water from crab apples, and milk of asses (taken hot), and foods to be used in the treatment of dysentery, *i.e.,* linseed, wheat flour, beans, millet, eggs and milk, and not forgetting barley mush. From this compendium one comes to realize that foods were to Hippocrates what we would now categorize as items of pharmacology, but of an unclear kind. The neglect of Hippocrates by modern nutrition writers is therefore understandable, and McCollum, a lover and student of

history, had to yield as much when he concluded "it is clear that Hippocrates had little understanding of the nature of nutrition, and held some groundless opinions about quality in foods."

There is no denying that Hippocrates began the first formulations of a scientific approach to medicine, but we are probably over-zealous to read too much into the ancient words, as was written in *Ancient Medicine:*

For the art of medicine would never have been discovered to begin with, nor would any medical research have been conducted—for there would have been no need for medicine—if sick men had profited by the same mode of living and regimen as the food, drink and mode of living of men in health(6)

From our vantage point in time we can sense the struggle toward understanding, but for that understanding a new science had to be born, a science of chemistry. Only then could one hope to untangle the mixture present in a grain of wheat and discern in what way that mixture was similar, and in what way different, from that of a grain of maize. But for a chemistry adequate for the task, the world waited two millenia.

THE CHEMICOANALYTIC ERA
(1750–1900 A.D.) (9)

Out of the mists of alchemy there gradually coalesced a subject matter and a discipline that we know as chemistry. The recognition of the central and necessary role of quantitation by Lavoisier placed chemistry on its proper foundation, and by the middle of the eighteenth century, with the added genius of men such as Black and Priestley, chemical investigations of all kinds were well under way. In the domain of what we now name as organic chemistry, the German Liebig began exploring the chemical nature of foods. It was soon evident that foods were complicated mixtures of many various chemical compounds. But what was the nutritional meaning of this complicated and extended array?

The view of Hippocrates, which had prevailed into the eighteenth century, was that there was but a single essential in all foodstuffs, with foods varying only in the amount of this single aliment that they might contain. But the new chemistry raised obvious difficulties. Among all the chemically defineable entities in the mixtures known as foods, which was the aliment of Hippocrates? This, of course, turned out to be a nonquestion; the single "aliment" of Hippocrates never existed except in the conceptual framework of the prechemical era. The new chemistry now forced a revision in concepts, and with the forceful ideas of Liebig and Mulder (who forwarded the notion that the nitrogenous constituents of foods were all one "protein") there gradually emerged by the middle of the nineteenth century a chemicoanalytic view of the basis of nutrition which rested not on one mysterious aliment, but on four chemically defined categories of substances: 1) protein, 2) carbohydrate, 3) fat, and 4) the minerals left as an ash when the food sample was totally combusted. Chemists then began to develope standardized analytic procedures to measure the agreed-upon four nutrient entities. This important step in the history of nutrition epitomized a significant commitment: the important essentials for animal nutrition were now known, these were four in number, and they were capable of analysis by the procedures of chemists. What is also worth remarking is that these developments took place in an economically important field, the scientifically advancing field of agricultural chemistry, and the same advances were being applied in many countries in rapidly increasing numbers of agricultural experiment stations.

For a while enthusiasm ran high that the analysts at the agricultural experiment stations at long last had a methodology that made possible rational advice to the farmer concerning profitable husbandry of his animals and crops to help him achieve the best possible results in the animal industries and place farming on a solid economic footing. It all made a lot of sense, but it was in the end all brought down by the very test that had been held up as the measure of the advance in the understanding of animal nutrition, *i.e.,* the prediction of the equivalence of nutritive value based on equivalent chemicoanalytic data, and the prediction of superior nutritive value based on analytic data being used to achieve the hypothetically ideal composition of rations. All collapsed in the tests of practical use. Farmers who followed the chemists' advice were sometimes successful, but sometimes the animals failed in their response, failed to thrive, and sometimes lay down and died.

By the end of the nineteenth century the disillusion with the chemicoanalytic approach to a nutritional science was growing. The agricultural chemists, sensing their failure, cast about to patch up matters. A massive effort was made, for example, to mesh the chemical analyses of foods with the calorimetry and respiratory exchanges of the animals consuming these foods. There resulted a marked advance in knowledge of ani-

mal energy requirements and the respiratory quotients associated with the catabolism of fats, carbohydrates, and protein, but no new solutions appeared for the overriding problem of the nature and the number of the essential nutrients. The agricultural chemists appointed committees to study the matter, and some refinements in analysis were made, but the ability to predict the nutritive value of a ration based on chemical analysis of the constituents remained impressively erratic and inadequate. The closing years of the century saw an increasing sense of crisis and frustration. Something was wrong, or missing. But what?

THE BIOLOGIC ERA (1900 A.D. TO THE PRESENT) (9)

The resolution of the crisis in nutritional understanding had its roots, as is so often the case, in preceding events whose relationships and usefulness were not appreciated at the time of their original occurrence. The new burst of understanding which launched the present, biologic era came from two sources. One line of research which proved illuminating, but which was pursued so sporadically as to leave but a handfull of papers in the scientific literature before 1906, was to give animals food that consisted of mixtures of relatively pure protein, carbohydrate, fat, and those minerals thought to be important. This was, of course, experimentation by means of assembly of the very same four categories that had been the target of chemical analyses and their endless refinement. Sparse though the published record was, it was unanimous in the observations that in all such experiments with chemically simplified diets the animals showed signs of malnutrition, survived for a short time, and died. The conclusion was inescapable that one or more unknown nutrients had not been included and must be sought as the clue to the support of animal health and life. This early record is one of failure, but from its methodology (the use of simplified diets of some chemical definition which could test the effectiveness of added supplements) investigators gradually fashioned a new and powerful paradigm, which in a Kuhnian sense (7) provided a revolutionary tool for resolving the crisis.

The second line of thought which contributed to the resolution of the crisis in nutritional understanding was the promulgation and investigation of the idea that certain human diseases were due to a dietary deficiency of certain specific chemical substances, which, it was proposed, could be isolated and identified. This second line of research is important since any link between nutrition and human disease is an obvious and legitimate concern of medicine. What was focused upon was no mundane concern with the economics of animal husbandry, important though that might be, rather nutrition was suddenly seen to touch human life and disease in a very direct way. It was at this point that, spanning the millenia from Hippocrates, the medicine of the West was diminishing its reliance on empiricism and expanding its scientific base and outlook. In an amazingly short time medicine embraced the idea of the deficiency diseases, an idea, it must be remarked, which in its univalent concept of etiology (one dietary deficiency, one disease) was harmonious with the similarly accepted univalent etiology of infectious disease (one pathogenic microorganism, one disease). The idea that disease could be caused by a lack of something as well as by the noxious and pathogenic presence of something was a revolutionary idea. First clearly demonstrated for human beriberi (4), the idea was given a broader generalization by Funk in 1912 (3) who proposed that not only beriberi but also scurvy, pellagra, and rickets were caused by a lack in the diet of "special substances which are of the nature of organic bases, which we will call vitamines." As the chemistry of these "special substances" was gradually mastered it became clear that they were not uniformly organic bases, but the term has obviously survived, although the "e" has been dropped (see Ch. 3).

The search for the life-sustaining missing dietary ingredient to be added to the chemically simplified diet and the quest for the deficiency disease–curing "vitamines" now were perceived as but one grand and unified agenda for nutrition research. A new era had begun which has not yet been replaced by any more-productive paradigm, although signs of strain have begun to appear. This new era in nutrition which began in 1900 and continues to the present day we have designated as the "biologic" era, in contrast to the "chemicoanalytic" era which preceded it. All this is to emphasize the fundamental nature in the changeover from the way in which nutritional research was conducted. Instead of presupposing that there were but four important categories of nutrients and that chemical analysis would reveal ideal relations between these, the new and revolutionary presupposition was made that still other important nutrients existed in the natural world of foodstuffs which would expand the list of necessary nutrients. These, it turned

out, were so small in their quantitative amounts as to escape the analyst. Instead of turning to analysts, experimenters turned to the experimental animals, in the biologic assay, to signal the presence of the missing and sought-for items. The four categories were now built upon as a basis for the burst of new knowledge, and as of the present about 50 chemically specified compounds are identified as necessary for the nutritional needs of animals, including man. We will not detail these items here further (see Chs. 2,3 and 4) except to record that since about 1950 no new vitamins have been added to that category, while the list of essential trace elements has been slowly growing, although the practical significance of many of these remains unspecified.

THE FUTURE OUTLOOK

The dazzling success of the univalent dietary deficiency hypothesis has placed the classic deficiency diseases under control, and they now occur, when they occur at all in developed countries, because of failures in health delivery systems, or—more usually—because of economic and social distortions of the dietary. But mankind is still left with a burden of diseases with unexplained and complicated etiologies. What, for example, can we say of the relationship of nutrition to coronary heart disease? If univalent etiology does not serve as a suitable framework for understanding causation, even hypothetically, then single entities are not likely to emerge as dominant controlling agencies to be grasped and mastered. Where will nutrition fit now? Although we have raised coronary heart disease as an important medical problem and disease burden in human populations, we have done so only to pose a more-general question; in the instance wherein we perceive (and our

investigations identify) multicausal sets of parameters, we are faced with the necessity of using a different grammar of biologic science, of abandoning the satisfying imagery of univalent concepts of causation and adopting the apparently necessary conventions and grammar of multivariance statistics. For some this is dismaying. The question seems to have changed from what is true to a recognition that many things are true, but we must decide what is true and important versus what is true but trivial. We now need methodologies for structuring hierarchies of the parameters we have identified. Sometimes, for a given disease, nutrition is but one parameter of many. It is inappropriate then to ask whether nutrition is *a* cause. We must learn to ask not questions but what can only be called a questionnaire. When our education in biology, in science, in medicine, has taught us that, we will be ready to begin. Perhaps, if we look about us, we have begun.

REFERENCES

1. Braidwood RJ: The agricultural revolution. Sci Am 203: 1–10, 1960
2. Dobzhansky T: The Biology of Ultimate Concern. New York, New American Library, 1967, pp 46–47, 50–52
3. Funk C: Discussion In McCollum EV: A History of Nutrition. Boston, Houghton Mifflin, 1957, p 217
4. Grijns G: Discussion In McCollum EV: A History of Nutrition. Boston, Houghton Mifflin, 1957, pp 216–217
5. Jolly A: The Evolution of Primate Behavior. New York, Macmillan, 1972, pp 55–69
6. Jones WHS: Hippocrates, Vol I. New York, Loeb Classical Library, Putnam's Sons, 1923, p 17
7. Kuhn TS: The Structure of Scientific Revolutions. Chicago, University of Chicago Press, 1962
8. McCollum EV: A History of Nutrition. Boston, Houghton Mifflin, 1957
9. Schneider HA: What has happened to nutrition. Perspect Biol Med 1:278–292, 1958

FUNDAMENTALS OF
NUTRITIONAL SCIENCES

2 Energy and metabolism

Carl E. Anderson

The main purpose of this chapter and the following two chapters is to provide the reader with a brief recall and review of those major sections of biochemistry and physiology that illuminate nutrition. The subject matter of each such chapter is in itself a large one containing much detail the scope of which would be beyond the practical confines of this book. For the reader wishing to probe more deeply into such detail, the suggested references at the end of this first chapter provide an excellent resource (1, 3, 4, 5–8, 11, 12).

ENERGY

In the United States in recent years consumers have become startlingly conscious of shortages in fossil fuel energy, particularly gasoline, so essential to move the automobile and other fuel-propelled machinery. Energy is similarly required to propel the human through his daily tasks whatever they may be, active or sedentary. Although the fuels may be different, gasoline in one instance and food in the other, the basic requirement is the same: the need for energy. The dramatic realities of shortages of energy become startlingly real when one considers a useless, nonrunning automobile or broken down piece of machinery on one hand, and malnutrition and starvation in the human on the other hand.

The human body needs energy for the metabolic work of the life processes, *e.g.*, the action of the heart in circulating blood; the movement of the diaphragm in breathing; osmotic work; to support physical activity, such as running, jumping, and working; for growth, as in the maintenance and biosynthesis of new tissue; for lactation; and to maintain body temperature, to name but a few of the body's living activities.

In the human, energy is provided by the carbohydrates, fats, and proteins of the diet. In some dietaries alcohol also must be considered because of the significant caloric value (7 Cal/g) of ethanol. Ethyl alcohol, of course, is toxic in high amounts. A typical American diet provides 50%–60% of its energy from carbohydrate, 10%–15% from protein, and 35%–45% from fat. The remaining components of the diet, *i.e.*, water, cellulose, minerals, and vitamins, do not contribute energy. Although carbohydrate has been the chief source of energy in the past, at the present time in the United States some people consume diets in which carbohydrate and fat make nearly equal contributions, approaching 46% and 42% respectively. The total protein consumed has remained nearly constant at 11%–12% of the dietary energy (10).

The energy value of food is expressed in terms of a unit of heat, the kilocalorie (kcal). This represents the amount of heat required to raise the temperature of 1 kg (1000 g) water 1°C at the temperature range from 15°C to 16°C. The large Calorie (Cal) used by nutritionists is equivalent to the kilocalorie and should not be confused with the small calorie (cal), which is 0.001 Cal. A proposal that the joule (1 Cal = 4.184 kilojoules) be adopted has been endorsed by a number of nutrition groups as a heat measurement unit, but is as yet not widely used.

Much of our information on the energy value of food is obtained by combustion methods or direct calorimetry using an oxygen bomb calorimeter (9). This instrument is a highly insulated boxlike container about 1 ft³ in size. The bomb chamber itself consists of a thick-walled metal vessel equipped with sample dish, electrodes for igniting the sample in an oxygen atmosphere, and a valve for introducing oxygen. This combustion chamber is surrounded with an outer chamber containing a measured quantity of water, a stirrer, and a thermometer. When a dried sample of food is completely burned in the oxygen-rich environment of the combustion chamber, the heat produced is absorbed by the weighed amount of water surrounding the

chamber. The change in temperature of the surrounding water is measured by an accurate thermometer. By definition a kilocalorie is the amount of heat required to change the temperature of the measured weight of water. Because the bomb is well insulated and no heat is exchanged with the environment, the amount of heat resulting from the complete burning of the measured sample can be calculated directly as Cal/g. The energy value of a sample of food thus obtained is known as the heat of combustion.

The first line of Table 2–1 presents the heat of combustion obtained from burning or oxidation of 1 g carbohydrate, fat, protein, or alcohol, respectively. The heat of combustion represents the total energy produced by the oxidation of the carbon of the food in the bomb calorimeter to carbon dioxide, the hydrogen to water, and the nitrogen of the protein to nitrous oxide. In the tissue cells the digested food products are also oxidized. However, unlike the bomb calorimeter, the heat lability of tissue cells prohibits as wasteful and destructive to the cell the direct oxidation of food. Rather, oxidation is accomplished by decarboxylations and by the gradual removal of the hydrogen and electrons of food via a respiratory cycle until the hydrogen and electrons can be united at the end of the cycle with molecular oxygen to form water. During this process the bond energies of the food molecule are released and captured in forming high-energy adenosine triphosphate (ATP) from adenosine diphosphate (ADP) present in the cell fluid. The combined process of the respiratory cycle and the capture of food bond energies as high-energy ATP is called coupled oxidative—phosphorylation. The high energy of ATP can be transferred to creatine phosphate for temporary storage or utilized directly to drive the physiologic processes of the living cell. However, the animal cell cannot release or utilize the complete energy potential of nitrogen in protein. Therefore, a deduction must be made in the case of proteins because these are not as completely oxidized in the body as in the bomb calorimeter. It is the nitrogen-containing product of protein, urea, that is not oxidized but excreted in the urine. The latent heat of this excreted nitrogen, which amounts to 1.3 Cal for each g protein burned in the tissue cell, must be subtracted from the heat of combustion of the protein, yielding a net heat of combustion of 4.35 Cal/g (see line 3 of Table 2–1).

Since the human body is not 100% efficient in digesting and absorbing or metabolizing the major nutrients, it is necessary in determining the amount of energy available to the body from the ingested nutrient to calculate the coefficient of digestibility for each nutrient. This coefficient expresses the percentage of the nutrient ultimately available to the body as fuel value. Carbohydrates are 98% digested, fat 95% digested, and protein 92% digested; the coefficients of digestibility are 0.98, 0.95, and 0.92, respectively. However, it must be recognized that these factors may vary somewhat for any one food. Furthermore, although these coefficients apply generally in the United States, other coefficients may be more appropriate in other countries, reflecting the digestibilities of the predominant foods. The physiologic fuel value for the major energy-yielding groups are shown in the last line of Table 2–1.

The use and application of these factors can be given in illustration. A sample of milk was found to contain 4.85 g carbohydrate, 3.68 g protein, and 3.80 g fat for every 100–g sample. Using the physiologic fuel values from the last line of Table 2–1, or 4.0 for carbohydrate, 4.0 for protein, and 9.0 for fat, the 100-g sample of milk will have a caloric value of:

Carbo-
hydrate 4.85 g × 4.0 Cal/g = 19.40 Cal
Protein 3.68 g × 4.0 Cal/g = 14.72 Cal
Fat 3.80 g × 9.0 Cal/g = 34.20 Cal
 Total = 68.32 Cal

TABLE 2–1. Physiologic Fuel Value of Major Nutrients

	Carbohydrate (Cal/g)	Fat (Cal/g)	Protein (Cal/g)	Ethanol (Cal/g)
Heat of combustion	4.1	9.45	5.65	7.1
Energy from combustion of nitrogen unavailable to the body			1.3	
Net heat of combustion	4.1	9.45	4.35	7.1
Coefficient of digestibility	0.98	0.95	0.92	Small loss in urine and breath
Physiologic fuel value	4.0	9.0	4.0	7.0

TABLE 2—2. Daily Energy Needs for Various Activities*

Activity	Men (Cal/kg/hr)	Women (Cal/kg/hr)
Very light		
Seated and standing activities, painting, trades, auto and truck driving, laboratory work, typing, sewing	1.5	1.3
Light		
Walking (2.5—3 mph), electric trades, carpentry, restaurant trades, washing clothes, golf, tennis, volley ball	2.9	2.6
Moderate		
Walking (3.5—4 mph), weeding, hoeing, scrubbing floors, cycling, tennis, dancing	4.3	4.1
Heavy		
Walking with load up hill, tree cutting, working with pick and shovel, swimming, climbing, football	8.4	8.0

*Adapted from RDA, National Research Council. For adjustments for heights and example calculation see p 29 of the RDA (10)

An 8-oz glass of milk is reported to weigh 244 g and therefore has a caloric value of 68.32 × 2.44, or 166.71 Cal.

ENERGY REQUIREMENT OF ADULTS

The National Academy of Sciences' recommendations of allowances for energy in the United States (10) (see Appendix) are given for two age categories for average mature adults engaged in various occupations. The two age categories are those 23–50 years of age and those over 50. The recommendations are made for energy allowances established at the "lowest intake to be consonant with good health in each age group." Since a large number of individuals in the American population are overweight, it is quite possible they may need less energy than is recommended because of their sedentary living patterns. Adults and children with excessive amounts of body fat and yet consuming energy-containing diets consistent with their body weight, sex, and age should increase their physical activity until a desired balance is achieved. Adjustments for various degrees of physical activity for body size, and sometimes for climatic changes, are made in the recommendations. When these factors are taken into consideration and allowances for hours of sleep at 90% of the basal metabolic rate are made, as well as adjustments for height, the energy recommendations for various activity periods are as shown in Table 2–2.

AGE

Energy requirements decline progressively after early adulthood because the resting metabolic rate declines and physical activity is slowed. For this reason the energy allowances for persons above 50 years of age should be reduced to 90% of the amount required as mature adults.

PREGNANCY

Additional energy is needed during pregnancy to build new tissues in the placenta and fetus and to accommodate the increased work load of the mother associated with movement. An extra allowance of 300 Cal/day throughout the pregnancy is recommended (10).

LACTATION

Energy allowances should be increased by 500 Cal/day during the first 3 months of lactation. Allowances should be increased if lactation continues beyond this period (10).

ENERGY REQUIREMENTS FOR INFANTS, CHILDREN, AND ADOLESCENTS

During the first year of life it is recommended that allowances be reduced in steps from a level of 120 Cal/kg at birth to 100 Cal/kg by the end of the first year (10).

Energy allowances for children of both sexes decline gradually to about 80 Cal/kg through 10 years of age. After the age of 10 there is a gradual further decline to 45 Cal/kg for adolescent males and 38 Cal/kg for adolescent females.

CARBOHYDRATES

Carbohydrates, especially glucose and glycogen, serve as the chief source of readily available energy for the human body. As a class, the carbohydrates are among the most abundant compounds found in nature and the largest component, aside from water, of most diets. They provide 50%–60% of the energy of the typical American diet. In poorer nations they may reach as high as 90% of the energy of the diet. Because plant life is quite abundant in carbohydrate, plant foods serve as the least expensive form of energy for the diet. In developing nations this reliance on plant foods may reduce the intake of more-expensive proteins and fats to critically low levels with prejudice to health.

CHEMICAL CONSTITUTION AND FUNCTION

As a class the carbohydrates are composed of carbon, hydrogen, and oxygen. As a rule they contain two atoms of hydrogen for each atom of oxygen. Since this is the same proportion as in water, they are termed carbohydrates.

Of the many compounds classed as carbohydrates, a few are of special importance and interest in human nutrition and metabolism. Among these are the polysaccharides amylose, amylopectin, components of starch, and the animal starch glycogen. These large molecules are all polymers of glucose. Cellulose, also a polymer of glucose, forms a large part of the diet but cannot be utilized because of the lack of a cellulose-splitting enzyme in the human GI tract.

The disaccharides in many common foods, *e.g.,* sucrose or ordinary table sugar, lactose (found in milk), and maltose (a key component of many polysaccharides), are important in carbohydrate metabolism primarily as sources of energy.

Of prime interest in human metabolism is the monosaccharide glucose, which in phosphorylated form is the chief sugar of carbohydrate metabolism and energy production (Fig. 2–1). Two other monosaccharides, fructose, a component of the disaccharide sucrose, and galactose, a component with glucose of the milk sugar lactose, are of interest (Fig. 2–1). The three monosaccharides are also known as hex-

Fig. 2–1. Chemical structures of important monosaccharides.

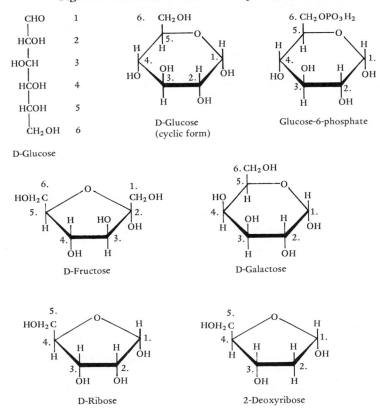

D-Glucose

D-Glucose (cyclic form)

Glucose-6-phosphate

D-Fructose

D-Galactose

D-Ribose

2-Deoxyribose

oses since each has 6 linear C atoms in their respective molecules.

Sometimes overlooked are two pentoses (5 carbons) of vital importance, ribose and deoxyribose (Fig. 2–1). These pentoses are components of nucleic acids and the nucleotides important in cellular biosynthesis and energy production.

The trisaccharides raffinose and the tetrasaccharide stachyose have been suggested as causing the flatulence that occurs after a meal rich in beans. The human small intestine does not produce an enzyme to hydrolyze these sugars.

STARCH

This important food component contains two polysaccharides: 1) amylose, a long unbranched chain of several hundred glucose units comprising about 15%–20% of starchy foods and 2) amylopectin, a major component of starch. The latter is a highly branched polymer with many glucose units. The animal starch of human liver and muscle, glycogen, resembles amylopectin but is more highly branched. Cellulose, like starch, is a polymer of glucose units in straight chains. However, the glycosidic linkages between successive glucose units in cellulose is a β-1, 4-linkage instead of the α-1, 4-linkage in starch. The human digestive system does not contain an enzyme that can hydrolyze the β-1, 4-linkage of cellulose. For this reason cellulose is not absorbable as a nutrient, but it does play a role in digestion by aiding in the maintenance of the tone of the intestine because of its bulk. Ruminants can digest cellulose because bacteria in the rumen contain cellulase, a β-1, 4-splitting enzyme.

DISACCHARIDES

Sucrose, or cane sugar, is composed of two monosaccharides: glucose and fructose. Lactose, a milk sugar, contains glucose and galactose, whereas maltose contains two glucose molecules joined by an α-1, 4-glucosidic linkage (Fig. 2–2).

MONOSACCHARIDES

D-glucose or dextrose, (see Fig. 2–1), also called grape sugar, is the chief sugar of human metabolism. It is the only hexose sugar known to exist in the free state in the human body. Blood glucose normally ranges from a concentration of

Fig. 2–2. Chemical structures of important disaccharides.

70–120 mg%, depending on the method of analysis used. Normal fasting blood sugar is about 90–100 mg%. When glucose levels rise to 160 mg%, the condition is known as hyperglycemia. Blood sugar levels below 60 mg% are characteristic of hypoglycemia. D-glucose contains an aldehyde group and is, therefore, an aldohexose.

Fructose or fruit sugar, also known as levulose, is a component of common table sugar sucrose and is found in many fruits, honey, and plant saps. It is a ketohexose (see Fig. 2–1).

Galactose along with glucose is a constituent of the milk sugar lactose. It is an aldohexose (see Fig. 2–1).

The pentoses ribose and deoxyribose are aldopentoses important in the structure of nucleic acids. D-xylose is also an aldopentose (see Fig. 2–1).

DIGESTION AND ABSORPTION

The major nutrients—carbohydrates, proteins, and lipids—are present in foods either as macromolecules or as other nonabsorbable forms and must be reduced in size before they can be

absorbed into the blood and lymph and utilized by the human body. Until this takes place, all food in the intestinal "tube" remains outside the body.

The first stage in the digestion of carbohydrates takes place in the mouth. Here starches and other polysaccharides are prepared for the catalytic activity of digestive juices by being chewed, mixed, and lubricated with saliva and formed into a bolus that can be swallowed. Some foods if not chewed fail to be digested properly and may cause intestinal flatulence. Other substances, the pith of the orange for example, if not broken up by chewing may coalesce in the stomach and form a ball, or bezoar, which can cause intestinal obstruction (2).

The digestion of starch begins almost at once when the stimulus of masticated food causes the secretion from salivary glands of a powerful starch-splitting enzyme, α-salivary amylase (called ptyalin in the older literature). This enzyme has the capacity to catalyze the hydrolysis of starch into the disaccharide maltose. The limited time food remains in the mouth before being swallowed does not permit extensive digestion. Nevertheless, the salivary enzyme mixed in the interior of the bolus can continue its starch-splitting activity until denatured by the strong acid of the stomach. Furthermore, the acidity of the gastric contents can also cause some hydrolysis of starches and simple sugars. There is no further enzymatic digestion of starches in the stomach.

The digestion of starches and carbohydrates in the lumen of the small intestine is accomplished by an α-amylase secreted in the pancreatic juice. The flow of pancreatic juice containing the amylase is stimulated by the intestinal hormones secretin and cholecystokinin-pancreozymin, produced when acid chyme is introduced into the duodenum. The optimum pH in the duodenum for pancreatic amylase is slightly on the alkaline side of neutrality, so its action is enhanced by the alkaline secretions of the pancreas and small intestine.

In the small intestine the amylose and amylopectin of food starches and the animal starch glycogen are broken down to their component disaccharides and glucose. These along with the table sugar sucrose and the milk sugar lactose and other simple dietary sugars are absorbed into the mucosal cells of the small intestine. In the microvilli of the brush border of the columnar cells of the intestinal epithelium they are further hydrolyzed to simple monosaccharides by the disaccharidases maltase, sucrase, and lactase. The end product of carbohydrate digestion —the monosaccharides glucose, fructose, and galactose—are absorbed by the portal blood.

If the function of the intestinal mucosa is impaired by disease, as in the malabsorption syndrome or for genetic reasons, patients may become intolerant of dietary sugars, which then can be lost in a watery diarrhea. Lactase deficiency of the small intestine is an example of such a condition.

Cellulose constitutes the great bulk of carbohydrates in nature and cannot be digested in the human GI tract. The human intestine does not produce a cellulase essential for the hydrolysis of cellulose. However, cellulose does contribute to mechanics of the digestive process by the stimulatory action of its fiber and bulk.

The monosaccharides are absorbed through the membranes of the mucosal cells at a rate greater than can be accounted for by such physical processes as diffusion. They are further absorbed against an increased concentration gradient. It is clear that the physiologically important sugars are absorbed by an active process requiring energy and an actively metabolizing intestinal cell as well as by a specific transport system. The various monosaccharides compete for this transport system so that individual absorptions take place at different rates. Galactose and glucose are absorbed most rapidly, followed by fructose, mannose, xylose, and arabinose in diminishing order. Xylose and arabinose are probably absorbed primarily by diffusion.

METABOLISM

Glucose can be utilized by all tissues of the body. Some tissues such as the brain use glucose exclusively as an energy source, whereas cardiac muscle uses proportionately more fatty acids for this purpose. Although glucose is the energy source normally used by the nervous system, in total starvation and after periods of adaptation, the brain can use ketone bodies formed from fatty acids and amino acids.

An obligatory reaction in the utilization of glucose by tissue cells is the phosphorylation of glucose as it passes into the tissue cell from the blood. In so doing the phosphorylated glucose (as glucose-6-phosphate) is locked into the tissue cell and commited to catabolic purposes. It is only with great difficulty, if at all, that it can diffuse back into the blood.

The phosphorylation of blood glucose by the enzyme hexokinase and the energy source ATP is an irreversible reaction because of the large

amounts of energy driving the biosynthesis of glucose-6-phosphate. This irreversibility has a number of important consequences in metabolism. It illustrates the fundamental rule that biosynthetic and degradative steps in biologic systems are always separate and distinct. Such a separation affords the body a degree of metabolic control that would not be present if both synthesis and degradation were conducted at the same time along similar pathways.

Liver glycogen is a storage form of glucose energy in the mammal. An important function of liver glycogen is to release glucose to the blood at a rate to maintain a minimal level of 90–100 mg glucose/100 ml blood. Since the hexokinase reaction described above is an irreversible reaction, this function of glucose release would not be possible were it not for an alternate pathway catalyzed by the liver enzyme glucose-6-phosphatase. This enzyme removes the phosphate moiety, enabling glucose to pass back into the blood and the tissues for oxidative purposes.

In glycogen storage disease there is a characteristic enlargement of the abdomen caused by a massive enlargement of the liver. A pronounced hypoglycemia between meals is also a characteristic symptom of this disease. This disease was first described by von Gierke in 1929. It is caused by a deficiency of glucose-6-phosphatase in the liver. In the absence of the enzyme, phosphate is not removed from glucose-6-phosphate and the liver is unable to contribute glucose to the blood, resulting in an enlarged glycogen-engorged liver and hypoglycemia. This was the first of several glycogen storage diseases to be described and is one of an increasing number of diseases recognized and designated as *inborn errors of metabolism* which are genetically determined. In muscle tissue there is no glucose-6-phosphatase, so glycogen serves its primary purpose of furnishing glucose as energy for the energy-demanding muscles.

Since the capacity to store glycogen is limited, when carbohydrate is plentiful in the diet excess glucose is converted to fat. The body has a virtually unlimited capacity to store fat and in the dietarily over-indulgent individual reveals the process in corpulence.

Once phosphorylated, glucose-6-phosphate has a number of metabolic options other than storage as glycogen, conversion to fat, or to maintain the blood glucose concentration. Its primary purpose in metabolism is to furnish an energy source for the energy-demanding and metabolizing cells. Once glucose is in the bloodstream the individual cells take it up and oxidize it at first to pyruvic acid by a process known as glycolysis and ultimately to CO_2 and water with the production of utilizable energy in the form of ATP. This latter oxidative phase takes place in the Krebs citric acid cycle located in the mitochondrion. This oxidation of glucose for energy purposes is the main thrust of carbohydrate metabolism.

Glucose can also furnish the metabolizing cells pentose sugars (ribose and deoxyribose) for nucleic acid and nucleotide synthesis and a source of reduced nicotinamide adenine dinucleotide phosphate (NADPH) for biosynthetic purposes. This takes place in the pentose or hexose monophosphate shunt or cycle.

Glucogenic amino acids can also contribute to the supply of glucose for energy purpose through the process known as gluconeogenesis.

FUNCTION AND REQUIREMENTS

The primary function of carbohydrate in the animal body is to provide a source of energy. Fat also contributes to this function to a significant degree, but carbohydrate, as glucose, is more readily available for use by the tissue cells.

Since carbohydrate, as glucose, can be made in the body from amino acids and the glycerol of fat, there is no specific requirement for this nutrient in the diet. Nevertheless, some preformed carbohydrate is beneficial in the diet to avoid ketosis, excessive breakdown of body protein, loss of cations, especially of sodium, and resulting dehydration (10).

The undigestible portion of carbohydrate in the diet furnishes fibrous matter to the intestine. Although there is no demonstrated requirement for fiber or bulk, the possible physiologic significance of this has not been adequately explored (10).

LIPIDS AND FATS

Dietary fat provides the human body with a highly concentrated form of energy. Gram for gram fat, or more precisely lipid, contains more than twice the energy (9.0 Cal/g) of either carbohydrate or protein (each 4.0 Cal/g). Ethyl alcohol more nearly approaches the energy value of fat with 7.0 Cal/g.

Lipids, like carbohydrates, contain the three elements carbon, hydrogen, and oxygen; complex lipids also contain phosphorus and nitrogen. However, unlike the carbohydrates, lipids contain much less oxygen per mole in proportion to the amount of carbon and hydrogen. In

neutral fat (triacylglycerols) for example, oxygen is confined to the ester linkages formed by the union of long hydrocarbon chain fatty acids with glycerol. Because they are anhydrous and reduced, triacylglycerols are a highly concentrated store of potential energy, and when metabolized by the tissue cell, they can combine with more oxygen and release more energy than either carbohydrate or amino acids. Since triacylglycerols are nonpolar they can be stored in a compact, nearly anhydrous form, whereas protein and carbohydrate being much more hydrated require much more tissue space.

There is, unfortunately, some inconsistency in the use of the terms fat and lipid. These terms are often considered synonymous by many people and are often used loosely, by lipid specialists. The biochemist uses the term "fat," or more properly "true fat," more precisely to refer to the esters of fatty acids, with glycerol traditionally designated as neutral fat, triglyceride, or more recently, triacylglycerols. This is the fat referred to as "visible fat," meaning butter, margarine, lard, vegetable oils, and the fat of the animal body depots. The term lipid is broader and includes the true fats, the source of energy in fat metabolism, as well as the structural and functional lipids named phospholipids, sphingolipids, cerebrosides, and the sterols.

Chemically, the lipids are a rather heterogeneous group of food substances with no common structural feature other than the presence of fatty acids, either actually or potentially, in the molecule. They are mostly insoluble in water but soluble in such organic solvents as ether, petroleum ether, chloroform, benzene, and hot alcohol.

In the United States the fat content of the average diet has steadily increased from 32% of calories in 1910 to over 41% , or about 160 g/person/day, at present. Most of these dietary lipids, about two-thirds, come from animal sources and the remaining one-third from vegetables, mostly as vegetable oils.

CHEMICAL CONSTITUTION AND FUNCTION

Functionally, the various classes of lipids can be divided as follows: 1) lipids that serve on oxidation as a source of metabolic energy and 2) lipids that form part of the structure of membranes, are concerned with the transport of fat, or serve as lipid precursors for the biosynthesis of key lipid hormones or catalysts. Cholesterol, for example, acts as a precursor for the biosynthesis of such important compounds as the bile acids, the steroid sex hormones, the adrenal cortical hormones, and vitamin D.

The simple lipid triacylglycerol, also called neutral fat and triglyceride, is the chief example of the group that is oxidized for energy (Fig. 2-3). This molecule of fat consists of glycerol, a trihydroxylic alcohol, esterified with three usually long-chain fatty acids. Naturally occurring fats in the adipose tissue are generally of the mixed type, meaning that the fatty acids represented by R_1, R_2, and R_3 are different. If the three fatty acids in the molecule were oleic, palmitic, and stearic acids, the name of the fat would be oleopalmitostearin. If all three fatty acids were palmitic acid, the compound would be tripalmitin. Triacylglycerols are the chief source of fat energy in the animal body.

The characteristic component of both simple and complex lipids is the fatty acid. Of the fatty acids found in nature, almost all are of the straight-chain type and have an even number of carbon atoms. Of these palmitic (16 C), stearic (18 C), and oleic (18 C:1) are the most commonly occurring. Human depot fat, for example, contains approximately 25% palmitic acid, 6% stearic acid, and 50% oleic acid. The fatty acids can be saturated ($-C-$) or unsaturated ($-C=C-$). The formulas of these typical fatty acids are shown in Table 2-3.

The structural and functional lipids include the phospholipids (also called phosphatides), the sphingolipids (sphingomyelin), glycolipids (cerebrosides), and the sterols.

The phospholipids are composed of glycerol, fatty acids, phosphoric acid, and a basic nitrogen compound. They contain, therefore, hydrogen, oxygen, carbon, phosphorus, and nitrogen. These differ from the triacylglycerols in that R_3 in the above structure for triacylglycerol is an inorganic acid, phosphoric acid, instead of a

Fig. 2-3. Chemical structure of triacylglycerol.

$$
\begin{array}{c}
\quad\quad\quad O \\
\quad\quad\quad \parallel \\
H_2-C-O-C-R_1 \\
| \\
\quad\quad\quad O \\
\quad\quad\quad \parallel \\
H\ -C-O-C-R_2 \\
| \\
\quad\quad\quad O \\
\quad\quad\quad \parallel \\
H_2-C-O-C-R_3
\end{array}
$$

TABLE 2–3. Composition of Typical Fatty Acids

Acid	Structure	Carbon Molecules	Double Bonds
Palmitic	$CH_3(CH_2)_{14}COOH$	16	None
Stearic	$CH_3(CH_2)_{16}COOH$	18	None
Oleic	$CH_3(CH_2)_7CH=CH(CH_2)_7COOH$	18	one

long-chain fatty acids. In addition these compounds contain nitrogenous bases esterified to the phosphoric acid. In lecithin, or more strictly phosphatidyl choline, the nitrogenous base is choline; in the cephalins (phosphatidyl ethanolamine and phosphatidyl serine) the nitrogenous base is, respectively, ethanolamine and serine. The phospholipids are key components of cellular membranes. The structures of phosphatidyl choline, a sphingomyelin, and cholesterol are illustrated in Figure 2–4.

The sphingomyelins are composed of a complex basic amino alcohol, sphingosine, with a fatty acid in amide linkage on the amino group and a phosphorylcholine group attached by way of the terminal alcohol group. Sphingomyelins are present in brain and nervous tissue.

Because of its much-discussed relationship to atherosclerosis, cholesterol is the best known of the sterols. It is also a constituent of gallstones. Cholesterol is a precursor of the bile acids, the steroid sex hormones, the adrenal cortical hormones, and vitamin D. Less is known of the metabolic origins and fates of glycolipids and the cerebrosides. The latter are found in relatively large concentrations in white matter of brain and in the myelin sheaths of nerves.

DIGESTION AND ABSORPTION

There is very little digestion of lipid in the stomach other than such small hydrolysis of lipid ester bonds that may be catalyzed by the acidity of the stomach chyme. A gastric lipase capable of mild fat-splitting is present in the stomach but does not appear to be important. A polypeptide hormone, enterogastrone, present in the duodenal mucosa, is activated by the discharge of food containing fat from the stomach. It inhibits gastric mobility and retards the discharge of food from the stomach. A meal rich in fat may therefore contribute to the feeling of satiety by delaying the emptying of the stomach, presumably by way of enterogastrone.

The introduction of acid chyme into the duodenum liberates two hormones of importance in intestinal digestion. Secretin, a polypeptide, is liberated from the duodenal mucosal

A lecithin (phosphatidyl choline)

A sphingomyelin

Cholesterol

Fig. 2–4. Chemical structures of phospholipids.

cells by the hydrochloric acid in the chyme and is carried by the blood to the pancreas, where it stimulates the flow of a pancreatic juice rich in bicarbonate. A polypeptide hormone, cholecystokinin-pancreozymin, is produced by the mucosa of the upper small intestine. It stimulates the pancreas to produce a juice rich in enzymes (as inactive zymogens) as well as bicarbonate. The cholecystokinin function of the hormone is to stimulate the contraction of the gallbladder and dilate the sphincter of Oddi.

In the small intestine, bile secreted by the gallbladder acts on the larger fat particles. Such fatty particles divide into smaller particles with greatly increased surface area, enabling the water-soluble pancreatic lipase to hydrolyze them with greater rapidity and ease. Bile salts, small quantities of fatty acids, and monoglycerides liberated by the pancreatic lipase are then able to further emulsify the fat in the alkaline medium of the small intestine (pH 6.0–8.5) with the formation of fine droplets or micelles. Once the fat molecules are reduced to a finely divided form, they are further acted on by pancreatic lipase, which hydrolyzes the triacylglycerols into fatty acids, diglycerides, monoglycerides, and glycerol. Hydrolysis is rapid at first but is slowed at the 2-monoglyceride stage. Pancreatic juice also contains phospholipases and cholesterol esterases that catalyze the hydrolysis of phospholipids and cholesterol esters.

The end product of the digestive phase is a clear emulsion of lipids, which is then absorbed into the microvilli of the mucous membrane of the small intestine. The bile salts are not absorbed into the microvilli at this point but continue down the lumen of the small intestine, where in the ileum they are reabsorbed into the blood and carried back to the liver and gallbladder for reuse. This cycle of bile acids is called the enterohepatic circulation of bile salts. Most fats are 95%–100% digestible, depending on the length of the fatty acid chain. Fats with melting points below 50°C are more rapidly and completely digested and absorbed than those with higher melting points.

The small fat particles, or micelles, pass into the intestinal mucosal cells, where further hydrolysis may take place and reesterification into new triacylglycerol molecules can take place. During this process new triacylglycerols are formed so that the neutral fat of the food loses its identity and new triacylglycerols characteristic of the human species is formed. These small new fat particles, called chylomicrons, are aggregates of triacylglycerols (80%), phospholipid (7%), and cholesterol (9%) coated with lipoproteins to produce very small particles (1 μ in diameter). The formation of chylomicrons renders the water-insoluble fat more soluble and transportable in the aqueous medium of the blood. The chylomicrons are secreted from the mucosal cell into the lacteals and lymphatics and finally into the systemic blood. Triacylglycerols that follow the lymphatic route are predominately the long-chain fatty acids. Medium-chain fatty acids (10 carbons or less) because of their greater water solubility are absorbed directly into the portal blood as free fatty acids bound to albumin.

Absence of bile in the small intestine as the result of disease or the malabsorption syndrome decreases the absorption of fat and results in an increase of undigested fat in the feces, a condition called steatorrhea.

METABOLISM

Blood lipids arising from the intestinal absorption of food fat are removed from the blood as it passes through the liver and other tissues. The triacylglycerols are hydrolyzed to fatty acids and glycerol by cellular lipases. Glycerol can be metabolized by entering carbohydrate pathways and is oxidized to CO_2 and water with the transfer of glycerol bond energy to high-energy phosphate bonds in ATP. The fatty acids arising from the adipose and other tissues reappear in the blood as components of lipoproteins. These lipoproteins facilitate the transport of water-insoluble fatty acids to various tissues where they can be oxidized via acetyl coenzyme A by removing 2 carbons at a time (β-oxidation) from the long-chain fatty acid molecule. The acetyl coenzyme A so formed can then be condensed with oxalacetate to form citric acid and oxidized in the Krebs aerobic citric acid cycle to CO_2 and water with release and capture of the large amount of potential energy in the fatty acid molecule as high-energy phosphate bond energy in ATP. Subsequently, this high-energy phosphate bond energy (ATP) can be utilized to cause molecular contractions and movement, to energize the flow and conduction of nerve impulses, to support the biosynthesis of tissues and vital metabolites, and to produce heat. When there is a diminished demand for fatty acids to be oxidized for energy purposes, the fatty acids can be stored in the fat depots for future use.

KETOSIS

The oxidation of fatty acids in the liver by β-oxidation normally produces acetoacetic acid (CH_3COCH_2COOH). At the pH of cellular fluids this acid exists as acetoacetate in its coenzyme A form (see Ch. 3). As a parent substance, acetoacetic acid can be degraded to form acetone (CH_3COCH_3) and by reduction, β-hydroxybutyric acid ($CH_3CHOHCH_2COOH$). Although this hydroxyacid is not strictly a ketone, all three substances are called ketone or acetone bodies.

Ketone bodies serve a very useful purpose in metabolism in that they can diffuse from the liver into the blood where they, especially acetoacetate, can be utilized by the muscles as a source of energy. Normally, small amounts of ketone bodies are present in the blood and urine.

Under abnormal circumstances (as in diabetes mellitus) ketone bodies can be produced in large quantities (ketosis) by the excessive production of acetoacetate by the liver. When acetoacetate, as acetoacetyl coenzyme A, is formed in the liver it has three possible options: 1) it can condense with oxalacetate and so form citric acid and be utilized as a source of energy; 2) it can be employed for the biosynthesis of fatty acids; or 3) it can be hydrolyzed to form acetoacetic acid and escape into the blood. When this latter strong acid is produced in large amounts it causes a condition called ketosis. Unless corrected, this can overwhelm the bloods buffer systems, causing ketonemia and acidosis, and in the urine ketonuria. The oxidation of some glucose seems necessary to prevent ketosis. One possible reason seems to be the need to maintain the level of oxalacetate in the citric acid cycle, a needed intermediate in the oxidation of acetoacetate to CO_2 and water via the Krebs citric acid cycle.

ESSENTIAL FATTY ACIDS

When weanling rats are placed on a fat-free diet they grow poorly and show signs of deficiency, including dermatitis, poor reproduction, lowered caloric efficiency, decreased resistance to stress, and impairment of lipid transport. If linoleic acid is present in the diet, these deficiency symptoms do not develop. Linolenic acid and arachidonic acid also prevent these symptoms. It is concluded that although mammals can synthesize saturated and monounsaturated (oleic) acids, they are unable to synthesize linoleic acid and y-linolenic acid, which contain respectively two and three unsaturated double bonds. Since linoleic acid and y-linolenic acid cannot be synthesized in mammalian tissues and are required in the diet, they are called essential fatty acids.

In tissue metabolism, the essential fatty acids have been shown to be precursors for a group of hormonelike compounds called prostaglandins. The name prostaglandin was given by the Swedish physiologist von Euler to those substances which are found in seminal plasma, the prostate gland, and the seminal vesicles. At least 14 prostaglandins occur in human seminal plasma. All the naturally occurring prostaglandins are derived biologically by cyclization of 20-carbon unsaturated fatty acids, such as arachidonic acid, which in turn is formed from the essential fatty acid linoleic acid. Therefore, the essential fatty acids can be considered necessary in the biosynthesis of the prostaglandins. The different prostaglandins have biologic activities that include lowering of blood pressure and causing smooth muscles to contract. The prostaglandins are among the most potent biologically active substances yet discovered. As little as 1 ng/ml causes contraction of smooth muscle. They have been suggested for use in prevention of conception, induction of labor at term, termination of pregnancy, the prevention or alleviation of gastric ulcers, control of inflammation and of blood pressure, and relief of asthma and nasal congestion.

REQUIREMENTS

In addition to serving as an important energy source, dietary fat serves as a carrier for fat-soluble vitamins and provides certain fatty acids that are essential nutrients. These needs can be met by a diet containing 15–25 g food fats. Therefore, except for these needs, there is no specific requirement for fat as a nutrient (10).

PROTEINS

The proteins were well named by the Dutch chemist Mulder in 1838 when he named them after the Greek *prōtos,* meaning "primary" or "holding first place." They are the most abundant organic molecule in cells and are fundamental to cell structure and function. The versatile structures of proteins enable them to act as enzyme catalysts that control the rate of biologic reactions, as carriers of essential metabolites within the organism, as regulators (hormones), and as building blocks for subcellular and cellu-

lar membranes and tissue structures. The enormous number of permutations possible from the 20-odd α-amino acids that make up protein structures forms the basis for the large number of proteins in nature.

CHEMICAL CONSTITUTION AND STRUCTURE

All proteins contain carbon, hydrogen, oxygen, and nitrogen. Some contain sulfur and others phosphorus, iron, zinc, and copper. All pure proteins on hydrolysis yield α-amino acids, which are the building blocks of protein structure. An examination of the α-amino acid structure in Figure 2–5 reveals that the molecule contains an amino group ($-NH_2$), a carboxyl group ($-COOH$), and an R group that can be aliphatic (hydrocarbon chain), aromatic as in phenylalanine, heterocyclic (tryptophan), or sulfur containing, as in methionine.

A simple amino acid such as glycine ($CH_2(NH_2)COOH$) in a solution of approximately neutral pH is doubly charged. In this

Fig. 2–5. Chemical structures of amino acids.

$$H$$
$$|$$
$$R - C - COOH$$
$$|$$
$$NH_2$$

An α-amino acid
(undissociated form)

$$H$$
$$|$$
$$R - C - COO^-$$
$$|$$
$$^+NH_3$$

Dipolar or zwitterion form

$$R_1 \quad\quad R_2$$
$$| \quad\quad\quad |$$
$$NH_2 - CH - C - NH - CH - COOH$$
$$\|$$
$$O$$

A dipeptide (showing one peptide bond)

doubly charged molecule the carboxyl group is negatively charged and the amino group is positively charged, giving the molecule a net charge of zero. Dipolar ions of this type are known as zwitterions. (see Fig. 2–5). Because of their zwitterion structure, amino acids can react both as weak acids and as weak bases, i.e., they are amphoteric. Most naturally occurring amino acids are L-α-amino acids. The simple properties briefly described above help in the understanding of protein structure.

Proteins are formed from amino acids united by peptide bonds (see Fig. 2–5). There may be many amino acids assembled from the 20-odd amino acids, and those selected determine the particular protein being synthesized. In this manner polypeptides and proteins are formed ranging in molecular size from a molecular weight of several thousand to as high as 40,000,000 as for the tobacco mosaic virus molecule.

DIGESTION AND ABSORPTION

There are no protein-hydrolyzing enzymes in the saliva, and therefore no protein digestion occurs in the mouth. The entrance of the bolus of food into the stomach stimulates the flow from the gastric glands of a strong acid juice containing hydrochloric acid and a powerful protein-splitting enzyme, pepsin. Hydrochloric acid is formed in the parietal cells of the stomach; the chief cells form pepsin in an inactive or zymogen form called pepsinogen. The formation of proteolytic enzymes in a precursor or zymogen form protects the protein structure of the enzyme-forming cells from self-digestion or autodigestion. The zymogen is activated normally, as in the case of pepsinogen, by the acid of the gastric juice. In this acid medium, pepsinogen loses a small masking section of its structure and becomes the active enzyme, pepsin.

Pepsin attacks specific peptide bonds in the food protein molecule, preferably those formed from aromatic amino acids, although peptide bonds formed by other amino acids can be hydrolyzed, but more slowly.

The entrance of the digestive mixture or acid chyme into the duodenum stimulates the hormones, secretin and pancreozymin-cholecystokinin, to cause the flow into the duodenum of a pancreatic juice rich in bicarbonate and enzymes. In the duodenum the food digest is neutralized and made slightly alkaline, producing a pH optimum range suitable for the activity of the pancreatic enzymes. In the upper small intes-

tine digestion of the dietary protein continues with pancreatic enzymes, such as trypsin, chymotrypsin, the carboxypeptidases, and dipeptidases. Again, as in the case of pepsin, these enzymes are made in the pancreas as zymogens and become active in the small intestine.

The final result of the action of proteolytic enzymes in the lumen of the small intestine is to hydrolyze proteins to peptides and amino acids. These are absorbed into the microvilli, where further hydrolysis catalyzed by peptidases in the microvilli converts them to the constituent amino acids.

The ultimate amino acids so formed in the process of digestion pass from the intestinal cell into the blood either by diffusion or by the energy-requiring process of active transport. From the intestine, the amino acids are transported by the blood of the portal vein to the liver, where they are released into the general circulation and carried to various tissues and cells for their use in repair and synthesis.

METABOLISM

Food proteins provide amino acids for the biosynthesis of body proteins and nitrogenous constituents for the synthesis of other tissue constituents. Since the body is in dynamic equilibrium, proteins themselves are constantly degraded and resynthesized. Some amino acids are reused for the synthesis of new tissue. However, the normal process of catabolism of amino acids removes the amino group. This can be converted to urea in the liver and excreted through the kidney into the urine. The keto acid remaining after removal of the amino group can enter the Krebs aerobic cycle and be oxidized to CO_2 and water with the release of bond energy, which can be stored as ATP.

Amino acids cannot be stored as such and when consumed in excess of the amount needed are rapidly degraded and secreted.

NITROGEN BALANCE

Nitrogen balance implies the balance between intake and output of nitrogen in the body. Here it should be pointed out that nitrogen is found also in other compounds than amino acids. Nonprotein nitrogen is present, for example, in urea, uric acid, ammonia, creatine, creatinine, and in other body tissues and fluids. A subject is said to be in N balance when the nitrogen intake in the diet equals the nitrogen output in the urine,

feces, and skin. The term negative nitrogen balance is used when the output of nitrogen exceeds the intake. Positive nitrogen balance refers to that state in which the intake of nitrogen exceeds its output.

ESSENTIAL AND NONESSENTIAL AMINO ACIDS

The human body can synthesize some amino acids. However, there are nine amino acids—histidine, isoleucine, leucine, lysine, methionine, phenylalaine, threonine, tryptophan, and valine—that either cannot be synthesized in mammalian tissues or in certain periods of life cannot be synthesized rapidly enough to fully supply the needs of the human. For example, histidine is required in the diet to maintain growth during childhood. These indispensable amino acids are called essential amino acids. They are essential in the diet in adequate amounts to maintain nitrogen balance.

PROTEIN QUALITY

The nutritive value of a protein depends on the relation of its amino acids to those required for the building of new tissue. A diet that is deficient in one or more of the essential amino acids cannot maintain nitrogen equilibrium. If however, the missing amino acid is provided by another protein added to the diet, nitrogen equilibrium and normal nutrition can be established. It is clear therefore that the quality of a protein depends on the balance of amino acids, especially the essential amino acids, that are present in the protein in question. In man, the protein requirement must be considered on the basis of the quality and not merely on the quantity of the protein. It is not just a matter of the total amount of protein needed but of the specific amino acids needed. Since the nonessential amino acids can be synthesized in the human body, it is the essential amino acids that are critical to the diet. All the amino acids necessary for the biosynthesis of a protein must be present at the same time, or the protein will not be formed.

PROTEIN ALLOWANCES

The National Academy of Sciences recommended dietary allowances (10) is based on an average requirement of 0.47 g protein/kg body weight/day. This value has been obtained by nitrogen balance studies and has been increased

further by 30% to take into account individual variability, giving allowances of 0.6 g/kg/day of high-quality protein. This value has been further increased by allowing for a 75% efficiency of utilization. The total recommended allowance, therefore, for mixed proteins in the United States diet is 0.8 g/kg body weight/day. The allowance for a 70-kg man is 56 g protein/day and for a 58-kg woman, 46 g.

The allowance for children is based on the amount of milk consumed and on the amount known to insure a satisfactory rate of growth. For ages up to one-half years the allowance is kilograms weight × 2.2; for one-half years to one year it is kilograms weight × 2.0 (10) (see Table A-1).

An additional 30 g protein/day is recommended for the pregnant woman, from the second month until the end of gestation, as a supplement to the 1.3 g protein/kg body weight recommended for a mature woman. For pregnant adolescents and for younger girls see the Tables of Allowances in the Appendix.

Lactation requires an additional 20 g protein/day above the maintenance allowance to cover the requirement for milk production and to allow for 70% efficiency of protein utilization.

REFERENCES

1. Bogert J, Briggs GM, Calloway DH; Nutrition and Physical Fitness, 9th ed. Philadelphia, WB Saunders, 1973
2. Davidson S, Passmore R, Brock JF, Truswell AS: Human Nutrition and Dietetics, 6th ed. New York, Churchill Livingstone, 1975
3. Guthrie HA: Introductory Nutrition, 3rd ed. St Louis, CV Mosby, 1975
4. Handbook on Nutritional Requirements. Food and Agriculture Organization of the United Nations, FAO Nutritional Studies No. 28, WHO Monograph Series 61, Rome 1974
5. Harper, HA: Review of Physiological Chemistry, 15th ed. Los Altos, Lange Medical Publications, 1975
6. Lehninger AL: Biochemistry, 2nd ed. New York, Worth Publishing, 1975
7. Mountcastle VB (ed): Medical Physiology, Vols I and II, 13th ed. St Louis, CV Mosby, 1974
8. Orten JM, Neuhaus O: Human Biochemistry, 9th ed. St Louis, CV Mosby, 1975
9. Oxygen Bomb Calorimetry and Combustion Methods. Technical Manual No. 130, Parr Instrument Co, Moline, Illinois, revised 1968
10. Recommended Dietary Allowances, 8th ed. Washington DC, National Academy of Sciences, 1974
11. Stryer L: Biochemistry. San Francisco, WF Freeman, 1975
12. Vander AJ, Sherman JH, Luciano DS: Human Physiology. The Mechanisms of Body Function, 2nd ed. New York, McGraw-Hill, 1975

3 Vitamins

Carl E. Anderson

It is not possible to sustain life in animals fed and maintained on a chemically defined diet containing only purified proteins, carbohydrates, fats, and the essential minerals and water. Additional "accessory food factors" called vitamins are necessary, although often they are required in only minute amounts. The amount required daily may be as low as a few micrograms to as high as 30 mg.

The first successful preparation of an essential food factor was obtained by Casimir Funk, a Polish biochemist working in the Lister Institute in London. He obtained a potent antiberiberi substance from rice polishings. Since the active factor was an amine and necessary for life, he called it a "vitamine." As work by many others progressed and other "vitamines" were discovered it was found that only a few were "amine" in nature, and so the final *e* was dropped to give the now-general term vitamin. Although a strict definition describing vitamins may be of only modest value, it does help jog the memory.

The vitamins are organic substances that the body requires in small amounts for its metabolism, yet cannot make for itself at least in sufficient quantity. For the most part they are not related chemically and differ in their physiologic role.

This definition holds reasonably true, yet in the light of the most recent work it may not be strictly so. Niacin and vitamin K can be made in the body, but perhaps not in sufficient amounts to allow the neglect of dietary sources. Niacin can be synthesized from the amino acid tryptophan. Vitamin K is a product of intestinal bacterial synthesis, is absorbed, and is, therefore, a nondietary source of the vitamin. In addition to being present as a dietary source, vitamin D can be produced in one human organ, the skin, and can effect such distant target organs as the intestine and bone, and therefore resembles a hormone in its activity.

During 1913–1914, McCollum and Davis extracted a factor from butter fat which they called "fat-soluble A" to distinguish it from the water-soluble unidentified dietary essential called the antiberiberi substance. These two dietary essentials became vitamin A and vitamin B (23). As one by one the vitamins were discovered, each was assigned a letter. The antiscorbutic factor became vitamin C, the antirachitic factor vitamin D, the antihemorrhagic factor, vitamin K, and so on. When through isolation and synthesis the chemical structure of the vitamin became known it was given a specific chemical name. Vitamin B_1 (other members of the B-complex vitamins were discovered, such as B_2 and so on) became thiamin and the antiscorbutic vitamin C became L-ascorbic acid. It was assumed the chemical name assigned the vitamin applied to a single chemical substance of definite activity. It is now clear that some vitamins consist of several closely related compounds. The term vitamin A is now used to refer collectively to all active and synthesized forms of the vitamin, vitamin A alcohol is now retinol, vitamin A aldehyde, retinal, and vitamin A acid, retinoic acid.

There are 13 or 14 vitamins essential in the human diet (Fig. 3–1). The higher figure is used if the person involved considers one or more of the vitamins in the diet not in conformity with the definition of a vitamin. Some, for example, do not consider choline a vitamin, although it is of importance in metabolism. The need for this substance for humans has not been proved, and it is retained in the classification as a vitaminlike substance.

The division into fat-soluble and water-soluble vitamins is retained because the four fat-soluble vitamins have some properties in common, although physiologically and structurally, they are quite different. For example, the lipid-soluble vitamins are absorbed from the intestine with dietary lipids. In the malabsorption syndrome (involving the failure of absorption of fat, resulting in steatorrhea) all the fat-solu-

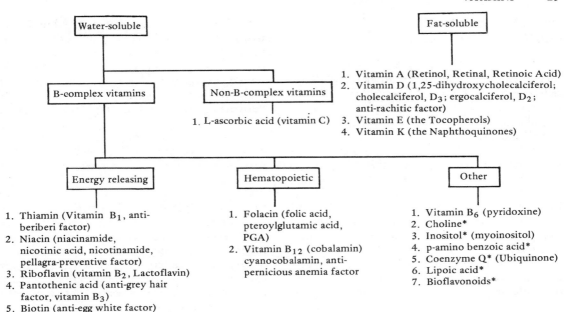

Fig. 3–1. The vitamins.

ble vitamins may be excreted, whereas the water-soluble vitamins may not be affected. Also, as a consequence of their lipid solubility significant quantities of the lipid-soluble vitamins are stored in the liver, but the storage of water-soluble vitamins is not significant. Therefore, although it is possible to administer a several weeks' supply of the lipid-soluble vitamins in a single dose, the water-soluble vitamins must be supplied frequently.

The B-complex vitamins are further separated into the group of energy-releasing vitamins, the vitamins concerned with blood formation (the hematopoietic group), and "others," a catch-all group with miscellaneous functions but still essential or important in metabolism.

There are similar properties and functions among the energy-releasing group of vitamins in that they all are components of enzyme systems as components of coenzymes. They have the ever-vital function in living cells of assisting in the capture of energy. The remaining non-B-complex vitamin is ascorbic acid, which is important in the synthesis of connective tissue.

Although at present there is a vast body of information on the vitamins, there are only the most meager clues to the mechanism connecting, in the vitamin deficiency, the tissue lesion with the biochemical defect. Much good research remains to be done.

THE WATER-SOLUBLE VITAMINS

THE ENERGY-RELEASING VITAMINS

THIAMIN (VITAMIN B_1)

FUNCTION. The principal role of thiamin, the antiberiberi vitamin, is as part of the coenzyme thiamin pyrophosphate in the oxidative decarboxylation of alpha-keto acids (see Table A-14). In animal cells this coenzyme plays a critical role in the attainment of energy. The decarboxylation of pyruvate to "active acetate," or acetyl coenzyme A, connects the glycolytic cycle of carbohydrate metabolism with the high energy–producing Krebs or citric acid cycle. Similarly, the decarboxylation of α-ketoglutaric acid to succinyl coenzyme A is a key step in the energy-producing Krebs cycle itself. In these steps other energy-connected vitamins and vitaminlike substances, i.e., lipoic acid, pantothenic acid, nicotonic acid, and riboflavin, also are involved. Thiamin also has a role in the conversion of the amino acid tryptophan to nicotinic acid and nicotinamide. It has been shown that

tryptophan normally contributes to the niacin supply of the body.

DEFICIENCY. A thiamin deficiency in animals, including the human, is called beriberi (Singhalese *beri*, weakness or I can't). It is characterized biochemically by an accumulation of pyruvic and lactic acids, particularly in the blood and brain. There is impairment of cardiovascular, nervous, and GI systems. The neurologic changes are believed by some to be due to other concomitant vitamin deficiencies. However, neurologic lesions have been induced by thiamin deficiency in pigeons and rats, and some evidence indicates that neurologic lesions in man can result from a thiamin deficiency.

The deficiency disease beriberi has been known since earliest time. In rice-eating people, it is endemic because of the still widespread consumption of decorticated or polished rice. In the Western world, particularly in the United States and Europe, where the diet contains more thiamin, the disease is rarely seen except in alcoholism, food faddism, and sometimes in the malabsorption syndrome. In the alcoholic, the deficiency may lead to Wernicke's disease and Korsokoff's syndrome (see Ch. 13). Here it is of importance to differentiate whether the Wernicke–Korsokoff syndrome is due to the alcohol consumed or to other causes of a thiamin deficiency. Irreversible brain damage may occur unless the disorder is recognized early and treatment properly instituted.

Beriberi can be separated into three forms: 1) wet beriberi, 2) dry beriberi, and 3) infantile beriberi. There are early clinical features common to both wet and dry beriberi. The deficient person tires easily, his limbs feel heavy and weak, and mild degrees of swelling may appear around the ankles. The legs may become numb, and a feeling of "pins and needles" in the leg may appear. Palpitation of the heart may occur. At this stage a close examination may reveal reduced motor power, alterations in gait, and patchy anesthesia over the skin of the lower legs. A better diet or thiamin administration can improve the condition. If left untreated the disease will progress to either the wet or dry beriberi.

In wet beriberi the main feature of the disease is the accumulation of edema fluid in the legs and often in the scrotum, face, and trunk. Cardiac palpitations, chest pains, and dyspnea may develop. The pulse is rapid and often irregular. The neck veins are distended with visible pulsations and the heart becomes enlarged. In spite of the edema the urine contains no albumin—an important diagnostic feature. Wet beriberi must be distinguished from renal edema and congestive cardiac failure. In both of the aforementioned conditions there is albuminuria; in beriberi there is none. A person with wet beriberi is in danger of rapid deterioration, acute circulatory failure, and death.

Dry beriberi is so called because edema is not a feature of the disease. The condition is similar to peripheral neuritis. A common feature is anesthesia and paraesthesia of the feet followed by difficulty in walking, a peculiar ataxic gait, foot drop, and wrist drop. Muscular wasting may occur, and anesthetic patches (especially over the tibia) occur. Tenderness of the calves and other muscles when pressure is applied may be present. The person may have great difficulty in rising from the squatting position. The disease may be chronic, and a better diet or thiamin supplementation improves the disease in most instances. Untreated the disease progresses; the person becomes bed ridden and often dies of some chronic infection.

Infantile beriberi may occur in otherwise normal infants under 6 months of age receiving inadequate thiamin in the milk of a lactating mother, particularly if her diet is deficient in thiamin. The mother may not present overt signs of beriberi. Infantile beriberi often occurs between 2–6 months of age. In the acute form the infant develops dyspnea and cyanosis and dies rapidly of cardiac failure. Aphonia may be present, and the infant may appear to be crying without emitting much sound. Diarrhea, wasting, and vomiting may occur. Edema is sometimes seen and convulsions may occur at the terminal stage. Measurement of thiamin in the blood is of limited value. Most useful are determinations of lactate and blood pyruvate, especially if performed after glucose administration and exercise.

CHEMICAL PROPERTIES AND STRUCTURE. Thiamin hydrochloride is a compound consisting of a pyrimidine ring joined by a methylene bridge to a thiazole nucleus. The bond between the two rings is weak with the result the compound is easily destroyed in an alkaline medium. The active coenzyme form is thiamin pyrophosphate (see Table A-14).

Thiamin is highly soluble in water and will resist destruction at temperatures up to 100° C. Since it can be destroyed if heated above 100° C, it will be destroyed in food fried in a hot pan or cooked too long under pressure. Because of its

solubility thiamin is easily leached out of food being washed or boiled.

ABSORPTION AND METABOLISM. Thiamin and its salts are easily, under normal conditions, absorbed from the small intestine. As with most of the water-soluble vitamins, the body is unable to store thiamin in any great quantity.

Liver, heart, and brain have higher concentrations of the active vitamin than muscle tissue or other organs. A person on a high-thiamin intake becomes saturated and begins to excrete increased quantities in the urine.

SOURCES. Thiamin is found in foods of both animal and vegetable origin. The richest sources among commonly eaten foods are pork, whole grains, enriched cereal grains, and legumes. Green vegetables, fish, meat, fruits, and milk all contain useful quantities. In cereals the vitamin is present mainly in the germ and in the outer coat of the seed. Much of the vitamin is lost if cereals are milled and refined.

REQUIREMENT. The activity of thiamin hydrochloride is expressed in milligrams of the chemically pure and synthesized substance. From 1.2 to 1.5 mg daily is recommended for the human male. Similar amounts are recommended for women. For allowances in pregnancy and lactation and in children, see Appendix Table A-1.

TOXICITY. Taken in excessive amounts thiamin is excreted in the urine and hence has no known toxicity. The kidney has no known threshold. Intolerance to thiamin is rare; daily doses of 500 mg have been administered for as long as a month without ill effects. A few cases of sensitization have been described following repeated parenteral injections.

NIACIN

The discovery of niacin (nicotinic acid, nicotinamide, pellagra-preventive factor) and its association with the disease pellagra are closely linked. Pellagra was first described by Casals, a physician in Spain in 1730, soon after the introduction of corn (maize) into Europe. It was given its name (It. *pelle*, skin, + *agra*, rough) in 1771 by an Italian physician, F. Frapolli. The disease seems to have spread with the cultivation of corn, but it was not until 1917, that Goldberger, studying the disease among the poor and those in prisons in southern United States, confirmed his theory that the incidence of the disease is closely related to the quality of the diet and that certain foods (*e.g.,* yeast, milk, and meat) are pellagra preventive and can be used to treat the disease.

In 1916 TN Spencer (45) a veterinarian of Concord, North Carolina, first called attention to the similarity between the symptoms of a spontaneous canine disease known to veterinarians as "blacktongue," and those of human pellagra. He diagnosed blacktongue as pellagra in dogs, and from his successes in curing the animals by giving them milk, eggs, and meat, he concluded that it was caused by a diet low in nitrogen.

In 1937 Elvehjem *et al.* (10,35) working at the University of Wisconsin found that nicotinic acid was effective in curing blacktongue in dogs and pellagra in man. Shortly thereafter the use of nicotinic acid in treating human pellagra brought dramatic curative results.

FUNCTION. Niacin (nicotinic acid) is an essential part of the enzyme system concerned with hydrogen transport (oxidation) in living cells. It is the functional group of two coenzymes: 1) nicotinamide adenine dinucleotide (NAD) and 2) nicotinamide adenine dinucleotide phosphate (NADP). As coenzyme components of dehydrogenase enzyme systems they assist in removing hydrogen from (oxidation of) the food substrate and then passing the hydrogens on to other components of the respiratory chain. At the end of the chain hydrogen is united to oxygen to form water. The energy released during the oxidation of the food substrate is captured as high-energy adenine triphosphate. This energy can then be released and transformed into other forms of energy (*e.g.,* mechanical, heat, the energy required for synthesis, and nervous energy) and used in other energy-requiring cellular functions.

DEFICIENCY. The specific disease caused by a deficiency of niacin is pellagra. The disease involves the skin, GI tract, and central nervous system. It progresses through dermatitis, diarrhea, depression, and unless corrected death. These are the four D's well known to medical students. The typical features of the disease are increasing weakness and a characteristic rash found only on the surfaces of the body exposed to the sun or heat. Early symptoms include glossitis, stomatitis, insomnia, anorexia, weakness, irritability, abdominal pain, burning sensations in various parts of the body, numbness, forget-

fulness, marked fears, and vertigo. There are ill-defined disturbances of the alimentary tract with changes of bowel function. Patients debilitated and weakened by diarrhea often die from infection or become subjected to mental disorder.

CHEMICAL PROPERTIES AND STRUCTURE. Niacin is a simple derivative of pyridine and is very stable. It is a water-soluble, white compound that is moderately resistant to heat and to both acid and alkali.

The human body has the ability to convert the amino acid tryptophan to niacin. It is believed that about 60 mg dietary tryptophan is equivalent to 1 mg niacin. Diets in the United States often contain 600 mg or more tryptophan, and this provides a substantial contribution to the niacin pool. For the structure of nicotinic acid and nicotinamide, see Table A-14.

SOURCES. Niacin is widely distributed in plants and in animal foods, but in most cases in small amounts. Particularly rich sources of niacin are lean meats (especially liver), peanuts, yeast, and cereal bran and germ. The main source in the diet is frequently the cereal staple consumed. Whole grain or lightly milled cereals contain more niacin than refined cereal grains and flours. Niacin is now often added to many manufactured food products, especially those made from cereals.

Corn is poor in niacin, and its principal protein, zein, is very low in tryptophan, a biosynthetic source of the vitamin. There is evidence that some of the niacin in corn is present in a bound form that may not be available.

REQUIREMENT. Estimations of niacin requirements are complicated by the fact that tryptophan is converted to niacin in man and by the paucity of studies of diets and of people at different ages. The allowance recommended for adults, expressed as niacin, is 6.6 mg/1000 Cal, and not less than 13 mg at caloric intakes of less than 2000 Cal. There is no data on the niacin requirements of children from infancy through adolescence. However, for recommendation, see Table A-1. There is no information on the niacin requirements of pregnant and lactating women.

TOXICITY. Niacin is related chemically to nicotine but has quite different physiologic properties. It is essentially nontoxic. Niacin (but not niacinamide) acts as a vasodilator and, therefore,

may cause flushing of the skin, dizziness, and nausea. These symptoms are temporary and not harmful but may be disturbing to those not aware of this physiologic effect.

RIBOFLAVIN

Riboflavin functions as a coenzyme or active prosthetic group in a group of flavoproteins concerned with tissue oxidation and respiration. Despite its fundamental role in the respiratory cycle as a hydrogen acceptor in energy and protein metabolism, no recognized disease is associated with an exclusive deficiency of riboflavin.

Riboflavin was discovered during the search for a hypothetical heat stable vitamin B_2. Using its growth-promoting properties in the rat, Kuhn and his colleagues in 1933 finally isolated from 5400 liters milk 1 g active crystalline riboflavin. Unfortunately, it did not have the properties previously ascribed to vitamin B_2, e.g., curing blacktongue in dogs. It was clear, therefore, that riboflavin was just another of several factors present in the heat-stable fraction of the vitamin B complex.

An important clue to the nature of Kuhn's crystals was that they had a yellow color. A year earlier Warburg and Christian described a "yellow enzyme," a respiratory catalyst capable of acting as a hydrogen acceptor and donor. Riboflavin and Warburg's yellow enzyme were found to be identical. The yellow enzyme proved to be a flavoprotein comprising a flavin pigment linked to a protein carrier. In 1935 riboflavin was synthesized by two independent groups, Kuhn and his colleagues in Heidelberg and Karrers' group in Basle.

FUNCTION. Combinations of riboflavin and various proteins form enzymes that function in tissue respiration as components of the electron-transport system. These include L-amino and D-amino oxidases, xanthine oxidase, cytochrome-c reductase, and a number of dehydrogenases. The flavin coenzyme or prosthetic group is usually flavin adenine dinucleotide (FAD), or in some instances it can be flavin mononucleotide (FMN). The flavoproteins, therefore, are an important group of enzymes involved in oxidation–reduction reactions.

DEFICIENCY. Characteristic lesions of the lips, the most common of which are angular stomatitis and cheilosis, occur in the deficiency. Localized seborrheic dermatitis of the face, a particu-

lar type of glossitis (magenta tongue), and certain functional and organic disorders of the eyes may result from riboflavin deficiency. Many of these symptoms are not due to riboflavin deficiency alone but result from other deficiencies of the B complex group.

CHEMICAL PROPERTIES AND STRUCTURE. The riboflavin molecule consists of an isoalloxazine nucleus with a ribityl side chain attached to the middle ring, as shown in the structure of riboflavin (see Table A-14). It is an orange-yellow crystalline compound. It is water soluble and heat stable, especially in acid solution, but is easily decomposed by light. It exhibits a yellow green fluorescence in water solution.

ABSORPTION AND METABOLISM. Riboflavin is readily absorbed from the small intestine. It is phosphorylated in the intestine, liver, and other tissues. The bulk of riboflavin in the body is stored to a limited extent in the liver, heart, and kidney. In man, riboflavin is excreted predominantly in the feces. Fecal riboflavin arises both from the intestinal wall and bacterial synthesis. It is excreted in the urine to some extent as riboflavin or riboflavin phosphate.

SOURCES. Riboflavin is widely distributed in plant and animal tissues. The best food sources include milk, eggs, liver, kidney, heart, and green leafy vegetables.

Riboflavin is lost in appreciable quantities in food preparation if the food is cooked while exposed to light. Losses also occur in dehydrated vegetables. Considerable quantities of riboflavin can be destroyed in milk if it is bottled and exposed to sun or bright daylight for any length of time.

REQUIREMENTS. Recommended allowances are 0.4 mg–0.6 mg for infants, 0.8–1.2 mg for children, 1.3–1.8 mg for males depending on age, and 1.1–1.3 mg for females. Increases as shown in the Appendix Table A-14, are made for pregnant and lactating women.

TOXICITY. There is no evidence of toxicity when large amounts are consumed in the human.

PANTOTHENIC ACID

Pantothenic acid is an essential vitamin to the nutrition of man, many species of animals, plants, bacteria, and yeast. Because of its widespread occurrence in food it was named from the Greek work *pantos,* meaning everywhere. It had been called vitamin B_3 and was given its present name by its discoverer, RJ Williams, in 1938. It occupies a central and basic role in the metabolism of carbohydrate, fat, and protein because of its position and role as a part of the structure of a key enzyme in metabolism, coenzyme A (Fig. 3–2).

FUNCTION. As a constituent of coenzyme A, pantothenic acid is essential to a number of fundamental reactions in metabolism. It participates in this way in the release of energy from the catabolism of all three energy yielding nutrients, *i.e.,* carbohydrate, fat, and protein. The acetyl coenzyme A that is formed from the three major nutrients combines with oxaloacetic acid to form citric acid, which initiates the citric acid or Krebs oxidative cycle, with the liberation and capture of the bond energies involved as high-energy adenosine triphosphate.

Pantothenic acid is involved in providing acetyl groups in the formation of acetyl choline

Fig. 3–2. Coenzyme A (CoA).

β-Mercaptoethylamine unit

Pantothenate unit

and with the sulfonamide drugs, which are acetylated prior to excretions.

Although a major function of pantothenic acid is in conjunction with its role as a constituent of coenzyme A, a protein-bound pantothenic acid is contained in a compound known as acyl carrier protein (33). Acyl carrier protein is a coenzyme required in the biosynthesis of fatty acids.

Pantothenic acid as a component of coenzyme A is also concerned with the biosynthesis of cholesterol and other sterols and of porphyrin, a component of hemoglobin.

Because of its role in energy metabolism, it can be considered to be vital to all energy-requiring processes within the cell.

DEFICIENCY. In man, pantothenic acid deficiency has been produced in volunteers by the use of a purified diet and a specific antagonist. Evidence of dietary deficiency has not been clinically recognized in man, and the administration of a metabolic antagonist appears to be necessary to produce clinical symptoms (15). The symptoms noted include fatigue, sleep disturbances, personality changes, nausea, abdominal distress, numbness and tingling of hands and feet, muscle cramps, impaired coordination, and loss of antibody production. All symptoms were cured by the administration of the vitamin. A well-defined pantothenic acid deficiency has not been observed in man under normal conditions, but it is an essential nutrient for all animal species that have been investigated.

In the rat, pantothenic acid deficiency is characterized by retardation of growth, impaired reproduction, graying of the hair of black rats, and hemorrhagic adrenal cortical hypofunction. This may be related to reports that indicate that the synthesis of coenzyme A from free pantothenic acid can take place in the zona fasciculata of the adrenal cortex. Pantothenic acid neither prevents nor cures graying of hair in the human, contrary to claims so made.

Calcium pantothenate has been used successfully in treating paralysis of the GI tract after surgery, which causes the accumulation of gas and severe abdominal pain. It may act by stimulating GI motility. High levels of the acid (10–20 g) cause diarrhea. Intestinal bacteria synthesize considerable amounts of pantothenic acid. This, together with its widespread natural occurrence, makes a deficiency unlikely.

CHEMICAL PROPERTIES AND STRUCTURE. Pantothenic acid is a pale yellow oily liquid that has never been crystallized, although its calcium salt crystallizes readily. It is generally available in this latter form. Though stable in neutral solution, it is easily destroyed both on the acid and alkaline side of neutrality. It is readily soluble in water, somewhat soluble in ether, and practically insoluble in benzene and chloroform.

The acid is a β-alanine derivative with a peptide bond linkage (see Table A-14). It is a component of coenzyme A, the critically essential cofactor for acylation reactions in the animal body (see coenzyme A, Fig. 3–2). As a component of coenzyme A, pantothenic acid is involved in the intermediary metabolism of carbohydrate, fat, and protein, leading to energy release, synthesis of fatty acids and sterols, gluconeogenesis, and many other essential reactions (20).

SOURCES. Pantothenic acid is widely distributed in food, especially in foods from animals sources. The best sources are liver, kidney, egg yolk, yeast, wheat bran, and fresh vegetables (100–200 μg/g dry material); broccoli, lean beef, skimmed milk, sweet potatoes, and molasses are fair sources (35–100 μg/g dry material). It is probably synthesized by intestinal bacteria.

In most cooking and baking procedures there is little loss of the vitamin, but temperature above the boiling point may cause considerable loss. Frozen meat may lose much of its original content in the drip that occurs with thawing.

REQUIREMENT. Pantothenic acid is readily available in most foods, and isolated dietary deficiencies are unlikely. Some subclinical deficiencies may be found in individuals who are greatly malnourished.

There is not yet adequate evidence on which to base recommended allowance for pantothenic acid. Dietary intake in the adult population is 5–20 mg/day. Diets that meet nutritional needs of children contain 4–5 mg/day of the vitamin. A daily intake of 5–10 mg is thought to be adequate for adults, with the upper level suggested for pregnant and lactating women.

TOXICITY. Toxicity from large intakes of pantothenic acid is not known to occur in man.

BIOTIN

Biotin is a water-soluble vitamin that is widely distributed in nature and is essential for many animal species including man (53). The addition

of 15%–30% raw, dried egg-white as a source of protein to a diet low in biotin will induce symptoms of biotin deficiency. Raw egg-white contains a glycoprotein, avidin, which binds biotin into a large biotin-avidin complex that cannot be absorbed from the GI tract.

Biotin was crystallized in 1936. It was given the name biotin because it is part of the "bios" factor needed for yeast growth, but early in the research of biotin deficiency it was also called the "anti-egg-white injury factor." Cooking denatures avidin so that it loses its ability to bind biotin and prevent absorption.

Ordinarily, biotin deficiency does not occur in man except when induced experimentally. In the human, a diet must provide 30% of its calories from egg white to induce a biotin deficiency. Since this represents the egg whites from more than two dozen eggs it is obvious that a reasonable intake of egg white will not precipitate a deficiency state.

FUNCTION. Biotin is one of the most-active biologic substances known. As little as 0.005 μg stimulates the growth of yeast and certain bacteria. In foods and tissues, biotin occurs bound to protein as part of an enzyme system (26).

Biotin functions primarily as a coenzyme for enzymatic reactions involving the addition of carbon dioxide to other units. Termed carbon dioxide fixation, this process is a means of lengthening carbon chains.

Biotin is of prime importance in the carboxylation that occurs in the conversion of pyruvic acid in mitochondria to oxaloacetate. This bypass of the pyruvate dehydrogenase system serves to replenish oxalacetate under metabolic conditions where there is a strain on the supply of α-keto acids, as in gluconeogenesis.

Biotin as a coenzyme carrier of carbon dioxide is essential for the carboxylation that occurs in the conversion of acetyl coenzyme A to malonyl coenzyme A in the biosynthesis of fatty acids. In a similar manner it functions in the conversion of propionyl coenzyme A to methylmalonyl coenzyme A in reactions involving the oxidation of odd-numbered carbon chains.

There are studies indicating that biotin may be involved in carbohydrate and protein metabolism. However, evidence for its role in these reactions is either meager or indirect (6).

DEFICIENCY. The effects of a biotin-deficient diet in animals are varied but seem to be characterized by early changes in the skin. Rats fed large amounts of egg white develop an eczemalike dermatitis characterized by either scaliness or hardening of the affected area and often starting as a characteristic alopecia in the region of the eye. This is sometimes called "spectacle eye." Loss of hair and muscular atrophy follow these signs.

Although no evidence exists of a natural biotin deficiency in human adults, evidence has suggested that two types of dermatitis, Leiner's disease and seborrheic dermatitis (which occurs in infants), may be caused by a lack of the vitamin. Both of these conditions respond rather dramatically to biotin therapy, although a similar condition in adults is not responsive.

Yeast and bacteria of many species either make or retain biotin. Conditions that reduce the number of microorganisms in the diet may reduce the amount of biotin synthesized. Sulfonamides and oxytetracycline are known to reduce the number of biotin-synthesizing organisms. It is possible, therefore, that some of the symptoms that develop with the use of sulfonamides may be evidence of biotin deficiency since biotin administration seems to counteract these antibiotics.

In a study of four human subjects, Sydenstricker et al. (51) showed that biotin is a dietary essential for man. They produced a biotin deficiency by feeding four volunteers a diet very poor in all vitamins of the B-complex except riboflavin supplied by the egg white. The diet was supplemented with dried uncooked egg white, which is high in avidin. The symptoms that developed were similar to those of thiamin deficiency, including dermatitis, glossitis, loss of appetite, nausea, loss of sleep and depression, muscle pains, and a high blood cholesterol. An injection of a concentrated preparation containing 150–300 μg biotin daily brought about a marked improvement of symptoms in 3–4 days.

A spontaneous case of biotin deficiency was reported by Scott (41) in a boy with bulbar poliomyelitis who had received six raw eggs daily by gastric tube for 18 months. He developed scaly dermatitis.

Baugh et al. (2) reported a deficiency in a man with cirrhosis of the liver who consumed raw eggs.

A biotin deficiency has been described by Williams (57) in a man whose diet consisted mainly of six dozen raw egg whites daily, washed down by four quarts of red wine. He developed a severe dermatitis that responded to injections of the methyl ester of biotin.

CHEMICAL PROPERTIES AND STRUCTURE. Biotin is a white compound stable to heat in cooking, processing, and storage. However, being a somewhat water-soluble vitamin, losses will occur during cooking. It is relatively insoluble in chloroform, ether, and petroleum ether. In 1942 biotin was synthesized and its structure determined (see Table A-14). Like thiamin it contains sulfur in its molecule. It is labile to alkali and oxidation.

Biotin has been isolated in at least five active forms. One of these, biocytin, is a combination of biotin with the amino acid lysine which may represent a fragment of the protein–coenzyme complex. Other important forms are biotin sulfone, a potent antagonist, and biotinal, which can be oxidized to an active form.

Protein-bound biotin in animal tissues is fat soluble, and the active substance in plants is water soluble. The bound form is liberated by the action of proteolytic enzymes, and therefore the linkage is believed to be peptide in nature.

SOURCES. Biotin is present in almost all foods particularly those known to be good sources of the B-complex vitamins. Human milk contains an average of 0.16 μg/100 ml and seems little affected by variations in diet (29). Human milk has only one-tenth as much biotin as cow's milk. Liver, kidney, milk, egg yolk, and yeast have been shown by biologic assay to be the richest sources. Pulses, nuts, chocolate, and some vegetables, e.g., cauliflower, are fair sources. Animal meats (except for those listed above), dairy products, and cereals (unless fortified) are relatively poor sources. Except for cauliflower, nuts, and legumes, most vegetables are poorer in content than the meats. Most diets contain 150–300 μg biotin, which is supplemented by bacterial intestinal synthesis that is stimulated by sucrose in the diet.

REQUIREMENT. It is believed that the body uses approximately 150 μg/day, an amount that appears to be adequately provided for in most diets, even without the amount of biotin provided by intestinal microorganism synthesis. Dietary intake of biotin is believed to be 100–300 μg daily.

Three to six times more biotin is excreted in the urine than is ingested, reflecting a major contribution of the active substance by the intestinal microflora (1). It seems probable, therefore, that man can obtain all the biotin he needs from the numerous microorganism present in his intestines.

Although biotin is recognized as being essential for man, because of the uncertainty as to the amount contributed by intestinal microorganisms, a recommended daily allowance cannot be established at this time (34).

TOXICITY. Biotin has little or no toxicity. It is well tolerated by animals given large doses over prolonged periods.

THE HEMATOPOIETIC VITAMINS

FOLACIN

The discovery of folacin (or folic acid, or pteroylglutamic acid) began with the studies of Dr. Lucy Wills in Bombay, India, in 1931, when she called attention to a megaloblastic anemia found in pregnant women. Wills produced the anemia in monkeys by feeding them a diet similar to that eaten by her patients—primarily polished rice and white bread. She was unable to prevent or cure the anemia by using any of the vitamins known at that time or by feeding purified liver extract. Good responses were obtained, however, by feeding autolyzed yeast that had been found ineffective in cases of pernicious anemia (58). Therefore, it appeared yeast contained an antianemic factor (Will's factor) that was different from the factor present in purified liver extract so effective in preventing pernicous anemia.

In 1941, Mitchell and coworkers in the United States obtained from spinach a factor that was a growth factor for Lactobacillus casei. They called the material folic acid because it came from foliage plants such as spinach. The pure synthetic substance, pteroylglutamic acid (folic acid), contained a complex component called pterin. This substance had been studied by Hopkins in England as early as 1885 during an investigation of the pigments of butterfly wings. Because of the similarity of his preparation to purine of nucleic acids Hopkins suggested they might be important in the metabolism of mammals.

Folic acid was found to be effective in curing the dietary anemia of chicks and also monkeys. In 1945, Spies found folic acid, or folacin, effective in the treatment of the macrocytic anemias of pregnancy and also of tropical sprue.

FUNCTION AND DEFICIENCY. Tetrahydrofolic acid plays an essential role in one-carbon transfers in metabolism. In this role it receives one-carbon radicals from such amino acids as serine,

glycine, histidine, and tryptophan and transfers them at two steps in purine synthesis. In pyrimidine synthesis it is essential in the insertion of the methyl group in deoxyuridylic acid to form thymidylic acid, the characteristic nucleotide of DNA. Failure in this synthetic step is responsible for the megaloblastosis seen in folate deficiency and in vitamin B_{12} deficiency.

Folic acid is needed for thymidylate synthesis as 5,10-methylene-tetrahydrofolate. This molecule is made from tetrahydrofolate via methyl-tetrahydrofolate, the principal form of folate in the human liver. The distinction between a folic acid deficiency and vitamin B_{12} deficiency appears to lie in that when vitamin B_{12} is deficient, most of the folate is trapped in the methyl-tetrahydrofolate, which cannot then be used in the subsequent necessary reactions for the formation of thymidylate for DNA synthesis.

CHEMICAL PROPERTIES AND STRUCTURE. Folacin is a yellow crystalline substance consisting of a pterin ring attached to a p-aminobenzoic acid and conjugated with glutamic acid. For structure, see Table A-14. It is sparingly soluble in water and stable in acid solution. When heated in neutral or alkaline solution it is rapidly destroyed. Consequently it may be destroyed by some methods of cooking.

Up to seven additional molecules of glutamic acid may be attached through the α-carboxyl moiety to pteroylmonoglutamic acid.

ABSORPTION. The small intestine has a conjugase (γ-L-glutamyl carboxypeptidase) in the intestinal epithelium which hydrolyzes polyglutamyl forms of folic acid to free folic acid. Free folic acid is then absorbed from the upper part of the small intestine. During absorption it is believed that folic acid is reduced and methylated to methyl-tetrahydrofolic acid. This form is the principal form of folate present in the liver as well as the plasma.

SOURCES. Good sources of folic acid are green leafy vegetables, liver, kidney, lima beans, asparagus, whole grain cereals, nuts, legumes, and yeast. The folacin content of many foods has not yet been established.

REQUIREMENT. The minimum need for adults is believed to be approximately 50 μg, or 0.05 mg. This allows a wide degree of difference that may be due to differences in the availability in various foods. For further recommendations in pregnancy and lactation and for children see Table A-1.

TOXICITY. No toxic reactions to folacin have been seen when doses up to 15 mg have been taken daily for 1 month. Certain synthetic analogues are toxic, such as methotrexate, which is used as an antimetabolite in the treatment of leukemia.

VITAMIN B_{12} (COBALAMIN, CYANOCOBALAMIN)

Thomas Addison, a physician, working in Guy's hospital, London, discovered in 1849 an anemia that occurred mostly in middle-aged and elderly patients and which led to the death of the patient in 2–5 years. So inevitable was death that the disease became known as pernicious anemia. Later, in 1926, Minot and Murphy in Boston found that a remission in pernicious anemia occurred when patients were fed large amounts of whole liver.

At this time, WB Castle, also in Boston, observed that pernicious anemia patients had an abnormal gastric secretion. From his observations of gastric secretion and the knowledge that the anti-pernicious anemia factor was present in liver and meat, Castle concluded that the disease was not dietary in origin but a failure of the stomach to secrete an "intrinsic factor" essential for the absorption of the dietary "extrinsic factor" from the small intestine. Progress in the search for the liver anti-pernicious anemia factor was impeded by the necessity for using the human being as a test animal. Fortunately, it was found that a microorganism *Lactobacillus lactis* also needed the factor. This finding greatly facilitated the search for the factor.

In the human an injection of a protein-free extract of liver is far more potent in preventing pernicious anemia than the equivalent amount of ingested liver. This cast doubt on Castle's theory that the extrinsic and intrinsic factors combined to form the anti-pernicious anemia factor, but it is now known that the favorable result obtained by feeding massive amounts of liver enabled the absorption by diffusion of a small amount of the liver factor (1%–3%) rather than by active transport. It is now believed Castle's extrinsic factor in food is the anti-pernicious anemia factor which is aided in its transport into the mucosal cell by the "intrinsic factor" secreted by the parietal cells of the gastric mucosa.

The observation that concentrated liver ex-

tract has a characteristic red color led rapidly to the isolation of the crystalline vitamin by Smith and Parker (44) in England and simultaneously in the United States by Rickes *et al.* (37a). Proof was soon obtained of the effectiveness of vitamin B_{12} treatment by the alleviation of both the hematologic and neurologic manifestation of pernicious anemia.

FUNCTION AND DEFICIENCY. Vitamin B_{12} is essential to the proper functioning of all mammalian cells. A lack of the vitamin is most severely felt in tissue where the cells are normally dividing such as the blood-forming tissues of the bone marrow, and in the GI tract. In the nervous system a deficiency may lead to degeneration of nerve fibers in the spinal cord and peripheral nerves. In the bone marrow abnormal cells, megaloblasts, can be seen. When these are present in the bone marrow the circulating red cells derived from them are bigger than normal (macrocytes) but usually carry a normal hemoglobin concentration (normochromic).

The formation of megaloblasts, or megaloblastosis, occurs because the formation of DNA is inhibited. Synthesis of RNA does not appear to be affected. Vitamin B_{12} has been shown to be necessary as a coenzyme in the synthesis of thymidylate, the nucleotide of thymidine which is the characteristic base of DNA. Folate is also necessary in the synthesis of thymidylate.

The manner in which vitamin B_{12} affects the nervous system is not clear. Carbohydrate metabolism may be involved since vitamin B_{12} helps keep glutathione, a part of several enzymes involved in carbohydrate metabolism, in its biologically active reduced state. Since the nervous system relies almost entirely on glucose as a source of fuel, any interference in the energy supply to the nervous system unquestionably has a profound effect.

Vitamin B_{12} also appears to be necessary for myelin formation since a deficiency gives rise to myelin damage. Here it is possible the mechanism may involve propionate or odd-chain fatty acid metabolism. In this pathway L-methylmalonyl coenzyme A is converted to succinyl coenzyme A by means of methylmalonyl CoA-mutase, which requires adenosyl B_{12} as a coenzyme. This pathway is important whenever fatty acids with odd numbers of carbon atoms are catabolized. The reaction requires biotin as well as vitamin B_{12}. Patients suffering from pernicious anemia who are deficient in vitamin B_{12}, usually because of a lack of the intrinsic factor,

excrete large amounts of methylmalonic acid and its precursor propionic acid in the urine.

Vitamin B_{12} is also involved in the metabolism of single carbon units.

CHEMICAL PROPERTIES AND STRUCTURE. Vitamin B_{12} is present in the body in several forms. The coenzyme form is 5-deoxyadenosyl cobalamin. The originally isolated vitamin B_{12} was a cyanocobalamin. This form has not been found in natural materials. In the isolation of the vitamin cyanide was added to promote the crystallization of the red crystals. The natural form appears to be hydroxycobalamin.

Crystalline vitamin B_{12} is freely soluble in water and is resistant to boiling in neutral solutions. It is unstable in solutions in the presence of alkali.

ABSORPTION. Vitamin B_{12} requires for intestinal absorption a heat-labile glycoprotein called by Castle the intrinsic factor. This substance is secreted from the parietal cells of the stomach during the normal secretion of gastric juice. Food vitamin B_{12} released from a protein complex binds to the intrinsic factor which it is believed helps attach the vitamin to a receptor in the intestinal mucosa of the lower ileum. Calcium seems to be required in this process. In the intestinal cell membrane, vitamin B_{12} is released from the intrinsic factor and absorbed into the blood.

If the gastric juice secreted by the stomach lacks intrinsic factor, absorption does not take place. Under these conditions massive intakes of vitamin B_{12} may be given on the assumption that some diffusion into the blood will take place.

The plasma concentration of the vitamin in healthy persons normally lies between 200–960 pg/ml. The capacity of the intestine to absorb cyanocobalamin is a valuable test (Shillings test) of absorptive capacity. Normal subjects usually absorb 30% of the test dose and excrete most of it in the urine. Persons with pernicious anemia absorb and excrete only 2% of the test dose.

SOURCES. Since plants are unable to synthesize vitamin B_{12} it can be found only in food of animal origin. Micoorganisms in the human GI tract can synthesize the vitamin, but the site of synthesis in the colon does not permit absorption. In ruminants, microorganisms synthesize vitamin B_{12} from the plants eaten, and this can then be absorbed from the GI tract. Therefore, domestic animals are a good food source.

Best sources of the vitamin are beef liver, kidney, whole milk, eggs, oysters, fresh shrimp, pork, and chicken.

REQUIREMENT. The human needs very small amounts of B_{12}. The recommended amount in the diet is 3 μg/day, of which 1–1.5 μg are absorbed. A range of 0.5–2.5 μg appears desirable. The average American diet contains 7–30 μg of the vitamin. The requirement is increased if the body metabolic rate is raised, as in fever or hyperthyroidism.

OTHER WATER-SOLUBLE VITAMINS

PYRIDOXINE (VITAMIN B_6)

Vitamin B_6 was first identified as essential in the nutrition of the rat for preventing a dermatitis called acrodynia. Acrodynia is characterized by a dermatitis that appears on the tail, ears, mouth, and paws of the rat and is accompanied by edema and scaliness of these tissues. A crystalline compound, pyridoxine, was isolated and when included in the diet of the rat prevented the dermatitis.

Pyridoxine owes its name to its structural resemblance to the pyridine ring. Originally, pyridoxine was used synonymously with vitamin B_6. From the work of Snell and colleagues it is now clear that pyridoxine (or pyridoxol, an alcohol) is biologically converted into two other compounds: 1) pyridoxal (an aldehyde) and 2) pyridoxamine (an amine). For the structure of these compounds see Table A-14. All three of these compounds are active biologically as the vitamin, and pyridoxine is often used as the collective term for all three. The active coenzyme forms of pyridoxine are pyridoxal phosphate and pyridoxamine phosphate.

It should be pointed out that other nutritional deficiencies can lead to dermatologic lesions similar to those described above for the rat. Only edema distinguishes acrodynia from the dermatitis of rats seen in a deficiency of essential fatty acids. It is possible, therefore, that acrodynia may reflect a deficiency in polyunsaturated fatty acids because of a failure of arachidonic acid synthesis, from linoleic acid, in the deficient rat.

FUNCTION. Unlike thiamin, niacin, and riboflavin, which act primarily as coenzymes for energy metabolism, vitamin B_6 plays no role in energy production. Instead the vitamin is involved primarily with reactions involving the synthesis and catabolism of amino acids and is therefore critical to protein synthesis.

Pyridoxal phosphate and pyridoxamine phosphate are very versatile coenzymes functioning in a large number of different enzymatic reactions in which amino acids or amino groups are transformed or transferred. For example, pyridoxal phosphate is required as a coenzyme in transamination reactions in which the α-amino acid groups of an amino acid is transferred to the α-carbon of an α-keto acid. In this manner the amino group of L-alanine in the presence of alanine transaminase transfers its amino group to α-ketoglutaric acid to form L-glutamate and pyruvate.

During the metabolic conversion of tryptophan to acetyl coenzyme A the enzyme kynureninase catalyzes the conversion of 3-hydroxykynurenine to 3-hydroxyanthranilic acid. This step requires pyridoxal phosphate. In the deficiency, large amounts of L-kynurenine are excreted in the urine. This step is critical in the biosynthesis of the vitamin nicotinic acid which will not be synthesized in a deficiency of pyridoxal phosphate.

Pyridoxal phosphate plays a role in hemoglobin synthesis as a cofactor in the formation of a precursor to porphyrin, an essential part of the hemoglobin molecule.

Pyridoxine appears to be involved in the metabolism of the central nervous system. Changes in electroencephalograms used to evaluate the function of the nervous system occur in pyridoxine deficiency. In a severe deficiency convulsive seizures take place, vitamin B_6 appears to be necessary to prevent uncontrolled excitation of the central nervous system, and eventual uncontrolled muscle seizures.

DEFICIENCY. In adults the only symptom that can be ascribed to a lack of pyridoxine is a microcytic hypochromic anemia. This occurs with a high serum iron level. Other symptoms are weakness, nervousness, irritability, insomnia, and difficulty in walking.

Efforts to produce a dietary deficiency have not been successful unless the antagonist deoxypyridoxine was fed. Glossitis, cheilosis, and stomatitis occurred; these were different from those seen in a niacin or riboflavin deficiency.

Since citrate favors the solubility of oxalates, it is possible that the formation of kidney stones which occurs in pyridoxine deficiency, may be due to low levels or the lack of citrate found in the deficiency.

ABSORPTION AND METABOLISM. Pyridoxine is water-soluble, heat-stable, but sensitive to light and alkalis. As with the other B vitamins it is absorbed in the upper part of the small intestine, where a lower pH facilitates passage. Once absorbed, all three forms are converted to pyridoxal phosphate, the coenzyme form.

Following absorption the vitamin phosphate is distributed throughout the body tissues, emphasizing its essential role in metabolism.

It is excreted in the urine chiefly as 4-pyridoxic acid along with small amounts of pyridoxal and pyridoxamine.

SOURCES. Pyridoxine is widespread in nature but frequently occurs in very small amounts. Good sources of the vitamin are yeast, wheat and corn, egg yolk, liver, kidney, and muscle meats. Limited amounts are present in milk and vegetables. Vegetables that are frozen may lose as much as 20% of their original activity. Milling of cereals can lead to losses as high as 90%.

REQUIREMENT. Since there are no areas in the world in which pyridoxine deficiency has been defined as a problem resulting in poor nutrition, establishing a firm requirement is difficult. The Food and Nutrition Board has recommended 2 mg/day for adults. Data are not sufficient to permit an evaluation of the requirement for pyridoxine or vitamin B_6 for children and adolescents. The allowances recommended range up to 2.0 g/day (see Table A-1).

TOXICITY. Toxicity has been described in men receiving 300 mg/day. Since this dose far exceeds any recommended for drug treatment and is impossible to obtain from food in the diet, one would expect that pyridoxine has little if any toxicity from normal daily required dietary amounts.

Rats can tolerate doses of pyridoxine up to 1 g/kg body weight. Above this amount convulsions appear, and with oral doses of 4–6 g/kg death occurs.

When pyridoxine is given intramuscularly to humans it causes some pain, probably due to the acidity of the solution.

ASCORBIC ACID (VITAMIN C)

The disease scurvy has been known to man for centuries. Before the substance necessary for its prevention and cure was found it was known as the scourge of sailors and soldiers because of the scorbutic diets they were fed. In 1753 Lind, a Scottish naval surgeon and outstanding investigator of the prevention and cure of scurvy, published the first edition of "A Treatise on the Scurvy." In this treatise he related the experience of the explorer of the St. Lawrence waterway, Jacques Cartier, when 110 men in his command were disabled by scurvy. Forced to spend the winter of 1535 in Canada, Cartier's men were saved because they learned from friendly Indians, who were familiar with the disorder, that an infusion of the needles of some evergreen trees was a remedy. In a second edition of his treatise in 1757 Lind described in vivid language the symptoms of scurvy he had seen in sailor patients on board the British ship Salisbury; all men suffered from putrid gums, spots caused by hemorrhage in the skin, lassitude, and weakness of the knees. Lind found that the symptoms disappearred when their diet was supplemented with oranges and lemons (23).

In 1907 Holst and Fröhlich (16) found that although guinea pigs remained healthy on a diet of cereal grains and cabbage when restricted to cereal grains alone they developed scorbutic lesions. Supplements of fruits, fresh vegetables, and juices protected the animals. An important aspect of this work was that it provided an experimental animal, the guinea pig, effective in the study of scurvy. Somewhat later (1928) while studying oxidation–reduction factors, Szent–Györgyi (52) isolated a very active hydrogen carrier in cell respiration from the adrenal gland, cabbages, and oranges and named it hexuronic acid. He was concerned chiefly with the reducing properties of the acid and did not recognize it as vitamin C.

Waugh and King (56) isolated the active substance from lemon juice and found that the crystalline material had antiscorbutic properties. They called the substance ascorbic acid, a shortened form of "antiscorbutic factor" effective in preventing scurvy (L. *scorbutus*). Svirbely and Szent–Györgi (50) found ascorbic acid to be identical with hexuronic acid.

Synthesis of ascorbic acid was first accomplished in 1933 by Reichstein, Grussner, and Oppenauer (37).

FUNCTION. Although it was assumed at one time that the metabolic role of ascorbic acid was related to its reversible oxidation and reduction properties, no role in biologic oxidation systems have been described in which ascorbic acid serves as a specific coenzyme.

However, there is no question but that ascor-

bic acid is essential in the daily diet of man. Many species of animals are able to synthesize ascorbic acid in their tissues and therefore do not require it in their diet. Man, however, and other primates, and the guinea pig, by consuming food deficient in ascorbic acid will soon develop scurvy, a potentially fatal disease characterized by a deterioration of collagenous connective tissues and structures.

Connective tissue consists of a system of insoluble protein fibers embedded in a continuous matrix called ground substance. Its chief function is supportive, and this is performed by fibrils of insoluble protein, such as collagen and elastin. Collagen is the most abundant protein in mammals, constituting one-quarter of the protein of tissues and providing the major fibrous structure of skin, cartilage, tendons, ligaments, blood vessels, bone, and teeth. The intercellular cement, collagen, functions to hold the tissue cells together in discrete organized systems.

The amino acid composition of collagen is unique among mammalian tissues. Glycine represents about one-third of the amino acids present. Amounts of proline are higher, and amounts of lysine slightly less, than those found in most proteins. Hydroxyproline and hydroxylysine, which are present in collagen, are found in only a few other proteins. They are vital in maintaining the tertiary structure of collagen. Neither hydroxyproline nor hydroxylysine are incorporated directly into the growing protein chains. There are no codons for these two amino acids. Rather hydroxylation of proline and lysine occurs after the peptide bond is formed in the growing polypeptide chain. Hydroxylation requires a proline hydroxylase and a lysine hydroxylase, molecular oxygen, ferrous ions, α-ketoglutaric acid, and a reducing substance in the reaction. Ascorbic acid appears to play a key role in the synthesis of collagen as the reducing substance (31).

In scurvy, the hydroxylation of collagen is impaired. The collagen synthesized in the absence of ascorbic acid cannot properly form fibers, thereby resulting in the skin lesions and blood vessel fragility prominent in scurvy. Without vitamin C to provide a firm wall, capillaries are easily ruptured with consequent diffuse tissue bleeding. Similar clinical conditions include easy bruising, pinpoint peripheral hemorrhages, easy bone fracture and joint hemorrhage, poor wound healing, and friable bleeding gums with loosened teeth (gingivitis).

Bone consists of an organic phase that is nearly all collagen and an inorganic phase that is calcium phosphate essentially. Collagen is necessary for the deposition of the calcium phosphate crystals and the formation of bone. Ascorbic acid appears essential in this process.

The participation of ascorbic acid in the synthesis of corticosterone and 17-hydroxycorticosterone may account for the high concentration of vitamin C in adrenal tissue as well as for its rapid disappearance following stress when cortical hormone activity is high.

Staudinger *et al.* (47) report ascorbic acid in the electron transport chain of mammalian microsomes and have suggested that this reaction is coupled with hydroxylation.

Ascorbic acid can function as a reducing agent for iron in the GI tract and thereby enhance its absorption into the intestinal mucosal cell.

DEFICIENCY. With knowledge of preventive measures, scurvy is not a common disease today. It can be observed in infants, food faddists or cranks, alcoholics, and in older people. Individuals with frank scurvy can be readily recognized, but borderline cases require experience in diagnosis. The gums are swollen, particularly between the teeth, and they bleed easily. Bleeding may occur in all parts of the body, and numerous small hemorrhages or petechiae may be seen under the skin. Trivial injuries may give rise to large bruises. Large joints, such as in the knee or hip, may appear swollen owing to bleeding into the joint cavity. Severe internal hemorrhages may lead to sudden death and heart failure. And adequate intake of ascorbic acid rapidly reverses these signs or symptoms.

The increased use of artificial milk products as a sole source of food for infants soon after birth produced an increase in the number of cases of infantile scurvy. In the older person, declining appetite, immobility, and reduced income tend to reduce the intake of ascorbic acid and produce borderline cases of ascorbic acid deficiency. In both of the above deficiencies the symptoms can be reversed and prevented by fruit juice or supplements of ascorbic acid.

CHEMICAL PROPERTIES AND STRUCTURE. L-ascorbic acid is a simple 6-carbon organic compound ($C_6H_8O_6$) closely related to glucose (for structure see Table A-14). It is an ene-diol lactone of an acid whose chemical configuration is analogous to L-glucose. The D-form of ascorbic acid and many such closely related compounds show very little antiscorbutic activity. To avoid confusion, it has been proposed that D-ascorbic acid (inactive) be called erythrobic acid.

Ascorbic acid is a white crystalline substance that is stable, when dry, in air and light. It is stable to acid but easily destroyed by oxidation, alkali, and heat. It is soluble in water (1 g/3 ml water), moderately soluble in alcohol, and practically insoluble in petroleum ether. In aqueous solution and in the presence of copper (but not aluminum) it is readily destroyed. This property is of interest in connection with cooking utensils.

The most prominent chemical properties of L-ascorbic acid are its acidity, due to the dissociation of the enolic hydroxyl groups, and its ready oxidation ($-2H$) to dehydroascorbic acid. This oxidation product has about 80% the activity of the vitamin itself. Further oxidation produces diketogulonic acid, which is inactive. This reaction is irreversible. In mammalian tissues the reversible reduction of dehydroascorbic acid to ascorbic acid appears to be aided by reducing agents, such as the sulfhydryl group of glutathione. In fact, it has been postulated that glutathione may be involved in maintaining the vitamin in the reduced form under physiologic conditions. Ascorbic acid itself is the most active reducing agent known to occur naturally in living tissues.

D-araboascorbic acid (isoascorbic acid) has antiscorbutic properties but cannot support growth.

Most animals have the ability to synthesize ascorbic acid and therefore need no dietary supply. However, a few species (man, monkeys, and the guinea pig) lack the necessary enzyme to complete the conversion of glucose or galactose to L-ascorbic acid. A dietary supply of the vitamin is therefore essential to prevent scurvy.

ABSORPTION. Ascorbic acid is easily absorbed in the normal human individual from the upper part of the small intestine. The exact mechanism is not clear, but there is evidence that in some cases it may be absorbed by simple diffusion and in others by an active sodium-dependent transport. Following absorption into the portal blood it passes into the tissues. There is no extensive storage of vitamin C, but certain tissues, such as the adrenal cortex, have relatively large amounts of the acid.

SOURCES. Fruits, especially citrus fruits, and tomatoes, are rich sources of vitamin C. Green vegetables are also good sources, but much of the vitamin C activity may be lost in preparation and cooking.

Although rather low in ascorbic acid potatoes and the root vegetables are consumed in such large quantities that they become a good source. Storage lowers the content of ascorbic acid in potatoes, and excessive cooking completely destroys the vitamin. Animal products, such as meat, fish, eggs, and milk, are not a good source. The vitamin C contained in meat is easily destroyed by heating.

The loss of ascorbic acid by oxidation in foods is hastened by the action of ascorbic acid oxidase, which is present in raw fruits and vegetables. This enzyme becomes active when leaves or fruits are damaged by drying, bruising, or cutting.

REQUIREMENT. An intake of 30 mg/day is sufficient to replenish the quantity of ascorbic acid metabolized daily. An intake of 45 mg/day will maintain an adequate body pool. Although not known precisely, the infant's need for ascorbic acid seems to be met satisfactorily by the amount provided by the milk of the adequately fed mother, 40–55 mg/liter. For children up to 11 years of age, 40 mg/day is recommended. For the adult male and female 45 mg/day is recommended. Pregnant women should receive 60 mg/day, with an increase to 80 mg/day for lactating women (34).

Large doses of ascorbic acid (0.5–5 g/day) have been reported as reducing the frequency of the common cold, but these claims have not been sufficiently substantiated.

TOXICITY. Ingestion by mouth of massive amounts of ascorbic acid have not produced a toxicity. This may be due to its rapid excretion in the urine and limited storage in the human body.

THE FAT-SOLUBLE VITAMINS

VITAMIN A

Although vitamin A was the first vitamin to be discovered and has been known chemically since Karrer determined its structure in 1931, the chief metabolic role or function of the vitamin is still puzzling and unclear. Active preformed vitamin A is found only in foods of animal origin. However, the carotenoid pigments of plants contain inactive precursor substances, or provitamins A, which can be converted to the active vitamin when eaten and digested by animals. There are therefore two sources of the vitamin: 1) the vitamin present in animal foods and 2) the inactive provitamins present in foods of plant origin.

Vitamin A is a collective term now used to

refer to all forms of the vitamin that are biologically active. Vitamin A alcohol is called *retinol*, vitamin A aldehyde *retinal*, and vitamin A acid *retinoic acid*.

FUNCTION

Even though at present it is not possible to relate the symptoms of vitamin A deficiency to a specific biochemical defect, except perhaps for the pigments of the eye, it is possible to identify five distinct metabolic roles for the vitamin: 1) visual purple and vision in dim light, 2) growth, 3) reproduction, 4) health of epithelial cells, and 5) a role involving the stability of membranes.

MAINTENANCE OF VISUAL PURPLE. The specific role of vitamin A in biochemical and physiologic mechanisms of vision has been worked out largely by Wald and Morton (27,55) (see Ch. 27). During the light reaction rhodopsin, a photoreceptor pigment or visual purple occurring in the rod cells of the retina, is split into a protein component, opsin, and vitamin A aldehyde or retinal. This reaction occurs during the light-bleaching reaction. As light strikes the retina, visual purple is bleached to visual yellow and retinal is separated from opsin. The reaction causes a light stimulus to excite the optic nerve, which in turn transfers the stimulus to the brain. During this process some retinal is reduced to retinol. Most of this retinol in the presence of a dehydrogenase is oxidized to retinal, which then can recombine with opsin to regenerate visual purple. Small losses occur through excretion, probably as retinoic acid, which must be replaced from the blood. The amount of retinal in the blood determines the rate at which rhodopsin is regenerated and made available to act as a receptor substance in the retina.

In vitamin A deficiency there may be a long lag in the ability of the visual mechanism to regenerate rhodopsin. This results in night blindness or nyctalopia. Examples of this phenomenon can be seen in the lag in adaptation to dim light of a person entering a dimly lit theater from a brightly lit street, or in the temporary blindness experienced by a driver at night meeting the headlights of an on-coming car.

The biochemical mechanism underlying color vision in the cones of the retina is analogous to that of rod vision. Here again retinal combines with a specific protein but which in this case differs from opsin.

GROWTH. An animal deprived of vitamin A will cease to grow and will die when its tissue reserves of vitamin A are depleted. A possible initial reason may be loss of appetite. This in turn can be attributed to loss of the sense of taste which may result from keratinization of taste bud spores.

One of the earliest symptoms to appear in a vitamin A deficiency, growth failure is due to a lack of retinoic acid, which normally promotes growth. It should be pointed out that growth failure is not peculiar to a lack of vitamin A since deficiencies of other vitamins and nutrients can produce similar results.

In young animals, experimentally produced vitamin A deficiency is accompanied by a cessation of bone growth. Bones fail to grow in length, and although there appears to be normal intramembranous bone formation, the remodeling sequences become abnormal and stop. The defect in bone growth is thought to result from a failure in the normal conversion of osteoblasts (cells responsible for an increase in the number of bone cells) to osteoclasts, which failure causes a breakdown of bone during the process of remodeling. The bones of young vitamin A–deficient animals may be short and thick. Bone disorders have not been observed in the adult during induced vitamin A deficiency.

Nerve lesions observed in experimental vitamin A deficiency are the result of disproportionate growth between nerve tissues and bone. Under conditions of bone growth failure, undue pressure may occur in the brain and other nervous tissues as the protective bony framework fails to grow fast enough to accomodate these tissues. Bone growth is stimulated when vitamin A again is made available.

A defective formation of nervous tissue independent of the effect of a deficiency of vitamin A on bone growth may occur. It is believed that in the absence of vitamin A the protective layer of tissue surrounding nerve fibers does not form satisfactorily.

REPRODUCTION. Vitamin A, either as retinol or retinal, is essential for normal reproduction. Retinoic acid does not appear to be involved in reproduction. In the absence of vitamin A, failure of spermatogenesis occurs in the male, and fetal resorption occurs in the female. The biochemical defect is unknown. A decrease in estrogen synthesis where there is a failure to convert cholesterol to the hormone may be related to the reproductive abnormality in the female. In the male vitamin A acts directly on the testes in some

unknown manner which is diminished in the deficiency.

MAINTENANCE OF EPITHELIAL CELLS. A major function of vitamin A is to maintain the health of the epithelial tissues. Epithelial cells are found in the linings of all openings into the interior of the body, *e.g.,* the alimentary tract, respiratory tract, and the genitourinary tract, as well as the glands and their ducts. They form the outer protective layer of the skin. It is clear, therefore, that these cells form an important "first-line of defense" against invading bacteria and other microorganisms. The presence of degenerative changes when vitamin A is lacking is evidence that vitamin A is essential to the normal biochemical reactions underlying the health of these cells. Epithelial cells are characterized by continuous replacement and differentiation. They produce protective mucopolysaccharides as secretary products.

When deprived of an adequate supply of vitamin A, epithelial tissues undergo changes that lead to a horny degeneration called keratinization. Drying of the cells of the cornea and skin occurs. The mucous membranes lining the mouth, throat, nose, and respiratory passages are damaged. This is one of the earlier signs of vitamin A deficiency. In addition to a general deterioration of the epithelial cells and membranes, the cells lack normal secretions and there is a loss of cilia, which by constant movement aid in keeping the membrane surface clean. Susceptibility to infections, such as sinus trouble, sore throat, and abscesses in ears, mouth, or salivary glands, is a common finding when vitamin A is lacking in the diet.

STABILITY OF CELL MEMBRANES. Vitamin A participates in some unknown manner in reactions involving the stability of the membranes of subcellular particles of the lysosomes and mitochondria as well as the cell membranes. The association between many of the changes just described and vitamin A cannot be explained with certainty. It is possible that vitamin A may play a role in cell differentiation through an influence on RNA and DNA.

DEFICIENCY

The liver reserves of vitamin A must be depleted before symptoms of a deficiency appear. Growth ceases when the reserves are depleted. Most deficiency symptoms seen are directly or indirectly a reflection of the health of epithelial cells. A deficiency can result from: 1) a low dietary intake of vitamin A for various causes; 2) interference with absorption from the small intestine due to diseases of the pancreas, liver, gallbladder, or mucosal cells, as in malabsorption; 3) interference with the conversion of carotene to vitamin A; and 4) rapid loss of vitamin A.

In a vitamin deficiency the concentration of vitamin A in the plasma is usually below 20 μg/100 ml, but may be so low as to be undetectable. It must be low for a prolonged period to produce clinical signs of vitamin A deficiency. Normal levels are 30–50 μg/100 ml.

NIGHT BLINDNESS. An early symptom of vitamin A deficiency is night blindness, or nyctalopia. The visual purple pigment rhodopsin in the receptor cells or cones of the retina is necessary for vision in dim light. These receptor cells require a constant replenishment of the small amounts of vitamin A lost in the visual cycle during which a nerve impulse is transmitted to the optic nerve and rhodopsin is regenerated. A low or depleted liver reserve of vitamin A is reflected in the blood level and slower rate of regeneration of vitamin A. If continued, this will show up as slow dark adaptation time and eventually night blindness.

XEROPHTHALMIA. This disease usually begins with a drying of the conjunctiva, which loses its shining luster. The condition may then spread to the cornea, which also becomes dull and loses its power to reflect. The lacrimal gland fails to secrete tears due to a blocking of the duct or a reduced ability to synthesize mucopolysaccharide. This pathologic dryness of the eye, which robs it of its normal epithelial protection, is called xerophthalmia and is a precursor to keratomalacia. If the condition remains untreated, ulceration leading to perforation, loss of intraocular fluid, and severe secondary infection may occur. Pus is exudated, and the eye will hemorrhage. This condition is known as Bitot's spots in its mildest form, as xerosis conjunctivae in moderately severe form, and as xerophthalmia in advanced stages. At this last stage, the patient is seriously ill with pyrexia and a grossly inflamed eye. Blindness in the infected eye is the inevitable result.

Severe cases of xerophthalmia should be treated at once as the sight and life of the individual, usually a child, is at stake.

Many children probably succumb to other

forms of vitamin deficiency or an infection before xerophthalmia develops. Xerophthalmia is frequent in children in developing tropical countries where a low protein intake may be a contributive factor.

CHANGES IN THE EPITHELIAL CELLS OF TISSUES. One of the chief functions of vitamin A is to maintain the health of epithelial tissues (see above).

FAILURE OF TOOTH ENAMEL. In the enamel organ of rats there is an atrophy and degeneration of ameloblasts (which ultimately change to keratin) when the animals are fed a vitamin A–deficient diet. Such a deficiency can slow down and even completely stop the growth of incisor teeth in rats. The deficiency is characterized by a disturbance in enamel formation which produces a hypoplastic and chalky white incisor as the result of a loss of orange pigment.

OTHER VITAMIN A DEFICIENCY ABNORMALITIES. Vitamin A deficiency can lead to a loss of taste and smell. This may be partially responsible for growth failure because of the decreased appetite and food intake.

The formation of thick bones in a vitamin A deficiency may cause an increase in cerebral spinal fluid pressure because of failure of absorption of fluid from the deficient membrane or because of the decrease in space resulting from the thickening of the bones.

CHEMICAL PROPERTIES AND STRUCTURE

Only foods of animal origin contain preformed vitamin A. The active vitamin is a complex primary alcohol containing a β-ionone ring with an unsaturated side chain terminating in an alcohol group. The structure is shown in Table A-15. The β-ionone ring is essential for vitamin activity, and when it is absent or altered structurally, the compound may become inactive. The compound is pale yellow almost colorless, soluble in fat or fat solvents, and insoluble in water. It can be destroyed by oxidation when exposed to air at high temperatures or to ultraviolet light. The vitamin A content of fats and oils can be destroyed by oxidation as they become rancid unless protected by antioxidants or stored in a cool, dark place.

The ultimate source of vitamin A is plants. Here the provitamin form occurs as highly colored yellow or orange carotenoid pigments or carotenes. These give color to carrots, sweet potatoes, peaches, and other colored vegetables and fruits. The green color of vegetables often masks the yellow orange color of the carotenes because of the green pigment chlorophyll, which does not have vitamin A activity. There are a number of carotenoid pigments in plants, but the three known as alpha (α), beta (β), and gamma (γ) carotene and a fourth, cryptoxanthine, the yellow pigment of corn, are of importance in human nutrition. Their ability to replace vitamin A in the diet depends on the integrity of the β-ionone ring. Of these forms β-carotene is the provitamin member that when eaten and digested is theoretically cleaved in the intestinal mucosal cell into two molecules of vitamin A. Unfortunately, the ability of the human mucosal cell to split β-carotene into the two active forms of vitamin A does not approach this degree of efficiency.

ABSORPTION AND METABOLISM

Both vitamin A and the carotenes are fat soluble. Their absorption from the intestine and utilization in tissues may therefore be decreased in the malabsorptive state. Such diseases as celiac disease and sprue, and liver disease which interferes with bile production or flow, may induce a vitamin A deficiency. Diarrhea and excessive intakes of mineral oil may also interfere with the absorption of vitamin A and the carotenes.

Preformed vitamin A in food, usually esterified with palmitic acid as retinyl palmitate, must be hydrolyzed by pancreatic enzymes before being absorbed by the muscosal cell as retinol. The carotenes and cryptoxanthine are absorbed intact in the presence of bile salts and are converted to retinol by a cleavage enzyme in the intestinal mucosal cell.

Retinol, either from dietary sources or the result of hydrolysis, is esterified inside the mucosal cell, preferentially with palmitic acid. Retinyl palmitate incorporated in chylomicrons is introduced to the bloodstream via the lymphatic system and thoracic duct; it is stored in the liver (29a,39).

SOURCES

Preformed vitamin A is available only in animal products in which the animal has converted the carotene of food into active vitamin A. Food sources of preformed vitamin, therefore, include liver, kidney, cream, butter, and egg yolk.

The major dietary source of active vitamin A are the provitamins in yellow and green vegetables and fruits, *e.g.,* carrots, sweet potatoes, squash, apricots, spinach, collards, broccoli, cabbage, and dark leafy greens. In some defects of the intestinal tract, *e.g.,* the malabsorption syndrome, because of lack of bile salts, defects in the epithealial cells of the intestinal mucosa, or conditions leading to diarrhea, the provitamins are not absorbed or converted to the active enzyme and are often excreted in the stools.

REQUIREMENTS

In the current National Academy of Sciences' Table of Allowances requirements are given in retinol equivalents (34). By definition, 1 retinol equivalent is equal to 1 μg of retinol or 6 μg of β-carotene or 12 μg of other provitamin A carotenoids. In terms of international units, 1 retinol equivalent is equal to 3.33 IU retinol or 10 IU β-carotene. The vitamin A values of diets, expressed as retinol equivalents, can be calculated by following the example presented in the RDA(34). The recommended allowances for infants, children, males, females, and pregnant and lactating women are presented in Table A-1.

TOXICITY

High intakes of vitamin A are toxic. Smith and Goodman (43) have reported three cases of human vitamin A toxicity. A four-year-old girl for two years before admission to a hospital had been given daily doses of 25,000 units vitamin A by her anxious, compulsive mother. Three weeks before admission she developed increasingly severe pain in the ankles and feet, followed by transient loss of vision. On the day of admission she was found to have papilledema by her pediatrician. In addition, she had a faint yellow tint to the skin over her palms; a faint, erythematous eruption over her wrists, hands, and buttocks; and widespread excoriated areas over her entire body. Vitamin A supplement was discontinued, and she was given a diet low in vitamin A and carotene. By the time of her discharge nine days after admission she no longer had visual difficulties, the dermatitis was improved, and the papilledema had disappeared. One month later she was asymptomatic except for continued scalp–hair loss.

A nine-year-old boy was admitted after a period of daily treatment with 50,000 units vitamin A. Prior to admission to a hospital a general-

ized erythematous eruption—"like sunburn"—developed. He complained of pain in all four extremities and became lethargic. On hospital admission he had dry, scaling skin; a maculopapular eruption, most pronounced over the extensor surfaces of the arms; and dried, fissured lips. The liver edge was palpable and nontender 4 cm below the right costal margin, and there was tenderness and soft-tissue swelling over his ankles and feet. After a hospital diet low in vitamin A and carotene his papilledema, dermatitis, and bone pain improved and he was discharged. When seen 33 days later he was asymptomatic.

A 20-year-old female college student who voluntarily had gradually decreased her weight from 56 to 41 kg was admitted to the hospital for evaluation of a possible cerebral neoplasm. On repeated questioning she indicated that a dermatologist had recommended vitamin A supplementation in doses of 50,000 units/per day for acne and that she had increased her daily intake to a maximum of 400,000 units in addition to eating six carrots/day in hopes of improving her complexion. After being placed on a diet low in vitamin A and carotene she was discharged and 22 days later was found to be asymptomatic.

Smith and Goodman (43) report that their limited clinical data support conclusions from detailed studies in hypervitaminotic rats which suggest that vitamin A toxicity occurs when excessive amounts of vitamin A are presented to cell membranes in association with plasma lipoproteins, rather than specifically bound to retinol-binding protein. Retinol-binding protein may not only regulate the supply of retinol to tissues but also protect surface-active properties of the vitamin.

The early explorers of the Arctic learned from the Eskimos that eating the liver of the polar bear caused drowsiness, headache with increased cerebrospinal fluid pressure, vomiting, and extensive peeling of the skin. Rodahl and Moore (38) found that polar bear liver may contain nearly 600 mg retinol/100 g liver.

Muenter *et al.* (28) have reported on 17 cases, mostly women, who had taken 14–19 mg retinol/day for over 8 years for chronic skin diseases. The clinical findings were skin changes, headache, muscular stiffness and enlarged liver. Plasma retinol concentrations were 0.8–20 mg/liter.

The symptoms of vitamin A toxicity are many: headache, drowsiness, nausea, dry skin and loss of hair, diarrhea in adults, scaly dermatitis,

weight-loss, anorexia, and in infants skeletal pain. Carotenoid deposits may cause a yellow dyspigmentation of the soles of the feet, palms of the hands, and nasolabial folds. Increased intracranial pressure and edema may develop. In young women following periods of excessive intake of vitamin A there is loss of hemoglobin and potassium from the red blood cells and cessation of menstruation.

Wide individual differences in sensitivity to high levels of vitamin A appear to exist. Infants have shown bulging on the head, hydrocephalus, hyperirritability, and increased intracranial pressure after doses of 25,000 IU/day for 30 days. At least one death has occurred in a food faddist (43).

Recovery from hypervitaminosis A is rapid and complete on withdrawal of the excessive intake. In some instances symptoms subside within 72 hr. Although permanent effects of vitamin A toxicity may be rare, high intakes by the mother can produce harmful effects in the fetus. Single injections of vitamin A to pregnant female animals have produced cleft palate in the young.

Excessive intake of carotenes does not appear to be harmful even though it may result in deposition of yellow pigments in the skin since the pigments disappear after reduction in the excessive intakes of the carotenoids, but toxic reactions do occur after the consumption of high doses of preformed vitamin A.

A high blood concentration of vitamin A can result in decreased stability of membrane structures. It is possible this may account for the increase in fragile bones when excess intake is provided since the resultant release of enzymes leads to degeneration or resorption of bone tissue. This may explain the simultaneous increase in calcium in both urine and blood.

Because of the toxicity that can be induced by high concentrations of vitamin A, the FDA has imposed a ceiling of 10,000 IU on the amount of vitamin A that can be included in a multivitamin preparation available without prescription.

VITAMIN D

In 1918 Mellanby (25) first clearly showed by his classic studies in puppies that rickets, a crippling bone deformity in children, is a nutritional disease responding to a fat-soluble vitamin present in cod-liver oil. If an infant lacks the vitamin, the growing portion of his bones are affected so that they do not harden. If the deficiency persists as the child grows, the bones are unable to support the weight of the body and this results in bowlegs, knock-knees, and enlarged joints. Other deformities of the chest, spine, and pelvis develop. The disease is known as rickets. The preventive or antirachitic substance in cod-liver oil is known as vitamin D.

Vitamin D is actually a group of closely related steroid alcohols with vitamin D activity that promote the absorption of calcium from the small intestine and are also involved in an essential way in the mineralization of bone. From the point of nutritional importance, vitamin D exists in two forms: 1) vitamin D_2 (ergocalciferol) and 2) vitamin D_3 (cholecalciferol). Vitamin D_1 is now known as an impure mixture of sterols (for structure see Table A-15).

FUNCTION

Vitamin E has been aptly described as "the vitamin in search of a disease." In a like spirit, vitamin D can be described as a vitamin with a split personality. It is present in foods and therefore functions as a vitamin in the diet of man. Since in the human, cholecalciferol is formed in one organ of the body (the skin) and acts on distant target organs (the intestine and bone); it also can be considered to function as a hormone (21). A recent thorough description of the chemistry and metabolism of vitamin D is contained in DeLuca HF and Schnoes HK (8a).

Vitamin D is necessary for the formation of normal bone. In this role it acts on the small intestine, where it promotes the absorption of calcium and phosphorus from the intestinal lumen. It is not certain but it also may act directly on the bone, kidneys, and other tissues. These functions of vitamin D depend on the conversion of cholecalciferol in the body into two more active substances (13,30). Dietary vitamin D is absorbed from the intestinal lumen and carried from the intestinal cell in chylomicrons. In the blood, vitamin D of both dietary and cutaneous origin is carried on an α-globulin to the liver. In the liver it is converted into 25-hydroxycholecalciferol (25-HCC). A summary of the metabolism of vitamin D is shown in Fig. 3–3. Carried in the blood from the liver to the kidney, 25-HCC is further hydroxylated to 1,25-dihydroxycholecalciferol (1,25-DCC) (19), which is secreted by the kid-

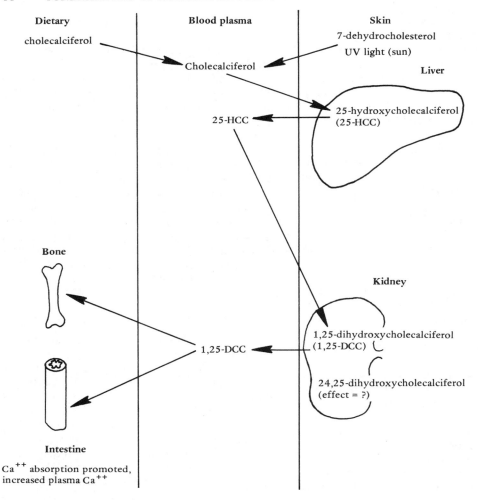

Fig. 3–3. Vitamin D metabolism.

ney into the blood and carried to the target tissues.

In the small intestine, 1,25-DCC enters the intestinal epithelial cell, where it functions apparently through DNA in the nucleus of the intestinal cell to initiate the synthesis in the cytoplasm of a specific calcium-binding protein. This calcium-binding protein serves to actively transport calcium from the brush border into the blood. The increased concentration of calcium in the blood promotes bone deposition. This may be regulated by calcitonin and parathyroid hormone, but the vitamin may have a direct action on bone by initiating a cellular transport system for calcium.

Vitamin D also promotes tubular absorption by the kidney of phosphate. An increased urinary excretion of phosphate and a fall in plasma phosphate may interefere with the mineralization of bone.

DEFICIENCY

Vitamin D deficiency in children is called rickets. In adults, vitamin D deficiency is known as osteomalacia.

Rickets is essentially a disease of defective bone formation caused by an inadequate deposition of calcium and phosphorus in bone. The bones are normally incompletely calcified at birth and in the deficiency remain soft and pliable. When these poorly calcified bones are called on to perform weight-bearing functions for which they are not properly prepared they yield, and bowing of legs occurs when the child starts to walk or to support on

the incompletely mineralized bone a weight of any kind. The ends of the large bones become enlarged, causing great difficulty in movement. At this stage, knock-knees can be seen. Deformities of the ribs results in a concave breast that causes crowding in the breast cavity. The ribs also develop irregularly spaced areas of swelling that take on the appearance of beading. The term rachitic rosary is applied to this condition. The failure of the fontanel of the skull to close, allowing rapid enlargement of the head, is also a condition of the developing deficiency. The eruption of teeth is delayed; they are poorly formed and subject to earlier decay. Growth is frequently retarded.

Rickets is primarily a deficiency of children. Unless effective measures are employed early in the disease, permanent malformation of bone may persist.

Osteomalacia, sometimes called adult rickets, is characterized by an accumulation of uncalcified osteoid tissue in the costochondral joints. It is prevalent in women, frequently in the orient, whose bodies have been depleted of calcium by numerous pregnancies, prolonged nursing, and long periods of protection from the sun, and who receive diets low in calcium and vitamin D.

CHEMICAL PROPERTIES AND STRUCTURE

Because vitamins D_2 and D_3 and some of their related metabolites produce similar effects in the body, vitamin D is used as a collective term to describe the effect of this group of antirachitic vitamins. Vitamin D_3, or cholecalciferol, is the natural form of vitamin D. Man can synthesize the vitamin by the ultraviolet irradiation of 7-dehydrocholesterol in the skin (for structure see Table A-15). Vitamin D_2, or ergocalciferol is produced by exposing ergosterol, a sterol found in ergot or black fungus, and yeast, to the action of ultraviolet light. Irradiation of ergosterol gives rise to a number of related substances, some toxic, of which only ergocalciferol has marked antirachitic properties. Ergocalciferol (D_2) has the same chemical structure as cholecalciferol (D_3) with the exception of the side chain, which has an unsaturated double bond and an extra methyl group. Ergosterol from which it is derived occurs only in plants. Although ergocalciferol is used as a therapeutic agent, it rarely occurs in nature.

SOURCES

Vitamin D occurs naturally in such animal foods as fatty fish, eggs, liver, and butter. Milk is a poor source of vitamin D unless fortified. Much of the milk now available has vitamin D added to provide a concentration of 400 IU (10 μg vitamin D_3) per quart. Cod-liver oil and other fish-liver oils are excellent natural sources of the vitamin. It is present in very small quantities in green plants and mushrooms.

Although the vitamin is not widely distributed in nature, consumption of the vitamin as it occurs naturally in food or by enriched foods, the irradiation of foods containing precursors of the vitamin, and irradiation of the skin with ultraviolet light or sunlight, all ensure an adequate daily human supply.

Vitamin D is stable in foods; storage, processing, and cooking do not affect its activity.

REQUIREMENT

Because there are two sources of vitamin D, the naturally occurring form (D_3) and the synthetic (D_2), the evaluation of minimum requirement is difficult. It is only when exposure to sunlight is inadequate, dietary intake restricted, and needs high, that deficiency symptoms develop. The amount of vitamin D needed, therefore, is determined by the degree of exposure to sunlight. A person living and working indoors, primarily, would need more vitamin D than a person working outdoors all day.

One international unit vitamin D equals 0.025 μg vitamin D, or cholecalciferol. The minimum requirement for vitamin D has not yet been established (34). The amount of vitamin D formed by the action of sunlight on the skin is dependent on a number of variables, including length and intensity of exposure and color of skin. Heavily pigmented skin can prevent up to 95% of ultraviolet radiation from reaching the deeper layers of the skin, where vitamin D is synthesized (21).

An intake of 2.5 μg (100 IU) vitamin D/day prevents rickets and ensures adequate absorption of calcium from the intestine, a satisfactory growth rate, and normal mineralization of the bone in infants. However, the ingestion of 7.5–10 μg (300–400 IU) vitamin D seems to promote better calcium absorption and some increase in growth. Therefore, this higher level is recommended as the daily allowance (RDA). For infants the allowance should be provided in

the diet or as a supplement since exposure to sunlight may be insufficient.

The precise requirement for vitamin D in older children and adults is not known. Normally, the requirement can be met by exposure to sunlight, but if exposure to sunlight is insufficient a dietary source must be provided. An intake of 400 IU vitamin D/per day is advisable for pregnant and lactating women, infants, children, and adolescents. Since the requirement for the normal healthy adult seems to be satisfied by nondietary sources, no dietary recommendation is necessary. However, a dietary intake of 400 IU for normal individuals of all ages incurs no risk of toxicity.

TOXICITY

The ingestion of vitamin D in excess of the recommended amounts (hypervitaminosis) provides no benefit, and large doses can be harmful. It should be emphasized that the fat-soluble vitamins, such as vitamin D, can be stored in the body for considerable lengths of time and that, since they metabolize slowly, they therefore may produce toxic symptoms. The reason for this toxicity involves the difficulty of excretion rather than its storage. Excretion is gradual and by the way of the bile. In contrast, the water-soluble vitamins are not stored to any great extent but when consumed in excess of needs are rapidly excreted in the urine.

There is evidence that infants are especially sensitive to the toxic effect of vitamin D. Infants need only 400 IU daily, whereas intakes such as 3000–4000 IU daily may produce toxic symptoms as shown by abnormally high calcium levels in the blood, loss of appetite, and retarded growth (32,36). With daily doses of 20,000–40,000 IU in infants, or 75,000–100,000 IU for adults, toxic symptoms usually develop. These symptoms include sudden loss of appetite, nausea, vomiting, intense thirst, and resulting polyuria. There may be diarrhea, and the child may become thin, irritable, depressed, and stuporous. Fatal cases have been reported in which the arteries, renal tubules, heart, and lungs have shown evidence of considerable calcification.

Vitamin D is probably the most toxic of all vitamins. Very high doses, *e.g.,* 100,000 IU, for weeks or months may, in addition to deposition of calcium in many of the organs such as the arteries and kidneys, induce characteristic dense calcification of the bone along the metaphysis. Such toxic symptoms may arise when the vitamin is given in massive amounts for the treatment of bone disease due to malabsorption of chronic renal disease.

The quantities of vitamin D necessary to induce toxic symptoms cannot be obtained from natural sources.

VITAMIN E (THE TOCOPHEROLS)

Current popular interest in vitamin E has probably come about through a hoped for but unwarranted expectation that results obtained and reproducible in experimental animals are without question directly applicable to man. Among conditions for which vitamin E is supposedly effective are sexual impotence, sterility, habitual abortion, muscular dystrophy, arthritis, aging, and acne, to name only a few. Fortunately, much confirmed biochemical and metabolic information rigorously obtained by experimentation in animals can be, with reason, applied to man. Unfortunately, this is sometimes not true. At present there is no satisfactory evidence that any of the human ailments noted above are correctible by eating, injecting, or any other means of taking vitamin E into the human body.

Vitamin E has been known as the antisterility vitamin since its discovery in 1922. In that year, Evans and Bishop (11) found a third unknown fat-soluble factor in lettuce, wheat germ, and dried alfalfa essential for successful reproduction in rats. A deficiency of their unknown "factor X" caused resorption of the fetus in the female and in the male atrophy of spermatogenic tissue and permanent sterility. Sure (48) in 1924, independently came to the same conclusion, and because the then four known vitamins were called A, B, C, and D, he suggested that this "fertility vitamin" be called vitamin E. Evans (12) in 1936 isolated crystalline vitamin E from the unsaponifiable fraction of wheat germ oil and named it tocopherol, an alcohol which helps in the bearing of young (Greek *tokos,* childbirth + *phero,* to bear + *ol,* an alcohol).

In some animals such as the rat, guinea pig, rabbit, and dog, the lack of vitamin E produces a condition resembling muscular dystrophy. The dystrophic muscles exhibit increased oxygen uptake. This may be due to increased oxidation of polyunsaturated fats, which appear to occur chiefly in the muscles. The degeneration is reported to resemble Zenker's necrosis observed in severe infections such as typhoid fever and epidemic influenzal pneumonia. Muscle fibers may be replaced by fat and connective tissue. Increased urinary excretion of creatine may re-

flect the inability of skeletal muscle to use creatine. A brown discoloration occurs in the voluntary muscles of these vitamin E–deficient animals, and similar pigmentation can be seen in the uterus, ovaries, and seminal vesicles. The increased oxygen consumption of the dystrophic muscles and other abnormal findings can be decreased, sometimes dramatically as in the rabbit, by adding the vitamin to the diet. The use of vitamin E as a curative agent in the treatment of muscular dystrophy in the human subject has without exception met with failure.

FUNCTION

It is reasonable to suspect from evidence that is now available that vitamin E may function in tissues as an antioxidant. In the tissues vitamin E may prevent the destructive nonenzymatic oxidation of polyunsaturated fatty acids by molecular oxygen. Some products that result from oxidation of fat may appear in tissues as pigments. These may be associated with cell damage, and they are found in tissues of older animals as well as animals on diets lacking in vitamin E. A role for vitamin E in tissues as an agent for preventing degenerative disorders therefore cannot be discounted. It is also possible that vitamin E may function either as a coenzyme or in some other manner in enzymatic reactions. The many questions that can be raised in regard to the functional role of vitamin E offer great opportunities for investigative work.

DEFICIENCY

At present, investigations conducted in laboratory animals have contributed to our knowledge of vitamin E. Data obtained from such animal experiments vary substantially when examined in such species as the rat, guinea pig, rabbit, dog, and chicken. Equally puzzling and seemingly unrelated is the variety of symptoms involving the reproductive, muscular, vascular, nervous, and glandular systems. Only recently have vitamin E deficiencies been observed in human beings, and the results are too incomplete to support firm conclusions or to verify the applicability of results obtained in animal experimentation to human beings.

DEFICIENCY IN ANIMALS

Reproduction. As pointed out earlier in this section, vitamin E deficiency results in infertility and reproductive failure in the rat. The female rat conceives normally, but the fetuses die during gestation and are reabsorbed. The deficiency in the female rat is not permanent, and if vitamin E is administered prior to the fifth or sixth day, resorption of the fetus can be prevented, allowing the female rat to continue to reproduce normally. If vitamin E restitution to the diet is delayed, many congenital abnormalities may occur. In the male rat, vitamin E deficiency produces permanent degeneration of testicular germinal epithelium and sterility. Liver degeneration may occur along with reproductive failure. The male mouse, however, does not show signs of testicular damage when made vitamin E deficient. In addition to α-tocopherol, the administration of selenium, cystine, and ubichromenol may be effective in relieving the reproductive symptoms. The element selenium either replaces vitamin E as an oxidant or spares it (40). The sulfur-containing amino acid cystine also may influence the antioxidative effectiveness of vitamin E. Ubichromenol and DPPD (N,N'-diphenyl-p-phenylenediamine) can replace vitamin E in preventing fetal resorption in rats.

In Muscles. A frequent finding in vitamin E deficiency in the guinea pig, rabbit, and monkey is muscular dystrophy. This is characterized by degenerative changes in skeletal muscle fibers followed by atrophy and replacement by connective tissue and fat. The weakened muscles, fatty degeneration, and fibrotic changes resemble the signs seen in muscular dystrophies in man. The muscular changes are accompanied by a large increase in urinary creatine, a decrease in muscle creatine, and an increase in the oxygen consumption of the muscle. Changes in EKG have been reported for cardiac muscles, and death may be caused by cardiac failure. No relationship has been established between human muscular dystrophy and the similar condition seen in experimental animals. Vitamin E supplementation does not appear to relieve the symptoms of human muscular dystrophy.

Encephalomalacia and Exudative Diathesis. In chicks vitamin E deficiency causes central nervous system changes known as encephalomalacia and exudative diathesis. In this latter condition, areas of fluid accumulation appear beneath the skin, on the breast, legs, abdomen, and neck. Hemorrhage and leakage of plasma from the capillaries are seen, particularly those under the skin. Encephalomalacia in chickens is characterized by

convulsions, paralysis, atoxia, head retraction, and sudden death.

Hepatic Necrosis. Hepatic necrosis in rats has been observed to be aggravated by a vitamin E deficiency. The condition was induced by a low-protein diet that was very low in cystine, a sulfur-containing amino acid. The condition was much improved when the diet was supplemented with cystine, vitamin E, and a selenium preparation. It was prevented, or did not occur, when the substances described above were included in the initial diet fed. It is possible selenium may replace or spare vitamin E in a mixed diet.

It is of interest that hepatic necrosis in the rat occurs only if the diet contains appreciable quantities of unsaturated lipids. Diets in which casein, rigorously purified, served as the sole source of protein resulted in one month or more in sudden death due to hepatic necrosis. A constituent found in food which has not been completely characterized but contains a selenite when added to the diet afforded complete protection.

Hemolysis of Red Blood Cells. In the presence of peroxide or dialuric acid (an alloxan derivative) the red blood cells of vitamin E–deficient animals are more easily hemolyzed than red blood cells not subjected to the influence of peroxide and acid. A macrocytic anemia has been observed in vitamin E–deficient monkeys.

Steatitis. In some animals the feeding of vitamin E–deficient diets containing large amounts of polyunsaturated fatty acids results in yellow fat disease or steatitis. Peroxidation and polymerization of the polyunsaturated fatty acids results in the production of acid-fast ceroid pigments, which deposited in the fat give it a brown or yellow orange appearance.

DEFICIENCY IN THE HUMAN. A vitamin E deficiency is rarely seen except in persons suffering from some form of the malabsorption deficiency. It may be that in normal individuals on a Western-style diet a vitamin E deficiency is not an important problem in human nutrition.

Studies conducted in new born infants and in children with steatorrhea have shown increased red blood cell hemolysis that has been related to low serum tocopherol levels.

Creatinuria, ceroid pigment deposition, increased hemolysis rates, and muscle lesions have been reported in individuals with cystic fibrosis of the pancreas, which reduces vitamin E absorption.

It is difficult to find a single theory to explain all the varied physiologic abnormalities cited above. It is possible that the ability of vitamin E to act as an anti-oxidant may underlie much of the pathology. Death of the rat fetus may result from the toxic effects of peroxides formed because of an absence of the vitamin or the increased oxygen consumption in dystrophic muscles in vitamin E–deficient animals may result from the low stores of vitamin E. The possibility of α-tocopherol participating in a specific enzyme system cannot be discounted.

CHEMICAL PROPERTIES AND STRUCTURE

Like vitamins A and D, vitamin E exists in more than one form. Of these, eight substances of plant origin (four tocopherols and four tocotrienols) are of interest (Fig. 3–4). All are derivatives of 6-hydroxychroman and contain a 16-carbon isoprenoid side chain. They differ structurally in the number and position of methyl groups in the ring structure, and in the case of the tocotrienols the side chain is unsaturated. All have the same physiologic properties, but α-tocopherol is the most

Tocols
$$R4 = (CH_2 \ CH_2 \ CH_2 \ CH)_3 \ CH_3$$
with CH_3 substituent

Tocotrienols
$$R4 = (CH_2 \ CH_2 \ CH = C)_3 \ CH_3$$
with CH_3 substituent

Tocol	Tocotrienol	Methyl positions
α -(alpha)	ζ-(zeta)	5, 7, 8
β-(beta)	ϵ-(epsilon)	5, 8
γ-(gamma)	η-(eta)	7, 8
δ-(delta)	8-methyl-tocotrienol	8

Fig. 3–4. Naturally occurring tocopherols.

active of the group as a vitamin (for structure see Table A-15). The remaining compounds have lower biologic activities estimated to be 1%–50% of the activity of α-tocopherol. Synthesized in 1938 by Karrer in Switzerland and Smith in the United States, this is the form in which the vitamin is produced commercially. In accordance with a recommendation by the IUNS Committee on Nomenclature (17) the term vitamin E should be used as the general description for all tocol and tocotrienol derivatives exhibiting qualitatively the biologic activity of α-tocopherol.

Vitamin E compounds are light yellow, viscous oils, insoluble in water but freely soluble in fat solvents. They are stable to heat but readily destroyed by oxidation and ultraviolet light and are not destroyed to any extent by temperatures used in cooking, though some loss occurs in frozen foods and processing.

Because vitamin E is capable of taking up oxygen and oxidizing slowly it can function in the body as a potent antioxidant to protect other vital metabolites such as vitamin A, the carotenes, and unsaturated fatty acids, from destructive oxidation. The tocopherols are the chief antioxidants in natural fats and act to prevent fats from becoming rancid.

The tocopherols are themselves easily oxidized, and this property presents difficulties in analytic procedures devised to estimate this vitamin (18).

ABSORPTION AND METABOLISM

As a fat-soluble substance, vitamin E requires the presence of bile for absorption from the small intestine. It is absorbed best in the presence of fat. Any abnormal or disease state that interferes with the absorption of fat, such as pancreatic, liver, and biliary disease, or diseases of the intestinal mucosal cell and transport, will interfere with the absorption of vitamin E. Although some vitamin E may be absorbed into the portal blood, the bulk of the vitamin enters unchanged into the lymph system and is transported to the bloodstream as tocopherol attached to lipoproteins. It is stored largely in adipose tissue, muscle, liver, and in somewhat smaller amounts in heart, uterus, testes, and adrenals.

SOURCES

The richest sources of vitamin E are the vegetable oils. Wheat germ oil, from which α-toco-pherol was first isolated, is a good source, as are salad oils and mayonnaise, beef liver, milk, eggs, butter, leafy vegetables, and cereals (particularly if fortified). Many of these foods are also excellent sources of polyunsaturated fatty acids.

Fish liver oils are rich in vitamins A and D but are low or devoid of vitamin E.

REQUIREMENT

As pointed out previously in this section the exact mechanism by which vitamin E functions in the body is unknown. Foods contain significant amounts of nearly all the eight tocopherols. For this reason the milligram of α-tocopherol equivalent has been recommended as a summation term for all vitamin E activity (42). Vitamin E is an essential nutrient. The National Research Council's revised statement of 1974 recommends about 5 IU vitamin E for infants, increasing to 15 IU for males and 12 IU for females (see Table A-1).

TOXICITY

Vitamin E appears to be relatively nontoxic. Human adults have been reported to consume as much as 1 g/day for months without developing signs of toxicity.

VITAMIN K (THE NAPHTHOQUINONES)

McFarlane and coworkers (24) in 1931 reported on experiments conducted to determine the needs of chickens for fat-soluble vitamins. In their work they employed a diet consisting of 70% polished rice, 15% yeast as a hydrolysate, together with protein from fish meal and casein. When their fish meal was ether-extracted before being fed, they sustained heavy losses of birds from hemorrhage. No losses or hemorrhage were noted when the fish meal was not ether-extracted. Also, they observed that when blood from their hemorrhagic chickens was kept overnight in the laboratory, it failed to clot. This latter observation appears to be the first relating blood-clotting time with an ether-soluble substance in fish meal (24).

In 1935 Henrick Dam (8) at the University of Copenhagen, studying hemorrhagic disease in chicks fed a fat-free diet, reported that bleeding could be prevented by giving a variety of foodstuffs, especially alfalfa and decayed fish. The active material could be extracted by ether. The

bleeding was not due to a lack of vitamin C (ascorbic acid). He succeeded in isolating the substance from alfalfa and showed that the antihemorrhagic substance was fat-soluble but not identified with vitamins A, D, or E. He called the active substance koagulationsvitamin (after the Danish word for coagulation) which then became vitamin K.

FUNCTION

The primary function of vitamin K is to catalyze the synthesis of prothrombin by the liver. Without this step, the normal process of blood clotting could not take place. In addition, the synthesis of other factors necessary in the clotting process, such as factors VII (proconvertin), IX (Christmas factor) and X (Stuart factor), depends on vitamin K. In the absence of vitamin K, hypoprothrombinemia develops and blood clotting is greatly prolonged. In fact, defective blood coagulation is the only well-established sign of vitamin K deficiency in animals. It should be pointed out that the ability of vitamin K to alleviate hypoprothrombinemia is dependent on the capacity of liver cells to produce prothrombin. Advanced liver damage, as in cirrhosis or carcinoma, may be accompanied by a prothrombin deficiency that cannot be reversed by vitamin K—a normal liver is required.

The major defense of the human body against blood loss is the formation of a blood clot. Normal human blood when shed will clot in 5–8 min at 37° C. The process of forming a clot is a complex cascade of enzyme activations in which a very small amount of the first factor initiates a series of catalytic reactions until the amplified response to the injury results in the formation of the clot. Prothrombin, a precursor enzyme, is in some way, not yet clear, formed as the result of the presence of vitamin K, which in the presence of thromboplastin and calcium ions is converted to the enzyme thrombin. This in turn catalyzes the conversion of the soluble protein dimer fibrinogen into the insoluble monomer fibrin, the basis of the clot.

The only generally accepted function of vitamin K in higher animals is that of regulating the synthesis of prothrombin and other plasma-clotting factors. The vitamin regulates the rate of synthesis of prothrombin after transcription, but the nature of the control site is still undetermined. Some investigators believe that protein synthesis is not required for the step sensitive to vitamin K in the production of prothrombin. Suttie (49) has found data consistent with the formation of a precursor protein in the liver which is converted to prothrombin in a step requiring vitamin K.

Certain snake venoms as well as strains of Staphylococci contain vitamin K–like proteolytic enzymes that can cause clotting.

DEFICIENCY

A dietary deficiency of vitamin K is unlikely because of the intestinal synthesis of the vitamin by microorganisms and because it is quite widely distributed in foods. As pointed out previously, a vitamin K deficiency may occur in biliary obstruction and in any defect in the intestinal absorption of fat, such as may occur in malabsorption syndromes, e.g., sprue and celiac disease, and in conditions giving rise to steatorrhea.

In severe liver disease the destruction of liver cells may cause a failure in the synthesis of prothrombin, and bleeding may result. Normal liver cells are necessary for vitamin K to participate in the synthesis of prothrombin.

The newborn infant has a sterile intestinal tract and is often fed on foods relatively free from bacterial contamination. Breast milk and cow's milk are very poor sources of the vitamin. As a result, the neonate may have a low prothrombin level and prolonged coagulation time. Usually, there is a spontaneous improvement in the prothrombin levels and clotting time, but where this does not occur, supplementation of the infant's diet with vitamin K is necessary. Treatment with antibiotics may give rise to a prothrombin deficiency.

Surgical procedures involving the biliary tract, such as operations on the common bile duct or removal of the gallbladder (cholecystectomy), usually necessitate vitamin K therapy to prevent excessive postsurgical hemorrhage.

Dicoumarol, which is used as an anticoagulant, resembles vitamin K in structure and can act as an antagonist to vitamin K, thereby giving rise to a hemorrhagic condition (46). An important therapeutic use of vitamin K is as an antidote to the anticoagulant drug. The prothrombin time, which is lengthened by the use of dicoumarol, will usually return to normal within 12–36 hr after the administration of the vitamin provided the liver function is adequate to synthesize prothrombin.

CHEMICAL PROPERTIES AND STRUCTURE

The term vitamin K is used to include a group of antihemorrhagic substances with similar biologic activity. There are two naturally occurring vitamins in the group, vitamin K_1 and vitamin K_2, required for the biosynthesis of prothrombin essential in the blood-clotting process. Vitamin K_1 is present in green leaves and other plant tissues that are eaten in the diet. Vitamin K_2 is present in putrefying fish meal and is synthesized by intestinal bacteria. Chemically, they are quinones and related to the parent compound α-methyl-1,4-naphthoquinone (Fig. 3–5).

Following the IUNS Committee on Nomenclature, vitamin K_1 is phytylmenaquinone (formerly phylloquinone or phylonadione), and vitamin K_2 multiprenylmenaquinone (formerly farnoquinone), of which there are several active forms in bacteria and in the animal body. Vitamin K_3 is menaquinone (formerly menadione), which is produced synthetically, is fat soluble, and has about twice the biologic activity of the natural forms of the vitamin. Vitamin K_2 has approximately 75% of the activity of vitamin K_1. It is believed that phytylmenaquinone is the biologically active form of the vitamin and that animal cells are able to convert the other forms into this active form.

When fat absorption is impaired, as in the malabsorption syndrome, several water-soluble and water-miscible preparations are available for the treatment of vitamin K deficiency. Menadione sodium bisulfite (Hykinone) and sodium menadiol diphosphate (Synkayvite) are water soluble; Mephyton, Konakin, and Mono-kay are water miscible.

All forms of the natural vitamin K are yellow oils. They are quite stable to heat, air, and moisture, but not to light. They are unstable in ultraviolet light and destroyed by oxidation. Cooking destroys very little of the activity because the natural forms are insoluble in water.

It has been known for some time that cattle develop a tendency to bleed if fed on spoiled sweet clover. The substance responsible for this bleeding tendency was isolated and synthesized by Link and his students, (46) as dicoumarol. Dicoumarol prolongs the prothrombin time of blood and so aids as an anticoagulant in the treatment of arterial and venous thromboses. Other synthetic analogues, such as warfarin (a rat poison which prevents the rat's blood from clotting) and phenindione, are antagonistic to the action of vitamin K and inhibit synthesis of prothrombin and blood-clotting factors (VII, IX, and X) in the liver.

It is believed that vitamin K_1 is an essential component of the phosphorylation processes concerned with photosynthesis in green plants and that it may have a similar role as a cofactor necessary in oxidative phosphorylation in animal tissues. It is similar in structure to coenzyme Q (see below).

Fig. 3–5. Chemical structure of some vitamin K compounds.

2-methyl-1,4-naphthoquinone

K_3, or Menaquinone _____ R = H

K_1, or Phytylmenaquinone _____ R = 3-phytyl-1,4-naphthoquinone

$$-CH_2-CH=C-(CH_2\ CH_2\ CH_2\ CH)_3-CH_3$$

with CH_3 substituents

K_2, or Multiprenylmenaquinone _____ R = 3-polyprenyl-1,4-naphthoquinone

$$-(CH_2-CH=C-CH_2)_n-H \ (n = 7, 8, \text{or } 9)$$

with CH_3 substituent

ABSORPTION

Like vitamins A, D, and E, vitamin K is fat soluble and requires a normal supply of bile for intestinal absorption. It is absorbed in the duodenum and jejunum of the small intestine. A deficiency of vitamin K can appear as a result of the malabsorption syndrome as for example, in biliary tract obstruction or if there is a defect in fat absorption, such as in sprue and celiac disease.

Normally, vitamin K is absorbed and enters the metabolic system by way of the lacteals, lymph and blood. It is transported from the intestine in chylomicrons and subsequently transported by the blood in β-lipoproteins.

SOURCES

The synthesis of vitamin K by intestinal bacteria and the levels obtained in a diet from vegetables, especially green leafy vegetables, normally supplies sufficient vitamin K. However, in the neonate before the establishment of intestinal bacteria; in malabsorption syndromes such as cystic fibrois, diarrhea, and failure of bile secretion; and in patients requiring antibiotics, the amount of vitamin K in the body is reduced and supplements of the vitamin are recommended.

Lettuce, spinach, kale, cauliflower, and cabbage, are excellent sources of vitamin K. Very little vitamin K is present in most cereals, fruits, carrots, peas, meats, and highly refined foods. Breast milk and cow's milk, although the latter is better than human milk, are very poor sources of the vitamin.

A primary deficiency of vitamin K in adults has never been clearly demonstrated. It must be assumed therefore that even a poor diet contains enough vitamin K to sustain normal human needs.

REQUIREMENT

Vitamin K is synthesized by intestinal bacteria. Although the role of the intestinal flora in synthesizing the vitamins is not fully known, absorption of synthesized vitamin K from the small intestine and of that supplied in the diet appears in the normal individual to be efficient. Therefore, because of the above observations and the abundance of vitamin K in the diet, no daily recommendation of intake is made. The American Academy of Pediatrics (54) estimates that the neonate requires 0.15–0.25 μg/kg/day. If about 10% of orally administered vitamin K is assumed, a daily intake of 0.2 mg (200 μg) appears adequate for the newborn infant. Adults are believed to require 0.3–15.0 μg/kg/day.

TOXICITY

The natural vitamins K_1 and K_2 are nontoxic in large doses. Excessive doses (over 5 mg) of menaquinone (formerly menadione) and its derivatives have led to hemolytic anemia in rats and kernicterus in low-birth-weight infants, due probably to an increased breakdown of red blood cells. Vitamin K_1 seems to be free from these side-effects (34).

VITAMINLIKE COMPOUNDS

The essential nutrients described in the previous sections of this chapter are definitely established as vitamins. In addition to these, there are vitaminlike substances that presently do not meet the necessary criteria to be classified as vitamins. These are choline, inositol, coenzyme Q, lipoic acid, p-aminobenzoic acid, and the bioflavonoids. All of these vitaminlike substances fail to meet one or more of the following established criteria for a vitamin: 1) they do not on the basis of present knowledge have an essential biological role; 2) the animal body can synthesize sufficient amounts to meet metabolic needs; 3) they are present in the diet and tissues in larger amounts than the catalytically involved and established vitamins.

As knowledge increases and the concept of what constitutes a vitamin changes, it is possible that some of these compounds may become established as true vitamins. For this reason descriptions of these substances are presented here.

CHOLINE

Choline is not a vitamin for man because it is synthesized in the body from the amino acid glycine, provided there is present another source of methyl groups, such as the methyl group in methionine. Furthermore, the amount of choline utilized by the human organism is much larger than the catalytic amounts expected in metabolic reactions involving vitamins. Choline probably cannot be considered a vitamin since the human is not dependent on a dietary source of either choline or a choline precursor. In addition, there is little evidence to suggest that in man the administration of choline allevi-

ates fatty liver, cirrhosis, chronic liver disease, or other defects that resemble those associated with a choline deficiency (5). However, among alcoholics choline may exert a protective effect in cirrhosis of the liver.

Choline is a simple molecule containing three methyl groups (see formula for choline in Table A-14). It is strongly alkaline in its free form. It is water soluble and takes up water (*i.e.,* it is hygroscopic) on exposure to air. Choline is more stable in the form of the chloride. It serves as a source of labile methyl groups. In many organic compounds the methyl group is fixed and not detachable. However, in choline the labile methyl groups can be transferred from one compound to another in a process called transmethylation. In this way, choline provides methyl groups, for example, for the synthesis of creatine and epinephrine and for methylating certain substances for excretion in the urine.

"Synthesis of choline requires a supply of labile methyl groups. Methionine is the ultimate methyl donor in the body, but methyl groups synthesized *de novo* by reactions that require vitamin B_{12} and folate coenzymes can be transferred to homocysteine to form methionine. The requirement for choline is influenced not only by the amounts of methionine, folic acid, and vitamin B_{12} in the diet, but also by the growth rate of the animal, its energy intake and expenditure, fat intake, and the type of dietary fat. In mature animals of several species fed an otherwise adequate diet, it is difficult to demonstrate a choline requirement, whereas in young animals fed a low-protein diet, severe choline deficiency can be produced." (34)

In the young growing rat on a low-protein diet, fatty livers develop in 4–6 weeks on a diet deficient in choline. Depending on the composition of the deficient diet and the length of time fed, there is poor growth, edema, and an impaired cardiovascular system, which in turn may result in hemorrhagic lesions in the kidney, heart muscle, and adrenal glands. Older animals and the young that survive may develop cirrhosis. Best and coworkers (3, 4) have shown that choline, and less efficiently betaine (another methyl group donor), prevents the occurrence of fatty livers in rats fed diets low in protein and high in fat, cholesterol, and sucrose. Betaine, which is formed by the oxidation of choline, has choline activity and resembles choline in that it has a nitrogenous base and three methyl groups.

Chickens and turkeys are quite immune to fatty livers but develop slipped tendon (a bowing of the legs) which makes walking so difficult death usually results in 6–8 weeks. Best and co-

workers found that lecithin (phosphatidyl choline) prevented fatty livers in dogs.

Choline is essential in the synthesis of phosphatidyl choline, a component of cell membranes and lipoproteins involved in the transport of fat-soluble substances. It is a constituent of sphingomyelin (a sphingolipid present in high concentrations in the brain) and acetyl choline, which functions in the transmission of nerve impulses.

Choline is present in foods in which phospholipids occur, *e.g.,* egg yolk (a very rich source), whole grains, legumes such as soybeans, peas and beans, meats of all types, and wheat germ. Vegetables and milk have small amounts. Fruits have low or no choline content.

The Food and Nutrition Board of the National Academy of Sciences does not suggest a human allowance of choline because of lack of evidence for a recommendation.

MYOINOSITOL

The inositols are cyclic alcohols (cyclohexanols). Chemically, inositol is hexahydroxycyclohexane. Because of the presence of hydroxyl groups in the molecule, inositols can be considered as related to the sugars. There are nine isomers of inositol (seven optically inactive forms and one pair of optically active isomers), but only the *myo*-inositol (also called *meso*-inositol or i-inositol) is biologically active and of importance in animal and plant metabolism. Inositol is found in nature in at least four forms: 1) free inositol; 2) phytin, a mixed calcium and magnesium salt of inositol hexaphosphate (phytic acid); 3) the phospholipid, phosphatidyl-inositol; and 4) a nondialysable, water-soluble complex. Large amounts of phytic acid in cereals and grains when taken into the GI tract can combine with calcium and prevent the absorption of this essential mineral by the excretion of the insoluble complex into the feces.

In mice a dietary deficiency causes alopecia and a failure of lactation and growth. It has sometimes been classified as a vitamin because mice require traces of *myo*-inositol in the diet. In rats a deficiency causes a "spectacled-eye" condition due to denudation about the eyes.

In inositol-deficient chicks an encephalomalacia and an exudative diathesis have been reported. There is no evidence for a requirement in man.

Eagle (9), studying the nutrient requirements of cells in tissue culture, found that 18 different human cell strains maintained on a semisynthetic

medium failed to grow without the addition of *myo*-inositol. None of the other isomers of inositol were effective. A similar finding was true of experiments in animals.

Like choline, inositol has a lipotropic effect in preventing certain types of fatty livers in experimental animals. This lipotropic activity may be associated with the formation of inositol-containing lipids such as phosphatidyl inositol.

In plants, monophosphoric, diphosphoric, and triphosphoric esters of inositol are found in large quantities. The hexaphosphatic phytic acid is present in high concentrations in grains. In nucleated erythrocytes of birds, phytic acid tends to bind hemoglobin in the same manner as 2,3-diphosphoglycerate in mammalian erythrocytes. It is of interest that McClure (22) has found a beneficial effect of phosphates, primarily in the form of phytates of whole grain cereals, in preventing dental caries. However, dietary phytic acid is rachitogenic because formation of the insoluble salt, calcium phytate, in the GI tract prevents normal absorption of dietary calcium, and possibly of iron as well.

Inositols occur widely in the plant kingdom in whole grains and nuts and in fruits and vegetables. Considerable concentrations are present in yeast and milk.

COENZYME Q (UBIQUINONE)

The biologically active and ubiquitous coenzyme Q is so widely distributed in nature that it is appropriately called "ubiquinone." It is the collective name for a group of chemical compounds that differ from one another merely by the number of isoprenoid units in a side chain. Thus far five crystalline homologues that differ from one another by the number of isoprenoid units have been obtained from natural sources. Coenzyme Q obtained from beef heart has 10 isoprenoid units in the side chain (Q_{10}); yeast (Saccaromyces cerevisia) has 6 units (Q_6) and the active material from Torula utilis 9 (Q_9). Coenzyme Q is quite similar in structure to vitamin K and vitamin E.

In recent years it has become clear that an additional electron carrier is present in the respiratory chain linking the flavoproteins to cytochrome b, the member of the cytochrome chain of lowest redox potential. Crane (7) has demonstrated such a function for coenzyme Q as an electron carrier in terminal electron transport and oxidative phosphorylation.

Coenzyme Q is a constituent of the phospholipids of the mitochondrial membrane. It exists in the mitochondria in the oxidized or quinone form under aerobic conditions and in the reduced or quinol form under anaerobic conditions.

Coenzyme Q is synthesized in the cell and therefore is not a true vitamin. However, it should be pointed out that the aromatic ring of coenzyme Q may have to be provided to the synthesizing cell.

α-LIPOIC ACID

Also called thioctic acid, α-lipoic acid is a sulfur-containing fatty acid. Both thiamin pyrophosphate and α-lipoic acid are required for the oxidative decarboxylation of α-keto acids, such as pyruvic acid to acetate or more properly to acetyl coenzyme A. This is a key step in the production of energy from carbohydrate, linking the oxidation of glucose in the mammalian glycolytic cycle with the complete oxidation of glucose to carbon dioxide and water in the citric acid or Krebs cycle. In this process the bond energy of the glucose molecule is captured as high-energy phosphate bonds in adenosine triphosphate (ATP).

The complete system for the oxidative decarboxylation of pyruvic acid involves not only thiamin and α-lipoic acid but also pantothenic acid (as coenzyme A), riboflavin (as FAD), and nicotinamide derivatives (as NAD). This step is considered in detail in the previous section on the function of thiamin as a coenzyme.

α-Lipoic acid occurs in a wide variety of foods and is active in extremely minute amounts. It has not been demonstrated to be required in the diet of higher animals. No attempt to induce a dietary deficiency of lipoic acid has been successful.

α-Lipoic acid is not considered a vitamin for mammals because it can be synthesized in adequate amounts in the mammalian cell.

p-AMINOBENZOIC ACID

p-Aminobenzoic acid (PABA) is a growth factor for bacteria and lower animals. It is synthesized by bacteria and is essential to the growth of the bacterial cell. It is antagonistic to the bacteriostatic action of sulfonamide drugs. It also acts as an antigrey hair factor in black rats and mice and as a growth-promoting agent in chicks. These properties are considered the basis of PABA's tentative status as a vitamin, but no role has been elucidated for man. Cruikshank (7a) has reported that an autopsy of two cases of acute rheumatic fever and one of arthritis treated with large doses of PABA showed fatty changes in the liver, kidneys, and heart of these individuals.

A portion of the folic acid molecule is formed by PABA, and its suggested role is to provide this chemical component for the synthesis of folic acid by those organisms that do not require a preformed source of folic acid. In chemical structure PABA resembles sulfanilamide, and it is a part of the folic acid molecule; this fact may underlie its activity as an antagonist to the bacteriostatic action of sulfa drugs.

When fed to deficient animals in which the intestinal synthesis of folic acid takes place, PABA has considerable folic acid activity. In the rat and the mouse it can completely replace the need for dietary folic acid. This may explain why it was once considered to be a vitamin. At the moment it is not certain whether PABA has a role in metabolism independent of folic acid.

The best food sources of PABA are yeast, liver, rice, bran, and whole wheat. Since PABA does exist in a free form in food, it can be considered a dietary precursor of folic acid. It is not regarded as a vitamin for animals.

BIOFLAVONOIDS

Extracts of lemon peel and red peppers contain a mixture of flavonoids called citrin by Szent-Györgyi in 1936. Citrin was found to be biologically active in maintaining normal capillary permeability and fragility. The active principal in citrin is hesperidin, which was designated vitamin P (for permeability). This term has now been dropped. A number of compounds with hesperidinlike structures, including the flavanones, flavones, and flavanols, have been found to have similar physiologic activity.

Bioflavonoid deficiency has been produced in animals, resulting in a syndrome characterized by increased capillary permeability and fragility. This vitamin C–like effect of the bioflavonoids appears to be due to an antioxidant effect which protects ascorbic acid from oxidative destruction. Their effect is therefore indirect.

At the present time insufficient evidence precludes classifying the bioflavonoids as vitamins.

REFERENCES

1. Appel TW: Studies of biotin metabolism in man. J Med Sci 204:856–875, 1942
2. Baugh CM, Malone JM, Butterworth CE: Human biotin deficiency. A case history of biotin deficiency induced by raw egg consumption in a cirrhotic patient. Am J Clin Nutr 21:173, 1968
3. Best CH, Channon HJ: The action of choline and other substances in the prevention and cures of fatty livers. Biochem J 29:2651–2658, 1935
4. Best CH, Hershey JM, Huntsman ME: The control of the deposition of fat. Am J Physiol 101:7, 1932
5. Best CH, Lucase CC: Choline malnutrition. In Jolliffe N (ed): Clinical Nutrition, 2nd ed. New York, Harper & Row, 1962, pp 227–260
6. Bridgens WF: Present knowledge of biotins. Nutr Rev 25:65–68, 1967
7. Crane FL, Hatefi Y, Lester RL, Widmer C: Isolation of a quinone from beef heart mitochondria. Biochim Biophys Acta 25:220–221, 1952
7a. Cruikshank AH, Mitchell GW, Jr: Myocardial, hepatic and renal damage resulting from para-aminobenzoic acid therapy. Bull Johns Hopkins Hosp 88:211, 1951
8. Dam H: Antihaemorrhagic vitamin of chicks: occurrence and chemical nature. Nature 135:652–653, 1935
8a. DeLuca HF, Schnoes HK: Metabolism and mechanism of action of vitamin D. Ann Rev Biochem 45:631–666, 1976
9. Eagle H, Oyama VI, Levy M, Freeman AE: Myoinositol as an essential growth factor for normal and malignant human cells in tissue culture. J Biol Chem 226:191–205, 1957
10. Elvehjem CA, Madden RJ, Strong FM, Woolley DW: The isolation and identification of the anti-black tongue factor. J Biol Chem 123:137–149, 1938
11. Evans HM, Bishop KS: On the existance of a hitherto unrecognized dietary factor essential for reproduction. Science 56:650–651, 1922
12. Evans HM, Emerson HP, Emerson GA: The isolation from wheat germ oil of an alcohol α-tocopherol, having the properties of vitamin E. J Biol Chem 113:319–322, 1936
13. Fraser DR, Kodicek E: Unique biosynthesis by kidney of a biologically active vitamin D metabolite. Nature 228:764–766, 1970
14. Griffith WH, Nye JF, Hartroft WS, Porta EA: Choline. In Sebrell WH, Harris RS (eds): The Vitamins, Vol III, 2nd ed. New York, Academic Press, 1971, pp 1–154
15. Hodges RE, Bean WB, Ohlson MA, Bleiler R: Human pantothenic acid deficiency produced by omega-methyl pantothenic acid. J Clin Invest 38:1421–1425, 1959
16. Holst A, Fröhlich T: Experimental studies relating to ship-beriberi and scurvy. II. On the etiology of scurvy. J Hyg (Camb) 7:634–671, 1907
17. IUNS committee on nomenclature. J Nutr 101:133–140, 1971
18. Köfler M, Sommer PF, Bolleger HR, Schmidli B, Veccki M: Physiochemical properties and assay of the tocopherols. Vitam Horm 20:407–439, 1962
19. Lawson DEM, Fraser DR, Kodicek E, Morris HR, Williams DH: Identification of 1,25-dihydroxycholecalciferol, a new kidney hormone controlling calcium metabolism. Nature 230:228–230, 1971
20. Lipmann F, Kaplan NO, Novelli GD, Tuttle LC, Guirard BM: Coenzyme for acetylation of a pantothenic acid derivative. J Biol Chem 167:869–870, 1953
21. Loomis WF: Skin-pigment regulation of vitamin D biosynthesis in man. Science 157:501–506, 1967
22. McClure FJ: Cariostatic effect of phosphates. Science 144:1337–1338, 1964
23. McCollum EV: A History of Nutrition. Boston, Houghton Mifflin, 1957

24. McFarlane WD, Graham WR, Richardson F: The fat soluble vitamin requirement of the chick. 1. The vitamin A and vitamin D content of fish meal and meat meal. Biochem J 25:358–366, 1931

25. Mellanby Sir E: A story of nutritional research: The Abraham Flexner Lectures, Vanderbilt Univ. Baltimore, Williams C Wilkins, 1950

26. Mistry SP, Dakshinamutri K: Biochemistry of biotin. Vitamins and Hormones: advances in research and applications 22: 1–55, 1964

27. Morton RA: Vitamin A and vision. Br J Nutr 5:100–104, 1951

28. Muenter MD, Perry HO, Ludwig J: Chronic vitamin A intoxication in adults. Am J Med 50:129–136, 1971

29. Neuweiter W, Ritter W: Über den biotingehalt den frauenmilk. Intern Z Vitaminforsch 21:239–245, 1949

29a. Olson JA: Metabolism and function of vitamin A. Fed Proc 28:1670–1677, 1969

30. Omdahl JL, DeLuca HF: Regulation of vitamin D metabolism and function. Physiol Rev 53:327–372, 1973

31. Peterkotsky B, Undenfriend S: Enzymatic hydroxylation of proline in microsomal polypeptide leading to formation of collagen. Proc Natl Acad Sci USA 53: 335–342, 1965

32. Prophylactic requirement and the toxicity of vitamin D. Committee on Nutrition, American Academy of Pediatrics. Pediatrics 31:512–525, 1963

33. Pugh EL, Wakil SJ: Studies on the mechanism of fatty acid synthesis. XIV. The prosthetic group of acyl carrier protein and the mode of its attachment to proteins. J Biol Chem 240:4727–4733, 1965

34. Recommended Dietary Allowances, National Academy of Sciences, 8th ed. Washington DC, National Academy of Sciences, 1974

35. Relation of nicotinic acid and nicotinic acid amide to canine black tongue. J Am Chem Soc 59:1767–1768, 1937

36. Relation between infantile hypercalcemia and vitamin. Committee on Nutrition, American Academy of Pediatrics. Pediatrics 40:1050–1061, 1967

37. Reichstein T, Grussner A, Oppenauer R: Synthesis of d-and l-ascorbic acid (vitamin C). Helv Chim Acta 16: 1019–1033, 1933

37a. Rickes EL, Brink NG, Konuiszy FR, Wood TR, Folkers K: Crystalline vitamin B_{12}. Science 107:396–397, 1948

38. Rodahl K, Moore T: The vitamin A content and toxicity of bear and seal liver. Biochem J 37:166–168, 1943

39. Roels OA: Vitamin A physiology. JAMA 214:1097–1102, 1970

40. Schwarz K, Foltz CM: Selenium as an integral part of factor 3 against dietary necrotic liver degeneration. J Am Chem Soc 79:3292–3293, 1957

41. Scott D: Clinical biotin deficiency (egg white injury). Acta Med Scand 162:69, 1958

42. Slover HT: Tocopherols in food and fats. Lipids 6: 291–296, 1971

43. Smith FR, Goodman DS: Vitamin A transport and toxicity. N Eng J Med 394:805–806, 1976

44. Smith EL, Parker LF: Purification of antipernicious anemia factor. Biochem J 43:viii, 1948

45. Spencer TN: "Black tongue" in dogs pellagra? Am J Vet Med 11:325, 1916

46. Stahmann MA, Huebner CF, Link KP: Studies on the hemorrahagic agent. J Biol Chem 138:513–526, 1941

47. Staudinger H, Krisch K, Leonhäuser S: Ascorbic acid in microsomal electron transport and the possible relationship to hydroxylation reactions. Ann NY Acad Sci 92:195–207, 1961

48. Sure B: Dietary requirement for reproduction. II. The existence of a specific vitamin for reproduction. J Biol Chem 58:693–709, 1924

49. Suttie JW: Mechanism of action of vitamin K. Demonstration of a liver precursor of prothrombin. Science 179:192–194, 1973

50. Svirbely JL, Szent–Györgyi A: The chemical nature of vitamin C. Biochem J 26:865–870, 1932

51. Syndenstricker VP, Singal SA, Briggs AP, deVaughn NM, Isbell H: Observations of the "egg-white injury" in man and its cure with biotin concentrate. J Am Med Assoc. 118:1199–1200, 1942

52. Szent–Györgyi A: Observations on the function of peroxidase systems and the chemistry of the adrenal cortex. Description of a new carbohydrate derivative. Biochem J 22:1387–1409, 1928

53. Terroine T: Physiology and biochemistry of biotin. Vitam Horm 18:1–42, 1960

54. Vitamin K compounds and the water-soluble analogues. Committee on Nutrition, American Academy of Pediatrics. Pediatrics 28:501–507, 1961

55. Wald G: The biochemistry of vision. Ann Rev Biochem 23:497–526, 1973

56. Waugh WA, King CG: Isolation and identification of vitamin C. J Biol Chem 97:325–331, 1932

57. Williams RH: Clinical biotin deficiency. N Eng J Med 288:247–252, 1943

58. Wills L Camb MA, Lond MB: The nature of the haemopoietic factor in Marmite. Lancet 224:1283–1286, 1933

SUGGESTED READING

Bogert LJ, Briggs GM, Calloway DH: Nutrition and Physical Fitness, 9th ed. Philadelphia, WB Saunders, 1973

Davidson S, Passmore R, Brock JF, Truswell AS: Human Nutrition and Dietetics, 6th ed. London, Churchill Livingstone, 1975

Guthrie HA: Introductory Nutrition, 3rd ed. St. Louis, CV Mosby, 1975

Handbook on Human Nutritional Requirements. (Monograph 61). Food and Agriculture Organization of the United Nations. Rome, WHO, 1974

Harper HA: Review of Physiological Chemistry, 15th ed. Los Altos, Lange, 1975

Mahler HR, Cordes EH: Biological Chemistry, 2nd ed. New York, Harper & Row, 1971

Nizel AE: Nutrition in Preventive Dentistry: Science and Practice. Philadelphia, WB Saunders, 1972

Nutrition: A Scope Manual. Kalamazo, MI, UpJohn Co 1970

Orten JM, Neuhaus OW: Human Biochemistry, 9th ed. St Louis, CV Mosby, 1975

Pike RL, Brown ML: Nutrition: An Integrated Approach. New York, John Wiley & Sons, 1967

Williams SR: Review of Nutrition and Diet Therapy. St Louis, CV Mosby, 1973

4 Minerals

Carl E. Anderson

NOMENCLATURE

There are 92 natural chemical elements, with 50 or more of these being found in human body tissues and fluids. Four elements, *i.e.,* oxygen, hydrogen, carbon, and nitrogen, form and make up 96% of the weight of the human body. Over one-half of this is oxygen, and oxygen and hydrogen together constitute three-fourths of the human body by weight, largely as vital body water. The remaining 4% of the body weight is composed of the essential and nonessential minerals and the mineral contaminants.

The term inorganic element or mineral is not entirely satisfactory as a true description for these nutrients. For example, although essential in the diet and an element, chlorine is not a mineral. Carbon, a major element in the organic matter of tissues, is neither inorganic nor a mineral. However, custom has established this terminology, and because of the lack of a better designation and to avoid confusion with the prexisting literature, these terms will be used in this chapter.

In accordance with present knowledge and the National Academy of Science's description and dietary recommendations (14, 23), the inorganic elements or minerals will be treated in this chapter under four headings: 1) the essential *macro*nutrients, *i.e.,* those minerals needed in the diet at levels of 100 mg/day or more; 2) the essential *micro*nutrients, *i.e.,* those minerals needed in amounts no higher than a few milligrams per day; 3) trace minerals that may be essential but for which human requirements have not been established although there is some evidence that they may be essential in animal metabolism (14); and 4) the trace contaminants. Many trace elements that have no essential function gain entrance to the human body through food, water, and air. Strontium, for example, is probably not an element essential for life, but small amounts often are associated with calcium in bone. In this way strontium -90 in the atmosphere from atomic bomb explosions may create a hazard by contaminating food and water.

It is possible that what is now regarded as mineral contaminants may be found in the future to be vital in man's metabolic processes. With the development of highly sensitive analytic tools such as atomic absorption spectrometry, flame photometry, purified diets, and the "isolator" technique for handling laboratory animals in a contamination-free atmosphere developed by Schwarz (27), such investigative work is possible. It is unfortunate that more work in this area is not vigorously pursued since detection and proof of essentiality may become increasingly difficult with increasing contamination of the air, sea, and earth by expanding populations, industrial wastes, and the application and use of radioactive substances.

The 4 groups of minerals may be listed as follows:

A. Essential *macro*nutrients (needed in amounts of 100 mg/day or more)
 1. Calcium
 2. Phosphorus
 3. Sodium
 4. Potassium
 5. Chlorine
 6. Magnesium
 7. Sulfur
B. Essential *micro*nutrients (trace elements needed in amounts no more than a few mg/day)
 1. Iron
 2. Copper
 3. Cobalt
 4. Zinc
 5. Manganese
 6. Iodine
 7. Molybdenum
 8. Selenium
 9. Fluorine
 10. Chromium

C. *Micro*nutrients that may be essential for the human
 1. Tin
 2. Nickel
 3. Silicon
 4. Vanadium
D. Trace contaminants
 1. Lead
 2. Cadmium
 3. Mercury
 4. Arsenic
 5. Barium
 6. Strontium
 7. Boron
 8. Aluminum
 9. Lithium
 10. Beryllium
 11. Rubidium
 12. Others

The essentiality of a mineral in animal and human metabolism is determined if: 1) altered or diminished physiologic function is observed in a diet adequate in all respects except for the mineral under study; 2) a growth response is demonstrated after repeated supplementation by the mineral in question, or 3) the deficiency state can be correlated with lower than normal levels of the mineral in blood or tissues of the body.

Although the essential mineral nutrients are present in only a small fraction of the total body tissue, they nevertheless are required for a large number of varied and essential purposes in body metabolism. They are interrelated to each other so that a deficiency of one inorganic element may affect the functioning of another. Additionally, the quantity of an essential mineral may not indicate its importance in body function. A very small amount of one mineral can be as essential as large quantities of another.

In general, the function of minerals in metabolism can be considered under two headings: 1) structural components of body tissues, *e.g.,* the insoluble portions of the skeleton and other softer tissues, and indispensable components of important metabolites, *e.g.,* phosphates; and 2) solutes and electrolytes in solution as free ions in body fluids.

STRUCTURAL COMPONENTS

Calcium, phosphorus, and magnesium provide hardness and rigidity to bones and teeth. The sulfur of the amino acids cystine and methionine is present in such protein-containing tissues as hair, nails, and skin. Iron is a vital component of hemoglobin, myoglobin, and—with copper—a component of metalloenzyme complexes, such as cytochrome oxidase, essential in the respiratory chain. Cobalt is an essential component of vitamin B_{12}, and iodine of thyroxine, the hormone of the thyroid.

SOLUTES AND ELECTROLYTES IN SOLUTION AS FREE IONS

Sodium, potassium, chlorine, and phosphorus are vital in the regulation of acid–base balance and normal metabolism. Sodium and potassium play a primary role in osmotic regulation and in the flow of tissue fluids, absorption and secretion. Calcium is important in cell permeability and with sodium and potassium and magnesium, and manganese ions function as enzyme activators. These are only a few illustrative roles for minerals in body metabolism.

ESSENTIAL MACRONUTRIENTS (100 MG/DAY OR MORE)

CALCIUM

FUNCTION AND DISTRIBUTION

The body of a healthy human adult contains about 1250 g calcium, 99% (about 1.2 kg) of which is in the bones and teeth as deposits of calcium phosphates. The small amount of calcium not present in the hard tissues is in the body fluids, partly ionized. In blood serum, calcium is present in small amounts, usually about 10 mg/100 ml (9–11 mg%). Approximately 60% of serum calcium is ionized; the remainder is bound to serum proteins. Tetany developes when serum calcium is reduced substantially. Such a reduction can lead to respiratory or cardiac failure because of impaired muscle function.

Calcium is deposited in an organic matrix in bone which is essential to normal calcification. The inorganic portion of bone is largely a crystalline form of calcium phosphate which resembles the mineral hydroxyapatite [$Ca_{10}(PO_4)_6(OH)_2$]. Additionally, bone contains a noncrystalline and amorphous calcium phosphate. This amorphous material is predominant in early life but is replaced in later life by the crystalline apatite (14).

Although it would appear that the mineral deposits in bone are permanent, bone is constantly being formed and resorbed. This occurs

at a rapid rate during the early developmental period of life and at a declining rate during adult life. In older people and with advancing age the bones become fragile and may break easily. When accelerated this process gives rise to the frequently painful and disabilitating disease known as osteoporosis. About 700 mg of calcium enters and leaves the bones each day.

SOURCES

A large variety of foods such as leafy vegetables, legumes and nuts, and whole grain cereal products contain calcium. Among common foods, milk and cheese are the richest source of calcium. Cow's milk contains 120 mg/100 ml, considerably more than human breast milk (30 mg/100 ml). Sardines and other small fish in which the bones are eaten can be important sources of calcium (17).

ABSORPTION AND METABOLISM

The absorption of calcium from the human intestine is influenced by a number of factors, including the pH, the Ca:P ratio, the presence of free fatty acids, and—importantly—vitamin D, which promotes the absorption of calcium. Even if the intake of calcium is adequate, calcium absorption is reduced and calcium balance may be negative if the individual is deficient in vitamin D.

Citric acid, lactose, and some amino acids enhance the absorption of calcium. On the other hand, phosphates, oxalates, and phytates inhibit calcium absorption. In the past the above factors weighed heavily in considering calcium absorption, however, it is doubtful if any of the above factors ordinarily affect the calcium requirement to any marked degree.

The average person has a high degree of adaptability to high or low amounts of calcium in the diet. Those eating low-calcium diets appear to have a more efficient absorption of calcium than those consuming a diet high in calcium. Thus, as the intake of calcium is lowered, intestinal efficiency and the ability to absorb and retain calcium increases, whereas raising calcium intake reduces utilization.

Calcium is present in the feces, urine, and sweat of humans. Fecal calcium is chiefly dietary calcium that for various reasons, such as the insolubility of some salts, has not been absorbed. Urinary calcium is variable and reflects the calcium that has been absorbed but not retained by the skeleton or soft tissues. Individuals working under conditions of high temperature may lose significant amounts of calcium.

There is very little calcium in blood cells. Most of the calcium is in the plasma. Here it exists both as ionized (also called diffusible calcium) and as un-ionized calcium largely bound to protein, including a small amount bound as a calcium–citrate complex. About one-half the calcium is in the ionized form, and the rest is un-ionized calcium. The calcium of blood, extracellular fluid, and soft tissues has important roles in metabolism, *e.g.,* in determining the excitability of peripheral nerves and muscle and in the clotting of blood. As noted previously, a decrease in the ionized fraction of serum calcium causes tetany.

Although a great deal of publicity has been given to the importance of a high calcium intake there is no convincing evidence to show that a deficiency of calcium even at low levels of 250–300 mg daily is harmful. Apparently the adult individual can achieve a balance at the level of intake supplied by their usual diet or in other words has the ability to adapt to the dietary intake.

Females on a habitually low-calcium intake can as the result of repeated pregnancies and prolonged lactation deplete their body stores of calcium. This can lead to the development of osteomalacia. However, evidence indicates that vitamin D deficiency probably plays a greater role in this condition.

Rickets is a disease characterized by faulty calcification of bones due to a low vitamin D content of the body, a deficiency of dietary calcium and phosphorus, or both. An increase of alkaline phosphatase activity is characteristic of rickets.

Osteoporosis is a common disease of aging in many parts of the world. There is some evidence that a high protein intake is associated with low calcium intake and may play a role in the pathogenesis of osteoporosis. Calcium losses can be large when protein intake is high. Also, there is evidence to show that a high intake of fluoride benefits calcium retention in osteoporosis (17). The effect of fluoride in calcium retention needs confirmation.

Appreciable losses or gains in calcium are often reflected in similar changes in phosphorus content.

REQUIREMENTS

The recommended allowance for adults in the United States is put at 800 mg calcium daily (see

Table A-1). This value is well above theoretic estimate of needs. For recommended allowances for infants, children, and during periods of increasing growth see RDA in the Appendix Table A-1.

The Food and Agriculture Organization of the United Nations (13) has stated that high intakes of calcium are unnecessary and that requirements can be met with one-half of the customary intakes and recommendations, or 400–500 mg daily for adults.

Additional calcium is needed during pregnancy and lactation to meet the needs of the growing fetus and mother. The full-term infant body contains about 25 g calcium. Most of this is deposited during the last 2–3 months of pregnancy. The RDA therefore recommends that 1200 mg calcium be given per day during lactation and pregnancy.

Because children are constantly rapidly increasing their skeleton in size they have an especially high calcium requirement. The 1974 RDA (see Table A-1) recommends 360–540 mg calcium/day for infants, 800 mg/day for children, and up to 1200 mg/day for the teen-age pubertal growth period.

TOXICITY

There are conditions in which excessive calcium is found in the serum, urine, or soft tissue. Idiopathic hypercalcemia is one such condition. Others are the "milk alkali syndrome" (alkalosis along with hypercalcemia and renal tubular calcification), renal stone formation, hypercalciuria, and fluorosis. At the present time there is no epidemiologic data to prove that a high calcium intake *per se* is responsible for these conditions.

PHOSPHORUS

FUNCTION AND DISTRIBUTION

Phosphorus constitutes 1% (0.8%–1.2%) of the human body weight. Along with calcium it has a chief role in the formation of bones and teeth. Because of its more-obvious role in the growth of the skeleton, an essential and perhaps more vital role in the production and transfer of high-energy phosphates is often overlooked.

The human adult body contains approximately 12 g phosphorus/kg fat-free tissue, or about 670 g in the adult male and 630 g in the adult female. About 80% of the phosphorus is combined with calcium in the form of insoluble calcium phosphate (apatite) in the bones and teeth.

CALCIFICATION OF BONES AND TEETH. The start of the calcification process involves the concomitant precipitation and fixation of phosphate to the matrix of bone and teeth. It should be pointed out that the term calcification has led to the belief by some that a lack of calcium is a major cause of failure of this process. On the contrary, failure of bone calcification results from a lack of phosphorus as often as from a lack of calcium. Where there is poor bone calcification there is an increase in the enzyme phosphatase, and this facilitates the hydrolysis of tissue metabolites into the blood to yield a proper calcium to phosphorus ratio, which is of importance in proper bone growth. Low phosphorus blood levels are more likely to be a reflection of excessive excretion of phosphorus in the urine than of inadequate dietary phosphorus.

REGULATION OF RELEASE AND TRANSFER OF ENERGY. The controlled release of energy resulting from the oxidation of carbohydrate, lipid (fat), and protein is accomplished through phosphorus-containing intermediates as phosphates. Prominent among these phosphates is adenosine triphosphate (ATP). Of the three phosphate bonds in ATP, two contain higher bond energies than the usual ester bond and are known as high energy phosphate bonds (A-O-P-O∼P-O∼P, the symbol ∼ indicates a high-energy bond). In a sense, ATP stores the bond energy released in the oxidation of foodstuffs.

As energy is needed by the body ATP is hydrolyzed to ADP (sometimes to AMP) and orthophosphate. The energy so released is used to drive many energy-consuming reactions of metabolism. In animals, including the human, a prime and essential function of living cells is the capture and transfer of food energy as high-energy phosphate bonds (ATP). This provides the energy to drive living processes.

ROLE IN THE ABSORPTION AND TRANSPORTATION OF NUTRIENTS. Many metabolites, as for example the monosaccharide glucose, are metabolized in the form of phosphorylated intermediates. The phosphorylation of glucose to glucose-6-phosphate is an obligatory process that must be accomplished before it can be metabolized properly. Fats are insoluble in the aqueous solution of the bloodstream, but by packaging or coating them with phospholipids and protein into fat droplets called chylomicrons

they are rendered transportable in the bloodstream. When glycogen is degraded in the liver and muscles, it appears as metabolizable phosphorylated glucose (glucose-6-phosphate) and is rapidly oxidized in the tissue cells.

AS COMPONENTS OF ESSENTIAL METABOLITES. The energy-releasing and vitamin-containing coenzymes, such as thiamin pyrophosphate, nicotinamide adenine dinucleotide (NAD), and pyridoxal phosphate, are active only in a phosphorylated form. Even more critical is the role of phosphate as part of the nucleic acids, such as DNA and RNA, both of which are essential for cell protein synthesis.

REGULATION OF ACID–BASE BALANCE. Because of an ability to combine with hydrogen ions, phosphorus-containing compounds are important as blood and tissue buffers. In this role they help prevent changes in the acidity of body fluids as protons are released in metabolism.

SOURCES

Animal foods rich in protein are also rich in phosphorus. Meat, fish, poultry, eggs, and cereal products are good sources of phosphorus for the average diet.

Whole grain cereals contain phytic acid, a phosphorus-containing organic acid (hexaphosphate of inositol). This acid many combine with calcium as an insoluble complex so that neither nutrient will be absorbed (2).

The high phosphorus content of carbonated beverages (up to 500 mg/bottle) can contribute, when taken in excess, to an imbalance of the calcium to phosphorus ratio and can cause abnormal intestinal absorption of these elements. A large excess of either element (unbalanced Ca:P ratio) seems to hinder absorption from the intestine (2).

ABSORPTION AND METABOLISM

The organic phosphorus of food particles must be hydrolyzed or removed from the food before phosphorus can be absorbed as phosphate. This is accomplished in the gastrointestinal (GI) tract. The amount of phosphorus absorbed will be conditioned by the amount made available during the process of digestion. Some phosphorus will be made unavailable for absorption by forming insoluble complexes with magnesium, iron, and other elements. Under these conditions

phosphorus is excreted in the feces. Fecal phosphate will also include organic and inorganic phosphates secreted into the intestine along with desquamated epithelial cells of the intestinal lining.

Unabsorbed phosphorus can be as much as 30% of dietary phosphorus. The control of the amount of phosphorus in the body is exercised through excretion in the urine rather than by control of absorption. Urinary phosphorus increases during the catabolism of body tissues and represents the phosphorus released from the tissues. It is temporarily decreased after the ingestion of those carbohydrate foods that require phosphorus for metabolism.

In addition to being associated in bone and tooth structures, calcium and phosphorus are influenced by the same metabolic and hormonal factors. The parathyroid, which regulates the level of blood calcium, also affects the level of blood phosphorus and its rate of resorption from the kidneys. Vitamin D (dihydroxycholecalciferol) facilitates absorption of calcium and phosphorus from the gut and also increases the rate of resorption of phosphorus from the kidney. In this way the level of both calcium and phosphorus needed for calcification of bone is raised simultaneously. Blood levels of total phosphorus may be 35–45 mg/100 ml, of which 3–5 mg is in the form of orthophosphate. Like calcium, phosphorus is in dynamic equilibrium between fluids and cells and is constantly being released and rebuilt into bone structure. Evidence exists (11) to indicate that the phosphorus of tooth enamel is exchanged with that of the saliva and the phosphorus of dentin with that of the blood supply.

REQUIREMENTS

The widespread distribution of phosphorus in food renders a phosphorus deficiency, except in the malabsorptive state and starvation, quite unusual.

SODIUM

FUNCTION AND DISTRIBUTION

Sodium is the principal cation of extracellular fluid, and potassium is the principal cation of intracellular fluid. Sodium is associated in the extracellular fluid with chloride and bicarbonate in the regulation of acid–base equilibrium. Another important function for sodium is maintenance of the osmotic pressure of body fluids,

which thereby protects against excessive fluid loss in the body. In addition, sodium has an important role in the preservation of normal muscle irritability and contractibility and the permeability of the cells. It has a vital role in maintaining the pH of blood.

Most of the sodium in the body is found in the extracellular fluid, but the inorganic portion of the skeleton contains about one-third of the total sodium content of the body.

SOURCES

Foods of both animal and plant origin contain sodium. As a rule, animal foods contain more than plant foods. In the United States, the chief source is common table salt.

ABSORPTION AND METABOLISM

The metabolism of sodium is influenced by the adrenocortical steroids. In a deficiency of these steroids a decrease of serum sodium and an increase of sodium excretion occurs. Excessive and prolonged periods of sweating may lead to signs and symptoms of salt depletion if only water and not salt is replaced. Under such conditions nausea, giddiness, apathy, exhaustion, cramps, and vomiting occur. Respiratory failure may be a consequence. These symptoms can be prevented by adding a little more salt to food or if necessary adding 1g salt/liter to the water consumed.

REQUIREMENTS

The Food and Nutrition Board (23) has not established dietary allowances for sodium. Intakes of sodium in the United States average about 5 g/person/day. This is about five times more than physiologic needs. A maximum sodium chloride intake of about 5 g/day may be permitted for adults who have no history of hypertension. This is about one-half the daily amount ordinarily consumed (14). For persons with a family history of hypertension Dahl (5) recommends a diet containing not more than 1 g sodium chloride/day.

POTASSIUM

FUNCTION AND DISTRIBUTION

As stated in the section on sodium, potassium is the chief cation of the intracellular fluid. Its concentration in this fluid is much greater than in the extracellular. Nevertheless, potassium does have a very important role in extracellular fluid in that it influences muscle activity, notably cardiac muscle. Within the cells it functions, like sodium in the extracellular fluid, by influencing acid–base balance and osmotic pressure, including water retention.

The concentration of potassium in tissue cells is about 440 mg/100 g. Blood contains 200 mg/100 ml, whereas plasma has 20 mg/100 ml. Muscle tissue contains 250–400 mg/100 g and nerve tissue 350 mg/100 g.

SOURCES

Potassium is present in most commonly eaten foods.

ABSORPTION AND METABOLISM

Potassium deficiency usually occurs as a result of inadequate intake coupled with excessive loss due to diarrhea, diabetic acidosis, or to the use of diuretic drugs or purgatives. The deficiency is associated with general muscle weakness. This may lead to reduced intestinal tone and distention to cardiac abnormalities and to respiratory failure. Common causes of potassium depletion are infectious and nutritional diarrheas of infancy (6).

REQUIREMENTS

The normal dietary intake of this element is about 4 g/day (14). It is so widely distributed a deficiency of it is unlikely to occur under normal dietary circumstances.

CHLORINE

FUNCTION AND DISTRIBUTION

Chlorine as chloride is present in body tissues and fluids. In extracellular fluids it is closely associated with sodium. It is essential in a number of vital body processes, including water balance, osmotic pressure regulation, and acid–base equilibria. In connection with this latter function, it should be noted that human life is possible only if blood is kept within a narrow range of neutrality, in health, between a range of pH of 7.35–7.45. As a component of gastric juice, the strong mineral acid hydrochloric acid is especially important in initiating the digestion of protein.

The chloride concentration is lowest in mus-

cle (40 mg/100 g tissue) and highest in spinal fluid (440 mg/100 ml). Intermediate values are: whole blood (250 mg/100 ml), plasma or serum (365 mg/100 ml), and nerve tissue (171 mg/100 g tissue) (14).

SOURCES

Chloride usually occurs in the diet as sodium chloride. For this reason an intake of chloride can be considered as satisfactory as long as the sodium intake is adequate.

ABSORPTION AND METABOLISM

During the loss of gastric juice by vomiting, or in pyloric or duodenal obstruction, there is often a loss of chloride in excess of sodium. This leads to a decrease in plasma chloride and is compensated for by an increase in bicarbonate which results in a state of hypochloremic alkalosis. In Cushing's disease, or after the administration of an excess of corticotropin (ACTH) or cortisone, hypokalemia with an accompanying hypochloremic alkalosis may be observed (14). In diarrhea due to an impairment of intestinal secretions and absorption there is often a loss of chloride.

Abnormalities of chloride metabolism are generally accompanied by abnormalities in sodium metabolism. Chloride disturbances can accompany excessive losses of sodium, as in diarrhea, profuse sweating, and endocrine disturbanaces.

REQUIREMENTS

Dietary chloride occurs almost entirely as sodium chloride. It has been known since the time of ancient man that the best available food preservative is salt. Salted meats and fish were an important part of the diet of hunting man. Yet, interestingly, a separate supply of salt in addition to that present in the food is not essential to man. Most people suffering from congestive heart failure or hypertension benefit if the salt in their diet is restricted (7).

MAGNESIUM

FUNCTION AND DISTRIBUTION

Magnesium is an essential constituent of all soft tissues and bone in the human. The adult body contains 20–25 g, of which 70% is combined with calcium and phosphate in bone, the rest being in the soft tissues and body fluids. This mineral is an important metallic cation and is required for the activity of a large number of enzymes concerned with oxidative-phosphorylation and the transfer in cells of phosphate bond energy. It seems the skeleton provides a reserve supply of magnesium, as it does for calcium and sodium, which becomes available when there is a shortage elsewhere in the body (7). Like the iron in hemoglobin, magnesium occupies a central role in the plant pigment chlorophyll. Whole blood contains 2–4 mg/100 ml, whereas serum contains less than one-half that amount.

SOURCES

Most foods, especially those of vegetable origin, contain useful amounts of magnesium. Whole grains and raw dried beans and peas contain about 100–200 mg/100 g. Cocoa, various nuts, soybeans, and some seafoods are rich in magnesium (100–400 mg/100 g). Human milk contains approximately 4 mg/100 ml; cow's milk has about 12 mg/100 ml (14). Meat and viscera are sources of the element. Fortunately, most foods contain useful amounts of magnesium, particularly those of vegetable origin, partly due to the magnesium-containing chlorophyll.

ABSORPTION AND METABOLISM

In contrast to calcium, vitamin D does not aid in the absorption of magnesium. Failure of absorption is not known to be a problem. Magnesium deficiency in humans occurs in such conditions as chronic malabsorption syndromes, acute diarrhea, chronic renal failure, chronic alcoholism, and protein–calorie malnutrition.

Magnesium deficiency in man has been described (9). Symptoms include emotional lability and irritability, tetany, hyperreflexia, and occasionally hyporeflexia. Alcoholics have low serum magnesium levels, but the condition responds dramatically to magnesium administration (32). Magnesium deficiency has been described in kwashiorkor (20). In the United States, many diets are marginal in their content of magnesium (17).

REQUIREMENTS

The recommended intake for adults is 350 mg/day. An intake of 300 mg/day has been found to maintain a positive balance in women

(23). Estimates of magnesium requirements are based on very limited information regarding the absorption, metabolism, and excretion of this nutrient (see Table A-1).

SULFUR

FUNCTION AND DISTRIBUTION

Sulfur is an essential macronutrient, present in the proteins of all cells, which represents about 0.25% of body weight. A large part of the sulfur in the human body is present in the amino acids methionine, cysteine, and cystine. It is present also in such physiologically important substances as the vitamins, thiamin, pantothenic acid, and biotin; hormones such as insulin and the anterior pituitary hormones; sulfhydryl-containing compounds of which glutathione is an example; and the bile acid taurocholic acid. Several enzyme systems, *e.g.,* those containing coenzyme A and glutathione, depend for their activity on free sulfhydryl (—SH) groups. Sulfur serves an important role in the body's detoxication mechanisms and as high-energy sulfur bonds, similar to the phosphate bonds in ATP and so important in the body's energy producing and transferring mechanisms.

SOURCES

Sulfur is ingested in the food as inorganic sulfates and as sulfur bound in organic form. The latter group contains: the complex sulfur-containing lipids, such as the sulfolipids and sulfatides; protein sulfur, derived from the sulfur-containing amino acids methionine, cysteine, and cystine and from glycoproteins, such as mucin, ovomucoid, and the chondroitin sulfuric acid in cartilage and tendons. The most important source of sulfur is the cystine and methionine of ingested proteins, both animal and vegetable. A diet containing 100 g protein will provide 0.6–1.6 g sulfur, depending on the quality of the protein.

ABSORPTION AND METABOLISM

Inorganic sulfur as sulfate is absorbed from the intestine into the portal circulation. It is believed not to be utilized. The sulfur-containing amino acids liberated by the digestion of protein are absorbed into the portal circulation and utilized for the synthesis of tissue protein and other amino acid–containing metabolites.

The highest concentration of sulfur is found in hair, skin, and nails. As far as is known, there is no reliable metabolic balance of sulfur intake and output in man (11). The urinary output of sulfur ranges up to 2.0 g daily, most of which is sulfate, with a small amount of organic sulfur. The bulk of the organic sulfur is oxidized in the liver to inorganic sulfur and is excreted in the urine. Some inorganic sulfate is combined in the liver with bilirubin and some phenol compounds, such as indole formed in the bowel through bacterial activity to form ethereal sulfates, which are excreted in the urine. Sulfur is excreted in the urine in the three forms found in the blood: 1) inorganic sulfate, 2) ethereal sulfate, and 3) neutral sulfur (organic sulfur-containing compounds) (18).

ESSENTIAL MICRONUTRIENTS

IRON

FUNCTION AND DISTRIBUTION

Although the total amount of iron in the adult human body is small (4–5 g, or 0.004%), it is one of the most important elements in nutrition and is of fundamental importance to life. Iron-deficiency anemia is a major public health problem especially in young girls and women in their child-bearing years. Its role in the human is almost exclusively confined to oxygen transport and cellular respiration.

Iron is a component of such important macromolecules as hemoglobin (60%–70% of the total adult body iron, or about 3.0 g); muscle myoglobin (3%–5%, or about 0.13 g); the iron porphyrin enzymes, catalase, and peroxidase (0.2%, or 0.008 g); ferritin, the storage form of iron (15%, or 0.4–0.8 g); and transferrin, the transport form of iron (0.004%, or 0.1 g).

SOURCES

The recommended allowances of 10 mg/day for adult males is readily obtainable from a normal diet; obtaining recommended allowances for women from dietary sources is difficult without including fortified foods.

The best dietary sources of iron are such organ meats as liver, heart, kidney, and spleen. Egg yolk, fish, oysters, clams, whole wheat, beans, figs, dates, molasses, and green vegetables are other good sources.

Meat extenders or meat analogs may not contain iron and other nutrients present in the meat they replace. Where these extenders replace

meat additional sources of iron as from meat extracts or the addition of ferrous sulfate USP should be considered.

ABSORPTION AND METABOLISM

Absorption of iron can take place from the stomach and the entire small intestine, but the greatest absorption occurs in the upper part of the small intestine. Normally, very little iron is absorbed, and the amounts excreted in the urine are exceedingly small (0.1 mg or less/day). In the male excretion from the body is less than 1 mg/day and in the female during the childbearing years 1.5–2.0 mg/day. Because there is no way to excrete excess iron, its absorption from the intestine must be controlled if iron is not to accumulate in the tissues in toxic amounts. In the ordinary diet, 10–20 mg iron are taken in each day, but less than 10% is absorbed. Only 10% of the iron present in cereals, vegetables, and pulses, excluding soybeans, is absorbed. Absorption from other foods, particularly meats and fish, is higher, for example, 20% from meat, 20% from soybean, and 15% from fish.

Food iron occurs in the ionic (Fe^{+++}) state, either as ferric hydroxide or as ferric organic compounds. During digestion the food-bound iron is broken down into free ferric ions. Ascorbic acid, sulfhydryl groups, and other reducing substances in the intestinal lumen reduce the ferric iron to the ferrous (Fe^{++}) state, in which form iron seems to be more readily absorbable.

There appears to be some control of absorption by the intestine, but the exact mechanism still is not clear. Recent work has shown evidence for the presence of a ferritin-independent active transport system for iron (14). The state of the body stores of iron appear to regulate the absorption of iron. Iron absorption increases when there is increased hemoglobin synthesis, as for example, following hemorrhage or as the result of anemia. Absorption increases during growth and pregnancy. Phytic acid and phosphates in excess may impair iron absorption.

Iron released from storage in the mucosal cell as ferritin is transferred to the plasma or tissues as transferrin. In the plasma the Fe^{++} iron is rapidly oxidized to the ferric (Fe^{+++}) state and then incorporated into the transport form transferrin. Normally, almost all the iron-bound transferrin is rapidly taken up by the bone marrow cells actively synthesizing hemoglobin.

The storage form of iron, ferritin, is found in the intestine, liver, spleen, and bone marrow. If iron is taken into the body, as for example parenterally, in amounts exceeding the capacity of the body to store ferritin, it accumulates in the liver as microscopically visible hemosiderin.

Iron deficiency anemias are of the hypochromic microcytic type. A deficiency of iron may result from inadequate intake of food iron or as the result of GI disturbances, such as diarrhea, steatorrhea, malabsorption syndromes, and surgery, as well as from excessive loss of blood.

Because of the absence of an excretory pathway for iron, patients receiving many blood transfusions over a period of years, or with an excessive capacity for iron absorption accumulate iron in the liver in a condition known as hemochromatosis.

Iron intake is often inadequate in: 1) infancy, because of the low iron content of milk and the low amount of iron in the infant at birth; 2) menstrual iron losses during the female reproductive period; and 3) pregnancy, due to the demands of the fetus and losses in childbirth due to hemorrhage at labor. A woman, therefore, during her reproductive life has a loss of iron at least double that of man (7). The intake of iron in the diet may often be insufficient to meet the demand, with the result that anemia is very common in women in all countries of the world. Fortunately there are simple automated methods for the determination of serum iron and total iron-binding capacity based in the color developed using 2,4,6-tripyridyl-1,3,5-triazine (34). Rapid determinations of blood and serum iron are therefore available to the physician from hospital or commercial laboratories for the assessment of the iron status of a patient.

REQUIREMENTS

Only very small amounts of iron are lost daily from the body. This loss occurs mostly in the cells or is shed from the skin and epithelial surfaces lining the alimentary and urinary tracts. The average loss of iron in the healthy adult is estimated to be only about 1 mg/day. During growth, pregnancy, and lactation additional iron is required. Pregnancy and lactation increases the iron requirement (see Table A-1). In addition to the physiologic losses, women who are menstruating normally also lose about 0.5 mg/day. This is the amount in menstrual blood averaged over a period of 1 month. In pregnant women iron is required in addition to basal physiologic losses to allow for expansion of the

red cell mass and to provide for the needs of the fetus and placenta.

The need for iron in the human diet varies greatly with different ages. The recommended intakes of iron for different age groups, including increases to accommodate for growth, pregnancy, and lactation, are given in detail in Table A-1 in the Appendix. Briefly, these daily allowances are for infants and children, depending on age, 10–15 mg/day; adult males, 10–18 mg; adult females, 10–18 mg, with increases to 18 and more mg/day during pregnancy and lactation.

Infants of low birth weight have relatively high iron needs because of their rapid growth. In the premature or low birth weight infant iron reserves are often low, whereas reserves of the full-term infant are rapidly depleted. It should be noted that milk, the usual food during the first months of life, contains negligible amounts of iron. Therefore, supplementary iron furnished, for example, by iron-fortified formulas, iron-enriched infant cereals, and by strained meats should be made available.

COPPER

FUNCTION AND DISTRIBUTION

Copper is an essential nutrient for all mammals (8). It is a component of, or essential to the activity of, such enzymes as cytochrome oxidase, tyrosinase, catalase, monoamine oxidase, ascorbic acid oxidase, and uricase. Copper has a role in the biochemical reactions whereby iron is inserted into the hemoglobin and cytochrome molecules and is also believed to facilitate the absorption of iron. The exact mechanism or role of copper in these enzyme systems has not been established.

A copper deficiency has not been reported in human adults, although moderate to severe degrees of anemia have been reported in infants. These infants manifest pallor, retarded growth, edema and suffer from anorexia. They are responsive to copper and iron therapy. Low serum levels of iron and copper are among the diagnostic signs.

In Wilson's disease, or hepatolenticular degeneration, there is accumulation of excessive copper in the body tissues, probably due to a genetic absence of a liver enzyme. This disease is characterized by neurological degeneration and cirrhotic liver changes. A reduction in dietary copper may be useful in the treatment of this disease, particularly the use of chelating agents to bind free copper (7).

SOURCES

Copper is widely distributed in foods and a diet containing 2–3 mg/day seems sufficient to meet human requirements. The richest sources of dietary copper are liver, kidney, shellfish, nuts, raisins, and dried legumes. Milk is a poor source of copper. Homogenized cow's milk may contain 0.015–0.18 mg copper/liter. This is much less than human milk, which can range from 1.05 mg/liter at the beginning of lactation to 0.15 mg/liter at the end (14).

REQUIREMENTS

A daily allowance of 2.5 mg copper has been suggested for adults, with about 0.05 mg/kg body weight being suggested for infants and children.

COBALT

This mineral is an integral part of vitamin B_{12} (29). As such it is an essential nutrient for man. There is no evidence that cobalt has a function in normal human nutrition other than as a component of the vitamin B_{12} molecule.

Cobalt is readily absorbed from the human intestinal tract, but most of the absorbed mineral is excreted in the urine. Retained cobalt appears to serve no physiologic function since human tissues cannot synthesize vitamin B_{12}.

A deficiency of cobalt in ruminants results in impaired growth, listlessness, emaciation, and varying degrees of anorexia (13).

ZINC

FUNCTION AND DISTRIBUTION

Zinc is a component of a number of enzyme systems. These include carbonic anhydrase, alcohol dehydrogenase, alkaline phosphatase, and enzyme systems concerned with nucleic acids and protein and carbohydrate metabolism (29). It is a structural and functional component of the digestive enzyme carboxypeptidase and participates directly in the catalytic activity of this enzyme (30). Zinc is also found in the insulin molecule. Here two zinc atoms are apparently involved in the spatial organization of the insulin molecule. For the above reasons, it is generally accepted that the human has a requirement for zinc.

SOURCES

In the United States an average mixed diet contains about 10–15 mg zinc. An intake of 8–10 mg/day appears to be sufficient to maintain zinc equilibrium in the adult. A breast-fed infant consumes 0.7–5 mg zinc/day. An additional allowance for lactation is therefore indicated for breast-feeding women. Recommended allowances for all ages and for growth, pregnancy, and lactation are given in the RDA included in the Appendix (Table A-1).

Meat, liver, eggs, and seafoods, especially oysters, are good sources of zinc. Milk and whole grains are also good sources. Fruits and leafy vegetables appear to be poor sources of zinc.

ABSORPTION AND METABOLISM

The highest concentration of zinc in human tissues are reportedly (7) found in the prostate gland, spermatozoa, and in parts of the eye.

Halsted, Reinhold, and coworkers (12) have reported a clinical syndrome characterized by small stature, hypogonadism, a mild anemia, and low plasma zinc in older children and adolescents in villages near Shiraz, Iran. The major constituent of the diet of these communities is unleavened bread prepared from low extraction flour. Zinc-chelating substances such as phytates probably are present in these breads and other nonabsorbable complexes. After giving supplements of 120 mg zinc sulfate daily for several months, puberty developed and growth rates were accelerated. It should be pointed out that Caughey (3) has suggested that the clinical features might be due to a dietary deficiency of protein since plasma albumin was also low in these cases.

Zinc appears to be necessary to maintain the normal concentration of vitamin A in the plasma. Here it seems to be involved in the mobilization of vitamin A from the liver (14). The occurrence of a marginal deficiency of zinc in apparently healthy children who show impaired taste acuity has been reported (14). Those children were found responsive to additional zinc in their diet. Accelerated rates of wound healing also have been observed with increased zinc intakes.

MANGANESE

This element is known to be needed for normal bone structure, reproduction, and the normal functioning of the central nervous system and is therefore an essential element in the human diet (4). Manganese deficiency has not been described in the human, but it can be produced in laboratory animals and may occur in cattle grazing on pastures poor in manganese. Under these circumstances the cattle exhibit poor growth and reproduction, bone changes, and disturbances of the nervous system.

The average adult daily dietary intake of 2.5–7 mg appears to be adequate. A recommended daily allowance cannot be made with the knowledge presently available.

The total body content of manganese is about 10 mg, with the kidney and liver being chief storage organs.

The functions in the human body of manganese are not known although *in vitro* manganese activates several enzymes including blood and bone phosphatases, liver and intestine phosphatases, arginase, carboxylase, and cholinesterase (14).

IODINE

FUNCTION AND DISTRIBUTION

Iodine is an essential nutrient for the human because it is an integral component of the thyroid hormones thyroxine and triiodothyronine. In an iodine deficiency, or if the availability of iodine is very low for a prolonged period of time, the gland attempts to compensate for the deficiency by increasing its secretory activity. This activity causes the thyroid to enlarge or hypertrophy, a condition known as simple or endemic goiter. The lack of hormones causes an accumulation of mucinous material under the skin and other areas which presents a coarseness of features giving the patient the characteristic appearance of myxedema.

SOURCES

Iodine is obtained from food and water. Since some soils have little or no iodide, vegetables and other plant foods grown in these soils are low or lacking in iodide. Seafoods are a rich source of iodide; products such as eggs may be low in iodine, depending on the iodine content of the poultry ration. In the United States and a number of other nations, a ready source of iodine is iodized salt. The current level of enrichment furnishes $76\mu g$ iodine/g salt. The use of iodized salt has caused a marked reduction in goiter in iodine-deficient areas.

ABSORPTION AND METABOLISM

Iodine is readily absorbed from the intestinal tract. About 30% is removed by the thyroid gland, and the remaining iodine is excreted in the urine. In the thyroid gland the iodide is oxidized to and bound to tyrosine with the formation of monoiodotyrosines and diiodotyrosines. These are converted into the thyroid hormones in the epithelial cells of the thyroid and bound to a globulin to form thyroglobulin, in which form the hormones are stored.

REQUIREMENTS

The body of an average adult contains 20–50 mg iodine. The suggested RDA (23) intake of iodine for adults is 1 μg/kg body weight/day. This is quite adequate for the adult. Growing children and women during pregnancy and lactation have increased needs (see Table A-1).

MOLYBDENUM

Evidence that molybdenum is an essential trace element for the human is based on the fact that it is a part of the molecular structure of two enzymes, xanthine oxidase and aldehyde oxidase; deficiencies have been produced in animals (14, 24).

The molybdenum content of foods is variable. Beef kidney, some cereals and some legumes seem to be good sources. The amount of the mineral in plant foods depends on the amount in the soil.

Molybdenum has been reported to have a cariostatic effect in animals, and dental caries rates are lower than average in children brought up in areas where the soil is high in this element (7).

There is no evidence suggesting that a low-molybdenum diet produces clinical deficiency signs in the human. A dietary intake of 2μg molybdenum/kg body weight has been suggested (7).

SELENIUM

Selenium appears to be a dietary essential, but direct evidence of a role for selenium in human nutrition is lacking (14). Little information is available regarding its biochemical role, function, or dietary requirement. The element is essential in the diet of a number of domestic and laboratory animals (e.g., sheep, cattle, pigs, poultry, rabbits, horses, mice, and rats). Its presence can be detected because certain weeds and grasses grow well in soils containing selenium. Horses grazing in these areas (central United States) develop an acute disease called "blind staggers" and a chronic disease called "alkali disease." Both of these diseases have been attributable to selenium (7). In New Zealand and in parts of the United States the addition of selenium to diets of lambs and calves markedly improves their health and reduces the incidence of "white muscle disease."

Schwarz (14) has evidence to indicate selenium may be an essential factor in tissue respiration. Hepatic necrosis produced in the rat by dietary means can be protected against by a "factor 3," which is an organic compound containing selenium as the active agent. Factor 3 and sodium selenite apparently not only prevent dietary liver necrosis in the rat but also multiple necrosis in mice, muscular dystrophy and heart necrosis in minks, and exudative diathesis in chicks, among other deficiency diseases. In some of these fatal diseases factor 3 seems to act synergistically with vitamin E and crystine (14). There is now evidence that selenium is an essential component of the enzyme glutathione peroxidase (25). This enzyme catalyzes the oxidation of glutathione, which in turn protects hemoglobin from oxidative damage.

There is insufficient evidence at this time for the establishment of a human requirement.

FLUORINE

FUNCTION AND DISTRIBUTION

Fluorine, as fluoride, is present in small and variable concentrations in nearly all soils, water supplies, plants, and animals. Because of its widespread distribution, it can be found as a constituent of most diets. In the human, fluoride deposition is found mainly in the teeth and skeleton, but the total quantity is small. Nevertheless, the presence of traces of this mineral in the teeth helps to protect them against dental caries. Fluorine is therefore essential to optimal health.

The protective effect of fluoride occurs primarily during infancy and early childhood when the teeth are developing. However, its caries-preventive action appears to be carried over into adulthood as long as fluoridated water is available.

Bernstein (1) has reported that an adequate intake of fluoride is important in the elderly as a protection against osteoporosis.

SOURCES

The main source of fluorine for humans is the drinking water. If this contains approximately 1 part per million (1 ppm) fluoride, it will supply adequate amounts of fluorine for the prevention of dental caries.

Where water supplies contain quantities of fluorine less than 1 ppm, the addition of fluoride (fluoridation) to reach a level considered optimal is an important public health measure. Such an addition of fluoride to drinking water has been shown to reduce the incidence of caries by 60%–70%. Many medical and public health measures have clearly demonstrated the safety and nutritional advantage that results from fluoridation of water supplies (10).

Tea and sardines are two good sources of dietary fluoride, the latter because of the bones consumed.

REQUIREMENTS

A deficiency of fluoride during infancy and childhood leaves the teeth unprotected from dental caries. There is evidence to suggest that in areas where the fluoride content of the water is high there is less osteoporosis than in comparable areas where the fluoride content of the water is low.

Bernstein (1) has obtained evidence to suggest that arterial calcification may be less marked in high than in low fluoride areas.

An intake of 1–2 mg/day is considered adequate. A water supply containing 1 ppm fluoride will supply 1–2 mg/day depending on the amount of water and liquids such as coffee, soft drinks, and frozen citrus drinks consumed.

TOXICITY

An excessively high intake of fluoride during childhood causes a condition known as dental fluorosis in which the teeth become mottled and discolored. Very large intakes of fluoride may also cause bone changes that increase bone density, calcification of muscle insertions, and exostoses. This can be diagnosed by radiography.

Dental and skeletal fluorosis do not occur in communities with a properly controlled fluoridated water supply of 1 ppm.

CHROMIUM

Chromium is present in most organic matter. Only the trivalent form is biologically active.

Mertz (19) has reported that trivalent chromium is required for maintaining normal glucose metabolism in experimental animals, and it may act as a cofactor for insulin. In some patients with impaired glucose tolerance, especially children with protein–calorie malnutrition, tolerance has improved after giving a chromium supplement.

Schroeder (26) found that the levels of chromium in tissues declined with age. A meaningful recommendation for chromium intake cannot presently be given.

MICRONUTRIENTS THAT MAY BE ESSENTIAL

TIN

At the present time naturally occurring tin deficiency is unknown either in animals or man. Schwarz (27), however, has presented evidence indicating that rats raised in an all-plastic "isolator" system to prevent trace element contamination and fed a highly purified basal diet do not grow normally until they receive a supplement of 8.5–17 μ mol (1–2 mg)/kg body weight. The weanling rats maintained on the basal diet showed signs of a deficiency within 1–2 weeks from the beginning of basal diet feeding. They grew poorly, lost hair, developed a seborrhea-like condition, and were lacking in energy and tonicity. Schwarz has proposed this work identifies tin as an element essential for the growth of rats maintained at first under trace element sterile conditions in the isolator system and later, similarly, in plastic cages instead of the isolator.

Human diets have been reported to contain 30–140 μ mol (3.5–17 mg) tin/day (7). Since the toxic dose for man is about 40–60 μ mol/kg body weight, such intakes have a high safety margin. The former widespread use of tin and tinfoil in cans and packages of food presents potential hazards to man. However, in most countries now, plastic containers or lacquer-coated containers greatly reduce the hazard of food contamination by tin.

The upper limit permissible in canned food is usually taken as 250 mg/kg (7).

Dietary tin is poorly absorbed and is mainly excreted in the feces. At this time there is a lack of information regarding the metabolic or dietary need for tin.

NICKEL

Traces of nickel are present in human tissues, and there is evidence suggesting that it is an

essential nutrient for rats and chicks (7). Nielsen (21) has concluded from work presently in the literature and from his own work with chicks that nickel might have an essential role in animals. In Nielsen's work, low levels of nickel in the diet of chicks caused changes including, "a different shade of yellow in the shank skin, slightly swollen hocks, slightly thickened legs, a dermatitis on the shank skin, a change in the texture and color of the liver, a reduction in ether-extractable lipid in the liver, heart, aorta, and kidneys" (21).

Nickel may play a role as an activator of liver arginase and in maintaining the conformation of membranes (22). The average intake of normal adults is 0.3–0.6 mg/day (22).

The occurrence of nickel in human tissues and the fact that a nickel deficiency has been produced in chickens and rats, both suggest some possibility of a human need for this trace element.

SILICON

Although deficiencies of silicon reportedly have been produced in laboratory animals, suggesting a possible human requirement, positive data implicating silicon in human nutrition are lacking. Carlisle (7) in 1972 reported that silicon is needed by the chick in microgram amounts for normal growth and bone development. There is some suggestion that silicon enhances calcification, especially when calcium is limited.

Silicon, as silicates, is ingested chiefly in vegetable foods. Human blood serum ordinarily carries about 1 mg/100 ml (7). Among stone workers the lungs are highest in silicon concentration because of inhalation of dust particles in stone-cutting and stone-working industries. Workman inhaling this dust often develop silicosis.

The amount of silicon in both plant and animal foodstuffs appears to be effective for normal growth and development. Therefore, a deficiency in the human appears to be remote. Milk is a good source of silicon for mammals.

VANADIUM

The essentiality of an element can be determined by reducing the level of the nutrient in a diet below the requirement of the organism. If fed under these conditions for an adequate length of time, deficiency symptoms will appear when contrasted to a control group receiving a supplement of the same nutrient in greater amount. In 1970, Hopkins and Mohr (15) pre-sented evidence that indicated the essentiality of vanadium in the diet of chicks studied under strict conditions of housing and diet. These investigators showed that when chicks were consuming a diet containing 10 parts per billion vanadium there was significantly slower growth in both the chicks wings and tail feathers. Blood cholesterol levels, interestingly, in these chicks were significantly lower than those in control animals. In 1971, Schwarz and Milne (28) showed that the growth of rats raised on carefully controlled and deficient diets under "ultra-clean" conditions increased their growth 40% in 21–28 days after the addition of 0.25–0.5 mg sodium orthovanadate/kg diet.

Vanadium is present in human body tissues. In view of this fact and the findings reported above for the chick and rat, there appears reason to believe that vanadium may be necessary for the human dietary (2). No figure can be given for the vanadium requirement of the human at present, but it may be in the range of 0.1–0.3 mg/day. Normal diets contain about 10 times this amount.

TRACE CONTAMINANTS

There are many elements present in trace amounts in human body tissues and fluids. Some of these are described briefly here, and others are merely listed as being present. As far as is known, all of these are foreign to the human and animal body function and metabolism and are present as trace contaminants. It is possible that as analytic tools become sharpened and refined more will be learned of these "incidental" tissue substances, including possibly their toxic qualities.

LEAD

Lead does not appear to have an essential role in animal metabolism. In fact, no biologic role in plants or animals is known. Rather, interest in lead is due its toxicity. In industrial societies people are at risk of absorbing toxic amounts in their drinking water, in their food, and from the air they breathe. Lead has been found in high concentrations in plants and soils in areas in the vicinity of major highways due to discharges of lead from automobile engines (2). In children, lead toxicity has occurred through chewing toys or other surfaces painted with lead paints. Some dishes with lead glazes can be toxic, particularly if used in cooking. The burning of refuse containing lead paints, old lead batteries, or other

lead-containing materials is a possible source of toxicity.

Lead is stored in the bones and, to a lesser extent, in the liver. Enzymes that depend on sulfhydryl groups (−SH) for their activity are inhibited by lead, *e.g.,* δ-aminolevulinic acid dehydratase, which is involved in the biosynthesis of heme. For this reason patients with lead poisoning causing an anemia will excrete coproporphyrin III in the urine. This is such a constant finding that the examination of urine is one of the best screening tests for suspected lead poisoning or toxicity (33).

In industrial areas, 1–2 μmol (200–400 μg) may be ingested daily. A blood concentration above 2 μmol/liter suggests more than usual exposure to lead, and higher amounts invite the risk of developing lead poisoning. A stool sample containing more than 4 μmol, or a urine sample with more than 400 μmol/liter is indicative of excess lead contamination of food (7).

CADMIUM

Although cadmium exists in tissues in trace amounts, it does not appear to be an essential nutrient. It is absent or extremely low in concentration in the body at birth. However, by age 50 the amount present in tissues has accumulated slowly to 200–300 μmol (20–30 mg) (7).

Cadmium poisoning is recognized as an industrial hazard. In Japan, cadmium has been shown to be the cause of a severe and often fatal osteomalacia with aminoaciduria called Itai-itai disease. This disease affected over 200 people living on rice grown on land irrigated by waste water from a zinc mine upstream from the area (7).

In 1960 Kagi and Vallee (16) isolated from equine renal cortex a metalloprotein containing cadmium. It contained 2.9% cadmium, 0.6% zinc, and 4.1% sulfur. Because of its high metal and sulfur content, it was named metallothionein. Although the metabolic function of this metalloprotein has not been explained, it may suggest a role for cadmium in biologic systems.

MERCURY

Compounds of mercury have a number of industrial uses, and the toxicity of the metal is therefore a hazard. Poisoning produces tremors and stomatitis, but the symptoms appear to be reversible when the patient is removed from further exposure to the metal. The dangerous forms of mercury are the alkyl derivatives, methylmercury and ethylmercury (7). When absorbed or ingested, these compounds produce an apparently irreversible encephalopathy. Mercury poisoning can be produced by eating fish from polluted waters containing these and other mercury-organo compounds or seed grains treated with mercurial fungicides to prevent fungal disease. Following a latent period of 2–5 weeks, ataxia and visual disturbances develop which may lead to permanent paralysis (7) or death.

Blood or hair can be examined when mercury poisoning is suspected. Concentrations below 100 μmol (20 μg/1iter) of whole blood are desirable.

ARSENIC

Although arsenic is present in soil, water, and in many plant and animal foods it does not seem to have an essential role in biology. In the form of organic arsenicals it is sometimes added to animal feeds to stimulate growth (7). Such animals may have higher than normal amounts of arsenic in their liver and muscles.

The diet of an adult man normally contains 6–50 μmol (0.4–3.9 mg)/day. It has been suggested that 43 μmol/day is an acceptable upper limit of intake (7).

STRONTIUM

As mentioned in the introduction to this chapter, the radioactive isotope of strontium (strontium-90) attracted attention first as fall-out from atomic explosions. Like calcium and magnesium it is a divalent ion, and its biologic behavior is somewhat similar to calcium. In general, strontium is present in foods rich in calcium, such as milk and to a lesser degree vegetables. It is stored in bone (7).

BORON

This element has been shown to be essential for plants, but there is no evidence that it plays a role as an essential nutrient in animal metabolism. The growth of laboratory animals (rats) maintained on diets very low in boron is not impaired (14).

ALUMINUM

Aluminum is the third most abundant element in the earth's crust, and the human body contains 50–150 mg. There is no evidence that it is essen-

tial. The hydroxide, however, has value as an antacid and appears to be effective in patients with chronic renal failure to help reduce phosphate absorption. The daily intake of aluminum in the human diet varies from 10 to over 100 mg, and in addition small amounts may be derived from aluminum cooking utensils or added to the diet as sodium aluminum sulfate in baking powder. Absorption of aluminum from the intestine is poor (14).

LITHIUM

This element is not an essential nutrient for animals or man. According to Voors (31) the concentration of lithium in drinking water appears to be inversely related to the prevalence of coronary heart disease. Lithium salts have been found to be effective in the treatment of mania and related mental disorders in which there is a disturbance of amine metabolism. It seems to have a place in psychiatry and is used in the prevention of recurrent attacks of mania and depression (7). This element inhibits the release of norepinephrine and serotonin from brain slices stimulated by an electric current.

REFERENCES

1. Bernstein DS, Sandowsky N, Hegsted M, Guri CD, Stare FJ: Prevalence of osteoporosis in high -and low-fluoride areas in North Dakota. JAMA 198:85–87, 1966

2. Bogert J, Briggs GM, Calloway CH: Nutrition and Physical Fitness, 9th ed. Philadelphia, WB Saunders, 1973

3. Caughey JE: Etiological factors in adolescent malnutrition in Iran. NZ Med J 77:90–95, 1973

4. Cotzias GC: Manganese in health and disease. Physiol Rev 38:503–532, 1958

5. Dahl LK: Salt intake and salt need. N Engl J Med 258:1152–1158, 1205–1208, 1958

6. Darrow DC, Pratt DL, Flett J, Gamble AH, Weise HF: Disturbance of water and electrolytes in infantile diarrhea. Pediatrics 3:129–156, 1949

7. Davidson S, Passmore R, Brock JF, Truswell AS: Human Nutrition and Dietetics, 6th ed. New York, Churchill Livingstone, 1975

8. Elvehjem CA:The biological significance of copper and its relation to iron metabolism. Physiol Rev 15:471–507, 1935

9. Flink EB: Magnesium deficiency syndrome in man. JAMA 160:1406–1409, 1956

10. Fluoride as a nutrient. Committee on Nutrition, American Academy of Pediatrics, Pediatrics 49:456–460, 1972

11. Guthrie HA: Introductory Nutrition, 3rd ed. St Louis, CV Mosby, 1975

12. Halsted JA, Ronaghy HA Abadi P, Haghshenass M, Amirhakemi GH, Barakat RM, Reinhold JC: Zinc deficiency in man. Am J Med 53:277–284, 1972

13. Handbook on Human Nutritional Requirements. Food and Agriculture Organization of the United Nations, FAO Nutritional Studies No. 28. Rome, WHO Monograph Series 61, 1974

14. Harper HA: Review of Physiological Chemistry, 15th ed. Los Altos, Lange, 1975

15. Hopkins LL, Mohr HE: The biological essentiality of vanadium. In Mertz W, Cornatzer WE (eds): Newer Trace Elements in Nutrition. New York, M Dekker, 1971

16. Kagi JHR, Vallee BL: Metallothionein: a cadmium -and zinc- containing protein from equine renal cortex. J Bio. Chem 235:3460–3465, 1960

17. Latham MC, McGandy RB, McCann MB, Stare FJ: Scope Manual on Nutrition. Kalamazoo, MI, Upjohn Co, 1970

18. Latner A: Clinical Biochemistry, 7th ed. Philadelphia, WB Saunders, 1975

19. Mertz W: Chromium occurrence and function in biological systems. Physiol Rev 49:163–239, 1969

20. Montgomery RD: Magnesium metabolism in infantile protein malnutrition. Lancet II: 74–75, 1960

21. Nielsen FH: Studies on the essentiality of nickel. In Mertz W, Cornatzer WE (eds): Newer Trace Elements in Nutrition. New York, M Dekker, 1971

22. Orten JM, Neuhaus OW: Human Biochemistry, 9th ed. St Louis, CV Mosby, 1975, p 551

23. Recommended Dietary Allowances, National Academy of Sciences, 8th ed. Washington DC, 1974

24. Rickert DA, Westerfeld WW: Isolation and identification of xanthine oxidase factor as Molybdenum. J Biol Chem 203:915–923, 1953

25. Rotruck JI, Pope AL, Ganther HE, Swanson AB, Hafeman DG, Hoekstra WG: Selenium: biochemical role as a component of glutathione peroxidase. Science 179:588–590, 1973

26. Schroeder HA, Balassa JJ, Tipton IH: Abnormal trace metals in Man—Chromium. J Chron Dis 15:941–964, 1962

27. Schwarz K: Tin as an essential growth factor for rats. In Mertz W, Cornatzer WE (eds): Newer Trace Elements in Nutrition. New York, M Dekker, 1971, p 314

28. Schwarz K, Milne DB: Growth effects of Vanadium in the rat. Science 174:426–428, 1971

29. Underwood EJ: Trace Elements in Human and Animal Nutrition, 3rd ed. New York, Academic Press, 1971

30. Vallee BL, Neurath H: Carboxypeptidase, a zinc metalloenzyme. J Biol Chem 217:253–261, 1975

31. Voors AW: Does lithium depletion cause atherosclerotic heart disease. Lancet II: 1337–1339, 1969

32. Wacker WEC, Moore FD, Ulmer DDD, Vallee BEJ: Normocalcemic magnesium deficiency tetany. JAMA 180:161–163, 1962

33. Wintrobe MM, et al. (eds): Harrison's Principals of Internal Medicine, 6th ed. New York, McGraw–Hill, 1970, p 665

34. Young DS, Hicks JM: Method for the automatic determination of serum iron. J Clin Path 18:98, 1965

MODALITIES OF APPLIED NUTRITION

5 Private practice of dietetics

Marcia A. Mills

ROLE OF THE DIETITIAN

The conventional portrait of the trained dietitian places the professional in a variety of institutional settings. It is probable that the most prominent among these, and the most familiar to the practicing physician, is the hospital. But this portrayal neglects a growing development in the application of the nutritional knowledge of the trained dietitian, a development indeed under way for at least 20 years in the United States (11). This is the private practice of dietetics by Registered Dietitians, separate from hospitals and clinics, or in independent association with these as will be further described below. The American Dietetic Association (ADA) has defined several terms to specify these relationships, new and old, to the application of the dietitian's expertise (1).

Nutritional care describes the application of the science of nutrition to the health care of people.

Dietary counseling is the process of providing individualized, professional guidance to assist people in adjusting their daily food consumption to meet their health needs. The objective of the dietary counseling is to modify the subject's behavior so that he chooses appropriate foods.

Team approach to nutritional care is a concept combining the expertise of physicians and dietitians plus other allied health professionals to improve the *health* of an individual. The team approach is now used in various hospitals which utilize over half of the practicing dietitians (13).

With these terms in mind it is possible to sketch and categorize the current systems of nutritional care.

CURRENT SYSTEMS OF NUTRITIONAL CARE

The nutritional care system available at the present time in the United States is delivered predominantly in hospitals, nursing homes, or large clinics by registered dietitians and occa-

sionally by dietetic technicians. The ADA-registered dietitian has successfully completed an examination and fulfills continuing education requirements in addition to having a Bachelor of Science or Arts degree in Dietetics. One can recognize a registered dietitian's title by the R.D. following the name. The registered dietitian provides nutritional care by applying science as well as the art of human nutrition to help people select food for the purpose of nourishing their bodies during health and disease throughout the life cycle (13).

The dietetic technician is a technically skilled person who has successfully completed an associate degree program that meets the educational standards established by the ADA. The dietetic technician works under the direct guidance of an R.D. and has specifically assigned responsibilities in food service management and in teaching food and nutrition principles or dietary counseling.

The practicing physician is likely to find access to professional dietetic assistance in the person of the dietitian in several settings: the hospital, the public health agency, and—as a relatively new development—the dietitian in private practice relating to the medical community through referrals.

HOSPITAL DIETITIANS

The nutritional care provided by hospitals focuses primarily on providing the appropriate food to patients while they are in the hospital.

Although the nutritional intake of the acutely ill hospitalized patient is important, nutrition is equally important in the care of the long-term chronically ill. The team concept has functioned in some hospitals that employ health professionals to work with patients having specific chronic diseases, *e.g.,* myocardial infarctions, renal disease, or diabetes (11). The dietitian, as a team member, monitors patient weight and food intake and records the appropriate information on

the medical record, thus enabling the rest of the team to use this data to plan the patient's care over a lengthy hospitalization.

Dietitians contribute effectively in the hospital setting while the patient is institutionalized. They also have the responsibility of preparing the patient to return home when the treatment requires additional or continuing dietary therapy. The dietitian uses previously gathered information about the patient's eating habits, food preferences, appetite, and socioeconomic background to aid in designing a dietary plan that will continue to be therapeutic and acceptable. The dietitian provides information about food purchasing, preparation, and food substitutes that are equivalent in nutrients, well accepted, and allowable within the dietary prescription. All too often, a quick course on the necessary dietary changes for home use is ordered by the physician during the last day of a patient's hospital stay. This procedure only strains the learning ability of patient and family when they are anxious to return home. Patient follow-up and support after discharge from the hospital makes a significant difference between success and failure of dietary prescriptions.

PUBLIC HEALTH NUTRITIONISTS

Public health nutritionists work in the community to survey community nutrition needs, plan nutrition components of community health programs, and provide training, consultation, and teaching materials for other public health workers, such as nurses and sanitation personnel (14). The public health nutritionist is usually perceived as a resource person by other allied health professionals (4).

The direct care provided by the public health nutritionist normally involves the therapeutic nutrition indicated for specialized groups of people under the direction of public health and nutrition programs (10). Seldom do the public health nutritionists use therapeutic dietetics on a one-to-one basis with a family.

APPLIED NUTRITION AND THE PRIVATE PHYSICIAN

The rapid increase in expectations of health care delivery and the equally rapid expansion of scientific knowledge has forced the physician in private practice to carefully evaluate his priorities for patient health care. Since the physician has been charged with the major responsibility of medical care in his community, he feels an increased pressure to decide which facet of health care each patient will receive. However, the private practitioner is well aware that a number of resources are available which will benefit both his patients and his practice. In other words, he is usually interested in building an effective health care team.

The private physician is hampered by the amount of time he can spend with patients. The average physician sees each patient for perhaps 15 minutes, during which he must evaluate the specific problem presented. In the past when the general practitioner dealt with a patient who needed dietary counseling, the favored tool was a diet sheet with allowed and prohibited foods printed in columns. Another common patient teaching device has been the 1000 and 1200-Cal menu plans given to a patient for weight loss. The time-limited practitioner often leaves the dietary changes necessary to lose weight to the patient's "will power." Since specific instructions are not given, this usually guarantees that the patient will do nothing more than he is already doing. The patient has probably used his will power, ineffectively, before he arrived at the doctor's office.

If the private medical practitioner did have the time to work individually with patients on dietary behavior changes, the cost to the patient would be extremely high. Health insurance companies generally do not provide third party payment for simple exogenous obesity. The discussion time necessary to discount misinformation on which the patient has based his food intake behavior would double the time required to provide factual information regarding a dietary change. The physician rarely has the required time to teach patients to the extent demanded.

The science of nutrition has grown tremendously in the past 50 years, and progress continues, but national food supplies continue to change qualitatively and quantitatively. The registered dietitian, having an educational background focusing on food consumption as well as on the role of food itself in the maintenance of health, is a logical source of continuing dietary information (8).

THE TEAM APPROACH IN THE MEDICAL COMMUNITY

The expanding advances of science have brought an increasing complexity to health care. The cooperation of a team of specialists who share their respective knowledge for the welfare of the patient is now required. A wide range of facilities is essential, but they must also be availa-

ble to the people whom the health care team seeks to serve.

Nutrition is an integral part of total health and life. All efforts in nutrition education, either normal or therapeutic, need to be multidisciplinary in approach. Registered dietitians are the most numerous professionally educated group whose primary concern is the application of nutrition science to the health care of people. Dietitians expectedly must be involved in the planning and execution of health care programs.

There has been a trend in recent years for the medical team approach, as applied in hospitals, to move into the community and work as a cooperative group. Physical therapists, nurse practitioners, and social workers, in addition to dietitians, have initiated private practices to serve the community in this manner.

THE PRIVATELY PRACTICING DIETITIAN AS A RESOURCE

Therapeutic dietary objectives can be specified following a medical diagnosis by the private physician. The dietitian–physician team then determines the therapeutic dietary means that need to be implemented.

The dietitian works with the patient to evaluate dietary recollections, or records, and then can suggest and plan with the patient the course of action to change dietary habits to meet objectives agreed upon by the physician–dietitian team. Follow-up with the patient is usually necessary so that new questions and situations can be handled appropriately. Dietitians work in their own offices, in the patients' food environment, or in other areas that influence the client's eating behavior. Dietitian and physician interaction at appropriate intervals is necessary after changes have taken place. This communication can take place via phone, letter, or personal discussion (9).

Patient self-referrals are also made to dietitians in private practice. The client may want to have his normal dietary intake evaluated to determine if his eating pattern meets the recommended dietary allowances (12). He may want to lose weight, having failed in the past. The self-referred client may want to improve the family's eating habits. Food habit change may be desired to reduce the cost of a well-balanced meal pattern or to switch to a lower animal protein dietary plan.

Consulting dietitians, in addition to working with physicians and patients, provide educational services for allied health professionals in the form of work shops, classes, or individual training in a specialized area of therapeutic dietetics.

Dietitians often set up consulting services within large clinics, or with groups of physicians, sharing office and waiting-room space and secretarial help. This practice enables convenient referral by the physicians within the same day, at a relatively low overhead cost to the dietitian. The disadvantage of having the dietitian's office within a medical complex is that other physicians in the community may be reluctant to send their patients to a different medical complex (6).

Private practices are established throughout the country in a variety of settings. Some registered dietitians have offices within their homes, in allied health buildings, in office buildings, or in physicians' offices, or they may exist solely through house calls. Practices are designed as solo practices, partnerships, and corporations.

A speciality group called "Consulting Nutritionists" has been established within the ADA. Members of this group are registered dietitians who have or plan to establish independent counseling practices throughout the United States, Canada, and Mexico. Through unity and communication the specialty group promotes consistency of quality among its members. Almost every state has a state coordinator for the group who can contact other dietitians in private practice within the state quickly and efficiently.

By combining individuals into a unified force, this professional group will hopefully be able to improve medical insurance coverage for physician-referred therapeutic diet instructions and create a professional unity visible to the allied health professionals and to the general public. The group will also provide the opportunity for improvement and growth in each dietitian's practice through planned meetings for continuing education credit.

To contact dietitians in private practice, consult the yellow pages of the telephone book under "Dietitians." Contact may also be made by locating the state or local dietetic association or major hospital chief dietitian.

DIETARY COUNSELING: AN INVESTMENT IN THE FUTURE

PREVENTIVE MEDICINE

Preventive medicine is a well-accepted concept in the effort to improve the health of the nation. Many medical problems are best solved before they become medical crises (3), and improved nutrition is a modality *par excellence*.

The consulting nutritionist can assist in evaluating present dietary habits. Some clients, in the absence of illness, are concerned about the quality of their diet for promoting optimum health. Other persons may look for assistance with making deliberate food changes, such as becoming a partial vegetarian.

Weight gain is one aspect of preventive medicine in which the consulting nutritionist can assist the physician or client. Young children, adolescents, and adults may desire and need to gain weight. Senior citizens sometimes lower their weight to such an extent that preventive dietary counseling may be desirable.

A physician may order some type of surgery which necessitates his patient be in optimum nutritional status before the stress and tissue injury of the surgery. Patients may need to lose weight before surgery can be contemplated due to the increased risk of obese surgery patients.

Postsurgical care ideally keeps the dietary intake at optimal levels within the restrictions of any necessary therapeutic changes. Home follow-up by the consulting nutritionist after surgery can help to maintain high levels of protein and calories while providing vitamins and minerals necessary for optimum healing to take place.

Nutrition consultants in several areas of the country consult within home environments as well. Close follow-up work enables patients to better gain control of diseases that require dietary changes within their own homes.

Dietitians in private practice are equipped to obtain and evaluate nutritional histories, perform dietary assessment, and teach patients to adapt prescribed dietary modifications to their life style. This service is particularly advantageous when multiple dietary restrictions are involved or when a patient needs to be followed over a period of time for dietary intervention. The nutrition consultant can assist the family to adapt special dietary combinations when several family members need dietary modifications (2). The dietitian also reinforces and offers more-detailed explanations to patients who are unable to follow a prescribed diet following a hospital diet instruction.

Chronic diseases or poor dietary habits require lifetime dietary modifications. These changes are difficult to comprehend by the patient or family who refuse to "go on a diet" when in reality their dietary habits are already one kind of "diet." Most people consider diets to be painful or a form of deprivation and thus view food habit changes in a negative sense.

Dietitians see food habits and therapeutic dietary changes as goal-oriented, with readily measurable objectives to be achieved. The dietitian takes time to explain the benefits of changing dietary habits and how these changes can be measured. The patient then knows where he is going and how he's going to get there, and he can then adopt a more-positive attitude toward taking responsibility of directing his behavior toward the new dietary goals. The patient and his family must participate in the dietary management that will eventually develop into permanent appropriate dietary habits for his particular disease or health.

Dietary instruction by a nutrition consultant can be seen as four distinct steps: 1) assessing current dietary habits, 2) creating the new therapeutic dietary habits with revisions for better patient acceptance, 3) assistance with implementing the changes, and 4) evaluating the changes made (4).

Individual likes and dislikes, allergies, and family composition must be considered during the creation of a therapeutic diet. If nutrient supplementation is necessary, the dietitian is in a position to suggest a supplementation to both the patient and the referring physician.

Several methods are available to help the family implement a dietary change. The technique chosen depends on the family's interests. Some techniques used could be shopping ideas or practice, menu planning, recipe modification, appropriate use of specially developed products or seasonings, food economy, or ways to incorporate new food habits while entertaining or dining in a restaurant.

Evaluations of changes made are assessed by designing suitable records for clients to keep with corresponding weight changes. Discussion of attitude changes are helpful to determine if the new habits will remain long term.

ECONOMICS OF DIETARY COUNSELING

The dietitian in private practice in the community may be viewed as an economy in view of historic costs of dietary counseling within institutions. Patients and physicians are well advised to ask how to obtain the best dietary management counsel economically.

The physician–dietitian team can reduce the frequency of hospitalization, and provide necessary management, for patients with diabetes, hyperlipidemia, and weight control problems who are screened through physical examinations

and routine laboratory procedure in the physician's office. The patient benefits by avoiding the negative effect of fears associated with hospitalization, and significant savings result for the health insurers.

The patient receives better follow-up and more time for learning with a consulting nutritionist at a lower cost than with a heavily scheduled physician. Flexible scheduling is more readily available with a dietitian in private practice.

Individual physicians or small groups of physicians can make referrals to a nutrition consultant from all parts of the community they serve and thereby save themselves the cost of retaining dietitians.

The insurance industry is now considering third party payment for therapeutic dietary counseling. In the past, health insurers paid only for crisis and disease–related treatment. This may be extended to preventive medicine and already has begun to provide payments for mental health (7).

Reimbursement of dietary counseling fees rarely occurs at the present time, although some labor union policies reimburse clients for such out-patient services. The majority of dietary counseling clients personally pay the charges, which are considered medical expenses by the Internal Revenue Service. When the insurance industry does move toward dietary coverage, professional qualifications will be closely related to the fee reimbursement. Dietetic registration as a requirement separate from membership in the ADA is a necessary step for the inclusion of nutritional services under this third party payment scheme (4). The ADA has made the appropriate changes in the national organization.

QUALITY OF CARE

In the opinion of many, the patient obtains improved care from a team approach. Physician and allied health professionals together use their expertise in an expedient manner, thus saving valuable time and money for the patient. The dietitian in this team personalizes dietary instruction and is capable of expending the effort necessary to use the best teaching tools available for each patient's individual needs and desires. The consulting nutritionist is particularly able to keep abreast of the expanding body of knowledge from nutrition scientists and medical research dealing with nutrition.

The communication feedback system between physician, dietitian, and patient allows consistent treatment, leading to greater progress and satisfaction for the client.

Hospital dietitians refer patients for outpatient care and follow-up to the consulting nutritionist. This continuation of health care in the community increases the probability of dietary compliance and attitude changes necessary for long-term improved health.

CONCLUSION

There is a well-documented relationship between adequate nutrition and health, vigor, and achievement. Poor nutrition can lead to poor health, reduced work output, and low morale. Good nutritional status is regarded as a desirable health-related goal. It is necessary to recognize that eating behaviors are learned. When nutritional care services are part of the community health team, the opportunity is available for the individual to learn new more-appropriate behaviors based on medical evaluations.

Nutritional care availability in the community will become a resource for the public by which to obtain reliable nutrition information. Nutrition consultants can provide better information to people in the community than earlier sources, often of misinformation, have in the past.

Preventive nutritional care is indeed a concrete way of decreasing the effect of poor nutrition and poor eating habits as major contributing factors in several expensive health problems, e.g., birth defects, anemia, diabetes, coronary heart disease, hypertension, dental disease, and obesity. In certain of these cases, diet becomes the basic means of managing the disease. Therapeutic nutrition education will probably shorten the time necessary for a person to reach certain health goals and therefore lessen the total amount of service needed, thereby reducing the cost of health care.

Health insurance coverage for dietary counseling and any national health insurance program adopted to provide both preventive and restorative nutrition care will solve numerous costly nutrition problems of the past. The current public interest in nutrition, the recognition of the significance of nutritional care to the maintenance and improvement of health, and the rising concern of government for making quality health care available to all people, all point to the greater utilization of nutritionists–dietitians in the community

The health care team has utilized nutritionists in health maintenance organizations, day care programs, and programs for the aging (5). Now

it is time to include the nutritionist, outside the hospital or special program, as part of the community's health care team.

REFERENCES

1. The American Dietetic Association Fact Sheet Nutritional Care-Dietary Counseling, Chicago, Illinois, October, 1974

2. Dresser CV, Roth JH: Private practice: nutritional counseling, perspectives in practice. J Am Diet Assoc 69: 475, 1975

3. Hallahan IA: Dietary counseling in ambulatory care. J Am Diet Assoc 68: 246, 1976

4. Hunerlach CL: Dietitians—Independent Practitioners. Ardmore, MD, C–N Publications, 1974

5. Light I: Challenging perceptions of the health team members. J Am Diet Assoc 59: 13, 1971

6. McRae NM: The dietitian in private practice. J Am Diet Assoc 51: 52, 1967

7. Myers ES: Insurance lowers the barriers to mental health care. Med Insight 3: 42, 1971

8. Ohlson MA: The philosophy of dietary counseling. J Am Diet Assoc 63: 13, 1973

9. Parant D: Starting a Private Practice—One Dietitian's Experience. New Haven, D Parant, 1974

10. Peck EB: The public health nutritionist-dietitian: an historical perspective. J Am Diet Assoc 64: 642, 1974

11. Perspectives 1974: Unusual positions and newer dietetic specialties. Perspectives in practice. J Am Diet Assoc 64: 649, 1974

12. Recommended dietary allowances. Washington DC, National Academy of Sciences, 1974

13. Titles, definitions and responsibilities for the profession of dietetics. J Am Diet Assoc 64: 661, 1974

14. Williams SR: Nutrition and Diet Therapy. St Louis, CV Mosby, 1973

6 Curative nutrition: protein-calorie management

George L. Blackburn, Bruce R. Bistrian

Among the essential nutrients required for daily metabolism are amino acids for protein synthesis and nonprotein calories (NPC) to provide the energy for cell work. Since these nutrients have the largest daily requirements and their utilization is uniquely interdependent (56) they are considered together in this chapter.

Protein-calorie malnutrition (PCM) results in deficiencies that the body is slow to restore since it is limited by a total body protein turnover of approximately 4% per day (79) with any surplus converted to fat. Restoration of body protein is particularly difficult due to the priority of energy over protein requirements and the complex interactions of the eight essential amino acids (37, 56).

Rarely will a clinician see a nutritional deficiency of significant medical importance that is not associated with PCM. A favorable outcome may sometimes result from therapies that selectively replace other nutrients before or without treatment of PCM, but given the overriding importance of protein and calories in the common clinical situation (6), this cannot be the usual goal and in some instances may even be detrimental. Restoration of iron depletion in the absence of proper therapy of PCM may paradoxically support bacterial growth and deny the host utilization of this cofactor (71). Conversely, protein and calorie repletion may precipitate acute vitamin A deficiency in children with kwashiorkor (45). The point to be made is not that protein and calories should be restored preferentially to other nutrients, but rather that the amounts of vitamins and micronutrients required are relatively minimal and easily restored.

Treatment of PCM is affected by certain key variables, particularly the degree of nutritional depletion and the degree of hypercatabolism (56). Many secondary conditions, such as the particular disease state (*e.g.,* cancer, trauma, or pneumonia) or age group (*e.g.,* pediatric, adult,

or geriatric), also influence the type and effectiveness of therapy. It is for this reason that we have chosen to consider first the metabolic response to illness, then the products available for treatment, then the nutritional state obtainable ("fed" state vs. the "nonfed" [starved] state), and finally the various patient conditions and organ failures that will affect the nutritional support plan.

THE METABOLIC RESPONSE TO ILLNESS

Trauma, sepsis, and injury have long been recognized as producing significant alterations in body metabolism (19, 22, 40, 46) which initiate from the central nervous system a sympathetic-mediated reaction that triggers the release of substrate "mobilizing" hormones (14, 77). Phagocytosis also represents an important mechanism for initiation of the metabolic response to illness (see Ch. 22). During the initial "acute phase," generous mobilization of metabolic reserves, including skeletal protein, ensures that an adequate supply of substrates is available for energy production and biosynthesis. This is quite different from starvation without injury, in which initial losses occur from the liver and other labile protein of the viscera and substantial depletion of skeletal protein begins only after 3–4 days (70).

With the stress of illness, the glucocorticoid-induced peripheral protein catabolism results in an overall negative nitrogen balance that has classically been deplored (22). Only recently has consideration been given to the possibility that peripheral catabolism might provide amino acids for synthesis of acutely needed blood proteins, structural proteins, and enzymes (14). The mobilization of body protein from skeletal muscle does provide energy fuels as precursors for gluconeogenesis, but it also enables the synthesis of acute phase globulins, white blood cells and

other protein mediators of immune function, host resistance, and wound healing. It is essential that this be recognized when nutritional support therapies are designed (3, 13).

ACUTE PHASE

The hormones released during the initial "acute" catabolic phase of the response to injury include signals to specifically antagonize the action of insulin, the key anabolic hormone for the two major peripheral tissues, skeletal muscle, and adipose tissue. Catecholamines inhibit the release of insulin, and glucocorticoids reduce the sensitivity of peripheral tissues to it. The body cell mass appears to be temporarily sacrificed during the "acute phase" in favor of maintaining a relative abundance of circulating substrates to meet any particular working cell's requirement.

The major energy reserves in the body are in the form of triglycerides stored in adipose tissue. Because of the high caloric value of fat and the low water content of adipose tissue, this tissue contains some 3500 Cal/pound. During the acute phase of injury, this energy reserve is mobilized to meet the metabolic demands, even in severely calorie-restricted states (10). It is clear that the concern about the lack of energy fuel substrate during the immediate postoperative period or during conditions of starvation do not appear to be warranted.

ADAPTIVE PHASE

This acute phase of illness gives way to an "adaptive phase" during which the organism seeks to adapt its metabolism to the changes in nutritional state. The timing of the transition between phases is dependent on the degree of illness, injury, or sepsis and associated nutritional depletion (13). Effective nutritional support can occur in this adaptive phase, once the strong catabolic signals resulting from high levels of catecholamines and glucocorticoids have subsided. The hormonal situation is complex and variable, but the adaptive phase can be identified by measurements of blood sugar, blood urea nitrogen, serum and urine ketones, and urinary urea nitrogen excretion. The adaptive phase of injury is recognized by falling glucose, normal blood urea nitrogen, ketosis, ketonuria, and decreasing excretion of urea nitrogen. A fall in blood glucose level is of major significance in identifying this transition since high rates of catabolism are associated with increased rates of gluconeo-

genesis and hyperglycemia (35). Administration of exogenous glucose, such as the infusion of isotonic 5% dextrose solutions, prevents the recognition of a transition and is of no demonstrable protein-sparing value during the acute phase of injury (32, 58).

It is important to design nutritional support with an appropriate sense of timing. Providing the patient with protein that will only be metabolized to glucose via gluconeogenesis and ureagenesis or with calories that will only result in lipogenesis can be considered detrimental since these processes require work and result in increased hypermetabolism (47, 56). Optimal nutritional support must be equated with the retention of administered protein (net protein utilization), and this depends on an appropriate hormonal situation.

PROLONGED STRESS

Special conditions exist during prolonged stress, such as that observed in major burns and in periods of systemic infection or sepsis (19, 77). The ability to develop an effective nutritional support plan is temporarily muted, and most efforts are limited to preserving the present nutritional state until the hypercatabolism and disease state can be treated (32). One important problem, particularly in conjunction with systemic infection or sepsis, is the increased use of protein as an energy source by muscle tissue, particularly the ketogenic amino acids: leucine, isoleucine, and valine. Effective therapy would logically be to increase the intake of dietary protein fortified with appropriate amounts of branched-chain amino acids in an attempt to normalize the profile of amino acids released from skeletal muscle as a result of selective loss of the branched-chain amino acids. Since injury is often associated with increased amounts of aromatic amino acids that are poorly "cleared" by the liver, their intake should be limited. Protein intakes of 1½–2 g/kg with 100–200 g carbohydrate to provide approximately 1000 Cal at a nitrogen to calorie ration of 1:50 appear to be indicated in these states. The resulting high rates of ureagenesis do not seem to be problem forming, and this high rate of amino acid infusion appears to be beneficial in stabilizing enzyme systems and promoting protein synthesis.

A contrasting hypothesis is that providing infusions of hypertonic glucose (400–600 g/day) with appropriate exogenous insulin and potassium is a means of curtailing the loss of body protein. Indeed, bolus doses of glucose, potas-

TABLE 6–1. Surgical Catabolism*

Degree of net catabolism	N_{obg}[†] (g urea-N/day)	% Increase of RME over BEE
1° Normal	<5	10–20
2° Mild	5–10	20–50
3° Moderate	10–15	50–80
4° Severe	>15	>80

*Classification of patients according to the following: 1) obligate nitrogen loss (N_{obg}) expressed in g urea-N/24 hr; 2) energy expenditure expressed as % increase of the resting metabolic expenditure (RME) over calculated basal energy expenditure (BEE)

[†]No nitrogen intake and 3 days of at least 100 g carbohydrate

sium, and insulin are known to be effective hemodynamic support during "low-flow" septic states. However, the preferential peripheral uptake of amino acids produced by this therapy may not result in effective support of visceral protein synthesis. This latter therapy could be viewed as the use of metabolism for a pharmacologic resuscitation, whereas the former uses metabolism to optimize nutrition. These contrasting nutritional therapies reemphasize the sophistication now necessary in this field. The use of standard parenteral hyperalimentation (hypertonic glucose and amino acids) as a combination of the two therapies does improve hemodynamic support by its inotropic effect on cardiac function (8, 19). A separate chapter will consider nutritional care of the burn patient (see Ch. 14).

Restoration of body cell mass and in particular the visceral compartment are the major goals of nutritional support. Maintenance of adequate protein synthesis will support body cell mass and provide optimal organ response to injury. Proper utilization of protein intake is dependent on adequate energy fuel substrate to meet caloric requirements so as to minimize oxidation of amino acids for energy via gluconeogenesis.

Factors that will best determine the nitrogen balance and net protein utilization include the

Fig. 6–1. Rate of endogenous protein breakdown rises with increasing degrees of hypermetabolism, reflecting relatively constant (12–16%) contribution of protein to energy expenditure during periods of catabolic stress in various disease states *(left)*. BSA, body surface area. Determination of daily urea nitrogen excretion (g/m²/day) can provide a simple and effective clinical estimate of magnitude of hypermetabolism, as percent above resting metabolic expenditure *(RME)*, normally obtained by measurement of oxygen consumption *(right)*.

Urea nitrogen excretion

O_2 Consumption (% of RME)

metabolic rate, nonprotein–calorie intake, nitrogen intake, and a favorable metabolic state, described above (56, 77).

The metabolic rate, although difficult to measure clinically, may be estimated by the equations of Harris and Benedict (56). Since this calculated basal energy expenditure (BEE) considers age, sex, height, and weight, its simple calculation will give a better estimate of caloric requirements than the standard practice using weight alone. The degree of increase of metabolic expenditure over BEE can be estimated from the daily urinary urea nitrogen loss (24, 56). Table 6–1 provides a classification for surgical catabolism and Figure 6–1 relates catabolic rates to energy expenditure. Most medical illnesses will fall in the first or second degree of catabolism. Utilizing regression analysis in a variety of mildly to moderately catabolic surgical patients, it has been found that the delivery of 1.76 times BEE can be expected to produce positive nitrogen balance with a 95% confidence interval during parenteral feeding, whereas an intake of 1.54 times BEE will be for effective oral intake at the same confidence limit. Net protein utilization is optimal (72% \pm 10%) at this level of intake. No benefit is observed in feeding 2 times BEE since further hypermetabolism results and the net protein utilization is diminished (56). Fourth degree hypercatabolism is seen primarily in major burns where energy requirements exceed 2.5 times BEE and the nitrogen–calorie ratio is 1:150 (77).

The optimal protein intake for positive nitrogen balance and restoration of lean body mass in depleted, stressed adults is 16%. This would appear to reflect the fact that 16% of the calorie expenditure comes from protein sources during injury (14). Since this value is approximately twice that seen during nonstress maintenance diets, the reutilization of body protein would appear to be decreased. Thus, a nitrogen–calorie ration of 1:150 would appear optimal to meet the protein requirements for anabolism. Special considerations are necessary in the nitrogen accumulation disorders, *e.g.,* renal failure, in which the nitrogen–calorie ratio may be 1:450 to 1:700 Cal/day (18). Liver failure also has an upper limit of tolerance of protein intake that may be metabolized without creating encephalopathy (27).

Maintenance diets where 8% of the calories are provided as protein result in effective preservation of lean body mass in convalescent patients (36). This 1:300 nitrogen–calorie ratio is an important consideration when "elemental" or chemically defined formula diets are used because each additional gram of amino acids over the ideal will influence osmolality, taste, and ultimate acceptability and utilization of protein intake. The source of the nonprotein calories, such as sugars, starches, dextrins, and medium-chain and long-chain triglycerides, are also important determinants of osmolality and digestibility and thus of the likelihood of meeting energy requirements (54).

In summary, careful appreciation of the metabolic response to illness is necessary prior to consideration of nutritional support plans (2). Knowledge as to the phase of response to illness or injury, degree of nutritional depletion, and degree of hypercatabolism will influence the attainable goals and timing of therapy (16, 10).

MODES OF THERAPY

ENTERAL FEEDING AND DEFINED FORMULA DIETS, NUTRITIONAL SUPPLEMENTS, MEAL REPLACEMENTS

Figure 6–2 provides a general scheme of nutritional products and feeding situations. Major consideration must be given to whether the goal of treatment is the "fed" state or "nonfed" (starved) state and to the route of administration, enteral versus parenteral. Combination of the various categories of feeding is implied from this figure since in many instances both parenteral and enteral feeding are used to obtain fed state requirements (16). For example, enteral feeding may require some additional parenteral feeding (*e.g.,* isotonic amino acids) to obtain the appropriate protein–calorie ratio in irritable bowel or malabsorption syndromes.

Classic hyperalimentation using hypertonic glucose and amino acids may be improved, in terms of support of visceral protein synthesis, by enteral feeding of small amounts of protein (11), or by "cyclic" hyperalimentation. In this latter instance hyperalimentation solutions are infused only at night and a nonfed routine is used during the day to free the patient of some of the constraints of his "lifeline" and provide a feeding schedule more compatible with normal feeding patterns (44).

A brief composition chart of the common nutritional supplements is provided in Table 6–2. In general these products provide 1 Cal/ml in their normal mixtures but differ widely in their protein and calorie sources and nitrogen–calorie ratios. In fact, many of the diets exceed the opti-

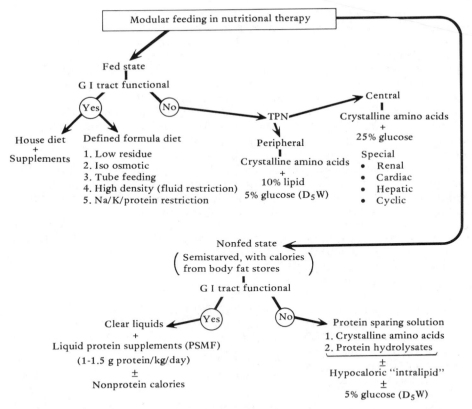

Fig. 6–2. Modular feeding. In all available therapies consideration is given to two nutritional states (fed and semistarved) and two possible means of delivery (enteral and parenteral). The use of this concept is depicted in this algorithm which allows a systematic approach to nutritional support. *PSMF*, protein-sparing modified fast.

mal nitrogen–calorie ratio and can therefore serve in a comprehensive nutritional support plan as "modules" to supplement low-protein, high-calorie food that is acceptable to the patient but which is by itself inadequate nutrition.

Since many patients in need of nutritional support have lactose intolerance and the oligosaccharides are less osmotically active than mono-forms or di-forms, the type of carbohydrate is specified for screening purposes. The complexity of fat digestion and its impairment in many disease conditions make it necessary when evaluating a product to consider fat levels beyond the minimal 1% required to prevent essential fatty acid deficiency. The rationale for utilizing medium-chain triglycerides as an energy source relates to their unique metabolism. Medium-chain triglycerides are digested more rapidly than long-chain triglycerides, are not dependent on micelle formation, and rapidly transported across the cell, and enter directly the portal cir-

culation where they are preferentially oxidized (58). The taste, osmolality, and viscosity are important depending respectively on patient cooperation, irritability of bowel, and whether tube feeding will be utilized. Most preparations are started at half strength and slow feeding rates to obtain the best utilization.

Most preparations in Table 6–2 contain a high biologic value protein. No important clinical difference has been shown in the digestibility and utilization of egg albumins, hydrolysates, or amino acids that have the egg protein profile (72). However, significantly improved patient taste acceptance and cost differential of whole proteins over hydrolysates or amino acids are a strong recommendation for their preferential use except in those few instances where protein maldigestion is likely to be clinically significant.

The American Medical Association Council of Food and Nutrition's recent conference on defined formula diets (DFD) (Table 6–3) pro-

TABLE 6–2. Composition and Indications for Use of Nutritional Supplements

	Cal/cc	mOsm/L	% Cal pro	% Cal CHO	% Cal fat	N:Cal	Protein source	Carbohydrate source	Fat source	mEq Na/L	Function
Supplements											
Citrotein	.53		24.1	73.2	2.3	1:93	Egg white solids	Sucrose	Mono and diglycerides	23	Contains 50% RDA of protein, vitamins and minerals
Lanolac	.66		21	30	49	1:81	Casein	Dextrin maltose Lactose	Coconut oil	1.1	Protein supplement for low-sodium diets
Lolactene vanilla	.8	670 mOsm/kg	26	52.8	21	1:70	Low lactose non fat milk	Corn syrup	Vegetable oil	36.2	Protein supplement minimal lactose content
Meritene (liquid) vanilla chocolate	1.0	640	24	46	30	1:79	Skim milk Casein	Sucrose Lactose Corn syrup solids	Vegetable oil	40.5	Protein supplement
Sustacal (liquid) vanilla chocolate	1.0	638 616	24	41.3	20.7	1:79	Skim milk	Sucrose Lactose Corn syrup solids	Partially hydrogenated soy oil	47.1	Protein supplement low lactose content
Meritene powder + skim milk	1.0		35.9	62.4	1.7	1:43	Skim milk	Lactose Corn syrup solids	Cow milk fat	39.1	Protein supplement utilizing skim milk
Meritene powder + whole milk	1.0		26.4	44.8	28.8	1:48	Milk	Lactose Corn syrup solids	Cow milk fat	39.1	Protein supplement utilizing whole milk
Sustagen powder (normal dilution) vanilla chocolate	1.8	721	24	68	8	1:79	Nonfat dry milk Powdered whole milk	Glucose Lactose Corn syrup solids	Cow milk fat	54.3	Protein supplement
Meal Replacements											
Compleat-B	1.0	468	16	48	36	1:131	Skim milk Beef	Lactose Sucrose	Corn oil Beef fat	59	Tube feeding-unflavored blenderized house diet for anabolism
Ensure vanilla black walnut	1.06	460	14	54.5	31.5	1:155	Casein Soy protein isolate	Sucrose Corn syrup solids	Corn oil	32	Tube or oral feeding lactose-free for anabolism
Isocal	1.05	350	12.9	49.6	38.5	1:169	Soy protein isolate Casein	Glucose Corn syrup solids	MCT Soy oil	22.6	Tube feeding-unflavored isotonic for anabolism
Nutri-1000	1.06	400	13	40	47	1:167	Skim milk	Glucose Sucrose Lactose Dextrin maltose	Corn oil	23	Tube or oral feeding for anabolism
Portagen	1.0	354	16	44	40	1:160	Casein	Sucrose Corn syrup solids	MCT Safflower oil	27	Oral feeding for malabsorption of long chain fats for anabolism
Precision isotonic vanilla	1.0	300 mOsm/kg	12	60	28	1:183	Egg albumin	Glucose Oligosaccharides Sucrose	Vegetable oil	34	Tube or oral feeding Isotonic lactose-free
Precision moderate Nitrogen vanilla citrus	1.2	395 mOsm/kg	12	60	28	1:169	Egg albumin	Maltodextrin Sucrose	Vegetable oil	43.3	Easily absorbed protein source Moderate fat content low osmolality

TABLE 6–3. Composition and Indications for Use of Defined Formula Diets

Defined formula diets	Cal/cc	mOsm/L	% Cal pro	% Cal CHO	% Cal fat	% Cal linoleic acid	N:Cal	Protein source	Carbohydrate source	Fat source	mEq Na/L	Function (all DFD are low residue clear liquid diets)
For maintenance												
Flexical orange vanilla banana fruit punch	1.0	805	8.8	61.1	30.1	2.16	1:264	Hydrolyzed protein + Methionine tyrosine tryptophan	Sucrose Dextrooligosaccharides	MCT Partially hydrogenated soy oil	15.2	30% Cal from fat 60% Cal from CHO Protein source requires some digestion
Jejunal beef broth beverage cherry pudding	.91	990 1200	9.1	90.0	.82	.56	1:252	Crystalline amino acids	Glucose Dextrins	Safflower oil	33.7	60:40 essential to nonessential amino acid Easily absorbed protein source of high biological value
Precision L-R cherry lemon lime orange	1.08	600	8.8	90.8	.65	.48	1:258	Egg albumin	Maltose Dextrins	Safflower oil	27.4	Low osmolality Protein source requires some digestion
Vivonex vanilla beef broth orange grape tomato chocolate	1.0	550	8.1	90.3	1.3	1.04	1:286	Crystalline amino acids	Maltose Dextrins	Safflower oil	37.3	High osmolality when flavored Easily absorbed protein source of high biological value
W-T low residue beef bouillon	.98	649	8.6	90.7	.7	.56	1:304	Crystalline amino acids	Dextrins	Safflower oil	68.8	Easily absorbed protein source of high biologic value
For anabolism												
Precision-HN citrus fruit vanilla	1.0	580	16.6	82.9	.42	.33	1:125	Egg albumin	Maltose Dextrins	Safflower oil	40.5	Low osmolality Protein source requires some digestions
Vivonex-HN beef broth orange grape strawberry	1.0	800	16.6	84.1	.78	.62	1:127	Crystalline amino acids	Glucose Maltose	Safflower oil	27.4	Easily absorbed protein source
Special DFD Aminade	2.02	1050	4	68	28	11	1:418	Essential amino acids	Sucrose Dextrins	Soybean oil	2	Provides high-calorie, low-protein diet of high biologic value (only essential amino acids) for use as Giordano-Giovanetti diet in renal failure Contains no vitamins

TABLE 6–4. Feeding Modules for Enteral Alimentation

Feeding Modules	Cal/cc	% Cal pro	% Cal CHO	% Cal fat	Protein source	Carbohydrate source	Fat source	mEq Na/L	Function
Carbohydrate									
Cal powder	2.28					Glucose		5.6	Concentrated carbohydrate source
Hy-Cal	2.3	5.2	86.9	7.8		Glucose		5.9	Concentrated carbohydrate source Low electrolyte
Controlyte (powder)	5.0/g	Traces	72	24	Amino acids	Hydrolyzed corn-starch	Vegetable oil	.43/100 g	Concentrated carbohydrate source Low electrolyte
Polycose (powder)	4.0/g					Hydrolyzed corn-starch		5.3/100 g	Concentrated carbohydrate source Osmotically less active
Fat									
Lipomul	6.6						Corn oil		Concentrated fat source
MCT oil	7.6						MCT		For malabsorption of long-chain fats
Protein									
EMF cherry green apple orange citrus	2.0				Hydrolyzed collagen w. limiting AA				Oral concentrated protein source May be used for protein supplement or protein-sparing modified fast
Pasteurized egg protein (powder)	3.5/g	92.9	6.6	.49	Powdered egg white			48	Oral concentrated protein source May be used for protein supplement or protein-sparing modified fast

vides a comprehensive review of these relatively new products (54). Generally known as elemental diets, these products originated from a NASA requirement for a low-residue, concentrated food compatible with the conditions on early spacecraft. This first generation of products was adapted for use in the medical field without due consideration of the differences in nutritional status, physical requirements, and activity between astronauts and hospitalized patients. Significant long-term comprehensive evaluation on the effect, utilization, efficacy, safety, and metabolism in a variety of patients utilizing these products is not available. A more-detailed discussion as to protein sources, fat content, carbohydrate content, osmolality, effect on gut flora, indications and methods of utilization are beyond the scope of this chapter and the reader is referred to the previously mentioned proceedings (54) and the bibliography of this chapter.

However, one important criticism is the fixed compounding of the products which makes it necessary to stock many products. For this reason we developed a concept of "modular" feeding (see Fig. 6–2). Maintaining one or two basic diets that would provide maintenance nutrition (30–35 Cal/kg/day with a nitrogen–calorie ratio of 1:300) and an anabolic nutrition product (40–45 Cal/kg/day with a nitrogen–calorie ratio of 1:150) appear adequate for most purposes. These products can be supplemented with a variety of single nutrient supplements as to protein, fat, and carbohydrate (Table 6–4). Indications for the modified and the standard DFD would come from the assessment of protein utilization, which has been previously described (9) (e.g., nitrogen balance using urinary urea nitrogen excretion).

Since these products are relatively expensive compared to the normal hospital food budget, it is important that they be provided in a way that results in optimal therapy. Equally important, however, is the cost in relation to total daily hospital cost. Considered in this way the cost is often small, particularly when compared to the benefit resulting from effective nutritional support. However, it is important that a qualified dietitian monitor the utilization of these products to insure that they are acceptable to the patient, are taken in sufficient but not excessive quantity, and are integrated into the medical/nursing plan for the care of the patient. Only with further experience in clinical nutrition will proper use of these beneficial products occur based on careful consideration of objective nutritional assessment and evaluation of nutritional

therapy. An appropriate use of these new modular forms is to prepare high density feedings, which contain 2–4 Cal/ml rather than the more usual 1 Cal/ml. The resulting small volume is an effective therapy for patients with a need for fluid restriction, such as those with renal or cardiac failure. This reduction in volume is also useful in patients with anorexia who must meet their protein and calorie requirements.

PARENTERAL FEEDING—TOTAL PARENTERAL ALIMENTATION

The recent development of total IV feeding by Dudrick and colleagues at the University of Pennsylvania (23, 76) in large part makes possible clinical nutrition as a full-time hospital medical specialty. The substantial life-saving results of total parenteral nutrition (TPN) require an experienced team to obtain appropriate risk/benefit and cost/benefit results. Table 6–4 lists the available or planned products for IV use. These products are by necessity modular in that the Maillard reaction precludes compounding them prior to use. In addition, recent reports by Freeman and Stegink (29) show significant chelation of zinc and cooper by sugar-amine complexes when protein and carbohydrate are autoclaved together.

When protein hydrolysates are compared to amino acid infusions in the same patient the former is found to be deficient by serum amino acid analysis and nitrogen balance techniques. That is, improved net protein utilization occurs with amino acid infusion (43); therefore, in computing the relative cost of hydrolysate versus crystalline amino acid one must take into consideration the percent of the product retained in evaluating cost/benefit ratios. This observation together with the relative availability of casein, fibrin, and amino acids has resulted in a substantial shift to amino acids as a source of protein for parenteral feeding. Furthermore, the potential for allergic reaction is minimized by amino acid infusion. A final advantage is the number of versatile patterns possible from amino acids, which can be expected to provide better treatment for renal failure (1), hepatic failure (27), and perhaps cancer (21). The cost of individual amino acids is variable, and by allowing utilization of cellular pathways for transamination and synthesis of nonessential amino acids, new patterns can be designed which will improve clinical results and reduce the cost of the first generation of products currently available. It is possible that single amino acids or various groups of amino

TABLE 6–5. Concentration* of Protein Hydrolysates, Amino Acids, and Various Salts of Commercially Available Products

Components	Aminosyn M 3.5% (Abbott)	Aminosyn 5% (Abbott)	Aminosyn 7% (Abbott)	FreAmine II 8.5% (McGaw)	Travasol 5.5% with electrolytes (Travenol)	Travasol 8.5% with electrolytes (Travenol)	Travasol 8.5% (Travenol)	Aminosol 5% (Abbott)	Protein Hydrolysate 5% Casein Hydrolysate 5g (Cutter)	Veinamine 8% (Cutter)	Hyprotigen 10% Casein Hydrolysate 10g (McGaw)
Essential Amino Acids (mg)											
L-isoleucine	252	360	510	590	263	406	406	218	240	490	500
L-leucine	329	470	660	770	340	526	526	636	415	350	820
L-lysine	252 (as Ac)	360 (as Ac)	510 (as Ac)	870 (as Ac)	318 (as HCl)	492 (as HCl)	492 (as HCl)	400	350	670	700
L-methionine	140	200	280	480	318	492	492	100	220	430	320
L-phenylalanine	154	220	310	340	340	526	526	100	230	400	400
L-threonine	182	260	370	340	230	356	356	232	180	160	380
L-tryptophan	56	80	120	130	99	152	152	50	50	80	80
L-valine	280	400	560	560	252	390	390	163	300	250	600
dL-methionine				450							130
dL-tryptophan											32
Nonessential Amino Acids (mg)											
L-alanine	448	640	900	600	1140	1760	1760			†	
L-arginine	343	490	690	310	570	880	880	290		750	
L-histidine	105	150	210	240	241	372	372	116		240	
L-proline	300	430	610	950	230	356	356			110	
L-serine	147	210	300	500							
Aminoacetic acid (glycine)	448	640	900	1700	1140	1760	1760	208		3390	
L-cysteine HCl				20				30		†	
L-tyrosine	31	44	44		22	34	34	110		†	
L-glutamic acid								30		430	
L-aspartic acid								30		400	
Electrolytes (mEq)											
Sodium	4.0			1.0	7.0	7.0	0.3	1.0	3.9	4.0	5.0
Chloride	4.0				7.0	7.0	3.4			5.0	3.6
Potassium	1.84	0.54	0.54		6.0	6.0		1.0	1.8	3.0	3.6
Magnesium	0.3				1.0	1.0				6.0	0.4
Acetate	2.7				10.0	13.0	5.2			5.0	†
Phosphate				2.0	6.0	6.0				†	5.0
Calcium					6.0	6.0					1.0

*Per 100 ml
†Reduced by process

acids and their ketoanalogues can also improve parenteral feeding by a pharmacologic effect (57). Despite the small contribution that branched-chain amino acids make to the caloric expenditure of muscle, this fraction appears to be important in control of muscle protein synthesis and the flux of amino acids to the liver to supply substrate for liver protein synthesis. Inappropriate amino acid mobilization in degree and composition occurs if there is impaired availability of nonprotein calories for muscle metabolism. With the consumption of branched-chain amino acids to meet muscle energy needs, the efflux of amino acids from catabolized protein is relatively devoid of branched-chain amino acids, and this imbalance upsets the amino acid profile for secretory protein synthesis by the liver. This is the usual finding during acute phase of stress and systemic infection and sepsis, where a combination of carbohydrate intolerance, impaired free fatty acid oxidation, and absence of ketones secondary to hyperinsulinism account for this phenomenon (13, 15). Continued research into replacement therapy with branched-chain amino acids or their ketoanalogues should improve nutritional therapy during major injury and sepsis.

Although good results may be obtained using commercially available "hyperalimentation kits," many ill patients can benefit from individualization of infusate composition. These products are already provided in separate modules, *i.e.*, protein, calories (glucose and fat), minerals, electrolytes, vitamins, and minerals, which may be tailored to the patient's requirements (Table 6–5). Customizing the formulation, infusion rates, and time feeding can result in better protein utilization (net protein utilization) with less alteration in blood chemistry and improved organ function. Proper concentrations and dilutions of formula should also allow fluid and electrolyte management in the presence of renal failure, cardiac failure, or fluid-losing conditions, such as gastric, fistula, or diarrhea drainage, without the need for supplementation by peripheral infusion. By the proper mix with other feeding techniques (oral fed or nonfed schedules) as well as the use of IV fat, optimal nutritional support can be obtained.

Some new developments and concepts in parenteral nutrition should be considered in more detail because they portray the increasing sophistication of this field. The consequence of over-feeding standard hyperalimentation is shown in Figure 6–3. The calculated specific dynamic action is twice that usually considered for fat metabolism (7). If excess calories are not provided, the energy cost incurred in the specific dynamic action of glucose conversion to fat will result in negative nitrogen balance. Increased caloric intakes that allow even or positive nitrogen balance are in themselves partially responsible for the hypercatabolism associated with TPN (7, 56).

An in-depth discussion of the science of hyperalimentation is beyond the scope of this chapter (see Chs. 11, 12; Refs. 42, 53, 75). Briefly, efforts should be made to maintain normal limits of serum electrolytes, blood urea nitrogen, glucose, near-normal liver function tests, avoidance of fatty liver, hepatomegaly, and impaired secretory protein synthesis (44, 53). Monitoring and provision of cofactors, such as phosphate (59), magnesium (61), iron (61), copper (68), zinc (29), and linoleic acid (73), are also essential.

Cyclic hyperalimentation provides for a daily "dextrose-free" period of 12–14 hours during which the standard infusion is discontinued. This can free the patient from "life lines" and so allow better exercise schedules, which prevent the adverse effect of immobilization while providing considerable psychological support of the long-term hospitalized patient. Cyclic techniques are also used for home hyperalimentation (17) to mimic more closely the normal feeding pattern. The essential fatty acid (EFA) deficiency produced by standard hyperalimentation (73) is also treated by this technique. Most hyperali-

Fig. 6–3. Glucose conversion to fat. Specific dynamic action (SDA) for dextrose given in excess of basal metabolic requirements is 70/370 × 100, approximately 20%. This is higher than normally considered.

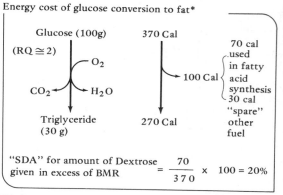

Energy cost of glucose conversion to fat*

"SDA" for amount of Dextrose given in excess of BMR $= \dfrac{70}{370} \times 100 = 20\%$

*Estimates based on *in vitro* carbon flow of glucose conversion to triglycerides

mentation patients have ample stores of linoleic acid (12%) in their body fat, and feedings designed for mobilization of this body fat can be incorporated into a daily plan (Fig. 6–4). A discontinuation of glucose infusions with or without substitution by isotonic amino acid solutions (30–60 g/12 hour) allows insulin levels to decline to a level that permits lipolysis. The composition of the released free fatty acids reflects previous dietary intake stored in adipose tissue (73). In those patients in whom EFA stores are truly deficient, IV fat (Intralipid) can be used.

From this discussion it can be seen that proper delivery of parenteral nutrition requires an experienced team with knowledge of nutritional metabolism. Clearly this therapy represents a major medical advance that ranks with antibiotics, heart–lung bypass machines, and renal dialysis in its influence on the survival of many patients. However, failure to recognize that the proper use of this therapy is a sophisticated science precludes satisfactory results in many patients. The practitioner responsible for this therapy must have proper training and must check his patients daily in order to avoid unnecessary complications and provide each patient with optimal care.

NONFED PARENTERAL

The starved state has been relatively ignored as a place for significant effort at nutritional support. Although the nutrient losses over the short term (67) and adverse findings of nutritional depletion (5, 41) are well documented, most practitioners have been counseled that it is not worthwhile to provide nutritional support during short periods of starvation (47). In part, this is justified in the well-nourished individual with losses occurring over a short period when the hormonal response is strongly catabolic and precludes significant utilization of exogenous nutrients, either as protein or calories (32, 35, 52, 56). However, many ill patients do not have a good nutritional state. Further, poor utilization of exogenous nutrients does not last as long as the classic catabolic phase of injury. Although net protein catabolism occurs from several days to weeks after injury, the ability to reverse this condition improves daily and justifies early efforts. Failure to minimize continuing losses from body cell mass, particularly in nutritionally depleted patients, affects the quality of recovery as well as morbidity and mortality (64).

The realization that substantial protein sparing could occur in the starved state came when

Fig. 6–4. Cyclic hyperalimentation. Preceded by a reduction in the infusion rate to 75–80cc/hr for one hour the infusion of hypertonic glucose and amino acids is discontinued for 8–10 hours of each day. Dextrose-free solutions, saline or isotonic 3% amino acids *(AA)* or oral protein 20–30 g bid or tid are administered in this period.

Owen and colleagues at the Joslin Research Laboratories demonstrated that ketones were a major fuel for brain energy requirements and therefore for total energy requirement (51). This observation accounted for the reduced requirement for glucose, decreased rates of gluconeogenesis, and amino acid oxidation seen late in fasting. Felig from the same group advanced the understanding of peripheral muscle metabolism, particularly the shuttle of gluconeogenic precursors (alanine and glutamine) to the liver for the production of glucose (26).

Blackburn and Flatt developed the metabolic fuel cycle that provided a first-order approximation of the interrelationship of protein, fat, and carbohydrate and provided a basis for meeting the protein–calorie requirements during the starved state (14) (28). In this state, substantial protein sparing could occur by the infusion of amino acid alone to maintain protein synthesis, particularly in the viscera, while allowing the continued mobilization of the body fat stores (13). The importance of ketone metabolism in this regard has been confirmed in recent studies by Felig (60).

This new concept runs counter to the inferred interpretation of Gamble's classic studies (31) on the life-raft ration. He noted decreased nitrogen losses in human volunteers without stress

fed 100 g glucose, and these findings were associated with elimination of ketosis and ketonuria. Others (49) have proposed that this technique represents the most effective protein-sparing therapy during the nonfed starved state. However, an increasing body of evidence indicates that during illness, surgery, or major trauma, glucose is not more protein sparing than total starvation in a control patient with stress or injury, or both (13, 52). The sympathetic-mediated response to injury increases the mobilization of peripheral stores of fat and improves utilization of the mobilized amino acids to maintain lean body mass better than starvation alone (33, 74). By raising insulin levels the administration of glucose preferentially shunts amino acids into the periphery and may be harmful for the important function of supporting visceral protein synthesis (5, 74).

The efficacy of carbohydrate in small amounts (either orally or intravenously) must now be subject to question (25). A growing body of evidence is being developed that the use of 1.0–1.5 g protein/kg ideal body weight/day with appropriate cofactors of vitamins, minerals, fluids, and electrolytes is the optimal modification of the starved state (12, 30, 39). This nutritional support is more compatible with the response to injury in preserving homeostasis and electrolyte balance. A characteristic series of changes in fluid and electrolyte status occur in the acute phase after injury. Insulin secretion is known to decrease after injury and lipolysis to increase in response to increased catecholamine levels. Secretion of ACTH produces a glucocorticoid response and is associated with insulin resistance, glucose intolerance, and proteolysis. The free water production by tissue catabolism of muscle and fat and the secretion of ADH produce increased free water retention. In addition, a natriuresis secondary to an obligate cation coverage of the metabolically generated anions for excretion occurs (62). Further, elevated plasma levels of glucagon and low plasma levels of insulin, characteristic of this natural state of injury, antagonize the action of aldosterone (63). Thus, given poor utilization of exogenous substrate, initial resuscitation fluid should contain slightly hypertonic balanced electrolyte solutions for optimal preservation of the metabolic response to injury (52). Once the acute phase of injury has passed, the judicious incorporation of isotonic amino acid solutions can be expected to best support the patient. Guidelines for this therapy are provided in Table 6–6. Further research

may demonstrate that even more vigorous use of oral and parenteral diets using formulas high in branched-chain amino acids and low in aromatic amino acids will benefit the acutely injured and septic patient unable to adapt to starvation by increased use of free fatty acids and ketone bodies.

ORAL PROTEIN SPARING

The provision of protein orally when gastrointestinal function permits contrasts with the current practice of providing clear liquids in the form of fruit juice and gelatin. Not only is nitrogen balance improved but oral protein may be selectively utilized by the GI tract, liver, and other key viscera as reflected by improvement in serum albumin and transferrin levels and by immunocompetence (5, 15, 74). Currently available liquid protein sources, *e.g.,* tryptophan-fortified collagen and soy protein isolate, allow early protein intake as clear liquid diets. Fifteen grams protein can be consumed in volumes as low as 30 cc. If delayed gastric emptying is a problem, more-dilute solutions can be utilized in which the protein intake is below 0.2 molar. It is important to remember the primacy of oral protein intake for reversing negative nitrogen balance and stimulating visceral protein synthesis whether in semistarvation or adequate nutrition. The ability of these therapies to retard or prevent the kwashiorkorlike state of visceral protein attrition makes it a highly important therapy, both for the pure nonfed state and its combination with parenteral nutritional therapies (cyclic hyperalimentation).

DEVELOPMENT OF A NUTRITION PLAN

A broad group of protein and nonprotein calorie sources exists (see Tables 6–1, 6–2, and 6–3). These products allow the nutritionist a versatile armamentarium to meet the many variations that various organ system failures and disease states present. Despite the potential complexity arising in patient care, nutrition support can easily be reduced to an effective plan by consideration of the following criteria:

A. Nutritional assessment (9)
 1. *i.e.,* Degree of depletion of lean body mass
 2. Viscera
 3. Fat

TABLE 6—6. Sample Order Sheet and Guidelines for Protein Sparing Therapy*

DOCTOR'S ORDER SHEET
New England Deaconess Hospital

IMPORTANT:
Please use a ballpoint pen
Press hard
You are making a copy

Date Ordered	O R D E R S	Time Transcribed
	ORDERS FOR PROTEIN SPARING THERAPY	
	It is recommended that patients receive only 1—2 liters of AA_3W during the first 2 days of therapy. The first liter of AA_3W should be followed by a liter of N.S. or 1/2 N.S. and then by as much of the second liter of AA_3W as can be tolerated. If there is no significant elevation in BUN (increase in BUN of greater than 10 mg%/day), if blood sugar falls below 100 mg%, and if ketones appear in the urine, then the rate of infusion of AA_3W should be increased slowly to a maximum of 3 liters/day	
	NO DEXTROSE should be administered at any time.	
	Medications should be administered in N.S. or 1/2 N.S.	
	Peripheral Line:	
	A. _____ ml 3% Amino Acids in water or _____% Amino Acids in water	
	B._____ ml of N.S. or 1/2 N.S. (please circle one)	
	Additives usually required, please specify	
	_____ mEq/day $KHPO_4$ (25 mEq/day)	
	_____ mEq/day NaCl (75—150 mEq/day)	
	_____ mEq/day Calcium Gluceptate (9 mEq/day)	
	_____ mEq/day $MgSO_4$ (8.1 mEq/day)	
	Additives that might be required, please specify	
	_____ mEq/day Na Acetate	
	_____ ml/day Multivit (5 ml/day)	
	_____ g/day Albumin (0—25 g/day)	
	_____ mg/day Folic Acid (0.5—1.5 mg/wk)	
	_____ μg/day vitamin B_{12} (10—100 μg/wk)	
	Other Additives	

	Additives should be administered in N.S. at the start of therapy, and as	
	therapy progresses, they will be administered in AA_3W.	

TO OBTAIN DUPLICATE OF ORDERS, NCR PAPER MUST BE VISIBLE AT CORNER

*Abbreviations: amp = ampoule μg = microgram
mEq = milliequivalents AA_3W = 3% amino acids in water
U = units N.S. = normal saline

B. Degree of hypercatabolism (56)
 1. Disease categories and measured or estimated metabolic rates
 2. Inspection of the patient, presence of tachycardia
 3. Rate of weight loss and nitrogen excretion (*e.g.,* urea nitrogen)
C. GI function
 1. Dietary history of intake: complete, partial, none
 2. Presence of a high fistula, low fistula
 3. Use of a nasogastric, transpharyngeal, gastric, enteric or transfistula feeding tube
D. Appetite
 1. Solid or liquid food preference
 2. Taste preference: bland, fruits, sweet food groups
E. Category nutritional support
 1. Fed
 2. Nonfed
 3. Combination
 4. Enteral vs. parenteral

Consideration of these questions plus calculation of the protein–calorie requirements based on age, sex, height, and weight allows development of a comprehensive nutritional support plan. Sample guidelines in Table 6–7.

SPECIAL DISEASE CONSIDERATIONS

RENAL FAILURE

The introduction of a low-protein diet containing protein of high biologic value and adequate-to-excess calories by Giordano and Giavonetti (34) in 1963 revolutionized the treatment of renal failure. The diet was based on the pioneering work of Rose *et al.* (55) which had established in the 1950s the human requirements for essential amino acids and nonessential nitrogen. Not only does the Giavonetti diet provide adequate essential amino acids, but experience has also shown that endogenous urea nitrogen can be recycled for protein anabolism (69). The benefit of this diet in the treatment of chronic renal failure has been demonstrated by improvement in the hypoplastic anemia, lower BUN levels, achievement of nitrogen balance, and disappearance or improvement of uremic symptoms, *e.g.,* anorexia, vomiting, muscle twitching, and mental changes. The effectiveness of this diet depends on 1) a low nitrogen–calorie ratio, 2) the number of calories delivered expressed in terms of the BEE, and 3) provision of adequate essential amino acids (15). Originally developed as an oral diet for chronic renal failure, it has been adapted to IV use for acute renal impairment, such as frequently occurs due to tubular necrosis in severely traumatized patients or after major surgery when the systemic catabolic response to injury is prominent. Since such patients are often unable to use their GI tracts for ingestion of nutrients, IV feeding can offer substantial support during recovery from various disease states and associated renal failure.

It is important to emphasize that this therapy is supportive and not a replacement for hemodialysis or peritoneal dialysis. Abel *et al.* (1) recently concluded extensive trials using essential amino acids in hypertonic glucose which confirmed the beneficial effects of renal failure hyperalimentation as a support therapy. In addition to optimizing wound healing, minimizing the catabolism of tissue proteins, and reducing the frequency of dialysis, metabolic benefits include normalization of serum protein, phosphate, and magnesium levels.

There are, however, several unanswered questions in the renal failure patients. Clinically, the use of solutions with both essential and nonessential amino acids in crossover studies with the patient receiving essential amino acids alone has not shown a substantial difference in the results (15). Several investigators have demonstrated the semiessential nature of histidine (4), and indeed improved utilization of protein has occurred with the provision of arginine and other nonessential amino acids. It would appear that provision of the optimal number of calories needed to meet the metabolic expenditure and sufficient protein for optimal protein synthesis and turnover are more important than the amino acid profile. Data would suggest that some 20–30 g protein/day results in the best protein utilization. An optimal nitrogen–calorie ratio ranges from 1:450 to 1:700. Defined formula diets containing essential amino acids and their ketoanalogues are also a promising variant in the nutritional support of the patient with chronic renal failure (57). The support of the patient on dialysis may further benefit in terms of time and interval of dialysis while preserving the lean body mass.

HEPATIC FAILURE

The failing liver is characterized by the decreased ability to metabolize various amino acids. The unique metabolism of the branched chain amino acids (50, 60) and aromatic amino acids (48) suggests that they represent the most

critically regulated amino acids in circulation. For example, tryptophan detoxification is primarily dependent on liver function. Therefore, it is not surprising that the level of tryptophan is elevated together with the other aromatic amino acids during liver failure. Branched-chain amino acids, on the other hand, are not significantly metabolized by the liver and become depleted during limited protein intakes. These observations form the basis for development of a liver failure diet formula that can be expected to be beneficial in future generations of products (27).

The nonprotein calories of liver failure are also important and have given rise to alcohol-free products that utilize medium-chain triglycerides and a judicious distribution of sugars, starches, and dextrins.

Again, the provision of calories sufficient to meet energy requirement without causing the extra work of lipogenesis, gluconeogenesis, and ureagenesis will minimize nutrient imbalances resulting from liver failure.

CANCER PATIENTS

Cancer is frequently associated with anorexia and semistarvation. Factors other than anorexia responsible for the weight loss in cancer include disease-related dysfunction of the GI tract, malabsorption, organ failure, and infection. Cancer therapy by surgery, chemotherapy, radiotherapy, and immunotherapy also contributes to cancer cachexia. Finally, alterations in intermediary metabolism produced by cancer can affect the utilization of food stuffs and the maintenance of the nutritional status of the patient.

These metabolic aspects of cancer and nutrition have been extensively reviewed (66). The maintenance of a favorable nitrogen economy is dependent on the organism's ability to regulate both the synthetic and catabolic processes of a diverse variety of protein and still maintain a relative constant whole body protein. Although the mechanisms are not precisely understood, it is felt that wasting in cancer is due to the use of both host and dietary proteins by the tumor. The relatively more-active metabolism of tumor tissues allows it to act as a nitrogen and energy trap, resulting in preferential growth at the expense of the host. Since the amino acids taken up by tumor anabolism are subsequently not recycled for use by the host, protein-deficient patients have inadequate supplies of amino acids for host protein synthesis.

Patients with the greatest weight loss also have the highest rates of Cori cycle activity, and this may imply a mechanism of cancer cachexia. However, the energy expenditure for this measured Cori cycle activity amounts to a small fraction of the total energy expenditure per day. Thus, although the mechanism of the nutritional depletion of cancer has remained unexplained, recent work demonstrates that weight loss does not necessarily have to result from tumor growth. Caloric requirements and energy expenditure of both neoplastic tissue and host can be met if dietary protein is not oxidized for energy and thus made unavailable for protein synthesis. These small increases in energy expenditures over resting metabolism and in protein needs over basal requirements appear similar to those of patients undergoing elective surgery. Forced protein–calorie feedings, both oral (65) and parenteral (20) can replete most nutritionally debilitated cancer patients. In those patients in whom weight gain cannot be obtained, response to cancer therapy is poor. Similarly if nutritional support does not result in improvement in immunocompetence, a poor prognosis exists (21).

The anorexia observed in many cancer patients is not conceptually different from the condition of anorexia nervosa (see Ch. 30). Although the metabolism of weight loss is quantitatively different in the two entities (e.g., increased basal metabolic rate vs. decreased basal metabolic rate), the basic deficiency is inadequate dietary protein and calorie intake secondary to anorexia. It is therefore important to develop techniques for producing behavior that will encourage the patient to maintain his nutritional status. The basic principle underlying behavioral approaches to anorexia involves positively reinforcing food intake while negatively reinforcing episodes of food rejection. The bestowal of various positive reinforcements is made contingent on weight gain, with progressively more-demanding weight gain criteria. Within a hospital ward, positive reinforcement may consist of increased activity, visiting privileges, and social activities. On an outpatient basis, visits from friends, the interest of professional staff, and special treats can also be made contingent on a minimal weekly weight gain. Continued outpatient care consists primarily of behavioral therapies to overcome loss of appetite. Such an approach does not require intensive psychological intervention or the use of psychotherapeutic drugs. The basic principles can be learned and implemented on a medical ward by

physicians, nurses, and dietary staff and at home by family and friends.

There can be little doubt that optimal nutritional support influences the results of new cancer therapies. Forced feeding programs using enteral and parenteral hyperalimentation serve as acute short-term nutritional support in conjunction with specific tumor therapy. Since the cancer patient with significant weight loss has a poor therapeutic response, it is important to minimize and repair protein–calorie deficiency. This enhances destruction of cancer cells and allows optimal function of normal tissue populations, particularly those cells or proteins with high rates of protein turnover, *e.g.,* the GI mucosa and visceral proteins. Proper nutrition may minimize the ability of tumors to parasitize nutrients from the host and may increase tumor cell mitoses, which is a desired effect during radiotherapy and chemotherapy. Conversely, nutrition-induced depression of cell-mediated immunity can be expected to have an adverse effect on certain aspects of cancer therapy, particularly but not exclusively, immunotherapy.

Nutritional therapy is now at a high enough level of development to provide support for the all-out attack on cancer and is one area where the patient has an important role and can actively participate in efforts to survive. Clearly, the multidisciplinary approach provided by a nutritional support service is essential. Although efforts to design diet therapy to satisfy individual taste and consistency using either solid or liquid foods with adequate amounts of nutrients are important, the long-term use of feeding tubes by nasogastric, transpharyngeal, or gastrostomy route together with "home hyperalimentation" parenteral feeding programs must be increasingly utilized in the care of these patients. It must be clearly understood that weight loss is not a necessary component of advanced cancer, and concentrated efforts at its treatment must be pursued simultaneously with specific cancer therapy.

PEDIATRIC PROTEIN AND CALORIE REQUIREMENTS

This discussion provides only general guidelines to pediatric nutritional therapy. Complications with initial therapy or metabolic disorders are extensively discussed in the bibliography (38, 2, 78), and it is essential that those physicians faced with difficult nutrition support problems in children use these primary sources (see Ch. 12).

The caloric requirement for newborn infants represents the highest concentration (Cal/kg) seen in man. The average basal metabolic requirement is assumed to be 55 Cal/kg/day; spontaneous activities require 25 Cal/kg/day, and weight gain of 8 g/kg/day requires 5 Cal/g. Thus the total desired oral intake would be 120 Cal/kg/day. Total parenteral feeding can produce weight gain and survival at levels less than 120 Cal/kg/day. It is yet to be established if any of these areas, *i.e.,* basal metabolism, activity, or weight gain, is compromised by such feedings. Winters has observed that maintenance of thermoneutrality will allow growth in the first few neonatal days with as few as 60 Cal/kg/day (see Ch. 12).

Once the infant's weight reaches 10–20 kg, caloric requirements drop to 50 Cal/kg/day and then to a resting metabolic rate requirement of 25 Cal/kg/day once weight is in excess of 20 kg. These levels are similar to those in adults. Similarly, when disease is associated with hypermetabolism from fever, sepsis, burns, and other major trauma, the desired caloric intake is 35–40 Cal/kg/day.

The protein requirement for growth in infants is usually 3–4 g/kg/day. Parenteral feeding of 2.5 g/kg/day is adequate to produce positive nitrogen balance. This level will decline to 2 g/kg/day in 10–20 kg infants and to the levels used in adults (1–1½ g/kg/day) when infant weight exceeds 20 kg.

PARENTERAL FEEDINGS

Peripheral total parenteral feeding requires the use of 10% Intralipid (40 ml/kg/24 hour) with a mixture of 10% dextrose and 3% FreAmine (85 ml/kg/24 hour), totaling 125 ml/kg/24 hour. This therapy delivers 2.5 g amino acid/kg/day and 80 Cal/kg/day. The peripheral line requires two infusion pumps and a millipore filter with the Intralipid infusion entering below the filter. In experienced hands infusion, via a 21–23 gauge scalp vein needle, may be given for many weeks in adequate amounts without requiring cutdown (2, 78).

Partial (supplemental) oral feedings can usually make up for any energy deficit. Indeed combined parenteral and enteral feeding is desirable in order to make up for any weight loss or temporary GI setbacks during the important early growing phase of the infant.

Central venous hyperalimentation also provides an opportunity to deliver high caloric intake with less fluid intake, but it increases serious

TABLE 6-7. Sample Order Sheet For Intravenous Hyperalimentation*

Date Ordered	O R D E R S	Time Transcribed

DOCTOR'S ORDER SHEET New England Deaconess Hospital **ADDRESSOGRAPH**

ALLERGIES:

IMPORTANT: Please use a ballpoint pen Press hard You are making a copy

Date Ordered	O R D E R S	Time Transcribed
	HYPERALIMENTATION FLUID ORDERS TO BEGIN ON COMPLETION OF	
	PREVIOUS ORDERS	
	From _____ to _____ to _____ _____	
	I. CENTRAL LINE:	
	A. _____ ml hyperalimentation (unless otherwise specified, the solution	
	will be 4.25% FreAmine, 25% Glucose)	
	or _____% FreAmine, _____% Glucose	
	Additive usually required, please specify:	
	_____ mEq/day NaCl (60–80 mEq/day)	
	_____ mEq/day KCl (60–100 mEq/day)	
	_____ mEq/day Calcium Gluceptate (9.0 mEq/day))	
	_____ mEq/day Magnesium sulfate (8.1 mEq/day)	
	_____ mEq/day Potassium phosphate (30–45 mEq/day)	
	_____ mg/day Folic acid (0.5–1.5 mg/wk) Monday only	
	_____ μg/day vitamin B$_{12}$ (50–100 μg/wk) Monday only	
	_____ ml/day Multivit (5 ml/wk) Monday only	
	_____ mEq/day Na Acetate (40 mEq/day)	
	_____ mEq/day K Acetate	
	_____ U/liter Reg. Insulin	
	_____ amp/day vitamin B + C Tuesday through Sunday	
	_____ Heparin (6000 U/day)	
	II. RATE OF INFUSION	
	_____ ml/hour	
	III. LABORATORY TESTS	
	_____ M.D.	

FORM 42 REV. 4/75

TO OBTAIN DUPLICATE OF ORDERS, NCR PAPER MUST BE VISIBLE AT CORNER

*Abbreviations: amp = ampoule
mEq = milliequivalents
U = units
μg = microgram

complications. Carbohydrate at an infusion rate of 20 mg glucose/kg/min can serve as the total source of calories with this technique. Since the rate of disappearance of glucose in the newborn is 3.5% per min, glucose homeostasis is maintained by this therapy.

The central venous technique requires a full-time physician, a nurse, and a pharmacist to direct IV nutritional support with an acceptable complication rate. Complications of central venous total parenteral feeding in children are similar to those in adults. In addition, amino acid intolerance, hyperaminoacidemia and septic complications are more frequently seen. These conditions require an experienced team to obtain a proper risk/benefit ratio from this important therapy.

ORAL FEEDINGS

Consideration of oral diets requires some knowledge of intestinal absorption and transport. Carbohydrate and protein are absorbed in the proximal small intestine after being digested to simple sugars and amino acids. Fat is absorbed throughout the small bowel and is dependent on lipase activity and bile salt for hydrolysis and absorption. Various difficulties with absorption after digestion have given rise to numerous special infant diets (see Ch. 29). Most oral diets contain predigested carbohydrate sources and are pH regulated to facilitate their absorption.

It is important to realize that infants have unique flavor tolerances and that unflavored products such as Vivonex HN and Pregestimil are well tolerated and effective feedings for many infants.

For many diseases predigested protein and carbohydrate are not essential. A lower osmolality can be obtained using medium-chain triglycerides along with proteins, dextrins, and hydrolyzed corn starch or its equivalent.

For many patients who have undergone prolonged bowel rest or significant bowel resection, considerable time is necessary to allow for the adaptation and restoration of intestinal villi. Gastric hypersection and bacterial overgrowth are also important factors to be considered in nutritional support during malabsorption.

SUMMARY

Protein–calorie curative therapy is uniquely influenced by disease, and effective nutritional support in the ill must consider nutritional status (particularly the degree of protein depletion) and the presence of hypercatabolism where the hormonal substrate response is distinctly antagonistic to replacement therapy. Further, enteral feeding regimens are often limited by impaired digestive function related to disease. Although each patient has a unique response, a systematic approach based on objective measures will more often result in effective nutritional therapy. The accomplished therapist will be aided by the modular approach using the wide variety of products and techniques now available. Certainly it is no longer considered good patient care to ignore the management of the semistarved state where it is possible to support, either orally or intravenously, protein synthesis and preserve lean body mass. With proper skill in the techniques of protein–calorie therapy, it can be expected that the morbidity and mortality of most disease states will be favorably influenced. The availability of adequate science and art in nutritional assessment and therapy now provides the basis for an important clinical specialty.

REFERENCES

1. Abel RM, Beck CH, Abbot WM, Ryan JA, Barnett GO, Fischer JE: Improved survival from acute renal failure after treatment with intravenous essential L-amino acids and glucose. New Engl J Med 288:695, 1973

2. Ballinger WF, Collins JA, Drucker WR, Dudrick SJ, Zeppa R: Manual of Surgical Nutrition. Philadelphia, WB Saunders, 1975

3. Beisel WR: Interrelated changes in host metabolism during generalized infectious illness. Am J Clin Nutr 25:1254, 1973

4. Bergstrom J, Bucht P, Furst E, Hultman B, Josephson LO, Noree E, Vinnars E: Intravenous nutrition with amino acid solutions in patients with chronic uraemia. Acta Med Scand 191:359, 1972

5. Bistrian BR, Blackburn GL, Scrimshaw NS, Flatt JP: Cellular immunity in semi-starved states in hospitalized adults. Am J Clin Nutr 28:1147, 1975

6. Bistrian BR, Blackburn GL, Vitale J, Cochran D, Naylor J: Prevalence of protein calorie malnutrition in general medical patients. JAMA 235:1567, 1976

7. Blackburn GL: Adipose tissue as a valuable source of essential fatty acids. Chicago, Proc on Fat Emulsions in Parenteral Nutrition, American Medical Association, 1975

8. Blackburn GL: Glucose, potassium and insulin therapy in critical clinical states. J St. Barnabas Medical Center Symposium on Surgical Advances. Dec 1975, p 43

9. Blackburn GL, Bistrian BR: Nutritional support resources in hospital practice. In Schneider H, Anderson C, Coursin D (eds): Nutritional Support of Medical Practice. Hagerstown, Harper & Row, 1977

10. Blackburn GL, Bistrian BR: Nutritional care of the injured and/or septic patient. Surg Clin North Am 56:5, 1976

11. Blackburn GL, Bistrian BR, Flatt JP, Page JH, Stone MS: Restoration of the visceral component of protein malnutrition during hypocaloric feeding. Clin Res 23:315A, 1975

12. Blackburn GL, Flatt JP: Metabolic response to illness: role of protein-sparing therapy. Comp Ther 1:23, 1975

13. Blackburn GL, Flatt JP, Heddle R, Page JG: The significance of muscle protein and fat mobilization following injury for the design of parenteral fluid, electrolyte and nutritional therapy. Cuthbertson D (ed): Glasgow Injury Symposium, 1975

14. Blackburn GL, Flatt JP, Hensle TE: Peripheral amino acid infusions. In Fischer J (ed): Total Parenteral Nutrition. Boston, Little, Brown, 1975

15. Blackburn GL, Rutten P, Stone M, Flatt JP, Trerice M, Mackenzie T, Hallowell E, Heddle R, Page G: Proc Int Conference on Parenteral Nutrition. Montpelier, France, 1974

16. Blackburn GL, Williams LF, Bistrian BR, Stone MS, Phillips E, Hirsch E, Clowes GHA Jr, Gregg J: New approaches to the management of severe acute pancreatitis. Am J Surg, January, 1976

17. Broviac JW, Cole JJ, Scribner BH: A silicone rubber atrial catheter for prolonged parenteral alimentation. Surg Gynecol Obstet 118:739, 1964

18. Close JH: The use of amino acid precursors in nitrogen accumulation diseases. N Eng J Med 290:663, 1974

19. Clowes GHA Jr, O'Donnell TF, Ryan NT, Blackburn GL: Energy metabolism in sepsis: treatment based on different patterns in shock and high output state. Ann Surg 175:584, 1974

20. Copeland EM, MacFadyen BV, Lanzotti VJ, Dudrick SJ: Intravenous hyperalimentation as an adjunct to cancer chemotherapy. Am J Surg 129:167, 1975

21. Copeland EM, MacFadyen BV, Rapp MA, Dudrick SJ: Hyperalimentation and immune competence in cancer. Surg Forum 26:138, 1975

22. Cuthbertson DP: Post-shock metabolic response. Lancet 25:235, 1942

23. Dudrick SJ, MacFadyen BV, VanBuren CT: Parenteral hyperalimentation: metabolic problems and solutions. Ann Surg 176:259, 1972

24. Duke JH, Jorgensen SB, Broel JR, Long CL, Kinney JM: Contribution of protein to caloric expenditure following injury. Surgery 68:168, 1970

25. Elwyn DH, Bryan–Brown CW, Shoemaker WC: Nutritional aspects of body water dislocations in postoperative and depleted patients. Ann Surg 182:76, 1975

26. Felig P, Wahren J: Protein turnover and amino acid metabolism in the regulation of gluconeogenesis. Fed Proc 33:1092, 1974

27. Fischer JE, Funovics JM, Aguirre A, James JH, Keane JM, Wesdorp RIC, Yoshimura N, Westman T: The role of plasma amino acids in hepatic encephalopathy. Surgery 78:276, 1975

28. Flatt JP, Blackburn GL: The metabolic fuel regulatory system. Implications for protein sparing therapies during caloric deprivation and disease. Am J Clin Nutr 27:175, 1974

29. Freeman JB, Stegink LD, Meyer PD, Fry LK, DenBesten L: Excessive urinary zinc losses during parenteral alimentation. J Surg Res 18:463, 1975

30. Freeman JB, Stegink LD, Meyer PD, Thompson RG, DenBesten L: Metabolic effects of amino acids vs. dextrose infusion in surgical patients. Arch Surg 110:916, 1975

31. Gamble JL: Physiological information gained from studies on the life raft ration. Harvey Lect 42:247, 1946

32. Giddings AE: The control of plasma glucose in the surgical patient. Br J Surg 6:787, 1974

33. Gilder H, Valcre M, DeLeon V, Sternberg D: Comparative effect of experimental injury and hydrocortisone injection on liver and plasma composition of rats. Metabolism 19:582, 1970

34. Giordano C: Use of exogenous and endogenous urea for protein synthesis in normal and uremic subjects. J Lab Clin Med 62:231, 1963

35. Gump FE, Long CL, Geiger JW, Kinney JW: The significance of altered gluconeogenesis in surgical catabolism. J Trauma 15: 704, 1975

36. Hallowell E, Sasvary D, Bistrian BR, Soroff H, Blackburn GL: Factors determining optimal use of defined (elemental) formula diets. Clinical Research XXIV: 500A, 1976

37. Harper AE, Benevenga NJ, Wohlhueter RM: Effects of ingestion of disproportionate amounts of amino acids. Physiol Rev 50:428, 1970

38. Heird WC, Winters RW: Total parenteral nutrition. J Pediatr 86:2, 1975

39. Hoover HC, Grant JP, Gorschboth C, Ketcham AS: Nitrogen-sparing intravenous fluids in postoperative patients. N Engl J Med 293:172, 1975

40. Kinney JA: Energy requirement of the surgical patient. In Manual of Surgical Nutrition. Philadelphia, WB Saunders, 1975, p 223

41. Law DK, Dudrick SJ, Abdou NI: Immunocompetence of patients with protein calorie malnutrition. Ann Intern Med 79:543, 1973

42. Lee HA: Parenteral Nutrition in Acute Metabolic Illness. New York, Academic Press, 1974

43. Long CL, Zikria BA, Inney JM, Geiger JW: Comparison of hydrolysates and crystalline amino acid solutions in parenteral therapy. Am J Clin Nutr 27:163, 1974

44. Maini B, Blackburn GL, Bistrian BR, Flatt JP, Page JG, Bothe A, Benotti P, Rienhoff HY: Cyclic hyperalimentation: an optimal technique for preservation of visceral protein. J Surg Res 20:515, 1976

45. McLaren DS: Xerophthalmia: a neglected problem. Nutr Rev 22:289, 1964

46. Moore FD: Metabolic Care of the Surgical Patient. Philadelphia, WB Saunders, 1959

47. Moore FD, Brennan MF: Current concepts: intravenous feeding. N Engl J Med 287:862, 1972

48. Munro HN, Fernstrom JD, Wurtman RJ: Insulin, plasma amino acid imbalance and hepatic coma. Lancet 1:722, 1975

49. O'Connell RC, Morgan AP, Aoki TT, Ball MR, Moore FD: Nitrogen conservation in starvation: graded responses to intravenous glucose. J Clin Endocrinol Metab 29:555, 1975

50. Odessey R, Khaitallah EA, Goldberg AL: Origin and possible significance of alanine production by skeletal muscle. J Biol Chem 249:7623, 1974

51. Owen OE, Morgan AP, Kemp HG, Sullivan JM, Herrera MG, Cahill GF: Brain metabolism during fasting. J Clin Invest 46:1589, 1967

52. Page G, Blackburn GL, Heddle R, Cochran D, Stone M: Crystalloid therapy in resuscitation during routine surgery and severe trauma. Surg Forum XXVI: 18, 1975

53. Parsa MH, Ferrer JM: Safe Central Venous Nutrition. Springfield, Ill, CC Thomas, 1975

54. Proceedings of AMA Conference on Defined Formula Diets, Washington, DC. Acton, MA, Publishing Sciences Group, 1975

55. Rose WC, Wixom RL: The amino acid requirements of man. XVI. The role of the nitrogen intake. J Biol Chem 217:997, 1955

56. Rutten P, Blackburn GL, Flatt JP, Hallowell E, Cochran D: Determination of optimal hyperalimentation infusion rate. J Surg Res 18:477, 1975

57. Sapir DG, Owen OE, Pozefsky T, Walser MJ: Nitrogen sparing induced by a mixture of essential amino acids given chiefly as their keto-analogues during prolonged starvation in obese subjects. J Clin Invest 54:974, 1974

58. Senior JR (ed): Medium Chain Triglycerides. Philadelphia, University of Pennsylvania Press, 1968

59. Sheldon GF, Grzyb S: Phosphate depletion and repletion: relation to parenteral nutrition and oxygen transport. Ann Surg 182:683, 1975

60. Sherwin RS, Hendler RG, Felig P: Effect of ketone infusions and amino acid and nitrogen metabolism in man. J Clin Invest 55: 1382, 1975

61. Shils ME: Guidelines for total parenteral nutrition. JAMA 220:14, 1972

62. Sigler M: The mechanism of the natriuresis of fasting. J Clin Invest 55:377, 1975

63. Sparks RF, Arky RA, Boulter PR, Saudek CD, O'Brian JT: Renin, aldosterone, and glucagon in the natriuresis of fasting. N Engl J Med 292:1335, 1975

64. Studley HO: Percent of weight loss: a basic indicator of surgical risk. JAMA 106: 458, 1936

65. Terepka AR, Waterhouse C: Metabolic observations during the forced feeding of patients with cancer. Am J Med 20:225, 1956

66. Theologides A: Pathogenesis of cachexia in cancer. Cancer 29:484, 1972

67. Trinkle JK, Fischer LJ, Ketcham AS, Berlin NI: The metabolic effects of preoperative intestinal preparation. Surg Gynecol Obstet 118:739, 1964

68. Vitter RW, Bozian RC, Hess EV, Zellner DC, Petering HG: Manifestations of copper deficiency in a patient with systemic sclerosis on intravenous hyperalimentation. N Engl J Med 291:188, 1974

69. Walser M: Urea metabolism in chronic renal failure. J Clin Invest 53:1385, 1974

70. Waterlow JC, Stephen JM: The measurement of total lysine turnover in the rat by intravenous infusion of L (U14C) lysine. Clin Sci 33:389, 1967

71. Weinberg ED: Nutritional immunity. JAMA 231:39, 1975

72. Weller LA, Calloway DH, Margen S: Nitrogen balance of men fed amino acid mixtures based on Roses's requirements, egg white protein, and serum free amino acid patterns. J Nutr 101:1499, 1971

73. Wene JD, Connor WE, DenBesten L: The development of essential fatty acid deficiency in healthy men fed fat-free diets intravenously and orally. J Clin Invest 56:127, 1975

74. Whipple GH, Hooper CW, Robscheit FS: Blood regeneration following simple anemia II fasting compared with sugar feeding. Am J Physiol 53:167, 1920

75. White PL, Nagy ME (eds): Total Parenteral Nutrition. Acton, MA, Publishing Sciences Group, 1974

76. Wilmore DW, Dudrick SJ: Safe long-term venous catheterization. Arch Surg 98:256, 1969

77. Wilmore DW, Long JM, Mason AD, Skreen RW, Pruitt BA: Catecholamines: mediator of the hypermetabolic responses to thermal injury. Ann Surg 180:653, 1974

78. Winters RW, Hasselmey EG: Intravenous Nutrition in the High Risk Infant. New York, John Wiley & Sons, 1975

79. Young VR, Steffee W, Pencharz P, Winterer JC, Scrimshaw NS: Protein turnover in the whole body. Nature (Lond) 253:157, 1975

7 Curative nutrition: vitamins

*Grace A. Goldsmith**

Vitamin deficiency diseases due primarily to an inadequate dietary supply of specific nutrients are relatively rare in the United States and other developed countries of the world although they remain common in many developing nations. However, these deficiences are encountered secondary to numerous pathologic conditions both in this country and elsewhere. Each of the vitamin deficiency diseases will be discussed separately, including prevalence, clinical and laboratory findings, diagnostic features, and treatment.

VITAMIN A

DEFICIENCY—XEROPHTHALMIA

PREVALENCE

Vitamin A (retinol) deficiency is extremely rare in North America and Western Europe, but it constitutes an important cause of preventable blindness in Southeast Asia, certain parts of Africa, and Central and South America. It is frequently associated with protein–calorie malnutrition. Severe deficiency occurs most frequently in infants and young children and is more common in males than in females. In this country, deficiency of vitamin A and its precursor, carotene, is observed as a result of a number of conditions in which fat absorption is defective. These include diets very low in fat, the steatorrheas (*e.g.,* sprue), fibrocystic disease of the pancreas and other pancreatic diseases, intestinal lipodystrophy (Whipple's disease), gluten-induced enteropathy, and intestinal defects following operative procedures. Since bile is necessary for the absorption of carotene and vitamin A, deficiency may occur when bile is absent or

when amounts in the intestinal tract are insufficient, such as in obstructive jaundice and biliary fistula. In cirrhosis of the liver, storage of vitamin A may be impaired with resultant deficiency. Infectious diseases associated with massive urinary excretion of vitamin A include tuberculosis, pneumonia, chronic nephritis, urinary tract infections, and prostatic diseases. Increased excretion also occurs in cancer. In children with vitamin A deficiency, there is a high incidence of respiratory infections, gastroenteritis, measles, and other infectious diseases. This is particularly true in areas where marasmus or kwashiorkor are endemic. Whether this susceptibility is due to vitamin A deficiency or whether the infection led to lowered vitamin A reserves is unknown. Vitamin A deficiency has been reported in diabetes mellitus and in myxedema, presumably due to failure of conversion of carotene to vitamin A.

CLINICAL FINDINGS

The earliest symptom of vitamin A deficiency is night blindness due to an inadequate supply of vitamin A aldehyde to the retina for the formation of rhodopsin. This lesion is fully reversible with prompt treatment but may be followed rapidly by structural changes in the retina. Night blindness may be difficult to detect in infants and young children. They may be seen to stumble at dusk or be unable to feed themselves when the light is failing.

A second early finding is xerosis (dryness) of the conjuntiva. The bulbar portion exposed in the eye slit is particularly affected. Oomen (4) describes the appearance as fatty dryness, most pronounced at the thickened, wrinkled corners of the eye. Slit lamp examination shows that the transparent structure has become opaque due to fine milky droplets. The white of the eye looks muddy and greasy, like oil paint. The pores of the meibomian glands enlarge and resemble a

*Grace Goldsmith's manuscript was received by the editors on February 27, 1975. It had been completed by her while hospitalized with what was to prove to be a fatal illness. She died April 28, 1975. She was a gallant lady. This chapter is part of her legacy to the science she loved so well.

101

string of beads along the margin of the eyelids. The skin is thin and dry around the eyes, and fine points of folliculosis may be present. The skin between the eyelashes is often scaly.

Xerosis may progress rapidly to xerophthalmia and keratomalacia. As the disease advances, the cornea is involved, appearing hazy, rough, and dry and becoming insensitive to touch. Small erosions or punctate superficial infiltrations may be seen on the surface, frequently in the lower nasal quadrant. These develop rapidly into small, dark, berrylike protrusions to which a tiny slip of iris is attached. Following this, perforation occurs, and the iris may collapse or the lens may be expelled. The condition is not painful, but the child keeps his eyes closed in order to avoid light. In late stages, there may be inflammatory symptoms that resemble conjunctivitis and—rarely—panophthalmitis. The end result is a large thick scar that prevents the entrance of light, and consequently blindness results.

Corneal involvement is called keratomalacia by some authors. Oomen, (4) however, considers the latter to be a different process, which he describes as colliquitive necrosis, or "a rather sudden, spongy swelling and melting down of the cornea with subsequent shrinkage of the eyeball without infection. The adjacent structures become irritated and xerosis of the bulbar conjunctiva is difficult to demonstrate." Keratomalacia is a medical emergency requiring immediate therapy. It usually involves both eyes. Blindness occurs if treatment is not instituted before an advanced stage is reached.

Several other findings are seen in association with vitamin A deficiency. Bitot's spots occur in the equatorial region of the eye on the lateral side. They are triangular in shape with the base lying at the corneoscleral junction. The appearance is similar to patches of paste that have been striated with a pin. The color resembles aluminum paint. Smears made from these areas show corynebacterium xerose and keratinized epithelium. Bitot's spots are probably nonspecific findings of malnutrition. They are found in areas where vitamin A deficiency is common but are seldom associated with night blindness, keratomalacia, or low concentrations of vitamin A in blood. Administration of vitamin A has not led to disappearance of the lesions. However, Bitot's spots are useful indicators of potential vitamin A deficiency due to their association with xerophthalmia.

A number of changes in the skin have been ascribed to vitamin A deficiency, including xeroderma, mosaic or crackled skin, phrynoderma, folliculosis, and follicular hyperkeratosis. All of these conditions are characterized by abnormal keratinization of the epithelium. Folliculosis of the skin around the eye is seen in xerophthalmia, and xeroderma may be present in children with this disease. Phrynoderma (toad skin) has been noted in children of school age with mild xerophthalmia but also in children without eye symptoms. The characteristic findings in phrynoderma are pointed, horny, pigmented spikes in the skin, particularly on the knees and elbows. Follicular hyperkeratosis may be a variant of this condition. Abundant evidence indicates that not all cases of xeroderma, crackled skin, phrynoderma, or follicular hyperkeratosis are due to vitamin A deficiency. Some investigators question whether follicular hyperkeratosis is ever due to deficiency of this vitamin alone. Administration of oils containing polyunsaturated fatty acids, without vitamin A, has resulted in a cure in some instances but not in others. In all likelihood, these abnormalities of the skin are of varied etiology, some due to lack of vitamin A, others to lack of essential fatty acids or ascorbic acid or to multiple deficiency.

BIOCHEMICAL FINDINGS

The concentration of vitamin A in serum of well-nourished subjects is 30–50 $\mu g/100$ ml. Concentrations less than $20\mu g/100$ ml, are considered low, and a level of less than 10 $\mu g/100$ ml is indicative of deficiency if infections are ruled out. In severe protein deficiency, such as kwashiorkor, vitamin A concentration in serum is very low. The level returns to normal in some subjects, but not in all, as a result of treatment with a high-protein diet. This is dependent on liver stores of vitamin A. When improvement occurs with protein alone, the low serum vitamin A was due to an inadequate amount of serum protein for transport of the vitamin. Determination of carotene in serum is useful in evaluating recent dietary intake of this substance. Normal levels are 50–150 $\mu g/100$ ml.

Absorption of vitamin A can be determined by administering a test dose and estimating the concentration in the serum at intervals thereafter. The maximum rise usually occurs in 3–6 hours.

The earliest abnormality in experimental vitamin A deficiency was detected by measurement of the visual fields under the condition of dark adaptation, that is, using rod scotometry.

PREVENTION AND TREATMENT

Vitamin A deficiency can be prevented by a diet that furnishes sufficient amounts of this vitamin to meet daily requirements. Administration of 100,000 IU vitamin A, orally or parenterally, every 6 months protects most of the preschool population. In the treatment of mild vitamin A deficiency, oral administration of 30,000 IU vitamin A daily is adequate. In severe xerophthalmia and keratomalacia, treatment consists of large doses that will cause a rapid increase in the level of vitamin A in the blood. The adult liver can absorb at least 500,000 IU. Accordingly, doses should be adjusted to make this amount available during the first few days of therapy. Somewhat smaller doses are used in children. On the first day, 100,000 IU of an aqueous dispersion of vitamin A, such as the palmitate (30,000 μg retinol), should be given parenterally. On the second through the sixth day, 50,000 IU should be given twice daily orally. Subsequently, 10,000 IU should be provided daily in the form of cod liver oil to promote storage and prevent relapse; 30 ml cod liver oil provides 25,000 IU vitamin A (7500 μg retinol). Aqueous preparations of vitamin A should be used in conditions in which there are abnormalities in intestinal absorption of fat. Supportive therapy includes a high-protein, high-calorie diet rich in sources of vitamin A and carotene. Antibiotics may also be required.

TOXICITY—HYPERVITAMINOSIS A

A single dose of a million units of vitamin A can cause severe, acute toxicity. Persons have died from eating large amounts of polar bear liver. Acute manifestations include transient hydrocephalus and vomiting. Chronic hypervitaminosis A has been observed with as little as 18,500 IU of the water-dispersed vitamin daily for 1–3 months in infants 3–6 months of age. In adults, chronic hypervitaminosis A has occurred in patients receiving large doses (20–30 times RDA) as a treatment for dermatologic conditions. It has been reported, also, in food faddists. Symptoms have included anorexia, irritability, loss of weight, low-grade fever, sparseness of hair, and a prurigenous rash. There is tenderness over the long bones, and periosteal elevations may be seen on x-ray examination. Hepatomegaly and splenomegaly have been reported. In a few instances, an increase in intracranial pressure has occurred

with signs suggestive of brain tumor. Concentrations of vitamin A in serum are greater than 100 μg/100 ml. The only therapy is to stop administration of vitamin A.

Hypercarotenemia may occur as a result of prolonged ingestion of large quantities of green leafy and yellow vegetables, carrot juice (often by food faddists), citrus fruits, and tomato. Hypercarotenemia may occur as a result of disturbed carotenoid metabolism in some cases of hypothyroidism, diabetes, and various hyperlipemic states. Yellow or orange discoloration of the skin may be present when serum carotene levels are above 250 μg/100 ml. Since carotenoids are secreted in sweat and sebum, the skin changes are especially prominent on the nasolabial folds, forehead, axilla, groin, palms of the hands, and soles of the feet. The scleral and buccal mucosa are unaffected, aiding in differential diagnosis from jaundice. Hypercarotenemia, *per se,* appears to be compatable with health and disappears within a few weeks in cases of dietary origin after withdrawal of the cause. Underlying metabolic disturbances require appropriate therapy.

THIAMIN DEFICIENCY

PREVALENCE

Thiamin deficiency occurs primarily in countries where polished rice is the staple cereal in the diet. Various preventive measures have decreased the incidence markedly, including the use of undermilled or parboiled rice, enrichment of rice with thiamin, and distribution of the vitamin itself in health clinics. In the United States, deficiency is seen primarily in association with chronic alcoholism (see Ch. 13). The increasing use of highly refined white flour in many African countries has increased the liability to deficiency, as occurred in Newfoundland some years ago. Thiamin deficiency may develop in pathologic states that interfere with ingestion and absorption of food and are characterized by profound anorexia, nausea, vomiting, and diarrhea. Diseases in which the metabolic rate is elevated can lead to deficiency. Thiamin requirement is related to caloric intake, the minimum need being in the neighboring of 0.3 mg/1000 kcal. Overloading the tissues with glucose may precipitate deficiency if thiamin intake has been borderline. Thiamin may be lost in the urine following the administration of diuretics.

CLINICAL SYNDROMES

The syndromes due to thiamin deficiency in man are beriberi, Wernicke's syndrome, and Korsakoff's syndrome. Manifestations of deficiency depend on the degree and duration of deprivation. Severe deficiency leads to Wernicke's encephalopathy and Korsakoff's syndrome, less severe deficiency to beriberi heart disease, and still milder deficiency to polyneuritis or dry beriberi.

WERNICKE'S ENCEPHALOPATHY AND KORSAKOFF'S SYNDROME

In the United States and Europe, these syndromes, which represent severe acute thiamin deficiency, are found primarily in alcoholics. They occasionally follow prolonged vomiting, such as in pyloric obstruction or toxemia of pregnancy, or they may occur in carcinoma of the stomach or other conditions of severe digestive failure. They have been precipitated by overloading the tissues with glucose when thiamin stores are depleted.

Wernicke's encephalopathy is characterized by mental disturbances, weakness, paralysis of the eye muscles, and an ataxic gait. Early symptoms are anorexia, nausea and vomiting, and also photophobia, diplopia, and failing vision. Eye signs are always present and include nystagmus, paralysis of the extraocular muscles (particularly the external rectus), and paralysis of conjugate gaze. Ptosis of the eyelids and abnormalities of the pupils may occur. Rarely, papilledema and hemorrhages of the retina are noted. Ataxia is a frequent finding both in standing and walking and is probably of cerebellar origin. Occasionally, cranial nerves other than those supplying the eye muscles are involved. The pyramidal tracts may be affected.

The most common mental symptoms are apathy and confusion. Less often, delirum dominates the picture. Following the administration of thiamin, the patient begins to improve, and the features of Korsakoff's syndrome become evident. A defect in memory retention, particularly for recent events, is the most important finding. This is often associated with confabulation. Retrograde amnesia may involve periods of months or years. Events that happened in the past cannot be recalled in proper sequence. Derangement in perception of time occurs. Delusions may be present, and defects in cognitive function may be observed. Some patients have polyneuropathy.

The mortality of Wernicke's syndrome is 90% without therapy, the most common cause of death being sudden heart failure. Early treatment may result in complete recovery. However, some findings of Korsakoff's syndrome may persist, including loss of memory or confabulation. Other residues may include nystagmus and slight ataxia (see Ch. 24).

BERIBERI (ADULT)

Symptoms and signs of beriberi and the course of the disease are extremely variable. Thus, it is difficult to describe a characteristic sequence of development. Early writers divided the disease into several types: 1) dry beriberi, characterized by peripheral neuritis; 2) wet beriberi, in which edema was a prominent finding (this was usually associated with some evidence of peripheral neuritis); and 3) acute, pernicious or cardiac beriberi. Any one of these forms may merge into another.

Early symptoms of neuritic beriberi include a sensation of numbness of the feet, heaviness of the legs, and paresthesias (e.g., sensations of pins and needles, numbness, formication, and itching). Pain and tenderness in the calf muscles is common. In early stages, the tendon reflexes may be exaggerated, whereas later they are decreased or disappear. These changes are bilateral. Muscular weakness develops gradually, beginning in the dorsiflexors of the foot and extending to the calf muscles, the extensor muscles of the legs, the gluteal muscles, and the flexors of the leg. The patient has difficulty in rising from a squatting position due to weakness of the quadriceps muscles. The squat test has been widely used in the diagnosis of beriberi in the Orient.

Sensory disturbances occur first on the inner surface of the legs below the knee and on the dorsum of the feet. Anesthesia over the tibia is common, as is delayed response to pain. In extensive polyneuritis, anesthesia may extend upward and involve both legs, the arms, the trunk, and even the face and neck. Factors that appear to influence the affected areas include length of the nerve, the amount of work done by the part, and—possibly—the blood supply.

Foot drop and wrist drop are observed in advanced polyneuritis. Aphonia is often noted due to paralysis of the muscles of the larynx as a result of involvement of the laryngeal nerves. Complete flaccid paralysis of the lower extremities or even of the upper extremities is observed occasionally. Paralysis is associated with marked

muscular atrophy and absence of deep tendon reflexes (DTRs).

Cardiac disturbances develop at some stage of beriberi in most subjects. Palpitation and dull precordial or epigastric pain are common complaints. The pulse may be rapid and bounding, although this is not always the case, and pulsations may be visible in the vessels of the neck. The extremities are pale and cold, and edema may be present. Cyanosis occurs when cardiac involvement is severe. The heart is enlarged to both sides, but enlargement is more marked to the right. Heart sounds are often loud, and systolic murmurs may be detected. Edema may occur without obvious cardiac involvement. When heart failure is present, the edema is dependent at first, gradually extending upward. Effusions may develop in all of the serous cavities. Edema of the lungs is a late occurrence. Oliguria is a prominent finding in wet beriberi.

Gastrointestinal (GI) disturbances, including anorexia, nausea, vomiting, and constipation, are usually noted in thiamin deficiency but are nonspecific.

The acute form of cardiac beriberi has been termed "sho-shin" by the Japanese. The patient is severely dyspneic and complains of violent palpitation and intense precordial pain. He is cyanotic and restless, tossing and turning violently from one side of the bed to the other. Hoarseness or aphonia may be present. The patient prefers the lying to the sitting position. Respiration is superficial and rapid, the pulse is weak and regular, about 120–150/min. Pulsations may be visible in the neck, precordium, and epigastrium. The heart is enlarged in all directions, but more to the right than to the left. The area of aortic dullness may be increased. Systolic murmurs are often present. The liver is enlarged and may pulsate. Pistol shot sounds are heard over the peripheral vessels. A stocking and glove type of peripheral cyanosis has been described. Systolic pressure may be normal and diastolic pressure low. The lungs are clear until just before death, when rales appear at the bases. At this time the pulse becomes thin, and the veins dilate. The patient usually dies intensely dyspneic and fully conscious.

The cardiac failure of beriberi is usually of the high output type. Circulation time is rapid, despite an elevated venous pressure. Serial ECGs show fleeting, variable, and nonspecific changes, such as transient T-wave inversion, S-T segment changes or low voltage of the QRS complexes. Roentgenographic examination of the chest shows generalized cardiac enlargement. Following therapy, the heart returns to normal size unless other factors are contributing to the heart failure.

Diagnosis of beriberi heart disease may be very difficult. Blankenhorn (5) suggests that the following criteria are useful: an enlarged heart with normal sinus rhythm, dependent edema, elevated venous pressure and an associated peripheral neuritis or evidence of deficiency of one or more of the B vitamins, nonspecific ECG changes, no other demonstrable etiology, and a history of a grossly deficient diet for three or more months. Improvement following the administration of thiamin rapidly corroborates the diagnosis. Digitalis is not effective in thiamin deficiency heart failure.

INFANTILE BERIBERI

This disease is seen in breast-fed infants, usually between the second and fifth months of life. It is rare in the United States. The mother may have no clinical signs of beriberi, but she will have a history of a poor diet and the milk is undoubtedly low in thiamin. As in the case of adults, several clinical syndromes may be observed, both acute and chronic. The acute cardiac form predominates and is initiated frequently by an infection. It begins with anorexia, vomiting, restlessness, insomnia, and pallor. Oliguria is noted frequently. Suddenly, the infant becomes cyanotic and dyspneic and the pulse rapid and weak. Death may occur within 24–48 hours. Partial or complete aphonia is characteristic in severe cases. The child appears to be crying, but no sound is heard or perhaps only a whine. Other common findings are vomiting, abdominal pain, convulsions, and coma. In the chronic condition, vomiting, inanition, neck contraction, and opisthotonus may develop. Constipation and meteorism are usually present.

The description by Albert of acute cardiac beriberi as quoted by Ramalingaswami (8) is worthy of repetition.

The baby around three months of age, apparently in good health, nursed entirely by its mother, is abruptly seized with an attack of screaming. As he utters his loud piercing cry his body stretches, the abdomen becomes hard, the pulse thready, respiration labored, his face either deadly white or cyanotic and an expression of profound terror or suffering grips the entire being. This state may last anywhere from one half to one hour and disappear spontaneously only to reappear with increasing severity and frequency until death supervenes or specific treatment is given promptly.

A pseudomeningitic type of beriberi has been described with CNS signs such as strabismus, nystagmus, spasmodic contraction of the facial muscles, convulsions, and fever. This is more common in infants aged 7–9 months. The spinal fluid is essentially normal except for being under increased pressure.

BIOCHEMICAL FINDINGS

The concentration of pyruvic acid in the blood is increased to several times normal. The ratio of lactic acid to pyruvic acid becomes abnormal and is of some value in diagnosis. The excretion of thiamin in the urine decreases and may be as low as 0–14 μg/24 hours. Early signs of deficiency may occur when excretion is less than 40 μg daily. The concentration of thiamin in whole blood falls in deficiency but not to a degree that is useful in making a definitive diagnosis in an individual subject. Thiamin concentration in beriberi has been reported to average 3.2 μg/100 ml. In thiamin deficiency, tests for methylglyoxal (pyruvic aldehyde) are positive in both blood and urine and also in the milk of mothers whose infants develop beriberi. One of the most useful tests in the diagnosis of thiamin deficiency is the measurement of transketolase activity in erythrocytes. This procedure is sensitive to mild degrees of depletion (6).

TREATMENT

Treatment includes institution of a good diet and administration of thiamin. Few foods are rich in this vitamin. Lean pork, beans, nuts, and certain whole grain cereals are the best sources; kidney, liver, beef, eggs, and fish contain moderate amounts.

In infantile beriberi, 2–5 mg thiamin may lead to marked improvement within a few hours. In adult beriberi, it is customary to give larger doses of thiamin, particularly when cardiac findings predominate. In such instances, 10–20 mg thiamin should be given intramuscularly several times daily. Similar therapy should be used in Wernicke's encephalopathy and Korsakoff's syndrome.

In severe heart failure, or when convulsions or coma occur in infants, 25–50 mg thiamin can be given intravenously, very slowly, followed by daily intramuscular doses. In critically ill adults, 50–100 mg may be administered intravenously followed by the same amount intramuscularly for the next few days. After improvement has occurred, oral therapy may be instituted.

In the treatment of polyneuropathy, 5–10 mg thiamin three times daily is usually adequate. Thiamin should be continued in these amounts until maximum improvement has been achieved.

Patients with beriberi may have deficiency of vitamins of the B complex in addition to thiamin. Accordingly, it is advisable to administer some form of the whole vitamin B complex, such as a multivitamin tablet, brewer's yeast, liver extract, wheat germ, rice polishings, rice bran, or yeast extract.

RIBOFLAVIN DEFICIENCY

PREVALENCE

Riboflavin deficiency is a relatively common disorder in practically all parts of the world, including the United States. It occurs primarily as the result of an inadequate dietary intake but may develop when some conditioning factor increases requirement or impairs absorption or utilization of the vitamin. Riboflavin deficiency is frequently observed in association with pellagra. In fact, lesions of riboflavin deficiency were considered to be part of the pellagra syndrome for many years. Deficiency is more frequent during periods of physiologic stress, such as rapid growth in childhood or during pregnancy and lactation. It may be the result of pathologic stress, including burns, surgical procedures, and other types of trauma. It occurs also in chronic debilitating illness (*e.g.,* tuberculosis, rheumatic fever) and in the course of congestive heart failure, hyperthyroidism, and malignancy. Malabsorption may be observed in chronic diarrheal diseases or following operations on the GI tract. Poor utilization may be the result of cirrhosis of the liver.

A relationship has been noted between the retention of riboflavin and that of protein. When protein is broken down, negative nitrogen balance occurs and urinary excretion of riboflavin increases. This has been reported in acute starvation, uncontrolled diabetes mellitus, and following trauma.

CLINICAL FINDINGS

Riboflavin deficiency is characterized by lesions of the lips (cheilosis), angular stomatitis, seborrheic dermatitis, and glossitis. In addition, ocular symptoms and signs that respond to administration of riboflavin have been reported.

Early symptoms of deficiency are soreness and

burning of the lips, mouth, and tongue and—at times—photophobia, lacrimation, and burning and itching of the eyes. Cheilosis begins with redness and denudation of the lips along the line of closure. The lips become dry and chapped and shallow ulcers may appear. Maceration and pallor develop at the angles of the mouth followed by fissures that may extend out from the mucous membrane for a centimeter or more. The fissures may be covered with yellow crusts. Following healing, scars may remain at the angles of the mouth, and the lips may become atrophic.

The seborrheic dermatitis of riboflavin deficiency has a red, scaly, greasy appearance. The areas involved are the nasolabial and nasomalar folds, the alae nasi and vestibule of the nose, the ears, and the skin around the outer and inner canthi of the eyes. Fine, filiform comedones may be seen over the bridge of the nose, on the malar prominences, and on the chin. Dermatitis of the scrotum and vulva may develop with redness, scaling, and desquamation as characteristic findings. Similar changes occur in adjacent areas of the thigh.

The tongue is purplish red or magenta in color and often deeply fissured. The papillae may be swollen, flattened, or mushroom shaped, causing a pebbled appearance. Atrophy of the papillae may occur in long-standing deficiency. It is difficult to differentiate the glossitis of riboflavin deficiency from that due to lack of niacin, folic acid, or vitamin B_{12}.

Superficial vascularization of the cornea may be observed. Early lesions consist of injection and proliferation of the vessels of the limbic plexus and can be seen only with a slit lamp. Later, circumcorneal injection may be visible without magnification. The capillaries of the limbic plexus proliferate and extend into the superficial layers of the cornea, anastomosing to form tiers of loops. Superficial punctate opacities and ulcerations have been observed, the latter being demonstrable with fluorescein staining. Iritis has been reported. The conjunctiva may be grossly inflamed and the eyelids red, swollen, and matted together with exudate. Photophobia may be severe.

None of the lesions described are pathognomonic of riboflavin deficiency. Lesions of the lips have been observed in experimental niacin deficiency, following administration of desoxypyridoxine, and—rarely—in iron deficiency anemia. Fissures at the angles of the mouth may be the result of poorly fitting dentures or malocclusion. Cheilosis may be due to allergy or to wind and cold. Superficial vascularization of the cornea is found in association with infections, trauma, and deficiency of dietary substances other than riboflavin.

In experimental deficiency produced by the administration of analogues of riboflavin, Lane, Alfrey, and their colleagues (13) report not only glossitis and seborrheic dermatitis, but also anemia and neuropathy later in the deficiency. The anemia was macrocytic and normochromic and was associated with a reduction in the reticulocyte count and hypoplasia of the bone marrow. The anemia may be related to disturbances of folic acid metabolism. Decreased levels of folic acid in serum and liver have been reported and conversion of folic acid to 5-N-methyltetrahydrofolic acid is impaired. These abnormalities are probably the result of diminished activity of flavoprotein enzymes that are required for utilization of folic acid.

BIOCHEMICAL FINDINGS

The urinary excretion of riboflavin falls to less than 50 μg daily in deficiency. An excretion of less than 27 μg riboflavin/g creatinine has been proposed as indicative of deficiency, although the excretion of 27–79 μg is considered low. Administration of a 1–mg test dose of riboflavin subcutaneously followed by measurement of excretion in the urine for 4 hours is useful in estimating tissue stores of riboflavin. In experimental deficiency, the excretion in 4 hours was 19 μg after 48 months of a diet that furnished 0.6 mg riboflavin daily. In subjects receiving 0.7–1.1 mg riboflavin daily, the 4–hour excretion was 56–81 μg. Subjects who received 1.6 mg riboflavin daily excreted an average of 235 μg.

Determination of flavoprotein enzymes in blood is not of much assistance in the diagnosis of deficiency. The concentration of riboflavin in erythrocytes decreases, and levels of less than 14 μg/100 ml have been suggested as indicative of potential deficiency. The activity of the enzyme erythrocyte glutathione reductase, and the magnitude of the increase in activity of this enzyme after ingestion of riboflavin, correlates with the dietary intake of the vitamin. The extent of stimulation of erythrocyte glutathione reductase activity in vitro by flavin adenine dinucleotide (FAD) is useful as an indicator of riboflavin nutriture.

Diagnosis of riboflavin deficiency is made by correlating dietary, clinical, and laboratory findings since there are no pathognomonic signs of this disorder.

TREATMENT

Treatment consists of institution of a good diet and administration of the vitamin. The best food sources of riboflavin are milk, liver, meat, eggs, and some of the green leafy and yellow vegetables. A quart of milk furnishes approximately 2 mg of the vitamin. Cereals and bread contain very little riboflavin, but enrichment of flour, bread, and cereals, as carried out in the United States, contributes significantly to the dietary supply.

Riboflavin should be administered orally in amounts of 5 mg, two or three times daily. In persons being fed parenterally, riboflavin should be included in the formula. The lesions of riboflavin deficiency heal rapidly, usually within a few days to a week or two.

NIACIN DEFICIENCY

PELLAGRA

PREVALENCE

Pellagra has occurred primarily in parts of the world in which corn is the staple cereal and has been noted chiefly among the poor. It has become relatively rare except in a few areas of the world where maize remains the principal constituent of the diet. It was common in the southern United States in the early 1900s, and the mortality was high. It is now seen in this country largely in association with chronic alcoholism (see Ch. 13). It occasionally develops in association with cirrhosis of the liver or in chronic diarrheal diseases, diabetes mellitus, neoplasia, prolonged febrile illnesses, and thyrotoxicosis. Pellagra may develop in patients who are fed parenterally without niacin supplementation.

Pellagra is due to an inadequate dietary intake of niacin and its precursor, the amino acid tryptophan. The association of corn diets with pellagra is due in large part to the low tryptophan content of this cereal. In addition, niacin is present in corn and certain other cereals in bound form and may not be available to the organism unless it is released by treatment with alkali. In certain areas, such as Central America, where it is common practice to treat corn with lime before incorporation in the diet, the incidence of pellagra is low, even when corn supplies a large percentage of the total food intake. Amino acid imbalance has been suggested as another factor in the pathogenesis of pellagra. Gopolan and his associates (17) in India produced experimental deficiency in animals with diets high in leucine.

In some instances, isoleucine counteracted this effect. Oral administration of leucine appears to inhibit synthesis of niacin adenine dinucleotide. Pellagra is found in India in association with the ingestion of millet (jowar), which is high in leucine. Some years ago it was suggested that corn contained an inhibitory factor. If this is the case, it appears to have a minor role in the etiology of human pellagra.

Sunlight and heavy work appear to precipitate pellagra. The seasonal incidence in the spring months may be the result of a decrease in niacin intake during the winter, followed by exposure to the sun and increased physical activity. Pellagra is still endemic in some countries in the Near East, Africa, southeastern Europe, and southern Asia, namely, the Arab Republic of Egypt, Lesotho, South Africa, Yugoslavia, and India.

Niacin deficiency may occur in patients with malignant carcinoid tumors due to a decrease in availability of tryptophan for conversion to niacin since a large percentage is converted to 5-hydroxytryptophan (serotonin). Deficiency develops occasionally during therapy with isoniazid. In these instances, pyridoxine deficiency induced by isoniazid results in a decrease in the conversion of tryptophan to niacin.

CLINICAL FINDINGS

Pellagra is characterized by dermatitis, inflammation of mucous membranes, diarrhea, and psychic disturbances. In its endemic form, it occurs characteristically in the spring of the year with an occasional second outbreak in the fall. This appears to be explained largely on the basis of diet, but increased physical activity—which may elevate requirement—and exposure to sunlight probably both play a role.

Early symptoms of deficiency include lassitude, weakness, loss of appetite, mild digestive disturbances (especially heartburn), and psychic and emotional changes (e.g., anxiety, irritability, and depression). Soreness of the tongue and mouth, aggravated by highly seasoned or acid food, is a frequent complaint.

Signs of advanced niacin deficiency vary with the severity and duration of depletion. The dermatitis of acute pellagra resembles ordinary sunburn in the early stages. The skin is red, and large blebs or blisters may develop. If these break, secondary infection may occur. The skin often peels away leaving large areas of denudation that resemble a severe sunburn. As deficiency progresses, the skin becomes darkly pig-

mented. Dermatitis is most often found on the face and neck, backs of the hands and forearms, and the anterior surfaces of the feet and legs. The lesions are usually bilateral and symmetric, and the damaged skin is clearly demarcated from the uninvolved portion. Dermatitis of the neck has been designated Casal's necklace due to its distribution and in recognition of the physician who first described it. Other areas of the skin may be involved, particularly those subjected to irritation and trauma, such as the axilla, groin, perineum, genitalia, elbows, knees, and areas under the breasts.

Skin changes of chronic pellagra are somewhat different. They are characterized by thickening, scaling, hyperkeratinization, and pigmentation. The face and neck are less often involved. Lesions are most common on the feet, hands, and points of pressure, such as the elbows and knees. Chronic pellagrous dermatitis has been confused with changes due to allergy, stasis, or irritation.

In acute pellagra, the mucous membranes of the GI and GU tracts are severely inflamed and fiery red in appearance. The tongue is sore, swollen, and scarlet in color, and the lingual papillae become atrophic. Chewing and swallowing are so painful that even liquids may be refused. White areas appear on the mucous membrane of the mouth, probably due to death of superficial tissue. Secondary infection with fungi or Vincent's organisms is common. Inflammatory changes also occur in the esophagus, stomach, and small and large intestines. Symptoms include heartburn, indigestion, diarrhea, abdominal pain, and soreness of the rectum. The stools are watery and may contain blood. Achlorhydria is characteristic. The patient complains that he feels sore from the mouth to the rectum. Due to the severe inflammatory process and hypermotility of the GI tract, nutrients are poorly absorbed, and this results in profound weight loss.

Inflammation of the lower urinary tract causes urethritis with burning, pain, and frequency of urination. In the female, severe vaginitis is observed, and amenorrhea is common.

The psychic manifestations of pellagra are variable. Common early findings are anxiety, irritability, and depression. In more-advanced deficiency, confusion, disorientation, delusions, and hallucinations may appear. Some patients are fearful, hyperactive, and manic; others are apathetic, lethargic, and stuporous. As the disease progresses, delirium ensues, and the patient may die in coma.

Other changes observed in pellagra include cheilosis, angular stomatitis, and seborrheic dermatitis, which may be due to niacin deficiency alone or to concomitant riboflavin deficiency. Anemia may occur and may be either macrocytic or microcytic and hypochromic. Neither of these types of anemia responds to niacin. The macrocytic anemia appears to be due to folic acid deficiency and the hypochromic anemia to an inadequate supply of iron.

Descriptions of pellagra in the older literature list neurologic abnormalities (e.g., incoordination, tremor, ataxia, reflex disturbances, and even sensory changes) as findings, but although these may have been manifestations of advanced niacin deficiency, they were more probably due to deficiency of other vitamins in the B complex. Neurologic changes have not been reported in experimental niacin deficiency.

NIACIN DEFICIENCY OTHER THAN PELLAGRA

CLINICAL FINDINGS

Early, mild niacin deficiency, in contrast to pellagra, may have as its only manifestation redness of the tongue with a slight atrophy or hypertrophy of the papillae.

Two syndromes other than pellagra have been described that appear to be due to acute, severe niacin deficiency. One of these is characterized by confusion, hallucinations, and disorientation, and the clinical picture resembles an acute toxic psychosis. The other syndrome is an acute encephalopathy characterized by clouding of consciousness, cogwheel rigidity of the extremities, and uncontrollable grasping and sucking reflexes. These syndromes may occur singly or in combination. They have been observed in malnourished subjects following IV administration of glucose without concomitant administration of niacin. Occasionally, they develop during the course of serious infections. Both syndromes respond dramatically to administration of niacin. Death may occur if treatment is not initiated promptly.

BIOCHEMICAL FINDINGS

Urinary excretion of niacin metabolites falls to low levels in pellagra, usually to less than 3 mg/day. The excretion of niacinamide is little changed, but there is a marked decrease in the excretion of N^1-methylniacinamide (N^1-ME) and pyridone. The niacin-containing coenzymes

in erythrocytes are not decreased significantly in pellagra, but coenzyme concentrations in liver and muscle decrease progressively as the disease advances. However, these estimates are not usually carried out in diagnosing niacin deficiency.

Measurement of excretion of N^1-ME in a random specimen of urine in relation to creatinine output gives useful information. An excretion of 0.5 mg N^1-ME/1 g creatinine is suggestive of deficiency, as is an excretion of less than 0.2 mg N^1-ME in 6 hours.

DIAGNOSIS

Mild niacin deficiency is characterized by glossitis, diarrhea, and nonspecific psychic disturbances. If there are no skin lesions, the diagnosis may be suspected on the basis of a dietary history indicating a poor intake of niacin and tryptophan. Diagnosis of acute pellagra is relatively easy, but the skin lesions of chronic pellagra may be confused with numerous other conditions, such as chronic irritation, stasis, or allergic dermatitis. Measurement of the urinary excretion of niacin metabolites is useful in establishing the diagnosis. Occasionally, a controlled therapeutic test is desirable.

TREATMENT

Niacin should be administered orally in most instances, the amount varying with the severity of the deficiency state. In acute pellagra, it is customary to give 300–500 mg niacin or niacinamide/day in divided doses of 50–100 mg each. If stomatitis and dysphagia are severe, 100 mg niacinamide should be given intramuscularly two or three times daily for the first 2 days. After subsidence of the acute symptoms, the dose may be decreased to 50–100 mg two or three times daily orally. Therapy should be continued until all lesions have healed.

In the treatment of mild niacin deficiency, administration of 50 mg niacinamide three times daily should be sufficient. Niacinamide is preferable to niacin since it does not induce vasodilating reactions. Niacin should not be given intravenously except in dilute solutions nor in amounts in excess of 25 mg. Niacinamide is safe for IV use.

In the treatment of severe pellagra, bed rest is essential. The diet must be liquid or soft at first because of stomatitis and pain associated with swallowing. Milk, eggs, strained cereals, and pureed vegetables are usually well tolerated. Skim milk powder may be added to whole milk to increase the protein and tryptophan content. As symptoms improve, the diet should be increased to include lean meat, glandular organs, vegetables, and fruits. Foods that are rich in niacin include lean meat (especially organ meats), legumes, nuts, and certain fish. Potatoes, some green vegetables, and whole wheat cereal and bread are fair sources of the vitamin. Refined white flour, cornmeal, and grits are low in niacin, but in the United States these cereals are enriched with niacin and accordingly add significant amounts to the diet. Not much niacin is present in milk or eggs, but these foods are high in tryptophan, as are most animal proteins with the exception of gelatin. Of the vegetable proteins, peanuts, beans, peas, and other legumes are good sources of both niacin and tryptophan.

If pellagra is complicated by deficiency of other vitamins of the B group, as is often the case, it is advisable to prescribe a tablet containing 5 mg thiamin, 5 mg riboflavin, 5 mg vitamin B_6, and 10 mg pantothenic acid, to be given once or twice daily. Brewer's yeast is an alternate and inexpensive supplement that may be given in amounts of 10–30 g daily.

FOLIC ACID (FOLACIN) DEFICIENCY

PREVALENCE

Folic acid deficiency is a widespread disorder that occurs throughout the world, particularly in the tropics, but not infrequently elsewhere. It is probably the most common hypovitaminosis of man. In underdeveloped countries where poor socioeconomic and dietary conditions prevail, the majority of the general population suffer from dietary folic acid deficiency often associated with cobalamin deficiency. In the United States it has been estimated that 45% of adult patients who are indigent or in the low income group are deficient in folic acid as reflected by low serum concentration of folate derivatives. In western countries, mild folic acid deficiency appears to be not uncommon among elderly patients.

Dietary deficiency of folic acid causes nutritional macrocytic anemia. This anemia is encountered in infants (megaloblastic anemia of infancy), during pregnancy, in sprue, and in a number of other malabsorption syndromes. Megaloblastic anemia of infancy, which develops in infants up to age two, is a major problem in developing countries. The role of folic acid deficiency in the development of this anemia is well established although other nutrients may be

involved. In these same countries, macrocytic anemia of pregnancy occurs in as high as 20% of pregnant women, and significant megaloblastic changes in the bone marrow may be found in more than 50%. Folic acid deficiency often occurs in chronic alcoholism. Anorexia in a number of chronic diseases may result in deficiency.

Deficiency may be encountered in some of the hemoglobinopathies, in certain inborn errors of metabolism, and following the administration of drugs, particularly several used in the treatment of epilepsy (see Ch. 18). Hemoglobinopathies in which folic acid deficiency has been observed include sickle cell disease, thalassemia major, and combined sickle cell and thalassemia traits. Administration of folic acid antagonists in the treatment of leukemia may produce the picture of folic acid deficiency. Folic acid deficiency can arise from the use of oral contraceptive agents.

CLINICAL FINDINGS

Folic acid deficiency is characterized by macrocytic anemia, megaloblastosis of the bone marrow, diarrhea, and glossitis. Weight loss occurs frequently. All of the signs associated with anemia and tissue anoxemia may develop, including weakness, syncopal attacks, severe pallor of the skin, and cardiac enlargement with congestive heart failure.

Macrocytic anemia of pregnancy is usually due to folic acid deficiency and rarely to lack of vitamin B_{12}. This syndrome appears to be due to dietary deficiency upon which pregnancy superimposes an increased need (see Ch. 26). Rarely, it may result from malabsorption of folic acid. Clinical findings in nutritional macrocytic anemia of pregnancy often include glossitis and diarrhea. The tongue is sore and red, and the papillae may be atrophic. Fever has been reported. The bone marrow is megaloblastic. There is leukopenia, with hypersegmentation of the polymorphonuclear leukocytes, and thrombocytopenia.

Megaloblastic anemia of infancy usually occurs between the ages of 6 months and 1 year (see Ch. 29). As observed in the United States, this anemia was found in children who received diets inadequate in ascorbic acid. Patients responded to treatment with folic acid, but the anemia could be prevented with ascorbic acid. A role of ascorbic acid in the conversion of folic acid to coenzyme form would explain the pathogenesis of this anemia. Megaloblastic anemia responding to folic acid has been reported in infants with protein–calorie malnutrition.

Sprue and gluten-induced enteropathy are malabsorption syndromes in which macrocytic anemia and megaloblastosis of the bone marrow are observed. Tropical sprue is endemic in India, the Far East, the Caribbean area, and is seen—at times—in the United States. The pathogenesis of tropical sprue is not understood in spite of extensive investigation. Although folic acid deficiency is a constant finding, it cannot be the sole cause of the condition. Signs of deficiency appear early, namely, macrocytic anemia, megaloblastosis of the bone marrow, and glossitis. The steatorrhea of tropical sprue may persist after folic acid therapy.

Folic acid deficiency is inconstant in gluten-induced enteropathy and appears to be a secondary phenomenon. Megaloblastic anemia that responds to folic acid may be associated with the disorders of the small intestine, such as diverticulosis, Whipple's disease, stricture and anastomoses, and resections.

BIOCHEMICAL FINDINGS

An abnormal amount of formiminoglutamic acid (FIGLU) is excreted in the urine. An intermediate in the breakdown of the amino acid histidine to glutamic acid, FIGLU accumulates when folic acid coenzymes that are needed for this metabolic process are lacking. The normal excretion of FIGLU is 0–6 μg/ml of urine or 0–4 mg in 24 hours. Excretion is usually measured after administration of histidine, given in three 5g doses in 24 hours. Normal FIGLU excretion with this test is less than 25 μg/ml of urine and less than 25 mg in 24 hours. In folic acid deficiency, excretion is greater than 30 μg/ml of urine and greater than 35 mg in 24 hours.

Measurement of folic acid concentration in serum by microbiologic assay using *Lactobacillus caseii* as the test organism is useful in the diagnosis of deficiency. It has been suggested that less than 3 ng/ml is indicative of deficiency. Folic acid can be measured also in whole blood, using several microorganisms, and in erythrocytes. Normal levels in erythrocytes are 160–650 ng/ml. Levels of 100–160 ng/ml are considered low, and concentrations less than 100 ng/ml are indicative of deficiency.

Plasma clearance and absorption tests for estimating folic acid nutrition have been suggested but have not been widely used. Determination of folate derivatives in serum is a reasonably satisfactory method of detecting folic acid deficiency unless cobalamin (vitamin B_{12}) deficiency

coexists. Erythrocyte folate levels are useful in some instances.

TREATMENT

In the past, therapy of folic acid deficiency consisted of oral administration of 5 mg daily to infants and 5 mg two or three times daily to adults. Recent studies indicate that much smaller doses are often effective, as little as 25–100 μg in certain syndromes. The oral route is satisfactory in most instances. Clinical and hematologic response is rapid. Within a few days, the patient feels better, and his appetite improves. There is an increase in the reticulocyte count and a gradual return of the blood picture to normal. Recurrance of megaloblastic anemia in subsequent pregnancies should be prevented by administration of 5 mg folic acid daily.

Folic acid is particularly abundant in green leafy vegetables, yeast, and liver. Other good sources are green vegetables, kidney, beef, and wheat. Many of the folates in food are labile and are easily destroyed by cooking, the loss being related to the amount of reducing agent in the food. Folates in food are classified into two main groups: 1) "free" folates, which are available without pretreatment with conjugase, and 2) total folates, consisting of free folates and the polyglutamates that are available only after conjugase treatment. Free folates make up about 25% of dietary folate and are readily absorbed. Much more information is needed on the amount and forms of folate in foods and of conjugase and conjugase inhibitors in the diet.

VITAMIN B_{12} (COBALAMIN) DEFICIENCY

PREVALENCE

Dietary deficiency of vitamin B_{12} is rare, occurring almost exclusively in vegetarians who do not include any foods of animal origin in the diet. Pernicious anemia is the most important condition resulting from vitamin B_{12} deficiency. In this disease, deficiency is caused by failure of absorption of vitamin B_{12} from the intestinal tract due to lack of intrinsic factor in the gastric juice. Pernicious anemia has a familial incidence that is high in persons of northern European ancestry. It is more common in older age groups and rare in childhood. Gastrectomy, total or at times partial, leads to vitamin B_{12} deficiency since the stomach is the organ that forms the intrinsic factor. Vitamin B_{12} is absorbed in the ileum, hence resection

of this area results in deficiency. Fish tapeworm infestation may cause vitamin B_{12} deficiency due to competition of the parasite with the host for the vitamin. Vitamin B_{12} deficiency may also occur in a number of malabsorption syndromes, such as sprue, gluten-induced enteropathy, intestinal inflammation, strictures, and anastomoses. In these conditions, folic acid deficiency is usually present as well. Occasionally, megaloblastic anemia in chronic liver disease responds to vitamin B_{12} administration, but improvement is more likely after folic acid.

CLINICAL FINDINGS

The most important manifestations of vitamin B_{12} deficiency are macrocytic anemia, megaloblastosis of the bone marrow, glossitis, and neurologic abnormalities, including subacute combined degeneration of the spinal cord and peripheral neuritis.

The earliest neurologic complaints are parasthesias involving the hands and feet. Degeneration of the posterior and lateral columns of the spinal cord results in loss of vibratory and position sense in the lower extremities, incoordination of the legs, and loss of fine coordination of the fingers. Romberg's sign is positive, as is the Babinski reflex. Spasticity and either increased or decreased deep tendon reflexes (DTRs) may be noted. Sphincter disturbances may occur. Typical findings of peripheral neuritis may be observed, including loss of sensation beginning in the feet and extending upward, muscular weakness and atrophy, and loss of the DTRs. Mental changes such as irritability, memory disturbances, and depression may occur.

The tongue is often bright red in color and smooth, the papillae being atrophic. When the anemia is severe, prominent features are weakness, fatigue, symptoms of cerebral anoxemia, or cardiovascular complaints (*e.g.,* dyspnea, chest pain, slight edema, or even chronic congestive heart failure). Low grade fever is present at times. In pernicious anemia, an additional finding is lemon yellow pallor of the skin. Gastrointestinal symptoms may occur, including anorexia, nausea and vomiting, vague indigestion, and midepigastric pain. Weight loss occurs occasionally. Diarrhea is common.

BIOCHEMICAL AND OTHER LABORATORY FINDINGS

Vitamin B_{12} deficiency is associated with a macrocytic anemia and megaloblastosis of the bone

marrow. The mean corpuscular volume is greater than normal, *i.e.,* 100–160 μ^3. The macrocytes are oval in shape, and nucleated red cells may be seen in the peripheral blood smear. The white cell count is low, and the polymorphonuclear neutrophilic leukocytes are multilobular. Platelets are usually reduced in number. The bone marrow is hyperplastic and contains large numbers of megaloblasts.

In pernicious anemia, no free hydrochloric acid is found in the gastric juice after stimulation with histamine and intrinsic factor is absent from the gastric juice. Serum bilirubin is slightly increased as is excretion of urobilinogen in the urine and stool. These findings are due to a decrease in the survival time of erythrocytes. A number of abnormal phenolic compounds are found in the urine also.

In vitamin B_{12} deficiency, the serum concentration of vitamin B_{12} may range from 0 to less than 100 pg/ml. There is an increase in urinary excretion of methylmalonic acid. Normal excretion in 24 hours is about 3 mg, but excretions of greater than 4 mg have been noted in patients with low levels of serum vitamin B_{12}. Excretion of more than 5 mg is considered indicative of vitamin B_{12} deficiency.

The cause of vitamin B_{12} deficiency can be determined by dietary history, the presence of some disease that influences the absorption or utilization of the vitamin, the clinical findings, and measurement of absorption of radioactive vitamin B_{12}. The most common test of absorption is that devised by Schilling in which a small dose of radioactive vitamin B_{12} (0.5 μg of cobalt 60 or 57 labeled B_{12}) added to 1.5 μg of unlabeled vitamin is administered orally and radioactivity is measured in the urine for 24 hours thereafter. A flushing dose of 1000 μg of the nonlabeled vitamin is given an hour after the oral dose. Normal individuals excrete at least 10%–40% of the vitamin in 24 hours, often more. In pernicious anemia, usually less than 2% is excreted. In such patients, the test is repeated, a concentrate of intrinsic factor being given in conjunction with the oral dose of radioactive vitamin B_{12}. This results in an increase in excretion to normal levels. In malabsorption syndromes of other causation, there is no increase in excretion when intrinsic factor is administered. Accordingly, two tests must be carried out to establish the diagnosis of pernicious anemia or of other malabsorption syndromes. When malabsorption is due to conditions other than intrinsic factor deficiency, GI x rays may be useful in diagnosis. Biopsies of the intestinal mucosa may also be of assistance.

TREATMENT

Treatment in most instances consists of parenteral administration of the vitamin. With severe deficiency, in which macrocytic anemia or neurologic abnormalities, or both, are present, vitamin B_{12} is given in amounts of 50–100 μg three times a week until findings have returned to normal. Patients with pernicious anemia, gastrectomy, or post ileectomy syndromes need a maintenance dose of vitamin B_{12} for the remainder of their lives. The usual dose is 50–100 μg once a month. Patients can be maintained satisfactorily on 1000 μg parenterally every two or three months. Vitamin B_{12} can be given orally and is effective in pernicious anemia if sufficiently large doses are prescribed, but it is expensive therapy and is seldom used. Oral treatment is not recommended except in the management of dietary deficiency.

Administration of vitamin B_{12} is followed by a reticulocyte response that reaches a maximum in 5–8 days. There is a gradual return of the blood count to normal in several months. Megaloblastosis of the bone marrow disappears rapidly, often within 24 hours. Subjective improvement occurs in the first few days. There is an increase in appetite and a sense of well-being, mental symptoms—if present—disappear, and glossitis recedes rapidly. Neurologic lesions heal slowly, but if they have not been of too long standing, complete recovery may occur. Improvement may continue for as long as a year or more.

VITAMIN B_6 DEFICIENCY

PREVALENCE

Primary vitamin B_6 (pyridoxine) deficiency in man is extremely rare. It was reported some years ago in infants fed an autoclaved commercial milk formula low in vitamin B_6. Experimental deficiency has been produced in adult subjects who received diets low in the vitamin and were also given a pyridoxine antagonist. A vitamin B_6–dependent syndrome of genetic origin has been reported in infants. Cases of pyridoxine responsive anemia have been described. Vitamin B_6 deficiency may occur in chronic alcoholism. A relationship between steroid hormones and vitamin B_6 has been observed, and abnormalities of vitamin B_6 metabolism have been

noted during pregnancy. Vitamin B_6 requirement may be increased in patients with hyperthyroidism. The administration of isonicotinic acid hydrazide (INH), a vitamin B_6 antagonist, may lead to deficiency.

CLINICAL FINDINGS

In infants, deficiency is characterized by irritability and convulsive seizures with abnormalities of the EEG. In experimental deficiency in two infants, convulsions developed in one instance and a macrocytic hypochromic anemia in the other. Some infants who develop convulsions shortly after birth respond to administration of pyridoxine. This appears to be a genetic pyridoxine deficiency or dependency syndrome.

In experimental deficiency in adults, the subjects became irritable, depressed, and somnolent. Seborrheic dermatitis appeared about the eyes, in the nasolabial folds, and around the mouth. In some instances, the lesions involved the face, forehead, eyebrows, and skin behind the ears. Occasionally, the scrotal and the perineal regions were involved. Intertrigo was noted under the breast and in other moist areas. In two subjects, pigmented scaly dermatitis resembling pellagra developed on the arms and legs. Glossitis, cheilosis and angular stomatitis indistinguishable from the lesions of niacin and riboflavin deficiency occurred in some subjects. A few patients developed peripheral neuritis. Weight loss was noted in all subjects, and there was a tendency to develop infections, particularly of the GU tract. High intakes of protein appear to hasten the onset of vitamin B_6 deficiency. Several reports of pyridoxine responsive anemia classified as sideroblastic anemia have been published.

BIOCHEMICAL FINDINGS

The urinary excretion of xanthurenic acid is determined after administration of a tryptophan load test (10 g DL tryptophan). Normal subjects excrete less than 50 mg xanthurenic acid in 24 hours, usually less than 30 mg. Excretion is increased in vitamin B_6 deficiency. There is also an increase in the excretion of kynurenine, 3-hydroxykynurenine, kynurenic acid, acetylkynurenine, and quinolinic acid. The levels of vitamin B_6 in plasma and blood, as well as the urinary excretion of the vitamin and of its metabolite 4-pyridoxic acid, fall with decreased dietary intake. In deficiency, there is a decrease in glutamic oxaloacetic transaminase (GOT) and

glutamic pyruvic transaminase (GPT) activities in blood. Women taking steroid hormones for contraceptive purposes excrete increased amounts of tryptophan metabolites following a tryptophan load test. During pregnancy, women may excrete abnormal amounts of kynurenine, xanthurenic acid, and 3-hydroxykynurenine. The concentration of the urea nitrogen in blood after administration of 30 g alanine should return to normal within 12 hours but may be delayed if pyridoxine is not available in adequate amounts.

TREATMENT

Vitamin B_6 deficiency can be prevented by the ingestion of a diet furnishing 2 mg vitamin B_6 daily for adults; 2.5 mg is recommended for pregnancy and lactation. Requirement is related to protein intake. In the treatment of deficiency, 10–150 mg/day have been used. The hypochromic anemia responds to 10–15 mg pyridoxine daily. Neuritis occuring in persons receiving INH can be prevented and treated with a daily dose of 50–100 mg. Therapy for various genetic and metabolic disturbances involving vitamin B_6 must be determined individually. Pyridoxine has been employed in the treatment of hyperoxaluria and recurrent oxalate kidney stones. The toxicity of pyridoxine is extremely low.

PANTOTHENIC ACID DEFICIENCY

PREVALENCE

Pantothenic acid is so widely distributed in food that dietary deficiency of the vitamin is exceedingly rare. Deficiency may develop in association with multiple B complex deficiency states, but clear-cut evidence for this has not been presented.

CLINICAL FINDINGS

Deficiency has been produced experimentally in man by Bean, Hodges, and their collaborators (21, 22) by marked restriction of pantothenic acid intake and by a combination of restricted diet and administration of an antagonist, ω-methyl pantothenic acid. The clinical picture includes personality changes, fatigue, malaise, sleep disturbances, and neurologic manifestations, such as numbness, parasthesias, and muscle cramps. Burning of the feet is observed occasionally. Motor coordination is impaired, resulting in a peculiar staggering gait. Personal-

ity changes included irritability, restlessness, and quarrelsomeness. At times, the subjects were sullen and petulant. Gastrointestinal complaints were common, including nausea, epigastric burning sensations, abdominal cramps, and occasional vomiting. The three most constant and annoying symptoms were fatigue, headache, and weakness. Some subjects had evidence of cardiovascular instability, *e.g.,* tachycardia and lability of the blood pressure, with a tendency to orthostatic hypotension. Infections were common in some subjects but not in others.

Pantothenic acid has been reported to have a role in stress. A deficiency of pantothenic acid may be responsible for the burning foot syndrome encountered in certain parts of the world, including prisoners of the Japanese during World War II. The syndrome is characterized by bilateral paresthesias affecting the feet and lower legs and severe shooting pains that are aggravated by exertion or warmth and alleviated by cold. No muscle wasting, paralysis, or areflexia was observed. The condition is reported to improve with the administration of pantothenic acid.

BIOCHEMICAL FINDINGS

In experimental human deficiency, the eosinopenic response to ACTH was impaired and the sedimentation rate elevated. Adrenocortical function appeared to remain normal. There was increased sensitivity to insulin. Antibody protection against tetanus was impaired. The combination of pantothenic acid and pyridoxine deficiency aggravated the impaired antigenic response when bacterial antigens were used.

There are no satisfactory tests for detecting pantothenic acid deficiency. Urinary excretion of less than 1 mg/day is considered abnormally low in adults. In patients with chronic malnutrition, including alcoholics, levels of pantothenic acid in blood and urine tend to be low.

TREATMENT

No clearly defined therapeutic use of pantothenic acid has been presented. It would seem desirable to provide pantothenic acid in multivitamin preparations employed for IV use and probably for oral administration as well. Diets of adults in the United States usually supply 10–15 mg pantothenic acid daily. The Food and Nutrition Board suggests that 5–10 mg daily is probably adequate for both children and adults. The best food sources of pantothenic acid are yeast,

liver, and eggs. Some meats, skim milk, and sweet potatoes, tomatoes, and molasses are fairly high in the vitamin.

BIOTIN DEFICIENCY
PREVALENCE

It is unlikely that spontaneous biotin deficiency will be observed in man. Biotin is obtained not only from the diet, but also from synthesis by intestinal bacteria. Urinary excretion of biotin often exceeds dietary intake. Biotin deficiency can occur if bizzare diets containing large amounts of raw egg white are ingested.

CLINICAL FINDINGS

Experimental biotin deficiency was produced in man by Sydenstricker and associates (23), who fed a diet rich in raw egg white to human volunteers. Raw egg white contains avidin, a protein that has the ability to inactivate biotin. The subjects developed a grayish pallor of the skin, a nonpruritic dermatitis, depression, lassitude, somnolence, muscle pains, and hyperesthesias. Later manifestations were anorexia, nausea, anemia, hypercholesterolemia, and changes in the ECG. All signs and symptoms disappeared in a few days following parenteral therapy with 150–300 μg biotin concentrate daily.

TREATMENT

In the usual case of deficiency due to ingestion of large amounts of raw egg white, biotin administration is indicated. Biotin has been reported to be useful in the treatment of seborrheic dermatitis in infants including Leiner's disease.

ASCORBIC ACID DEFICIENCY— SCURVY
PREVALENCE

Scurvy occurs in infants in many parts of the world, but it is less frequent than in former years. It develops primarily in infants who have been fed cow's milk and—rarely—in breast-fed infants, unless the mother's diet has been very inadequate. The disease appears usually between the ages of 6 and 12 months. Scurvy is also seen in adults, particularly in persons living alone on very restricted diets. It may be found in chronic alcoholism and in diarrheal diseases.

Thyrotoxicosis may increase the utilization of ascorbic acid.

CLINICAL FINDINGS

INFANTS

The disease occurs in non-breast-fed infants due to failure to include ascorbic acid in the feeding regimen. With the introduction of formulas containing ascorbic acid for infant feeding, scurvy has become a relatively rare disease. Early symptoms include poor appetite, increased irritability, and minimal growth failure. Then, tenderness of the legs and pseudoparalysis, usually involving the lower extremities, appears. Bleeding into the skin or gums is a fairly frequent manifestation.

In advanced scurvy, the clinical picture is characteristic. The marked tenderness of the legs results in failure of the infant to move them, causing pseudoparalysis. The infant lies quietly with the legs flexed at the knees and the hips flexed and externally rotated. The slightest jar or motion induces crying because of severe pain due to subperiosteal hemorrhage, usually in the distal femur. Similar pseudoparalysis of the arms can occur. Small and large hemorrhages may appear almost anywhere in the body, most frequently under the periosteum of the long bones or in the gums, skin, and mucous membranes. Subperiosteal hemorrhages occur in about two-thirds of the infants and are most frequent at the lower end of the femur and proximal end of the tibia. Hemorrhage of the gums is common if the teeth have erupted or are about to erupt. The gums are swollen, tense, livid, and bleed easily. Infection and ulceration may occur and the teeth may become loose and fall out. Petechiae and ecchymoses are seen in the skin near the bone lesions and on the eyelids and forehead. Hematuria, hematemesis, and bloody diarrhea may be found. Meningeal hemorrhage occurs occasionally. The scorbutic infant is often febrile.

Costochondral beading is the most frequent finding and may be confused with rickets. The deformity feels sharp on palpation, the so-called "bayonet" deformity, as compared with the rounded type of beading noted in rickets. This change occurs as a result of fractures and replacement of the growing ends of the ribs by fibrous tissue. The cartilagenous portion of the anterior chest wall is pulled toward the spine during breathing.

Radiographic examination shows characteristic changes at the cartilage-shaft junction, appearing earliest at the sites of most active growth, i.e., the sternal ends of the ribs, distal end of the femur, proximal end of the humerus, both ends of the tibia and fibula, and the distal ends of the radius and ulna. Radiologic diagnosis is made by recognizing a group of characteristic changes, no one of which is diagnostic by itself. The cortex is thin and may be absent as it approaches the cartilage–shaft junction. The trabecular structure of the medulla atrophies and assumes a "ground glass" appearance. The zone of provisional calcification is widened and more dense than normal. Immediately shaftward, an area of decreased density appears, at first near the periphery, the "corner sign" of Park. This area is the site of multiple small fractures and disorganization. It may collapse and result in impaction of the calcified cartilage onto the shaft. The brittle zone of provisional calcification may break into two or more pieces, or it may be detached from the shaft and displaced several centimeters with the epiphysis. Subperiosteal hemorrhages may be visible; these calcify with healing. Eventually, the normal architecture of the bone is restored.

ADULTS

Adult scurvy is relatively rare, and the severe type observed in the previous century is seldom encountered. It is now seen primarily in the food faddist, the alcoholic, and the psychiatric patient. The time required for development of scurvy is 4–7 months after institution of a grossly insufficient diet. Nonspecific findings appear first: weakness, lassitude, irritability, and vague aching pains in the joints and muscles. Weight loss may occur. The earliest physical sign in experimental scurvy was perifollicular hyperkeratotic papules, which appeared first on the buttocks, thighs, and legs and later on the arms and back. Subsequently, the hairs became buried in the lesions and petechiae appeared around the follicles. The petechiae then became generalized over the lower legs. The only early change in the gums was an interruption of the lamina dura shown on x rays of the teeth.

In more-advanced deficiency, the tendency to hemorrhage becomes marked. Symptoms are dependent on the number, amount, and location of the hemorrhages. They are found most frequently in the skin, muscles, and gums and may be accompanied by edema. The involved areas of the legs tend to ulcerate. Ulcers and other wounds do not heal normally. Scars of previous

trauma may become red and break down. Interstitial hemorrhages occur in the muscles, primarily in the thigh and leg, especially around the knee joint. Suppuration may develop in hematomas and lead to formation of large abcesses. Hemarthroses may occur, in which case the joint becomes swollen, hot, and painful, and motion is limited. Bleeding from the mucous membranes of the GI, GU, or respiratory tracts may occur. Hemorrhagic fluid may be found in the pleural and pericardial cavities. At times, intracranial hemorrhage may develop.

Changes in the gums are a relatively late manifestation of scurvy. They become swollen, red, and spongy, bleeding easily. Such lesions occur only in the presence of teeth. Thromboses of vessels and infarcts of the gums may lead to ulceration and sloughing. The teeth may become loose and fall out due to the loss of gum tissue and softening of the bony structure of the alveolus.

Anemia is seen in both infantile and adult scurvy. It may be hypochromic in type caused by iron deficiency secondary to blood loss. In severe scurvy, particularly in infants, the anemia may be macrocytic with megaloblastosis of the bone marrow. In some instances this type of anemia responds to ascorbic acid. However, the administration of folic acid stimulates more-prompt blood regeneration and restoration to normal. The iron deficiency anemia may be related to the intake of cow's milk rather than to bleeding.

BIOCHEMICAL FINDINGS

The concentration of ascorbic acid in plasma falls to practically zero in scurvy. This occurs before clinical signs appear. The concentration of ascorbic acid in the white cell–platelet layer of blood decreases to 2 mg/100 g or less when scurvy develops, but this determination is difficult and is seldom available. A useful test is the administration of a large dose of ascorbic acid orally followed by measurement of changes in blood concentration or urinary excretion in a given period of time. A load test that is simple to use in infants is administration of 200 mg ascorbic acid intramuscularly, determining serum concentration before and 4 hours after the dose. In scurvy, the 4–hour value is usually less than 0.2 mg%, indicating depleted tissue stores. In infants with poor recent intake but no tissue depletion the 4–hour value often rises to 1 mg%.

A low hydroxyproline–creatinine ratio may suggest the presence of scurvy. The value of this test should be studied further.

TREATMENT

In treating infantile scurvy, 25 mg ascorbic acid may be administered four times daily added to the milk. Some pediatricians prescribe 50–100 mg four times daily. After a week, the amount of ascorbic acid may be reduced to about 30 mg/day. This can be given in the form of orange juice or as ascorbic acid *per se*. In the therapy of adult scurvy, 250 mg should be administered four times daily. This amount is sufficient to replenish body stores, which amount to 2–3 g, within less than a week. The dose may then be decreased to 50–100 mg several times daily until healing is complete.

The diet should be adequate in all respects. Excellent sources of ascorbic acid are citrus fruits, oranges, grapefruit, lemons, limes, and pineapple. Other good sources are strawberries, cabbage, tomatoes, and green vegetables. Other fruits and vegetables contain some ascorbic acid; even turnips and potatoes are useful in large amounts. Much of the vitamin C in foods may be lost in cooking and storage because of destruction by heat and oxidation. Ascorbic acid is relatively stable in canned and frozen foods.

Wound healing is impaired in scurvy since ascorbic acid is necessary for the formation of collagen. The amount of ascorbic acid in the diet is related to the strength of healing wounds and also to the concentration in scar tissue. A decrease in plasma ascorbic acid occurs following trauma or surgical procedures, apparently due to a shift of ascorbic acid from the serum to the site of wounding. Low ascorbic acid concentrations are found almost routinely in patients with wound disruption. Patients admitted to surgery with concentrations of less than 8 mg/100 g in the white cell–platelet layer of blood should receive extra ascorbic acid as there is an eight-fold increase in incidence of wound dehiscence in these patients.

Administration of ascorbic acid in amounts of several hundred milligrams has been found to increase the assimilation of food iron. It may also function in the release of ferric iron from linkage to the plasma protein, transferrin, for subsequent incorporation into tissue ferritin.

Pauling (39) suggests administration of large doses of ascorbic acid, 1–5 g daily, in the prevention of the common cold and even larger doses in treatment. Recent controlled studies indicate that these doses do not prevent the common cold but may slightly decrease its duration.

TOXICITY

There is little evidence that ascorbic acid is toxic as excessive amounts are excreted by the kidneys. Larges doses may cause GI irritation. The use of 4–12 g daily for acidification of the urine in chronic urinary tract infections may result in the precipitation of urate or cystine stones. No data are available on the effects of prolonged administration of ascorbic acid in amounts of several grams daily.

VITAMIN D DEFICIENCY

PREVALENCE

Vitamin D deficiency has become a rare disease in the United States, whereas at one time it was a common affliction of infancy and childhood. Eradication of this deficiency has been due largely to the widespread practice of feeding infants cow's milk or preparations based on cow's milk, which are enriched with irradiated ergosterol so as to contain 400 units of vitamin D in the amount of food equivalent in calories to a quart of milk. Since the vitamin D requirement of infants approximates 100–150 units daily, the intake of a quart of milk by infants over 2–3 months of age provides a considerable margin of safety. Breast-fed infants require supplementary vitamin D unless they are exposed to adequate amounts of ultraviolet irradiation. It is common practice to prescribe 400 IU daily in the form of vitamin concentrates.

Vitamin D deficiency in older children and adults is unusual if they are exposed to sunlight and to minimal dietary sources of the vitamin. Vitamin D deficiency during pregnancy is seen primarily in countries where cultural patterns prevent women from receiving exposure to sunlight.

RICKETS

CLINICAL FINDINGS

Manifestations of vitamin D deficiency in infants are due to reduction of serum ionized calcium with resultant tetany and convulsions or to deficient mineralization of growing bones leading to skeletal deformities and retardation of growth. Evidence of deficiency rarely appears before 3–4 months of age. An early finding is hypocalcemia, which is rarely symptomatic. If vitamin D deficiency continues, the clinical picture of infantile rickets develops.

The major manifestations of rickets are progressive bony deformities, resulting from the mechanical weakness of bone and the response of growing bone to deforming stresses. The earliest sign of rickets in the infant under 6 months of age is craniotabes. This consists of areas of softening of the skull, usually located in the occipital and parietal bones along the lambdoidal sutures. Pressure of the fingers on the skull causes indentation, and the bone seems to snap back when pressure is released. In chronic rickets, the skull becomes thickened with enlargement of the frontal and parietal areas causing "bossing" of the skull. Enlargement of the costochondral junctions of the ribs produces the "rachitic rosary." Retraction of the rib cage at the attachment of the diaphragm results in what is known as Harrison's groove. The growing ends of the long bones are widened at the wrists and ankles. As the child stands and walks, a deformity of the pelvis develops, which may result in serious problems in the female in childbearing later in life. The bones of the lower extremities may become bent and twisted causing bowing of the legs and abnormalities of gait with a characteristic waddling appearance. Scoliosis of the spine may develop with sitting. In advanced rickets, the costal cartilages may be pulled in causing the sternum to protrude, producing the pigeon breast deformity. The teeth are delayed in eruption, and enamel development is defective. The final result of rickets is a deformed child with reduced stature.

Roentgenograms are useful in the diagnosis of rickets in advanced stages. Abnormal findings may be seen at the cartilage–shaft junction and in the shafts of the bones. The former are characterized by cupping, spreading, fringing, and stippling, which may be seen first at both ends of the fibula and the lower end of the ulna. Similar findings due to weakness of the cartilage–shaft junction have been noted in the lower end of the radius, both ends of the tibia, and the lower end of the femur. In the shaft the trabecular meshwork becomes coarse, and in severe rickets there is a loss of bone density. The cortex may appear abnormally thin in advanced cases, but at times it is thickened or duplicated. Curvature of the long bones may be seen on x ray. Following treatment with vitamin D, a characteristic transverse line of radio-opacity (Mueller's line) makes its appearance, crossing the cartilage in advance of the

end of the shaft and parallel to it. This represents newly calcified cartilage.

BIOCHEMICAL FINDINGS

Hypocalcemia is the earliest manifestation. This is associated with normal or slightly reduced concentrations of serum phosphorus, which differentiates it from hypoparathyroidism. Serum alkaline phosphatase is elevated to 20–30 Bodansky units or more. As vitamin D deficiency progresses, the serum phosphate concentration decreases to values as low as 2–3 mg/100 ml. When hypophosphatemia develops, the serum calcium concentration rises to approach normal values, although it usually remains slightly low.

OSTEOMALACIA

CLINICAL FINDINGS

In the United States, osteomalacia due to primary deficiency of vitamin D is extremely rare. It is usually secondary to defective intestinal absorption or to abnormalities of renal function. It is found most often in association with chronic steatorrhea in which faulty digestion and absorption of fat lead to formation of insoluble calcium salts that are lost in the stool along with vitamin D. Pregnancy and lactation intensify the symptoms.

The most frequent complaint is pain in the bones, particularly in the lower part of the back and in the legs, which is often worse while standing and walking. These symptoms are due to microfractures and compression of the weight-bearing bones, the vertebrae, and lower extremities. The bones become soft due to failure of mineralization as they undergo remodeling. Wide zones of demineralized osteoid tissue are found at the junction of mineralized bone and the layer of osteoblasts. Defects of bone structure, pseudofractures, occur at the sites of muscle attachment. Cyst-like zones of demineralization may be seen in the metaphyseal region. Muscular weakness is a common finding. The bones are sensitive to light pressure, e.g., over the ribs, hips, and thighs. The tendency of the bones to bend leads to a waddling gait. Tetany may develop. Roentgenograms show extensive decalcification. Deformities of the pelvis and sacrum are common. In the long bones, the cortex is thin and separated into many layers. The bones may become curved and show fractures or pseudofractures. Biochemical findings are similar to those found in rickets.

TETANY ASSOCIATED WITH OSTEOMALACIA AND RICKETS

Tetany is characterized by hyperirritability of the nervous system and is evidenced by carpopedal spasm, convulsions, and—occasionally—laryngospasm. Chvostek's sign is positive, and Trousseau's phenomenon can be demonstrated. Galvanic stimulation shows anodal reversal and an anodal opening reaction with a stimulus of less than 5 ma. In tetany, protein-bound calcium is normal. Total serum calcium measures 7–7.7 mg/100 ml and ionized calcium is less than 4.3 mg/100 ml.

TREATMENT

In the treatment of infantile rickets, administration of vitamin D in amounts of 1200 IU daily is usually sufficient. Evidence of healing will be noted in the x ray after about 3 weeks of therapy. Mueller's line, which indicates calcium salt deposition in the cartilage, will appear, and the concentration of phosphorus in plasma will rise. If rickets is severe, it may be advisable to give larger amounts of the vitamin, such as 5000 IU daily. It is safe to continue to administer these higher doses for 5–6 weeks. Treatment should be continued until the bone ends have filled in, at which time dosage should be decreased to the preventive level, i.e., 400 IU daily.

In the treatment of osteomalacia, vitamin D has been given in amounts of 5,000–20,000 IU or more daily. Calcium may be prescribed in the form of milk, or as calcium gluconate or lactate, 5 g three times daily dissolved in water.

The immediate treatment of acute tetany is the injection of a calcium salt intravenously. Calcium gluconate may be given, 10–20 ml, in 10% solution, 1 g gluconate providing 90 mg calcium. After relief of the acute episode, calcium may be given orally in association with vitamin D as outlined above.

SECONDARY VITAMIN D DEFICIENCY DUE TO INCREASED REQUIREMENT

Rickets and osteomalacia may occur in subjects who have been receiving what are ordinarily adequate amounts of vitamin D as a result of poor absorption from the intestinal tract due to the malabsorption of fats (e.g., as a consequence of lack of bile salts) or to small intestinal disease

(*e.g.,* gluten-induced enteropathy or pancreatic disease).

Increased vitamin D requirement may result from hepatic disease since the initial step in the conversion of cholecalciferol or ergocalciferol to the physiologically active compound is 25-hydroxylation by a liver enzyme. In severe renal disease, osteodystrophy is due in large part to increased requirement of vitamin D, presumably because of a block in the formation of 1,25-dihydroxycalciferol. Increased requirement of vitamin D may also result from a genetically determined abnormality in metabolism at the final site of action of vitamin D, so-called vitamin D–dependent rickets. Anti-vitamin D factors may operate through unknown mechanisms. Some patients with epilepsy who receive multiple anticonvulsant drugs have an increased need for vitamin D to prevent hypocalcemia, hypophosphatemia, rickets, and osteomalacia (see Ch. 3).

TOXICITY

Vitamin D is toxic in doses of 2000–5000 units (50–125 μg) per kg per day if taken over a period of several weeks. Important manifestations of toxicity include hyperabsorption of calcium, hypercalcemia, and hypercalciuria. The latter two findings result in renal calcinosis and injury, which may result in progressive renal insufficiency. Symptoms are polyuria and polydipsia, anorexia, nausea, vomiting, constipation, and hypertension. Drowsiness and coma may be observed due to extreme hypercalcemia or to hypertensive encephalopathy. Calcium is deposited in the blood vessels and around the joints, findings that may be visible on x ray. There is increased density at the growing ends of bones with diminished density in the shaft. Dense metaphyseal lines may be seen. Hypercalcemic levels in serum are 12 mg/100 ml or more.

Treatment consists of correction of dehydration and electrolyte loss and administration of cortisone. The latter should be continued until calcium levels in the serum are less than 12 mg/100 ml.

VITAMIN E (TOCOPHEROL) DEFICIENCY

PREVALENCE

Although evidence indicates that vitamin E is essential in human nutrition, deficiency is not observed in healthy subjects who consume and absorb the constituents of an average American diet. In newborn and premature infants, the tocopherol concentration in blood and tissues is low. Breast feeding results in a prompt rise to normal levels, but cow's milk, which has a lower tocopherol concentration, is less effective. Tocopherol deficiency may occur in children with cystic fibrosis of the pancreas or with congenital atresia of the bile ducts. Adult subjects with either malabsorption syndromes and steatorrhea or xanthomatous biliary cirrhosis may develop tocopherol deficiency (see Ch. 3).

CLINICIAL AND BIOCHEMICAL FINDINGS

In premature infants, anemia and a syndrome consisting of edema, skin abnormalities, an elevated platelet count, and morphologic changes in the red cells has been attributed to deficiency of vitamin E.

Infants and children with cystic fibrosis of the pancreas have low levels of serum tocopherol and an increased susceptibility of erythrocytes to hemolysis. In some instances, creatinuria is observed accompanied by a decrease in plasma creatine and an increase in muscle creatine. Ceroid pigment has been found in increased amounts in children with cystic fibrosis of the pancreas and in patients with celiac disease and sprue. Similar pigment has been found in vitamin E–deficient animals.

Infants with congenital atresia of the bile ducts have low concentrations of plasma tocopherol, abnormal erythrocyte hemolysis tests, and creatinuria. Focal lesions resembling those seen with vitamin E deficiency in several animal species have been found in muscle.

In adults with malabsorption syndromes and steatorrhea, low serum tocopherol concentrations and increased susceptibility of erythrocytes to hemolysis may be observed. Comparable findings plus creatinuria have been reported in xanthomatous biliary cirrhosis.

Experimental vitamin E deficiency in man was produced by Horwitt and associates (43) in subjects who received a diet high in polyunsaturated fats for several years. In addition to changes in the level of serum tocopherol and in erythrocyte susceptibility to hemolysis, a slight decrease in erythrocyte survival time was observed. When tocopherol was administered, a small increase in reticulocytes in the peripheral blood was noted.

PREVENTION AND TREATMENT

Vitamin E requirement appears to be related to the polyunsaturated fat content of a diet. A recommended intake of 10–30 mg/day for adults, depending on the type of fat in the diet, has been suggested. It is desirable to keep the level of tocopherol in serum above 0.5 mg/100 ml. In the treatment of tocopherol deficiency, 30–100 mg or more may be prescribed daily. Toxicity of this vitamin has not been reported even in persons receiving more than a gram a day for many months. Benefits claimed for therapy with large doses of vitamin E have not been substantiated. Vegetables and seed oils are the largest contributors of tocopherol to the diet.

VITAMIN K DEFICIENCY

PREVALENCE

Vitamin K deficiency due solely to an inadequate diet has not been reported. In conjunction with synthesis of vitamin K by intestinal bacteria, the average diet provides adequate amounts.

The newborn infant has low serum levels of prothrombin and several other coagulation factors related to vitamin K. Deficiency of this vitamin develops in the absence of bile from the intestinal tract and is found in chronic biliary fistula and obstructive jaundice. Inadequate absorption of vitamin K also occurs in the steatorrheas, e.g., sprue, gluten-induced enteropathy, various lesions of the small intestine, short circuiting operations, and chronic pancreatic diseases. Deficiency may result from prolonged administration of antibiotics or sulfonamides. In patients receiving salicylates, hypoprothrombinemia has been reported.

CLINICAL AND BIOCHEMICAL FINDINGS

In newborn infants, a low level of prothrombin and other coagulation factors in serum has been observed. In normal infants, prothrombin concentration may decrease to as low as 20% in the second and third day of life and then gradually increase to normal adult values over a period of weeks. If values fall below 10%, hemorrhagic disease of the newborn may occur. The situation in the infant may be due to delay in establishing bacterial flora for vitamin K synthesis, insufficient bile in the first few days of life for vitamin K absorption, or delay in manufacture of prothrombin by the liver.

The clinical manifestation of vitamin K deficiency in all age groups is hemorrhage. In patients with obstructive jaundice, hemorrhage is most apt to occur after surgical intervention and is usually noted between the first and fourth postoperative days. Slow oozing from the operative incision is common, as is bleeding from the gums, nose, or GI tract. The prothrombin clotting time is prolonged. Hemorrhage also occurs in various intestinal disorders in which vitamin K absorption is impaired or in patients who have received prolonged antibiotic therapy.

In the presence of severe liver damage, a marked prolongation of prothrombin time which is not responsive to administration of vitamin K may be observed. This failure of response has been used as a test of liver function.

Diagnosis of vitamin K deficiency is dependent on detection of diminished prothrombin activity in the blood. In most instances, prothrombin activity has fallen to less than one-third of normal before bleeding occurs. The technique developed by Quick, or some modification thereof, is frequently used to determine prothrombin clotting time.

PREVENTION AND TREATMENT

It is commonly recommended that the infant be given a dose of 1–2 mg vitamin K shortly after birth to prevent hemorrhagic disease of the newborn. As an alternative, it has been suggested that 2–5 mg vitamin K be given to the mother prior to delivery, but the value of this therapy is controversial.

The treatment of hypothrombinemia due to vitamin K deficiency consists of administration of the vitamin in doses of 2–5 mg daily.

Synthetic water-soluble preparations of vitamin K or menadione are equally effective. Water-soluble preparations are preferable when deficiency is due to absence of bile from the intestinal tract or in the steatorrheas. If menadione is given, it must be used in conjunction with 1–3 g bile salts to facilitate absorption.

In the preparation of patients with obstructive jaundice for surgery, vitamin K should be given even if prothrombin activity is normal. A postoperative decrease in prothrombin can be prevented by 1–2 mg vitamin K daily. If prothrombin time is prolonged, larger doses (up to 5 mg daily) should be given. The vitamin may be administered intravenously in similar amounts if bleeding is present. Transfusions are needed when hemorrhage is severe to combat shock and provide a temporary supply of prothrombin. The amount of

prothrombin furnished by transfused blood is effective for about 6–12 hours. In the therapy of hypoprothrombinemia due to administration of anticoagulants, vitamin K_1 has been found to be the most effective preparation.

TOXICITY

The administration of large amounts of vitamin K to newborn infants, particularly in water-soluble form, may be responsible for hemolytic anemia, hyperbilirubinemia, and kernicterus. Prematurity and vitamin E deficiency increase the susceptibility to the toxic effects of vitamin K. In adults, 20–40 mg vitamin K daily have been given for several weeks without evidence of toxicity. Quantities larger than this may cause vomiting. Very large doses have been associated with porphyrinuria and albuminuria. Occasionally, such doses of vitamin K have been reported to depress prothrombin activity in patients with severe disease of the liver.

REFERENCES

VITAMIN A

1. Hume EM, Krebs HA: Vitamin A requirement of human adults. Med Res Counc Spec Rep Ser (Lond) 264, HMSO, 1949
2. McLaren DS: Malnutrition and the Eye. New York, Academic Press, 1963
3. McLaren DS, Oomen HAPC, Escaponi H: Ocular manifestations of vitamin A deficiency in man. Bull WHO 34:357–361, 1966
4. Oomen HAPC: An outline of xerophthalmia. Int Rev Trop Med 1:131–213, 1960

THIAMIN

5. Blankenhorn MA: The diagnosis of beriberi heart disease. Ann Int Med 23:398–404, 1945
6. Brin M: Thiamin deficiency and erythrocyte metabolism. Am J Clin Nutr 12:107, 1963
7. Goldsmith GA: The B vitamins: thiamin, riboflavin, niacin. In Beaton GH, McHenry WE (eds): Nutrition: A Comprehensive Treatise, Vol 2. New York, Academic Press, 1964, pp 109–206
8. Ramalingaswami V: Beriberi. Fed Proc 17 (2):43–46, 1958
9. Williams RR: Toward the conquest of beriberi. Cambridge, Harvard University Press, 1961

RIBOFLAVIN

10. Bro–Rasmussen F: The riboflavin requirements of animals and man and associated metabolic relations. Nutr Abstr Rev 28:369–386, 1958

11. Goldsmith GA: Clinical aspects of riboflavin deficiency. In Rivlin RS (ed): Monograph on Riboflavin. New York, Plenum Publishers, 1975
12. Horwitt MK, Liebert E, Kreisler O, Wittman P: Investigations of human requirements for B–complex vitamins. Natl Res Counc Bull 116, 1948
13. Lane M, Alfrey CP, Mengel CE, Doherty MA, Doherty J: The rapid induction of human riboflavin deficiency with galactoflavin. J Clin Invest 43:357–373, 1964

NIACIN

14. Goldsmith GA: Experimental niacin deficiency in man. J Am Diet Assoc 32:312–316, 1956
15. Goldsmith GA: Niacin-tryptophan relationships in man and niacin requirement. Am J Clin Nutr 6:479–486, 1958
16. Goldsmith GA: Niacin:antipellagra factor, hypocholesterolemia agent. JAMA 194:116–176, 1965
17. Gopolan C: Some recent studies in the nutrition research laboratories, Hyderabad. Am J Clin Nutr 23:35–51, 1970
18. Manual For Nutrition Survey, Interdepartmental Committee on Nutrition for National Defense. Washington, US Government Printing Office, 1957

VITAMIN B_6 DEFICIENCY

19. Coursin DB: Present status of vitamin B_6 metabolism. Am J Clin Nutr 9:304, 1961
20. Mueller JF, Vilter RW: Pyriodoxine deficiency in human beings induced with desoxpyridoxine. J Clin Invest 29:193–201, 1950

PANTHOTHENIC ACID

21. Bean WB, Hodges RE, Daum K: Pantothenic acid deficiency induced in human subjects. J Clin Invest 34:1073–1084, 1955
22. Hodges RE, Bean WB, Ohlson MA, Bleiler R: Human pantothenic acid deficiency produced by omega-methyl panthothenic acid. J Clin Invest 38:1421–1425, 1959

BIOTIN

23. Syndenstricker VP, Singal SA, Briggs AP, Devaughn NM, Isbell H: Observations on the "egg white injury" in man. JAMA 118:1199, 1942

FOLIC ACID

24. Blakely RL: The biochemistry of folic acid and related compounds. New York, American Elsevier, 1969
25. FAO—WHO Expert Group: Requirements of ascorbic acid, vitamin D, vitamin B_{12}, folate, and iron. WHO Tech Sym Ser 452:43, 1970
26. Goldsmith GA, Hunter FM, Prevatt AL, Unglaub WG: Vitamin B_{12} and the malabsorption syndromes. Am J Gastroenterol 32:453–466, 1959
27. Herbert V: Experimental nutritional folate deficiency in man. Trans Assoc Am Physicians 75:307–320, 1962

28. Herbert V: Nutritional requirements for vitamin B_{12} and folic acid. Am J Clin Nutr 21:743–752, 1968

29. Herbert V: Folic acid deficiency: introduction. Am J Clin Nutr 23:841–842, 1970

30. Luhly AL, Cooperman JM: Folic acid deficiency in man and its interrelationship with vitamin B_{12} metabolism. In Advances in Metabolic Procedures. New York, Academic Press, 1964, pp 263–334

VITAMIN B_{12}

31. Baker SJ: Nutrition and diseases of the blood: the megaloblastic anemias. In International Encyclopedia of Food and Nutrition. London, Pergamon Press, 1977 (in press)

32. Beck WS: The metabolic functions of vitamin B. N Engl J Med 266:708–714, 1962

33. Herbert V: The Megaloblastic Anemias. New York, Grune & Stratton, 1959

34. Schilling RF: Intrinsic factor studies. J Lab Clin Med 42:860–866, 1953

ASCORBIC ACID

35. Barnes AE, Bartley W, Frankaw IM, Higgins GA, Pemberton J, Roberts GL, Vickers HR: Vitamin C requirements of human adults. Med Res Counc Spec Rep Ser (Lond) 280, 1953. (Compiled by Bartley W, Krebs HA, O'Brien JP)

36. Goldsmith GA: Human requirements for vitamin C and its use in clinical medicine. Ann NY Acad Sci 92:1, 230–245, 1961

37. Hodges RE, Baker EM, Hood J, Sauberbich HE, Marsh SC: Experimental scurvy in man. Am J Clin Nutr 22: 535–548, 1969

38. Lind J: A treatise of the scurvy. In Stewart CP, Guthrie D (eds): Lind's Treatise on Scurvy. Edinburgh, University Press, 1953

39. Pauling L: Vitamin C and the Common Cold. San Francisco, WH Freeman & Co, 1970

40. Woodruff CW: Ascorbic acid—scurvy. In International Encyclopedia of Food and Nutrition. London, Pergamon Press, 1976

VITAMIN D

41. DeLuca HF, Suttie JW (eds): The Fat Soluble Vitamins. Madison, University of Wisconsin Press, 1969

42. Park EA: Vitamin D and rickets. In Jolliffe N (ed): Clinical Nutrition. New York, Harper & Row, 1962, pp 506–564

VITAMIN E

43. Horwitt MK, Harvey CC, Duncan GD, Wilson WC: Effects of limited tocopherol intake in man with relationships to erythrocyte hemolysis and lipid oxidations. Am J Clin Nutr 4:408–419, 1956

44. Vitamin E. Minneapolis, General Mills, 1973

VITAMIN K

45. Dam H: Vitamin malnutrition, vitamins E and K. In International Encyclopedia of Food and Nutrition. London, Pergamon Press, 1977 (in press)

46. Martius C: The metabolic relationships between the different K vitamins and the synthesis of the ubiquinones. Am J Clin Nutr 9:97–102, 1961

8

The dietitian in the hospital setting

Frances E. Fischer

In recent years, research has clearly shown that optimal nutrition plays an important role in the maintenance of health as well as in the recovery from illness or injury and in the long-term treatment of many chronic disease conditions. Newly discovered facts about the role of nutrition are constantly being reported, but it is not enough just to have such knowledge available—it must be used. The dietitian is the specialist responsible for the nutritional care of individuals and groups (5) and as such must translate the science of nutrition into the skill of furnishing optimal nutrition to people (6). It is therefore the role of the dietitian to provide leadership in the nutritional support of medical practice, and the physician has the right to expect the dietitian to provide this leadership.

Over half of the dietitians practicing today are employed in hospitals. The historic role of dietitians in hospitals has been to prepare and serve food to patients, and obviously this role must still be fulfilled. However, the present day dietitian must use the current knowledge of nutrition to actively participate in the care of patients. This expanded role requires that the dietitian assess needs of patients, prepare and implement nutrition care plans, monitor and evaluate the care plans, and change them as necessary. A large part of the dietitian's time will be spent with patients who have special nutritional problems, but the dietitian must be concerned with the nutritional status of every patient, providing information about the maintenance of normal nutrition as well.

NUTRITIONAL CARE OF PATIENTS

It has been documented that many patients enter the hospital in poor nutritional status either as a factor related to the cause of hospitalization or simply because of their eating habits (2,4). It has also been documented that the nutritional status of patients may deteriorate during hospitaliza-

tion (1,3). This may be due to the patient's unfamiliarity with the food that is served or to the fact that a particular illness or medication may depress the appetite, sometimes even to the point of nausea. Often the patient's anxieties regarding hospitalization result in limited food intake. Hospital procedures may be a factor. Frequent tests may result in patients missing meals, either because the tests must be performed in the absence of food or because the patient is absent from his room when the meal is served. Sometimes patients are in such a weakened condition that eating sufficient food to meet their needs is impossible, and IV or tube feedings are required.

IN-PATIENT CARE

EVALUATION OF NUTRITIONAL STATUS

It is necessary for the dietitian to gather and evaluate much information in order to be sure that the patient's nutritional intake is appropriate to his status and his needs. This information will be obtained from the patient, from the medical record, and from others involved in the care of the patient. From the patient, the dietitian can obtain a record of eating habits prior to hospitalization. Assessment of this diet history will provide a basis for nutritional planning during hospitalization. Even more important, especially for patients who may be too ill to provide a diet history, is the monitoring of food intake. Although dietetic department records show what food is served to each patient, it is the dietitian's responsibility to know what is eaten. If the patient's condition warrants or if ordered by the physician, the dietitian should be able to provide an accurate account of the calories and nutrients consumed by the patient, a "weigh-back." As an alternate, the dietitian may report that the patient is eating all food served, none, or perhaps half. Whichever method is used, it is important that the monitoring be consistent so that as soon

as the nutritional intake becomes marginal, supportive measures can be undertaken. For febrile patients, or for those recovering from surgery or infection, or in a weakened, debilitated condition for any reason, maintaining a nutritional intake sufficient to avoid further loss of body tissue is of utmost importance. Frequent feedings of whatever will tempt the patient's appetite should be provided with emphasis on adequate calorie and protein intake. If in spite of all efforts to encourage eating, the patient is not able to consume sufficient calories and protein to prevent wasting and effect improvement in his condition, the dietitian should consult with the physician and recommend alternative methods of increasing the nutritional intake.

MEDICAL RECORDS

In addition to the information obtained from the patient, *i.e.,* his diet history and the record of his eating, information in the medical record must be used in planning the nutritional care of each patient. Particularly useful for the dietitian are the records of height and weight, hematology and serum chemistry laboratory values, orders for any medications (*e.g.,* antibiotics) which may interfere with absorption, orders for vitamin supplements, and orders for IV or tube feedings. All of this information must be considered along with the food intake in determining whether the patient's nutritional needs are being met.

CONSULTATION

The third important source of information for the dietitian is consultation with other professionals involved in the care of the patient. Attendance at patient rounds is the best way for the dietitian to benefit from knowledge others have gathered and to provide input of information gathered and evaluated in the area of dietetics. Problems relating to providing adequate nutritional intake could be presented along with recommendations for changes in diet or for diet supplementation.

Besides being an important source of information for the dietitian, the medical record also provides a way in which information about the nutritional care can be communicated to others. The dietitian should record the assessment of the patient's nutritional needs, the proposed nutritional care plan, the patient's response, any changes in the plan, and a summary evaluation. Accepted standards of patient care mandate that all care be documented for review. Along with all other health professionals, dietitians are accountable for the care they provide.

LONG-TERM CARE

Although nutritional intake is an important component of the care of acutely ill patients, it is equally important in the care of the long-term chronically ill. For a variety of reasons, patients in nursing homes may not consume sufficient food to meet their needs. Here too, the critical factors are likely to be calories and protein. Most of these patients eat some food regularly, but often in small quantity and of limited variety. The effects of the inadequate intake are therefore slow and insidious in developing, but they are just as devastating. The loss of weight and muscle tissue is gradual and may be overlooked unless weight and food-intake records are regularly monitored. Accompanying the loss of weight and muscle tissue is decreased activity, generalized weakness, and decreased resistance to infection. If calorie and protein intake can be maintained, it is likely that the intake of other nutrients will be adequate and the quality of life of these patients vastly improved.

OUT-PATIENT CARE

Dietitians have an important role in the care of institutionalized patients, but they have an equally important role in preparing these patients for return to the community. Many times a change in diet is part of the regime to be followed by the patient upon discharge. Information previously gathered from the patient regarding usual eating habits, food preferences, appetite, and ethnic and socioeconomic background are considered by the dietitian in formulating a plan that the patient will be able and willing to follow at home.

A change in diet may involve a change in life-style for the patient's family as well as for the patient. This can sometimes be an overwhelming challenge. It is unrealistic to think that a few hours spent discussing a diet with a hospitalized patient will provide answers to all the questions that will arise when the diet is being followed at home. Continuing encouragement and assistance is most important at this stage if, as in diabetes, the diet is to be of more than a temporary measure. For this reason, patients and their families need more opportunity for sound nutrition education. The dietitian's function in helping patients cope with dietary problems is similar to

that of physicians helping patients cope with their medical problems.

In counseling patients the dietitian must do more than provide knowledge about the foods that meet the diet prescription. Suggestions about food purchasing and preparation must be provided. Directions for combining foods and recipes using food substitutes or exchanging foods that are nutritionally equivalent may help make the diet more acceptable to the patient. For example, patients with lactose intolerance must be counseled regarding which foods will supply the protein, calcium, and riboflavin needed when milk is omitted from the diet. For some patients, the purchase of foods prepared without sugar or without salt may be necessary. Other patients must be alerted to the fact that their particular "special diet" does not require the use of "special foods," which are usually more expensive. Because the cost of food is such an important factor, the dietitian may suggest comparable foods at varying costs to suit the economic level of the patient. Knowledge of composition and relative cost of the new "convenience" foods enables the dietitian to advise patients on the suitability of these foods in meeting their needs. Opportunity for the dietitian to discuss a patient's diet with other family members, particularly the "cook" in the family, usually proves profitable at this time.

The increasing number of people who are adopting new eating styles provides different challenges in counseling patients. People who wish to follow a vegetarian diet often need assistance if they are to meet normal nutrient needs, particularly if any modified diet is prescribed for them.

Ideally each patient should become accustomed to the changed diet while in the hospital, where he should also be motivated and thoroughly educated in how to follow it after discharge. Unfortunately, this is not always possible. Follow-up and support of the patient after discharge is most important and often makes the difference between success and failure in effecting the change. This follow-up and support can be provided in various settings. Some dietitians are staff members of hospital ambulatory patient departments, some are employed by physicians in group practice, and in a recent trend some may have offices in proximity to physicians where they counsel patients by physician referral on a fee-for-service basis.

Dietitians may at times make follow-up visits to patients' homes in order to have first-hand knowledge of factors influencing compliance with the diet. Logistics of the kitchen may appear mundane, but they are frequently of major importance. Availability of a freezer, refrigerator, range, storage space, and even of a table, chairs, and dishes determines a family's buying and eating style. Through home visits as well as information provided by the patient, the dietitian may become aware of these and other problems and may be able to suggest referral to appropriate community resources for further assistance.

CHANGING ROLE OF THE DIETITIAN

The present state of knowledge of nutrition allows the dietitian greater opportunity and an expanded responsibility. Education of dietitians in both bachelors and advanced degree programs has changed during recent years in an effort to prepare practitioners who will assume this greater responsibility in patient care. Opportunities for specialization in both academic and clinical education have been defined. Emphasis is being placed on applying the academic study of nutrition and other sciences, e.g., biochemistry and physiology, to the nutritional care of patients. Communication skills are being stressed, and continued emphasis is being placed on application of knowledge of the behavioral sciences in the development of nutritional care plans. Students entering the profession are eager to assume an active leadership role in the nutritional care of patients. Continuing education programs for the practicing dietitian have been developed to meet this goal as well. Through regular participation in quality continuing education programs monitored by the American Dietetic Association, dietitians may become registered. Most employers today require registration as a condition of employment for dietitians.

Individual dietitians, regardless of their abilities and desires, cannot provide the necessary nutritional support unless this is a high priority of the institution and the department of dietetics. Some administrators and departments see the provision of food to patients as the primary goal of the department of dietetics. Closely allied to this and of increasing importance in the present economy is maintaining the quality of food provided while controlling costs. These are worthy goals. However, just making food available to patients is not enough.

It should be the goal of every department of dietetics to meet all the nutritional needs of every patient. Dietitians in the clinical areas will require sufficient time to read medical records

and attend patient rounds. They will need sufficient supportive staff to monitor patients' eating practices and report for follow-up any patients whose food intake is not meeting his needs. They may need full departmental support in developing and implementing a policy to have height, weight, and certain key laboratory values recorded for every patient. They will need sufficient time and resources for dietary counseling.

Departments of dietetics which adopt patient-centered goals rather than meal-centered goals will find that it may be necessary to provide more dietitians and more supportive personnel in the clinical areas. Certain tasks may have to be reassigned, and time on duty may have to be changed. With patient-centered goals, dietitians will have to be on duty when patient rounds are scheduled rather than having on-duty time dictated by the hours of meal service. With patient-centered goals, the dietitians in the out-patient service will do more than counsel patients on special diets; they will provide classes on timely nutritional subjects to groups of out-patients or to community groups on request and will also serve as consultants to various community activities.

If additional services are provided to patients, departments of dietetics will undoubtedly show an increased expenditure. However, aggressive nutritional care of in-patients may well reduce the length of hospitalization. For out-patients, nutritional care may aid in delaying or even avoiding hospitalization. Therefore, although a strong nutritional support program will involve increased charges for departments of dietetics, the overall total cost of health care for the patient and the nation will be reduced.

Today we are hearing more and more about accountability in health care. All professionals are being asked "what are you doing for patients." Dietitians are prepared to do more than "feed" them. Physicians and dietitians should work together to achieve a reordering of administrative goals so that each patient will be assured of receiving quality nutritional care.

REFERENCES

1. Bistrian BR, Blackburn GL et al.: Protein status of general surgical patients. JAMA 230:858, 1974

2. Bollet AJ, Owens S: Evaluation of nutritional status of selected hospitalized patients. Am J Clin Nut 26:931, 1973

3. Butterworth CE Jr: The skeleton in the hospital closet. Nutr Today 9:4, 1974

4. Leevy CM et al.: Incidence and significance of hypovitaminemia in a randomly selected municipal hospital population. Am J Clin Nutr 17:259, 1965

5. The Profession of Dietetics. Chicago, Report of the Study Commission, American Dietetic Association, 1972

6. Titles, definitions and responsibilities for the profession of dietetics—1974. J Am Diet Assoc 64:661, 1974

9 Food fads

Roslyn B. Alfin-Slater, Lilla Aftergood

From the earliest days of recorded history man has been endowing certain foods with properties and qualities above and beyond those benefits derived from nutrient composition. The reasons for this type of food faddism are many and varied, including tales and traditions handed down from parents and grandparents, cultural practices, religious beliefs, and misinformation dispensed freely—but not without cost— through books, magazines, newspapers, radio, and television. The last two decades have been accompanied by an increased interest in foods and nutrition by the general public. In the United States, improved food technology has made possible the distribution and increased the availability of a wide variety of food products. International cooperation, ease of travel, and the subsequent intermingling of peoples of different religious and cultural backgrounds have introduced new types of foods and new methods of preparing existing foods. Furthermore, the need to feed increasing numbers of people has brought about improved agricultural methods and new means of food processing which provide more food for more people with a minimum of contamination and spoilage. Yet, although improved communication serves a nutrition-conscious public by introducing new types of food and food preparation, it also provides an excellent medium for the wide dissemination of misinformation about foods and their role in health and disease.

Knowing what to eat is not instinctive. The selection of food is influenced by many factors, but a knowledge of nutrient requirements seems to be the least available and least considered of these. Since food faddism thrives on ignorance and superstition, the new awareness of food as a factor in health coupled with a lack of nutrition information provides productive ground for the food faddist movement. Food becomes more than a source of nutrients; it is endowed with glamorous and beneficial properties that appeal to the imagination and hope of both sick and healthy.

There are many reasons for this preoccupation with food. First of all, the fear of incapacitating illness and disease, the uncertainty of life, and the innate dread of death make most people susceptible to nutritional quackery. A particularly vulnerable group is the elderly, who are urged to spend money needlessly on useless supplements and special food items. Then, too, people may be exploited due to their ignorance of nutrition. Most lay people have little basis for judgment in the area of nutrition and therefore believe the exalted claims for special diets and foods. They may also believe that the faddist is privy to some discovery of which medical science is still ignorant, that he or she is too far ahead of his time to be accorded recognition, or that he or she is a victim of organized medical jealousy or professional monopoly. It is difficult for the average person to distinguish between the respectable scientist and the self-proclaimed expert, and there are too few places where people may seek reliable nutrition information. Also, in some cases, even reputable scientists disagree in their interpretation of research findings.

In many cases, food faddism and self-medication result from dissatisfaction with medical care, *e.g.,* the high cost of an office visit, the lack of communication between patient and busy clinician, and the inability of many people to accept reality when faced with an incurable illness. Obviously, in such instances a sympathetic health food proponent will find a very receptive customer for any dietary regimen that promises help.

Also, the appeal of food fads has recently been enhanced by an outgrowth of the ecological movement; people are abandoning food treated with pesticides and various chemical additives and turning to "natural," "organically grown" foods. The "naturalist" argument against such

additives as preservatives, stabilizers, and emulsifiers seems self-evident to the lay person overcome by the complicated chemical names of these substances, and the food faddist exploits this denouncement of processed foods to sell his "natural" product at elevated prices.

Furthermore, the many environmental problems of our industrial society, *e.g.,* air and water pollution, oxidants in smog, pesticide residues in foods, have led some people to the feeling that something extra must be done to protect their health. Hence, large amounts of vitamins, especially vitamins C, E, and A, are ingested as a result of newspaper reports of preliminary experiments yet to be evaluated by the scientific community under laboratory conditions.

Finally, the faddist may seek fulfillment of specific desires and needs. Certain foods are supposed to act as aphrodisiacs; others are supposed to increase intelligence and brain function, reproductive ability, strength, beauty, and vision. Still other special foods are associated with religious and ceremonial practices. The Zen macrobiotic diet has been said to make an individual "transcend to a level of consciousness never before experienced by ordinary man."

In a society where people are hungry, obtaining food for survival becomes a goal and it is difficult to relate to commercial food faddism, but when food is plentiful and time and money is available the climate is ripe for an increased interest in nutrition. Such interest without knowledge can lead to eating habits that range from a conscious avoidance of certain food items ordinarily considered edible to the ingestion of one food or group of foods at the exclusion of all others in the hope that these new patterns of eating may be the ultimate cure for all physical and mental ills. Although sometimes limited only to a financial drain, the results may lead to suboptimal or frank malnutrition and may be expressed in serious physiologic or pathologic changes, or both.

In the following review some of the more popular nutritional misconceptions and the potential dangers that threaten the adherents will be discussed.

NUTRIENTS IN DISEASE THERAPY

It has long been known that nutrition plays a role in the management of certain chronic disease conditions, *e.g.,* diabetes, hypertension, certain anemias. However, self-administration of specific nutrients as "cures" for specific diseases is a dangerous practice, especially when their promotion leads to avoidance of or delay in seeking proper medical advice (7). Although it is true that many factors concerning the relationship of pathologic conditions to nutritional deficiencies remain unknown, it should be remembered that not all disease is nutritionally generated and that nutritional deficiencies are usually not the sole cause or cure for all pathologic conditions. The true role of nutrients in the maintenance of health rather than their possible role in curing disease should be a prime consideration.

CANCER

The two diseases in this country which take the largest toll of lives are heart disease and cancer. Although heart disease results in more deaths per annum, cancer is probably the more frightening of the two. Yet many types of malignant diseases are curable if they are detected and treated early. Self-treatment with nutritionally related cures is not only ineffective, it also delays the inception of potentially more successful and expedient methods of therapy. Perhaps the best known of these ineffective cures is the preparation made from apricot kernels and known as Laetrile—or as it has been unofficially designated, vitamin B_{17}. Actually, extracts of apricot kernels have been shown to contain small amounts of hydrocyanic acid (HCN), a potent toxic compound that in small quantities can be detoxified and metabolized by the organism. Laetrile has been subjected to many tests and found ineffectual in the treatment of cancer; it is not approved by the FDA for its use in this context. Other "cures" involving the use of laxatives, mineral oil, grape juice, and other foods given special complicated names are equally ineffective. As of now, no food or special diet has been shown to cure cancer.

HEART DISEASE

The relationship of diet to heart disease is real. High intakes of foods rich in saturated fats, which result in hypercholesterolemia in many people, is one of the remediable risk factors in heart disease. A diet lower in fat and possibly cholesterol, where the fat ingested is high in polyunsaturated fatty acids, has been shown to reduce serum cholesterol levels and has been advised for many years by the American Heart Association and by scientists and clinicians knowledgeable in this area. The effectiveness of these dietary changes has already been shown

experimentally. In a 12–year controlled clinical trial in mental hospitals it was found that deaths from coronary heart disease could be significantly reduced by a serum cholesterol-lowering diet (19). However, it will take longer before this dietary change can be evaluated in large "normal" populations. As a result, other dietary measures of unproved effectiveness, *e.g.,* lecithin and large amounts of several vitamins—particularly vitamins E and C—are being advised by food faddists.

VITAMIN E

Vitamin E therapy is being practiced by individuals and is prescribed by clinicians as well for a variety of ailments, including heart disease, with no experimental substantiation. A recent statement of the Food and Nutrition Board, Division of Biology and Agriculture, National Research Council (21), points out that the claims for vitamin E's curative effect on such noninfectious diseases as heart disease, sterility, muscle weakness, cancer, ulcers, skin disorders, burns, and shortness of breath, result from misinterpretations of research on experimental animals or from fertile imaginations. Similarly fallacious are the claims that vitamin E promotes physical endurance, increases sexual potency in men, enhances the reproductive performance in women, prevents heart attacks, and delays the aging process. It is true that vitamin E deficiency in animals interferes with reproduction in the female, (2) results in testicular degeneration and the formation of immature sperm in the male (17), and causes cardiac fibrosis in the ruminant. A nutritional muscular dystrophy has been induced in susceptible species of animals by vitamin E deprivation. However, supplementation with the vitamin E requirement for these animals (1 mg DL-α-tocopherol for the rat) prevents and cures these deficiency symptoms (20).

Studies done over a number of years have not been able to prove any of the virtues claimed for large doses of vitamin E. In fact, there is increasing evidence that vitamin E in excess is similar to excesses of the other fat-soluble vitamins A and D and may have some measure of toxicity. In studies with chicks, scientists from the University of British Columbia showed that large doses of vitamin E depressed growth, interfered with the uptake and release of iodine by the thyroid, and increased the requirement for vitamins D and K (18). The interference of large doses of vitamin E with vitamin K activity

has recently been confirmed (10). Other studies, in rats, have resulted in fatty livers containing elevated levels of cholesterol and triglycerides after 6 months' supplementation with high levels of vitamin E (1). A report on the development of "flu-like" symptoms in humans taking 800 mg vitamin E/day which disappeared when the dose was reduced in half also indicated that excess vitamin E may not be as well tolerated as had been previously believed (9).

This in no way should be interpreted as an indication that vitamin E is not essential in the diet. The 1974 Recommended Dietary Allowance (RDA) for vitamin E for adults is 12–15 IU or mg/day. The present intake in this country is 5–10 mg/1000 Cal and seems to be adequate to maintain health. The main sources of vitamin E are the polyunsaturated oils—corn, soybean, cottonseed—and wheat germ. Approximately 64% of our dietary vitamin E comes from fats and oils; fruits and vegetables supply 11%, and cereal and grain products supply 7%. Vitamin E is also present in egg yolk and in very small amounts in meats.

VITAMIN C

It has been suggested that ascorbic acid plays a role in cholesterol metabolism. The exact nature of this relationship is not well defined, and the reports in the literature are often contradictory. When hypercholesterolemic subjects, marginal with respect to vitamin C status, were given large doses of vitamin C, their serum cholesterol levels were decreased (14). On the other hand, a recent report of the pilot study by Gatenby-Davies and Newson (13) suggests that low tissue ascorbate levels are accompanied by low serum cholesterol levels and vice versa. The role of ascorbic acid in atherosclerosis still needs clarification.

When Linus Pauling's *Vitamin C and the Common Cold* was published in 1970 (23), the public rushed to buy every conceivable type of vitamin C preparation available. It was an appealing idea —that an extra amount of a vitamin found in such "anticold" foods as citrus fruits could protect against an affliction that plagues the population at the most inconvenient times. Pauling recommended 1–5 g vitamin C daily to prevent a cold and to treat a cold, a substantial 15 g daily. The maintenance or prophylactic dose was arrived at from extrapolations of calculations of how much vitamin C a gorilla normally consumed from vegetation and how much vitamin

C the rat could synthesize per day. The therapeutic dose was derived principally from personal recommendations. Unfortunately, scientific evidence for the efficiency of vitamin C in preventing colds has not been conclusive; the experiments available to date are open to criticism and controversy. Although doses larger than the 1974 RDA (45 mg for adults) may possibly be advantageous in treating respiratory ailments, large amounts of vitamin C are not without toxic effects (8). Reports indicate that the resultant acid urines may contribute to the formation of renal calculi in those with a tendency to gout. Furthermore, ascorbic acid is metabolized through the formation of oxalic acid, a substance that also contributes to renal calculi (5). Large amounts of vitamin C also interfere with the activity of certain drugs (26). A recent report indicates that the ingestion of over 500 mg vitamin C/day results in lower serum vitamin B_{12} levels (15). Other possible toxic effects as well as beneficial effects await further investigation.

However, it should be noted that Anderson's report at the Western Hemisphere Nutrition Congress on his studies with massive doses of vitamin C (3) concluded that large doses (250–2000 mg) may under certain circumstances indeed reduce the severity of upper respiratory infections in those individuals whose tissues are not fully saturated with this vitamin. He pointed out, however, that levels above those necessary for tissue saturation could conceivably be harmful, but also indicated that respiratory infections might increase the amount of vitamin C required for tissue saturation. Obviously more research on large numbers of persons is required to resolve this controversy.

NIACIN

Large doses of niacin in amounts over and above those recommended by the Committee on Dietary Allowances of the Food and Nutrition Board, National Research Council, have been used to reduce hypercholesterolemia. Although side effects were noted early in the treatment ("flushing" reactions), changes in the form of niacin used and a decrease in the amount minimized these undesirable effects. However, although niacin is a water-soluble vitamin and, in general, water-soluble vitamins are nontoxic even when consumed in relatively large amounts, recent studies on humans (16) strongly suggest that large doses of niacin have

an undesirable effect on the metabolism of the heart muscle. In fact, it is suggested that excessive niacin might be especially dangerous if taken by athletes before an event.

LECITHIN

Lecithin is a phospholipid present in many foods, especially in egg yolks and meats. Commercial preparations are made from soybeans. It can also be synthesized in the body from readily available precursors. When ingested in foods, lecithin is broken down into glycerol, phosphate, choline, and fatty acids. In the body, phospholipids are essential parts of living cells; appearing particularly in cell walls and mitochondria, they are used in transport and utilization of fats and fatty acids. There is no good evidence available as yet to indicate that lecithin lowers serum cholesterol levels nor that it has a role in the treatment of coronary disease. Nor is there any evidence for the miraculous effects attributed to a combination of lecithin, kelp, cider vinegar, and vitamin B_6 in removing fat deposits from special places in obese subjects. In fact, overusage of kelp (dried seaweed) may result in iodine toxicity.

HYPERVITAMINOSIS A

It is known that vitamin A is an essential nutrient required for the maintenance of healthy epithelial tissue, for growth, and for vision. Vitamin A deficiency causes impaired dark adaptation and night blindness. The recent 10–State Nutrition Survey revealed that a significant proportion of the population had a low vitamin A intake (below the 5000 IU recommended for adults in the 1974 RDA), and methods to increase the vitamin A intake by proper selection of foods and diets should be advised by nutritionists and clinicians.

On the other hand, there is no advantage to be derived from exceeding the recommended level of vitamin A. Excessive intake may result in toxic effects. For example, five times the RDA or 25,000 IU vitamin A (which is unfortunately present in some vitamin preparations), when taken daily for extended periods is risky, especially during pregnancy. Ingestion of such amounts by pregnant women may produce in them CNS anomalies, and in the fetus teratologic effects have been observed (6). In older children or adults, hypervitaminosis A may result in increased intercranial pressure with its

accompanying effects on the CNS in as little as 30 days of ingesting 25,000–50,000 IU/day. (12) Longer usage has been shown to result in optic atrophy and blindness.

Large doses of vitamin A (50,000–150,000 IU/day) have been prescribed for adolescents in the treatment of *acne vulgaris.* The benefits of this treatment have not been substantiated, nor is there a valid reason for the use of this treatment. If it is necessary to take vitamin supplements, the vitamin A content of the supplement should approximate the RDA.

NATURAL AND SYNTHETIC FOOD

PROCESSED AND REFINED FOODS

The need for increased supplies of food to feed a burgeoning population and the changes in life style which have come about in the last 20 years have led to remarkable advances in food technology, as is reflected by the large numbers and variety of food products with greater visual and taste appeal now available. To circumvent problems involved in food storage and transportation, new ways of treating raw materials were devised to assure the least spoilage and a longer shelf-life. Furthermore, there is a great demand for convenience foods that are easily and quickly prepared. No longer does either the housekeeper or family cook devote a large part of the day for meal preparation. In the first place, housekeepers are no longer readily available; the wife and mother has been liberated from the kitchen, and cooking "from scratch" has become the exception rather than the rule.

Food processing is done for a number of reasons, one of which is to increase the shelf-life of the product. Wheat is processed to yield white flour because whole grain products have comparatively low keeping qualities, and millers and bakers therefore make use of large amounts of the more-stable refined products. Obviously, processing or refining foods results in the loss of several nutrients, but modern processing methods attempt to keep nutrient losses as low as possible. Furthermore, processed foods are enriched to restore some of the nutrients that may be removed in their preparation. For example, white flour is now enriched with thiamin, riboflavin, niacin, and iron. Minor quantities of other nutrients present in small amounts in whole grain which might be lost during processing are widely available in other foodstuffs. Man does not–and should not–live by eating bread alone, even whole wheat bread.

The refining of sugar causes a similar loss of minute amounts of vitamins and some minerals. To the faddist, honey, brown, and raw sugar possess great nutritional value, whereas refined sugar does nothing but cause dental caries, obesity, and heart disease. Actually, sugar in any form essentially provides only calories. Honey, raw sugar, brown sugar, and white sugar are nutritionally practically the same. Honey, raw, and brown sugar possibly have more pleasant flavors, as well as traces of minerals and vitamins due to the presence of small amounts of molasses, but these are of no real significance. Sugars eaten in moderate amounts are not harmful—they add taste, color, and texture to the diet. The danger arises when these are consumed in excess. The possible role of sugar in the genesis of diabetes, heart disease, cancer, and other diseases is a controversial subject.

Related to the problem of processed food is the controversy surrounding the question of raw versus pasteurized milk. It is claimed that the pasteurization process destroys important enzymes and vitamins found in raw milk. Actually, the enzymes that are present are of no use to humans; since enzymes are protein in nature, they are denatured and destroyed by the acid of the stomach. Furthermore, the small amount of vitamin C present in milk which is destroyed by heating it to 60°C, as required in the pasteurization process, is of little consequence as far as human diets are concerned. Milk is not considered a source of vitamin C; other foods in a balanced diet provide sufficient amounts of this vitamin to more than satisfy the recommended dietary allowance. Pasteurization was adopted to destroy pathogenic microorganisms that might be present in milk and therefore to provide a safe product for the greatest number of people. Although the standards for the safety and cleanliness of certified raw milk are quite high, there is always a possibility that some pathogens will find a way into the final product. Pasteurization has largely eliminated undulant fever and tuberculosis; the organism that caused them may be found in fresh milk. The preparation of yogurt from milk involves introducing a nonpathogenic bacterial culture that produces an acid taste and changes the consistency of the milk. The same nutrients are present in yogurt that are present in milk except for the partial breakdown of lactose (milk sugar) into its components, glucose and galactose.

ADDITIVES

Few topics have aroused more heated comment than the practice of adding various substances to food. On one hand, the food industry maintains that food additives enhance the quality, attractiveness, and nutritive value while reducing the perishability and therefore the price of the product. On the other hand, representatives of various consumer groups claim that all kinds of chemical substances are added to food without regard for the consequences. Actually, many allowable food additives are derived directly from food itself, and some that are synthesized are identical to those found in food. All additives are chemicals, and the body does not distinguish between those isolated from food and those synthesized in the labotatory.

Additives are used for specific purposes, *e.g.,* to preserve the quality of the food, improve the nutritive value, add or enhance flavor, texture, color, and odor. One of the oldest additives known is salt. Spices have also been used for a long time. Both of these were and are used as preservatives as well as for flavor. Nutritional supplements are also additives. For example, the B vitamins and iron added to bread for "enrichment" are considered to be additives, as is the vitamin D added to milk and the vitamin A added to margarine. The addition of potassium iodide to salt provides iodine in a safe, effective way, especially for those areas where goiter is a prevalent disease. Probably still one of the most contested issues is the question of adding fluoride to water to bring the level up to 1: 1,000,000 in order to decrease the incidence of dental caries, particularly in children. Although many studies have shown that fluoride at this level is safe and effective (11a), the outspoken and vigorous opponents of fluoridation have blocked attempts of government agencies at various levels to adopt a uniform policy on fluoridation. Most of the opposition to fluoride stems from misinterpretation of data concerning people who have been subjected to high fluoride levels. The opponents of fluoridation feel that the line of demarcation between what is safe and what is dangerous is not that well defined. If the fluoride concentration in drinking water exceeds 1.4–1.6 ppm the first signs of dental fluorosis (mottled enamel) may appear (11). Also, sodium fluoride itself bears the stigma of being a component of rodenticides and some insecticides. In the meantime many children who are not receiving fluoride treatments will needlessly suffer the discomfort and expense of unhealthy teeth.

Other intentional additives include those that are added to enhance flavor. If food lacks flavor, it will not be eaten. Our cultural life style includes living in large cities away from the source of farm crops, including fresh fruits and vegetables, and synthetic flavors are used when natural ones are in short supply. The increased use of quick, easy to prepare, convenience foods has led to the increased use of both natural and synthetic flavoring agents, but synthetic flavors may also be used to give consistently good flavor where the naturally occurring flavors may be destroyed or altered in processing.

Antioxidants are also added to foods to reduce food spoilage. Foods are at their best immediately after they are harvested. As a result of oxidative processes that continue to function in the food until it is used, fresh fruits and vegetables—and processed foods as well—change in color, flavor, texture and appetite appeal as they age. The enzymatic browning of sliced fresh apples, peaches and potatoes can be prevented or delayed by the use of such antioxidants as vitamins C or E, and these antioxidants seem to be generally acceptable since they are natural food components. However, butylated hydroxytoluene (BHT) and butylated hydroxyanisole (BHA), commercial antioxidants usually added to polyunsaturated oils to prevent the formation of toxic lipoperoxides, are suspect even though they have been tested and found to be acceptable at the levels used because they are "chemicals" with unpronounceable names. Antioxidants of all types lengthen the shelf-life of a variety of products and therefore help maintain a reasonable price on many foodstuffs.

Other additives that are suspect are emulsifiers, stabilizers, thickeners, acids, synthetic coloring agents, alkalis, buffers, neutralizing agents, leavening agents, bleaching agents, sequestrants, humectants, foaming agents, foam inhibitors, and many others. Whether all of these are necessary is open to question. The food industry claims that they are safe, nutritious, and essential for satisfying consumers' tastes and convenience, and it feels that meeting the food demands of this country would be impossible without food additives. Critics of food additives contend that some are hazardous to humans, others are suspect, and most are designed to deceive the consumer. The United States government through the FDA protects the food purchaser by the National Pure Food and Drug Law, which requires that chemicals used in food production must be shown to be safe before they may be used commercially. The Food Additives amend-

ment requires that manufacturers of food additives test their substances and then submit evidence for the safety of these substances to the Food and Drug Administration, which examines the tests and evidence and then rules on whether the product is indeed safe. Only after they are given this clearance are they placed on the generally recognized as safe (GRAS) list and cleared for commercial use. It is a fact, however, that some additives now on this list have not been given this rigorous testing but were part of a "grandfather" clause on the basis of experience drawn from their common and safe use in food over many years (prior to 1958).

We probably could get along without additives, but not very well. The variety and quality of foods would be drastically reduced, the nutritional and keeping qualities of foods sharply curtailed, and the price of foods considerably higher. The alternative is to keep the additives and encourage more testing and more vigilance on the part of the FDA, and this would seem to be a partial answer to the growing suspicion of "chemicals" added to foods.

FERTILIZERS VERSUS "ORGANICALLY GROWN" FOODS

Organically grown foods are defined as "foods grown without the use of any agricultural chemical and processed without the use of food chemicals or additives" (28). Unfortunately, no agency of law defines or supervises the label "organic" and certifies that foods so labeled actually fit this description.

Claims have been made that organically grown foods are nutritionally superior to foods grown under more-usual agricultural conditions during which chemical fertilizers are used. However, there are no scientific experiments or reports to support these claims. It is known that the nutrient composition of a fruit or vegetable is determined genetically—the seed carries this information. Furthermore, organic fertilizers (*e.g.,* compost, manure) cannot be absorbed *per se* by plants. They must be broken down to inorganic compounds (the same compounds found in chemical fertilizers) by the bacteria in the soil since plants only absorb inorganic compounds. Moreover, there is the risk that manure and moldy leaves and other organic material used as fertilizers in organic gardening may be infected with any number of mycotoxins (fungal toxins, *e.g.,* aflatoxin, which is an extremely potent carcinogen) which could be transferred to the plant by means of maggots, insects, and other pests

that have been shown to concentrate some of these fungal toxins. Also, there is the possibility of Salmonella contamination, which can result in food poisoning.

Chemical fertilizers are needed to produce enough food for our population. For the commercial production of food, nutrients that promote good plant growth are added to the soil in these fertilizers and the food crops that result have the expected nutritional value.

The use of pesticides seems to be a necessary evil in our modern civilization. Although methods of pest control without the use of toxins are now in effect in limited areas, *e.g.,* the use of natural predators and insect hormones, it will be many years before these methods are sufficiently effective and widespread to protect the food supply in the same way as the pesticides now in use. Even the banning of DDT, a "hard" pesticide that was found to be stored in adipose tissue, is not well received in some areas, where it is feared that there will be a reappearance of the malaria-bearing Anopheles mosquito.

Pesticide residues on plants are carefully monitored by both the FDA and the Environmental Protection Agency (EPA); if a pesticide is allowed, the amount is set at the lowest level that will accomplish the desired purpose, even when larger amounts would still be safe.

DIETS

FAD REDUCING DIETS

The dictionary defines obesity as "an excessive accumulation of fat in the body." The reasons for this accumulation are now recognized to be of complex etiology, involving genetics, physiologic, psychological, and socioeconomic factors to various degrees, and perhaps other undefined environmental factors. Once the complexity of this disorder is recognized, it becomes obvious that there is no simple cure and that weight reduction and maintenance requires a variety of treatments, including the motivation of the subject, a diet that is nutritionally adequate except for calories, and a learning process wherein the palate is reeducated to new dietary patterns. This cannot be accomplished overnight.

And yet, there are many fad reducing diets available today which promise quick weight loss with no discomfort—no abstinence from high-caloric, high-fat foods, no need to count calories, no need for exercise—a veritable "something for nothing." These diets are dissimilar from the ordinary in that they 1) differ in the proportion

of fat, carbohydrate, and protein which is allowed; 2) make use of a limited number of foods, and 3) are usually deficient in one or more essential nutrients.

It is of course possible to lose weight on these diets, but in most cases the weight is usually quickly regained. The small number of foods allowed results in a diet that becomes monotonous and therefore cannot be followed for long periods of time. Furthermore, no education has been achieved, and a return to the prediet eating pattern is accompanied by a return of the lost pounds. When essential nutrients are missing from a reducing diet, long-term adherence is dangerous and may lead to pathologic deficiency symptoms.

LOW-CARBOHYDRATE DIETS

The more popular fad diets today are based on the low-carbohydrate principle. Since protein in the diet is limited by the fact that most high-protein foods are less than 40% protein, these are actually high-fat diets. These diets have high satiety value and do show an encouraging quick weight loss. The proponents of low-carbohydrate diets maintain that they are effective because in the overweight person carbohydrates are rapidly converted to adipose tissue (rather than being used for energy) whereas the calories from fat and protein are used in metabolic processes and do not form fat nor are they stored as body fat. This convenient theory has no justification. Actually, the initial weight loss on the low-carbohydrate diet is due to a shift in water balance and a loss in body water (22, 24). The continued weight loss is a result of the self-imposed calorie restriction because of the monotony and high satiety value of the allowable foods (29).

Restriction of carbohydrate to under 100 g results in the synthesis of glucose from protein with an extra load imposed on the kidney to excrete the nitrogen by-products. Furthermore, carbohydrate is required for the complete oxidation of fat. In the absence of sufficient carbohydrate, acetyl-CoA molecules (intermediary products in fat metabolism) accumulate and condense, forming ketone bodies, and these accumulate in the blood, cause ketosis, and disturb the acid–base balance of the body. High-fat diets also may be undesirable in that they may promote or aggravate atherosclerosis. And low-carbohydrate diets are often deficient in fiber, minerals, and vitamin C.

DR. STILLMAN'S DIET. Dr. Stillman's reducing diet (27) is basically a carbohydrate-restricted, high-protein, high–animal fat diet. Experimental subjects lost weight in the early period of the diet but showed a 16.3% increase in serum cholesterol levels after 5 days. Most subjects also complained of fatigue, lassitude, nausea, and diarrhea.

DR. ATKINS' DIET. Dr. Atkins' Diet Revolution (4) is another variant of the low-carbohydrate diet. Potential hazards of this diet include the possibility of hyperlipidemia with the risk of accelerating atherosclerosis. Ketogenic diets also may cause elevations in blood uric acid concentration with a possibility of inducing gout in susceptible individuals. Subjects on this diet also complained of fatigue, lack of energy, and other symptoms previously described due to the low-carbohydrate diet. Dr. Atkins' book contains statements that have never been substantiated; for example, he claims that this diet promotes the production of a "fat mobilizing hormone" (FMH), which is why his diet is successful and all others fail. Unfortunately, no such hormone has been positively identified in man. Among Dr. Atkins' other recommendations are megadoses of the vitamin B complex and vitamins C and E, which are supposed to help keep blood sugar at an even level. This has never been found to be either necessary or efficacious in patients with deranged carbohydrate metabolism. All in all, the rationale given to justify this diet is without scientific merit.

SIMEONS REGIMEN

The most recent of the fad reducing diets to achieve popularity is the use of human chorionic gonadotropin (HCG) obtained from the urine of pregnant women in conjunction with a 500–Cal diet, the so-called "Simeons regimen." Patients are given daily IM injections of 125 IU of HCG six times per week for a total of 40 injections. The 500–Cal diet is given in two daily meals. The weight loss is inevitable if the patient adheres to the low-calorie diet, but whether HCG contributes to this weight reduction is questionable. Here again, there have been no well-designed studies to determine the relative influences of HCG, caloric restriction, and the psychologic effects of daily injections and daily weighings on weight reduction. It is known that HCG stimulates testes to produce androgens and at high doses produces headache, restless-

ness, depression, pain at the injection site, edema, and fatigue. However, the amount of HCG used for weight reduction is much less than that which has been shown to produce these symptoms. The 500–Cal diet, which is actually semistarvation, probably results in the loss of considerable protein from the body, and malnutrition could be expected. In summary, the efficacy of this regimen has not been confirmed.

The cure for obesity is not in fad "quick weight loss" diets but rather in the maintenance of correct balance between energy intake and energy expenditure. And prevention is always better than cure. Good habits of food intake and physical activity should be initiated early in childhood.

VEGETARIANISM

Although the number of adherents to vegetarian diets has increased considerably in recent years, especially in the younger populations, vegetarianism is not a new pattern of eating. Large populations of the world have lived for generations on diets almost or completely vegetarian, either because of religious beliefs or because of the unavailability of animal protein. The newer proponents of vegetarianism believe that this type of diet is more conducive to good health and also that it preserves the life of animals—a fact that cannot be argued.

The several different types of vegetarian diets have in common the fact that they do not include meat, poultry, or fish. They do contain vegetables, fruits, enriched or whole grain bread and cereals, dry beans and peas, lentils, nuts, and seeds. A pure vegetarian diet excludes all foods of animal origin; an ovolactovegetarian diet allows eggs and dairy products, whereas the lactovegetarian diet includes dairy products but excludes eggs.

Vegetarian diets can be nutritionally adequate if the foods are selected wisely (25). They should include as much of a variety of foods as is permissible to make sure that all of the nutrients required for good health are present. One of the main concerns in adherence to an all-vegetable diet is the quality of the protein component. It has long been known that animal protein has a higher biologic value than do vegetable and grain proteins, which are often lacking in one or more essential amino acids. However, individual vegetable proteins with low biologic value can be mixed with others to provide an amino acid pattern that is adequate for growth and maintenance of populations. For example, grain–legume combinations provide much better nutrition than either grains or legumes separately. This mixing of two incomplete proteins to provide a complete mixture is known as mutual supplementation.

One difficulty arising during the use of vegetarian diets is the possible lack of vitamin B_{12}, which is found only in foods of animal origin, *e.g.,* meat, fish, eggs, and dairy products. Although there is no problem for the ovolactovegetarians or lactovegetarians, those whose protein is derived solely from vegetable sources (vegans) must either select foods fortified with vitamin B_{12} or take a vitamin B_{12} supplement. Strict vegetarians who do not ingest a source of vitamin B_{12} may develop nerve damage and blood dyscrasias.

Other nutrients that may be in short supply in persons consuming only vegetable products are calcium, since milk and milk products are the major sources of calcium; vitamin D, which occurs naturally only in foods of animal origin (but this is a problem only for children since vitamin D can be manufactured in sufficient quantities to satisfy adult requirements by the action of sunlight on the skin); and—possibly—riboflavin and iodine. However, by the proper selection of foods, based on a knowledge of the nutrient composition of foods and of the requirements for health as recommended by the RDA, there is no reason why a vegetarian diet cannot be as nutritious as one that includes animal products. Only when the selection of foods is limited do vegetarians encounter potential dangers of malnutrition.

ZEN MACROBIOTIC DIET

The potential for malnutrition develops when the so-called Zen macrobiotic diet is religiously followed. This diet represents the extreme in adherence to a natural diet containing only organic foods. It is supposed to create a spiritual rebirth and to be a cure for all disease, tension, and aging. The prescribed diets (there are ten) are predominantly vegetarian and range from a rather varied diet (Diet−3) to the final Diet+7. Diet+7 is composed of 100% cereals with fluid restriction as well and is said to achieve the ultimate in well-being. True adherents of this mode of eating risk the danger of developing serious nutritional deficiencies. Depending on the length of adherence to this diet, cases of scurvy, anemia, hypoproteinemia, hypocal-

cemia, emaciation, loss of kidney function and death have been reported.

CONCLUSIONS

It has been estimated that the direct economic waste attributable to food faddism reaches approximately $500,000,000 per year. However, the greatest damage lies in the deliberate and distorted misinformation given to the public and in the suspicion that is aroused concerning our food supply, which is probably the most abundant and the most nutritious of any in the world. Furthermore, promises of cures for incurable and terminal diseases have caused much anguish as well as financial ruin to the many people unlucky enough to be deceived by nutritional "confidence artists."

The scientific community is only now beginning to fight back vigorously by countering misinformation and false claims with data based on experimental fact and providing information on nutrition where none has been available before. It is absolutely essential that more valid information on nutrition be provided to the public as simply and as comprehensively as possible. In particular, nutrition education is needed for those who influence the public—physicians, dentists, public health workers, social workers, and teachers at all levels of instruction.

Another answer to the problem lies in governmental regulation. The advent of food labeling has involved setting up stringent new labeling requirements for foods designated for "special dietary use." No longer may foods be said to prevent or treat disease because of nutrients they may or may not contain. No longer can it be claimed that a diet of ordinary foods cannot supply adequate nutrition and that our "deficient" soil produces "deficient" food. No longer can suspicion be thrust on the nutrient content of a food because it is "processed." Foods that contain substances whose need in human nutrition has never been established cannot be claimed to have special properties as far as concerns health. Furthermore, it will now be prohibited to claim that natural vitamins are in any way superior to synthetic vitamins. From now on, a vitamin is a vitamin is a vitamin.

Finally, the public must become more discriminating in the evaluation of nutritional reports made directly available through various mass media channels. In the past, nutritional scientists reported their studies in scientific journals, and their work was reviewed and evaluated by their peers prior to publication. Furthermore, scientists with divergent opinions were then able to look critically at areas where there were points of contention. A third or fourth study might be necessary to clarify a confusing situation. Now, unevaluated findings are reported in newspapers, magazines, radio, and television, promising immediate solutions to very complex problems. As a result, pressure is brought to bear on government agencies to rule on issues where available information may be inadequate and irrelevant. The public must realize that many of these reports are derived from persons with little or no education or training in nutrition and biochemistry and who are not recognized as part of the reputable scientific community. The problem is one of informing the public on what is known and what is guesswork, and to accomplish this resource facilities should be designated where valid scientific facts would be freely available to those who seek it.

REFERENCES

1. Alfin–Slater RB, Aftergood L, Kishineff S: Investigations on hypervitaminosis E in rats (abstr). IX Int Congr Nutr, 1972, p 191
2. Ames SR: Age, parity, and vit A supplementation and the vit E requirement of female rats. Am J Clin Nutr 27:1017, 1974
3. Anderson TW: Vitamin C: report of trials with massive doses (abstr). IV Congr West Hem Nutr, 1974, p 67
4. Atkins RC: Dr. Atkins' Diet Revolution. New York, David McKay, 1972
5. Baker EM, Saari JC, Tolbert BM: Ascorbic acid metabolism in man. Am J Clin Nutr 19:371, 1966
6. Bernhardt IB, Dorsey DJ: Hypervitaminosis A and congenital renal anomalies in a human infant. Obstet Gynecol 43: 750, 1974
7. Bruch HJ: The allure of food cults and nutrition quackery. J Am Diet Assoc 57:316, 1970
8. Chalmers TC: Effects of ascorbic acid on the common cold: an evaluation of the evidence. Am J Med 58: 532, 1975
9. Cohen HM: Fatigue caused by vitamin E? Calif Med 119:72, 1973
10. Corrigan JJ, Marcus FI: Coagulopathy associated with vit E ingestion. JAMA 230: 1300, 1974
11. Dean HT: Fluorine in the control of dental caries. Int Dent J 4: 311, 1954
11a. Fluorides and human health. (Monograph 59) Geneva, WHO, 1970
12. Furman KI: Acute hypervitaminosis A in an adult. Am J Clin Nutr 26: 575, 1973
13. Gatenby-Davies JD, Newson J: Ascorbic acid and cholesterol levels in pastoral peoples in Kenya. Am J Clin Nutr 27:1039, 1974

14. Ginter E, Kajaba I, Nizner O: The effect of ascorbic acid on cholesterolemia in healthy subjects with seasonal deficit of vitamin C. Nutr Metab 12:76, 1970

15. Herbert V, Jacob E: Destruction of vitamin B_{12} by ascorbic acid. JAMA 230:241, 1974

16. Lassers BW, Wahlqvist ML, Kaijser L, Carlson LA: Effect of nicotinic acid on myocardial metabolism in man at rest and during exercise. J Appl Physiol 33:72, 1972

17. March BE, Wong E, Seierl, Sim J, Biely J: Hypervitaminosis E in the chick. J Nutr 103: 371, 1973

18. Mason KE, Horwitt MK: Tocopherols X. Effects of deficiency in animals. In Sebrell WH Jr, Harris RS (eds): The Vitamins. New York, Academic Press, 1972, p 272

19. Miettinen M, Turpeinen O, Karvonen MJ, Elosuo R, Paavilainen E: Effect of cholesterol-lowering diet on mortality from coronary heart disease and other causes. Lancet 2:835, 1972

20. National Research Council. Nutrient requirement of the laboratory rat. In Nutrient Requirements of Laboratory Animals. Washington DC, Nat Acad Sc 10: 64, 1972

21. Nutrition misinformation and food faddism. Nutr Revs (Suppl) 32(1): 37, 1974

22. Olesen ES, Quaade F: Fatty foods and obese. Lancet 1: 1048, 1960

23. Pauling L: Vitamin C and the Common Cold. San Francisco, WH Freeman, 1970

24. Pilkington TRE, Gainsborough H, Rosenouer VM, Carey M: Diet and weight reduction in the obese. Lancet 1: 856, 1960

25. Register UD, Sonnenberg LM: The vegetarian diet. J Am Diet Assoc 62:253, 1973

26. Rosenthal G: Interaction of ascorbic acid and warfarin. JAMA 215:1671, 1971

27. Stillman IM, Baker SS: The Doctor's Quick Weight Loss Diet. New York, Dell Publishing, 1967

28. White HS: The organic foods movement. Food Technol 26:29, 1972

29. Yudkin J, Carey M: The treatment of obesity by the "high fat diet". The inevitability of calories. Lancet 2: 939, 1960

SUGGESTED READING LIST

McBean LD, Speckmann EW: Food faddism: a challenge to nutritionists and dieticians. Am J Clin Nutr 27:1071, 1974

Nutrition misinformation and food faddism. Nutr Rev 32, July 1974

Recommended Dietary Allowances. Washington DC, National Academy of Sciences, 1974

10 Nutritional support resources in hospital practice

George L. Blackburn, Bruce R. Bistrian

The advent of total parenteral nutrition (TPN) and oral defined formula diets (DFD) has made it possible to feed patients in most disease states (20, 51). Although the benefits of providing optimal amounts of nutrients are not disputed, only with the development of these new clinical techniques for feeding in the presence of disease or impaired gastrointestinal (GI) function has this goal been achieved. In certain conditions, *e.g.,* inflammatory bowel disorders (23), fistulas of the alimentary tract (13), acute and chronic pancreatitis (10, 22), and acute renal failure (1), parenteral or enteral nutrition has become a primary mode of therapy. In others, particularly cancer, optimal nutritional support has been a useful adjunct to primary immunotherapy, chemotherapy, or radiotherapy (17). In most hospitalized patients, whatever the underlying problem, ignoring nutrition even for a short period of time can result in malnutrition marked by negative nitrogen balance and significant electrolyte and mineral losses (37, 54) (see Chs. 14, 29). In patients with moderate degrees of malnutrition at the onset of their illness difficult problems appear which require sophisticated counseling and treatment to avoid unnecessary morbidity and mortality (10, 18, 52, 53). It is the purpose of this chapter to describe the techniques necessary for nutritional counseling as well as for establishing a nutritional support service.

NUTRITIONAL SUPPORT SERVICES

Concern about the poor nutritional status of hospitalized patients (3, 6, 11) and the general lack of nutritional knowledge both in the diagnosis and treatment of malnutrition led to the development of a nutrition support service (7). The goal of this service is to monitor the nutritional status of all hospitalized patients, to consult and supervise appropriate therapeutic support in selected patients, and to provide a multidisciplinary approach to the nutritional problems that arise in the hospital. Particularly with TPN a team approach and standard guidelines are needed if dangerous complications (*e.g.,* sepsis, pneumothorax, hyperosmolarity) are to be minimized (26).

A nutrition support service should combine the services of nursing, dietetics, pharmacy, and physical therapy with the major clinical disciplines while emphasizing treatment of protein–calorie malnutrition (PCM). There is a high prevalence of this disorder in hospital settings (3,6), in large measure due to disease, but in part resulting from the frequent association of semistarvation with medical treatment. A minimum of 5% of the patients in any acute medical/surgical hospital will meet established criteria for severe PCM and require intensive nutritional support. Thus any hospital caring for patients should have an identifiable nutrition counseling service, even if only consisting of an interested physician, a therapeutic dietitian, and a nurse who also functions as an epidemiologist. Education in nutrition has been so limited and poorly organized in most medical schools that most physicians are unable either to recognize nutritional problems or to utilize available nutritional techniques to reverse PCM, which is characteristically slow to respond (10).

The smallest hospital dealing with the acutely ill medical and surgical patient requires a full-time nurse clinician, and a therapeutic dietitian under the supervision of a properly trained physician to care for routine nutritional problems that seriously affect response to illness. The hospital nutrition service developed in larger hospitals should expand to include a multidisciplinary team able to use the many scientific and technologic advances in nutrition. Another responsibility that can be assumed by this enlarged service would include clinical evaluation of the safety and efficacy of many meal replacement items, food supplements, defined formula diets as well

139

as parenteral feeding solutions (see Ch. 6). A larger contribution to postgraduate and undergraduate training through grand rounds, consultations, supervised therapy, lectures and formal continuing education courses are useful spinoffs.

The established nutritional support service in larger hospitals will be able to provide outpatient nutritional support for patients undergoing cancer therapy or those with convalescent nutritional problems secondary to primary diseases, e.g., "short gut," inflammatory bowel disease, pancreatic insufficiency, renal disease, or obesity. Major research efforts would normally involve metabolism, endocrinology, gastroenterology, nephrology, and cardiology, in addition to clinical nutrition.

An ancillary, important, and entirely appropriate role of all nutritional support services, large and small, is to correct by lay nutritional education the misinformation and half-truths that exist among the community at large. Through these efforts, nutritional support services will rapidly attract the lay and professional attention, respect, and support necessary to bring nutrition abreast with the other health care specialties. The public health nutritionist with his role in community medicine is a separate entity and beyond the scope of this chapter. Further, the primary function of a nutrition service is hospital patient treatment, not public health nutrition, which is best served through other agencies. These two specialists can, however, complement each other, and mutual referrals may be an appropriate avenue for exchange of experiences.

MECHANISM FOR ESTABLISHING A NUTRITIONAL SUPPORT SERVICE

Establishment of a nutritional support service begins with the formation of an ad hoc committee from the hospital medical staff and the administration. Representatives on this committee should include administration; interested staff from medicine, surgery, pediatrics, obstetrics, gastroenterology, oncology, and other subspecialties; a senior therapeutic dietitian; a pharmacist; a nurse clinician; and the supervisor of nurses. The purpose of such a committee is to ascertain the needs of the hospital for nutritional support, to provide guidelines for parenteral "hyperalimentation" and nutritional assessment, to prepare standard order sheets and instructions for therapeutic dietitians, and to establish guidelines for pharmacy. In addition, determination

of personnel requirements and job descriptions are appropriate roles. Application for status as a reimbursable service from third-party carriers, development of a schedule of charges, and preparation of a budget are prerequisites for viability.

ROLE OF PERSONNEL

The chairman of the committee would be the anticipated nutrition service director, a physician who must have the time and interest to develop knowledge in clinical nutrition and the techniques of parenteral and enteral hyperalimentation. Within the framework of a hospital nutrition support service the first priority for this physician is to develop a team that will deliver hyperalimentation (either parenteral or enteral) effectively since this represents the most unique aspect in terms of availability and efficacy. Further expansion of nutritional techniques to include defined formula diets and other tube feedings in the "fed" state and with various protein-sparing regimes in the semistarved state should follow (see Ch. 6). Programs for nutritional rehabilitation of patients with inadequate digestive function (e.g., short bowel syndrome, jejunoileal bypass, radiation enteritis, Crohn's disease) and of oncology patients both prior and subsequent to specific therapy are other situations that will require protocols for nutritional therapy. As the nutritional aspects of other diseases (i.e., renal, cardiac, pulmonary, gastroenteric) are explored, associates from other specialties can contribute to the expansion of knowledge in clinical nutrition (see section on Application of Nutrition to Clinical Specialties).

Clinical laboratory facilities are necessary to determine parameters of energy and nitrogen metabolism, i.e., urinary urea nitrogen (36), body composition, i.e., creatinine height index (5), and assays of micro and macro nutrient components of tissues and blood fluids, i.e., albumin, transferrin, carotene, B_{12}, ascorbic acid. Bacteriologic facilities and infectious disease consultants are essential due to the reduction in host immune function in the malnourished patient (34) and to the increased incidence of serious infection with TPN (26) (see Chs. 21, 22).

In the smaller hospital providing only TPN, total staff may include only one nurse, or dietitian, a physician, and a pharmacist. The full-time nurse clinician will be the key person to insure safe and optimal delivery of parenteral hyperalimentation (58). In addition, she can serve the hospital as an infectious disease epidemiologist.

Other duties should include responsibility for integrating the nursing care plan for the patient in order to insure that a diagnostic work-up takes place in an efficient manner while not interfering with basic requirements for adequate nutrition and exercise.

The therapeutic dietitian-nutritionist would coordinate her work with a nurse and assume particular responsibility for composition and techniques of oral feedings (30). Either or both nurse and dietitian can gather the data necessary for the nutritional assessment of the patient.

Preparation of parenteral feeding solutions and procurement of many dietary supplements require a pharmacist who specializes in this area to protect against errors in medication orders, prepare the nutritional products for patient use, and deal with the manufacturing representatives for these products (12).

The supervision of these specialists requires an interested and properly trained physician. His primary training need not interfere with the ability to learn and to deliver nutrition for all types of patients since the major nutritional problem in American hospitals is PCM, which transcends specialty lines.

In larger hospitals a team with increased number, types, and time commitment of personnel is desirable. Additional functions can be assumed by this multidisciplinary team, such as clinical investigation to advance nutrition. Consideration should be given to the establishment of a special area with quasimetabolic ward characteristics for nutritional care in complicated cases when careful monitoring of intake and output are necessary. Finally, a nutrition outpatient clinic for follow-up care and management will extend the benefit of the service to the ambulatory patient and to the community at large.

In both large and small hospitals the nutritional support service personnel should conduct intensive education for house staff and practicing physicians by informal rounds, bedside instruction, and the consultation service. A library of basic nutrition information and recent developments in the treatment of hospital PCM should be provided, and periodic newsletters and memoranda involving techniques of parenteral and enteral feedings should be distributed to the hospital community, including the patient and his family, to encourage everyone's interest and compliance in nutritional therapies.

FUNCTION OF THE NUTRITIONAL SUPPORT SERVICE

Because the development of nutritional support services is recent (7), a description of the functioning of the service at the New England Deaconess Hospital must serve as a model. Under the director and his assistant, it consists of therapeutic dietitians, physical therapists, nurse clinicians, pharmacists, and a nurse epidemiologist. Several residents from medicine and surgery and a nutritional fellow(s) complete the consulting team, although consultants from several specialty services dealing with infectious disease, renal, pulmonary, and GI disorders can be utilized. The major concentration has been in the area of PCM due to the frequency and severity of protein catabolism in the seriously ill, hospi-

Fig. 10–1. Computer/calculator determination of protein and calorie requirement for nutrition maintenance or anabolism either orally or parenterally. Estimates based on surface area plus age and sex (see text).

Data fed into computer
1. Height in.
2. Weight (usual) lb
3. Frame type (ring) small, medium, large
4. Weight (at Rx) lb
5. Weight (ideal) lb
6. Surface area M^2 (Based on weight at Rx)

Computer feedback
Height cm (in. x 2.54)
Weight (usual) kg (lb x 2.2)
Weight (at Rx) kg (lb x 2.2)
Weight (ideal) kg (lb x 2.2)
Usual weight − ideal weight
Weight at Rx − ideal weight
Weight at Rx/ideal weight %
Weight at Rx/usual weight %

Basal energy expenditure (BEE)
Cal/24 hr
Cal/hr/M^2

Anabolic requirements (Cal/24 hr)
IV (BEE x 1.76) Cal
Oral (BEE x 1.54) Cal

Nitrogen anabolic requirements/24 hr
IV (Cals ÷ 150) g
Oral (Cals ÷ 150) g

Protein (amino acid) requirements/24 hr
IV (nitrogen x 6.25) g
Oral (nitrogen x 6.25) g

Maintenance requirements (Cal/24 hr)
Oral (BEE x 1.22) Cal

Nitrogen maintenance requirements/24 hr
Oral (Cals ÷ 300) g

Protein (amino acid) requirements/24 hr
Oral (nitrogen x 6.65) g

Derived clinical metabolic rate

Identification data

Name	John Doe
Hospital	New England Deaconess
Record No.	
Building and Room No.	Farr 715

Input

Height (in.)	70.0
Body type	Medium
Usual weight (lb)	160.0
Weight at initiation of therapy (lb)	137.0
Ideal weight (in lb from a nomogram)	153.0
Age (years)	55.0
Body surface area (M^2 − from a nomogram)	1.781
Sex	Male

Output

Height (cm)	178	
Ideal weight (kg)	69.5	
Weight on initiation of therapy as % of ideal weight	89.6%	
Weight on initiation of therapy as % of usual weight	85.7%	
Basal energy expenditure (BEE)	1585	Cal/day
Calories required for anabolism in this patient	2908	Cal/day
BEE corrected for BSA and hourly requirements	37.0	Cal/hr/M^2

Metabolic maintenance required at two different nitrogen-to-calorie ratios

1. 1-to-150 ratio −	nitrogen required	16
	protein required	99
2. 1-to-300 ratio −	nitrogen required	8
	protein required	50

Fig. 10–2. Individual patient nutritional requirements to aid NSS and staff in developing a nutrition therapy plan.

talized patient (21) and the inattention to PCM that exists in American hospitals (3, 6, 11).

Patients admitted to the hospital who are in a state of moderate PCM necessitating parenteral or enteral nutrition and hospitalized patients whose nutritional requirements cannot be met by standard nutritional practice are referred to the service. Data procured from both categories of patients include:

1. Age
2. Sex
3. Height
4. Usual weight
5. Present weight
6. Nutritional assessment and characterization

The data accumulated in Figure 10–1 is derived from a series of nomograms incorporated into a computer program that provides the metabolic data necessary to formulate a nutritional program for treatment when parameters 1–6 are provided (Figs. 10–1, 10–2). The basal energy expenditure (BEE) is derived from *Har-*

ris–Benedict standards (40), which by considering the four above parameters allow better adjustment for factors not adequately covered by formulas based on weight alone. In states of mild to moderate catabolism, delivery of standard TPN at 1.75 times BEE should produce positive nitrogen balance (40). By the oral route 1.3–1.5 times BEE is sufficient for maintenance. After the protein and calorie requirements for maintenance and anabolic therapy have been obtained, selection of parenteral and oral diet may be begun; fed *vs.* starved, oral *vs.* IV route decisions are determined by the results of nutritional assessment.

Metabolic and biochemical data necessary to determine the progress of therapy (Fig. 10–3) allow the consultant to formulate the best available diet therapy for the individual patient. Formula diets, supplemental feedings, and parenteral feedings provide a wide variety of techniques to overcome the catabolic response to illness, and modification of a fast by oral or IV protein (8, 24) can minimize protein catabolism by maximum utilization of endogenous fat.

The group functions in the following manner: after a consultation request is received, the nutritional fellow or resident, the therapeutic dietitian, and the hyperalimentation nurse together provide "on the spot" expertise to the ward team. At this time each member of the group can review and evaluate with the house staff the theoretic and practical aspects of available nutritional therapies. Direct responsibility for nutritional support is often assumed by our service at the responsible physician's request and invariably is assumed for cases requiring TPN. After the course of therapy has been decided, each group member provides guidelines for application of the therapy to the particular patient. The physician discusses medical care and fluid, electrolyte, and nutrition monitoring procedures. The nurse instructs and supervises in special nursing procedures, including a nursing plan that minimizes immobilization and weakness created by bed rest. The dietitian establishes and monitors all oral and tube feedings and vitamin supplementation and also works with the patient to stress the importance of nutritional therapy. A pharmacist trained in additive techniques under aseptic conditions is essential if complications are to be minimized and good results achieved. Each of these positions requires a mature, empathetic specialist who is able to communicate with these seriously ill patients, gain their confidence and cooperation, and design an appropriate plan to optimize patient care.

Each consultation is monitored by the director and his assistant, as is the daily follow-up of the patient throughout the course of therapy during which special laboratory data is interpreted and staff education provided. In patients requiring TPN the nutritional service provides the primary care for this process, writing all orders, inserting catheters, and being responsible on a 24-hour basis. The nurse clinician generally handles the three times weekly dressing changes except for special care units or when the IV therapy department substitutes for the off-duty "hyperal" nurse. This approach has virtually eliminated the infectious complications generally associated with TPN.

Although the primary responsibility for oral hyperalimentation with formula diets is generally assumed by the nutrition fellow or resident, most maintenance nutritional therapy with chemically defined diets, meal replacements, meal supplements, or special diets (e.g., Giavanetti, diabetic) and peripheral IV feeding with amino acids (9) is handled by the house staff with advice from the NSS.

Regular meetings of the NSS are attended by the member physicians, therapeutic dietitians, specialized nurses, and supportive members. Patient cases are reviewed, therapies discussed, new products evaluated, and policies and procedures for special therapies established.

In the short time since its formation, some spectacular success in a group of high-risk patients has increased the credibility and teaching commitments of the NSS. Course subject matter covers such topics as: 1) metabolic basis of optimal nutrition in cachexia; 2) total parenteral nutrition—theory, administration, special aseptic techniques, and nursing procedures; 3) elemental diets—rationale and administration; 4) tube feedings—rationale and administration; 5) diet as related to GI dysfunction; 6) protein-sparing therapies; 7) interpretation of biochemical data; and 8) nutritional assessment of the hospitalized patient.

NUTRITIONAL ASSESSMENT OF THE HOSPITALIZED PATIENT

The mortality, morbidity, cost, and other significant effects of PCM await proper surveillance before attempts at control and proper therapy can be fully implemented. The failure to survey incidence and prevalence of hospital malnutrition and to examine its relationship to the prognosis of various diseases cannot be consistent with good patient care. This is not meant to imply that nutritional status during hospitalization generally results from the nutritional support received, but rather that little attempt is made to reverse malnutrition.

ANTHROPOMETRY

These techniques may be considered crude when compared with more-sophisticated biochemical techniques, but the aim is to identify normal, malnourished, and severely malnourished patients with the least amount of staff, equipment, and complicated techniques. Anthropometric measurements are not only simple and easy to perform, they also reflect physiologically important tissues. Three tissues are available to meet energy requirements in the semi-starved state generally present in ill patients: 1) skeletal muscle protein, 2) visceral protein, and 3) fat (Fig. 10–4), and the state of each can be independently assessed. Triceps skin fold thickness (TSF) indicates fat stores and arm muscle circumference (AMC) the state of muscle protein, whereas weight-height, even when not dis-

Fig. 10–3. Expanded Nutritional Assessment and Metabolic Status form for clinical studies. This detailed assessment will allow accurate interpretation of the role of nutrition in clinical studies.

Record No. _____ **New England Deaconess Hospital** Room/Ward _____

Dates
Admission to hospital
Admission to ICU (if relevant)
Initiation of therapy
Termination of therapy
Discharge or death

Average caloric intake for 2 weeks Cal/24 hr prior to evaluation
Nutritional support for 2 weeks prior to evaluation and present
 nutritional status (ring) fed, starved, semistarved; minimally,
 moderately, severely depleted
Time elapsed since onset severe caloric deprivation (days)

Assessment of nutritional or metabolic status

Information on assessment for computer

Feed in

Height (in.)
Weight (usual) lb
Body type (ring) small, medium, large
Weight (at Rx) lb
Weight (ideal) lb
Age (years)
Surface area (m^2)
 (based on weight at Rx)

Computer feed back

Height cm (in. x 2.54)
Weight (usual) kg (lb \div 2.2)
Weight (at Rx) kg
Weight (ideal) kg
Usual weight $-$ ideal weight kg
Weight at Rx $-$ ideal weight kg
Weight at Rx/ideal weight %
Weight at Rx/usual weight %

Triceps skinfold (TSF) mm
 (Standard for adult male 12.5 mm, female 16.5 mm)
Mid-upper arm circumference (AC) cm
 (Standard for adult male 29.3 cm, female 28.5 cm)
Mid-upper arm muscle circumference (AMC) = AC $-$ π x TSF (cm)
 (Standard for adult male 25.3 cm, female 23. 2 cm)
Albumin
 (Standard 3.5 g/100 ml)
24-Hour urinary creatinine
Creatinine height index (CHI) = 24-hr creatinine
 excretion of patient \div 24-hr creatinine excretion
 of "normal" adult of same height
 (based on creatinine excretion values of "normal"
 males and females)

White cell count
 (normal 5$-$10,000/mm^3)
Differential lymphocyte count
Total lymphocyte count
 (Standard 1500/mm^3)
Transferrin mg
 (Standard 200 mg/100 ml)

Basal energy expenditure [BEE] (Harris-Benedict formula)

Cal/24 hours
Cal/hr/m^2

Anabolic requirements Cal/24 hrs C:N ratio 150:1
IV (BEE x 1.76) Cal
Oral (BEE x 1.54) Cal

Nitrogen anabolic requirements g/24 hr
Cal:N ratio 150:1
IV (Cal $-$150) g
Oral (Cal $-$150) g

Protein (amino acids) anabolic requirements g/24 hr
IV (N g x 6.25) g
Oral (N g x 6.25) g

Maintenance requirements Cal/24 hr Cal:N ratio 300:1
Oral (BEE x 1.22) Cal

(continued)

Assessment of nutritional or metabolic status

Information on assessment for computer

(continued)

Nitrogen maintenance requirements/24 hr Cal:N ratio 300:1
Oral (Cal ÷ 300) g

Protein (amino acids maintenance requirements)
Oral (N × 6.25) g

24-hr anabolic requirements standard hyperalimentation (TPN) or high-N defined formula diet (DFD) Cal:N 150:1 1 ml = 1 Cal
4.25% Amino acids ml (=Anabolic IV Cal)
 25% Glucose − TPN
High-N DFD ml (=Anabolic oral Cal)

24-hr maintenance requirements oral Cal:N 300:1
Standard DFD ml (=Maintenance Cal)

Percentage standard nutritional parameters

Triceps skinfold
Mid-upper arm circumference
Mid-upper arm muscle circumference
Albumin
Creatinine height index
Total lymphocyte count
Transferrin

Cellular immunity skin testing expressed as mm percentage normal reaction (read all reactions > 2 mm; standard = 5 mm)

Candida (Hollister-Stier) and Varidase (Lederle) 0.1 ml solution diluted 1:100

Immediate	Immediate
@ 24 hr	@ 24 hr
@ 48 hr	@ 48 hr

Dinitrochlorobenzene contact sensitization
@ 24 hr, @ 10-14 days
2000 μg
 50 μg
 50 μg (challenge dose)
If positive at 2000 μg or 50 μg site at 10-14 days without challenge, consider 90%.
If positive only on challenge, consider 60-90%.

Standard parameters	> 90%	60%−90%	< 60%
Weight/Height			
Triceps skinfold			
Mid-upper arm circumference			
Mid-upper arm muscle circumference			
Albumin			
Creatinine height index			
Lymphocyte count			
Transferrin			
Cellular immunity SK/SD			
Other Candida			
DNCB			

Nutritional or metabolic status (check)
> 90% Standard Not depleted
60−90% Standard Moderately depleted
< 60% Standard Severely depleted

Type of protein-calorie malnutrition (check)

Acute visceral attrition (Kwashiorkorlike)
 (Wt/Ht, TSF, AC, AMC, CHI preserved; albumin and transferrin acutely depressed)

Adult marasmus (Cachexia)
 (Wt/Ht, TSF, AC, AMC, CHI depressed; albumin and transferrin preserved until late)

Intermediate states

Acute visceral attrition superimposed on adult marasmus
 (Wt/Ht, TSF, AC, AMC, CHI depressed; albumin and transferrin rapidly and acutely depressed)

Primary diagnosis

torted by disease, is a composite measure. Levels of serum albumin or transferrin indicate visceral protein status.

The anthropometric determinations are also important in the nutritional assessment of hospitalized populations because other clinical signs of malnutrition are rarely observed in adult patients. Hospital protein malnutrition often develops rapidly and appears before the classic signs usually associated with syndromes of pediatric malnutrition (44).

WHO standards (29) for weight-height, AMC, and TSF are used, with severe depletion considered 60% standard and below and 60%–90% standard classified as moderate depletion.

WEIGHT-HEIGHT

Measurement of weight and height is widely used in underdeveloped countries as a measure of nutritional status and is effective in the hospital to diagnose chronic malnutrition (cachexia or adult marasmus). In the hospitalized adult with PCM, however, gross abnormalities in body composition caused by disease (38, 41) reduce the reliability of weight as an index of protein depletion. Disease or therapy that causes fluid retention adds a further difficulty to the use of weight as a measure of nutritional status. For example, with TPN, weight gain too large to attribute to anabolism can increase or even restore weight-height despite significant PCM.

Weight loss, however, is an extremely important index of change in nutritional status since weight loss usually reflects caloric inadequacy of the diet, which mandates an increased loss of protein from the body cell mass.

SKINFOLD THICKNESS AND ARM MUSCLE CIRCUMFERENCE

Although used extensively in underdeveloped countries for survey purposes, these particular anthropometric measurements of PCM have not been generally applied to the assessment of nutritional status in hospitalized patients. Subcutaneous fat, measured as skinfold thickness over the triceps muscle, reflects caloric reserve. Arm circumference (AC) serves both as a measurement of caloric reserve and muscle mass. Arm muscle circumference (AMC) (AC in cm $- \pi \times$ skin thickness $=$ AMC, a derived parameter) re-

Fig. 10–4. Body composition and energy equivalence of stored metabolic fuel. (Blackburn GL, Flatt JP, Hensle TE: Peripheral amino acid infusions. In Fischer J (ed): Total Parenteral Nutrition. Boston, Little, Brown, 1975, p 365)

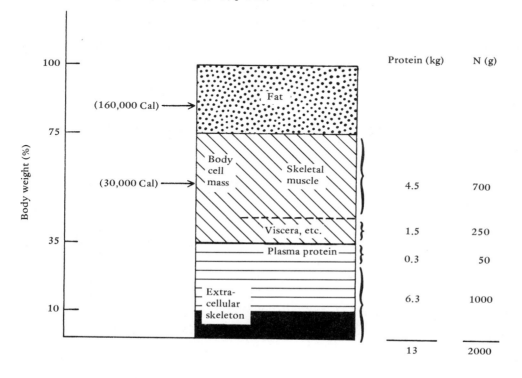

flects muscle mass alone. This measurement is of particular importance in evaluating the relative contribution of muscle protein and visceral protein to catabolism. Arm muscle circumference is the best available measure of PCM since, unlike serum albumin, it is not primarily affected by renal, hepatic, or GI disease and can only mean protein depletion. One might question the use of 90% standard as the threshold level for PCM, but significant PCM exists even if the 80% level is chosen (3, 6). More importantly, the standards for muscle circumference and skinfold are derived from a nonindustrialized society, which if one accepts the likelihood that a United States population is more well-nourished, tends to underestimate the prevalence of PCM.

BIOCHEMISTRY

ALBUMIN-TRANSFERRIN

Low serum albumin and transferrin levels (Fig. 10–5) are constant features of kwashiorkor and are also a useful measure of significant visceral protein deficit in adults (4). Various biochemical alterations characteristic of pediatric kwashiorkor occur when serum levels of albumin are below 3.0 g % (57). The child with kwashiorkor developing in the setting of infection and a high-carbohydrate, low-protein diet bears important similarity to the catabolic adult receiving dextrose (D_5W) infusion as routine nutritional support (4). Both types of patients have preservation of anthropometric measures in the face of lower serum protein levels, depression in peripheral lymphocytes, anergy, reduced antibody responses to stimulation, diminished lymphocyte transformation to nitrogens, all of which respond to nutritional repletion (4, 33).

These secretory proteins with short half-lives are particularly sensitive to deficiencies of calories and precursor amino acids, with slowing of their synthesis during semistarvation (28). This is true whether available muscle stores are blocked from mobilization (as in visceral attrition) or less available (as in the adult marasmic patient). Serial measurements, particularly of transferrin, can be used to assess the results of nutritional therapy. A low serum albumin or transferrin may be due to reasons other than decreased intake, including increased loss (as in renal or GI disease) or reduced synthesis (as in liver disease). However, it is difficult to consider a patient with hypoalbuminemia well nourished, whatever the etiology. The significant correla-

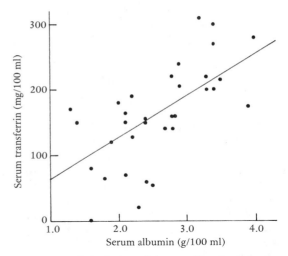

Fig. 10–5. Correlation of serum albumin and transferrin in malnourished adult patients. Serum albumin has a long half-life and is in slow equilibrium with extravascular albumin whereas serum transferrin has a more rapid turnover rate and equilibrium. Thus the latter represents a more sensitive indicator of secretory protein metabolism and will more accurately reflect decreased or increased synthesis rate in serial measurements. (Bistrian BR, Blackburn GL, Scrimshaw NS, Flatt JP: Am J Clin Nutr 28:1150, 1975)

tion of muscle circumference with serum albumin supports this conclusion (3, 6).

HEMATOLOGY

In the Minnesota experiment on semistarvation (31) PCM was shown to reduce leukocytes without alteration of the differential count. Complete starvation of obese adults, on the other hand, produces neutropenia unresponsive to folic acid supplements (19). Peripheral lymphocytopenia in hospitalized patients who become acutely malnourished as a result of stress and low-calorie feeding is associated with an impairment of cellular immunity (4).

URINARY TESTS

Analysis of an aliquot of a 24-hour to 48-hour urine sample for sodium, potassium, urea, and creatinine is particularly helpful in assessing the nutritional status of the patient and the effect of therapy. Additional aliquots can be used to screen specific nutrient breakdown products.

Information on electrolyte balance not only aids assessment of kidney function and metabolic response to infused electrolytes, but also

often reflects the completeness of dietary intake. The most difficult part of nutritional assessment is the patient's recent dietary intake; it is invariably overestimated and poorly recorded by house and nursing staffs. Assuming the patient is in salt balance, knowledge of the salt content of the diet and of sodium excretion can readily resolve this discrepancy in most instances.

A clinical estimate of total nitrogen excretion can be obtained by measuring the urinary urea nitrogen and adding 3.5 g nitrogen to account for nonurea nitrogen (2 g) and for stool and cutaneous nitrogen losses (1.5 g) (36). Knowledge of protein intake then allows calculation of nitrogen balance and approximate net protein utilization. This obviates the measured determination of total nitrogen loss by Kjeldahl digestion, which is not clinically practical.

CREATININE HEIGHT INDEX

A creatinine height index (CHI) is defined as the 24:hr urinary creatinine excretion of a particular subject divided by the expected 24-hour urinary creatinine excretion of a "normal" male or female of the same height. The "normal" urinary creatinine excretion (Table 10–1) is calculated as the product of the mean creatinine excretion for males on a creatine and creatinine-free diet (23 mg/kg body weight (45)) and the ideal weight for each height, according to Metropolitan Life Insurance standards (16). Since height

TABLE 10–1. Expected 24-hr Urine Creatinine Excretion of "Normal" Adult Males of Different Heights*

Height (in.)	(cm)	Ideal weight† (kg)	Creatinine coefficient (mg/kg)	24-Hr urine creatinine (g)
62	157.5	56.0	23	1.29
63	160.0	57.6	23	1.32
64	162.5	59.0	23	1.36
65	165.1	60.3	23	1.39
66	167.6	62.0	23	1.43
67	170.2	63.8	23	1.47
68	172.7	65.8	23	1.51
69	175.3	67.6	23	1.55
70	177.8	69.4	23	1.60
71	180.3	71.4	23	1.64
72	182.9	73.5	23	1.69
73	185.4	75.6	23	1.74
74	188.0	77.6	23	1.78
75	190.5	79.6	23	1.83
76	193.0	82.2	23	1.89

*Bistrian BR, Blackburn GL, Sherman M: Surg Gynecol Obstet 141:516, 1975
†Metropolitan Life Insurance standards. Chicago Society of Actuaries Build and Blood Pressure Study, 1959

remains essentially unaltered by malnutrition (29) and creatinine excretion continues to correlate with body cell mass (41), a CHI affords a means of assessing the nutritional status of the metabolically active tissue by allowing a comparison between expected body cell mass for height and actual body cell mass (56). Preliminary results in females suggest a creatinine coefficient of 18 mg/kg under these same conditions (unpublished observation).

CELLULAR IMMUNITY

Cell-mediated immunity (CMI) is an important host defense system against infection, and its depression is associated with increased morbidity and mortality from infectious disease in man (39, 46). Susceptibility of malnourished children to viruses and gram-negative bacteria (2, 35), the absence of tuberculin reactions in kwashiorkor (35), and the failure to develop a positive tuberculin tests after BCG injection (27) have been considered secondary to nutrition depression of thymus-derived (T) lymphocytes (see Ch. 21).

In vitro and *in vivo* measurement of cellular immunity in malnourished children have confirmed impairment (25, 42, 47, 50) as have postmortem studies revealing severe lymphocyte depletion of lymph nodes and thymus (43, 55).

Depressed cellular immunity and the effect of short-term nutritional repletion to improve this function has been described in hospitalized adults (4, 33) who became malnourished as a result of disease and the semistarvation regimens routinely employed. Serum albumin and transferrin are excellent markers of significant protein deficit and cellular immune function in both childhood and adult PCM.

In vitro and *in vivo* tests of cellular immunity include: 1) lymphocyte transformation to antigens and mitogens, 2) T and B cell indentification, 3) dinitrochlorobenzene (DNCB) sensitization by the Catalona technique (14), and 4) skin tests with recall antigens (candida, varidase (SK/SD), mumps). Only the latter 2 tests have widespread availability since the former 2 are research techniques. Since DNCB tests the general inflammatory response by the appearance of a prominent blister at 24 hours and also results in a prominent delayed hypersensitivity response when positive, this test is customarily performed only when the recall antigens give negative or

equivocal results or when detailed information on CMI is important.

Impaired cellular immunity may be associated with other immunologic and hematologic defects, including those of polymorphonuclear leukocytes (48) and bursa-derived (B) cells. Equally important as the number of leukocytes is their ability to ingest and kill gram-negative organisms, an ability impaired in PCM (15, 48). The specific mediators of the immune response, including components of complement (49) and levels of other circulating factors, also can be expected to be affected by nutritional status.

DIAGNOSTIC AND THERAPEUTIC CATEGORIES OF MALNUTRITION

It is of the utmost importance when making nutritional assessments to classify malnutrition categories in order to tailor the support plan to the individual patient. Our assessment of 380 patients over two years led to the characterization of three common types of PCM: 1) visceral attrition state, 2) adult marasmus or cachexia, and 3) intermediate states.

VISCERAL ATTRITION STATE

This is a common syndrome in the well-nourished or over-nourished individual in whom the combination of severe catabolic stress and the standard semistarvation diets combine to selectively depress the levels of visceral protein and immunologic competence. As in children, this kwashiorkorlike state evolves from a low or protein-free diet in which the calories delivered are primarily in the form of carbohydrate. Due to the rapidity of onset, these patients maintain their anthropometric measurements (weight-height, TSF, and AMC) despite severe depression of serum proteins, such as transferrin and albumin. Associated with this visceral protein depletion is a depression of cellular immune function as measured by delayed hypersensitivity skin testing and lymphocyte counts. In visceral attrition, fat stores and skeletal muscle reserves are adequate to sustain the patient's calorie and protein requirements, but they are unavailable for use. Protein-sparing regimens (9, 24) that provide fluids, electrolytes, vitamins, minerals, and protein at levels slightly greater than the RDA are often quite effective at restoring visceral protein despite continued fat and weight loss.

ADULT MARASMUS OR CACHEXIA

The marasmic-type picture of chronic illness is obvious even to the nutritional novice. Markedly depleted anthropometric measures occur but with the maintenance of serum protein until late in the course. This type of malnutrition is common. It is usually present on admission and is produced by an inadequate diet of some duration associated with mild catabolic illness. The adult marasmic patient can benefit from vigorously pursued standard hospital diet therapies if given adequate time to restore the body reserves, but this does require the "fed" state. Net anabolism in both skeletal muscle and visceral protein can only be achieved when daily protein and calorie requirements are fully met.

INTERMEDIATE STATES

The moderate-to-severe stress of serious heart failure, trauma, or major surgery can produce severe protein catabolism (32). In the marasmic patient, already depleted of his skeletal muscle protein reserve, rapid depression of visceral protein levels occur if semistarvation regimens are employed. These patients are less able to withstand catabolic stress than the adult with adequate fat and skeletal muscle protein. Therefore the necessity for vigorous nutritional therapy is much more urgent and the care more sophisticated. Marasmic kwashiorkorlike patients require vigorous hyperalimentation, either oral or parenteral. Since repair of any significant PCM is difficult in the presence of severe stress, anticipated hypercatabolism from elective surgery may justify delay until partial repletion is accomplished (10).

If the field of nutrition is to stay abreast of the time and obtain the interest, respect, and curriculum support it deserves, it must establish its importance as a clinical specialty. A nutritional service is the ideal vehicle to exemplify nutrition's role in curative medicine. While delivering patient care, the NSS can nutritionally characterize and closely document a patient population and thus provide an excellent base to further knowledge in clinical medicine.

The metabolic consequences of severe illness oblige us to employ diet therapy with maximum leverage to reduce morbidity and mortality and improve the quality of existence in many disease states. Unfortunately, the lack of sufficient knowledge has prevented general recognition of the extent of the problems involved with hospi-

tal dietary deficiencies and of the techniques for reversing those deficiencies. The multidisciplinary approach of the NSS in patient care, education, and research, however, can lead to increased awareness of the importance of nutritional support and to widespread implementation of optimal nutritional care for the hospitalized patient.

REFERENCES

1. Abel RM, Beck CH, Abbot WM, Ryan JA, Barnett GO, Fischer JE: Improved survival from acute renal failure after treatment with intravenous essential L–amino acids and glucose. N Engl J Med 288: 695, 1973

2. Becker WB, Kipps A, McKensie D: Disseminated herpes simplex virus infection; its pathogenesis based on virological and pathological studies in 33 cases. Am J Dis Child 115:1, 1968

3. Bistrian BR, Blackburn GL, Hallowell E, Heddle R: Protein status of general surgical patients. JAMA 230: 858, 1974

4. Bistrian BR, Blackburn GL, Scrimshaw NS, Flatt JP: Cellular immunity in semi-starved states in hospitalized adults. Am J Clin Nutr 28:1148, 1975

5. Bistrian BR, Blackburn GL, Sherman M: Therapeutic index of nutritional depletion in hospitalized patients. Surg Gynecol Obstet 141:512, 1975

6. Bistrian BR, Blackburn GL, Vitale J, Cochran D, Naylor J: Nutritional status of general medical patients. Clin Res 22: 692A, 1974

7. Blackburn GL, Bistrian BR, Page G: Role of a hospital nutrition support service. Proc Am Coll Nutr 1974

8. Blackburn GL, Flatt JP, Clowes GHA Jr, O'Donnell TF, Hensle T: Protein sparing therapy during periods of starvation with sepsis or trauma. Ann Surg 177: 588, 1974

9. Blackburn GL, Flatt JP, Hensle TE: Peripheral amino acid infusions. In Fischer J (ed): Total Parenteral Nutrition. Boston, Little, Brown, 1976

10. Blackburn GL, Williams LF, Bistrian BR, Stone MS, Phillips E, Hirsch E, Clowes GHA Jr, Gregg J: New approaches to the management of severe acute pancreatitis. Am J Surg 131: 114, 1976

11. Bollet AJ, Owens SO: Evaluation of nutritional status of selected hospitalized patients. Am J Clin Nutr 26: 931, 1973

12. Burke WA: Hospital practice: preparation including incompatability and instability. Chicago, Proc on Total Parenteral Nutrition. American Medical Association, 1972

13. Bury KD, Stephens RV, Randall HT: Use of a chemically defined liquid elemental diet for nutritional management of fistulas of the alimentary tract. Am J Surg 121: 174, 1971

14. Catalona WJ, Taylor PT, Rabson AS, Chretien PB: A method for dinitrochlorobenzene contact sensitization. N Engl J Med 286: 399, 1972

15. Chandra RK: Immunocompetence in undernutrition. J Pediatr 81: 1194, 1972

16. Chicago Society of Actuaries Build and Blood Pressure Study, 1959

17. Copeland EM, MacFayden BV, Lanzotti VJ, Dudrick SJ: Intravenous hyperalimentation as an adjunct to cancer chemotherapy. Am J Surg 129: 167, 1973

18. Daly JN, Vars HM, Dudrick SJ: Effects of protein depletion on strength of colon anastomosis. Surg Gynecol Obstet 134: 15, 1972

19. Drenick EJ, Alvarez LC: Neutropenia in prolonged fasting. Am J Clin Nutr 24: 859, 1971

20. Dudrick SJ, Long JM, Steiger E, Rhoads JE: Intravenous hyperalimentation. Med Clin North Am 54: 577, 1970

21. Duke JH Jr, Jorgensen SB, Broel JR, Long CL, Kinney JM: Contribution of protein to calorie expenditure following injury. Surgery 68: 1968, 1970

22. Feller JH, Brown RA, Toussaint GP, Thompson AG: Changing methods in the treatment of severe pancreatitis. Am J Surg 127: 196, 1974

23. Fischer JE, Foster GS, Abel RM, Abbot WM, Ryan JE: Hyperalimentation as primary therapy for inflammatory bowel disease. Am J Surg 125: 165, 1973

24. Flatt JP, Blackburn GL: The metabolic fuel regulatory system: implications for protein-sparing therapies during caloric deprivation and disease. Am J Clin Nutr 27: 175, 1974

25. Geefhuysen J, Rosen EV, Rosen J, Katz T, Ipp T, Metz J: Impaired cellular immunity in kwashiorkor with improvement after therapy. Br Med J 4: 527, 1971

26. Goldman DA, Maki DG: Infection control in total parenteral nutrition. JAMA 223: 1360, 1973

27. Harland PSEG: Tuberculin reactions in malnourished children. Lancet 2: 719, 1965

28. Hoffenberg R, Black E, Brock JF: Albumin and gamma globulin tracer studies in protein depletion states. J Clin Invest 45: 143, 1966

29. Jelliffe DB: The Assessment of Nutritional Status of the Community. Geneva, WHO, 1966, p 221

30. Johnson EQ: The therapeutic dieticians role in the alimentation group. J Am Diet Assoc 62: 648, 1973

31. Keys AJ, Brozek A, Henschel A, Mickelsen D, Taylor HL: The Biology of Human Starvation, Vol I. Minneapolis, University of Minnesota Press, 1950, p 257

32. Kinney JM: The effect of injury on metabolism. Br J Surg 54: 435, 1967

33. Law DK, Dudrick SJ, Abdou NI: Immunocompetence of patients with protein calorie malnutrition. Ann Intern Med 79: 543, 1973

34. Law DK, Dudrick SJ, Abdou NI: The effects of protein calorie malnutrition on immune competence. Surg Gynecol Obstet 139: 257, 1974

35. Lloyd A: Tuberculin test in children with malnutrition. Br Med J 1: 407, 1968

36. Mackenzie T, Blackburn GL, Flatt JP: Clinical assessment of nutritional status using nitrogen balance. Fed Proc 33: 683, 1974

37. Moore FD: Metabolic Care of the Surgical Patient. Philadelphia, WB Saunders, 1966, p 32

38. Moore FD, Olesen KH, McMurrey JD, Parker HV, Ball MR, Boyden C: Body Composition in Health and Disease. Philadelphia, WB Saunders, 1963, p 491

39. Phillips I, Wharton B: Acute bacterial infections in kwashiorkor and marasmus. Br Med J 1: 407, 1968

40. Rutten P, Blackburn GL, Flatt JP, Hallowell E, Cochran D: Determination of optimal hyperalimentation infusion rate. J Surg Res 18: 475, 1975

41. Ryan RJ, Williams JD, Ansell BM, Bernstein LM: The relationship of body composition to oxygen consumption and creatinine excretion in healthy and wasted men. Metabolism 6: 365, 1967

42. Schlesinger L, Steckel A: Impaired cellular immunity in marasmic infants. Am J Clin Nutr 27: 615, 1974

43. Schonland M: Depression of immunity in protein calorie malnutrition: a post mortem study. Environ Child Health 18: 217, 1972

44. Scrimshaw NS: Kwashiorkor, marasmus, and intermediate forms of protein-calorie malnutrition In Beeson P, McDermott W (eds): Cecil and Loeb Textbook of Medicine. 13th ed. Philadelphia, W B Saunders, 1971, p 1433

45. Scrimshaw NS, Hussein MA, Murray E, Rand WM, Young VR: Protein requirements of man: variations in obligatory urinary and fecal nitrogen losses in young men. J of Nutr 102: 1595, 1972

46. Scrimshaw NS, Taylor LE, Gordon JE: Interactions of nutrition and infection. (Monograph 57) Geneva, WHO, 1968, p 262

47. Sellmeyer E, Bhettay E, Truswell A, Meyers O, Hansen J: Lymphocyte transformation in malnourished children. Arch Dis Child 47: 429, 1972

48. Selvaraj RJ, Seetharon Bhat K: Metabolic and bactericidal activities of leukocytes in protein calorie malnutrition and effect of dietary treatment. Am J Clin Nutr 25: 166, 1972

49. Sirinsiha S, Suskind R, Edelman R, Charupatana C, Olson RE: Complement and C-3 proactivator levels in children with protein calorie malnutrition and effect of dietary treatment. Lancet 1: 1016, 1973

50. Smythe P, Schonland M, Brereton–Stiles G, Cooradia HM, Grace H, Loening WER, Parent MA, Vos GH: Thymolymphatic deficiency and depression of cell-mediated immunity in protein calorie malnutrition. Lancet 2: 939, 1971

51. Stephens RV, Randall HT: Use of concentrated, balanced, liquid elemental diet for nutritional management of catabolic states. Ann Surg 170: 642, 1969

52. Studley HO: Per cent of weight loss: a basic indicator of surgical risk. JAMA 106: 458, 1936

53. Thoburn R, Fekety FR, Cluff LE, Marvin VB: Infections acquired by the hospitalized patient. Arch Intern Med 121: 1, 1968

54. Trinkle JK, Fisher LJ, Ketcham AS, Berlin NI: The metabolic effects of preoperative intestinal preparation. Surg Gynecol Obstet 118: 739, 1964

55. Vint FW: Post mortem findings in natives in Kenya. East Afr Med J 130: 332, 1937

56. Viteri FE, Alvarado J: The creatinine height index: its use in the estimation of the degree of protein depletion and repletion in protein-calorie malnourished children. Pediatrics 46: 696, 1970

57. Whitehead GR, Coward WA, Lunn PG: Serum albumin concentration and the onset of kwashiorkor. Lancet 1: 63, 1973

58. Wilmore D. Report on workshop no. 4: evaluation of the patient. Chicago, Proc on Total Parenteral Nutrition. American Medical Association, 1972

11

Parenteral nutrition: principles, nutrient requirements, techniques, and clinical applications

H. C. Meng

Adequate nutrition is necessary to maintain health. This is true especially in patients having trauma or major surgical procedure. In these conditions, patients are hypercatabolic with marked increases in energy expenditure and nitrogen loss. Furthermore, they are usually anorexic or unable to eat. In some instances, such as injury, surgery, or disease of the GI tract, oral feeding can aggravate the disease or be detrimental to wound healing. For these reasons, parenteral nutrition would be an important or the only form of therapy to meet nutritional needs.

Parenteral nutrition concerns the administration of nutrients by routes other than the GI tract. This excludes also feedings by the gastric or duodenal tube or by the rectal route. Since the amounts of nutrients and the volume of nutrient solutions are large, it is not convenient to use subcutaneous, IM, or intraperitoneal routes. In addition, the absorption of the major foodstuffs (carbohydrate, protein, and fat) is slow, time-consuming, and not without discomfort. Thus, the only practical route for the introduction of all nutrients in adequate amounts is IV administration.

The field of parenteral nutrition is not new. The IV use of glucose for nutrition purpose was begun at the end of the 1890s. In 1911, Kausch reported the use of intravenously infused glucose to a patient following surgery. A quantitative study of the disappearance of IV glucose was reported in 1915. The use of fat emulsion in dogs was accomplished by Marlin and Riche in 1915 and by Yamakawa and associates in patients in 1920. L. E. Holt was the first to administer fat emulsions intravenously to pediatric patients in 1935 in the United States. Henriques and Anderson demonstrated nutritional utilization of hydrolyzed protein after IV injection in animals, and protein hydrolysate was first given to a patient in 1939 by Elman.

Attempts were also made in 1876 to give all nutrients subcutaneously by injections. Clark and Brunschwig were the first to administer solutions containing the 3 major nutrients, carbohydrate, protein, and fat, for IV nutrition to adult patients in 1942. Another documented success of parenteral nutrition in an infant was reported by Helfrick and Abelson in 1944. Subsequent attempts to provide complete parenteral nutrition met with failure. In 1949, Meng and associates were the first to provide dogs complete parenteral nutrition, including all six essential nutrients: 1) protein, 2) fat, 3) carbohydrate, 4) vitamins, 5) electrolytes and some inorganic trace minerals, and 6) water (86). They demonstrated that long-term complete parenteral nutrition exclusively by continuous infusion into the superior vena cava via an indwelling catheter is capable of achieving weight gain, positive nitrogen balance, general health, and sense of well-being. However, research in the field of parenteral nutrition has progressed at a slow pace, although much enthusiasm existed in the development of fat emulsions as a concentrated calorie source in the 1950s and early 1960s. Because of the adverse effects encountered after long-term administration of Lipomul, a 15% cottonseed oil emulsion, physicians were compelled to return to the conventional IV therapy, which consists of 5%–10% glucose and occasional protein hydrolysate.

Parenteral nutrition entered into a new era in the late 1960s. In 1968, Dudrick *et al.* (39) demonstrated in puppies, in an infant, and in postoperative patients that normal growth, development and positive nitrogen balance can be achieved by continuous administration via an indwelling catheter into the superior vena cava of a solution containing protein hydrolysate and concentrated glucose along with vitamins and minerals. Further work reported by Dudrick

and associates also showed favorable results (37, 38). Many other reports (8, 56, 60, 88, 104, 127) have since appeared in the literature showing the effectiveness of this procedure in achieving body weight gain, positive nitrogen balance, wound healing, and spontaneous closure of enterocutaneous fistulas in patients after surgery or with various diseases. Thus, this supportive regimen was recognized as being so useful that its application was accepted by many. Today, parenteral nutrition has wide use in the practice of medicine to maintain adequate nutrition in patients who cannot or should not eat by mouth. In addition, many medical centers have established parenteral nutrition units as one of the services to improve patient management.

Parenteral nutrition is indicated when patients are unable to eat by mouth and tube feeding is contraindicated or has failed. Indications are

1. Abnormality of GI tract
 a. Ingestion of food impossible or unwise, *e.g.,* obstruction, peritonitis
 b. Inability to retain ingested food, *e.g.,* vomiting, diarrhea, or fistula
 c. Impaired digestion and absorption, *e.g.,* malabsorption syndromes, regional enteritis, or ulcerative colitis
 d. Trauma or elective surgery
 e. Edema due to severe malnutrition
2. Preparation for surgery in nutritionally depleted and emaciated patients
3. After surgery or trauma, especially burns or multiple fractures with complications such as sepsis
4. Coma, anorexia nervosa, or refusing to eat
5. Supplementation of inadequate oral feeding in patients with cancer, especially those receiving chemotherapy or radiation therapy, and those with renal or hepatic failure, or other diseases

It is important to institute parenteral nutrition as early as possible to check starvation and prevent further deterioration. Furthermore, consideration must be given to administer all nutrients, protein, carbohydrate, fat, vitamins, electrolytes, and water in adequate amounts and proper proportion since it is known that efficient utilization of one nutrient requires the presence of others. However, one should consider the specific disease condition of the patient and prescribe for him according to his needs rather than follow a standard formulation for all patients. It should also be remembered that rehabilitation of nutritionally depleted patients is slow. Once

parenteral nutrition is initiated, it should be pursued with vigor to improve the patient's nutritional status, assist his recovery, and permit prolonged treatment of underlying disease states. It may be emphasized that substitution of IV for oral feeding requires meticulous care and is inconvenient, time consuming, and expensive. Therefore, total parenteral nutrition (TPN) should be replaced by oral feeding as soon as the patient is able to eat a "reasonable" amount of food by mouth.

In this chapter the principles, nutrient requirements, techniques, and clinical use of parenteral nutrition are briefly presented. For further understanding, readers are referred to reviews (36, 52, 73, 83) and proceedings of symposia on this subject (32, 44, 70, 87, 132, 133).

NUTRIENT REQUIREMENTS

From the standpoint of cellular nutrition, it makes little difference whether the nutrients are administered orally (enterally) or parenterally. In either route, the nutritional requirements in adults are generally similar when age, sex, height, and weight are considered. However, the principle of furnishing adequate nutrients to meet the needs of specific patients should always be kept in mind (for requirements of pediatric patients, see Ch. 12).

PROTEIN

One of the most important tasks of parenteral nutrition is to prevent further depletion of the body protein stores, to maintain nitrogen balance, and to promote protein synthesis for tissue repair and wound healing. In addition, the synthesis of hormones and enzymes is necessary for the control of biochemical and physiologic activities and the regulation of metabolic processes.

REQUIREMENT

Recommended Dietary Allowances suggest that the protein requirement for a "reference" young adult of 22 years of age, man, or woman, is 50 g/day, or approximately 0.8 g/kg body weight/day, to maintain nitrogen equilibrium (105). Expressed in terms of nitrogen, this is approximately 8.0 g/day (the conversion factor is 6.25 g protein = 1g nitrogen). The available information concerning any increase in protein requirement in elderly people is not conclusive

(13, 68, 95). It may be stated that the total nitrogen need in adult patients requiring parenteral nutrition is 8–16 g/day irrespective of their age. In the author's experience (88, 127), 12–13 g/day have been found adequate to maintain positive nitrogen equilibrium in most of the patients except those with severe trauma, such as major burns and sepsis. Patients with chronic renal failure have been given 1.5–4 g nitrogen/day as essential amino acids, permitting utilization of endogenously produced urea. With this nitrogen intake and adequate calories, nitrogen equilibrium and weight gain can be accomplished.

SOLUTIONS FOR PARENTERAL NUTRITION

Currently available preparations that are being used as a nitrogen source in parenteral nutrition are hydrolysates, crystalline amino acids, whole blood, plasma, and serum albumin.

PROTEIN HYDROLYSATES. Four preparations of protein hydrolysates are available in the United States. They are prepared by either enzymatic hydrolysis of casein (Hyprotigen, CPH, and Travamin) or by acid hydrolysis of plasma fibrin (Aminosol). They are fortified by adding certain amino acids that have been destroyed during hydrolysis. In these preparations of partially hydrolyzed proteins, as much as 40% of the total amino acids may be in the form of short peptides of 2–4 amino acids. It has been reported that utilization of peptides is not as efficient as that of free amino acids, and their loss in the urine may be considerable.

In general, protein hydrolysates are fairly well tolerated, although mild adverse reactions such as nausea and vomiting are occasionally encountered. Decreasing the rate of infusion usually reduces the incidence of reactions. One gram protein hydrolysate is equivalent to about 0.75 g protein. Such preparations are usually available as a 5% or 10% solution. Thus, 75–100 g protein hydrolysate/day, or 1.0–1.5 g, or 20–30 ml/kg body weight/day should be sufficient for most of the patients except those with major burns or sepsis.

CRYSTALLINE AMINO ACID MIXTURES. Recently, the use of crystalline amino acid mixtures in parenteral nutrition has been revived. The advantages of using amino acids are: 1) pure starting material is used, 2) composition of amino acids can be formulated according to needs, and 3)

absence of peptides, which increases the utilizable nitrogen and reduces the urinary loss. Currently, only one crystalline amino acid solution is commercially available in the United States. This preparation, FreAmine II is a mixture of L-amino acids, except methionine which is in DL-form. It is likely that other solutions of L-amino acids for parenteral nutrition will be available in the near future. The amino acid composition of FreAmine II and Travasol is shown in Tables 11–1 and 11–2. Travasol may become commercially available soon. There are several amino acid solutions for parenteral nutrition in European countries (Vamin, and Aminofusin) and in Japan. The cost of crystalline amino acid solutions is somewhat higher than that of protein hydrolysates at present.

WHOLE BLOOD, PLASMA, AND SERUM ALBUMIN. For the purpose of protein nutrition, neither whole blood, plasma, nor serum albumin is a preparation of choice. Utilization of these preparations is slow and insufficient. In addition, they are expensive and may produce adverse effects such as hepatitis. However, they may be indispensible for replacement therapy.

SELECTION OF SOLUTIONS. In selecting an amino acid solution for parenteral nutrition, it is important to consider the following factors: 1) total nitrogen given should be adequate to meet the daily need; 2) all 8 essential amino acids should be present in adequate amounts and in proper balance (Table 11–3); 3) the ratio (E/T) of essential amino acids (g) to total amino acids (g) should be considered—this ratio of dietary protein for adults and for infants is about 0.20 (20%) and about 0.40 (40%) respectively, but it has been suggested that the E/T ratio should be about 40% regardless of age, except for patients with uremia or hepatic failure; 4) the presence of several nonessential amino acids is more effective in maintaining nitrogen balance than the use of only one (42, 95); and 5) L-amino acids are better utilized than those in DL-form. Histidine has been found essential for growth in infants and perhaps also in uremic adults. Adequate amounts of arginine are needed to prevent hyperammonemia, and proline, after hydroxylation, is required for the synthesis of collagen, which is necessary for wound healing. In addition, alanine is the main form of transport for amino nitrogen between tissues, and it seems preferable to include this as a major part of the nonessential amino acids for parenteral nutrition. However, it should be remembered that at

TABLE 11—1. Composition of FreAmine II*

Essential amino acids	mg/100 ml	Nonessential amino acids	mg/100 ml
L-Isoleucine	590	L-Alanine	600
L-Leucine	770	L-Arginine	310
L-Lysine	770	L-Histidine	240
DL-Methionine	450	L-Proline	950
L-Phenylalanine	480	L-Serine	500
L-Threonine	340	Glycine	1790
L-Tryptophan	130	L-Cysteine HCl H$_2$O	20
L-Valine	560		

*McGaw laboratories: Amino acid concentration is 8.5 g/100 ml, and nitrogen concentration is 1.25 g/100 ml

TABLE 11—2. Composition of Travasol*

Essential amino acids	mg/100 ml	Nonessential amino acids	mg/100 ml
L-Isoleucine	263	L-Alanine	1140
L-Leucine	340	L-Arginine	570
L-Lysine (as HCl salt)	318	L-Histidine	241
L-Methionine	318	L-Proline	239
L-Phenylalanine	340	L-Tyrosine	22
L-Threonine	239	Glycine	1140
L-Tryptophan	99		
L-Valine	253		

*Travenol laboratories: Amino acid concentration is 5.5 g/100 ml

TABLE 11—3. "Ideal Dietary Essential Amino Acid Pattern, Whole Egg, FAO Recommendation and the Minimum Requirements of Rose*

Amino acid	Ideal protein[+]	Whole egg	FAO[‡]	Rose[§]
Isoleucine	4.5	5.6	4.5	4.2 (0.70)
Leucine	6.8	6.4	5.1	6.6 (1.10)
Lysine	5.2	5.0	4.5	4.8 (0.80)
Methionine	3.7	2.9	2.4	
Methinoine + Cystine	5.5	4.5	4.5	6.6 (1.10)
Phenylalanine + Tyrosine	8.0	7.5	6.0	6.6 (1.10)
Tryptophan	1.0	0.9	1.5	1.5 (0.25)
Valine	4.3	5.1	4.5	4.8 (0.80)
Threonine	3.0	3.0	3.0	3.0 (0.50)

*Relative figures achieved by setting threonine at 3.0 to make comparison
[+]Longenecker JB: In Albanese AA (ed): New Methods of Nutritional Biochemistry New York, Academic Press, 1963
[‡]Protein Requirement. Report of a Joint FAO/WHO Experts Group, WHO Technical Report series, No 301, 1965
[§] Rose WC: Nutr Abst Rev 27:631, 1957. Figures in parentheses are minimum requirements of Rose. The values of methionine and phenylalanine were attained when no cystine or tyrosine was added to the diet; cystine was found to spare methinoine requirement by 80%—89%, and tyrosine was found to spare phenylalanine requirement by 70%—75%

TABLE 11—4. Estimated Total Caloric Need

Requirement	Patient 1	Patient 2	Patient 3
Calculated basal*	1449	1701	1853
Fever (8% of basal/1° F)	81	272	444
Specific dynamic action (8% of basal)	135	136	148
Bed activity (30% of basal)	506	510	556
Total estimated	2171	2619	3001
Total measured[†]	2422	2653	2925

*From the DuBois chart on the basis of the height, age and sex of the patient
[†]Determined by Jones Metabolism apparatus. From Rice CD, Orr B, Enquist I: Ann Surg 131:289, 1950

present, it is difficult to consider any one crystalline amino acid solution "ideal" for parenteral nutrition in patients with a variety of diseases such as uremia, hepatic failure, or sepsis.

ENERGY (CALORIES)

REQUIREMENT

Recommended Dietary Allowances suggest 2700 and 2000 Cal/day for a "reference" young man and woman, respectively, who are engaged in moderate physical activities (105). The estimation of caloric requirement is shown in Table 11–4. The energy expenditure is said to be progressively decreased with age. Again, the general rule of thumb is that calories given should be adequate to maintain the body weight in patients who are in a reasonably good nutritive state; this is about 30–35 Cal/kg/day. In patients who have lost considerable weight, more calories are necessary to achieve weight gain; in some cases, 55 Cal/kg/day were given. As shown in Figures 11–1, 11–2 and 11–3 energy expenditure as well as nitrogen loss is further increased in patients with severe trauma or sepsis (74, 102). It is important to remember that utilization of amino acids or nitrogen for protein synthesis is reduced considerably without concomitant administration of adequate calories.

Although some amino acids are being utilized for energy, it is suggested that only adequate nonprotein calories should be considered. Since monosaccharides, glucose and fructose, are used in parenteral nutrition in the United States, 3.75 Cal/g glucose or fructose should be used for calculation. Each gram fat and ethanol furnishes 9.0 and 7.0 Cal, respectively. The unit of energy may be expressed as kilocalories (Cal or kcal), as it has been used traditionally, or as kilojoules (kJ); 1 Cal = 4.184 kJ and 1000 Cal = 4.184 megajoules (MJ). The Joint FAO/WHO Ad Hoc Expect Committee suggests that values be expressed in both joules and calories (41).

SOURCE

GLUCOSE (DEXTROSE). In the common American diet, carbohydrates are usually consumed primarily as starch. Some sucrose and a small amount of lactose are also ingested. After digestion in the intestine monosaccharides, which consist of about 80% glucose, 15% fructose, and 5% lactose, are formed. Thus, glucose is a most important physiological sugar; it can be obtained in pure form and is inexpensive. In addition, it is readily available as an energy source. Since fat emulsion was not commercially available in the United States until November, 1975, glucose has been given as the sole calorie source in parenteral nutrition by most investigators. Concentrations of commercially available glucose solutions are 5%–50%. There are also 60% and 70% glucose solutions, which are used under Investigation of New Drugs (IND) for parenteral nutrition in the home and in uremic

Fig. 11–1. Duration of negative nitrogen balance following surgically uncomplicated operation or trauma. (From Meng HC, Law DH (eds), PARENTERAL NUTRITION, 1970. Courtesy of Charles C Thomas, Publisher, Springfield, Illinois.)

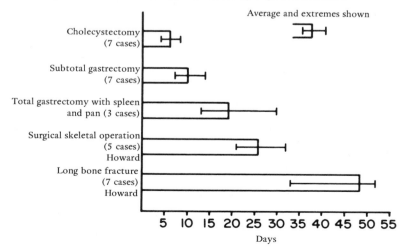

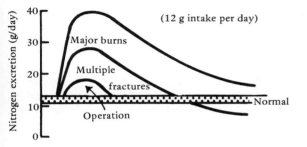

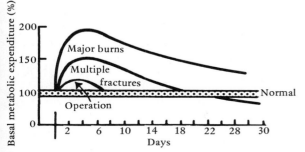

Fig. 11–2. Influence of trauma on nitrogen excretion and metabolic expenditure. (From Meng HC, Law DH (eds), PARENTERAL NUTRITION, 1970. Courtesy of Charles C Thomas, Publisher, Springfield, Illinois.)

patients. The glucose concentration of solutions given to patients is usually 20%–40%. This is necessary in order to supply the daily need of about 3000 Cal without fat.

FRUCTOSE (LEVULOSE). Since glucose intolerance exists in many conditions such as severe trauma, major surgery, diabetes mellitus,

hepatic disease, uremia, sepsis, and excessive stress, studies to use glucose substitutes have been conducted; among these are fructose and invert sugar. Fructose is also a physiological sugar; its quantity in the body is smaller than glucose. It was reported that IV administration of fructose produced lactic acidosis, hyperuricemia, and depletion of adenosine triphosphate. Thus, it is not likely that fructose may replace glucose as the sole source of calories in long-term parenteral nutrition. In addition, fructose intolerance has been reported in some individuals. Dietary history concerning this possibility must be ruled out before fructose is administered.

INVERT SUGAR OR COMBINATION OF GLUCOSE AND FRUCTOSE. Invert sugar is a hydrolytic product of sucrose composed of equal amounts of fructose and glucose. The early results reported by various investigators concerning the advantages of invert sugar over glucose are controversial and inconclusive. However, recent observations at Vanderbilt University School of Medicine suggest that the use of a mixture consisting of 10% fructose and 10% glucose is better tolerated than that of a 20% glucose solution in premature and postoperative infants. Meng *et al.* (92) have also observed better tolerance in adult postoperative patients for esophageal cancer given a combination of 15% fructose and 10% glucose than in those given 25% glucose. Further study on the use of a mixture of fructose and glucose of various ratios and of invert sugar is warranted. Currently, 5% and 10% fructose

Fig. 11–3. Comparative daily nitrogen losses after surgery of a 70-kg man. (Lawson LJ: Br J Surg 52:795, 1965)

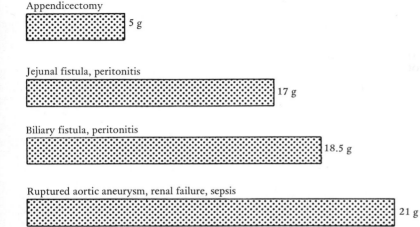

Appendicectomy
5 g

Jejunal fistula, peritonitis
17 g

Biliary fistula, peritonitis
18.5 g

Ruptured aortic aneurysm, renal failure, sepsis
21 g

and invert sugar are commercially available. Invert sugar must not be given to patients with fructose intolerance.

SORBITOL AND XYLITOL. Sorbitol is a 6-carbon sugar alcohol. It is oxidized to fructose and then converted to glucose; it is metabolized as such thereafter. It has been suggested that some sorbitol is also converted to glucose directly. Sorbitol, as 5%–30% solutions, has also been used in parenteral nutrition in Europe. It is not commercially available in the United States.

Xylitol is a 5-carbon sugar alcohol. Conversion of xylitol to glycogen via the pentose phosphate pathway had been reported many years ago. Much work has also been done on the metabolism and utilization of xylitol. Clinical use of xylitol in parenteral nutrition has been reported and is being used in Germany and Japan. Due to toxicities observed following the IV administration of xylitol, its clinical use for parenteral nutrition in the United States has not been fully studied. However, long-term studies in dogs show that xylitol is fairly well tolerated when the total daily dosage is not excessive (10 g/kg/day), the infusion rate is not more than 0.4 g/kg/day, and the concentration of the solution is not above 15% (84). Thus, a well-controlled, carefully managed study in man using limited amounts of xylitol in combination with glucose seems warranted.

MALTOSE. Maltose is a disaccharide. Each mole of maltose forms 2 moles of glucose after complete hydrolysis. It has been reported that IV maltose is metabolized. Recently, the possibility of using maltose as an energy source in parenteral nutrition has been considered. The advantage of maltose is that it is not hyperosmolar as compared to glucose of the same concentration. Levenson *et al.* (118) report that maltose is tolerated by dogs and can be used for parenteral nutrition. This should eliminate or minimize the adverse effects frequently encountered in patients given hyperosmolar glucose. However, Yoshimura *et al.* (140) showed an excessive urinary loss of maltose in rats receiving an IV infusion of maltose. The use of maltose for parenteral nutrition in man has not been studied.

GLYCEROL. The caloric value of glycerol is approximately the same as that of glucose. Given as a diluted solution in moderate dosages, glycerol is tolerated by man and animals (52). Large doses of glycerol can cause hemolysis, hypotension, central nervous disturbances, and convulsions (52). Its substitution for glucose in parenteral nutrition does not appear warranted except for special reasons.

ALCOHOL (ETHANOL). Ethyl alcohol supplies 7 Cal /g if completely oxidized. The liver is the main site of its metabolism, and the rate of metabolism has been estimated to be 100–200 mg/kg/hr, but the range of individual differences is large. Evidence for utilization of the IV alcohol as an energy source has been reported. It is usually given as a 2.5%–5.0% solution. (Rice *et al.* (106) have used alcohol in parenteral nutrition and have demonstrated its nitrogen-sparing effect.) However, the rate of alcohol infusion must be carefully controlled so blood levels are not higher than 0.08% or even 0.05% in order to avoid intoxication and urinary loss. It should be remembered that hepatotoxic effects have been noted despite the consumption of an adequate diet. It has also been reported that older debilitated patients often do not tolerate even diluted solutions of alcohol well. Thus the use of alcohol in parenteral nutrition is not recommended, although there may be times when it seems appropriate because of its tranquilizing effect.

FATS. As stated previously, an adequate and well-balanced diet should include all nutrients. Fat, as an important or essential nutrient, should be given in parenteral nutrition if a suitable, nontoxic preparation is available. It is not only a concentrated source of energy (9 Cal/g), providing a large amount of calories in a small volume of water which may be advantageous in some patients, but it also supplies essential fatty acids. Essential fatty acid deficiency has been observed in adult patients as well as in infants and children on long-term parenteral nutrition devoid of fat (57, 107). Fat emulsions are isotonic and may be infused into a peripheral vein.

Recently, a fat emulsion (Intralipid) for parenteral nutrition, has become commercially available in the United States. It contains 10% soybean oil, 1.2% purified egg phosphatides for emulsification, and 2.5% glycerol for isotonicity. Much work has been done concerning the safety and efficacy of Intralipid (55, 81, 82, 139). It is well tolerated and is effective as a source of essential fatty acids and calories. Severe toxic effects such as "overloading syndrome," which was observed in some patients given Lipomul, a 15% cottonseed oil emulsion (78, 89, 94), were not encountered. (Lipomul was withdrawn from

the market by the manufacturer in 1964). Other fat emulsions are available in other countries, *e.g.,* Lipofundin S.

The exact requirement of essential fatty acids in man is not clearly defined. Collins *et al.* suggest that at least 7.5 g linoleic acid/day, which furnishes 2.2% of the total caloric intake, is necessary to correct essential fatty acid deficiency (24). However, at this intake, the plasma triene-tetraene ratio (eicosatrienoic acid, 20:3 w 9 to arachidonic acid, 20:4 w 6) remained greater than 0.3 (less than 0.3 is considered normal). When 22.5 g linoleic acid/day furnishing 6.4% of the total caloric intake were given, the percentage of eicosatrienoic acid decreased from 9.9% to 1.2% of the total plasma fatty acids on the first day of treatment. Jeejeebhoy *et al.* (62) suggest that 25 g linoleic acid/day may be required. Perhaps the essential fatty acid requirement in man is within the range of 7.5–25 g/day. However, it may be further stated that this range may represent the maintenance and therapeutic requirements and may vary with the length of the period required to show the therapeutic effect. It is interesting that Press and associates (99) have daily applied and rubbed 230 mg sunflower oil (containing 120 mg linoleic acid) on the surface of one forearm of 3 adult patients with essential fatty acid deficiency. They found that this treatment was capable of increasing the levels of linoleic and arachidonic acids and decreasing eicosatrienoic acid in the serum toward normal. These results suggest that the daily requirement of essential fatty acids may be as low as 2–3 mg/kg/day. It seems generally agreed that the optimal requirement for linoleic acid in infants and children is 4.0% of the total caloric intake, as originally suggested by Holman and associates (58).

The optimal requirement of fat for calories other than essential fatty acids is not known. Based on the information of the daily fat intake in the United States, it is about 1.5–2.5 mg/kg in individuals consuming 2500–3500 Cal. This is the number of calories given to most adult patients receiving parenteral nutrition, except those who have major burns, severe trauma, and extensive surgery. However, some investigators have given as much as 5.0 g/kg/day or more to adult patients; this is not recommended. It should be remembered that the daily dosage of fat given should be below the metabolic capacity of the patient receiving long-term parenteral nutrition so that a "margin of safety" is preserved to avoid "overloading" or other adverse effects.

CARBOHYDRATE–FAT CALORIE RATIO

The optimal ratio of carbohydrate to fat calorie is not known. In newborn infants on breast milk, 50%, 38%, and 12% of the total caloric intake is supplied by fat, carbohydrate and protein, respectively (119). Based on the average daily consumption of fat per person in the United States, the percent of calories contributed by fat is 30%–55% of the total intake in most individuals. Since the percent of calories supplied by protein is usually 10%–15%, the carbohydrate calories should contribute 30%–60% of the total. Thus, the carbohydrate–fat calorie ratio probably ranges between 60%: 30% and 30%: 55%. In some countries, the dietary fat intake is low, contributes no more than 10%–15% of the total caloric intake. It is clear that the carbohydrate–fat calorie ratio of food consumed orally varies widely, and it is difficult to suggest what may be the optimal carbohydrate–fat calorie ratio for parenteral nutrition. It seems, however, that a minimum of 10%–15% of the total caloric intake and a maximum of 55% of the total caloric intake may be given as fat; 25%–35% of the total caloric intake supplied as fat may be a reasonably educated guess. Again, it must be pointed out that the needs and disease states of the individual patients must be taken into consideration.

NITROGEN–CALORIE RATIO

The importance of nitrogen–calorie relationship is exemplified in Table 11–5. It is noted that giving only 5% or 10% glucose without nitrogen does not provide adequate calories and would result in a marked negative nitrogen balance. Increasing both nitrogen and caloric intake can significantly reduce the nitrogen loss. Calloway and Spector (20) review the relationship between nitrogen and calorie intake and nitrogen equilibrium. Their findings show that for normal young, active men on a protein-free diet the negative nitrogen balance can be maximally reduced by supplying about 700 nonprotein calories; further protein-sparing effect is not observed even if the intake is increased to as high as 2800 Cal in the absence of protein. When the caloric intake is 3350–3500, nitrogen equilibrium is achieved with a daily nitrogen intake of about 8.5 g; the nitrogen–calorie ratio in this case is about 1: 410. Using the estimations on body weight loss as results of fasting, elective surgery, trauma, and sepsis, Kinney (67) suggests a nitrogen–calorie ratio of about 1: 120 to

TABLE 11–5. Nitrogen Balance of Patients on Parenteral Nutrition

Author	Surgical procedure	Nitrogen intake (g/kg)	Cal/kg	Daily Nitrogen Balance (g)					Cumulative nitrogen balance
				Operation	1	2	3	4	
Krieger	Subtotal	0 (10)*	13	−13.7	−11.6	−12.4	−10.7	−12.8	−57.9 (−11.6)[†]
et al.**	Gastric	0.17 (6)	23	− 2.6	− 9.4	− 9.4	− 8.2	− 8.6	−38.2 (− 7.6)
	Resection	0.28 (10)	38	− 3.3	− 1.2	− 1.2	− 3.2	− 2.9	− 7.3 (−1.5)
Wadstrom	Cholecys-	0 (10)	10						−11.9 (−6.0)[†]
and	tectomy	0.10	10						− 4.8 (2.4)
Wirklund[††]		0.10	35						− 1.2 (0.6)
Heller [‡‡]	Hyster-	0 (10)	0	− 7.4	− 9.3	− 6.8			−23.5 (−7.8)[†]
	ectomy	50[‡] (9)	0	− 4.5	− 4.3	− 3.7			−12.5 (−4.2)
		50[‡] (19)	1000 [§]	− 3.4	− 2.3	− 2.3			− 8.0 (−2.7)

*Figures in parentheses are the number of patients
[†]Figures in parentheses represent average nitrogen balance per day
[‡]50 g amino acids as Aminofusin L-600, which represents about 7.6 g nitrogen
[§] 1000 Cal/day/patient
**Krieger H, Abbott WE, Leavy S, Holden WD: Gastroenterol 33:807, 1957
[††]Wadstom LB, Wirklund PE: Acta Chin Scand 325:50, 1964
[‡‡]Heller L: Scand J Gastroenterol [4 suppl] 3:7, 1969

1: 180. At Vanderbilt University Medical Center, patients (excluding those with major burns) receiving parenteral nutrition, a daily intake of nonprotein (glucose) calories and nitrogen (crystalline amino acids) is approximately 2532 and 12.5 g, respectively; the nitrogen–calorie ratio is 1: 202. The protein contribution to the total caloric intake (glucose + protein) is about 11%. Wilmore (134) reports that the nitrogen requirement is 21–25 g/m² body surface/day during the period of 30–40 days of postburn (see Ch. 14). With the combination of tube feeding and IV nutrition, 4000–8000 Cal have been given daily. This amount was able to correct the negative nitrogen balance. The nitrogen–calorie ratio of these regimens is certainly greater than

TABLE 11–6. Vitamins in Solution for Parenteral Nutrition

Vitamin	Amount*	
	1 liter	3 liter
A	1400 USP units	4200 USP units
D	140 USP units	420 USP units
C	70 mg	210 mg
Thiamine HCl (B_1)	7.0 mg	21.0 mg
Riboflavin (B_2)	1.4 mg	4.2 mg
Niacinamide	14.0 mg	42.0 mg
Pyridoxine (B_6)	2.1 mg	6.3 mg
Dexpenthenol	3.5 mg	10.5 mg
B_{12}	5.0 μg	15.0 μg
Folate	200 μg	600 μg

*1.4 ml aqueous multivitamin infusion solution (MVI) is added to 1 liter infusate for parenteral nutrition; B_{12} and folate are added separately. Vitamin K is not added to the infusate; it is given as AquoMEPHYTON (2.5 mg/7–10 days) intramuscularly

1: 200. Peaston (98) also preferred more than 200 Cal: 1 g nitrogen. Recently, Chen et al. (23) measured blood and urinary urea in patients receiving parenteral nutrition. They found that for the complete utilization of 1 g nitrogen, approximately 425–450 Cal of nonprotein source is required. In addition, one must consider the amino acid pattern and the condition of patients, which are also important factors affecting protein and calorie utilization.

VITAMINS

Vitamins are needed for proper metabolism of amino acids, fat, and carbohydrates and for the maintenance of certain physiological and biochemical functions. However, the knowledge of vitamin requirements in TPN is meager. In addition, patients who require TPN are under stress, nutritionally depleted, critically ill, septic, or any combination of these. Such conditions may further alter vitamin requirements. Generally, vitamins given to patients receiving parenteral nutrition are based on assumptions made from oral requirements previously established. In addition, the dosages of vitamins are also subject to the availability of preparations that can be obtained commercially. In the author's practice, 1.4 ml Multiple Vitamin Injection (MVI) is added to 1 liter amino acid–glucose solution, and 3 liter this solution, or 4.2 ml of the 10 ml ampule MVI, are given daily to an adult patient. Folate, 200 μg, and B_{12}, 5 μg, are added to 1 liter infusate (Table 11–6). Vitamin K as AquaMEPHYTON is given every 7–10 days by IM injection as needed. Based on these intakes,

all serum vitamin measurements show satisfactory levels [except those of vitamins D, K, and B_6, which were not measured (96)]. Serum levels of vitamin E were also acceptable (normal values are 0.5–1.5 mg/100 ml). The need for vitamin E may be increased when fat emulsion containing considerable amounts of polyunsaturated fatty acids is used. However, there is no injectable vitamin E commercially available at this time. Biotin is currently not added to parenteral nutrition solution in most studies. Perhaps it should be given, especially in patients on antibiotics that may change the intestinal flora. A daily dosage of 60 μg is adequate for maintenance in patients with normal vitamin status.

ELECTROLYTES AND INORGANIC TRACE MINERALS

The requirements for electrolytes vary widely in individual patients depending on volume and type of fluid loss, preexisting deficits, cardiovascular, renal and endocrine status, and type and amount of nutrients given. It is essential to monitor plasma electrolyte levels at frequent intervals to afford a rational basis for adjusting dosages until the preexisting deficits and abnormal acid–base balance are corrected. It should be pointed out also that the dosages of electrolytes given by various investigators vary. The article on "Minerals" by Shils may be consulted (116).

SODIUM AND POTASSIUM

In patients without excessive loss, 60–100 mEq sodium/day are adequate. Less sodium should be given to patients with renal insufficiency or cardiovascular diseases. Sodium deficit decreases protein utilization. Potassium is needed during glucose infusion. It also plays an important role in protein synthesis. Davidson *et al.* (33) report that hyperaminoaciduria occurred in the presence of potassium deficiency but disappeared when potassium was replaced. Cannon *et al.* (21) have shown that administration of protein hydrolysate to potassium-depleted rats will not promote growth; the addition of potassium results in growth and nitrogen balance. The ratio between urinary potassium and nitrogen during fasting is 10 mEq: 1 g; a ratio similar to this is also found in normal muscle. In the author's practice, 120 mEq/day are given to an adult patient. This dosage should be adequate in most of the patients.

MAGNESIUM AND CALCIUM

Magnesium serves as a cofactor in a number of enzyme reactions (130). The magnesium (as magnesium sulfate) concentration of the solution currently used at Vanderbilt University Medical Center is 10 mEq/liter, or 30 mEq/day in an adult. The quantity of calcium required in parenteral nutrition to maintain balance, bone mineralization, and normal function of the parathyroid gland is not known. The parenteral nutrition solution contains 4.5 mEq (90 mg) calcium/liter as calcium gluceptate; in a patient receiving 3 liter infusate, the total calcium intake is 13.5 mEq (or 270 mg)/day, a value which appears satisfactory. Shils suggests 200–400 mg calcium/day for an adult patient (115). It should be pointed out that immobilization increases urinary excretion and that the presence of intestinal drainage also contributes to its loss. In this case, 400–500 mg/day may be needed.

PHOSPHORUS, CHLORIDE, AND ACETATE

The infusate used at Vanderbilt University Medical Center contains 420 mg elemental phosphorus as a mixture of potassium acid and dibasic phosphate; the total daily dose in an adult patient is 1260 mg (40.6 mEq). Although inorganic phosphate given by investigators varies widely, it is likely that this daily dosage is large for most patients. Half of this amount may meet the daily requirement in most of the patients if there is no excessive loss. It should be stated as of historic interest that most investigators did not add phosphorus to the parenteral nutrition solution in early studies. This may not be significant when casein hydrolysate containing this element is used. However, when the nitrogen source was supplied by plasma fibrin hydrolysate or crystalline amino acids with no added phosphorus, hypophosphatemia was noted (126). Although the clinical significance of hypophosphatemia remains to be elucidated, it is not difficult to recognize the importance of phosphorus in intermediary metabolism, in bone formation, and as an essential component in certain compounds such as ATP, phospholipids, and nucleic acids.

The parenteral nutrition infusate used by the author contains 30 mEq chloride and 25 mEq acetate/liter. Excessive chloride should be avoided, to prevent hyperchloremia. A considerable amount of anions should be given as acetate. It is good bicarbonate precursor and maintains acid–base equilibrium.

INORGANIC TRACE MINERALS

Iron is not added to parenteral nutrition solutions at Vanderbilt University Medical Center. It is given IM every week at a dosage of 50 mg, as Imferon, as needed. Iodine has not been given to patients receiving parenteral nutrition. However, it should be given to patients on long-term nutrition. It has been suggested that the requirement of iodine may be in the order of 100–150 µg/day for "goitre control." Other inorganic trace elements, *e.g.,* zinc, copper, manganese, chromium, nickel, cadmium, molybdenum, selenium, and vanadium, have been reported as essential nutrients, but the requirements for these metals in man are not known. Recommended Daily Allowances suggest that 15 mg zinc be given daily to an adult (105). Based on current knowledge regarding the absorption of zinc after oral ingestion, it was proposed that 2–4 mg elemental zinc/day should be given IV to an adult. Usually 5 mg zinc sulfate is added to each liter of parenteral nutrition infusate; 3 liter of this infusate supply 15 mg zinc sulfate or about 5 mg zinc. According to the serum zinc levels that were observed, this intake (5 mg zinc) may be somewhat low in some patients, but zinc deficiency has not been documented by the author. Zinc deficiency has been reported by others in patients receiving parenteral nutrition (49, 66).

Copper deficiency has been observed in patients on long-term TPN (49, 65, 129). It is recommended that copper be added to the infusate for parenteral nutrition. However, the copper requirement in humans is not known. According to the suggestion of the WHO Expert Committee, the estimated requirements are 80 µg/kg/day for infants, 40 µg/kg/day for older children, and 30 µg/kg/day for adult males (125). Vilter *et al.* (129) administered 1 mg copper as copper sulfate to a 56-year-old woman who had copper deficiency as the result of long-term parenteral nutrition. She responded to the treatment immediately with an increase in white blood cell count and in nuetrophilic leucocytes in bone marrow.

Chromium deficiency has also been reported in a patient receiving long-term parenteral nutrition (61). It seems reasonable to assume that chromium should be given to these patients. The urinary loss, which constitutes the major portion of the daily loss of chromium, is 5–10 µg/day; this amount could be considered the minimum requirement and must be replaced in order to maintain balance in an adult (125). According to

available information from toxicity studies in various laboratory animals, a daily dose of 10–20 µg chromium is not likely to produce any toxic effect in man.

WATER

Since all nutrients given for parenteral nutrition are administered in aqueous solutions or oil-in-water emulsion, it is clear that problems of hydration and excretion must be met to achieve successful therapy and to avoid overhydration or dehydration. Obviously, water requirements vary in individual patients, depending on their pathologic conditions. Consideration should be given first to correct any preexisting abnormality, especially in the presence of water deficits, extensive water loss from fistulas of the GI tract, denuded body surfaces, or severe diarrhea. The quantity of water which fulfills the need of excretions (urine and stools), insensible water loss, and proper tissue hydration of a normal adult is approximately 100 ml/100 Cal/day or about 2600 ml. The fluid volume usually given to an adult patient is about 3 liter/day or 30–45 ml/kg/day. However, in patients with renal or pulmonary disease or cardiac decompensation, a large volume of fluid cannot be tolerated. In general, if one avoids osmotic diuresis, water requirements usually present no problems. Careful attention to urinary output and observation of fluid retention should provide information of appropriate daily fluid loads.

TECHNIQUES AND PROCEDURES
COMPOSITION OF INFUSATE FOR PARENTERAL NUTRITION

Law (73) has compiled the composition of several solutions used by various investigators who have documented their effectiveness in correcting negative nitrogen balance, achieving weight gain, and promoting wound healing. Parenteral nutrition solutions of similar composition have also been used by other workers. However, due to lack of objective methods for the evaluation of the efficacy of these preparations it is difficult to select any one of them as being superior to the others. The composition of the parenteral nutrition solution currently given to adult patients at Vanderbilt University Medical Center is shown in Table 11–7. Each liter of this solution contains 250 g glucose (dextrose monohydrate, USP), furnishing about 844 Cal (1 g dextrose yields 3.75 Cal). The nitrogen, at a concentration of

4.2 g/1000 ml, is supplied as a formulated mixture of essential and nonessential amino acids with a protein equivalent of 26 g. Three liters of this solution provide 12.5 g nitrogen, or 78 g protein equivalent, and 2532 Cal. The nitrogen–calorie ratio is 1 g:202 Cal; the nitrogen and caloric intake is about 0.21 g and 42 Cal/kg body weight/day, respectively.

As stated previously, the need of adequate calories for amino acid utilization for protein synthesis is well known. To achieve the effectiveness of both calories and nitrogen, they must be administered concurrently. The importance of the temporal relationship of nitrogen and calorie administration has been demonstrated by Elman (40). This temporal relationship is probably also applicable to vitamins and electrolytes in the utilization of amino acids, carbohydrates, and fats. Examples for these are numerous, and some of them have been cited.

PREPARATION OF SOLUTIONS

As suggested by Burke (19) the preparation of solutions for parenteral nutrition should be the responsibility of the pharmacy staff. However, the justification for setting up a parenteral nutrition program depends on the individual hospital. In hospitals that wish to establish such programs, the guidelines suggested by Shils may be helpful (115). Vanderbilt University Medical Center uses three procedures to prepare parenteral nutrition solutions.

The first is similar to that reported by Flack and associates (48) and is used when a large volume of the solution is required (127). This method yields 5-gallon batches. All solutions and containers are sterilized. The solutions of amino acids, glucose, electrolytes, and vitamins are added together, mixed, and bottled through a cellulose ester membrane filter (Millipore filter, pore size 0.22 μ) under nitrogen in a closed system in a Laminar air flowhood. The solution is then capped, labeled, and sampled at random for sterility and pyrogenicity before being released for infusion. When modification of the electrolyte content is necessary, it is done in the pharmacy. The solution has been stored at 4° C 1–2 months without adverse effects.

In the second method, a predetermined volume of a solution of amino acids is transferred into a 1-liter plastic bag (Viaflex) containing 500 ml 50% glucose. The transfer is made using a VicVac unit connected to a suitable vacuum source. Vitamin and electrolyte preparations are

TABLE 11–7. Solution for Parenteral Nutrition

Component	Amount/liter	Amount/day[‡]
Glucose (monohydrate)	250 g	750 g
Amino acids	28.2 g	8.5 g
Nitrogen	24.7 g	12.5 g
Glucose	900 Cal	2700 Cal
Na+	33 mEq*	99 mEq
K+	40 mEq	120 mEq
Mg++	10 mEq	30 mEq
Ca++	4.5 mEq	13.5 mEq
CL−	30 mEq	90 mEq
Acetate	25 mEq	75 mEq
P (inorganic phosphorus)	420 mg	1260 mg
ZnSO4	5 mg	15.0 mg
Vitamins[†]	1.4 ml	4.2 ml

*30 mEq/liter were added as sodium chloride and 3 mEq/liter were in FreAmine as sodium bisulfite
[†]Vitamins were given as aqueous multivitamin infusion solution (MVI 10 ml – ampule – see Table 11–6). Folate and B$_{12}$ were added to the infusate separately. Iron as Imferon was given separately when needed
[‡]Amount in 3 liters given to an adult patient daily

added to sterile distilled water and are then transferred into the bag containing the glucose and amino acids. The bag is kneaded gently to achieve thorough mixing. Mixing and transferring are done in a Laminar air flowhood.

The third procedure is the use of commercially available "hyperalimentation kits," which consist of either protein hydrolysate or crystalline amino acid solution and 50% glucose. One solution is transferred into the other, and electrolytes and vitamins are then added under a Laminar air flowhood.

ADMINISTRATION.

CENTRAL VENOUS CATHETER

Most of the solutions currently used for TPN in the United States are hyperosmolar. To prevent or minimize damage to the vein, a central vein must be used for infusion. The technique introduced by Wilmore and Dudrick (135) is the most widely used. At Vanderbilt the procedure is to place a 1.6-mm Silastic catheter into the subclavian or an external jugular vein percutaneously or through a cutdown; the catheter is then directed into the superior vena cava. The position of the catheter must be verified radiographically, and then it is sutured to the skin. The internal jugular vein has also been used for the placement of the central venous catheter. The use of brachial, axillary or femoral vein is not recommended. This small lumen of the vein per-

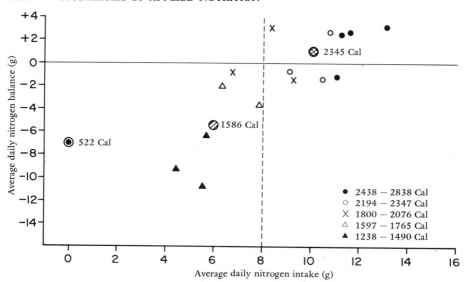

Fig. 11–4. Relationship between nitrogen intake and nitrogen balance in patients receiving varying caloric intake. (VanWay CW III, Meng HC, Sandstead HH: Arch Surg 110:272. Copyright 1975, American Medical Association)

mits little blood flow between the vessel wall and the catheter, and would thus contribute to the occurrence of phlebitis. Furthermore, a long catheter is an inconvenience to the patients and may increase the possibility of contamination. Placement of the central venous catheter must be done in accordance with strict aseptic techniques. Povidone–iodine solution is applied to the skin surrounding the catheter entry site, and a completely occlusive sterile dressing is applied. Dressings are changed at least every 48 hr. All procedures must be done with meticulous care to avoid infection. It is suggested that the dressing changes be done by a limited number of staff physicians or nurses who know the procedure well.

PERIPHERAL VENOUS INFUSION

Occasionally it is impossible or unwise to use a central venous catheter. In this case, peripheral venous infusion may be used. Three liters of a solution containing 10% glucose and 1.4% amino acids along with vitamins and electrolytes supplying about 1200 Cal and 6.25 g nitrogen (38 g protein equivalent) may be beneficial. However, VanWay, Meng, and Sandstead (128) have shown that the intake of nitrogen as crystalline amino acids and calories less than 8 g and 1800 Cal/day, respectively, did not significantly improve the negative nitrogen balance over that observed in patients receiving no nitrogen and

only 550 Cal/day (Fig. 11–4). An additional 1000 Cal supplied by 1 liter 10% fat emulsion should be given. The fat emulsion and glucose–amino acid solution should be administered concurrently through a Y-tube connected to the catheter (Fig. 11–5). Since fat emulsion dilutes the glucose–amino acid solution, the concentration of amino acid can be slightly increased. Total parenteral nutrition by peripheral vein has been used successfully in infants by Borressen, Coran, and Knutrud (16), by the author's group (97), and by others (34, 55).

USE OF ARTERIOVENOUS SHUNT

The arteriovenous shunt that is used for hemodialysis has been modified for TPN by Shils and associates (117) and by Scribner and associates (112) with apparent success. However, it is not recommended for long-term use.

OTHER CONSIDERATIONS RELATED TO ADMINISTRATION

USE OF IN-LINE FILTER AND PUMPS. Generally, the nutrient solution is delivered from a bottle or plastic bag to a patient by gravity. An in-line Millipore filter about 2.5 cm in diameter interposed between the infusion tubing and the catheter is a helpful addition. A filter with a porosity of 0.22 μ provides absolute sterility, but a peristaltic pump must be used to overcome the resist-

ance exerted by the filter and to assure constant and adequate flow. Since the use of a pump creates the risk of air embolization, close supervision is strongly recommended. The use of filters of this porosity is not recommended for the infusion of fat emulsion. Millipore filters with a porosity of 0.45μ will prevent the passage of some microorganisms and particulate matters; they do not accomplish absolute sterility.

CHANGES OF INFUSION TUBING AND ADMINISTRATION OF DRUGS. The infusion bottle that contains 1 liter parenteral nutrition solution should be changed every 12 hr even if it is not completely empty. The infusion tubing from the bottle down to the catheter hub must be changed at least once every 24 hr. To prevent contamination and avoid physical or chemical incompatibility between parenteral nutrition solution and drugs, especially antibiotics, nothing should be added to the bottle or injected into the infusion line. Transfusion or withdrawal of blood through the catheter must be avoided. Such practices usually are responsible for infection or plugging of the catheter.

RATE OF INFUSION. The optimal infusion rate for glucose is said to be 0.5–0.75 g/kg/hour, although 0.35 g has been proposed to avoid hyperglycemia and urinary spillage. The rate de-

Fig. 11–5. Y-tube connecting infusion sets from amino acid–glucose solution and fat emulsion bottles with the central venous catheter.

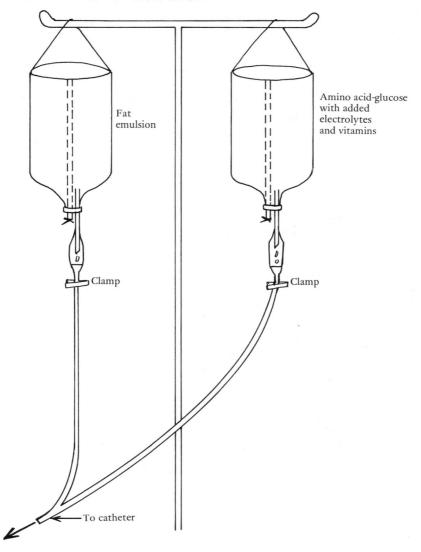

pends on the individual patient's condition. Insulin must be administered to some patients. The dosage of insulin is based on urinary glucose loss given at appropriate intervals. Some investigators prefer to add insulin into the infusate; 1 unit insulin to 7–10 g glucose. Information concerning urinary loss of amino acids during infusion of protein hydrolysate or amino acid solutions at different rates is not available. It has been proposed that 0.02–0.03 g nitrogen/kg/hour may be given continuously during a 24-hr period producing no adverse effects. In most patients except those with renal and cardiac disease, 3 liter of the solution shown in Table 11–7 are given during the 24-hr period. On the first day 1 liter is administered, 2 liter on the second day, and 3 liter on the third and succeeding days. Additional fluid is given when needed during the first 2 days. A continuous infusion rate of 125 ml/hour provides 3 liter in 24 hr. If the infusion should fall behind, the deficit may be corrected by increasing the rate of administration slowly. If the infusion stops completely, measures must be taken to avoid reactive hypoglycemia especially when insulin has been added to the infusate; usually 5% or 10% glucose should be given. The rate of infusion of fat emulsion may be maintained at 0.1–0.5 g/kg/hour. Regardless of the daily dosage, the infusion rate should be maintained at about 0.5–1 ml/minute during the first 15–30 min to avoid possible adverse effects. The initial dosage of fat should be given at 0.5 g/kg/day; it is increased stepwise to 1, 1.5, 2, and 2.5 g/kg/day in 4 or 5 days. Plasma triglyceride or optical density should be measured before each increment is made. The increase in dosage should be delayed when hyperlipidemia or hypertriglyceridemia is observed; in fact, the dosage may be reduced or administration of fat emulsion temporarily discontinued when hyperlipidemia persists.

CLINICAL APPLICATION IN VARIOUS DISEASE STATES

In the past 10 years parenteral nutrition has become widely used as a form of therapy in patients who cannot eat by mouth. It has been given not only to postoperative or posttraumatized patients but also to those with a variety of disease states. This section is not intended to review thoroughly the clinical applications of parenteral nutrition but merely to present some examples in the major areas of medicine in which parenteral nutrition, given either totally or in combination with other forms of nutrition

therapy, has been found to be beneficial or even life-saving. Fischer (44) reviews these subjects in detail.

SURGERY AND TRAUMA

It is believed by some that well-nourished patients with uncomplicated major surgery or moderately severe trauma may not need an extensive TPN program. In these cases, a well-planned IV therapy is sufficient to maintain adequate circulatory volume and provide fluid, electrolytes, and glucose for preventing dehydration, electrolyte imbalance, and continued body protein loss (101). Moore (93) even suggests that vigorous attempts at TPN may be deleterious by delaying the return of appetite and intestinal functions. Blackburn et al. (15) have proposed peripheral venous nutrition with 3.5% amino acid solution containing adequate vitamins and electrolytes but devoid of glucose; the primary source of energy is the mobilized triglyceride from the adipose tissue in the form of free fatty acids. However, in patients who are severely debilitated because of chronic disease or prolonged malnutrition, or both, or in those who are unable to eat for an extended period of time as the result of severe trauma, sepsis, or complications of surgery, vigorous TPN must be carefully planned and initiated. In these patients, substantial weight loss, marked reduction of skeletal muscle mass, and total body protein are invariably experienced. In addition, energy storage in the adipose tissue is depleted. Lawson (74) has observed that an acute loss of 30% of body weight was uniformly fatal in a series of severely ill surgical patients. Randall (103) has estimated that the nitrogen loss that a patient can sustain acutely and still have sufficient muscle strength to survive is about one-third of his total protein nitrogen or somewhat less than 50% of skeletal muscle protein; this would be a negative nitrogen balance of about 350 g, representing 2200 g protein or 13 kg muscle. It is apparent that a patient with a negative nitrogen balance of this magnitude is usually unable to survive for more than 2 weeks if adequate nutritional support is not given.

Parenteral nutrition that can significantly decrease nitrogen loss at the peak of catabolic response has also been demonstrated by many investigators prior to 1967. Many more reports have been published showing the effectiveness of TPN since Dudrick et al. first introduced the technique of "intravenous hyperalimentation."

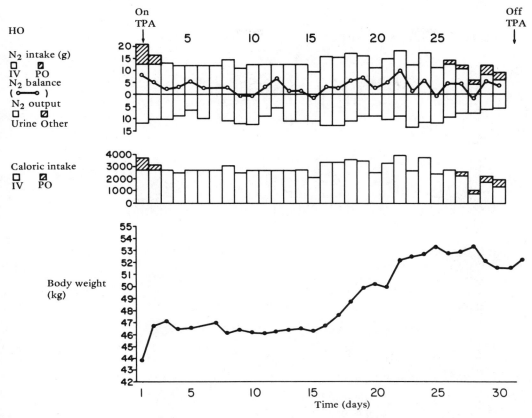

Fig. 11–6. Daily caloric intake, body weight, and nitrogen balance of patient H.O. (VanWay CW III, Meng HC, Sandstead HH: Ann Surg 177:103, 1973)

Fig. 11–7. Continued weight gain and persistent positive nitrogen balance accompanied by successful esophagomyotomy on day 13 in patient with achalasia, tuberculosis, and recurrent staphylococcal infections. (Dudrick SJ, Wilmore DW, Vars HM, Rhoads JE: Ann Surg 169: 974, 1969)

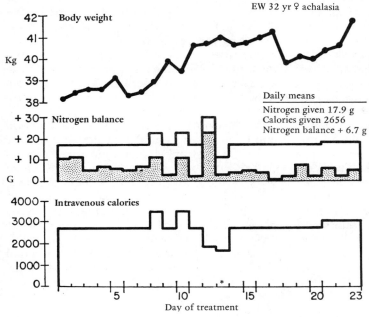

*Operation

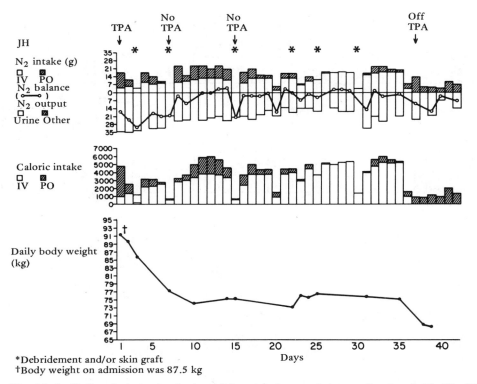

Fig. 11–8. Daily caloric intake, body weight, and nitrogen balance of patient J. H. (VanWay CW III, Meng HC, Sandstead HH: Ann Surg 177:103, 1973)

The following cases are presented to exemplify the importance and effectiveness of maintaining adequate TPN in surgical and traumatized patients.

Patient H. O. received TPN for 30 days (Fig. 11–6). Six years before admission, the patient, a 70-year-old man, had undergone total gastrectomy with en bloc resection of omentum, spleen, left hemi diaphragm, left lower lobe of the left lung, body and tail of the pancreas, left lobe of the liver, left adrenal gland, and splenic flexure of the colon. The pathologic diagnosis was reticulum cell carcinoma of the stomach. His preoperative weight was about 70 kg but was subsequently stabilized at around 55 kg. He had persistant anemia and hypoalbuminemia. During the previous 2–3 years, he had begun to lose weight gradually so that he weighed only 45 kg on admission. There was no evidence of a recurrent tumor. A course of TPN was elected and continued for 30 days. During the period of parenteral nutrition his average daily caloric intake was 2865 Cal with an average daily nitrogen intake of 13.43 g as crystalline amino acids. The average daily nitrogen retention was 3.32 g, and he gained 9.6 kg body weight in a month;

most of the weight gain occurred during the second half of the parenteral nutrition period. He required diuretic therapy for control of pedal edema during this period but showed no other signs of fluid overload. As his general conditions improved, he was able to maintain his weight by oral alimentation. One month after discharge from the hospital he weighed 53 kg.

During the period of TPN in a 32-year-old woman with achalasia the average daily nitrogen intake was 17.9 g given as a protein hydrolysate and an average daily caloric intake of 2656; continued weight gains and persistent positive nitrogen balance were observed (Fig. 11–7).

A 28-year-old chemical plant worker with phosphorus burns on 70% of the body surface involving the trunk and all four extremities received nutritional therapy (Fig. 11–8). About 30% of the body had full-thickness skin loss. After stabilization of the initial fluid and electrolyte imbalances, 6 days after the burn, he was placed on parenteral nutrition as a part of the program of nutritional supplementation, which included oral feedings of hospital diets and oral feeding of an elemental diet (Vivonex-100). Except for days 3 and 7, the caloric intake fur-

nished by oral and parenteral routes was about 3000 Cal/day during the first 10 days of nutritional therapy; the average daily caloric intake during the 35-day period was 4137 Cal. The average daily nitrogen intake was 15.3 g with a net nitrogen loss of 15.8 g/day during the first 10 days. The weight loss during this period was very rapid with an average of 1.7 kg/day. From days 11–35 the body weight was maintained between 73–77 kg. The average daily nitrogen and caloric intake was 16.5 g and 4684 Cal, respectively, with an average net nitrogen loss of 3.4 g/day. Further weight loss was observed when parenteral nutrition was discontinued and oral intake was inadequate. This patient represents a fairly typical major burn. Such patients have an astounding catabolic drain. Despite attempts made to institute a program for vigorous nutritional supplementation by all routes available, he still lost a total of 16 kg during the 35-day period on TPN. This was due, in part, to difficulties encountered in administering enough nitrogen and calories to meet extensive loss. The nitrogen loss during the first 6 days on nutritional therapy was 30–35 g/day. Beginning from the 8th day of nutritional therapy, the nitrogen balance was almost maintained and body weight was stabilized. Nutritional supplementation in

the range of 4000–6000 Cal/day with a nitrogen balance of 20–30 g as amino acids is necessary to maintain a patient with severe burn in nutritional balance after the initial 10–14 days. Wilmore *et al.* (134) have shown that with daily intakes of 4000–8000 Cal by combined IV–enteral nutritional support, weight gain was achieved in some patients in the latter phase of severe burns (see Ch. 14).

GASTROINTESTINAL DISEASES

Maldigestion and malabsorption are invariably associated with diseases of the GI tract, especially the chronic inflammatory disease of the bowel such as regional enteritis. Short bowel syndrome and fistula formation may result following surgical intervention. The occurrence of intestinal cutaneous fistulas is associated with significant morbidity; mortality rates have been reported as high as 65%. In addition, complications of fluid and electrolyte imbalances, infection, starvation, and skin erosion often lead to progressive deterioration of the patient's condition. Excessive weight loss, marked reduction of serum albumin and delayed wound healing are encountered. Failure to ameliorate or correct the abnormal conditions even when the

Fig. 11–9. Daily caloric intake, body weight, nitrogen balance, and nitrogen loss from fistula drainage of patient D. B. during parenteral nutrition. (Meng HC, Sandstead HH: Long-term total parenteral nutrition in patents with chronic inflammatory diseases of the intestines. In Wilkinson AW (ed): Parenteral Nutrition. Edinburgh, London, Churchill Livingstone, 1972, p 213)

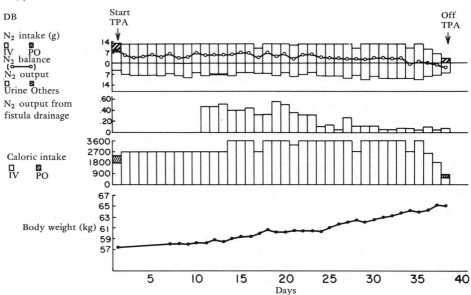

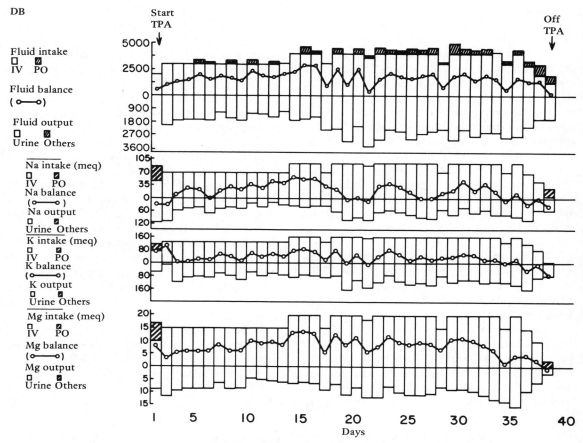

Fig. 11–10. Fluid, sodium, potassium, and magnesium balances of patient D. B. during TPN. (Meng HC, Sandstead HH: Long-term total parenteral nutrition in patents with chronic inflammatory diseases of the intestines. In Wilkinson AW (ed): Parenteral Nutrition. Edinburgh, London, Churchill Livingstone, 1972, p 213)

bowel was put at rest was attributed to the lack of proper nutrition by some. The importance of nutrition during fistula therapy was first emphasized by Chapman and associates in 1964 (22); they reported that at caloric intakes of 1500–2000 Cal/day, the mortality rate of their patients was considerably improved. Sheldon and coworkers (113) further emphasized the importance of adequate nutrition in the treatment of intestinal fistulas. MacFadyen *et al.* (80) reported a study of 62 patients with 78 GI fistulas who were treated with TPN and bowel rest as an adjuvant to conventional surgical measures. Spontaneous fistula closure occurred in 70.5%, and of the patients requiring operation, successful closure occurred in 94%. The overall mortality rate in this series was 6.45%.

The balance studies obtained from a patient D. B. are shown in Figures 11–9 and 11–10.

This patient was a 28-year-old man with a 5-year history of regional enteritis involving duodenum, jejumum, ileum, and colon. He also had a draining fistula from the perirectal area to the back of the right thigh. A gastrojejunostomy and vagotomy were performed for the posterior duodenal ulcer about 3 years prior to the present admission. Oral intake of food was intolerable because of frequent diarrhea. The patient was anorexic and mentally depressed. He had lost more than 40 kg body weight since the beginning of his illness. Total parenteral nutrition was given for 38 days during which time he received nothing by mouth except water. The total intake of amino acids and glucose by the IV route was 3.06 kg and 29.04 kg, respectively. The average daily nitrogen intake was 11.85 g and the average daily caloric intake 3056 Cal. Figure 11–9 shows the caloric intake, body weight gain, ni-

trogen balance and the progressive decrease in nitrogen loss from the fistula drainage. It can be noted that he gained about 1.5 kg body weight after 14 days of parenteral nutrition, furnishing 2700 Cal/day from nonnitrogen sources (47 Cal/kg/day). Increasing nonnitrogen calories to 3600 (60 Cal/kg/day) seemed to improve the curve of body weight gain. The total weight gained was 7.0 kg with an average daily gain of 0.19 kg. The nitrogen balance was maintained positive throughout the period of TPN except the last 3 days when caloric and nitrogen intakes were reduced. The daily average of nitrogen retention was 4.14 g. The volume of (and the nitrogen loss from) fistula drainage were progressively decreased throughout the period of TPN.

The fluid balance was calculated as the difference between the sum of water intake by mouth plus the volume of parenteral nutrition given by vein and the sum of urinary output plus fistula drainage. The insensible water loss was not considered. It is seen from Figure 11–10 that, in general, there was considerable water retention. The average daily water retained was 1652 ml. Sodium, potassium, and magnesium balances were maintained positive except for the last 3 days when intakes of these electrolytes were reduced resulting in negative balance. The daily

average of sodium, potassium, and magnesium retention was 17.8, 36.2, and 8.1 mEq, respectively; the ratios of nitrogen to potassium and nitrogen to magnesium were 4.14:36.2 (or approximately 1:9) and 4.14: 81 (or approximately 1:2), respectively. Figure 11–11 shows the appearance of the enterocutaneous fistula before and after the period of TPN. The size of skin erosion was reduced and the erosion appeared dry at the end of the parenteral nutrition period. The fistula was closing. Dressner et al. (35) and Aguirre and associates (8) also have presented radiologic evidence documenting spontaneous closure of intestinal fistulas in patients given TPN. Fischer et al. (45) have considered hyperalimentation as a primary therapy for inflammatory bowel disease, and Layden and associates have observed the reversal of growth arrest in adolescents with Crohn's disease after parenteral nutrition (76).

CANCER

Loss of weight is common in patients with cancer and cachexia due, in part, to anorexia. In addition, impaired intestinal absorption often accompanies malignant tumors. The nutritional state of the host is further affected by GI and other side-effects of chemotherapy or radiation therapy,

Fig. 11–11. The enterocutaneous fistula of patient D. B. before and at the end of TPN.

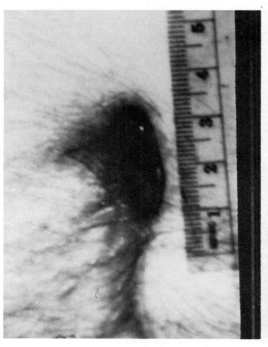
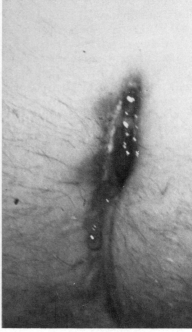

e.g., loss of appetite, nausea, vomiting, and diarrhea. Thus, a vicious cycle results: a cancer patient who is malnourished and requires treatment. The chemotherapy or radiation therapy produces malnutrition because of its toxic effects; malnutrition further delays wound healing and decreases immune responses, leading to infection and other complications. Provision of adequate nutrients by TPN can interrupt this vicious cycle.

Nutritional rehabilitation of cancer patients was attempted by Terepta in 1956 (124). He force-fed adults with a variety of neoplasms and was able to demonstrate weight gain in 7 out of 9 and positive nitrogen in all patients. In 1971, Schwartz *et al.* (111) gave combined parenteral nutrition and systemic chemotherapy to a group of 10 patients with widespread malignant disease. They showed that almost all patients had decreased analgesic requirements, improved performance, increased appetite and oral intakes, and reversal of the downward weight trend. In addition, there was a striking absence of GI toxicity despite the administration of extremely large doses of chemotherapeutic agents over prolonged periods of time. The question, whether or not good nutrition may promote the growth of tumors, has been asked. In fact, Steiger and associates have shown that hyperalimentation stimulated tumor growth in rats (122). However, no clinically apparent increase in cancer cell replication has been documented in human subjects receiving adequate parenteral nutrition support (27). Recently, Copeland *et al.* (29) observed a possible correlation between nutritional status and response to chemotherapy in patients with adenocarcinoma or squamous cell carcinoma of the lung. Furthermore, the GI toxic side-effects of chemotherapy are usually better tolerated even at high dosages in patients receiving parenteral nutrition with weight gain as compared to those receiving no nutritional therapy. Similar results were also obtained in patients with head and neck cancer in response to radiation therapy as well as chemotherapy (30). Copeland *et al.* also report that adequate parenteral nutrition improved the immune response. They further demonstrated that the use of central venous parenteral nutrition did not increase the incidence of catheter-related sepsis even in patients on chemotherapy (28). This is an important finding since it has been reported that chemotherapy invariably causes leucopenia and immunodepression (51). Meng *et al.* (85) have also demonstrated that adequate parenteral nutrition is capable of improving the nutritional

status and achieving weight gain and positive nitrogen balance in cancer patients with little or no oral intake. Most significantly, the nutritional improvement permitted vigorous chemotherapy. Furthermore, therapy with a second chemotherapeutic agent has been given because of nonresponsiveness to the first in some patients during the long-term parenteral nutrition. Lanzotti and coworkers (72) have reported findings that suggest the response to chemotherapy in patients with cancer is related to concurrent IV hyperalimentation. Although additional investigation is necessary, it seems reasonable to state that adequate parenteral nutrition can produce protein repletion and weight gain in patients who have severe malnutrition with malignant neoplasia while receiving chemotherapy or radiation therapy. It is hopeful that cancer patients may increase their ability to withstand major surgery, aggressive chemotherapy, or radiation therapy if adequate nutritional support can be given prior to cancer treatment.

RENAL FAILURE

In spite of improvements in the management of patients with renal failure, malnutrition continues to be a problem. This is due to the fact that the intake of protein, sodium, and water is necessarily restricted because of the difficulty in the disposal of these substances and nitrogenous metabolites. In addition, these patients are usually anorexic and also may have disturbances of intestinal absorption. Readers are referred to the review by Abel. The generally agreed upon concept of dietary management of renal failure is to give a small amount of nitrogen as protein of high biological value or essential amino acids and relatively high-caloric intake. It has been well documented that endogenous urea as well as exogenous nitrogenous compounds can be utilized for protein synthesis when essential amino acids and adequate calories are given. For the sake of clarity, the discussion of parenteral nutrition in renal failure patients is divided into two parts: 1) acute and 2) chronic renal failure.

ACUTE RENAL FAILURE

Lawson *et al.* (75) have given diets supplying 1200–1400 Cal and up to 40 g protein of high biologic value to patients with acute renal failure; they observed no significant increase in blood urea. Other similar dietary regimens have also been designed to maintain the nutritional

status of acute renal failure patients (12). However, frequently one has to treat patients with hypercatabolic acute renal failure in whom only the IV route is possible. Thus, TPN with or without fat emulsion has been used and found successful (77). Following the concepts of low dietary nitrogen as essential amino acids and relatively high-caloric intake for the management of uremic patients, Wilmore and Dudrick (136) demonstrated in 1969 that weight gain, wound healing, and positive nitrogen balance may be achieved by TPN with a solution containing the eight essential amino acids and hypertonic glucose in a patient with acute renal failure and severe abdominal injuries. Furthermore, blood urea remained stable and other symptoms of uremia were resolved. From 1970 through 1974, Abel and associates (3–7) gave TPN to a large number of patients with acute renal failure at the Massachusetts General Hospital. Based on these findings, the following conclusions are made (4):

a. in certain instances of nonoliguric acute renal failure, dialysis may become unnecessary or the frequency with which it is generally employed may be decreased; b. the BUN-lowering effects of the Giordano–Giovannetti diet are confirmed in a variety of clinical situations; c. this form of intravenous therapy may be particularly helpful following aortoiliac surgery with the onset of acute renal failure under conditions of and prolonged adynamic ileus; d. serum potassium, phosphate and magnesium decreased in association with therapy; these effects prevent demise from ionic intolerance or toxicity; e. in certain instances of reversible acute renal failure treatment with essential L-amino acids and hypertonic glucose intravenously may result in improved survival; f. recovery of renal function appeared to be more rapid in patients with acute tubular necrosis than in a matched group of control patients receiving hypertonic glucose alone; g. there is an apparent rapid clearance from the blood of the administered amino acids, suggesting full utilization of the exogenous amino acids.

The following results obtained from a representative patient (Fig. 11–12). Six days after abdominal aortic aneurysmectomy, parenteral nutrition was instituted with a solution consisting of the eight essential L-amino acids in 47% glucose by constant infusion into the superior vena cava. Despite a continuing rise in the serum creatinine level, the BUN value began to decline. Due to the unavailability of the essential amino acid solution, glucose alone was given for a brief period. This was accompanied by a recurrent increase in BUN, which was again brought under control by the 17th day, coincident with the reinstitution of essential amino acid administration. Stabilization of BUN value continued to the 25th day postoperatively, and a gradual improvement in renal function was observed at the time. By the 28th day the patient's prolonged adynamic ileus had resolved and he was able to tolerate some oral feedings. Supplementary parenteral nutrition, with casein hydrolysate and 23% glucose, was given on the 35th day, and an increase in BUN to 75 mg/100 ml was observed. However, after reducing the total nitrogen intake, the BUN level slowly returned to normal. During the parenteral nutrition period, serum potassium was decreased, requiring replacement therapy to maintain the normal levels. Marked hypophosphatemia and hypomagnesemia also occurred requiring replacement therapy.

The composition of the parenteral nutrition solution given to patients with acute renal failure at Vanderbilt University Medical Center is shown in Table 11–8. The nitrogen is supplied as FreAmine E, a solution containing the 8 essential amino acids. One unit of 250 ml FreAmine E is mixed with 600 ml 70% glucose solution. After the addition of vitamin and electrolyte solutions, an appropriate volume of sterile distilled water is added to make a total volume of 1 liter. One liter of the infusate contains 420 g glucose and 13.1 g essential L-amino acids (1.46 g nitrogen). The amounts of the 8 essential amino acids per liter solution furnish twice the minimal requirement of Rose (108). Vitamins given were the same as shown in Table 11–6.

TABLE 11–8. Parenteral Nutrition Solution for Renal Failure Patients*

Component	Amount/liter
Glucose (monohydrate)†	400–440 g
L-Amino acids‡	13.1 g
Isoleucine	1.4 g
Leucine	2.2 g
Lysine HCl	2.0 g
Methionine	2.2 g
Phenylalanine	2.2 g
Threonine	1.0 g
Tryptophan	0.5 g
Valine	1.6 g
Total nitrogen	1.46 g
Calories	1400–1540
Fluid volume	1000 ml

*Vitamin composition is as shown in Table 11–6. Electrolytes are added according to patient's needs
†70% Glucose Solution Injection (McGaw laboratories). More glucose is sometimes added to achieve desired concentration
‡L-essential amino acids are supplied as 250 ml FreAmine E (McGaw laboratories)

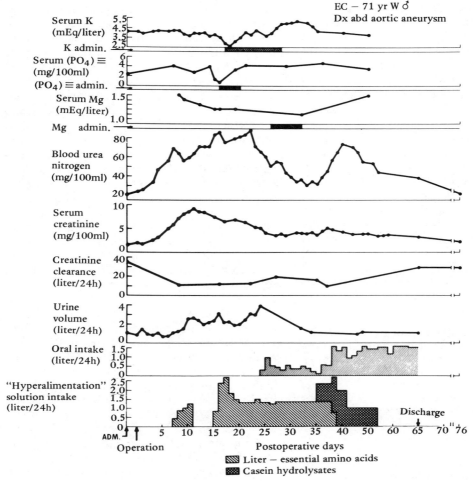

Fig. 11–12. Renal function and electrolyte determinations in a 71-year-old man in acute renal failure following resection of an abdominal aortic aneurysm. (Abel RM, Abbott WM, Fischer J: Arch Surg 103:513. Copyright 1971, American Medical Association)

However, the electrolytes are usually added according to the patient's need. The volume of the solution given depends on the tolerance of the patient; it may be as much as 3–4 liter/day. Favorable results similar to those of Abel *et al.* have been obtained (91). It is stated that TPN has been found to be a life-saving procedure in some patients with acute renal failure.

CHRONIC RENAL FAILURE

Severe nutritional depletion is frequently experienced in patients with chronic renal failure. Most of the chronic uremic patients can tolerate some oral intake, but usually it is far from adequate. In some cases oral consump-

tion of food or even tube-feeding is impossible because of complications; TPN must be instituted. Lee *et al.* (77) have shown the beneficial effect of TPN in chronic uremic patients. Administering approximately 1 liter solution shown in Table 11–8 per day, similar results have been observed (91).

It is appropriate to point out the possible important or essential role of histidine in chronic uremic patients. This amino acid was found to be essential for infants but not for normal adults. Giordano and associates (53) indicated that small amounts of histidine added to a low-nitrogen diet increased the rate of amino acid incorporation into hemoglobin in chronic uremic patients. They also reported a decreased concentration of serum histidine in these patients and

concluded that the anemia associated with chronic uremia may be related to a relatively low histidine deficiency. Josephson *et al.* (64) made similar observations in a group of chronic uremic patients who improved following the addition of histidine to a solution of essential L-amino acids. Bergstrom and associates (11) also found improvement of nitrogen balances when histidine was administered in addition to the 8 essential amino acids. Similar results demonstrating the essential role of histidine in uremic patients have also been reported by others. However, evidence has also been reported showing no significant differences in fasting blood concentrations of histidine between normal and uremic subjects (26), although elevation of 3-methylhistidine was observed in severe uremic patients. It is suggested at the present that histidine at a dosage of 1 g/day may be given to patients with severe uremia. In addition, it has been reported that the requirement of vitamin B_6 is markedly increased in uremic patients (123) and should be supplemented; 25–50 mg B_6 seem to be adequate.

HEPATIC FAILURE

A state of malnutrition is usually associated with patients suffering from hepatic failure. It is also well appreciated that oral intake of protein may induce hepatic encephalopathy in some susceptible patients with chronic liver disease. It is generally known that the generation of ammonia, various mercaptans and probably other nitrogenous substances from protein by bacteria, occurs within the gut. In addition, ingested protein is converted to urea by the liver, and the urea, which undergoes an enterohepatic circulation in the gut, is hydrolyzed by bacterial urease to ammonia (63, 137, 138). Thus, the relationship between protein intake, bowel flora, and hepatic coma seems fairly well defined. Theoretically, therefore, administration of nitrogen directly into the blood circulation should bypass the intestinal bacterial flora and allow better nutrition without the risks of encephalopathy.

Schiff (110) states that IV glucose and protein hydrolysate can be given to patients with severe liver disease, but the dosage is not given. Freeman and MacLean (50) report their limited experience with four patients (two of whom were comatose) suffering from advanced liver disease. Of the 24-hour fluid requirement, 90% was given as hypertonic glucose and the remainder as protein hydrolysate. If no changes occurred in the BUN, blood ammonia, or neurologic status, more protein hydrolysate was substituted for glucose until the conventional 750:350 mixture was attained. "Suprising success" with this treatment was achieved. They also stated that the frequency of glycosuria did not appear to be increased when patients with liver disease were given hypertonic glucose. Based on theoretic considerations, they suggest that fructose is is a better sugar than glucose. In 1972, Host, Serlin, and Rush (59) first reported their attempts in treating 11 cirrhotic patients with parenteral nutrition. The solution they used contained either protein hydrolysate or crystalline amino acids, glucose (20%), vitamins, and electrolytes and was administered via a central venous catheter. Some beneficial effect was achieved. However, positive nitrogen balance was not accomplished, due in part, to the inadequate intake. Blood ammonia levels were increased, but no adverse mental symptoms occurred. Sodium intolerance and acidosis were also observed. Fischer and coworkers (47), using a mixture of essential amino acid (FreAmine E, used for renal failure) or a mixture of essential and nonessential amino acids (FreAmine), found that although the tolerance of cirrhotic patients to protein infusion was greater than tolerance to similar amounts of protein given orally, the daily total intake of patients receiving infusions was not very much greater than that of patients on oral protein-restricted diets. Encephalopathy was observed in all cirrhotic patients regardless of the route of protein administration, orally or IV as crystalline amino acids. The important finding in this study is the significant imbalance in plasma amino acids in patients given either FreAmine or FreAmine E. This finding of plasma amino acid imbalance is consistent with other clinical and experimental observations showing the elevations of phenylalanine, methionine, and tyrosine and decreases in the branched amino acids, leucine, isoleucine, and valine. It is also interesting to point out that in dogs with chronic end-to-side portal–caval shunts, survival may be related to the feeding of different diets, survival being the shortest with a meat diet and longest with a milk diet (25). The length of survival is related inversely to the content of aromatic amino acids such as phenylalanine, tryosine, and tryptophan in various diets; meat diets have the highest content of these amino acids, and the milk diet the lowest (25). Blood was less well tolerated than was casein when given in isonitrogenous amounts to patients with hepatic insufficiency (14). A milk diet was better tolerated in patients

with hepatic insufficiency than was a similar amount of protein given as meat (43). This difference in tolerance could be related to the amino acid compositions in these proteins. Thus, Fischer (9, 46) suggests the following requirements in treating patients suffering from liver disease with parenteral nutrition: 1) provide adequate nitrogen and calories; 2) avoid plasma amino acid imbalance; 3) maintain electrolyte and acid–base balance; 4) prevent neurologic or encephalopathic symptoms; and 5) administer the volume of fluid tolerable to patients. Based on these criteria, Fischer and associates have developed a solution of crystalline L-amino acids for parenteral nutrition in patients with liver disease. The amino acid composition of this solution is shown in Table 11–9. One liter of the infusate used contained 40 g protein equivalent (6.25 g nitrogen) either as FreAmine II or FO80, hypertonic glucose (23%), 40 mEq HCl, 30 mEq sodium acetate, 6 mEq magnesium sulfate, 25 mEq phosphate, and 4 mEq calcium. The results showed that normalization of the plasma amino acids, which could be achieved by the administration of FO80, may be of value in controlling the hepatic encephalopathy in dogs with portal–caval shunts. Obviously, the use of parenteral nutrition as an adjunct in the management of hepatic insufficiency remains in the investigational phase. However, it is not difficult to understand that parenteral nutrition with a balanced amino acid mixture to maintain plasma amino acids within the normal levels and an appropriate calorie source, vitamins, and electrolytes may become the most effective procedure in improving the nutritional status of patients with liver failure without inducing hepatic encephalopathic symptoms.

TABLE 11–9. Two Amino Acid Solutions to Dogs With Porta-Caval Shunts

Essentials L-Amino acids	FreAmine II* (g/liter)	FO80† (g/liter)
Isoleucine	2.95	4.50
Leucine	3.85	5.50
Valine	2.80	4.20
Threonine	1.70	2.25
Methionine	2.25	0.50
Phenylalanine	2.40	0.50
Tryptophan	0.65	0.38
Lysine HCl	3.85	3.80

*FreAmine II, McGaw laboratories, is commercially available
†A special formation designed for use in hepatic insufficiency. From Fischer JE, Funovics JM, Aguirre A, James JH, Keane JM, Wesdorp RIC, Yoshimura N, Westman T: Surg 78:276, 1975

OTHER ILLNESSES

There are other illnesses that affect the dietary intake, leading to malnutrition or nutritional deficiency. Among these, cardiac disease is especially outstanding. As Abel (1) points out, there seems to be an increasing percentage of older hospitalized patients who have moderate-to-severe impairment of cardiac function. About 50% of these patients in the age group of over 60 years may require parenteral nutrition therapy regardless of their primary manifestation, surgical or medical. However, the management of parenteral nutrition in this group of patients is complex. It requires a thorough understanding of the physiopathologic status of their cardiac, renal, pulmonary and liver functions, hormonal and metabolic changes, and fluid and electrolyte tolerance in order to achieve successful objective. In some patients with psychiatric problems, such as anorexia nervosa, hysterical vomiting, pathologic food faddism, and the obstetric syndrome of hyperemesis gravidarium, parenteral nutrition support may be useful in preventing severe morbidity and even death.

LONG-TERM PARENTERAL NUTRITION AT HOME—THE CONCEPT OF AN ARTIFICIAL GUT

Because of the potential risks of infection and metabolic disturbances and the complex procedures in the preparation of nutrient infusate and catheter care, most of the patients given parenteral nutrition are those who are hospitalized. In some instances, e.g., short gut syndrome, as the result of radiation, resection, or certain diseases, impairment of GI function may reach a degree that would result in death. The combination of long-term access to the circulation by means of arteriovenous shunts and extensive experience with use of self-administered hemodialysis at home resulted in the proposal for long-term TPN at home, which Scribner et al. (112) describe as "the concept of artificial gut." Following the work of Scribner and associates, Shils (117) also reported a patient in whom long-term parenteral nutrition was given through an external arteriovenous shunt. However, the use of arteriovenous shunts for long-term parenteral nutrition at home has proved unsatisfactory. Broviac et al. (17) designed a right atrial catheter suitable for long-term use. Jeejeebhoy and coworkers (62, 71) have also given long-term parenteral nutrition to patients at home and observed excellent results. However, Shils (114)

seems to prefer the one that was used by Belin *et al.* (10). Solassol and associates (121) have developed and used another type of catheter and techniques for long-term parenteral nutrition with success. Solassol and Joyeux (120) termed their procedure "Ambulatory Parenteral Nutrition."

To assure the success of long-term parenteral nutrition at home, the following basic principles must be considered:

1. Selection of a method of circulatory access or a catheter system for continuous IV infusion of concentrated nutrition solution.
2. Selection of available sterile nutrient solutions that can be mixed easily and safely by the patient or some member of the family just prior to infusion; the composition of the infusate is predetermined and has been adapted to the patient during hospitalization.
3. Selection of a suitable delivery system, preferably with pump and alarm device to provide a constant infusion rate and to warn the patient that the infusion bottle is nearly empty. This is necessary especially if the infusions are given during the night.
4. The suitability of the patient for long-term parenteral nutrition at home must be carefully considered for insuring proper execution of the procedure.

Shils (114) suggests the following criteria:

1. A relatively stable clinical state with expectancy of a reasonably comfortable home life for many months.
2. A suitable home environment with supportive family members or other individuals who are conversant with all aspects of the techniques.
3. Availability of a trained nurse to periodically visit the home to follow the clinical status and to supervise for an initial period the change of filters (if applicable) and dressings, the care of the catheter, and mixing of the infusate.
4. When the patient lives some distance from the hospital, cooperation of a physician in the town of residence who will assume responsibility for medical care.

In addition, the patient and the individual(s) who will assist him at home must be trained to perform the mixing of the infusate and to care for the delivery system. The patient must be given the same infusate while in the hospital to ensure metabolic adaptation and to avoid complications at home. Some biochemical tests, *e.g.,* blood glucose and serum electrolytes, should be done before discharge of the patient to his home, and dietary programs must be carefully planned to assure the tolerance of oral intake both from the quantitative and qualitative points of view.

The parenteral nutrition program suggested by Broviac and Scribner (18) is to mix two 500 ml bottles of amino acid solution (FreAmine, II) with 1000 ml 60% glucose. The glucose solution is in a half-filled 2-liter bottle in vacuum. Vitamins and electrolytes are added using aseptic procedures. Two liters of this solution containing 600 g glucose and 85 g crystalline L-amino acids (12.5 g nitrogen), along with appropriate amounts of vitamins and electrolytes, are given during the night on a 5 night/week schedule. The infusion usually is started at about 7:00 or 8:00 PM and is completed in about 12 hr. The patient is free to visit or even to work during the day. The organization and the training program are discussed by Shils (114) and Solassol and Joyeux (120). It is essential to consider all aspects of the problems before the "parenteral nutrition" at home is initiated.

LABORATORY FINDINGS

BIOCHEMICAL, PHYSIOLOGICAL AND CLINICAL MONITORING

All aspects of the patient's condition must be monitored: vital signs, mental state, daily body weight, daily fluid intake, and daily fluid output —including fistula or wound drainage, urine, stools, GI aspirates, and other losses. The patient's state of hydration must always be considered. Serum sodium, potassium, chloride, bicarbonate, and urea should be monitored daily at first and then once a week when stabilized. Serum magnesium, calcium, phosphorus, and plasma protein should be measured, and a hemogram should be done at weekly intervals. In critically ill patients, it is often necessary to measure blood gasses, pH, and osmolarity. Liver function tests including serum glutamic oxaloacetic transaminase, lactic dehydrogenase, serum bilirubin, serum alkaline phosphatase, and prothrombin time should be obtained at weekly or biweekly intervals. Nitrogenous compounds besides urea that should be monitored are serum creatinine and uric acid and blood ammonia.

Frequent monitoring of blood and urinary glucose should be done during the early days of parenteral nutrition, especially in debilitated, el-

derly, stressed, or diabetic patients. Adjustments must be made in the infusion if the urinary glucose exceeds 2+. In patients with renal dysfunction, the urinary glucose value may be misleading and blood Dextrostix is more valuable than fractional urine determinations. In order to prevent the urinary loss of glucose, the rate of administration should be reduced or insulin should be given. The insulin dosage should be based on the blood glucose level. Subcutaneous administration of 8 units regular insulin every 4–6 hr, with stepwise increments of 5–10 units/dose as needed, has been found to give better control than a sliding scale of insulin dosage based on the urinary glucose level. Because of the great variation of the renal threshold for glucose even in patients with normal renal function, treatment must be individualized to maintain the blood glucose level below 180 mg/100 ml. As stated previously, some physicians prefer to add insulin to the infusate at ratios of one unit insulin to 7–10 g glucose. When fructose or invert sugar is given, serum lactate should also be determined at frequent intervals.

When fat emulsion is used, a plasma lipid profile including triglycerides, phospholipids, cholesterol, and free fatty acids should be determined at 1-week intervals. If laboratory facilities are limited, it is acceptable to use the plasma optical density as a qualitative index of plasma triglyceride before each dosage increase and then at weekly intervals. However, it should be remembered that the measurement of optical density or light scattering is not reliable in the presence of endogenous hyperlipoproteinemia. In this case, plasma triglyceride should be determined by a chemical method. When parenteral nutrition is given without fat, serum total fatty acid patterns should be determined for the possible development of essential fatty acid deficiency. In addition to lipid profiles, liver enzymes, platelet count, coagulation time, partial thromboplastin time, and prothrombin time must be measured at weekly intervals in patients receiving fat emulsion over a long period of time.

As a means to avoid morbidity in the patient who is receiving TPN, ambulation should be encouraged if possible. A patient may walk while guiding a mobile IV infusion pole; this type of activity will assist in the maintenance or restoration of muscle tone, skeletal, and vascular competence. Ambulation while receiving parenteral nutrition is possible even if the use of a light-weight, portable, battery-operated pump is necessary. Activity is important; however, as the patient must have adequate control of his physical and mental facilities.

COMPLICATIONS

The very impressive beneficial effects of parenteral nutrition have not occurred without their costs to patients. However, the incidence of complications has decreased in recent years as the techniques and knowledge in nutrient requirements and metabolism have advanced. For historic interest and prevention of complications, readers are referred to several reviews on the subject (50, 73, 83, 109). It may be briefly stated that complications have occurred in the following areas.

CENTRAL VENOUS CATHETER

The central venous catheter has been found responsible for various complications, including perforation of the heart and major vessel, with extravasation of blood or solutions, obstruction of the major vessels, pneumothorax, as well as air embolism. In addition, thrombophlebitis may develop around the catheter, especially if it is introduced into an arm vein. The formation of a fibrin sleeve around the catheter may cause pulmonary embolus.

Catheter-related sepsis, bacterial or fungal, is one of the most common dangerous complications, ranging from skin infection to fatal septicemia. The most prevalent serious infection appears to be yeast or fungal involvement. At the onset of an unexplained fever or signs of sepsis, the catheter should be withdrawn and the tip as well as the blood cultured. Serial blood cultures 2–3 days after withdrawal of the catheter may help decide the subsequent course of therapy.

Patients with septic foci may seed infection to their IV catheter. Infection also may occur due to contamination of the delivery system, especially if additives or medications are given via the infusion line. However, long-term parenteral nutrition without sepsis is possible and has been reported recently.

METABOLIC DISTURBANCES

Hyperglycemia is a common problem, particularly in patients with glucose intolerance. Hyperglycemia may lead to osmotic diuresis, dehydration, and nonketotic hyperosmolar syndrome progressing to coma. On the other hand,

hypoglycemia has been observed with excessive insulin administration when technical failure of the infusion system occurs. Hypoglycemia may also occur after abrupt cessation of infusion of parenteral nutrition infusate containing hypertonic glucose.

Elevation of the blood urea nitrogen level has been observed in some patients secondary to excessive administration of nitrogen or to dehydration. Hyperammonemia also has been observed. This may be due to the presence of a large amount of free ammonia or ammonia ion in protein hydrolysate or to an inadequate amount of arginine in amino acid solutions; this can be corrected by the administration of additional arginine. Abnormal liver function also may be a factor.

ELECTROLYTE IMBALANCE

Electrolyte imbalance usually results from administration of a standard solution without consideration of the patient's special needs. Hyponatremia may occur in the presence of increased loss or inadequate intake of sodium. Hypernatremia may be secondary to prerenal azotemia associated with excessive diuresis or to the hyperosmolar syndrome. Hypophosphatemia has been a common finding in patients receiving TPN containing concentrated glucose solutions that have little or no phosphorus. Recently, hypophosphatemia has not been common because of the addition of this element to the infusate.

Hyperchloremic acidosis has been observed, especially in infants. This is primarily due to high chloride content in the infusate. Chloride ion is present in protein hydrolysate. It is also present in crystalline amino acid solution; some amino acids are in HCl form. In addition, the use of sodium and potassium as chloride salts further increases the supply of this anion. It is recommended that some sodium and potassium be given as acetate. Recent attempts have also been made to use amino acids, such as lysine, in a base form.

OTHER COMPLICATIONS

Rare allergic reactions following the administration of protein hydrolysate have occasionally been observed in some patients. When this occurs, it should be discontinued. Either another protein hydrolysate or crystalline amino acid solution should be used.

CONCLUSIONS

Conventional IV nutrition with 5%–10% glucose, saline, and occasionally protein hydrolysate is grossly inadequate to meet the needs of a stressed and hypercatabolic patient. Today, long-term TPN with adequate calories and nitrogen is possible. The calories and nitrogen are given as a solution containing concentrated glucose (20%–40%) and protein hydrolysate or crystalline amino acid mixture with vitamins and minerals. Because of the hyperosmolarity of these solutions, they are infused continuously into a central vein, usually the superior vena cava, via an indwelling silastic catheter during a 24-hr period. The method is effective in maintaining nitrogen balance and promoting weight gain and wound healing in patients with a variety of disease states. The use of fat emulsion (Intralipid, a 10% soybean oil emulsion), has been found beneficial to correct or prevent essential fatty acid deficiency; it also furnishes additional calories. To assure safe and effective parenteral nutrition, the following aspects should be considered.

In the planning of parenteral nutrition, it is of paramount importance to consider the condition of the patient and his nutritional needs. Nitrogen as protein hydrolysate or crystalline amino acids should be adequate. In addition, ample calories along with vitamins and minerals should be given concurrently with nitrogen to achieve maximum amino acid utilization for protein synthesis. The total fluid volume and the amount of each nutrient given should be carefully considered and the rate of administration carefully regulated. In general, 12–13 g nitrogen as crystalline amino acids and 2500 Cal/day with a nitrogen–calorie ratio of 1:200 are adequate for most patients. Fat emulsion should also be given at a daily dosage of 1–2.0 g/kg in adults and 2–4 g/kg in infants and young children.

Constant, meticulous care must be given to the central venous catheter and its site of insertion in order to avoid infection. In addition, the clinical condition and mental state of the patient must be frequently observed. Serum electrolytes must be monitored frequently. In older, debilitated, diabetic, and stressed patients who may have glucose intolerance or inadequate insulin secretion, the administration of exogenous insulin may be required to maintain blood sugar levels between 100–180 mg% to avoid hyperglycemia, osmotic diuresis, and hyperosmolar syndrome.

REFERENCES

1. Abbott WM, Abel RM, Fischer JE: Intravenous essential L-amino acids and hypertonic dextrose in patients with acute renal failure. Effects on serum potassium, phosphate and magnesium. Am J Surg 123: 632, 1972

2. Abbott WM, Abel RM, Fischer JE: Treatment of acute renal insufficiency after aortoaliac surgery. Arch Surg 103:590, 1971

3. Abel RM: Parenteral nutrition for patients with severe cardiac illness. In Fischer JE (ed): Total Parenteral Nutrition. Boston, Little, Brown and Co, 1976, p 171

4. Abel RM: Parenteral nutrition in the treatment of renal failure. In Fischer JE (ed): Total Parenteral Nutrition. Boston, Little, Brown and Co, 1976, p 143

5. Abel RM, Abbott WM, Fischer JE: Acute renal failure. Treatment without dialysis by total parenteral nutrition. Arch Surg 103:513, 1971

6. Abel RM, Beck CH Jr, Abbott WM, Ryan JA Jr, Barrett GO, Fischer JE: Improved survival from acute renal failure after treatment with intravenous essential L-amino acids and glucose. N Engl J Med 288:695, 1973

7. Abel RM, Shik VE, Abbott WM, Beck CH Jr, Fischer JE: Amino acid metabolism in acute renal failure: influence of intravenous essential L-amino acid hyperalimentation therapy. Ann Surg 180:350, 1974

8. Aguirre A, Fischer JE, Welch CE: The role of surgery and hyperalimentation in therapy of gastrointestinal–cutaneous fistulae. Ann Surg 180:393, 1974

9. Aguirre A, Funovics J, Wesdrop RIC, Fischer JE: Parenteral nutrition in hepatic failure. In Fischer JE (ed): Total Parenteral Nutrition. Boston, Little, Brown and Co, 1976, p 219

10. Belin RP, Koster JK, Bryant LJ, Griffin WO Jr: Implantable subcutaneous feeding chamber for noncontinous central venous alimentation. Surg Gynecol Obstet 134:491, 1972

11. Bergstrom J, Bucht H, Furst P, Hultman E, Josephson B, Noree LO, Vinnars E: Intravenous nutrition of amino acid solutions in patients with chronic uremia. Acta Med Scand 191:359, 1972

12. Berlyne GM, Bazzard FJ, Booth EM, Janabi K, Shaw AB: Dietary treatment of acute renal failure. Quart J Med 35:59, 1967

13. Bertolini AM: Gerontologic Metabolism. Springfield, Charles C Thomas, 1969, p 143

14. Bessman AN, Merick GS: Blood ammonia levels following the ingestion of casein and whole blood. J Clin Invest 37:990, 1958

15. Blackburn GL, Flatt JP, Clowes GHA, O'Donnell TE: Peripheral intravenous feeding with isotonic amino acid solutions. Am J Surg 125:447, 1973

16. Borresen HC, Coran AG, Knutrud O: Metabolic results of parenteral feeding in neonatal surgery: a balanced parenteral feeding program based on a synthetic L-amino acid solution and a commercial fat emulsion. Ann Surg 172:291, 1970

17. Broviac JW, Cole JJ, Scribner BH: A silicone rubber artrial catheter for prolonged parenteral nutrition. Surg Gynecol Obstet 136: 602, 1973

18. Broviac JW, Scribner BH: Prolonged parenteral nutrition in the home. Surg Gynecol Obstet 139:24, 1974

19. Burke WA: Preparation and guidelines to utilization of solutions. In White PL, Nagy ME (eds): Total Parenteral Nutrition. Action, Publishing Sciences Group, 1974, p 329

20. Calloway DH, Spector H: Nitrogen balance as related to caloric and protein intake in active young men. Am J Clin Nutr 2:405, 1954

21. Cannon PR, Frazier LE, Hughes RH: Influence of potassium on tissue protein synthesis. Metabolism 1: 49, 1952

22. Chapman R, Foran R, Dunphy JE: Management of intestinal fistulas. Am J Surg 108:157, 1964

23. Chen WJ, Ohashi E, Kasai M: Amino acid metabolism in parenteral nutrition: with special reference to the calorie: nitrogen ratio and the blood urea nitrogen level. Metabolism 23: 1117, 1974

24. Collins FD, Sinclair AJ, Royle JP, Coats DA, Maynard AT, Leonard RF: Plasma lipids in human linoleic acid deficiency. Nutr Metab 13:150, 1971

25. Condon RE: The effect of dietary protein on symptoms and survival in dogs with an Eck fistula. Am J Surg 121:107, 1971

26. Condor JR, Asatoor AM,: Amino acid metabolism in uremic failure. Clin Chim Acta 32:333, 1971

27. Copeland EM, MacFayden BV Jr, Dudrick SJ: Intravenous hyperalimentation in cancer patients. J Surg Res 16:241, 1974

28. Copeland EM, MacFayden BV Jr, Dudrick SJ: The use of hyperalimentation in patients with potential sepsis. Surg Gynecol Obstet 138:377, 1974

29. Copeland EM, MacFayden BV Jr, Lanzotti VJ, Dudrick SJ: Intravenous hyperalimentation as an adjunct to cancer chemotherapy. Am J Surg 129:167, 1975

30. Copeland EM, MacFayden BV Jr, MacComb WS, Guillamondegui O, Jesse RH, Dudrick SJ: Intravenous hyperalimentation in patients with head and neck cancer. Cancer 35:606, 1975

31. Copeland EM, MacFayden BV Jr, Rapp MA, Dudrick SJ: Hyperalimentation and immune competence in cancer. Surg Forum 24: 138, 1975

32. Cowan GSM, Scheetz WL (eds): Intravenous Hyperalimentation. Philadelphia, Lea and Febiger, 1972

33. Davidson LAG, Flear CTG, Donald KW: Transient amino aciduria in severe potassium depletion. Br Med J 1:911, 1968

34. Dietel M, Kaminsky V: Total nutrition by peripheral vein—the lipid system. Can Med Assoc J 111:152, 1974

35. Dressner TA, O'Grady WP, Thorbjarnarson B: Parenteral hyperalimentation and multiple gastrointestinal fistulas. NY State J Med 71:665, 1971

36. Dudrick SJ, Copeland EM, MacFayden BV: Long term parenteral nutrition: its current status. Hosp Prac 10: 47, 1975

37. Dudrick SJ, Rhoads JE: New horizon for intravenous feedings. JAMA 215:939, 1971

38. Dudrick SJ, Wilmore DW, Vars HM, Rhoads JE: Can intravenous feeding as the sole means of nutrition support growth in the child and restore weight loss in an adult? an affirmative answer. Ann Surg 169: 974, 1969

39. Dudrick SJ, Wilmore DW, Vars HM, Rhoads JE: Long-term total parenteral nutrition with growth, de-

velopment, and positive nitrogen balance. Surg 64: 134, 1968

40. Elman R: Time factors in the utilization of a mixture of amino acids (protein hydrolysate) and dextrose given intravenously. J Clin Nutr 1: 287, 1953

41. Energy and Protein Requirements, FAO/WHO Expert Report, World Health Organization Technical Report Series No 522, Geneva, WHO, 1973

42. Fekl W: Some principles of modern parenteral nutrition. Scand J Gastroenerol [4 Suppl] 3:3, 1969

43. Fenton JCB, Knoght EJ, Humpherson PL: Milk and cheese diet in portal-systemic encephalopathy. Lancet 1: 164, 1966

44. Fischer JE (ed): Total Parenteral Nutrition. Boston, Little, Brown and Co, 1975

45. Fischer JE, Foster GS, Abel RM, Abbott WM, Ryan JA: Hyperalimentation as primary therapy for inflammatory bowel disease. Am J Surg 125: 164, 1973

46. Fischer JE, Funovics JM, Aguirre A, James JH, Keane JM, Wesdorp RIC, Yoshimura N, Westman T: The role of plasma amino acids in ehpatic encephalopathy. Surg 78: 276, 1975

47. Fischer JE, Yoshimura N, Aguirre A, James JH, Cummings MG, Abel RM, Deindoerfer F: Plasma amino acids in patients with hepatic encephalopathy. Effects of two amino acid solutions. Am J Surg 127:40, 1974

48. Flack HL, Grans JA, Serlick SE, Dudrick SJ: The current status of parenteral hyperalimentation. Am J Hosp Pharm 38: 326, 1971

49. Fleming CR, Hodges RE, Hurley LS: A prospective study of serum copper and zinc levels in patients receiving total parenteral nutition. Am J Clin Nutr 29: 70, 1976

50. Freeman JB, MacLean LD: Intravenous hyperalimentation: a review. Can J Surg 14: 180, 1971

51. Freii E: Combination cancer therapy: presidential address. Cancer Res 32: 2593, 1972

52. Geyer RP: Parenteral nutrition. Physiol Rev 40: 150, 1960

53. Giordano C, DePasquale C, DeSanto NG, Esposita R, Cirillo D, Stangherlin P: Disorder in the metabolism of some amino acids in uremia. Proceedings of the Fourth International Congress of Nephrology, Stockholm, Karger, Basel, 2: 196, 1969

54. Greene HL: Vitamins. In White PL, Nagy ME (eds): Total Parenteral Nutrition. Acton, Publishing Sciences Group, 1964, p 241

55. Grotte G, Jacobson S, Wretlind A: Lipid emulsions and techniques of peripheral administration in parenteral nutrition. In Fischer JE (ed): Total Parenteral Nutrition. Little, Brown and Co, 1976, p 335

56. Heller L: Clinical and experimental studies in complete parenteral nutrition. Scand J Gastroenterol [4 Suppl] 3:7, 1969

57. Holman RT: Essential fatty acid deficiency in humans. In Calli C, Jacini G, Pecile A (eds): Dietary Lipids and Postnatal Development. New York, Raven Press, 1973, p 127

58. Holman RT, Carter WD, Wiese HF: The essential fatty acid requirement of infants and the assessment of their intake of linoleate by serum fatty acid analysis. Am J Clin Nutr 10: 70, 1964

59. Host WR, Serlin O, Rush BF: Hyperalimentation in cirhotic patients. Am J Surg 123: 57, 1972

60. Jacobson S: Complete parenteral nutrition in man for seven months. In Berg G (ed): Advances in Parenteral Nutrition, Symposium of the International Society of Parenteral Nutrition. Prague, Georg Thieme Verlag, Stuttgart, 1969

61. Jeejeebhoy KN: Personal communication

62. Jeejeebhoy KN, Zohrab WJ, Lauger B, Phillips MJ, Kuksis A, Anderson GH: Total parenteral nutrition at home for 23 months, without complication and with good rehabilitation. Gastroenterol 65: 811, 1973

63. Jones, EF, Smallwood RA, Craigie A, Rosenoer VM: The enterohepatic circulation of urea nitrogen. Clin Sci 37: 825, 1969

64. Josephson B, Bergstrom J, Buckt H, Furst P, Hultman E, Noree LO, Vinnars E: Intravenous amino acid treatment in uremia. Proceedings of the Fourth International Congress of Nephrology, Stockholm, Karger, Basel, 2: 203, 1969

65. Karpel JT, Peden VH: Copper deficiency in long-term parenteral nutrition. J Pediatr 80: 32, 1972

66. Kay RG, Tasman–Jones C: Acute zinc deficiency in man during intravenous alimentation. Aust NZ J Surg 45: 325, 1975

67. Kinney JM: Energy requirements for parenteral nutrition. In Fischer JE (ed): Total Parenteral Nutrition. Boston, Little, Brown and Co, 1976, p 135

68. Kountz WB, Hofstatter L, Ackerman PG: Nitrogen balance studies in four elderly men. J Gerotol 6: 20, 1951

69. Krieger H, Abbott WE, Leavy S, Holden WD: The use of fat emulsion as a source of calories in patients requiring intravenous alimentation. Gastroenterol 33: 807, 1957

70. Lang K, Fekl W, Berg G: Balanced Nutrition and Therapy. Prague, Georg Thieme Verlag, Stuttgart, 1972

71. Langer B, McHattie JD, Zohrab WJ, Jeejeebhoy RN: Prolonged survival after complete small bowel resection using intravenous alimentation at home. J Surg Res 15: 226, 1973

72. Lanzotti VJ, Copeland EM III, George SL, Dudrick SJ, Samuels ML: Cancer chemotherapeutic response and intravenous hyperalimentation. Cancer Chem other Rep 59:437, 1975

73. Law DH: Total parenteral nutrition. Adv Int Med 18: 389, 1972

74. Lawson LJ: Parenteral nutrition in surgery. Br J Surg 52: 795, 1965

75. Lawson LJ, Blainey JD, Dawson–Edwards P, Tonge SM: Dietary management of acute oliguric renal failure. Br Med J 1: 293, 1962

76. Layden T, Rosenberg J, Nemchausky B, Elson C, Rosenberg I: Reversal of growth arrest in adolescents with Crohn's disease after parenteral nutrition. Gastroenterol 70: 1017, 1976

77. Lee HA, Sharpstone P, Ames AC: Parenteral nutrition in renal failure. Postgrad Med J 43: 81, 1967

78. Levenson SM, Upjohn HL, Sheehy TW: Two severe reactions following the long-term infusion of large amounts of intravenous fat emulsion. Metabolism 6: 807, 1967

79. Longenecker JB: Utilization of dietary proteins. In Albanese AA (ed): New Methods of Nutritional Biochemistry. New York, Academic Press, 1963

80. MacFadyen BV Jr, Dudrick SJ, Ruberg RL: Management of gastrointestinal fistulas with parenteral hyperalimentation. Surg 74: 100, 1973

81. Meng HC: Fat emulsions. In White PL, Nagy ME (eds): Total Parenteral Nutrition. Acton, Publishing Sciences Group, 1974, p 155

82. Meng HC: Fat emulsions in parenteral nutrition. In Fischer JE (ed): Total Parenteral Nutrition. Boston Little, Brown and Company, 1976, p 305

83. Meng HC: Parenteral nutrition: principles, nutrient requirements and techniques. Geriatrics 30: 97, 1975

84. Meng HC: Sugars in parenteral nutrition. In Supple HL, McNutt KW (eds): Sugars in Nutrition. New York, Academic Press, 1974, p 528

85. Meng HC, Caldewll MD, Sandstead HH: Total parenteral nutrition in patients with cancer. Am J Clin Nutr 29: 481, 1976

86. Meng HC, Early F: Studies of complete parenteral alimentation on dogs. J Lab Clin Med 34: 1121, 1949

87. Meng HC, Law DH, (eds): Proceedings of an International Symposium on Parenteral Nutrition. Springfield, Charles C Thomas, 1970

88. Meng HC, Law DH, Sandstead HH: Some clinical experiences in parenteral nutrition. In Berg G (ed): Advances in Parenteral Nutrition. Prague, George Thieme Verlag, Stuttgart, 1970, p 64

89. Meng HC, Kaley JS: Effects of multiple infusions of a fat emulsion on blood coagulation, liver function and urinary excretion of steroids in schizophrenic patients. Am J Clin Nutr 16: 156, 1965

90. Meng HC, Sandstead HH: Long-term total parenteral nutrition in patients with chronic inflammatory diseases of the intestines. In Wilkinson AW (ed): Parenteral Nutrition. Edinburgh, London, Churchill Livingstone, 1972, p 213

91. Meng HC, Sandstead HH, Walker PH, Ackerman JP, Johnson KH: The use of essential amino acids for parenteral nutrition in patients with chronic and acute renal failure. The Xth International Congress on Nutrition and International Society of Parenteral Nutrition Meeting. Kyoto, Japan, Aug 1975 (Abstract), p 241

92. Meng HC, Wang PY, Lu KS: The use of fructose and glucose as an energy source in total parenteral nutrition. Int J Vitam Nutr Res 15:252, 1976.

93. Moore FD: Surgical nutrition—parenteral and oral. In Committee on Preoperative and Postoperative Care of the American College of Surgeons: Manual of Preoperative and Postoperative Care Philadelphia, WB Saunders, 1967

94. Mueller JF, Viteri FE: Clinical studies in patients receiving long-term infusions of fat emulsions. J Okla State Med Assoc 53: 367, 1960

95. Munro HN: Protein hydrolysate and amino acids. In White PL, Nagy ME (eds): Total Parenteral Nutrition. Acton, Publishing Sciences Group, 1974, p 59

96. Nicholalds GE, Meng HC, Caldwell MD: Circulating levels of vitamins in adult patients receiving total parenteral nutrition. (In press)

97. O'Neill JA Jr, Meng HC, Caldwell MD, Otten A: Variations in intravenous nutrition in the management of catabolic states in infants and children. J Pediatr Surg 9: 889, 1974

98. Peaston MJT: Maintenance of metabolism by complete parenteral nutrition in acutely ill patients. In Meng HC, Law DH (eds): Parenteral Nutrition. Springfield, Charles C Thomas, 1970, p 499

99. Press H, Hartop PJ, Prottey C: Correction of essential fatty acid deficiency in man by the cutaneous application of sunflower seed oil. Lancet 1: 597, 1974

100. Protein Requirement. Report of a Joint FAO/WHO Experts Group, WHO Technical Report Series, No 301, 1965

101. Randall HT: Fluid and electrolyte therapy. In Committee on Preoperative and Postoperative Care of the American College of Surgeons: Manual of Preoperative and Postoperative Care. Philadelphia, WB Saunders, 1967

102. Randall HT: Indications for parenteral nutrition in postoperative catabolic states. In Meng HC, Law DH (eds): Parenteral Nutrition. Springfield, Charles C Thomas, 1970, p 13

103. Randall HT: Nutrition in surgical patients. Am J Surg 119:530, 1970

104. Rea WJ, Wyrick WJ Jr, McClelland RE, Webb WR: Intravenous hyperosmolar alimentation. Arch Surg 100: 393, 1970

105. Recommended Dietary Allowances. A Report of the Food and Nutrition Board, National Research Council, National Academy of Science, 8th ed. 1974

106. Rice CO, Orr B, Enquist I: Parenteral nutrition in surgical patients as provided from glucose, amino acids and alcohol—the role played by alcohol. Ann Surg 131: 289, 1950

107. Richardson TJ, Sqoutas D: Essential deficiency in four adult patients during total parenteral nutrition. Am J Clin Nutr 28: 258, 1975

108. Rose WC: The amino acid requirements in adult man. Nutr Abst Rev 27: 631, 1957

109. Ruberg RL: Hospital practice of total parenteral nutrition. In White PL, Nagy ME (eds): Total Parenteral Nutrition. Acton, Publishing Sciences Groups, 1974, p 349

110. Schiff L: Diseases of Liver, 3rd ed. Philadelphia, Lippincott, 1969, p 397

111. Schwartz FG, Green HL, Bendon ML, Graham WP III, Blakemore WS: Combined parenteral hyperalimentation and chemotherapy in the treatment of disseminated tumors. Am J Surg 121: 169, 1971

112. Scribner BH, Cole JJ, Christopher G, Vizzo JE, Atkins RC, Blagg CR: Long-term total parenteral nutrition. JAMA 212: 457, 1970

113. Sheldon GF, Gardiner BN, Way LW, Dunphy JE: Management of gastrointestinal fistulas. Surg Gynecol Obstet 133: 385, 1971

114. Shils ME: A program for total parenteral nutrition at home. Am J Clin Nutr 28: 1429, 1975

115. Shils ME: Guidelines for total parenteral nutrition. JAMA 220: 1721, 1972

116. Shils ME: Minerals. In White PL, Nagy ME (eds): Total Parenteral Nutrition. Acton, Publishing Sciences Group, 1974, p 257

117. Shils ME, Wright WL, Turnbull A, Brescia R: Long-term parenteral nutrition through an external arteriovenous shunt. N Engl J Med 283: 341, 1970

118. Signer R, Stanford W, Levenson SM, Seifter E: Maltose in parenteral alimentation. Am J Clin Nutr 26: 28, 1973

119. Slater JE: Retention of nitrogen and minerals by babies one week old. Br J Nutr 15: 83, 1961

120. Solassol Cl, Joyeux H: Ambulatory parenteral nutrition. In Fischer JE (ed): Total Parenteral Nutrition. Boston, Little, Brown and Co, 1976, p 285

121. Solassol Cl, Joyeux H, Etco L, Pujol H, Romieu C: New techniques for long-term intravenous feeding: an artificial gut in 75 patients. Ann Surg 179: 519, 1974

122. Steiger E, Oram–Smith J, Miller E, Kuo L, Vars HM: Effects of nutrition on tumor growth and tolerance to chemotherapy. J Surg Res 18: 455, 1975

123. Stone WJ, Warnock LG, Wagner C: Vitamin B_6 deficiency in uremia. Am J Clin Nutr 28: 950, 1975

124. Terepka AR, Waterhouse C: Metabolic observation during the forced feeding of patients with cancer. Am J Med 20: 225, 1956

125. Trace Elements in Human Nutrition. Report of WHO Expert Committee, World Health Organization Technical Report Series No 532, Geneva, 1973

126. Travis SF, Sugarman HJ, Ruberg RL, Dudrick SJ, Delivoria–Papadopoulos M, Miller LD, Oski FA: Alterations of red cell glycolytic intermediates and oxygen transport as a consequence of hypophosphatemia in patients receiving intravenous hyperalimentation. N Eng J Med 285: 763, 1971

127. VanWay CW III, Meng HC, Sandstead HH: An assessment of the role of parenteral nutrition in the management of surgical patients. Ann Surg 177: 103, 1973

128. VanWay CW III, Meng HC, Sandstead HH: Nitrogen balance in postoperative patients receiving parenteral nutrition. Arch Surg 110: 272, 1975

129. Vilter RW, Bozian RC, Hess EV, Zellner DC, Peterling HC: Manifestations of copper deficiency in a patient with systemic sclerosis on intravenous hyperalimentation. N Engl J Med 291: 188, 1974

130. Wacker W: The biochemistry of magnesium. Ann NY Acad Sci 162: 717, 1969

131. Wadstrom LB, Wirklund PE: Effect of fat emulsion on nitrogen balance in the postoperative period. Acta Chin Scand 325: 50, 1964

132. White PL, Nagy ME (eds): Total Parenteral Nutrition. Acton, Publishing Sciences Group, 1974

133. Wilkinson AW (ed): Parenteral Nutrition. Edinburgh, London, Churchill Livingstone, 1972

134. Wilmore DW, Curreri PW, Spitzer KW, Spitzer ME, Pruitt BA Jr: Supranormal dietary intake in thermally injured hypermetabolic patients. Surg Gynecol Obstet 132: 881, 1971

135. Wilmore DW, Dudrick SJ: Safe long-term venous catheterization. Arch Surg 98: 256, 1969

136. Wilmore DW, Dudrick SJ: Treatment of acute renal failure with intravenous essential L-amino acid. Arch Surg 99: 669, 1969

137. Wolpert E, Phillips SF, Summerskill WHJ: Ammonia production in the human colon. Effects of cleansing, neomycin and acetohydroxamic acid. N Engl J Med 283: 159, 1970

138. Wolpert E, Phillips SF, Summerskill WHJ: Transport of urea and ammonia production in the human colon. Lancet 2: 1387, 1971

139. Wretlind A: Fat emulsions. In White PL, Nagy ME (eds): Total Parenteral Nutrition. Acton, Publishing Sciences Group, 1974, p 201

140. Yoshimura, NN, Ehrlich H, Westman TL, Deindoerfer FH: Maltose in total parenteral nutrition of rats. J Nutr 103: 1256, 1973

12 Parenteral nutrition: pediatrics*

William C. Heird, Robert W. Winters

The subject of parenteral nutrition has evoked wide interest in the field of pediatrics since it bears upon a number of subspecialties of modern pediatric practice, notably neonatalogy, gastroenterology, nephrology, metabolism, endocrinology and, of course, nutrition. Because of the complexities of this field we have chosen to limit this chapter to a critical and selected survey of results of clinical studies. Furthermore, we intend to concentrate only on total parenteral nutrition (TPN), the provision of all nutrients by the parenteral route.

One of the earliest documented successes of TPN in an infant was published by Helfrick and Abelson in 1944 (37). Their patient was a 5-month-old male suffering from extreme marasmus who had reached the point that "all observers agreed that he would not survive more than a day or two at most." Using alternate infusions of a mixture of 50% glucose–10% casein hydrolysate and electrolytes followed by a "do-it-yourself" homogenized olive oil–lecithin emulsion, these investigators were able to deliver 130 Cal in 150 ml/kg/day via ankle veins. Despite repeated thrombophlebitis, Helfrick and Abelson were able to provide TPN for 5 days. Towards the end of this period they noted that "the fat pads of the cheeks had returned, the ribs were less prominent, and the general nutritional status was much improved." In addition, "(his) former expression of dire misery was gone." The patient ultimately survived.

This early demonstration of the efficacy of TPN, although offering great promise, also pointed out some important problems. During the next 20 or so years, many investigators tried to duplicate this impressive performance, usually without success. Such failures were ascribable to two general reasons: 1) the extreme hypertonicity of the infusate necessitated frequent changing of peripheral vein sites because of

thrombophlebitis and 2) insufficient calories were provided along with the amino acids to allow the latter to be anabolized into new tissue protein.

In 1966, Dudrick (18) provided a major breakthrough that made TPN a practical reality. Dudrick devised a method by which a plastic catheter could be implanted and maintained for long periods of time in the superior vena cava, first of a dog and later of an infant and adult man. Since the blood flow in this central vein is high, Dudrick reasoned that giving the strongly hyperosmolar nutritive fluid by a slow, continuous infusion would dilute it and thus prevent damage to the vein. Using this type of delivery system with a hypertonic glucose–protein hydrolysate fluid to which electrolytes, minerals, and vitamins had been added, Dudrick showed good growth and development, first in beagle puppies (19) and subsequently in an infant with a short gut (62). This dramatic demonstration provided the stimulus for the now widespread use of TPN in pediatric patients.

COMPOSITION OF FLUIDS FOR TOTAL PARENTERAL NUTRITION

The general nutritive requirements for TPN as it is currently used in this country and the general sources available to meet such requirements are as follows:

1. Amino acids: Hydrolysates (fibrin, casein); Crystalline amino acid mixtures
2. Calories: Glucose, fructose, lipid, alcohol
3. Electrolytes (Na,K,Cl): Additives
4. Minerals (Ca,Mg,P): Additives
5. Fat- and water-soluble vitamins: Additives
6. Essential fatty acids: lipid
7. Trace minerals (*e.g.,* Zn, Cu): Additives

First, a source of nitrogen providing both the essential and nonessential amino acids must be given. Two general types of nitrogen sources are used: 1) an acid hydrolysate of fibrin or an en-

*The original research of the authors is supported by grants from the National Institutes of Child Health and Human Development (HD-08434 and RR-00645).

zymatic hydrolysate of casein or 2) a mixture of pure crystalline amino acids. In passing, it should be noted that only about 50% of the total nitrogen content of protein hydrolysates consists of amino acids. The remainder consists of di–, tri–, or even larger peptides (5), the precise metabolic fate of which is unknown. This feature coupled with the well-known lot to lot variation in the composition of the hydrolysates led to the advent of crystalline amino acid mixtures, of which only one, FreAmine, is at present commercially available in this country (others are in various phases of experimental development). The general range of intake from either of these nitrogen sources is 2.5–4.0 g/kg/day in infants. We prefer to use the lower figure since we have found it to give a positive nitrogen balance equivalent to the higher figure with less risk of azotemia (35). Although both the hydrolysates and the current crystalline amino acid mixtures produce growth and development under appropriate conditions, it seems fair to conclude that we still do not have an ideal amino acid solution for infants.

A second requirement is the provision of enough nonprotein calories to meet full caloric expenditure. In the United States, glucose or a mixture of glucose and fructose are most commonly used. In Canada and in Europe, various IV fat preparations, e.g., Intralipid or Lipofundin-S, are used along with monosaccharides and polyols. Ethanol, having a caloric density of 7 Cal/g, has also been used (7) but in general most investigators have shied away from its use in infants, particularly in view of the documented unpredictability of blood alcohol levels in infants (48). We use glucose as the exclusive nonprotein caloric source, and the amounts required are 25–30 g/kg/day in an infant (31).

Other nutritive requirements, including electrolytes, minerals, and vitamins, are provided by various additives to the infusate. Generally we provide the usual maintenance requirements for electrolytes (65), but we wish to emphasize that in the case of minerals and vitamins there is no precise knowledge of parenteral requirements in infants, or for that matter in adults. With some of these substances (e.g., calcium, magnesium, phosphorus, vitamin A, and vitamin D), the parenteral requirement is likely to be substantially different from the oral. Clearly much additional research must be done in these areas.

Finally, note should be taken of the need for essential fatty acids and trace metals. Again we have no precise information on parenteral requirements, but based on a large body of background evidence, both are likely to be required

for TPN (39,59). In the conventional TPN mixtures currently being used in this country, neither essential fatty acids nor trace metals are included, and these are potentially important omissions. Although periodic blood or plasma transfusions have been suggested as a means of meeting these requirements, transfusions are probably grossly inadequate, at least in the case of essential fatty acids (7). The amount of trace minerals present as contaminants in the infusate is also likely to be far below any reasonable estimate of the range of requirements (27).

Table 12–1 shows the usual composition of the nutritive fluid that our group uses. It is obvious that such a complex chemical mixture invites many types of interaction among constituents [see, for example, Steginक et al. (53)]. Such fluids are also excellent culture media for microorganisms, particularly certain fungi (3, 5, 25). Meticulous aseptic technique in mixing the fluid is thus a most important precaution in minimizing the risk of sepsis.

It is well to bear in mind that the composition of the infusate should by no means be uniform from patient to patient. The glucose concentration must be started at a relatively low level (e.g., 10%) and slowly increased in accordance with the ability of the patient to adapt to an increasing carbohydrate load. The electrolyte and mineral contents of the infusate may have to be altered frequently in accordance with clinical and chemical feedback information. To achieve this type of flexibility, which is absolutely essential for the infant, requires a team approach to TPN; this point will be discussed in detail later.

Figure 12–1 vividly demonstrates the osmotic problem of the conventional fat-free TPN fluid, illustrating the separate osmolar contributions of the electrolytes and minerals, the amino acids, and especially the glucose. The final osmolality

TABLE 12–1. Usual Composition of Infusate

Component	Daily intake
Nitrogen source	2.5 g/kg
Glucose	25–30 g/kg
NaCl	3–4 mM/kg
KH_2PO_4	2–3 mM/kg
Ca gluconate	0.25 mM/kg
	(0.5 mEq/kg)
$MgSO_4$	0.125 mM/kg
	(0.25 mEq/kg)
MVI*	1 ml
Vitamin B_{12}	10 μg
Folic acid	50–75 μg
Vitamin K_1	250–500 μg
Total volume	130 ml/kg

*US Vitamin Corp, Tuckahoe, NY

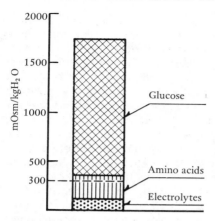

Fig. 12–1. Osmolality of usual infusate whose composition is shown in Table 12–1. Such a fluid provides about 110 Cal/kg/day in a volume of 125 ml/kg/day. (From Heird, William C., and Winters, Robert W.: Total Parenteral Nutrition: The state of the art, J. Pediatr. 86:2–16, 1975)

of such a solution is about 1740 mOsm/kg water or nearly 6 times the isotonic value of 300 mOsm/kg water. Only by the use of a slow, continuous infusion in a central vein can hyperosmolar damage to the vein be avoided.

Figure 12–2 illustrates the delivery system originally perfected by Dudrick *et al.* (62) and now widely used in infants. A silastic catheter is inserted into the internal jugular vein through a small wound in the neck and threaded down into the superior vena cava. It is essential to verify the location of the tip of the catheter radiograph-

ically. The other end of the catheter is threaded through a subcutaneous skin tunnel to exit on the scalp behind the ear, a location which removes it from the oral secretions and also makes the triweekly dressing changes much simpler. All nutritional fluids for infants should be delivered by pump. A 0.22-μ Millipore filter is usually placed in the line although its efficacy as a preventive against sepsis has never been critically tested. Once in place, the entire delivery system must be considered inviolate—*i.e.,* no drugs are added via the system and no blood sampling is permitted from the catheter.

RESULTS OF TOTAL PARENTERAL NUTRITION

PEDIATRIC SURGICAL PATIENTS

One of the widest uses of TPN in pediatric patients is in those patients, particularly newborn infants, who have surgical disease of the GI tract secondary to major malformations. From our rather large experience with such patients, we have chosen a representative group of 21 who illustrate both the short-term as well as long-term metabolic changes (36). These patients consisted of newborn infants born with major anomalies of the GI tract, the most dramatic of which required major resections of small bowel. Other anomalies included organic or functional intestinal obstruction, necrotizing enterocolitis, and a group of other disorders. None of the patients were able to tolerate sufficient enteral

Fig. 12–2. Insertion of catheter. (Winters RW (ed): The Body Fluids in Pediatrics. Boston, Little, Brown, 1973, p 668)

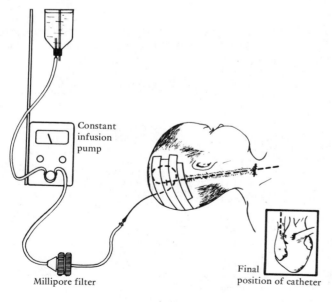

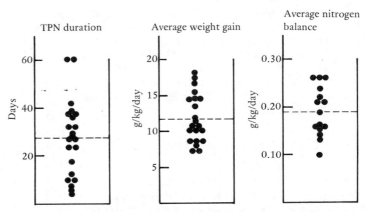

Fig. 12–3. Duration of TPN, average daily gain in body weight, and average daily nitrogen balance in surgical patients on TPN receiving at least 100 Cal/kg/day. (From Heird, William C., and Winters, Robert W.: Total Parenteral Nutrition: The state of the art, J. Pediatr. 86:2–16, 1975)

findings to promote normal growth and development. Indeed, in almost all of the infants the tolerable quantity of enteral feedings was nearly zero.

METABOLIC STUDIES

Figure 12–3 summarizes metabolic data obtained during 21 periods of TPN in these infants. The mean duration of TPN was 27 days with a range of 5–60 days. The average weight gain after achievement of a caloric intake of greater than 100 Cal/kg/day was 11.8 g/kg/day (range 7.5–17.5 g/kg/day). All babies were in positive nitrogen balance, varying from a daily average of 0.10–0.26 g/kg, with a mean of 0.19 g/kg. As we have pointed out before (31), it is likely that the wide variation in both the daily weight gain and daily nitrogen balance is accounted for by two factors: 1) the previous nutritional status of the infant and 2) the general degree of on-going stress.

In considering the overall metabolic results obtained by our group, two additional points are worthy of detailed discussion: 1) importance of caloric intake and 2) interpretation of nitrogen balance data. Both derive from published data in surgical patients, but both have relevance to the metabolic effects of TPN in infants generally.

IMPORTANCE OF CALORIC INTAKE

Coran (13) reports the growth performance of 17 surgical infants who received TPN delivering an IV fat emulsion (Intralipid) and glucose as calorie sources with a daily total non-protein-

caloric intake of 88 Cal/kg. The entire nutritive infusate was given by peripheral vein. Comparison of the growth performance of this group of infants to that of a matched group of 14 of our surgical patients who received 110–120 Cal/kg/day from glucose alone by central vein revealed a highly significant difference in the daily rate of weight gain. Despite similarities in duration of TPN, initial body weight, and diagnosis, Coran's infants gained only 8.7 g/kg/day (average), whereas our group averaged 12.6 g/kg/day. Considering this difference, it is difficult to escape the conclusion that caloric intake is all important in promoting optimal weight gain in TPN.

Intralipid has been highly recommended as a source of calories with the implication that central venous delivery and its attendant risks can be avoided. This conclusion may be premature, since if one wishes to provide a caloric intake and therefore a weight gain comparable to the conventional glucose fat-free regimen, either the final infusate will be quite hypertonic or else the total volume will have to be markedly increased, thus posing a potential threat of overhydration (Fig. 12–4). With a daily caloric intake of 110 Cal in a reasonable total volume of 125 ml/kg, the fat-glucose infusate would have a final osmolality of about 1268 mOsm/kg water, which is still about four times the isotonic value and therefore likely to damage peripheral veins. Thus if one were to use this fat-containing regimen, which should give better growth than that observed by Coran, one must be prepared either to change peripheral veins frequently or to continue to use the central venous route. Certainly,

IV fat emulsions are helpful in providing both calories and essential fatty acids, and less highly concentrated fat–glucose infusates given by peripheral vein along with some oral caloric intake are likely to find wide usage, but when long-term TPN is called for, it is still likely that central venous delivery will produce the best growth performance.

INTERPRETATION OF WEIGHT GAIN AND NITROGEN BALANCE

The second, generally relevant point has to do directly with the interpretation of data on weight gain and nitrogen balance in infants receiving TPN and indirectly with the quality of growth that occurs in infants being fed under these conditions. In Figure 12–5 the total body water (TBW) plus body protein is regarded as equivalent to the lean body mass (LBM). It is important to note that since body fat is nearly anhydrous, there will be a reciprocal relationship between TBW and fat per unit body mass. This is even more important when considering the body composition of the full-term and—especially—the pre-term infant (Fig. 12–6). It is clear from this figure that during the later part of gestation, body fat shows a considerable increase at the expense of TBW, with body protein remaining reasonably constant.

Fig. 12–4. Comparison of osmolality of equicaloric nutrient mixtures providing 110 Cal/kg/day in a volume of 125 ml/kg/day. *Left bar,* osmolality of mixture with glucose as sole source of calories; *right bar,* final osmolality delivered from infusates containing glucose and IV fat emulsion (Intralipid) in which fat is administered at 4 g/kg/day, the usually recommended upper limit. (From Heird, William C., and Winters, Robert W.: Total Parenteral Nutrition: The state of the art, J. Pediatr. 86:2–16, 1975)

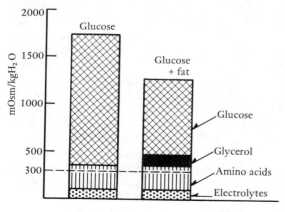

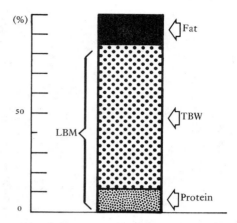

Fig. 12–5. Highly simplified view of body composition showing fat, water, and protein as sole components. *LBM,* sum of *TBW* and body *protein.* (From Heird, William C., and Winters, Robert W.: Total Parenteral Nutrition: The state of the art, J. Pediatr. 86:2–16, 1975)

Figure 12–7 enlarges on this background. The expression at the top of the figure shows that LBM is related approximately to the nitrogen content of the body through a factor (*f*). The curve, adapted from Widdowson's data on the composition of human fetuses (60), predicts the approximate variation of the value for the factor (*f*) in infants of various weights and gestational ages, after an assumed 10% loss of TBW as an immediate postnatal diuresis. Thus with a birth weight of 1.0 kg, *f* would have a value of about 62 g LBM/g nitrogen, whereas at a birth weight of 2.5 kg or greater, its value would be closer to 42 g LBM/g nitrogen. This fall occurs, of course, because of the increasing fat deposition and the reciprocal decrease in TBW in the face of a relatively constant proportion of body protein during the latter part of gestation (see Fig. 12–6).

These background considerations can be used as the basis for a rough approximation of the increase in LBM which would be expected for a given degree of nitrogen retention. Thus in a steady state, a 2.5-kg infant showing a 1-g positive N balance would be expected to deposit about 42 g LBM, since *f* at this age is 42 g LBM/g N.

The above relationship can be used to evaluate our data on nitrogen balance in relation to the quality of growth being observed in TPN. Thus we observed total daily weight gain of 11.8 g/kg and a corresponding average N balance of 0.19 g/kg/day (see Fig. 12–3). This corre-

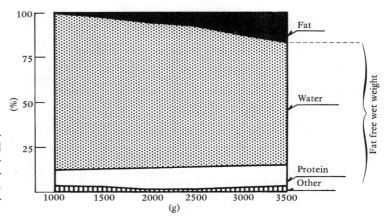

Fig. 12–6. Changes in body composition as a function of fetal weight and gestational age based on data of Widdowson. (Davis JA, Dobbing J: Scientific Foundations of Pediatrics. London, William Heinemann Medical Books, 1974, p 153)

sponds to an estimated deposition of 8.0 g/kg/day of LBM; the weight gain unaccounted for by LBM is therefore 5.9 g/kg/day. This increment in weight is likely to be partly or completely fat. It certainly cannot all be extracellular fluid since if it were our infants would have been grossly edematous at the end of the average of 27 days of TPN; in fact, little or no edema was ever observed.

One other implication of the above discussion deserves comment. It is widely recognized that the technique of nitrogen balance is filled with errors, nearly all of which are in the positive direction (57). In the absence of significant changes in hydration, sustained gain of body

Fig. 12–7. Expected relationship between the factor (*f*) relating nitrogen balance to body weight and gestational age. Curve was derived from data shown in Figure 12–6 and corrected for an assumed 10% loss of TBW by early postnatal diuresis (see text for usefulness of *f*). (From Heird, William C., and Winters, Robert W.: Total Parenteral Nutrition: The state of the art, J. Pediatr. 86:2–16, 1975)

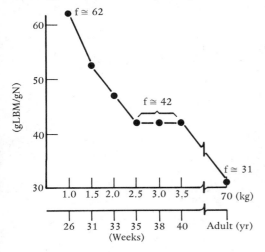

weight of infants on TPN is probably as good or even a better index of growth than is nitrogen balance.

CLINICAL RESULTS

The follow-up clinical results of our 21 patients (presented above), obtained at least 1 year after TPN, have been most rewarding. Of the 21, 15 were well and had normal GI function, as indicated by their growth performance, by their ability to ingest a normal diet for age, and by normal bowel habits. Two subjects still required special diets. Four infants died, all of causes unrelated to TPN.

These results are typical of those being obtained in other centers, all of which show a rather dramatic positive outcome in a group of patients who prior to the advent of TPN would certainly have had very high mortality rates. All in all, the surgical neonates are a most gratifying group to deal with, and given appropriate patient selection, TPN can truly be regarded as life-saving.

CHRONIC INTRACTABLE DIARRHEA

Another group of patients in whom TPN appears to be useful are those infants with chronic intractable diarrhea, since the mortality of such infants who are managed conventionally is very high (1).

CLINICAL RESULTS

Infants with this disease or diseases usually present with moderate or severe malnutrition secondary to protracted diarrhea. Admission weight is often less than birth weight. Extensive diagnostic studies to reveal a specific cause of the diarrhea (*e.g.,* stool and urine cultures, barium

TABLE 12–2. Results of TPN in Chronic Intractable Diarrhea*

Study group		Outcome	
Number of infants:	16	Normal GI function:	15[†]
Age of infants:	3 weeks	Died (sepsis):	1
	(2½–12 weeks)		
Duration of TPN:	28 days		
	(14–42 days)		

*Data of Keating JP, Ternberg JL: Am J Dis Child 123:336, 1971, and Keating
JP: In Winters RW, Hasselmeyer EG (eds): Intravenous Nutrition in the High
Risk Infant. New York, John Wiley & Sons, 1975, p 117
[†]6 intolerant to lactose

studies, sweat test, immunoglobulins, catecholamines) are uniformly negative. The diarrhea of such babies is unresponsive to any type of formula feeding. Keating, who has had extensive experience in treating these infants (43,44), was led to try TPN in the belief that a complete absence of oral feedings might improve these infants by providing "complete bowel rest." Keating studied 16 such patients, all of whom fulfilled the above criteria. His results are summarized in Table 12–2. The average age of the patients was 3 weeks, and the average period of TPN was 28 days. Of the 16 infants, 15 survived and at follow-up, which was at least 1 year, all had normal GI function, with the exception that 6 (all of whom were black) were lactose-intolerant. One infant died of sepsis, an ever-present risk of TPN using central venous delivery.

Such results in managing this previously troublesome disorder are most impressive. Our own experience and that of others (29,40) bears out these overall positive results. One need only read Avery et al. (1), which was published just prior to advent of TPN, to realize how dramatically the outcome of this group of infants can be changed by TPN.

These observations raise interesting questions about the nature of the disease or diseases that masquerade under the label of chronic intractable diarrhea. Avery et al. (1) discussed the evidence and advanced the hypothesis (Fig. 12–8) that chronic diarrhea begets malnutrition through malabsorption of nutrients as well as a failure of replacement of stool losses of nutrients via the oral intake. Once malnutrition is well established, either because of a deficiency of protein, calories, vitamins, or ions, or a combination of these, it in turn begets adverse changes on GI mucosa, flora, reflexes, and motility. The cycle is thus closed and the diarrhea perpetuated.

In such infants, TPN seems to produce "bowel rest" and breaks the cycle, presumably by favorably altering gut structure and function, so that nutrients given by mouth are absorbed

and utilized. Indeed, Greene et al. (29) have shown that TPN can produce a marked favorable change in intestinal morphology. In Greene's studies, for example, the crypt-to-villus ratio increased from about 1:1 prior to TPN to about 1:4 after TPN. This finding and other histologic changes all suggest that the mucosal absorptive surface is greatly increased by TPN in babies with chronic intractable diarrhea. Regardless of mechanism, the overall clinical results of TPN in these infants rank alongside those obtained in selected surgical patients as life-saving.

VERY-LOW-BIRTH-WEIGHT INFANTS

A third group of pediatric patients in whom TPN has been evaluated in a preliminary fashion are infants of very low birth weight (*i.e.,* less than 1200 g). In contrast to the two other groups of patients discussed above, we regard TPN in this group as a strictly investigational

Fig. 12–8. Interrelationships between chronic diarrhea and malnutrition (see text). (From Heird, William C., and Winters, Robert W.: Total Parenteral Nutrition: The state of the art, J. Pediatr. 86:2–16, 1975)

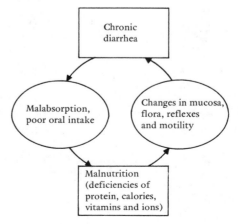

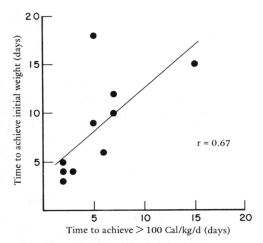

Fig. 12–9. Relationship between time to regain initial body weight and time to achieve intake greater than 100 Cal/kg/day in low-birth-weight infants on TPN. (From Heird, William C., and Winters, Robert W.: Total Parenteral Nutrition: The state of the art, J. Pediatr. 86:2–16, 1975)

procedure and certainly not as an accepted form of routine neonatal care.

The problems and risks of establishing a completely adequate enteral intake in the very low birth weight infant are well known. There is, in addition, the added concern, based principally on animal studies, that malnutrition at some critical point of brain growth may lead to non-recoupable losses of brain cell number (64) (see Ch. 30).

CLINICAL AND METABOLIC RESULTS

In order to ascertain the feasibility and safety of this method of feeding, our research group (16)

undertook a preliminary *uncontrolled* study of TPN in 14 consecutive low-birth-weight infants. The mean birth weight of these infants was 863 g with a range of 720–1150 g. In 8 infants, TPN was started within the first 48 hours of life using the umbilical vein initially and then changing to the superior vena cava. In the 6 others, TPN via the superior vena cava was started after unsuccessful attempts at oral feedings. The average period of TPN was 17.7 days with a range of 5–25 days. In 10 of the 14 babies, caloric intakes greater than 100 Cal/kg/day were achieved over an average period of 5.6 days. The principal determinant for regaining initial body weight seems to be the time needed to achieve a full caloric intake (Fig. 12–9). The wide variations in the time needed to achieve a full caloric intake reflects the unpredictability of the individual infant's ability to adapt to the high glucose loads. Extremely close monitoring of blood and urine glucose levels is absolutely necessary under conditions of increasing glucose load in order to avoid hyperglycemia, which may appear rapidly and reach extreme levels. With stringent clinical and chemical monitoring, we have used small amounts of insulin (0.25–0.50 IU) in the hope of speeding this adaptive response. This seems to be a useful maneuver, but very close monitoring is an absolute essential.

Figure 12–10 shows balance studies on eight of the low-birth-weight infants who received TPN for an average of 15.5 days. During this period the eight infants showed an average daily weight gain of 15.2 g/kg after full caloric intake had been achieved. The average daily nitrogen balance was 0.22 g/kg. The weight gain unaccounted for by lean body mass (presumably fat) was 3–4 g/kg/day, depending on the precise figure chosen for the factor *(f)* (see above).

Of the original 14 infants, 6 died, 5 from

Fig. 12–10. Duration of TPN, average daily gain in body weight, and average daily nitrogen balance in very-low-birth-weight infants on TPN receiving at least 100 Cal/kg/day. (From Heird, William C., and Winters, Robert W.: Total Parenteral Nutrition: The state of the art, J. Pediatr. 86:2–16, 1975)

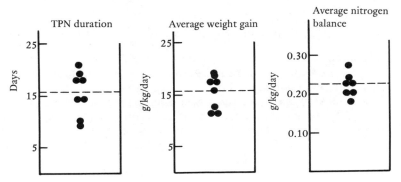

respiratory insufficiency, 1 from sepsis. Of the 8 infants who survived, 3 were normal, 2 were suspect, and 2 were definitely abnormal at follow-up (17–36 months). In one of the latter, the abnormality was almost certainly secondary to a subsequent unrelated illness.

COMMENT

Results in this group of infants conclusively demonstrate that TPN can produce good growth and positive nitrogen balance without undue risk. However, the results are inconclusive as to whether short-term or long-term outcome is favorably affected. One fact that emerged is that a large number of babies will be needed for any controlled study aimed at demonstrating the superiority of TPN over conventional feeding practices in low-birth-weight infants with respect either to short-term or long-term variables. We compared obvious short-term variables in the 14 infants receiving TPN and in a group of 23 infants of similar size who were managed conventionally during the 2-year period immediately prior to the use of TPN. Mortality in the TPN-managed group was 45%, whereas in the conventionally managed group it was 56%. If these differences were to prevail in a controlled study, at least 75 infants would be needed to show 5% statistical significance and about twice that many to show 1% significance. Clearly if any such controlled study is ever mounted, it will require the participation of a number of neonatal centers.

The short-term and long-term outlooks for very low birth weight babies is obviously a multifactorial problem. Early adequate nutrition is only one possible factor. Until that factor can be isolated and studied in a controlled fashion, TPN cannot be regarded as having any proven place in the routine management of these babies. On the other hand, we have shown that with adequate precautions it can be used without undue risk and that it certainly deserves further study.

GRANULOMATOUS BOWEL DISEASE

Still another group of pediatric patients in whom TPN may be useful is older children and adolescents with granulomatous bowel disease (see Ch. 20). Since granulomatous bowel disease(s) also affects the upper range of the pediatric age group, attention should be called to the work of

Cohen *et al.* (12). These investigators treated 13 such patients, predominantly in the teen-age group, to ascertain whether complete "bowel rest" induced by TPN would improve their underlying disease. All 13 patients had had previous unsuccessful trials of surgery, steroids, and azulfidine, singly or in combination. They also had a high incidence of perianal disease, notably fistula or abscess formation, or both, and nutritional debilitation was moderate or severe.

Without any other therapy TPN was administered for an average of 5 weeks to 11 of the 13 patients. Of these, 6 had a complete remission for 12–18 months; in another 3, partial remissions lasting up to 12 months were induced. Nutritional status was much improved, and the perianal fistulae closed spontaneously. Two patients died of their disease. In the remaining 2, short-term TPN was used as a preoperative adjunct.

Cohen and his colleagues feel that TPN has a definite role in managing patients with granulomatous bowel disease, and their data certainly bear out this conclusion (12). Similar results in larger groups of adult patients have been obtained by others (21,45). Although not a panacea, TPN certainly seems deserving of a trial in this group of troublesome disorders, particularly if surgery, steroids, and azulfidine can be avoided, or even if these latter agents can be used in small doses for brief periods to manage mild relapses after a course of TPN.

COMPLICATIONS OF TOTAL PARENTERAL NUTRITION

METABOLIC COMPLICATIONS

GENERAL

Metabolic complications of almost every conceivable type have been seen in the course of TPN (Table 12–3). Hyperglycemia with attendant osmotic diuresis and secondary changes in water and electrolyte metabolism are always threats and may, if undetected, lead to extreme degrees of hyperosmolarity, coma, and death (10). Hypoglycemia may also occur with sudden cessation of the glucose load, *e.g.,* when the catheter becomes dislodged or when the infusion is abruptly stopped for some other reason.

Disorders of electrolyte and mineral metabolism occur when either too much or too little of these substances are given with respect to the individual patient's needs. Hypophosphatemia

may be a particularly important complication since Travis *et al.* (56) have shown that this is accompanied by changes in organic phosphate compounds of the erythrocyte, and these changes in turn affect the oxygen dissociation curve.

In formulating the electrolyte and mineral intake, one must take into account the presence of any of these substances in the particular nitrogen source being used. For example, casein hydrolysate contains appreciable amounts of phosphate because casein is a phosphoprotein. Generally, the crystalline amino acid mixtures have little added electrolyte or minerals. Shortly, McGaw Laboratories intends to market an amino acid mixture (FreAmine II) which contains some added phosphate, although probably not enough for infants.

Disorders of acid–base equilibrium are uncommon in patients receiving hydrolysates; when they do occur they can usually be explained by other obvious causes. However, a hyperchloremic metabolic acidosis occurs rather consistently in infants receiving the crystalline amino acid mixture FreAmine (30), which problem will be discussed in more detail below.

Azotemia occurs frequently in small infants receiving 4 g/kg/day nitrogen source; in our experience, it is uncommon with a recommended intake of 2.5 g/kg/day.

Hyperammonemia is an interesting complication which our group (34) has studied. Because the hydrolysates contain appreciable amounts of preformed ammonia and because Johnson *et al.* (41) had documented moderate but asymptomatic hyperammonemia in infants receiving hydrolysates, we switched to the crystalline mixture FreAmine, which has no preformed ammonia. We were very surprised, therefore, to encounter four cases of severe symptomatic hyperammonemia, all in surgical infants who had received TPN for more than 3 weeks. We showed that the hyperammonemia rapidly responds to either arginine or ornithine infusions, and can be prevented by supplementing FreAmine with 0.5–1.0 mM/kg/day arginine (34). On the basis of these observations, which have been confirmed by others (17, 26), we believe that FreAmine is relatively deficient in arginine, particularly for long-term TPN in infants.

Abnormal plasma aminograms have been noted (15, 22, 33, 49, 52). In general, the pattern of the plasma aminograms tends to reflect the amino acid composition of the infusate.

Hypovitaminosis, as well as hypervitaminosis,

TABLE 12–3. Metabolic Complications of TPN

System affected	Systemic disorder
Glucose	Hyperglycemia (osmotic diuresis, hyperosmolarity)
	Hypoglycemia
Electrolytes	Hyper- or hypo-natremia, -kalemia, -chloremia
Minerals	Hyper- or hypo-calcemia, -phosphatemia, -magnesemia
Acid-base	Hyperchloremic metabolic acidosis
N metabolism	Azotemia
	Hyperammonemia
	Abnormal plasma aminograms
Vitamins	Hyper- or hypo-vitaminoses
Fatty acids	Essential fatty acid deficiency
Trace minerals	Zn, Cu deficiencies
Hepatic	Elevated SGOT, SGPT; hepatomegaly

especially of vitamins A and D, have been recorded. Decimal errors in the addition of the vitamins to the nutrient infusates have been implicated as causes, but since there is no precise knowledge of parenteral requirements of the two fat-soluble, potentially toxic vitamins A and D, it may be (46) that even the usual vitamin recommendations will produce subclinical hypervitaminosis A and perhaps D.

Essential fatty acid deficiency has been commented on recently by a number of investigators (6, 39, 47, 58). Likewise, deficiencies of trace metals, such as copper and zinc, have been reported (27, 42) and probably will be seen more often as soon as they are sought in a systematic fashion.

Finally, disorders of hepatic function and structure are often seen (11, 31, 61). There are rather consistent modest rises in serum transaminase levels when TPN is initiated, and these enzyme changes are sometimes associated with hepatomegaly. In our experience both of these abnormalities are transient despite continuation of the TPN regimen (31).

Many of the metabolic complications can be corrected if detected early by changes in the composition of the infusate. This implies that patients should be monitored intensively, especially in the face of metabolic instability. Using a stringent monitoring schedule (65, 66) coupled with the flexibility to rapidly adjust the infusate composition, we have been able to maintain plasma electrolyte, acid–base, mineral, glucose, and urea values within normal limits in the majority of the cases. When abnormalities do occur in these variables, they are usually not severe and can be readily corrected by appropriate alteration(s) of the composition of the infusate.

METABOLIC ACIDOSIS

The hyperchloremic metabolic acidosis that occurs with certain of the crystalline amino acid mixtures deserves more-detailed discussion because there seems to be considerable confusion as to its precise cause.

In our early studies, we (30) demonstrated that infants receiving the hydrolysate Aminosol as the nitrogen source showed no significant deviation of acid–base status, whereas those receiving FreAmine showed a mild hyperchloremic metabolic acidosis and those receiving the experimental crystalline mixture, NeoAminosol, showed a more severe acidosis.

A variety of sometimes confusing explanations have been offered as the cause of the acidosis (Table 12–4). All TPN solutions have acid pH values and positive values for titratable acidity, and these had been implicated by some (9) as the cause of the acidosis. In fact neither of these variables is relevant unless precise knowledge of the chemical composition of the specific nutritional fluid is available. Thus, we showed that the hydrolysates that do not usually produce acidosis have titratable acidities three to four times those of the crystalline mixtures that do produce acidosis. Even this observation is not necessarily relevant since the chemical composition and the metabolic fate of the substances being titrated in the hydrolysates is not precisely known. Furthermore, in the case of the crystalline mixtures, the chemical composition of which is accurately known, the exogenous load of titratable acid is too small to account for the acidosis.

The general problem of evaluating the titratable acidity of a given solution in relation to its acidogenic properties can be illustrated by considering two solutions of acid: 0.1 M lactic acid and 0.1 M hydrochloric acid. Both of these solutions have acid pH values and both have identical values for titratable acidity. But whereas infusion of lactic acid into an otherwise normal individual does not cause a sustained metabolic acidosis since lactic acid is metabolized to carbon dioxide and water, infusion of equal amounts of hydrochloric acid does cause a sustained metabolic acidosis because it is not metabolizable and can only be excreted by the kidney, which process requires an appreciable interval of time.

The third possibility, excessive endogenous production of organic and sulfuric acids was proposed by Chan (8), who reported equivalently high values in patients on TPN receiving either type of nitrogen source (*i.e.*, casein hydrolysate or crystalline amino acids) compared to infants receiving glucose and water alone, an inappropriate comparison. Furthermore, since this study can be faulted on both theoretic and methodologic grounds (36), this theory can be dismissed as an explanation for the origin of the metabolic acidosis pending the publication of more-reliable data.

The fourth and fifth possibilities, excessive stool base loss and defective renal net acid excretion, deal with abnormal losses of base, either in the stool or in the urine. Stool base loss in infants on TPN was low, and renal net acid excretion was normal or supernormal in our study (30), thereby excluding both of these possibilities.

This left the sixth and final possibility—namely, that infusates containing the crystalline amino acids delivered a load of potential acid not present in the hydrolysates. Determination of the inorganic cation–anion pattern of each revealed the main cause of the acidosis. Figure 12–11 shows the overall pattern of results obtained. With both fibrin and casein hydrolysates, the inorganic cations were found to exceed the inorganic anions, resulting in an anion gap. This anion gap is probably accounted for by glutamate, aspartate, and negatively charged peptides, substances which on metabolism, in effect, yield bicarbonate. However, the crystalline amino acid mixtures, especially NeoAminosol and to a much less extent Fre-

TABLE 12–4. Explanations of Metabolic Acidosis in TPN

Theoretic cause	Objections	Evaluation of cause
Acid pH of infusate	All pH values < 6.0	Irrelevant
Excessive load of preformed acid (TA)	TA hydrolysates \gg crystalline mixtures	? Relevant; small effect
Excessive endogenous production of acid	"High" (both types of N sources)	Erroneous theory and methods
Excessive stool base loss	Low stool base	Unimportant
Defective renal net acid excretion	Normal or high net acid excretion	Excluded
Excessive load of potential acid	Cation gap in crystalline mixtures; anion gap in hydrolysates	Major effect

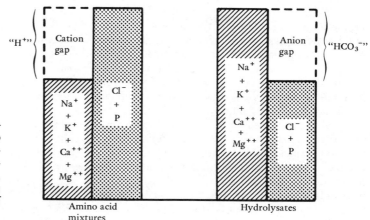

Fig. 12–11. General types of cation–anion patterns seen in crystalline amino acid mixtures, which produce metabolic acidosis, and in protein hydrolysates, which do not. (From Heird, William C., and Winters, Robert W.: Total Parenteral Nutrition: The state of the art, J. Pediatr. 86:2–16, 1975)

Amine, contain a cation gap. This was accounted for fully by arginine and lysine, which were present as the hydrochloride salts. These substances are known to generate hydrochloric acid on metabolism regardless of whether they are catabolized or anabolized. Furthermore, they are present in sufficient amounts to cause the observed acidosis, particularly when their contributions are added to the smaller contributions from the titratable acidity of the crystalline mixtures.

Acidosis is not a serious problem once it is recognized. It can be immediately prevented or treated by adding a metabolizable base instead of chloride to the infusate. It could be ultimately prevented if the manufacturers would add arginine and lysine as metabolizable salts, *e.g.,*

acetate, rather than as the hydrochloride salts. FreAmine II substantially incorporates these suggestions and should not produce acidosis.

ESSENTIAL FATTY ACID DEFICIENCY

Another important metabolic complication of TPN is documented in the increasing number of recent reports of chemical and clinical essential fatty acid (EFA) deficiency in patients on fat-free TPN for prolonged periods (6, 39, 47, 58). Figure 12–12 summarizes some of the more important effects that have been documented in EFA-deficient animals and in human subjects as well (38, 39). The top part of the figure shows some of the relatively gross pathophysiologic changes that EFA deficiency may produce:

Fig. 12–12. Effects of EFA deficiency in animals and man (see text). (From Heird, William C., and Winters, Robert W.: Total Parenteral Nutrition: The state of the art, J. Pediatr. 86: 2–16, 1975)

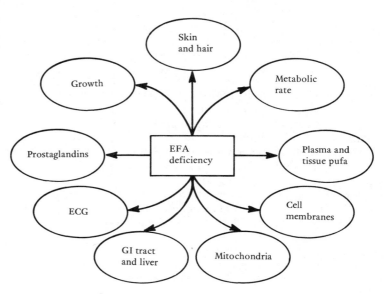

growth failure, the well-known lesions in the skin and hair, and a substantial increase in metabolic rate. Characteristic changes occur in the pattern of polyunsaturated fatty acids (PUFA) of the plasma lipids and in the lipid fractions of various tissues, including the brain. These presumably underlie the pathophysiologic effects. Specifically, EFA are known to be important components of cell membranes, and abnormalities of the red cell membrane have been directly documented in human subjects on fat-free TPN regimens (63). Similar changes may underlie the structural and functional abnormalities noted in EFA-deficient mitochondria, which seem to behave in an overall fashion as though they were oxidatively uncoupled. Membrane changes could also be involved in the abnormal ECG patterns as well as in the abnormalities noted in small bowel and hepatic structure in animals. Finally, there is the tantalizing question of the role of EFA deficiency in altering the synthesis of the prostaglandins.

It seems quite clear that a great deal remains to be learned about the physiology and biochemistry of EFA deficiency in the context of conventional fat-free TPN as well as in assessing the effects of providing what is certainly a vast excess (of the order of ten-fold) of polyunsaturated fatty acids in patients receiving IV fat-emulsions, such as Intralipid.

Recently a report appeared (50) suggesting that EFA deficiency in patients receiving TPN can be corrected by cutaneous application of sunflower-seed oil, a rich source of linoleic acid. These provocative results deserve confirmation.

CATHETER-RELATED COMPLICATIONS

The second main category of complications are those related to the catheter and the delivery system. Of these, sepsis—and particularly the fungemias—is the most important. Thrombosis and dislodgement of the catheter occur occasionally; malposition and perforation are avoidable with good technique.

In approaching the general problem of catheter-related complications, it is of paramount importance to emphasize strict adherence to aseptic principles during catheter insertion, catheter care, and mixing of infusates. These complications can be kept to an acceptable minimum only by following this rule.

Our low record of catheter-related complications in a high-risk population of sick infants has been equalled or bettered in other centers (23). These results certainly do not justify the exten-

sive publicity (20) given to the high sepsis rates reported by Currie and Quie (14).

Some investigators (4) have suggested that amphotericin, pushed periodically through the catheter, may reduce septic complications from Candida. This so-called "amphotericin flush" seems unnecessary; certainly, it is no substitute for rigid adherence to Listerian surgical principles in the insertion and care of the catheter, in the triweekly dressing changes, or in the mixing of the nutritive infusates (24).

TECHNICAL CONSIDERATIONS

TEAM APPROACH TO TOTAL PARENTERAL NUTRITION

As we have documented in this paper, the simplicity of the technique of TPN is deceptive. To carry it out properly requires a well-trained and dedicated team (Fig. 12–13) consisting of pediatricians and pediatric surgeons, working in concert; one of these must be the primary physician. A pharmacist trained in additive techniques is also an absolute necessity as is responsive microbiologic and microchemical laboratory support. In addition, a nurse specifically assigned to the team is essential. If the team can be flexible, complications can be minimized and good results maximized. At Babies Hospital, TPN is administered only in the setting of an intensive care unit. The patient is seen by the primary physician in the morning and again in the late afternoon; at the later time, the clinical and chemical monitoring data for the day are reviewed and the fluid prescription for the next day's infusate is written. The pharmacist mixes

Fig. 12–13. Composition of the IV nutrition team. (Winters RW (ed): The Body Fluids in Pediatrics. Boston, Little, Brown, 1973, p 680)

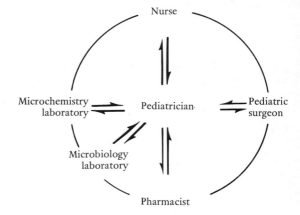

the fluid in the early evening, and it is delivered to the ward to begin in the late evening or on the following morning. This approach minimizes complications and maximizes good results. In our opinion, institutions unable or unwilling to mount such a team should refer pediatric patients to other institutions of proven competence in TPN.

AREAS OF FUTURE RESEARCH

It should be evident from the above discussion that there are a number of major unanswered questions in the field of TPN, especially in pediatrics. First and most important, it is clear we need better amino acid solutions, a problem to be discussed below in more detail. We also need better calorie sources. Fat emulsions hold promise, but there are a number of unanswered questions, particularly for the infant, *e.g.*, the problem of competitive binding of fatty acids and bilirubin (55), the effects of IV fat on pulmonary diffusion capacity (28), and the upper metabolic limit of infants for clearing the infused fat. These and others must be answered. Intravenous maltose (67) and oligosaccharides deserve further evaluation as sources of calories. We also need precise definition of parenteral requirements for essential fatty acids, vitamins, and trace metals and safe ways of delivering them. The vast array of potential endocrine and metabolic responses deserve thorough and systematic exploration. Finally, there is great need for a more accurate definition of indications, nonindications, and contraindications in various categories of patients. Our plea would be that every pediatrician who performs TPN should try not only to improve his patient but also to answer at least one of these questions in a systematic fashion.

"IDEAL" AMINO ACID MIXTURES

The problem of defining the "ideal" amino acid solution for infants, in our opinion, is the most pressing. Obviously, the essential amino acids for infants must be provided, and these should include histidine, cystine, and probably tyrosine (51, 54). Because of poor solubility, the latter two will likely have to be provided as soluble metabolizable derivatives, such as simple peptides.

An essential to nonessential amino acid ratio of about 1:1 is probably desirable since tissue proteins generally have approximately this ratio.

Furthermore, this ratio approximates that recommended for oral amino acid requirements for growing infants. Diversification of the nonessential amino acids is also important. The practice of "topping off" the mixture with excessive glycine produces attendant marked hyperglycinemia (8) and should be avoided. Alanine, proline, serine, and adequate arginine ought to be provided. There seems to be an unwarranted fear of glutamate and aspartate in the crystalline amino acid mixtures, particularly in the light of the fact that these amino acids have been given for years in the hydrolysates. This entire problem should be rationally reviewed.

The arginine requirement and its role in preventing hyperammonemia as well as the acidogenic or alkalogenic potential of the mixture have already been mentioned. On the basis of present information, neither of these problems is insurmountable. Finally, it should be obvious that only the L forms of amino acids should be used. This is not as obvious as one might think. One commercially available mixture provides methionine as a mixture of the D and L forms. It is no surprise, therefore, that the plasma methionine levels of infants receiving this mixture are quite high.

Investigators as well as pharmaceutical companies in this field have an interdependent relationship in the development and clinical testing of new TPN mixtures. In addition, both parties have a further complex relationship and responsibility with the Food and Drug Administration. Since we as investigators speak ultimately for the patient, we must assume independent responsibility in finding ways of accelerating FDA approval of new mixtures without lowering standards.

CONCLUSION

Many significant new medical discoveries seem to follow a sine curve, and TPN is no exception. Initially there was an uncritical acceptance—TPN was the greatest thing that ever happened. But as increasing septic and metabolic complications were reported, the curve went from a peak of uncritical acceptance to a trough of uncritical rejection. In pediatrics at least, we are now slowly rising out of this depression as systematic studies of risks, indications, and nonindications and solid metabolic and clinical results accumulate. We do not know precisely where this curve will come to rest. Our personal opinion is that when the above factors have been accurately and carefully defined, TPN will find a proven and

even life-saving place in the nutritional management of selected infants and children.

REFERENCES

1. Avery GB, Villavicencio O, Lilly JR, Randloph JG: Intractable diarrhea in early infancy. Pediatrics 41:712, 1968

2. Benda GI, Babson SG: Peripheral intravenous alimentation of the small premature infant. J Pediatr 79:494, 1971

3. Boeckman CR, Krill CE Jr: Bacterial and fungal infections complicating parenteral alimentation in infants and children. J Pediatr Surg 5:117, 1970

4. Brennan MF, Goldman MH, O'Connell RC, Knudsin RB, Moore FD: Prolonged parenteral alimentation: Candida growth and the prevention of candidemia by amphoterician instillation. Ann Surg 176:265, 1972

5. Brennan MF, O'Connell RC, Rosol J, Kundsin RB: The growth of Candida albicans in nutritive solutions given parenterally. Arch Surg 103:705, 1971

6. Caldwell MD, Johnson HT, Othersen HB: Essential fatty acid deficiency in the infant: a real danger during prolonged parenteral alimentation. J Pediatr 25:897, 1972

7. Caldwell MD, Meng HC, Jonsson HT: Essential fatty acid deficiency (EFAD)—now a human disease. Fed Proc 33:915, 1974

8. Chan JCM: The influence of synthetic amino acid and casein hydrolysate on the endogenous production and urinary excretion of acid in total intravenous alimentation. Pediatr Res 6:789, 1972

9. Chan JCM, Malekzadeh M, Hurley J: pH and titratable acidity of amino acid mixtures used in hyperalimentation. JAMA 220:1119, 1972

10. Chance GW: Results in very low birth weight infants (< 1300 gm birth weight). In Winters RW, Hasselmeyer EG (eds): Intravenous Nutrition in the High Risk Infant. New York, John Wiley & Sons, 1975, p 39

11. Cohen MI: Changes in hepatic function. In Winters RW, Hasselmeyer EG (eds): Intravenous Nutrition in the High Risk Infant. New York, John Wiley & Sons, 1974, p 293

12. Cohen MI, Daum F, Boley F: Personal communication

13. Coran AG: The long-term total intravenous feeding of infants using peripheral veins. J Pediatr Surg 8:801, 1973

14. Curry CR, Quie PF: Fungal septicemia in patients receiving parenteral hyperalimentation. N Engl J Med 285:1221, 1971

15. Das JB, Filler RM: Amino acid utilization during total parenteral nutrition in the surgical neonate. J Pediatr Surg 8:793, 1973

16. Driscoll JM Jr, Heird WC, Schullinger JN, Gongaware RD, Winters RW: Total intravenous alimentation in low-birth-weight infants: a preliminary report. J Pediatr 81:145, 1972

17. Dudrick SJ, MacFadyen BV Jr, Van Buren CT, Ruberg RL, Maynard AT: Parenteral hyperalimentation: metabolic problems and solutions. Ann Surg 179:259, 1972

18. Dudrick SJ, Vars HM, Rhoades JE: Growth of puppies receiving all nutritional requirements by vein. Fortschritte der parenteralen Ernährung. International Society of Parenteral Nutrition. Munich, Pallas Verlag, 1967, p 2

19. Dudrick SJ, Wilmore DW, Vars HM, Rhoades JE: Long-term total parenteral nutrition with growth, development, and positive nitrogen balance. Surgery 64: 134, 1968

20. Duma RS: Editorial: First of all do no harm. N Engl J Med 185:1258, 1971

21. Fischer JE, Foster GS, Abel RM, Abbott WM, Ryan JA: Hyperalimentation as primary therapy for inflammatory bowel disease. Am J Surg 125:165, 1973

22. Ghadimi H, Abaci F, Kumar S, Rathi M: Biochemical aspects of intravenous alimentation. Pediatrics 48:955, 1971

23. Goldmann DA: Microbiological safety of solutions and delivery to the patient: delivery to the patient. Symposium on Total Parenteral Nutrition, Jan 17–19, 1972. Council on Foods and Nutrition of American Medical Association, p 132

24. Goldman DA, Maki DG: Infection control in total parenteral nutrition. JAMA 223:1360, 1973

25. Goldmann DA, Martin WT, Worthington JW: Growth of bacteria and fungi in total parenteral nutrition solutions. Am J Surg 126:314, 1973

26. Greene HL: Personal communication

27. Greene HL: Trace metals and vitamins. In Winters RW, Hasselmeyer EG (eds): Intravenous Nutrition in the High Risk Infant. New York, John Wiley & Sons, 1975, p 273

28. Greene HL: Effects of intralipid on the lung. In Winters RW, Hasselmeyer EG (eds): Intravenous Nutrition in the High Risk Infant. New York, John Wiley & Sons, 1975, p 369

29. Greene HL, McCabe DR, Stifel FB, Merenstein GB, Herman RH: Protracted diarrhea and malnutrition in infancy: changes in intestinal morphology and disaccharidase activities during treatment with total intravenous nutrition or oral elemental diets. J Pediatr 87: 695, 1975

30. Heird WC, Dell RB, Driscoll JM Jr, Grebin B, Winters RW: Metabolic acidosis resulting from intravenous alimentation mixtures containing synthetic amino acids. N Engl J Med 287:943, 1972

31. Heird WC, Driscoll JM Jr, Schullinger JN, Grebin B, Winters RW: Intravenous alimentation in pediatric patients. J Pediatr 80:351, 1972

32. Heird WC, Driscoll JM Jr, Winters RW: Total parenteral nutrition in very low birth weight infants. In Size at Birth. Ciba Symposium, 1974 Amsterdam, ASP (Elsevier—Excerpta Medica), p 329

33. Heird WC, Nicholson JF: Unpublished data

34. Heird WC, Nicholson JF, Driscoll JM Jr, Schullinger JN, Winters RW: Hyperammonemia resulting from intravenous alimentation using a mixture of synthetic L-amino acids: a preliminary report. J Pediatr 81:162, 1972

35. Heird WC, Winters RW: Unpublished data

36. Heird WC, Winters RW: Total parenteral nutrition: the state of the art. J Pediatr 86:2, 1975

37. Helfrick FW, Abelson NM: Intravenous feeding of a complete diet in a child: report of a case. J Pediatr 25:400, 1944

38. Holman RT: Essential fatty acid deficiency. In Holman RT (ed): Progress in the Chemistry of Fats and

Other Lipids, Vol IX. Oxford, Pergamon Press, 1968, p 275

39. Holman RT: Essential fatty acid deficiency in humans. In Galli C, Jacini G, Pecile A (eds): Dietary Lipids and Postnatal Development. New York, Raven Press, 1973, p 127

40. Hyman CJ, Reiter J, Rodman J, Drash AL: Parenteral and oral alimentation in the treatment of the nonspecific protracted diarrheal syndrome of infancy. J Pediatr 78:17, 1971

41. Johnson JD, Albritton WL, Sunshine P: Hyperammonemia accompanying parenteral nutrition in newborn infants. J Pediatr 81:154, 1972

42. Karpel JT, Peden VH: Copper deficiency with parenteral nutrition. J Pediatr 80:32, 1972

43. Keating JP: Parenteral nutrition in infants with malabsorption. In Winters RW, Hasselmeyer Intravenous EG (eds): Nutrition in the High Risk Infant. New York, John Wiley & Sons, 1975, p 117

44. Keating JP, Ternberg JL: Amino acid-hypertonic glucose treatment for intractable diarrhea in infants. Am J Dis Child 123:336, 1971

45. MacFadyen BV Jr, Dudrick SJ, Ruberg RL: Management of gastrointestinal fistulas with parenteral hyperalimentation. Surgery 74:100, 1973

46. O'Tuama LA, Kirkman HN, James PN: Raised intracranial pressure after hyperalimentation. Lancet 2: 1101, 1973

47. Paulsrud JR, Pensler L, Whitten CF, Stewart S, Holman RT: Essential fatty acid deficiency in infants induced by fat-free intravenous feedings. Am J Clin Nutr 25:897, 1972

48. Peden VH, Sammon TJ, Downey DA: Intravenously induced infantile intoxication with ethanol. J Pediatr 83:490, 1973

49. Pildes RS, Ramamurthy RS, Cordero GV, Wong PWK: Intravenous supplementation of L–amino acids and dextrose in low-birth-weight infants. J Pediatr 82:945, 1973

50. Press M, Hartop PJ, Prottey C: Correction of essential fatty acid deficiency in man by the cutaneous application of sunflower-seed oil. Lancet 1:597, 1974

51. Synderman SE: The protein and amino acid requirements of the premature infant. In Jonxis JHP, Visser HKA, Troelstra JA (eds): Nutricia Symposium, Metabolic Processes in the Foetus and Newborn Infant. Leiden, Stenfert Kroese, 1971, p 128

52. Stegink LD, Baker GL: Infusion of protein hydrolysates in the newborn infant: plasma amino acids concentrations. J Pediatr 78:595, 1971

53. Stegink LD, Shepard JA, Fry LK, Filer LJ Jr: Sugar-amino acid complexes in parenteral alimentation. Pediatr Res 8:386, 1974

54. Sturman JA, Gaul G, Raiha NCR: Absence of cystathionase in human fetal liver: is cystine essential? Science 169:74, 1970

55. Thiessen H, Jacobsen J, Brodersen R: Displacement of albumin-bound bilirubin by fatty acids. Acta Paediatr Scand 61:285, 1972

56. Travis SF, Sugerman HJ, Ruberg RL, Dudrick SJ, Delivoria–Papadopoulos M, Miller LD, Oski FA: Alterations of red-cell glycolytic intermediates and oxygen transport as a consequence of hypophosphatemia in patients receiving intravenous hyperalimentation. N Engl J Med 285:763, 1971

57. Wallace WM: Nitrogen content of the body and its relation to retention and loss of nitrogen. Fed Proc 18:1125, 1959

58. White HB Jr, Turner MD, Turner AC, Miller RC: Blood lipid alterations in infants receiving intravenous fat-free alimentation. J Pediatr 83:305, 1973

59. WHO Expert Committee: Trace elements in human nutrition. (Tech Rep no. 532) WHO, Geneva, 1973

60. Widdowson E: Changes in body proportions and composition during growth. In Davis JA, Dobbing J (eds): Scientific Foundations of Paediatrics. London, Wm Heinemann Medical Books, 1974, p 153

61. Wigger JH: Cholestasis in premature infants receiving total intravenous alimentation. Toronto, Pediatric Pathology Club, 1971

62. Wilmore DW, Dudrick SJ: Growth and development of an infant receiving all nutrients by vein. JAMA 203: 860, 1968

63. Wilmore DW, Moylan JA, Helmkamp GM, Priutt BA Jr: Clinical evaluation of a 10% intravenous fat emulsion for parenteral nutrition in thermally injured patients. Ann Surg 178:503, 1973

64. Winick M: Malnutrition and brain development. J Pediatr 74:667, 1969

65. Winters RW: Maintenance Fluid Therapy In Winters, R.W. (ed.): The Body Fluids in Pediatrics. Boston, Little, Brown, 1973, p 113

66. Christensen, H.H.: Factors that should be considered for the improvement of amino acid solutions for intravenous nutrition. In Winters RW, Hasselmeyer EG (eds): Intravenous Nutrition in the High Risk Infant. New York, John Wiley & Sons, 1975, p 237

67. Young JM, Weser E: The metabolism of circulating maltose in man. J Clin Invest 50:986, 1971

APPLICATION OF
NUTRITION TO
CLINICAL SPECIALTIES

13 Alcoholism

Spencer Shaw, Charles S. Lieber

The relationship between nutrition and alcohol is complex, stemming from many levels of interaction. Alcoholic beverages are themselves nutrients, predominantly providing caloric food value, but in an intricate way. Ethanol affects the level of food intake by displacing required nutrients in the diet, by its effect on appetite, and by its multiple actions on almost every level of the gastrointestinal (GI) tract. The obligatory metabolism of ethanol by the liver alters this organ and profoundly affects the metabolism of many nutrients. Ethanol alters the storage, mobilization, activation, and metabolism of nutrients and has a significant effect on almost every organ. Thus, ethanol alters nutrition extensively at the level of supply and demand.

Alcohol is directly toxic to many bodily tissues. The synergism of malnutrition and alcohol in this regard, especially with respect to alcoholic liver injury, remains to be fully clarified. With the increase in alcoholism the extent of related physical damage in our society has dramatically increased. The resulting pathologic alterations represent an enormous medical burden requiring complex nutritional therapy. Alcoholism remains one of the major causes of nutritional deficiency syndromes in the United States. Nutritional therapy in the alcoholic is often a balance between maximizing recovery and avoiding iatrogenic complications. For example, patients with alcoholic liver disease may develop encephalopathy with levels of dietary protein below the daily requirement; since tolerance in a given patient may change from day to day, daily evaluation is often necessary. The multitude of physiologic systems affected by alcohol makes a simple prescription difficult. Although much information is available about pathophysiology and the problems of iatrogenic complications, few well-controlled clinical studies are available. This chapter is devoted to providing a basis for the diagnosis and management of nutritional problems in the patient with alcoholism.

NUTRITIVE ASPECTS OF ALCOHOL
NUTRITIONAL VALUE OF ALCOHOL

The estimated contribution of alcohol to the average American diet is 4.5% of total calories, based on national consumption figures (135). The share of dietary calories is much greater in the heavy drinker, generally estimated to be more than half their daily caloric intake.

Alcoholic beverages differ little in nutritive value except for carbohydrate content, which varies considerably, trace amounts of B vitamins (especially niacin and thiamin), and iron content (58). The significance of congeners in beverages remains largely unexplored except for occasional instances in which harmful amounts of iron, lead, or cobalt may be present.

Calorimetrically, the combustion of ethanol liberates 7.1 Cal/g, but ethanol does not provide caloric food value equivalent to carbohydrates. Isocaloric substitution of ethanol for carbohydrate as 50% of total calories in a balanced diet results in a decline in body weight (Fig. 13–1). When given as additional calories, ethanol causes less weight gain than calorically equivalent carbohydrate (Figs. 13–2, 13–3). Support for the view that ethanol increases the metabolic rate is provided by the observation that ingestion of ethanol increases oxygen consumption in normal subjects, and this effect is much greater in alcoholics (144). Oxidation without phosphorylation through stimulation of the microsomal ethanol oxidizing system or other catabolic pathways remains a possible explanation for the observed differences. Evidence for interference with digestion or absorption to account for caloric value differences is lacking. In summary, alcoholic beverages provide little nutritive value aside from calories; as such, alco-

202

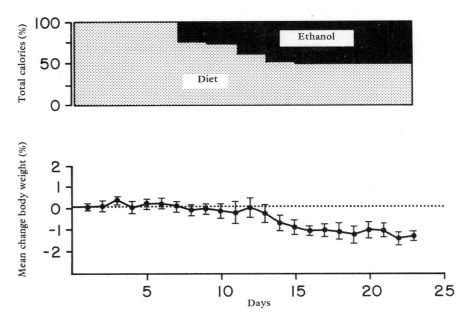

Fig. 13-1. Body weight changes after isocaloric substitution of carbohydrate by ethanol in 11 subjects (means \pm standard errors). *Dotted line,* mean change in weight in control period. (Pirola RC, Lieber CS: Pharmacology 7:185, 1972. Permission from S Karger AG, Basel)

Fig. 13-2. Effect on body weight of adding 2000 Cal/day as ethanol to diet of one subject. *Dotted line,* mean change during control period. (Pirola RC, Lieber CS: Pharmacology 7:185, 1972. Permission from S Karger AG, Basel)

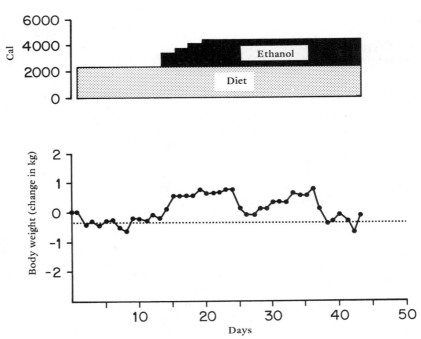

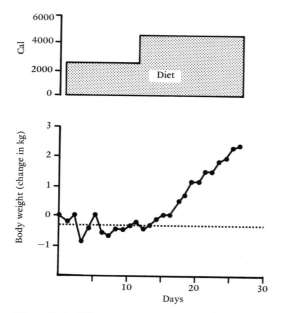

Fig. 13–3. Effect on body weight of adding 2000 Cal/day as chocolate to diet of same subject as in Figure 2. *Dotted line,* mean change during control period. (Pirola RC, Lieber CS: Pharmacology 7:185, 1972. Permission from S Karger AG, Basel)

hol is not as adequate as equivalent carbohydrate.

NUTRITIONAL STATUS OF ALCOHOLICS

The nutritional status of alcoholics is generally considered to be very poor. Iber (49) estimated that 20,000 alcoholics suffer major illnesses due to malnutrition requiring hospitalization each year accounting for 7½ million hospital days. The spread of alcoholism to various socioeconomic classes, and possibly the greater availability and enrichment of foods, have modified the traditional nutritional view of the alcoholic. Neville (103) found no evidence of marked change in nutritional status in the alcoholic and the nonalcoholic matched for socioeconomic and health history. The impact of drinking patterns on dietary intake was studied by Bebb (9), who found little significant impact on nutrition as a result of moderate ethanol consumption. However, heavier consumption of alcohol may lead to a decrease in food intake, and the caloric load of alcohol has been postulated as a cause of appetite suppression (151). Other factors that may limit intake in the alcoholic include gastritis and depressed consciousness. Sample selection may have accounted for stereotyped past impressions; also, there is often a lack of correlation of biochemical, dietary, and clinical data. But although the stereotype of the malnourished alcoholic may be unfounded as it applies to the millions of alcoholics in the United States, alcohol remains one of the few causes of florid nutritional deficiency in our society. The impact of more-subtle nutritional alterations produced by alcohol, as they relate to ethanol-induced and other disease states, remains to be elucidated. Alcohol-related diseases requiring hospital and outpatient dietary therapy have become one of the United States' largest health care problems. The theory of nutritional deficiency as a cause of alcoholism has not proven valid, and nutritional therapy as a cure for alcoholism has not been successful (44).

LIVER INJURY

PATHOGENESIS

RESPECTIVE ROLES OF ALCOHOL AND MALNUTRITION

The role of nutrition in the pathogenesis of alcoholic liver injury (fatty liver, hepatitis, and cirrhosis) is a very significant question in terms of prevention and therapy. Patek *et al.* (110, 111) and Morrison (101) demonstrated the efficacy of a normal protein, normal fat, vitamin-enriched diet in the treatment of cirrhosis as measured by clinical response and longevity. Erenoglu *et al.* (26), extending previous work, treated cirrhotic patients with 198 ml ethanol daily and an adequate diet; they found no adverse effects and a possible benefit from higher dietary protein. Hartroft and Porta (38) conducted parallel studies in experimental animals demonstrating the importance of nutritional factors in pathogenesis and prevention. The role of nutrition in the genesis of alcoholic liver injury has also been implicated by analogy: the fatty liver of kwashiorkor, the frequency of cirrhosis in underdeveloped countries where malnutrition is common, and fatty liver and possible progression to cirrhosis after intestinal bypass (95).

The studies that demonstrated no adverse effects of ethanol in the presence of adequate nutrition generally can be criticized because of the use of dosages of alcohol much below those of heavy drinkers. Experimental models of nutritional injury may not be relevant to humans especially with regard to lipotropes. Epidemiologic studies have not born out a relationship between cirrhosis and malnutrition in underdeveloped countries (21). By contrast, a direct relationship between alcohol consumption and

frequency of cirrhosis has been demonstrated in studies dealing with prohibition in the United States and during the rationing of alcoholic beverages during World War II (59, 145). Lelbach (64) shows a direct relation between the duration and quantity of alcohol consumption and liver injury in chronic alcoholics. Menghini (96) shows that in sufficient quantity ethanol decreases the clearance of hepatic fat. Most significantly, alcohol has been shown to be directly hepatotoxic histologically (light and electron microscope) and biochemically in both alcoholic and nonalcoholic regardless of dietary variation in fat, protein, vitamins, and lipotropes (57, 73, 70, 127, 128). Recently, fatty liver, hepatitis, and cirrhosis have been produced in a primate model given alcohol in the presence of an adequate diet (68, 69, 129).

Ethanol and nutrition may interact with respect to their effects on the liver (56, 67, 75, 77). The role of nutrition in the recovery from alcoholic liver injury has been alluded to before and will be discussed subsequently. Erenoglu (26) pointed out that alcoholics are unable to drink in moderation; therefore, in spite of his study he recommended abstinence. The evidence for the direct toxicity of ethanol makes such advice especially warranted. Alcohol is metabolized predominantly by the liver and profoundly alters the metabolic function of this organ. As such it affects the metabolism of almost every nutrient as will be discussed later. The significance of congeners, moderate dosages of alcohol, genetic factors, and marginal nutritional deficiencies with respect to alcoholic liver injury remains to be clarified. The long pathogenesis, the unreliability of alcoholic populations, the difficulty of nutritional evaluation, and the variability of disease expression make the resolution of these questions difficult.

LIPOTROPES

The question of the significance of and requirements for lipotropes in alcoholism is beset by confusion because of inappropriate extrapolations from animal models. Though in growing rats, deficiencies in dietary protein and lipotropic factors (choline and methionine) can produce fatty liver, primates are far less susceptible than rodents to protein and lipotrope deficiency (46). Clinically, treatment with choline of patients suffering from alcoholic liver injury has been found to be ineffective in the presence of continued alcohol intake (107) and experimentally, massive supplementation with choline

failed to prevent fatty liver produced by alcohol in volunteers (128). This is not surprising since there is no evidence that a diet deficient in choline is deleterious to adult man. Unlike rat liver, human liver contains very little choline oxidase activity, which may explain the species difference with regard to choline deficiency. The phospholipid content of the liver represents another key difference between the ethanol and choline deficiency fatty liver. After the administration of ethanol, hepatic phospholipids increase (70), whereas in the fatty liver produced by choline deficiency, they decrease. Thus, hepatic injury induced by choline deficiency appears to be primarily an experimental disease of rats with little if any relevance to human alcoholic liver injury. Even in the rats massive choline supplementation failed to prevent fully the ethanol induced lesion whether alcohol was administered acutely or chronically (66). Although excess lipotropes are of no proven value in recovery from liver injury, they may prove harmful as an excess nitrogen load (112).

CLINICAL SPECTRUM

Alcohol-related liver injury includes fatty liver, hepatitis, and cirrhosis. These morphologic categories may overlap, as do the clinical findings characteristic of each group. The most severe complications, such as encephalopathy and ascites, occur most frequently in cirrhosis but are well documented in the presence of fatty liver alone. Liver injury, especially cirrhosis, is the most common clinical problem resulting from alcohol that requires nutritional therapy. Each patient must also be evaluated for associated problems.

FATTY LIVER

Fatty liver is a benign reversible condition characterized by deposition of lipid within hepatocytes. It is an early stage of liver injury indicating a severe metabolic derangement that is felt to be a forerunner of more severe parenchymal injury (74). Most persons do not seek or require medical attention. Clinical findings are variable, depending on population selection. Typical findings in a series of 270 hospital patients are shown in Table 13–1.

ALCOHOLIC HEPATITIS

This stage of liver disease is characterized morphologically by extensive necrosis and inflamma-

TABLE 13–1. Fatty Liver—Clinical Aspects*

Finding	Occurence
Hepatomegaly	75%
Tenderness	18%
Jaundice	15%
Spider nevi	8%
Splenomegaly	4%
Biochemical tests (e.g., alkaline phosphatase, SGOT, SGPT, prothrombin time) are usually minimally elevated	

*Leevy CM: Medicine (Baltimore) 41:249, 1962

tion. The onset usually follows a bout of heavy drinking. Patients tend to require medical attention more often than with fatty liver. Typical clinical findings in a series of hospitalized patients are presented in Table 13–2.

CIRRHOSIS

Cirrhosis is characterized morphologically by scarring and regeneration. It represents the most advanced and least reversible stage of liver injury. Patients may have the highest incidence of associated complications, or they may be completely asymptomatic. Stigmata of chronic liver disease, such as spider nevi, liver palms, muscle wasting, testicular atrophy, gynecomastia, parotid enlargement, ascites, and collateral venous abnormalities, are common in this group. Biochemical abnormalities (including hypoalbuminemia, BSP retention, and prolongation of the prothrombin time) are also common. Clinical problems of encephalopathy, sodium and water retention, renal failure, and specific nutritional deficiencies must be carefully evaluated in this group.

TREATMENT

Since the work of Patek (110) little has been added to the dietary armamentarium for specific therapy of alcoholic liver disease. Advances have been made in the understanding and avoidance of iatrogenic problems and the therapy of associated conditions, such as sodium and water retention and encephalopathy. The basic diet of normal protein and fat content with vitamin supplements remains the mainstay of therapy.

PREVENTION

Ethanol consumed in large amounts has been shown to be directly hepatoxic despite adequate nutrition including high-protein, low-fat, vitamin-enriched, and lipotrope-supplemented diets. Problem drinkers are generally felt to be unable to drink in moderation. There is no established prophylactic regime except abstinence. Liver injury is time and dose related. Although a moderate level of consumption may be safe in a number of individuals, a no-effect dose level has not been established clinically.

FATTY LIVER

Therapy for fatty liver includes abstinence and a regular diet. Specific nutritional deficiencies or clinical problems are treated if present.

ALCOHOLIC HEPATITIS

SUPPORTIVE. Patients who are acutely ill with fever, nausea, vomiting, and encephalopathy may require fluid and electrolyte replacement and parenteral alimentation. Generally, dextrose is given intravenously to prevent hypoglycemia and to provide calories. Hypokalemia, if present, is corrected with attention to renal function. The B vitamins are generally given with dextrose to insure against precipitating a deficiency syndrome. The usual regime includes 50–100 mg thiamin and several times the daily requirement for the B vitamins (except folate and B_{12}) along with vitamin C.

CALORIES. Calories must be provided in sufficient quantity to allow regeneration and maximize nitrogen sparing. Estimates for a reasonable minimum are 25 Cal/kg or approximately 1600 Cal/day (28). A level of approximately 2600 Cal, depending on activity and associated problems, is desired. Intravenous glucose may

TABLE 13–2. Alcoholic Hepatitis—Clinical Aspects*

Finding	Occurence
Hepatomegaly	81%
Anorexia	77%
Nausea and vomiting	59%
Abdominal pain	46%
Jaundice	46%
Ascites	35%
Fever	28%
Encephalopathy	11%
Malnutrition (e.g., weight loss, muscle wasting, overt vitamin deficiency)	55%
Leucocytosis	34%
Frequently elevated alkaline phosphatase, moderate elevations of SGPT, SGOT	
Fever	25%

*Lischner MW et al.: Am J Dig Dis 16:481, 1971

be necessary to supplement dietary calories if nausea, vomiting, and anorexia persist for a long period of time. The nitrogen-sparing effect of calories prevents endogenous protein catabolism.

PROTEIN. Protein intake must be adequate to prevent nitrogen wasting short of precipitating hepatic coma. Initially 0.5g/kg/day high-quality protein may be tried (approximately 30–35 g/day) unless encephalopathy is present. This may be increased with increments of 10–15 g/day every 5–7 days until a level of approximately 70 g/day is reached. Benefit from dietary protein above this level is not established, and the risk of encephalopathy is increased. A zero protein regimen, which may be indicated initially when hepatic encephalopathy is present, should not be continued for more than a few days to minimize resultant endogenous protein catabolism. If a minimum of 20–35 g/day is not tolerated, neomycin or lactulose or both should be employed (see section on Hepatic Encephalopathy).

Amino acids differ with respect to ammonia production (131), but other than theoretic justifications for high-quality protein the efficacy of specific protein or amino acid mixtures has not been established. Parenteral amino acids entail the risk of precipitating hepatic coma and remain experimental at this time.

FAT. Low-fat diets, although of theoretical interest, are not advocated because of the lack of palatability of such regimes, especially in an already anorectic patient (19). Resulting inadequate caloric intake promotes protein catabolism. Fat is generally not restricted unless GI intolerance develops because of jaundice, pancreatic insufficiency, or other causes of steatorrhea.

VITAMINS. Specific vitamin deficiencies should be corrected immediately (often with parental administration). Usually, patients are treated with B vitamins. Suggested amounts are approximately five times the daily requirements listed in Appendix Table A-1 although several times these amounts are commonly given without apparent harm or proven efficacy. Generally, fat-soluble vitamins are not deficient. Vitamin K may be administered intramuscularly (10 mg/day for 3 days) if the prothrombin time is prolonged. Failure to correct a prolonged prothrombin time indicates severe hepatocellular injury.

MISCELLANEOUS. Small frequent feedings may be useful in maintaining an adequate diet. Value of lipotrope therapy is not established and may be harmful in excess. Trace elements remain of theoretic interest except in extreme deficiency states.

CIRRHOSIS

Dietary therapy remains similar to that in alcoholic hepatitis except that greater vigilance for and management of associated problems is necessary. Problems of encephalopathy, salt and water retention, renal failure, jaundice, and specific nutritional deficiencies are discussed in subsequent sections.

ALCOHOL AND THE GASTROINTESTINAL TRACT

STOMACH

Ethanol affects the stomach by increasing acid secretion, impairing motility, and altering the mucosa. Secretory changes may be due to direct stimulation, vagal effects, and gastrin release (16). Chronic ethanol administration first increases mean daily acid secretion and then gradually decreases it (17). Increased acid secretion may result in enhanced iron absorption (14). Alcohol delays gastric emptying (7). Ethanol disrupts the mucosal barrier and may act synergystically with other drugs in producing injury this way (20). It is an accepted cause of acute gastritis, but its role in the pathogenesis of duodenal ulcer, gastric ulcer, and chronic gastritis remains controversial (86). Acute gastritis may decrease appetite and produce iron deficiency through hemorrhage.

SMALL INTESTINE

Alcohol has been shown to be directly injurious to the small intestine, in the absence of nutritional deficiency, as measured histologically (by gross, light, and electron microscopic studies) and by measurement of mucosal enzymes (6, 126). Failure to observe gross morphologic lesions in the duodenum in man (114) may have been due to the transient nature of these lesions. Studies with oral and IV alcohol have revealed an inhibition of type I (impeding) waves in the jejunum and an increase in type III (propulsive) waves in the ileum (121). These changes may account for the diarrhea commonly observed in binge drinkers. Malnutrition itself may lead to

intestinal malabsorption (52, 93). Folate depletion, which is common in alcoholics, has been especially implicated (36, 37, 42, 153). Impaired absorption of fat, xylose, folate, thiamin, and B_{12} have been described in chronic alcoholics with recovery after withdrawal of ethanol and institution of a nutritious diet (36, 81, 98, 123, 142, 143). Acute alcohol impairs the absorption of many other nutrients as well (44, 51). Chronic ethanol administration in man has resulted in impaired absorption of B_{12} in well-nourished volunteers in spite of supplementary intrinsic factor and pancreatin (82). The nutritional significance of the many changes observed in small intestinal function due to ethanol remains to be established. The alterations in intestinal flora, bile salts, and pancreatic function that occur in alcoholism may potentiate the direct effects of ethanol.

PANCREAS

GENERAL

Pancreatic function may be altered by acute and chronic ethanol administration. Oral administration of ethanol causes chiefly an increase in pancreatic secretion of water and bicarbonate. This may result from ethanol-stimulated gastric acid secretions reaching the duodenum and causing release of secretin (133, 149). If gastric juice is prevented from reaching the duodenum, IV or intragastric ethanol administration results in a decrease in water, bicarbonate, lipase, and chymotrypsin secretion (90, 102). Although acute ethanol administration causes an increase in tone at the sphincter of Oddi (115), the ethanol-induced decrease in pancreatic secretion persists when the pancreatic duct is directly cannulated in dogs (8). With chronic alcohol administration, the response to acute ethanol is modified. Under these conditions, an increase of protein content of pancreatic juice occurs without a concomitant increase in water or electrolyte content. This may be due to enhanced choycestokinin–pancreozymin release, enhanced gastrin release, or through increased parasympathetic tone (133). The obstruction by the precipitated excess protein within the pancreatic ducts, especially when calcified, has been proposed as a key pathologic alteration in alcohol-induced chronic calcific pancreatitis (132). The role of nutrition in the pathogenesis of this entity is complex; both malnutrition and a high-fat, high-protein diet may be contributory. Pancreatic insufficiency due to alcoholic

pancreatitis may contribute to the steatorrhea and malabsorption observed in cirrhosis.

CLINICAL CONSIDERATIONS

Alcoholics may have acute or chronic pancreatitis. The dietary management of acute pancreatitis includes intravenous fluid and electrolyte administration associated with nasogastric suction. Diet is slowly initiated to minimize pancreatic stimulation. Clear liquids are generally given first. The major therapeutic considerations for chronic pancreatitis are discussed below (see Malabsorption section below). Glucose intolerance with both acute and chronic pancreatitis should be looked for.

BILE SALTS

Intraluminal bile salts are decreased by the acute administration of ethanol into the jejunum or intravenously (90). Experimentally, ethanol feeding prolongs the half excretion time of cholic acid and chenodeoxycholic acid, increases slightly the pool size, and decreases daily excretion (63). In the same model, hepatic esterified cholesterol and serum free and esterified cholesterol are increased. In cirrhotics, bile salt–related steatorrhea may be due to decreased cholic acid synthesis, decreased total bile acid pools (148), diminished concentrations of bile salts in bowel juice, and deconjugation of bile salts in the upper GI tract by altered flora (84). Alcohol-induced ileal dysfunction has been suggested as a cause of decreased cholic acid pools (22). Increased gallstone formation in alcoholic liver disease and increased tone in the sphincter of Oddi with acute ethanol administration have been observed(105, 115).

MALABSORPTION

Malabsorption, especially steatorrhea, may occur with acute or chronic alcoholism. Malabsorption may be caused by the acute effects of alcohol on intestinal mucosa, bile salts, pancreatic function, intestinal motility, and specific intestinal absorptive processes. These acute alterations generally revert to normal with abstinence. Steatorrhea in cirrhosis (fecal fat greater than 30 g/24 hours on 100 g fat/day diet) is infrequent and in one series was present in only 9% (84). Folate deficiency with megaloblastic intestinal changes may cause malabsorption that responds to folic acid administration. Pancreatic insuffi-

ciency due to chronic alcoholic pancreatitis may result in steatorrhea. Replacement therapy with pancreatic extract may result in improvement. Altered bile salts and abnormal GI flora may contribute to fat malabsorption. A low-fat diet and treatment with medium-chain triglycerides may be helpful. Medium-chain triglycerides are triglycerides that contain fatty acids with carbon skeletons of 6–12 atoms. They have several advantages compared with long-chain triglycerides normally found in the diet with respect to digestion and absorption: increased enzyme hydrolysis within the GI tract, greater water solubility and thus decreased bile salt requirement, some direct absorption without hydrolysis, and portal transport as medium-chain fatty acids as opposed to lymphatic transport for long-chain fatty acids (34). However, in the alcoholic, CNS sensitivity and difficulty in handling the appreciable sodium load present in some preparations must be considered (84).

The main dietary consideration with respect to jaundice is the effect impaired bile salt secretion has on fat absorption. Dietary fat may have to be restricted in symptomatic patients. Portal hypertension has been postulated as a possible cause of malabsorption (88). Specific therapeutic interventions, such as neomycin, may themselves cause malabsorption (27). The effect of congeners on the GI tract is unknown. Alcoholics may have other coincidental causes of malabsorption (see Ch. 20).

METABOLIC EFFECTS OF ALCOHOL

PROTEIN

The metabolism of protein in alcoholism is especially relevant from two points of view: the role of protein in recovery from injury and its potential for producing encephalopathy. Nitrogen balance studies have revealed essentially normal protein requirements in cirrhosis (30), and some studies suggest increased nitrogen retention (130). Experimentally, ethanol has a complex effect on nitrogen balance depending on dietary conditions. Given as supplementary calories it may be nitrogen sparing, but given as an isocaloric substitute for carbohydrate it increases urea excretion in the urine (55, 122). Although gross nitrogen balance may be unremarkable, alterations in amino acid transport, hepatic uptake, plasma clearance, and metabolic pathways have been observed. These changes are reviewed by Gabuzda and Orten (30, 108). Protein synthesis may be blocked acutely by ethanol with reversal

of this effect by amino acid administration experimentally (53, 124). The nutritional and pathogenetic significance of these changes remain unknown. The caloric requirement to achieve maximal nitrogen sparing in alcoholism or alcoholic liver disease is not established (28).

CARBOHYDRATES

Glucose homeostasis is impaired in alcoholic liver disease. With severe decompensation and with prolonged fasting following heavy drinking, symptomatic hypoglycemia may occur. Possible mechanisms include autonomic dysfunction, impaired gluconeogenesis, glycogen depletion, and endocrine effects (1). On the other hand, alcoholics with fatty liver or cirrhosis have impaired glucose tolerance, elevated insulin levels, and abnormal responses to glucagon (119). Alcohol has a priming effect on glucose-mediated insulin release (97) and directly causes glucose intolerance itself (113). These and other endocrine effects of ethanol are reviewed by Axelrod (4). The absorption and digestion of carbohydrates in alcoholism are generally regarded as normal (28) although experimentally chronic alcohol administration impairs jejunal mucosal uptake and transport of carbohydrates (83). The effect of alcohol on the intermediary metabolism of carbohydrates has been reviewed by Arky (1).

URIC ACID

The clinical observation of the relationship between alcohol and gout has stimulated investigations of uric acid metabolism in alcoholism. Acute administration of oral or IV alcohol has been shown to produce hyperuricemia in patients without known disorders of renal function or uric acid metabolism (71). Since the elevations of serum uric acid were significantly above normal levels and persisted in some instances for several days, a physician unaware of this effect of ethanol might inadvertently treat hyperuricemia of this secondary type. The mechanism by which hyperuricemia occurs appears most clearly related to decreased urinary excretion of uric acid secondary to elevated serum lactate. This is illustrated in data from one patient in Figure 13–4. Lactate is produced in the liver from pyruvate by the action of nicotinamide adenine dinucleotide (NADH), which is generated in the metabolism of ethanol by alcohol dehydrogenase. Depending on the metabolic state of the liver, this inward NADH generation either en-

hances hepatic lactate production or prevents the liver from completing the Cori cycle and utilizing lactate originating in peripheral tissues, especially lactate produced from muscle activity in alcoholic withdrawal (104). Other possible causes of hyperuricemia include alcohol-induced hyperlipemia and ketogenesis and starvation-induced ketosis. The mechanism by which increased serum lactate decreases urinary uric acid secretion is unclear. It is known that it is not due to a pH effect on the urine (71) and occurs despite probenecid administration (89). Acute gouty attacks have been observed in patients with gout in relation to changes in serum uric acid associated with alcohol administration or starvation (89).

LIPIDS

ALTERED HEPATIC LIPID METABOLISM

The metabolism of ethanol in the liver by alcohol dehydrogenase results in an increase in the ratio of NADH/NAD. In addition, metabolism of alcohol results in mitochondrial damage within the liver. These two alterations may in large part account for the observed increased hepatic ketogenesis, decreased fatty acid oxidation, and increased fatty acid synthesis that are observed effects of alcohol (65). Triglycerides are thus produced in excess and may either accumulate in the liver (and thus create a fatty liver) or be released into the blood as lipoproteins. The effect of ethanol on intestinal production of very low density lipoproteins (100) may also be contributory, although this mechanism appears to play only an insignificant role (5). Ethanol increases hepatic cholestergenesis and decreases bile salt secretion (63); it may thus elevate the serum cholesterol.

HYPERLIPIDEMIAS

The administration of ethanol to man consistently results in hyperlipidemia; the response is modified by associated dietary and pathologic conditions. The major elevation occurs in the serum triglycerides, and this response may be greatly enhanced by a fat-containing meal (152). When alcohol is administered for several weeks at a dosage of 300 g/day the initial several-fold increase in triglycerides gradually returns to

Fig. 13–4. Blood and urine studies with oral ethanol. (Lieber CS, Jones DP, Losousky MS *et al.* J Clin Invest 41:1863, 1962)

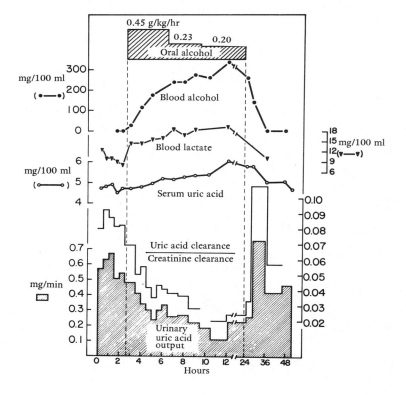

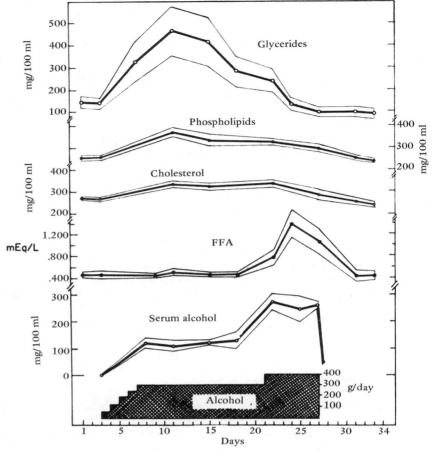

Fig. 13–5. Effect of prolonged alcohol intake on serum lipids in 7 chronic alcoholic individuals. (Lieber CS, Jones DP, Mendelson J *et al.* Trans Assoc Am Physicians 76:289, 1963)

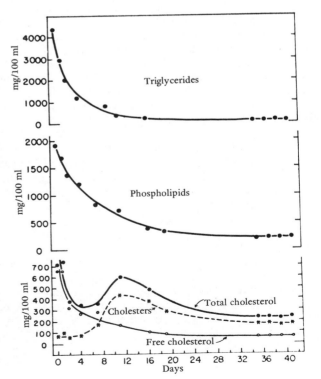

Fig. 13–6. Changes in plasma lipid fractions of a patient during recovery from alcoholic hyperlipemia. (Losowsky MS, Jones DP, Davidson CS *et al.* Am J Med 35:794, 1963)

normal (72) (Fig. 13–5). One explanation for this observation is that continued ethanol administration results in hepatic impairment. Hyperlipemia is usually absent with severe liver injury (e.g., cirrhosis), and hypolipemia is usually present (35, 92).

CHARACTERISTICS. A characteristic feature of alcohol-induced hyperlipemia is that all of the lipoprotein fractions are increased, although to a variable degree. Alcoholic hyperlipemia is usually classified as type IV according to the International Classification of Hyperlipidemias and Hyperlipoproteinemias; the increased particulate fat behaves predominantly as very low density lipoproteins. In an additional 8%, chylomicrons or chylomicron-like particles can be increased even in the fasting state (13). These patients are classified as type V. Furthermore, 6% of alcoholics have hypercholesterolemia due to hyper-β-lipoproteinemia (type II). Alcohol-induced hyperlipemia may change rapidly with clearance of triglycerides being most rapid and cholesterol and phospholipids slower; thus it is difficult to classify alcoholic hyperlipemia to a single group (Fig. 13–6).

MARKED HYPERLIPEMIA. Some patients may demonstrate a marked sensitivity to the hyperlipidemic effects of alcohol. This may be observed in patients with type IV familial or carbohydrate-induced hyperlipidemia (31), patients with defective removal of serum lipids (decreased post heparin lipoprotein lipase (87)), diabetics, and in patients with pancreatitis. The latter condition has been associated with an inhibitor of post heparin lipoprotein lipase (54). Significant elevations in serum lipids with moderate dosages of alcohol, as occur in daily use, have been observed in patients with type IV hyperlipidemias (31).

CLINICAL SIGNIFICANCE. Elevations of serum cholesterol and triglycerides have been directly attributed to alcohol in epidemiologic studies (109). Moderate ethanol dosage may increase serum lipids in patients with type IV hyperlipidemias. The significance of such elevations as possible risk factors in coronary artery disease remains to be clarified. Ethanol may unmask a subclinical hyperlipidemia and should be excluded as a cause or contributor to an observed hyperlipidemia. Marked hyperlipidemias may be accompanied by hemolysis (154), which is transient and clears at the same time as the hyperlipidemia. The constellation of hyperlipemia alcoholic fatty liver, jaundice, and hemolysis constitutes what has been termed Zieve's syndrome. Abdominal pain may occur with hyperlipidemia; differentiation of a primary effect from associated pancreatic, hepatic, or GI pathology may be exceedingly difficult. Dietary lipids may alter intrahepatic fat accumulation (67); however, a low-fat diet may not be practical in a clinical setting because its lack of palatability may result in inadequate caloric intake (19).

WATER-SOLUBLE VITAMINS

GENERAL

Vitamin metabolism demonstrates the many levels at which alcohol may impair nutrition. Abnormalities of ingestion and absorption have been discussed. Decreased hepatic stores of folate, nicotinic acid, B_6, and B_{12} have been described (62), and decreased hepatic affinity, as measured by displacement studies, has been demonstrated for folate (15). Impaired utilization of folic acid, thiamin, and B_6 has been reported (18, 25, 45, 139, 146). Pyridoxine is normally converted by the liver to pyridoxal phosphate, which is the active coenzyme form of the vitamin. Evidence has been presented that decreased activation of pyridoxine is due to displacement of pyridoxal phosphate from hepatic cytosol binding proteins by acetaldehyde produced by ethanol metabolism. This facilitates hydrolysis by pyridoxal phosphatase and results in a net decrease in activation (146). Circulating levels of vitamins reveal abnormalities in 40% of chronic malnourished alcoholics with folate and pyridoxine being most often depressed (61). Clinical correlations are greatest with megaloblastic and sideroblastic anemias and with neurologic syndromes related to thiamin deficiency. Although vitamins are clearly important in such cellular processes as DNA synthesis, the significance of mild deficiencies and massive vitamin therapy in altering recovery from liver injury remains unclear. Vitamin deficiencies have been proposed as causes of alcoholism and vitamin therapy as a cure: both, unsuccessfully. Since trace elements such as Zn and Mg play a role in the function of some water-soluble vitamins, alcohol-related deficiencies of these elements may further exacerbate borderline insufficiencies. Increased requirements for vitamins have not been established in alcoholism, except perhaps for folate.

BERIBERI HEART DISEASE

Specific nutritional heart disease in the alcoholic occurs in the form of beriberi heart disease. Symptoms classically include those of congestive heart failure accompanied by a hyperkinetic circulation (12). Low urinary thiamin and red blood cell transketolase confirm the clinical diagnosis. Other symptoms of thiamin deficiency may be present (see Ch. 7). Therapy with 5–10 mg thiamin three times daily is probably adequate although larger doses may be given. The B vitamins are usually given as a group along with an adequate diet to the alcoholic whether or not a specific diagnosis is made.

ASSOCIATED NEUROLOGIC DISEASES

Alcoholics remain one of the few patient groups in the United States to present clinically with nutritional deficiency syndromes, and the most dramatic of these syndromes involve the neurologic manifestations. The interaction of diet and alcohol in producing these deficiencies remains to be explored. Hypovitaminoses of the B vitamins remain the most well delineated of the deficiency states. Administration of carbohydrates such as IV glucose to a marginally vitamin-depleted alcoholic may precipitate a florid syndrome if supplementary vitamins are not provided. Although dramatically responsive to replacement therapy and pathogenetically fascinating, the deficiency syndromes are relatively rare, constituting only 1%–3% of alcohol-related neurologic admissions (23).

POLYNEUROPATHY. This syndrome is characterized by generalized symmetric involvement of peripheral nerves which spreads proximally. First symptoms include discomfort and fatigue in the anterior tibial muscles and paresthesias in the feet. This is usually followed by weakness in the toes and ankles, diminished ankle jerks, and decreased fine movements and vibratory sense. Finally, glove and stocking hypesthesia, hypalgesia, and severe weakness may result (47). Thiamin deficiency has been most strongly implicated in etiology, but other B vitamins have also been implicated. Pyridoxine, B_{12}, nicotinic acid, and riboflavin deficiency can be associated with peripheral neuropathy, and pantothenic acid deficiency may produce symptoms of peripheral nerve disease (47). Although the optimal therapeutic dosage has not been established, one recommendation is 10 times the normal daily requirement for 1 week and 5 times the daily requirement thereafter (47). The daily requirement of vitamins is presented in Appendix Table A-1.

WERNICKE–KORSAKOFF SYNDROME. Wernicke–Korsakoff syndrome is the most common CNS-related neurologic problem in the alcoholic. Characteristic findings include weakness of eye movements, ataxia of gait, and mental disturbance. Horizontal nystagmus, paralysis of external recti, paralysis of conjugate gaze, and ataxia of gait and stance may be observed (see Ch. 24). The psychosis is characterized initially by apathy and global confusion followed by memory deficits and confabulation. Cognitive function defects are also present (147). The Wernicke syndrome responds dramatically to thiamin administration. Although 2–3 mg may be sufficient, large doses (approximately 50 mg) are usually given. Rapidity of response depends on the conversion of thiamin to its active form in the liver. Patients with cirrhosis or significant hepatic disease may therefore have a delayed response (18).

NUTRITIONAL AMBLYOPIA. This disorder is characterized by central or centrocecal scotomata. Evidence is highly suggestive of a B vitamin deficiency, but a specific etiology is not established (147). Oral or parenteral B vitamins, abstinence from alcohol, and regular diet are indicated.

PELLAGRA. Neurologic symptoms in pellagra include psychosis, dementia, posterior and lateral column disease, and neuropathy. Skin changes and diarrhea accompany the neurologic findings. Pellagra is rare now, probably because of enrichment of bread. Nicotinic acid is specific, but B vitamins are generally administered as a group.

MISCELLANEOUS. Nutritional factors are generally felt to be unrelated to states of acute alcohol intoxication and withdrawal. The role of nutritional factors in central pontine myelenosis, Marchiafava Bignami syndrome, alcoholic cerebellar degeneration, and other rarer syndromes remains speculative. The response of cerebellar degeneration to massive thiamin administration has been reported (33). Vitamin B administration in any alcohol-related neurologic state seems prudent.

HEMATOLOGIC CONSIDERATIONS

GENERAL. Hematologic abnormalities are among the most clearly delineated pathologic alterations resulting from an interaction of alcohol and diet. The frequency and nature of observed abnormalities are highly dependent on the population selected. Small amounts of pyridoxine and folic acid in the diet may prevent megaloblastic and sideroblastic anemias. In one series of 65 patients admitted for alcoholism and not selected for hematologic problems, 40% had megaloblastic erythropoesis secondary to folate deficiency, 30% had sideroblasts in the erythroid marrow, and a small percentage had iron deficiency anemia. A total of 75% had either anemia or bone marrow abnormalities. In middle and upper class alcoholics folate levels are generally normal (24). Small amounts of folic acid (250 μg IM and 150 μg by mouth) prevent megaloblastic changes, and 1 mg pyridoxine/day prevents sideroblastic changes during ethanol administration. However, pharmacologic doses of folic acid do not prevent vacuolization of erythroid elements in patients fed alcohol with an adequate diet (79). Thus, alcohol has a direct toxic effect on the bone marrow. The timing of a bone marrow examination is important in establishing a diagnosis since improvement of bone marrow abnormalities may be rapid.

ANEMIAS. Anemia, low serum folate, and megaloblastic marrow with or without sideroblasts may be used to diagnose folate and pyridoxine-related hematologic abnormalities. Therapy includes abstinence and vitamin supplementation. Smaller doses may be adequate, but many times the daily requirement of folate and pyridoxine are generally administered. Although B_{12} absorption may be affected by acute alcohol administration (80), B_{12} deficiency anemia is not very common among alcoholics and will not be discussed here.

PLATELETS AND WHITE BLOOD CELLS. Thrombocytopenia and granulocytopenia have been described in alcoholics with varying frequency depending on patient selection. Causes of thrombocytopenia in the alcoholic include a direct effect of acute alcohol ingestion, folate deficiency, hypersplenism, infection, and disseminated intravascular coagulation. Ethanol causes a depression in circulating platelets despite the concomitant administration of a nutritious diet and vitamin supplements including

large doses of folic acid (79). In addition, chronic alcohol administration along with an adequate diet and folate supplements impairs platelet function (40). Granulocytopenia has been reported in alcoholics associated with alcohol intoxication in the absence of folate deficiency, hypersplenism, or infection and with rapid recovery after alcohol withdrawal (78). However, in patients given chronic alcohol administration in the absence of nutritional deficiency, granulocytopenia does not develop (79). Acute alcohol administration impairs leukocyte mobilization (11).

FAT-SOLUBLE VITAMINS

Fat-soluble vitamins are usually not deficient in the alcoholic, but marginal nutrition, severe steatorrhea, altered GI flora, and hepatocellular injury may act synergically to cause deficiencies. The major vitamins to be considered are vitamin K and vitamin D.

VITAMIN K

Vitamin K deficiency may result from dietary deficiency, malabsorption, or decreased synthesis by intestinal flora. Failure of clotting factor synthesis due to alcoholic liver injury may result in prolongation of the prothrombin time. Although deficiency-related abnormalities are uncommon in the alcoholic, vitamin K may correct a prolonged prothrombin time resulting from interaction of the above factors (120). Generally, vitamin K is given intramuscularly (10 mg/day) for 3 consecutive days. Failure to correct the prothrombin time indicates severe parenchymal injury.

VITAMIN D

Vitamin D metabolism in conjunction with calcium metabolism is of special interest in the alcoholic. Alcoholic populations have been observed to have decreased bone density (134), increased susceptibility to fractures (106), and increased frequency of osteonecrosis (138) compared with other populations. Vitamin D metabolism may be affected at many levels in the alcoholic. In addition to decreased dietary intake, decreased absorption may occur due to pancreatic insufficiency and bile salt abnormalities. Similarly, calcium absorption may be impaired. Patients with alcoholic cirrhosis have been found to have decreased clearance of plasma

cholecalciferol and decreased urinary glucuronide conjugates (3). The liver is the first site of hydroxylation of vitamin D_3 (cholecalciferol) which is necessary for its activation; thus, hepatocellular injury may result in deficient activation of dietary vitamin D and resistance to parenteral vitamin D therapy (2). Other postulated mechanism of possible alterations in vitamin D metabolism include increased degradation of activated vitamin D by the cytochrome P 450 system (which may be stimulated by alcohol) and decreased storage depots of fat and muscle in debilitated patients with chronic liver disease (2). The increased urinary losses of calcium induced by alcohol, ethanol-induced hypercorticism, and parathyroid stimulation secondary to calcium-binding proteins in cirrhosis are other mechanisms by which bone metabolism may be altered. The extent to which altered vitamin D metabolism specifically contributes to clinical musculoskeletal diseases in alcoholic populations and the site or sites of the abnormalities involved remains to be clarified.

IRON

IRON AND THE LIVER

The question of the metabolism of iron in the alcoholic is particularly relevant because of the association of hepatic injury with excess iron. Acute alcohol administration may increase iron absorption possibly through stimulation of gastric acid secretion, resulting in increased solubility of ferric ion in the small intestine (14). Alcoholics may receive excessive dietary iron from the beverages they drink, such as certain wines, or through inadvertent treatment with iron-containing vitamin preparations. In addition, anemias unrelated to iron deficiency may be incorrectly treated with iron. Pancreatic insufficiency, folate deficiency, portosystemic shunting, and cirrhosis may increase iron absorption (32). The potential for excess iron to produce tissue injury and the finding of increased iron stores in a significant percentage of patients with alcoholic cirrhosis makes this an important area for future investigation.

IRON DECIENCY ANEMIA

Iron deficiency anemia is uncommon in alcoholics unless factors such as GI bleeding from varices, ulcers and gastritis, repeated phlebotomies, dietary extremes, and chronic infections are present (25). However, as discussed above, alcoholics have a propensity to develop increased iron stores that may potentiate tissue injury in the liver and other organs. Transfusions and iron therapy should be used with caution and only to the point of correcting deficiencies. Routine iron supplements are not indicated.

MINERALS AND ELECTROLYTES

PATHOGENESIS

Alcoholics with chronic liver disease may have disorders of water and electrolyte metabolism. Sodium and water retention may be the most common abnormalities that present clinically as ascites, edema, and pleural effusions. Postulated mechanisms include portal hypertension, hypoalbumenemia, altered renal hemodynamics, endocrine abnormalities, and changes in lymph flow (140). Low body potassium stores may result acutely from vomiting and diarrhea or as a result of hyperaldosteronism, muscle wasting, renal tubular acidosis, and diuretic therapy. Depletion of potassium may be especially significant because of consequent increased renal vein ammonia and worsening of hepatic coma (137). Alcoholics may have decreased plasma levels of zinc, calcium, and magnesium resulting from ethanol-induced renal losses and decreased dietary intake (91, 94, 117). The similarity of the neuromuscular excitability of hypomagnesemia and acute alcoholic withdrawal has aroused considerable interest; however, as with other trace elements, clinical correlations have not been significant, and florid deficiency states remain exceedingly rare (41). Abnormalities of other trace elements, e.g., manganese and copper, in chronic liver disease have been discussed by Prasad (117). They remain chiefly of investigational interest at present.

ASCITES AND EDEMA

The alterations leading to salt and water retention in liver disease have been discussed. Increasing abdominal girth, weight gain, a dragging sensation in the abdomen, shortness of breath, and swelling of the ankles may be typical presenting symptoms. The presence of shifting dullness, pitting edema, effusions on chest x ray, and the finding of fluid on paracentesis confirm the diagnosis. Dietary regime is adjusted according to the severity of salt and water retention. Severe symptoms and refractory cases may require rigid sodium restriction (250 mg/day).

Restriction at this level is advocated even if mild hyponatremia is present, *i.e.,* if the serum sodium level is 125–130 mEq/liter (29). Symptomatic hyponatremia with serum sodium below this level may require intervention with hypertonic saline and rigid water restriction. Fluid restriction of 1500–2000 ml/day (including all liquids taken with medications) is recommended, especially if hyponatremia is present. With less-severe retention, sodium restriction of 500–2000 mg/day may be tried. Daily weights and serum electrolytes are necessary to guide therapy. Summerskill (140) recommends not exceeding a weight loss of 5 kg/week by dietary or diuretic therapy. In refractory cases, especially with symptoms such as severe dyspnea, paracentesis may be necessary. Two liters per 24 hours has been recommended as a safe rate of removal; more-vigorous therapy may cause acute depletion of albumin salt and water and result in cardiovascular collapse. Replacement therapy with IV albumin and saline may be required during such therapy. Diuretics may be used with attention to the possible development of hypokalemia and hyponatremia. Following restriction, diuresis and improved handling of dietary sodium may result. A ceiling of 2500 mg of Na in the diet has been suggested (28).

MISCELLANEOUS
RENAL FUNCTION

Patients with chronic liver disease may have difficulty in handling fluid loads. A daily total volume of 1500–2000 cc is recommended with observation for adequate urine output, weight gain, and hyponatremia. Oliguria, azotemia, and elevated creatinine may indicate deteriorating renal function. Patients with alcoholic liver disease are especially susceptible to acute tubular necrosis through such complications as variceal bleeding. Spontaneous renal failure or the so-called hepatorenal syndrome may also occur. Rising serum urea due to renal failure may present a special problem in the patient with alcoholic liver disease. Urea is secreted into the GI tract and hydrolyzed to ammonia; thus, it acts like any nitrogenous compound. With increasing levels of urea the resultant ammonia becomes a significant problem and may worsen or precipitate hepatic coma. In this case antibiotics (see below, Hepatic Encephalopathy) may be given to prevent conversion of urea to ammonia, and enemas may decrease the total load of nitrogenous compounds absorbed. Administration of limited amounts of mixtures of essential amino acids to patients with diminished protein tolerance because of renal failure has been advocated (140). The dietary management of acute renal failure is otherwise the same as in other etiologies and will be discussed elsewhere.

HEPATIC ENCEPHALOPATHY

Hepatic encephalopathy represents a neuropsychiatric syndrome secondary to liver disease with a wide clinical spectrum ranging from personality changes to deep coma. Confusion, apathy, irritability, and other personality changes may represent the earliest findings. Constructive apraxia, hypothermia, asterixis, and EEG changes may provide clinical evidence. The stages of hepatic coma and concomitant clinical findings are presented in Table 13–3. The etiology and pathogenesis of encephalopathy is complex. The major dietary considerations for the clinician include exogenous and endogenous nitrogen loads and potassium and acid–base balance (136).

Acutely, protein restriction, correction of hypokalemia and alkalosis, and prevention of endogenous protein catabolism are the major interventions. Hypokalemia increases renal vein ammonia via a direct effect of increased renal

TABLE 13—3. Stages in the Onset and Development of Hepatic Coma

Grade or Stage	Mental state	Tremor	EEG changes
Prodrome or Stage 1 (often diagnosed in restrospect)	Euphoria, occasionally depression; fluctuant, mild confusion; slowness of mentation and affect; untidy; slurred speech; disorder in sleep rhythm	Slight	Usually absent
Impending coma or Stage 2	Accentuation of Stage 1; drowsiness; inappropriate behavior; able to maintain sphincter control	Present (easily elicited)	Abnormal generalized slowing
Stupor or Stage 3	Sleeps most of the time, but is rousable; speech is incoherent; confusion is marked	Usually present (if patient can cooperate)	Always abnormal
Deep coma or Stage 4	May or may not respond to noxious stimuli	Usually absent	Always abnormal

ammonia production and possibly through the increased back diffusion of ammonia from alkaline urine (137). Parenteral or oral potassium may be given in a dosage of approximately 100–200 mEq/day until deficits are corrected, provided normal renal function is present. Nitrogen sparing should be maintained through IV glucose if caloric intake is not adequate. Since 5% dextrose contains only 200 Cal/liter, it may be necessary to administer hypertonic glucose through a large bore catheter, especially if fluid restriction is a consideration. Dietary protein may be eliminated completely at first but must be resumed after a few days to prevent endogenous protein catabolism. Neomycin, lactulose, enemas and divided small feedings may enhance protein tolerance. Neomycin inhibits the action of GI flora that convert protein and urea to ammonia and other potentially toxic nitrogenous products within the gut. Decreased renal function, as with the hepatorenal syndrome, may result in ototoxic and nephrotoxic blood levels of neomycin; dosage must be markedly lowered or the drug discontinued under such circumstances. Lactulose may act though acidification of bowel contents with resultant ammonia trapping (as ammonium) or through increased motility, but the precise mechanism has not been clarified (48). Constipation and hypercatabolic states, such as with infections, may diminish tolerance and worsen encephalopathy by creating an endogenous nitrogen load. Protein tolerance may vary, and so daily evaluation is required. A composite sheet with the patient's daily signature, the construction of figures such as a clock face and a record of performance of serial sevens and degree of asterixis may provide a useful way of following patient status. Medications that cause CNS depression and diuretics that may cause hypokalemia must be used with caution. Patients with portacaval shunts may be especially sensitive to dietary protein.

ALCOHOLIC CARDIOMYOPATHY

The chronic alcoholic may present with symptoms of congestive heart failure and clinical features of cardiomyopathy. Essentially, by process of exclusion, a diagnosis of alcoholic cardiomyopathy may be made. In contrast to beriberi heart disease, low cardiac output and peripheral vasoconstriction are usually present. Characteristic electron microscopic changes in the myocardium have been described (43) which have been compared to those produced experimentally in hypomagnesemic rats (141). This has heightened interest in a possible nutritional etiology. However, chronic alcoholics without evidence of heart disease or nutritional deficiency have been found to have abnormal left ventricular function when stressed (118). Acute and chronic alcohol alters myocardial metabolism (150). Acute alcohol in adequate doses (blood level of 150 mg%) causes a rise in end diastolic pressure and decreases stroke output. Chronic alcohol administration in the face of a normal diet caused similar changes that persisted for several weeks after withdrawal (118). Cardiomyopathy in the alcoholic, even with an equivocal diagnosis of alcoholic cardiomyopathy, is prudently treated with complete abstinence from alcohol and vitamin supplements. Diet therapy chiefly entails sodium restriction and is similar to other cardiomyopathies in this regard (see Ch. 15).

INTERACTIONS WITH DRUGS AND DISEASE STATES

Alcoholism may interact with other clinical states and complicate therapy. Pregnancy and birth control pills may potentiate folate deficiency in the alcoholic (44). The hyperuricemia induced by alcohol must be considered in the patient with gout. Alcohol-induced glucose intolerance, hypoglycemia, ketosis, and acidosis may make the management of the diabetic more difficult. Ethanol may interact with many drugs and so alter the management of many disease states. Ethanol can be oxidized in the liver by a microsomal system that shares many properties with the microsomal drug detoxifying systems (50). Competition for this system may explain the inhibition of drug metabolism by ethanol (125). Chronic alcoholism causes increased clearance of drugs which may be explained by stimulation of this system (99). Clinically, alcoholics may have delayed clearance of many drugs if they drink at the same time. This is especially significant for hypnotic–sedative drugs whose depressant effects may be potentiated by alcohol. On the other hand, chronic alcoholism may result in increased metabolism of many drugs, which may thus require dosage adjustment. Drugs such as barbiturates, anesthetics, phenothiazines, coumadin, oral hypoglycemics, and many others may be affected. Finally, through a similar mechanism of accelerated metabolism, the alcoholic may be more susceptible to toxic agents, such as CCl_4 (39) and isoniazid.

The preceding sections outline the many lev-

els at which alcohol and nutrition interact; the focus is at the level of the individual. Alcoholism has an enormous impact on society in terms of resources and productivity. Alcohol-related hospitalizations, medical treatment, absenteeism, welfare, crime, and accidents represent a tremendous burden in this regard. In a world with increasingly precarious food and energy resources these social effects of alcohol manifest themselves in the field of nutrition in its broadest sense.

REFERENCES

1. Arky RA: The effect of alcohol on carbohydrate metabolism: carbohydrate metabolism in alcoholics. In Kissin B, Begleiter H (eds): Vol I. Biology of Alcoholism, New York, Plenum Press, 1974, p 197

2. Avioli LV, Haddad JG: Vitamin D: current concepts. Metabolism 22:507, 1973

3. Avioli LV, Lee SW, McDonald JE et al.: Metabolism of $D_3^{-3}H$ in human subjects: distribution in blood, bile, feces and urine. J Clin Invest 46:983, 1967

4. Axelrod DR: Metabolic and endocrine aberrations in alcoholism. In Kissin B, Begleiter H (eds): Biology of Alcoholism, Vol III. New York, Plenum Press, 1974, p 291

5. Baraona E, Pirola RC, Lieber CS: The pathogenesis of postprandial hyperlipemia in rats fed ethanol containing diets. J Clin Invest 52:296, 1973

6. Baraona E, Pirola RC, Lieber CS: Small intestinal damage and changes in cell populations produced by ethanol ingestion in the rat. Gastroenterology 66:226, 1974

7. Barboriak JJ, Meade RC: Effect of alcohol on gastric emptying in man. Am J Clin Nutr 23:1151, 1970

8. Bayer M, Rudick J, Lieber CS et al.: Inhibitory effect of ethanol on canine exocrine pancreatic secretion. Gastroenterology 63:619, 1972

9. Bebb HT, Houser HB, Witschi JC et al.: Calorie and nutrient contribution of alcoholic beverages to the usual diets of 155 adults. Am J Clin Nutr 24:1042, 1971

10. Best CH, Hartroft WS, Lucas CC et al.: Liver damage produced by feeding alcohol or sugar and its prevention by choline. Br Med J II:1001, 1949

11. Brayton RG, Stokes PE, Schwartz MS et al.: Effect of alcohol and various diseases on leukocyte mobilization, phagocytosis and intracellular bacterial killing. N Engl J Med 282:123, 1970

12. Burch GE, Giles TD: Alcoholic cardiomyopathy. In Kissin B, Begleiter H (eds): Biology of Alcoholism, Vol III. New York, Plenum Press, 1974, p 435

13. Chait A, February W, Mancini M et al.: Clinical and metabolic study of alcoholic hyperlipidaemia. Lancet ii:62, 1972

14. Charlton RW, Jacobs P, Seftel H et al.: Effect of alcohol on iron absorption. Br Med J 5422:1427, 1964

15. Cherrick GR, Baker H, Frank O et al.: Observations on hepatic avidity for folate in Laennec's cirrhosis. J Lab Clin Med 66:446, 1965

16. Chey WY: Alcohol and gastric mucosa. Digestion 7: 239, 1972

17. Chey WY, Kosay S, Lorber SH: Effects of chronic administration of ethanol on gastric secretion of acid in dogs. Digest Dis 17:153, 1972

18. Cole M, Turner A, Frank O et al.: Extraocular palsy and thiamine therapy in Wernicke's encephalopathy. Am J Clin Nutr 22:44, 1969

19. Crews RH, Faloon WW: The fallacy of a low-fat diet in liver disease. JAMA 181:754, 1962

20. Davenport HW: Gastric mucosal hemorrhage in dogs —effects of acid, aspirin, and alcohol. Gastroenterology 56:439, 1969

21. Davidson CS: Nutrition, geography and liver diseases. Am J Clin Nutr 23:427, 1970

22. Desai HG, Merchant PC, Zaveri MP et al.: Mechanism of steatorrhea in cirrhosis of liver: correlation between cholate concentration and BSP retention and vitamin B_1 excretion. Ind J Med Res 60:1464, 1972

23. Dreyfus PM: Diseases of the nervous system in chronic alcoholics. In Kissin B, Begleiter H (eds): Biology of Alcoholism, Vol III. New York, Plenum Press, 1974, p 265

24. Eichner ER, Buchanan B, Smith JW et al.: Variations in the hematologic and medical status of alcoholics. Am J Med Sci 263:35, 1972

25. Eichner ER, Hillman RS: The evolution of anemia in alcoholic patients. Am J Med 50:218, 1971

26. Erenoglu E, Edreira JG, Patek AJ Jr: Observations on patients with Laennec's cirrhosis receiving alcohol while on controlled diets. Ann Intern Med 60:814, 1964

27. Faloon WW: Metabolic effects of nonabsorbable antibacterial agents. Am J Clin Nutr 23:645, 1970

28. Gabuzda GJ: Nutrition and liver disease. Med Clin North Am 54:1455, 1970

29. Gabuzda GJ: Cirrhosis, ascites and edema: clinical course related to management. Gastroenterology 58: 546, 1970

30. Gabuzda GJ, Shear L: Metabolism of dietary protein in hepatic cirrhosis. Am J Clin Nutr 23:479, 1970

31. Ginsberg H, Olefsky J, Farquhar JW et al.: Moderate ethanol ingestion and plasma triglyceride levels: a study in normal and hypertriglyceridemic persons. Ann Intern Med 80:143, 1974

32. Grace ND, Powell LW: Iron storage disorders of the liver. Gastroenterology 67:1257, 1974

33. Graham JR, Woodhouse P, Read FH: Massive thiamine dosage in an alcoholic with cerebellar cortical degeneration. Lancet ii:107, 1971

34. Greenberger NJ, Skillman TG: Medium chain triglycerides, physiologic considerations and clinical implications. N Engl J Med 280:1045, 1969

35. Guisard D, Gonand JP, Laurent J et al.: Etude de l'epuration plasmatique des lipides chez les cirrhotiques. Nutr Metab 13:222, 1971

36. Halsted CH, Robles EA, Mezey E: Decreased jejunal uptake of labeled folic acid (^3H-PGA) in alcoholic patients: role of alcohol and nutrition. N Engl J Med 285:701, 1971

37. Halsted CH, Robles EA, Mezey E: Intestinal malabsorption in folate-deficient alcoholics. Gastroenterology 64:526, 1973

38. Hartroft SW, Porta EA: Alcohol, diet and experimental hepatic injury. Can J Physiol Pharmacal 46:463, 1968

39. Hasumura Y, Teschke R, Lieber CS: Increased carbon tetrachloride hepatotoxicity and its mechanism, after chronic ethanol consumption. Gastroenterology 66:415, 1974

40. Haut MJ, Cowan DH: The effect of ethanol on hemostatic properties of human blood platelets. Am J Med 56:22, 1974

41. Heaton FW, Pyrah LN, Beresford CC et al.: Hypomagnesaemia in chronic alcoholism. Lancet ii:802, 1962

42. Hermos JA, Adamas WH, Liu YK et al.: Mucosa of the small intestine in folate-deficient alcoholics. Ann Intern Med 76:957, 1972

43. Hibbs RG, Ferrans VJ, Black WC et al.: Alcoholic cardiomyopathy: an electron microscopic study. Am Heart J 69:766, 1965

44. Hillman RW: Alcoholism and malnutrition. In Kissin B, Begleiter H (eds): Biology of Alcoholism, Vol III. New York, Plenum Press, 1974, p 513

45. Hines, JD: Altered phosphorylation of vitamin B_6 in alcoholic patients induced by oral administration of alcohol. J Lab Clin Med 74:883, 1969

46. Hoffbauer FW, Zaki FG: Choline deficiency in baboon and rat compared. Arch Pathol 79:364, 1965

47. Hornabrook RW: Alcoholic neuropathy. Am J Clin Nutr 9:398, 1961

48. Hubel KA: Lactulose works, but why? Comment. Gastroenterology 65:349, 1973

49. Iber FL: In alcoholism, the liver sets the pace. Nutr Today 6:2, 1971

50. Ishii H, Joly J–G, Lieber CS: Effect of ethanol on the amount and enzyme activities of hepatic rough and smooth microsomal membranes. Biochim Biophys Acta 291:411, 1973

51. Israel Y, Valenzuela JE, Salazar I et al.: Alcohol and amino acid transport in the human small intestine. J Nutr 98:222, 1969

52. James WPT: Intestinal absorption in protein-calorie malnutrition. Lancet i:333, 1968

53. Jeejeebhoy KN, Phillips MJ, Bruce–Robertson A et al.: The acute effect of ethanol on albumin, fibrinogen and transferrin synthesis in the rat. Biochem J 126:1111, 1972

54. Kessler JI, Kniffen JC, Janowitz HD: Lipoprotein lipase inhibition in the hyperlipemia of acute alcoholic pancreatitis. N Engl J Med 269:943, 1963

55. Klatskin G: The effect of ethyl alcohol on nitrogen excretion in the rat (abstr). Yale J Biol Med 34:124, 1961

56. Klatskin G, Krehl WA, Conn HO: The effect of alcohol on the choline requirement I: changes in the rat's liver following prolonged ingestion of alcohol. J Exp Med 100:605, 1954

57. Lane BP, Lieber CS: Ultrastructural alterations in human hepatocytes following ingestion of ethanol with adequate diets. Am J Pathol 49:593, 1966

58. Leake CD, Silverman M: The chemistry of alcoholic beverages. In Kissin B, Begleiter H(eds): Biology of Alcoholism, Vol I. New York, Plenum Press, 1974, p 575

59. Lederman S: Alcool, Alcoolisme, Alcoolisation. Paris, France: Institut national d'etudes demographiques, Travaux et Documents, Cahier No. 41, Presses Universitaires de France, 1964

60. Leevy CM: Fatty liver: a study of 270 patients with biopsy proven fatty liver and a review of the literature. Medicine (Baltimore) 41:249 1962

61. Leevy CM, Baker, H, tenHove W et al.: B-complex vitamins in liver disease of the alcoholic. Am J Clin Nutr 16:339, 1965

62. Leevy CM, Thompson A, Baker H: Vitamins and liver injury. Am J Clin Nutr 23:493, 1970

63. Lefevre AF, DeCarli LM, Lieber CS: Effect of ethanol on cholesterol and bile acid metabolism. J Lipid Res 13:48, 1972

64. Lelbach WK: Leberschaden bei chronischem Alkoholismus. Acta Hepatosplenol (Stuttg) 14:9, 1967

65. Lieber CS: Effects of ethanol upon lipid metabolism. Lipids 9:103, 1974

66. Lieber CS, DeCarli LM: Study of agents for the prevention of the fatty liver produced by prolonged alcohol intake. Gastroenterology 50:316, 1966

67. Lieber CS, DeCarli LM: Quantitative relationship between the amount of dietary fat and the severity of the alcoholic fatty liver. Am J Clin Nutr 23:474, 1970

68. Lieber CS, DeCarli LM: An experimental model of alcohol feeding and liver injury in the baboon. J Med Primatology 3:153, 1974

69. Lieber CS, DeCarli LM, Rubin E: Sequential production of fatty liver, hepatitis and cirrhosis in sub-human primates fed ethanol with adequate diets. Proc Natl Acad Sci USA 72:437, 1975

70. Lieber CS, Jones DP, DeCarli LM: Effects of prolonged ethanol intake: production of fatty liver despite adequate diets. J Clin Invest 44:1009, 1965

71. Lieber CS, Jones DP, Losowsky MS et al.: Interrelation of uric acid and ethanol metabolism in man. J Clin Invest 41:1863, 1962

72. Lieber CS, Jones DP, Mendelson J et al.: Fatty liver, hyperlipemia and hyperuricemia produced by prolonged alcohol consumption, despite adequate dietary intake. Trans Assoc Am Physicians 76:289, 1963

73. Lieber CS, Rubin E: Alcoholic fatty liver in man on a high protein and low fat diet. Am J Med 44:200, 1968

74. Lieber CS, Rubin E: Alcoholic fatty liver. N Engl J Med 280:705, 1969

75. Lieber CS, Spritz N: Effects of prolonged ethanol intake in man: role of dietary, adipose, and endogenously synthesized fatty acids in the pathogenesis of the alcoholic fatty liver. J Clin Invest 45:1400, 1966

76. Lieber CS, Spritz N, DeCarli LM: Role of dietary, adipose and endogenously synthesized fatty acids in the pathogenesis of the alcoholic fatty liver. J Clin Invest 45:51, 1966

77. Lieber CS, Spritz N, DeCarli LM: Fatty liver produced by dietary deficiencies: its pathogenesis and potentiation by ethanol. J Lipid Res 10:283, 1969

78. Lindenbaum J, Hargrove RL: Thrombocytopenia in alcoholic. Ann Intern Med 68:526, 1968

79. Lindenbaum J, Lieber CS: Hematologic effects of alcohol in man in absence of nutritional deficiency. N Engl J Med 281:333, 1969

80. Lindenbaum J, Lieber CS: Alcohol-induced malabsorption of vitamin B_{12} in man. Nature 224:806, 1969

81. Lindenbaum J, Lieber CS: Effects of ethanol on the blood, bone marrow, and small intestine of man. In Roach MK, McIsaac WM, Creaven PJ (eds): Biological Aspects of Alcohol, Vol III. Austin, University of Texas Press, 1971, p 27

82. Lindenbaum J, Lieber CS: Effects of chronic ethanol administration on intestinal absorption in man in the absence of nutritional deficiency. Ann NY Acad Sci, 1975 (In press)

83. Lindenbaum J, Shea N, Saha JR, Lieber CS: Alcohol-induced impairment of carbohydrate (CHO) absorption. Clin Res 20:459, 1972

84. Linscheer WG: Malabsorption in cirrhosis. Am J Clin Nutr 23:488, 1970

85. Lischner MW, Alexander JF, Galambos JT: Natural history of alcoholic hepatitis. I. The acute disease. Am J Dig Dis 16:481, 1971

86. Lorber SH, Dinoso VP, Chey WY: Diseases of the gastrointestinal tract. In Kissin B, Begleiter H (eds): Biology of Alcoholism, Vol III. New York, Plenum Press, 1974, p 339

87. Losowsky MS, Jones DP, Davidson CS et al.: Studies of alcoholic hyperlipemia and its mechanism. Am J Med 35:794, 1963

88. Losowsky MS, Walker BE: Liver disease and malabsorption. Gastroenterology 56:589, 1969

89. MacLachlan MJ, Rodnan GP: Effects of fast food and alcohol on serum uric acid and acute attacks of gout. Am J Med 42:38, 1967

90. Marin GA, Ward NL, Fischer R: Effect of ethanol on pancreatic and biliary secretions in humans. Dig Dis 18:825, 1973

91. Markkanen T, Nanto V: The effect of ethanol infusion on the calcium-phosphorus balance in man. Experientia 22:753, 1966

92. Marzo A, Ghirardi P, Sardini P et al.: Serum lipids and total fatty acids in chronic alcoholic liver disease at different stages of cell damage. Klin Wochenschr 48:949, 1970

93. Mayoral LG, Tripahty K, Garcia FT et al.: Malabsorption in the tropics: a second look. I. The role of protein malnutrition. Am J Clin Nutr 20:866, 1967

94. McCollister RJ, Flink EB, Lewis MD: Urinary excretion of magnesium in man following the ingestion of ethanol. Am J Clin Nutr 12:415, 1963

95. McGill DB, Humpherys SR, Baggenstoss AH et al.: Cirrhosis and death after jejunoileal shunt. Gastroenterology 63:872, 1972

96. Menghini G: L'Aspect morpho-bioptique du foie de l'acoolique (non cirrhotique) et son évolution. Bull Schweiz Akad Med Wiss 16:36, 1960

97. Metz R, Berger S, Mako M: Potentiation of the plasma insulin response to glucose by prior administration of alcohol. Diabetes 8:517, 1969

98. Mezey E, Jow E, Slavin RE et al.: Pancreatic function and intestinal absorption in chronic alcoholism. Gastroenterology 59:657, 1970

99. Misra PS, Lefevre A, Ishii H et al.: Increase of ethanol, meprobamate and pentobarbital metabolism after chronic ethanol administration in man and in rats. Am J Med 51:346, 1971

100. Mistilis SP, Ockner RK: Effects of ethanol on endogenous lipid and lipoprotein metabolism in small intestine. J Lab Clin Med 80:34, 1972

101. Morrison LM: The response of cirrhosis of the liver to an intensive combined therapy. Ann Intern Med 24:465, 1946

102. Mott C, Sarles H, Tiscornia O et al.: Inhibitory action of alcohol on human exocrine pancreatic secretion. Dig Dis 17:902, 1972

103. Neville JN, Eagles JA, Samson G et al.: Nutritional status of alcoholics. Am J Clin Nutr 21:1329, 1968

104. Newcombe DS: Ethanol metabolism and uric acid. Metabolism 21:1193, 1972

105. Nicholas P, Rinaudo PA, Conn HO: Increased incidence of cholelithiasis in Laennec's cirrhosis. Gastroenterology 63:112, 1972

106. Nilsson BE: Conditions contributing to fracture of the femoral neck. Acta Chir Scand 136:383, 1970

107. Olson RE: Nutrition and alcoholism. In Wohl MG, Goodhart RS (eds): Modern Nutrition in Health and Disease. Philadelphia, Lea & Febiger, 1964

108. Orten JM, Sardesai VM: Protein nucleotide and porphyrin metabolism. In Kissin B, Begleiter H (eds): Biology of Alcoholism, Vol I. New York, Plenum Press, 1974, p 229

109. Ostrander ID, Lamphiear MA, Blcok WD et al.: Relationship of serum lipid concentrations to alocohol consumption. Arch Intern Med 134:451, 1974

110. Patek AJ, Post J: Treatment of cirrhosis of the liver by a nutritious diet and supplements rich in vitamin B complex. J Clin Invest 20:481, 1941

111. Patek AJ, Post J, Ratnoff OD et al.: Dietary treatment of cirrhosis of the liver. JAMA 138:543, 1948

112. Phear EA, Ruebner B, Sherlock SA et al.: Methionine toxicity in liver disease and its prevention by chlortetracycline. Clin Sci 15:93, 1956

113. Phillips GB, Safrit HF: Alcoholic diabetes: induction of glucose intolerance with alcohol. JAMA 217:1513, 1971

114. Pirola RC, Bolin TD, Davis AE: Does alcohol cause duodenitis? Am J Dig Dis 14:239, 1969

115. Pirola RC, Davis AE: Effects of ethyl alcohol on sphincteric resistance at the choledocho–duodenal junction in man. Gut 9:557, 1968

116. Pirola RC, Lieber CS: The energy cost of the metabolism of drugs including alcohol. Pharmacology 7:185, 1972

117. Prasad AS, Oberleas D, Rajasekaran G: Essential micronutrient elements: biochemistry and changes in liver disorders. Am J Clin Nutr 23:581, 1970

118. Regan TJ, Levinson GE, Oldewurtel HA et al.: Ventricular function in noncardiacs with alcoholic fatty liver: role of ethanol in the production of cardiomyopathy. J Clin Invest 48:397, 1969

119. Rehfeld JF, Juhl E, Hilden M: Carbohydrate metabolism in alcohol-induced fatty liver (evidence for an abnormal insulin response to glucagon in alcoholic liver disease). Gastroenterology 64:445, 1973

120. Roberts HR, Cederbaum AI: The liver and blood coagulation: physiology and pathology. Gastroenterology 63:297, 1972

121. Robles EA, Mezey E, Halsted CH et al.: Effect of ethanol on motility of the small intestine. Johns Hopkins Med J 135:17, 1974

122. Rodrigo C, Antezana C, Baraona E: Fat and nitrogen balances in rats with alcohol-induced fatty liver. J Nutr 101:1307, 1971

123. Roggin GM, Iber FL, Kater RMH et al.: Malabsorption in the chronic alcoholic. Johns Hopkins Med J 125:321, 1969

124. Rothschild M, Oratz M, Mongelli J et al.: Alcohol-induced depression of albumin synthesis: reversal by tryptophan. J Clin Invest 50:1812, 1971

125. Rubin E, Gang H, Misra PS et al.: Inhibition of drug metabolism by acute ethanol intoxication. A hepatic microsomal mechanism. Am J Med 49:801, 1970

126. Rubin E, Rybak BJ, Lindenbaum J, et al.: Ultrastructural changes in the small intestine induced by ethanol. Gastroenterology 63:801, 1972

127. Rubin E, Lieber CS: Experimental alcoholic hepatic injury in man: ultrastructural changes. Fed Proc 26:1458, 1967

128. Rubin E, Lieber CS: Alcohol-induced hepatic injury in non-alcoholic volunteers. N Engl J Med 278:869, 1968

129. Rubin E, Lieber CS: Fatty liver, alcoholic hepatitis and cirrhosis produced by alcohol in primates. N Engl J Med 290:128, 1974

130. Rudman D, Akgun S, Galambos JT et al.: Observations on the nitrogen metabolism of patients with portal cirrhosis. Am J Clin Nutr 23:1203, 1970

131. Rudman D, Galambos JT, Smith RB et al.: Comparison of the effect of various amino acids upon the blood ammonia concentration of patients with liver disease. Am J Clin Nutr 26:916, 1973

132. Sarles H: Chronic calcifying pancreatitis-chronic alcoholic pancreatitis. Gastroenterology 66:604, 1974

133. Sarles H, Tiscornia O: Ethanol and chronic calcifying pancreatitis. Med Clin North Am 58:1333, 1974

134. Saville PD: Changes in bone mass with age and alcoholism. J Bone Joint Surg [AM] 47:492, 1965

135. Scheig R: Effects of ethanol on the liver. Am J Clin Nutr 23:467, 1970

136. Schenker S, Breen KJ, Hoyumpa AM: Hepatic encephalopathy: current status. Gastroenterology 66:121, 1974

137. Shear L, Gabuzda GJ: Potassium deficiency and endogenous ammonium overload from kidney. Am J Clin Nutr 23:614, 1970

138. Solomon L: Drug induced arthropathy and necrosis on the femoral head. J Bone Joint Surg [Br] 55:246, 1973

139. Sullivan LW, Herbert V: Suppression of hematopoiesis by ethanol. J Clin Invest 43:2048, 1964

140. Summerskill WHJ, Barnardo DE, Baldus WP: Disorders of water and electrolyte metabolism in liver disease. Am J Clin Nutr 23:499, 1970

141. Susin M, Herdson PB: Fine structural changes in rat myocardium induced by thyroxine and by magnesium deficiency. Arch Pathol 83:86, 1967

142. Thomson AD, Baker H, Leevy CM: Patterns of ^{35}S-thiamine hydrochloride absorption in the malnourished alcoholic patient. J Lab Clin Med 76:34, 1970

143. Tomasulo PA, Kater RMH, Iber FL: Impairment of thiamine absorption in alcoholism. Am J Clin Nutr 21:1340, 1968

144. Tremolieres J, Carre L: Etudes sur les modalites d'oxydation de l'alcool chez l'homme normal et alcoolique. Rev Alcoolisme 7:202, 1961

145. US Bureau of the Census: Vital statistics rates in the United States, 1900–1940. Washington DC, Government Printing Office, 1943

146. Veitch RL, Lumeng L, Li TK: The effect of ethanol and acetaldehyde on vitamin B_6 metabolism in liver. Gastroenterology 66:868, 1974

147. Victor M, Adams RD: Neurological and hepatic complications of alcoholism. Etiology of the alcoholic neurologic diseases with special reference to the role of nutrition. Am J Clin Nutr 9:379, 1960

148. Vlahcevic SR, Juttijudata P, Bell CC et al.: Bile salt metabolism in patients with cirrhosis. II. Cholic and chenodeoxycholic acid metabolism. Gastroenterology 62:1174, 1972

149. Walton B, Schapiro H, Woodward ER: The effect of alcohol on pancreatic secretion. Surg Forum 11:365, 1960

150. Wendt VE, Wu C, Ajluni R et al.: The acute and chronic effects of alcohol on the myocardium (abstr). Ann Intern Med 62:1068, 1965

151. Westerfeld WW, Schulman MP: Metabolism and caloric value of alcohol. JAMA 170:197, 1959

152. Wilson DA, Schreibman PH, Brewster AC et al.: The enhancement of alimentary lipemia by ethanol in man. J Lab Clin Med 75:264, 1970

153. Winawer SJ, Sullivan LW, Herbert V et al.: The jejunal mucosa in patients with nutritional folate deficiency and megaloblastic anemia. N Engl J Med 272:892, 1965

154. Zieve L: Jaundice, hyperlipemia and hemolytic anemia: a heretofore unrecognized syndrome associated with alcoholic fatty liver and cirrhosis. Ann Intern Med 48:471–496, 1958

14 Burns

Elinor Pearson, Harry S. Soroff

In 1975 the loss of life in fires was 11,800 and approximately 300,000 people sustained serious burn injuries. This results in many millions of days of hospitalization, loss of productivity, and permanent disability and disfigurement in many instances. The patient who is burned and survives endures many days of unrelenting pain. He must learn to deal with possible disfigurement and loss of function of his injured limbs, fears of rejection by family and friends, concern over gainful employment in the future, and the financial burden of hospitalization.

The immediate treatment of the burned patient consists of the life-saving measures of correcting fluid imbalance and caring for the wound and any associated injuries, but the ultimate survival of a severely burned patient is profoundly influenced by the adequacy of nutritional replacement and support. A rapid and severe weight loss is an ominous portent to the patient's survival. In addition, wound healing proceeds more satisfactorily and the hazards of infection are lessened when nutritional status is maintained.

Patients with small burns who were in good health at the time of injury seldom develop nutritional problems. They will soon be able to eat increasing amounts of food and can voluntarily achieve an adequate intake. The same is true in cases where the burn is predominantly partial thickness. In these patients a weight loss roughly proportional to the extent of the burn can be expected, but this is generally not of clinical importance. They can be encouraged to eat a high-protein, high-calorie diet, and the wounds heal well. But, patients who were in a poor state of nutrition at the time of injury and those with extensive and deep burns provide a nutritional challenge that requires the most intensive nutritional support. Before discussing what comprises a desirable intake and methods of achieving it, it is well to consider why serious depletion of body reserves can occur and why nutrition

becomes such a vital factor in the successful treatment of these patients.

It is the purpose of this chapter to set forth a summary of the quantitative aspects of the nutritional losses of the burned patient and to suggest various approaches to replacing them.

METABOLIC RESPONSE

The ultimate survival of the severely burned patient depends largely on his ability to respond successfully to the stress of infection, although the response of other organ systems also plays a vital role. The hypermetabolism associated with a severe burn is very complex in its nature, and its precise genesis is not clearly understood. Suffice it to say, the metabolic response results in a weight loss that is closely correlated with the extent and depth of the burn. In large full-thickness burns, the weight loss during the recovery period is often 30%–40% of the preburn weight. One of the important tasks of the clinical team is to provide a calorie and protein intake that, at the very least, minimizes the weight loss and, at best, fully meets energy, protein, and other nutritional requirements of the patient. It should be pointed out, however, that Wilmore et al. (25) have found that even if patients are offered an adequate amount of calories and proteins, many may still succumb to sepsis and other complications of the burn injury.

PROTEIN METABOLISM

One classic approach to the study of metabolism is the measurement of nitrogen balance, which is a quantitative estimate of the net gains and losses of various nutrients. The nitrogen balance should ideally be determined from chemical analyses of both the total intake and output. For practical purposes, intake can be calculated from food tables. Fecal and exudate losses can be estimated using information derived from previ-

ous studies. If a normal individual consumes 12 g nitrogen in 75 g protein, he will excrete a similar amount, thus maintaining nitrogen equilibrium. Following injury, however, several factors occur which lead to a depletion of nitrogen (protein). Nitrogen intake decreases and output increases, resulting in a negative nitrogen balance. The period of negative balance is called the catabolic phase. Its duration and the total loss of nitrogen are related to the severity of the trauma (Table 14–1). In the burned patient the severity of the catabolic phase as well as its duration are related to the quantity of tissue destroyed and the degree of sepsis.

The daily changes in the nitrogen balance of a well-nourished, 32-year-old male with a 70% second degree burn (Fig. 14–1) indicate the relative contributions to the total output of three sources of loss: 1) urine, 2) feces, and 3) exudate. Most of the nitrogen lost from the body is excreted via the urinary tract, and in this patient

TABLE 14–1. Effect of Trauma on Nitrogen Loss

Trauma	Negative nitrogen balance		Duration of catabolic phase (days)
	(total g)	(average g/day)	
Appendectomy	26	2.2	12
Osteotomy	32	2.3	14
Fracture of humerus	98	3.4	29
Fracture of femur	124	3.0	41
Burns	200	4.5	44

it increased approximately three-fold, to as much as 30 g/day. In the absence of diarrhea, the fecal nitrogen remains essentially normal at about 1.5–2.0 g/day. A variable yet substantial source of nitrogen loss in the burned patient is that in the exudate. In this patient it was as high as 8.4 g/day. Since it is known that 1 g nitrogen is equivalent to 30 g lean tissue, such a loss is equivalent to a loss of 252 g lean tissue/day (N × 30). During the 32 days required for the

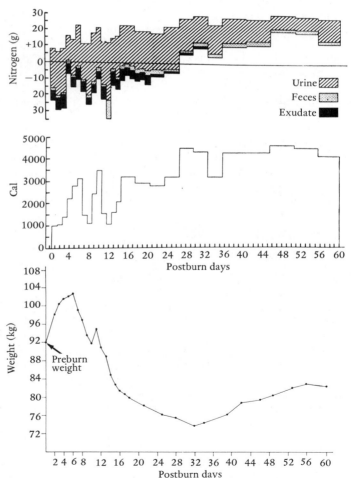

Fig. 14–1. Nitrogen balance *(top)*, caloric intake *(center)*, and weight curve *(bottom)* of a patient with 70% partial thickness burn. Intake is charted from zero line upward, and output, from top of intake line downward. Shaded areas below zero line indicate negative balance; clear areas above zero line indicate positive balance. Contributions of urine, feces, and exudate to output are shown by different shading. (Artz CP, Moncrief JA: The Treatment of Burns, 2nd ed. Philadelphia, WB Saunders, 1969, p 294)

TABLE 14–2. Estimated Body Fat Changes

Phase	Duration (days)	Nitrogen balance (g)	Weight change Theoretic* (kg)	Actual (kg)	Discrepancy (kg)
Catabolic	28	−390	−11.7	−15.8	−4.1
Anabolic	33	+415	+12.4	+ 6.6	−5.8

*Theoretic weight change (kg), based on lean tissue changes, equals $\dfrac{N\ (g)\ \times\ 30}{1000}$

wounds to heal, the total loss of nitrogen in the exudate was 137 g, equivalent to 4.1 kg lean tissue. The exudate losses accounted for 35% of the total loss during this period. It is of interest to note that during the acute postburn phase, when the nitrogen balance was strongly negative, the patient's superficial wounds healed well.

Although this patient had a large burn, his appetite and motivation were good, and by the second postburn week his protein intake was more than 140 g/day. However, this was not enough to offset the large nitrogen losses. When the catabolic phase ended and the anabolic phase began, nitrogen was stored in as dramatic a fashion as it had been lost, and during the portion of the anabolic phase studied, the losses were more than replaced.

The magnitude of the urinary nitrogen output in this patient is a reflection of the size of his lean body mass. At the time of injury he weighed 90 kg. In contrast, patients who are in a poor nutritional state at the time of their injury do not have as brisk or as large a urinary nitrogen loss, since their body cell mass is smaller. This is also true of women who normally have more body fat and thus relatively less lean tissue than men.

ENERGY METABOLISM

ENERGY REQUIREMENTS

It is obvious to those who have treated burn patients, that in addition to protein, many constituents of the body are lost during the catabolic phase. The fat stores provide a major source of energy during convalescence. It is possible to estimate the changes in body fat from nitrogen balance data by determining the discrepancy between the actual measured change in body weight and the change in the weight of lean tissue calculated from the nitrogen balances (N × 30). This is illustrated by the nitrogen data presented above.

During the catabolic phase of 28 days, this patient (see Fig. 14–1) lost 15.8 kg; the nitrogen loss of 390 g represents a loss of 11.7 kg lean tissue with an estimated fat loss of 4.1 kg (Table 14–2). Although he gained weight at the rate of 0.2 kg/day during the anabolic phase, at postburn day 60, when the study ended he was still 7 kg below his preinjury weight. The storage of 415 g nitrogen was sufficient to form 12.4 kg lean tissue. However, since his weight gain was only 6.6 kg, apparently an additional 5.8 kg fat had been lost while lean tissue was being replaced. This suggests that, although his intake was large enough to cause an increase in weight, his consumption of 4000–6000 Cal/day was not sufficient in itself to supply the energy required to replace the lean tissue. An additional 52,200 Cal (5.8 kg fat × 9000 Cal/kg fat) or 1,580 Cal/day were mobilized to support the reparative processes.

The enormous amounts of energy lost by the severely burned patient are in part secondary to the evaporative water loss from the burned surface. The average daily loss of water through normal skin is 960 g/m². When skin is destroyed by burning or abrasion, the daily evaporative loss can increase to 3000 g or more/m². Harrison *et al.* (13) estimated the average water loss of patients with burns of various extents (Table 14–3). The evaporation of 1 g water at the normal skin temperature of 32°C requires 0.579 Cal. Thus, the calorie cost of the insensible water loss from intact skin is about 600 Cal/m²/day, about 21% of the daily heat loss (Table 14–4). If a patient has a large burn, as many as 6200 Cal/day may be required to support the water loss from the burned area. These exaggerated energy expenditures increase with the size of the burn and may be 30%–300% above basal levels, remaining above normal until grafting is completed.

PROTEIN INTAKE

From these brief considerations of a representative nitrogen balance and the calorie expenditure associated with insensible weight loss, it becomes apparent why every effort must be

made to provide burned patients with an adequate intake as soon as possible. It is also obvious why the general recommendation is for a high-calorie, high-protein diet for adults, although suggestions vary widely concerning specific quantities.

Few attempts have been made to quantitate the nutritional requirements for burned patients since a homogeneous population of patients with burns of a similar extent and large enough to produce a significant catabolic response must be available. Soroff, Pearson, and Artz (21) were able to study such a group at the United States Army Institute of Surgical Research at Fort Sam Houston. This study gave an estimate of the nitrogen (protein) requirements for burned patients during four phases of the postburn course. Of 11 patients studied, all were young men with burns of a similar size: at least 15% of the body surface had burns of third degree severity, and the burn index was in the range of 20–35, calculated from the third degree area plus one-quarter of the second degree area (3). The four 10-day study periods began on postburn days 7, 30, 60, and 90. Earlier experience had shown that on postburn day 7 the patients are still in the acute catabolic phase and the constant intake necessary for successful balance studies can generally be begun at this time. The anabolic phase of the postburn course usually begins about the 30th day in patients with a burn of the magnitude selected for this study. By the 60th postburn day all areas of full thickness injury had been resurfaced with split thickness grafts. The period beginning on the 90th postburn day represents the phase of late convalescence in patients who still show marked depletion of nitrogen and fat. Normal young men were also studied for a 10-day period as a control.

The intake used in this study provided 3500 Cal/m² body surface and seven levels of nitrogen ranging from nearly 0 to 30 g/m². The sequence in which the levels of nitrogen were given was randomized throughout each of the 10-day study periods. From balance data the regression lines of nitrogen balance on intake were calculated for each period. The point at

TABLE 14–3. Average Water Loss in Burns

Area of burn (%)	Daily water loss* (g water/kg/% burn)
8–40	3.1
40–91	2.0

*Evaporative loss is 60% of total; respiratory loss is 10.8% of total

TABLE 14–4. Partition of Daily Heat Loss in Normal Man

	Cal	Total loss (%)
Heat of inspired air and work	128	4
Evaporation of water	558	21
Conduction and convection	833	31
Radiation	1181	44
Total	2700	100

which the regression line crossed the zero line was considered as the intake necessary for equilibrium, that is, where intake and output are equal (Fig. 14–2).

These requirements for equilibrium have been converted from g nitrogen/m² surface area to g protein/kg body weight and are summarized in Table 14–5. During the strongly catabolic phase requirements were 3.2–3.9 g/kg, which amount is similar to the upper limit of intake of 2–4 g/kg recommended by Blocker (4). In the early anabolic phase following postburn day 30, 2.0–2.5 g protein/kg were necessary for equilibrium in patients with moderate burns. By the time the patients had their wounds grafted and had become ambulatory, the protein requirement for equilibrium had decreased to 0.5–1.0 g/kg. This was similar to the requirement of 0.7–1.05 g/kg determined for control subjects who were not burned. These estimates are in good agreement with recommendations of the National Academy of Science—National Research Council (NAS-NRC) of 0.8 g/kg for the "reference," normal 70 kg man (11).

In considering the results of this study as a guide for planning protein intake for other burn patients, it is important to remember that these patients were young men on active military duty and were thus presumably in good physical condition with a large, intact body cell mass at the time of injury. Although these estimated protein requirements do not represent the specific amounts needed by burned patients, they do serve as an indication of the relative magnitude of the quantities needed. That is, the requirements are greater during the strongly catabolic phase than they are during late convalescence. It is also important to be aware of the fact that if the patient is malnourished with body stores depleted when he is injured, he should be given more protein than is required for equilibrium. The therapeutic goal is to promote protein storage in order to replace the losses that occurred before a satisfactory intake could be instituted.

The total daily calorie intake in this study was 3500 Cal/m², or 86.5 Cal/kg. This level was

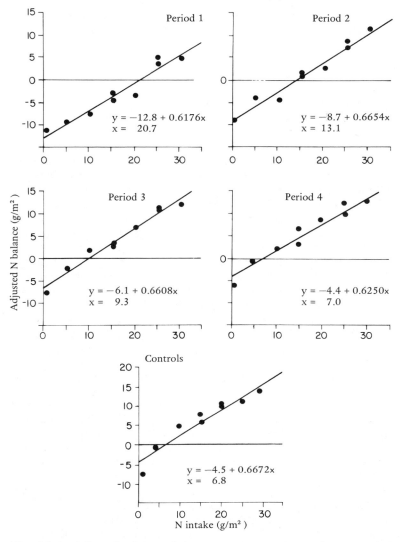

Fig. 14–2. Adjusted nitrogen balances. Regression lines of nitrogen balance on intake calculated by method of least squares. The given x values are in grams of nitrogen per square meter necessary for equilibrium. Postburn days: *Period 1,* 7th–16th; *Period 2,* 30th–39th, *Period 3,* 60th–69th; *Period 4,* 90th–99th.

arbitrarily selected with the thought in mind that energy requirements would be met from non-protein sources, thus allowing dietary protein to be utilized only to replace the body's protein losses. Blocker (4) recommends an intake of 45–85 Cal/kg. Sutherland (24) used a formula that took into account both body size and the area of the burn: 20 Cal/kg + 70 Cal/percent burn. More recently, Curreri (7) has published a similar formula for estimating calorie intake: 25 Cal/kg + 40 Cal/percent of body surface having burns.

Results of a study of the energy requirements of patients of various ages and size burns done

by Harrison *et al.* (13) are summarized in Tables 14–6 and 14–7. The administration of 3000 Cal or about 1600 Cal/m² resulted in energy equilibrium. It is noteworthy that when Harrison *et al.* administered the 3500 Cal/m² which was the amount given in our earlier study, a markedly positive energy balance was observed.

These recommendations for protein and calorie intakes are by no means precise, but they do serve as useful guidelines in planning a diet that is appropriate for each patient. It is the authors' opinion that the higher figures more closely approximate the needs of these patients. It is important to remember, however, that the prog-

ress of each patient must be continuously monitored to determine the success of the nutritional program.

CARBOHYDRATE AND FAT INTAKE

The efficiency of utilization of the oral diet is in part dependent on the relative amounts of each of the major constituents: fat, carbohydrate, and protein. In order that protein can function in its primary role for building and repair, it is important to provide sufficient nonprotein calories as carbohydrate and fat to meet the energy requirements of the patient. Although no recommendation is made for required amounts of carbohydrate and fat, in practice most diets furnish 45%–55% of the calories as carbohydrate and 30%–40% as fat.

The optimal partitioning of nonprotein calories between fat and carbohydrate is debatable. Fat is the most concentrated source of calories since 1 g fat furnishes 9 Cal, whereas 1 g carbohydrate furnishes only 4 Cal. Therefore, fat will contribute more calories with less bulk than carbohydrate. Fat, however, has a high satiety value, and if supplemental feedings are high in fat, they may cause a diminished appetite for the succeeding meal.

Some believe that the diet should be high in carbohydrate because if the liver and muscle reserves of carbohydrate become exhausted, proteins will be used for gluconeogenesis. Cuthbertson (9) maintains that protein is best utilized when abundant carbohydrate is present and that the most efficient utilization of protein is achieved when it is given simultaneously with carbohydrates and fat. Dietary protein must be of good quality and must contain all of the essential amino acids. Foods from animal sources are considered superior. However, since foods in the usual mixed diet supplement each other, obtaining all of the essential amino acids seldom poses a problem.

CHILDREN

In 1956 as a result of her studies of children, Sutherland (24) recommended that they be

TABLE 14–5. Protein Requirements for Equilibrium

Period	Postburn day	Protein requirement (g/kg body weight)
1	7–16	3.20–3.94
2	30–39	2.02–2.53
3	60–69	1.44–0.51
4	90–99	1.08–0.51
Controls		1.05–0.71

TABLE 14–6. Energy Requirements in Burns*

	Cal/m^2/24 hr	
	0–40% Burn	40% Burn
Child 6–10 years	1350–1450	1950–2050
Adolescent	1200–1300	1675–1850
Young adult	1100–1150	1550–1625

*Maximum requirement – 5000 Cal/day
Adapted from Harrison, HN; Moncrief, JA; Duckett, JW; Mason, AD Jr: The relationship between energy metabolism and vaporizational water loss in severely burned patients. Ann Res Prog Rep U.S. Army Surg Res Unit. Brooke Army Med Center. Fort Sam Houston, Texas. Section 27, 30 June, 1964

given 1.50 times their normal requirement of protein and 1.33 times the normal number of calories (Table 14–8). In 1968 (23) she reported the results of additional studies which caused her to modify her earlier recommendations. In doing balance studies, a constant intake is desirable. To standardize the intake among the children, Sutherland calculated the amount to be given from the child's weight and the extent of the burn. This provided 3 g protein/kg plus 1 g for each percent burn with 60 Cal/kg plus 35 Cal for each percent burn. It was reasoned that in a child growth has priority over other metabolic demands, and thus a greater quantity was allotted for body size. However, some children were unable to maintain a constant intake of this magnitude. In view of this, the quantity was reduced and the children were offered only normal amounts of protein and calories. Although on this smaller intake the weight loss was greater, the children quickly achieved a positive nitrogen balance and made an uncomplicated recovery. On the basis of these findings, Sutherland concluded that burned children can be maintained on a protein and calorie intake similar to what is required for good health. However, she stressed the importance of maintaining this level of intake since if children are allowed to consume less for even a few days, a marked deterioration in their condition can occur. She and her associates feel that this level of intake can be achieved most easily with a liquid intake.

MINERAL AND VITAMIN REQUIREMENTS

MINERALS

No specific allowances have been recommended for the mineral elements during recovery from trauma. It is assumed that if the patient receives

TABLE 14—7. Effect of Caloric Intake on Energy Expenditure*

	Caloric intake (Cal)	Respiratory quotient (RQ)	Basal caloric expenditure (Cal/24 hr)	Energy balance (Cal)
5% dextrose solutions	600	0.77	2255	−1655
Enteral diet	3000	0.85	2464	+ 536
Enteral and parenteral feedings	6000	1.00	2587	+3413

*Adapted from Wilmore DW, Curreri PW, Spitzer KW, Psitzer ME, Pruitt BA: Surg Gyn Obst 132:881–886, 1971

sufficient protein and calories from a normal variety of foods, the intake of minerals will be adequate.

SODIUM

Following the acute early phase of the postburn course, the requirement for sodium is not unusual unless some other underlying condition necessitates a modification in the intake. In the authors' study of nitrogen requirements (22), sodium balances were also measured. Regression analysis of the sodium balance on intake showed that after postburn day 30 the intake of sodium required to achieve equilibrium varies between 69–80 mEq/m²/day, or 1.7–2.0 mEq/kg (Fig. 14–3; Table 14–9). For the 70-kg man this is equivalent to 8 g sodium chloride, which is the lower estimate of the amount furnished by the usual American diet. This does not imply that any attempt should be made either to limit the salt intake to this amount or to insist that the patient consume this quantity if his normal preference dictates otherwise.

POTASSIUM

Shortly after the acute postburn phase, as the urinary excretion of potassium decreases to 25 mEq or less, supplemental potassium should be given to burned patients. The serum potassium should be closely monitored, and if hypokalemia develops after the first postburn week, sufficient IV potassium should be given to maintain a normal plasma level. During our study of nitrogen requirements, the potassium requirements for equilibrium were also estimated (17). During the first period, beginning on postburn day 7, some of the patients still required more potassium than was furnished by the intake (Fig. 14–4). As the postburn course progressed the apparent requirements for potassium diminished from 2.69 mEq/kg during Period I to 0.74 mEq/kg in the last phase of convalescence that was observed (Table 14–10). The normal controls also required 0.74 mEq potassium/kg for equilibrium.

Potassium and nitrogen must be given simultaneously to promote the effective utilization of nitrogen (15) since these two elements are intimately associated in lean tissue. The ratios of nitrogen and potassium requirements for equilibrium were calculated (Table 14–11). Although the intake used in this study contained 8 mEq potassium/g nitrogen, it was calculated that during the first three periods approximately 6 mEq potassium/g nitrogen would be required at equilibrium. This is similar to the ratio in an average diet and agrees with Frost and Smith (15) who recommend an intake of 5 mEq potassium/g nitrogen. When a satisfactory oral intake can be maintained, the potassium:nitrogen ratio is of little concern because of the abundance of potassium in foods. However, these ratios serve as a valuable guide for the amount of potassium to administer with nitrogen when an adequate intake of natural food cannot be given.

CALCIUM

The calcium intake of a burned patient is often as high as 4 g/day if milk is served as a beverage with meals and a milk-based supplement is given. The prolonged immobilization often necessary during recovery from a burn causes bone demineralization with an increased urinary and fecal excretion of calcium. The increased urinary calcium is considered to be a potential danger

TABLE 14—8. Calorie and Protein Requirements of Normal Children

Age (yrs)	Weight (kg)	Height (cm)	Calories	Protein (g)
1–2	12	81	1100	25
2–3	14	91	1250	25
3–4	16	100	1400	30
4–6	19	110	1600	30
6–8	23	121	2000	35
8–10	28	131	2200	40

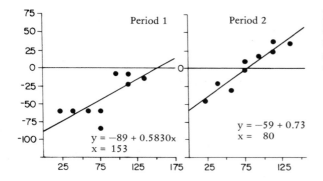

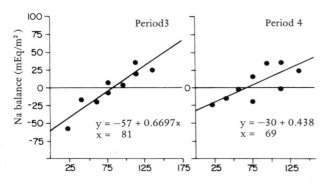

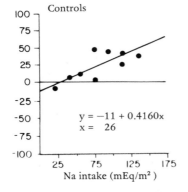

Fig. 14–3. Adjusted sodium balances. Regression lines of sodium balance on intake calculated by the method of least squares. The given x values are in milliequivalents of sodium per square meter necessary for equilibrium.

since insoluble calcium phosphate may be precipitated and this can lead to the formation of renal calculi, especially if the urine volume is low. However, in a series of patients treated at the United States Army Institute of Surgical Research, where milk-based supplements were used routinely, the incidence of renal calculi was only 0.8% (19). From the standpoint of the side effects of a high-calcium intake, each patient must be considered individually. Most surgeons prefer the benefits gained by serving calcium-rich foods to the limited risk of the formation of kidney stones. The practice of early ambulation and passive exercises are in part attempts to decrease these hazards.

TABLE 14–9. Sodium Requirements for Equilibrium

Period	Postburn day	Sodium requirement (mEq/kg)
1	7–16	3.78
2	30–39	1.98
3	60–69	2.00
4	90–99	1.70
Controls		0.64

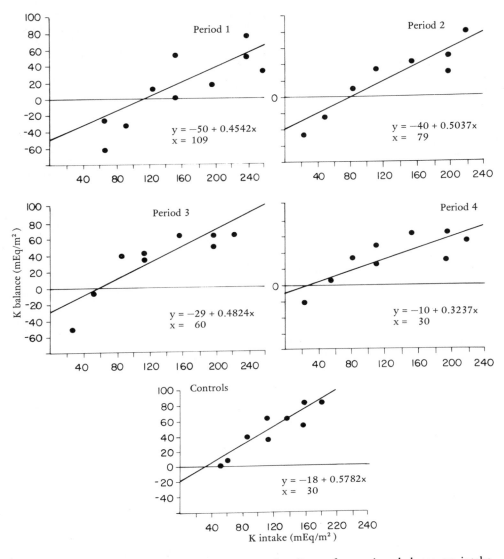

Fig. 14–4. Adjusted potassium balances. Regression lines of potassium balance on intake calculated by method of least squares. The given x values are in milliequivalents of potassium per square meter necessary for equilibrium.

TABLE 14–10. Potassium Requirements for Equilibrium

Period	Postburn day	Potassium requirement (mEq/kg)
1	7–16	2.69–4.32
2	30–39	1.95–2.17
3	60–69	1.48–(−4.35)
4	90–99	0.74–(−1.73)
Control		0.74–0.57

PHOSPHORUS

An adequate phosphorus intake is not difficult to obtain if the calcium intake is sufficient since these elements appear together in many foods. At one time, the suggested ratio in which calcium and phosphorus should be present in the diet was 1:1. In recent studies the ratio concept has been deemphasized, and it is now considered to be important only when one of these two minerals is not present in the intake in sufficient amounts.

MAGNESIUM

Under normal conditions, the adequacy of the magnesium intake is seldom questioned. The first recommended daily allowance of 350 mg magnesium for normal adult males was made in 1968 by the NAS-NRC, and this recommendation was not changed in the 1974 revision (11). The study by Reiss, Pearson, and Artz of a group of burned patients on an *ad libitum* intake (19) is in general agreement with the above recommendation.

IRON

The daily allowance of iron for normal women is 18 mg, and it has been found difficult to plan reasonable intakes of usual foods to include the amount recommended. If iron deficiency becomes a problem in the burned patient, it probably could not be solved by dietary means. In 1945 the NRC suggested a daily supplement of 1.5 g ferrous sulfate for the burned patient.

ZINC

Zinc metabolism following various surgical conditions has been studied extensively in recent years. Metabolic studies have shown that in healthy adults an intake of 8–10 mg/day is sufficient to achieve zinc equilibrium, and the average diet furnishes about 15 mg/day. The exact requirement for burned patients has not been determined, but it appears to be much higher than the recommended allowance for the normal individual, which was set at 15 mg/day by the NAS-NRC in 1974. From an analysis of 140 samples of hair taken from burned patients, Pories (18) reported that a deficit of zinc may develop shortly after the burn occurs, often persisting for 2–3 months after injury. Larson (14) reported that in burned children wounds heal more quickly and grafts take better when a supplement of zinc sulfate is given. However, since the metabolic response to the burn injury is so complicated, it is not clear that zinc alone is responsible. Cloutier, Pearson, and Soroff (6) studied the healing of experimental wounds in a burned patient with and without zinc supplementation. A 3-cm² wound was excised on the volar surface of the forearm using a template to standardize the size of the wound. When the first wound had healed, a second one was made on the other forearm and zinc supplementation was begun. The progress of healing was fol-

TABLE 14–11. Potassium:Nitrogen Requirement for Equilibrium

Period	mEqK/gm N	
1	5.2	6.8
2	6.0	5.4
3	6.4	—
4	4.2	—
Controls	4.5	5.0

lowed from daily photographs by measuring the rate of contraction and the rate of epithelization with a planimeter. The second wound healed more quickly, requiring only 23 days in comparison to 31 days for the first one. Thus it would appear that zinc supplementation might well be beneficial for the burned patient.

VITAMINS

The specific requirements for the various vitamins have not been scientifically determined for burned patients. Different authors have made different recommendations for the absolute amounts of vitamins that should be given. In animals subjected to experimental burns, a deficiency of vitamin B complex and vitamin A caused delayed healing (5). On the basis of this and similar experiments, increased intakes of vitamins have been recommended. For nontraumatized patient requirements see Ch. 7.

The role of vitamin C in maintaining normal matrixes of cartilage, dentine, and bone has been established, and wound healing is thought to be improved when therapeutic levels of this vitamin are given. Therefore, it is the practice to administer 1–2 g ascorbic acid daily.

Thiamin is essential for the metabolism of carbohydrate, and the recommended requirement is based on the daily caloric intake. Since the latter is increased in burned patients, the B vitamins should also be increased proportionately. The same holds true for the intake of vitamins A and D, the fat-soluble vitamins. Since an excess of vitamins A and D cannot be excreted, the advisability of giving massive doses is questionable. However, it is doubtful if a fat-soluble vitamin toxicity would develop during the usual duration of the postburn course.

In clinical practice 1–2 g vitamin C and 2 multivitamin capsules are usually administered daily. In view of our present state of knowledge, it is best to give supplemental vitamins during the entire course of the illness since the body is able to excrete excess amounts of the water-soluble vitamins.

DIETARY CARE

In general, nutritional requirements are related to the size of the burn. Since patients with large burns have the most difficulty in maintaining an adequate oral intake, burned patients sometimes become debilitated even in a well-organized and well-staffed burn center. It was believed at one time that malnutrition was inevitable until the granulating areas were completely covered with skin grafts because of the continued loss of proteins from the raw granulating area. The widespread use of xenografts as a temporary biologic dressing has been a boon in this respect. Because of the several methods available for providing nutrients to the burned patient, malnutrition need no longer be an inevitable occurrence. The development of commercially available fluids for IV nutritional support, the availability of bulk-free elemental diets, the many commercially prepared supplements, and the wide selection of normal foods, all insure that an adequate intake can be provided, if the medical team is aggressive in their use of this nutritional armamentarium.

It would be appropriate at this point to consider the mechanics of maintaining the patient's nutritional status. During the immediate postburn period, the intake of the severely burned patient will be by the IV route and will be directed towards maintaining a normal fluid volume and electrolyte balance. In our experience, it is unwise to immediately institute a forced feeding program by the oral route in an attempt to offset the nitrogen losses. During the first 5–10 postburn days patients often have nausea, vomiting, and decreased peristalsis. When the GI tract is capable of receiving food, the patient should be encouraged to ingest increasing amounts.

Sutherland *et al.* (24) suggest the following schedule to institute a nutritional program using a liquid intake: days 0–2, IV therapy; days 2–4, whole milk; days 4–7, half volume of final feeding; days 7–10, three-quarters volume of final feeding; and from day 10 on, the total amount. Thus a good intake of a high-protein, high-calorie diet should be attainable within 7–10 days following the burn if no major complications arise. Whatever the form of the final intake, food should be given in small quantities at first and gradually increased as tolerated. Some clinicians recommend elemental diets as the initial intake since they are readily absorbed, are residue-free, and require a minimum of peristaltic action by the GI tract.

It is impossible for the patient to consume the required quantities of nutrients from the food served as the customary three meals each day. If an attempt is made to do this, the mere bulk of the food would be intimidating. Instead, the three regular meals should contain attractive combinations of food that the patient likes in quantities he can consume easily. The additional nutrients must be given as supplements between meals with several additional servings after the evening meal before going to sleep. Supplements are generally given as high-protein liquid concoctions since more calories and protein can be contained in less bulk in fluid form. The protein content of these mixtures can be increased with powdered skim milk. In some institutions nurses give medication with an eggnog-type beverage, but there is no rigid rule that states that the supplements must be in a fluid form. It is vital that supplementation be food which the patient will accept, and so it may well be necessary to use a combination of methods.

The patient who inadvertently becomes a "chronic burn" will undoubtedly be suffering from malnutrition and wound infection. In the treatment of such a burned patient, nutritional problems take precedence and all efforts should be made to correct the malnutrition while the wounds are being prepared for grafting. Although it is possible to achieve positive nitrogen balance in a debilitated patient with a small intake of protein, every attempt should be made to replete the body stores of lean tissue and to achieve some gain of fat. Patients who are malnourished respond dramatically to forced feeding. However, it should be remembered that the forced feeding program should not be begun immediately, but that the level of intake should be increased gradually until the final desired amount is reached.

EMOTIONAL AND PHYSICAL FACTORS

Defining the optimal diet which the burned patient should receive is but the first step in insuring an adequate nutritional intake. We have all experienced the following clinical situation: during the daily rounds of the clinical service, it is noted that one of the patients appears to be emaciated. Interns and dietitians questioned about the nature of the patient's food intake usually reply that it is "quite good," and that the patient is receiving a "high-calorie, high-protein" diet. On further questioning, it appears that what has occurred is that although a very well balanced and adequate diet is placed before the patient, it

sits at his bedside and he either eats none of it or picks away at portions. Yes, he has been given an adequate diet, but he hasn't eaten it!

The appetite of any severely injured patient and especially of a patient with a major burn is precarious for many reasons. It is often difficult and painful for the burned patient to move his hands and arms, or he may be immobilized after grafting with a portion of his body in an uncomfortable position. Burns around the face and neck often are associated with scarring, which make eating and chewing painful and difficult. In addition, burns of the face and hands are usually extremely threatening as far as the patients self-image is concerned and are often a source of extreme anxiety regarding his acceptability to society and loved ones. He may manifest this by withdrawal from the people around him and by a loss of a real desire to eat (1).

The pain associated with a large burn requires the use of either narcotics or some form of sedation. All of these agents inhibit appetite, and they are sometimes associated with nausea and constipation (3). Side effects with regard to the appetite and food intake of the patient should be kept in mind and noted.

An additional problem peculiar to the management of the burned patient which can complicate his nutritional program is the necessity for frequent dressing changes and grafting procedures in the operating room. This often requires the patient to miss at least one meal on these days and should be considered in planning the surgery schedule. Severely burned patients should be among the first in the operating room so that they may miss as few meals as possible.

The management of the emotional and psychological needs of these patients can best be served by the active participation of professionals with a wide variety of skills and interests. These problems are often difficult for the patients to perceive and express, but they are frequently brought to light and solved when psychiatrists, psychologists, social workers, dietitians, and occupational and physical therapeutists work with the patient and with the surgical team in combined, daily bedside rounds.

TUBE FEEDINGS

Cuthbertson (9) states that when anorexia is present, it may be kinder to tube feed the patient than allow him to deteriorate. When tube feedings are necessary, they should be started slowly, 40–50 ml/hour for adults. Levenson (15)

recommends beginning with a mixture of half skim milk and half water or one of the protein hydrolysates and carbohydrate. The feedings can be increased gradually over a period of a week to 10 days to a maximum of 100–200 ml every 2 hours. If the volume to be given by tube is large, the feedings should be extended over the 24-hour period to avoid overstimulation of the gastric mucosa and to help prevent gastric hemorrhage.

Tube feedings may also be used as supplements to the regular meals of poorly cooperative patients. The patient is allowed to eat as much as he can of the food from his tray. Then the tube feeding of choice may be given to furnish the balance of his daily intake.

Several characteristics are typical of the ideal tube feeding. It must support and supply adequate nutrition. If necessary, it must be modified to fulfill the patient's own special dietary requirements, *e.g.,* low sodium or modified fat. To be effective it must be well tolerated and not cause vomiting or diarrhea. For ease of administration and to supply sufficient water, it must be of the proper fluid consistency and particle size. It must be prepared easily from readily available and reasonably inexpensive materials. And, although not of prime importance, palatability should be considered, otherwise an unpleasant aftertaste will occur if there is regurgitation (16).

Many types of feedings suitable for administration by tube have been devised. Tube feedings made from normal foods converted to a fluid consistency by homogenizing and diluting with liquids are well tolerated by most patients. Such products are also available commercially. Baby foods may be combined in a nutritious mixture, thus avoiding the labor of homogenization. Commercial products designed as supplements can be given by tube as well as orally and can be obtained either as liquids or as powders that can be dissolved in milk or some other liquid.

Elemental diets have become a very useful part of our nutritional armamentarium. They are ideal for giving by tube and also may be taken by mouth. Composed of amino acids, simple carbohydrates, vitamins, minerals, and a small amount of fat, they generally provide 1 Cal/ml diet. Since they are free of bulk, these diets result in a minimum of fecal output, and their use should be considered when the patient has burns of the buttocks or perineum. The manufacturers recommend that the initial feedings should be diluted and given slowly, gradually increasing to

full strength since not all patients can initially tolerate these diets at their full strength. If expense is a consideration, the elemental diets may be contraindicated because they cost more than homogenized food or milk-based mixtures.

HAZARDS OF TUBE FEEDING

Diarrhea may be a complication of tube feeding, especially if too concentrated a feeding is used initially and a large quantity is given. As a means of correcting the diarrhea, the rate of administration may be slowed, the feeding diluted, or a feeding or two omitted. The addition of Kaopectate or applesauce to the feeding has been suggested. The total solute concentration may be the cause for diarrhea since a hypertonic solution tends to draw water into the intestinal tract (16). The factors that contribute to the osmotic pressure of the mixture are carbohydrate and electrolytes, chiefly sodium, potassium, and chlorides, whereas fat and protein exert negligible effects. If the function of the GI tract is normal, fat can be used to furnish approximately 50% of the total calories.

In a comatose patient, care must be taken to provide an adequate intake of water so that he does not become dehydrated while being tube fed. Normally, in the conscious patient the sensation of thirst serves as an adequate guide for water intake, but the unconscious patient cannot make his need for water known.

Another possible hazard of high-carbohydrate feeding is a syndrome termed stress pseudodiabetes (2), which is characterized by hyperglycemia, glycosuria without acetonuria, a high urine specific gravity, and a marked osmotic diuresis. The latter leads to severe dehydration with an elevation of the nonprotein nitrogen and hematocrit as well as an increase in the serum sodium and chloride. This syndrome is best treated by water replacement and insulin to control the hyperglycemia.

The single greatest hazard of tube feeding, especially in the elderly patient, is aspiration. A number of common sense precautions should be part of the routine of administration of tube feedings. The tube should be aspirated before each feeding. If more than 50 ml residual are present, the feeding should be delayed. The head of the patient must be elevated to some extent, and the patient should be turned during the feeding so that his right side is dependent in an effort to aid gastric emptying.

INTRAVENOUS NUTRITION

Nutritional support by the IV route (10) has been successful in many types of patients (see Chs. 11, 12). The solutions consist of hypertonic glucose, 5% protein hydrolysate, minerals, and vitamins administered as a mixture through a central venous catheter. With burn patients, finding a suitable vein without going through the burn surface is often a problem. Great care must be taken to prevent contamination of the catheter. As stated earlier, IV feeding has been combined successfully with oral feeding making it possible to give burned patients as many as 6000 Cal/day (25).

It should be stressed that no single program can be advocated to maintain the nutrition of the burned patient since each patient will require careful evaluation of his entire clinical course including the dietary consideration. Each patient must be considered from the point of view of what he requires to meet his psychologic needs as well as his own physiologic demands.

The dietitian is the member of the team who should help plan the nutritional program of the patients and who will be held responsible for following the physician's dietary orders. The patient and the family should be consulted to learn of food preferences, and the meals and supplements should be planned accordingly. The dietitian should be asked to calculate the calorie and protein intake each day and to record the amounts in the patient's chart. This keeps the surgeons aware of what the patient is actually consuming.

As a check on their nutritional progress and as part of their routine care, burned patients should be weighed frequently, daily if possible. After the initial period of weight gain due to fluid retention, the patient with a large burn will lose weight for some time. But if the nutritional program is successful, it should be possible to maintain him at a satisfactory, although lower than normal weight. Everyone involved in the care of the severely burned patient should be aware of the critical importance of nutrition to his survival and well-being and should use every strategy to encourage the patient to eat.

SUMMARY

The ultimate survival of patients with large burns depend on the maintenance of his nutritional status. It must be recognized that nutritional requirements are increased over those of

the normal individual and all means must be utilized to meet their needs.

As guidelines for planning the intake, the following suggestions are offered: Cal = 25 × body weight (kg) + 40 × percent of body surface that is burn area; protein = 2–4 g/kg; vitamin C, 1–2 g, multivitamins 2–4/day. If the calories and protein are obtained from normal foods, it is probable that the mineral requirements will be met.

As an assessment of the success of the nutritional program, the patient should be weighed frequently. Although it is impossible to maintain the patient at his normal, preburn weight, the stabilization of the weight at a lower level is acceptable with an ultimate gain in weight beginning as the wounds heal and grafting is completed.

Each patient must be considered as an individual and the nutritional program should be adjusted to meet his needs.

REFERENCES

1. Andreasen NJC, Noyes R, Hartford CE, Brodland G, Proctor S: Management of emotional reactions in seriously burned adults. N Engl J Med 286:65–69, 1972

2. Arney GK, Pearson E., Sutherland AB: Burn stress pseudodiabetes. Ann Surg 152:77–90, 1960

3. Artz CP, Moncrief JA: The Treatment of Burns. 2nd ed. Philadelphia, WB Saunders, 1969, p 298

4. Blocker TG, Levin WC, Nowinski WN, Lewis SR, Blocker V: Nutrition studies in the severely burned. Ann Surg 141:589–597, 1955

5. Brown SO: Burn healing in albino rats and mice fed diets deficient in certain vitamins. In Artz CP (ed): Research in Burns. Washington, American Institute of Biological Science, 1962, p 137

6. Cloutier CT, Pearson E, El-Zawahry D, Riihimaki H, Schwartz MS, Soroff HS, MacAulay AC: The effects of the administration of zinc sulfate on the healing of wounds in the burned patient. In Matter P, Barclay TL, Konickova Z (eds): Research in Burns. Bern, Hans Huber, 1971, p 623

7. Curreri PW, Richmond D, Marvin J, Baxter CR: Dietary requirements of patients with major burns. J Am Diet Assoc 65:415–417, 1974

8. Cuthbertson DP: Metabolic effects of injury and their nutritional implications. Nurs Times 61:179–180, 1965

9. Cuthbertson DP, Tilstone WJ: Nutrition of the injured. Am J Clin Nutr 21:911–922, 1968

10. Dudrick SJ, Wilmore DW, Vars HM, Rhoads JE: Can intravenous feeding as the sole means of nutrition support growth in the child and restore weight loss in an adult? An affirmative answer. Ann Surg 169:974–984, 1969

11. Food and Nutrition Board, National Research Council: Recommended Dietary Allowances. 8th ed (Revised). National Academy of Sciences, Washington, D.C., 1974

12. Frost PM, Smith JL: Influence of potassium salts on efficiency of parenteral protein alimentation in the surgical patient. Metabolism 2:529–535, 1953

13. Harrison HN, Moncrief JA, Duckett JW, Mason AD Jr: The relationship between energy metabolism and vaporizational water loss in severely burned patients. Ann Res Prog Rep. USASRU, BAMC, Fort Sam Houston, Texas. Section 27, 30 June, 1964

14. Larson DL, Maxwell, R, Abston, S, Dobrkovsky M: Zinc deficiency in burned children. Plast Reconstr Surg 6:13–21, 1970

15. Levenson SM, Green RW, Lund CC: An outline for treatment of severe burns. N Engl J Med 235: 76–79, 1946

16. Masterton JP, Dudley HAF, MacRae S: Designs of tube feeds for surgical patients. Brit Med J 2:909–913, 1963

17. Pearson E, Soroff HS, Arney GK, Artz CP: An estimation of the potassium requirements for equilibrium in burned patients. Surg Gyn Obst 112:269–273, 1961

18. Pories WJ, Henzel JH, Rob CG, Strain WH: Acceleration of wound healing in man with zinc sulphate given by mouth. Lancet 1:121–124, 1967

19. Reiss E, Pearson E, Artz CP: The metabolic response to burns. J Clin Invest 35:62–77, 1956

20. Schwartz MS, Soroff HS, Artz CP: An evaluation of mortality and the relative severity of second and third degree injuries in burns. USASRU, Research Report MEDEW-RS-12-56, 1956

21. Soroff HS, Pearson E, Artz CP: An estimation of the nitrogen requirements for equilibrium in burned patients. Surg Gyn Obst 112:159–172, 1961

22. Soroff HS, Pearson E, Arney GK, Artz CP: An analysis of alterations in body composition in burned patients. Surg Gyn Obst 112:425–434, 1961

23. Sutherland AB, Batchelor ADR: Nitrogen balance in burned children. Ann NY Acad Sci 150:700–710, 1968

24. Sutherland AB: The nutritional care of the burned patient. Brit J Plast Surg 8:68–74, 1956

25. Wilmore DW, Curreri PW, Spitzer KW, Spitzer ME, Pruitt BA: Supranormal dietary intake in thermally injured hypermetabolic patients. Surg Gyn Obst 132: 881–886, 1971

26. Wilmore DW: Nutrition and metabolism following thermal injury. Clin Plast Surg 1:603–619, 1974

15 Cardiology

René Bine, Jr.

It is trite but true that the epidemic of the twentieth century is heart disease. In adults it is a problem of the affluent society linked strongly with stuffing, sitting, smoking, and sipping. The variety of food available in America is fantastic, but the usual American diet abuses this abundance by being excessive in total calories, saturated fats, cholesterol, sugars, and salt. Although such eating patterns contribute to the development of several cardiovascular risk factors, principally high blood cholesterol, hypertension, obesity, and diabetes, these can be controlled by proper therapeutic and preventive efforts, many of them in the field of nutrition.

ATHEROSCLEROTIC CARDIOVASCULAR DISEASE

Atherosclerosis is a pathologically defined clinical entity peculiar to the human species as a spontaneous process. Having plagued mankind since antiquity, it currently results in tremendous morbidity and mortality and yet remains a considerable medical enigma. It is a condition of the intima of the medium and larger arteries wherein are formed fibrous and fibrofatty plaques on which thrombi may develop. No symptoms appear until these progressively obstruct a lumen and thrombus actually occludes the vessel to cause ischemia or infarction with death of tissue. In the coronary arteries this results in angina, myocardial infarction, and sudden death. In the arteries of the neck and circle of Willis it results in stroke—either transient ischemic attacks due to platelet microemboli or full-blown paralysis due to actual infarction of brain tissue. In the leg arteries it causes claudication and gangrene, and in the renal arteries it may produce hypertension and poor renal function.

There is at present no certain cure or preventive measure for atherosclerosis. Among the factors that seem to play some role in its etiology are some about which at the present time we can do nothing, *e.g.,* age, sex, and genetic predisposition. Excess cigarette smoking is definitely a factor; stress and lack of exercise are probably incriminated, and the rest fall directly or indirectly into the realm of nutrition if nutrition is considered as anything that the body absorbs through the mouth (or bloodstream). Factors include, then, hypertension, diabetes, hypercholesterolemia, hypertriglyceridemia, obesity, hyperuricemia, minerals, and trace elements.

Some investigators believe that atherosclerosis is a thrombotic disease *per se* and that the plaques represent mural thrombi that have undergone organization. Pickering (17) believes that arterial pressure, while being a factor in the production of myocardial and cerebral infarcts, is perhaps not the prime factor since hypotensive drug therapy does not proportionately reduce coronary artery disease. The majority of investigators believe that atherosclerosis represents some disturbance of lipid metabolism.

Wissler (6) points out that the most common "pure" lesion of the atherosclerotic plaque consists mostly of small accumulations of lipid, whereas the other components, *e.g.,* collagen, fibrin, elastin, and mucopolysaccharides, develop primarily in reaction to the presence of lipid in the intimal and intermedial layers of the artery wall. Therefore, if lipid deposition is the primary event, it must be considered in relation to the hyperlipidemia (cholesterol and other serum lipids) that is likewise associated with atherosclerosis. Wissler's studies with rhesus monkeys afford a great contribution in this area by pointing out the effect and importance of alterations in the

diet on the development of and regression of the atherosclerotic lesions.

CORONARY ATHEROSCLEROTIC HEART DISEASE

INCIDENCE

Coronary atherosclerotic heart disease (CAHD) is certainly the commonest underlying cause of cardiovascular disability and death. The association of coronary occlusion and myocardial infarction with atherosclerosis was established only about 100 years ago, and the clinical pathologic correlations that allowed establishment of the diagnosis during life were worked out at about the beginning of this century. It is not quite clear whether this illness actually reached its current proportions during the last few decades or is merely being recognized more readily than heretofore. It is four times as frequent in men, having a ratio of 8:1 before age 40, but after 70 the ratio is 1:1. Women, however, are fast shortening these odds. The peak incidence in men is at age 50–60, whereas in women it is at 60–70. It is most significant that advanced stages of CAHD remain clinically silent until found incidentally after death of other etiology.

CLINICAL CONDITIONS (13, 16)

The clinical expression of this disease may be by

1. Angina pectoris—representing transient localized myocardial ischemia
2. Preinfarction angina (unstable angina)—occurring as prolonged myocardial ischemia with or without myocardial necrosis. This may represent a minor occlusion with sufficient collateral circulation remaining but may also be a precursor of an actual myocardial infarction
3. Acute myocardial infarction—with arterial occlusion
4. Heart failure due to fibrosis or thinning of the myocardial wall, or both, resulting in weakening of the heart as a pump
5. Acute and chronic arrhythmias, conduction disturbances, abnormal EEGs, and/or gradual fibrosis of the myocardium or the conduction system, which may result from any of the above
6. Sudden death—due to any of the above plus ventricular arrhythmias or Stokes–Adams attacks

NONNUTRITIONAL THERAPY

The nonnutritional treatment of CAHD requires knowledge and evaluation of the various stages and complications of the disease. These commonly coexist and interact, and caution must be exercised, for any specific program, procedure, or medication that may be indicated for one case may be contraindicated in another. For example, physical rest is indicated in preinfarction angina, myocardial infarction, arrhythmias, and congestive failure, yet such inactivity is not desirable in angina *per se;* and although propanolol is useful in angina and arrhythmias, it is interdicted in congestive failure. Table 15–1 lists general therapeutic measures and certain specific ones utilizing various medications as well as physical, mechanical, and surgical measures.

The clinical manifestations of cardiac arrhythmias may vary from trivial palpitations to a clinical state of the utmost urgency, as when ventricular tachycardia complicates acute infarction. Consequently definition of the type of arrhythmia is also essential.

When congestive failure exists, the objectives of therapy are to increase the strength and efficiency of the myocardial contraction and to reduce the abnormal retention of sodium and water. Consequently digitalis and the diuretic drugs are mainstays in therapy though some feel that in the majority of cases diet with diuretics alone can and should be used because of complications with digitalis (*e.g.,* anorexia, nausea, hypokalemia, cardiac arrhythmias). The diuretics have their own list of possible complications (*e.g.,* hypokalemia, hyperuricemia, hyperglycemia, wide swings in electrolyte balance and blood volume, nausea, allergy).

NUTRITIONAL MODALITIES OF THERAPY

DIRECT AND PRIME NUTRIENTS INVOLVED

LIPIDS

Evidence for lipid etiology. One possible common denominator through which the multiple contributors to atherosclerosis operate may involve the blood lipids, their transport and metabolism. Broadly based evidence in animal experiments, human metabolic studies, clinical experience, autopsy correlations, and retrospective and prospective epidemologic studies specifically seem

TABLE 15—1. Nonnutritional Treatment of CAHD

Disorder	General	Specific
Angina	Eliminate smoking Improve physical fitness by a regular exercise program. (Caution: unusual exertion is hazardous.)	Medical Nitroglycerin Drug of choice for acute attack May use before starting an activity Longer-acting nitrates Propanolol (β blocker) Surgical Aortocoronary bypass graft Ventricular aneurysmectomy
Pre-infarction angina (Unstable Angina)	Eliminate smoking Rest Sedation	Medical Analgesics Anticoagulants Nitroglycerin Long-acting nitrate Propanolol Surgical Aortocoronary bypass graft Ventricular aneurysmectomy
Acute myocardial infarction	Rest, physical and mental Eliminate smoking Analgesia — opiates, nitroglycerin Oxygen Sedation Possible use of anticoagulant therapy Varied activity status in convalescence	Shock Therapy unsatisfactory generally Vasopressors Inotropic agents Digitalis Intraaortic balloon Assisted circulation Counterpulsation Congestive failure (see below) Arrhythmias (see below) Stokes-Adams attacks (see below) Thromboembolic phenomena Anticoagulants Shoulder-hand syndrome Analgesics, aspirin, and/or opiates Physiotherapy Intraarticular xylocaine and corticosteroids
Arrhythmias	Rest, and reassurance Eliminate smoking Loosening of binding clothing (*e.g.,* corsets) Precipitate vomiting if just had big meal Attempt to remove cause, *i.e.,* alcohol, tobacco, stress Oxygen occasionally helpful Stimulant Rxs	Physical measures Carotid massage Valsalva maneuver Vagal stimulation Medications Tachycardias Quinidine Digitalis Potassium Lidocaine Propanolol (caution in bronchospasm or failure) Procainamide (long term use danger of LE syndrome) Tensilon Dilantin Conduction defects Atropine Ephedrin Isuprel Epinephrin Steroids Mechanical measures Cardioversion Pacemakers
Congestive heart failure	Rest Oxygen Find and Rx extracardiac causes Thyrotoxicosis Anemia Myxedema Nutritional causes, *e.g.,* Vitamin B deficiency	Surgical Ventricular aneurysmectomy Valvular replacements for stenosis and/or severe insufficiency Mechanicophysical IPPB Paracentesis Venesection *(continued)*

TABLE 15—1. Nonnutritional Treatment of CAHD *(continued)*

Disorder	General	Specific
Congestive heart failure *(continued)*	Polycythemia Pagets disease of bone Find and eliminate precipitating factors Infection, including endocarditis Pulmonary infarction Increased sodium intake Stopping of medications Arrhythmias Myocardial infarction Anemia, sudden Propanolol	Medications Removal of sodium and water by Digitalis Diuretics (thiazide, mercuria) Ethacrynic acid, aldosterone antagonists Morphine Demerol Aminophyllin

to link blood cholesterol with atherosclerosis and CAHD. The major features of this are

1. Diseases associated with hypercholesterolemia, *e.g.,* diabetes and hypothyroidism, are also associated with atherosclerosis.
2. Persons with inborn errors of cholesterol metabolism, *e.g.,* β-lipoproteinemia, develop extremely precocious atherosclerosis.
3. Serum cholesterol concentrations are higher in those groups with established coronary heart disease, especially those who acquire it early in life.
4. Risk of coronary heart disease is proportional to the elevation of cholesterol as determined in prospective studies.
5. Coronary death rates are high in nations with high average cholesterol values, and vice versa.
6. Atherosclerotic deposits are generally loaded with cholesterol and other lipids. Movement of lipid from the blood into the deposits has been demonstrated. No indications exist that there is any other source than circulating lipoproteins for the accumulated cholesterol in atherosclerotic arteries.
7. Populations with high cholesterol values have diets different from those with low values. (Significant correlations exist between quantity and quality of dietary fat intake and the incidence of ischemic heart disease in most population groups throughout the world.)
8. Migrants from "low cholesterol" areas to "high cholesterol" areas commonly have higher cholesterol values after changing their dietary pattern.
9. Manipulation of diet can alter serum cholesterol values in a predictable fashion in humans. The degree of reduction depends on several factors, *e.g.,* beginning level, individual variation—which may be genetically determined—and composition of diet.
10. In mammals, inducing high lipid levels by dietary alteration produces atherosclerotic deposits, whereas on reducing the cholesterol level, the deposits regress.

A great deal of research on the role of lipids in atherogenesis has incriminated virtually every blood lipid fraction: triglyceride, phospholipid, and nonesterified fatty acid. In addition, the lipoproteins and proteins to which the lipids are linked for transport have been separately blamed. Whether one or several of these are fundamentally involved in atherogenesis is admittedly not clear. Furthermore, all the lipoprotein fractions transport some cholesterol, and it is not clear whether the partition of the total cholesterol among these fractions influences its atherogenicity.

A high serum cholesterol value can be reached through a number of mechanisms. It may be secondary to other diseases that affect lipid metabolism (*i.e.,* diabetes, thyroid disease, obstructive liver disease). It may be "primary" and caused by some ill-defined disorder of lipid metabolism resulting from an "abnormal" diet or faulty handling of a normal diet. Sometimes it is caused by excessive alcohol consumption. It may also be the result of inborn errors of lipid metabolism. The atherogenicity of each variety of hyperlipidemia requires further clarification. Uncertainty still exists concerning the regulation of cholesterol in the body, the optimal range of values, the details of its involvement in atherogenesis, and its chief determinants within populations. Bortz (4), in reviewing the pathogenesis of hypercholesterolemia, proposes that the most frequent biologic risk factor underlying many of the other seemingly separate causes is the excessive flux of fat to the liver. Despite the uncertainties, cholesterol is clearly somehow intimately involved in the evolution of atherosclerotic dis-

ease. Whether its role is fundamental or not, it is obvious that blood lipids can be used as biochemical predictors of clinical coronary events.

A disproportionate amount of CAHD in the general population develops out of the upper quartile of the distribution of lipids (*i.e.,* cholesterol between 250–350 mg%), which is apparently lethal and cannot be disregarded as "within normal limits," as on most lab reports. Risk of clinical CAHD is decidedly proportional to the antecedent level of each of the major blood lipids and lipoproteins from the lowest to the highest values observed, even within the range generally conceded to be normal. To visualize the atherosclerotic diseases as the product of any single etiologic agent, however, is a mistake. In different populations, as in the United States, everyone has enough lipid to manufacture atheromata, but the rate of its development appears to depend on multiple contributing factors, as well as the degree of elevation of the blood lipid content. The ingredients of the multifactorial coronary profile include largely normal body constituents and are more a matter of degree than kind. As regards atherogenesis, it is hard to specify normal levels for any of the major atherogenic coronary precursors, including lipid, blood pressure, and impaired carbohydrate tolerance since most values are continuously distributed in the population with no bimodality to designate where abnormal begins.

Metabolism of Fats. Fats in our food consist primarily of triglycerides. Animal fats contain cholesterol as well; vegetable oils do not, and some plant sterols actually interfere with the absorption of cholesterol. Phospholipids occur in small amounts in these edible fats and act as emulsifying agents in the digestion of fats in general. The digestibility, absorption, and fate of the molecule of triglyceride depends on the chain length and degree of unsaturation of its fatty acid components (1 triglyceride molecule equals 1 glycerol molecule and 3 fatty acid molecules).

Fats leave the stomach, where they are separated from carbohydrates and proteins, in the form of a coarse undigested emulsion. Hydrolysis takes place in the distal duodenum where the fat is mixed with bile and pancreatic lipase (the saturated fatty acids hydrolyzing slower than the unsaturated). Bile salts make the lipids soluble so they may be taken from the lumen by the absorptive cell. Cholesterol occurs in the esterified and the free form in foods, but since only free cholesterol is absorbed by the intestine, pancreatic cholesterol esterase converts cholesterol ester to free cholesterol and fatty acids. Other dietary fats aid the absorption of cholesterol, presumably by stimulating the flow of bile and providing the fatty acids with which cholesterol is esterified. In the mucosa some esterification occurs again. The fatty acids and the free (30%) and esterified (70%) cholesterol then pass into the lymph with the triglycerides and phospholipids in the form of chylomicrons (10).

The rapidity of fat absorption may be of particular importance since the quickly absorbed type of fat, although less likely to give digestive upsets, can cause sudden large lipemias that may be a factor in sudden deaths occurring a couple of hours after meals, particularly with exercise. The slowly absorbed fats, on the other hand, remain in the GI tract longer, increase the period of satiety, and sustain a lower level of lipemia.

Since all of the blood lipids are insoluble in aqueous solution, all enter, circulate, and leave the blood bound to specific proteins. Lipoproteins are the principal transporters of lipids in the blood. Lipoproteins are produced in two places: 1) in the intestinal wall after initial ingestion, digestion, and absorption of exogenous fat in a meal and 2) in the liver from endogenous fat sources. The lipoproteins are classified into four groups: 1) alpha, 2) pre-beta, 3) beta, and 4) chylomicrons. These lipoproteins can be identified in terms of their flotation constraints by ultracentrifugation, thus the classification on a physical–chemical basis into high-density lipoprotein (HDL), low-density lipoprotein (LDL), very low–density lipoprotein (VLDL), and chylomicrons. Phospholipids and fatty acids are found primarily in α-lipoprotein, or HDL. Chylomicrons, the largest of the lipoproteins, are formed in the intestinal cells, consisting mainly of dietary triglycerides. They thus transport all of the medium and long-chain fatty acids to the plasma via the thoracic duct. Enzymes such as lipoprotein lipase (LPL) remove the majority of triglycerides from the capillaries of adipose muscle and heart tissue. If an individual is lacking in LPL, chylomicrons will persist in the plasma for a prolonged period.

Triglycerides predominate in the pre-β VLDL fraction (fasting specimen) and chylomicrons (postprandial specimen) and are the major lipids transported through the blood—and are also therefore a major determinant of lipid transport. Each day 70–150 g triglycerides enter and leave the plasma compared to about 1 g cholesterol or phospholipid. Triglyceride primarily of hepatic origin is transported by VLDL into the plasma.

The plasma carries it to peripheral sites, primarily adipose tissue and muscle for storage or utilization.

Dietary carbohydrate and increased free fatty acid flux to the liver stimulate VLDL production and therefore are considered primary precursors of triglyceride. Once in the plasma, VLDLs are quickly attacked by the same lipase that acts on chylomicrons and in a few hours native VLDL becomes a lipoprotein intermediate form shorn of much of its glyceride and some of its protein. In 2–6 hours this lipoprotein intermediate is further degraded through the removal of more glyceride to low density. Cholesterol is found in the β-lipoprotein on electrophoresis, and in the ultracentrifuge classification 1/2–2/3 of total plasma cholesterol is carried in the LDL. As mentioned above, LDL is in part, if not entirely, a remnant of VLDL metabolism. These remnant forms are then removed actively but comparatively more slowly by the liver and have a half-life of about 3 days. Referring then to Table 15–2, the hyperlipoproteinemias may be listed:

Type I is chylomicronemia;

Type II is increased LDL or β-lipoprotein;

Type III is increased lipoprotein intermediates;

Type IV is increased VLDL or pre-β;

Type V is increased VLDL or pre-β and chylomicrons.

To distinguish these most of the time neither ultracentrifugation nor electrophoresis is necessary. Since all the lipoprotein families have relatively fixed composition and since two refract light and produce turbidity, observation of the standing plasma and an accurate cholesterol and triglyceride determination identify the hyperlipoproteinemia. Except perhaps in rare type IIIs, a history and physical examination confirm the diagnosis.

Steps and cautions in arriving at a diagnosis of hyperlipoproteinemia may be listed as follows:

1. Patient in steady state on regular diet for 1 week.
2. Recent weight gain or weight loss can affect results.
3. Illness at the time can affect results.
4. Serum lipoproteins change dramatically immediately after myocardial infarction.
5. Certain drugs affect plasma lipid levels (caution re female sex hormones).
6. Chylomicrons normally appear 2–4 hours after a meal.
7. A serum specimen of 12–16 hours of fasting is necessary.
8. If results are abnormal on cholesterol and triglyceride determinations, at least two confirmatory samples should be obtained before recommending definitive therapy.
9. Lipoprotein electrophoresis if cholesterol or triglycerides are abnormal.
10. Secondary hyperlipidemia should be ruled out. (Treatment of the secondary disorder will usually effectively modify the hyperlipoproteinemia.)

CALORIES. For most individuals caloric intake must be adjusted to achieve and maintain ideal weight while supplying proper and adequate supplies of other nutrients.

With age and a lessening of physical activity, lean muscle mass decreases and consequently so-called "normal weight" calculated on the basis of height no longer applies. Furthermore, tables that are based on "height measured in 1-in. heels for males and 2-in. heels for women" and "weight measured in indoor clothing" provide an inadequate standard. Patients should be weighed routinely with as little clothing as possible and certainly without shoes.

SODIUM. Sodium is one of the most important nutrients dealt with in the practice of cardiology. The average American takes in at least two times any reasonable amount per day. The appetite for salt is acquired, developed from infancy when the mother's habits and tastes were foisted on the child and further fortified through the years as a result of social and dietary customs. The minimum requirement for sodium can be thought of in terms of the amount lost when none is fed. At this time all bodily functions operate maximally to conserve sodium and excretion falls to under 200 mg/day. This, of course, is the output by an already-depleted individual and allows no safety margin for changing day-to-day needs. A safe level of intake for an individual in a temperate climate, performing ordinary activities, is approximately 2.0–2.5 g/day (40–45 mEq/day). Obviously, in cases where sweating is considerable, additional sodium is needed in the diet. However, since sweat contains less than 1 g/liter, in America more than 4–5 g would rarely be required except in unusual circumstances of location, climate, and occupation. Humans can adapt to a wide range of sodium intake due to the renal–endocrine system, which regulates body sodium within certain fine limits by varying excretion

TABLE 15—2. Characteristics of Hyperlipoproteinemias

Diagnosis	Normal	Type I	Type II A (endogenous)	Type II B (exogenous)
Chemistries	Cholesterol 220 mg TGY 150 mg C:T ratio = 1.5:1.0	Cholesterol normal or slight high TGY 5,000—10,000 C:T ratio = 0.1:1.0	Cholesterol 300—600 TGY normal C:T ratio = > 1.5:1.0	Cholesterol 300—600 TGY moderately high C:T ratio = variable
Appearance of serum	Clear except in lymphosarcoma or cryoglobulinemia	Creamy top layer, clear infranatant	Clear	Slightly turbid
Lipoprotein pattern By ultracentrifuge		↑ Chylomicrons (LDL and VLDL normal or ↓)	↑ LDL (VLDL normal)	↑ LDL ↑ VLDL
By electrophoresis		Dense chylomicron band	Dense β band	Dense β and pre-β bands
Epidemiologic features Age		Early childhood (before age 10)	Early childhood in severe, all ages	Usually adult
Frequency		Rare	Common	
Primary metabolic features		Genetic basis for lipoprotein Lipase deficiency transmitted as simple recessive trait	Primary (familial) transmitted as autosomal dominant trait; one or both parents; at least ½ of kindred affected; detectable at birth	
Etiologic features		Severe fat intolerance	LDL accumulation due to increased production or more usually decreased removal	
Secondary causes or associations with		Hypoinsulinemic diabetes, hypothyroidism, dysgammaglobulinemia, LPL inhibitors may occur in alcoholism, pancreatitis and LE	Hypothyroidism, multiple myeloma, macroglobulinemia, nephrosis, obstructive liver disease, porphyria	
Clinical features		Xanthomas, hepatosplenomegaly, lipemia retinalis, abdominal pain, pancreatitis	Severe and premature atherosclerosis, Homozygote: xanthomas, arthritis, premature vascular (childhood) Heterozygote: tendon and tuberous xanthomas, adult xanthelasma, premature corneal arcus, and premature vascular disease No eruptive xanthomas	

TABLE 15—2. Characteristics of Hyperlipoproteinemias *(continued)*

Type II (environmental)	Type III	Type IV	Type IV (En)	Type V
Similar to other type II levels	Cholesterol 350—800 TGY 400—800 C:T ratio = 1.0:1.0 range = 0.3—> 2.0:1.0	Cholesterol normal or slight high TGY 200—2000 C:T ratio = variable	Similar to other type IV but TGY lower	Cholesterol 250—350 TGY 500—5000 C:T usual >0.15:1.0 and <0.60:1.0
Similar to other type II sera	Moderate to very turbid, frequently faint creamy layer, depends on TGY level	Moderate to very turbid, no creamy layer	Similar to other type IV	Creamy top layer turbid infranatant
Similar to other type II patterns	↑Lipoprotein intermediates (β-migrating lipoprotein of LVLDL)	↑VLDL (no ↓VLDL and no chylo)	↑VLDL (no ↓LDL and no chylo)	↑VLDL ↑Chylomicrons
Similar to other type II patterns	Broad β and pre-β bands (may have chylo)	Dense pre-β band	Same as other type IV	Dense chylomicrons, β and pre-β bands
Approximately 1/3 of men age 25—45	Adult (over 20 and before 35 in men — 10—15 years later in women)	Adult and ages 20—30; uncommon in children		Early adult but ages 10—20
Environmental	Less common than II and IV	Probably most common type	Environmental	Uncommon
National dietary hyper-cholesterolemia: Dietary pattern of 40% of calories from fat, predominantly saturated fats; and cholesterol of 600—1000 mg/day Smoking Psychic stress	Predominantly familial, probably transmitted as auto-somal recessive trait. (Presumptive heterozygotes may actually have type IV)	Primary — affects ½ of parents or siblings By obesity, alcohol, and stress	Possibly provoked by obesity, excess carbohydrates, and alcohol	Transmitted as recessive trait. Deficiency of lipoprotein lipase or may be normal (Adipose and muscle cells unresponsive — and delay or don't remove all glyceride-rich particles)
	May be block in intra-vascular degradation of VLDL to LDL 40% have carbohy-drate intolerance and uricosemia Fat intolerance may be slight abnormal	VLDL particles over produced by liver or poorly cleared at periphery 70% carbohydrate intolerance 40% uricosemia	Approximately 50% of carbohydrate in American diet is sugar Alcohol part of social pattern	Carbohydrate intolerance increasing with age Uricosemia
	Hypothyroidism, dysgammaglobuli-nemia, multiple myeloma, diabetic acidosis	Hypothyroidism, diabetes, pancreatitis, nephrotic syndrome, pregnancy, glycogen storage disease, Werner's syndrome, acute or chronic, alcoholism	Female sex hormones may cause type IV (Estrogen can cause excess TGY in type V with abdominal pain — Progesterone alone may be therapeutic)	Alcoholism, hypothy-roidism, nephrosis, diabetic acidosis, pancreatitis, glycogen storage disease
Similar to other type II patterns	Tuberoeruptive xanthomas, on extensor surfaces and buttocks Tendon xanthomas in ages 30—40 (meta-carpals and achilles) Planar xanthomas — orange-yellow deposits in palmar and digital creases Xanthelasma Corneal arcus Premature cardiovascular disease — ages 40—50	When TGY exceeds 1000: lipemia retinalis, eruptive xanthomas (common in showers over buttocks — small red orange elevations), hepatosplenomegaly, abdominal pain, premature corneal arcus, Premature vascular disease	Similar to other type IV patterns	Obesity, abdominal pain (abdominal scars may be present), pancreati-tis, lipemia retinalis, eruptive xanthomas

according to intake and nonrenal losses. The hormonal system (renin, angiotension, and adrenal mineralocorticoids) and the kidney are the key factors in the physiologic regulation of blood pressure, and there is considerable variability, genetically determined, within this control system (see below, Congestive Heart Failure; Hypertension).

POTASSIUM

Metabolism. Whereas sodium is distributed extracellularly, particularly in the ground substance and the circulation, 90% of the body's potassium is found intracellularly. Of the remaining 10%, most (7.6%) is in bone; 1.4% is in the two phases of extracellular fluid, plasma, interstitial fluid, and lymph; and the remaining 1% is in transcellular fluids. To maintain potassium balance the body must ingest and excrete equal amounts. The usual daily potassium intake of 40–100 mEq is normally cleared daily. The kidneys excrete 40–90 mEq/day, 5–10 mEq leave via the feces, and sweat accounts for less than 5 mEq/day. A negative balance may not reflect true potassium depletion or deficiency since the quantity of potassium within the cells is related to protein and glycogen levels. Consequently, if potassium loss is balanced by protein and glycogen losses (loss of potassium capacity), the quantity of potassium per unit cell mass remains the same. On the other hand, if potassium loss occurs without equivalent losses of protein and glycogen, the intracellular potassium falls and true potassium deficiency ensues. The kidney's ability to conserve potassium is limited (in contrast to its action with sodium). Even with zero potassium intake, the urine continues to have 5–20 mEq/day. Potassium depletion thus results if intake is below 5–20 mEq/day or if extrarenal losses (vomiting) are large.

Potassium and the Heart. Besides its role in electrolyte balance, one of potassium's prime functions is to maintain the excitability of nerve and muscle tissue by maintaining the proper resting membrane potential. This varies depending on the ratio of intracellular to extracellular potassium. Generally, hypokalemia leads to increased resting potential or sluggishness and varying degrees of weakness, whereas hyperkalemia leads to decreased membrane potential and an increased state of excitability. The effects of abnormal membrane potential on cardiac muscle and on depolarization and repolarization are usually manifested in a characteristic sequence in ECG

tracings. Cardiac arrhythmias are common with either hyperkalemia or hypokalemia, ranging from extrasystoles and the gamut of tachycardias to block or cardiac arrest, or both. Hyperkalemia produces arrest in diastole whereas hypokalemia produces arrest in systole. In the presence of hypokalemia, digitalis toxicity can result even from relatively low doses. Although it does not affect serum potassium levels, propanolol along with potassium may overcome acute digitalis toxicity, the effects being additive.

Hyperkalemia. Hyperkalemia occurs when the excretion rate is less than the intake. This can occur if there are disorders of the mechanisms that normally rapidly clear dietary potassium from the plasma, such as varying degrees of renal insufficiency. Likewise the injudicious use of potassium-sparing drugs can produce this even with borderline renal insufficiency.

Minimal hyperkalemia usually responds to manipulation of dietary potassium and sodium or to withholding potassium-sparing diuretics. Moderate or severe hyperkalemia requires immediate therapy with calcium, glucose and insulin, sodium bicarbonate, hypertonic saline, cation exchange resins, or dialysis; the prime object is to antagonize the cardiac membrane effects of hyperkalemia.

Hypokalemia. Hypokalemia may occur as a result of: 1) insufficient intake (*e.g.,* malnutrition, anorexia, malabsorption); 2) extrarenal loss (*e.g.,* vomiting, diarrhea, malabsorption syndromes); 3) renal loss (*e.g.,* organic nephropathies, hypercorticoidism, metabolic alkalosis, diuretic therapy); or 4) others (*e.g.,* parenteral alimentation with glucose, protein hydrolysates or amino acids, dialysis).

Patients on long-term diuretic therapy are often encouraged to increase their intake of potassium-rich foods. Although this approach may suffice in some cases, patients treated with diuretics may need 40–60 mEq potassium daily in addition to their ordinary diet. Since the usual dietary intake of potassium may be in the range of 80 or more mEq, the bananas or orange juice needed to supplement this would add a caloric and economic factor, besides which those with the most severe potassium problems frequently have poor appetites and cannot therefore compensate for urinary losses by dietary means. In these instances supplemental potassium therapy can be used. Administration of potassium chloride is usually the treatment of choice since hypochloremia almost always accompanies po-

tassium deficiency. However, there are numerous adverse reactions to all potassium supplements, specifically, complaints of the poor taste, abdominal cramps, nausea, diarrhea, vomiting, and the GI ulcerations from slow-acting preparations. Furthermore, supplemental potassium therapy doesn't always increase serum potassium levels, and the dose must be individualized. Also, the renal system needs 2–3 weeks to adapt to large increases in potassium load. Consequently, an attempt to correct a marked deficiency rapidly will result in positive potassium balance and varying degrees of hyperkalemia. Therefore, particularly if a large supplement is required to maintain a proper serum level, potassium-sparing diuretics are more convenient and generally better tolerated than larger doses of potassium chloride. These preparations are likewise rather definitely preferred when aldosterone levels are high (as in CHF). Patients on long-term diuretic therapy for edema may have low body potassium despite supplements, and the effect of larger doses of potassium are often not appreciable; it is questionable if they are even sustained.

CARBOHYDRATES. The influence of carbohydrate on serum lipids, especially triglycerides, depends on a number of factors. However, convincing studies in regard to sucrose *per se* can be found in equal numbers both implicating and exonerating it in the pathogenesis of atherosclerosis and CAHD. Thus the significance of an increased intake of refined sugars on the development of CAHD remains unsettled. There seems to be a very individualistic variability in lipid response to carbohydrate feeding, and interchanging certain sugars for starch seems to cause significant changes in lipids only in certain individuals.

Impaired glucose tolerance, with or without overt diabetes, has been found to be associated with CAHD, but it is not known how much risk is contributed by hyperglycemia *per se* and how much by the frequently coexisting conditions of hyperlipidemia, obesity, and hypertension. Although diabetics have about twice the incidence of arteriosclerotic vascular disease as nondiabetics, there is no definitive relationship between the degree of hyperglycemia and cardiovascular risk or any firm evidence supporting the idea that lowering blood sugar lowers risk of CAHD deaths in diabetics.

Hodges' studies, Keys, and others support the view that a high intake of simple sugars is accompanied by an increase in cholesterol and other fats in blood and that, conversely, a high intake of complex carbohydrates is accompanied by a decrease in cholesterol and lipids in the blood (1). Also the complex carbohydrates have a greater satiety value. An interesting study from Iowa (9) indicates that the intestinal mucosa plays a key role in the etiology of carbohydrate-induced hypertriglyceridemia as well as being a direct or indirect contributor to plasma triglyceride and cholesterol levels in the absence of dietary lipids. When the gut mucosa was bypassed, carbohydrate-induced hypertriglyceridemia did not occur, and both triglyceride and cholesterol levels decreased greatly. This would explain lowering of triglyceride and cholesterol levels when the patient is fed intravenously with glucose solution.

SECONDARY AND SUPPORTIVE NUTRIENTS INVOLVED

COFFEE. Some studies show a relationship between the development of acute myocardial infarction and the intake of coffee—not that coffee can cause a myocardial infarct, but that there is some association. However, there is considerable controversy over the subject and no conclusion has been reached (5, 14). Coffee, however, is a stimulant and certainly can cause irritability, insomnia, increased cardiac rate, and arrhythmias of various types in susceptible individuals.

MINERALS AND TRACE ELEMENTS. Relationships between several minerals and cardiovascular disease have been investigated and proposed, but at present there is no proof of any of the linkages, with the exceptions of the apparently real but unexplained excess of cardiovascular disease in soft-water regions and the possible relationship of cadmium and hypertension. A few minerals bear separate mention.

Calcium. Increased calcium can cause increased contractility, extrasystoles, and idioventricular rhythm. These responses are accentuated in the presence of digitalis. Severe calcium toxicity can produce cardiac arrest in systole. A low concentration of calcium diminishes contractility of heart and prolongs S–T segments. Absorption of calcium requires the presence of fat in diet, although at very high levels of fat, absorption of calcium is depressed. Similarly, for optimal absorption of fat, some calcium is required.

Magnesium. Magnesium seems to play an important role in CAHD, particularly by its metabolic effects in the maintenance of the functional and structural integrity of the myocardium at the cellular level. It counteracts the adverse effects of excessive intracellular calcium and is essential for normal metabolism of potassium in man (retaining intracellular potassium) (25). It may very well protect against the effects of myocardial ischemia, and it helps the myocardial cell resist other cardiotoxic agents and maintain normal rhythmicity of the heart.

Chromium. In animals, chromium deficiency seems to play a part in carbohydrate and lipid metabolism causing impairment of glucose tolerance and—in rats—an increased incidence of atherosclerosis and diabetes. The evidence for an association with atherosclerosis in man is incomplete, and if one exists, it is by an indirect route. It is noteworthy that refined sugars (and flour) contain almost no chromium, and whereas any sugar causes mobilization of human chromium with resultant loss in the urine, unrefined sugars contain enough chromium to replace the losses. Some studies (11) have shown deficiencies in tissues of heart attack victims, but no conclusions can be drawn as yet.

Zinc and Copper. A recent paper (15) relates increased zinc:copper ingestion with hypercholesterolemia. Consumption of increased amounts of sugar and soft water with a decrease in vegetable fiber intake and a lack of exercise increases the ratio of zinc:copper available for absorption from the GI tract. The resultant increase in the zinc:copper ratio of body stores or the change in amounts of these elements in certain organs causes a rise in serum cholesterol. Earlier studies have diametrically opposed this theory, but it will be worthwhile to follow future research.

Vanadium. Vanadium may have a protective effect by influencing lipid metabolism (24). Vanadium is found mostly in bread, grains, nuts, and vegetable oils; levels in milk, meats, and certain vegetables are low.

Manganese. In animals manganese deficiency supposedly causes disturbances in lipid metabolism (10).

Cobalt. Some synergistic relationship may exist between the toxic effects of cobalt and ethanol in the congestive heart failure of "beer-drinker's cardiomyopathy."

VITAMINS

Vitamin A. Although vitamin A has no effect on atherosclerosis, some people on cholesterol-reduction diets are inclined to limit their intake of foods containing vitamin A and consequently may develop a vitamin A deficiency. If they used as much margarine as they formerly used butter, they would obtain an abundance, but there seems to be a tendency to omit table spreads entirely. Similarly, elimination of egg yolks, liver, and other organ meats from the diet further reduces the intake of vitamin A. This can readily be compensated for by eating adequate salads and the yellow and green vegetable group.

Nicotinic Acid. Large doses of nicotinic acid (not nicotinamide) reduce serum levels of cholesterol, B-lipoproteins, and triglycerides, but prolonged use may result in gastric irritation and possible liver damage. The usual dosage is 3–6 g/day.

Thiamin. Chronic deficiency of thiamin can of course lead to beriberi heart disease (see Chs. 3, 13). Suffice it to say here that the therapy consists first in reducing the cardiac overload.

Vitamin C. Vitamin C or ascorbic acid is believed to play a part in cholesterol metabolism, although as yet this is not well defined and clinical evidence often conflicts with laboratory evidence. To discuss the hypothetical protective or curative effects of high doses of vitamin C on the cardiovascular system would be premature. To date there has been conflicting as well as inconclusive evidence and some poorly controlled studies, both pro and con.

Vitamin E. Vitamin E therapy must still be regarded as experimental, and to date one must say that massive doses of vitamin E are useless in the prevention or treatment of CAHD. It does seem clear that when polyunsaturated fatty acid intake supplies only the minimal needs for health, relatively little vitamin E is required. Increasing the levels of unsaturated lipids in the diet, which in turn increases the levels of polyunsaturated fatty acids in the various tissues at different rates, does increase the requirement for vitamin E (7).

Vitamin K. Anticoagulant therapy with coumarin drugs affects vitamin K and may result in bleeding at various sites, most commonly at predisposed sites, *e.g.,* ulcers, hidden carcinomas.

ALCOHOL. Alcohol can cause a spectrum of cardiac problems, including the production of arrhythmias (*e.g.,* premature beats, simple tachycardias, supraventricular tachycardia, or auricular fibrillation), cardiac enlargement, and frank heart failure. It was believed that this was due to a vitamin deficiency or other malnutrition and indeed beriberi heart disease may occur in alcoholism, but the latter is very rare.

The toxic effect of alcohol is demonstrated by coronary sinus catheterization studies, which show increased potassium, phosphatases, SGOT, and a change in the substrate from free fatty acids to triglycerides. This occurs regularly when blood alcohol levels are 200 mg or more for longer than 2 hours.

One fifth (25.6 ounces) of scotch contains 2200 Cal, and an alcoholic who consumes this amount daily will find it difficult to obtain sufficient protein, vitamins, and other minor food substances. The lack of these is definite, but the effects of these deficiencies on the heart *per se* are not known except in the case of thiamin chloride.

FIBER. Recently there has been renewed interest in the question of dietary fiber. There is some experimental evidence that dietary fiber plays a role in the prevention of cholesterol gallstones and in the control of obesity. Currently at the Wistar Institute controlled studies are being done to try to clarify the effect of fiber on lowering serum cholesterol, or triglycerides, or both (8, 19). At the present time all that is known is that dietary fiber is an important component of food which helps prevent obesity because the high bulk plant materials, though comparatively low in calories, produce a feeling of fullness.

ENZYMES. A recently–propounded theory implicates the enzyme xanthine oxidase of bovine homogenized milk as being the etiologic agent for the development of the initial lesion of atherosclerosis (22). Currently there is no available scientific data to support this hypothesis.

THERAPY OF HYPERLIPOPROTEINEMIAS. Major differences exist regarding specific treatment for the individual types of hyperlipoproteinemias. Different diet patterns and medications are suggested for various hyperlipidemias, but in all cases the emphasis is, first, on attaining ideal weight while the underlying illness and—if any exist—secondary causes are treated, and, second, on treating specifically the elevated lipoproteins (*e.g.,* cholesterol, triglycerides, or chylomicrons). Table 15–3 summarizes these

differences (1, 18, 21), and Table 15–4 gives a suggested pattern for practical use.

THERAPEUTIC RECOMMENDATIONS FOR SPECIFIC CLINICAL CONDITIONS SECONDARY TO CAHD

ANGINA AND PREINFARCTION ANGINA

The nutritional therapy for angina consists primarily in restricting calories to attain ideal weight, prescribing small—perhaps frequent—meals and controlling hyperlipidemia. The diet therefore should be low in calories, total fat, saturated fat, cholesterol, and carbohydrates; amounts of polyunsaturated fat should be specified. Measurement of calories and triglycerides should be repeated at specified intervals to determine whether or not the diet has been successful in lowering the triglycerides in the serum. If diet has not produced expected results, further characterization of the lipoproteinemia must be done before more specific dietary instructions can be given. Some patients with stable angina pectoris have pain after eating or when walking after eating. In these patients small portions are indicated; at times it is wise to prescribe nitroglycerin before eating.

ALCOHOL. Alcohol in moderation may be helpful but only as a sedative (rather than as a coronary dilator—no prevention of S–T abnormalities is demonstrated in exercise tests). It adds to caloric intake and will be a problem especially if there is an elevated triglyceride level; and although it may increase cardiac output in a healthy individual (mostly by increasing heart rate), in cardiac patients output tends to decrease. Further, alcohol is occasionally associated with arrhythmias.

ACUTE MYOCARDIAL INFARCTION

METABOLIC EFFECTS. Nutritional therapy for the individual with the diagnosis of acute myocardial infarction must take into account the metabolic sequelae. These changes vary temporally and from individual to individual. However, there does seem to be a common pattern and approximate temporal sequence for the occurrence of such metabolic effects. The clinical history, related conditions, nutritional status (including special diets), and prior drug therapy all play a part and must be evaluated in relation to the possible metabolic changes. Drugs used prior to or during the episode, *e.g.,* sympathetic amines, α or β adrenergic blockers, barbitu-

TABLE 15—3. Dietary Rx of Hyperlipoproteinemias (Variations in Recommendations)

Composition of diets	I	II A (endogenous)	II B (exogenous)	III	IV	V
Calories	First aimed at decreasing to ideal lean weight and maintenance to hold					
Cholesterol mg/day	60—100 mg to no restrict	100—300 mg (low)	100—300 mg (low)	100—300 mg (low)	100—300 mg (low)	60—500 mg
Fats†	12—20 (very low fat)*	20—35	20—35	20—40	20—35	12—30
Saturated fat†	5.3 to "kind of fat not important"	4—7.6	4—6.1 to those not specified	4—7.6	4—7.6	5.3 to "kind of fat not specified"
Polyunsaturated fat†	8.1 to "kind of fat not important"	8—13 (high)	8—13 (high)‡	8—13 (high)‡	8—13 (high)‡	8.1 to "kind of fat not specified"‡
P:S ratio	Not specified	1.5:1—3.0:1	± 1.9:1	1.2:1—2.4:1	1.0:1—2.4:1	0.5:1—1.5:1
Carbohydrates†	65—75 to no restrict	50—65 to no restrict	40—65 concentrated sweets restricted	40—65 concentrated sweets restricted	40—55 concentrated sweets restricted	45—70 concentrated sweets restricted
Protein†	15—20 to no limit	15—26 to no limit	15—26	15—26	15—26	15—25
Alcohol	None to "not recommended"	Not recommended if weight control	Not recommended or two 1½-oz drinks whiskey/day	Limit to two 1½-oz drinks whiskey/day	Limit to two 1½-oz drinks whiskey/day	Not recommended

*Very low fat but enough for fat-soluble vitamins and essential fatty acids, with extreme decrease of long-chain fatty acids and medium-chain triglycerides
†Percent of total calories
‡NIH diets do not specify percentage of polyunsaturated fat but do state that polyunsaturated fats are recommended

TABLE 15—4. Dietary Rx of Hyperlipoproteinemias

Composition of diets	I	IIA (endogenous)	II B (exogenous)	III	IV	V
Calories	First aimed at decreasing to ideal lean weight and maintenance to hold					
Cholesterol mg/day	All less than 300 mg with further restriction if results not adequate					
Fats*	15	27	27	30	30	18
Saturated fat*	4	5	5	6	7	5
Polyunsaturated fat*	6	12	12	13	13	7
Monounsaturated fat*	5	11	10	11	10	6
P:S ratio	1.5:1	2.4:1	2.4:1	2.1:1	1.8:1	1.4:1
Carbohydrates*	70	50	48	45	43	58
Protein*	15	23	25	25	27	24
Alcohol	None	Recommend none, but maximum if any of 60 cc/day			None	

*Percent of total calories

rates, and thiazide derivatives, may influence carbohydrate metabolism or insulin secretion, but heparin elevates serum free fatty acid levels by triggering the release of lipoprotein lipase. Naturally, consideration must be given to the patient's immediate condition, the extent of myocardial damage, and the existence of shock, acidosis, or both.

The approximate temporal sequence following infarction includes:

1. Metabolic acidosis occurring in the first 12 hours (the severity of which seems related to higher mortality due to hypotension and arrhythmias)

2. Increased sympathetic activity with elevation of serum adrenal medullary hormones and urinary catecholamines for the first 24—72 hours

3. Increased serum-free fatty acids occur at the time of infarction but rapidly decrease in the first 12—24 hours, followed by a gradual return to normal over the next 48 hours

4. Decreased serum total fatty acids from the 1st to 5th day

5. Increased plasma hydrocortisone

6. Decrease in serum cholesterol from the 2nd to 17th day, followed by an increase to normal in 4—8 weeks

7. Hyperglycemia of variable onset and duration
8. Depressed glucose utilization found by IV glucose tolerance test for the first 48 hours
9. Hyperinsulinemic response to IV glucose load during 6th–14th day
10. Elevation of growth hormone level in some patients in the initial 4 days of infarction.

NUTRITIONAL THERAPY FOR ACUTE MYOCARDIAL INFARCTION. The metabolic distinctiveness of each patient sustaining an acute myocardial infarction precludes any predefined formula for nutritional care. However, remembering that the nutritional plan should be regarded as part of the total patient care plan to be implemented from the time of the patient's admission to the coronary care unit (CCU) through full recovery, discharge, and follow-up care, the preceding information may be used as a base.

During the acute phase, nutritional therapy should consist of nothing by mouth until physician evaluation has determined its safety. Generally, IV solutions are given (if for no other reason than to have them running in case of need for rapid drug administration). During the first 24 hours and possibly longer, especially if serious arrhythmias exist, diet should be liquid with only small amounts given at a time, to a total of 1000–1500 ml/24 hours, representing 500–800 Cal. (Foods may include clear soups, broth, skim milk, fruit juices, decaffeinated beverage, weak tea, ginger ale, and water; unless specified, soups and broth may contain undue amounts of sodium, especially for the patient with incipient or frank congestive failure.) Patients should be allowed to feed themselves unless physically handicapped (iatrogenically or otherwise).

During the subacute phase, after the first 24–48 hours, the patient should be considered for dietary progression. Intake at a caloric level of 1000–1200 Cal should fulfill basal metabolic requirements and supply optimal levels of essential micronutrients without increasing oxygen uptake. Approximate proportions should be: protein 20%; carbohydrate 45%–50%; fat 30%–35% (low saturated fat with polyunsaturates as the primary source of dietary fat). Cholesterol should be limited to 300 mg/day. Moderate sodium restriction is a good precautionary measure, taking into account the patient's clinical status, associated illness, and medications administered. Potassium content of the diet likewise may need attention. Beverages should be served within the limits of allowed total intake, continuing to avoid extremes in temperature and stimulants. Caffeine, being an active stimulant to many, may precipitate extrasystoles or other arrhythmias. The patient must be questioned to avoid abdominal distention suffered by those intolerant to milk (lactase deficiency, especially in Black and Asian populations), excessive amounts of fruit juices, and carbonated beverages (use apple juice or fruit nectars). Small, frequent meals cut down the possibility of postprandial dyspnea or pain, which coincidentally may contribute to a cholesterol–lowering effect of the diet. The foods should be easily digested and free of gastric irritants. Soft, low roughage foods are preferred, such as cooked cereals, simple puddings, gelatin desserts, plain breads, cooked or canned vegetables and fruits, as well as lean portions of meat, fish, or fowl. A cholesterol-free egg substitute should be used in place of eggs. Yogurt or low-fat cottage cheese may be used for those intolerant of milk as one way of getting easily digestible protein.

During the rehabilitative phase the patient becomes able to engage in moderate activity, and a greater choice of foods can be used. The principle of the fat-controlled diet still applies, and sodium must still be restricted. At this stage caloric intake is adjusted to maintain or achieve optimal weight, remembering that the patient may be relatively inactive for the next 2–3 months.

The most effective dietary recommendations can, of course, only be made after determining cholesterol levels, triglyceride levels, and—perhaps—lipoprotein electrophoretic patterns. Lipid determinations are frequently performed shortly after an acute myocardial infarction, but their interpretation is fraught with hazard. Prudence would indicate sampling again at 6 months and 1 year after the myocardial infarction before diagnostic inferences are firmly drawn. However, the odds are that a patient with a myocardial infarction also has a lipid abnormality, and it is better to so treat him than to assume the opposite and take a "do nothing" attitude.

During his hospital stay the patient and his family should be taught the principles governing his particular diet. The hospital tray can be an important educational tool. With some dietary thought and imagination, the dietitian can use it to demonstrate various ways different foods can be combined or flavored to make tasty, attractive, and satisfying meals.

To be effective, the patient's new dietary regimen must become a way of life, and it is vital that he get all the support and encouragement the hospital staff can give. Physicians and nurses should adopt a positive attitude toward the new diet.

CONGESTIVE HEART FAILURE

METABOLIC EFFECTS. Congestive heart failure (CHF) is a disorder of the cardiovascular system caused by the failure of the heart as a pump. It may be the end result of a wide variety of different types of heart disease and therefore might be considered a "functional diagnosis." The etiologic diagnosis must be made separately (*e.g.,* rheumatic, hypertensive, arteriosclerotic, CAHD, or cardiomyopathies). It may be acute, or chronic, or left or right sided. These divisions, although often helpful, are also arbitrary and may coexist.

In CHF the weakened myocardium fails to maintain an adequate cardiac output to propel the blood through the circulatory system. As a result, a disporportionate amount of blood stagnates in that part of the vascular system returning blood to the weakened side of the heart, be it right or left. There is an increase in the filling pressure of the respective ventricles, and backward as well as forward failure occurs. The increased venous pressure counteracts the normal capillary fluid shift mechanism, and fluid diffuses through the walls of the blood vessels into tissue spaces of the various parts of the extracellular fluid compartment of the body (*e.g.,* lung, liver, peripheral tissues). The decreased cardiac output affects renal hemodynamics by reducing renal blood flow and pressure, and this in turn sets off the hormonal factors and releases renin, which combines with angiotensinogen to produce angiotensin I and II. The latter stimulates the adrenals to put out more aldosterone, which increases sodium reabsorption in the ion exchange process that goes on in the distal tubules of the nephron. Consequently, water absorption increases, and a vicious cycle begins whereby there is increased sodium and water retention in the tissues, weight gain, edema, and peripheral congestion. Many gaps in our knowledge remain to be filled before there is a unified concept of the mechanisms of salt and water retention in congestive failure, but unquestionably the aldosterone–renin–angiotensin system is active. Likewise, the so-called extraadrenal sodium-retaining factor, or factors, play a part, as when cardiac stress and reduced renal flow cause release of vasopressin, the antidiuretic hormone from the pituitary gland that stimulates water reabsorption in the distal tubules of nephrons.

THERAPY. Digitalis and diuretic drugs are the principal medications used to increase the strength and efficiency of the myocardial contraction and to reduce the abnormal retention of sodium and water (see Table 15–1). These drugs themselves create nutritional problems in regard to sodium and potassium (see sections on Sodium; Potassium) over and above those inherent in the congestive failure process itself. As a consequence, a true juggling act is necessary for the proper regulation of the patient with this problem. The patient must be involved in his own therapy since it involves drug therapy, activity restrictions, and dietary restrictions.

Sodium. The patient with acute congestive failure should be restricted to 500 mg/sodium, 22 mEq sodium (1.3 g salt/day). Later, titration of the sodium restriction, the patient, and his other therapy will usually lead to settling on a dietary level of 1000 mg, = 43.5 mEq sodium/day. Because of their long-acquired taste for salt, many people balk at even this restriction by not eating, and as a result higher levels of sodium with higher doses of diuretics must sometimes be allowed. Frequently, using digitalis and spironolactone to counteract the secondary hyperaldosteronism, patients can be controlled without diuretics if they merely follow the dietary regimen properly. It would certainly be folly to allow upwards of 2000 mg sodium/day in anyone who has or has had congestive failure. The possible deleterious effects of any of the diuretics far outweigh those of a 2000 mg sodium diet. Depletion of salt occurs particularly in elderly patients on marked sodium restriction and must be watched for; it is manifested by weakness, lassitude, anorexia, nausea, vomiting, mental confusion, abdominal cramps, and aches in skeletal muscles. Unfortunately, these symptoms differ little from those of digitalis toxicity in this group of people.

Salt Substitutes and Seasoning. All available salt substitutes are potassium salts, and since these generally taste of potassium chloride, they are only grudgingly accepted by most patients. Some have additional seasoning to make them more palatable. In cooking with these substitutes, the high concentration of potassium frequently ruins the taste of certain foods, and some items taste better when the substitute is added after cooking. However, the most important thing to remember when preparing foods for low-sodium meals is that the other seasonings and spices must be added in far greater quantities than usual (4 to 6 times the amount called for in the recipes). Properly used in various combinations, Italian herbs, thyme, sage, oregano, rosemary,

tarragon, dry chives, dill weed, garlic powder, onion powder, curry powder, and ginger powder (the powders, not the salts) can disguise a sodiumless dish so that even a dyed-in-the-wool salt lover will forget to add salt to it. In seasoning meats, or anything with sauces, small amounts of lemon juice serve to bring out the flavor. Wine, white or red, likewise adds to the flavor of almost any meat, fish, or fowl dish.

Specific Diet Patterns. Specific sodium content of food can be found in Table A-5. For daily dietary patterns for sodium-restricted regimens, consult the American Heart Association pamphlets (500 mg, 1000 mg, and Mild Sodium Restriction—EM 380, 380A, 380B) or your local Heart Association. The diet should fit the individual as regards age, ethnic, economic, work factors, or differences in personal idiosyncrasies of likes and dislikes. Above all else, the patient and his family should know why he must follow such a restricted sodium regimen and what foods are high and low in sodium. Read labels every chance you get. Dietitians, particularly at your local hospital or Heart Association, can be of help.

Fluid Intake. Fluid intake for the patient with congestive failure need not ordinarily be restricted. In fact, the fluid intake may enhance diuresis. Up to 2500–3000 ml/day can be allowed. However, if the sodium intake is reduced to about 200/mg day or if there is especially active diuresis, dilutional hyponatremia may occur. This leads to lowering of extracellular sodium concentration while total body sodium remains excessive. Since there is refractoriness to diuretics, restriction of fluid is urgently needed rather than administration of added salt.

Protein. There is no reason for a drastic reduction of protein, but neither should it be high since the effect of the specific dynamic action of protein places an extra demand for energy on the heart.

Caloric Restriction. Obesity can be a handicap to the circulation and respiration, and it may become a serious factor in congestive failure due to elevation of the diaphragm, decrease in lung volume, and change in position of the heart. Adiposity of the cardiac muscle may be another factor resulting in inadequate myocardial function, and certainly obesity increases the work of the heart during exertion. Therefore, the diet should be low in calories to eliminate excess weight and maintain cardiac work at as low a level as possible. In fact, undernutrition at this point is not bad from a cardiac standpoint as such a state decreases bodily consumption of oxygen with resultant decrease in cardiac work.

The nutritional intake for the patient with congestive failure must be adjusted to maintain dry body weight at normal or slightly below normal levels. There should be frequent small feedings to prevent fatigue and dyspnea. Meals should be well balanced, light, nutritious (perhaps bland and low residue in the acute phase), eaten slowly, with adequate, easily assimilated carbohydrates, moderate protein, enough fat to meet caloric needs, adequate vitamin content (as restricted diets and anorexia may lead to avitaminosis), and graded restriction of salt. The patient, of course, shares considerable responsibility in the management of his case as the therapy is long term in all 3 modalities: 1) activity restrictions; 2) use of drugs; and 3) changes in life style, eating patterns, and habits.

OVERALL NUTRITIONAL THERAPEUTIC RECOMMENDATIONS FOR CORONARY ATHEROSCLEROTIC HEART DISEASE

SECONDARY PREVENTION

Underlying the specific therapy directed at the immediate acute problems occurring as a result of CAHD (as already outlined) is the effort to decelerate the atherosclerotic disease process (secondary prevention). The details of this are basically the same as those presented for the type II in Table 15–4, which deals with the therapy of the various hyperlipoproteinemias. These consist of: 1) adjusting caloric intake to attain and maintain ideal weight; 2) limiting total fat calories, achieved primarily by a substantial reduction in dietary saturated fatty acids; 3) increasing polyunsaturated fatty acids so that the polyunsaturated–saturated ratio is in the range of 1.5:1.0 or greater; 4) maintaining a ratio of polyunsaturated to monounsaturated fatty acids of approximately 1.0:1.0; 5) reducing cholesterol to 300 mg/day; and 6) balancing carbohydrates, depending to a certain extent on triglyceride levels but generally getting carbohydrate in a complex form, *e.g.,* bread, cereals, potatoes, and starch, rather than from table or added sugar, or other concentrated sweets.

In most instances these patients are being asked to make modest nutritional life-style

changes. The physician must be cognizant of certain cautions and controversies when prescribing such regimens. He should be aware that more than a modest increase in polyunsaturated fatty acids may be associated with an increase in cholelithiasis in those who are 20 or more pounds overweight, particularly males. The first order is to reduce weight.

Furthermore, in experiments with rhesus monkeys coconut oil, a highly saturated fatty acid, caused deposition of a lot of lipid but relatively little collagen in the intima of arteries. Surprisingly, peanut oil, an unsaturated oil, caused severe atherosclerotic lesions in their aortas and coronary arteries, despite the fact that lipid levels were lower with corn oil (another unsaturated oil) feedings. In theory, peanut oil should have acted like corn oil, protecting from the deposition of lipids. Doubt exists as to the cause of this reaction, which may be the content of arachidic and behenic fatty acids or the arrangement of the fatty acids in the triglycerides of peanut oil. It is not known whether there is any applicability to the clinical situation in man.

Then, too, there has recently been another flurry in regard to trans-fatty acids. From some reportedly poorly designed experiments, the conclusion was reached that a hydrogenated fat containing trans-fatty acids (margarine base stock) was more atherogenic when fed to swine than various cholesterol-containing supplements such as beef tallow, butterfat, or powdered eggs. This conflicts with evidence in the literature and should not be taken seriously.

ELECTROLYTES

Attention to the electrolyte balance is a must in the therapy of CAHD, particularly potassium in reference to arrhythmias and sudden death, and sodium in reference to heart failure, as described in preceding sections. The therapeutic use of magnesium in acute episodes of CAHD may also be well justified.

DRUG-NUTRITION INTERACTION

Finally, with all forms of cardiovascular disease, the physician must be knowledgeable concerning the multiplicity of interactions that exist between drugs and nutrition. Drugs used in cardiology, either as direct cardiologic medications or as supplements to medications, can have a definite effect on nutrition. The most common deleterious effect of all medications is their tendency to produce anorexia, nausea, vomiting, and diarrhea. Although drug-induced nutritional deficiencies can occur with normal food intake, marginal or frankly inadequate diets greatly increase vulnerability. Drugs can also affect nutrition by increased excretion of nutrients in the urine or bile. For example, cholesterol-lowering agents affect the bile, and diuretics decrease body sodium and potassium. Nutrition likewise may alter drug metabolism by affecting the route of metabolism or dose requirements. Doses depend in part on serum albumin (*e.g.,* digitoxin is bound to protein, whereas digoxin is not). A malnourished patient may require larger doses of certain drugs or—more commonly—lesser doses in view of greater liability to toxicity. Some examples are listed:

1. Digitalis and its glycosides can produce anorexia, nausea, and vomiting.
2. Diuretics can cause sodium, potassium, mineral, and vitamin losses.
3. Hydralazine causes B_6 deficiency by binding B_6 and increasing its excretion.
4. Dilantin causes increased plasma cholesterol, triglycerides, and VLDL.
5. Doriden may produce multiple vitamin deficiencies.
6. Clofibrate may induce nausea, and there may be some abnormality in muscle metabolism.
7. Cholestyramine promotes fecal excretion of bile acids and may give vitamin A or K deficiency, or both, since they need bile acids for optimal intake from the intestine.
8. Nicotinic acid can produce abnormalities in glucose metabolism.
9. Antibiotics may change bacterial flora with concomitant effect on vitamin K and may thus complicate anticoagulant therapy.
10. Estrogens cause hyperlipidemia (increasing cholesterol and/or triglycerides).
11. Oral contraceptives, dilantin, and—to some extent—phenobarbitone cause folate deficiency, and megaloblastic anemia may result.
12. Steriods can act as enzyme inducers.
13. Thyroid derivatives increase caloric expenditure and vitamin requirements.

ATHEROSCLEROTIC CEREBROVASCULAR DISEASE

RISK FACTORS

The major variety of stroke is atherothrombotic brain infarction (ABI). The principal precursors

of ABI are hypertension, cardiac abnormalities, dysrhythmias, and advanced occlusive cerebral arterial disease, as evidenced by the occurrence of transient ischemic attacks (TIA). Hypertension, both systolic and diastolic, is far and away the most prevalent, most powerful, and most correctable of these. Even modest blood pressure elevations may affect stroke risk in a deleterious manner.

NONNUTRITIONAL THERAPY

Once an ABI has occurred, medical therapy depends on the presence of paralysis; the ability to talk, move, and feed oneself; and the level of hypertension or existence of other medically important conditions. Physiotherapy, occupational therapy, good nursing care, feeding orally or parenterally, and the therapy of the hypertension are the areas for attention.

Current general medical therapy for TIA is the same as that for CAHD, *i.e.,* cessation of smoking; a balance between rest, recreation and work; and treatment of hypertension and of associated conditions, particularly diabetes. Recently there has been some evidence (6) that altered platelet behavior contributes to the pathogenesis of, and mortality caused by, occlusive arterial disease in man, perhaps in all areas, *i.e.,* peripheral, extracranial and intracranial cerebral, and coronary arteries. As a result, therapy has been directed at increasing survival and decreasing turnover and aggregation of platelets by means of either aspirin, Anturane, or Persantin, alone or in combination. The dangers, of course, are those of gastric irritation, bleeding (particularly from the GI tract), drug sensitivity, or orthostatic hypotension, as in the case of Persantin.

NUTRITIONAL THERAPY

The patient must be maintained in an adequate state of nutrition generally, but at the same time his diet should aid in the lowering of blood pressure. The diet should include low sodium intake —if not contraindicated—along with other measures mentioned in other sections of this chapter in regard to atherosclerosis in general, *e.g.,* cardiac failure, arrhythmias, and caloric restrictions.

In regard to platelets, studies in laboratory animals (12) have shown that arterial thrombus formation is significantly delayed by a high polyunsaturated–saturated fat ratio in the diet and that long-chain saturated fatty acids can both enhance blood coagulation and cause platelet aggregation. Epidemiologic data suggest that individuals on high-fat diets have an increased susceptibility to both arterial and venous thrombosis. Since atherosclerosis is not a feature of the latter conditions, the implications are that diet influences the mechanisms of thrombosis itself. Human subjects given a diet rich in egg yolk and butterfat have a shorter platelet survival and greater platelet turnover (both features of increased coagulation) than those on a low-fat diet or on a diet rich in corn oil. In other studies, (6) when unsaturated fats were substituted in the diet, there was no increased suceptibility to the so-called endotoxin-induced platelet thrombosis.

PERIPHERAL VASCULAR ATHEROSCLEROTIC OCCLUSIVE DISEASE (PVAOD)

DESCRIPTION

Men age 50 or older are those most commonly affected by PVAOD. Many are smokers or have concomitant CAHD or hypertension.

Atherosclerotic changes occur in the intima and media, often with associated perivascular inflammation and calcified plaques in the media progressing on to complete occlusion.

The primary symptom is intermittent claudication, and objectively one finds weak or absent pulses in the lower extremities. Severe restriction of circulation, particularly if there is the slightest trauma to an area, can lead to gangrene.

NONNUTRITIONAL THERAPY

Nonnutritional therapy includes the immediate cessation of smoking. Surgical therapy is considered if claudication interferes with the patient's essential activities or work, the objective being to reestablish blood flow through the narrowed or occluded segment. This is accomplished by sympathectomy, endarterectomy, or both, or even amputation if gangrene is present.

NUTRITIONAL THERAPY

Nutritional therapy is the same as for prevention of further atherosclerosis in the coronary arteries. In type III hyperlipoproteinemia there is evidence that some of this process is reversible with proper therapy.

PREVENTION STRATEGIES FOR ATHEROSCLEROTIC CARDIOVASCULAR DISEASE

The prevention strategies for all the atherosclerotic cardiovascular diseases require a moderate change in life style for most Americans. Granted, the etiology of this disease is not as yet clearly understood, and, consequently, preventive measures are either controversial or poorly defined. Nonetheless, if the current epidemic is to be stemmed, the physician must: 1) identify in his patients and their families the known risk factors that can increase the likelihood of this condition; 2) begin, early, to have all of his patients attempt to prevent the development of such risk factors (this requires an ongoing educational system for patients and their families) (20); 3) keep abreast of almost day-to-day changes in the scientific concepts governing this as well as other fields of medicine; and, above all, 4) discard the "do nothing" policy in regard to nutrition in the prevention of atherosclerosis.

Basically, then, prevention consists of moderately changing nutritional life style (as outlined in section on Secondary Prevention for CAHD), advising avoidance of excessive salt and—particularly—of water-softened water for cooking or drinking purposes, prohibiting smoking, recognizing and controlling hypertension and diabetes, recommending regular exercise (e.g., brisk walking or bicycle riding), and—if possible—decreasing psychosocial tension. There is ample evidence from numerous studies, particularly from the Framingham studies (2), of the interaction of all these factors.

HYPERTENSION

INCIDENCE AND SIGNIFICANCE

Hypertension is a leading cause of morbidity and mortality in this country (10, 17). It is an especially significant cause of death in black Americans. Of the 28,410,000 Americans who have some form of heart and blood vessel disease, approximately 23,000,000 have hypertension (approximately 1 in every 6 adults of the total population). Nevertheless, only 50% know that they have it and only 10%–25% of hypertensive patients are currently receiving effective preventive therapy. Hypertension is uncommon before age 20, but it has been documented as low as age 4. Systolic and diastolic hypertension are of equal importance and are associated with increased clinical atherosclerotic coronary disease, stroke, CHF, and renal failure.

The higher the blood pressure, the greater the severity of atherosclerotic disease.

PRIMARY HYPERTENSION

No etiology can be established in about 85% of hypertensive vascular or cardiovascular disease. This condition has its onset usually between ages 25 and 55 and occurs more commonly in women than men. The family history is usually suggestive (e.g., stroke, sudden death, heart failure). Of significance is that elevations of pressure are transient early in the course but eventually become permanent.

SECONDARY HYPERTENSION

Secondary hypertension is considerably rarer and may arise from renal vascular or parenchymal lesions, endocrine causes, coarctation of the aorta, tumors, toxemias, collagen diseases, and others. Some further divide hypertension into hypertensive vascular disease (when the heart is not demonstrably affected) and hypertensive cardiovascular disease (when left ventricular hypertrophy (LVH), heart failure, or CHD is present).

Elevated arterial pressure is deleterious, as it results in

1. Cardiac failure secondary to increased work of the heart and relative or absolute coronary insufficiency
2. Development of atheromas, especially in the cerebral and coronary arteries, with syndromes resulting from vascular occlusion
3. Acute vascular necrosis resulting from rapid sustained rises of diastolic blood pressure, usually exceeding 130 mm mercury, which produces the complication known as the malignant phase. Renal failure occurs almost exclusively in this last group.
4. Hemorrhagic stroke
5. Dissecting aneurysm of the aorta

NONNUTRITIONAL MODALITIES OF THERAPY OF HYPERTENSION

GENERAL

Treatment of the hypertensive patient as a whole is necessary. The blood pressure readings are important, but so is the general well-being of the patient. Fears, anxieties, and tensions must be allayed. Rest, recreation, vacations, and work loads must be balanced.

SPECIFIC

The first drug of choice is a thiazide diuretic. Then a Rauwolfia drug, methyldopa, propanolol, or hydralazine may be added. Aldosterone antagonists are mildly antihypertensive in effect and will potentiate the effect of the thiazides; they are therefore doubly useful. Propanolol is particularly effective when a tachycardia is a feature of the hypertensive patient's makeup and in this regard is also helpful when given along with hydralazine. The last group of drugs generally to be prescribed are the postganglionic and ganglionic-blocking agents.

By and large, once begun, antihpyertensive agents in proper combination will and should be continued indefinitely. See Table 15–5 for common complications of these drugs.

NUTRITIONAL MODALITIES OF THERAPY OF HYPERTENSION

DIRECT AND PRIME NUTRIENTS INVOLVED

SODIUM

Epidemiology. The average American intake of sodium is about 5 g/day (10–15 g salt). There is certainly no evidence of the essentiality or desirability of this great an intake. In fact, there is a low incidence of hypertension in several primitive ethnic groups where the sodium intake is only 1–2 g/day. In Northern Honshu in Japan where the mean intake is 10.4 g/day (26 g salt), 40% of the population is hypertensive; Japan also has a high death rate from cerebral hemorrhage. Interestingly, in the United States hypertension is more common in soft-water areas, in high rainfall areas (where low levels of calcium and magnesium are commonly associated with increased sodium content), and in areas with high concentrations of sodium in drinking water.

Experimental Hypertension. Dahl (10,17) bred two strains of rats, one highly susceptible to, and the other highly resistant to, salt hypertension. Tobian (17) did some unique kidney-transplanting experiments in which Dahl's rats and some Goldblatt hypertensive rats were used. It seemed clear that the kidneys of salt-sensitive rats had some genetic defect that promoted the acquisition of hypertension whereas this genetic defect was absent in salt-resistant rats, who resisted most forms of hypertension. The inevitable conclusion was that chronic or established essential hypertension is caused primarily by a deranged kidney function, even though this is not visible on tissue sections, and that there will be a greater derangement of some specific component or renal function as life progresses. Consequently, continued high-salt intake speeds up the deterioration of this specific antihypertensive function whereas a low-salt intake may slow it down. Intakes of 3–8 mEq/kg/day induce hypertension in nonselected laboratory rats; lesser

TABLE 15–5. Hypotensive Drugs and Their Complications

Drug	Complication
Oral diuretic agents Thiazides Ethacrynic acid Furosemide	Hypokalemia — may use aldosterone antagonists but avoid if renal function impaired and do not use with supplemental potassium intake. Hyperuricemia and/or hyperglycemia — may require treatment
Aldosterone antagonists	Danger of hyperkalemia, even with concomitant use of potassium-wasting drugs Triamterene may increase BUN and uric acid Spironolactone may give gynecomastia in men and menstrual disturbances or lactation in women
Rauwolfia drugs	Gastric acidity, sodium retention, severe depression Do not use if history of previous depression
Methyldopa	Requires close supervision — can get positive Coombs' test (uncommon hemolytic anemia, fever, postural hypotension, and/or drowsiness)
Propanolol	Bradycardia, increase in asthma, and/or alternation of insulin dosage
Hydralazine	Large doses commonly give headache, palpitation, tachycardia, and/or a syndrome resembling LE, but small doses rarely give special problems
Postganglionic and ganglionic-blocking agents	Postural hypotension, diarrhea, muscle aching, lack of ejaculation, acute hypotensive reactions, acute or progressive renal failure, vascular thrombosis and renal failure in older patients, constipation, dry mouth, and others

amounts induce hypertension in genetically se-lected rats. Early feeding of salt to sensitive rats predisposes to hypertension later. Adding potas-sium to the diet to maintain a sodium–potassium ratio of 2:1 protects against the induction of hy-pertension. Resistant rats tolerate high sodium intakes.

There is some evidence that borderline hyper-tensives may have abnormalities in neurogenic or autoregulatory adjustments to salt excesses since such sodium loading increases intraarterial pressure and potentiates vasoconstrictor re-sponses to neurogenic stimuli but not to norepi-nephrine without altering renin or aldosterone levels. Also, regulation of body potassium in re-sponse to variation in intake is dependent on elements in the sodium control system. Blood pressure is affected by variations in the sodium–potassium ratio in diet as well as the dietary intake of potassium alone.

Treatment in Hypertension. A fantastic development of potent antihypertensive drugs in the last two decades has revolutionized therapy and made it feasible to effectively treat hypertensive patients without the rigid dietary sodium restriction as in the Kempner (rice–fruit) semistarvation diet. However, it is essential to remember, as rein-forced in a recent well-controlled cross-over type study (3), that the effectiveness of these drugs is definitely enhanced by moderate so-dium restriction, *i.e.,* by dropping from the usual 5 g sodium/day (100 mEq) to 2 g sodium/day (40 mEq). Specific instructions to the patient along these lines is particularly necessary be-cause the salt depletion produced by diuretic therapy may otherwise cause him to increase his intake. Depending on the individual response to the antihypertensive agents in regard to blood pressure and relief of symptoms, if they exist, further sodium limitation may be indicated. Limitations rarely extend below 1000 mg sodi-um/day unless, of course, the hypertension is complicated by congestive failure, when further restriction could be required (see Therapy for Congestive Heart Failure section). At this point one can only pause and wonder at the signifi-cance of the fact that the 2 most dramatically effective agents available for therapy of severe acute hypertension (diazoxide and minoxidil) are both sodium-retaining vasodilators or that Lasix and Edacrin, which produce the greatest sodium loss, are less effective than thiazide diu-retics in reducing blood pressure.

Complications of Sodium Restriction. In the course of antihypertensive therapy, with or without so-dium restriction, hypotensive reactions are gen-erally indications for decreasing the dosage of one or more of the drugs rather than for increas-ing sodium intake. Increasing sodium intake can actually aggravate the chronic sodium depletion produced by the diuretics. Sodium restriction in some hypertensives may be deleterious since it decreases the glomerular filtration rate and in-creases BUN and creatinine. Patients with hy-pertension and chronic renal failure are best controlled by the same means, but they often walk a narrow line between excess sodium ex-acerbating hypertension and sodium deficiency with reduction of renal function. Therefore when patients have renal failure, particular care must be used to avoid sodium restriction so se-vere as to cause depletion of their extracellular volume. Interestingly, some patients with severe or malignant hypertension have shown general improvement and lowering of pressure during the administration of saline solution aimed at correcting the severe sodium depletion accom-panying their renal failure (17).

CALORIES. Obese hypertensives have a greater risk of CAHD than the nonobese hypertensives, and mortality rates for obese hypertensives are higher than for those with either obesity or hy-pertension alone. In the Framingham studies (2) weight gain was on the average associated with substantial rises in blood pressure, although there were many exceptions. Normotensive obese persons were often found to develop hy-pertension after some time lag. Lean hyperten-sives seemed to show increased propensity to obesity; the converse was also true. Therefore it was suggested that some third factor might be related to the development of both obesity and hypertension, but more research is needed to elicit the mechanism of blood pressure rise in some obese persons.

Nonetheless it is known that obesity is com-mon in patients with hypertension and that, al-though in most cases reduction of excess weight is not accompanied by more than a mild decrease in blood pressure, in some cases the drop can be striking. Therefore total caloric intake should be restricted in the overweight hypertensive. Fur-thermore, great fluctuations in blood pressure often occur after ingestion of large meals be-cause of decreased efficiency of vasomotor regu-lation in these patients; and in all types of myo-cardial insufficiency, filling the stomach can

result in embarrassment of the heart, which then labors under the double load of hypertension and obesity.

SECONDARY AND SUPPORTIVE NUTRIENTS INVOLVED

POTASSIUM

Potassium loss from diuretic therapy for uncomplicated essential hypertension usually progresses slowly, and even after 2–3 months a total deficit of only 300 mEq might result. Quantitatively this loss is not severe in healthy adults, but with concomitant disease, or other conditions or therapy with potential potassium loss, it could be serious. The same animal model of Dahl's that shows the bad effect of sodium on blood pressure showed that the pressure may be lowered to a more normal level if potassium is increased along with the increased level of sodium in the rat diet. Of course, the best response resulted from simultaneous increase of potassium and decrease of sodium.

POTASSIUM AS PROTECTIVE IN HYPERTENSION. Since natural foods usually contain increased amounts of potassium and decreased amounts of sodium, it is thought that this may explain the low incidence of hypertension in some of the more primitive areas, where natural food is consumed in fairly large quantities.

FLUIDS

Hypertensives should be allowed a normal intake of fluid in the absence of evidence of cardiac or renal insufficiency. Coffee or tea may be permitted unless the patient is, has, or develops nervousness, irritability, insomnia, or arrhythmias.

PROTEIN

There is no evidence that ingestion of protein plays any role in the reduction or aggravation of hypertension. Therefore, there is no reason for rigid restriction as long as the kidneys are able to excrete nitrogen adequately. Moderation in this area, as in the case of all foods in the diet of the hypertensive, is recommended. However, one must always take into account the sodium content of the specific proteins utilized.

CADMIUM

The evidence for a connection between cadmium and hypertension is suggestive. All adult Americans have relatively large concentrations of cadmium in their kidneys. Cadmium accumulates throughout life, but particularly in the first two decades (23). In hypertensive subjects there seems to be an abnormally high concentration of renal cadmium. However, patients with chronic cadmium poisoning show no increased incidence of essential hypertension.

Long-term feedings of low levels of cadmium to experimental animals has resulted in renal cadmium concentrations equivalent to that of the average American adult and has produced hypertension.

It has been suggested that cadmium in the diet in the United States is derived from canned food. In Britain, however, cadmium dissolved from galvanized pipes in soft-water areas has been considered the source of the higher levels found in the ribs of people in sudden death case studies.

CALCIUM

In the experiments on rats and dogs where these animals were fed large amounts of salt and developed hypertension, an excess intake of potassium protected them to a great extent, if not completely; but, conversely, low-calcium diets increased the blood pressure-raising effect of the sodium. In this regard there is some suggestion that hypertension is more prevalent in populations having a low-calcium intake, and one wonders about the relationship between the high incidence of hypertensive diseases in certain low socioeconomic groups, particularly in blacks in the South, and their low intake of milk products and high intake of salt.

THERAPEUTIC RECOMMENDATIONS

Since the treatment of hypertension must be continued indefinitely after normalization of the pressure, the dietary changes must be considered in this light—the patient is not "going on a diet," but he is changing his life style in regard to eating. Nutritional therapy of hypertension, then, means caloric adjustment towards attaining ideal weight, limiting sodium to about 2000 mg/day, and paying particular heed to potassium as well as sodium balance.

PREVENTIVE STRATEGIES FOR HYPERTENSION

The prevention of hypertension and its sequelae requires early recognition (in childhood as well), early initiation of therapy, and continued follow-up of such treatment. The prevention of kidney and urinary tract infections is basic, along with the need to attain proper lean weight and stop (or never start) smoking. Through their propensity to cause glomerulonephritis, streptococcic infections can lead to hypertension; therefore, for the sake of hypertension prevention, it is important to fully treat such infections, just as in the prevention of rheumatic fever.

Although it is still unknown whether salt intake induces hypertension, and in particular whether salt consumption by the general population in this country constitutes a risk, there is no question that increased sodium intake increases the blood pressures of most hypertensive patients, and vice versa. It seems reasonable, therefore, to limit sodium intake to known needs (2500 mg/day), cautioning certainly against the "salt before tasting" habit. For those whose hereditary and genetic makeup predisposes them to hypertension, close following of blood pressure and sodium intake should be the rule.

The use of oral contraceptives has been found to allow early discovery of an inherited risk of developing hypertension. Certainly no female with hypertension should be advised to take these drugs, and oral contraceptives should be stopped promptly if hypertension develops. Those taking such drugs would do well to cut down their sodium intake.

CARDIAC DISEASES OF INFLAMMATORY, COLLAGEN, OR DEVELOPMENTAL ETIOLOGY

RHEUMATIC FEVER, RHEUMATIC HEART DISEASE, AND OTHER ACQUIRED VALVULAR DISEASE

GENERAL DESCRIPTION

Rheumatic fever is a subacute or chronic systemic disease initiated by an infection with group A β-hemolytic streptococcus, which for unknown reasons may either be self-limiting or may lead to slowly progressive cardiac valvular deformity. It is somewhat more common in males, and in urban areas incidence rates are higher among blacks than among whites. The disease has a peak incidence between ages 5–15,

being rare before age 4 or after age 50 (16).

Rheumatic fever is the commonest cause of heart disease in people under age 50, and rheumatic heart disease ranks third behind hypertension and CAHD in overall incidence.

Chronic rheumatic heart disease results from single or repeated attacks of rheumatic fever which produce rigidity and deformity of the valve cusps, fusion of the commissures, or shortening and fusion of the chordae tendinae. Through such a mechanism rheumatic fever is the primary cause of valvular heart disease, the other principal causes being lues, pronounced hypertension, aortic atherosclerosis, and dissecting aneurysm of the aorta. Stenosis or insufficiency, or both, may result, but one or the other predominates. In the order of frequency this may involve the mitral, aortic, tricuspid, or pulmonic valves, or any combination thereof. Combined mitral and aortic disease is common in rheumatic heart disease, whereas aortic insufficiency is most commonly caused by the other conditions mentioned. On the other hand, aortic stenosis of varying degree is often combined with other valvular lesions whose clinical and pathologic features frequently overshadow or obscure those of the aortic stenosis.

It is significant that following the first episode of rheumatic fever in childhood, 33% (and after 10 years, 66%) of surviving patients have detectable valvular disease—usually mitral stenosis—whereas if the disease is contracted in adult years, less than 20% have residual heart damange—and this is generally mitral insufficiency.

The complications of rheumatic and other acquired valvular heart disease may be congestive heart failure, arrhythmias, hypertension, obesity, subacute bacterial endocarditis, or atherosclerosis, including CAHD. Additionally, acute rheumatic fever may be complicated by myocarditis, pericarditis, or pulmonary embolism.

Significantly, disturbances in circulatory dynamics and the symptomology and type of heart failure that occur are determined more often by the valvular lesion than by the disease that produced it. This is not to obscure the fact that the presence of active rheumatic inflammation, the extent of myocardial damage, the association of hypertension, and the interference with coronary blood flow by atherosclerosis or luetic ostial stenosis are vital factors that reduce the heart's ability to tolerate the strain of valvular disease, thus leading to failure.

NONNUTRITIONAL THERAPY OF RHEUMATIC FEVER

The principles of therapy for rheumatic fever consist of bed rest until all signs of active infection have disappeared, the proper use of large doses of salicylates, penicillin to eradicate any streptococcic infections, and—in severe cases—corticosteroids to reverse the acute exudative phase. The salicylate of choice is sodium salicylate, but aspirin must be used if there is any associated CHF. Corticosteroids may also be a problem in the presence of heart failure. Hopefully, these patients do not have associated conditions, such as GI ulcers, that prevent the use of either aspirin, the steroids, or both.

Treatment with digitalis poses a problem in the CHF of acute rheumatic fever as it may increase myocardial irritability, causing arrhythmias, but it may be used with caution. Many cases of CHF in this group are secondary to acute myocarditis, and these respond to ACTH or corticosteroids.

Therapy for rheumatic or acquired valvular heart disease, be it medical, surgical, or nutritional, depends on the symptoms, complications, and underlying causes of the disease, including: 1) vocational guidance, depending on limitations of patient; 2) early recognition of conditions that can serve to bring on other specific complications, e.g., anemia; 3) maintenance of general health and avoidance of obesity and undue physical exertion; 4) avoidance of exposure to streptoccocic infections; 5) prompt and adequate therapy of infections due to hemolytic streptococcus, with consideration of continuous antibiotic prophylaxis in certain patients under age 35, who have been exposed to such infections; 6) advice to patients regarding dental and other surgical procedures to prevent bacteremia and possible subacute bacterial endocarditis (SBE); 7) specific therapy directed at the underlying cause (e.g., rheumatic or luetic inflammation, or hypertension); 8) specific therapy directed at the complications; 9) surgery to correct the valvular defect or to completely replace the diseased or inefficient valve is frequently indicated, depending on the frequency of complications, existing concurrent conditions, and the age and limitations of the patient.

NUTRITIONAL THERAPY OF RHEUMATIC FEVER AND RHEUMATIC HEART DISEASE

It is important to maintain good nutritional health in these diseases, empirically treating the patient with nutrients of high vitamin content. Calories should be adjusted so as to attain ideal, or even less than ideal, weight while yet being adequate to combat the ravages of infections if they supervene (as SBE). Avoidance of obesity can be particularly advantageous in later years by reducing the strain on the heart. Limiting sodium intake to 2000–5000 mg/day is a good early precaution since most of these patients will develop CHF later in life when habit changes are more difficult. Obviously, the complications must be specifically treated nutritionally, as detailed elsewhere in this chapter (e.g., Congestive Heart Failure section).

PREVENTIVE STRATEGIES FOR RHEUMATIC FEVER AND RHEUMATIC HEART DISEASE

The prevention of rheumatic fever entails living, if possible, in stable climates where streptococcic infections are less common; identifying streptococcic infections by early and frequent use of throat cultures; and treating patients immediately, even before the culture report returns, when there is a reasonable index of suspicion. Penicillin, the sulfas, and erythromycin are the effective drugs for acute infection, the first two being used for long-term administration.

The prevention of rheumatic valvular heart disease depends on the effective prevention of rheumatic fever, and the prevention of recurrent attacks requires motivation of the patient to persist with long-term prophylaxis and continued medical care to monitor and reinforce this prophylaxis. Those with valvular disease of any etiology need protection against SBE, given in the form of one of the above antibiotics, prior to any dental or surgical procedure, particularly of the urinary tract.

Nutrition will have its greatest impact in these conditions in the attainment and maintenance of ideal weight with long-term attention to caloric intake and a mild limitation of sodium (2500 mg sodium).

CONGENITAL HEART DISEASE

GENERAL DESCRIPTION

Congenital anomalies of the heart and great vessels are due to arrested or defective prenatal development. There is a multiplicity of such lesions, which may occur either as isolated congenital lesions or as part of multiple structural or

physiologic abnormalities of the body. Congenital cardiac lesions account for about 2% of all heart disease in adults.

NONNUTRITIONAL THERAPY

Prognosis is generally poor for therapy with pure medical treatment except for the atrial or ventricular septal defects. Treatment therefore consists primarily of surgery and the prevention and specific therapy of complications.

NUTRITIONAL THERAPY

Whether children or adults, the patients in this group are subject to many of the same complications found in CAHD, *e.g.,* CHF, arrhythmias, hypertension, and sudden death. Consequently, the medicinal or nutritional therapy would be the same irrespective of basic etiology.

PREVENTIVE STRATEGIES FOR CONGENITAL HEART DISEASE

Hopefully, proper care of the mothers through prevention of rubella with vaccine prior to the first trimester of pregnancy and by the control of their weight, diabetes, and potentially harmful medications during pregnancy, will reduce the incidence of congenital malformations.

Animal experiments suggest that dietary deficiency in the mother may result in congenital malformations (see Ch. 26), but there is no significant evidence of such relationship between vitamin or other nutritional deficiencies and the occurrence of congenital heart disease in man.

CARDIAC DISEASES OF INFECTIOUS, COLLAGEN, OR UNKNOWN ETIOLOGY

BACTERIAL ENDOCARDITIS, ACUTE AND SUBACUTE

Acute bacterial endocarditis is an infection of normal or abnormal valves and is usually secondary to heavy bacteremia from acute infections elsewhere or from the use of "main-line" narcotics.

Subacute bacterial endocarditis (SBE) is a smoldering bacterial infection of the endocardium which is usually superimposed on preexisting rheumatic or calcific valvular or congenital heart disease.

Both acute and subacute bacterial endocarditis can result in arrhythmias, anemia, multiple emboli, severe valvular damage, and CHF.

NONNUTRITIONAL TREATMENT. The best treatment is prevention by means of streptococcic detection in throat cultures and the prophylactic use of penicillin. When the infection exists, various combinations of specific antibiotics in large doses are required. The treatment of complications depends on which complication(s) exist. Anticoagulants, though dangerous, may have to be considered, but they are usually not indicated.

PERICARDITIS—ACUTE, CHRONIC CONSTRICTIVE, OR WITH EFFUSION

ETIOLOGY. Pericarditis may occur in or as a result of infectious agents, collagen disorders, allergic disorders, tumors, uremia, myxedema, myocardial infarction (including postinfarction syndrome), trauma, Reiter's syndrome, or pericarditis following pericardiectomy. Prognosis depends on the etiology, but it is worst in tuberculous chronic constrictive pericarditis.

NONNUTRITIONAL THERAPY. Therapy must be directed primarily at the basic cause and the secondary complications, such as the rare CHF, ascites (in chronic constrictive type), tamponade, hemorrhage due to inflammation, or bleeding due to antecedent anticoagulant therapy.

COR PULMONALE

ETIOLOGY. The etiology of acute cor pulmonale is most often pulmonary embolism, whereas chronic cor pulmonale is due to chronic elevation of pulmonary arterial pressure resulting from pulmonary parenchymal or vascular disease and leading to right ventricular hypertrophy and eventual failure. It is commonly due to chronic obstructive pulmonary disease, such as emphysema, asthma, and bronchitis. Most of its subjective and objective features depend on the primary disease and its effects on the heart. Complications may occur from intercurrent respiratory infections and respiratory acidosis. The prognosis is very poor once cardiac failure supervenes, perhaps 2–5 years.

NONNUTRITIONAL THERAPY. Nonnutritional therapy is generally with antibiotics, oxygen, assisted respiratory excursion (IPPB), and the treatment of heart failure.

LUETIC CARDIOVASCULAR DISEASE

EFFECTS. Lues affects the valves of the heart, primarily the aortic valve and—most commonly —the aorta itself. It is usually diagnosed between the ages of 33 and 55, some 10–20 years after the acute infection. It occurs three times more frequently in males than in females and accounts for less than 5% of all heart disease in population groups with an access to effective therapy (16).

NONNUTRITIONAL THERAPY. Nonnutritional therapy consists of therapy for syphilis and any valvular complications as well as for aneurysms, which occur with some frequency.

CARDIOMYOPATHIES

MYOCARDITIS

Etiology. Myocarditis may occur in or as a result of infectious agents (myocardial disease of obscure origin—the idiopathic cardiomyopathies, hemochromatosis, sarcoidosis, systemic lupus erythematosus, scleroderma, amyloidosis, Fiedler's, storage disease, or endocardial fibroelastosis) or may be induced by drugs, toxic substances, or hypersensitivity reactions.

Nonnutritional therapy. Nonnutritional therapy is directed at the general principles used in cardiac failure and arrhythmias, there being no specific cardiac therapy, except perhaps propanolol or anticoagulants. Certainly if there is a therapy for the underlying cause, this must be taken care of.

HYPERTROPHIC CARDIOMYOPATHY (IDIOPATHIC HYPERTROPHIC AORTIC STENOSIS). Treatment of this is primarily with β-adrenergic blocking agents.

NUTRITIONAL THERAPY FOR CARDIAC DISEASES OF INFECTIOUS, COLLAGEN, OR UNKNOWN ETIOLOGY

The major areas to consider in nutritional therapy for this group are those relating to: 1) good general nutrition; 2) the prevention and/or therapy of iron-deficiency anemias, as found especially in SBE; 3) the prevention and/or therapy of malnutrition (poor caloric and poor nutrient intake) or of overnutrition, the latter controlled by reduction to and attainment of ideal weight by caloric adjustment and the small, frequent meal pattern; 4) the prevention and/or therapy of CHF; and 5) the prevention and/or therapy of electrolyte imbalances.

PREVENTIVE STRATEGIES

The prevention of these diseases ultimately will depend on: 1) maintenance of good general health; and 2) discovery of as yet unknown etiologies.

SUMMARY

Nutritional support is basic to the proper practice of the specialty of cardiology. Such support must come from the knowledgeable physician, from community-based and hospital-based dietitians and nutritionists, from the local Heart Association (all affiliates and chapters of the American Heart Association), and from various industries that have shown their willingness to cooperate in stamping out many of the conditions dealt with here. A continued emphasis on research in this field is a must, and it will not be surprising to find that established "facts" are no longer "facts" at all in the 1980s. At the moment, however, patients should be treated nutritionally on the basis of these current facts. This, along with a good and continuing educational program for the physician, patient, and public will hopefully continue to decrease the morbidity and mortality from this group of diseases.

REFERENCES

1. American Heart Association: The way to a man's heart: EM 455 (51–018). Planning fat controlled meals: EM 288 & 288A (50–017–A & B). A maximal approach to the dietary treatment of the hyperlipidemias: EM 585, 585A, B, C, D (70–017–A,B,C,D,E)
2. American Heart Association: Coronary Risk Handbook: EM 620–PE 1973. Stroke Risk Handbook: 70–007–APE 1974
3. Amery AKPC: Moderate sodium restriction and diuretics in treatment of hypertension. Am Heart J 85:1–22, 1973
4. Bortz WM: The pathogenesis of hypercholesterolemia. Ann Intern Med 80:738, 1974
5. Boston Collaborative Drug Surveillance Program: Coffee drinking and acute myocardial infarction. Lancet 2:1278, 1973
6. Braunwald E(ed): The Myocardium: Failure and Infarction. New York, HP Publishing, 1974, pp 155, 186, 189
7. Briggs GM, Calloway DH, Bogert LG (eds): Nutrition and Physical Fitness. 9th ed. Philadelphia, WB Saunders, 1973, p 213
8. Cummings JH: Progress report: dietary fibre. Gut 14: 69, 1973

9. DenBesten L et al.: High carbohydrate diets given orally or intravenously: effects on serum lipids and fecal steroids. J Clin Invest 52:1384, 1973

10. Goodhart RJ, Shils ME (eds): Modern Nutrition in Health and Disease. 5th ed. Philadelphia, Lea & Febiger, 1973

11. Hambridge KM: Chromium nutrition in man. Am J Clin Nutr 27: 505, 1974

12. Hornstra G et al.: Influence of dietary fat on platelet function in man. Lancet 26:1156, 1973

13. Hurst JW, Logue RB, Schlant RC, Wenger NK (eds): The Heart, Arteries and Veins. 3rd ed. New York McGraw-Hill, 1974

14. Klatsky AL et al.: Coffee drinking prior to acute myocardial infarction: Results from the Kaiser–Permanente epidemiologic study of myocardial infarction. JAMA 226:540, 1973

15. Klevay LM: Hypercholesterolemia in rats produced by an increase in ratio of zinc to copper ingested. Am J Clin Nutr 26:1060, 1973

16. Krupp MA, Chatton MJ (eds): Current Medical Diagnosis and Treatment. Los Altos, Lange Medical Publications, 1974

17. Laragh JH (ed): Hypertension Manual, Mechanisms Methods Management. 1st ed. New York, Yorke Medical Books, 1973, pp 31, 156

18. Levy RI, Stone NJ: The Hyperlipidemias and Coronary Artery Disease. Chicago, Year Book Medical, 1972

19. Medical World News: Roughage in diet. Sept 6, 1974

20. Mitchell SC: Prevention of atherosclerosis at the pediatric level. Am J Cardiol 31: 539, 1973

21. NIH: The dietary management of hyperlipoproteinemia. DHEW Pub No. (NIH) 75–110. Diet pamphlets for patients: (NIH) 73–111, 74–112, 73–113, 74–114, 73–115

22. Oster KA: Plasmalogen diseases: a new concept of the etiology of the atherosclerotic process. Am J Cl Res 1:2, 30–35, 1971

23. Perry MH: Minerals in cardiovascular disease. J Am Diet Assoc 62:631, 1973

24. Sandstead HD, Nielsen FH: Are nickel, vanadium, silicone, fluorine and tin essential for man? Am J Clin Nutr 27:515, 1974

25. Seelig MS Heggtveit HA: Magnesium interrelationships in ischemic heart disease: a review. Am J Clin Nutr 27:59, 1974

16 Skin

*Robert A. Briggaman, Robert G. Crounse**

Nutrition and skin interrelate in several important areas. Skin suffers, with the rest of the body, in the deprivation syndromes caused by deficiency of essential nutrients and also from derangements induced by excesses of certain other nutrients. Frequently, cutaneous manifestations of these syndromes contribute significantly to morbidity, and knowledge of these features aids greatly in diagnosis. Conversely, events in the skin may affect the rest of the body. It has become increasingly apparent that malfunction associated with certain skin diseases, such as psoriasis or exfoliative dermatitis, can induce significant systemic nutritional and metabolic disturbances. On the positive side, skin is capable of providing the entire requirement of vitamin D by the reaction of a provitamin in the epidermis with ultraviolet light. Only when ultraviolet light is inadequate on the surface of the skin does vitamin D become an essential dietary factor. In yet another area, manipulation of the diet and the use of specific nutrient factors have been widely employed in the treatment of a variety of cutaneous diseases. In subsequent sections of this chapter, we will discuss these various areas in detail.

CUTANEOUS MANIFESTATIONS OF SYNDROMES OF NUTRITIONAL DEFICIENCIES AND EXCESSES

OBESITY

Obesity is the most commonly encountered nutritional problem in this country and in other developed nations. It is a disease of multiple etiology, the most frequent of which is overeating associated with minimal physical activity. The obese patient is prone to a variety of cutaneous problems. Accumulation of excessive fat creates redundant and prominent body folds where

*The authors wish to thank Dr. Clayton E. Wheeler, Jr., for his review and comments on the manuscript.

friction between the skin surface and maceration from accumulated moisture lead to intertrigo. Infection of these areas by *staphylococci, Candida,* and superficial dermatophytes is common, especially in the obese, diabetic patient. In obese patients, the thickened subcutaneous fat layer makes dissipation of heat more difficult so that sweating is increased, sometimes profusely and miliaria rubra and other sweat retention syndromes are more commonly encountered (see Ch. 25).

UNDERNUTRITION

Undernutrition presents similar cutaneous findings whether starvation occurs in war victims or patients with anorexia nervosa or prolonged wasting illness (35). The skin tends to become thin, loose, inelastic and pale with the pallor being out of proportion to the degree of anemia. The skin is cool to touch and manifests a tendency to cyanosis in cold weather. Dryness may be seen, sometimes accompanied by scaling or fine mosaic fissuring. Occasionally, follicular hyperkeratosis occurs in the absence of a specific nutritional deficiency. Abnormalities of pigmentation may take the form of generalized hypermelanosis with predominance on light-exposed areas, localized hyperpigmented areas around the mouth, eyes, and cheeks or pigmented areas on the shins and dorsa of the feet. Scalp hair becomes thin, and the remaining hair tends to fall out easily. Alterations in hair color, particularly the development of graying or a reddish hue, may be observed. Body hair also tends to decrease and may disappear. Occasionally, a paradoxical increase of fine downy hair may be noted on the body. Fingernails and toenails tend to become brittle and dystrophic. Oral mucous membranes appear erythematous accompanied by atrophy of the papillae of the tongue. The skin of the starved subject is particularly prone to purpura and ecchymosis. Resistance of the

skin to trauma and infection decreases, which may play an important role in the pathogenesis of tropical ulcer and noma seen in malnourished patients.

PROTEIN DEFICIENCY

Proteins represent the major components of ectodermal tissues (hair, epidermis, and nails) and of mesodermal tissue (dermis). Ectodermal proteins, loosely termed "keratin," are unique in that they represent a fibrous end-product of protein metabolism which is not further recycled biochemically but is rather gradually sloughed or mechanically removed from the body. One of them, hair keratin, is remarkable in the magnitude of its cellular production since hair root doubles its mass in protein every 24 hours. Mesodermal proteins make up the bulk of full thickness skin and consist largely of collagen.

Both ectodermal protein (keratin) and mesodermal protein (collagen) are quite inert proteins in their final differentiative stage (for biochemical details of these "structural" proteins the reader is referred to appropriate biochemical texts and research journals). Protein or protein precursor deficiencies, *e.g.,* starvation, malnutrition, GI resection, have relatively little if any effect on the fully formed end products. The earliest manifestations of protein deficiency can ordinarily be detected more readily in the production of such proteins as serum albumin or transferrin. The exception may be protein production in the highly metabolically active hair root, where early changes can be detected biochemically and even morphologically (4,10). More-advanced stages of protein deprivation or deficiency are required to affect the cutaneous structures in an obvious way, as seen by decreased skin thickness, hair and nail changes, and a series of clinical skin manifestations.

Protein deficiency in the absence of any other deficiencies, be they carbohydrate, essential fatty acid, vitamin, or minerals, may be relatively uncommon, save in specific circumstances. Perhaps the "purest" example is the syndrome known as kwashiorkor. This term is used to describe the condition resulting from abrupt removal of an infant or young child's prime protein source, *i.e.,* human milk, and substitution of a low-protein, relatively high–carbohydrate diet. The resultant signs vary, depending in part on geographic origin, and may relate to the composition of the substitute food source. A substitute diet prominent in corn meal, for example, may induce pellagra in addition to general protein deficiency.

Because of the mixed deficiencies, descriptions of kwashiorkor from Africa, India, South America, or the Caribbean area do not always coincide precisely.

In addition, a series of highly descriptive clinical term defy accurate comparison. "Enamel-paint" dermatosis, "flaky paint" dermatosis, "crazy-pavement" skin, "mosaic" skin, "crackled" skin, "elephant" skin, "dyschromic" skin, "rabbit-fur" hair, "the flag sign," "achromotrichia," "pellagroid" changes (41), while graphic, do not permit accurate interchange among observers who use these terms. Strangely, edema, which may be reflected in overlying skin changes, is often treated separately from the skin.

Certain factors should be clearly understood in order to interpret the cutaneous manifestations of protein deficiency. First, pigmentary changes depend in part on racial and genetic origin. The same deficiency may give rise to different clinical signs in lightly and darkly pigmented individuals. (Phenylketonuria, though genotypically similar, shows with different phenotypic appearances in different races). Second, "multiple deficiency" syndrome, or infantile starvation, cannot be equated with protein deficiency alone. Third, even what is now called kwashiorkor may turn out to be specific manifestations of quite different deficiencies (*e.g.,* essential fatty acids) or widespread genetic differences in essential mineral requirements (witness the recent reports of apparent dramatic reversal of hair and skin changes of acrodermatitis enteropathica in response to supplemental zinc). Fourth, every attempt must be made to exclude cutaneous changes known to be associated with vitamin deficiencies before a given constellation is ascribed to protein deficiency. Fifth, advances in clinical research may eventually allow segregation of the effect of protein deficiency from that of other deficiencies, such as carbohydrate. The suggestion that protein malnutrition may result in decreased hair diameter or diminution in hair root protein, DNA, or volume whereas carbohydrate deficiency may result predominantly in increase of anagen to telogen (growing to resting) conversion in scalp hair roots, might allow accurate differentiation between the two.

Bearing these factors in mind, the following cutaneous signs are commonly attributed to human protein deficiency. The earliest signs are probably dryness and increased wrinkling and scaling with greater or lesser degrees of fissuring, especially on extensor surfaces. All of these are "ichthyosiform" changes, which have led to

such labels as "crackled," "mosaic," or "elephant" skin. In darkly pigmented individuals, pigmentary changes ("dyschromia") may predominate. "Enamel-paint" dermatosis is descriptive of well-demarcated plaques, especially in flexures, of intensely pigmented shiny skin, as if enamel paint had been dabbed or dropped thereupon. Fissuring and desquamation ("flaky paint" dermatosis) may result in virtual denudation of some areas. If a spot of dark skin is desquamated, the resulting depigmented or pink area surrounded by hyperpigmentation as well as darker intervening skin has been termed "crazy-pavement" dermatosis. This term has been applied by some to the ichythyosiform changes as well. Severe cases of protein deficiency manifest extensive blisterlike denudation, probably an indication of loosening of the epidermal–dermal adhesion. It should be remembered that these changes occur in relatively advanced protein deficiency states. Up to 50% of cases of kwashiorkor are said to have no prominent skin changes.

The classic sign of kwashiorkor in the hair is the so-called "flag" sign ("signa de la bandera" as described in Central America). This represents a zone of hypopigmentation (or reddish pigmentation in otherwise black hair) corresponding with a period of hair growth during which protein deficiency was present, followed by a restoration of normal hair color during dietary supplementation and continued hair growth. The band of lighter color (sometimes mislabeled "achromotrichia," which technically means no color in the hair) is propagated outward as the hair continues to grow. Alternate periods of deficiency and dietary restoration may result in multiple banding. More-advanced hair signs include loss of pigment and curl ("rabbit-fur" hair), especially in lateral scalp areas, and loss of hair. Hair is often at this stage described as easily removed by gentle plucking. Since resting hairs are normally easily plucked, this latter manifestation could represent carbohydrate deficiency as well as protein deficiency. Simple microscopic observation of plucked hairs can readily distinguish resting from growing hair roots (11) and could prove useful in future clinical studies. In any case, hair roots are extremely active mitotically and metabolically and provide a sensitive index for measuring protein malnutrition. In contrast to the rapid production of hair shaft, fingernail and toenail growth is quite slow. Several months are required to produce a nail of normal length. The dramatic "flag" sign of hair has no such obvious counterpart in nails, though transverse lines may occur in response to systemic metabolic insults. Decreased nail thickness or toughness have been reported, but these are not well documented in kwashiorkor. Certainly the alternations are less dramatic, or perhaps overlooked, in contrast to skin and hair changes. Nevertheless, both nails and hair represent long-term continuously produced and retained products of ectodermal biochemical systems, and as such, surely reflect past events as well as any organ system. All evidence indicates the likelihood that protein deprivation leaves a chronologic marker in nails which we cannot assay accurately.

Bearing in mind tendencies to refer to protein–calorie malnutrition as a blanket term for severely undernourished children, many still prefer to differentiate kwashiorkor, principally a protein deficiency, from marasmus, or general protein–carbohydrate deprivation or starvation. Since kwashiorkor usually results from removal from breast-feeding and substitution of a low-protein diet, it occurs most often in the second and third year of life. Marasmus occurs in infancy, often when breast-feeding is unsuccessful, or at any time later in life when conditions of starvation prevail. Both conditions exhibit growth failure, but kwashiorkor typically has edema, hair and skin changes as described, hepatomegaly, and poor appetite, none of which are common in marasmus. Marasmus tends to exhibit severe wasting and wizened facies, but normal skin and hair and no edema.

Vitamin deficiencies can be differentiated (even if concomitant) by appropriate clinical signs. Vitamin A lack causes cutaneous dryness with follicular hyperkeratosis in combination with night blindness and conjunctival dryness (xeropthalmia) leading to keratomalacia and blindness. Thiamin deficiency may include "dry" beri-beri (fatigue, mild ankle edema, paresthesias, reduced muscle strength, and focal cutaneous hyperesthesia), "wet" beri-beri (pronounced edema, cardiac failure), or "infantile" beri-beri (aphonia, diarrhea, vomiting, and wasting). Pellagra is characterized by a photosensitive dermatitis, oral changes, and nervous system signs and progresses to classic dementia. Scurvy and rickets do not produce signs readily confused with kwashiorkor.

Clearly, restitution of dietary proteins is essential to the treatment of kwashiorkor. Milk is a useful therapeutic supplement because of casein. Soybean is an excellent protein food. Skim milk is often tolerated better than whole milk in initial treatment and may be given by gastric

tube if necessary. Hospitalization with attention to fluid balance, electrolyte balance, and infection is often required for severe cases.

VITAMIN A

EPITHELIAL EFFECTS OF VITAMIN A

Vitamin A has important biologic activities on various epithelia including skin and its appendages (34, 43). Vitamin A is essential to the maintenance of epithelial integrity. Available information is largely confined to observations on epithelia exposed to excessive vitamin A or to vitamin A deficiency. In general, vitamin A deficiency leads to epithelial keratinization and excessive vitamin A promotes mucous production of an epithelium, but the vitamin A response of a given epithelium is highly individualized.

In vitamin A deficiency (see Ch. 3), the epidermis tends to become hyperkeratotic. The glandular epithelium of sweat glands is replaced by metaplastic keratinizing squamous epithelium. Similar keratinizing squamous metaplasia is seen in various epithelia of the mucous membranes of the eye, nose, trachea, bronchi, salivary glands, and GU tract, which accounts for much of the clinical abnormalities in these systems. Intestinal mucosal epithelium undergoes atrophy and goblet cell degeneration but not keratinization.

In their classic experiment, Fell and Mellanby observed the effects of excessive vitamin A on embryonic chick epidermis in organ culture (13). Embryonic chick epidermis, which normally keratinizes, became mucous-producing epithelium under the influence of excessive vitamin A. This supported the concept of the antikeratinization effect of vitamin A on epithelia. Several epithelia with mucous potential (*i.e.,* embryonic rat esophagus, rat buccal mucosa, and hamster cheek pouch) also undergo mucous metaplasia under the influence of excessive vitamin A. However, mammalian epidermis, whether fetal or adult, cannot be induced to undergo mucous metaplasia with vitamin A. Mammalian epidermis exposed to excessive vitamin A shows alterations, but these are regarded as disturbance of keratinization rather than inhibition. Therefore, the so-called "antikeratinizing effect" of vitamin A finds little experimental support in studies on mammalian epidermis.

The effects of excessive vitamin A on the epidermis are complex and conflicting, owing in large part to the variables in different studies that include the chemical form of the vitamin A used, its concentration and duration of application, route of administration (whether topical or systemic), and the techniques to demonstrate effects. Species differences, regional differences within a species, and embryonic *vs.* mature tissues may also affect the result. The most frequently reported epidermal response to excess vitamin A is epidermal hyperplasia, parakeratosis, and increased mitosis associated with a several-fold increase in the epidermal transit time. Different effects at various dose levels may account for some of the variability since at very high levels of vitamin A there is a failure to induce epidermal hyperplasia and an actual decrease in mitotic activity may occur. An intermediate dose response probably accounts for the previously noted epithelial hyperplasia, parakeratosis, and increased mitotic activity. Increased prominence of the granular layer probably results from relatively low dosage of vitamin A.

VITAMIN A DEFICIENCY IN MAN

Vitamin A deficiency in man seldom occurs as an isolated event but is more commonly seen in association with deficiencies of other nutritional factors, such as proteins or vitamin B complex. For this reason it is difficult to isolate specific manifestations of vitamin A deficiency from other deficiencies. In animals, epidermal changes are seldom a feature of vitamin A deficiency although hair abnormalities have been described. In prolonged and severe vitamin A deficiency, involvement of the skin and its appendages may be seen in man. These are usually described as widespread dryness (xerosis), scaling and slate gray pigmentation. Follicular papules associated with prominent keratotic plugs in the follicular orifice have been described as a prominent feature in clinical vitamin A deficiency (phyrnoderma). In experimental vitamin A deficiency (28, 48), follicular hyperkeratoses developed after prolonged vitamin A deprivation. In one recent study (48), follicular hyperkeratosis was seen in all subjects and was frequently the earliest detectable manifestation. Vitamin A replacement induced resolution of the hyperkeratoses over a period of several months. These studies prove beyond any question that vitamin A deficiency can induce follicular hyperkeratoses, but this finding can be seen in a variety of other nutritional deficiencies, including those of protein, vitamin C, riboflavin, pyridoxine, and essential fatty acids.

Defects in cutaneous appendages have also been reported in human vitamin A deficiency. Scalp hair may be decreased in amount, and luster of the hair may be lost. Eyelashes may become straight and irregular. Longitudinal furrowing of the fingernails and toenails has been reported.

HYPERVITAMINOSIS A

Hypervitaminosis A (58) may result from either acute massive or chronic prolonged ingestion of excessive amounts of vitamin A. In infants and young children, the acute ingestion of several thousand units of vitamin A results in sudden increase in intracranial pressure with bulging of the anterior fontanels and vomiting. This usually is followed by spontaneous recovery. In the adult, several million units produce a similar picture with increased intracranial pressure, headache, vomiting, and CNS impairment followed in 1–2 days by intense erythema around the mouth, face, and upper trunk, resulting later in large areas of desquamation. The prolonged use of vitamin A prescribed therapeutically for a variety of dermatologic conditions, particularly acne, has been a source of hypervitaminosis A. Hypervitaminosis A is more frequent in children and is characterized by anorexia, painful extremities, hepatomegaly, dry skin, and sparse hair. Anemia and leukopenia frequently accompany this condition. Radiologically, periosteal thickening may be noted in the area of the painful extremities. If vitamin A is to be used therapeutically, interruptions in therapy for a period of 1–2 months after 4–6 months treatment may decrease the likelihood of complications. Nevertheless, patients on vitamin A must be followed with vigilance. Concomittent administration of vitamins A and E may result in severe hypervitaminosis A so that these should not be given together (30).

CAROTENOID PIGMENTS

Hypercarotenosis results from prolonged ingestion of large quantities of foods containing carotenoids, *e.g.,* carrots (see Ch. 3). The condition may also be a result of disturbed carotenoid metabolism, as in diabetes mellitus, hypothyroidism, some hyperlipemis, and anorexia nervosa. The principal manifestion of the disorder is a yellow to orange discoloration of the skin, most prominent on the palms and soles, nasolabial fold, forehead, axillae,

and groin. That sclerae and the buccal mucous membrane are spared serves as a distinguishing feature from jaundice. The typical skin pigmentation is usually not prominent until the carotene plasma level is more than 250 μg/100 ml. Skin pigmentation results from secretion of the carotenoids in sweat and sebum and the subsequent reabsorption by the stratum corneum. Hypercarotenosis is not associated with hypervitamosis A.

Lycopenemia is a condition similar to carotenemia resulting from excessive consumption of foods containing lycopene, which is a carotenoid without provitamin A activity. A yellowish orange discoloration of the skin is the only manifestation of this harmless condition.

ESSENTIAL FATTY ACID DEFICIENCY

At least two polyenoic fatty acids, linoleic and arachidonic acid, and perhaps a third, linolenic acid, have been shown to be essential in a wide variety of experimental animals. Linoleic acid plays the central role in the prevention of essential fatty acid deficiency. Arachidonic acid can be synthesized from linoleic acid, but all vertebrates lack the ability to form linoleic acid *de novo*. The biologic activities of the essential fatty acids have not been fully defined, but essential fatty acids are known to be constituents of cellular membranes and precursors in the synthesis of prostaglandins. In the latter synthesis, linoleic acid is converted to arachidonic acid and hence to prostaglandins.

Cutaneous alterations, including scaly dermatitis—particularly of the feet, ears, and tail—hair loss, and increased capillary fragility are prominent features in essential fatty acid deficient animals. Excessive percutaneous water loss, which results in the need to consume huge quantities of water, indicates a defect in the normal barrier function of the stratum corneum in these animals. Poor wound healing has also been noted. The mechanism by which the scaly dermatitis is produced is not understood; however, some recent information indicates that prostaglandins may be involved. Topical application of prostaglandin E2 (PGE2) will completely clear the skin lesions in essential fatty acid deficient animals, but only in the region of application, not at distant sites. Systemically administered PGE2 is without effect. Significant amounts of prostaglandins are known to be synthesized by skin. Prostaglandins may have an important

function in epidermal biology and perhaps a role in some scaly cutaneous diseases in man.

ESSENTIAL FATTY ACID DEFICIENCY IN MAN

The occurrence of essential fatty acid deficiency in human infants and children and even adults has now been established. The clinical syndrome bears a close resemblance to that seen in animals. A dry, scaly, usually erythematous eruption has been reported in most subjects. The eruption may be generalized or localized and affects the trunk, legs, and intertriginous areas. Diffuse hair loss is frequently seen, particularly in infants. Wound healing is poor in some of the patients.

Essential fatty acid deficiency has been reported in several clinical situations. Markedly restricted unsaturated fat content in the infant diet (skim milk only) may produce essential fatty acid deficiency. In total parenteral hyperalimentation of patients with severe malabsorption problems, essential fatty acid deficiency may result if the essential fatty acids are not contained in the hyperalimentation formula (5). In this country, provision of essential fatty acids is difficult due to the unavailability of essential fatty acid preparations for IV administration. The weekly administration of plasma for its fat content is routinely used but may not be sufficient to prevent the development of essential fatty acid deficiency. Essential fatty acid deficiency may also be seen in patients with severe malabsorptive defects who are not on total parenteral hyperalimentation but who either absorb fats very poorly or whose dietary fats are restricted to control diarrhea or steatorrhea (44). In several studies, biochemical confirmation of the essential fatty acid deficient state was provided by the detection of low plasma levels of linoleic and arachidonic acid and by the presence of 5, 8, 11 (9ω)–eicosatrienoic acid in plasma or tissue phospholipids. The abnormal presence of the latter compound results from the lack of inhibition of its synthesis from oleic acid, which is normally provided by linoleic acid. Reversal of the clinical deficiency state, including clearing of the skin lesions, restoration of normal wound healing, and correction of the biochemical alterations, follows promptly after the replacement of essential fatty acids either in the diet or by parenteral therapy. A 10% soybean oil emulsion containing linoleic acid 56 g/liter (Intralipid) appears to provide a safe means of administering linoleic acid IV.

NICOTINAMIDE (NIACIN) DEFICIENCY AND PELLAGRA

Pellagra has long been known to be endemic in populations forced to rely on maize (corn) as the main dietary staple (46). Maize is low in both tryptophan and niacin and the niacin is present in an unavailable, bound form. Diet-induced pellagra is now seen in the U.S. largely in chronic alcoholics, food faddists and patients with gastrointestinal malabsorption. An endemic type of pellagra is also seen in India among persons who consume millet (jowar, Sorgham vulgaris) as their dietary staple. Jowar contains a high content of leucine which has been incriminated in the development of pellagra. Alteration in the metabolic pathways of nicotinamide and tryptophan may produce secondary pellagra. In functional carcinoid syndrome (6), some patients develop pellagra presumably because of the deviation of significant amounts of ingested tryptophan into serotonin production. Pellagra is occasionally seen in patients receiving isoniazid, which is thought to interfere with the conversion of tryptophan to nicotinamide. A pellagrous eruption is part of Hartnup's disease, and several other disorders of tryptophan metabolism, e.g., hydroxykynurinemia and congenital tryptophanuria. In secondary pellagra, decreased dietary intake of niacin contributes to the development of overt disease, and the administration of niacin cures the manifestations of pellagra.

Pellagra begins with a prodromal phase during which the patient feels bad and may complain of a variety of minor symptoms. Overt disease manifests itself with cutaneous changes, GI disturbances, and mental and neurologic alterations. The course of the disease varies greatly. In the progressive cases, there follows more-severe neuropsychiatric involvement and a downhill wasting illness terminating in death. A common picture is one of recurrent episodes, usually each spring, with a tendency to worsen with successive occurrences. Sometimes, the disease progresses to a fatal termination with the first attack. Also, the disease may resolve completely without specific treatment.

Skin manifestations are important signs of pellagra and occur in virtually all cases. A bright erythema in light-exposed areas is the first evidence of disease. Over a period of weeks, the color deepens to a reddish brown or chocolate hue; desquamation ensues, usually beginning in the center of an area of erythema and progressing toward the periphery. The scale, which may

be composed of either fine or large flakes, renders the skin surface rough, hence the name: pele (skin) and agra (rough). In some cases, induration may accompany the erythema and eventuate in vesiculation and bulla formation, which further evolves into oozing, eroded, crusted, or ulcerated areas, i.e., the wet form of pellagra. Another characteristic skin lesion is the thickened, hyperkeratotic darkly pigmented plaque, which tends to form fissures in skin creases. Hyperpigmentation, sometimes of marked degree, follows resolution of the active phase of the dermatoses. In general, pellagrous lesions are sharply marginated and symmetrically distributed. Although almost any area of the skin may be affected, there is a striking predilection for light-exposed areas, particularly the face, dorsum of the hands, lower arm, upper chest and neck (Casal's necklace), shins, and extensor surfaces of the feet. Intertriginous sites such as the groin and medial upper thighs may exhibit a similar eruption. In these sites, heat and pressure are thought to play a role in the production of lesions. Burning and itching frequently accompany the dermatosis. Burning may sometimes be so violent as to cause the sufferer to plunge into water for relief.

Oral mucous membranes and skin are usually involved concomitantly, but oral changes may precede the skin changes. The tongue is most commonly affected, becoming bright red and presenting a smooth, denuded surface, worse at the tip and along the margins. In more-severe involvement, superficial ulceration may occur at the margins and undersurface accompanied by a yellowish sloughing. Buccal and other oral surfaces may be similarly involved.

The pathogenic mechanism by which niacin deficiency produces the cutaneous lesions is unknown and, indeed, has received little attention. Findley's (14) finding that diphosphyopyridine nucleotide (NAD) levels decrease in pellagrous epidermis provides a basis for the idea that the eruption results from disruption of biochemical pathway in skin. Although the skin lesions occur in light-exposed areas, there is confusion in the literature as to whether the patients are photosensitive. Smith and Ruffin (51) were able to induce skin lesions by sunlight exposure in over half of their patients. However, others have had negative results. Findley studied the effect of light on pellagrous Bantu skin and found the cycle of postburn erythema, scaling, and tanning to be more prolonged than in ordinary sunburn (16). Pellagrous skin lesions may result from failure of the skin to heal normally following physical injury, such as that from light, heat, and pressure (15). This idea has some support in the previously mentioned prolonged sunburn response. The resemblance of the skin lesions of pellagra to drug- or plant-induced phototoxic reactions is noteworthy. Porphyrins, which may produce photoinduced skin lesions, are elevated in some cases of pellagra; however, this is not a likely explanation for the photosensitivity since porphyrins are not elevated in all patients and show no correlation with the eruption (46). Porphyrin elevations are usually seen in alcoholic pellagrins and may be related to alcoholism rather than pellagra. Ingestion of plant toxins may predispose some patients to the development of a phototoxic eruption, but this seems unlikely to be the explanation for the eruption in all patients with pellagra (46).

In addition to its physiologic role as a vitamin, nicotinic acid has been used as a vasodilator and as a cholesterol-lowering agent. Nicotinic acid produces a brisk red flush, especially when administered IV. Nicotinamide does not have this effect and should be used in situations where flushing is not desired.

Large doses of nicotinic acid (3–6 g/day) employed in the therapy of hypercholesterolemia may produce a generalized ichthyosiform eruption associated histologically with marked hyperkeratosis (47). Relationship to nicotinic acid can be demonstrated by repeated induction and remission of the eruption by alternately administering and withholding the agent.

RIBOFLAVIN

The features of experimental ariboflavinosis (riboflavin deficiency) in man are angular stomatitis, a seborrheic dermatitislike eruption involving the face, eyelids, and ears, but sparing the scalp and dermatitis in the groin area (31, 49). In the clinical setting, a syndrome termed the oculoorogenital syndrome, has been ascribed to ariboflavinosis. In addition to the symptoms described under experimental ariboflavinosis, painful magenta-colored tongue and various eye manifestations, including vascularization of the cornea, epithelial keratitis, and nutritional amblyopia, have been reported. None of the individual signs of ariboflavinosis described here are diagnostic since they can all be seen as manifestations of other conditions. However, in the aggregate, they are highly suggestive of riboflavin deficiency.

A therapeutic trial remains the best test of the validity of a clinical diagnosis. Following the ad-

ministration of a therapeutic dose of 5–15 mg riboflavin/day, symptoms usually disappear within a few days, and lesions dissolve over a period of several weeks. A zero or near zero urinary excretion of riboflavin is suggestive of the diagnosis.

PYRIDOXINE (VITAMIN B$_6$)

Several disease states have been related to pyridoxine deficiency in man, including convulsive disorders, anemia, and peripheral neuropathy associated with isoniazid administration. Cutaneous and mucous membrane manifestations are a significant part of the pyridoxine deficiency state induced in man by the administration of the pyridoxine antagonist, 4-desoxypyridoxine (55). In this study glossitis and a seborrheic dermatitislike eruption on the face, neck, and intertriginous regions are the most commonly encountered findings. Cheilosis, angular stomatitis, conjunctivitis, and a pellagra-like hyperpigmentation of the arms and legs are seen less frequently. All of the above manifestations respond to replacement with pyridoxine but are not influenced by the administration of other B-complex vitamins. Clinical observers in the past have noted a response of angular stomatitis and cheilosis to pyridoxine but not to riboflavin, suggesting that clinically important pyridoxine deficiency does occur. The similarities to riboflavin and niacin deficiency are noteworthy.

VITAMIN C DEFICIENCY AND SCURVY

Scurvy has long been known to be due to a deficiency of a dietary factor in fresh fruits and vegetables, subsequently identified as L-ascorbic acid. The manifestations of scurvy are mild at the onset but progress in severity as the ascorbic acid depletion persists (2, 26, 27). The earliest manifestations of scurvy occur in the skin as follicular hyperkeratoses, which are followed later by perifollicular erythema and hemorrhage, usually on the extremities. Nonfollicular petechiae are also present. As scurvy persists, hemorrhages into the skin become more frequent and more ecchymotic. In addition, they are distributed more widely over the body. Splinter hemorrhages may be seen at the distal ends of the nail beds. "Woody" edema of the legs associated with pain, hemorrhage, and brownish pigmentation may be seen in chronic, long-standing scurvy. This may advance to a scleroderma-like stage (57). Poor wound healing is noted in new or recent wounds, which become hemorrhagic and tend to break down. Fatigue, muscular pains and aches (particularly in the limbs), swollen and painful joints, peripheral edema, and dyspnea on exertion are characteristic features of both clinical and experimental scurvy. Scorbutic gingivitis begins with redness, swelling, and hemorrhage in the interdental papillae. With progression, the gums become purplish, more swollen, and spongy. Necrosis and free bleeding of the gums may occur. In advanced cases, the teeth are lost. More-severe changes are seen in subjects with preexisting gingival disease, and edentulous patients are usually spared.

Infantile scurvy differs in several ways from the picture presented by adult scurvy. Joint, bone, and muscle involvement dominates the clinical presentation. Scorbutic infants exhibit irritability when moved, tenderness of the legs, and pseudoparalysis, but skin hemorrhage is quite infrequent compared to adult scurvy.

Several alterations that are not considered part of clinical scurvy have been observed in experimental scurvy in man, including: 1) exacerbation of acne; 2) Sjögren syndrome with xerostomia, keratoconjunctivitis sicca, and enlargement of salivary glands; 3) excessive hair loss; and 4) conjunctivial telangiectasis and hemorrhage (2, 26, 27). Anemia is frequently a feature of clinical scurvy but is not seen in experimentally induced ascorbic acid deficiency.

Senile purpura and sublingual hemorrhages in the elderly are not due to ascorbic acid deficiency, despite the frequent finding of latent scurvy that has been demonstrated biochemically in this age group.

Hemorrhagic phenomena are an essential component of the pathology of scurvy and account for many of the manifestations of the disease, including the skin petechiae and ecchymoses, the muscle pain that results from hemorrhage into muscles, and the joint pain and effusion from hemorrhage into joints.

Recent studies have shed some light on the mechanism by which ascorbic acid deficiency results in the clinical picture of scurvy (see Ch. 3).

BIOTIN

Biotin is inactivated by a protein, avidin, present in egg whites. On rare occasion, biotin deficiency has been noted in human subjects who

subsist on a diet of raw egg whites. Manifestations of the deficiency are fine scaly dermatitis, grayish pallor of the skin and mucous membranes, conjunctivitis, and atrophy of the lingual papillae together with lassitude, depression, and other constitutional symptoms. An instance of exfoliative dermatitis has been reported in long-standing biotin deficiency.

PERNICIOUS ANEMIA AND OTHER VITAMIN B$_{12}$ DEFICIENCIES

Mucocutaneous manifestations of pernicious anemia are uncommon except for involvement of the tongue, which may be seen in approximately half the patients. The glossitis may be an early symptom occurring even before anemia. The severity of the tongue involvement varies greatly but at its worse can present a painful, beefy red tongue devoid of papillae, occasionally with shallow ulcerations on the surface. The well-known lemon yellow pallor of the skin is a late feature of the pernicious anemia usually associated with severe anemia.

Cutaneous hyperpigmentation has been reported as a sign of vitamin B$_{12}$ deficiency in dark-skinned patients (1). Pigmentation is usually present on the extremities, especially the fingers and dorsum of the hand, and may be either diffuse or patchy. A peculiar poikilodermatous hyperpigmentation has been reported on the neck, abdomen, groin, and thighs of a Caucasian girl associated with megaloblastic anemia (20). Epidermal cells were noted to have unusually large nuclei in the pigmented areas of skin similar to the large nuclei seen in other cells in vitamin B$_{12}$ deficiency. Vitamin B$_{12}$ therapy resulted in clearing of the hyperpigmentation as well as resolution of anemia and nuclear enlargement.

FOLIC ACID DEFICIENCY

Folic acid deficiency is known to produce characteristic changes in the bone marrow and other sites of rapid cell proliferation, notably the GI tract. The primary abnormality in folic acid deficiency is inhibition of DNA synthesis. Cutaneous manifestations of folic acid deficiency are rare, but pigmentation of the skin similar to that seen in vitamin B$_{12}$ deficiency has been reported (3). A papulosquamous eruption has also been observed in a patient with prolonged and severe folic acid deficiency (42). The skin eruption and associated anemia responded to folic acid treatment.

MINERAL AND TRACE METALS

IRON

Iron has important metabolic functions throughout the body in addition to its prime role in the hematopoietic system. Epithelial changes have been observed in iron deficiency. Nail changes are frequently seen and may be an early manifestation, occasionally even before the presence of anemia. The nails are dull, lusterless, brittle and tend to break at the free distal edge. The normally convex nail plate flattens and may become concave (koilonychia). The tongue may also be involved, commonly with loss of papillae, soreness, erythema, and loss of papillae, but not to the degree seen in pernicious anemia. Fissures may be present at the angles of the mouth. Postcricoid dysphagia together with koilonychia, atrophic glossitis, and angular stomatitis constitute the Plummer–Vinson (Patterson–Kelly) syndrome. Whether this syndrome is caused by the iron deficiency or by some associated factors is debatable. Hair growth may also be altered in iron deficiency and occasionally may be seen even before overt anemia occurs (8, 23). Iron deficiency is an uncommon cause of diffuse hair loss where a low serum iron level and favorable response to iron replacement help to establish the diagnosis. Vulvovaginitis may also complicate iron deficiency.

Porphyria cutanea tarda is associated with abnormalities of iron metabolism, which may be important in its pathogenesis.

ZINC

Zinc is a component of a large number of important enzymes and at least one hormone (insulin). Zinc deficiency produces a variety of manifestations in different animals, including psoriasiform dermatitis, hair loss, inflammatory paronychia-like lesions, growth retardation, and diarrhea. Human zinc deficiency was thought not to occur until recently, when zinc deficiency was clearly linked with acrodermatitis enteropathica (40), a rare, inherited disorder that usually appears with weaning or earlier in infants who are not breast-fed. The clinical features of acrodermatitis enteropathica correlate closely with those described for zinc deficiency in animals. Diodoquin or human breast-milk usually controls the disease, which often terminates in death if untreated. Low plasma zinc levels were found in patients with acrodermatitis enteropathica. Zinc supplements in the physiologic range of

35–150 mg/day resulted in prompt resolution of all features of the disease. These observations have now been confirmed by several other groups. The precise defect in the induction of zinc deficiency in these children is not understood.

COPPER

Copper deficiency produces several disorders in animals which may involve skin. A hair abnormality called steely hair has been noted in sheep, and a defect in elastic tissue resulting in arterial abnormalities has been found in various animals. Recently an x-linked inherited disease, Menkes' kinky (steely) hair syndrome, has been shown to be due to copper deficiency (11). This disease has widespread manifestations, including progressive mental retardation and convulsions, arterial lesions, and scurvy-like bone abnormalities. Death at an early age is the rule. The disease gains its name from an abnormality of scalp hair which may not be present at birth but develops later. The hair appears depigmented and lusterless, stands on end, and tends to tangle, rendering an appearance more like "steel wool" than the original descriptive term "kinky" hair. On microscopic examination of the hair, pili torti (twisted hair) is seen. Some heterozygous females may have microscopic pili torti. A peculiar facies and seborrheic rash are also present.

Low levels of serum copper and ceruloplasmin occur in all patients. Parenteral administration of copper salts corrects the low copper and ceruloplasmin levels, but oral copper administration is not effective. This point, together with the observed elevation of copper in intestinal mucosa, indicates a block in the absorption of copper as the primary defect in the disease. Unfortunately, the brain and vasular abnormalities are not affected by copper replacement. Nevertheless, since the disorder is potentially treatable, physicians should be alert for early cases prior to development of severe irreversible complications.

ARSENIC

Inorganic arsenic may be ingested in excessive quantities either as intentional poisoning or inadvertently in water or foodstuffs. In scattered areas of the Southwestern United States and Taiwan, water supplies may contain high arsenic levels. Tranverse white bands, called Aldrich–Mees lines, appear several months after acute arsenic poisoning and grow distally with time. The bands are usually single and occur in all the nails. In acute poisoning, hair may be removed and analyzed for its arsenic content, thereby confirming the diagnosis.

Chronic arsenic exposure produces a wide variety of characteristic cutaneous manifestations that may occur years after exposure and persist thereafter. Generalized hypermelanosis speckled with more-deeply pigmented macules, a pattern that has been likened to "rain drops on a dusty road," may be seen. Keratoses characteristically develop on the palms and soles as well as on other areas of the body. Arsenic exposure predisposes to both cutaneous and internal malignancy. Sometimes arsenic keratoses progress into overt squamous cell carcinomas. Bowen's disease (intraepidermal carcinoma) or invasive squamous cell carcinoma may arise de novo in the skin of the arsenic-exposed patient. Carcinoma of the lung, stomach, and GU tract should be looked for in these patients.

CUTANEOUS EFFECTS ON NUTRITIONAL AND METABOLIC PROCESSES

SYSTEMIC NUTRITIONAL AND METABOLIC DISTURBANCES ASSOCIATED WITH SKIN DISEASES

Extensive skin disease can induce clinically significant systemic nutritional and metabolic disturbances. The severe oral mucous membrane bullae and erosions seen in pemphigus vulgaris or severe erythema multiforme (Steven–Johnson syndrome) present obvious problems in providing for the nutritional needs of the patients. Many severely ill patients with mycosis fungoides or other cutaneous lymphomas, lupus erythematosus, pemphigus, or exfoliative dermatitis have poor appetites, which further complicates their disability through undernutrition. Beyond these more-general considerations, skin disorders can induce specific nutritional deficiencies (50).

PROTEIN AND WATER LOSS

Desquamation of the superficial layers of the stratum corneum is a normal sequence of epidermal activity. Nitrogen loss resulting from desquamated scale under normal conditions has been estimated to be approximately 380 mg/m² body surface/day. Skin diseases associated with pronounced scaling, e.g., exfoliative dermatitis,

psoriasis, and lamellar ichthyosis, result in marked nitrogen loss in the exfoliated proteinaceous scale. In severe generalized exfoliation, as much as 20–30 g nitrogen m² may be lost each day. On an adequate protein diet of 1 g nitrogen/k body weight, normal nitrogen balance is maintained until the scale loss exceeds 17 g/m²/day when negative nitrogen balance ensues (17). If negative nitrogen balance persists, as may be the case in chronic exfoliative dermatitis, the consequences are hypoalbuminemia, edema, and loss of muscle mass. Hypoalbuminemia is a common complication of prolonged exfoliative dermatitis, occurring in half or more of the cases (53). If dietary protein intake is poor, negative nitrogen balance and its sequelae may be expected to occur at a lower rate of scale loss. Roe (45) theorizes that a vicious cycle is established wherein malnutrition leads to dermatitis, as in the case of kwashiorkor or pellagra, and that dermatitis then further complicates the malnutrition by excessive cutaneous protein loss.

Extrarenal water loss (cutaneous insensible water loss plus sweating) normally approximates 400 ml/day at rest in a temperate environment. This may be increased threefold to fivefold or more in extensive exfoliative skin diseases (17). The water loss is proportional to the extent of the exfoliative process and rapidly decreases as the skin disease resolved. Water loss may be significant in a hot environment and might contribute to dehydration.

METABOLIC ABNORMALITIES ASSOCIATED WITH SKIN DISEASES

Approximately 0.5 mg iron/day is lost through normal epidermal desquamation. Although accurate measurements are not available, it is presumed that severe exfoliative skin disease increases the iron loss, which may lead to iron deficiency. Low serum iron concentration associated with normal or decreased serum iron-binding capacity has been noted in patients with various skin diseases, e.g., exfoliative dermatitis and psoriasis (36). Ferrokinetic studies in patients with skin diseases show that a more-complicated derangement in iron metabolism may be present, as manifested by variable absorption of [59] Fe, rapid disappearance of IV administered [59] Fe with a normal or slightly decreased iron turnover, normal red blood cell [59] Fe incorporation, and normal marrow iron (50).

Folic acid deficiency can be demonstrated in patients with extensive dermatoses and psoriasis (29, 54). The frequency may be as high as one-third of all patients admitted to the hospital for skin disease. Greatly increased turnover of diseased epidermis may increase utilization of folic acid to a degree that a conditioned deficiency results. Malabsorption may also contribute to folic acid deficiency. Occasionally, folic acid deficiency associated with skin diseases may produce overt megaloblastic anemia.

Patients with exfoliative dermatitis may have low blood ascorbic acid levels and exhibit prolonged saturation times with ascorbic acid (52), which are thought to result from increased utilization of vitamin C by the diseased skin.

VITAMIN D

Skin plays an essential role in the biogenesis of vitamin D. Under conditions where adequate sunlight is provided to the skin surface, skin produces all the vitamin D that is needed. Only when sunlight is not available does vitamin D become an essential dietary requirement. Human rickets is caused by vitamin D deficiency. The prevalence of rickets today depends on whether artificial vitamin D supplements or sunlight, or both, are provided rather than on what foods are consumed since most foods contain negligible amounts of vitamin D. The relationship between sunlight and the development of rickets has been recognized for a long time and is supported by the following observations. Rickets is more frequent during the winter months, and its incidence is increased in dark-skinned people or in persons who avoid sunlight exposure to the skin surface (e.g., Moslem women). Both artificial ultraviolet light and natural sunlight irradiation can prevent or cure rickets. The only known precursor of vitamin D in skin, 7-dehydrocholesterol, is found in relatively large amounts within the epidermis where irradiation is thought to occur.

USE OF DIET AND SPECIFIC NUTRIENTS IN DERMATOLOGIC THERAPY

Therapy of nutritional deficiency diseases and their cutaneous manifestations has already been covered in previous sections of this chapter. The response to therapy in deficiency syndromes is usually prompt and complete, as in scurvy or pellagra. In some instances the nutritional deficiency may progress to a stage where irreversible damage is done so that treatment results in incomplete remissions or even failure to re-

spond at all. Early diagnosis and treatment must be stressed in order to avoid these consequences. In several inherited diseases where specific diet therapy is beneficial, *e.g.,* phenylketonuria or acrodermatitis enteropathica, devastating consequences may result in untreated patients.

In this section, we will be concerned with a variety of skin diseases that are amenable to a greater or lesser degree to therapy employing dietary adjustments or provision of specific nutrients. This type of therapy of skin disease had a great vogue in the past, but the pendulum has swung away from stressing dietary factors and specific nutrients in the treatment of dermatologic diseases due to improved understanding of the pathogenesis of many of these diseases and to the availability of more-effective therapy.

URTICARIA

Urticaria may be a particularly vexing problem due to its frequent chronicity and the difficulties of identifying a specific etiology from the wide range of possibilities. Some cases of urticaria can be clearly linked to a specific food or constituent of a food product. However, the frequency with which a food can be found to be the cause of urticaria varies greatly among published cases from as high as 44% in one group of urticarial children (22) to a very small percentage in other studies (7).

The patient may be able to provide a clue that a food precipitates his urticaria. The association of urticara with a particular food may be substantiated by withholding and then readministering the food in question. A positive association should be demonstrated more than once to avoid misinterpretation of spontaneous fluctuations in the course of urticaria. When the patient is unable to provide a lead, elimination diets may prove helpful. The approach is to have the patient either avoid food entirely, or more usually, to consume foods that are seldom eaten or which rarely produce urticaria. An example of such a diet might be lamb, rice, sugar, lettuce, and pears. The diet is usually continued for a period of 1–2 weeks. If the patient continues to experience hives on the elimination diet, food as a cause of the urticaria can be discarded for practical purposes. If the urticaria clears on the elimination diet, specific foods are returned, usually one per day, and the effect on the urticaria noted. Presumptive evidence of an association between the food and the urticaria is provided

if the urticaria returns the day a specific food is readministered.

Several chemicals, particularly penicillin and salicylates, have frequently been incriminated in the production of urticaria. These materials can be found in a wide variety of foods where their presence is frequently hidden. For example, penicillin can be found in milk as a result of treating cows for mastitis or in cheese from penicillin mold.

PSORIASIS

Psoriasis is a chronic papulosquamous disease characterized by accelerated epidermal proliferation, rapid turnover and incomplete maturation of epidermal cells, and production of excessive scale, sometimes of marked degree. For a long time, variations in the diet, particularly protein consumption, have been thought to modify psoriasis. Increased meat eating was noted to worsen the eruption and elimination of protein to improve the disease. A convincing demonstration of this was provided by a psoriatic studied in a metabolic ward whose psoriasis improved on a synthetic diet containing 3.5 g nitrogen as amino acids and relapsed on resumption of a high-protein meat diet (32). Recently a controlled study failed to demonstrate a consistent beneficial effect of low-protein diet on psoriasis (60).

Dramatic clearing of long-standing psoriasis was reported after the institution of a diet in which the protein source consisted of white turkey meat, which was thought to contain low levels of tryptophan. These results were not confirmed by others (12). Actually, it was shown that turkey contained significant amounts of tryptophan.

Taurine, a sulfur-containing amino acid derived from animal protein sources has been implicated in psoriasis. In one study, when a diet with high-taurine content had an adverse effect on psoriasis, and a low-taurine diet either cleared or improved the cutaneous lesions, it was suggested that taurine might be involved in the pathogenesis of psoriasis. The importance of taurine in psoriasis has been questioned by others (59).

Other attempts to benefit psoriasis by dietary manipulations have yielded negative results. A diet rich in zinc proved ineffective (56) even though serum zinc levels were previously reported to be low. A low-calorie weight reduction diet also failed to improve psoriasis (61).

In summary, despite some studies that seem to

show a relationship of dietary components to psoriasis, recent controlled studies fail to demonstrate a consistent, favorable influence on the disease.

PITYRIASIS RUBRA PILARIS

Pityriasis rubra pilaris is a rare, chronic disorder of unknown etiology which may affect patients of any age. The disease is characterized by follicular hyperkeratotic papules and psoriasiform plaques in both limited and generalized distribution. Because of the similarity of cutaneous eruptions of pityriasis rubra pilaris to vitamin A deficiency, it was natural to consider vitamin A as a possible etiologic cause. Several reports indicate that serum vitamin A levels of patients are low, but this finding is not constant, and the disease is not thought to be due to vitamin A deficiency. Vitamin A in doses of 150,000–200,000 units/day for several months may improve or even clear some cases. Vitamin A may be employed on a trial basis for a period of 1–2 months. If ineffective, the medication should be discontinued. If effective, vitamin A therapy may be continued for 4–6 months. Interruptions in therapy are advisable to decrease the likelihood of hypervitaminosis A. Some patients remain clear following cessation of therapy, but most relapse after several months and require further treatment.

Good results have also been reported using topical application of vitamin A as 250,000–500,000 units/oz lotion base under occlusive plastic wrappings. Topical vitamin A acid may also cause improvement.

ICHTHYOSIFORM DERMATOSES

The ichthyosiform dermatoses are a heterogeneous group of inherited and acquired diseases in which the skin is dry and scaly or hyperkeratotic. Because of the vague similarity to vitamin A deficiency, vitamin A was extensively tried in many of these disease, but its use has been largely abandoned.

Several rare ichthyosiform diseases have recently been shown to be manageable by dietary modification. Refsum's disease is caused by the deficiency of an enzyme involved in the degradative metabolism of phytanic acid, a branched-chain fatty acid derived from exogenous dietary sources (24). The disease is manifested by a generalized or localized ichthyosiform dermatosis accompanied by extensive neurologic and ocular manifestations.

The disease is partially correctible by a diet low in phytols. Another example is Richner–Hanhart syndrome (tyrosinemia with plantar and palmar keratosis and keratitis) which is manifested by mental retardation, painful plantar and palmar keratosis, and dendritic keratosis of the cornea frequently leading to blindness. A defect in tyrosine metabolism associated with tyrosinemia and increased urinary excretion of metabolites of tyrosine has been identified in this disease (21). The epithelial lesions resolve on a low-tyrosine, low-phenylalanine diet.

ACNE VULGARIS

The relationship of dietary factors to acne vulgaris has been the subject of controversy for years. A popular belief held by many patients and some physicians is that certain foods aggravate or even cause acne. The most frequently incriminated agents are chocolate, cola drinks, nuts, milk and dairy products, iodine-containing foods, and diets rich in carbohydrates and fats. There is some evidence that diets rich in carbohydrates may alter the composition of surface lipids, presumably those of sebaceous gland origin. However, in a controlled study, no modification in the course of acne vulgaris was noted in patients on a high vs. normal carbohydrate intake (9). In addition, little evidence is available that dietary fats significantly influence acne. Large quantities of iodides and bromides have been known for a long time to produce exacerbations of pustular acne in acne patients or to produce a pustular acneiform eruption in patients without acne. Some believe that even small traces of iodides in foods, particularly seafood, or iodized salt may precipitate acne. However, it is doubtful that iodides are a significant pathogenic factor (25). Chocolate, which is often blamed for aggravating acne, has been the subject of controlled clinical studies in which it had no deleterious effect (19).

Vitamin A has been used frequently in the past for the treatment of acne. However, it has been shown to be without effect so that its use can no longer be recommended, particularly since the administration of relatively high doses of vitamin A for prolonged periods may lead to serious vitamin A toxicity.

ROSACEA

Rosacea is a common disorder of older persons. The disease is characterized by facial erythema, telangiectasia, and inflammatory papules and

pustules. Dietary indiscretions were previously thought to be important factors in causing rosacea. Tea, coffee, alcoholic beverages, and highly spiced foods do apparently provoke more flushing in rosacea patients than in control subjects (38). Any of these which specifically produce flushing should be avoided, but the elaborate dietary restrictions of the past are no longer necessary since tetracycline treatment is more effective.

DERMATITIS HERPETIFORMIS

Dermatitis herpetiformis is a chronic recurrent, pruritic, papulovesicular disease which is usually relieved by treatment with sulfapyridine or sulfones. An association with gluten-sensitive enteropathy has been found recently. Flattening of villi of the small intestines similar to that seen in gluten-sensitive enteropathy is present in most patients with dermatitis herpetiformis. Occasionally, patients with dermatitis herpetiformis have evidence of malabsorption, but this is seldom manifested clinically. Beneficial effects of a gluten-free diet on the skin lesions have been noted following therapy for many months (18), but not all patients improve on a gluten-free diet (37). However, a gluten-free diet may be a helpful adjunct to therapy in patients resistent or sensitive to sulfapyridine or sulfones.

ERYTHROPOIETIC PROTOPORPHYRIA

Carotenoid pigments are capable of preventing photosensitivity in light-sensitive variants of several bacteria and plants. In addition, β-carotene prevents photosensitive reactions in mice rendered photosensitive by the administration of large amounts of hematoporphyrin. As a result of these observations, β-carotene was used successfully in the human disease, erythropoietic protoporphyria (39). This disease is characterized by marked photosensitivity, which is manifested by a burning sensation, edema, crusting, and scarring of light-exposed areas. Preliminary results suggest that some other photosensitive eruptions including polymorphous light eruption may also respond to β-carotene administration. In the effective dose range of 50–75 mg β-carotene/day, cutaneous pigmentation of hypercarotenosis results. Serum vitamin A levels are not elevated (33); on the contrary, vitamin A blood levels tend to decrease, and these seemingly paradoxical results have not been explained.

REFERENCES

1. Baker S, Ignatius M, Johnson S, Vaish S: Hyperpigmentation of the skin: a sign of vitamin B_{12} deficiency. Br Med J 1:1713–1715, 1963
2. Bartley W, Krebs H, O'Brien J: Vitamin C requirements in human adults. London, Med Res Counc Spec Rep Ser No. 280, 1953
3. Bauslag N, Metz J: Pigmentation in megaloblastic anemia associated with pregnancy and lactation. Br Med J 2:737–739, 1969
4. Bradfield RB, Bailey MA: Hair Root Response to Protein Undernutrition in Hair Growth. New York, Pergamon Press, 1969
5. Caldwell M, Jonsson H, Othersen H: Essential fatty acid deficiency in an infant receiving prolonged parenteral alimentation. J Pediatr 81:894–898, 1972
6. Castiello R, Lynch P: Pellagra and the carincoid syndrome. Arch Dermatol 105:574–577, 1972
7. Champion R, Roberts S, Carpenter R, Roger J: Urticaria and angioedema. Br J Dermatol 81:588–597, 1969
8. Comaish S: Metabolic disorders and hair growth. Br J Dermatol 84:83–86, 1971
9. Cornbleet T, Gigli I: Should we limit sugar in acne? Arch Dermatol 83:968–969, 1961
10. Crounse RG, Bollet AJ, Owens S: Quantitative assay of human malnutrition using scalp hair roots. Nature 228: 465–466, 1970
11. Danks D, Campbell P, Stevens B, Mayne V, Cartwright E: Menkes's kinky hair syndrome: an inherited defect in copper absorption with widespread effects. Pediatrics 50:188–201, 1972
12. Farber E, Zackheim H: Turkey, tryptophan and psoriasis. Lancet 2:944, 1967
13. Fell HB, Mellanby E: Metaplasia produced in cultures of chick ectoderm by high vitamin A. J Physiol 119: 470–488, 1953
14. Findley G: Epidermal diphosphopyridine nucleotide in normal and pellagrous Bantu subjects. Br J Dermatol 75:249–253, 1963
15. Findley G: Pellagra kwashiorkor and sunlight. Br J Dermatol 77:666–667, 1965
16. Findley G, Rein L, Mitchell D: Reactions to light on the normal and pellagrous Bantu skin. Br J Dermatol 81: 345–351, 1969
17. Freedberg I, Baden H: The metabolic response to exfoliation. J Invest Dermatol 38:277–284, 1962
18. Fry L, Seah P, Riches D, Hoffbrand A: Clearance of skin lesions in dermatitis herpetiformis after gluten withdrawal. Lancet 1:288–291, 1973
19. Fulton J, Plewig G, Kligman A: Effect of chocolate on acne vulgaris. J Am Med Assoc 210:2071–2074, 1969
20. Gilliam J, Cox A: Epidermal changes in vitamin B_{12} deficiency. Arch Dermatol 107:231–236, 1973
21. Goldsmith L, Kang E, Beinfang D, Jimbow K, Gerald P, Baden H: Tyrosinemia with plantar and palmar keratosis and keratitis. J Pediatr 83:798–805, 1973
22. Halpern S: Chronic hives in children: an analysis of 75 cases. Ann Allergy 23:589, 1965
23. Hard S: Nonanemic iron deficiency as an etiologic factor in diffuse loss of hair of the scalp in women. Acta Dermatol Venereol 43:562–569, 1963

24. Herndon J, Avigan J, Steinberg D: Refsum's disease: characterization of the enzyme defect in cell culture. J Clin Invest 48:1017–1032, 1969

25. Hitch J, Greenberg B: Adolescent acne and dietary iodine. Arch Dermatol 84:898–911, 1961

26. Hodges R, Baker E, Hood J, Sauberlich H, March S: Experimental scurvy in man. Am J Clin Nutr 22:535–548, 1969

27. Hodges R, Hood J, Canham J, Sauberlich H, Baker E: Clinical manifestations of ascorbic acid deficiency in man. Am J Clin Nutr 24:432–443, 1971

28. Hume EM, Krebs H: Vitamin A requirements of human adults: an experimental study of vitamin A deprivation in man. Med Res Counc Spec Rep Ser No. 264, 1949

29. Knowles J, Shuster S, Wells G: Folic acid deficiency in patients with skin disease. Lancet 1:1138–1139, 1963

30. Kusin JA: Vitamin E supplements and absorption of massive dose of vitamin A. Am J Clin Nutr 27:774–776, 1974

31. Lane M, Alfrey C, Mengel C, Doherty M, Doherty J: The rapid induction of human riboflavin deficiency with galactoflavin. J Clin Invest 43:357–373, 1964

32. Lerner M, Lerner A: Psoriasis and protein intake. Arch Dermatol 90:217–225, 1964

33. Lewis M: The effect of beta-carotene on serum vitamin A levels in erythropoietic protoporphyria. Aust J Dermatol 13:75–78, 1972

34. Logan WS: Vitamin A and keratinization. Arch Dermatol 105:748–753, 1972

35. McLaren D: Undernutrition. In Bondy P (ed): Diseases of Metabolism, 6th ed. Philadelphia, WB Saunders, 1969, pp 1245–1260

36. Marks J, Shuster S: Iron metabolism in skin disease. Arch Dermatol 98:469–475, 1968

37. Marks J, Shuster S: Intestinal malabsorption and the skin. Gut 12:938–947, 1971

38. Marks R: Concepts in the pathogenesis of rosacea. Br J Dermatol 80:170–177, 1968

39. Mathews–Roth M, Pathak M, Fitzpatrick T, Harber L, Kass E: Beta-carotene as a photoprotective agent in erythropoietic protoporphyria. N Engl J Med 282:1231–1234, 1970

40. Moynahan EJ: Acrodermatitis enteropathica: a lethal inherited human zinc deficiency disorder. Lancet 2:399–400, 1974

41. Moynahan EJ: Kwashiorkor. In Demis DJ, Crounse R, Dobson R, McGuire J (eds): Clinical Dermatology. Hagerstown, Harper & Row, 1972

42. Nagaraju M, Adamson D, Rogers J: Skin manifestation of folic acid deficiency. Br J Dermatol 84:32–36, 1971

43. Olson J: The biological role of vitamin A in maintaining epithelial tissues. Israel J Med Science 8:1170–1178, 1972

44. Press M, Kikuchi H, Shimoyama T, Thompson G: Diagnosis and treatment of essential fatty acid deficiency in man. Br Med J 2:247–250, 1974

45. Roe D: Nutritional significance of generalized exfoliative dermatoses. NY State J Med 62:3455–3457, 1962

46. Roe D: A Plague of Corn: the Social History of Pellagra. Ithica, Cornell University Press, 1973

47. Ruiter M, Meyler L: Skin changes after therapeutic administration of nicotinic acid in large doses. Dermatologica 120:139–144, 1960

48. Sauberlich H, Hodges R, Wallace D, Kolder H, Canham J, Hood J, Raica N, Lowry L: Vitamin A metabolism and requirements in the human studied with use of labeled retinol. Vitam Horm 32:251–275, 1974

49. Sebrell W, Butler R: Riboflavin deficiency in man. Public Health 53:2282–2284, 1938

50. Shuster S: Systemic effects of skin disease. Lancet 1:907–912, 1967

51. Smith D, Ruffin J: Effects of sunlight on clinical manifestations of pellagra. Arch Intern Med 59:631–645, 1937

52. Tickner A, Basit A: Vitamin C and exfoliative dermatitis. Br J Dermatol 72:403–408, 1960

53. Tickner A, Basit A: Serum proteins and liver functions in exfoliative dermatitis. Br J Dermatol 72:138–141, 1960

54. Touraine R, Revuz J, Zittoun J, Jarret J, Tulliez M: Study of folate in psoriasis: blood levels, intestinal absorption and cutaneous loss. Br J Dermatol 89:335–341, 1973

55. Vilter R, Mueller J, Glazer H, Jarrold T, Abraham J, Thompson C, Hawkins V: The effect of vitamin B_6 deficiency induced by desoxypyridoxine in human beings. J Lab Clin Med 42:335–357, 1953

56. Voorhees J, Chakrabarti S, Botero F, Miedler L, Harrell E: Zinc therapy and distribution of psoriasis. Arch Dermatol 100:669–673, 1969

57. Walker A: Chronic scurvy. Br J Dermatol 80:625–630, 1968

58. Yaffe S, Filer L: The use and abuse of vitamin A. Pediatrics 48:655–656, 1971

59. Zackheim H, Farber E: Taurine and psoriasis. J Invest Dermatol 50:227–230, 1968

60. Zackheim H, Farber E: Low protein diet and psoriasis. Arch Dermatol 99:580–586, 1969

61. Zackheim H, Farber E: Rapid weight reduction and psoriasis. Arch Dermatol 103:136–140, 1971

17

Diabetes mellitus

Kelly M. West

CHARACTERISTICS AND PREVALENCE

The cardinal manifestation of diabetes is hyperglycemia. This and most, if not all, of the pathologic expressions of diabetes are attributable to insulin deficiency, either absolute or relative. The two factors that most commonly contribute to the development of diabetes are obesity and a genetic diathesis. Separately or together these may lead to β-cell decompensation of varying degree. Obesity is usually associated with insensitivity to insulin in fat, muscle, and liver and leads, therefore, to compensatory hyperinsulinism. Years of hyperinsulinism often result in eventual decompensation of β-cell function. Maturity-onset diabetes in fat subjects is typically characterized by mild to moderate hyperglycemia and little propensity to ketonemia. Serum insulin levels of fat diabetics are often in the normal range, but they are seldom as high as one would expect in equally fat nondiabetics in whom a comparable degree of hyperglycemia is artificially induced. If decompensation progresses, insulin levels may eventually become subnormal. Insulin deficiency may, therefore, progress from relative to absolute. Complete β-cell failure is, however, not common in this group.

In most affluent Western societies about 70%–90% of diabetics are of the fat, adult-onset type, while about 5%–10% are lean youth-onset cases with little or no endogenous insulin and severe diabetes. The latter patients require insulin therapy for survival because no dietary treatment can adequately control the severe metabolic abnormalities that attend total failure of β-cell function. The most characteristic and immediate expressions of this complete deficit are severe hyperglycemia and ketonemia, but many other metabolic abnormalities attend total insulin deficiency which if unchecked lead to diabetic ketoacidosis, coma, and death. Serum lipid abnormalities are common in both types of dia-

betes. In North America and Europe a substantial majority of maturity-onset cases are fat, but maturity-onset diabetes also occurs in lean adults and may be either mild, moderate, or severe. In youth-onset cases, β-cell decompensation is occasionally incomplete in the early stages, resulting in mild diabetes for months or years, but severe diabetes usually follows.

Many other less common circumstances can also cause or precipitate diabetes either by producing resistance to insulin or by damaging β cells directly. These conditions include pancreatitis, cancer of the pancreas, hemochromatosis, acromegaly, pheochromocytoma, and Cushing's syndrome (either endogenous or drug induced).

In the United States rates of known diabetes are about 3% in middle-aged subjects and about 5% in the elderly. The rate in school-age children is roughly 0.1%. In preschool children the disease is even more rare. Roughly 0.4% of young adults are known to have diabetes. In North American adults the rate of occult diabetes is at least as great as the rate of known diabetes. By certain commonly employed criteria, more than one-third of elderly Americans have impairment of glucose tolerance. Although there is considerable disagreement and uncertainty about these diagnostic standards, particularly in subjects over 40 years of age, by any of the standards that have been advanced the rate of diabetes in the elderly Americans (known plus occult) exceeds 10% when figures are based on extrapolations from glucose-loading tests in population samples.

In the United States about one-quarter of the known diabetics are being treated with insulin, about half are receiving oral agents and about one-quarter are not receiving any antidiabetic medication. With optimum long-term diet therapy only about 25% would require any kind of medication. The high frequency with which medications are used is largely a reflection of the

infrequency with which long-term diet therapy is successfully implemented in fat diabetics.

The major cause of death in American diabetics is coronary disease, which is roughly two to three times more common in diabetics than in nondiabetics. Renal failure secondary to diabetic glomerulosclerosis is the most common cause of death in youth-onset cases. Fatal coronary disease is also common in youth-onset diabetics and now closely rivals glomerulosclerosis as the leading cause of death in this group. In certain age groups diabetes is the leading cause of new cases of blindness. This is mainly the result of diabetic retinopathy, but cataract is also especially common in diabetics. A major cause of morbidity in diabetics is gangrene secondary to occlusive vascular disease. Impaired sensation attributable to diabetic neuropathy is also a frequent contributing factor in the genesis of gangrene. Other frequent manifestations of neuropathy include pain in the extremities, muscle weakness, bladder weakness or paresis, and sexual impotence in males. Diabetic coma is no longer a leading cause of death in diabetics, but death from ketoacidosis is by no means rare.

Many diabetics now live as long with diabetes as they would be expected to live without it. Yet, on the average, life expectancy at onset is still only about half of normal in childhood-onset cases and roughly two-thirds of normal in maturity-onset diabetics. There is still considerable uncertainty and controversy about the extent to which various types of therapy affect risk and degree of each of the several major manifestations of diabetes, but most agree that risk of death and morbidity are considerably reduced with well-conceived therapy. It is clear, however, that the clinical instruments currently at hand are not completely effective even in highly skilled hands. One of the best comprehensive sources of information on diabetics is Joslin's book (32). A good, inexpensive, small book is published by the American Diabetes Association (39).

NUTRITIONAL FACTORS IN ETIOLOGY AND PREVENTION

DIETARY FACTORS AS CAUSES OF DIABETES

The genetic mechanisms of diabetes are still poorly understood, but it has long been evident that hereditary factors are often etiologically important. Until recently the categorization of diabetes as a genetic disorder tended to limit the priority assigned to the study of the importance and character of environmental factors as etiologic agents. Although it seemed that rates of diabetes were different among certain societies, it was commonly thought that these differences were mainly attributable to racial factors. Moreover, it seemed quite possible that some of these differences were more apparent than real because of marked differences among societies in the frequency with which screening and diagnostic tests were performed. It is now clear, however, that environmental factors sometimes exert a profound influence on rates of diabetes (42, 46). Prior to World War II, for example, it was widely believed that diabetes was common in Jews and rare in American Indians, but more-recent studies have shown that in each of these races rates of diabetes vary as much as tenfold depending on environmental circumstances (12, 46). Very high and very low rates have been observed in communities of both of these races (12, 46). These marked intraracial variations in rates of diabetes have also been confirmed in East Indians (6), Polynesians, Micronesians, whites, and blacks (46, 48). In general, recent epidemiologic evidence suggests that economic, cultural, and other environmental circumstances are more important than race in determining risk of diabetes (23, 42, 43, 46, 48).

Several considerations suggest that diet may play a very important role in determining susceptibility to diabetes. In adults, rates of diabetes are closely related to adiposity both among and within populations (48, 49). Among populations there is an imperfect but general association between rates of diabetes and levels of consumption of both fat (24, 49) and sucrose (6, 11, 12, 23, 49). It is not yet certain, however, to what degree these latter associations have a cause and effect relationship. It is also possible that some of these associations may reflect a significant but indirect relationship. For example, even if fat and sucrose have no immediately deleterious effects on β-cell integrity, they may under some conditions enhance risk of obesity, thereby increasing risk of diabetes (23, 49). Although it is apparently possible to remain lean on a high-fat diet (as do the Masai tribesmen of East Africa) and to become obese on a low-sugar diet (23, 25), this does not exclude the possibility that dietary fat and sucrose may tend generally to enhance risk of adiposity. However, in one British group studied by Keen and his associates (23), fat people seemed to eat less sugar than lean persons.

Our studies in 12 populations show a decid-

edly negative correlation between starch consumption and prevalence of diabetes in adults (23, 49). Himsworth (24) obtained similar results in a pioneering study of nutrition and diabetes. This evidence does not necessarily mean that eating starch prevents diabetes but does suggest strongly that eating starch does not in itself incite diabetes, and it is possible that in so far as risk of diabetes is concerned, starch may be one of the most innocuous of the major foodstuffs. Generally speaking, societies with high protein intakes have high rates of diabetes, but certain exceptions suggest that this correlation may be coincidental. For example, in rural Uruguay, where protein consumption is high, diabetes is infrequent (47), and diabetes is also quite rare among primitive Eskimos, whose diets are very high in protein (46).

Some evidence and considerations suggest that adiposity is the most important of the many factors that contribute to the genesis of diabetes in adults (23, 43, 49). In several populations the greater rates of diabetes in females is explained entirely by their greater adiposity (48, 49). In two of these populations the association of parity and diabetes is probably also attributable to the greater fatness of the multiparous women (48). Although dietary factors undoubtedly have considerable importance in determining risk of obesity, it also seems likely that physical indolence plays a major role in the genesis of both obesity and diabetes (3, 45). Epidemiologic studies in diabetes are often rather difficult to interpret in some respects because certain variables tend to change simultaneously. In most societies where rates of diabetes have increased dramatically, sugar consumption has risen sharply, but usually there has also been a rise in fat consumption together with a decline in exercise and a rise in adiposity. This is true, for example, among certain East Indians, American Indians, Eskimos, and Polynesians, in each of which groups rates of diabetes have risen sharply (6, 46).

Although fatness and family history of diabetes are in most societies the principal risk factors in maturity-onset diabetes, there are several other important etiologic agents. Moreover, Jackson (25) studied a group of fat African females in whom diabetes was uncommon. Several possible explanations for this include genetic factors, relatively high levels of exercise (unusual but possible in obesity), and a relatively short duration of obesity (duration of obesity was not known in this latter group). In several societies excessive consumption of iron leading to hemochromatosis is a major cause of diabetes (e.g., in parts of Ghana and in certain Bantu communities). In most of the affluent societies in which diabetes rates are high, pancreatitis is a significant but not a major factor in producing the high rates. However, in a few lean societies where alcohol consumption is very high (e.g., certain communities in Africa), pancreatitis is a leading cause of diabetes. In some disadvantaged communities of India and Africa a substantial portion of diabetes is the result of pancreatic disease associated with pancreatic calcification in persons who are not alcoholic. The etiology of this pancreatic disease is uncertain, but it may have its roots in nutritional deprivations of childhood and intoxicity from high levels of consumption of cassava (tapioca). In this type of diabetes, symptoms of diabetes typically begin in adolescence or early adult life, but clinical diabetes is often antedated by other signs of pancreatic disease. Under some circumstances deprivation of certain trace metals, e.g., chromium and zinc, may have unfavorable effects on glucose tolerance. It is not yet certain, however, whether such deficiencies play a significant role in determining risk of clinical diabetes.

The extent to which nutritional factors influence risk of juvenile insulin-dependent diabetes is not clear. Because this disorder is relatively uncommon, it has been difficult to gather and interpret epidemiologic data. It does seem that juvenile diabetes is substantially more common in North America than in Japan (the difference may be as much as tenfold), and nutritional factors may or may not explain these differences. Apparently juvenile diabetes is also particularly uncommon in Eskimos and North American Indians (46). It is even rare in American Indian communities in which adult-onset diabetes is rife (46).

NUTRITIONAL FACTORS AND THE MANIFESTATIONS OF DIABETES

There is now considerable evidence that nutritional factors also play an important role in determining risk of certain complications of diabetes. In affluent societies the major cause of death of diabetics is coronary disease. In both primitive and affluent societies, diabetics have more coronary disease than nondiabetics (49). Even so, clinical coronary disease is uncommon among diabetics of many underprivileged societies (20, 43, 46). The relative importance of various factors in enhancing rates of coronary disease among diabetics is not yet established. Among the possibilities is the unfavorable effect

of diabetes on serum lipids and the direct effect of hyperglycemia (31). Probably the main cause of the diminished coronary blood flow is the enhanced rate of atherosclerosis, but occlusive disease of the coronary microvasculature may contribute to some extent in diabetics.

There is a very impressive association in groups of diabetics between coronary disease and consumption of saturated fat. For example, diabetics in several Latin American societies have much less coronary disease than in the United States diabetics (49). Most scholars in this field believe this association between atherosclerosis and consumption of saturated fat has a causal relationship. Although both cholesterol and triglyceride levels in the serum are often within the "normal" range in diabetics, cholesterol levels tend to be somewhat higher in diabetics and serum triglycerides are decidedly higher in diabetics.

Under certain conditions the feeding of carbohydrate leads to elevations of fasting triglyceride levels. Also, in some studies the risk of coronary disease seems to be affected by serum triglyceride levels (1). On the other hand, elevations in triglyceride levels produced by increasing dietary carbohydrates tend to decline with time unless calories are excessive. Moreover, prevalence of coronary disease in diabetics is generally lowest in societies where starch consumption is high (23, 49). For example, in Nigeria and Japan, both diabetics and nondiabetics derive a substantial majority of calories from starch, and coronary disease in these countries is much less common as a complication of diabetes than in North America or Western Europe. Triglyceride levels are low in Japan and in certain Micronesian societies (46) despite high-starch diets. This and other evidence suggests that: 1) serum triglyceride levels are in the long run much more responsive to calories than to starch itself and 2) the very high rates of coronary disease in the diabetics of affluent Western societies are not the inevitable result of genetic diabetes, or even of hyperglycemia. Rather, risk of coronary disease in diabetes is markedly affected by dietary factors. This does not exclude the possibility that risk of coronary disease may relate to intensity of hyperglycemia under certain conditions. However, in some circumstances coronary artery disease is uncommon even when hyperglycemia is considerable, *e.g.,* in Navajo (46) and Nigerian diabetics (20). Finally, it is not yet certain whether atherosclerosis is enhanced by either triglyceridemia or obesity.

Diabetics also have more cerebral atherosclerosis than nondiabetics, although this increased risk does not usually match that which attends coronary atherosclerosis in diabetics. On the other hand, vascular disease of the lower extremity is very greatly enhanced in diabetics. It is quite likely that some of the same factors discussed above account for increased amounts of atherosclerosis in large and medium-sized arteries of the head and legs in diabetics. For example, gangrene is relatively uncommon in diabetics of Japan. Studies of rates of clinical atherosclerosis in diabetics of various American Indian communities also suggest strongly the possibility that nutritional factors contribute significantly to the genesis of these lesions (46). Risk of cerebrovascular disease in diabetes in some circumstances may relate more to dietary sodium than to cholesterol or animal fat consumption. Stroke is less common in diabetics of North America than in diabetics of certain Japanese communities where sodium intake is high.

Evidence that risk and extent of diabetic microvascular disease are influenced by diet is less impressive. To the extent that diet is capable of mitigating hyperglycemia it may reduce rates at which these lesions develop. In certain animals, for example, it has been shown that control of hyperglycemia produces favorable effects on the degree of nephropathy and retinopathy (4, 31). However, when groups of diabetics from populations observing widely varying diets are compared, differences in rates of microvascular disease are generally less than differences in atherosclerosis. In diabetics of Japan, for example, the rates and extent of microvascular disease seem to be similar to those observed in Western societies. However, in a few societies, including Libya, Nigeria, and the Navajo Indians (46), diabetics seem to be less prone to retinopathy. Nutritional factors might or might not account for these peculiarities. Under certain conditions modification of diet may significantly improve retinal exudates, but immediate improvement of other manifestations of retinopathy is uncommon with diet therapy.

Ketosis seems to be peculiarly uncommon in the lean diabetics of certain societies. The reasons for this are incompletely understood. Probably dietary factors play a role, (*e.g.,* low levels of dietary saturated fat, paucity of fat cells and peculiarities of their function secondary to extreme nutritional deprivations of infancy). Little is known about the effect of diet on diabetic neuropathy, although some recent evidence suggests that the degree of hyperglycemia may influence at least some aspects

of these pathologic changes in nerve tissue. Neuropathy seems to be quite common, however, in groups of diabetics observing diets that differ qualitatively quite widely (*e.g.,* Nigeria, Asia, and North America).

It is of great importance that several groups of genetically susceptible individuals have largely escaped both diabetes and its vascular lesions. The microvascular lesions of diabetes are rife in certain communities of Jews (12), whites, blacks, Indians (43), and American Indians (46) When, however, these races are protected by environmental conditions from developing hyperglycemia, they also escape the microvascular lesions (43, 48, 49). This epidemiologic evidence lends no support to the hypothesis that these microvascular lesions are independent of hyperglycemia, but rather suggests that prevention and control of hyperglycemia has potential for prevention and mitigation of these microvascular lesions. Thus, diet modification has great potential for preventing and ameliorating not only diabetes but also certain of its complications.

DIET THERAPY

PRINCIPLES, OBJECTIVES AND STRATEGIES

The history of concepts and practice of diet therapy has been reviewed in an interesting essay by Wood and Bierman (50). Principles of modern therapy have recently been promulgated by the Nutrition Committee of the American Diabetes Association (2).

Four therapeutic goals may be listed. The applicability and priority of each of these four objectives in individual patients vary considerably with circumstances as will be explained below. Dietary objectives may include: 1) reversal of the diabetic state toward or to normal with improvement in glucose tolerance and β-cell reserve and amelioration of resistance to insulin; 2) mitigation and regulation of glycemia, including the control of symptoms of diabetes and prevention and therapy of hypoglycemia; 3) prevention or reduction in progression of certain complications of diabetes, *e.g.,* vascular disease, neuropathy, cataract, and ketosis—control of both hyperglycemia and hyperlipemia has a role in this; 4) management of certain complications of diabetes, *e.g.,* pregnancy, renal failure, and hypertension. In typical obese patients the strategy with greatest potential for achieving the first three objectives is reduction of the excessive fat tissue. Table 17–1 contrasts objectives and strategies in the two most common types of diabetes.

EFFECTIVENESS AND FEASIBILITY OF DIET THERAPY

For centuries there has been controversy about the best kind of diet and the extent to which any diet therapy is effective. As indicated in other sections of this chapter, there have been dis-

TABLE 17–1. Dietary Strategies for the Two Main Types of Diabetes*

Dietary strategy	Obese patients who do not require insulin	Insulin-dependent nonobese patients
Decrease calories	Yes	No
Protect or improve β-cell function	Very urgent priority	Seldom important (β-cells usually extinct)
Increase frequency and number of feedings	Usually no[†]	Yes
Day-to-day consistency in intake of calories, carbohydrate, protein, and fat	Not crucial if average caloric intake remains in low range	Very important
Day-to-day consistency in ratios of carbohydrate, protein, and fat for each feeding[††]	Not crucial	Desirable
Consistency in timing meals	Not crucial	Very important
Extra food for unusual exercise	Not usually appropriate	Usually appropriate
Use of food to treat, abort, or prevent hypoglycemia	Not necessary	Important
During complicating illness provide small, frequent feedings of IV CHO to prevent starvation ketosis	Often not necessary because of resistance to ketosis	Important

*Adapted from West KM: Ann Intern Med 79:425–434, 1973

[†]There are some theoretic advantages in dividing the diet into four or five feedings even in mild diabetes if this can be done without increasing caloric consumption. However, because limitation of calories has highest priority in obese diabetics, there are potential disadvantages in providing extra feedings. Giving fat people an opportunity to eat at bedtime is particularly "risky" if weight reduction is the prime goal

[††]The total daily insulin requirement is apparently not much affected when dietary constituents are changed under isocaloric conditions, but insulin requirement immediately after a high-carbohydrate meal is higher than immediately after a low-carbohydrate meal, even if the meal is isocaloric

agreements among authorities for at least several decades concerning what priority should be assigned to the limitation of starch and sugar. It has long been evident that the diabetic liver can readily make sugar out of noncarbohydrate foodstuffs and that overproduction of glucose plays a major role in maintaining hyperglycemia. This kind of evidence led many to doubt the utility of limiting carbohydrates when they are entirely replaced with other calories. Some even concluded that if carbohydrate limitation didn't help, then no diet therapy was likely to be very effective.

Soon after the discovery of insulin, free diet was advocated by a few. In the 1940s several groups advocated "free diet," "unrestricted diet," and "liberal diets," basing their recommendations on the following considerations and opinions. Some doubted that traditional diet therapy was effective in preventing the long-term complications of diabetes. Those advocating free diet also argued that the vascular lesions of diabetes were probably unrelated to the degree of glycemia. They also pointed out that most patients didn't follow their prescribed diets. It was thought that conventional diets were often onerous and that under certain conditions juvenile diabetics observing traditional diets might be more susceptible to insulin reactions than those on less formal regimens. Studies of Knowles (27) have also cast doubt on whether certain traditional diets for juvenile diabetes are any more effective than less-complex regimens similar to the normal diet.

Some well-qualified scholars still believe it appropriate to assume that moderate hyperglycemia is innocent until proven guilty. Most, however, believe that the possibility of guilt is sufficiently great to warrant attempts to mitigate hyperglycemia even in asymptomatic patients. Almost all agree that modest hyperglycemia is preferable to hypoglycemia and that the theoretic risks of minimal asymptomatic hyperglycemia do not warrant making life a perpetual and rigid metabolic clinic. The possible direct and indirect effects of hyperglycemia on atherosclerosis have been reviewed above. Outlined below are other considerations that argue the priority of ameliorating hyperglycemia. All agree that control of marked hyperglycemia is desirable, but there is still considerable controversy about the feasibility and priority of treating moderate elevations of the blood glucose in asymptomatic patients, particularly those with labile insulin-dependent diabetes. There also is disagreement about the degree of danger attending hypoglycemic episodes that may be produced by aggressive therapy.

Yet an increasing body of evidence suggests that hyperglycemia in itself may be noxious to small vessels, nerves, and—perhaps—to large arteries (4, 31, 32). Rates at which cataracts develop seem to be affected by degree of glycemia. There is some evidence that resistance to infections may be impaired by hyperglycemia, but it is not clear at what level this untoward effect begins. Under certain conditions mitigation of glycemia may improve glucose tolerance and protect overstrained β cells from exhaustion. Diabetes may sometimes, in fact, be entirely reversed with return of glucose tolerance to normal. Thus, to the extent that diet modification can ameliorate hyperglycemia, this is a useful objective, although by no means is it the only purpose of diet therapy. Among the strongest arguments for dietary mitigation of hyperglycemia are the favorable effects on serum lipids induced by control of the blood glucose. The degree and character of these effects depend on many factors, but control of glycemia often lowers serum cholesterol levels (to varying degrees) while regularly and substantially lowering serum triglycerides.

Not surprisingly, physicians who know little about dietary strategies and techniques are more likely to doubt the feasibility and effectiveness of dietary measures in controlling hyperglycemia or reducing morbidity. It is well established that diet therapy of diabetes is ineffective when carried out clumsily without enthusiasm, and there is considerable evidence that diabetics seldom follow their diet prescriptions very well (44). This raises the question as to whether diet therapy is really feasible. It is, however, evident that under certain conditions, patients do follow their prescriptions and that measurable clinical benefits are observed (13, 18, 19, 21, 35, 37, 41, 44).

Despite these disagreements and uncertainties, most authorities have continued to advocate diet modifications of varying types and degrees in the therapy of diabetes. Although certain areas of controversy remain, better understanding of the nature of diabetes and its complications has tended to mitigate the previous disagreements. Most of the previous controversy was based on poor definition and understanding of the issues. We now understand much better, for example, the very substantial differences between the dietary principles in the two main types of diabetes (see Table 17–1). No disagreement remains about the potentially great effec-

tiveness of limiting calories in fat maturity-onset diabetics. Although some authorities still believe that carbohydrate restriction may have a favorable effect unrelated to its effect on caloric intake, most now give little priority to starch restriction in fat diabetics except as it may relate incidentally to caloric restriction. Thus, there is now a wide concensus that in this type of diabetes the prime objective is caloric restriction irrespective of source of calories. We are beginning to understand better the importance of distinguishing between the diet prescription and the actual diet. It is possible, for instance, that the failure of diet therapy to effect outcome is in some circumstances attributable to the rarity with which patients follow their prescriptions (44).

Some of the previous arguments are attributable in part to semantic problems and misunderstandings concerning definitions. Most patients on so-called free diets, for example, were actually observing dietary modifications of varying degree. These often included proscribing or limiting sugar intake and, in the case of insulin-dependent patients, dividing feedings into more than three meals or eating regularly at scheduled times. High rates of atherosclerosis in patients on conventional "strict" diets are probably attributable in part to the fact that these "strict" diets have not usually been strict in their allowance of cholesterol and animal fat. Rather, they have tended to increase consumption of fat and cholesterol. Insulin-dependent diabetics who have been told to follow unimaginative and impractical "strict" regimens often have a greater fluctuation from day to day in their actual eating patterns than certain patients who "follow no diet." Insulin-dependent diabetics who like their assigned diets are more likely to follow them regularly; and those on "rigid diets" often follow them carefully—part of the time. Sugar consumption is usually reduced, but a major objective (achieving consistency of intake) is frustrated. It is now evident that in the regulation of the blood glucose levels of insulin-dependent patients, regulation and predictability of diet is more important than proscription of any specific food items. Another problem is that there has been no unanimity about definitions of popular terms and expressions, e.g., "careful diet," "watch your diet," "strict diet," or "diabetic diet," but for the most part these expressions were strongly associated with proscription and deprivation of carbohydrates. In insulin-dependent patients, the need to trade food items imaginatively and to adjust continuously to the vagaries of exercise, illness, or work schedules

suggests that the term "dietary regulation" fits the appropriate regimen better than terms such as "rigid diet" or "strict diet." In formulating the diet prescription, the physician should keep in mind that the coronary arteries of Asian and African diabetics who were never seen by a physician usually look much better than those of patients in the United States who have had the "advantage" of traditional "diabetic diets" of the past.

In fat maturity-onset diabetics, diet has potential not only for controlling diabetes, it can actually reverse the disease. Reduction in adiposity improves sensitivity to insulin and usually improves glucose tolerance and β-cell function. Diet only rarely returns glucose tolerance to normal, but the infrequency of this accomplishment is mainly the result of the rarity with which substantial and sustained weight reduction is achieved in these obese patients. It seems likely that complete reversal of diabetes would be commonplace if a substantial percentage of fat patients were able to lose all or most of their excess adiposity. Although successful treatment of obesity is uncommon, it is clear that under certain circumstances very significant rates of success have been achieved (13, 18, 19, 21, 44). In view of the profoundly beneficial effects of weight reduction in obese diabetics, a rather substantial effort is often justified. The management of obesity is reviewed in Chapter 25.

FORMULATING THE PRESCRIPTION

Tables 17–1 and 17–2 and the following list suggest many of the considerations that apply in developing, implementing, and adjusting the dietary prescription. Among the determinations to be made are the total number of calories; the characteristics and amounts of the specific foods to be allowed, encouraged, limited, or avoided; the number, characteristics, and relative sizes of the various feedings; and the timing of these feedings. The following "check list" (44) will aid dietitians and physicians in formulating and implementing a diet prescription for a specific patient:

1. *In order of priority* what are the main general purposes (not strategies or methods) of this patient's prescription?
2. How much should the patient weigh? How much do the doctor, the dietitian, and the patient think he should weigh? How much would the patient *like* to weigh?
3. What is the appropriate level of caloric consumption for this patient?

TABLE 17—2. Distribution of Major Nutrients in Normal and Diabetic Diets (as percentages of total calories)

	Starch and other polysaccharides* (%)	Sugars† and dextrins (%)	Fat (%)	Protein (%)	Alcohol (%)
Typical American diet	25—35	30—30	35—45 2/3 saturated	12—19	0—10
Traditional diabetic diets	25—30	10—15‡	40—45	16—21	0
Newer diabetic diets	30—45	5—15‡	25—35 less than 1/2 saturated	12—24	0—6

*A very substantial majority of these calories are starch, but complex carbohydrates also include cellulose, hemicellulose, pentosans, and pectin
†Monosaccharides and disaccharides, mainly sucrose, but also includes fructose, glucose, lactose and maltose
‡Almost exclusively natural sugars, mainly in fruit and milk (lactose)

4. Does the patient require insulin? If so, is the blood glucose relatively stable, moderately labile, or severely labile? What kind of insulin is to be given, at what time, in what amounts?

5. What and when and how much would the patient *like* to eat if he did not have diabetes? Are there any special considerations relating to economic factors or to family or cultural dietary propensities?

6. Is the level of carbohydrate to be fixed? To what level or range? To what extent and under what conditions, if any, are concentrated carbohydrates to be used?

7. Any special requirements concerning levels of protein?

8. Are there any specific or general requirements with respect to levels of dietary fat, either saturated or unsaturated?

9. How much alcohol is to be permitted? Under what conditions? Should alcohol be exchanged for another food? If so, what kind and in what amounts?

10. If time distribution of food is of any importance, are there specific requirements concerning: 1) the relative size and timing of each of the three main meals? 2) the timing, size and characteristics of any extra feedings?

11. To what degree is day-to-day consistency required in: 1) total calories 2) size and characteristics of specific feedings such as lunch?

12. Are dietary adjustments to be made for exercise or marked glycosuria? Of what nature?

13. Are there any special conditions unrelated to diabetes requiring special diet (*e.g.,* gout, hyperlipidemia, and renal or cardiac failure)?

14. Can all elements of the prescription be reconciled, and how should this be done? (For example, it is usually not feasible to construct a palatable diet for a lean diabetic if the prescription calls for a diet that restricts both carbohydrate and fat.)

15. What kinds and what degree of changes are to be made subsequently by the dietician without consulting the physician?

16. What should this patient do if he finds it necessary to postpone or modify a meal (*e.g.,* at a dinner meeting or social affair)? How should he adjust diet if his appetite fails (*e.g.,* during illness)?

17. Tactical questions: 1) How much precision is required in the various elements of this prescription? 2) What foods can be freely allowed? 3) What foods, if any, are to be weighed or measured? 4) Are any modifications of the standard exchange system appropriate, such as simplification? 5) In general, is food to be unmeasured, estimated, measured, or weighed? 6) Is it necessary or desirable to teach this patient the carbohydrate, protein, and fat content of the common foods? 7) Under what circumstances are artificial sweeteners and diet drinks to be used?

18. Has this patient's understanding of dietary principles and methods been systematically evaluated?

CALORIES

Caloric requirements of the prescription vary considerably depending on factors such as the

weight, desirable weight, and activity of the patient. It is not urgent that a precise determination be made initially of level of calories to be prescribed. An estimate can be made with appropriate adjustments subsequently on the basis of experience. Elsewhere in this book and in many other sources may be found more-detailed information relative to the assessment of caloric requirement. A few simple generalizations may be helpful. A typical young man weighing 70 kg (154 lb) who is moderately active requires about 2800 Cal daily (40 Cal/kg). While relatively inactive (*e.g.*, ambulatory but hospitalized) he may require as few as 2100 Cal (30 Cal/kg). Men of this size who habitually engage in heavy exercise may require as much as 3500 Cal (50 Cal/kg). A typical young woman weighing 58 kg (128 lb) who is moderately active requires about 2000 Cal. Older patients usually require somewhat less in relation to body size. Children under 12 years of age require an average of 1000 Cal plus 100 Cal per year of age. Thus, a 7-year-old child would require roughly 1700 Cal/day. Because sizes and activity levels vary considerably in children of the same age, the formula above should be used only as a crude guideline.

A strategy commonly employed is to prescribe a number of calories somewhat less than the number intended for consumption under the assumption that there is a natural tendency to eat a bit more than the amount prescribed. In insulin-dependent patients this is undesirable because it often leads to irregularity of intake. Under-prescription of calories is also common when estimates are based mainly on the new diabetic's description of his normal diet. There is a general tendency toward underestimation even by nonobese patients. The main reason for this is that many tend to underestimate the calories taken outside their typical meals (*e.g.*, alcohol, soft drinks, sugar and cream in coffee, candy, large meals on special occasions). New, lean diabetics often feel at first that the prescribed diet is generous or even excessive because foods high in calories (sugar and fat) are replaced by foods many of which are less concentrated in calories and because consumption of calories is now confined to prescribed feedings. In lean patients an initial prescription that is generous helps to make the point that the main objective is regulation rather than deprivation. In lean patients, satiety, appetite, and hunger are usually reliable guides to the caloric requirements; of course, body weight is the definitive long-term guide. Accuracy of the initial estimate of caloric requirement is, therefore, not crucial.

Obese patients may, according to circumstances, be given prescriptions ranging from total starvation to as much as 2000 Cal/day, but long-term reduction diets typically provide 1000–1400 Cal. These allotments should be raised when and if weight approaches an optimum level. Caloric requirements of obese patients are well related to weight, but these patients are usually less active than lean persons. In most, weight maintenance requires roughly 30–35 Cal/kg. If they are understood and followed, prescriptions of about 20 Cal/kg provide the desired weight reduction. Increasing exercise will, of course, be helpful.

SIZE, DISTRIBUTION, AND TIMING OF FEEDINGS

Typical diet prescriptions provide about 25%–35% of total calories as lunch, 25%–35% as supper, 10%–30% as breakfast, and 0%–25% as between-meal snacks. In most patients, allowances of some degree can be made for the preferences and life style of the patient before fixing the distribution scheme. In insulin-dependent patients consistency of timing and distribution has considerable priority, but there is usually some flexibility of alternatives determining the distribution pattern to be regularly followed. For example, a farmer who prefers or requires an early breakfast of generous size may be given a greater portion of his daily allotment as breakfast (*e.g.*, as much as 30%). Such adjustments are often made possible by the substantial number of available alternatives with respect to tactics of insulin therapy. For example, the insulin-dependent diabetic who prefers a small breakfast may receive a smaller dose of plain quick-acting insulin before breakfast or no rapidly acting insulin at that time. Or he may be given a mixture containing less Semilente and more Ultralente insulin. Some persons who prefer or need a larger breakfast may be given a larger dose of the quick-acting insulin before breakfast, or the insulin may be given 30–40 min before breakfast instead of 10–30 min before eating. Patients who eat breakfast late and take no quick-acting insulin may do well with a small breakfast.

Most insulin-dependent patients are more effectively treated when they have two to three snacks and smaller main meals. In insulin-dependent patients, regular ingestion of a mid-afternoon snack often facilitates a better fit with the time-action characteristics of the intermediate-acting insulins, such as NPH or Lente. Occa-

sionally, however, the mid-afternoon feeding may not be necessary (*e.g.,* when lunch is large and the time interval between lunch and supper is relatively short). It is crucial that the character of these snacks fit the circumstances under which the patient is supposed to consume them. One may ask the patient, for example, if a "coffee break" is traditional in the afternoon at his place of employment and what kinds of foods or drinks are most appealing and readily available on these occasions. When other options are cumbersome, it may be appropriate occasionally in an insulin-dependent patient to prescribe modest amounts of concentrated carbohydrate on these occasions, *e.g.,* a doughnut, soft drink, or even sugar in coffee or tea. Of prime importance in insulin-dependent patients is that these feedings be predictable in their size, timing, and general characteristics. If the patient consumed 8 ounces of a soft drink containing 27 g sugar at 3 PM on a regular and predictable basis it would be much better than if he consumed irregularly a more conventional but less convenient snack. When the character of the snacks are well suited to the patient's tastes and schedules, they are likely to become a pleasant habit and therefore, a dependable element of the therapeutic program. This again introduces the point, often unappreciated, that the dietary objectives in lean, insulin-dependent diabetics are regulation and consistency of distribution, not proscription and deprivation. Many of these patients and some physicians have erroneously concluded that the main point of the diet is to eat as little carbohydrate as possible. Table 17–1 outlines considerations concerning the temporal distribution of feedings in typical fat diabetics. Usually snacks are unnecessary.

CARBOHYDRATES, FATS AND PROTEINS

Table 17–2 shows the distribution of the major nutrients in traditional diabetic diets and compares this to the typical American diet and the "modernized" diabetic diet. Until recently, carbohydrate restriction usually received prime priority in the dietary management of diabetes. As a matter of fact, the most widely used standard diets in America and Europe still recognize this priority. In 1950 the American Diabetes Association was joined by the American Dietetic Association and the U.S. Public Health Service in promulgating standard diets (7), all of which were low in carbohydrates and high in fats. Although a change in these standards has been recently endorsed by these agencies, the old diets are still in wide use. The Nutrition Committee of the American Diabetes Association, however, issued an informational statement in 1971 calling attention to the disadvantages of standard diabetic diets that are high in fat (2). This publication also pointed out that when calories are controlled at appropriate levels, diets high in carbohydrate are well tolerated by diabetics. Another recent publication (44) reviews a great deal of evidence indicating that insulin requirement is more closely related to calorie intake than to carbohydrate intake. One of the reasons for this is the excellent capability of the diabetic liver for manufacturing glucose from a variety of noncarbohydrate sources.

Indeed, under certain conditions, even high-sugar diets are well tolerated by diabetics (5, 44). However, several considerations have led most authorities to recommend that refined sugars be proscribed or sharply limited in diabetic diets. Particularly when served as part of major meals, sugars tend to produce sharp elevations of the blood glucose, and even though these elevations tend to be evanescent when calories are appropriately limited, there are other effects that may be deleterious. For example, in some circumstances sucrose and other sugars, particularly fructose, may raise serum triglyceride levels.

On the other hand, high-starch diets are very well tolerated when caloric intake is appropriately controlled (23, 44). In obese patients who refuse to limit calories, fasting serum triglycerides tend to be higher when starch or sugar is substituted for much of the fat in equicaloric amounts. These elevations may abate with time, but they may persist to varying degrees, particularly if caloric intake remains excessive. However, postprandial triglyceride levels are usually higher when fat is substituted for carbohydrate. Epidemiologic evidence has been cited above suggesting the favorable effects of high-starch, low-fat diabetic diets on both serum triglyceride levels and vascular disease. Much of the confusion and uncertainty concerning the effects of dietary carbohydrates result from failing to distinguish between 1) effects of starches and the various sugars, 2) short-term and long-term effects of diet modifications, 3) added carbohydrates and added calories, and 4) effects on fasting and postprandial triglyceride values that sometimes differ.

These considerations have led to the development of a "modernized" dietary regimen for diabetics of Western societies (see Table 17–2).

About half of the calories of such diets are derived from carbohydrates, mainly starch. A small amount of sugar remains, principally as fruit or fruit juice. These diets provide as much or more starch (*e.g.,* bread, cereals, vegetables) than the traditional American diets of nondiabetics. About 30% of calories are derived from fat. It is usually feasible to limit saturated fat (*e.g.,* meat, milk, eggs) to about one-third of total fat (10% of total calories). The remaining two-thirds of this fat can be derived from polyunsaturates (*e.g.,* vegetable oils, special margarines) and from monosaturates (*e.g.,* nuts, poultry fat, olive oil) in approximately equal amounts (9). This contrasts with the typical American diet (about 40% fat, of which about two-thirds is saturated). Limitation of saturated fat also tends to limit, incidentally, cholesterol consumption. Eggs are a particularly rich source of cholesterol. In many persons, limiting or eliminating the habitual consumption of eggs in itself substantially reduces total cholesterol consumption. Special egglike products free of cholesterol are now widely available. Most patients find it possible to reduce animal fat intake by 50% or more without making sacrifices they consider particularly onerous, provided they are allowed to participate in the consideration of alternatives. Appendix Table A-3 shows amounts of cholesterol and amounts and types of fatty acids in specific foods. In many patients, saturated fat intake can be reduced considerably by simply proscribing or limiting fried foods. Another alternative attractive to some is frying in polyunsaturated oil. Several recent studies have demonstrated the feasibility and effectiveness of dietary measures in reducing serum lipid levels of diabetics, including juveniles.

Proteins usually provide about 20% of calories in these newer diabetic diets, but lower and higher amounts may be appropriate. In most adults a much smaller intake of protein, as low as 0.9 g/kg/day would suffice, but the necessity to control fat intake and sharply limit sugar tends to raise the level of protein in the diet. Patients who trim all gross fat from meat and those who eat leaner meat (*e.g.,* fowl and fish) often find it feasible and desirable to consume more protein to replace the fat contained in ordinary cuts of meat. The standard meat exchange of 1 ounce (see below) contains an average of 7 g protein and 5 g fat, while an ounce of very lean meat may contain as much as 9 g protein and as little as 2 g fat. In some patients, who find meat protein and certain polyunsaturates too expensive, starch can usually be substituted to replace much of the energy previously derived from sugar and fat. The mistaken notion that "diabetic diets" are necessarily expensive is based largely on the outmoded concept that starch is bad for diabetics and must be replaced with more-expensive foods, such as meat and dairy products. Moreover, the protein requirement of adult diabetics is usually far below the amounts in the old standard diets. Protein consumption should, however, exceed 1.5 g/kg daily in children and in pregnant and lactating women.

ALCOHOL

Since the metabolism of alcohol does not require insulin, it would appear to offer some theoretic advantages in the diet therapy of diabetes. There are, however, several disadvantages. Alcohol is high in calories (7 Cal/g) and devoid of nutritional value, except as a source of calories. It frequently tends to promote hypertriglyceridemia. In a small minority of patients who have high sulfonylurea levels, alcohol produces distressing symptoms, which include palpitation and flushing. The mechanism of these reactions is not well understood, but the symptoms are similar in some respects to those produced by the combination of alcohol and disulfiram (Antabuse). In fasting insulin-dependent patients, alcohol in large amounts may precipitate hypoglycemia by abetting insulin in reducing liver glucose output, and this hypoglycemia may be unrecognized because symptoms are attributed to intoxication. Many alcoholic drinks, *e.g.,* beers and wines, also contain appreciable amounts of carbohydrate, which amounts may or may not be known and taken into account by the patient. The direct and indirect effects of alcohol on glucose tolerance under various circumstances are still incompletely understood, as are its indirect effects on insulin requirement. In some patients, alcohol is more difficult to ration and regulate predictably than other foods. Not infrequently, alcohol consumption is attended by irregularities in the timing of the regular feedings and of their amounts and characteristics.

Even so, in most patients an occasional drink can be permitted. A convenient method is to trade fat calories for alcohol calories. One advantage of this is to demonstrate how high in calories alcoholic drinks are (one drink equals 15–20 g fat or 3–4 fat exchanges).

VITAMINS AND MINERALS

Special vitamin and mineral supplements are not ordinarily required. Diets of the type described

above usually supply all nutritional requirements. There are a few exceptions. Very fat persons who consume diets containing less than 1000 Cal over a long period may need supplemental nutrients on a temporary basis. Poor patients on high-starch, low-fat, low-protein diets may at times require supplements, such as iron or additional calcium. Profound hyperglycemia over long periods can lead to nutritional deficits, including negative nitrogen balance and muscle wasting. Vitamin supplements, including vitamins B_1 and B_{12}, have frequently been given in the hope they might ameliorate diabetic neuropathy, but there is no evidence suggesting that they are effective. However, diabetics with diarrhea secondary to pancreatitis or diabetic neuropathy may require vitamin and mineral (e.g., calcium) supplements. It has been suggested that metabolic aberrations of diabetes might lead to an increased need for ascorbic acid, a relative deficiency of which might contribute to the development of the microvascular lesions. However, this has been offered only as a hypothesis and not as a recommendation for therapy. There is no direct evidence at present that supplemental vitamin C is helpful in this respect. Profound deficiencies of potassium, chromium, and zinc have been associated with impairment of glucose tolerance, but replacement of these elements is seldom necessary as a regular part of the diabetic diet.

ADJUSTMENTS FOR UNUSUAL EXERCISE, POSTPONED MEALS, OR ILLNESS

All insulin-dependent patients should have specific instructions on the need for extra food to balance episodes of unusual exercise. Usually no extra feedings are required for exercise of short duration or of modest intensity (e.g., walking one-half mile at a moderate pace), but more-extensive exercise that is not habitually performed usually requires 10–50 g extra carbohydrate. A typical prescription might include 10–15 g/hour for moderate exercise (e.g., hunting or playing golf) and 20–30 g/hour for vigorous exercise (e.g., playing basketball or digging). Insulin-dependent patients should also have specific instructions on dietary measures to assure that hypoglycemia does not occur while driving. Some who are relatively insensitive to the potential dangers to themselves or others are more responsive to the possibility of losing their driver's license. Patients with labile diabetes should be given specific instructions on what to do when meals are unavoidably delayed. Usually the ingestion of 15–30 g carbohydrate (e.g.,

a few crackers, a large glass of fruit juice, one soft drink) protects from hypoglycemia for 1–2 hours on these occasions.

When illness curbs appetite in insulin-dependent patients, special measures are required. These should be prescribed to fit the circumstances, but some generalizations may be made. Consumption of carbohydrate in any form at the rate of about 50–75 g/6–8 hour usually suffices to prevent the ketosis of starvation. Often the lessening of insulin requirement which attends diminished caloric intake is at least balanced by an increase in requirement induced by the illness. Nevertheless, small frequent carbohydrate feedings are desirable as a means for protecting against hypoglycemia and ketosis.

In hospitalized insulin-dependent patients whose food intake is unpredictable (e.g., postsurgical state, GI problems), it is desirable that there be some kind of standard operating procedure with respect to the replacement of prescribed food that is not consumed or retained. This standard operating procedure can, of course, be modified according to the prevailing circumstances, but there should be an understanding among physicians, dietetic staff, and nursing staff concerning what is to be done routinely if specific orders are not promulgated. A typical plan is to try to replace, in the 3–hour period following the meal, enough food to bring intake of carbohydrate and calories to at least half that prescribed in the feeding. If this cannot be accomplished, the physician is informed, and he or she then determines whether additional measures (e.g., IV carbohydrate, changes in insulin dosage or diet) are warranted. It is frequently desirable during such occasions to revise diet prescriptions temporarily to lighter and more-digestible regimens that may contain a higher portion of simple carbohydrates and lesser amounts of complex carbohydrates, proteins, and fats (e.g., less A and B vegetables, less meat, more fruit juices). During some illnesses it may also be desirable to reduce calories in the prescription on a temporary basis. When sickness impairs appetite and digestion it is sometimes appropriate to permit or encourage refined sugars that are not ordinarily in the diet prescriptions, such as ginger-ale or other soft drinks. In these situations priority should be given to avoidance of starvation and vomiting and to predictability of intake and retention; carbohydrate restriction itself has little or no priority. In hospitalized patients who are acutely ill or in a postsurgical state, one way to make this point with the dietetic and nursing staffs is to order that the "diabetic diet" be temporarily

discontinued and replaced with a regimen along the lines described above. This temporary revision of priorities and strategies should also be explained to the patient.

SPECIAL TYPES OF DIABETES AND THE HYPERLIPEMIAS

Not all diabetics have features conforming to those of the two main classic types (fat maturity-onset and lean youth-onset insulin-dependent). A small percentage of insulin-dependent patients are also fat, and severe diabetes occasionally begins in later life. Diabetes of mild to moderate degree is not infrequently observed in lean adults. Not much direct evidence is available to suggest the optimum diet for the latter group of patients. Most diabetologists advise these patients to give up refined carbohydrates, but there is less unanimity concerning the types of foods that should replace these refined sugar calories (typically 10%–25% of the total). Based on considerations described above, in these patients I usually recommend a diet moderate in calories and low in sugars and animal fats with moderate-to-high levels of protein and vegetable fats and liberal amounts of starches.

Patients with hyperlipoproteinemias may present special problems. Although special measures are sometimes warranted, in a substantial majority of cases good control of diabetes and the diets recommended above will substantially ameliorate or completely control these hyperlipidemias. In diabetics the most common type is an excess of very low-density lipoproteins with high serum triglyceride levels and with serum cholesterol levels that are in or near the normal range (Type IV). These patients are usually obese. Only rarely does mitigation of obesity and hyperglycemia fail to ameliorate substantially the serum lipid abnormalities in patients with Type IV abnormalities. This type of hyperlipoproteinemia has been referred to as a "carbohydrate-sensitive" condition based on the assumption that restriction of carbohydrate is helpful. It now appears, however, that most of this benefit is incidental to the decrease in caloric consumption that so often attends carbohydrate restriction. Thus, the most critical factors in the control of triglyceridemia of fat diabetics are control of hyperglycemia and calories. Control of obesity and hyperglycemia also regularly mitigates the high cholesterol levels seen in patients with Type II, IIa, or Type V lipid patterns. On the other hand, diabetics with high cholesterol levels not infrequently require additional measures, such as further reduction of dietary cholesterol and saturated fat, further increasing the ratio between unsaturated and saturated fat, and antilipemic medications. Albrink (1) has recently published a good review of the therapy of the hyperlipidemias in diabetes.

PREGNANCY

Additional dietary requirements are few in diabetics who become pregnant. To assure a daily level of at least 1.5 g/kg it may be necessary to raise levels of protein in the prescription. Patients who have been under poor control may require, temporarily, even higher levels of protein intake to repair deficits resulting from the negative nitrogen balance that attends marked hyperglycemia. In the last half of pregnancy, a modest increase in calories (300–800 Cal/day) is indicated in lean patients, but total weight gain should not exceed 25 lb. Because of the higher frequency of toxemia and polyhydramnios in diabetics, dietary salt should be limited routinely in the last trimester to levels below 3–4 g daily. This can usually be accomplished simply by discontinuing use of table salt and avoiding or limiting a few foods that are grossly salty, such as bacon. If special risk factors exist or if early signs of toxemia, polyhydramnios, or edema develop, a more-rigorous and systematic restriction of sodium is usually appropriate.

DIETARY IMPLICATIONS OF COMPLICATING CONDITIONS

Provided one has a thorough understanding of the principles and priorities of diet therapy in diabetes, it is seldom difficult to adjust the diet prescription to meet the needs of other conditions requiring diet manipulation. Caso (8) has developed some standardized procedures for making such modifications. Among the common coincidental conditions are renal failure, congestive heart failure, peptic ulcer, and other GI disorders. The dietary requirements in these conditions are described in other sections of this book (see Chs. 15, 20, and 21). Many of the previous difficulties and concerns about reconciling dietary objectives have been mitigated by the knowledge that dietary carbohydrate is well tolerated by diabetics so long as calories are controlled. It is now evident, for example, that in patients with severe renal failure the control of diabetes is not adversely affected by diets high in starch and low in protein if calories are not excessive.

MAKING THE PRESCRIPTION FEASIBLE AND ATTRACTIVE

The best way to start this formulation is to find out what, when, and how much the patient would eat if he did not have diabetes. It is also helpful to know the food preferences and eating schedules of those with whom the patient is living and eating. Both new and long-standing diabetics often have erroneous notions about objectives and priorities of diet therapy. These should be identified and disspelled. It is appropriate to emphasize that the diabetic diet permits a great variety of attractive foods. Lean diabetics can be told that they are expected to eat as much as they would if they did not have diabetes. Most patients benefit from a systematic review of the principles outlined in Table 17–1. Lean insulin-dependent patients may have received certain written or verbal dietary instructions applicable only to fat maturity-onset cases and vice versa. It should be pointed out to the patient that it may be appropriate to modify the diet prescription from time to time because of future changes in factors such as work schedules, insulin therapy, food preferences, body weight, exercise patterns, and severity of diabetes.

It is desirable in determining the prescription to give as much consideration as possible to the patient's own preferences with respect to kinds of foods and eating schedules. Insulin-dependent adults given a standard diet containing 100 g protein may, for example, abandon this diet either because they find it difficult to buy this much protein or because they find the protein allowance well below their preference. As a matter of fact, it often would not matter whether the prescription contained 70 g or 130 g protein. Review of the last line of Table 17–2 shows that the requirements and objectives of the diabetic diet usually allow considerable flexibility of choice in deciding the proportions of carbohydrate, protein, and fat to be prescribed in any individual patient. It is, therefore, almost always possible to construct a prescription that is attractive as well as appropriate.

It should be kept in mind that some people are strongly rooted to habit and others are not. Most patients are quite receptive to modest changes in sources of calories, provided that they are offered some alternatives in the method by which these changes are achieved. If, for example, one of the dietary objectives is to reduce saturated fat, several possibilities may be offered. A patient may find it very difficult to give up certain fatty meats, while being neutral about eggs, or vice versa. He may dislike the specially con-stituted low-fat egg products, but he may like buttermilk (very low in fat) or polyunsaturated margarine, or vice versa. Developing a prescription that is reasonably consistent with the patient's preferences and situation greatly increases the likelihood that it will be regularly observed. Even if the prescription is slightly suboptimal, if well followed it is usually preferable to a theoretically ideal prescription that is unattractive or unfeasible.

SUMMARY OF STRATEGIES FOR DEVELOPING AND MODIFYING THE DIET PRESCRIPTION

First, a determination of dietary objectives and priorities is made based on such factors as the degree of deficit of endogenous insulin secretion, fatness, age, type of drug therapy required, and the presence of any special requirements (e.g., complicating illness, pregnancy, hyperlipoproteinemia). Then an analysis is made of the patient's attitudes, propensities, dietary preferences, preferred feeding patterns, and capacity for self-discipline. Having gained insights into both dietary requirements and dietary preferences, it is usually possible to constitute a prescription that is suitable, attractive, and feasible. The best way of constructing the prescription is to begin with the diet that the patient would follow if he did not have diabetes, modifying this only to the degree necessary to meet the truly essential requirements imposed by the metabolic disorder. Unfortunately, few physicians know enough about dietetics to construct these "personalized" prescriptions, and few dietitians have a sufficient clinical acumen to evaluate all the considerations that may determine dietary priorities and degree of precision required in a given patient. For example, the prescription for supper might appropriately provide exactly 4 ounces lean meat, 3–5 ounces, or an unlimited amount, depending on several factors such as the severity of diabetes, age, and adiposity of the patient. For these reasons, it is usually best that the prescription be developed as a joint enterprise involving the physician, dietitian, and the patient. Tables 17–1 and 17–2 suggest the considerations that apply. The physician may, for example, tell the dietitian that the initial prescription should contain about 2400 Cal daily, of which roughly 20% should be derived from animal fat. He may add, however, that if problems of feasibility arise, these figures can be adjusted within certain limits, e.g., 2200–2600 Cal and 15%–25% animal fat.

In a substantial majority of diabetics who are not insulin dependent, diet prescriptions and technical in-

structions can be quite simple. A typical prescription might provide only for limiting calories initially to a level in the range of 1200–1500 daily, proscribing or sharply limiting refined sugars, and reducing saturated fat and cholesterol intake to roughly half of previous amounts. Because implementation of such a prescription does not require great precision, this patient might not be required to learn the details of the standard exchange system. Time saved in simplifying the technical aspects of teaching fat diabetics should be reinvested in the counseling required in changing well-entrenched attitudes and behavior and in creating and strengthening incentives to develop new habits of diet and exercise.

Of great importance is the need for continuing review and adjustment of the initial prescription. One reason for this need is that the feasibility, appropriateness, and effectiveness of the initial prescription can only be estimated. Subsequent experience is very helpful in determining how best to compromise the therapeutic objectives with the patient's preferences and changing patterns of living. The substantial discrepancies between the diet consumed and the diet prescribed are in no small measure attributable to the failure to make appropriate adjustments to fit changing conditions.

MECHANICS OF IMPLEMENTING THE PRESCRIPTION

With few exceptions it is best to give the patients written instructions summarizing the purposes and potentials of the diet as well as its characteristics and mechanics. In children, for example, it should be stressed that regularity and predictability of intake are more important than proscription. Written instructions usually include a list of foods that may be taken in any amount and a list of those that should be avoided entirely. Standard lists of this kind are widely available and can be modified if necessary to fit the specific needs of the patient at hand. The size and characteristics of each meal are usually described, including the limits of variation permissable. These limits may be narrow or wide depending on the clinical circumstances. An elderly thin patient may be told, for example, that he may eat as he wishes, except that he should omit or limit a short list of foods that contain sugars. A middle-aged, fat patient with mild diabetes might be told only to omit a list of specified sweets and to reduce animal fat to about half of the previous amount.

A variety of methods have been employed to achieve precision and reliability while avoiding monotony. In insulin-dependent patients who may require a high degree of constancy and predictability of dietary intake, the best method is to teach them the concentrations of carbohydrate, protein, and fat in common foods ("diet calculation"). This provides a wider range of attractive options than the simpler but less flexible standard exchange system described below. Patients or parents of juvenile diabetics of average intelligence can usually learn how to formulate or select meals containing the appropriate amounts of fat, carbohydrate, protein, and calories. Often it is desirable in these patients to begin at first with the standard exchange method before proceeding later to the more-complex system of "diet calculation." Weighing food portions is seldom necessary on a long-term basis, but patients or mothers of juvenile diabetics who have weighed and measured portions for a few weeks gain considerable precision in estimating portion weights and amounts.

THE STANDARD EXCHANGE SYSTEMS AND STANDARD DIETS

The standard exchange systems are designed to allow the patient a considerable degree of day-to-day flexibility of diet while achieving a moderate degree of constancy with respect to amounts and distribution of the major food elements (carbohydrate, protein, fat, and calories). The most widely used exchange system is that developed and promulgated by the American Diabetes Association, the American Dietetic Association, and the U.S. Public Health Service (7). This general method with or without minor modifications is used in most hospitals in the United States. Similar approaches have been employed in other countries, although details differ slightly. The details of these well-known "A.D.A." exchange lists are not presented here because they are already widely available in hospitals, diet manuals, and books on nutrition and diabetes. This system was revised in 1976. The newer revision is recommended.

This standard American system involves the categorization of the foods allowed into six groups based on general characteristics. Foods consisting mainly of protein appear, for example, on a "meat exchange list," and foods containing mainly fat appear on a "fat exchange list." The lists indicate how much of each of these foods is equivalent to the standard exchange unit and how much carbohydrate, protein, and fat is in the unit. For example, the

bread exchange list shows that one small serving of potato and certain specified portions of the many other foods on this list are all equivalent to one standard slice of bread and that each contains about 15 g carbohydrate, 2 g protein, and negligible amounts of fat. For each feeding prescribed, the patient is told how many exchange units he may have from each of these lists. For example, breakfast might consist of two meat exchanges, three bread exchanges, two fat exchanges, two fruit exchanges, and one-half milk exchange.

This system may be easily modified to fit the needs of specific patients. For instance, a certain patient may be told that he can have unlimited amounts of vegetables except for those on the bread exchange list that are higher in calories. It may be appropriate to permit certain patients to make exchanges between the fruit list and the bread list under the assumption that one bread exchange is roughly equivalent to one and a half fruit exchanges. Amounts of fat in various meats differ greatly. Trimming gross fat from meat servings and selecting especially lean meats, such as chicken and certain fish, reduces fat from an average of 5 g per ounce to about 3 g per ounce thereby reducing cholesterol, and calories as well. Some foods on the old meat exchange lists (*e.g.,* eggs and certain cheeses) contain as much as 6–7 g fat per exchange. Saturated fat calories, trimmed from the diet can be replaced if necessary with starch, vegetable fat, or protein.

A publication entitled "Meal Planning and Exchange Lists" is widely available and may be obtained from the American Diabetes Association or the American Dietetic Association. In addition to the exchange lists, this booklet contains standard lists of foods to be omitted and those that may be freely consumed. Several recipes and some general instructions are also included. Recipes are available in several cookbooks, for diabetics. These recipes yield food portions with defined amounts of carbohydrate, protein, and fat. Typically these constituents correspond to units or combinations of units of the standard exchange system.

The American Diabetes Association and the American Dietetic Association also promulgated nine standard diets with a range in daily caloric content of 1200–3500. These diets were conceived in the 1940s and reflect the priority given at that time to restriction of carbohydrate. Most authorities now believe that these standard diets contain too much fat. Endorsement of these traditional diets by these organizations was discontinued in 1976. These standard diets are, however, still very widely used. One reason is that most physicians have very limited capacity for developing individualized diet prescriptions. Another reason is that their use often saves time initially. Moreover, they may serve as a framework for a more-individualized prescription produced by modifying the standard regimen. But the two disadvantages of these present diets should be kept in mind if they are used since their indiscriminate use may increase intake of saturated fat and militate against the development of a prescription based on the patient's individual preferences and metabolic needs. If used judiciously and modified appropriately, standard diets will continue to have utility, particularly after they are modernized along lines suggested in Table 17–2.

SPECIAL FOODS AND FOOD SUBSTITUTES

No special low-carbohydrate foods are required in the diabetic diet. The use of special foods marketed as "dietetic" often leads to difficulties. Although most of these contain less carbohydrate and calories than the food they are designed to emulate, many contain appreciable carbohydrate and calories, the amounts of which may not be specified or understood by the patient. However, when the constituents of these special foods are clearly stated and understood, they may have value in making the diet more attractive. Canned fruit without sugar may, for example, be useful and economical. The uses of low cholesterol and polyunsaturated fat products has been mentioned above.

With respect to the use of artificial sweeteners, two different approaches are possible. The patient may be encouraged to become accustomed to a low-sugar regimen. One can point out, for example, that in cultures where sugar has been unknown people find their diets palatable and attractive because they are accustomed to these foods. Not infrequently, diabetic children after a period of time lose their craving for sweets. On the other hand, in many circumstances the use of artificial sweeteners is warranted. Many fat diabetics, for example, like artificially sweetened drinks about as well as the standard products. Some of these "dietetic" drinks can be allowed freely, but some contain appreciable amounts of sugar. Even so, if their composition is known, they may sometimes be included in the diet by exchanging other foods in the prescription for them. Older patients are often firmly attached to

the sweetening of tea or coffee. Frequently they find saccharin or other substitutes quite acceptable as replacements for sugar.

Fructose has been suggested as a substitute for sucrose for two reasons: 1) under most but not all conditions, it is considerably sweeter, by as much as 70%, than sucrose, so a relatively small amount is required for sweetening, and 2) it does not require insulin for certain steps in its metabolism. Much of this advantage is, however, mitigated by the capacity of the liver to convert appreciable amounts of fructose and its metabolic products to glucose. Moreover, under certain conditions serum triglyceride levels may be higher after fructose than after other simple sugars. Fructose has been used effectively under some conditions as part of the diabetic diet. Its role deserves further exploration, but the potential practical advantages that attend use of fructose products do not seem substantial.

Sorbitol has been widely used as a sugar substitute in dietetic foods because it is slowly absorbed and does not require insulin in the initial steps of its metabolism. Its use is not recommended. Sorbitol contains approximately as many calories as the sugar it replaces, and it is only 60% as sweet as sucrose. It may produce diarrhea if consumed in large amounts. Sorbitol is metabolized to fructose, which in turn is partly converted to glucose.

EDUCATING THE PATIENT

The discussion above has emphasized the importance of conveying to the patient an understanding of both the objectives and the mechanics of diet therapy. There is also need for a systematic program to identify any deficits or misunderstandings. The checklist that appears above (see Formulating the Prescription section) was designed to help the physician and the dietitian in this respect. Group instruction may be helpful and economical, but the principles of diet therapy are quite different in the two main types of diabetes (fat insulin-dependent and lean insulin-dependent), and any group teaching must take this into account. In fact, good argument can be made for separating entirely the dietary instruction of these two main subgroups. Instruction of hospital patients who are not acutely ill should be initiated on entry rather than at time of discharge. At the time of admission, the physician should whenever possible conceive in consultation with the dietitian a prescription for both the hospital diet and the approximate diet anticipated on discharge.

Under proper supervision and after adequate training, other professionals and subprofessionals (36) may play effective roles in the diet instruction of diabetics (15). This includes nurses, "physician's assistants," social workers, lay groups (e.g., "Weight Watchers," "TOPS"), and diabetics themselves. The general dietary strategies pursued by the Weight Watchers organizations usually fit well the dietary requirements of obese diabetics. However, they often suggest consumption of liver on a regular basis because it is low in calories and nutritious. I usually limit liver or make it optional because it is high in cholesterol, it is not necessary, and many people don't like it.

A variety of educational resources are available without charge from the drug companies. For example, the U.S. Vitamin Corporation has produced diet plans especially created for different ethnic groups, such as Mexican-Americans, Jews, Chinese, Italians. The American Diabetes Association publishes information materials relating to diet therapy (1 West 48th Street, New York, NY 10020). The North Carolina Diabetes Association has sponsored a simplified exchange system, developed by Catherine Wason and her associates, which is useful in patients with limited education (412 West Franklin Street, Chapel Hill, NC 27514). Tani and Hankin (40) describe a self-learning unit that employs computers and principles of programed learning. Automated instruction has been described by Young and associates (51). Special teaching centers for diabetics have been developed and are highly recommended (14, 16, 29).

One of the few inconveniences with the diabetic diet is the need to abstain from certain mixed dishes served outside the home, the constituents of which are highly uncertain. I advise the fat diabetic simply to decline these whenever feasible. When no alternatives are easily available to him, I advise the lean insulin-dependent diabetic to accept the dish after crudely estimating its constituents and taking them into account, erring on the side of overconsumption. Subsequent urine testing readily identifies any need for compensatory adjustments in therapy. Gross and persistent aberrations of glycemia are never the result of miscalculation of the constituents of a single dish. Even dietary indiscretions of gross degree, if they are temporary (e.g., single feast), seldom lead to any serious immediate problems, such as ketosis. Insulin-dependent patients on completely free diets who eat regularly usually feel quite well if they get enough insulin to avoid gross polyuria and acidosis. Patients are often given exaggerated notions about the im-

mediately deleterious effects of dietary indiscretions. When they learn through experience that they still feel pretty well after dietary indiscretions, they may come to the conclusion that the physician and dietitian are inclined to exaggeration or even ignorance. Patients should understand, therefore, the important distinction between the relatively innocuous short-term effects of overconsumption and the more-deleterious effects that follow persistent dietary indiscretion.

WHO IS QUALIFIED AND WHO SHOULD BE RESPONSIBLE FOR DIET THERAPY?

Ultimately, the patient treats himself. The role of the physician, the dietitian, and those who help them is to teach the patient what he should do. This teaching, however, must extend well beyond technical details, such as the number of bread exchanges in lunch. The patient must understand the advantages to be gained by modifying the diet and the reasons for and relative importance of the various strategies employed. A frequently overlooked point is that the more the patient knows about principles and details, the greater are his tactical options and the easier and more pleasant his regimen.

Unfortunately, only a minority of physicians have the time, inclination, and expertise to conceive and implement optimal diet therapy, and the dietitian who knows all about diet exchanges may have little understanding of certain important metabolic or clinical considerations. Even physicians who have considerable clinical sophistication are often quite ignorant concerning certain aspects of dietetics. When physicians and dietitians work closely together in designing and implementing the prescription and in teaching the patient, many of these difficulties are overcome. Insulin-dependent patients in particular require special expertise that is not possessed by most dietitians and most physicians. It is not difficult for the physician to learn these rudiments—they are not complex—but the physician who does not know the major nutritional constituents of common foods and how to calculate, modify, and individualize diets probably shouldn't attempt to treat patients with labile diabetes. And dietitians who are responsible for teaching insulin-dependent diabetics also require special training in order to understand the principles and strategies as well as the tactics of diet therapy. The major role of the physician is to see that the patient learns these principles and how to implement them. Much of this responsibility can be delegated to dietitians or others with special knowledge in the field, but the physician must assume responsibility for developing these mechanisms and applying them to the specific needs of individual patients.

OTHER SOURCES OF INFORMATION

Hardinge, Swarner, and Crooks (22) have published a list describing the specific carbohydrates present in various foods. The H. J. Heinz Company and the Campbell Soup Company publish lists showing the composition of their soups. Kaufman (26) has published a useful guide giving the amounts of cholesterol and carbohydrate in various brand name foods. The publication of Church and Church (10) gives details on the composition of foods, as does Handbook Number 8 of the Department of Agriculture. This and other useful information on diet appear in Joslin's book on diabetes (28), in publications of Ohlson (34), and of Christakis and Miridjarian (19). Stone (38) has written a good review for dietitians. A recent book concerns diabetes and nutrition (17). Kay (26a) has published a short review on this subject with emphasizing recent progress in understanding the general principles rather than details of clinical dietetics. Levine (30) has written an excellent essay on dietary carbohydrates.

REFERENCES

1. Albrink MJ: Dietary and drug treatment of hyperlipidemia in diabetes. Diabetes 23: 913–918, 1974
2. Bierman EL, Albrink MJ, Arky, RA et al.: Special report: principles of nutrition and dietary recommendations for patients with diabetes mellitus. Diabetes 20: 633–634, 1971
3. Bjorntorp P, Fahlen M, Grimby G, Gustafson A, Holm J, Renstrom P, Schersten T: Carbohydrate and lipid metabolism in middle-aged, physically well-trained men. Metabolism 21: 1037–1044, 1972
4. Bloodworth JMB: Diabetes mellitus and vascular disease. Postgrad Med: 84–89, 1973
5. Brunzell JD, Lerner RL, Hazzard WR et al.: Improved glucose tolerance with high carbohydrate feeding in mild diabetes. N Engl J Med 284: 521–524, 1971
6. Campbell GD, Batchelor EL, Goldberg MD: Sugar intake and diabetes. Diabetes 16: 62–63, 1967
7. Caso EK: Calculation of diabetic diets: report of the committee on diabetic diet calculations, American Dietetic Association. J Am Diet Assoc 26: 575–583, 1950
8. Caso EK: Supplements to diabetic diet material. J Am Diet Assoc 32: 929–934, 1956
9. Christakis G, Miridjanian A: The nutritional aspects of diabetes. In Ellenberg M, Rifkin H (eds): Diabetes Mellitus: Theory and Practice. New York, McGraw-Hill, 1970, p 594
10. Church CF, Church HN: Food Values of Portions Commonly Used, 11th ed. Philadelphia, JP Lippincott, 1970

11. Cleave TL: The Saccharine Disease. Bristol, England, John Wright & Sons, 1974

12. Cohen AM: Environmental aspects of diabetes. Isr J Med Sci 8: 358–363, 1972

13. Davidson JK: Effect on withdrawing oral and antidiabetic medication together with intensification of diet therapy. In Epidemiologic Studies and Clinical Trials in Chronic Diseases. Washington DC, Proc Pan Am Health Org, 1972, pp 44–48

14. Ehrenfeld I, Matison JA: A hospital-sponsored diabetic instruction program. Hospitals 39: 67–68, 1965

15. Etzwiler DD: Who's teaching the diabetic? Diabetes 16: 111–117, 1967

16. Etzwiler DD: Developing a regional program to help patients with diabetes. J Am Diet Assoc 52: 394–400, 1968

17. Froesch ER, Yudkin J (eds): Nutrition and Diabetes Mellitus. Milan, Casa Editrice II Ponte, 1972 (This was also published in Acta Diabetol Lat [Suppl] 9(1), 1972)

18. Goldberg RB, Bersohn I, Joffe BI, Krut LH, Seftel HC: Hyperlipidaemia, obesity and drug misuse in a diabetic clinic. S Afr Med J 48: 270–280, 1974

19. Goodman JI, Schwartz ED, Frankel L: Group therapy of obese diabetic patients. Diabetes 2: 280–284, 1953

20. Greenwood BM, Taylor JR: The complications of diabetes in Nigerians. Trop Geogr Med 20: 1–12, 1968

21. Gulati PD, Bhaskar Rao M, Vaishnava H: Letter: Diet for diabetics. Lancet 2: 297–298, 1974

22. Hardinge MG, Swarner JB, Crooks H: Carbohydrates in foods. J Am Diet Assoc 46: 197–204, 1965

23. Hillebrand SS (ed): Is the risk of becoming diabetic affected by sugar consumption? Proc VIII Int Sugar Res., Bethesda, International Sugar Research Foundation, 1974

24. Himsworth HP: Diet and the incidence of diabetes mellitus. Clin Sci 2: 117–148, 1935–1936

25. Jackson WPU, Goldberg MD, Marine N, Vinik AL: Effectiveness, reproducibility and weight-relation of screening tests for diabetes. Lancet 2: 1101–1105, 1968

26. Kaufman WK: Brand Name Guide to Calories and Carbohydrates. New York, Pyramid, 1973

26a. Kay RM: Nutrition in the etiology and treatment of diabetes mellitus. Nutrition 28: 97–109, 1974

27. Knowles HC Jr: Long-term juvenile diabetes treated with unmeasured diet. Trans Assoc Am Physicians 84: 95–101, 1971

28. Krall LP, Joslin AP: General plan of treatment and diet regulation. In Marble A et al. (ed): Joslin's Diabetes Mellitus, 11th ed. Philadelphia, Lea & Febiger, 1971, pp 255–286; 832–857

29. Krall LP, Joslin AP: Hospital teaching unit. In Marble A et al. (ed): Joslin's Diabetes Mellitus, 11th ed. Philadelphia, Lea & Febiger, 1971, pp 256–258

30. Levine R: Carbohydrates. In Goodhart RS, Shils ME (eds): Modern Nutrition in Health and Disease. Philadelphia, Lea & Febiger, 1973, pp 99–116

31. Lundbaek K: Diabetic angiopathy. Mod Concepts Cardiovasc Dis XLIII: 103–107, 1974

32. Marble A et al. (ed): Joslin's Diabetes Mellitus, 11th ed. Philadelphia, Lea & Febiger, 1971

33. Reference deleted

34. Ohlson MA: Experimental and Therapeutic Dietetics, 2nd ed. Minneapolis, Burgess, 1972

35. Olefsky J, Reaven GM, Farquhar JW: Effects of weight reduction on obesity: studies of lipid and carbohydrate metabolism in normal and hyperlipoproteinemic subjects. J Clin Invest 53:64–76, 1974

36. Reardon E: Can sub-professionals assist in teaching patients with diabetes? Current comment. J Am Diet Assoc 52: 405–406, 1968

37. Stone DB: A study of the incidence and causes of poor control in patients with diabetes mellitus. Am J Med Sci 241: 64–70, 1961

38. Stone DB: A rational approach to diet and diabetes. J Am Diet Assoc 46: 30–35, 1965

39. Sussman K, Metz R: Diabetes Mellitus, Vol IV: Diagnosis and Treatment. New York, American Diabetes Association, 1975

40. Tani GW, Hankin JH: A self-learning unit for patients with diabetes. J Am Diet Assoc 58: 331–335, 1971

41. Weinsier RL, Seeman A, Herrera MG, Simmons JJ, Collins ME: Diet therapy of diabetes: description of a successful methodologic approach to gaining diet adherence. Diabetes 23: 669–673, 1974

42. West KM: Epidemiology of diabetes. In Sussman KE, Fajans SS (eds): Diabetes Mellitus, Vol III: Diagnosis and Treatment. New York, American Diabetes Association, 1971

43. West KM: Epidemiologic evidence linking nutritional factors to the prevalence and manifestations of diabetes. Acta Diabetol Lat [Suppl] 9(1): 405–428, 1972

44. West KM: Diet therapy of diabetes: an analysis of failure. Ann Intern Med 79: 425–434, 1973

45. West KM: Epidemiology of adiposity. In Vague J, Boyer J (eds): The Regulation of the Adipose Tissue Mass. Int Congr Series No. 315 (SBN 90 219 0225 7). Marseilles, Proc IV Intern Mtg Endocrinol, 1973

46. West KM: Diabetes in American Indians and other native populations of the new world. Diabetes 23: 841–855, 1974

47. West KM, Kalbfleisch JM: Glucose tolerance, nutrition and diabetes in Uruguay, Venezuela, Malaya and East Pakistan. Diabetes 15: 9–18, 1966

48. West KM, Kalbfleisch JM: Diabetes in Central America. Diabetes 19: 656–663, 1970

49. West KM, Kalbfleisch JM: Influence of nutritional factors on prevalence of diabetes. Diabetes 20: 99–108, 1971

50. Wood FC Jr, Bierman EL: New concepts in diabetic dietetics. Nutr Today 7: 4–10, 1972

51. Young MAC, Buckley PH, Wechsler H, Demone HW Jr: A demonstration of automated instruction for diabetic self care. AMJ Public Health 59: 110–122, 1969

18 Drug and nutrient interactions

Richard C. Theuer, Joseph J. Vitale

Attention has recently focused on drug–drug interactions as sources of therapeutic failure and therapeutic overtreatment (5). Physicians and pharmacists are becoming aware that they must know the variety of drugs a patient is taking in order to gauge the effect and proper dosage of any additional ones. Drug–nutrition interactions are less well studied, but they are being recognized as the source of some clinically observable side effects and adverse reactions. There are two basic drug–nutrition interactions. Firstly, nutritional status affects the rate of drug metabolism. For example, the vitamin C–deficient organism more slowly metabolizes barbiturates and has a prolonged sleeping time (40). Secondly, drugs affect nutritional status. Anticonvulsant drugs can produce vitamin D–deficiency rickets (2, 22, 23, 31); oral contraceptives can produce vitamin B_6–responsive mental depression (1) and folic acid–responsive megaloblastic anemia (29, 30). This chapter will emphasize the direct effects of various therapeutic categories of drugs on nutritional status and the clinical manifestations of these effects.

Table 18–1 summarizes major drug effects on vitamins and minerals and the known and postulated clinically observable effects that result.

SPECIFIC EFFECTS OF DRUGS

ANTICONVULSANT AND SEDATIVE DRUGS

VITAMIN D

Children and adults receiving anticonvulsant drugs have lower serum calcium and phosphorus levels and higher serum alkaline phosphatase levels than those not receiving such drugs (2). Roentgenologic examination of wrists, knees, and elbows reveals morbidic changes in patients receiving anticonvulsant drugs, even though children only rarely develop frank rickets. The clinical picture is similar to vitamin D–deficiency rickets and responds rapidly to small amounts of vitamin D. For instance, 89 of 342 residents at a school for retarded children in Utah had rickets as defined by low serum calcium and phosphorus levels, elevated serum alkaline phosphatase levels, and appropriate bone changes (31). Of patients who had received either diphenylhydantoin (DPH) or phenobarbital, or both, for one year or more, 65% had rickets. Of 11 patients receiving a regular vitamin D supplement in addition to DPH or phenobarbital, 9 also had rickets.

Four basic factors affect the probability that a patient will develop rickets when he receives an anticonvulsant drug. The first factor is the total amount and the total number of anticonvulsant drugs. The higher the dose and the greater the number of drugs, the greater the chance of rickets. The second factor is vitamin D intake. The average vitamin D intake is higher in Canada and the United States than in Europe, and the incidence of rickets is less. The third factor is sunlight exposure. Sunlight is necessary for synthesis of vitamin D in the skin. The more sunlight exposure, the more vitamin D produced in the skin and the less rickets. The fourth factor is skin color. Darker skin allows less penetration of ultraviolet light and thus less synthesis of vitamin D. Case reports of drug-induced rickets in the American literature indicate a predominance of blacks developing the problem (23).

The main circulating form of vitamin D is 25-hydroxycholecalciferol (25-HCC). Several metabolites of 25-HCC are now known to exist, perhaps the most important of them being 1,25-dihydroxycholecalciferol (1,25-DHCC). Vitamin D after being absorbed from the gut is transformed to 25-HCC in the liver, and this is transformed to the active form 1,25-DHCC in the kidney. Anticonvulsant drugs apparently not only inhibit the conversion of vitamin D to 25-HCC in the liver, they may also enhance the

TABLE 18—1. Major Drug Effects on Vitamins and Minerals

Therapeutic class	Major drugs	Nutritional effect	Clinical effect
Anticonvulsants and sedatives	Diphenylhydantoin Phenobarbital Glutethimide	Accelerated vitamin D metabolism Accelerated vitamin K metabolism Folic acid deficiency	Rickets Neonatal hemorrhaging Megaloblastic anemia Gingival hyperplasia (?) Neurologic deterioration (?) Congenital malformations (?)
		Vitamin B_6 deficiency	None established
Corticosteroids	Cortisone Prednisone	Accelerated vitamin D metabolism Increased vitamin C excretion Increased vitamin B_6 requirement	Accelerated bone loss None established Abnormal glucose tolerance (?) Mental depression (?)
		Increased zinc excretion Increased potassium excretion	Slow wound healing Muscle weakness
Alcohol		Vitamin B_1 deficiency	Wernicke's encephalopathy Korsakoff's psychosis
		Impaired vitamin B_6 activation	Peripheral neuropathy (?) Sideroblastic anemia (?) "Rum fits" (?)
		Folic acid deficiency Increased magnesium excretion	Anemia (?) ECG changes Delirium tremens
Nonabsorbed antibiotics	Neomycin Kanamycin	Reduced lactase levels	Lactose intolerance
Antitubercular drugs	Isoniazid	Vitamin B_6 deficiency Niacin deficiency	Polyneuritis Pellagra symptoms
Diuretics	Chlorthiazide	Increased potassium excretion Increased magnesium excretion	Muscle weakness Magnesium depletion
	Spironolactone	Reduced potassium excretion	Hyperkalemia
Hypotensives	Hydralazine	Vitamin B_6 depletion	Polyneuritis
Antiinflammatory drugs	Aspirin Indomethacin	GI bleeding	Iron deficiency anemia
	Phenylbutazone	Folic acid deficiency	Megaloblastic anemia
Oral contraceptives and estrogens	Mestranol Ethinyl estradiol	Vitamin B_6 depletion	Mental depression Abnormal glucose tolerance
	Conjugated estrogens	Folic acid deficiency	Megaloblastic anemia Megaloblastic cervical cytology Increased megaloblastic anemia in subsequent pregnancy
		Reduced calcium excretion	Reduced bone loss

conversion of vitamin D to inactive metabolites (2,23).

The amount of vitamin D required to compensate for the anticonvulsant drug-induced acceleration of vitamin D metabolism is estimated to be 600–1000 IU daily or more. This is about 4–10 times the normal requirement, and 1 ½–2 ½ times the RDA (2) (see Table A-1).

VITAMIN K

In clinical practice, vitamin K deficiency usually results from either: 1) inadequate intake, which is rare; 2) failure of absorption from the intestinal tract; 3) a defect in the bacterial synthesis of vitamin K in the colon; 4) inadequate vitamin reserves in the newborn due to low vitamin K stores in the mother (37); and 5) administration of vitamin K antagonists or various drugs, e.g., anticonvulsants (5). Thus, vitamin K deficiency almost invariably represents a conditioned deficiency resulting from a coexistent disease or from the administration of vitamin antagonists or drugs that block its utilization. The use of vitamin K in counteracting drug or anticonvulsant therapy may complicate subsequent therapy and delay the reestablishment of proper dosages to the detriment of the patient.

The same microsomal enzyme system metabolizes vitamins K and D, and vitamin K needs appear to be increased by anticonvulsant drugs (5). Babies born to mothers who received anticonvulsants or anticoagulants during pregnancy can have subnormal levels of blood-clotting factors. Neonatal hypoprothombinemia and hemorrhaging can be prevented by administering vitamin K immediately at birth (37, 5).

FOLIC ACID

It has been known for 30 years that anticonvulsant drugs commonly produce folic acid deficiency (20). Megaloblastic anemia occurs in as many as 50% of epileptics receiving anticonvulsant drugs and low serum folic acid levels occur in as many as 75% (20, 38). Folic acid deficiency is produced by DPH alone or in combination with other drugs, primidone alone or in combination with other drugs, and barbiturates alone or in combination with other drugs (23).

Several clinically important side effects of anticonvulsant drugs may be related to the folic acid deficiency. Gingival hyperplasia is very common in patients receiving anticonvulsants, and 15 mg folic acid has corrected severe gingival hyperplasia within 8 days (28). Neurologic impairment and deterioration occur in some individuals receiving high dosages of anticonvulsants (21). It has been suggested that this may be due to chronic folic acid deficiency (21); folic acid and vitamin B_{12} supplementation may be useful prophylaxis (13). Anticonvulsant drugs are teratogenic. The higher incidence of congenital malformations among mothers taking these drugs may be the result of an induced folic acid deficiency (23).

A number of other drugs, *e.g.,* antimalarials and oral contraceptives, can induce folate deficiency disease (23, 29, 38). These same agents may also adversely affect vitamin B_{12} metabolism, but the evidence for such an action is not as clear-cut as that for folate (6, 38). Thus, when long-term therapy with any of these drugs is employed, it is necessary to supplement the patient's intake with both vitamin B_{12} and folic acid. If folic acid is administered alone, a deficiency of vitamin B_{12} may be precipitated. Conversely, folate administration may increase the metabolism of various anticonvulsant drugs (23). Thus, in patients receiving folate therapy and anticonvulsants, the increased frequency of seizures which has been observed may be mitigated by decreasing the amount of folate administered (38). It is now clear that the seizures are attributable neither to folate nor to folate deficiency but rather to the action of folate on the metabolism of these anticonvulsants (23).

The FDA recognizes the need for increased folic acid supplementation for individuals receiving anticonvulsant drugs. Folic acid administration orally or parenterally in doses of 1–5 mg daily appears to be sufficient to overcome the deficiency without impairing the drug effect (20).

VITAMIN B_6

Vitamin B_6 deficiency can be common in children using anticonvulsants. Of epileptic children, 30%–60% exhibit various biochemical indices of vitamin B_6 depletion (19). Initiation of DPH therapy causes a decline in vitamin B_6 serum levels (18). Vitamin B_6 deficiency in infancy is associated with convulsions, and attempts have been made to provide large amounts of vitamin B_6 as direct therapy for epilepsy. Occasional success has been reported, but a lack of effect is more generally observed (19).

The minimum amount of vitamin B_6 which will reverse the biochemical abnormalities reported in children on anticonvulsant drugs has not been precisely defined. Dosages of 60–120 mg daily successfully reverse these changes; lower dosages have not been tried. The normal child requires only 1–2 mg vitamin B_6 daily, and a daily supplement of 10 mg vitamin B_6 should be sufficient for the patient being treated with anticonvulsants.

CORTICOSTEROIDS

Corticosteroids increase the rate of vitamin D metabolism in the same way as anticonvulsant drugs. When rheumatoid arthritic patients receive corticosteroids, the onset of their osteoporosis is more rapid (12). Increased urinary calcium and magnesium excretion caused by corticosteroids may be related to accelerated bone resorption. Corticosteroids decrease calcium absorption (23). Calcium and vitamin D supplement may reverse some of these effects of corticosteroids. Corticosteroids increase vitamin C requirement (11).

Corticosteroids increase the need for vitamin B_6 (25). The abnormal metabolism resulting from vitamin B_6 inadequacy may be the biochemical reason that patients receiving corticosteroids become insulin-resistant and glucose-intolerant (25).

Urinary excretion of zinc is increased by corticosteroids (8). Many of the elderly have bedsores, decubitus ulcers, and other venous drainage problems that may be related to inadequate zinc intake. Zinc supplements improve wound healing in those with low initial plasma zinc levels. Corticosteroids can lead to delayed wound healing that can be overcome by zinc supplementation (8). Thus, increased urinary zinc excretion due to corticosteroids may precipitate a marginal zinc deficiency.

Potassium losses can lead to muscle weakness,

which can be overcome by foods rich in potassium or by potassium supplements (see Ch. 15). Corticosteroids produce potassium loss (10).

ALCOHOL

Excessive alcohol ingestion is associated with a number of vitamin and mineral deficiencies (34) (see Ch. 13). Deficiencies of thiamin, folic acid, magnesium, and iron are most often exhibited by chronic alcoholics. Deficiencies of pyridoxine, pantothenic acid, riboflavin, zinc, and copper also occur. The correlation between alcoholism and vitamin and mineral deficiencies may be primary or secondary in nature. Recent evidence suggests that alcohol produces its deleterious nutritional effects by acting directly on tissues and enzyme systems, principally in the liver, which is the major site for both ethanol oxidation and vitamin storage, rather than by simply reducing nutrient intake. Excessive alcohol ingestion undoubtedly decreases the intake of essential nutrients, but a diseased organ—through interacting factors of altered absorption, decreased storage capacity (in terms of both concentration and functional mass), defective activation of vitamins, and metabolic aberrations—can exacerbate a dietary deficiency. Thus alcoholics sampled by socioeconomic status rather than by incidence of hepatic disease may have a nutritional status not markedly inferior to that of nonalcoholics (34).

THIAMIN

One of the more serious diseases of alcoholism is Wernicke's encephalopathy, which is definitely associated with an acute, severe deficiency of thiamin (vitamin B_1) (34). Certain signs of Wernicke's syndrome respond well to prompt treatment with thiamin, and it may be necessary to provide other vitamins as well. Korsakoff's psychosis, another syndrome associated with alcoholism in which thiamin deficiency may be implicated, should be treated accordingly. Some clinicians have used as much as 50 mg thiamin/day orally with prompt remission of such signs as nystagmus, ataxia, and ophthalmoplegia (34).

Additional factors involved in thiamin deficiency are: 1) recentness of alcohol ingestion (which adversely affects absorption even in healthy subjects), 2) acute liver injury (the degree of which can be correlated with red blood cell transketolase activity), and 3) the presence of magnesium deficiency. Magnesium deficiency, which appears induced by chronic alcoholism, seems to compound the manifestations of thiamin deficiency. Thiamin-magnesium–deficient rats respond less well than thiamin-deficient rats to administration of thiamin, as measured by both growth response and liver transketolase levels. The mechanism by which excessive ethanol may effect magnesium deficiency is not clear. Alcohol intake increases urinary loss of magnesium (in both alcoholics and nonalcoholics), but the loss is not directly related to urinary lactate excretion, nor can red blood cell levels of transketolase, serum magnesium, or serum lactate be correlated (34).

VITAMIN B_6

Alcohol-induced deficiency of pyridoxal phosphate, the active form of vitamin B_6, may cause several clinical disorders seen in the alcoholic patient, including peripheral neuropathy, convulsions, sideroblastic anemia, and liver disease. Patients with severe alcoholic fatty liver and cirrhosis have decreased plasma pyridoxal phosphate levels and a decreased content of vitamin B_6 in their livers (34). Vitamin B_6 deficiency may be involved in the seizures seen in some alcoholics during the 36–72 hours following an alcoholic binge ("rum fits"). Pyridoxine deficiency and convulsions are associated in these individuals (16). In contrast, vitamin B_6 deficiency generally is not seen in patients with other neuropathies, such as Wernicke's and Korsakoff's syndromes.

FOLIC ACID

Evidence elucidating the mechanisms of folate deficiency in chronic alcoholism is somewhat equivocal. However, it appears that folate deficiency may be secondary to liver disease (in terms of increased release of folic acid or possibly decreased affinity for folate) and changes in absorption (which are most notable following a concentrated drinking spree), rather than due to a primary dietary deficiency. Other inconclusive evidence includes the fact that alcohol reversibly suppresses the hematopoietic response to folic acid in anemic folate-deficient patients, and malabsorption of folic acid cannot completely account for the effect (33).

MAGNESIUM

The ECG changes of alcoholic heart disease are similar to those of magnesium deficiency, but

neither is specific and both may mimic those of potassium deficiency (16). Many patients with a cardiomyopathy have a history of chronic alcoholism. Even those alcoholic patients who appear healthy and do not have other diseases may show abnormal cardiac performance. Alcohol increases the excretion of magnesium in the urine and can produce a low blood level of magnesium. In the withdrawal phase, alcoholics who have low serum magnesium levels are more prone to seizures and delirium tremens. Magnesium sulfate given intravenously to alcoholic patients with a low seizure threshold can increase the threshold to normal. An abrupt and significant fall in serum magnesium follows cessation of alcohol drinking. In alcoholic patients admitted to hospitals, the administration of magnesium (as magnesium sulfate—$MgSO_4 \cdot 7H_2O$ IM or IV, 8–10 g or 64–90 mEq over a 24-hour period for 1–2 days) may mitigate the seizures associated with the withdrawal of alcohol and concomitant fall in serum magnesium. Serum magnesium levels must be followed and moderate-to-severe uremia makes careful monitoring of the patient mandatory (34).

OTHER MINERALS

Alcohol increases zinc excretion. The depletion of body zinc caused by alcohol could be partially responsible for the poor wound healing seen in chronic alcoholics. Alcoholism adversely affects calcium metabolism. Alcoholics have decreased bone mineral content due to accelerated bone loss with age (15). The effects of this depletion of bone mass are an increased incidence of bone fractures and a more-advanced degree of periodontal disease. Alcohol alters the stomach mucosa and can produce gastritis and blood loss. When blood is lost, iron is lost, and iron nutrition suffers.

ANTIBIOTIC AND ANTIMITOTIC DRUGS

Methotrexate, sulfamethoxazole, and the combination of trimethoprim and sulfamethoxazole are folic acid antagonists (38). The antimicrobial and antimetabolic effects of each of these compounds are based on inhibition of a step in folic acid metabolism. They can thus precipitate folic acid deficiency, including megaloblastic anemia and pancytopenia, in patients with preexisting borderline folic acid deficiency. The teratogenicity of these compounds may be related to their folic acid antagonistic effects (38).

In the infant, antibiotic therapy (which alters the intestinal flora), diarrhea, malabsorption, and the diet (*i.e.,* breast milk versus cows' milk) may all contribute to a serious deficiency of vitamin K (5). For the newborn infant, a single IM dose of 1 mg vitamin K_1 immediately after birth is adequate to prevent a hemorrhagic diathesis (37).

Oral neomycin, kanamycin, bacitracin, polymixin, and paramomycin produce malabsorption (especially of vitamin B_{12} and folic acid) and reduce lactase levels and the intestinal synthesis of folic acid (6, 23). Neomycin and other poorly absorbed broad spectrum antibiotics may reduce intestinal bacterial synthesis of vitamin K. Neomycin and other antimitotic agents, *e.g.,* 5-fluorouracil, interfere with absorption of nutrients from the gut (23). Colchicine is an antimitotic agent that has an effect on the gut very much like that of neomycin. It reduces the levels of disaccharidases, especially lactase, and decreases the absorption of lactose, fat, sodium, potassium, and vitamin B_{12} (23).

Tetracycline compounds can chelate minerals such as calcium, magnesium, and iron. Coadministration of tetracycline and materials such as antacids, milk, and iron preparations (which contain these metals) can reduce the absorption of both the tetracycline and the mineral. The physiologic result is lowered blood levels of tetracycline antibiotic (14).

ANTILIPEMIC DRUGS

Clofibrate potentiates the hypoprothombinemic effect of warfarin in some individuals (5). This may be related to the antilipemic effect of clofibrate. The reduction in blood lipids may include a reduction in circulating vitamin K levels.

Cholestyramine is an anion-exchange resin that binds bile acids in the intestine, increases their excretion in the feces, and thus reduces serum cholesterol levels, since cholesterol is converted to bile acids. Cholestyramine reduces fat absorption. Cholestyramine contains metabolically available chloride ions whose subsequent excretion in the urine produces increased calcium excretion, which is associated with increased bone resorption. Hyperchloremic acidosis has been observed in children given high doses of this drug (23).

ANESTHETICS

The postsurgical effects of the anesthetic succinyl choline are modified by ascorbic acid. Giving ascorbic acid, 500 mg b.i.d., the day before,

the day of, and the day after surgery has resulted in less muscle pain (9). Succinyl choline is thought to produce hypercalcemia and muscle fasciculations, which are diminished by magnesium administration.

ANTITUBERCULAR DRUGS

The major drugs used for tuberculosis therapy are isoniazid (isonicotinic hydrazide, INH), paraaminosalicylic acid (PAS), and antibiotics such as streptomycin. Isoniazid, an antagonist of nicotinic acid, binds vitamin B_6 and can produce pellagra symptoms that are responsive to niacin (23). Vitamin B_6 corrects the polyneuritis produced by isoniazid without impairing the therapeutic efficacy of isoniazid. Paraaminosalicylic acid therapy reduces vitamin B_{12} absorption and reduces the serum vitamin B_{12} level (6, 23).

DIURETICS

Diuretics increase the excretion of sodium and water and can lead to sodium depletion in some patients if severe sodium restriction is simultaneously imposed. Approximately 20%–25% of patients receiving chronic thiazide diuretic therapy have serum potassium levels below the normal range (10). About 20% of individuals receiving thiazide diuretics may complain of muscle weakness due to the loss of potassium (10). Several potassium supplements are commercially available.

Several diuretics are potassium sparing. Amiloride has a mild, temporary potassium-conserving effect. In contrast, spironolactone has a very marked potassium-retaining characteristic. The combination of a thiazide with spironolactone produces some potassium depletion but with a much lower incidence than does the thiazide diuretic alone.

Mercurial diuretics increase calcium excretion, as do furosemide and ethacrynic acid, whereas thiazide diuretics reduce calcium excretion. These observations have been used to advantage. Hydrochlorthiazide has been used to reduce calcium levels in the urine of hypercalciuric patients. Furosemide has been used to increase calcium excretion. All diuretics increase magnesium excretion (thiazide diuretics by as much as 50%), and this can lead to magnesium depletion (37). Thiazide diuretics also increase zinc excretion by as much as 50%, so that chronic diuretic therapy may result in impaired wound healing.

Triamterene is a folic acid antagonist (38), but no studies of the effects of diuretics on folic acid status are available.

HYPOTENSIVE DRUGS

HYDRALAZINE

Hydralazine adversely affects vitamin B_6 metabolism by forming a complex with vitamin B_6 and causing its excretion in the urine (22). The polyneuritis that develops in some individuals receiving hydralazine therapy responds to vitamin B_6 supplementation. Hydralazine also increases manganese excretion and may lead to manganese depletion, which may be related to the systemic lupus erythematosis syndrome seen in some patients receiving hydralazine (4).

METHYLDOPA

Methyldopa is an amino acid. The parent compound, dopa, reduces tryptophan absorption from the intestine (23). Dopa and methyldopa require vitamin B_{12} and folic acid for metabolism, suggesting an increased vitamin B_{12} and folic acid requirement for individuals receiving large amounts of these drugs (17).

CARDIAC GLYCOSIDES

The action of digitalis and other cardiac glycosides is modified by potassium and magnesium status. Potassium and magnesium status, as indicated above, can be adversely influenced by diuretics. There is normally a very slim margin of safety between the therapeutic dose and the toxic dose, and digitalis has a much greater toxicity in the magnesium-depleted subject (27). Potassium-depleted subjects have increased ventricular irritability, which digitalis may accentuate, and the magnesium-depleted individual frequently is potassium-depleted (37). Attempts to reverse this potassium depletion by giving potassium supplements may prove ineffective unless the magnesium depletion is corrected.

NONSTEROIDAL ANTIINFLAMMATORY DRUGS

Aspirin, indomethacin, and phenylbutazone can cause GI bleeding. One to three grams aspirin can cause 5 ml blood loss and the loss of 2 mg iron. Absorption of dietary iron cannot readily replace these losses. Severe and chronic GI bleeding can lead to iron deficiency anemia.

Aspirin increases thiamin excretion (3) and

ascorbic acid excretion (7). Aspirin and indomethacin decrease the level of vitamin C in platelets; this block can be overcome by giving large doses of vitamin C, *e.g.,* 100–200 mg daily, (22). Chronic use of phenylbutazone has caused folic acid-responsive megaloblastic anemia. Newer antiinflammatory drugs are similar in action to indomethacin.

HYPOGLYCEMIC DRUGS

The major biguanide is phenformin, which reduces intestinal absorption of glucose, amino acids, and other compounds that are actively transported across the gut. Vitamin B_{12} malabsorption can be produced by phenformin (6, 23). It has been proposed that serum B_{12} levels be measured annually and a vitamin B_{12} supplement provided to patients on chronic phenformin therapy (32).

The sulfonylureas are the most common oral hypoglycemic agents. These compounds are chemically analogous to the sulfonamides ("sulfa drugs"), which are antifolic acid agents. No nutritional effects have yet been described for these compounds.

ORAL CONTRACEPTIVES AND ESTROGENS

VITAMIN B_6

The requirement for vitamin B_6 increases dramatically with use of synthetic estrogens, *e.g.,* stilbestrol and ethinyl estradiol, and natural estrogens, *e.g.,* conjugated equine estrogens. This occurs whether the estrogen is administered alone or in combination with a progestogen as an oral contraceptive agent (OCA). There is an observable defect in tryptophan metabolism, and a ten-fold or greater increase in the amount of vitamin B_6 required to correct this defect (29, 30).

Oral contraceptives increase the requirement for vitamin B_6 in an overwhelming majority of women using these estrogen-containing preparations. About 80% of OCA users have vitamin B_6 depletion, with 20% of OCA users having an absolute deficiency of this vitamin. Of postmenopausal women receiving conjugated equine steroids or diethyl stilbestrol, 75%–90% show evidence of vitamin B_6 depletion. The biochemical picture is abnormal by the end of the first OCA cycle and returns to normal 1–15 weeks following discontinuation of the OCA (30).

The minimum daily oral dose of vitamin B_6 necessary to normalize metabolism in OCA users is about 25 mg pyridoxine hydrochloride (20 mg vitamin B_6). Thirty mg pyridoxine hydrochloride daily (25 mg vitamin B_6) was recommended as a safe daily dose (29). In the United States, even a good diet provides only about 2 mg vitamin B_6 per person per day (30).

The increased spontaneous excretion of hydroxyanthranilic acid in women taking oral contraceptives is corrected by administration of vitamin B_6. Hydroxyanthranilic acid is a carcinogen in experimental animals (30).

The oral glucose tolerance commonly deteriorates in OCA users. A vitamin B_6 supplement partially corrects this alteration.

The depression occasionally seen in women using oral contraceptives can be related to vitamin B_6. In a double-blind crossover study, depressed women with evidence of absolute vitamin B_6 deficiency responded clinically to vitamin B_6 administration (1).

FOLIC ACID

Oral contraceptives adversely affect folic acid metabolism, and some users of OCAs have developed folate-responsive megaloblastic anemia (30). Folic acid deficiency appears to be involved in the megaloblastic cytologic changes seen in the cervical mucosa of about 20% of women using OCAs (39).

Severe malabsorption of folate polyglutamate in susceptible women may precipitate severe deficiency. Abnormally low folic acid status occurs in about 20%–30% of OCA users (29). Importantly, the folic acid status of pregnant women is poorer if they used OCAs prior to pregnancy.

OTHER VITAMINS

Tissue ascorbic acid levels are depressed by estrogen and OCAs. Users of OCAs excrete half as much ascorbic acid as women consuming the same diet but not using OCAs. The amount of supplemental vitamin C required to normalize vitamin C blood levels of OCA users and estrogen users may be 150–500 mg (29, 30).

Vitamin B_{12} absorption is normal in OCA users, but serum vitamin B_{12} levels are rapidly and significantly depressed by OCAs. Women taking oral contraceptives apparently have an increased rate of metabolism of vitamin B_{12} (30).

Circulating vitamin A levels increase dramatically in OCA users within the first cycle of drug use. Complete return to predrug vitamin A levels is not attained within 3 months following drug discontinuation. Prior OCA use has no effect on the blood vitamin A levels during early pregnancy. Users of OCAs have poorer riboflavin (vitamin B_2) status (26) and thiamin (vitamin B_1) status.

MINERALS

Calcium, phosphorus, magnesium, and zinc are involved in bone formation, and bone is the major storage organ for them. Estrogens are frequently used to treat postmenopausal osteoporosis since both natural and synthetic estrogens inhibit parathyroid hormone–induced bone resorption. Estrogens and estrogen-containing oral contraceptives increase the incorporation of these minerals into bone and reduce their circulating levels and their urinary excretion (30).

Estrogens and OCAs improve calcium and magnesium balance. Estrogens and OCAs reduce serum zinc levels (30).

Iron needs are reduced by OCAs. Serum levels of iron and transferrin, the serum iron-containing protein, are increased in women taking OCAs. Hemoglobin levels in women taking OCAs are no different from those of women not using OCAs. Users generally report lighter menstrual bleeding than they experienced before initiation of the OCA (29, 30).

Blood copper levels are greatly increased by estrogens and OCAs. The highest levels of serum copper and serum ceruloplasmin were observed in OCA users with cholestasis (30). Bile is a major excretory route for copper.

IMMUNOLOGIC IMPLICATIONS OF DRUG-INDUCED VITAMIN DEPLETION

A wide variety of drugs are known to suppress one or more components of the host-defense system. In addition, adverse effects may be compounded by the nutritional deficiencies induced by the administration of these drugs. It is safe to say that a deficiency of almost every known essential nutrient has some adverse effect on one or more components of the host-defense systems. Roitt's (24) review of these systems is excellent, as is Vitale and Good's (35) review of the relation between nutritional status and susceptibility to infectious diseases (see Ch. 22).

In a drug-oriented society (including alcohol), it is safe and pragmatic to assume that a great deal of morbidity may be attributed to the ingestion of drugs and alcohol. Certainly, alcohol has been shown to have a number of deleterious effects on a number of components of both the phagocytic and immune systems (cell-mediated and humoral immunity). Such commonly used agents as aspirin have also been shown to have adverse effects on cell-mediated immunity. It is essential that the physician be aware of the potential hazards and adverse effects of a whole host of drugs, some of which may appear to be innocuous, on phagocytosis and on cell-mediated and humoral antibody response.

REFERENCES

1. Adams PW, Rose DP, Folkard J, Wynn V, Seed M, Strong R: Effect of pyridoxine hydrochloride (vitamin B_6) upon depression associated with oral contraception. Lancet 1: 897–904, 1973
2. Anticonvulsant osteomalacia. Lancet 2: 805–809, 1972
3. Cleland JB: The effect of salicylates (A) on the estimation of thiamine by the thiochrome method, (B) on the excretion of thiamine. Aust J Exp Biol Med Sci 21: 153–158, 1943
4. Comens P: Manganese depletion as an etiological factor in hydralazine disease. Am J Med 20: 944–945, 1956
5. Conney AH, Burns JJ: Metabolic interactions among environmental chemicals and drugs. Science 178: 576–586, 1972
6. Corcino JJ, Waxman S, Herbert V: Absorption and malabsorption of vitamin B_{12}. Am J Med 48: 562–569, 1970
7. Daniels AL, Everson GJ: Influence of acetylsalicylic acid (aspirin) on urinary excretion of ascorbic acid. Proc Soc Exp Biol Med 35: 20–24, 1936
8. Flynn A, Pories WJ, Strain WH, Hill OA Jr: Zinc deficiency with altered adrenocortical function and its relation to delayed healing. Lancet 1: 789–791, 1973
9. Gupte SR, Savant NS: Post suxamethonium pains and vitamin C. Anaesthesia 26: 436–440, 1971
10. Manner RJ, Brechbill DO, DeWitt K: Prevalence of hypokalemia in diuretic therapy. Clin Med 79: 19–22, 1972
11. McWhirter WR: Ascorbic acid and long-term steroids. Lancet 2: 776, 1974
12. Mueller MN, Jurist JM: Skeletal status in rheumatoid arthritis. A preliminary report. Arthritis Rheum 16: 66–70, 1973
13. Neubauer C: Mental deterioration in epilepsy due to folate deficiency. Br Med J 2: 759–761, 1970
14. Neuvonen PJ, Gothoni G, Hackman R, Björksten K: Interference of iron with the absorption of tetracyclines in man. Br Med J 4: 532–534, 1970
15. Nilsson BE, Westlin NE: Changes in bone mass in alcoholics. Clin Orthop 90: 229–232, 1973

16. Olson RE: Nutrition and alcoholism. In Goodhart RS, Shils ME (eds): Modern Nutrition in Health and Disease. Philadelphia, Lea & Febiger, 1973, pp 1037–1050

17. Ordonez LA, Wurtman RJ: Folic acid deficiency and methyl group metabolism in rat brain: effects of L–dopa. Arch Biochem Biophys 160: 372–376, 1974

18. Reinken L: Die wirkung von hydantoin und succinimid auf den vitamin B_6-stoffwechsel. Clin Chim Acta 48: 435–436, 1973

19. Reinken L, Hohenauer L, Ziegler EE: Activity of red cell glutamic oxalacetic transaminase in epileptic children under antiepileptic treatment. Clin Chim Acta 36: 270–271, 1972

20. Reynolds EH: Mental effects of anticonvulsants and folic acid metabolism. Brain 91: 197–214, 1968

21. Reynolds EH, Rothfeld P, Pincus JH: Neurological disease associated with folate deficiency. Br Med J 2: 398–400, 1973

22. Roe DA: Drug-induced deficiency of B vitamins. NY State J Med 71: 2770–2777, 1971

23. Roe DA: Minireview effects of drugs on nutrition. Life Sci I 15: 1219–1234, 1974

24. Roitt IM: Essential Immunology. Oxford, Blackwell Scientific, 1974

25. Rose DP: Aspects of tryptophan metabolism in health and disease: a review. J Clin Pathol 25: 17–25, 1972

26. Sanpitak N, Chayutimonkul L: Oral contraceptives and riboflavine nutrition. Lancet 1: 836–837, 1974

27. Seller RH: The role of magnesium in digitalis toxicity. Am Heart J 82: 551–556, 1971

28. Stein GM, Lewis H: Oral changes in a folic acid deficient patient precipitated by anticonvulsant drug therapy. J Periodontol 44: 645–650, 1973

29. Theuer RC: Effect of oral contraceptive agents on vitamin and mineral needs: a review. J Reprod Med 8: 13–19, 1972

30. Theuer RC: Effect of estrogens and oral contraceptive agents on vitamin and mineral needs. Evansville Mead Johnson, 1973

31. Tolman KG, Jubiz W, DeLuca HF, Freston JW: Rickets associated with anticonvulsant medications (abstr). Clin Res 20: 414, 1972

32. Tomkin GH: Malabsorption of vitamin B_{12} in diabetic patients treated with phenformin: a comparison with metformin. Br Med J 2: 673, 1973

33. Vitale JJ: Deficiency diseases. In Robbins SL (ed): Pathologic Basis of Disease. Philadelphia, WB Saunders, 1974, pp 475–508

34. Vitale JJ, Coffey J: Alcohol and vitamin metabolism. In Kissin B, Begleiter H (eds): The Biology of Alcoholism, Vol I. New York, Plenum Press, 1971, pp 327–352

35. Vitale JJ, Good RA (ed): Nutrition and immunology. Am J Clin Nutr 27: 623–669, 1974

36. Vitamin K supplementation for infants receiving milk substitute infant formulas and for those with fat malabsorption. Committee on nutrition, American Academy of Pediatrics. Pediatrics 48: 483–487, 1971

37. Wacker WEC, Parisi AF: Magnesium metabolism. N Engl J Med 278: 712–717, 1968

38. Waxman S, Corcino JJ, Herbert V: Drugs, toxins and dietary amino acids affecting vitamin B_{12} or folic acid absorption or utilization. Am J Med 48: 599–608, 1970

39. Whitehead N, Reyner F, Lindenbaum J: Megaloblastic changes in the cervical epithelium. JAMA 226: 1421–1424, 1973

40. Zannoni VG, Lynch MM: The role of ascorbic acid in drug metabolism. Drug Metab Rev 2: 57–69, 1973

19

Endocrinology

Mark E. Molitch, William T. Dahms, George A. Bray

Hormones have a direct effect on every aspect of the body's handling of nutrients, including appetite, absorption from the GI tract, transport across cell membranes, and metabolism of substrates (storage, catabolism, and excretion). Conversely, changes in an individual's nutritional state have profound effects on the functioning of the endocrine system. Many of the concepts to be discussed below have been familiar for decades, particularly some of the physiologic effects of thyroxine, cortisol, and insulin. However, in the last 10 years, after the introduction of techniques for radioimmunoassay into endocrinology, these basic concepts have been greatly expanded, and it is now apparent that the metabolism of carbohydrate, fat, and protein are each influenced in some way by every major hormone. This chapter will focus first on those aspects of calcium and iodine metabolism in which endocrinology and nutrition directly affect each other, on the way in which the body deals with an excess and deficiency of calories, and finally on the more-subtle aspects of nutrition and endocrinology.

ENDOCRINE AND NUTRITIONAL CONTROL OF CALCIUM AND MAGNESIUM METABOLISM

Calcium is one of the major ionic constituents in the body. The recommended levels of calcium intake may be somewhat below the optimal levels needed to prevent osteoporosis. Moreover, the high intake of phosphate associated with ingesting large amounts of meat may play a role in the development of osteoporosis in susceptible individuals. The control of serum calcium is closely regulated by the interaction between vitamin D on the one hand and the parathyroid gland on the other. The way in which vitamin D enhances intestinal calcium absorption has been clarified by

the finding that an active form of vitamin D is produced by chemical reactions occurring in the liver and kidneys. Drugs such as diphenylhydantion (Dilantin) can accelerate this conversion and increase the dietary requirement for vitamin D. This metabolically active form of vitamin D may become important in treating some of the metabolic bone diseases often associated with renal failure which become so important to the physician who is responsible for patients receiving chronic hemodialysis. The differential diagnosis of hypocalcemia and hypercalcemia involve a myriad of endocrine and nutritional diseases.

Magnesium is mainly located within cells. Deficiency of magnesium, which may occur in alchoholism and many other diseases, may impair the release of parathyroid hormone and thus produce hypocalcemia.

Phosphate deficiency is a clinically defined entity that may lead to poor formation of bones by its effect on calcium metabolism.

Mineral homeostasis is thus achieved by an intricate process in which dietary intake and excretory losses of calcium (Ca), phosphorus (P), and magnesium (Mg) are regulated by vitamin D and parathyroid hormone. Before the nutritional aspects of Ca metabolism can be discussed, a brief review of recent advances in this field is appropriate.

ENDROCRINE CONTROL OF CALCIUM AND MAGNESIUM

CALCIUM HOMEOSTASIS

Over 90% of the 1000–1200 g Ca in the body is located in the hydroxyapatite crystals of the skeleton, with the rest present in the extracellular fluid and within cells. In the plasma, 47.5% of Ca is present as free ions, 46.0% is bound to protein, 1.6% is complexed as $CaHPO_4$, 1.7%

Fig. 19–1. Vitamin D metabolism in preparation for function. (DeLuca HP: Am J Med 58:42, 1975)

is complexed with citrate, and 3.2% is complexed with unidentified cations (58).

Vitamin D is the most important regulator of intestinal Ca absorption, but the dietary form of this vitamin must first be converted to an active form (Fig. 19–1). Dietary vitamin D_3* is first hydroxylated in the liver to 25-hydroxycholecalciferol (25-OHD$_3$), which is then further hydroxylated in the kidney to 1,25-dihydroxycholecalciferol (1,25-(OH)$_2$D$_3$), the active form of vitamin D in the human being. Conversion to 1,25-(OH)$_2$D$_3$ is stimulated by a high serum parathyroid hormone (PTH) level and a low serum level of P and is inhibited by high serum calcitonin (CT) levels. When this second (1-alpha) hydroxylation step is decreased, there is an increase in 24 hydroxylation of the 25-OHD$_3$ to give 24,25-(OH)$_2$D$_3$, which is a metabolically inactive product. Finally, 24,25-(OH)$_2$D$_3$

*Or, 7-dehydrocholesterol converted to vitamin D$_3$ in the skin by exposure to sunlight.

can then be hydroxylated in the 1 position to give 1,24,25-(OH)$_3$D$_3$. There is some preliminary evidence that this last compound might be important in regulating the intestinal absorption of Ca. According to current endocrine terminology, then, dietary vitamin D$_3$ is a "prohormone" that is enzymatically converted to an active hormone 1,25-(OH)$_2$D$_3$, which is secreted by the kidney into the bloodstream to exert its effects on Ca metabolism at distant sites in bone, intestine, and possibly kidney (19).

Parathyroid hormone (PTH) is synthesized as a 12,000-dalton inactive prohormone (ProPTH), which is converted in the parathyroid glands to the 84 amino acid (9,500-dalton) peptide, the main form released into the blood. Within 48 min after PTH is secreted, it is completely cleaved into two parts, a carboxy-terminal fragment that is biologically active and an amino-terminal inactive fragment (16). Hypocalcemia stimulates the intracellular conversion

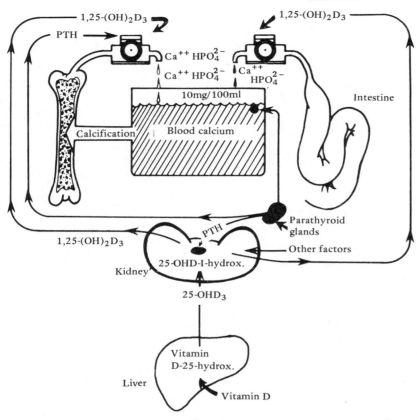

Fig. 19–2. Calcium homeostasis system, which includes regulation of kidney hydroxylase systems. Note that $1,25\text{-}(OH)_2D_3$ functions in intestine without presence of PTH, whereas its function in bone requires presence of that hormone. (Holick MF, Kleines–Bossaler A, Schnoes HK, DeLuca HP et al.: J Biol Chem 248:6691, 1973)

of proPTH to PTH and the secretion of PTH into the blood. In turn, PTH increases the conversion of $25\text{-}OHD_3$ to $1,25\text{-}(OH)_2D_3$. Thus, hypocalcemia increases the peripheral blood concentrations of both PTH and the active form of vitamin D. Hypophosphatemia does not stimulate the release of PTH but does enhance the conversion of $25\text{-}OHD_3$ to $1,25\text{-}(OH)_2D_3$.

In the intestine, bone, and kidney PTH and $1,25(OH)_2D_3$ interact to increase blood Ca (Fig. 19–2). Dietary Ca and P are absorbed in the duodenum and upper jejunum. Absorption is promoted by $1,25(OH)_2D_3$, possibly through the stimulation of the synthesis of an intracellular Ca-binding protein in the brush border of the intestine, and PTH probably influences absorption indirectly by stimulating synthesis of $1,25(OH)_2D_3$ (19). In bone, PTH acts to increase bone resorption by increasing the activity and number of the osteoclasts while at the same time decreasing the activity of the osteoblasts.

The activity of osteoclasts is enhanced by $1,25(OH)_2D_3$, thereby mobilizing Ca and P from mineralized bone (59). Each hormonal process needs the other's presence for maximal action on bone. In the kidney, PTH acts in the proximal tubule to reduce the reabsorption of Ca and bicarbonate and, to a lesser extent, the reabsorption of amino acids, magnesium, and potassium. In the distal tubule, the hormone increases Ca absorption. The net effect on the kidney is to increase Ca reabsorption.

Calcitonin (CT) is a 32–amino acid polypeptide secreted by the parafollicular "C" cells of the thyroid. It may be important in growing bone, but its physiologic role in adult humans is unclear. Patients with medullary carcinoma of the thyroid secrete large quantities of CT. Such patients and those receiving exogenous CT in pharmacologic amounts have reduced numbers of osteoclasts and osteoblasts and a suppression of osteocytic

osteolysis. Thus, the net effect of CT is to decrease resorption of bone (44).

MAGNESIUM HOMEOSTASIS

The total body content of Mg is about 21–28 g, or about 2000 mEq. Half of it is found in the skeleton, 1% in the extracellular fluid, and the rest within the cells. The average daily intake is about 25 mEq, and an intake of 0.30 to 0.35 mEq/kg body weight/day is necessary to maintain a positive Mg balance. The most common dietary source of Mg is green vegetables. Magnesium is absorbed primarily in the small intestine, but it can also be absorbed in the colon. The proportion of intestinal Mg absorbed varies inversely with the intake. Absorption of 76% occurs with a diet containing 1.9 mEq Mg/day, an absorption of 44% occurs from a diet containing 20 mEq/day, but only 23.7% is absorbed when the diet contains 47 mEq/day. In Mg deprivation, the renal loss is restricted to less than 1 mEq/day (73). The mechanisms controlling serum concentrations of Mg are not well understood. Parathyroid hormone and vitamin D seem to be involved, but the experimental data are conflicting. Small changes in serum Mg affect PTH secretion as do similar changes in serum Ca. Prolonged Mg depletion, however, blocks both the release of PTH by the parathyroid glands and the action of PTH on the kidney.

EFFECT OF NUTRITION ON CALCIUM METABOLISM

CALCIUM

In normal individuals Ca balance is determined largely by whether the dietary intake is adequate since urinary excretion in the adult is relatively fixed. Losses of 100–200 mg/day in the urine, 140–175 mg/day in the biliary and pancreatic excretion, and 20 mg/day in desquamated skin and sweat are the main routes. The total daily loss in a normal individual is, therefore, 260–400 mg/day. During pregnancy, an additional 25–30 g Ca is transferred to the fetus. In the postpartum period, lactation may account for the loss of another 750 mg/day. To balance these losses and maintain Ca balance, a high dietary intake must be maintained. The efficiency of absorption of Ca is inversely proportional to the dietary intake (Table 19–1), effects on absorption being probably mediated through PTH and vitamin D. An intake well in excess of 1000 mg/day is required to maintain a positive Ca

TABLE 19–1. Dietary Calcium and Calcium Absorption*

Subject	Dietary intake (mg/day)	Efficiency of absorption (% ± SD)	Absorbed calcium (mg/day)
12	<150	59.3 ± 49.6	89
40	150–300	38.1 ± 22.5	114
34	300–400	35.2 ± 21.8	141
13	400–600	27.1 ± 24.7	163
16	600–800	26.5 ± 21.8	212
23	800–1000	23.9 ± 22.5	239
77	1000–1200	27.5 ± 16.6	330
30	1200–1400	20.9 ± 46.6	293
34	1400–1600	24.9 ± 23.0	398
32	>1600	25.2 ± 23.8	504

*Lutwak L, Singer FR, Urist MR: Ann Intern Med 80:639, 1974

balance, and this level substantially exceeds the recommended daily allowance of 800 mg proposed by the National Research Council. Dietary surveys of young adults in the United States have shown that the average intake is closer to 400 mg/day. Using the calculations of Lutwak et al. (see Table 19–1) the actual amount absorbed is thus between 150–200 mg/day, leaving a net daily loss of 50–100 mg. Over 30–40 years this might produce a loss from the skeleton of up to 1000 g, or two-thirds of the original amount of Ca present in the skeleton at the end of adolescence. Lutwak and his colleagues have proposed that this continued loss of Ca may be the major cause of osteoporosis in middle and older-aged individuals, especially in women who have a less-dense bone matrix than men. In addition, the presence of intestinal lactase deficiency in 47% of the Caucasian population with osteoporosis would further decrease the dietary intake of Ca.

The current American diet has an average calcium–phosphorus ratio of 1:4. This results from the low intake of milk, the high meat intake, and a high intake of carbonated soft drinks (which have a high content of phosphorus). Beagle dogs placed on a diet in which the Ca–P ratio was 1:10 developed marked osteoporosis and secondary hyperparathyroidism (44). When the Ca–P ratio was reduced to 1:1, the osteoporosis resolved. Because of these findings, Lutwak has recommended a diet containing at least 1000 mg Ca/day and a Ca–P ratio of 1:2 or less.

Intestinal malabsorption of fats can produce a negative Ca balance by causing a loss of the fat-soluble vitamin D. Calcium absorption may also be decreased after damage to the absorbing surface of the intestine. A decrease in magnesium absorption because of damage to the absorbing surface of the intestine may lead to decreased

secretion of PTH as noted above. The diagnosis of hypocalcemia must be made with care in states of malabsorption since 45%–50% of Ca exists in serum bound to protein and total serum proteins are often low in patients with malabsorption. A correction factor of 0.5 mg Ca/1 g total protein below the average of 7.4 g may be used to correct for altered protein levels. In all states of hypocalcemia not due to hypoparathyroidism, a secondary hyperparathyroidism develops, with effects on bone and kidney similar to those of primary hyperparathyroidism.

VITAMIN D

In addition to inadequate dietary Ca, a dietary deficiency of vitamin D may produce rickets in children and osteomalacia in adults. The recommended daily intake of 400 IU vitamin D is usually adequate for children and adults; clinical osteomalacia may be produced when the intake is less than 70 IU/day. The best natural sources for vitamin D are eggs, butter, cream, liver, and fish. Since in the United States it is standard practice to add 400 IU vitamin D to each quart of milk, simple vitamin D deficiency is rare in this country.

There are several disease states in which the nutritional requirements for vitamin D are greatly increased. As mentioned above, intestinal malabsorption with steatorrhea can often lead to malabsorption of vitamin D. In biliary cirrhosis, absorption of vitamin D may be reduced. Hydroxylation of vitamin D_3 to 25-OHD_3 may also be impaired. Several drugs, including the anticonvulsants, phenobarbital, and diphenylhydantoin, separately and additively induce hepatic microsomal enzymes that increase the conversion of vitamin D to inactive metabolites. This may lead to reduced serum levels of calcium and 25-OHD_3 and eventually to decreased bone density. The recommended daily allowances of vitamin D for patients on anticonvulsant drugs is now 8,000–10,000 IU/week (30).

In renal failure, defective conversion of 25-OHD_3 to $1,25(OH)_2D_3$ occurs for two reasons: 1) the high level of phosphate shuts off the conversion of 25-OHD_3 to $1,25-(OH)_2D_3$ and 2) there is a relative lack of normal renal tissue to effect this conversion. Very large doses of vitamin D have been used to overcome these defects. However, administration of small amounts of the active $1,25-(OH)_2D_3$ to uremic subjects also repairs the malabsorption of Ca. Several

analogs of vitamin D in which the 1 position is hydroxylated are also effective in treating the bone disease found in patients with renal failure. Since the analogs are much easier and cheaper to synthesize than $1,25-(OH)_2D_3$, it is hoped that they will soon be available for clinical use.

Vitamin D–dependent rickets is now thought to represent a defect in the conversion of 25-$OH-D_3$ to $1,25-(OH)_2D_3$. This syndrome is characterized by hypocalcemia, hypophosphatemia, and clinical rickets. It can be treated with 10,000–50,000 IU vitamin D_3 or with very small quantities of $1,25-(OH)_2D_3$. Vitamin-D resistant rickets, on the other hand, appears to be a defect in the renal tubular transport of P and is not really a deficiency state of vitamin D (15).

PHOSPHATE

Dietary phosphate deficiency is far less common than deficiency states for either Ca or vitamin D. Prolonged ingestion of phosphate-binding antacids or parenteral hyperalimentation can both induce phosphate depletion (43). Hypophosphatemia stimulates the synthesis of $1,25-(OH)_2D_3$, which increases the intestinal absorption of Ca and phosphate. Prolonged hypophosphatemia also increases urinary Ca excretion, decreases urinary losses of phosphate, and thus produces a net negative Ca balance. A low phosphate intake also decreases red blood cell 2,3-diphosphoglycerate (2,3-DPG) and adenosine triphosphate (ATP) with an associated decrease in the ability of the red cell to release oxygen to the tissue (71). Clinically, the hypophosphatemic syndrome presents with vague complaints of weakness, anorexia, malaise, bone pain, and joint stiffness. When severe and prolonged, it can lead to severe osteomalacia.

MAGNESIUM

Magnesium deficiency in human beings occurs in alchoholics who eat little food or in patients with intestinal malabsorption. Other less-common causes of Mg depletion include protein–calorie malnutrition, hyperparathyroidism, hyperaldosteronism, thyrotoxicosis, diabetic ketoacidosis, early renal insufficiency, and diuretic therapy. As discussed above, Mg deficiency can lead to defective secretion or action of parathyroid hormone, or both, resulting in a hypocalcemic state that is responsive to Mg repletion alone. Clinically, Mg deficiency leads to neuro-

muscular hyperexcitability, with tetany, tonic–colonic seizures, ataxia, vertigo, tremors, weakness, depression, irritability, and psychoses as the major manifestations.

EFFECTS OF ENDOCRINE DISEASE ON CALCIUM METABOLISM

HYPOCALCEMIA

Damage to the parathyroid glands during surgery on the thyroid gland is the most common etiology for this disorder. Neonatal immaturity, congential absence of the parathyroid glands (along with the thymus in the DiGeorge syndrome), idiopathic glandular failure, Mg deficiency, a defect in the receptor mechanism for parathyroid hormone (pseudohypoparathyroidism), and a defect in the hormone molecule itself are other etiologies for hypocalcemia. After surgical removal of a parathyroid adenoma, there is a transient (1–14 days) hypoparathyroidism because secretion from the other glands is suppressed by the adenoma. In addition, postoperatively, the bones affected with osteitis fibrosa in patients with hyperparathyroidism often avidly incorporate Ca. For both of these reasons, hypocalcemia may develop which requires treatment with extra Ca and sometimes with vitamin D for several weeks. In states of permanent hypoparathyroidism, requirements are very large for both Ca (1–2 g/day) and vitamin D (25,000–200,000 IU/day) in order to maintain the serum Ca at a normal level. The reason for this extraordinary vitamin D "resistance" appears to be that parathyroid hormone is necessary for the hydroxylation of vitamin D_3 in the 1 position.

HYPERCALCEMIA

Elevated levels of parathyroid hormone are one cause for hypercalcemia and hypophosphatemia. In rare situations, a dietary deficiency of vitamin D can partially ameliorate this hypercalcemic response to excessive parathyroid hormone, but the histologic picture is confusing, showing combined osteomalacia and osteitis fibrosa. Secondary hyperparathyroidism is a usual accompaniment of vitamin D deficiency or renal failure, but hypercalcemia is not seen. In states of other causes for hypercalcemia, secretion of parathyroid hormone is suppressed. Of special importance is vitamin D intoxication, which may result from 50,000 IU or more/day. Treatment consists of hydration and the administration of 50–100 mg hydrocortisone/day. In sarcoidosis, there seems to be an increased sensitivity to the effects of vitamin D, but the frequency of hypercalcemia is probably quite low (2.2%) and is associated with widespread sarcoidosis. Sarcoid-induced hypercalcemia is readily reversible with glucocorticoids. The milk–alkali syndrome of Burnet consists of hypercalcemia due to the proloned and excessive intake of milk and alkali, but the exact mechanism of the hypercalcemia is obscure. Ingestion of vitamin A in excessive doses (> 100,000 IU/day) over a period of years has been associated with hypercalcemia in rare instances.

OTHER HORMONAL EFFECTS ON CALCIUM METABOLISM

In hyperthyroidism, there is an increase in bone remodelling with hypercalcuria and progressive loss of bone Ca. Hypercalcemia may occur in up to 17% of cases. In addition, there is decreased GI absorption of Ca, probably because of increased transit time. For these reasons, osteoporosis is often present in long-standing hyperthyroidism. As mentioned above, glucocorticoids antagonize the action of vitamin D on the intestine and also stimulate bone resorption. In Cushing's syndrome, or when excessive doses of glucocorticoid is used in therapy, osteoporosis frequently occurs and hypercalciuria is common. Growth hormone also causes an increase in intestinal absorption of Ca and P and an increase in periosteal bone growth, but produces a decrease in cancellous bone formation. Finally, when administered exogenously in pharmacologic doses to osteoporotic postmenopausal women, estrogens initially cause a decrease in bone resorption, but after 6–12 months resorption of bone returns to pretreatment levels. The actions of estrogens in physiologic amounts on bone are unknown.

IODINE AND THYROID METABOLISM

The importance of iodine in human thyroid metabolism has long been recognized. Major emphasis during most of the twentieth century has been on providing adequate levels of iodine intake in those regions of the world where iodine deficiency is an endemic problem. With the introduction of iodized salt, the problem of iodine deficiency has largely disappeared, but in its place, people in many areas of the world now have excessive intakes of iodine resulting from the addition of iodide to table salt and the use of

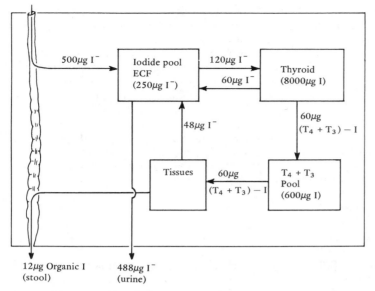

Fig. 19–3. Iodine metabolism in a state of iodine balance. Note that most (approximately 90%) of body iodine stores are present in thyroid (chiefly in organic form); approximately 10% are present as iodide. Arrows indicate daily flux of iodine. In this example, one-fifth (120 μg/608 μg) of the iodide entering iodide space is accumulated by thyroid. Peak thyroid uptake of ^{131}I should be 20%, and rate of turnover of thyronine–iodine peripherally 10%/day. (Ingbar SH, Woeber KA: The thyroid gland. In Williams RH (ed): Textbook of Endocrinology. Philadelphia, WB Saunders, 1974, p 100)

iodate as a preservative in bread. The high intake of iodine in many regions of the United States has altered the interpretation of tests measuring the radioactive iodine uptake by the thyroid gland so that normal values are now lower than they were 10 years ago. The range of normal values for radioactive iodine uptake has been lowered to 7%–33% in 24 hours, compared to the old normal range of 15%–45% (22). Excess iodine may also be responsible for the decreased effectiveness of oral antithyroid drugs as a form of treatment for hyperthyroidism. Excess iodine may also be related to the increasing incidence of Hashimoto's disease. The increased requirements for vitamins and minerals in hyperthyroidism is well recognized as is the reduced turnover that occurs when thyroid hormone is deficient.

IODINE AND THE THYROID

The only known function of iodine in animals is to be part of the thyroid hormone molecule (Fig. 19–3). Inorganic iodide derived from nutritional sources is actively transported into the thyroid, a process stimulated primarily by thyrotropin as well as by a complex intrathyroidal

autoregulatory system. Additional iodide (about ⅔ of the total free iodide in the gland) is liberated by the deiodination of the iodotyrosines that are formed when thyroglobulin is hydrolyzed. The free iodide in the thyroid is either discharged into the blood or reoxidized to iodine by a peroxidase(s). The iodine is then "organified" into the tyrosine residues of thyroglobulin to form monoiodotyrosine (MIT) and diiodotyrosine (DIT). Finally, these two precursors are "coupled" within the thyroglobulin molecule to form triiodothyronine (T_3) and thyroxine (T_4). Proteolysis of thyroglobulin releases T_3 and T_4 into the blood, but the iodotyrosines are dehalogenated by iodotyrosine deiodinase. Several enzyme deficiencies can occur in this pathway, and most lead to goiter and hypothyroidism.

In the United States, dietary iodine intake averages 500 μg daily and iodine deficiency is very rare. Iodine undergoes compartmentalization in the body (see Fig. 19–3). There is an exchangeable extrathyroidal pool of 250 μg iodide and an intrathyroidal pool of 8000 μg iodine. The circulating pool of T_4 and T_3 contains 600 μg iodine. Iodide is filtered and partially reabsorbed by the kidney. Renal iodide clearance is 30–40

ml/min, making this the major pathway for loss of iodine from the body. Minimal amounts of iodide are lost via the GI tract except in states of malabsorption. In addition, large amounts of iodide and iodine can be lost through lactation.

Dietary iodine deficiency occurs where the soil has a low iodine content. The minimum daily requirement is 40–70 μg (Table 19–2). Iodine deficiency usually results in a goiter and can be diagnosed when the urinary excretion is less than 50 μg iodide/24 hours. Why some patients with iodine deficiency do not develop goiters and others do is unclear, but those with goiters have lower serum T_4 and higher serum TSH. Most people in iodine-deficient regions are not clinically hypothyroid, even though their serum T_4 may be low, because the synthesis of T_3 is increased. This appears to be an adaptive response of the thyroid to iodine deficiency. Some patients, of course, do become hypothyroid, and there is an increased incidence of cretinism in regions of iodine deficiency. Because these areas are usually in poorly developed countries with limited access to medical care, the standard treatment consists of injections of an iodized oil that releases iodide slowly over 1–3 years.

Hyperthyroidism occurs in areas of iodine deficiency, but the incidence of "T_3 toxicosis" (a state of hyperthyroidism due to excessive serum levels of T_3 and normal levels of T_4) is three times greater than in areas of normal iodine intake (33). When iodine is administered to a population with iodine deficiency, some patients become hyperthyroid due to the unmasking of a preexisting tendency toward hyperthyroidism that had been prevented by the deficiency.

Iodide therapy can also produce goiters in certain susceptible subjects. Excess iodide can inhibit thyroid hormone formation (Wolff–Chaikoff effect), but its effect is usually transient and subjects treated with iodine usually "escape" from this inhibition after several days. The patients who develop goiters while on treatment with iodide apparently do not escape and become hypothyroid with goiter formation secondary to a rise in TSH. Patients with preexisting Hashimoto's thyroiditis, in which there is a basic defect in organification of iodine, seem to be particularly susceptible to this form of goiter and can develop such goiters on the doses of iodide used in treatment of chronic lung disease. Since iodide can cross the placenta, iodide-induced goiters may also occur in newborn infants of mothers who have taken pharmacologic doses of iodides for pulmonary disease. Other

TABLE 19–2. Iodine Content of Some Foods*

Food	Iodine content (μg/kg fresh weight)
Milk	26–370
Cheese	26–450
Eggs	6–20
Meat	21–420
Chicken	200–230
Saltwater fish	163–9860
Shellfish	150–2000
Freshwater fish	17–40
Cereals	14–80
Vegetables	9–201
Fruits	10–94
Beer	43–46
Wine	8–32

*Werner SC, Ingbar SH (eds): The Thyroid. New York, Harper & Row, 1971, p 410

side effects of iodide therapy include skin rashes, coryza, fever, headache, dysgeusia, conjunctivitis, lymphadenopathy, and parotid swelling. Cardiac irritability has been seen in a case of massive iodide overdose.

In recent years, lithium carbonate has been used extensively to treat patients with manic–depressive illness. Lithium is able to block the thyroidal release of T_3 and T_4, and the thyroid usually escapes from this effect, but the escape may occur over a several-month period. Here, again, some patients do not escape from this inhibition and develop lithium-induced hypothyroidism and goiters, which at least in some cases, are reversible with the cessation of lithium therapy. There is some evidence that many of these patients may also have a defect in iodine organification (i.e., an underlying Hashimoto's thyroiditis). It is important to note that this effect of lithium is not a dose-related effect and seems rather to reflect a defect within the thyroid itself (21).

THYROID HORMONES

Secretion of thyroid hormone is regulated by thyrotropin (TSH) which is secreted by the anterior pituitary (35). Recent experimental data have shown that the release of TSH is, in turn, stimulated by the release of thyrotropin-releasing hormone (TRH) from the hypothalamus into the hypothalamic-pituitary portal blood system. A second hypothalamic inhibitory hormone called somatostatin inhibits TSH secretion. The active hormones secreted by the thyroid gland are thyroxine (T_4) and triiodothyronine (T_3). Although T_3 is secreted by the thyroid, approximately 70%–80% of the cir-

culating T_3 is derived from peripheral conversion from T_4, with only 20%–30% being secreted directly by the thyroid. On a molar basis, T_3 is approximately four times more potent than T_4. Since the affinity of T_3 for thyroxine-binding globulin (TBG) is about one-tenth that of T_4, and since the concentration of free T_3 in the serum is only one-fifth of the concentrations of free T_4, it has been estimated that these hormones contribute equally to biologic activity. At one time, T_4 was thought to be simply a "prohormone" for production of T_3 because T_4 is converted to T_3 in peripheral tissues. Most investigators now believe, however, that T_4 is an important contributor to the overall biologic activity of the circulating thyroid hormones.

The thyroid hormones affect metabolic process in all areas, although the precise mechanisms are unknown. These hormones stimulate an increase in oxygen consumption (*i.e*, basal metabolic rate). Since the rise in metabolic rate occurs after a lag phase lasting several hours, it has been hypothesized that the change in oxygen consumption is in part mediated by new protein synthesis. Moreover, in experimental animals, the increase in metabolic rate can be blocked by inhibitors of protein and RNA synthesis, such as puromycin and actinomycin D. Thyroid hormones in physiologic amounts are necessary for protein synthesis and also promote nitrogen retention.

By affecting insulin-mediated synthesis of glycogen and epinephrine-mediated glycogenolysis, thyroid hormones in small amounts promote glycogen synthesis, whereas in excess amounts they promote glycogenolysis. In addition, thyroid hormones promote intestinal absorption of glucose and galactose and the uptake of glucose by adipocytes. The general metabolic rate controlled by thyroid hormones influences insulin degradation and can be important in states of thyroid overactivity and underactivity.

Thyroid hormones directly increase lipolysis and also sensitize adipose tissue to the actions of other lipolytic hormones. The mobilized free fatty acids and glycerol increase triglyceride synthesis, but the level of lipoprotein lipase is also higher so that the levels of triglycerides are not increased. Thyroid hormones, on the other hand, lower the serum cholesterol by increasing the removal of low-density lipoproteins, which are the main carriers of cholesterol. This occurs by increasing the conversion of cholesterol to bile acids and by increasing the excretion of cholesterol and bile salts in the feces. Thyroid hormones also promote cholesterol synthesis but to a lesser extent than its elimination so that the net effect is to lower serum cholesterol. The oxidation of the free fatty acids mobilized from fat tissues is also increased by thyroid hormones.

THYROID DISEASE

HYPERTHYROIDISM

Hyperthyrodism results in an increased basal metabolic rate (BMR) and weight loss in spite of increased appetite and food intake. Increased perspiration, heat intolerance, and a slightly elevated basal body temperature (54) may also be present. The rise in cellular metabolism is reflected in the increased number and size of mitochondria. Protein synthesis is accelerated even more. In the child, acceleration of linear growth and bone maturation are an early manifestation of hyperthyroidism, but if the hypermetabolic state continues to the point of decreased nutrition and weight loss, growth may be retarded. When protein catabolism is severe, patients are often found to have a real myopathy with muscle wasting and weakness.

Glucose intolerance occurs frequently in hyperthoroidism. This appears to be due to: 1) increased insulin degradation, 2) increased glycogenolysis, 3) increased intestinal absorption of glucose, and 4) increased gluconeogenesis from the protein catabolism. Preexisting diabetes can be made worse by hyperthyroidism. Triglyceride levels are lowered in hyperthyroidism because of the increase in degradation.

Vitamin requirements are usually elevated in hyperthyroidism for two reasons: 1) the requirements for thiamin, riboflavin, B_{12}, ascorbic acid, pyridoxine, and vitamins A, D, and E are all increased because of enhanced cellular metabolism and 2) degradation of many vitamins is accelerated in hyperthyroidism. Hyperthyroidism also stimulates Ca resorption from bone, with resultant hypercalciuria and osteopenia if the process is prolonged. Varying degrees of hypercalcemia develop at least transiently in up to 17% of patients with hyperthyroidism, probably on the basis of an increase in bone resorption greater than the renal excretion of Ca.

Increased dietary intake of iodine may influence the therapy of hyperthyroidism. A review of the studies in which hyperthyroid patients were treated with antithyroid drugs has shown that the remission rate induced by these drugs has progressively declined from 50%–60% in the 1950s to 13% in 1973 (75). This change corresponds with a rise in iodine intake, leading

these workers to conclude that this phenomenon results from the increase in iodine intake.

Because of the characteristic weight loss in patients with hyperthyroidism, both T_4 and T_3 (8) have been used experimentally to induce weight loss in obese patients. Patients so treated predictably lose weight, but much of the weight loss is from catabolism of protein containing lean body tissue. The substitution of a high-protein diet, however, may obviate this effect (40). Surprisingly, patients treated with very large doses of T_3 (225 μg/day) and T_4 (900 μg/day) exhibited very few subjective manifestations of hyperthyroidism other than a minimal increase (6 beat/min) in heart rate and some perspiration.

An analog of the naturally occurring hormone, D-thyroxine, has also been used to treat hypercholesterolemia and hyperlipidemia. The lipid-lowering effects of this compound have not been entirely separable from its other metabolic effects. As a result, increased symptoms of coronary artery disease have been noted in patients treated with D-thyroxine. In a large study assessing the effects of several lipid-lowering drugs, this drug was discontinued because of undesired cardiovascular side effects.

HYPOTHYROIDISM

In hypothyroidism, there is a decrease in BMR. Clinically, these patients show weight gain in spite of a decreased appetite. Cold intolerance and a decreased basal body temperature also occur. Nitrogen balance is positive, indicating that the slowing of protein degradation is of a greater magnitude than the slowing of protein synthesis. Hypothyroidism in children results in delayed growth and bone maturation or, in its most marked form, in cretinism.

Oral glucose tolerance tests show a flattened response, possibly due to slowed absorption of glucose from the intestine. Insulin secretion is also delayed as is its degradation; this latter effect accounts for the decreased insulin requirements in diabetics who become hypothyroid. Lipid metabolism is also decreased more than its synthesis so that triglycerides and cholesterol are increased in the blood. The concentration of the low-density lipoproteins which are the main carriers of cholesterol increased more than the triglycerides. In hypothyroidism, there is a decrease in the conversion of carotene to vitamin A, and serum carotene levels are often increased, giving the skin a yellowish hue. Hypercalcemia occurs only rarely in this disease. It has

been hypothesized that when this does occur, it is due to an increased intestinal absorption of Ca in conjunction with an impaired rate of deposition into the bones and excretion in the urine. Hypothyroid patients are often hyponatremic with an impairment in the clearance of free water that is probably due to the decreased GFR and resulting low rate of delivery of filtrate to the distal diluting segment.

EFFECTS OF NUTRITION ON THE ENDOCRINE SYSTEM

An affluent society is associated with an increased frequency of obesity (see Ch. 25). The importance of obesity resides in part in its effects on high blood pressure, gall bladder disease, and diabetes mellitus. The diagnosis of many endocrine diseases in the presence of obesity can be a complex problem because corpulence *per se* modifies the response to many of the usual endocrine tests.

At the other extreme from obesity is the problem of malnutrition, which occurs in many forms and may be used as a treatment for obesity. One important variety of malnutrition and growth retardation results from maternal or environmental deprivation. Anorexia nervosa, a psychiatric complex appearing at puberty, may also cause malnutrition and requires careful evaluation to exclude organic forms of malnutrition (see Ch. 30).

The interaction of endocrine diseases with trace elements is complex and frequently difficult to assess. Zinc deficiency produces hypogonadism and growth retardation. Chromium metabolism may be important in glucose and insulin metabolism.

OBESITY

INSULIN SECRETION

The islets of the pancreas are enlarged in obese patients. A similar hyperplasia of islet tissue has been demonstrated in experimental obesity produced by hypothalamic injury, as well as in genetically obese animals. Obese patients also have increased levels of insulin. The degree of elevation in insulin is correlated with the degree of obesity. In addition to the increase in basal secretion of insulin, obese subjects almost uniformly show an increase in the secretion of insulin after administration of glucose, the injection of glucagon, or the infusion of L-leucine. Patients with long-standing obesity show more im-

pairment of glucose tolerance than those with recent onset of obesity. The rise in insulin of obese, normal, and diabetic subjects in response to glucose has been carefully analyzed, with the conclusion that the increment in insulin following an oral glucose load is comparable in these 3 groups if it is expressed as a percentage increment above the fasting or basal level. This implies that the effects of obesity are manifested largely through the increased basal levels of insulin. Other studies have indicated that in obese subjects the maximal rise in insulin is greater than in normal subjects, but that the concentration of glucose required to produce half of this maximal rise remains the same (37).

The data from obese patients showing increased levels of insulin in response to a challenge with glucose, glucagon, and L-leucine raise two important questions: 1) by what mechanism does obesity produce hyperinsulinemia? and 2) by what mechanism does the body prevent the drop in glucose in the presence of increased circulating levels of insulin? One explanation for the increased concentration of insulin in obesity would be provided if proinsulin represented a large fraction of the circulating radioimmunoassayable insulin. The converstion of proinsulin to insulin involves cleavage of a connecting peptide (C-peptide), which joins the alpha and beta chains during synthesis of insulin. Most antibodies to insulin cross-react with proinsulin as well as with insulin itself, yet the biologic activity of proinsulin is only 1%–2% that of native insulin. Secretion of proinsulin is detected as an increase in insulin in the circulation in most laboratory measurements. The possibility that obese patients secrete increased amounts of proinsulin has been examined. Normally, proinsulin accounts for no more than 10% of total insulin, and a similar proportion is present in obesity. During stimulation of insulin secretion with glucose, both insulin and proinsulin rise, but the relative amounts do not differ from normal. Thus, the proinsulin–insulin ratio in obesity appears to approximate the normal ratio.

A decrease in insulin turnover would also explain the higher levels of basal insulin. The available data on the turnover and metabolism of insulin in obesity, however, does not support this possibility, and it must be concluded that the increased concentration of insulin in obesity results from increased secretion and not from a reduced removal of this hormone.

Since the increased basal levels of insulin reflect enhanced secretion, the question then becomes: by what mechanism is the secretion of

insulin augmented? The factors that modulate insulin secretion can be divided into three groups: 1) nutrients, 2) hormones, and 3) neural factors. Increased glucose concentration might be an important factor in enhancing the secretion of insulin in obesity. Fasting glucose levels in many obese individuals are higher than those in normal individuals. The small increases in glucose observed in obese individuals might be a reflection of their state of overnutrition and in turn might signal the pancreas to secrete more insulin.

Increased concentrations of amino acids might also increase basal insulin in obesity. Plasma arginine, leucine, tyrosine, phenylalanine, and valine are increased in the obese (22), but the remaining amino acids are normal. This increase in amino acids might be in part responsible for the enhanced insulin output. Both arginine and leucine are potent stimulators of insulin secretion. In addition, the small increase in leucine might act synergistically with glucose to stimulate insulin secretion. It has been confirmed that an infusion of amino acids potentiates the effects of glucose on the secretion of insulin. If an infusion of glucose at 100 mg/min is given on one day, an infusion of a mixture of four insulin-stimulating amino acids on another day, and the combined infusion on a third day, the insulin levels are much higher when the amino acids and glucose are given together. Thus, a small rise in glucose and a small rise in the concentration of leucine and arginine might be sufficient to account for the increased levels of insulin in obese subjects. The sequence of events leading to hyperinsulinemia in obesity might be depicted as shown in Figure 19–4.

The autonomic nervous system is one regulator of basal insulin levels in obesity. The infusion of epinephrine into normal subjects increases the concentration of glucose but blocks the rise in insulin. In obese patients, an infusion of epinephrine also increases the concentration of glucose and actually reduces the concentration of insulin below control levels. Blockade of the alpha receptors in the islet of Langerhans by infusing phentolamine reverses the block to insulin release and there is a rise in insulin in normal subjects. This implies that there is normally some sympathetic inhibition of insulin secretion. In obese patients, on the other hand, phentolamine did not significantly change the concentration of insulin, raising the possibility that tonic sympathetic activity was not suppressing insulin release in the obese patients. This would mean that a significant portion of the rise in basal insu-

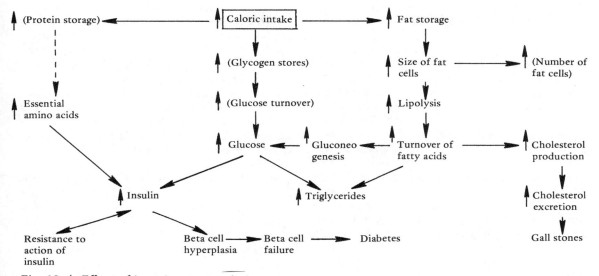

Fig. 19–4. Effects of ingesting excess calories.

TABLE 19–3. Endocrine and Metabolic Changes in Spontaneous and Experimental Obesity*

Parameters	Spontaneous obesity	Experimental obesity	Parameters	Spontaneous obesity	Experimental obesity
Adipose tissue			Evidence of insulin resistance		
Cell size	↑	↑	Insulin:glucose ratio	↑	↑
Cell number	↑	U	Adipose tissue metabolism		
Caloric Balance			Sensitivity to insulin in vitro	↓	↓
Calories required to maintain obese state (Cal/m^2)	1300	2700	Sensitivity to insulin in vivo	↓	↓
Return to starting weight	Rapid	Rapid	Forearm muscle metabolism		
Spontaneous physical activity	↓	↓	Insulin-stimulated glucose uptake	↓	↓
Appetite late in the day	↑	↑	Insulin inhibition of release of amino acid		↓
Fasting concentrations in blood			Hormones possibly affecting insulin resistance		
Cholesterol	↑	↑	Glucocorticoids		
Triglycerides	↑	↑	Plasma cortisol	N or ↓	U
Free fatty acids	↑	U or ↓	Cortisol production rate	↑	↑
Amino acids	↑	↑	Urinary 17-hydroxycorticoids	↑†	↑†
Glucose	N or ↑	↑	Growth hormone		
Insulin	↑	↑	Response to glucose	↓	↓
Glucagon	N		Response to arginine	↓	↓
Growth hormone	N or ↓	U or ↓	Nocturnal rises		↓
Glucose tolerance					
Oral	↓	↓			
Intravenous	↓	↓			
Insulin release					
After oral glucose	↑	↑			
After IV glucose	↑	↑			
After IV arginine	↑	↑			

*Horton ES, Danforth E Jr, Sims EAH, Salan LB: In Bray GA (ed): Obesity in Perspective. DHEW Publ No (NIK) 75-708, 1976, p 324

†Normal/kg body weight

U = unchanged

N = normal

lin in obesity might represent withdrawal of tonic inhibition by the sympathetic nervous system.

The second problem to be examined is the paradox of an elevated glucose along with high levels of insulin. Factors that might control the responsiveness to insulin are: 1) the size of the adipocytes (61), 2) the total caloric intake (66), 3) the fraction of carbohydrate in the diet prior to testing the effects of insulin (29), 4) the presence of functional beta cells (46), and 5) the degree of physical training (5). By perfusing the human forearm, it was concluded that both muscle and adipose tissue of obese subjects are less responsive (i.e., "resistant") to the actions of insulin than are the same tissues in normal subjects (57). The study of adipose tissue incubated in vitro before and after weight loss has also been utilized to examine the apparent reduction in the effectiveness of insulin in obesity (62).

Composition of the diet is another factor that influences the sensitivity to insulin. When adipose tissue from lean subjects who have eaten a high-carbohydrate diet is incubated with insulin, more glucose than fat is oxidized from the same subjects fed a low-carbohydrate diet. Recently, the effect on the size of fat cells and the composition of the diet on glucose metabolism and the response to insulin have been reexamined (61). Fat cells were obtained by needle aspiration of subcutaneous tissue in volunteers who were fed diets of known carbohydrate content before and after weight gain and in obese patients who were also fed controlled diets before and after weight loss. Large fat cells from either group were less responsive to insulin than small fat cells. When the size of the fat cells remained constant, however, increasing carbohydrate in the diet increased both the basal and insulin-stimulated metabolism of glucose.

Although the size of the adipocyte appears to be one factor in determining the resistance to insulin, it appears that total carbohydrate and caloric intake are at least as important. It seems unlikely that "resistance," i.e., reduced responsiveness of fat cells to the action of insulin, can provide the entire explanation for impaired effectiveness of this hormone in obese subjects. For one thing, the quantity of glucose metabolized by adipose tissue accounts for only a small fraction of total glucose metabolism. In addition, studies in obese subjects indicate that muscle is also resistant to the action of insulin. Finally, the utilization of glucose by the liver is also reduced in obese patients, suggesting that resistance to the action of insulin occurs in many tissues.

Additional insights have been obtained as to the role of diet and weight gain on the development of insulin resistance in man. One group of investigators (66) asked the following question: Can the endocrine profile of spontaneous obesity be reproduced when lean subjects gain weight by a period of self-induced overeating? The results of these studies are summarized in Table 19–3. Approximately 70% of the weight gained by these subjects was fat, and the remainder was water and protein. The fat was stored by increasing the size of preexisting fat cells. Plasma glucose was significantly increased. Of particular note is the fact that glucose was raised even when fat provided the entire caloric supplement used to produce weight gain. The basal levels of insulin were also increased after weight gain, regardless of the type of diet used to increase body weight. Cortisol secretion was elevated and the release of growth hormone in response to several stimuli was blunted. The concept that hyperinsulinemia and glucose intolerance are consequences of excess caloric intake is consistent with the improvement in glucose tolerance and the fall of insulin levels during weight loss.

GLUCAGON SECRETION

The studies on glucagon levels in obesity are conflicting. Some have found that basal levels of glucagon are unchanged by obesity and that the rise after infusing alanine is smaller in obese subjects than in the lean ones. On the other hand, infusion of arginine rather than alanine stimulated a larger rise in glucagon in obese patients than in normal ones. More recently, another group of investigators used a similar method with contradictory results (i.e., in the obese patients, the rise in glucagon was smaller than in normal subjects). One possible explanation for this difference is diet. Since glucagon is a hormone of "glucose need," the level of carbohydrate in the diet might change the basal level as well as the stimulated level of glucagon in obese patients.

ADRENAL FUNCTION

The concentration of cortisol is usually normal in the circulation of obese patients. In addition, the diurnal rhythm is preserved. Obese patients frequently show higher afternoon values of plasma cortisol than normal, but these suppress normally with dexamethasone. Obese patients

who do not suppress are a small group for whom more-complex procedures are needed to exclude the possibility of Cushing's syndrome. The response to most provocative stimuli is normal in the obese patient.

Although plasma cortisol is usually normal, the cortisol production rate (CPR) is frequently increased. Since the secretory rate is correlated with the body weight, expressing the data as mg/kg/24 hour or mg/m² body surface area/24 hour will usually distinguish between obese patients and patients with Cushing's syndrome. The increased output of adrenal steroids is metabolized by the liver, and the increased quantity of metabolities is excreted in the urine. Urinary free cortisol is, however, normal in obesity.

Another feature of steroid physiology and obesity that deserves mention is the finding that obese individuals excrete significantly less dehydroepiandrosterone (DHEA) than do control subjects. This steroid is a potent inhibitor of glucose-6-phosphate dehydrogenase and is also a hypocholesterolemic agent in rats. Glucose-6-phosphate dehydrogenase is the entry point into the pentose phosphate cycle, which provides about two-thirds of the NADPH needed for synthesis of fatty acids. It is evident, therefore, that any drug or chemical that reduces the activity of the pentose phosphate cycle by inhibiting glucose-6-phosphate dehydrogenase might inhibit lipogenesis. Conversely, deficiency of a substance that could block a process that normally inhibits lipid formation might accelerate fat deposition (42). The physiologic and potential therapeutic significance of this finding are unknown, and additional studies are needed to clarify it.

GROWTH HORMONE SECRETION

The effects of obesity on growth hormone have been studied extensively. The basal concentrations of growth hormone are normal or reduced in obese subjects. The induction of hypoglycemia with insulin usually does not stimulate a significant rise in growth hormone in obese patients, and a reduced growth hormone response to IV arginine has also been demonstrated. The nocturnal rise in growth hormone associated with sleep is significantly reduced in obese children and nearly absent in obese adults. Exercise, which also stimulates a rise of growth hormone in normal individuals, fails to do so in the obese. In normal subjects, an acute reduction

in plasma free fatty acids is followed by a secondary rise in growth hormone 2 hours later. In obese subjects, a reduction in fatty acids has no significant effect on the level of growth hormone. The response to L-dopa, like the responses mentioned above, is also blunted in the obese. Thus, as a general rule, obesity blunts the responsiveness to all factors that normally stimulate the release of growth hormone. These observations raise two critical questions: 1) is the reduced response of growth hormone a consequence of obesity? and 2) by what mechanism does this effect occur?

It has been conclusively shown that growth hormone dynamics are altered by weight gain in normal volunteers (66). Three provocative tests were used for this demonstration: 1) the late rise in growth hormone after a glucose tolerance test, 2) the response to an infusion of arginine, and 3) the rise during sleep. With all three stimuli, the rise of growth hormone was blunted in lean volunteers who had gained 15%–25% above their initial body weight. Conversely, responsiveness of growth hormone was restored after weight loss in these normal volunteers and in obese patients. In addition, growth hormone concentrations in very muscular but overweight men rose during an infusion of arginine whereas obese patients showed very little response.

Growth hormone is lipolytic and enhances the utilization of fatty acids. The low levels of this hormone in obesity might tend to perpetuate the excess weight. This possibility has stimulated studies on the actions of growth hormone in obese individuals. It has been shown that the rise in free fatty acids produced by growth hormone is comparable in lean and obese patients when the doses of growth hormone are given on the basis of body weight.

During prolonged treatment with growth hormone, obese subjects show a significant increase in oxygen consumption. The calorigenic effect of this hormone enhances the rate at which fatty acids from adipose tissue are catabolized. During prolonged treatment, growth hormone can significantly reduce nitrogen excretion and reverse the catabolic effects on nitrogen breakdown observed during simultaneous treatment with triiodothyronine. The most-striking metabolic effects of exogenous growth hormone, however, have been observed when it is given during prolonged fasting in obese subjects. After fasting for more than 14 days, the administration of growth hormone produces nausea, vomiting, ketosis, and acidosis. This suggests that the relative resistance to ketosis in obese

subjects may be the result of low levels of growth hormone. This concept has been tested by fasting obese subjects before and after treatment with growth hormone. The development of ketosis was not altered by this treatment.

REPRODUCTIVE FUNCTION

In obesity, the onset of menstruation (menarche) and the regularity of menses may be deranged. The onset of menarche in obese girls frequently occurs at a younger age than in girls of normal weight. Frisch (24) claims that menstruation is initiated when body weight reaches a critical mass. As the rate of growth accelerates in late childhood, the entrance into this critical weight range initiates the pubertal process. The maximum rate of weight gain occurs at 39 kg, and menstruation begins when body weight is 48 kg (22% body fat). Since obese girls grow faster and enter this critical mass at a younger age, menstruation starts at an earlier age. However, many other investigators have been unable to verify this hypothesis.

The obese patient often shows a decrease in the regularity of menstrual cycles and an increase in the frequency of menstrual abnormalities. In one study, 43 of 100 women with menstrual disorders, which included amenorrhea, functional uterine bleeding, premature menopause, and infertility, were overweight (i.e., 20% above standard weight) (6a). In contrast, only 13% of 201 women with no menstrual abnormalities were overweight. In a follow-up study, 32 women with amenorrhea were evaluated after therapeutic weight reduction. All women were initially at least 20% overweight and 20 were 50% or more above the standard weight. Of the 32 patients, 13 lost weight and, coincidentally, began to menstruate (6a). The weight loss ranged from 13–69 pounds (5.9–31.5 kg), and, in general, the onset of menses occurred at 1–4 months after initiating the 1200 Cal diet. It would thus appear that alterations in body weight can influence both the onset of menstruation and the subsequent initiation of menstrustion in women who have developed secondary amenorrhea.

An analysis of the menstrual cycle in six obese women has been recently published (65). These obese women had two abnormalities: 1) the rise in FSH in the first half of the cycle was lower than normal, and 2) progesterone failed to rise normally in the second half of the menstrual cycle. The mechanism of these distortions in obese women is unknown, but they are reversible after weight loss.

ALDOSTERONE AND SALT WATER BALANCE

The inability of many obese patients, particularly those with extreme weight problems to excrete both salt and water normally is now generally recognized. The problem of water retention in obesity is aggravated by carbohydrate intake and becomes more severe with refeeding at the end of a period of starvation. With the onset of fasting, there is an enhanced excretion of sodium, chloride, and potassium, which peaks at 2–4 days and then gradually subsides. With refeeding, carbohydrate or protein, sodium excretion falls to essentially zero and fluid retention occurs.

Several hypotheses have been advanced to explain the mechanism for salt loss during starvation and the retention of salt and water during refeeding with carbohydrate (69). Since sodium excretion is partly under the control of aldosterone, changes in the circulating level of this hormone or in its action on the kidney could explain the alterations in sodium excretion. With short-term starvation, the secretion of aldosterone rises slowly and then gradually returns to normal. With refeeding, aldosterone may rise. In one study, the sodium retention with refeeding was blocked by spironolactone, which inhibits the action of aldosterone. In an earlier study, there was no effect (6a). The injection of aldosterone after 7 days of fasting reduced sodium excretion, indicating that the renal tubule can still respond to this hormone. The implication of aldosterone has also raised the possibility that renin may be involved. Renin, an enzyme secreted by the kidney, can increase aldosterone secretion by raising the concentration of angiotensin, a small peptide that directly stimulates aldosterone production. Measurement of plasma renin showed no consistant changes during fasting, but a small rise is observed after refeeding.

The acidosis that develops during starvation may play a role in the loss of sodium. If a metabolic acidosis is induced by giving ammonium chloride, the loss of sodium during subsequent starvation will be markedly reduced.

Finally, it has been proposed that glucagon may be important in the loss of sodium in starvation. During starvation, both glucagon and sodium excretion rise in parallel, but more importantly, infusing glucagon enhances sodium

secretion to achieve the levels reached during fasting. The following sequence may thus be constructed. The early loss of sodium occurs to provide cations for excretion of anions during the development of acidosis. If acidosis is produced before starvation begins, most of the initial salt loss is prevented. The retention of sodium with refeeding can be inhibited by spironolactone, implying that aldosterone plays an important role in the retention of sodium after carbohydrate or protein (but not fat) are given. The special effect of carbohydrate in shutting off sodium loss suggests that it may provide a necessary source of energy to the aldosterone-mediated transport of sodium in the renal tubule and that the glucagon rise may block aldosterone action.

MALNUTRITION

Malnutrition has profound effects on the endocrine system (27). This section will consider the endocrine changes in four types of malnutrition: 1) acute starvation, 2) chronic malnutrition, 3) emotional deprivation, and 4) anorexia nervosa.

ACUTE STARVATION

As fasting begins, the levels of glucose and insulin decrease. In contrast, glucagon levels rise, promoting the breakdown of hepatic glycogen to provide glucose. However, in man, glycogen stores are exhausted in less than 24 hours, and since glucose remains the primary energy source for brain and blood cells during a short fast, the body must make more glucose. The two carbon acetate fragments produced during the metabolism of fatty acids cannot be converted back into glucose. Thus, the liver is required to use amino acids from protein as the source of carbon for new glucose. If the body continued to use protein during prolonged starvation at the same rate that it does in early starvation, the protein stores would be rapidly exhausted and death would occur (78). However, as starvation continues, the brain adapts to use ketones as a major energy source. Thus, nitrogen loss decreases after 30 days of fasting to one-fifth of the value found during early fasting. This process is mediated by the complex interplay between hormones. The increase in circulating glucagon enhances the hepatic production of glucose and ketones, and the fall in insulin reduces glucose entry into most tissues (10,78).

CHRONIC MALNUTRITION

Endocrine changes in chronic malnutrition have been studied in the childhood syndromes of marasmus and kwashiorkor (26). The requirement of growing children for calories and protein makes them especially susceptible to deficits in nutrients (see Ch. 29).

Marasmus is characterized by inadequate calorie intake beginning in the first few months of life and is usually found in underdeveloped countries where breast feeding is discontinued early. Clinically, the patients are short for their age with an even greater decrease in weight. Fat stores are depleted and muscle wasting occurs. Serum albumin is normal or slightly decreased, and edema is not present.

This picture contrasts with that seen in patients with kwashiorkor, where the caloric intake is normal but the protein intake is severely deficient. This usually occurs after 1 year of age. The patients have edema and hepatomegaly, and serum albumin is low. The skin and mucous membranes are abnormal. However, the form of malnutrition frequently cannot be categorized this clearly since elements of both marasmus and kwashiorkor are often present. Protein–calorie malnutrition (PCM) is thus a preferable term.

Since the pattern of malnutrition varies from country to country, endocrine studies are in conflict. When body weight is 30% or more below normal, a number of endocrine changes take place. The BMR is decreased. Plasma thyroxine (T_4) and the uptake of radioactive iodine (RAI) by the thyroid and may be normal or slightly low. Thyroid-binding globulin is normal in marasmus but low in kwashiorkor. Free T_4, however, is normal or elevated in both. Plasma thyrotropin (TSH) is usually in the normal range and responds normally to the administration of hypothalamic-releasing factor (thyrotropin-releasing hormone). Exogenously administered TSH causes a normal increase in thyroid uptake of RAI by the thyrroid gland (27). In adults with malnutrition, plasma TSH and plasma T_4 are normal before and after refeeding. However, the free T_4 is high, and plasma triiodothyronine (T_3) is low before treatment, suggesting that in malnutrition, there is a peripheral defect in conversion of T_4 to the metabolically more active T_3 (12). The deficit is not permanent and is corrected by refeeding.

The levels of growth hormone (GH) in marasmus may be high, normal, or low. Regardless of the level, there is no increase after infusing arginine or injecting hypoglycemic doses of

insulin, both of which normally increase growth hormone. In marasmus, growth hormone returns to normal with refeeding, and responsiveness to arginine and insulin-induced hypoglycemia returns. In kwashiorkor, growth hormone is very high but, as in marasmus there is no response to provocative stimulation. After recovery in kwashiorkor, the fasting levels of growth hormone decrease to normal and responsiveness to stimulation returns. Despite elevated levels of growth hormone, patients with kwashiorkor have low levels of somatomedin. During dietary treatment, somatomedin rises even though growth hormone is falling (28). Since it is believed to be made in the liver, somatomedin levels could be a reflection of hepatic dysfunction in kwashiorkor.

In both kwashiorkor and marasmus, plasma cortisol levels increase, but a normal diurnal variation remains. Urinary excretion of free cortisol also remains normal (3). In malnourished adults, plasma cortisol is high with high urinary free cortisol (67). Plasma ACTH, however, is not suppressed by the elevated concentrations of cortisol and oral dexamethasone also fails to suppress cortisol normally. The response to oral metyrapone and to IV ACTH is normal, and the metabolic clearance rate of cortisol is reduced. These findings suggest that the pituitary–adrenal axis is intact but with elevated ACTH secretion, which produces an elevated plasma cortisol. Children with kwashiorkor have elevated plasma aldosterone with normal aldosterone secretory rates (2).

Glucose levels are normal or slightly low. Serum insulin is low, as expected. In PCM, patients generally show decreased tolerance to oral or IV glucose with a blunted rise in serum insulin (1).

In men with PCM, the total and unbound plasma testosterone is low, with elevated levels of plasma luteinizing hormone and FSH. The rise in serum testosterone after IM human chorionic gonadotropin is subnormal. After refeeding, the testosterone and FSH levels return to normal, but the luteinizing hormone level may remain elevated. This suggests that Leydig cell function is diminished and that refeeding does not completely reverse the deficit (68).

EMOTIONAL DEPRIVATION

A group of pediatric patients with short stature, delayed bone age, decreased weight for height, and developmental retardation have been described (25). All patients have an emotionally deprived home environment. Upon changing the environment to provide more emotional rewards, these patients become more responsive and resume normal growth. The syndrome has been divided into subgroups: patients who are less than 3 years old have been termed maternal deprivation; the older children have been termed psychosocial deprivation. It is not clear how much of a role primary malnutrition plays in the development of this clinical picture. In several patients with psychosocial deprivation, access to food was considered normal; indeed, in some, food intake was thought to be adequate for growth (56). In the younger patients with maternal deprivation, it appeared that mothers were offering an inadequate diet. The hormonal changes in emotional deprivation are similar to those in malnourished children. Thyroid function is normal or low. In children with psychosocial deprivation, the growth hormone levels are low or normal with an inadequate response to hypoglycemia. In younger patients with maternal deprivation, the rise in growth hormone in response to hypoglycemia is normal. The response to metyrapone is dose related (39); administration of 300 mg/100 lb for 1 day produces an inadequate rise in 11-deoxycortisol, but administration of 300 mg/m² for 2 days produces a normal response.

ANOREXIA NERVOSA

Anorexia nervosa is a clinical diagnosis characterized by an aversion to food (36, 74) (see Ch. 30), usually occurring in females between 10–30 years of age. These women reject food in all forms, even engaging in hiding of food and self-induced vomiting to avoid calorie consumption. In spite of the developing malnutrition, these patients remain physically active and may even increase activity with programs of vigorous exercise. They have a distorted body image, often believing themselves to be overweight, and view their developing emaciation as a positive accomplishment. The etiology of the disease is probably psychophysiologic.

It is common for females with anorexia nervosa to develop amenorrhea, often before they have lost much weight. Even during recovery, as weight is regained, there is frequently a delay before the resumption of menses. This has focused interest on the reproductive system. Plasma luteinizing hormone and FSH are low in most patients. The 24-hour pattern of luteinizing

hormone secretion is prepubertal. After weight gain, the pattern returns to normal (6). The low levels of the gonadotropins are reflected in the low urinary and serum estrogens in females and the low plasma testosterone in males. There is no increase in serum luteinizing hormone after the administration of clomiphene when the patient's weight is less than 80% of normal, but when the patient's weight rises to greater than 80% of normal, the response to clomiphene returns. In one study (48), most patients had a normal rise in luteinizing hormone and FSH after receiving gonadotropin-releasing hormone (GnRH) intravenously. In another study (64), the luteinizing hormone response after IV GnRH was strikingly impaired when the patients weighed 53%–64% of ideal body weight, but after therapy, when the patients weighed 90%–94% of ideal body weight, their responses were normal. The rise in FSH after IV GnRH was normal both before and after weight gain. These data suggest that the defect at the pituitary and hypothalamic level is secondary to the weight loss.

Fasting growth hormone levels are increased and the response to arginine infusion and induced hypoglycemia is subnormal. Despite increased growth hormone concentrations, somatomedin levels are normal. In some cases, a paradoxical rise in growth hormone occurs when glucose is given by mouth.

The BMR, serum T_4, and RAI uptake by the thyroid are all normal or slightly low, but plasma T_3 is very low, suggesting a defect in peripheral conversion of T_4 to T_3 (52). Basal thyrotropin is normal, as is the rise in TSH when the hypothalamic thyrotropin-releasing hormone (TRH) is given.

Plasma cortisol is slightly elevated, but the secretory rate for cortisol, the response to ACTH, and metyrapone are all normal. The increased concentration of cortisol does not suppress normally with administration of dexamethasone. These data suggest that the increase in cortisol is due to increased protein-bound hormone and not to increased physiologically active hormone. The glucose tolerance is decreased with mild insensitivity to insulin.

The similarities between the thyroid, adrenal, growth hormone, and insulin systems in anorexia nervosa and malnutrition strongly suggest that the hormonal changes in anorexia nervosa are secondary to malnutrition.

In summary, endocrine responses to various types of malnutrition are complex. It is clear that these changes are not simply the result of pituitary insufficiency as was once believed.

TRACE ELEMENTS

Knowledge is rapidly expanding in the field of trace elements and their importance in biologic functions (60). Iodine, which is the most important trace element in endocrine function, has already been discussed in the section on the thyroid gland. Evidence is accumulating that zinc and chromium are also important for normal endocrine function.

ZINC

Zinc deficiency has been implicated as a cause of short stature and delayed sexual development (9). The syndrome has been described in two groups: 1) in Iranian males who consumed large amounts of clay which chelated zinc in the intestine and 2) in Egyptian males who had parasitic infestation producing chronic blood loss. Treatment of these patients with supplements of zinc increased the rate of growth and accelerated development of secondary sexual characteristics. Zinc deficiency has also been implicated as a cause of short stature and delayed sexual development in several patients with malabsorption (63).

During a screening program for zinc deficiency in humans, 10 of 132 children living in Denver were found to have low levels of serum zinc (32). Most of these patients had a poor appetite and showed decreased growth and taste acuity. Treatment with zinc produced normal taste acuity and increased the zinc level to normal. The effect on their short stature has not yet been reported.

Endocrine studies on the zinc-deficient Egyptians have shown decreased serum testosterone with a normal increase following administration of human chorionic gonadotropin (14). This suggests that patients with zinc deficiency may have a defect in the release of pituitary gonadotropins. Growth hormone secretion was also decreased in the zinc-deficient subjects after hypoglycemia, but it was decreased as well in control subjects without zinc deficiency. Further studies are needed to define the role of zinc in short stature and delayed sexual development.

CHROMIUM

Chromium is necessary for the normal metabolism of glucose in animals (31). This has been shown not only *in vivo,* but also by using isolated adipose tissue *in vitro.* Chromium appears to act as a cofactor in the peripheral action of insulin.

Brewer's yeast contains high concentrations of a specific chromium complex which has been purified and found to be more active than chromium alone in improving glucose metabolism (51). Studies in human beings with normal chromium nutrition have shown a rise in serum chromium during an oral glucose tolerance test. Chromium or Brewer's yeast has been given to adults having maturity onset diabetes with variable results. Some investigators found that patients had improved glucose tolerance, but in other studies, chromium produced no change in glucose metabolism (41, 73). Chromium administered to malnourished children has improved IV glucose tolerance. These data suggest that in some human beings with decreased glucose tolerance, chromium deficiency may be a factor in the impaired metabolism of glucose, but there is as yet no clinical indication for use of chromium in treatment of diabetes.

EFFECTS OF THE ENDOCRINE SYSTEM ON NUTRITION

PITUITARY–HYPOTHALAMUS

The hypothalamus and pituitary function as an integrated unit. This section will discuss the effect of the hypothalamic hormones and growth hormone on nutrition. The other pituitary hormones are discussed in the following sections which deal with their target glands.

HYPOTHALAMUS

The hypothalamus controls the secretion of pituitary hormones by the elaboration of releasing factors and inhibiting factors. Some of these factors have been isolated and their chemical structure determined (4). Hypothalamic releasing factors are abnormal in the syndrome of generalized lipodystrophy, a rare congenital disease characterized by an absence of all body fat, an early increase in growth, hyperpigmentation, and an elevated level of glucose. These patients have high circulating levels of the hypothalamic-releasing factor that releases ACTH, as well as high levels of gonadotropin-releasing factors (LRH) and melanocyte-stimulating-hormone-releasing factor (MSH-RH) (45). Following treatment with pimozide, a selective inhibitor of cerebral dopaminergic receptors, one patient had decreases in the circulating level of hypothalamic-releasing factors, in triglycerides, and in insulin and glucose. Since hypophysectomy does not effect the long-term course of this disease, these data suggest that a hypothalamic hormone may have an important effect on the peripheral metabolism of fat.

Hypothalamic injury has produced syndromes of overnutrition and undernutrition. Hypothalamic obesity, which is characterized by the absence of satiation and chronic weight gain, occasionally follows hypothalamic tumors or surgery in this region of the brain (7) and is very similar to the syndrome produced in animals by the destruction of the ventromedial region of the hypothalamus. Most endocrine changes in hypothalamic obesity are the same as those present in obesity of other causes and will be discussed in a latter section. One exception is that the concentration of insulin is higher.

The diencephalic syndrome is characterized by an absence of cutaneous fat, normal or increased appetite, increased growth, hyperactivity, and euphoria and is associated with tumors of the hypothalamus or third ventricle. Increased fasting growth hormone is not suppressed after oral or IV administration of glucose (55), but this minor abnormality does not appear to account for the profound metabolic changes in these children. The extreme loss of fat in the presence of a normal appetite and food intake suggests that the hypothalamus may be producing a substance that blocks storage of calories in adipose tissue.

GROWTH HORMONE

Human growth hormone (hGH) is a polypeptide secreted by the pituitary under the control of the hypothalamus which affects carbohydrate, fat, and protein metabolism throughout the body (50). It increases cellular uptake of amino acids and facilitates incorporation of amino acids into protein. Replication of DNA and RNA is increased in cartilage. Conversion of proline to hydroxyproline for use in collagen syntehsis is enhanced. All of these actions of hGH are mediated by somatomedin, a growth hormone–dependent peptide produced in the liver (72) which increases cellular utilization of glucose and decreases adipose cell lipolysis. The insulin-like effects of somatomedin are in marked contrast to the anti-insulin effects of hGH itself. In pharmacologic doses, somatomedin decreases the uptake of glucose by adipose cells, increases the release of pancreatic insulin, increases lipolysis in adipose tissue, and elevates plasma free fatty acids. It also increases Ca absorption from the GI tract and thus enhances retention of Ca both in bone and urinary excretion.

A group of children with familial dwarfism

have been described (20) who have very high concentrations of hGH and low serum levels of somatomedin. Their serum somatomedin levels do not rise after administration of hGH, suggesting a defect in somatomedin production. One tribe of African Pygmies has been found to have normal levels of hGH and somatomedin, but they appear to have decreased peripheral tissue sensitivity to both hormones. Low somatomedin levels in the presence of normal or high hGH levels may be responsible for poor growth in children taking glucocorticoids and in children with chronic renal failure.

Patients with hGH deficiency have short stature, delayed bone age, hypoglycemia with increased glucose tolerance, and mild obesity. With the administration of hGH, they show positive nitrogen balance, increased growth rate, normal glucose tolerance, and decreased body fat. Since many patients with hGH deficiency have deficiencies of other pituitary hormones, these must be tested for and replaced as required. Thyroid hormone replacement is especially important since hGH is not effective in hypothyroidism.

Excessive secretion of hGH before epiphyseal closure results in gigantism. Adult heights of up to 9 feet have been recorded. Excess hGH after epiphyseal closure produces acromegaly. Here the increase of bone growth is restricted to facial bones, particularly the mandible, and cortical portions of the membranous bones. In both syndromes, there is increased growth of connective tissue, body hair, cartilage, and enlargement of visceral organs (*i.e.,* liver, kidneys, spleen, and thyroid). In these patients, plasma hGH does not decrease after oral glucose. Glucose tolerance is occasionally impaired, but compensatory hyperinsulinism often prevents overt diabetes (17).

ADRENAL CORTEX

The adrenal cortex produces three groups of steroids: 1) the androgens, 2) the glucocorticoids, and 3) the mineralocorticoids (13). The androgenic steroids and their modes of action are discussed in a separate section.

ADRENAL CORTICOSTEROIDS

As with the other steroid hormones, the corticosteroids appear to exert their effects by binding to a specific protein receptor in the cell cytoplasm and then passing into the nucleus to modify the synthesis of protein and enzymes.

Cortisol, the principal glucocorticoid, exerts far-reaching effects on protein, carbohydrate, and fat metabolism (18, 49). Glucocorticoids inhibit the incorporation of amino acids into protein with a resultant rise in levels of blood amino acids. In addition, these hormones directly stimulate the synthesis of hepatic enzymes that synthesize glucose (*i.eg.,* glucose-6-phosphatase, fructose 1, 6-diphosphatase, pyruvate carboxylase, phosphoenolpyruvate carboxykinase, tyrosine aminotransferase, glutamic pyruvic transaminase, and tryptophan pyrrolase). The elevated levels of alanine thus provide the substrate for hepatic glucose synthesis. Glucocorticoids also stimulate glucagon release, which also enhances glucose formation in the liver. In otherwise-normal subjects, these steroid hormones decrease the hypoglycemic effect of injected insulin. They inhibit fatty acid synthesis (*i.e.,* lipogenesis) and permit the enhanced lipolytic effects of catecholamines in some tissues (*e.g.,* the subcutaneous fat cells of the arms and legs), but in other tissues, glucocorticoids stimulate lipogenesis (*e.g.,* the dorsal and supraclavicular fat pads). In addition to their effects on intermediary metabolism, glucocorticoids are necessary for the excretion of dilute urine by the kidneys, and they also antagonize the effect of vitamin D on Ca absorption by the intestine. This effect of steroids is particularly useful in the treatment of hypercalcemia due to sarcoidosis.

Aldosterone is the primary mineralocorticoid in humans. It regulates sodium balance by the kidneys independently of the hypothalamic–pituitary axis. Secretion of aldosterone is regulated primarily by the renin–angiotensin system. Briefly, the kidney secretes renin in response to sodium depletion; renin then converts circulating angiotensinogen to angiotensin I, which is further cleaved to angiotensin II in the pulmonary circulation. Angiotensin II is a direct vasoconstrictor and stimulates aldosterone secretion from the zona glomerulosa of the adrenals. Hyperkalemia also stimulates aldosterone secretion. Aldosterone acts primarily on the distal convoluted tubule and collecting tubules to increase the reabsorption of sodium from the urine; the sodium reabsorption is, in turn, "coupled" to the excretion of potassium and hydrogen ion.

EFFECTS OF EXCESSIVE ADRENAL CORTICOSTEROIDS

The administration of glucorticoids (*e.g.,* cortisone, prednisone, dexamethasone) or the endogenous secretion of excess cortisol results in a

state of "hypercortisolism" and can, therefore, be considered as a single entity for the purposes of this discussion. Increased concentrations of glucocorticoids exert an effect on carbohydrate, protein, and lipid metabolism. In about 15% of patients receiving exogenous steroids, a mild, nonketotic form of diabetes occurs, but 95% of patients with full-blown Cushing's syndrome show an abnormal glucose tolerance test (47). It is said that those patients receiving exogenous glucocorticoids have a much lower incidence of glucose intolerance, but the reason is not clear. Catabolic effects on protein are often the most-striking changes. Muscle wasting, thinning of the skin, dissolution of vertebral bone matrix, poor wound healing, and growth retardation in children are frequently found. The varying influences on lipid metabolism discussed above result in the peculiar truncal obesity seen in Cushing's syndrome, with loss of subcutaneous fat tissue from the arms and legs and excessive deposition in the dorsal and ventral fat pads, the supraclavicular and mediastinal areas, and the abdominal walls. Excessive cortisol stimulates the appetite and can thus contribute to the obesity. The antagonistic effects of glucocorticoids on the action of vitamin D produces a markedly negative Ca balance. Along with the enhanced catabolism of protein, this may lead to the appearance of osteoporosis with vertebral fractures and occasionally with aseptic necrosis of the femoral head. High cortisol levels often exert a mineralocorticoidlike effect even though the levels of aldosterone are not elevated. The result is hypertension, which may be associated with hypokalemic alkalosis. This mineralocorticoid-like effect is commonly seen in patients with neoplasms producing ACTH and is not usually seen in patients treated with the newer synthetic glucocorticoids. In a few reports, glucocorticoid therapy has also resulted in zinc depletion with resultant delayed wound healing. This is correctable using oral supplements of zinc. The effects of glucocorticoids on the metabolism of other trace metals and vitamins have not been adequately investigated.

Hyperaldosteronism or Conn's syndrome is a disease with excessive secretion of aldosterone. Metabolically, this results in hypertension and hypokalemic alkalosis. Thus, the possibility of high levels of aldosterone should be considered whenever a low serum potassium is detected. Hypokalemia interferes with the release of insulin and may lead to abnormal glucose tolerance test.

DEFICIENCY OF ADRENAL CORTICOSTEROID

Addison's disease can occur because of primary adrenal failure or because the pituitary fails to secrete ACTH (47). Most cases of Addison's disease are "idiopathic" and probably result from an "autoimmune" adrenalitis in which the adrenal medulla is spared. Less than one-third of cases are now due to tuberculosis, histoplasmosis, or other infectious diseases. Patients with adrenal insufficiency frequently manifest weight loss, weakness, loss of body hair in the female (loss of adrenal androgens), reactive hypoglycemia following a carbohydrate meal, and occasionally hypercalcemia. Statistically, there is an increased incidence of both diabetes mellitus and Hashimoto's thyroiditis in patients with idiopathic Addison's disease.

Deficiency of aldosterone itself can occur congenitally, or it may appear in older diabetics with mild renal insufficiency. This latter form is frequently due to primary deficiency of renin with a secondary hypoaldosteronism. In all of these forms, the major manifestation is hyperkalemia with occasional modest hyponatremia and acidosis. Other metabolic effects are rarely seen. In addition, there are rare instances of end-organ resistance to the action of aldosterone (pseudohypoaldosteronism).

ADRENAL MEDULLA

Epinephrine is the major catecholamine secreted by the adrenal medulla, but norepinephrine is also released in smaller amounts (53). Epinephrine stimulates both alpha and beta receptors, whereas norepinephrine predominantly activates the alpha receptors. The principal metabolic effect mediated through alpha receptors is the inhibition of insulin secretion. Stimulation of beta receptors, on the other hand, causes an increase in glycogenolysis in both muscle and liver along with an inhibition of glycogen synthetase in muscle and a mild increase in insulin secretion. This process also activates hormone-sensitive lipase in fat cells and results in the breakdown of triglycerides with liberation of free fatty acids. Blockade of beta receptors by propranolol can result in impaired secretion of insulin and hyperglycemia. If allowed to continue, hyperosmolar nonketotic coma may occur, but this apparently happens only in patients with a preexisting tendency to diabetes.

In patients with pheochromocytomas, epinephrine secretion is often greatly increased whereas norepinephrine is only modestly in-

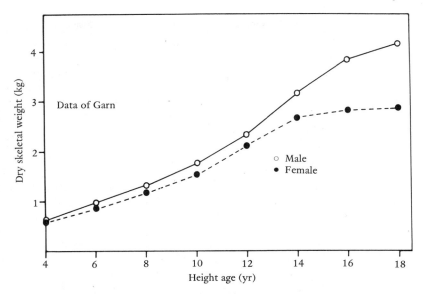

Fig. 19–5. Growth of skeleton versus height-age. Clearly, the greater gain in body and muscle of the male is associated with greater gain in skeletal mass. (Cheek DB: Body composition, hormones, nutrition and adolescent growth. In Grumbach MM, Grave GD, Mayer FE (eds): Control of the Onset of Puberty. New York, John Wiley & Sons, 1974, p 430)

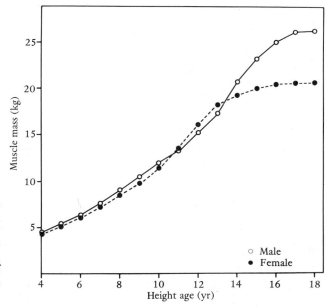

Fig. 19–6. Muscle mass (from creatinine excretion) is plotted against height-age for males and females. Note that muscle mass doubles in males from 10 to 17 years. (Cheek DB: Body composition, hormones, nutrition and adolescent growth. In Grumbach MM, Grave GD, Mayer FE (eds): Control of the Onset of Puberty. New York, John Wiley & Sons, 1974, p 426)

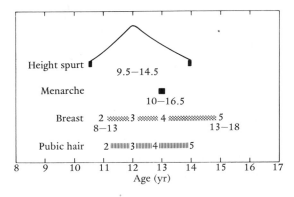

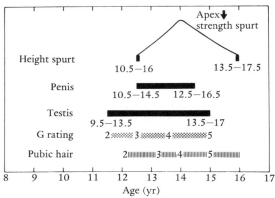

Fig. 19–7. Events at puberty. Average female *(upper)* and male *(lower)* are represented. Range of ages within which each event charted may begin and end is given by the figures placed directly below its start and finish. (Tanner JM: Sequences and tempo in the somatic changes in puberty. In Grumbach MM, Grave GD, Mayer FE (eds): Control of the Onset of Puberty. New York, John Wiley & Sons, 1974, p 460)

creased. In this disease, glucose intolerance is impaired because insulin release is blocked. Alpha receptor blockade with phenoxybenzamine restores insulin secretion to normal in these patients, but glucose intolerance may persist.

ESTROGENIC AND ANDROGENIC STEROIDS

In the male, the principal circulating androgen is testosterone (T). About 97%–99% of this hormone is bound to testosterone-binding globulin. In most tissues, dihydrotestosterone (DHT) is the active form of testosterone. About 90% of DHT is produced from testosterone in peripheral tissues by the enzyme dihydroreductase; the remaining 10% is produced by the

testes (77). This enzyme system has not been demonstrated in muscle, and testosterone itself might be the active agent there. In females, the most important androgens are testosterone and androstenedione, which are secreted by the ovary, and dehydroepiandrosterone, which is secreted by the adrenals. About 5%–20% of blood testosterone is directly secreted by the ovaries, 50%–70% is converted from androstenedione, and about 15% is derived from dehydroepiandrosterone (38).

In females, the main estrogen secreted by the ovary is estradiol. Estrone circulates in plasma at levels similar to those of estradiol and is largely a conversion product of androstenedione. The physiologic significance of estrone is uncertain since it has much less estrogenic activity than estradiol. Progesterone is secreted by the ovary during the luteal phase and is only present in minimal amounts before puberty.

At the cellular level of responsive tissues, testosterone, dihydrotestosterone, and estradiol stimulate messenger and ribosomal RNA synthesis with resultant protein synthesis. In addition, these hormones also cause a decrease in protein catabolism, thus producing a positive nitrogen balance. In the secondary sex organs, muscle, and bone, androgen stimulation results in tissue growth and is reflected by a rise in lean body mass and a decrease in fat mass at the time of adolescence. The lean body mass and skeletal mass, at adolescence, increase faster with age in males than in females. In boys and girls, the heights at each age are similar until about height-age 9 (*i.e.,* 137 cm), when the male height for age accelerates faster than that of the female (11). Similarly, the skeletal mass (Fig. 19–5) and muscle mass diverge at this point, with an eventual rate of growth in muscle that is three times faster in boys (Fig. 19–6). Multiplication of muscle cells parallels these changes in muscle mass. As these increments in lean body mass occur, total caloric and protein intake increase concomitantly.

Figure 19–7 shows the spurt in height in relation to other pubertal changes in both sexes. It is felt that this increase in height and lean body mass in females is attributable to adrenal androgens, the smaller increment in total androgens in the female possibly accounting for the smaller increases in height and lean body mass. The role of increasing estrogen levels on linear growth at puberty is unclear but may be also important.

At the same time that androgens are stimulating bone growth, along with estrogens they

Fig. 19–8. Increasing fatness of males and females during adolescence. (Cheek DB: Body composition, hormones, nutrition and adolescent growth. In Grumbach MM, Grave GD, Mayer FE (eds): Control of the Onset of Puberty. New York, John Wiley & Sons, 1974, p 426)

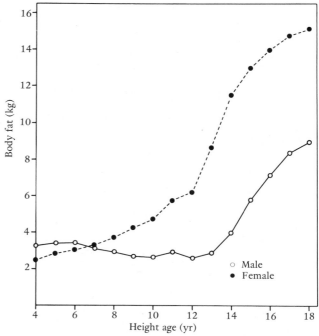

also cause a maturation and eventual closure of the bony epiphyses. In precocious puberty and the virilizing forms of congenital adrenal hyperplasia, there is a marked early increase in muscle mass and linear skeletal growth along with virilization. Because the androgens also accelerate closure of the epiphyseal centers, however, these children usually become short adults. Conversely, eunuchoid individuals with androgen deficiency, *e.g.,* Klinefelter's syndrome, often have a slow but continued growth without an adolescent growth spurt, so that they end up taller than predicted from early growth records.

In addition to the changes in lean body mass that occur at puberty, there are also changes in distribution of the body fat. The increase in fat is much greater in females than in males (Fig. 19–8), and this occurs at about the same time as the divergence in lean body mass (11). Estrogens are probably responsible for the development of the female body contour. Interestingly, Simeons first proposed using human chorionic gonadotropin for treating obesity because he thought that this substance might help to bring back the lost female body contour; neither he nor the subsequent users of this drug have ever substantiated the efficacy of human chorionic gonadotropin for the treatment of obesity.

REFERENCES

1. Becker DJ, Primstone BL, Hansen JDL, MacHutch B, Drysdale A: Patterns of insulin response to glucose in protein-calorie malnutrition. Am J Clin Nutr 25:499–505, 1972

2. Beitins IZ, Graham GG, Kowarski A, Migeon CJ: Adrenal functions in normal infants and in marasmus and kwashiorkor: plasma aldosterone concentration and aldosterone secretion rate. J Pediatr 84:444–451, 1974

3. Beitins IZ, Kowarski A, Migeon CJ, Graham GG: Adrenal functions in normal infants and in marasmus and kwashiorkor. J Pediatr 86:302–308, 1975

4. Besser GM, Mortimer CH: Hypothalamic regulatory hormones: a review. J Clin Pathol 27:173–184, 1974

5. Bjorntorp P: Effects of age, sex and clinical conditions on adipose tissue cellularity in man. Metabolism 23:1091–1102, 1974

6. Boyal RM, Katz J, Finkelstein JW, Kapen S, Weiner H, Weitzman ED, Hellman L: Anorexia nervosa, immaturity of the 24-hour luteinizing secretory pattern. N Engl J Med 291:861–865, 1974

6a. Bray GA: The Obese Patient. Philadelphia, WB Saunders, 1976

7. Bray GA, Gallagher TF Jr: Manifestations of hypothalamic obesity in man: a comprehensive investigation of eight patients and a review of the literature. Medicine 54(4):301–330, 1975

8. Bray GA, Melvin KEW, Chopra IJ: Effect of triiodothyronine on some metabolic responses of obese patients. Am J Clin Nutr 26:715–721, 1973

9. Burch RE, Hahn HKJ, Sullivan JF: Newer aspects of the roles of zinc, manganese and copper in human nutrition. Clin Chem 21:501–520, 1975

10. Cahill GF Jr: Starvation in man. N Engl J Med 282: 668–674, 1970

11. Cheek DB: Body composition, hormones, nutrition and adolescent growth. In Grumbach MM, Grave GD, Mayer FE (eds): Control of the Onset of Puberty. New York, John Wiley & Sons, 1974, pp 424–442

12. Chopra IJ, Smith SR: Circulating thyroid hormones and thyrotropin in adults patients with protein-calorie malnutrition. J Clin Endocrinol Metab 40:221–227, 1975

13. Christy NP (ed): The Human Adrenal Cortex. Hagerstown, Harper & Row, 1971

14. Coble YD Jr, Bardin CW, Ross GT, Darby W: Studies of endocrine function in boys with retarded growth, delayed sexual maturation, and zinc deficiency. J Clin Endocrinol 32:361, 1971

15. Coburn JW, Hartenbower DL, Norman AW: Metabolism and action of the hormone vitamin D. Its relation to disease of calcium homeostasis. West J Med 121:22–44, 1974

16. Cohn DV, MacGregor RR, Chu LLH, Huang DWY, Anast CS, Hamilton JW: Biosynthesis of proparathyroid hormone and parathyroid hormone. Am J Med 56:767–773, 1974

17. Daughaday WH: The adenohypophysis. In Williams RH (ed): Textbook of Endocrinology. Philadelphia, WB Saunders, 1974

18. David DS, Grieco MH, Cushman P Jr: Adrenal glucocorticoids after twenty years. A review of their clinically relevant consequences. J Chronic Dis 22:637–711, 1970

19. DeLuca HP: The kidney as an endocrine organ involved in the function of vitamin D. Am J Med 58:39–47, 1975

20. Elders MJ, Garland JT, Daughaday WH, Fisher DA, Whitney JE, Hughes ER: Laron's dwarfism: studies on the nature of the defect. J Pediatr 83:253–263, 1973

21. Emerson CH, Dyson WL, Utiger RD: Serum thyrotropin and thyroxine concentrations in patients receiving lithium carbonate. J Clin Endocrinol Metab 36:338–345, 1973

22. Felig P, Marliss EB, Cahill GF Jr: Plasma amino acids levels and insulin secretion in obesity. N Engl J Med 281:811–814, 1969

23. Fisher DA: Advances in the laboratory diagnosis of thyroid disease. J Pediatr 82:1–9, 1973

24. Frisch RE, McArthur JW: Menstrual cycles: fatness as a determinant of minimum weight necessary for their maintenance on onset. Science 185:949–952, 1974

25. Gardner LI: Deprivational dwarfism. Sci Am 227:76–82, 1972

26. Gardner LI, Amacher P (eds): Endrocrine Aspects of Malnutrition. Santa Ynez, The Kroc Foundation, 1973

27. Graham GG, Baertl JM, Claeyssen G, Suskind R, Greenberg AH, Thompson RG, Blizzard RM: Studies in normal and severely malnourished infants and small children. J Pediatr 83:321–331, 1973

28. Grant DB, Hambley J, Becker D, Pimstone BL: Reduced sulfation factor in undernourished children. Arch Dis Child 48:596–600, 1973

29. Grey N, Kipnis DM: Effect of diet composition on the hyperinsulinemia of obesity. N Engl J Med 285:827–831, 1971

30. Hahn TJ, Hendin BA, Scharp CR, Boisseau VC, Haddad JG Jr: Serum 25-hydroxycalciferol levels and bone mass in children on chronic anti-convulsant therapy. N Engl J Med 292:550–554, 1975

31. Hambridge KM: Chromium nutrition in man. Am J Clin Nutr 27:505–514, 1974

32. Hambridge KM, Hambridge C, Jacobs M, Baum JD: Low levels of zinc in hair, anorexia, poor growth and hypogeusia in children. Pediatr Res 6:868–874, 1972

33. Hollander CS, Stevenson C, Mitsuina T, Pineda G, Shenkinar L, Sitva E: T3 toxicosis in an iodine deficient area. Lancet 2:1276–1278, 1972

34. Horton ES: Epidemiologic aspects of obesity. In Rubin LD (ed): Understanding and Successfully Managing Obesity. Postgrad Med Symp, 1974

35. Ingbar SH, Woeber KA: The thyroid gland. In Williams RH (ed): Textbook of Endocrinology. Philadelphia, WB Saunders, 1974, pp 95–232

36. Kanis JA, Brown P, Fitzpatrick K, Hibbert DJ, Horn DB, Nairn IM, Shirling D, Strong JA, Walton HJ: Anorexia nervosa: a clinical, psychiatric, and laboratory study. Q J Med 43:321–338, 1974

37. Karam JH, Grodsky GM, Ching KN, Schmid F, Burrill K, Forsham PH: "Staircase" glucose stimulation of insulin secretion in obesity. Measure of beta-cell sensitivity and capacity. Diabetes 23:763–770, 1974

38. Kirschner MA, Bardin CW: Androgen production and metabolism in normal and virilized women. Metabolism 21:667–688, 1972

39. Krieger I, Mellinger RC: Pituitary function in the deprivational syndrome. J Pediatr 79:216–225, 1971

40. Lamki L, Ezrin C, Koven I, Steiner G: L–thyroxine in the treatment of obesity without increase in loss of lean body mass. Metabolism 22:617–622, 1973

41. Levander OA: Selenium and chromium in human nutrition. J Am Diet Assoc 66:338–344, 1975

42. Lopez–S A, Krehl WA: In vivo effect of dehydroepiandosterone on red blood cell glucose 6-phosphate dehydrogenase. Proc Soc Exp Biol Med 126:776–778, 1967

43. Lotz M, Zisman E, Bartter FC: Evidence for a phosphorus-depletion syndrome in man. N Engl J Med 278:409–415, 1968

44. Lutwak L, Singer FR, Urist MR: Current concepts of bone metabolism. Ann Intern Med 80:630–644, 1974

45. Mabry CC, Hollingsworth DR, Upton GV, Corbin A: Pituitary-hypothalamic dysfunction in generalized lipodystrophy. J Pediatr 82:625–633, 1973

46. Mahler RJ, Szabo O: Amelioration of insulin resistance in obese mice. Am J Physiol 221:980–983, 1971

47. Mason AS (ed): Disease of the adrenal cortex. Clin Endocrinol Metab 1:331–558, 1972

48. Mecklenburg RS, Loriaux DL, Thompson RH, Andersen AE, Lipsett MB: Hypothalamic dysfunction in patients with anorexia nervosa. Medicine 53:147–159, 1974

49. Melby JC: Systemic corticosteroid therapy: pharmacology and endocrinologic considerations. Ann Intern Med 81:505–512, 1972

50. Merimee TJ, Rabin D: A survey of growth hormone secretion and action. Metabolism 22:1235–1251, 1973

51. Mertz W, Toepfer EW, Roginski EE, Polansky MM: Present knowledge of the role of chromium. Fed Proc 33:2275–2280, 1974

52. Moshang T, Parks JS, Baker L, Vaidya V, Utiger R, Bongiovanni AM, Snyder PJ: Low serum triiodothyro-

nine in patients with anorexia nervosa. J Clin Endocrinol Metab 40:470–473, 1975

53. Odell WD, Bray GA, DeQuattro V, Fisher DA, Goldberg MA, Sperling MA, Swerdloff RS: Catecholamines. Calif Med 117:32–62, 1972

54. Odell WD, Fisher DA, Korenman SG, Solomon DH, Chopra IJ, Swerdloff RS: Hyperthyroidism. Calif Med 113:35–65, 1970

55. Pimstone BL, Sobel J, Myer E, Eale D: Secretion of growth hormone in the diencephatic syndrome of childhood. J Pediatr 76:886–889, 1970

56. Powell GF, Brasel JA, Raiti S, Blizzard RM: Emotional deprivation and growth retardation simulating idiopathic hypopituitarism. II. Endocrinologic evaluation of the syndrome. N Engl J Med 276:1279–1283, 1967

57. Rabinowitz D: Some endocrine and metabolic aspects of obesity. Ann Rev Med 21:241–258, 1970

58. Rasmussen H: Parathyroid hormone, calcitonin, and the calciferols. In Williams RH (ed): Textbook of Endocrinology. Philadelphia, WB Saunders, 1974, pp 660–773

59. Rasmussen H, Bordier P, Kurokawa K, Norgata N, Ogata E: Hormonal control of skeletal and mineral homeostasis. Am J Med 56:751–758, 1974

60. Reinhold JG: Trace elements—A selective survey. Clin Chem 21:476–500, 1975

61. Salans LB, Bray GA, Cushman SW, Danforth E Jr, Glennon JA, Horton ES, Sims EAH: Glucose metabolism and the response to insulin by humans in spontaneous and experimental obesity: effects of dietary composition and adipose cell size. J Clin Invest 53:848–856, 1974

62. Salans LB, Knittle JL, Hirsch J: The role of adipose cell size and adipose tissue insulin sensitivity in the carbohydrate intolerance of human obesity. J Clin Invest 47:153–165, 1968

63. Sandstead HH: Zinc nutrition in the United States. Am J Clin Nutr 26:1251–1260, 1973

64. Sherman BM, Halmi KA, Zamudio R: LH and FSH response to gonadotropin-releasing hormone in anorexia nervosa: effect of nutritional rehabilitation. J Clin Endocrinol Metab 41:135–142, 1975

65. Sherman B, Korenman SG: Measurement of serum LH, FSH, estradiol and progesterone in disorders of the human menstrual cycle: the inadequate luteal phase. J Clin Endocrinol Metab 39:145–149, 1974

66. Sims EAH, Danforth E Jr, Horton ES, Bray GA, Glennon JA, Salans LB: Endocrine and metabolic effects of experimental obesity in man. Recent Prog Horm Res 29:457–487, 1973

67. Smith SR, Bledsoe T, Chhetri MK: Cortisol metabolism and the pituitary-adrenal axis in adults with protein-calorie malnutrition. J Clin Endocrinol Metab 40:43–52, 1975

68. Smith SR, Chhetri MK, Johanson AJ, Radfar N, Migeon CJ: The pituitary-gonadal axis in men with protein-calorie malnutrition. J Clin Endocrinol Metab 41:60–69, 1975

69. Spark RF, Arky RA, Boulter PR, Saudek CD, O'Brien JT: Renin, aldosterone, and glucagon in the natriuresis of fasting. N Engl J Med 292:1335–1340, 1975

70. Tanner JM: Sequences and tempo in the somatic changes in puberty. In Grumbach MM, Grave GD, Mayer FE (eds): Control of the Onset of Puberty. New York, John Wiley & Sons, 1974, pp 448–470

71. Travis SF, Sugarman HJ, Ruberg RL, Dudrick SS, Delivoria–Papadoulos M, Miller LD, Oski FA: Alterations of red cell glycolytic intermediates and oxygen transport as a consequence of hypophosphatemia in patients receiving intravenous hyperalimentation. N Engl J Med 285:763–768, 1971

72. Van Wyk JJ, Underwood LE, Hintz RL, Clemmons DR, Voina SJ, Weaver RP: The somatomedins: a family of insulin-like hormones under growth hormone control. Recent Prog Horm Res 30:759–818, 1974

73. Wacker WEC, Parisi AF: Magnesium metabolism. N Engl J Med 278:658–663, 1969

74. Warren MP, VandeWiele RL: Clinical and metabolic features of anorexia nervosa. Am J Obstet Gynecol 117:435–449, 1973

75. Wartofsky L: Low remission after therapy for Grave's disease. J Am Med Assoc 226:1083–1085, 1973

76. Werner SC, Ingbar SH (eds): The Thyroid. New York, Harper & Row, 1971

77. Wilson JD: Recent studies on the mechanism of action of testosterone. N Engl J Med 287:1284–1291, 1972

78. Young VR, Scrimshaw NS: The physiology of starvation. Sci Am 225:14–21, 1971

20

Gastroenterology

Keith B. Taylor

It is gratifying to observe an erosion of the dogmatism that has for decades restricted the application of sensible and scientific principles of nutrition to diseases of the gastrointestinal (GI) tract. Early writing on this topic abounds with inadequately tested precepts for the management of peptic ulcer, colitis, diverticulosis, and the like, many of which suggest more the physician's treating himself than the patient. The results are not always harmless to the latter. At best, needless dietary hardship or monotony may be imposed on patients and their immediate entourages, especially spouses. At worst, severe and specific deficiencies or intoxications may result. For example, Hawkins (5) describes a woman aged 60 who developed scurvy as a consequence of having been advised by a doctor 40 years earlier to eat no fruit or vegetables as treatment for dyspepsia. The doctor had subsequently died without rescinding his advice, so that she had been subjected to a dull and dangerous diet for her whole adult life. Another example is the milk–alkali syndrome, now fortunately rare, which is a consequence of overenthusiastic application of an effective treatment for the pain of peptic ulcer.

One very effective way of favorably influencing the general life style of a patient may be the imposition of a new set of precepts, of which diet is understandably important. Patients have familial and cultural preconceptions about food, both in relation to health and disease. They expect to have such beliefs confirmed by their medical advisors or, if contrary advice is given, they require explanations couched in terms they can grasp and which are to them intellectually satisfying. If the doctor fails to consider dietary matters the patient will seek advice elsewhere. A recent survey revealed that in the United States the public puts doctors at the top of the list of those from whom they would seek dietary advice. Health food stores were not too far behind.

It is a truism that in establishing a therapeutic regimen each component should be carefully scrutinised for adequacy and acceptability as well as for potential value and undesirable side effects; this applies as much to nutritional and dietary factors as any other.

Certain milestones signify important improvements in the dietary approach to GI disease. Meulengracht (9) was courageous enough to challenge the rigidly applied regimen of Sippy (12) and others in the treatment of the bleeding peptic ulcer. The principle was a simple one; feed the hungry patient. No evidence has been advanced to question its validity. A controlled clinical trial by Doll *et al.* (3) and a subsequent one by Truelove (13) made it clear that diets previously accepted as aiding the healing of peptic ulcers do not possess this property to a significant degree. Currently, there appears to be a growing body of evidence that diverticular disease of the colon is better managed by the use of diets of high, nonabsorbable content and additional stool-bulk producers than by the traditional "low-residue" diets, though no formal examination of this has been reported. Whether diverticular disease of the colon can be prevented by a high dietary bran content is quite unproven; the proposition currently rests on inadequate epidemiologic evidence and requires a long-term prospective trial.

EXCLUSION DIETS

Consideration of exclusion diets would alone fill a whole volume. Many patients with irritable bowel syndromes have been committed to a lifetime of rigid and unappetising diets from which some essential nutrients have in many cases been partly or wholly excluded on the basis of medical superstition and inadequate empirical testing. This should not be interpreted as implying that all exclusion diets are unnecessary.

ENZYME DEFICIENCY STATES

Congenital absence of certain enzyme systems, such as the lactase of the intestinal brush border, may be an indication for the exclusion of a specific sugar. The classic, still almost unique instance of celiac disease or nontropical sprue provides an example of the undisputed therapeutic value of a diet from which one factor is excluded, namely wheat gliadin. The underlying mechanism of the toxic effect of gliadin on the intestinal mucosa, which Dicke (2) first established, is still uncertain. Three theories currently being examined are 1) avidity of the mucosal epithelial cell (the enterocyte) for gliadin or one of its breakdown products, 2) lack or some abnormality of a proteolytic enzyme in the enterocyte, or 3) immunologic hypersensitivity to gliadin.

GASTROINTESTINAL ALLERGIES

Hypersensitivity to other foodstuffs has been well documented ever since the observations of Prausnitz and Küstner (10) more than half a century ago. Many patients have alimentary allergic reactions as acute and severe as those of Prausnitz, and these problems may often be at least partly remedied. The nature of the particular allergen or allergens to which the patient is sensitive may be an important determinant of success. Caviar is more easily avoided, at least in Western cultures, than soybean protein or spray-dried skim milk, which seem sometimes to be ubiquitous. Heiner (6) has recently estimated that 0.3%–0.7% of infants are hypersensitive to cow's milk protein. This may express itself in a failure to thrive, a fretful, flatulent child, or in extreme cases, in a hemorrhagic colitis with secondary iron-deficient anemia.

The suspected but less severe and less acute GI and alimentary allergies create greater therapeutic problems. Patients in this group may present in the clinic seriously underweight and overanxious, sometimes displaying symptoms and signs of specific nutritional deficiency. They may, by a reductive process, have adopted a diet of overcooked lamb and rice or something similar. They are often desperate but initially impervious to rational management. Enquiry elicits the fact that their original symptoms may have been only a transient bout of nausea or of diarrhea, sometimes associated, although this was not initially recognised, with some medication, often an oral antibiotic for intercurrent infection. Many subjects believe themselves, for the above or other reasons, to be allergic to some foods. To prove an allergy is almost always difficult and often impossible. It is likely that informative tests that are more permissible in this hepatitis-ridden age than the original Prausnitz–Küstner test, which requires transfer of human serum, may shortly become available. The addition of suspected allergens to amino-acid diets, which are to a large extent allergen-free, for testing on a double-blind basis has in our hands proved disappointing since these diets are unappetising and are so poorly tolerated that most test subjects fail to stay on them the required 10–14 days.

Earlier claims by Rowe and others that inflammatory bowel diseases, such as nonspecific ulcerative colitis, were an expression of a chronic dietary allergy have never been fully substantiated, although Wright and Truelove (14) found that a cow's milk exclusion diet appeared to result in a significantly reduced relapse rate in about one-sixth of a group of patients with ulcerative colitis. In the treatment of patients with nonspecific ulcerative colitis our policy has been to advise the exclusion of milk and milk products initially only to those who give a history of intolerance to milk at any time from infancy on and subsequently to the few who fail to respond promptly to conventional modes of medical therapy before considering surgery.

In managing alimentary allergies the doctor must take a thorough, probing history. He should never express scepticism but should rather attempt to gain the patient's confidence and then design a dietary regimen of addition of foodstuffs one by one. The help of the dietitian is valuable here.

Two principles should be kept in mind. As far as it is consonant with achieving and maintaining satisfactory nutrition, the aim should be to devise an attractive dietary. Eating is one of life's pleasures and it outlasts all the others, as Brillat-Savarin noted in 1825 (1). Secondly, as with other therapeutic components, diet should be regularly reviewed. The value of the trained dietitian's assistance cannot be exaggerated in achieving these aims and it is regrettable that their aid is not solicited more by medical practitioners, since they possess the expertise and the opportunity to apply themselves single-mindedly to these matters (see Chs. 5,8).

GASTROINTESTINAL DISEASE

Since the digestive system is essential for the digestion and assimilation of ingested aliments

and nutrients, it is inconceivable that the processes involved should not be jeopardised when GI disease supervenes. Further, evidence is accumulating that nutritional deficiency may impair the proper functions of the GI tract, so that a vicious cycle may occur.

Nutritionists studying communities in which undernutrition is widespread emphasise the special vulnerability of certain subsets of the population, such as the weaned and preschool child, pregnant women, and—more recently—the old. Even in western industrial countries a similar emphasis obtains and could well be applied to overnutrition as well as undernutrition. For the purpose of emphasis, analogous subsets may be recognised in GI diseases:

1. Malabsorption—due to pancreatic disease, abnormal flora in the proximal small bowel, inflammatory bowel disease, including celiac sprue, regional enteritis, intestinal resection, irradiation, and ischemia
2. Chronic peptic ulcer disease
3. Immediate and long-term consequences of gastric surgery
4. GI disease in the aged

MALABSORPTION

The causes are manifold but fall conveniently into four categories: 1) pancreatic disease, 2) bacterial overgrowth in the upper small intestine, 3) disease of the intestinal wall, and 4) surgical excision of absorptive surface.

PANCREATIC DEFICIENCY

The important causes of pancreatic disease are cystic fibrosis (or mucoviscidosis) and chronic pancreatitis.

CYSTIC FIBROSIS

Cystic fibrosis is a generalized disease of all the exocrine glands which is genetically transmitted as an autosomal recessive characteristic with a gene frequency of 1:20. Mucous secretions are abnormally viscous and secretions of sweat have an abnormally high content of sodium, potassium, and chloride. The pancreas, which is involved in about 80%–90% of cases, ultimately becomes a small, fibrosed organ as a consequence of atrophy of the exocrine structures consequent on the obstruction of the ductular system by plugs of eosinophilic debris. The volume, ph, lipase, amylase, trypsin, chymotrypsin,

and carboxypeptidase contents of pancreatic secretion are much reduced, and malabsorption of fat and protein, large carbohydrates, water- and fat-soluble vitamins, and some minerals results. Until the last two decades most children affected died of the pulmonary effects of the disease, bronchiolar plugging, and obstructive emphysema resulting in bronchopulmonary infections. Significant improvements in respiratory toilet have resulted in survival into adult life of many subjects with this disease. In addition to malabsorption, subjects may also develop focal biliary cirrhosis as a consequence of intrahepatic cholangiolar plugging and pericholangitis leading to portal hypertension with its complications.

Treatment of the malabsorption consists of providing adequate oral supplements of pancreatic extracts; a high-carbohydrate, low-fat diet; all vitamins (if necessary by injection); and extra sodium chloride, particularly in hot weather (Table 20–1). Usually oral supplements of calcium and magnesium are also required, as determined by estimating blood levels. If a desirable rate of growth is not maintained, added calories may be provided by a palatable form of medium-chain triglycerides, which do not require pancreatic lipase or bile salts for their absorption, and by amino-acid supplements given with meals in the form of one or another amino-acid diet, thus by-passing the need for effective pancreatic proteolytic activity.

CHRONIC PANCREATITIS

Chronic pancreatitis, in which inflammation and scarring of the exocrine glandular tissue of the pancreas occur, has many causes, of which alcohol appears to be the most important in the United States. The lesion is functionally similar to that in fibrocystic disease. However, since it is a disease of adults, the nutritional problems may be somewhat less exacting. Usually oral supplementation with pancreatic extract (Cotazym 20 tabs daily) and vitamin supplementation are adequate. In some patients the extracts are poorly tolerated or less effective and supplements of medium-chain triglycerides and amino-acid mixtures should be given, using the patient's weight as guide.

BLIND-LOOP SYNDROMES

Bacterial overgrowth in the upper small intestine occurs usually because of anatomic changes associated with degenerative or inflammatory

TABLE 20—1. Rational Dietary and Other Treatment in Conditions Associated with Malabsorption

Disease or special circumstance	Aliments and nutrients	Comments
Pancreatic insufficiency	High protein and carbohydrate; fat to tolerance; medium-chain triglycerides; all vitamins; extra sodium chloride in hot weather $Ca^{++}Mg^{++}$	Supplementation with pancreatic extracts up to 12 g daily; amino-acid supplement in intractable cases
Blind loop syndromes	Medium-chain triglycerides; vitamin B_{12} IM	Surgical revision; oral antibiotics
Radiation enteritis	High protein; medium-chain triglycerides; oral vitamin supplements	Glucocorticoids
Crohn's disease	High protein; oral vitamin B_{12} IM if necessary; low oxalate	Glucocorticoids; avoid indigestible residues liable to cause obstruction
Short bowel	As above (Crohn's disease); add Ca^{++} and Mg^{++} if necessary	
Celiac sprue (gluten enteropathy)	Gluten-exclusion (see Table 20—2 for short-term treatment)	Long-term treatment

disease and surgical intervention, occasionally as a consequence of loss of neuromuscular activity or impairment of secretory activity. Normally the proximal segments of the small intestine have only a very small bacterial population, which so far as we know does not interfere with the absorption of nutrients. Although the absorptive capacity of the intestine is greater in gnotobiotic (germ-free) than in conventional animals, this is not necessarily applicable to man since the species studied have been coprophagous. Dilatations proximal to strictures, diverticular out-pouchings of the gut wall and surgical constructions of poorly draining cul-de-sacs, as in a Billroth II gastrectomy, may provide sites where bacteria flourish and form large colonies. The major consequences may be malabsorption of fat and of vitamin B_{12}. Steatorrhea may be accompanied by failure to absorb fat-soluble vitamins and some mineral elements, such as calcium and magnesium. The steatorrhea is currently held to be due to deconjugation of bile salts. Conjugated bile salts (glycocholate and taurocholate) are essential for the formation of micelles, which is a prerequisite of fatty-acid absorption. Vitamin B_{12} malabsorption is believed to be due to bacterial sequestration, the B_{12} bound to some microorganisms being no longer available for absorption in the ileum.

Treatment of these conditions varies according to the cause. Surgical revisions or excisions may be appropriate and curative. Where this is not feasible, oral antibiotics may be effective. Frequently this initial beneficial effect is not maintained. However, a long-term minor improvement of a degree consonant with maintenance of fair nutrition may be achieved. Medium-chain triglycerides may be used as a supplement and also to replace longer-chain dietary triglycerides since their absorption does not require bile salts and vitamin B_{12} may be given parenterally.

DISEASES OF THE INTESTINAL WALL

RADIATION ENTERITIS

The commonest disease of the wall of the small gut in present day medical practice is caused by irradiation for pelvic and retroperitoneal malignancy. Immediate changes occur in the mucosa, where cellular turnover is inhibited; the integrity of the epithelium is breached, and secondary infection and inflammation supervene. The subacute and more-chronic effects are on the vascular supply. An obliterative endarteritis may result in ischemia of the whole thickness of the bowel wall. Fibrosis and stricture may be the consequence. Radiomimetic drugs and antimetabolites, such as the folic acid antagonist methotrexate, may reproduce the acute effects of irradiation.

CROHN'S DISEASE

Crohn's disease or nonspecific regional enteritis behaves rather similarly to radiation enteritis in its effects on the intestine as regards inflammation, damage to the mucosa, and stricture formation. It has a special predilection for the terminal

ileum. Cramping pains and diarrhea are usually the main symptoms; sometimes, and especially when many segments of the small bowel are affected, malabsorption may occur.

The terminal 90 cm of the ileum play a major and essential role in the absorption of vitamin B_{12} and bile salts, both of which undergo enterohepatic recirculation. Failure to absorb both exogenous and endogenous vitamin B_{12} as a consequence of disease or resection results in a deficiency that may lead to both megaloblastic anemia and neurologic damage. In such a situation the vitamin must be provided by IM injection since oral supplementation is likely to be ineffective. Rather than subject a patient to a lifetime of regular IM injections, a preliminary test of absorption of the vitamin should be done in all but exceptional circumstances to ensure that absorption is defective.

Unabsorbed bile salts probably irritate the colon and inhibit its normal function of resorption of water, so that diarrhea may occur. No case has yet been made for supplementation with oral bile salts on the grounds that depletion leads to inadequate formation of micelles in the proximal intestine and consequent malabsorption of fat. The only means of dealing with bile salt malabsorption is to feed an exchange resin, cholestyramine, which traps the bile salts and prevents their irritating the colon.

More-widespread involvement of the small bowel results in a variable degree of malabsorption of fats, protein, and—rarely—carbohydrates. Low-fat, high-carbohydrate and protein diets (or amino-acid supplements) are used together with oral supplements of water- and fat-soluble vitamins for long-term management. Since medium-chain triglycerides are more readily absorbed, they may sometimes provide a valuable source of calories, thus sparing protein. In acute situations the parenteral route may have to be used (see Table 20–1).

SHORT-BOWEL SYNDROME

Resection of a short segment of small bowel at any level usually has no sequel of disturbed function. Providing the duodenum, distal ileum, and ileocecal valve are spared, up to 40% of the small intestine may be removed without significant sequela. More-extensive resection (50% or more, or resection of distal ileum and ileocecal valve) may result in variable malabsorption, the severity of which depends on three factors: 1) the extent of resection, 2) the site of resection,

and 3) the presence of retained diseased segments.

Ischemia, due to thrombosis or embolism, is the commonest reason for resection. Crohn's disease, trauma, and malignant infiltration are less common reasons for extensive resection. All nutrients may be malabsorbed. Early postoperative fluid loss is often heavy but usually diminishes. Thus vigorous parenteral fluid, electrolyte, carbohydrate, and protein replacement are administered initially, usually for 5–20 days, though sometimes longer. Careful monitoring of the patient on parenteral nutrition is essential. Subsequently, malabsorption of protein, fat, carbohydrate, water and fat-soluble vitamins, iron, calcium, and magnesium may persist despite some partial attempts at compensatory hypertrophy by the remaining small bowel. Frequent meals, high protein and carbohydrate and fat to tolerance, and all vitamin supplements are given. Some fat may be given as medium-chain triglyceride. If the terminal ileum has been resected, 100 μg vitamin B_{12} must be given by IM injection every 3–4 weeks. Calcium and magnesium supplements may have to be given orally. Anticholinergic drugs are often required to reduce diarrhea.

CELIAC SPRUE

Celiac sprue is considered separately from radiation enteritis and Crohn's disease, although the malabsorptive lesion may be indistinguishable in many patients, with the exception of vitamin B_{12}, because this disease affects the proximal small intestine and not the terminal ileum. Thus folic acid deficiency is far more common than vitamin B_{12} deficiency in celiac sprue.

The aim of the doctor managing celiac disease is to encourage the patient to adopt and rigidly adhere to a gluten-free diet. If this can be achieved, recovery of bowel function occurs in all but a very few subjects, and no dietary supplementation is needed. Exclusion of gluten is difficult since wheat flour is used as an extender in many processed foods. Each component of the diet should therefore be carefully evaluated by dietitian and patient, who must be aware that even traces of gluten may inhibit mucosal recovery or precipitate a relapse. The diet should be balanced and as varied as possible. In the early stages of treatment, milk and milk products may cause symptoms of bloating and diarrhea, whereas subsequently they seem to be well tolerated. This may be a consequence of lactase defi-

ciency. In the initial treatment, before response to gluten-exclusion has occurred, vigorous nutritional support may be necessary since patients may be deficient both in electrolytes—especially potassium, calcium, and magnesium—and in nutrients such as fat- and water-soluble vitamins. So far as possible, oral supplementation should be used. The daily supplements are shown in Table 20–2. Supplements of medium-chain triglycerides and high-protein intake may be used until recovery of absorption has occurred.

In recent years it has become evident that the high incidence of urinary calculi associated with small intestinal inflammatory disease and the short-bowel syndrome may be due to increased absorption of oxalate from the bowel for unknown reasons. The consequent hyperoxaluria can be prevented or minimised by use of diets with low oxalate content. Foods to be avoided are indicated in Table 20–3.

ULCERATIVE COLITIS

In nonspecific ulcerative colitis the role of any special dietary regimen is not established. In the acute phase of a severe attack, including toxic megacolon, oral feeding is suspended and effective IV nutrition must be maintained. However, if the patient can tolerate food by mouth, the diet should be designed first to stimulate the individual appetite and secondly to provide high nutritional value. Protein losses from the diseased colon can be very large. Only well-tolerated foods are given. A history of cow's milk intolerance justifies its exclusion. The intolerance may be a consequence of hypersensitivity to the protein content or of primary or secondary alactasia and lactose intolerance. My own practice is to advise milk exclusion for those patients who fail to respond favorably to what is now a proven medical regimen. Where necessary, a soy-protein substitute for cow's milk may be used. As regards supplementation with amino-acid diets, my own experience has been to avoid them. They are unappetising as well as being hyperosmolar, and since there is no evidence of significantly impaired small-intestinal proteolysis in ulcerative colitis (or any other bowel disease other than severe pancreatic deficiency) there is no rationale for their administration. High-protein intake can be designed around egg or meat protein, with some vegetable proteins included, and if as sometimes happens, normal dietary fats can be ingested in rather limited amounts, useful minor sup-

TABLE 20–2. Daily Oral Supplements in Untreated Nontropical Sprue or Before a Response is Obtained

Nutrient	Daily dosage
Potassium chloride	
Calcium gluconate	
Magnesium sulfate	
Vitamin A	25,000–50,000 units
Vitamin D	30,000 units
Vitamin K (Mephyton)	10 mg
Vitamin B complex tablets containing daily requirements of thiamin, riboflavin, and niacin	2–3 tbsp
Vitamin B$_{12}$	100 μg/3 weeks IM
Folic acid	15 mg
Vitamin C	50 mg

TABLE 20–3. Oxalic Acid in Foods

Foods containing over 0.1% oxalic acid	Foods containing 0.02%–0.1% oxalic acid
Vegetables, Herbs	*Vegetables*
Beets	Beans, green and wax
Beet greens	Carrots
Chard	Celery
Lambsquarters	Dandelion greens
Parsley	Endive
Pepper	Okra
Poke	Onions, green
Purslane	Peppers, sweet green
Spinach	Potatoes, sweet
Fruits	*Fruits*
Rhubarb	Blackberries
Nuts	Gooseberries
Almonds	Grapes, concord
Cashews	Lemon peel
Miscellaneous	Oranges
Dry cocoa	Raspberries, black
Chocolate	Strawberries
Poppy seeds	

TABLE 20–4. Dietary in Ulcerative Colitis

Degree of disorder	Aliments and nutrients
Mild or moderately severe	High protein; vitamin supplement
	Exclude cow's milk if history of intolerance or failure to respond to medical treatment
	Avoid citrus fruits and other laxative foods and beverages. Treat iron deficiency by IM route
Severe	Parenteral fluid replacement; calories and amino acids until controlled

plementation with medium-chain triglycerides in a palatable form, *e.g.,* mayonnaise, and in cooking is worth testing.

Citrus fruits and other laxative foods and beverages should be excluded during an attack and taken in remissions, if the patient feels seriously deprived, with caution and moderation. The major points of dietary in inflammatory large bowel disease are tabulated in Table 20–4.

NUTRITIONAL MANAGEMENT IN DISEASE STATES

MEDICAL MANAGEMENT OF PEPTIC ULCER

This has for decades provided almost unparalleled opportunities for the gastroenterologist and other medical practitioners to impose what are often deeply held superstitions on their patients. Particularly noteworthy are the use of white meat in so-called but quite-undefined bland diets and the proscription of spicy foods. Ingelfinger (7) has expressed views very similar to this author's, which essentially are opposed to any rigid dietary limitations by subjects with gastric or duodenal ulcer disease. Patients should be encouraged to eat whatever does not seem to be associated with unpleasant consequences. There are a few provisos. They may have to watch their weight. In the past 2–3 decades it has become clear that many subjects with chronic duodenal ulcers become obese and display a high incidence of myocardial infarction, presumably as a consequence of excessive consumption of cow's milk. That its proteins buffer acid and serve temporarily to relieve pain is clear, but its fat content fattens. There is also evidence that acid secretion may be stimulated by the protein content. This may constitute another reason against human adult consumption of cow's milk. The time of eating may be important. Late evening snacks should be discouraged since they may stimulate nocturnal acid secretion.

Factors that stimulate gastric acid secretion are usually advised against, as a consequence of the adage "no acid, no ulcer." Coffee and alcohol are those most often prohibited. For the tea-drinking teetotal patient this presents no problem, but for many the exclusion of either may constitute real hardship. Reason (there are no experimental data) suggests that a glass of wine with a meal is less of an insult to the gastric mucosa than two martinis before a meal and that the effect of the wine on acid secretion must be totally eclipsed by the effect of the meal itself.

Similarly a cup of coffee at the end of a meal is not to be equated with continuing coffee consumption between meals. There is little evidence for the long-held belief that citrus juices increase gastric acidity. Intolerance of orange juice certainly occurs (in my experience this usually presents with symptomatology suggesting peptic esophagitis), but why it occurs is at present unknown.

Any rigid exclusion of foodstuffs is bad medicine in that it ignores individual needs (and will probably be disregarded by many patients). The pain of an uncomplicated peptic ulcer is relieved by antacids and buffering foods, and its relief is a definable goal the patient can understand. But we do not at present have the knowledge to achieve healing of an ulcer, and attempting to impose irrational dietary restrictions, instead of encouraging the patient to use his own judgment and experience, is probably an expression of the frustration of ignorance.

DIET AFTER GASTRIC SURGERY

Major surgery has profound short-term catabolic effects similar to those of other forms of trauma. These effects are short-lived, but since they may often be superimposed on a preoperative period of undernutrition due to intolerance of food and the withholding of food during diagnostic work-up of the patient, which might well be termed "diagnostic starvation," the cumulative deficiencies, particularly of protein, may be quite severe. There is a good case to be made for parenteral nutritional support, therefore, in the first 5–6 postoperative days, using one of the many available amino-acid preparations now available. Feeding by mouth should commence as soon as the patient feels hungry and bowel sounds have returned.

Trauma to the lower esophagus caused during truncal vagotomy may result in some dysphagia with substernal pain in the first 10–15 postoperative days. The patient should be encouraged to eat despite this, using a soft diet.

The long-term consequences of gastric surgery are more important. Some derangement of GI function almost always ensues. Weight loss is a common sequel. After total gastrectomy it is invariable (Everson (4)). It occurs in 5%–42% of patients undergoing a Billroth I procedure (according to different series) and more often after Billroth II and similar procedures. The major cause is diminished food intake. Loss or reduction of appetite is due to an early sensation of fullness on eating and to dumping, a term

coined by Mix 50 years ago to describe the nausea, abdominal bloating, cramping pains, and diarrhea, together with vasomotor disturbances such as palpitations, sweating, weakness, drowsiness, and dyspnea, which may follow 5–90 min after eating. The syndrome occurs in approximately 20% of subjects after partial gastrectomy (Table 20–5).

A later phenomenon is reactive hypoglycemia, which is equally unpleasant to the patient. Johnson *et al.* (8) showed that average caloric intake in underweight, postgastrectomy subjects was 25% less than the calculated requirements to maintain normal weight. Successful persuasion to eat sufficient food resulted in satisfactory weight gain. However, some careful dietary planning may be necessary. Patients should be encouraged, like horses, to take fluids before instead of with food, to eat rather dry foods, to eat smaller, more frequent meals, to avoid diets containing small-molecule carbohydrates, such as sucrose and glucose, and to take fat to tolerance levels. Judicious use of a preprandial anticholinergic may reduce symptoms.

Malabsorption may be a late manifestation after gastric surgery and is marked by steatorrhea, the cause of which is unclear but which may be an expression of incoordinated gastric and gall bladder emptying and pancreatic secretion. Bacterial proliferation may also occur in the upper small intestine, causing deconjugation of bile salts, failure of formation of micelles, and malabsorption of fat. Pancreatic supplements are sometimes effective as are, occasionally, oral broad spectrum antibiotics, but the first approach is dietary, using frequent appetising feeds, supplementation with vitamins and with medium-chain triglycerides if necessary.

Malabsorption of dietary organic iron occurs in about one-third of subjects following partial gastrectomy, and oral or parenteral iron supplements should be used in such patients. Vitamin B_{12} deficiency is much less common but does occur in 6%–12% of partial gastrectomy patients, owing to a deficiency of gastric intrinsic factor; folic acid deficiency occurs in 1%. Serum levels of these vitamins should be measured, and if found to be low, appropriate supplementation should be given, the IM route being used for vitamin B_{12}.

GI DISEASE IN THE AGED

Gastrointestinal diseases and symptoms increase with age. In patients over 70 years carcinoma of stomach or large bowel, peptic ulcer, and intestinal obstruction due to hernias and colonic diverticular disease constitute the major part of the 20% of all deaths attributable to GI disease. Such disorders in the older patient require the same modalities of management, including attempts to maintain calorie and nitrogen balance, as in younger patients. More important as special problems of the elderly are: 1) anorexia, 2) nausea and vomiting associated with extraintestinal diseases and their treatment, 3) diarrhea, with or without fecal incontinence, and 4) constipation.

The National Nutrition Survey directed by Schaefer during 1968–1970 revealed that in low-income areas children, adolescents, and those over 60 displayed most evidence of nutritional deficiency (11).

Loneliness, lack of motive, and loss of gustatory sensation are major factors in development of malnutrition in the old. When disease of the GI tract supervenes, as a consequence of direct involvement or of the secondary effects of extraintestinal disease, such as heart failure, or of the effects of drugs, such as digitalis, latent malnutrition may be compounded and overt changes appear. Older patients should always be monitored very carefully, special attention being paid to their nutrition. Food should be attractively prepared, supplemented with high-protein preparations and the subject encouraged to eat communally, rather than alone. Dentition should be checked and corrected if necessary.

A full treatment of the problems of diarrhea and constipation in the aged is outside the range of this text. The former may be due to fecal impaction, and this can be discouraged, as can constipation without pseudodiarrhea, by adding bran to the diet. However stool-softeners and laxatives may also be required. It cannot be emphasised enough that underlying organic causes must first be sought.

TABLE 20–5. Incidence of Dumping

Operation	Moderate symptoms (% of patients)	Severe symptoms (% of patients)
Billroth II	20	3.0
Vagotomy and gastrojejunostomy	19	2.0
Vagotomy and pyloroplasty	10	0.5

DIET IN DISEASE OF THE LIVER

In the patient with established cirrhosis from whatever cause, a nutritious diet has proven useful in improving the patient's subjective outlook and also the function and—possibly—the histology of the liver.

When liver failure is not present, a diet that contains 2500 cal including 80–100 g protein is commonly recommended. No restriction of fat is necessary. Supplements of all the water-soluble vitamins should be given, using a standard vitamin B complex preparation and adding 50 mg ascorbic acid and 5–10 mg folic acid daily.

When ascites is present, the above diet must be modified to restrict daily sodium intake to less than about 20 mEq, preferably less than 10 mEq, since the kidneys may excrete less than 10 mEq/day. Since most animal proteins contain sodium, a sodium-free protein supplement and salt-free bread and butter are used. No salt should be added in cooking. Tables of salt content of foods should always be consulted.

The treatment of hepatic precoma and coma is first to exclude all dietary protein and to provide about 1600 cal daily using glucose (40%) by drip into the innominate vein or vena cava. When the patient is recovering and taking food by mouth, protein may be reintroduced at the rate of 20g/day, divided between four meals, for 2 days. An increment of 20g is then added every other day, aiming for a daily protein intake of 80–100 g. Following recovery from acute hepatic failure this is often attained, but in chronic hepatic failure it may be necessary to restrict the daily protein intake to below 60 g (sometimes below 40 g) in order to prevent disturbance of consciousness.

REFERENCES

1. Brillat–Savarin J-A: The physiology of taste. Paris, 1825
2. Dicke WK: Therapy of celiac disease. Ned Tijdschr Geneesk 95:124, 1951
3. Doll R, Friedlander P, Pygott F: Dietetic treatment of peptic ulcer. Lancet 1:5, 1956
4. Everson TC: Nutrition following total gastrectomy, with particular reference to fat and protein assimilation (abstr). Int Surg 95:209, 1952
5. Hawkins C: Personal view. Br Med J 4:362, 1970
6. Heiner DC, Wilson JF, Lahey ME: Sensitivity to cow's milk. JAMA 189:563, 1964
7. Ingelfinger FJ, Relman AS, Finland M (eds): Controversy in Internal Medicine. Philadelphia, WB Saunders, 1966
8. Johnson IDA, Welbourn RD, Acheson K: Gastrectomy and loss of weight. Lancet 1:1242, 1958
9. Meulengracht E: Treatment of hematemesis and melena with food. Acta Med Scand [Suppl] 59:375, 1934
10. Prausnitz C, Küstner H: Studier über die Ueberemphindlichkeit. Zentralbl Bakteriol [Orig] 86:160, 1921
11. Schaefer AE: National nutrition survey, 1968–1970. DHEW Pub. no. (HSM) 72–8130–34
12. Sippy BW: Gastric and duodenal ulcer: medical care by an efficient removal of gastric juice corrosion. JAMA 64:1625, 1915
13. Truelove SC: Stilbestrol, phenobarbitone and diet in chronic duodenal ulcer. Br Med J 2:559, 1960
14. Wright R, Truelove SC: A controlled therapeutic trial of various diets in ulcerative colitis. Br Med J 2:138, 1965

21 Immunology

W. Page Faulk, Joseph J. Vitale

PART 1. THEORETIC CONSIDERATIONS

W. Page Faulk

One of the most important functions of the immune system is to protect from infectious diseases. This point is demonstrated by the increased incidence of infections in patients with immunodeficiency diseases (9). The fact that persons suffering malnutrition also sustain many infections suggests that a type of immunodeficiency may result from suboptimal nutrition. This concept has recently received considerable attention (2), and studies of the immune response have begun to piece together a preliminary picture of immunologic function in malnutrition (14). These investigations will be briefly reviewed in the following paragraphs, with an effort to relate laboratory and field studies to the realities of clinical nutrition. Insofar as it is possible, comments will be limited to studies on human populations.

HISTOPATHOLOGY

The skin and mucous membranes are normally effective barriers to the penetration of microbiologic agents, but resistance to penetration is lowered during malnutrition. In malnutrition the skin is thinned, and mucous membrane microvilli are flattened; connective tissues are sparse, skin collagen is diminished (50), and fibroblastic proliferation is decreased (4). Histologic studies of the immune system show several characteristic features. The thymus is markedly involuted and assumes an embryonal appearance (2, 15, 52); lymph nodes and spleen are depleted of lymphocytes, especially in their thymic-dependent areas (15, 47); gut-associated lymphoid tissues, *e.g.,* Peyer's patches, are atrophic (40); and bone marrow is hypocellular with little evidence of hematopoiesis (27). These reports put forward morphologic evidence for impaired host resistance during malnutrition.

SECRETORY SYSTEM

One of the first immunologic defenses that a microorganism would encounter while attempting to penetrate a mucous membrane, whether in the eye, sinopulmonary complex, GI system, or GU tract, would be that of secretory immunoglobulin-A (S-IgA). This component of the immune system is responsible for surface immunity of mucous membranes. It is composed of two molecules of IgA coupled together by a joining or "J" chain and one molecule of secretory-piece (51). Secretory-piece and IgA are made by different cells, and S-IgA is capable of being secreted onto the surface of mucous membranes by virtue of its association with secretory-piece (48). Through classic immunologic mechanisms, *e.g.,* virus neutralization (36), S-IgA protects mucous membranes, and those persons who lack S-IgA tend to have repeated infections and allergies of the lungs and gut (49). There is not a great deal of quantitative information about S-IgA in malnutrition, but several studies reported at the Second International Congress of Immunology (7) suggest that S-IgA is depressed in conditions of suboptimal nutrition. This is consistent with clinical and epidemiologic observations that malnourished children have repeated pulmonary and GI infections (29).

PHAGOCYTOSIS

If a microorganism were able to penetrate the skin or mucous membranes and avoid recogni-

tion by S-IgA, it would still have to reckon with phagocytic cells such as macrophages and neutrophils. Phagocytes generally recognise invading organisms in the following way. An organism is marked for phagocytosis by serum factors such as opsonins and complement; receptors on cell membranes of phagocytes receive the sensitized organism, and it is endocytosed into a phagosome; the phagosome fuses with a lysosome to form a phagolysosome into which are poured proteolytic enzymes, resulting in death and degradation of the organism (11). It should be emphasized that this is not the only mechanism available to phagocytic cells. Also, it doesn't necessarily follow that an organism is doomed on being taken into the interior of a phagocytic cell; for instance, intracellular bacteria are characteristic of both leprosy and tuberculosis. However, the general scheme is correct, and it illustrates the interdependence of the several steps that lead to phagolysosome formation and the subsequent enzymatic degradation of microbes.

The increased number and severity of infections in malnutrition suggest that phagocytosis may be defective, and studies have been done to measure the three principal events in the phagocytosis and killing of bacteria: 1) normal functioning of biochemical–enzymic processes 2) uptake of bacteria, and 3) killing of phagocytosed bacteria. For review, see reference 11a. Very briefly, some of the biochemical systems of macrophages from malnourished persons have been shown to be defective (43), but the exact relationship of these deficiencies to inadequate phagocytosis and killing remains to be established. The uptake of sensitized bacteria by phagocytes from malnourished patients has been reported as being both depressed (44) and normal (45). If uptake is depressed, it is likely to be secondary to a biochemical defect because it is difficult to imagine that malnourished cells would have less receptors. Most investigators have found a decreased killing of phagocytosed bacteria by malnourished macrophages which is reversed following nutritional therapy. Kinetic studies have recently shown that the decreased killing is in fact a delayed killing, and that the malnourished cells will kill as many bacteria as control cells if the reaction is allowed a longer incubation period (12). Finally, it is important to appreciate that factors other than protein–calorie malnutrition can have an effect on the killing of phagocytosed bacteria. For instance, the killing defect reported in one study was corrected by giving iron (1), suggesting that iron-depend-

ent enzyme systems, such as myeloperoxidases, may be affected in the complex syndrome of human malnutrition.

HUMORAL IMMUNITY

If a microorganism were able to penetrate the skin or mucous membranes, avoid S-IgA, and escape being phagocytosed, it would still have to reckon with the heterogeneous system of humoral immunity found in plasma, lymph, and body fluids. The humoral factors responsible for this immunity are primarily immunoglobulins (Ig). The five known Ig classes are referred to as IgG, IgM, IgA, IgE, and IgD. Each class is defined by chemical, physical, biologic, and antigenic criteria, and some of the classes are divided into subclasses (35). All antibodies are of course Ig, but all Ig do not show antibody activity, although it is generally agreed that this is theoretically possible. It is relatively easy to measure Ig using quantitative precipitation techniques, but the accuracy of this procedure depends on the use of characterized or standardized antisera. There have been many studies of Ig in malnutrition (for reviews, see 11a, 15, 15a, and 17), and the results indicate that serum Ig levels are generally not depressed, even when the tests have been done on blood from patients with very low globulin and serum albumin values. Sometimes the serum Ig values are elevated; this is especially true for IgA (30). There is no clear reason why Ig synthesis should be spared the effects of malnutrition, but it has been suggested that this may be due to a continued or increased antigenic stimulation secondary to infection. This suggestion seems unlikely because even intense antigenic stimulation affects only a small number of cells. A more-general stimulus, such as a hormonal effect, would seem to be a more-likely cause, but for the moment the reason for normal or elevated Ig values in malnutrition is unknown.

It has been known for many years that plasma cells produce Ig, but it has only recently been appreciated that plasma cells are fully differentiated cells with a very short halflife and that Ig are produced by a bone marrow–derived population of lymphocytes popularly known as B cells (historically the B signified "bursa," a lymphoid structure in the bowel of birds, but it is currently conveniently translated as "bone" marrow). The B cells can be identified and quantified by several relatively simple techniques. Normal B cells manufacture only one class, subclass, or genetic type (allo-

type) of Ig (20), and one of the most reliable tests for these cells is membrane immunofluorescence with fluoresceinated anti-Ig sera (16). Flurochrome or isotopically labeled materials may also be used to identify and quantify B cells by virtue of their membrane receptors for antigen, immune complexes, and aggregated gamma globulins. Several rosetting techniques are also available for the identification and quantitation of B cells (26). The methods rely on the fact that B cells have membrane receptors for the Fc portion of IgG and for the C3 component of complement. Antibody-coated or antibody-and-complement-coated erythrocytes are thus used to form rosettes with B-cell Fc or C3 receptors, respectively. In this manner the total number of B cells in a sample of blood can be measured, and when these measurements are used in malnutrition the number of B cells has been found to be normal (3). Again, there is no explanation why B-cell production should be spared in malnutrition, but the results are clearly consistent with the quantitative precipitation experiments for serum Ig mentioned in the previous paragraph.

There have been a vast number of studies of antibody responses following immunization in malnutrition (for reviews, see 2, 11a, 15, 15a, 17, and 41). Many of these investigations are unfortunately of little value because the antigen was not standardized, the type of adjuvant was not specified, the method of antibody titration was inadequate, or no information was provided as to whether or not primary or secondary responses were being studied. These criticisms are not entered to damn earlier studies, but to encourage more careful technique and documentation in future investigations. The general message that has emerged from studies thus far indicates that one might expect either a decreased or a relatively normal antibody response and that the response seems to depend on both the type and physical state of the antigen. For instance, live vaccines such as measles or polio seem to produce adequate antibody responses, but some bacterial toxoids fail to produce measurable antibody titres. The fact that some vaccines fail and others succeed is compatible with current immunologic concepts. Some antigens are primarily dependent on B cells for antibody production, and other antigens require another lymphocyte population (*i.e.,* T cells, to be discussed later) to cooperate with B cells to generate antibody production. We have seen that B cells and B-cell products are often normal in malnutrition, so one might expect that those vaccines that are primarily B-cell dependent would produce adequate antibody responses in undernourished patients. However, the response might be inadequate if the vaccine is dependent on a depleted population of lymphocytes. This question still requires research into the problem of what vaccines depend on what populations of lymphocytes.

Some of the biologic effects of antibodies are amplified by blood complement. For example, antibody-sensitized erythrocytes are lysed by the addition of complement (38), and the cell walls of some opsonized bacteria are damaged when exposed to complement (34). Complement basically consists of nine interdependent components (C1–C9) that react sequentially in a cascade type of system reminiscent of blood clotting. The system can be physiologically activated by antibody at C1, or the early reacting steps (C1,C4,C2) can be by-passed and the sequence entered at C3 through the mediation of a C3-proactivator (33). Normal host defenses require complement, and persons with various forms of immunodeficiency who lack certain complement components tend to have repeated infections. There are very few studies of blood complement in malnutrition, but one careful study has shown that most complement components are depressed (46). It is tempting to think that low blood complement values are part of the syndrome of nutritionally induced immunodeficiency, but confirmatory studies in other genetic groups with other types of infections are needed.

Humoral immunity is strictly Ig, antibodies, and complement, but there are other humoral factors that influence immunity and resistance. These are generally grouped as nonspecific factors of resistance, including C-reactive protein, lysozyme, β-lysins, and hormones (6). There is very little information about nonspecific factors in malnutrition, but some attention has focused on the transferrins. These are iron-binding proteins that reportedly bear a bad prognosis if depressed (31). It is not altogether clear why depressed serum transferrin values should herald a poor prognosis, but this may be related to their iron-binding capacity. Iron is important in the killing of endocytosed bacteria by phagocytes (1), and certain bacteria require iron to manifest their pathogenicity (23). Studies of the general role of iron and transferrins in host resistance are needed, and it would seem to be particularly useful to know more about transferrins in malnutrition.

CELL-MEDIATED IMMUNITY

It is difficult to define cell-mediated immunity (CMI). Coombs (8) has classified immunopathologic reactions into four types: type I includes tissue-sensitizing antibodies, type II involves cytotoxic reactions of antibody and complement, type III includes immune-complex diseases, and type IV involves tissue damage by antigen-activated lymphocytes in the absence of antibodies and complement.

The classic example of a type IV reaction is skin testing for delayed hypersensitivity, for instance with purified protein derivative (PPD) following *Bacille* Calmette–Guérin (BCG) immunization. Immunodeficiency patients with antibody (*i.e.,* B cell) deficiency syndromes are unable to mount an antibody response (*e.g.,* lack type II reactions) but maintain their capacity to mount a type IV reaction. Similarly, immunodeficient patients with deficient CMI are often able to mount type II reactions but fail to give type IV reactions (9). The cells responsible for type IV reactions are generated in the thymus, circulate in the blood and lymph as small lymphocytes, and are identified in the paracortical areas of peripheral lymphatic tissues. These lymphocytes are popularly known as T (for "thymus") cells. Reactions dependent on T cells might be expected to be depressed in malnutrition because (as reported in the section, Histopathology) the thymus is involuted and thymic-dependent areas of lymph nodes and spleen are depleted of lymphocytes. Many excellent studies of delayed hypersensitivity reactions in malnutrition have been done (for reviews, see 2, 11a, 15, 15a, and 17), and the results confirm and extend the expected results: delayed hypersensitivity reactions are significantly depressed in malnourished subjects tested with several antigens (28, 13), and depressed reactions revert to normal following dietary therapy. These results suggest a reexamination of BCG vaccination campaigns, especially in areas of endemic malnutrition. One normally considers a positive delayed hypersensitivity reaction with PPD following BCG as indicative of reasonable protection from tuberculosis. However, the results of skin tests in malnourished populations suggest that the anticipated degree of protection is not being conferred. This interpretation is compatible with the observation that tuberculosis is relatively common in malnourished people.

Since T cells are characteristic of CMI, it is important to know more about these cells. In mice, T cells are distinguished by characteristic membrane markers, and human T cells are identified by several rosetting and mitogenic tests. Human T cells form spontaneous rosettes with sheep erythrocytes which do not require antibody or complement, as do the B-cell rosettes mentioned earlier. This test simply provides information about the number of T cells. It measures neither the capacity of T cells to respond to an environmental stimulus nor T-cell function. Diminished numbers of T-cell rosettes have been reported both in chronic infections (12a, 24) and in certain immunodeficiency states (9). The capacity of T cells to respond to an environmental stimulus can be measured with a nonspecific T-cell mitogen, *e.g.,* phytohemagglutinin (PHA), or with specific antigens. In either case a proliferative response is generated, and the number of cells responding can be measured either by counting cells in metaphase or by pulsing the culture with a labeled DNA precursor such as tritiated thymidine. Antigen, of course, stimulates only a small clone of committed T cells, but the proportion of cells responding to PHA should be roughly the same as the proportion of cells forming spontaneous rosettes. Furthermore, the sum of the percentage of T-cell rosettes in a normal blood sample plus the percentage of B-cell rosettes in the same sample should equal about 100%. Normally this is about 70% T cells and 30% B cells, but this type of genrality is an over-simplification.

One aspect of T-cell function can be measured by the capacity of stimulated cells to release a soluble factor that inhibits the outward migration of macrophages from a capillary reservoir. This soluble factor, popularly known as macrophage-inhibitory-factor (MIF) is only one of a heterogeneous group of substances released from activated T cells which are known as lymphokinins (10). It might be borne in mind that most of these assays are specific for T cells only within the context of the test-system employed. For example, cells other than T cells will form spontaneous rosettes with sheep cells (37), many cells have PHA receptors and some of these will actually incorporate tritiated thymidine when stimulated with PHA (18), and MIF is found in several types of cells (5). Nevertheless, tests for T-cell numbers, T-cell responses, and T-cell function are reliable and accurate tools if carefully used and controlled, and they have produced very useful information about the immunobiology of malnutrition in humans.

As discussed above, some evidence for depressed CMI in malnutrition comes from studies showing deficient delayed hypersensitivity (type

IV) reactions. Several investigators have also measured the number of T cells by spontaneous rosette-forming cells in the peripheral blood of malnourished children (19,3). In those studies where T-cell and B-cell rosettes were measured simultaneously, the usual observation has been a normal percentage of B-cell rosettes and a diminished number of T-cell rosettes (3). The T-cell responses to several antigens and mitogens such as PHA have also been measured, and most investigators have reported a decreased response (7, 21,25,42,47). However, one study (32) has reported that a factor responsible for diminished PHA responses in malnutrition is found in plasma. This brings up the basic question as to why T-cell responses are depressed in malnutrition. One might assume that the diminished response is due to a direct effect of undernutrition on T cells, but depressed responses can also be caused by plasma factors. Another reason for diminished T-cell responses may be related to elevated plasma cortisol levels during malnutrition (39) or to endotoxemia secondary to bacterial infections. Finally, it is possible that diminished T-cell function in malnutrition allows the activation of latent viruses, and that these viruses further surpress T cells. The problem of depressed T-cell responses in malnutrition needs a good deal more research, especially regarding whether or not the effect is primary or secondary. Whatever the cause, it seems as though T-cell responses are decreased during malnutrition, and this defect clinically manifests itself by increased infections, particularly infections such as measles and tuberculosis, which rely on adequate T-cell responses.

THE FUTURE

This brief review of nutritional-immunologic interactions has dealt primarily with the obvious common denominator of infectious diseases. This is of theroetic and practical importance to public health. There are, however, other aspects that were not considered, e.g., the impact of nutritionally induced immunodeficiency on immunosurveillance and the development of malignancies, the effect of intrauterine malnutrition on the ontogenesis of the immune system, and long-term effects on the immune system of nutritional deprivation early in life. Nutritional–immunologic technology has evolved sufficient sophistication to tackle some of these problems both in the laboratory and in the field, and it is exciting to notice that national and multinational bodies, such as the

World Health Organization (2, 15a), are encouraging and generating research in this area. The concept of nutritionally induced immunodeficiency is not new (22), but it is only recently that this idea has been translated into cellular and molecular immunologic mechanisms. If these events can now be interpreted by the expanding field of immunotherapy, there will emerge new and promising approaches to therapy. Standard nutritional therapy should, however, be used until there is a clearer path to these anticipated advances.

REFERENCES

1. Arbeter A, Echeverri L, Franco D et al.: Nutrition and infection. Fed Proc 30: 1421–1428, 1971
2. Awdeh ZL, Bengoa J, Demaeyer EM et al.: A survey of nutritional-immunological interactions. Bull WHO 46:537–546, 1972
3. Bang F: Personal communication, 1974
4. Bhuyan UN, Deo MG, Ramalingaswami V et al.: Fibroplasia in experimental protein deficiency: A study of fibroblastic growth and of collagen formation and resorption in the rat. J Pathol 108: 191–197, 1972
5. Bloom B: Personal communication, 1974
6. Braun W, Ungar J: 'Non-specific' Factors Influencing Host Resistance. Basel, S Karger, 1973
7. Chandra RK: Interactions of infection and malnutrition. Prog Immunol II (4): 355–358, 1974
8. Coombs RRA: Immunopathology. Br Med J 1: 597–602, 1968
9. Cooper MD, Faulk W, Fudenberg HH et al.: Classification of primary immunodeficiency. N Engl J Med 288: 966–967, 1973
10. David JR, David RA: Cellular hypersensitivity and immunity. Inhibition of macrophage migration and the leukocyte mediators. Prog Allergy 16: 300–449, 1972
11. De Duve C, Trouet A: Lysosomes and lysosomotropic drugs in host-parasite relationship. In Braun W, Ungar J (eds): 'Non-specific' Factors Influencing Host Resistance. Basel, S Karger, pp. 153–170, 1973
11a. Douglas SD, Faulk WP: Immunological aspects of protein–calorie malnutrition. In Thomsom RA (ed): Advances in Clinical Immunology. London, Churchill-Livingstone, 1977 (in press)
12. Douglas SD, Schopfer K: Phagocyte function in protein-calorie malnutrition. Clin Exp Immunol 17: 121–128, 1974
12a. Dwyer JM, Bullock WE, Fields JP: Disturbance of the blood T:B lymphocyte ratio in lepromatous leprosy. N Engl J Med 288: 1036–1039, 1973
13. Edelman R, Suskind R, Olson RE et al.: Mechanism of defective delayed cutaneous hypersensitivity in children with protein-calorie malnutrition. Lancet 1: 506–509, 1973
14. Faulk WP: Nutrition and immunity. Nature 250: 283–284, 1974
15. Faulk WP, Chandra RK: Nutrition and resistance. In CRC Handbook of Nutrition and Food. Cleveland, CRC Press, 1977 (in press)

15a. Faulk WP, Demaeyer EM, Davies AJS: Some effects of malnutrition on the immune response in man. Am J Clin Nutr 27: 638–646, 1974

16. Faulk WP, Hijmans W: Recent developments in immunofluorescence. Prog Allergy 16: 9–39, 1972

17. Faulk WP, Mata LJ, Edsall G: Effects of malnutrition on the immune response in humans: a review. Trop Dis Bull 72: 89–103, 1975

18. Faulk WP, Temple A: Fibroblast immunobiology. In Talwar GP (ed): Regulation and Growth of Differentiated Function in Eukaryote Cells. New York, Raven Press, 1975

19. Ferguson AC, Lawlor GJ Jr, Neumann CG et al.: Decreased rosette-forming lymphocytes in malnutrition and intrauterine growth retardation. J Pediatr 85: 717–723, 1974

20. Fröland SS, Natvig JB: Class, subclass, and allelic exclusion of membrane-bound Ig of human B lymphocytes. J Exp Med 136: 409–414, 1972

21. Geefhuysen J, Rosen EU, Katz J et al.: Impaired cellular immunity in kwashiorkor with improvement after therapy. Br Med J 4: 527–529, 1971

22. Gell PGH: Discussion on nutrition and resistance to infection. Proc R Soc Med 41: 323–324, 1948

23. Glynn AA: Bacterial factors inhibiting host defense mechanisms. In Smith H, Pearce JH (eds): Microbial Pathogenicity in Man and Animals. Cambridge University Press (Society for General Microbiology), 1972

24. Good RA: Personal communication, 1974

25. Grace HJ, Armstrong D, Smythe PM: Reduced lymphocyte transformation in protein-calorie malnutrition. South Afr Med J 46: 402–403, 1972

26. Greaves MF, Owen JJT, Raff MC: T and B lymphocytes. Amsterdam, Excerpta Medica, 1973

27. Guggenheim K, Buechler E: The effect of quantitative and qualitative protein deficiency on blood regeneration. I. White blood cells. Blood 4: 958–963, 1949

28. Harland PSE: Tuberculin reactions in malnourished children. Lancet 2: 719–721, 1965

29. Hodges RE: Nutrition in relation to infection. Med Clin North Am 48: 1153–1167, 1964

30. Mata LJ, Faulk WP: The immune response of malnourished subjects with special reference to measles. Arch Latinoamer Nutr 23: 345–362, 1973

31. McFarlane H, Reddy S, Adcock KJ et al.: Immunity, transferrin, and survival in kwashiorkor. Br Med J 4: 268–270, 1970

32. Moore DL, Heyworth B, Brown J: PHA-induced lymphocyte transformations in leucocyte cultures from malarious, malnourished and control Gambian children. Clin Exp Immunol 17: 647–656, 1974

33. Muller–Eberhard HJ, Grötze O, Kolb WP: Activation and function of the alternate complement pathway. Adv Biosciences 12: 251–262, 1973

34. Muschel LH: Immune bactericidal and bacteriolytic reactions. In Wolstenholme GEW, Knight J (eds): Complement. London, J&A Churchill, 1965, pp 155–174

35. Natvig JB, Kunkel HG: Human immunoglobulins: classes, subclasses, genetic variants, and idiotypes. Adv Immunol 16: 1–59, 1973

36. Ogra PL, Karzon DT: Formation and function of poliovirus antibody in different tissues. Prog Med Virol 13: 156–193, 1971

37. Papamichail M, Gutierrez C, Temple A et al.: Spontaneous rosette formation by mouse L-cells. Immunol 30: 129–134, 1976

38. Perucca PJ, Faulk W P, Fudenberg HH: Passive immune lysis with chromic chloride-treated erythrocytes. J Immunol 102: 812–820, 1969

39. Rao KSS, Srikantia SG, Gopalan L: Plasma cortisol levels in protein-calorie malnutrition. Arch Dis Child 43: 365–367, 1968

40. Schonland M: Depression of immunity in protein-calorie malnutrition: a post-mortem study. J Trop Pediatr 18: 217–224, 1972

41. Scrimshaw NS, Taylor CE, Gordon JE: Interactions of nutrition and infection. (Monograph 57) Geneva, WHO 1968

42. Sellmeyer E, Bhettay E, Truswell AS et al: Lymphocyte transformations in malnourished children. Arch Dis Child 47: 429–435, 1972

43. Selvaraj RJ, Bhat KS: Phagocytosis and leucocyte enzymes in protein-calorie malnutrition. Biochem J 127: 255–259, 1972

44. Selvaraj RJ, Bhat KS: Metabolic and bactericidal activities of leukocytes in protein-calorie malnutrition. Am J Clin Nutr 25: 166–174, 1972

45. Seth V, Chandra RK: Opsomic activity, phagocytosis, and bactericidal capacity of polymorphs in undernutrition. Arch Dis Child 47: 282–284, 1972

46. Sirishinha S, Suskind R, Edelman R et al.: Complement and C3-proactivator levels in children with protein-calorie malnutrition and effect of dietary treatment. Lancet 1: 1016–1020, 1973

47. Smythe PM, Schonland M, Brereton–Stiles GG et al.: Thymolymphatic deficiency and depression of cell mediated immunity in protein-calorie malnutrition. Lancet 2: 939–943, 1971

48. Tomasi TB: Secretory immunoglobulins. N Engl J Med 287: 500–506, 1972

49. Tomasi TB, Grey HM: Structure and function of immunoglobulin A. Prog Allergy 16: 81–213, 1972

50. Vasantha L, Srikantia SG, Gopalan C: Biochemical changes in the skin in kwashiorkor. Am J Clin Nutr 23: 78–82, 1970

51. Walker WA, Hong R: Immunology of the gastrointestinal tract. J Pediatr 83: 517–530, 1973

52. Watts T: Thymus weights in malnourished children. J Trop Pediatr 15: 155–158, 1969

PART 2. CLINICAL CONSIDERATIONS

Joseph J. Vitale

THERAPY AND NUTRITIONAL SUPPORT

The phenomena of human immunology have biochemical-nutritional parameters, as Part 1 of this chapter has set forth. Here we will be concerned more directly with those considerations that are capable of formulation in terms of therapy and nutritional support in the human patient, especially in the hospital setting.

IATROGENIC MALNUTRITION

In a recent article by Butterworth and Blackburn (1), the problem of iatrogenic malnutrition in the hospitalized patient is viewed as a very serious problem. It is not certain whether hospital-induced malnutrition has always been with us and is just now being recognized by newly nutrition-conscious physicians, or whether this problem is an unexpected by-product of the sophisticated food service systems now popular in institutions. Regardless of etiology, malnutrition in the community at large and in the hospitalized patient is becoming a recognizably prevalent health problem with serious professional and legal implications. Thus, it behooves the practicing physician not only to recognize nutritional deficiencies even in their mildest forms, but also to recognize and understand that infectious diseases and other illnesses may precipitate nutritional deficiencies.

INFECTION

Part 1 of this chapter has discussed the effects of nutritional deficiencies on various components of the immune system. Equally important, however, is the observation that most infectious processes stress many components of the immunologic apparatus and will, as well, result in the sequestering and increased utilization and excretion of essential nutrients. Thus, a vicious cycle is established whereby malnutrition may diminish immunologic response, with consequent deepening of the nutrient losses (see Ch. 22).

TRAUMA

Surgery or trauma may also cause increased excretion or catabolism and sequestration of essential nutrients. When such conditions exist, the need for nutritional support becomes obvious. For example, it has been shown that when serum albumin levels fall below 3% g (normal levels are greater than 3.5% g), the patient becomes anergic, and thus becomes more susceptible to the multiplicity of microorganisms to be found in a hospital setting and to infectious diseases (11). How to deal with this and similar nutritional problems in the surgical patient is discussed adequately elsewhere in this text (see Ch. 32). It is not within the scope of this review to deal with all of the specific nutritional deficiencies that might occur during any one of various illnesses or with those associated with surgery, trauma, or sepsis (see Ch. 14).

NUTRITIONAL DEFICIENCIES AND THE IMMUNE SYSTEM

It would be correct to assume that most health professionals in this country have the impression that malnutrition always presents with gross, overt signs such as edema, hair changes (discoloration), dermatoses and GI disturbances (*e.g.,* diarrhea), or at the other extreme, with muscle wasting and cachexia (*e.g.,* the moribund cancer patient). Both presentations are seen and both may present the physician with different and difficult nutritional therapeutic challenges. The therapeutic measures for such patients are discussed elsewhere. However, a large number of patients seen in the office setting do not present with such overt signs and may be, nonetheless, malnourished. As a result, such individuals may be anergic or may have defects in one or more components of their immune system (*e.g.,* phagocytosis) and thus they may be more susceptible to infectious agents. Indeed, medical literature contains reports of individuals who have chronic infections and in whom defects are found in one or more components of the complement system. Additionally, individuals, with iron deficiency but without anemia and without any significant findings on routine physical examination have also been shown to have impaired immune function.

IRON DEFICIENCY

Experiments with patients with chronic mycocutaneous candidiasis, a fungal disease, have in-

dicated that their abnormal immunologic status can be linked to disturbances in iron metabolism (5). Joynson *et al.* (6) have shown that iron deficiency depresses the incorporation of 3H thymidine into DNA of human proliferating lymphocytes. In other studies utilizing Hela cells, it was noted that, during mitosis, iron present in the nucleolus is normally transferred to the chromosomes, but once the iron-chelating agent, desferrioxamine, has been introduced into the culture of the living cells, DNA synthesis is inhibited (9). The same defect in normal synthesis is found in patients with iron-deficiency anemia (4).

Pertinent to this discussion of iron metabolism and host-defense mechanisms is a review by Weinberg (12). Clearly, the extent to which an infectious agent results in illness will depend on the outcome of competition between the host and the infectious agent for available iron, which in turn depends on the nutritional status of the individual. No one would prescribe iron to a patient with an infectious disease and an "infectious disease–iron deficiency anemia." Providing iron to such a patient, as Weinberg points out, would also provide iron to the infectious agent and could possibly enhance the disease process. Indeed, in patients with infectious disease, fever and a decrease in plasma iron may be viewed as adaptive responses by the host to the invading infectious agent. Obviously, there remains a great deal to learn about the administration and use of excess (above those normally required) nutrients in a great many situations.

IMMUNOSUPPRESSIVE DEFICIENCIES

A number of other nutritional deficiencies have been associated with defects in immunocompetence in experimental animals and in man. These include deficiencies of folic acid, vitamin C, pyridoxine, magnesium, and zinc, to name a few. A number of drugs used routinely by many physicians (see Ch. 18) and alcohol (see Ch. 13) can induce a number of nutritional deficiencies without gross signs and can be immunosuppressive. Infectious processes may produce similar findings; that is, immunosuppression as well as an increased excretion or sequestration of nutrients can be demonstrated in a patient with an infectious disease. In general terms, the forms of infection-induced nutritional wastage, according to Beisel (2; see Ch. 22) are

1. Absolute losses, *i.e.*, measurable excretory losses of constituent nutrients from body tissues
2. Functional losses, *i.e.*, losses occurring within body tissues due to metabolic or pathophysiologic responses
 A. Overutilization of nutrients
 B. Diversion of nutrients
 C. Sequestration of nutrients

ABSOLUTE LOSSES

During the process of an infectious illness, absolute losses occur shortly after the fever's onset and may continue during the entire period of the illness. The extent of the loss is basically proportional to the severity of the illness. One of the more-common losses is in body protein, resulting in negative nitrogen balance. A number of factors may be involved, including diminished intake of food during the illness, the hypermetabolic effects of fever, and the increased excretory loss of nitrogen via the urine and occasionally via sweat and feces. Associated with the loss of body protein are losses of potassium, magnesium, phosphate, and perhaps other essential minerals. The loss is roughly proportional to body weight loss. By controlling the fever and increasing the caloric intake it is possible to reduce these losses somewhat. On the other hand, reducing the loss of these nutrients may be impossible during the acute stage of the illness, and one must consider replacement during early convalescence through extra feedings.

FUNCTIONAL LOSSES

These losses usually result from altered metabolic processes and in some cases may be considered physiologic adaptations to the infectious process by the cellular components of the body. However, the functional losses may in turn set up a different kind of vicious cycle, resulting in absolute losses. According to Beisel (2), functional losses may be divided into three groups: 1) overutilization, 2) diversion, and 3) sequestration of essential body nutrients (see Ch. 22).

The utlization of nutrients is accelerated during the acute infectious process, causing what is sometimes termed overutilization. Fever, among other defense responses, increases the demands on and thereby depletes the normal body supply of nutrients. A clearly defined example of overutilization is that of the increased utilization of amino acids. As increased amounts

of carbohydrates are required to meet the fever's caloric demands, increased quantities of amino acids are used as substrates, and contractile muscle protein is sacrificed to provide amino acids for use in the synthesis of glucose. There is some evidence that glucose synthesis is accelerated during the infectious process and that this is triggered by the interplay of several carbohydrate regulating hormones (8).

Diversion of nutrients into metabolic pathways less useful to the maintenance of normal health may in fact be considered a protective measure for the host. During infection there may be *de novo* synthesis of phagocytic cells, interferon, or specific-antibody proteins. It has been established that some amino acids are taken into the liver to be used for glucose synthesis. Others are incorporated into hepatic enzymes or newly synthesized acute phase–reactant plasma proteins, the function of which are not exactly known, but which may be part of the defense mechanism against invading microorganisms (3, 7).

Sequestration of nutrients may also occur, rendering a nutrient useless for normal metabolic processes. For example, sodium and iron are two nutrients that are essentially lost to the body during an infectious process. With sodium sequestration there may be fluid overloading, whereas the sequestration of iron may lead to anemia. However, iron sequestration is also thought to aid the body's defense system, as its sequestration denies the invading bacteria an essential ingredient for proliferation.

In conclusion, in addition to the measures taken to directly combat the infection, a physician must consider the nutritional defense as a support of therapy. It is important that a patient be given adequate quantities of protein and calories to meet "normal" as well as "fever" requirements. Measures should also be taken to control the febrile process and thereby reduce nutritional losses. For example, the correction of hypoferremia should not be accomplished by giving iron, but secondarily by eliminating or controlling the virulent invading microorganisms. Finally, it must be emphasized that the nutritional deficits that usually accompany an infectious process may also increase the patient's susceptibility to subsequent, secondary, or superimposed infections (10). Early convalescence is also a critical period, and nutritional therapy must be continued to prevent a vicious cycle of nutritional deficiency and recurrent infections.

REFERENCES

1. Butterworth CE, Blackburn G: Hospital malnutrition. Nutrition Today 9: 4–8, 1974
2. Beisel WR: Effects of infection on nutritional status. Boston, Boston University Medical Center, 1975
3. Cockerell GL: Changes in plasma protein-bound carbohydrates and glycoprotein patterns during infection, inflammation and starvation. Proc Soc Exp Biol Med 142:1072–1076, 1973
4. Hersko C, Karsai A, Eylon L, Izak G: The effect of chronic iron deficiency on some biochemical functions of the human hematopoietic tissue. Blood 36: 321–327, 1970
5. Higgs JM, Wells RS: Mucocutaneous candidiásis. Br J Dermatol 86 (B): 88–92, 1972
6. Joynson DHM, Jacobs A, Walker DM, Dolby AE: Defect of cell-mediated immunity in patients with iron deficiency anaemia. Lancet 2: 1058–1059, 1972
7. Powanda MC, Cockerell GL, Pekarek RS: Amino acid and zinc movement in relation to protein synthesis early in inflammation. Am J Physiol 225:399–401, 1973
8. Rayfield EJ, Curnow RT, George DT, Beisel WR: Impaired carbohydrate metabolism during a mild viral illness. N Engl J Med 298: 618–621, 1973
9. Robbins E, Pederson T: Iron: its intracellular localization and possible role in cell division. Proc Natl Acad Sci USA 66: 1244–1251, 1970
10. Scrimshaw NS, Taylor CE, Gordon JE: Interactions of nutrition and infection. (Monograph 57) Geneva, WHO, 1968
11. Vitale JJ: Unpublished observations
12. Weinberg ED: Roles of iron on host-parasite interactions. J Infect Dis 124: 401–409, 1971

22 Infectious diseases

William R. Beisel

A generalized infectious illness causes widespread metabolic responses in the host and may consequently lead to overt nutritional deficiencies. Furthermore, localized infections may also result in metabolic and nutritional derangements if the accompanying inflammatory response is of sufficient magnitude and severity.

During the first decades of this century, the medical management of infectious illnesses consisted solely of symptomatic therapy, with much importance placed on the dietary aspects of treatment regimens. However, the close attention given to nutritional management diminished with the advent of the antibiotic era. As various new antimicrobial agents were recognized for their primary importance as specific therapeutic agents, the nutritional or dietary aspects of therapy were either neglected or relegated to an occasional role, often to the detriment of medical care (7).

Observations in man and a variety of laboratory animal species indicate that deficiencies of isolated nutrients and more-generalized forms of protein–calorie malnutrition may result in impairment of host defensive mechanisms (14). On the other hand, infectious illnesses produce a wasting of nutrients that can result in the occurrence of nutritional deficiencies. Thus, there is a tendency for a sequence of infection and malnutrition to develop into a synergistic cycle, with each new infection causing more-profound nutritional deficits, which can, in turn, predispose the host to secondary infections. Such a vicious cycle occurs most often in children of underdeveloped nations and accounts for their high mortality rates in preschool age groups.

Much new information is now available concerning the nutritional impact of infectious illness in patients with optimal nutritional status. During an infection, some nutrients are lost from the body in measurable quantities because of negative body balances (1, 5), whereas others are lost as secondary responses to hormonal and biochemical events (1). As will be detailed below, functional forms of wastage include overutilization, diversion from normal pathways of metabolism, and an apparently wasteful sequestration of other nutrients within body pools or depots in a manner that renders them unavailable for utilization in meeting body needs.

In order to develop a comprehensive nutritional plan for assisting in the therapy of infectious diseases, this chapter briefly reviews the underlying biochemical, metabolic, and hormonal mechanisms that account for a wastage of body nutrients. By understanding these mechanisms and being able to predict their time of onset, magnitude, and duration, the thoughtful clinician should be able to anticipate the patterns of probable nutritional deficits so that he can employ appropriate measures for providing optimal supportive care. In infectious diseases for which specific antimicrobial therapy is neither available nor effective, the clinician is still faced with the need to resort to nutritional measures as a key aspect of supportive management.

FORMS OF NUTRIENT WASTAGE DURING INFECTION

NEGATIVE BODY BALANCES (ABSOLUTE LOSSES)

Studies in volunteers have documented the changes in body balances of many elements of nutritional importance during the course of experimentally induced bacterial, viral, or rickettsial diseases (5). Information has been obtained concerning the time of onset, magnitude, and sequential patterns of response during the prodromal and early febrile periods of acute infectious illnesses. Although these prospective studies include only a small variety of illnesses that are treated promptly and have an early uncomplicated recovery, such baseline information can assist in the interpretation of data derived from

patients with clinical illnesses of overwhelming severity or a chronic protracted nature.

STEREOTYPIC PATTERNS OF ABSOLUTE LOSS

Perhaps the most important single nutritional consequence of an infectious illness is the absolute loss of body constituents that accompanies the disease process. Such losses can be estimated most easily in patients with naturally acquired illnesses by losses of body weight and by the clinical findings of lost muscle tone and a progressive wastage of muscle mass and body fat. These losses are associated with negative body balances of the principal intracellular elements, including nitrogen, potassium, magnesium, inorganic phosphorus, zinc, and sulfur (5). Losses of nitrogen serve as a prototype for losses of all other intracellular components.

Negative nitrogen balances do not begin during the incubation period of an infection or even during the first day or two of clinical illness and fever. However, once a febrile response is fully established, body balances become negative. Measured losses of nitrogen and other intracellular elements then exceed their respective intake values. As an acute infection persists, the daily losses accumulate to cause a progressive depletion in body pools of many elements.

This absolute wastage, with the loss of body weight that accompanies a hypercatabolic illness, generally produces changes that overshadow other metabolic responses of the body. The catabolic changes are qualitatively similar during the febrile illnesses caused by many different types of infectious microorganisms and seem to represent a common consistent steroyped host response during illnesses of relatively short duration. Not all elements follow the pattern of cumulative wastage seen with the principal intracellular elements. Although some loss of sodium and chloride has been detected at the onset of febrile infections, a variety of hormonal mechanisms quickly come into play to produce urinary salt retention during the febrile phase of acute infections. The body then tends to retain water as well as salt.

Thus, body composition during a severe generalized infection is altered by a combination of factors, including increased metabolic needs of body tissues, a lessening of dietary intake, complex endocrine responses, an overall wastage of most body nutrients, and a retention of salt and water. Portraying this situation during septic starvation, Moore *et al.* (10) comment, "the body cell mass quickly melts away into a hypotonic ocean of extracellular fluid."

FACTORS CONTRIBUTING TO NEGATIVE BALANCES

FEVER. Fever itself is a major factor in initiating body nitrogen losses. Such losses are provoked equally by infectious fevers and by the induction of noninfectious fevers, using bacterial endotoxin or hot, humid environments (2). The mechanism whereby a febrile process results in catabolic losses is not yet clear. It is known, however, that for each degree centigrade elevation of body temperature basal metabolic rates increase by 11%–13%. In addition, the febrile state may initiate other direct losses via sweat. The magnitude of catabolic loss appears proportional to the severity and duration of fever. The catabolic losses resulting from brief febrile periods may require several weeks for correction (2, 5).

ANOREXIA. Body deficits may also result from the anorexia experienced by most patients during an infection. Anorexia leads to a marked diminution in the consumption of foods and a reduced intake of calories, protein, vitamins, and other nutrients. If food intake is restricted to a comparable degree in a noninfected normal volunteer, metabolic processes readjust rapidly, endogenous nitrogen sources are conserved, greater amounts of energy are derived from fat depots, and the body diminishes its rates of loss of vital nutrients. Nitrogen-sparing responses typical of those seen in simple starvation, however, do not occur readily in the presence of fever. In a febrile patient, body losses via the urine and stool tend to continue at preillness rates rather than decline as in simple starvation. Indeed, some febrile patients actually increase nitrogen losses via the urine to above-normal values despite the anorexia and diminished intake of food. Should diarrhea or vomiting develop, additional losses occur via the intestinal tract. This combination of events leads to measurable body decrements of a large variety of nutrients during periods of acute infection.

ENDOCRINE RESPONSES. Hormonal responses during infection are generally of limited duration and magnitude.

Adrenal Hormones. An increased secretion of adrenal glucocorticoid hormones begins with, or

shortly before, the onset of fever. Increases in daily rates of cortisol production may reach values two to five times normal. Plasma cortisol loses its circadian periodicity and generally maintains concentrations near, or slightly above, usual peak morning values. The increase in glucocorticoid secretion is accompanied by smaller increases in the output of adrenal keto-steroids and pregnanetriol. These ACTH-mediated adrenocorticoid responses do not persist beyond the onset of recovery. If an infection becomes subacute or chronic, the urinary excretion of adrenal steroids generally falls below normal.

The onset of septic shock or the progression of infectious illness to an agonal stage is often accompanied by steadily increasing plasma cortisol concentrations. High values result from a functional failure of hepatic enzyme systems that normally degrade these steroids. On the other hand, hemorrhage into the adrenal gland during bacterial sepsis may cause glucocorticoid production to cease.

Changes in aldosterone secretion do not coincide with those of cortisol. Increased production of aldosterone becomes evident only after fever has begun and abates gradually in early convalescence. The increases in aldosterone secretion contribute to the well-documented renal retention of sodium and chloride during acute infections. In addition, a tendency for excessive body water to accumulate during many severe infections has been attributed to an inappropriate secretion of antidiuretic hormone.

Thyroid Hormones. Changes in thyroid hormone economy are best evaluated in relation to the stage of an infectious process. A biphasic pattern of thyroid response seems evident. Accelerated disappearance rates of thyroxine and triiodothyronine from plasma as well as low protein-bound iodine (PBI) values occur during the early stages of infection. These early changes suggest an increased utilization or deiodination of thyroid hormones, or both, by peripheral tissues during fever or periods of increased phagocytic activity. A sluggish response of the pituitary–thyroid axis helps to account for the initially depressed PBI values, but eventually the thyroid is activated. Thus, during early convalescence, serum PBI values may be increased and the rate of thyroxine disappearance slowed. These latter observations are in keeping with an eventual "overshoot" in thyroid gland activity in response to the earlier acceleration of hormone degradation. Further, thyroid glands from

patients with overwhelming infections show histologic changes typical of increased secretory activity.

Glucoregulatory Hormones. Hormones that influence carbohydrate metabolism are intimately involved in host responses during febrile illnesses. Fasting plasma concentrations of glucose, insulin, glucagon, cortisol, and even growth hormone tend to be increased (13). If carbohydrate tolerance is measured by means of an IV glucose load during early fever, the insulin responses and glucose disappearance rates show changes approaching those characteristic of maturity-onset diabetes. Elevated fasting glucagon values decline appropriately after IV glucose test loads, but growth hormone secretion seems to undergo an acute paradoxical stimulation (13). Few quantitative details are available concerning catecholamine responses during infection.

These combined hormonal responses initiate molecular mechanisms to release glucose from stored hepatic glycogen and increase rates of gluconeogenesis from available substrates. An increased flux of gluconeogenic amino acids, such as alanine, from muscle to plasma to liver supports this activity. The increase in hepatic gluconeogenesis may be great enough to cause modest hyperglycemia despite an increased rate of glucose utilization by body cells. In contrast, during overwhelming sepsis in newborns or in patients with severe liver damage, such as that due to viral hepatitis or yellow fever, glycogen reserves in liver and skeletal muscles become depleted and hypoglycemia may result. No specific point of failure has been identified in any biochemical pathway that could account for an agonal breakdown in carbohydrate synthesis.

DURATION OF ILLNESS. In the event that a febrile illness is of only brief duration, negative balances are quickly reversed and the body begins to retain depleted nutrients. Thus, in order to reconstitute normal composition, a patient generally develops positive balances for most elements in early convalescence. The magnitude and duration of positive balances appear to be determined by type and quantity of dietary intake as well as by the extent of cumulative deficits incurred during the illness. For most uncomplicated minor illnesses, deficits are reconstituted within a period of several weeks in a manner similar to convalescent patterns of recovery after wounding or trauma.

Should an acute infectious process become chronic, daily nitrogen balances gradually be-

come less negative each day. Thus, as day-by-day losses diminish, a chronically ill patient begins to return to a new equilibrium state, although at a wasted, cachectic level. The body can generally reconstitute such chronic losses if protracted infections are treated successfully.

SEVERITY OF ILLNESS. As a general rule, severe infectious illnesses produce greater nutritional insults than do mild ones. However, an overwhelmingly severe infection that leads to death in a matter of hours or days may run its course before an appreciable wasting of body tissue has a chance to occur.

FUNCTIONAL FORMS OF NUTRIENT WASTAGE

In addition to direct losses of body nutrients, metabolic and biochemical host responses produce several functional forms of nutrient wastage (1). In facing the challenge of an acute infectious illness, the body utilizes muscle protein, metabolizable endogenous fuels, and other nutrients in an apparently inefficient and wasteful manner. Although they may serve in some yet unrecognized host defensive mechanism, these functional forms of wastage add to the nutritional requirements of the body and must be considered when planning a comprehensive therapeutic approach to infection.

OVERUTILIZATION OF NUTRIENTS

Overutilization of body nutrients is one example of functional wastage. Increased cellular needs for body fuel can virtually deplete glycogen stores during severe sepsis or endotoxemia. Even during uncomplicated infections, however, amino acids and other substrates for gluconeogenic activity are metabolized in excessive quantities. The presence of fever has long been known to increase the metabolic rate of body tissues. An accelerated utilization of metabolizable fuel by cells throughout the body is accompanied by a mobilization of lipids from body fat depots, accelerated rates of hepatic synthesis of cholesterol and triglycerides, degradation of liver and muscle glycogen, and the wasteful utilization of amino acids for the production of glucose and ketone bodies.

An increased utilization of vitamins must also be anticipated. Severe infections in man have been found to precipitate clinically apparent vitamin deficiency states, *e.g.,* scurvy, beriberi, pellagra, or vitamin A deficiencies. Vitamin losses via urine during infection do not seem to account for such instances of overt vitamin deficiency. Of 14 vitamins included for study during the course of experimentally induced sandfly fever in volunteers, only vitamin B_2 showed an increased rate of urinary loss from the body (3). Thus, a depletion of vitamin stores in the tissues during infectious illnesses or the decline in blood concentrations of several vitamins can generally be ascribed to an overutilization of vitamins by body tissues rather than to measurable excretory losses.

DIVERSION OF NUTRIENTS

The second form of functional wastage is related to nutrient overutilization and involves the diversion of nutrients from their usual metabolic pathways. The infectious process stimulates a marked increase in the rate of uptake of plasma amino acids by the liver. In addition to their enhanced hepatic utilization for gluconeogenesis, the exaggerated movement of amino acids into the liver is followed in many instances by rapid incorporation into newly synthesized acute phase reactant plasma proteins. These proteins include α_1-antitrypsin, seromucoid, α_2-macroglobulins, ceruloplasmin, C-reactive protein, and others. The purpose served by these proteins during inflammatory states remains a mystery, but their synthesis has a high cost in terms of amino acid and energy expenditures.

Some of the amino acids that enter the liver in excess are used for incorporation into newly synthesized hepatic enzymes, some are diverted for ketone formation, and some enter their usual metabolic pathways in excess amounts. An example of the latter possibility is the accelerated metabolism of tryptophan via the kynurenin pathway during many infections, especially typhoid fever (12). A variety of metabolic products of tryptophan are then excreted in excess and lost from the body as urinary diazo reactants.

SEQUESTRATION OF NUTRIENTS

Another form of nutrient wastage during an infection is represented by the sequestration of nutrients in relatively inaccessible body pools (1, 4). For example, an increased movement of iron from plasma to liver is a characteristic host response typical of many infectious diseases, especially those accompanied by a prominent in-

flammatory response. Iron in the form of homosiderin or ferritin then enters hepatic storage depots, where it becomes relatively sequestered, and is not readily reutilized for the formation of hemoglobin as long as the infection persists. This sequestration of iron can eventually produce "anemia of infection," which resembles iron deficiency anemia in its peripheral red blood cell and serum iron values. Unlike iron deficiency anemia, however, there are plentiful supplies of iron in body stores during infection, and serum iron-binding capacity tends to decrease rather than to increase. If parenteral iron therapy is given while a generalized infectious process remains active, most of the administered iron also becomes sequestered in storage pools and is not utilized to correct the anemia.

Sodium can also become sequestered in cells during periods of severe illness, especially those accompanied by marked acidosis.

CELLULAR NEEDS

An infectious illness is accompanied by hypermetabolism and accelerated utilization of energy by body cells. For example, a sudden increase of energy expenditure by single cells occurs whenever phagocytes engage in direct antimicrobial activity. A burst of glycolytic energy production and expenditure develops as neutrophilic leukocytes initiate activity leading to the phagocytic uptake and lysis of bacteria or other microorganisms. Most body cells, however, need to be supplied continually with energy from circulating metabolic fuels in order to perform their normal or infection-stimulated functions.

To meet the added demands for cellular energy, the body rapidly gears up its molecular machinery for producing glucose. This process involves the increased secretion of hormones such as glucagon, the adrenal glucocorticoids, and the catecholamines; these hormones combine to induce two related patterns of response within the liver. The enzymes that control the release of glucose from glycogen stores are activated. In addition, the rate of production of glucose is accelerated, utilizing a group of gluconeogenic amino acids represented by alanine as substrates.

Well-controlled insulin-dependent diabetic patients who develop an acute infection are likely to develop hyperglycemia with glycosuria. It has long been taught that these diabetic patients need additional amounts of insulin if they develop an infection. Infection-induced hyperglycemia has traditionally been thought to represent an impairment of the ability of insulin to act on peripheral body cells. Recent studies that have measured the kinetic disappearance rates of radioactively tagged glucose in septic subjects (9) show that most of the changes in glucose metabolism during infection are the result of great increases in both production rates and body pool sizes of glucose, with an increased rate of glucose turnover within the enlarged pools. Thus, it is evident that the body is willing to sacrifice scarce amino acids and other nutrient precursors to provide body cells with more than adequate concentrations of glucose during periods of acute febrile illness. Studies performed in volunteers exposed to experimental bacterial and viral infections suggest that this response begins within several hours of the onset of fever (13).

In addition to producing additional amounts of glucose during infection, the liver also speeds up its synthesis of cholesterol from acetate and other precursors and of triglycerides from fatty acids derived from the plasma pool.

SUMMARY OF NUTRITIONAL CHANGES

Even the least complicated forms of generalized infection, including those that are self-limited and relatively mild, stimulate a wide variety of metabolic and nutritional responses; these tend to result in wasteful expenditures or overt losses of essential body nutrients. Loss of body weight is the combined result of fever-induced hypermetabolism, impaired appetite, and an interlocking complex series of hormonal and physiologic responses that lead to absolute losses of body nitrogen, potassium, magnesium, zinc, and sulfur. There are increased, possibly wasteful, expenditures of calories, vitamins, and amino acids. Optimal host defensive mechanisms require the body to increase its formation of new cells, such as those of the phagocytic and lymphoid series; to manufacture a variety of intracellular enzymes, hormones, and cellular products; and to synthesize new serum proteins, such as the acute phase reactants and specific antibodies.

Approaches to nutritional therapy should be based on the metabolic responses known to occur during an infection. The absolute loss of body nutrients can be reduced or even prevented during an infectious illness. As will be described, an adequate intake of total calories, protein, and specific nutrients should be provided during and after fever, and excessive nutrient requirements should be reduced by thera-

peutic measures to diminish the febrile response and eliminate invading microorganisms.

GENERAL MANAGEMENT OF INFECTIOUS PROBLEMS

INCIDENCE OF INFECTIOUS DISEASES

Infectious diseases occur at every age and in all population groups. In addition to the frequency of infectious illnesses as primary medical diseases, infection-related problems may play a secondary or complicating role in patients with most other varieties of medical, surgical, or pediatric illness.

Infectious disease problems continue to be of greatest importance in patients at the extreme ends of the normal human life span. Although no age group is free of infectious diseases, middle-aged persons generally have the lowest incidence of serious infections.

Contrary to the hopes and expectations that accompanied the advent of the antibiotic era several decades ago, infectious diseases have not been eliminated from the medical scene, even in the most-advanced societies. Although modern therapeutic developments and advances in medical and surgical technology have increased survival rates, they have done so at the cost of introducing nutritional debilities, immunologic defects, and other iatrogenic factors that break down the natural host defensive mechanisms. As a result, the incidence of opportunistic infections has increased in major hospitals around the world. This unanticipated consequence of medical progress has forced practitioners of all medical specialty fields to face new varieties of infections caused by bacteria, fungi, viruses, and parasites not previously known to be widely pathogenic or of more than incidental concern in scattered rare instances.

General improvements in sanitation and vigorous programs of preventive medicine and public health have shown that it is possible to control or virtually eliminate many of the epidemic or endemic infectious disease problems of previous years. The incidence of tuberculosis, enteric diseases due to *Salmonella* and *Shigella* bacteria, and the parasitic and venereal diseases, for example, can be minimized by such measures. Development of safe and effective vaccines has gone far toward eliminating of such epidemic diseases as small pox, diphtheria, pertussis, measles, and poliomyelitis from the highly industrialized nations. Yet, although each of these advances has lessened the danger from common infectious killers of previous generations, infectious diseases continue to cause death and debility in modern societies. Further, infectious diseases account each year for more deaths on a global scale than any other form of illness.

Thus, despite the availability of antibiotics and effective immunoprophylactic measures, infectious diseases are likely to remain a continuing and serious health problem. In addition to the growing incidence of opportunistic infections in advanced medical centers, the reemergence in some localities of venereal diseases, malaria, and poliomyelitis show how easily an apparently well-controlled situation can be reversed unless proper prophylactic and public health measures are pursued with continuing diligence.

Of major concern is the well-recognized synergistic cycle that relates infectious disease to malnutrition. The prevalence of malnutrition and infection continues to produce high mortality rates in the underdeveloped nations, especially those of the tropical and subtropical climates. This problem is of mounting global concern in the presence of world population growth and continuing failures to produce or distribute sufficient food for all people.

THERAPEUTIC MODALITIES

The obvious aim of therapy is to control and eliminate invading microorganisms before serious illness or lasting complications can occur. The first line of medical management is to identify the causative agent—if this is possible—and to determine whether any effective chemotherapeutic or immunotherapeutic approach can be used.

Proper antibiotic management involves the selection of the drug and dosage schedules most likely to produce complete and rapid control of the infection without initiating untoward secondary effects. An exact identification of the infecting microorganism and its range of sensitivity is valuable if this can be obtained. However, if the symptoms, severity, and course of an infectious illness require that decisions regarding antibiotic therapy be made in the absence of such information, judgments must be based on a careful evaluation of the available clinical and laboratory findings.

A number of infections require the use of immunotherapeutic procedures (such as the administration of purified γ globulin or high-titer specific antiserum), the rapid stimulation of active immunity, or the use of new therapeutic

approaches, *e.g.,* inoculations with transfer factor.

Nutritional modalities of therapy are usually, and most appropriately, classified among the secondary forms of general supportive therapy. Nevertheless, this support can be of benefit to patients receiving specific antimicrobial therapy. For infectious diseases that lack effective means of specific therapy, nutritional support is of even greater importance. Nutritional therapy is especially useful in patients with viral illnesses or in individuals with preexisting overt or borderline nutritional deficiency states. In rare instances, the correction of a life-threatening physiologic or biochemical imbalance can be achieved only through the administration of an essential nutrient such as water, glucose, or electrolytes. Under such conditions, emergency replacement therapy could be considered as a form of nutritional management taking precedence over other forms of therapy.

NUTRITIONAL MODALITIES OF THERAPY

DIRECT NEEDS

There are relatively few instances in clinical medicine where nutritional modalities of therapy are of specific direct importance in managing an immediate life-threatening problem. However, these situations must be recognized quickly and treated effectively when they occur. Perhaps the best example of such an emergency requirement is the need to correct the massive loss of body fluids and electrolytes that can occur during severe states of acute diarrhea. In patients with cholera or severe *Escherichia coli* enterotoxemia, intestinal losses of water, sodium, chloride, and other nutrients can precipitate the occurrence of hypovolemic shock and death.

Other forms of acute nutritional imbalance may occur in infections that damage key body cells and thereby cause a secondary depletion of body nutrients or an accumulation of toxic products or metabolites. If of sufficient severity, infectious hepatitis may produce hypoglycemia or hepatic failure. Severe hypoglycemia is also a common danger in neonatal infants with sepsis. Life-threatening hypoglycemic shock can be suspected through its clinical signs, diagnosed by blood glucose analysis, and corrected with glucose infusions. In contrast to the infection-induced depletion of an essential body nutrient such as glucose, the accumulation of potentially toxic metabolic products such as ammonium can

occur in patients with liver failure of infectious origin. Endogenous ammonium toxicity must be managed promptly by the use of intestinal antibiotics and nutritional measures to reduce blood ammonium concentrations as outlined in Chapter 20.

SECONDARY AND SUPPORTIVE MODALITIES

Supportive nutritional therapy should be employed in the management of patients with infectious illnesses. Such planning can be implemented in either the hospitals or the home and can be based on the anticipated wastage of nutrients. The practitioner should actively seek to prevent or lessen the harmful consequences of nutritional wastages. Supportive therapy should be initiated concurrently with antimicrobial measures.

FEVER

Catabolic losses in a patient with an infectious process generally do not begin until after the onset of the febrile phase of illness. Thereafter, the presence and severity of fever serve to indicate the occurrence and magnitude of both absolute and functional wastages. Although the management of fever is not generally considered to be a nutritional form of therapy, it has important consequences. Attempts to control fever by antipyretic drugs or by direct physical methods, *e.g.,* sponging, serve to reduce the nutritional needs for the excessive energy production associated with the presence of fever. Control of fever also reduces any dermal losses of nutrients that occur during fever-induced diaphoresis.

If fever cannot be eliminated or controlled, its impact must be taken into account when calculating the daily caloric and protein needs of a sick patient.

ANOREXIA

One major nutritional problem associated with acute infectious illness is the presence of anorexia as an important symptom. If simple anorexia progresses to overt nausea or vomiting, it becomes extremely difficult, if not impossible, for a patient to meet the desired requirements for the oral intake of fluids, calories, protein, and other nutrients. This problem can rarely be solved merely by ordering sufficient amounts of a properly calculated dietary intake to be deliv-

ered to the bedside or by instructing a sick patient to ingest the quantities and varieties of foods calculated to meet his nutritional needs. Kindly and purposeful attention of an attentive nursing staff or family is in many instances similarly ineffective. However, a sick patient should be offered whatever kinds of food he can consume and encouraged to eat despite the presence of anorexia. Soft or liquid foods of high nutrient and caloric value have long been used for this purpose. When marked anorexia and nausea severely restrict food intake, anticipated deficits should be prevented by the parenteral administration of key nutrients. Such a requirement reaches its ultimate limits with the use of total parenteral nutrition, as discussed below.

ESTIMATION OF CALORIC NEEDS

The calculations concerning the caloric needs of a patient with an infectious illness should include recommended daily dietary allowances for normal individuals plus extra amounts that may be needed because of fever. Basal requirements can be derived from standard normal values (see Table A-1), and the added needs can be calculated according to the amount of fever (13%/°C).

Thus, a 35-year-old male weighing 70 kg, who ordinarily requires an energy intake of 2700 Cal (Table A-1), with a body temperature 1.5°C above normal, would require 2700 Cal, plus 1.5 × 13% of 2700 Cal. This amounts to 2700 plus 526.5 Cal, or 3227 Cal/day.

A combination of oral and parenteral routes may be needed to provide such a caloric intake. Individualized adjustments should be made on a daily basis to account for changes in the severity of fever. Caloric adequacy during an acute illness can also be determined by changes in body weight. As a simple rule, loss of body weight during an infection can be taken as evidence that the caloric needs of the patient are not being met. This judgment must be tempered by the knowledge that weight loss may be masked by the tendency for febrile patients to retain salt and water.

In some individuals, water retention of one or more kilograms during a febrile illness will obscure equivalent losses in lean body mass or fat, or both. The true extent of body loss may not become apparent until several days after the cessation of fever, when postfebrile diuresis causes excessive fluid accumulations to be excreted. If caloric intake has not kept pace with body needs

during an illness, deficits should be made up as early as possible in the convalescent period.

PROTEIN REQUIREMENTS

The functional adequacy of every host defensive mechanism is ultimately dependent on the protein-synthesizing capabilities of individual cells. Nevertheless, the body will still sacrifice its scarce supply of amino acids through functional forms of wastage (as described above) to provide for its total caloric needs. Thus, the protein requirements of a patient who is febrile because of an infectious process will depend to a great extent on the total supply of caloric energy provided each day.

If total caloric intake is inadequate, some portion of the amino acids derived from dietary protein or existing body pools is diverted wastefully for meeting energy needs rather than for such specific uses as incorporation into the structure of new proteins or use as substrate for metabolic pathways that are unique for individual amino acids. Since metabolic energy must be expended to deaminize amino acids diverted for carbohydrate synthesis, the use of amino acids for calorigenesis is doubly wasteful.

It is possible, even in febrile patients on a constant intake of dietary protein, to reduce excessive losses of body nitrogen by increasing the intake of total calories. Although the extra energy needs of febrile patients should preferably be met by adding nonnitrogenous sources of calories to the daily nutrient intake, the body should not be forced to depend on endogenous tissue protein for its amino acid requirements. Further, it has been argued that glucose infusions stimulate a secretion of insulin that diminishes the utilization of body lipids for energy production, whereas an adequate input of amino acids allows a greater contribution of body fats for energy needs. At a minimum, protein should be given in quantities sufficient to meet the recommended daily dietary allowances based on age, weight, and sex (see Table A-1). It has not been determined with certainty that the protein-sparing effect of extra calories (provided as outlined above) will always suffice. Thus, it may be necessary to increase the intake of protein somewhat above minimal values in order to meet body requirements for protein during acute febrile periods of illness. The recommended normal dietary protein allowances should be increased by 10%/°C of fever, especially if weight loss has not been controlled.

Several simple methods are available for estimating protein requirements. Urinary urea nitrogen assays can be performed on 24–hour urine specimens by most clinical laboratories. A daily urea nitrogen excretion value plus 4 (2 for nonurea nitrogen in urine and 2 for stool nitrogen) will provide a reasonably accurate estimate of the body nitrogen loss. If this value is compared with an estimate of nitrogen intake based on table values, a rough idea of nitrogen balance can be obtained. Serial measurements of albumin concentration and midarm muscle circumference can also be of value in determining the adequacy of protein intake, especially in patients whose illness is protracted.

ACID–BASE STABILIZATION

Infectious diseases are known to initiate a variety of changes in the acid–base equilibrium of the body. Different pathogenic mechanisms may allow metabolic alkalosis, metabolic acidosis, respiratory alkalosis, or respiratory acidosis to develop singly or as complex physiologic derangements. The clinician must be aware of these possibilities to determine if corrective therapy is required during illness or replacement therapy during the convalescent period.

RESPIRATORY EFFECTS. The pathophysiologic course, duration and severity of an infectious process, together with its complications may cause a complex sequential development of respiration-induced changes in acid–base equilibrium. Fever is typically accompanied by an increase in both cardiac and respiratory rates. Fever-induced hyperventilation leads to an increased rate of gas exchange within the lungs and causes an exaggerated loss of dissolved carbon dioxide from the blood. This produces a state of uncompensated respiratory alkalosis that predominates during periods of rising fever. Respiratory alkalosis may persist during infection as long as tachypnea exists in the presence of a free exchange of gases within the pulmonary alveolae. Rarely, however, is respiratory alkalosis of sufficient severity to produce carpopedal spasm or require therapy.

On the other hand, if a pulmonary infection prevents adequate gaseous exchange within the lungs, respiratory acidosis is observed. Impaired gaseous exchange can also become a problem in infections such as poliomyelitis or tetanus which destroy or impair neuromuscular components of pulmonary function. Under these conditions, oxygen becomes a nutrient that must be supplied by mechanical measures (see Ch. 31).

METABOLIC EFFECTS. In addition to the respiratory factors that can alter acid–base balance in either direction, metabolic factors will influence acid–base equilibrium if an infectious process becomes chronic or severe. In the presence of high fever or prolonged illness, the generation of lactic acid and other metabolic products exceeds the capacity of the body to dispose of them. If the quantity of acid metabolites produced during an infection is sufficiently great, a state of metabolic acidosis begins to emerge. If bacterial sepsis leads to hypotension and vascular stasis in capillary beds, impaired oxygen transport will lead to cellular hypoxia, an exaggerated formation of lactic acid, and a further increase in the severity of metabolic acidosis.

Severe or protracted diarrheal diseases can produce two different additional varieties of acid–base imbalance. Since the lower small bowel and proximal colon contain intraluminal bicarbonate concentrations almost double those of plasma, massive diarrhea causes large amounts of bicarbonate to be lost from the body. The loss of bicarbonate can lead acutely to metabolic acidosis in patients with severe diarrhea, but as will be described, this can be treated by adding bicarbonate or lactate to replacement fluid infusions. Replacement of bicarbonate should be continued until the urine pH becomes alkaline.

In severe or chronic diarrheas, large amounts of potassium are also lost from the body. If these losses are sufficiently great, vacuolar degeneration of body cells may be observed histologically, especially in epithelial cells of the renal tubules. A massive loss of body potassium will also produce severe metabolic alkalosis, which can persist for many months unless treated. The consequences of hypokalemic nephropathy and metabolic alkalosis can be corrected by replacement therapy with potassium. This essential nutrient can be provided by using commercially prepared IV solutions containing 35 mEq/liter potassium. During the illness the massive losses of potassium in severe diarrhea can be treated by potassium-containing maintenance fluids given primarily to compensate for continuing losses of water. Any residual or chronic deficits should be corrected through the use of foods with a high-potassium content during the convalescent period.

ELECTROLYTE AND WATER REQUIREMENTS

An infectious process may lead to death from diverse body fluid imbalances, which can range from severe overload to severe dehydration. Direct losses of salt and water occur in diseases accompanied by severe or protracted diarrhea or vomiting or marked diaphoresis. In the absence of such direct losses, the body tends to retain fluid and electrolytes. With severe illness, sodium may accumulate within body cells and cause hyponatremia despite a normal total body content of sodium. Water retention due to inappropriate antidiuretic hormone secretion may also exaggerate the severity of the observed hyponatremia. Appropriate therapy in the presence of the latter types of salt and water derangements may require a restriction of fluid and electrolyte intake. Thus, a patient with infectious illness may have an emergency need for electrolyte replacement or may, on the other hand, be seriously harmed by fluid or electrolyte administration. An understanding of the pathophysiologic mechanisms leading to deranged fluid and electrolyte balance is therefore necessary when deciding on the proper therapeutic measures.

SODIUM WASTAGE. The losses of body water and electrolytes during Asiatic cholera provide insight into the conceptual approaches required for planning optimal therapy for exaggerated forms of acute diarrhea. In a massive, protracted diarrhea, the watery stools are virtually isoosmotic with plasma. Because such losses are isoosmotic, water does not move from body cells into the extracellular space, and the immediate threat to life is due to hypotension and circulatory failure. Losses of body water and electrolytes in equivalent isoosmotic amounts lead to body dehydration without appreciable changes in the concentrations of plasma sodium in relation to plasma water. In such instances, however, the degree of body dehydration can be assessed by clinical signs together with high hematocrit values and increased concentrations of total plasma proteins in relationship to plasma water. This type of dehydration increases the specific gravity of both whole blood and plasma. Because plasma proteins may undergo a two-fold increase in concentration during severe cholera, measured sodium and chloride concentrations may appear to be diminished if calculated and expressed, as conventionlly, on the basis of whole plasma values. To be physiologically accurate and therapeutically meaningful, electrolyte

concentrations of such dehydrated patients must be recalculated to reflect the high protein concentration and diminished amount of water present in the plasma.

Isoosmotic dehydration due to massive diarrhea must therefore be corrected by the use of isotonic replacement fluids. Replacement fluids should be given on an emergency basis to correct shock and acidosis and to return hematocrit and plasma protein concentrations to normal. Thus, in studies performed in Southeast Asia, isotonic saline was used first to replace the fluid loss and bring the cholera patient out of shock, and the acidosis was corrected with 500 ml 2% sodium bicarbonate for each 4 liters saline. After initial rehydration, homeostasis was maintained by infusing these solutions at a rate to match the measured stool volume; potassium deficiency was made up by mouth or by adding potassium chloride to the fluid after initial rehydration was completed.

In the Indian subcontinent, however, severely dehydrated hypotensive cholera patients often had pulmonary rales when first examined or else developed acute pulmonary edema when rehydration was initiated with isotonic saline (6). This cardiopulmonary problem was due to the severe coexisting acidosis, but it could be overcome successfully by the use of bicarbonate-containing resuscitation fluids designed to correct acidosis concomitantly with the correction of dehydration (6). In most clinical situations, however, the prevention or correction of hypovolemia and shock allow other homeostatic mechanisms to correct the problems of metabolic acidosis.

SODIUM RETENTION AND SEQUESTRATION. In generalized infectious diseases that do not include diarrhea, vomiting, or massive sweating as important factors, dehydration is not usually a problem. Rather, the onset of fever is accompanied by an increased secretion of aldosterone by the zona glomerulosa of the adrenal cortex and of antidiuretic hormone by the posterior pituitary gland. These hormones, acting in concert on distal renal tubular cells, cause the kidneys to retain both salt and water. Because of these responses to fever, both sodium and chloride may virtually disappear from the urine, and urine volume may be sharply reduced.

A retention of body water may persist even in the presence of declining concentrations of both sodium and chloride. In such instances the secretion of antidiuretic hormone persists in an inappropriate fashion. Because of the retention of

salt and water in most generalized infectious illnesses, it is generally unwise to administer IV saline as a nutritional or therapeutic measure. Further, if chronic metabolic acidosis develops, variable amounts of sodium may accumulate within body cells. This form of functional nutrient wastage due to the sequestration of sodium within body cells is evidence of severe illness and is not easily reversed. The unwise administration of saline in an attempt to correct depressed serum sodium concentrations in such patients may have serious consequences, such as cardiac failure, or in children with meningoencephalitis, fatal cerebral edema.

Patients with severe hyponatremia that cannot be explained by direct sodium losses should be managed by restricting their salt and water intake until after the infectious process is controlled and serum sodium concentrations begin to increase. This type of problem is most common in the aged and in children with CNS infections, Rocky Mountain spotted fever, or other severe generalized infections. Daily fluid intake should be restricted to 800 ml/m² body surface area. Body weight, urinary specific gravity and volume, and serum and urine values for sodium and osmolality should be measured each day. When urinary specific gravity begins to decline and the daily urine volume increases, fluid intake can be liberalized.

MINERAL AND TRACE ELEMENT REQUIREMENTS

Changes in the metabolism of several body minerals have been reported during infectious illnesses (4), but relatively little is known about the role or importance of these changes. Similarly, little direct information is available about the need to employ any of the minerals or trace elements as therapeutic agents. Knowledge concerning the impact of infectious illness on trace element metabolism is increasing rapidly, however, as new analytic methods are being brought into use (4). For the present, the wisest course of action would seem to demand that natural foodstuffs be given—if possible—in adequate quantities during illness, and certainly during early convalescence, in an effort to correct or restore any infection-induced mineral or trace element imbalances or deficits.

MAGNESIUM. Magnesium concentrations in serum may decline somewhat during the course of a generalized infection as the result of a dilutional phenomenon associated with the reten-

tion of body water. On the other hand, metabolic balance studies in volunteers with relatively mild infections demonstrate net negative balances of magnesium (5). These occur in close parallel with negative balances of nitrogen. Since potassium is also lost in generally equivalent amounts, it can be postulated that these nitrogen-equivalent losses are derived from cellular pools. No data are available concerning the use of magnesium supplements as an approach to supportive therapy in infectious illnesses, but they may be needed if there is a prolonged negative balance of this element, as during surgical complications that induce major direct losses of magnesium from sites of intestinal drainage or burned surfaces.

CALCIUM. Calcium concentrations in plasma may also undergo a slight dilutional decline, but otherwise there is little to suggest that calcium metabolism is influenced importantly by mild infectious illnesses. On the other hand, body balances of calcium and other bone minerals become negative if an infectious disease produces prolonged immobilization or paralysis. It is also known that calcium ions accumulate in areas of devitalized tissues, and the tendency for granulomatous tubercular lesions to become calcified is well known. Although a high calcium intake was employed in the preantibiotic management of tuberculosis, there is little to suggest that this single nutritional component is of specific importance in arresting the disease process. On the other hand, tuberculous patients may develop a sarcoidosislike hypersensitivity to vitamin D; if this occurs and hypercalcemia results, vitamin D and calcium intakes must be carefully controlled.

PHOSPHORUS. Inorganic phosphate has been shown to undergo a complex variety of changes in different infectious illnesses. These changes include altered phosphate concentrations in body fluids as well as negative balances. Unusually low serum concentrations of inorganic phosphate have been reported in patients with gram-negative sepsis and in Reye's syndrome. Reduced serum phosphate concentrations have been suggested by a possible diagnostic indicator of sepsis. Serum phosphate values also decline rapidly but transiently during the early stages of fever, apparently as a secondary manifestation of respiratory alkalosis. When hypophosphatemia occurs during an acutely rising body temperature, it is accompanied by the virtual disappearance of phosphate from urine and

sweat. These changes occur too rapidly to be accounted for by parathyroid gland responses.

In volunteers with experimentally induced infections, body balances of phosphorus become negative (5). Like the negative body balances of potassium and magnesium, this negativity can be shown to parallel quite closely the magnitude and pattern of losses of body nitrogen.

The participation of organic phosphates in energy metabolism and many other aspects of intermediary metabolism is well recognized, and various organic phosphate moieties and high-energy phosphate bonds must participate at the cellular level in host responses to infection. Marked infection-related changes also occur in the phosphatase enzymes contained in many body cells and serum. It is not known how these changes may influence the outcome of an infection, and there is no direct evidence that the administration of phosphate as a single nutrient would be likely to influence favorably the course of illness.

IRON. Iron metabolism is markedly altered by an infectious process. Acute sepsis and many bacterial and viral infections can increase the rates of red blood cell destruction. In addition, it has been known for many decades that the concentrations of iron decline rapidly in serum at the onset of an infectious illness. This change appears to be due to a flux of iron from serum to liver and other cells where the iron becomes sequestered in tissue stores of hemosiderin and ferritin. The initial acute decline in serum iron occurs without an appreciable decline in serum iron-binding capacity. As a result, the quantity of unsaturated transferrin is increased in serum during the initial stages of infection. If an infectious process becomes chronic, serum iron values remain low and iron-binding capacity begins to decline slowly. The iron sequestered in tissue stores represents a form of functional wastage inasmuch as it seems to be trapped in a form that becomes unavailable for reutilization in the synthesis of hemoglobin for new red blood cells. This infection-induced sequestration of iron, together with a tendency for red blood cell survival times to become shortened can give rise to the so-called "anemia of infection."

The combination of low serum iron values with increased concentrations of unsaturated transferrin appears to have some protective value for the host (15). Because of the extreme insolubility of ferric iron in body fluids, many bacteria synthesize siderophores to acquire needed iron. The siderophores have association constants high enough to compete successfully with saturated transferrin for iron (15). The increased concentration of unsaturated transferrin in an infected host thus makes it difficult for many pathogenic bacteria to acquire sufficient iron to carry out their normal metabolic functions, to achieve logarithmic growth patterns, or to produce certain of their toxic products.

During ongoing chronic but active infections, the administration of iron by either oral or parenteral routes is not only unnecessary, it is ineffective in reversing the anemia of infection. Liver extract, the folates, or vitamin B_{12} are similarly without value.

Further, if iron therapy is used in children with kwashiorkor or protein–calorie malnutrition, it can have disastrous consequences. The additional therapeutic iron serves to saturate the low serum iron-binding capacity common in protein-malnourished children. The presence of saturated transferrin in serum makes iron available to aerobic and facultative bacterial pathogens that can then proliferate rapidly and overwhelm the already impaired host defensive mechanisms of the malnourished child. Thus, if total serum iron-binding capacity is depressed in a malnourished child, iron therapy is actually contraindicated until appropriate protein repletion therapy can be employed to increase serum iron-binding capacity to normal values.

COPPER. Copper metabolism is also altered during infectious processes, concentrations of copper in serum usually showing an increase. These increases can be accounted for by an accelerated hepatic synthesis and release of ceruloplasmin, the principal copper-binding protein. It is not known if this change has potential value with respect to host defensive mechanisms, but its occurrence is observed consistently during infectious illnesses. Copper and ceruloplasmin values tend to remain elevated for several weeks during early convalescence.

ZINC. Zinc metabolism is also altered during acute infectious illnesses. Like iron, serum zinc appears to move rapidly from serum into the liver during the early stages of most infectious illnesses, but the depression of serum zinc values is not usually as great as that of iron. Unlike iron, however, no specific storage sites for zinc have been identified within the liver. The purpose of the flux of zinc from serum to liver has not been clarified, although the additional zinc may enhance protein-synthesizing capabilities of the liver during early infection. As illness pro-

gresses, zinc balances can become negative as a result of diminished dietary intake of the metal along with increased losses in urine and sweat.

VITAMIN REQUIREMENTS DURING INFECTION

Ever since the discovery of vitamins, research efforts and clinical trials have been testing the attractive hypothesis that the ability of a host to resist infection is closely related to the adequacy of his vitamin nutrition. Acute infections in man are known to be followed in some instances by the onset of clinically apparent, classic vitamin A deficiency or overt beriberi, pellagra, or scurvy (14). Blood concentrations of several vitamins, such as A, B_6, or C, have been shown to be reduced during acute bacterial and viral illnesses as well as during malaria or chronic tuberculosis. Such findings were generally observed in patients whose antecedent nutritional status was either unknown or poor. Depressed concentrations of several vitamins in blood or tissues have also been reported in a variety of experimental infections in laboratory animals (14).

In contrast, it has also been shown that healthy volunteers, when given normal recommended daily amounts of vitamins throughout the course of a mild viral illness, experience relatively little change in either the urinary excretion or blood concentrations of most vitamins (3). However, an increased excretion of urinary riboflavin in these subjects began coincidentally with the onset of fever. The losses of riboflavin increased in magnitude during the early convalescent period and could be explained by the concomitant occurrence of negative nitrogen balance.

Despite the paucity of detailed information concerning the rate of utilization or metabolic fate of vitamins in body stores during an infectious process, there can be no doubt that the metabolic actions of many vitamins are required to activate various host responses. The adrenal content of vitamin C has long been known to be depleted by active steroidogenesis. The group B vitamins, vitamin C, and the folates all contribute to the adequacy of phagocytic activity by host cells. The antioxidant activity of vitamin E may have a role in protecting the lipoprotein membrane of cellular lysosomes in leprosy. Absorption of B_{12} is impaired by competition from fish tapeworms within the gut of infested patients, and the absorption of fat-soluble vitamins, folates, and B_{12} may also be impaired transiently in patients with enteric infections or parasitic infestations.

The antimicrobial drugs can also influence vitamin metabolism. Isoniazid, for example, has been thought to induce peripheral neuropathy in some tuberculous patients by causing a deficiency of vitamin B_6. Pyridoxine supplementation has therefore been suggested for patients taking isoniazid. On the other hand, patients with tuberculosis may become overly sensitive to the normal action of vitamin D and may become hypercalcemic.

The majority of published studies indicate that normal quantities of vitamins and other nutrients help to maintain host resistance at optimal levels. No clear evidence has been developed, however, to show that megavitamin therapy really benefits the host by improving resistance against the invasion and proliferation of viruses or other infectious microorganisms. Nevertheless, this prophylactic or therapeutic concept continues to intrigue both lay and scientifically trained individuals alike. As an example, recent suggestions concerning the possible value of taking vitamin C in massive quantities have been widely publicized. Although the possible values of such megavitamin therapy may seem attractive on the basis of well-told anecdotal stories or marginal differences in field studies, the carefully prepared statement of the American Academy of Pediatrics Committee on Drugs (8) points out that there is no acceptable scientific evidence that ascorbic acid prevents the common upper respiratory viral infections. In this regard, some studies currently under evaluation include sizable numbers of control subjects but have not as yet provided acceptable data supporting an antiinfectious role of gram-sized doses of ascorbic acid.

Based on the evidence presently available, the practicing physician should employ vitamins in their normally recommended doses throughout the course of an infectious illness, or at most, should increase these amounts one-fold or two-fold to cover the possibility that vitamins may be metabolized or excreted in increased amounts during hypermetabolic states. The scientific evidence needed to justify megavitamin therapy in the treatment or prevention of infectious illnesses has not as yet been generated.

POSSIBLE USE OF NEW ALIMENTATION TECHNIQUES DURING INFECTION

Techniques developed during the past decade to meet the unusually large nutritional requirements of severely burned or traumatized patients now allow surgeons to provide the total

daily caloric requirements of patients who suffer from a variety of surgical complications and sepsis. The technique of total parenteral feeding is described in other chapters of this textbook (see Chs. 11, 12). Another technique for supplying adequate calories involves using a constant-drip gavage of a chemically defined diet. Gavage is accomplished through thin-walled nasogastric catheters; the procedure has been termed "enteral hyperalimentation." Balanced amino acid and carbohydrate mixtures, when given at proper concentrations and rates, can be fully absorbed in the upper intestine with a minimum of digestive work, and gavage can therefore be used in patients with lower intestinal lesions. Because of their proven usefulness, these new concepts for providing nutritional support should be considered in the management of patients with severe primary infections.

In individuals whose nutritional stores have been depleted by severe disease or a complex surgical problem, secondary sepsis is a relatively common complication. It is generally difficult, if not impossible, to control or eliminate the septic process in such patients, even with the most vigorous utilization of antibiotics that are normally appropriate and effective. In contrast, when total parenteral alimentation is used to provide adequate nutritional support, these patients have been shown to become free of fever, to clear their blood and tissues of the invading microorganisms, and to heal their surgical lesions.

The correction of nutritional deficiencies in patients with severe septic complications appears to permit host defensive mechanisms to regain their functional adequacy. It is therefore reasonable to consider the possible usefulness of total parenteral nutritional support for overwhelming infections of a primary nature. Because of the technical need to infuse hypertonic solutions via chronically implanted central venous catheters, the process is not without danger. Microorganisms can gain access to the body through or around the catheters, and thrombus formation can be initiated within major blood vessels. Early experiences with techniques of total parenteral nutrition were frequently complicated by the contamination of the catheter, infusion solutions, or catheter dressing sites. In addition, hyperosmolality caused by the infused nutrients can produce an osmotic diuresis with dehydration and, further, may cause impaired function of phagocytic cells. Hypertonic glucose concentrations may also disturb phagocytic functions. Severe hypophosphatemia can develop in patients receiving total parenteral alimentation;

this has been shown to reduce leukocytic ATP content and to produce a marked depression in chemotactic, phagocytic, and bactericidal activities of granulocytes. Fluid overload must also be avoided. The potential value of "enteral hyperalimentation" must also be weighed on the basis of its potential dangers, which include induction of diarrhea, regurgitation, changes in gut flora, and hyperosmolar dehydration.

Currently available evidence suggests that despite the potential dangers of these newer forms of nutritional therapy, patients with severe sepsis or long-standing infectious processes may benefit by their usage. In any event, it has been shown that life-threatening septic processes due to opportunistic microorganisms can often be eliminated if appropriate antimicrobial therapy is supplemented by vigorous nutritional measures. Such demonstrations are highly instructive, for they point out the value of nutritional therapy in an unequivocal manner. This approach to therapy can sometimes be achieved with a combination of several nutritional measures. When possible, oral and IV therapy should be used to reach adequate or near-adequate intakes of calories and other nutrients throughout the acute states of a hypercatabolic infectious process.

LONG-TERM NUTRITIONAL ADJUSTMENTS

Infection-induced changes in the nutritional status of a subject, including the long-term depletion of body nutrients, are potentially reversible conditions. The full restitution of nutritional deficits that result from even a mild, self-limited infection of relatively brief duration may require several weeks of convalescence. The prolonged periods required for reconstituting body pools of essential nutrients following an infection resemble the prolonged periods of convalescence necessary after severe trauma or operative procedures. Thus, careful attention must be paid to the maintenance of optimal nutrient intakes during convalescence from an infection (7). Despite the best aims of nutritional therapy during the course of an acute infectious process, the presence of anorexia and exaggerated excretory losses from the body may create deficits that persist in the convalescing patient. Good medical practice requires that patients be instructed about the need for maintaining a nutritional program that will allow for the reconstitution of measured or suspected losses.

Although nutritional therapy during convales-

cence should correct deficits incurred during an acute infection, the temporary presence of these deficits can predispose a patient to secondary infections or weaken his resistance against an invasion by other virulent microorganisms. This problem is generally greatest in infants and small children whose nutritional requirements for growth are superimposed on nutritional needs for the maintenance of body homeostasis or for the reconstitution of nutrients pools after an infection. Thus, in the growing child, an infection often creates nutritional defects that lead to new problems with secondary infections. Such synergistic cycles are the rule rather than the exception in children who suffer from preexisting deficits of protein, calories, or both. In this case, long-term nutritional therapy may be life saving by reversing the cycle of infection, further malnutrition, and reinfection.

STRATEGIES FOR PREVENTION

NONNUTRITIONAL

Nonnutritional approaches have been highly effective in lowering the incidence of many diseases, including the historic scourges of mankind. For example, the widespread utilization of vaccines has been of major importance in helping to control or prevent infectious diseases, especially those of viral origin. The development of toxoids has been of further help in markedly reducing the toxic consequences of such diseases as diphtheria and tetanus. Improvements in sanitation and various environmental measures have gone far to eliminate water-borne and food-borne infectious diseases and to virtually eradicate arthropod-borne infections, *e.g.,* yellow fever and malaria, in the highly developed nations. A combination of effective antibiotic therapy and case-finding measures to identify carriers has helped to reduce the incidence of tuberculosis and the venereal diseases. Although none of these measures can entirely prevent infectious diseases, their implementation has proven to be of inestimable value in changing the patterns of disease incidence within the past century.

NUTRITIONAL

Evidence derived from laboratory studies, clinical observations, and field investigations, suggests that the ability of the human or animal host to resist infection reaches optimal levels when host nutritional status is adequate and there are no overt or borderline nutritional deficiencies. Further, there is evidence that an overabundance of some nutrients may be harmful and may, in fact, increase host susceptibility to infection. Obesity causes an increase in susceptibility to many infections in humans and laboratory animals (11). If an overabundance of minerals, trace elements, or vitamins reaches toxic levels, the host's ability to defend against certain microbial invaders is impaired. Thus, body nutrient stores should be adequate but not excessive if all aspects of normal host defensive mechanisms are to function optimally.

EVIDENCE OF INTERACTION

An impaired nutritional status generally lessens the ability of host defensive mechanisms to prevent infectious illnesses. This type of interaction is best exemplified by impairments in host immune mechanisms that may accompany various forms of malnutrition. These deficits in immunologic functions are seen most commonly in children with nutritional deficits of proteins, calories, or both, but they occur as well in adults who develop acute nutritional losses as a result of serious disease or surgical procedures. Impaired immune function has also been recognized in individuals with deficiencies of single vitamins or other nutrients.

The increased incidence and severity of infectious diseases in malnourished individuals can best be explained by functional inadequacies of both immunologic and nonspecific systems of host defense. Subtle-to-marked derangements develop in virtually every facet of immunologic function that can be studied in patients with nutritional inadequacies.

The immunologic abnormalities of malnourished patients can generally be corrected by nutritional therapy, but animal studies suggest that some residual defects may persist.

The ability to synthesize new proteins from amino acid precursors is a key necessity for producing either cellular or humoral immunity. Protein synthesis is also a basic requirement for maintaining nonspecific host defensive mechanisms, including the formation of phagocytic cells as well as their ability to mobilize and function. In protein–calorie malnutrition, competition appears to exist among tissues that need amino acids for growth, maintenance of body homeostasis, diverse subcellular activities, and immunogenesis. With such nutritional deprivations, body systems are unable to function optimally, and even a

mild infection can stimulate an excessive body demand for scarce nutrients.

The cellular uptake of free amino acids is governed by their intracellular and extracellular concentrations as well as by hormonal and metabolic influences on amino acid receptor sites of cell surface membranes. The body does not appear to possess a centralized control mechanism or specific priority system through which individual amino acids might be distributed equitably among various body cells. In a malnourished individual, the lack of a priority-defining mechanism seems to work to the detriment of cells of the lymphoid system which are responsible for immunogenesis. Immunocompetent cells must therefore compete with amino acid–hungry cells, such as those of muscle and liver, or with cells taking up the amino acids needed to permit body growth of children.

Published data show that a deprivation of body protein, with or without a coexisting deficit in caloric intake, will lead to widespread anatomic abnormalities of lymphoid tissues. These anatomic changes include thymic and tonsilar atrophy, generalized lymphoid hypoplasia, and a reduction in the number of circulating blood lymphocytes.

Malnourished individuals often show a depressed antibody response after immunization with widely used vaccines, although normal responses are also seen. Some of the differences in response during malnutrition may be related to the antigenic nature and potency of a vaccine. It has been found that children with kwashiokor who respond normally to a live polio vaccine may show a depressed antibody response to a live yellow fever vaccine. Children with kwashiokor also show an impaired ability of peripheral blood leukocytes to respond to the mitogenic actions of phytohemagglutinin or to mount a delayed dermal hypersensitivity reaction to skin test antigens, such as tuberculin, when these are used to evaluate cell-mediated immunity. Malnutrition also leads to impaired phagocytic activity or bactercidal capacity of peripheral blood neutrophils and to diminished concentrations of most components of the complement system in serum.

FINAL EVALUATION

Approaches to the nutritional management of infectious disease problems can be summarized in a series of guidelines and therapeutic steps of value in most clinical situations.

Body defensive mechanisms to prevent or minimize infectious illnesses seem to function best when a patient is in normal nutritional balance. Deficits or excesses of nutrients may predispose a patient to an increased risk of infection or to an infection of increased severity.

Although nutritional management during the therapy of most infections falls into the realm of secondary or supportive care, on rare occasions immediate correction of a nutritional abnormality may be of life-saving importance and should then take precedence in the management of the illness. These emergency situations generally involve the correction of severe fluid and electrolyte imbalances or acid–base abnormalities. Severe hypoglycemia must also be corrected without delay.

In most nonviral infections the selection of an appropriate antimicrobial drug and dosage schedule, or a combination of these drugs should form the major bulwark of therapy. In a previously healthy person, the nutritional management of infection should aim at preventing or lessening the absolute and functional forms of anticipated nutrient wastage. Control of fever will lessen the ultimate severity and duration of nutrient wastage and can thus be categorized as a preventive measure in nutritional management. In addition to the control of fever, efforts should be made to supply adequate amounts of key nutrients to meet body needs during the illness.

Maintenance of an adequate caloric intake is the most important single need. Adequate but not excessive intakes of protein (or other amino acid sources) and vitamins are important secondary goals. Adequate nutritional therapy may require the use of parenteral infusions to meet the caloric needs of a patient. In patients who are already severely malnourished, the use of parenteral nutrients may make it possible to control and eliminate septic processes that cannot be managed by antibiotics alone. The administration of specific minerals or trace elements is not generally required during an acute brief infectious illness.

Nutritional deficiencies begin to develop in infections of even short duration and become clinically important if febrile patients are unable to consume dietary nutrients. Should an infectious process become chronic, it will be accompanied by a more complex variety of nutritional inadequacies, some of which are difficult to correct until the infectious process can be controlled or eliminated.

Because of their nutritional deficits, patients who recover from an acute infectious illness

face greater-than-normal danger from occurrence of secondary infections during early convalescence. This danger can be lessened by vigorous attempts to repair or correct nutritional deficits suffered during the acute phases of illness.

Finally, in patients with overt preexisting nutritional defects, corrective nutritional therapy should lead to a reversal of abnormal host defensive functions and lessen the danger from superimposed new infections.

REFERENCES

1. Beisel WR: Nutrient wastage during infection. In McKigney JI, Munro HN (eds): Nutrient Requirements in Adolescence. Cambridge, MIT Press, 1975, pp 257–278

2. Beisel WR, Goldman RF, Joy RJT: Metabolic balance studies during induced hyperthermia in man. J Appl Physiol 24:1–10, 1968

3. Beisel WR, Herman YF, Sauberlich HE, Herman RH, Bartelloni PJ, Canham JE: Experimentally induced sandfly fever and vitamin metabolism in man. Am J Clin Nutr 25:1165–1173, 1972

4. Beisel WR, Pekarek RS, Wannemacher RW Jr: The impact of infectious disease on trace-element metabolism of the host. In Hoekstra WG, Suttie JW, Ganther HE, Mertz W (eds): Trace Element Metabolism in Animals—2. Baltimore, University Park Press, 1974, pp 217–240

5. Beisel WR, Sawyer WD, Ryll ED, Crozier D: Metabolic effects of intracellular infections in man. Ann Intern Med 67:744–779, 1967

6. Benenson AS: Cholera. In Mudd S (ed): Infectious Agents and Host Reactions. Philadelphia, WB Saunders, 1970, pp 285–302

7. Butterworth CE Jr: Malnutrition in the hospital. JAMA 230:879, 1974

8. Committee on Drugs, American Academy of Pediatrics: Vitamin C and the common cold. Nutr Rev [Suppl] 32 (1):39–40, 1974

9. Long CL, Spencer JL, Kinney JM, Geiger JW: Carbohydrate metabolism in man: effect of elective operations and major injury. J Appl Physiol 31:110–116, 1971

10. Moore FD, Olesen KH, McMurrey JD, Parker HV, Ball MR, Boyden CM: Acute injury and infection: operation, open trauma, sepsis, burns, fractures. In The Body Cell Mass and its Supporting Environment. Philadelphia, WB Saunders, 1963, pp 224–277

11. Newberne PM, Young VR, Gravlee JF: Effects of caloric intake and infection on some aspects of protein metabolism in dogs. Br J Exp Pathol 50:172–180, 1969

12. Rapoport MI, Beisel WR: Studies of tryptophan metabolism in experimental animals and man during infectious illness. Am J Clin Nutr 24:807–814, 1971

13. Rayfield EJ, Curnow RT, George DT, Beisel WR: Impaired carbohydrate metabolism during a mild viral illness. N Engl J Med 298:618–621, 1973

14. Scrimshaw NS, Taylor CE, Gordon JE: Interactions of Nutrition and Infection. (Monograph 57) Geneva, WHO 1968

15. Weinberg ED: Iron and susceptibility to infectious disease. Science 184:952–956, 1974

23 Renal disease

Todd S. Ing, Robert M. Kark

Patients with renal disease can be characterized into two main groups: 1) those who have primary renal disease involving the parenchymal structures of the kidneys and 2) those whose renal abnormalities are secondary to disease processes elsewhere in the body. This latter group can be further subdivided into those with renal parenchymal disturbances secondary to disease in the conduit of the urinary tract (*e.g.,* urinary tract obstruction and urinary tract infection) and those in whom the disease process is the result of such disparate systemic abnormalities as systemic lupus erythematosus (lupus glomerulonephritis), hypertension (ischemic interstitial nephritis), diabetes (diabetic nephropathy), Wilson's Disease (secondary Fanconi syndrome), septic shock (acute renal failure), and methicillin hypersensitivity (acute interstitial nephritis).

Disorders which affect the kidney can in the main be grouped into the following series of different syndromes with varied presentations, findings, and therapeutic managements:

Obstructive uropathy (benign prostatic hypertrophy; urethral strictures)

Acute nephritic syndrome (poststreptococcal nephritis, Henoch–Schönlein purpura)

Acute renal failure (shock, hepatic failure, acute renal artery obstruction, mismatched blood transfusions)

Acute pyelonephritis (*E. coli* infection, staphylococcal infection)

Nephrotic syndrome (lipoid nephrosis, membranous nephropathy)

Interstitial nephritis (analgesic nephropathy, drug toxicity)

Renal calculi (oxalate, urate)

Renal tubular disorders (renal tubular acidosis, nephrogenic diabetes insipidus)

Besides these syndromes, abnormal urinalyses may indicate syndromes of:

Hematuria (benign recurrent hematuria, neoplasm of the kidney, papillary necrosis)

Proteinuria (orthostatic; fixed and persistent)

Pyuria (prostatitis, urethritis, systemic lupus erythematosus)

Other abnormalities

In most patients, urologists and nephrologists work together to treat the patients by operation or with antibiotics, steroid hormones, cytotoxic agents, and antihypertensive drugs. The complications of disease involving the kidneys produce end-stage renal disease in which there is increasing functional failure (chronic renal failure, uremic syndrome). Chronic renal failure can be managed by dialysis or renal transplantation and by manipulations of dietary intake. Fluid, electrolyte, and acid–base problems develop frequently and require precise control. Acute functional failure (acute renal failure syndrome) is also managed by dialysis and nutritional manipulations of dietary intake. Renal calculi may respond to nutritional care as does the nephrotic syndrome and some forms of tubular disease.

The incidence of renal stones is one hospitalization per thousand of the population per year whereas primary parenchymal renal disorders are not common. Chronic renal failure develops in about 40 persons per million per year in the Western world. However, considering the total numbers of aged persons and the high incidence of diabetes and primary hypertension in our population, the number of patients who have the potential to develop chronic renal failure in the population is astronomic. No figures are available, but if one considers, for example, that 20% of the population has hypertension and that at a minimum one-fifth of them will develop chronic renal failure, then more than 8 million of the hypertensives now in the United States may ulti-

*We wish to thank Ms. Jeanne Ward, RD, and Ms. Judy Beto, RD, for assistance in the preparation of the chapter.

mately require nutritional care and dialysis. The problems of nutrition and dialysis in both chronic and acute renal failure are paramount in the renal physician's practice.

CHRONIC RENAL FAILURE

If man were like the hibernating black bear, perhaps the most difficult nutritional problems in patients with renal disease might be easily managed. The black bear goes into hibernation some time in November and usually comes out in April. During all this time, hibernating bears do not urinate or pass feces. During the winter sleep, some urine is formed and is reabsorbed through the bladder wall. However, what is most remarkable is that at the end of the 100 days or so of anuria, there is no net accumulation of the common metabolic end-products of protein catabolism in the blood. The concentrations of total amino acids, total protein, urea, ammonia, and uric acid remain unchanged throughout the winter. The concentrations of individual amino acids in the blood do not change consistently during hibernation. There is no fecal storage of nitrogenous substances, as fecal samples obtained on the first day after winter sleep contain virtually no nitrogen. On the other hand, when the bears are starved during the summer and water is withheld, they become dehydrated and do not adapt as they do in the winter. Blood urea levels then rise rapidly and urea excretion continues in the concentrated urine.

Excluding dehydration and other extrarenal azotemic disturbances, oliguria or anuria in man is associated with acute or chronic renal failure, or with urinary tract obstruction. These latter three syndromes produce nitrogen retention because the body is unable to efficiently recycle the nitrogen derived from protein metabolism. As a result, nitrogenous waste-products such as ammonia, urea, creatinine, uric acid, phenols, trimethylamines, methylguanidine, and guanidino-succinic acid accumulate in the body. Many of these nitrogenous compounds (and other unknown ones) are suspected by some to be uremic "poisons." Whether they are or not, their presence in high concentration in the body is associated with signs and symptoms of renal insufficiency and their removal by dialysis is associated with marked clinical improvement in the patient.

But to return to the hibernating bear, who has been brilliantly studied by Nelson and his colleagues (16). Since nitrogenous end-products do not accumulate during hibernation in the blood and are not excreted in the urine or stored in the feces, the metabolism of nitrogen must be altered to maintain lean body mass. Nelson *et al.* have speculated that ammonia resulting from the catabolism of tissue amino acids in the black bear's body may efficiently be recycled for the synthesis of the two amino acids, glutamic acid and alanine, utilizing glycerol released from adipose tissue deposits during the winter:

1. Glycerol → Pyruvic acid
2. α-Ketoglutaric acid + NH_3 → Glutamic acid
3. Pyruvic acid + Glutamic acid → Alanine + α-Ketoglutaric acid
 Sum: Glycerol + NH_3 → Alanine

The hormonal control of hibernation has been related to the brown fat organ, and it is tempting to postulate that eventually we may find hormones in bears and other hibernators which when injected into man may allow more-efficient recycling of nitrogen. If true, this could have tremendous implications for human nutrition, not only in renal insufficiency, but in relation to world protein needs and many other situations where problems with protein depletion exist.

Be that as it may, in 1973, Walser *et al.* (24) first used a diet, in which a mixture of α-keto-acid analogues of essential amino acids (namely, valine, leucine, isoleucine, methionine, phenylalanine, tryptophan and histidine) was used to feed patients with severe uremia. The aim of therapy was to reutilize urea nitrogen for conversion of α-keto acids to the corresponding essential amino acids, thus lowering blood urea concentration and promoting protein synthesis, and it was found that such a diet apparently diminishes the rate at which urea accumulates in the body fluids of uremic subjects. Since then treatment of end-stage renal failure with α-keto-acid diets has been under study in a number of clinical research units.

While the usefulness of α-keto-acids and essential amino acids is under study, there are still the day-to-day problems of nutrition in chronic renal failure. Initially, nearly all patients with chronic renal failure begin with a program of conservative management, and most of these, at least in the United States, move on to a program of maintenance dialysis. With the tremendous development of dialysis programs, the nutritional care of patients with end-stage renal failure has become one of the most important and taxing problems in nephrology, but dialysis and nutritional care are not and can never be totally satisfactory since healthy kidneys perform many

functions besides excretory ones. Restoration to nutritional and metabolic health occurs only with successful renal transplantation.

CONSERVATIVE MANAGEMENT OF CHRONIC RENAL FAILURE

In patients with chronic renal failure (2, 4), few functioning nephrons remain. These are usually hypertrophied and functioning at the upper limits of their activity. They have little reserve left to deal efficiently with new catabolic loads that may appear as a result of infection, trauma, drug administration, or excessive dietary intakes. Moreover, during the slow development of chronic renal failure, the cells of the body are bathed in an abnormal fluid and, in many cases, appear to have come into a new homeostatic equilibrium with the altered humoral environment. In fact, some patients with progressive renal disease have done very well for years without the special attention of a physician. These patients spontaneously modified their dietary and fluid intake to keep themselves alive and functioned very well till near the end, when their homeostasis was overwhelmed by the inevitable destruction of nephrons. Therefore, it is important to recognize that changing personally established patterns of fluid intake and diet, which so often occurs when these patients are admitted to hospital for any cause, may do more harm than good. Under these circumstances, establishing new dietary regimens must be done cautiously and with circumspection.

All patients with chronic renal failure need thorough investigation when first seen to make sure that remediable causes, such as obstructive uropathy, renal artery stenosis, hypercalcemia, or analgesic abuse, are not overlooked. Before long-term plans may be formulated it is important to know the patient, his family, and his environment. It is then possible to instruct and reinstruct the patient and the family on the problems of care, be they nutritional, drug-related, or environmental. The usefulness and limitations of dialysis and transplantation must be discussed in detail because there is a tendency at present for families and friends to expect too much from such treatments.

In chronic renal failure, the aims of treatment are to minimize protein catabolism, to avoid dehydration and overhydration, to maintain electrolyte balances within normal limits as far as possible, to gently correct acidosis, and finally, to treat complications such as hypertension, renal osteodystrophy, and central nervous sys-tem abnormalities. In these patients, nutritional status is nearly always below par and one must try to keep it at a reasonable level.

Very few patients in this society have the ability and stamina to accept, day in and day out, monotonous, limited, and tasteless foods or to subsist on synthetic mixtures of amino acids, fats, and carbohydrates, important as they may be at times in sustaining life. It is easy to ensure an adequate intake of vitamins, iron, minerals, and trace elements by regularly using one of the formulated therapeutic mixtures that are available. For the long haul, creative dietetics, innovative meal planning, and skilled cooking are needed to make the restricted regimens as palatable as possible. The physician looking after such patients must educate and encourage each patient's family to: 1) seek variety in meals, *e.g.*, by the use of such books as Bowes and Church's *Food Values of Portions Commonly Used*, from which they can select foods low in protein; 2) learn to use ale, wines, and spices to add some joy to life; and 3) experiment with unusual protein-free foods, *e.g.*, cornstarch, sago, arrowroot, and tapioca. They should learn all about the use of eggs and egg protein in preparing main courses and in concocting desserts, such as nougats. Of course, dietitians carry the major burden of the day-to-day nutritional care of the patient. It is imperative for the physician to work hand in glove with the "renal dietitian" and to support his or her function by positive discussions with the patients about their intakes of food and fluid. This is necessary to maintain morale in those doing well, and it is absolutely necessary when patients are not heeding advice.

PROTEIN NITROGEN AND CALORIC INTAKE

How can protein catabolism be reduced to prevent the accumulation of toxic end-products? A diet completely free of protein has been tried in numerous metabolic experiments but is very ineffective and proves very soon to be disastrous. Starvation may initially control nausea, if present, but tissue protein breaks down more rapidly. On the other hand, an excellent intake of non-protein calories does reduce protein catabolism.

Giordano (8) and Giovanetti *et al.* (9) reasoned that if one provided a diet containing ample calories and balanced amounts of essential amino acids as the main source of nitrogen according to Rose's formula for man the body would mop up urea for synthesis of nonessential

amino acids. To encourage utilization of urea, exogenous nonessential amino acids must be depleted. When the above diet was given to azotemic patients, the blood urea and nonurea nitrogen levels fell and clinical improvement occurred. Giovanetti and his colleagues planned diets for their Italian patients with a powdered essential amino-acid mixture or eggs as the source of prime protein and supplied calories through sugar, honey, jams, unsalted butter, unsalted lard, vegetable oils, special wafers made from maize starch, and spaghetti prepared from a low-protein wheat starch (9). The amino-acid pattern of eggs comes very close qualitatively and quantitatively to Rose's formula, and eggs have the highest biologic value of any protein tested. Berlyne *et al.* (3) report similar successes with a British modification of the diet in Manchester, England, using an 18-g protein diet consisting of animal protein in the form of egg and milk and vegetable protein.

A strict Giordano–Giovanetti diet produces a remarkable reduction in uremic symptoms and a steady fall in blood urea value, but not in serum creatinine level. The main problem with these diets is the difficulty of providing adequate carbohydrate and fat calories in a palatable form, particularly in regards to protein-free, or protein-poor, cereal products. Fat and a moderate alcohol intake can provide additional calories. On such a diet, severe acidosis and hyperkalemia are common and adherence to such a diet requires tremendous perseverence on the part of the patient and his family, the dietitian, and the physician (3). The patient may feel that the diet is worse than the disease, particularly if symptoms were few to begin with.

Fortunately, Kopple and Coburn (13) have shown recently that, in chronically uremic patients with glomerular filtration rates above 4 ml/min/1.73 m², a protein-restricted, high-calorie diet consisting of 0.6 g/kg body weight/day (about 40 g) of protein of which a minimum of 70% is of high biologic value, resulted in a similar amelioration of uremic symptoms as a Giordano–Giovanetti type (20 g protein) diet. In addition, better nitrogen and potassium balances were obtained. The availability of 20 extra grams of protein per day allows a more varied and palatable meal pattern. As a result, patients accept and follow such a diet much more readily.

With regard to meal planning and preparation, the Mayo Clinic Renal Diet Cook Book (Margie, JD *et al.,* Western Publishing Company, NY, 1975) provides exchange lists, recipes, and menus. It is most useful and should be consulted. Local chapters of the Kidney Foundation and the National Kidney Foundation have councils on renal nutrition which work on exchange lists and provide recipes. The renal dietitians are continuously exchanging new recipes. In addition, new dietary products for chronic renal failure patients are being produced all over the world as well as in the United States. Natural low-protein carbohydrate foods such as sago and arrowroot are available in grocery stores across the United States. Low-protein flour (*e.g.,* Paygel–P Wheatstarch Flour, Dietetic Paygel Baking Mix, Cellu-low Protein Baking Mix, and Aproten Pasta) is now available and can be used to make baked goods, pasta, or pancakes. Various kinds of jams, preserves, sugar, honey, hard candies, jelly, popsicles, and gum drops also supply protein-free calories, but their sweetness tends to cloy the palate. Liquid glucose and corn syrup are complex carbohydrates produced by hydrolysis of starch; they supply protein-free and electrolyte-free calories and are less sickly tasting than sucrose. The hydrolysis and treatment of starch has made available protein-free and electrolyte-free carbohydrate preparations having a neutral taste (*e.g.,* Polycose, Hycal, Cal-Powder, and Controlyte). Some of these, when taken in concentrated quantities, tend to produce diarrhea due to hyperosmolality. However, when administered properly, hyperosmolality can be avoided.

In the United States, government support for end-stage renal disease has allowed an increasing pool of patients to be accepted for maintenance dialysis. In addition, this support is at present available for all patients on maintenance dialysis, and there are no restrictions for age, or disease processes involving the kidneys. The size of the pool of patients appears increasing very rapidly, and it is obvious that a wide variety of patients with common disorders such as diabetes or rare diseases such as tuberose sclerosis may present themselves for treatment. As selection committees rarely reject any patients for maintenance dialysis, proper nutritional care of the primary disease as well as the renal failure produces at times complex dietary problems that have to be solved.

As most patients develop chronic renal insufficiency slowly, there is usually more than ample time to train the patient and his family. The patient learns about the long-term life style that he has to adopt to survive. The family, hopefully, learns how to support the patient to reach the nutritional goals set by the physician and the

dietitian. On the other hand, the physician, the dietitian, and the social worker learn about the patient's desires and ability to comply to the regimen, and whenever necessary the physician and his staff can provide educational, behavioral, or psychiatric modalities of care to help those patients who fail to comply.

The selection of a diet for the individual patient is based on the degree of renal insufficiency, the presence or absence of hypertension, and the ability of the patient to respond to diuretics. Many patients first come to the attention of renal physicians seriously ill with uremia, water and electrolyte disturbance, edema, anemia, and a host of other problems. Some have massive proteinuria, and others have developed irreversible acute renal failure. There is no time to indoctrinate these patients before they start maintenance dialysis. Many must be managed in an intensive care unit and require immediate hemodialysis or peritoneal dialysis. This is another reason why nutritional instruction has to be on an individual basis, but nevertheless, classes for patients and their families on the simple facts of renal disease, intercurrent illnesses, behavioral disturbances, water and electrolyte control, caloric, protein, carbohydrate, lipid, mineral and vitamin consumption, care of shunts and fistulae, as well as principles and practice of dialysis are most helpful.

For each patient, there has to be a prescription for calories, protein, carbohydrate, and fat. Intake should be planned in accordance with estimated ideal lean body mass. Total calories provided should be in the neighborhood of 35–45 Cal/kg body weight/day (2500–3000 Cal). Protein requirement should be 0.6–0.8 g/kg body weight/day (40–60g) when the patient's serum creatinine reaches 4–6 mg %. At least 70% of the protein should be of high biologic value. This degree of protein restriction commonly leads to amelioration of uremic symptoms, but with progressive deterioration of renal function, uremic symptoms will develop even though the patient is placed on a 40-g protein diet. At this stage, it usually means that the creatinine clearance is low enough (less than 5 ml/min) to require dialytic therapy. If there is gross proteinuria, e.g., 10 g protein/day, this same amount of protein is added to the dietary prescription. Thus, protein provides 160–240 Cal while the rest of the calories has to come from both carbohydrates and fat.

Providing this many calories from palatable carbohydrate sources that are relatively free of vegetable protein while at the same time at-tempting to provide as much animal protein (eggs, chicken, veal, beef, pork) as possible is very difficult. The protein content of staple foods such as bread (8%–10%), potato (2%), rice (7%), and corn (3.5%) provide considerable amounts of vegetable protein. The more vegetable protein the patient consumes, the less animal protein becomes available on the diet each day. Thus the dietary fat content is often increased to provide calories. Hyperlipidemia and vascular disease are common complications of chronic renal failure, but the influences of diet and antilipemic drugs on the lipid abnormalities are still unclear. In order for a low-protein diet to be acceptable for long-term treatment, variety and palatability are essential. The dietitian arranges the diet by taking into account the family pattern of eating and works continuously with the patient to assist in making selections of food when the dietary restriction food lists are used. A meal plan is organized for each patient at the prescribed protein level, giving the number of food exchanges which the patient can have each day. Maintenance of weight is stressed, and the patient is encouraged to consume nonprotein foods. For better nitrogen utilization, the patient is taught to divide the high biologic value animal protein foods evenly between the meals, with carbohydrates and fat being consumed along with dietary protein.

SODIUM AND WATER

The physician dealing with a patient in chronic renal failure must ascertain how much sodium and water the patient can excrete and how much he should consume. If given too little sodium and water (a common occurrence), the patient will become dehydrated, glomerular filtration will decline, and he will become more uremic. On the other hand, if excessive sodium and water are allowed in a patient whose renal insufficiency has progressed to the point at which he can no longer properly handle sodium and fluid loads, overhydration, edema, hypertension, congestive heart failure, and death are the consequences. In other words, the kidney's ability to conserve sodium in the presence of sodium depletion and to dispose of sodium in the face of sodium excess is impaired in chronic renal insufficiency. Indeed, sodium depletion and dehydration constitute one of the commonest reversible causes for deterioration of renal function in patients with chronic renal failure. This is particularly true in patients with interstitial nephritis,

pyelonephritis, hydronephrosis, medullary cystic disease, polycystic kidney disease, analgesic nephropathy and other so-called "sodium-losing" nephropathies who may excrete exceedingly large quantities of sodium and water in the urine.

It is important for the physician to be able to tell the nonedematous patient how much sodium and water he needs to take. Any sodium and water deficits should, first of all, be amply replaced. A good way to ensure sodium and water repletion is to slowly increase intakes under controlled conditions until slight edema appears. The patient is then placed on a fixed sodium intake, *e.g.,* 50–80 mEq/day and daily urine sodium levels are determined. If the level of the patient's urinary sodium excretion exceeds that in the diet, sodium intake is increased gradually to the point at which sodium intake and output are approximately equal. Patients who lose enormous quantities of sodium should be given extra packets of salt to sprinkle on their food. The use of salt tablets is not recommended since they do not dissolve easily in the bowel and may cause intestinal distress. In patients who have worsening of hypertension with sodium repletion, appropriate antihypertensive agents should be used. With regard to water requirement, an easy way to determine how much water the patient needs is to have him urinate daily into a large measuring jar. The next day's fluid requirements can be assumed to be the previous day's urine output plus 400 ml (*i.e.,* insensible loss of 800 ml minus water of metabolism of 400 ml). The optimal fluid intake for each patient varies but is usually of the order of 2.5–3 liter a day. Frequent monitoring of the patient's weight is a valuable guide to the state of hydration. Other patients may not be able to excrete the 50–80 mEq sodium in their trial diet, and their urinary sodium losses will be less than their sodium intakes. They gain weight, develop edema, and become hypertensive. The excess sodium and water retained can then be got rid of with potent diuretics and subsequent sodium and water intakes should then be reduced in accordance with urinary outputs.

In the patient in whom fluid overload with sodium retention or oliguria is a problem, potent diuretics such as furosemide should be tried. The usual doses of furosemide, which in normal persons can induce massive diuresis, are not effective in severe renal failure. Daily dosages of several hundred milligrams to several grams are usually required to ensure an adequate urine output. After correction of the excessive sodium and water retention, the patient can be placed on maintenance therapy with the drug and subsequent sodium and water allowances regulated according to urinary losses. When using this regime, dehydration and sodium depletion must be carefully guarded against. Salt substitutes should be used cautiously if at all since they contain ammonium or potassium salts. In the latter instance, severe hyperkalemia may develop.

As the patient's disease worsens, changes in sodium requirements will occur and adjustments in sodium intake will have to be made. Weight loss, lethargy, and decreasing urinary output may indicate that the patient needs more salt and water, whereas hypertension, weight gain, and edema usually indicate that the patient needs less salt and water.

POTASSIUM

Even though hyperkalemia is an ever present danger and a common cause of death in patients with chronic renal insufficiency, potassium retention is usually not seen until the glomerular filtration rate is severely compromised, *i.e.,* below 5 ml/min, or when sodium intake is severely restricted. Sodium restriction will decrease delivery of sodium to the distal tubule (where sodium-potassium exchange takes place) with a resultant fall in potassium excretion. Unnecessarily large intakes of potassium and potassium-sparing diuretics such as spironolactone and triamterene should, however, be avoided. Patients can receive large quantities of potassium in certain foods (see Table A-5), in transfusions of old blood, and through large doses of drugs administered as potassium salts, such as potassium penicillin. Electrocardiograms (EKG) are helpful in detecting serum potassium abnormalities, but significant hyperkalemia or hypokalemia may be present without startling EKG changes. Generally, severe dietary restriction of potassium is not required until renal insufficiency is far advanced. Hyperkalemia usually responds well to simple measures (life-threatening hyperkalemia is dealt with in the section on Acute Renal Failure). This may be accomplished by the use of the cation exchange resin, sodium polystyrene sulfonate (Kayexalate), which should be given with a purgative to promote diarrhea in order to avoid the formation of concretions in the gut. It can be given orally in a dose of 15 g dissolved in 20 ml of a 70% sorbitol solution several times a day. If faster action is

required or if the patient cannot tolerate oral medications, it can be given as a retention enema (50 g mixed with 50 ml of a 70% solution of sorbitol and 100 ml water). It is desirable that the resin remain in the colon for 30–60 min. Enemas may be given hourly until the crisis is over and thereafter may be used, if necessary, several times a day. In the gut, approximately 1 mEq potassium will exchange with each gram of the drug.

PHOSPHATE, CALCIUM, AND VITAMIN D

As nephron population declines, the fall in glomerular filtration rate leads to retention of phosphate. This results in lowering the ionized calcium level, which stimulates the secretion of parathyroid hormone. The latter increases the excretion of phosphate and raises the serum ionized calcium level. When the creatinine clearance falls below 25 ml/min, parathyroid hormone secretion is no longer sufficient to lower the serum phosphate level and increase the serum calcium concentration to normal values. Persistent hypocalcemia then results in a sustained elevation of the parathyroid hormone concentration. This phenomenon induces bone reabsorption and in the most advanced cases leads to osteitis fibrosa cystica.

A chronically diseased kidney is unable to convert 25-hydroxycholecalciferol (produced by the liver from vitamin D_3) into 1,25-dihydroxycholecalciferol (1,25-DHCC), which is believed to be the biologically active form of vitamin D_3 (see Ch. 19).

This vitamin hormone is believed to be responsible for the maintenance of plasma calcium and phosphate concentrations at supersaturating levels so that mineralization of newly formed bone can take place. The vitamin achieves its action by promoting the mobilization of calcium and phosphate from previously formed bone (the concomitant presence of parathyroid hormone being necessary for this process) and by facilitating the absorption of these two ions from the small intestine. In chronic renal failure a deficiency of 1,25-dihydroxycholecalciferol results in failure of the calcification process to proceed at a rate sufficient to mineralize newly formed areas of bone. As a consequence, rickets is obtained in children and osteomalacia in adults (7).

Daily microgram doses of 1,25-DHCC over many weeks slowly correct the serum calcium levels and improve muscle power and the abnormal histologic and radiologic appearance of bone. Bone pain disappears. At present, apart from the level of dosage, there does not seem to be any difference in the effects produced by milligram dosages of vitamin D. The principal advantage of 1,25-DHCC over vitamin D is that its duration of action is relatively short, so that it is unlikely to be stored in the tissues (whereas vitamin D is). It is hoped that 1,25-DHCC or a synthetic analogue, 1-α-hydroxycholecalciferol will soon be commercially available.

Oral doses of vitamin D (about 50,000–100,000 IU/day) or of dihydrotachysterol (0.25–0.375 mg or more daily) are helpful in improving hypocalcemia and healing the lesion of osteomalacia. Dihydrotachysterol is preferred on account of its shorter half-life. However, to prevent metastatic calcification serum calcium levels must be followed weekly and therapy discontinued if there is hypercalcemia or if the product of serum calcium and phosphate concentrations (both expressed as mg %) exceeds 70.

Lowering phosphate intake by reducing dietary protein as outlined previously is helpful in decreasing phosphate levels. Aluminum hydroxide gel given by mouth (30 ml three or four times daily) will bind phosphate in the gut and thereby lower the serum phosphate level. Vigorous lowering of hyperphosphatemia with phosphate restriction and aluminum salts helps to elevate serum calcium level and alleviate secondary hyperparathyroidism (21).

In the face of hypocalcemia, calcium can be given in the form of calcium salts, *e.g.,* calcium carbonate, calcium lactate, or calcium gluconate. One to three grams calcium can be supplied daily this way. Calcium supplements are contraindicated in the presence of hypercalcemia or if the product of serum calcium and phosphate levels is greater than 70.

MAGNESIUM

Magnesium excretion is impaired in renal insufficiency, and dangerous serum levels of magnesium may be reached if the intake of this ion is high. Symptoms of hypermagnesemia include hypotension and respiratory paralysis. In patients with renal insufficiency the use of magnesium-containing compounds such as antacids or laxatives should be avoided. Non-magnesium-containing substances should be used instead.

VITAMINS

When the daily protein intake is less than 50 g, multivitamin supplements should be taken daily.

MANAGEMENT OF PATIENTS ON MAINTENANCE DIALYSIS

Early decision for maintenance dialysis or transplantation in a patient with chronic renal failure is essential as it permits proper indoctrination of the patient and his family and allows treatment to begin before debilitation sets in. Patients with glomerular filtration rates in the neighborhood of 10 ml/min usually manage to get along reasonably well with conservative management. However, maintenance dialysis should be initiated at the first signs of irreversible clinical deterioration. This usually occurs when the patient's creatinine clearance approaches 5 ml/min. By this time, the patient and his family will hopefully have acquired a good understanding of the nutritional problems associated with chronic renal failure. Moreover, by the time the patient is ready for hemodialysis, an arteriovenous fistula should have been created and should have "ripened" for use. But all too often patients are first encountered in a seriously decompensated state with previously unrecognized chronic renal failure. As a result, peritoneal dialysis frequently must be performed promptly, with the patient learning about the nutritional care of his illness under far from ideal circumstances. Primary care physicians should realize that it is important to have patients with early chronic renal failure taken care of jointly with nephrologists long before advanced renal decompensation sets in. Once maintenance dialysis is begun, the intake of protein is liberalized so that patients can be kept as nutritionally healthy as possible. This is achieved by prescribing 1–1.25 g protein/kg body weight/day (70–90g) for hemodialysis patients, and 1.5–2.0 g protein/kg body weight/day (110–140g) for peritoneal dialysis patients. At least 70% of the protein should be of high biologic value. An ample protein intake will usually make up for the loss of amino acid that occurs with each hemodialysis (equivalent to less than 10 g protein) or for the loss of protein that accompanies each peritoneal dialysis (20–150 g protein). Should the patient's BUN be unduly high with the above levels of protein intake, dialysis can be increased. Intakes of calories should be those prescribed prior to the initiation of maintenance dialysis. The sodium intake is set at 20–130 mEq daily, depending on the degree of hypertension and the amount of urinary sodium loss. Potassium intake is usually limited to 50–80 mEq daily. In addition, an appropriate amount of fluid is allowed so that patients do not gain more than 0.5 kg/day between dialysis treatments. The amount of fluid intake allowed daily should be 500–800 ml plus the daily urine volume. This, together with the water contained in ingested food as well as the water of oxidation, should cause the patient to gain no more than the above-stated amount. Strict control of both sodium and fluid intake is essential in patients with marked hypertension (10). Water-soluble vitamins including folic acid are dialyzable and should be supplemented. Phosphate binders in the form of aluminum hydroxide should be given to lower hyperphosphatemia. After a normal serum phosphorus level has been achieved, persistent hypocalcemia can be treated with calcium in the form of oral calcium supplements and a high-calcium dialysate bath, as well as with vitamin D or related drugs. In the presence of uremic osteomalacia, vitamin D therapy is definitely indicated. On account of frequent blood losses, either from GI bleeding or from the usual external loss attending hemodialysis, body iron content is frequently low and an oral iron preparation such as ferrous sulfate, 300 mg three times daily, is often prescribed. When absorption of oral iron is defective or iron stores are inordinately low, IV iron dextran injection therapy may be administered. The total quantity of the drug required to bring the patient's hematocrit to the desired level is calculated. A test dose of 0.5 ml is first given. Should no untoward reactions occur, 2 ml of the medication is administered slowly during each dialysis until the total dose is completed over a period of weeks. Androgens are also usually given to alleviate the anemia by inducing red cell production and increasing erythropoietin levels. A commonly used preparation is nandrolone decanoate, 100–200 mg/week given intramuscularly.

MANAGEMENT OF PATIENTS AFTER RENAL TRANSPLANTATION

After a successful renal transplantation, dietary restriction is no longer necessary except perhaps in those who develop hypertriglyceridemia. In such patients, the use of a low calorie, low carbohydrate diet has been recommended by some investigators.

RENAL DISEASE STATES

ACUTE TUBULAR NECROSIS

The vast majority of patients with acute renal failure have acute tubular necrosis (also known as vasomotor nephropathy). It has been 35 years since Bywaters and Beal described the crush syndrome. This is the first clear-cut description of acute tubular necrosis, which was observed to develop in the citizens of London buried under the rubble of buildings bombed by the Germans in World War II. In 1947, Borst described his rational diet of butter balls and sugar with a restricted fluid intake for its nutritional management. From a clinical and nutritional point of view, the major problems encountered in dealing with acute tubular necrosis are infections, GI bleeding, and hypercatabolism. When these complications occur, mortality is usually inordinately high (50%–80%).

Acute tubular necrosis is a symptom complex associated with a sudden decrease in renal function. Usually, there is oliguria. On occasion, there is no decrease found in urinary volume, but there is failure to excrete the waste products of catabolism. This is "nonoliguric or polyuric renal failure" (*e.g.*, such as occurs with methoxyflurane toxicity). Acute tubular necrosis may be brief with spontaneous recovery, or prolonged (two to three weeks or longer). In the latter situation, there may be no recovery of function. The first order of business in dealing with the patient is to diagnose and remove the cause, correct its total effect on the body's economy, restore fluid volume and acid–base and electrolyte imbalances to normal, alleviate suffering and anxiety, adjust cardiovascular function, and repair tissue damage. These measures are instituted as quickly as possible while avoiding overtreatment. The physician must be sure that there is no obstruction to the flow of urine from the kidneys and must remember that since many of the drugs and antibiotics required for the treatment of acute renal failure are excreted by the kidneys their dosage must be reduced to avoid toxicity.

The classic indications for dialysis used to be hyperkalemia, gross overhydration, acidosis (CO_2 content less than 15 mEq/liter), marked azotemia (BUN over 150 mg/100 ml), and clinical deterioration, especially appearance of uremic pericarditis. Nowadays, patients are dialyzed early so that these complications are rarely allowed to occur. In the absence of hypercatabolism, the daily rise of BUN will be in the region of 20 mg/100 ml or less. Major operations, severe trauma, overwhelming shock, serious infections, and complicated illnesses all suggest that a hypercatabolic situation is present or will appear. On the other hand, a brief hypotensive episode, during a GI hemorrhage in an otherwise healthy young man or in a pregnant healthy young woman with placenta previa suggests a mild short period of oliguria. The physician also recognizes that nausea, vomiting, GI operations, abdominal crises, and trauma may make oral feeding impossible. He knows that if the renal failure persists more than several days, repeated dialysis is likely to be necessary to prevent uremic complications.

When the patient is in the early stage of acute tubular necrosis and the BUN is not greater than 80 mg/100 ml, conservative management is indicated. If the patient can eat, the intake is set at 35–45 Cal/kg body weight/day, with 0.25 g high biologic value protein/kg body weight. High biologic value protein can be provided in the form of essential amino acid preparations (*e.g.*, Amin–Aid, which also contains a large amount of nonprotein calories). Caloric requirement can be met by using various carbohydrate and fat products (see Chronic Renal Failure section). The basic principle underlying the dietary management of acute tubular necrosis is no different from that of chronic renal failure. Should oral feeding be impossible due to nausea, vomiting, or recent abdominal surgery, 10% glucose or fructose solution, or 10% fat emulsion (*e.g.*, Intralipid) can also be given intravenously to provide calories. A multivitamin preparation should also be given either orally or intravenously. If the patient is normally hydrated and does not lose water and sodium from extrarenal sources, total daily fluid intake is restricted to daily urine output plus 400 ml and sodium intake to urinary sodium loss. Appropriate modifications from the above regime are employed should overhydration, dehydration, or extrarenal routes of sodium and water losses be present. Potassium is usually not needed unless there are major sources for potassium loss with resultant hypokalemia. Mild acidosis does not require treatment. Should the patient have clinically significant acidosis, *e.g.* CO_2 content less than 15 mEq/liter, oral or IV sodium bicarbonate can be given until the CO_2 content is slightly above 15 mEq/liter. However, the amount of sodium present in this drug should be taken into consideration in the computation of sodium intake. If urinary or extrarenal excretion of water and sodium is adequate, appropriate sodium bicarbonate therapy tailored to the degrees of acido-

sis and extracellular hydration is relatively safe. In the absence of urinary or extrarenal water and sodium loss, however, administration of large amounts of hypertonic sodium bicarbonate can result in the extraction of excessive fluid from the intracellular into the extracellular compartment with the risk of causing congestive heart failure. Needless to say, excessive and abrupt correction of systemic acidosis might result in acidosis of the cerebrospinal fluid and clinical deterioration. Hyperphosphatemia should be treated with oral phosphate-binders if possible. The lowering of serum phosphate may help to alleviate hypocalcemia. Nutritional control is facilitated by carefully recording daily fluid intakes and outputs and by taking accurate body weights on a daily or twice daily basis. Since it is usually impossible to meet the patient's caloric requirement, he tends to oxidize his own tissue and should lose about 0.2–0.3 kg body weight/day. The levels of BUN, serum creatinine, and serum electrolytes are followed daily. The total 24-hr urinary sodium and potassium outputs should also be monitored. Should the renal failure persist, hemodialysis or peritoneal dialysis may be initiated once the BUN value exceeds 80 mg/100 ml. This particular approach is followed in patients whose kidneys have endured profound ischemic or nephrotoxic insults, whose BUN's and serum creatinines have climbed steeply and predictably every day as a result of hypercatabolism, and whose oliguria and renal failure are so marked that the chances of a speedy recovery appear quite remote. Subsequently, the BUN level should be maintained below the above value with repeated dialysis treatments. This regime of early, aggressive, and prophylactic dialytic therapy reduces the incidence of uremic complications as well as the mortality rate of acute renal failure (5). What is more, should clinical deterioration or uremic manifestations occur early, dialysis may even be begun sooner in spite of a lower BUN value.

If the patient is hypercatabolic, he will require dialysis treatment each day to prevent hyperkalemia and other uremic manifestations. With daily dialysis, liberalization of protein intake is made possible. The daily intake of protein has to be individualized, but a minimum of 1 g/kg body weight is commonly given together with 45 Cal or more/kg body weight. Foods possessing protein of high biologic value, e.g., milk, eggs, and meat, should be used. However, since such foods also contain relatively large amounts of potassium, the danger of hyperkalemia is increased substantially. The serum potassium value should be monitored at least twice daily by biochemical means and continually with a cardiac monitor. It is essential to maintain the serum potassium level within normal limits by regulating potassium removal during dialysis.

Since hyperkalemia can cause sudden death from the development of cardiac arrhythmias or cardiac standstill (e.g., serum potassium greater than 7 mEq/liter), immediate treatment should consist of the IV administration of glucose and insulin, 300–500 ml 20% glucose solution with 20–35 units insulin given over a period of 30 min. Sodium bicarbonate (44.6 mEq) can be given intravenously over several minutes, and this dosage repeated again in 10–15 min. Calcium gluconate may also be given, 10 ml 10% solution injected intravenously in 2 min and repeated in 5–10 min. Once IV treatment has been started, sodium polystyrene sulfonate therapy given by both the rectal and the oral routes, as described above should be used. Of course, hyperkalemia can also be lowered with dialytic therapy.

Hyperalimentation (TPN) with IV essential amino acids and glucose were most effective in a prospective double-blind study by Abel and his colleagues (1). Not only was there increased survival, but the duration of the renal failure appeared to be shortened. This modality of nutritional care will likely become a standard treatment for acute tubular necrosis, but its use at present requires rigid control in the pharmacy and at the bedside to prevent infection and thrombosis. The latter complications are the main deterrents for its universal use in patients with acute tubular necrosis, and its use is recommended only for patients with severe and prolonged failure, especially those who are hypercatabolic and unable to eat. The availability of IV fat for use in the United States will probably make TPN combined with dialysis even more effective than described by Abel et al. (see Ch. 11).

Hyperalimentation, which is usually administered through the subclavian vein, may be given through the arteriovenous shunt prosthesis. Scribner and his colleagues have devised a silicon-rubber side-arm for use with the shunt through which the parenteral nutritional solution can be administered.

In some patients, the oliguric phase of acute tubular necrosis is followed by a diuretic phase. In the past, about 25% of deaths have occurred due to fluid and electrolyte imbalances during the diuretic phase of the syndrome. Because of improved care, when acute tubular necrosis first

develops, diuresis is no longer the problem it used to be; nevertheless, the physician must be aware that it can occur, that urinary sodium excretion may increase to several hundred mEq/day, and that gross losses of potassium, calcium, magnesium, phosphate, and water-soluble vitamins can also take place. Daily serum and 24-hr urinary electrolytes as well as twice daily weights must be obtained. Half-hourly or hourly adjustments must be made in the quantities of fluids and electrolytes given to prevent rapid development of hypovolemic shock or electrolyte dislocations. If diuresis is prolonged (more than 5–6 days) after onset and renal function has markedly improved, judicious reduction of fluid replacement with close monitoring of urine output, pulse, and blood pressure should be tried. The physician may then find that he is potentiating the diuresis after the diuretic phase is over by giving an unnecessarily large fluid load, which is excreted by kidneys whose function has since recovered.

For most patients, there is eventual adequate recovery. Dietary adjustment of protein, water, and electrolytes toward normal are made by continual vigilance of daily weights, urine outputs, serum electrolytes, BUN, and serum creatinine levels. In those patients whose renal function does not improve, their nutritional intake will continue to be adjusted to what pertains for chronic renal failure and maintenance dialysis.

ACUTE NEPHRITIC SYNDROME

Many disorders produce the classic clinical picture of acute nephritis, i.e., hematuria, edema, and hypertension, and the histologic picture of glomerulonephritis, with involvement of glomeruli, tubules, and interstitial tissue. Among these are post-streptococcal nephritis, Henoch–Schönlein purpura, lupus nephritis, and necrotizing lesions such as seen in Goodpasture's syndrome. Of all these diseases, post-streptococcal nephritis is the most common and deserves the most attention. Of children admitted to hospital with poststreptococcal nephritis, 85%–95% make a complete recovery, but when adults are sick enough to be admitted, only about 50% get completely well. Complications that are important from a nutritional point of view are edema, hypertension, massive persistent proteinuria with or without nephrotic edema, oliguria or anuria (acute renal failure), and chronic renal failure.

This disorder is surrounded by controversies. The nutritional controversy concerns the use of a low-protein diet. Those who used to employ boiled rice and fruit juice to treat children and adults with acute nephritis based their regimen on the erroneous concepts of Addis and others. These investigators believed that dealing with the waste products of protein catabolism was the normal work of the kidneys. Thus they sought to limit dietary protein to "rest" the organ and so speed repair. This is now known to be a fallacious concept. The chemical energy supplied to the kidney is mainly used in the active transport of electrolytes in the convoluted tubules, and not in discharging urea.

Modern clinical studies have indicated that protein restriction is without value. Illingworth et al. (11) treated 42 patients by allocating them at random to two dietary regimens: 1) strict protein restriction and 2) the ordinary diet of the children's ward. The children were observed for at least a year, and strict criteria were used to assess cure. No advantage was found by restricting protein.

There is, therefore, no rational reason to restrict protein in acute poststreptococcal nephritis unless oliguria or anuria develops. When this complication appears in children, it usually lasts a few days and a conservative regimen for acute renal failure is called for. In adults, and occasionally in children, severe and very prolonged anuria develops.

Sodium is not restricted unless hypertension, edema, or oliguria are judged to be potential hazards. Thus, in most patients with acute poststreptococcal glomerulonephritis, dietary management is not crucial; bed rest and drugs are central to treatment.

NEPHROTIC SYNDROME

The metabolic, nutritional, and clinical consequences of continued massive proteinuria constitute the nephrotic syndrome. Florid cases are readily recognized from infancy to extreme old age, and the diagnosis can be confirmed rapidly in the laboratory by urinalysis and simple biochemical studies of the blood.

BIOCHEMICAL CHANGES

The well-known metabolic hallmarks of the nephrotic syndrome are proteinuria, hypoalbuminemia, and hypercholesterolemia (12), but the full-blown picture presents many more biochemical aberrations. Albumin is the major protein lost in the urine, accounting for approxi-

mately 70% of the total in most cases. Other nutritionally important plasma proteins, such as ceruloplasmin, also run to waste in the urine. The continued drain of nitrogen in the urine compromises the tissue and cellular stores of protein, resulting in tissue wastage, malnutrition, fatty metamorphosis of the liver, sodium retention, hydremia, and edema. The marked increase in circulating serum lipids and relatively large plasma proteins, *e.g.,* cholinesterase and fibrinogen, remains more difficult to explain.

Treatment in the nephrotic syndrome should be directed to the patient's principal complaint of edema, to the malnutrition, to the underlying renal condition, and to the specific etiologic factors when these can be determined. At present, most treatment is necessarily of a nonspecific nature, although with increasing accuracy in diagnosis, this situation will change.

SODIUM RESTRICTION

Sodium restriction is one of the most important of the measures designed to prevent edema and initiate diuresis, but whereas low-sodium diets are widely prescribed, little attention is paid by many clinicians to ensuring that these are sufficiently low in sodium. A sodium intake of less than 10 mEq/day (580 mg sodium chloride) almost always prevents the accumulation of edema and will often start a diuresis even without other forms of therapy. Limitation of sodium intake to this level is now relatively easy with low-sodium milk powders (Lonalac) or low-sodium fresh milk since the diet can be given mainly in the form of drinks, or in severely edematous subjects with poor appetites, by nasogastric drip feeding. Modern diuretic agents are most useful in producing natriuresis.

The use of diuretics is based on symptomatic relief of edema and does not affect the underlying process *per se.* Since most nephrotics exhibit features of secondary hyperaldosteronism, spironolactone (an aldosterone-blocking agent) is frequently effective in initiating a diuresis.

PROTEIN INTAKE

The level of protein intake required by these patients has been the cause of much dispute. High-protein diets of 150 g/day or more were originally advocated by Epstein and employed with considerable success. Later writers, however, observed a rise in the urinary protein loss

on such diets, and interpreted this as deterioration in the renal condition. On the basis of animal studies, it was also argued that high-protein diets were undesirable as the prognosis in nephrotoxic serum nephritis was worse when high-protein diets were given, and the kidney was said to be required to do more "work" in excreting the additional urea load. Neither of these hypotheses is tenable, as it has been shown that increased proteinuria is to be expected with small rises of serum proteins and the work caused by the excretion of urea is only a very small fraction of that required by other tubular secretory processes in the kidney either normally or in the nephrotic syndrome. The demonstration that patients on high-protein diets may have prolonged positive nitrogen balances, at times amounting to 500 g nitrogen in some patients with proteinuria of many months' duration, suggests the presence of a severe body deficit of protein of which the reduced serum protein level is but one manifestation. In adult patients, no maximal level of protein intake could be observed other than that set by the patient's appetite, and positive nitrogen balances have been recorded with protein intakes high enough to result in such balances, with higher intakes leading to higher positive balances. Since this body nitrogen deficit seems to be of fundamental importance in the patient with prolonged proteinuria, it would appear advisable to replace protein as rapidly as possible. In practice, it has been found that for the average adult intakes of 120 g/day with high caloric intakes (50–60 C/kg) have provided satisfactory repletion without having to use unpalatable diets. Higher levels may be obtained on occasion with continuous tube feeding, and there seems to be no contraindication to their use. It is, of course, essential to ensure that patients actually take such diets; too often, high-protein, high-calorie diets are advised but not consumed. The poor appetite of the edematous patient requires constant supervision and coaxing to ensure that adequate intakes are obtained.

HYPERLIPIDEMIA

The nephrotic syndrome is characterized by high levels of cholesterol, phospholipids, and triglycerides. Berlyne and Mallick have shown that nephrotic patients have an increased incidence of coronary artery disease and death. They suggest that measures to decrease hyperlipidemia (*e.g.,* unsaturated fats in the diet and

use of hypocholesterolemic agents) be taken in chronic nephrotic patients.

KALIOPENIC NEPHROPATHY

Potassium depletion produces functional and structural derangement in the kidneys of man. The large majority of patients seen with potassium deficiency are, in the main, brought to this state by the injudicious use of diuretic agents or adrenal corticoid hormones.

The relationship of renal disease to potassium depletion was not clearly recognized until Perkins et al. (18) first described renal lesions in patients with potassium deficiency due to chronic diarrhea. Potassium depletion may develop as a result of many disorders producing either a renal or a GI loss of the element. Of course, potassium loss is common in wasting disorders such as cirrhosis, but these losses occur pari passu with nitrogen wasting, and thus the effect is different from that of loss of potassium alone. The best-known effects of potassium depletion—aside from its potentiation of digitalis action and its effects on the EKG—are nocturia, muscle weakness or paralysis, vasopressin-resistant failure to concentrate the urine, and inability to acidify the urine.

Striking vacuolization of the cells of the proximal and distal convolutions of the tubules is characteristic of potassium depletion in man. This histologic change is believed to be reversible with potassium repletion, at least in the early stages of potassium deficiency. Whether prolonged potassium depletion can result in interstitial nephritis or not is still uncertain.

Kaliopenic nephropathy is not an emergency, and oral potassium therapy is desirable and generally adequate. Prophylaxis should consist of dietary supplementation with potassium-rich foods, e.g., oranges, bananas, and tomatoes, or with potassium salts, or both.

Prevention and treatment with enteric-coated tablets of potassium chloride was once commonly used, but patients may get abdominal cramps from the hypertonic solution formed during dissolution of the tablets in the gut, or as sometimes happens, the tablets may cause dangerous small bowel disease, including ulceration and obstruction. A liquid formula is thus preferable, e.g., a 10% solution of potassium chloride, flavored and diluted in a glass of juice and given immediately after meals three times a day to minimize gastric irritation. Each 15 ml contains 20 mEq potassium. Dosages vary from 40–120 mEq or more daily, depending on the patient's needs.

Overly aggressive potassium therapy may lead to cardiotoxic levels in the blood since the cation must traverse the small extracellular pool (65 mEq) to replenish the large intracellular stores (3000 mEq). This is particularly important in situations of dehydration, acidosis, and renal insufficiency. During therapy, serum potassium levels should be monitored frequently, especially when the above situations exist.

Hypokalemia often results in metabolic alkalosis; therefore, potassium chloride is the drug of choice. It is believed that chloride alleviates alkalosis by causing expansion of the plasma volume with resultant increased renal excretion of bicarbonate (15).

RENAL STONES

The management of patients who form renal stones (6,17,19,20,22,23,25) is beginning to be based more and more on physiologic principles; however, dietary regimens used to treat patients with stones are still somewhat empiric. In spite of such empiricism, central to all treatment is encouraging the patient to consume a large fluid intake during each 24 h. Patients should have little trouble drinking 3–4 l/day, and this is the minimum they should consume. They should be trained to drink every time they urinate. Another way of helping them when treatment is instituted is to provide a very large bottle (a plastic one will do) on which the physician has marked a 3-l line and a 4-l line in red. They should fill the bottle with their urine over 24 h, initially to the 3-l mark and later to the 4-l one, so that they will learn how much they have to drink. This training can take place over weekends. It is also necessary to train them to drink fluids before they go to bed and in the middle of the night when they get up to urinate. Overnight urines are concentrated, especially in hot weather and hot climates. The urine is then supersaturated, and the situation is ideal to trigger deposition of calcium salts in the collecting system. In essence, there is no sense in having a dilute urine for only two-thirds of the time. One should never allow a stone-forming patient to become dehydrated so that the passage of concentrated urine can be avoided. The physician must check at each visit the patient's adherence to high intake of fluids by determining if the urine is dilute (specific gravity below 1.015).

It has long been known that obstruction to the urinary flow down the conduit, especially when coupled with infection, is prone to cause stones. It is also known that in the renal stone belt areas

of the Middle East and India, and in the bladder stone areas of developing countries like Thailand, the disorder can reach epidemic proportions. Possibly malnutrition might play a part, but the exact cause for these urinary calculi has not been clarified. It is important to find out if patients with renal calculi have renal or lower urinary tract defects and to ensure that they are not consuming fad-diets or large amounts of vitamin D unnecessarily. To determine a specific underlying cause for nephrolithiasis may require a thorough and laborious laboratory investigation, but this may be simplified if the patient has recovered a stone that can be analyzed. Therefore, it is vital that patients be told how to collect stones with a funnel and a piece of gauze and that no stones be discarded. The modern crystallographic analyses of calculi by polarization microscopy and x-ray diffraction photography are more accurate and preferable to chemical methods.

CALCIUM STONES

Calcium stones make up 90% of all renal calculi in the U.S. and are composed of calcium oxalate, calcium phosphate or a mixture of both. The most common causes for calcium stones are idiopathic calcium stone disease and primary hyperparathyroidism. Other well-known causes are chronic small bowel disease, medullary sponge kidneys, renal tubular acidosis, sarcoidosis, hyperthyroidism, immobilization, vitamin D or calcium excess, urinary infection, Paget's disease, Cushing's syndrome, primary oxaluria, alkali abuse, and acetazolamide therapy.

Most calcium stones consist of either a mixture of calcium oxalate and calcium phosphate or pure calcium oxalate, as in idiopathic calcium stone disease. Pure calcium phosphate stones are less common. In primary hyperparathyroidism and distal renal tubular acidosis, stones are largely composed of calcium phosphate while in primary oxaluria, they are made up mostly of calcium oxalate.

IDIOPATHIC CALCIUM STONE DISEASE. This syndrome accounts for about 70 to 80% of all cases of urolithiasis. It probably represents several entities comprising different patient populations. The latter includes patients with idiopathic hypercalciuria, those with "idiopathic" hyperoxaluria (17,19) and those without apparent discernible abnormality of calcium or oxalate metabolism.

CALCIUM STONES DUE TO IDIOPATHIC HYPERCALCIURIA. The usual Western diet provides about 1000 mg calcium/day, of which 10%–20% is absorbed and excreted in the urine. Of the 10 g calcium filtered each day through the glomeruli, 98% is reabsorbed in the tubules and 2% excreted. This latter percentage is approximately what is absorbed by the gut.

The usual criterion for hypercalciuria with uncontrolled dietary intake is a calcium excretion of greater than 4 mg/kg body weight/day (greater than 250 mg/24 hr for women and 300 mg/24 hr for men). However, more recent data indicate levels as high as 400 mg for men. In idiopathic hypercalciuria, high urinary calcium is associated with normocalcemia, a tendency to hypophosphatemia and renal stone formation. About 30%–40% of patients with idiopathic recurrent calcium stones have idiopathic hypercalciuria (6). It has been suggested that this syndrome may constitute at least two separate entities, namely, "renal hypercalciuria" and "absorptive hypercalciuria." However, many gaps in current knowledge still exist, and the exact pathogenetic mechanisms of idiopathic hypercalciuria have not been fully ascertained (6). Idiopathic hypercalciuria is commonly found in middle-aged, obese men with a strong family history of nephrolithiasis. Stones usually occur after the age of 20 years (25). When these patients are treated with thiazide diuretics, there is a reversal of the hypercalciuria to normal. Moreover, in these patients, long-term treatment with thiazide diuretics alone may significantly reduce the rate at which new stones are formed (25). Thiazides probably act by causing depletion of the extracellular fluid volume from natriuresis, leading to increased renal tubular reabsorption of calcium and hypocalciuria. They also cause increased urinary excretion of magnesium, which is an inhibitor of stone formation. In addition, oral administration of inorganic phosphates is effective in reducing stone recurrence (23). A neutral mixture of monobasic and dibasic phosphate salts of sodium or potassium, made isotonic to reduce the cathartic effect and given in three divided doses totaling 1.5–3.0 g phosphorus/day, is recommended. The mechanism of action of these salts has not been established, but they lower urinary calcium and raise urinary pyrophosphate. The latter is a potent inhibitor of stone formation. For the group of patients in whom intestinal hyperabsorption of calcium predominates, the use of cellulose phosphate to inhibit calcium absorption from the gut with re-

sultant reduction in urinary calcium excretion has been suggested.

Attempts to lower urinary calcium excretion by restricting calcium intake in patients with idiopathic hypercalciuria have been successful in some cases but not in others. Calcium intake can be markedly reduced by eliminating milk and milk products from the diet. There is also evidence that high-sodium intake, alcohol, and glucose also increase urinary calcium excretion in normal individuals, but the effect of elimination of these foodstuffs on formation of renal calculi is still not known.

At the present time, then, the nutritional regimen of care for patients with idiopathic hypercalciuria and renal calculi is to reduce calcium intake to 200–300 mg/day (Table A-4 lists foods high in calcium to be avoided); to avoid consumption of calcium-containing medications (*e.g.,* calcium carbonate; calcium gluconate); and to avoid vitamin D and vitamin D-fortified foods. A high-fluid intake as described above is mandatory. Hydrochlorothiazide, 50 mg twice daily, should be given. On the other hand, phosphates may be used alone or in conjunction with dietary calcium restriction and thiazide diuretics.

HYPERURICEMIA AND HYPERURICOSURIA IN PATIENTS WITH IDIOPATHIC CALCIUM STONES. In man, urate excretion varies with total consumption of purine, production of urate, and renal urate excretory mechanisms. Normal excretion in a population is hard to define. Conventional upper limits are 800 mg/24 hr for men and 750 mg/24 hr for women. Hyperuricemia and hyperuricosuria are common in patients with idiopathic calcium stone disease.

In such patients, a low-purine diet can be tried. However, strict restriction of purine-rich foods (meat, poultry, and fish) is difficult to follow. The use of allopurinol in these patients has been suggested.

CALCIUM OXALATE STONES. Increased oxalate excretion in the urine occurs with excessive ingestion of oxalate or its precursors, with chronic small bowel disorders, in a small number of patients with idiopathic calcium oxalate stone formation (19), and in primary hyperoxaluria.

Certain vegetables (*e.g.,* spinach, rhubarb, Swiss chard, and beetroots), cocoa (chocolate), and tea contain substantial amounts of oxalate. It has been recommended that dietary oxalate restriction be observed in patients with idiopathic calcium oxalate stone disease and elevated urinary oxalate excretion.

In chronic small bowel disorders, such as Crohn's disease, there appears to be an increased absorption of oxalate from the bowel and a relatively high incidence of oxalate stones (22). Patients with these disturbances not only have acquired hyperoxaluria secondary to enhanced absorption of dietary oxalate but also suffer from recurrent episodes of dehydration due to copious diarrhea, resulting in the passage of highly concentrated urine. Investigations have shown the effectiveness of cholestyramine in binding oxalate in the gut in these patients. The consumption of a diet low in oxalate and fat but high in calcium to prevent the development of stones is recommended, but the possible usefulness of cholestyramine for the same purpose has not yet been delineated.

For the large group of patients with idiopathic calcium stone disease without any recognizable disorder of calcium or oxalate metabolism, thiazides have been used and inorganic orthophosphate salts have been found to be quite effective in reducing stone recurrence (23). Finally, the use of magnesium compounds for the purpose of inhibiting stone formation, as well as the institution of low oxalate diets have also been suggested.

MAGNESIUM AMMONIUM PHOSPHATE STONES

These stones constitute about 10% of all stones and occur in patients with recurrent urinary tract infections from urea-splitting organisms such as *B. proteus* and various coliforms. The ammonia generated through the action of urease produces a highly alkaline urine that facilitates the precipitation of magnesium ammonium phosphate crystals. Acidification of urine should be beneficial in recurrent magnesium ammonium phosphate stone-formers. Methionine in a dosage of 8–12 g daily in divided doses, or ascorbic acid, 500 mg given several times a day, can be given to render urine acidic (14). Urine pH should be tested at frequent intervals by the patient using phenaphthazine (Nitrazine) paper. Needless to say, acidification of urine must be carried out in conjunction with therapy to eliminate any associated urinary tract infection. However, the above acidifying agents are not practical and are probably suitable only for short-term use, as they have a tendency to cause metabolic acidosis and therefore increase urinary calcium.

URIC ACID STONES

These stones comprise 5%–10% of all renal calculi. In patients with uric acid nephrolithiasis, the critical factors that trigger stone formation are those that lead to the production of scanty and concentrated urine, the oversaturation of urine with free uric acid and the generation of acid urine. The consumption of large quantities of fluid will lower the effective concentration of uric acid in the correspondingly large volume of urine. In hyperuricemic hyperuricosuric patients, a low-purine diet can be prescribed but probably plays only a small role in prevention of recurrence. If the uric acid output is increased as a result of high endogenous production, allopurinol can be used to inhibit the synthesis of uric acid from hypoxanthine and xanthine with reduction of the total urinary uric acid output. A most important approach is to take advantage of the remarkable increase of urate solubility that takes place with rises in urinary pH. Patients should be given an alkalinizing salt to maintain the urinary pH at 6.0–6.5. An oral sodium citrate and citric acid mixture in the form of Shohl's solution (1 ml forms 1 mEq bicarbonate), given at a dosage of 10–30 ml or more after each meal, at bedtime, and in the middle of the night, is more palatable and tolerable than sodium bicarbonate.

A urine pH higher than the above range should probably be avoided on account of the dangers of producing calcium phosphate stones (20). The latter may occur because calcium phosphate tends to precipitate in an alkaline medium. Patients should be taught to check their urine pH often with phenaphthazine paper.

CYSTINE STONES

These stones constitute 2%–3% of all calculi and occur in patients with cystinuria in whom there exists a genetically determined defect in the renal and small intestinal transport of cystine, lysine, arginine, and ornithine. Treatment is designed to lower the concentration of cystine in the urine by increasing urinary volume through consumption of 3–4 liters fluid daily, including 1 liter in the middle of the night. Half a liter of fluid should be taken before retiring and the same amount repeated when the patient is awakened by the stimulus of a full bladder or by an alarm in the small hours of the night. The consumption of an adequate quantity of fluid at night is crucial since urine is both more concentrated and more acid during the night. Alkalinization of the urine to a pH of 7.5 or higher will increase the solubility of cystine in urine. However, it is very difficult to elevate urine pH to the above high level, and large amounts of alkalis such as Shohl's solution (160–270 ml daily in 3 or 4 divided doses) may be required in an adult. Patients unable to tolerate this large quantity of alkali or those who excrete in excess of 2 g cystine daily should be treated with D-penicillamine (23). Adequate treatment may not only prevent recurrence of stone but may also result in dissolution of stone *in situ,* thus obviating the need for surgical intervention in some patients (17). The risk of developing calcium phosphate stones as a consequence of increased alkalinization of the urine probably also applies to patients with cystinuria. However, it is possible that such a risk may be attenuated by the maintenance of a high daily urine volume.

REFERENCES

1. Abel RM, Beck CH Jr, Abbott WM et al.: Improved survival from acute renal failure after treatment with intravenous essential L-amino-acids and glucose. N Engl J Med 288:695, 1973

2. Armbruster KFW, Ing TS, Kark RM: Nondialytic treatment of chronic renal insufficiency. Ration Drug Ther 7 (5):1–6, 1973

3. Berlyne GM, Shaw AB, Nilwarangkur S: Dietary treatment of chronic renal failure: experiences with a modified Giovannetti diet. Nephron 2:129, 1965

4. Blagg CR, Scribner BH: Diet, drugs and dialysis in the management of chronic renal failure. In Edwards KDG (ed): Progress in Biochemical Pharmacology, Vol 7, Drugs Affecting Kidney Function and Metabolism. New York, S Karger, 1972, p 452

5. Chawla SK, Najafi H, Ing TS et al.: Acute renal failure complicating ruptured abdominal aortic aneurysm. Arch Surg 110:521, 1975

6. Coe FL, Kavalach AG: Hypercalciuria and hyperuricosuria in patients with calcium nephrolithiasis. N Engl J Med 291:1344, 1974

7. DeLuca HF: Vitamin D today. DM, March, 1975

8. Giordano C: Use of exogenous and endogenous urea for protein synthesis in normal and uremic subjects. J Lab Clin Med 62:231, 1963

9. Giovannetti S, Maggiore Q: A low-nitrogen diet with proteins of high biological value for severe chronic uremia. Lancet 1:1000, 1964

10. Hampers CL, Schupak E: Long-term hemodialysis. New York, Grune & Stratton, 1967, p 67

11. Illingworth RS, Philpott MG, Rendle–Short J: Controlled investigation of the effect of diet on acute nephritis. Arch Dis Child 29:551, 1954

12. Kark RM, Pirani CL, Pollack VE et al.: The nephrotic syndrome in adults: a common disorder with many causes. Ann Intern Med 49:751, 1958

13. Kopple JD, Coburn JW: Metabolic studies of low protein diets in uremia. Medicine 52:583, 1973

14. Kunin CM: Detection, Prevention and Management of Urinary Tract Infections. Philadelphia, Lea & Febiger, 1972, pp 147, 191

15. Kurtzman NA, White MG, Rogers PW: Pathophysiology of metabolic alkalosis. Arch Intern Med 131:702, 1973

16. Nelson RA, Jones JD, Wahner HW et al.: Nitrogen metabolism in bears:urea metabolism in summer starvation and in winter sleep and role of urinary bladder in water and nitrogen conservation. Mayo Clin Proc 50: 141, 1975

17. Nordin BEC, Hodgkinson A: Urinary tract calculi. In Black D (ed): Renal Disease, 3rd ed. Oxford, Blackwell Scientific, 1972, p 759

18. Perkins JG, Petersen AB, Riley JA: Renal and cardiac lesions in potassium deficiency due to chronic diarrhea. Am J Med 8:115, 1950

19. Robertson WG, Peacock M, Nordin BEC: Measurement of activity products in urine from stone-formers and normal subjects. In Finlayson B, Hench L, Smith LH (eds): Urolithiasis: Physical Aspects. Washington DC, National Academy of Science, 1972, p 79

20. Smith LH Jr, Williams HE: Kidney stones. In Strauss MB, Welt LG (eds): Diseases of the Kidney, 2nd ed. Boston, Little, Brown, 1971, p 973

21. Slatopolsky E, Bricker NS: The role of phosphorus restriction in the prevention of secondary hyperparathyroidism in chronic renal disease. Kidney Int 4:141, 1973

22. Stauffer JQ, Humphreys MH, Weir GJ: Acquired hyperoxaluria with regional enteritis after ileal resection-role of dietary oxalate. Ann Intern Med 79:383, 1973

23. Thomas WC Jr: Medical aspects of renal calculous disease. Urol Clin North Am 1:261, 1974

24. Walser M, Coulter AW, Dighe S et al: The effect of keto-analogues of essential amino acids in severe chronic uremia. J Clin Invest 52:678, 1973

25. Williams HE: Nephrolithiasis. N Engl J Med 290:33, 1974

24 Neurologic disease

Pierre M. Dreyfus

The nervous system, both central and peripheral, can be affected by clinical states brought about by either improper or inadequate nutrition. The most common nutritional disorders of the nervous system are caused by the deficiency of essential nutrients and vitamins as the consequence of chronic alcoholism (15), debilitating diseases of the gastrointestinal (GI) tract, food faddism, poverty, and ignorance. Nutritional depletion can also occur in the presence of an adequate diet when the body, including the nervous system, is under stress. Prime examples are chronic infection, endocrine imbalance, and overwhelming psychiatric disease. The adult nervous system is generally more resilient to altered nutrition than is the developing and actively myelinating nervous system, which is particularly sensitive to protein–calorie undernutrition. However, the immature nervous system may be the victim of a number of genetically determined errors of metabolism which not infrequently respond favorably to nutritional manipulation. In some of these diseases, vitamin utilization or conversion to active forms is either faculty or incomplete (12). It has been established that the nervous system is dependent on most, if not all, of the water-soluble vitamins for its development and for the subsequent maintenance of its function. Under normal dietary circumstances, the recommended minimal daily allowance of vitamins, taking into consideration the patient's age and medical status, adequately protects the integrity of the nervous system, and, with very few exceptions, the use of massive doses of vitamins does not hasten or enhance the regeneration of diseased structures, nor does it improve their function. Protein–calorie malnutrition, a serious and devastating problem in a large segment of the infant population in most developing countries of the world, has deleterious effects on the ultimate physical and psychologic development of the afflicted subjects. Whereas much is known about the nutritional, biochemical, and metabolic aspects of the problem, information on psychosocial and environmental factors that may further complicate the effects of protein–calorie malnutrition remains inadequate.

In general, knowledge concerning the effects of malnutrition or vitamin deficiencies on the nervous system has been derived from experiments conducted on human volunteers and animals using synthetic diets and contrived circumstances that bear little or no resemblance to the naturally occurring diseases in man. Although useful data, some of which find direct application to man, have been obtained, the wholesale extrapolation of experimental results gleaned from animals to the complex problems of human nutrition is totally unwarranted.

Unfortunately, the scientific basis of nutrition continues to be obscured by clever commercialism, fads, frauds, and cults, all of which contribute heavily to the improper use of nutrients or vitamins in the management of patients afflicted with neurologic disease. In this chapter, the diseases of the nervous system which are known to have a nutritional etiology will be reviewed briefly, and a practical approach to their dietary management will be outlined. An attempt is made to separate fact from fiction by discussing common neurologic disorders in which the use of vitamins or special diets has no proven scientific validity.

NEUROLOGIC DISEASES OF NUTRITIONAL ETIOLOGY

In the developed countries of the world a large majority of nutritional disorders of the nervous system are the result of chronic alcoholism coupled with malnutrition and undernutrition. It has been shown that during periods of heavy drinking, the absorption of vitamins, their intestinal transport, tissue storage, utilization, and

conversion to metabolically active forms is sharply curtailed, while the need for vitamins and essential nutrients increases (13). In addition to causing abnormal vitamin metabolism, chronic alcoholism may have profound effects on mineral, carbohydrate, protein, and lipid metabolism (see Ch. 13). The majority of nutritional disorders of the nervous system, although most commonly associated with chronic alcoholism, have also been encountered in malnourished, debilitated, nonalcoholic individuals suffering from various illnesses, such as malabsorption syndromes, renal disease, and neoplasia. Actually, alcohol-engendered nutritional syndromes of the nervous system are relatively rare considering the size of the chronic alcoholic population and the magnitude of the sociologic, physiologic, and general medical problems caused by chronic alcoholism. It is estimated that nutritional disorders constitute only approximately 1%–3% of the alcohol-related neurologic diseases requiring hospitalization. The various alcoholic nutritional syndromes may present separately in relatively pure form, but more frequently they occur together in varying combinations, some decidedly more prevalent than others (14). It is not known why under seemingly identical circumstances one nutritionally depleted patient develops one or several neurologic complications and another seems to emerge essentially unscathed. The chronic alcoholic patient not infrequently presents with symptoms and signs of withdrawal which may in part mask those attributable to nutritional depletion. The relatively frequent coexistence of these two alcoholic complications should be kept in mind when therapeutic measures are instituted. It is particularly important to remember that in patients who are marginally depleted, a full-blown nutritional syndrome can be precipitated by injudicious use of the calorie-rich parenteral effective fluids in treating withdrawal symptoms. Therefore, an adequate dose of all of the B vitamins should always be administered, despite the fact that withdrawal symptoms are not caused by vitamin deficiency.

WERNICKE–KORSAKOFF SYNDROME

DIAGNOSIS

Wernicke–Korsakoff syndrome is probably the most common alcoholic nutritional complication affecting the central nervous system (CNS). Contrary to common belief, the Wernicke–Korsakoff syndrome is not restricted to the alcoholic population but is also encountered in patients who suffer from severe nutritional depletion unrelated to drinking (9). In order of frequency the most common presenting symptoms are mental confusion that soon gives way to a characteristic disorder of memory (faulty immediate recall and recent memory) and confabulation, ataxia (primarily of stance and gait), abnormal ocular motility (ophthalmoplegia followed by nystagmus), and peripheral neuropathy. The correct diagnosis may be obscured when symptoms and signs of abstinence, e.g., delirium tremens and hallucinosis, are superimposed on those of Wernicke–Korsakoff syndrome. Careful clinical studies (16) have clearly demonstrated that a specific deficiency of thiamin (vitamin B_1) plays a central role in the pathogenesis of this disorder. Since the disturbance of immediate recall and recent memory associated with Korsakoff syndrome may become irreversible, this condition requires prompt recognition and therapeutic intervention. The improvement of neurologic signs can be closely correlated with levels of activity of blood transketolase (a thiamin-dependent enzyme), which are reduced prior to thiamin administration and revert toward normal with clinical improvement (4, 5).

TREATMENT

An initial dose of 50–100 mg thiamin hydrochloride, either IV or IM, usually results in reversal of ocular paralysis within a matter of 2–5 hours and prevents the advent of a severe disturbance in memory. The administration of thiamin by the IV route should proceed slowly with caution since severe idiosyncratic reactions resulting in acquired sensitivity to the vitamin and even sudden death have been reported (17). The use of oral thiamin preparations should be avoided during the acute phase of the illness since the vitamin may be absorbed in an erratic and unpredictable manner. Initial thiamin treatment should be followed by the regular administration of thiamin (25–30 mg, 3 times daily IM or PO) and a well-balanced diet. In the presence of significant liver disease, thiamin therapy alone may not bring about the expected rapid response. In such instances, the prolonged administration of a nutritious, vitamin-supplemented diet including folate and vitamin B_{12} is essential.

NUTRITIONAL NEUROPATHY

DIAGNOSIS

Nutritional neuropathy, the most common of all the nutritional diseases of the nervous system, may occur in a variety of clinical settings. Although it is most frequently encountered in malnourished, chronic alcoholic patients, it may complicate a number of other systemic illnesses in which malnutrition is an important feature, such as those resulting from malabsorption syndromes, renal dialysis, and food faddism. Typically, the neuropathy is symmetric, distal, arreflexic, mixed motor, and sensory, affecting legs more than arms. Occasionally, it involves the peripheral autonomic nervous system (10). The malnourished patient may complain of severe burning, shooting, lightning, or "electric" types of pain in the feet, but no clear-cut clinical signs of neuropathy can be elicited. This particular neuropathic disorder, generally known as the "burning feet syndrome," is believed to be due mainly to a lack of pantothenic acid. Neuropathy caused by a deficiency of pyridoxal phosphate, the active vitamin B_6 cofactor, may develop in the course of isonicotinic acid hydrazide (INH) therapy for tuberculosis. The drug has been found to interfere with the phosphorylation of pyridoxine.

TREATMENT

Nutritional polyneuropathy is most probably caused by a deficiency of a combination of B vitamins. Therefore, therapy for this disorder should include a minimum of thiamin 25 mg, niacin 75 mg, riboflavin 5 mg, pyridoxine 5 mg, and vitamin B_{12} 5 μg, all taken three times daily. When nutritional polyneuropathy is caused by GI malabsorption, vitamins should be administered by the parenteral route. Recovery from nutritional polyneuropathy is notoriously slow, requiring a period of several months to a year; prolonged and continuous dietary treatment and physiotherapeutic maneuvers are consequently of the utmost importance. Patients afflicted with the burning foot syndrome should receive pantothenic acid (10–20 mg/day), whereas those being treated with INH should have the benefit of pyridoxine (150–300 mg/day).

NUTRITIONAL AMBLYOPIA

DIAGNOSIS

Nutritional amblyopia, also known as tobacco–alcohol amblyopia or nutritional retrobulbar neuropathy, is a remarkably uniform and stereo-typed visual disturbance in which bilaterally symmetric central, cecocentral, or paracentral scotomata of varying sizes can be elicited (5). Although the syndrome most frequently afflicts those persons chronically addicted to alcohol or —occasionally—to tobacco who neglect their nutrition, it has been encountered in undernourished populations all over the world during periods of famine and among civilian and military prisoners of war who have had no access to alcohol or tobacco. Occasionally, a similar syndrome may present as a complication of pernicious anemia (8).

TREATMENT

Nutritional amblyopia is readily reversible provided the patient receives the benefit of oral or parenteral B vitamins and improved nutrition. Improvement occurs despite continued drinking or smoking, the degree and speed of recovery being largely dependent on the severity of the amblyopia and the duration before therapy was instituted. As yet, the specific nutrient the absence of which is responsible for the syndrome has not been identified, hence all of the B vitamins should be included in the treatment of this disorder.

CEREBELLAR CORTICAL DEGENERATION

DIAGNOSIS

Cerebellar cortical degeneration, better known as alcoholic cerebellar degeneration, is a syndrome characterized primarily by progressive unsteadiness of stance and gait, with relative sparing of arms and cranial nerves and demonstrable ataxia of trunk and legs (5). Clinical evidence suggesting that alcoholic cerebellar degeneration has a nutritional etiology is not as clear-cut as that in Wernicke–Korsakoff, neuropathy, or amblyopia, and the relationship between clinical improvement and nutritional replenishment appears to be fortuitous.

TREATMENT

It has been alleged that improved nutrition and supplementary B vitamins result in some degree of amelioration of ataxia. On the other hand, the cessation of heavy drinking may have a similar effect.

CENTRAL PONTINE MYELINOLYSIS

Central pontine myelinolysis, a rare disorder originally described in alcoholic patients, has also been seen in abstemious individuals, young and old, who are afflicted with neoplasia, chronic renal disease, hepatic insufficiency, or a variety of infectious disorders. The etiology of central pontine myelinolysis remains totally unknown. The symptoms are progressive quadriparesis leading to quadriplegia, dysphagia, emotional lability, decerebrate posture, respiratory paralysis, coma, and—eventually—death, all of which is indicative of a spreading pontine lesion. These symptoms may be associated with a poor nutritional status, but a causal relationship is not evident and a biochemical lesion pointing to altered nutrition is totally lacking (5).

TREATMENT

Supportive therapy may tide the patient over the worst part of the illness while spontaneous recovery takes place.

MARCHIAFAVA–BIGNAMI DISEASE

DIAGNOSIS

Marchiafava–Bignami disease, about which very little is known, is not seen exclusively in alcoholic subjects. The neurologic symptoms and signs include disturbance of language, gait, and motor skills; seizures; incontinence; rooting; grasping; sucking; delayed initiation of action; tremulousness of hands; and dysarthria. The clinical description in the literature and the pathologic attributes suggest a nutritional etiology (5).

TREATMENT

Since the diagnosis is usually not established in the living patient, no specific treatment can be recommended.

PELLAGRA

DIAGNOSIS

The neurologic manifestations of pellagra, *i.e.,* mental symptoms (confusion, delusion, disorientation, and hallucinations), spasticity, ataxia, and—occasionally—peripheral neuropathy, have become increasingly rare in the western world as a consequence of education about nutrition, the enrichment of flour, and the practice of vitamin self-medication. In the United States, pellagra was most prevalent among impoverished and chronic alcoholic individuals (5). Today, sporadic cases are encountered in severely malnourished patients and food faddists (see Ch. 7).

TREATMENT

Since a deficiency of nicotinic acid (niacin) or its precursor, tryptophan, is responsible for the disease, these must be included in the diet. The patient's diet should contain 500–1000 mg tryptophan and 10–20 mg niacin/day.

VITAMIN B_{12} DEFICIENCY

DIAGNOSIS

Vitamin B_{12} deficiency is caused by its absence from or by its insufficient absorption by the GI tract, as may occur in pernicious anemia, tapeworm infestation, malabsorption syndromes, GI surgery, and—occasionally—vegetarianism; it may cause subacute degeneration of the spinal cord, optic nerves, cerebral white matter, and peripheral nerves (see Ch. 7).

Progressive symmetric paresthesias of feet and hands, weakness, spasticity, and ataxia of legs, occasional confusion and dementia and sometimes bilaterally failing vision constitute the main neurologic symptoms of vitamin B_{12} deficiency. Diminution or loss of position and vibratory senses (blunting of pain, temperature, and tactile sensations over the distal parts of the legs) and hyperactive knee jerks in the absence of ankle jerks are the main neurologic findings.

Both vitamin B_{12} and folic acid deficiency have been implicated in the etiology of rare cases of dementia without other neurologic manifestations in elderly patients. Clinical reports indicate definite improvement following the administration of the appropriate vitamin. It is now well established that patients receiving anticonvulsant medications, particularly diphenylhydantoin, may develop folic acid deficiency. Conversely, the administration of folic acid has been found to significantly reduce the blood levels of these drugs. Presumably, the vitamin and the drug compete for intestinal absorption.

TREATMENT

Since the early neurologic manifestations of vitamin B_{12} deficiency are rapidly and completely

reversible, prompt initiation of therapy is of the utmost importance. In patients with pernicious anemia, the greatest degree of improvement is achieved when treatment takes place within 3 months of the onset of symptoms, although variable degrees of amelioration can be obtained after longer untreated periods (6–12 months). In the first 2 weeks, daily IM injections of 50 μg cyanocobalamin or an equivalent amount of liver USP should be administered. During the next 2 months, 100 μg of cyanocobalamin should be injected twice a week. For the remainder of his life, the patient should receive a minimum of 100 μg IM every month to prevent a relapse, such as that which might be caused by the metabolic stress induced by systemic illness or surgery. The administration of oral vitamin preparations containing folic acid must be avoided in patients suffering from an anemia of unknown etiology since in unsuspected instances of pernicious anemia folic acid, while reversing the anemia, fails to improve and may in fact worsen the neurologic complications of the disease.

Elderly, demented patients whose vitamin B_{12} or folic acid serum levels have been found to be reduced to significantly low levels (usually below 50% of normal) should receive doses of the appropriate vitamin to bring serum levels to within normal limits. Subsequently, maintenance doses of these vitamins should be given. Patients who develop anemia during the course of anticonvulsant therapy should have the benefit of both serum folate and anticonvulsant blood level determinations, and the dose of either vitamin or drug should be adjusted accordingly.

VITAMIN-RESPONSIVE DISEASES

During the past decade, a number of genetically determined diseases referred to as vitamin-responsive or vitamin-dependent states in which either a vitamin-dependent enzymatic step or a reaction involved in the conversion of a vitamin to its active form is faulty have been identified (12). These disorders are further characterized by the absence of biochemical evidence of vitamin deficiency. Some of these diseases may affect the nervous system, the symptoms ranging from mental retardation, psychosis, and convulsive seizures to ataxia, spasticity, and peripheral neuropathy (Table 24–1). As their name implies, these diseases are responsive to the appropriate vitamin, showing marked improvement of neurologic symptoms after treatment by doses far exceeding the minimal daily requirement.

VITAMIN E DEFICIENT STATES

Vitamin E and its use in health and disease continues to be the subject of considerable controversy. Experimentally induced deficiency of the vitamin in animals has resulted in a dystrophic process of voluntary muscles, pathologic changes in the spinal cord, and the deposit of a pigment usually associated with aging in muscles and nerve cells. The persistent inability to absorb fats is the most likely mechanism by which human subjects become deficient in this fat-soluble vitamin.

In children, the most common underlying causes of deficiency are coeliac disease, cystic fibrosis, and biliary atresia. In the adult, sprue and chronic pancreatitis have been the most frequent offenders. On occasion, a progressive myelopathy presumably caused by a deficiency of vitamin E has been reported in both children and adults. In such circumstances supplemental vitamin E, perhaps as much as 500–1000 IU/day, appears to be indicated.

Recently it has been suggested that the administration of a mixture of 2 g vitamin E, 200 mg butylated hydroxytoluene, 1 g L-methionine, and 0.5 g vitamin C has a beneficial effect on the course of Batten's disease (18). This disease, a juvenile form of amaurotic familial idiocy, is characterized by progressive visual disturbance, seizures, and neurologic impairment.

The administration of the vitamin may also be useful in the treatment of infantile neuroaxonal dystrophy, a rare disorder of the nervous system of early childhood characterized by progressive spasticity, seizures, blindness, and mental deterioration.

In all of the above-mentioned neurologic diseases, vitamin E appears to act as a nonspecific antioxidant, and as such it appears to prevent the peroxidation of polyunsaturated fatty acids, the

TABLE 24–1. Vitamin-Responsive Diseases*

Vitamin	Disease
Thiamin (vitamin B_1)	Pyruvic decarboxylase deficiency
	Maple syrup urine disease
Pyridoxine (vitamin B_6)	Neonatal convulsions
	Homocystinuria
	Cystathioninuria
	Xanthurenic aciduria
Cobalamin (vitamin B_{12})	Methylmalonic aciduria
	Homocystinuria
Folic acid	Homocystinuria
Nicotinamide	Hartnup disease

*Adapted from Rosenberg LE: In Plum F (ed): Brain Dysfunction in Metabolic Disorders. New York, Raven Press, 1974

product of peroxidation being highly damaging to nerve cells.

NEUROLOGIC DISEASES OF NON-NUTRITIONAL ETIOLOGY

Despite recent advances in the field of neurology, the etiology and pathophysiology of a relatively large number of diseases of the nervous system continue to be poorly understood. Therefore, it has been impossible to devise rational therapy for many of these disorders. Lack of knowledge, frustration on the part of the patient and the physician, and the desire to try any essentially harmless "shotgun" therapeutic measure have led to the irrational and scientifically unsound use of vitamins and special diets in the treatment of neurologic disorders of obscure nature. The popularity of prescribing large doses of B vitamins as therapy for neuropathies, peripheral nerve injuries, neuralgias, and demyelinating diseases stems from the fact that experimentally induced deficiencies of these vitamins in animals frequently result in lesions of the peripheral and central nervous systems which can be reversed by their administration. This has led to the common belief that the treatment of diseases characterized by demyelination or destruction of nerve fibers with vitamins, in doses far exceeding their physiologic range, will either hasten their improvement or protect the involved structures from further damage.

Thus, thiamin (vitamin B_1), also known in the past as aneurin (an abbreviation for antineuritic factor), has been administered in increasingly large quantities since it was first synthesized in 1936. It appears to be reasonably well established that the diphosphoric and triphosphoric esters of thiamin are involved in the function of excitable membranes, where these esters are presumably situated (6). Thus they are presumed to regulate the sodium influx and efflux through axonal and other membranes of peripheral nerves. This function of thiamin, which is independent of its function as a coenzyme, fails in severe states of vitamin deficiency and may actually be responsible for some—if not all—of the neurologic manifestations, particularly those that respond rapidly and dramatically to a single dose of thiamin, e.g., the ophthalmoplegia in Wernicke's disease. Recently it has been demonstrated that thiamin and its active phosphoric esters are not related to the myelin sheath in either the central or the peripheral nervous system. Based on these observations, it is conceivable that the administration of large doses of thiamin may enhance the function of nervous tissue while having no effect on reparative processes, such as remyelination. It seems unlikely, therefore, that large doses of thiamin are "useful" in the management of trigeminal and postherpetic neuralgia and various forms of neuritis, except for the neuropathy seen in conjunction with severe malnutrition or undernutrition.

The same can be said for the use of vitamin B_{12}, which does not appear to influence the metabolism of nerves that are not deprived of the vitamin. The literature contains reports suggesting that B vitamins are useful in the treatment of migraine and Ménière's disease. At the present time there appears to be no scientific basis for this assertion. Since neurologic diseases such as trigeminal and postherpetic neuralgia, Meniere's disease, and certain types of peripheral nerve disorders are self-limiting and tend to improve spontaneously, it is most difficult to assess the value of vitamin therapy in an objective manner. The administration of vitamins is undoubtedly responsible for a significant placebo effect, which helps the physician in the management of patients afflicted with essentially incurable diseases. Although large oral doses of vitamins tend to be harmless, their repeated parenteral administration may result in symptoms and signs of hypersensitivity; anaphylactic reactions and sudden death have been reported (17).

Nutritional therapy utilizing vitamins or other substances has been advocated for a number of neurologic diseases of unknown etiology. Although supplemental B vitamins may benefit patients afflicted with multiple sclerosis, they do not influence the course of the disease. A low-fat diet has been recommended as an effective means of reducing the incidence of exacerbations in patients with known multiple sclerosis. To date, however, it has not been possible to evaluate the efficacy of this mode of treatment by statistical means.

Epidemiologic studies relating multiple sclerosis to nutritional factors have revealed a possible correlation between the incidence of the disease and the total fat intake and the percent of calories of animal origin consumed. Multiple sclerosis tends to be more prevalent in countries where the use of animal fats is high. Whether the restriction of dairy products and other foods high in the content of animal fats is useful in the management of multiple sclerosis cannot be ascertained from available data (1).

More recently, it has been suggested that the administration of the unsaturated fatty acids, linoleic or arachidonic, may reduce the number and the severity of multiple sclerosis attacks (7). This is based on the observations that multiple

sclerotic brain and spinal cord are relatively deficient in the content of unsaturated fatty acids and that linoleic and arachidonic acid strongly inhibit the lymphocyte-antigen interaction, a cellular mechanism that may be responsible for demyelination. It is believed that during attacks of multiple sclerosis, sensitized lymphocytes interact with myelin components in the affected parts of the nervous system. Whether the prolonged ingestion of unsaturated fatty acids, such as linoleic acid, which is contained in safflower oil, has any effect on the course of multiple sclerosis remains to be demonstrated.

A nutritional approach to the management of chronic neurologic diseases affecting intellectual function, *e.g.,* dementia or mental retardation, has been advocated by therapeutic enthusiasts who believe that certain vitamins, substances, or foods can enhance the metabolic activity of the brain and thus raise the patient's IQ. Vitamin B_6, which is an essential cofactor for biochemical reactions involved in the synthesis of biogenic amines (serotonin and dopamine) and the inhibitory substance γ-aminobutyric acid, found uniquely in the brain, has been used in large doses and indiscriminately in children afflicted with a variety of diseases characterized by seizures and mental retardation. Similarly, glutamic acid, the precursor of γ-aminobutyric acid, has been administered to both demented adults and mentally retarded children. Except for specific instances where a pyridoxine-dependent metabolic block (such as occurs in homocystinuria, cystinuria, and xanthurinic aciduria) or pyridoxine-responsive seizures of the neonate could be demonstrated, the use of large doses of the vitamin seems to have been inappropriate and the claimed therapeutic success could not be evaluated by statistical means. Contrary to popular belief, it is doubtful that so-called "brain foods" (fish heads, squeezed calves brains, and certain vegetable juices) have any influence on the chemical composition of the nervous system, its metabolism, or its function.

Finally, some neurologic diseases, such as Parkinson's disease, which does not have a nutritional etiology, respond favorably to a combination of specific therapy and dietary manipulation. Parkinson's disease, a degenerative disorder of the nervous system characterized by symptoms of rigidity, bradykinesia, and tremor, can be treated with some degree of success by the administration of the amino acid levodopa (1-dihydroxyphenylalanine), which upon entry into the appropriate nerve cells of the affected

parts of the brain is converted to the deficient catecholamine, dopamine. The majority of ingested levodopa is converted to dopamine in the nerve cells located in peripheral ganglia, and only about 1% of the amino acid is made available to the brain. The enzymatic reaction that converts levodopa to dopamine, a vitamin B_6 (pyridoxine)–dependent decarboxylase, can be stimulated by excessive amounts of the vitamin. It has been observed that the beneficial effects of levodopa on the neurologic symptoms of the disease may be markedly reduced when supplemental vitamin preparations containing pyridoxine are added to the daily dose of levodopa. Therefore, vitamin preparations containing pyridoxine should be avoided. In addition, it has been demonstrated that amino acids contained in the diet tend to compete with the absorption of levodopa. Consequently, it is recommended that the daily protein intake of the patient receiving levodopa be kept in the vicinity of 0.5 g protein/kg/day (11) and that the medication not be ingested together with food rich in amino acids, such as milk or cheese.

CONCLUSION

Scientific knowledge gathered to date about nutrition as it pertains to the etiology or treatment of diseases of the nervous system is relatively meager when one considers recent advances in the fields of biochemistry and nutrition. If indeed nutrition has a wider application to the management of neurologic disorders than has been recognized heretofore, more-sensitive and critical techniques for assessing the nutritional status of the nervous system and evaluating treatment are required before rational methods of therapy can be devised.

REFERENCES

1. Alter M, Yamour M: Multiple sclerosis prevalence and nutritional factors. Trans Am Neurol Assoc 98:253–254, 1973
2. Bayliss EM, Crowley JM, Preece JM, Sylvester PE, Marks V: Influence of folic acid on blood-phenytoin levels. Lancet 1:62, 1971
3. Brin M: Erythrocyte transketolase in early thiamine deficiency. Ann NY Acad Sci 98:528, 1962
4. Dreyfus PM: Clinical application of blood transketolase determinations. N Engl J Med 267:596, 1962
5. Dreyfus PM: Diseases of the nervous system in chronic alcoholics. In Kissin B, Begleiter H (eds): The Biology of Alcoholism, Vol III. New York, Plenum Press, 1974, pp 265–290

6. Dreyfus PM, Geel S: Vitamin and nutritional deficiencies. In Albers RW et al. (eds): Basic Neurochemistry. Boston, Little, Brown, 1972, pp 517–535

7. Field EJ: A rational prophylactic therapy for multiple sclerosis? Lancet ii:1080, 1973

8. Lerman S, Feldmahn AL: Centrocecal scotoma as a presenting sign in pernicious anemia. Arch Ophthalmol 65:381–385, 1961

9. Lopez RI, Collins GH: Wernicke's encephalopathy. A complication of chronic hemodialysis. Arch Neurol 18:248–259, 1968

10. Mayer RF, Garcia–Mullin R: Peripheral nerve and muscle disorders associated with alcoholism. In Kissin B, Begleiter H (eds): The Biology of Alcoholism, Vol II. New York, Plenum Press, 1972, pp 29–65

11. Mena I, Cotzias GC: Protein intake and treatment of Parkinson's disease with levodopa. N Engl J Med 292:181–184, 1975

12. Rosenberg LE: Vitamin-responsive inherited diseases affecting the nervous system. In Plum F (ed): Brain Dysfunction in Metabolic Disorders. New York, Raven Press, 1974

13. Tomasulo PA, Kater RMH, Iber FL: Impairment of thiamine absorption in alcoholism. Am J Clin Nutr 21:1340–1344, 1968

14. Victor M: The effects of nutritional deficiency on the nervous system. A comparison with the effects of carcinoma. In Brain L, Norris FH (eds): The Remote Effects of Cancer on the Nervous System. New York, Grune & Stratton, 1965

15. Victor M, Adams RD: On the etiology of the alcoholic neurologic diseases with special reference to the role of nutrition. Am J Clin Nutr 9:379–397, 1961

16. Victor M, Adams RD, Collins GH: The Wernicke–Korsakoff's Syndrome. Philadelphia, FA Davis, 1971

17. Weigand CG: Reactions attributed to administration of thiamin chloride. Geriatrics 5:274–279, 1950

18. Zeeman W: Studies in the neuronal ceroid-lipofuscinoses. J Neuropathol Exp Neurol 33:1–12, 1974

25 Obesity

I. Frank Tullis, Kenneth F. Tullis

Human obesity is the disorder in which excessive amounts of fat are stored in adipose tissue cells of the body. Its prevalence in the United States rises rapidly at age 25, and by the 50–59 age decade, virtually one-third of our men and one-half of our women exceed desirable weight by at least 20% (33). Most Americans consider obesity the number one nutrition problem, and some 50 million of them spend an estimated $100 million each year looking for an easy way to lose weight. This figure soars to about $10 billion annually if one includes dietetic foods, "fat mills," "health spas," appetite-suppressing drugs, special exercise equipment, and numerous devices and appliances for spot fat loss. It would be a blessing if such sums of money could be diverted toward solving the protein–calorie malnutrition so common and so lethal in many parts of today's world.

Authors of the mid-twentieth century have often alluded to obesity as a disorder of overnutrition, principally to contrast it with undernutrition or malnutrition, these latter usually being more prevalent and more severe in less-industrialized areas of the world. Many, however, feel that overnutrition connotes "more-than-necessary good nutrition." This connotation is not desirable, and hopefully the terminology "caloric excess" (2) will be universally adopted.

SOCIAL ATTITUDES TOWARD OBESITY

HISTORY

Today most people look upon obesity as undesirable, but this has not always been true. Shakespeare's Falstaff described himself as "a goodly portly man, i'faith, and a corpulent. . . (25)." Charles Dickens' boy in *The Pickwick Papers* was so fat that he fell asleep standing at the door. The female form is often represented in Renaissance art as quite plump, and it was common for children to be represented as fat and chubby cheeked. Painters who chose to portray their subjects as stout individuals included: Peter Paul Rubens (1632), Jan Vermeer (1665), Eugene Delacroix (1845), and Pierre Auguste Renoir (1884).

Since around the beginning of the nineteenth century, however, there has been a gradual transition to the attitude that slenderness is ideal. Social historians say that the 1920s saw the idealization of the female form known as the "boyish figure." Clothing fashions of that decade firmly established that a stylish person had to be slender. Professional models are traditionally thin, and beauty contest winners are rarely an ounce overweight.

By the early 1900s, being overweight had come to be considered an undesirable abnormality. Life insurance companies began collecting statistics on the relationship of body weight to life span. From these records and studies have come the tables used to define desirable weight according to sex, height, and general body frame. Newer tables came from the results of the Build and Blood Pressure Survey 1959 in which a large number of people were actually measured (see Appendix Table A-9).

Social attitudes concerning overweight in recent years are well expressed in the results of a Gallup Poll taken in 300 localities in the United States, March 30–April 2, 1973 (10). The subjects of the poll were 3052 adults 18 years of age or older. Each individual in the survey was asked questions about his view of his own weight. Overall, more than half of the women interviewed considered themselves overweight; more than a third of the men so responded. In addition, nearly half of the women and a third of the men were dieting or exercising to lose weight or to maintain their weight at that time.

OBESITY AND SOCIAL CLASS

In the last few years, interest in obesity has increased exponentially, bringing together such various groups as internists, surgeons, psychiatrists, psychologists, sociologists, nutritionists, economists, and politicians. Obesity is a form of malnutrition that is most prevalent in the lower socioeconomic groups. Several studies have verified this fact, but the most frequently quoted study appears to be the Midtown Manhattan Study, published in 1962 (27). The data from this study were carefully analyzed in separate reports by three experts, and the results showed that of 1660 adults, randomly sampled from census tract data, 32% of the men and 30% of the women in the lower socioeconomic group were obese in contrast to 15% of the men and 5% of the women in the upper socioeconomic group.

THE MYTH OF THE JOLLY FAT MAN

Today most people just do not like to be fat. They dislike the unattractive appearance, the general discomfort, and the social stigma of obesity. They agonize over getting into a small car, walking appreciable distances, or simply buying new suits or dresses. The "jolly" fat man or woman is a myth. Limited contact with severely obese persons might leave the impression that they are jovial, good-natured, friendly to all, and constantly smiling. Close and repeated contact, by contrast, often discloses subtle signs of despondency, dependency, manipulation, and hostility. In fact, psychological studies have shown that a key behavior reaction among obese persons is hostility, although it is usually disguised during casual meetings and is often denied by them.

DIAGNOSIS OF OBESITY

Although cause and effect have not been clearly established, obesity has a high association with coronary artery heart disease, hypertension, smoking, and maturity onset diabetes (19). In fact, it is estimated that 70%–80% of maturity onset diabetics are obese. Such diabetes appears to develop about four times more often in fat persons than in others. Furthermore, complications are more common in the obese during acute illness, and following accidents, general anesthesia, and surgery. The overall death rate of the appreciably overweight population is at least 50% greater than that of the normal-weight of similar age.

"OVERWEIGHT" AND "OBESE"

Technically, overweight is weight greater than normal as compared with sex–height and body–frame weight tables. This refers to excess weight of everything in the body, *i.e.,* fat as well as bone, muscle, tissue, minerals, and water. By contrast, obesity refers only to abnormal amounts of body fat. The two are not always synonymous. A good example is a well-trained football player who weighs 220 pounds with a height of 6 feet. Technically, he is overweight because of muscular development, but he certainly has no excess fat.

There are two types of weight tables: 1) desirable weights based on sex–height and body–frame tables and 2) standard weights, which is simply the average of many measurements. The most recent sex–height and body–frame table was derived from the Build and Blood Pressure Survey of 1959 and was based on those weights most desirable for longest life. Standard weights, on the other hand, do not attempt to define desirable weights.

Even though overweight and obesity are not always synonymous, in practical terms almost all individuals are obese when they become 15%–20% overweight.

MEASUREMENTS OF OBESITY

LABORATORY TECHNIQUES

There are ways to measure body fat somewhat more accurately. In one, weight in air is compared with weight under water (with appropriate attention to the lungs). In another, total body volume is determined in a special body volume chamber, and the necessary calculations are made. In each method, total body water is determined by a technique such as radioactive tritium administration and subsequent measurement of labeled water. Unfortunately these techniques, although valuable in the research laboratory, are not really practical.

SKIN-FOLD THICKNESS

Another more-direct method to determine body fat is that of measuring a fold of skin with special calipers. Good locations for measuring fat in this way include the triceps area on the back of the arm, at the angle of the scapula, over the lower abdomen and other areas. The measurement is made by "pinching up" a fold of skin (actually a double skin-fold) and determining its thick-

ness. Measurement must be made with a special caliper engineered to provide constant pressure regardless of thickness of the double skin-fold. Of these measurements the triceps skin-fold thickness is probably the easiest and most representative of total body fatness. Seltzer and Stare (24) have proposed the figures of 23 mm and 30 mm for male and female Caucasian American adults respectively as minimums defining the presence of obesity.

SIMPLE TESTS FOR OBESITY

Two very simple tests, however, serve to determine the presence of obesity. In the "mirror test" the individual views himself standing nude before a mirror and looks for a "fat" appearance. In the "ruler test" the individual, while lying flat on his side, places a ruler running from the rib cage to the pelvis and observes whether there is a straight or rounded contour. These tests do not accurately measure the degree of obesity but may dramatically confront an individual with the fact that he has a weight problem.

TYPES OF OBESITY

Obesity is not one entity common to all fat people. This has led many experts to talk of "the obesities." Classification of the types of obesity is clearly in its infancy, however, and probably will undergo many modifications in the future. The following classification, similar to one published by Bray (2), provides a check list to aid in diagnosing the type of obesity. Regardless of the type, obesity develops because caloric intake exceeds caloric utilization. This is true whether obesity occurs in an otherwise healthy person or in an individual suffering from some other disease.

 I. Hypertrophic obesities
 1. Adult onset obesity—the "creeping waistline"
 2. Hypothalamic obesity
 a. Tumors
 b. Inflammation
 c. Trauma
 d. Increased intracranial pressure
 II. Hyperplastic obesity
 1. Juvenile onset obesity
 a. Type I vs. Type II—based on age of onset
 b. Hyperphagia vs. inactivity—based on activity level

 III. Endocrine-related obesities
 1. Cushing's
 2. Insulinoma
 3. Castration
 4. Stein–Leventhal
 5. Pregnancy
 6. Thyroid deficiency
 IV. Genetic obesities
 1. Laurence–Moon–Bardet–Biedl syndrome
 2. Hyperostosis frontalis interna
 3. Alstrom's syndrome
 4. Prader–Willi syndrome
 V. Drug-related obesities
 1. Cyproheptadine
 2. Phenothiazines
 3. Tricyclic antidepressants
 VI. Special psychologic obesities
 1. The night-eater
 2. The binge-eater

HYPOTHALAMIC–ENDOCRINE– GENETIC OBESITIES

Associated signs and symptoms will usually alert the physician to hypothalamic obesities. These appear to be caused by lesions in the brain specifically damaging the area of the hypothalamus, which has long been felt to be one of the brain's sensitive control centers for weight maintenance. Of those tumors which may encroach upon the ventromedial nucleus of the hypothalamus, craniopharyngiomas were most common in a series analyzed by Bray (2). As with the hypothalamic obesities, associated signs and symptoms should alert the physician to unusual endocrine-related and genetic obesities. On the other hand, careful history is essential to determine juvenile onset obesity, drug-induced obesity, special psychological obesities, and adult onset obesity. In general, the hypothalamic obesities and endocrine-related obesities represent a small fraction of the total population of obese individuals and so will not be reviewed in depth in this presentation.

THE THYROID MYTH

In years past, the majority of obese individuals were thought to suffer from thyroid deficiency. This apparently stemmed from the fact that the basal metabolic test for thyroid activity once in use—the measurement of oxygen consumption—was lower in individuals with greater body surface area. Thus, large body size of an obese person introduced an error

that led to low basal metabolic values for most overweight persons. With the development of newer blood–thyroid tests, such as T_3 and T_4, this error has been overcome to a considerable degree, and now the majority of obese people are found to have the same blood–thyroid levels as everyone else.

Rather recently, thyroid antibodies, presumably against the protein of thyroxin, have been demonstrated in obese patients. This finding has led to the hope that obesity in some individuals may be caused by or aggravated by these antibodies. In an obese individual with normal serum T_3 and T_4 determinations, the tissue effectiveness of these hormones conceivably could be nullified by interaction of the antibodies and the thyroid hormone. However, if such a category does indeed exist, it must be extremely small since only rarely can antibodies be demonstrated in obese subjects by a sensitive hemagglutination technique.

SPECIAL PSYCHOLOGICAL OBESITIES

Two small subgroups of obese persons are characterized by abnormal, stereotyped food intake patterns.

THE NIGHT-EATER

The night-eater is more commonly a woman who has morning anorexia, evening hyperphagia, and insomnia—the triad usually precipitated by stressful life situations. Once begun, the syndrome tends to recur daily until alleviation of the stress. Stunkard (29) estimates that approximately 10% of obese individuals have this pattern and warns that weight reduction with these people has an unusually poor outcome. Investigators have recently suggested antidepressants to treat these patients (6).

THE BINGE-EATER

The binge-eater suddenly and compulsively eats very large amounts of food in a very short period of time, usually with great subsequent agitation and self-condemnation. It, too, represents a reaction to stress, but the bouts are not usually periodic. Stunkard (29) estimates that approximately 5% of obese persons have this pattern and suggests that the small percentage of obese persons who later develop anorexia nervosa appear to have been binge-eaters.

JUVENILE VS. ADULT ONSET OBESITY

The separation of those obese individuals who gain most of their excess fat as children—hence the name juvenile onset obesity—from those individuals who gain their excess fat as adults is an important step based on relatively recent research. Investigators used biopsies of actual fat tissue to examine the fat cell, or adipocyte, and determined that in all forms of obesity studied the obese individual has enlarged, or hypertrophied, adipocytes compared to those in nonobese populations. Amazingly, however, the total number of fat cells was the same in the obese and nonobese, with one important exception. In obese individuals of juvenile onset type, it was clearly demonstrated that they have a greater number of fat cells than the nonobese or the adult onset obese individuals (13). Hence, the term hyperplastic obesity is used in reference to juvenile onset obesity.

JUVENILE ONSET OBESITY

Juvenile onset obesity is clearly different from other forms of obesity and is difficult to treat. Predisposing factors include being the youngest or only child, being the product of an unwanted pregnancy, experiencing psychological trauma (3), having obese parents or siblings (7), having physical handicaps that limit mobility (12), and having a family structure in which the father is subordinate to the mother (4). One study (16) demonstrated that in a group of obese children a history of separation from the mother was nearly four times more frequent than among control children, thus raising the question that separation anxiety in children is a possible cause of obesity in some of these cases.

Furthermore, if one observes the eating behavior of a newborn infant, it is easily seen how parental teaching and attitudes begin to influence these behaviors. For example, the breast-fed child sucks until satisfied, and the mother does not know how much milk he has ingested. Physiologically, the mother produces milk according to the demands of the child. This important biologic feedback system is disrupted when the breast is replaced by the bottle. The mother then has a visual cue and can see how much milk the child has ingested, making it possible for her to overfeed or underfeed her child based on her own attitudes about how much he should eat (15).

Forbes (8) suggests two subtypes of juvenile obesity based on age of onset: Type I is charac-

terized by an increase in lean body mass, a tendency to tallness, advanced bone age, and a history of overweight since infancy whereas Type II shows no increase in lean body mass and normal growth characteristics, with obesity developing during the childhood years.

Based on activity level, two subtypes of childhood and adolescent obesity have been suggested: 1) the hyperphagic type, in which the imbalance seems primarily due to excess intake, and 2) the low-activity type, in which the imbalance seems primarily due to decreased caloric expenditure. In several studies obese girls actually ate less than the controls but spent two-thirds less time in active pursuits (20).

Body image, which refers to "the picture that a person has of the physical appearance of his body," is disturbed in a high percentage of individuals with juvenile onset obesity. It appears that body image disturbances may occur almost exclusively in this juvenile onset group and that adolescence may be the period during which such disturbances most likely begin or surface. Furthermore, almost all adolescents with body image disturbances have serious difficulties in relationships with the opposite sex (31).

ADULT ONSET OBESITY

By far the largest number of obese Americans, perhaps 95%, fall into the adult onset category. Typically, this person remains in some sort of weight equilibrium until around age 25, when weight becomes a problem year-by-year until around age 55. The story often sounds like a broken record: he loses weight, gains it back, loses it again, gains it back plus a little more—hence, the name "creeping waistline" obesity. Many of these obese persons have literally lost their entire body weight several times over the years but have almost always gained the weight back.

TREATMENT—GENERAL CONSIDERATIONS
STANDARD TREATMENT

Treatment of any disorder is generally unsatisfactory when etiology and pathogenesis are still inadequately defined. The routine approach to treatment of obesity usually involves a short office visit during which the patient may be handed a diet with limited instruction; he is often given a prescription for medicine and usually counseled on the need for self-control. Some

physicians have tried additional measures for treatment of obesity, including hospitalization with drastic reducing diets or periods of fasting. Such approaches were in vogue during the late 1950s and early 1960s. Later in the 1960s, commercial outpatient treatment facilities emerged as an approach to obesity treatment with emphasis on group reinforcement. These facilities have thrived.

The success rate for all forms of treatment of obesity is not good. Impressive data showing large weight loss in a short period appear widely in the literature, yet such data are deceptive. First, just losing weight is not the primary problem. The problem is keeping it off—that is, weight maintenance. It is estimated that at least 60%–75% of those who try to lose weight in a serious way can usually achieve a fair degree of success, but of that same group, only about 5% will keep their weight down (30). Furthermore, it is frankly admitted by many medical experts that medical research facilities provide no better results in weight reduction and maintenance than those achieved by self-help groups such as TOPS (Take Off Pounds Sensibly) or organizations such as Weight Watchers.

THE NEED FOR 5-YEAR STATISTICS

It is now generally agreed that reporting impressive weight loss over several weeks or months is useless unless: 1) the dropout rate is stated and those who dropped out are followed and 2) the weight loss is maintained and documented for at least 2 and preferably 5 years after initial weight loss. This, in effect, would be similar to 5-year cure rate statistics in cancer research. At present, very little data of this type are available.

WHY TREATMENT FAILS

There are several reasons why traditional treatment of obesity fails. First, many times in the doctor's office, the physician's attitude often is that all the patient has to do is follow his doctor's good advice and demonstrate his self-control. Failure to follow "doctor's orders" is seen as proof of the patient's weakness or uncooperativeness. Physicians rarely consider the possibility that this noncompliance may itself be part of the problem (21). Secondly, there is a tendency for physicians to underestimate the resistance of the obese person to permanent change. Caloric imbalances occur on a day-to-day basis and involve complicated eating and activity patterns.

Practiced and strengthened daily for many years, these patterns provide immediate positive reinforcement by satisfying taste, relieving hunger, and often—temporarily—alleviating anxiety. Such patterns are usually very resistant to permanent change. Thirdly, unlike many disorders which may be successfully treated by completely avoiding an offending agent, obesity cannot be treated successfully by avoiding food. Sooner or later every dieter must again face food and must again face a rather sedentary life style reinforced by a society that stresses the importance of minimal as opposed to maximal effort.

THE PHYSICIAN'S ATTITUDE

The first step in initiating treatment of an obese individual is honest evaluation by the physician of his own attitudes toward treatment. The physician should recognize that: 1) obesity is a serious disorder and not an afterthought problem, 2) controlling rather than curing obesity is the best approach at present, and 3) successful treatment (control) requires a large investment of his own time. The physician who himself is obese may be likely to overlook the problem in his patient. If the physician is obese, smokes cigarettes, and follows no active physical fitness program, he will likely have a negative influence on his patient's weight control regardless of his approach. Many physicians just plainly do not like to treat obese patients, possibly because they themselves have never experienced a weight problem and hence have little empathy for the obese patient. Other physicians are discouraged by the many frustrations and poor cure rates that go along with treating obese patients. In such instances, everyone is better off if the patient is referred to another physician.

SPECIAL EVALUATION

The second step in treatment is correct diagnosis of the type of obesity. As previously mentioned, the patient with an endocrine-related, genetic, or hypothalamic obesity should be detected by a degree of suspicion and associated signs and symptoms of the basic abnormality. These cases should be referred to appropriate specialists for treatment of the primary disorder. The diagnosis of juvenile onset obesity is made by establishing that the patient was obese in childhood. Fat tissue biopsy is confirmatory but seldom needed. Careful consideration should be given to referring such cases to physicians with particular in-

terest in obesity since weight loss and weight maintenance are considerably more difficult than in the adult onset type. In fact, recent research (14) suggests that at desirable weight such a patient may actually be living in a state of semi-starvation! The patient with a concomitant psychiatric disorder should be treated in consultation with a psychiatrist. Severe depression, strong suicidal tendencies, psychosis, and massive weight gain at puberty are some of the indications for such consultation.

THE PATIENT'S CHANCES FOR SUCCESSFUL WEIGHT CONTROL

The third step in treatment is evaluation of the patient's chances for successful weight control. Generally, the more obese the patient and the younger the patient at the time of onset of obesity, the poorer are his chances for successful weight control. Furthermore, a history of repeated dieting, weight loss, and subsequent weight gain decreases the chances for successful weight control. Finally, the patient has a poor chance for successful weight control who: 1) expects dramatic results, 2) places the burden for success on the physician or on some special "gimmick," or 3) fails to see obesity as a serious disorder that is at best controlled—not cured.

MEDICAL EVALUATION

The patient should have had a recent physical examination, and if significant exercise is anticipated the patient needs a CBC, chest film, urinalysis, 2-hour postprandial glucose, EKG, T_3 and T_4 determinations, serum lipid profile, and hemagglutination determination for thyroid antibodies.

DEALING WITH RATIONALIZATIONS

The medical evaluation, which is usually reassuring to the patient, serves to introduce the second part of the evaluation—uncovering the patient's rationalizations for obesity. This is time consuming but essential. The obese patient often has several excuses to explain his problem. At times these excuses center around medical problems and many times include a strong belief that he has a slow metabolism. In addition to medical excuses, the obese patient may quote at least three myths that the physician should be prepared to deal with firmly. First, the patient may be convinced that "calories don't count—it's all

in the diet." This is not true. Secondly, he may be convinced that "exercise just tones up muscles rather than burning calories." This is not true. Thirdly, he may be convinced that "exercise stimulates the appetite and, therefore, offsets weight loss." This is not true. All of the patient's rationalizations and misconceptions regarding his obesity should be uncovered as soon as possible, and firmly, but compassionately, dealt with throughout treatment.

TREATMENT MODALITIES

DIETS

Of the treatments for obesity, various types of diets probably far exceed all other types of treatment combined. Reducing diets have been around for quite a while. New diets come and go, but curiously, the majority of them employ the same basic principles and are regularly rediscovered and brought back to life under a new name. One such fad diet was introduced by Dr. William Harvey, the well-known British surgeon, in 1863. A similar diet, called the Pennington diet, surfaced nearly a century later, in about 1953. Successors included the Air Force diet—which has nothing to do with any nation's air force, Dr. Herman Taller's diet 'Calories Don't Count' in 1961, "The Drinking Man's Diet" in 1964, a low-carbohydrate diet in 1965, and Dr. Irwin Stillman's "The Doctor's Quick Weight Loss Diet" in 1967. More recent in the diet parade have been "Dr. Atkins' Diet Revolution," touted as a "High Calorie Way to Stay Thin Forever," and Dr. David Reuben's "The Save-Your-Life Diet," substituting high-fiber food for low-roughage dishes.

The common thread through all of these diets is a generally low carbohydrate intake. Taller's plan provided a high-protein, high-fat, low-carbohydrate diet with which safflower oil capsules were taken. These supplements were supposed to flush the body fat out of the system. For the first week of Atkins' program, the dieter excluded all carbohydrates from his daily food, producing ketosis, a condition whereby products of fat breakdown caused by lack of carbohydrates in the diet are excreted in the urine. Atkins makes a big point that calories "flow out of the body" with the ketones as a special feature of the diet. However, Dr. Philip White, secretary of the Council on Foods and Nutrition of the American Medical Association, estimates that no more than 100 Cal are lost via ketone excretion (34). In each of these diets, the immediate effect is a sharp drop in body weight through loss of body water, not fat. This is due primarily to the low carbohydrate factor—carbohydrates being a water-retaining substance via their effect on sodium balance. The long-term effect appears to be decreased calorie intake through boredom with the diet's composition.

Another revived plan is Simeons' 500 Cal diet plus injections of human chorionic gonadotrophin, commonly called HCG shots. This program consists of a series of 125 units HCG injections usually given daily for 23 days and never more than 40–45 days, at which time resistance develops (26). It is touted that the HCG "fools" the body into releasing special fat stores as though giving it to a fetus and at the same time produces a sense of well-being that enables the dieter to stay on the 500 Cal diet. Simeons himself insists that it will not work at even a modest increase to 600 Cal/day. Furthermore, once weight is lost, his approach to maintaining the weight loss consists of having one's own portable bathroom scales always at hand, weighing without fail every morning, and never allowing more than a 2-pound increase!

FREQUENCY OF MEALS

Along with diet composition, frequency of meals has received considerable attention. It has been observed that most obese individuals usually eat little or no breakfast, and often a light lunch. Based on the notion that Paleolithic man was a hunter who ate only when he was hungry rather than by the clock, some authors have suggested that excessive weight, increased serum cholesterol, and proneness to diabetes may be more common among those who eat three or fewer meals daily than among those who eat five meals. Other authors strongly oppose the notion that body weight and fat are affected by frequency of meals. In a like vein some investigators have reported successful weight loss with two meals per day. Long-term data are inadequate, and it would appear that for the obese person who enters a weight reduction program with a significantly reduced caloric intake, three balanced meals are preferred.

THERAPEUTIC FASTING

Since ancient times people have gone without food for protracted periods. Economic deprivation, political abuse, religious rituals, and in more-recent times treatment of obesity have

prompted fasting techniques. Total fasting requires adequate fluid intake, vitamins, and electrolyte supplements. With total fasting, the average patient experiences hunger cravings for 48–72 hours but then no longer has appreciable hunger, possibly due to accumulation of ketones. Many people continue to have preoccupation with food, however, and often dream of food or talk about food. Physical complications of fasting include hepatic dysfunction, infection, cardiac complications, and high levels of uric acid. Usually, total fasting produces losses of 1–2 pounds (mostly water) daily until a plateau is reached after 2–3 weeks, presumably due to water retention. Three major fasting techniques are: 1) short-term fasting up to 3 weeks, 2) intermittent fasting using repeated periods of fasting interrupted by specific diets, and 3) prolonged fasting for months. Most studies show that although short-term fasting produces minimal psychological and physical discomfort in the majority of cases it invariably has little effect on long-term management of obesity unless eating habits and activities are altered.

Intermittent fasting, consisting of a short-term fast up to 14 days followed by 1 or 2-day fasts per week until reaching ideal weight, also appears to produce minimal psychological and physical discomfort but must be coupled with a realistic weight management plan.

Prolonged fasting of hospitalized patients produces impressive weight loss, but there is some danger of disruptive psychological reactions during such treatment—including irritability, depression, dependency, aggressiveness, and paranoid reactions. Follow-up of patients subjected to prolonged fasting often reveals regained weight and bitterness toward the medical profession because of lack of success in maintaining weight loss—suggesting that these patients view the starvation program as a magical technique resulting in large, permanent weight losses.

MEDICATIONS

Medications are widely used in weight loss programs for direct appetite suppression, diuresis, increasing dietary bulk to suppress hunger, or increasing the metabolic rate. Amphetamine derivatives suppress appetite and tend to increase activity level, but these effects usually last 4–6 weeks and can be associated with significant difficulties, including severe paranoid reactions and addiction. More-recent appetite suppres-sants claim to produce less problems and may be used cautiously. Diuretics produce results on the scales but merely reflect water loss. Furthermore, diuretics are dangerous unless carefully monitored. They can produce electrolyte imbalances and are indicated only when obesity is associated with a disorder that is properly treated by a diuretic, e.g., hypertension with edema. Likewise, digitalis should be used only when indicated by the patient's cardiac status. The artificial bulk-producing agents such as methyl cellulose have not been shown to have any special merit. Natural bulk-producing agents such as apples, celery, raw carrots, and salads are more palatable and may be beneficial in slowing the rate of eating, thus allowing time for satiety phenomena to take place. For stimulating metabolism, various thyroid preparations have been used. Desiccated thyroid and synthetic thyroid agents should be used only when the obesity is associated with well-documented hypothyroidism.

SURGERY

Of the more-permanent solutions to weight management, stomach and bowel surgery is one of the most drastic and is at present ordinarily reserved for extremely obese patients. One procedure, called jejunoileal bypass, consists of short-circuiting the absorptive area of the small bowel by connecting the jejunum directly to the ileum. Theoretically, then, the obese individual can eat whatever he wants but his system simply won't digest and absorb all of it because of the short-circuit. Unfortunately, the overall mortality rate is upward to 9% in some series, the patient is limited in what he can eat by diarrhea—actually steatorrhea, or fatty diarrhea—and there are reported problems involving potassium, calcium, and magnesium ions. Finally, some patients develop severe liver damage.

WIRING THE JAWS CLOSED

More recently, obese patients have resorted to having their jaws wired closed with bands connecting their upper and lower teeth. Wire cutters are carried in the event of nausea with impending vomiting. Essentially the patient is reduced to a liquid diet through a straw but most patients learn to use a blender to increase significantly the quality of the liquid diet.

INDIVIDUAL PSYCHOTHERAPY

Forms of psychotherapy aimed at uncovering psychological mechanisms underlying the patient's obesity generally have proved unrewarding, although isolated successes are reported. Psychiatric treatment can produce good results if the patient has a treatable psychiatric disorder with obesity as a recent manifestation. For example, many cases of clear-cut depression are associated with rapid weight gain rather than the "classic" weight loss. In such cases prompt, adequate treatment of the depression may adequately treat the obesity. In this context, however, it is worth remembering that most tricyclic antidepressants, as well as many other psychotropic drugs, appear to be associated with significant weight gain.

GROUP PSYCHOTHERAPY

Various types of group therapy have been utilized for treatment of obesity. Insight-oriented groups based on theories viewing obesity as a symptom of an underlying "psychic abnormality" have been popular from time to time but usually fail to produce weight loss. Social pressure groups based on creating a high positive expectation for losing weight have become popular recently. In such groups various techniques have been employed: support from other group members, competition among members, positive reinforcement from a therapist, and—occasionally—negative reinforcement, e.g., wearing signs denoting failure to lose weight. Numerous organizations have programs containing these characteristics. Adequate data are not available to determine their long-term success, but most authorities agree that some of these organizations probably surpass the success rate of standard treatment by physicians. Focal behavior modification groups are superior to social pressure groups in producing greater weight loss during 12 weeks of treatment and at 8 weeks after termination (35). The techniques of focal behavior modification are discussed below.

BEHAVIOR MODIFICATION

Of the various modalities for treatment of obesity, behavior modification is probably receiving the most attention at present. In this approach obesity is defined as a learned behavior disorder. Using principles of behavior modification psychology, appropriate eating behavior is learned and inappropriate eating behavior is eliminated.

Attention is focused on changing observable, specific behavior rather than on hypothetical or inferred entities such as "self-control," "motivation," "compliance," or "will power."

The treatment, which is essentially a reeducation process, reflects several basic learning principles (22):

1. Specific and precise target behaviors to be changed are selected.
2. Shaping of behavior is achieved by stressing one small, achievable step at a time until the ultimate goal is reached.
3. Measurement of behavior and feedback provides the patient with knowledge of how closely his behavior approximates his goal.
4. Positive reinforcement encourages appropriate behaviors.
5. Environmental control factors are recognized as a key to shaping and maintaining behavior. This is especially relevant in view of recent research indicating that obese patients are relatively insensitive to appropriate internal physiological hunger and satiety cues.

Several obesity experts suggest that obese persons eat in response to situational cues from the environment, such as time and visibility of food (23). Thus, careful studies are made almost minute-by-minute of exactly what an obese person eats, where he is when he eats, how he feels, with whom he eats, and what are his exact activities. From these data, a rational program of change is developed with a positive reward system and an overriding theme of "don't attempt any change that you can't live with the rest of your life."

HYPNOSIS

The use of hypnosis for treatment of obesity is not widespread, and little scientific data are available to determine its long-term effectiveness. Several authors have reported impressive results with treatment programs centered around posthypnotic suggestion. Several principles are employed. The first is symptom substitution, through which one can "trade down" to other eating behaviors, such as chewing gum. In symptom transformation, overeating is transferred by posthypnotic suggestion to other behaviors, such as physical exercise or shopping. In symptom amelioration overeating is reduced, and in symptom utilization activity of an aversive nature

toward the faulty eating pattern is encouraged (17). Numerous other techniques are employed, including age regression, hypnotic anesthesia to control hunger pains, and suggestions to think of a nauseating smell whenever eating something not on one's diet.

WEIGHT LOSS VS. WEIGHT MAINTENANCE

All of the above treatment modalities usually produce some weight loss. In years past many physicians and patients assumed that removal of excess weight would instill renewed "will power" to prevent future weight gain, but such magical change seldom occurred. Almost invariably the patient regained weight after the initial weight loss. Observant physicians and patients alike watched repeated failures and recognized that another phase of treatment was essential, namely, weight maintenance. This phase quickly proved to be more difficult to manage and as experience with weight maintenance increased, the approach to treatment of obesity underwent considerable evolution with greater emphasis on a gradual and practical transition from the weight loss phase to the weight maintenance phase.

It is now clear that any weight loss plan which does not include a weight maintenance plan is almost certainly doomed to fail based on a 5-year "control rate." Furthermore, the concept of weight maintenance must be introduced early and repeatedly during the weight loss phase. Some authors suggest that the two phases must begin simultaneously. In general, the physician must accept a great deal of responsibility for the weight loss phase. This leaves him in a difficult position. On the one hand he must control the weight loss phase sufficiently to produce results (after all, the patient would not be obese if he could treat himself); yet, on the other hand he must successfully shift some degree of responsibility for maintaining the weight loss to the patient. At the present time, weight maintenance must be viewed as an ongoing process since there are no known cures for most types of obesity. This is comparable to the management of diabetes, in which the physician initially accepts responsibility for diagnosing and controlling the illness, after which the patient must learn to manage the illness on a daily basis with urine checks, diet adjustment, insulin, and adjustments in activity under the physician's guidance.

ESSENTIAL ELEMENTS OF A TREATMENT PLAN

Two elements are essential to a successful treatment plan for obesity: 1) decreased caloric intake and 2) increased caloric expenditure.

DECREASED CALORIC INTAKE

Many misunderstandings about obesity and fat reduction stem from inadequate knowledge about what should constitute a diet, particularly the relative proportions of carbohydrates, fat, and protein. Several scientists have demonstrated that at a given caloric level with a constant energy output, the greatest body weight loss occurs when most calories come from a fatty diet. The next greatest derives from a protein diet, and the least from a carbohydrate diet. Also, it has been shown that the carbohydrate effect on sodium balance is the critical factor in this diet. Urinary excretion of both sodium and water is increased, dramatically decreasing total body water. The scale then shows an obviously impressive drop in weight, but the drop is caused by water loss and not by fat reduction. Over a long period of time the composition of the diet is not important as long as it is nutritionally adequate.

Another factor involved in diet makeup is the "boredom component." Even though high-protein and high-fat foods so integral to fad diets seem so glorious to the obese dieter at first, after a time they lose their luster. No longer enjoying the constant eating of these foods, the dieter either discontinues the diet or, hopefully, begins to decrease his total caloric intake below caloric expenditure. If this happens then, and only then, will he lose body fat.

If a person's inability to follow a diet program is ignored for the moment, weight control is no more than the perfectly simple phenomenon of eating less food than is burned up. Although not everyone can translate the following instructions into action, the essential features of a good diet program are the following:

1. Keep the diet nutritionally adequate, including:
 a. Lean meat, fish or fowl twice daily plus three or four eggs weekly
 b. Cereal or bread three times daily
 c. Green or yellow vegetables twice daily
 d. Fruit or fruit juice twice daily, including a citrus juice

2. Eat enough calories to permit physical activity
3. Take in at least 300 Cal at each of three or four meals without snacking
4. Take reasonably sized portions without second servings
5. Broil, boil, bake, or roast meat, fish, and poultry; remove visible fat from meat; and use only natural juice instead of thickened gravy
6. By using low-fat milk, a small amount of margarine, preferably a corn-oil type, may be used to season vegetables
7. Cook vegetables without fat and add allowed margarine after cooking; flavor cooking water with herbs or bouillon cubes
8. Favor green, yellow, or red vegetables over starchy ones
9. Use low-calorie dressings, lemon juice, or vinegar on vegetables or fruit salads
10. Favor plain fruit over pastries for dessert
11. Sweeten only with sugar substitutes and use only sugar-free soft drinks
12. Eat meals at about the same hour each day to allow a consistent interval between each
13. Take little or no alcoholic beverages

INCREASED CALORIC EXPENDITURE

Many misunderstandings about obesity and fat reduction also stem from inadequate knowledge of the relationship of exercise to appetite. Exercise does not necessarily increase appetite. In fact, it has been shown that at low levels of exercise, usually less than 1–2 hours/day, an increase in exercise is *not* accompanied by an increase in food intake. At very low levels of activity, below 1 hour/day, voluntary food intake is often greater than at moderate activity levels (18).

Stuart (28) in 1975 concluded that an ideal exercise program should have four characteristics. First, it should be an aerobic activity—that is, an activity in which submaximal exertion levels are maintained for enough time to increase the body's capacity to process oxygen. This is best suited to most people because compared to other types of exercise it is relatively free of side effects and is most likely to be interesting and, therefore, sustainable. Secondly, it should produce a discernable level of fatigue and should begin at about 80% of a stress test capacity. Stress tests for measuring capacity include the 1) bicycle ergometer, 2) motor-driven treadmill, 3) the Master's two-step test, and 4) Cooper's run-jog-walk test. Stuart suggests that a target

heart rate be selected and exercise terminated when that level is achieved. Fox *et al.* (9) suggest peak load levels of 170 beats/min for 20–29 year olds, with the load diminished by 10 beats/minute for each decade. Thus, 80% of this would be a safe starting level. Thirdly, the exercise program should last for between 15 and 45 min per session; fourthly, it should occur three to five times weekly.

Recognizing this program as the ideal, Stuart suggested that the individual patient should be given latitude for adapting a suitable program for his or her life style. Some people may opt for an obtrusive program that interrupts the flow of events in each day. Others may seek less-obtrusive programs in order to maintain the even pace of their lives. Overall, if the program is to be successful, patients must be encouraged to evaluate, realistically and creatively, the time slots and type of exercise compatible with their life styles. In this way exercise becomes a positive factor in self-expression and weight management.

TREATMENT—SPECIFICS

OBESITY IN CHILDHOOD

Extreme obesity in childhood usually prompts medical evaluation to rule out an underlying hypothalamic-endocrine-genetic disorder. In the absence of such a disorder, or in cases of milder obesity, the old phrase "he'll grow out of it" simply is not true. Obese children warrant professional help. Often the pediatrician is the first professional contacted.

Both in preventing and treating obesity in childhood, parental reeducation is essential. In general, the treating physician should discourage such notions as "a fat baby is a happy baby" and "children should clean their plates." Furthermore, he should discourage snacking while watching television and should encourage a good breakfast with adequate protein.

If the mother is obese she should be referred for proper treatment since fat parents statistically "fatten their children." Furthermore, if an obese mother has just delivered a baby, breast feeding should be considered to prevent obesity in the child, since breast feeding, as mentioned before, does not leave the mother as much chance to alter the natural feedback mechanism of the hunger-satiety response in the child.

A careful history of the family life style will alert the physician to tensions in the family which may result in a poorly adapted, obese child. As noted before, separation from the

mother is a possible key element in this context.

Along with reeducation of the parents and situational adjustments within the family, a sensible diet and exercise plan are essential, with consistent long-term follow-up of the child and parents.

OBESITY IN ADOLESCENCE

Treatment of obese adolescents is difficult and often frustrating. Classic stereotyping, such as "fixated in the oral stage of psychosexual development," seldom appears to have significant treatment value and often allows the physician, especially the psychiatrist, to "explain away" the obesity without facing the problem. Anyone who has dealt with an obese adolescent will agree that obesity in teenagers is often associated with problems in personality development. Beyond this, one must be cautious about conclusions. A careful history would appear essential, and this should include birth weight, whether breast or bottle fed, age of onset of obesity, rate of growth and maturation, age of menarche in girls, familial occurrences of obesity, and accurate activity levels.

Most of the guidelines for treating obesity in childhood also apply to treating obesity in adolescence, except that adolescents' eating behaviors are generally less influenced by their parents. Body image appears to play an important role in a high percentage of adolescents with juvenile onset obesity. Three prerequisites for the development of a distorted body image, according to one study (5), are as follows: 1) the person developed obesity in childhood or adolescence, 2) the person suffers from an emotional disturbance, and 3) the obesity was the focus of derogatory parental concern. Since these serious psychological problems are carried into adulthood, prolonged intensive psychotherapy is indicated for obese adolescents who demonstrate these particular characteristics.

Treating physicians should be particularly alert for low-activity obesity, especially in obese adolescent girls. Careful history usually uncovers the inactivity, in spite of the sincere belief held by many that they are "constantly on the go." Carefully monitored treadmill tests often enforce needed caloric expenditures, increase aerobic capacity, and graphically show these patients what is meant by strenuous activity. Such enforced treadmill exercising appears to be one of the most effective methods for "forcing" exercise. Eventually, however, the emphasis must shift from physician-forced exercise to patient-motivated exercise. This requires careful planning and selection of a sensible program, with the physician encouraging the patient to accept responsibility for weekly exercise plans.

ADULT ONSET OBESITY

Adult onset obesity probably has the best chance for adequate control. The "ideal" patient is around 30, has gained only 10–15 pounds since age 25, is attempting weight loss for the first time, and is highly motivated to control his weight. (Such a patient is seldom considered for weight management until he is 45, has smoked for 10 years, and has developed other medical problems.)

In treating the above patients, intense individual psychotherapy is expensive and probably not indicated. Various "gimmicks" are widely used by these patients over the years, but few attempt long-term, consistent treatment. Physicians tend to overlook weight gain in these patients since the physicians often outweigh them. Consequently many doctors may contribute to the lack of consistent identification and treatment of such patients.

At the present time modification of eating patterns and exercise patterns appears to offer these patients the best chance for successful long-term weight control. In treatment the physician should: 1) determine where the patient is out of caloric balance (overeating, inactivity, or both), 2) pinpoint the patient's "problem" times of day and associated activities, 3) encourage small but well-reinforced changes (*i.e.,* ones with high odds of permanence, such as extra walking instead of a 5-mile jog at 5:00 AM), 4) encourage about 1–2 pounds of weight loss per week, which requires approximately a 500-Cal deficit each day, and 5) discourage fad diets, emphasizing instead a sensible diet centered around the patient's usual menu.

Numerous behavioral gimmicks have been employed by various investigators with some success, but it is essential to individualize these techniques. The principles behind these are, for the most part, scientifically sound. For instance, if the rate of eating a meal can be slowed to approximately 20 min, the patient will be satisfied with less food rather than "overshooting" his satiety point. Waiting 1 min before beginning to eat, laying utensils down between mouthfuls, and chewing each mouthful 10 or more times are several of the techniques employed to slow the rate of eating. Another principle is to keep food out of sight. Serving the

plates away from the table, serving smaller portions on smaller plates, throwing away leftovers, grocery shopping on a full stomach, and keeping food in covered containers are some of the techniques to reduce the visibility of food. A third principle is that people will eat less if eating is a "pure" behavior unpaired to other pleasurable events. Theoretically this encourages focusing on appropriate physiologic cues of hunger and satiety. Eating in one room, without TV or other activities, often helps the patient to focus on hunger and satiety cues. An additional principle is that people will eat less if they are engaged in activities requiring both hands, thus preventing eating. Hence, knitting at a particularly "high risk" time for snacking may result in a small but daily decrease in caloric intake. Group behavior modification, based on such principles, has been quite promising in maintaining weight loss in these patients.

EXTREME OBESITY IN ADULTS

Extreme obesity in adults is virtually incurable today and is at best barely controllable. With such patients, the physician must be prepared to invest much time. Usually these patients have lost weight before, only to regain it. Outwardly they appear enthusiastic to the point of looking for an instant, magic cure, but invariably, they secretly expect "another failure." This hampers treatment from the first and makes such patients extremely difficult to treat on a long-term basis. Outwardly they are often overly compliant, virtually putting their destiny in the hands of the physician, who almost instinctively accepts such responsibility willingly. This transaction usually places the physician in the role of a scapegoat. Secretly the patient knows he can escape responsibility by saying "that doctor failed to cure me," a phrase familiar to anyone casually acquainted with an extremely obese individual.

Even though the burden of responsibility for weight loss and maintenance must rest on the patient, the observant physician recognizes that he must initiate the program and carefully follow the patient for many years, if not indefinitely. Such patients simply cannot lose weight on their own and are often discouraged by behavior modification techniques alone. When a patient weighs 200 pounds and should weigh 110 pounds the thought of losing only 1–2 pounds/week is a dismal prospect that requires at least a year or two just to approach an ideal weight! However, if the patient can accept such a program, the obvious advantage is that one or

two years of sustained effort demands that the patient attempt only techniques "he can really live with," and this increases the chances of maintaining the weight loss.

Often, extremely obese patients, or their treating physicians, or both, are discouraged by the above approach and wish to produce early rapid weight loss "to get the patient over the initial hump." Such a philosophy is appropriate provided that the physician makes it clear that this is not a magic cure and that he begins early to focus on realistic day-to-day changes aimed at maintaining a progressive 1–2 pounds/week weight loss after the initial rapid loss. An obvious drawback to such a program lies in the fact that the patient usually sees the initial phase of rapid loss as a "magic solution" and is almost always disappointed when the rate of weight loss decreases to 1–2 pounds/week in the next stage of treatment.

FASTING

Any of the fasting techniques mentioned previously can be used by well-informed physicians who are aware of possible associated liver enzyme changes, potassium loss, ketosis, dehydration, hyperuricemia, and psychiatric problems. Hospitalization with available psychiatric consultation is probably best.

FORCED EXERCISE

If forced exercise on a treadmill is employed, the patient should not be on total fasting but should have a daily intake of at least 800 Cal with highest possible protein. Generally, forced treadmill exercising is associated with changes in the obese patient's personality from "jovial" to passive-aggressive to almost childlike refusal to cooperate even after 100 pounds of weight loss! Side effects of the treadmill include joint problems, especially pain and swelling of the ankles or knees, and low-back pain. Consequently, supervision is essential, and any treadmill regimen should start out slowly and gingerly. A questionable ankle or knee probably should be taped or wrapped with an ace bandage prior to using the treadmill (11).

APPETITE SUPPRESSANTS

Appetite suppressants, used carefully, may help the extremely obese patient overcome that initial hump. Again, it is essential for the physician

to explain that such medication is temporary and not a magic solution. He must focus almost immediately on realistic day-to-day changes aimed at obtaining a weekly weight loss of 1–2 pounds.

JEJUNOILEOSTOMY

Jejunoileostomy is relatively popular in treatment of extremely obese patients but should be undertaken cautiously. Psychiatric consultation is customary to screen for any serious emotional problems that could be aggravated by such surgery. Careful medical work-up is important to determine the patient's cardiovascular, renal, and liver functions prior to surgery, both as baseline information and to screen for surgical contraindications. After surgery, the patient with a jejunoileal bypass, commonly called "the shunt," must be followed at regular intervals. Virtually all shunt patients develop diarrhea, which begins with the first bowel movement after surgery and usually continues for 3–6 months with up to 15–20 liquid eliminations daily. The major factor in controlling the diarrhea appears to be careful adherence to a diet consisting of bland, fat-free foods, no raw vegetables or other roughage, and liquids between meals. Careful prescription of codeine, opium preparations, or Lomotil may further help control the diarrhea. Problems related to the diarrhea, such as perianal skin irritation, proctitis, hemorrhoids, and anal fissures, are frustrating for the patient and require instruction in proper perianal skin care. Electrolyte imbalances and other metabolic problems may occur after surgery. For instance, deficiencies of potassium and calcium may occur and usually respond to dietary supplements. Serum iron levels tend to drop below normal, but because iron is absorbed in the duodenum and the first part of the jejunum, oral administration of iron usually corrects this deficiency. Impaired absorption of vitamins B_{12} and fat-soluble vitamins A, D, and K should be anticipated and can be treated with injections of these vitamins at regular intervals. Renal calculi, usually of the calcium oxalate type, may occur after surgery. Impaired liver function is probably the most serious and most difficult problem (1). Fatty infiltration of the liver may increase after surgery, and hepatocellular enzymes may be elevated in the early postoperative period, indicating liver damage. Some patients develop irreversible liver damage, which can lead to death. Fortunately, hepatic damage is usually reversed by reanastamosis.

Regardless of the procedures used to initiate weight loss in extremely obese patients, the physician must arrange for follow-up of these patients at regular intervals to insure the best chance of successful weight maintenance. Experience has shown that the majority of extremely obese patients sooner or later are lost to follow-up either by their own failure to keep appointments or by the physician's failure to follow through. In this respect, patients with jejunoileal shunts may have an advantage over other patients. There is probably a greater motivation for careful follow-up of these patients, both by the treating physician and by the shunt patient who is aware of potential complications that require physical examination and laboratory procedures to detect.

REFERENCES

1. Bleicher J, Cegielski M, Saporta J: Intestinal bypass operation for massive obesity. Postgrad Med 56:68–69, 1974

2. Bray G: Types of human obesity—a system of classification. Obesity and Bariatric Medicine 2:147, 1973

3. Bruch H: Obesity in childhood. Am J Dis Child 59:739, 1940

4. Bruch H: The Importance of Overweight. New York, WW Norton, 1957, p 198

5. Carrera F: Obesity in adolescence. In Kiell N (ed): The Psychology of Obesity. Springfield Ill, CC Thomas, 1973, p 119

6. Carrera F: Obesity in adolescence. In Kiell N (ed): The Psychology of Obesity. Springfield Ill, CC Thomas, 1973, p 121

7. Ellis R, Tallerman K: Obesity in childhood: study of 50 cases. Lancet 2:615, 1934

8. Forbes G: Weight loss during fasting: implications for the obese. Am J Clin Nutr 23:1212–1219, 1970

9. Fox S et al.: Exercise and stress testing workshop report. J SC Med Assoc 65:74, 1969

10. Gallup G: 46% of U.S. adults rate selves overweight. Minneapolis Tribune, August 26, 1973, p 14B

11. Goodman C, Kenrick M: Physical fitness in relation to obesity. Obesity and Bariatric Medicine 4:14, 1975

12. Green J: Clinical study of the etiology of obesity. Ann Intern Med 12:1797, 1939

13. Hirsch J, Knittle J: Cellularity of obese and nonobese human adipose tissue. Fed Proc 29:1516–1521, 1970

14. Jordan H: In defense of body weight. J Am Diet Assoc 62:17, 1973

15. Jordan H, Levitz L: A behavioral approach to the problem of obesity. Obesity and Bariatric Medicine 4:60, 1975

16. Kahn E: Obesity in children. In Kiell N (ed): The Psychology of Obesity. Springfield Ill, CC Thomas, 1973, p 111

17. Kroger W: Systems approach for understanding obesity. In Kiell N (ed): The Psychology of Obesity. Springfield Ill, CC Thomas, 1973, pp 273–278

18. Mayer J: Overweight. Englewood Cliffs, Prentice–Hall, 1968, pp 71–75

19. Mayer J: Overweight. Englewood Cliffs, Prentice–Hall, 1968, pp 100–115

20. Mayer J: Overweight. Englewood Cliffs, Prentice–Hall, 1968, pp 124–128

21. Musante G: Obesity: a behavioral treatment program. Am Fam Physician 10:96, 1974

22. Musante G: Obesity: a behavioral treatment program. Am Fam Physician 10:98, 1974

23. Schacter A, Gross L: Manipulated time and eating behavior. J Pers Soc Psychol 10:98–106, 1968

24. Seltzer C, Stare F: Obesity: how it is measured, what causes it, how to treat it. Med Insight, July–August, 1973, p 10

25. Shakespeare W: King Henry IV. Act 2, scene 4. In Humphreys AR (ed): King Henry IV, Part One. New York, Barnes and Noble, 1965

26. Simeons A: Pounds and Inches. Rome, ATW Simeons, Salvator Mundi International Hospital, 1967

27. Srole L, Langer T, Michael S, Opler M, Rennie T: Mental Health in the Metropolis. Midtown Manhattan Study. New York, McGraw–Hill, 1962

28. Stuart R: Exercise prescription in weight management: advantages, techniques and obstacles. Obesity and Bariatric Medicine 4:21, 1975

29. Stunkard A: Obesity. In Freedman A, Kaplan H (eds): Comprehensive Textbook of Psychiatry. Baltimore, Williams & Wilkins, 1967, p 1061

30. Stunkard A, McLaren–Hume M: The results of treatment for obesity. A review of the literature and report of a series. Arch Inter Med 103:84, 1959

31. Stunkard A, Mendelson M: Obesity and the body image. In Kiell N(ed): The Psychology of Obesity. Springfield Ill, CC Thomas, 1973, pp 42–44

32. Todhunter N: A guide to nutrition terminology for indexing and retrieval. Washington DC, US Government Printing Office, 1970

33. Weight, height, and selected body dimensions of adults. US Public Health Service, Washington DC, US Government Printing Office, 1965

34. White P: The dangers in diet advice. Med Insight, July–August, 1973, p 30

35. Wollersheim J: Effectiveness of group therapy. In Kiell N (ed): The Psychology of Obesity. Springfield Ill, CC Thomas, 1973, p 260

26 Obstetrics and gynecology

Roy M. Pitkin

Obstetrics and gynecology is that branch of medicine concerned with the female reproductive system. Strictly speaking, obstetrics refers to pregnancy, its antecedents and sequelae, whereas gynecology deals with diseases of the female reproductive tract. In addition, the obstetrician–gynecologist, by virtue of being considered the "woman's doctor," is responsible for primary health care for a substantial proportion of the female population.

The subject matter of obstetrics and gynecology includes a number of areas with profound nutritional implications. Some of these are common to other medical specialities, and others are unique to the discipline. This chapter reviews three specific areas in the latter group—pregnancy, lactation, and sex hormone therapy. Each area is considered separately with emphasis on altered nutrient needs, and each section concludes with a brief summary statement of clinical implications.

NUTRITIONAL SUPPORT DURING PREGNANCY

Nutrition as an influence on the course and outcome of pregnancy is a subject of considerable current interest, as evidenced by several recent reviews (46, 54). During the course of pregnancy the maternal organism undergoes a remarkable series of physiologic adjustments in order to provide for fetal growth and development and at the same time preserve maternal homeostasis. Concomitantly, the fetus exchanges materials with its mother across the placenta and modifies its own development by its maturing regulatory processes. The resultant physiologic system is complex, integrated, and intricate, as well as being dynamic in the sense of constantly changing throughout the course of pregnancy. Many of its aspects are either nutritional in nature or have obvious implications with respect to nutrition.

ENERGY, WEIGHT, AND WEIGHT GAIN

ENERGY REQUIREMENTS

In the mature nonpregnant individual, energy sources are required to maintain basic metabolic processes and provide for physical activity. Pregnancy imposes additional energy needs for growth of the fetoplacental unit and added maternal tissues as well as for support of increases in maternal metabolism. The total energy cost attributable to pregnancy, calculated from the amounts of protein and fat accumulated by mother and fetus and the addition to metabolism incurred by these additions, amounts to approximately 75,000 Cal (33). Caloric expenditure is not evenly distributed throughout pregnancy nor does it parallel fetal growth. Instead, it is minimal during early pregnancy, increases sharply during the first trimester, and remains essentially constant to term. During the second trimester, the extra caloric cost is due principally to maternal factors (expansion of blood volume, growth of uterus and breasts, and accumulation of storage fat), whereas that of the third trimester is related mainly to growth of the fetus and placenta.

Since caloric expenditure is relatively constant —though for varying reasons—throughout the last three-quarters of gestation, the added daily increment necessary for pregnancy can be estimated by dividing the total cumulative caloric cost of pregnancy by its duration. Thus, the Recommended Dietary Allowances (RDA) of the Food and Nutrition Board (see Table A-1) contain an added allowance of 300 Cal/day throughout pregnancy, and the Food and Agriculture Organization–World Health Organization (35) recommends an additional 150 Cal/day during the first trimester and 350 Cal/day during the last two trimesters. These values represent in effect the amount required by pregnancy and do not take into account such variables as ambient temperature, physical activity, or

growth requirements unrelated to pregnancy (*e.g.,* as in the adolescent).

WEIGHT GAIN

The question of normal or optimal weight gain in pregnancy has been the subject of seemingly endless speculation. No reliable data on which to base such a judgment are available. Nor, indeed, is it clear that a specific value for weight gain is optimal for all individuals. Data regarding average gain, which may or may not be optimal, have been calculated, and in spite of methodologic discrepancies such as differing dietary advice and variable methods of determining baseline weight, these show a remarkable degree of consistency. From an extensive review of the literature in 1944, Chesley (13) found the average to be 11 kg (24 pounds). This value is identical to that reported more than 25 years later by the Committee on Maternal Nutrition of the National Research Council (46) and is at the midpoint of the 10–12 kg stated by the Committee on Nutrition of the American College of Obstetricians and Gynecologists (54). A slightly larger amount, 12.5 kg, is suggested by Hytten and Leitch (33) for healthy primigravidas eating without restriction. The slight difference may be due to age since younger women tend to gain more than older (13, 71) or it may reflect a somewhat more lenient British attitude regarding weight gain during pregnancy. It should be reemphasized that all of these figures refer to *average* rather than *optimal* gain. However, the best overall reproductive performance (*i.e.,* the lowest combined incidence of obstetric complications) does apparently occur at weight gains around these average values, and it therefore seems likely that average and optimal, at least in this case, are not substantially different.

The great emphasis on *total* weight gain is almost certainly misplaced. Of much greater importance is the *pattern* of accumulation. The usual pattern consists of minimal gain (1–2 kg) during the first trimester and a progressive accumulation thereafter to term. Although the maximal rate occurs during the second trimester, for practical purposes the rate of gain may be considered linear from approximately 10 weeks until term, averaging 0.35–0.4 kg/week. These relationships are expressed in Figure 26–1, which also illustrates the components of gain. It is apparent from a consideration of Figure 26–1 that most of the accumulation during the second trimester is related to the maternal compartment and that most gain during the third involves the fetal compartment. At term, the mother accounts for slightly more than half, and the fetus slightly less than half, of the total cumulative gain.

RELATIONSHIP TO BIRTH WEIGHT

Although there remain many unresolved questions regarding the influence of pregnancy nutri-

Fig. 26–1. Average maternal weight gain during pregnancy.

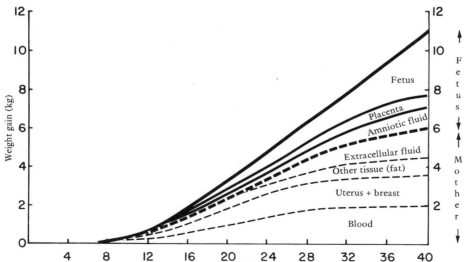

tion on fetal development in the human, the relationship between weight gain during pregnancy and birth weight of the infant seems clear. Virtually all major studies have documented a positive correlation between total maternal gain and birth weight (7, 20, 49) with weight gain ranking second only to duration of pregnancy as a determinant of infant weight. Maternal prepregnant weight is also related to birth weight, usually ranking behind, though occasionally ahead of, weight gain during pregnancy.

Confirmatory evidence comes from certain "natural experiments" in human malnutrition. Two particularly well-studied episodes occurred during World War II with the siege of Leningrad in 1942 (3) and the famine in western Holland during the winter of 1944–1945 (65). Both were characterized by severe protein–calorie malnutrition, and pregnancies during the period of deprivation produced infants with significantly lower mean birth weights than those recorded before and after the famine. In Holland birth weight fell by an average of 250 g; in Russia the drop was twice as great. The difference between the Dutch and Russian experiences was probably related to differing quality of nutritional status prior to the famine as well as to the severity of deprivation.

Further confirmatory evidence is provided by several current nutritional intervention studies. These projects, conducted in various areas of the world, in general indicate that protein–calorie supplementation during pregnancy to populations of known or presumed deficient nutritional status is associated with statistically significant increases in mean birth weight and decreases in proportion of infants of low birth weight.

In spite of the reasonably well-documented relationship between pregnancy weight gain and birth weight, many questions regarding the influence of maternal nutrition on the fetus remain unresolved. Weight gain is at best a crude index of nutrition, providing little information regarding nutrients other than energy, and birth weight is a similarly gross index of fetal development.

DEVIATIONS IN WEIGHT AND WEIGHT GAIN

Deviations from usual values for either prepregnant weight or weight gain during pregnancy are relatively common. Though standard definitions are lacking, the following are suggested as reasonable guidelines:

Underweight: prepregnant weight 10% or more below ideal weight for height (see Appendix Table A-11)

Overweight: prepregnant weight 20% or more above ideal weight for height (see Table A-11)

Inadequate gain: gain of 1 kg or less per month in the second or third trimester

Excessive gain: gain of 3 kg or more per month

The hazards presented by the underweight obstetric patient have been generally underemphasized. The likelihood of a low-birth-weight infant is increased substantially. Higgins (29) has shown that intensive dietary counseling and supplemental feeding of underweight patients increases mean birth weight.

The obese woman entering pregnancy faces increased risk of several complications, notably hypertensive disorders and diabetes mellitus, which have adverse effects on pregnancy outcome (73). Some have advocated restriction of weight gain in such patients so they conclude pregnancy with a net loss. However, the advisability of such a course seems questionable on several grounds. In the first place, severe dietary restriction to limit calories may also result in displacement of other nutrients from the diet. Secondly, optimal protein utilization in pregnancy apparently requires a minimum of approximately 30 Cal/ kg/ day (50). Thirdly, severe dietary restriction results in catabolism of fat stores, which in turn produces ketonemia. This consideration may be particularly important in view of recent data suggesting that women with acetonuria during pregnancy (presumably as a result of starvation) have children who score less well on IQ tests at age 4 compared with children of nonacetonuric women (14).

The patient with inadequate gain during pregnancy presents an increased risk of delivering a low-birth-weight infant. She should be followed closely and receive careful dietary counseling in an effort to bring her weight gain to normal.

Excessive weight gain during pregnancy has long been thought to be associated with several obstetric complications. The past several generations of American physicians have been taught that excessive weight gain leads to preeclampsia and that dietary restriction, particularly caloric restriction, protects against its development. Moreover, the definition of excessive weight gain has often been considerably more stringent than that proposed here. Total weight gains as

low as 16 lb have been advocated. Undoubtedly, much of the confusion surrounding the relationship between weight gain and preeclampsia results from failure to differentiate between weight due to actual tissue accumulation and that due to fluid retention. Since edema is one of the signs of preeclampsia, any group of edematous patients will have a somewhat higher incidence of preeclampsia, as well as greater mean total weight gain, than will a group of nonedematous pregnant women. However, traditional concepts notwithstanding, the evidence fails to support a relationship between caloric intake (as reflected in weight gain) and preeclampsia (46). Energy intake above normal requirements during pregnancy results in increased fat deposition, and this increase, if not lost after delivery, may contribute to obesity. To prevent initiation of this chain of events, some limitation of excessive gain may be desirable. The aim of such management should be to bring the rate of gain near the normal, rather than to markedly restrict gain.

PROTEIN

REQUIREMENTS

Additional needs for protein during pregnancy are related to both mother and fetus. Amino acids derived from dietary protein are required in increased amounts for protein synthesis in the expanded maternal plasma, uterus, and breasts and for fetal synthesis of its own proteins.

The magnitude of the increased protein requirement may be estimated in two ways, and the derived values depend on the method used. The "factorial" approach utilizes the quantities of protein present (calculated from nitrogen contents) in the maternal and fetal compartments. From a consideration of representative values (Table 26–1) it is apparent that total protein accumulation during term pregnancy amounts to slightly less than 1 kg. This level of protein accretion amounts to 3.4 g/day over the whole of pregnancy, or to 0.8, 4.4, and 7.2 g/day in first, second, and third trimesters, respectively. Correcting the values for individual variability, efficiency of conversion of dietary to tissue protein, and biologic quality of food protein leads to recommended additional protein intakes of 11–15 g/day (0.19–0.26 g/kg/day) throughout the last half of pregnancy (35).

Another method of estimating protein requirements involves nitrogen balance studies, in which intake and losses are carefully measured over a range of protein intakes to determine the level required to maintain the subject in nitrogen equilibrium. Such studies have, in general, led to estimations of protein requirements that are some two to three times those calculated by the factorial method. For example, a recent investigation (37) indicates continued nitrogen retention at the highest level tested. If valid, such studies indicate that pregnancy involves nitrogen storage in unknown sites. Alternatively, the discrepency may simply reflect a systematic tendency on the part of balance studies to overestimate requirements.

Although the protein requirement during pregnancy is unclear, the philosophy prevailing at present, in view of the uncertainty surrounding protein storage in gestation, appears to tentatively accept the higher values. Thus, the current RDA is 30 g/day in addition to the basic protein allowance, and that for total protein during pregnancy is 1.3 g/kg/day in the mature woman, 1.5 g/kg/day in the ado-

TABLE 26–1. Cumulative Protein Increment in Maternal and Fetal Compartments*

	Cumulative incremental protein content (g)		
	End of first trimester	End of second trimester	End of third trimester
Blood proteins	10	100	135
Uterus	30	90	166
Breast	12	65	81
(Maternal subtotal)	(52)	(255)	(382)
Fetus	1	150	440
Placenta	3	55	100
Amniotic fluid	0	2	3
(Fetal subtotal)	(4)	(207)	(543)
	56	462	925

*Hytten FE, Leitch I: The Physiology of Human Pregnancy, 2nd ed. Oxford, Blackwell Scientific Publ, 1971

lescent aged 15–18, and 1.7 g/kg/day in the girl under 15.

SERUM PROTEINS

It has long been recognized that the total serum protein concentration falls during pregnancy. The pattern is largely due to albumin, which declines fairly rapidly during the first trimester and somewhat more slowly during the second trimester, reaching a nadir of approximately 30% below nonpregnant levels during the third trimester. Globulins behave somewhat differently, with α globulins rising minimally, β rising more substantially, and γ globulins changing little, if any.

The explanation of these changes is obscure, but they probably reflect normal physiologic adjustments. Dietary protein deficiency is almost certainly *not* a significant factor in the hypoalbuminemia of pregnancy for it does not seem to be influenced by protein intakes ranging from high to extremely low (33). Endocrine factors may be partially responsible since changes in serum proteins similar to those of pregnancy occur in nonpregnant individuals taking estrogenic hormones (48).

EFFECT ON PREGNANCY OUTCOME

Numerous studies in experimental animals have indicated that restriction of maternal dietary protein intake during pregnancy is associated with a variety of observable effects in the offspring. Particularly provocative are the findings with respect to structure and function of the CNS. Restriction during the critical period of development apparently results in the adult brain having fewer cells than it would if the maternal diet were not restricted. Moreover, although correcting dietary deprivation after the phase of cell division has ceased can rectify abnormalities of cell size, it is without effect on cell number. A functional correlation of these abnormalities has been described in studies suggesting impaired abilities in maze-solving.

Although these studies in lower animals indicate the critical nutrient to be protein, available data in the human suggest that energy may be more important. For example, a recent nutritional intervention study (23) found that supplementation of a population of nutritionally deficient pregnant women increases birth weight to the same degree whether the supplement is protein and energy or energy alone.

The metabolic interrelationship between energy and protein are so inextricable as to make precise determination of their differential effects all but impossible. Optimal protein utilization presupposes adequacy of energy sources.

IRON

BLOOD VOLUME CHANGES

The changes in maternal blood volume accompanying pregnancy represent a fundamental physiologic adjustment. Plasma volume begins to increase during the first few weeks after conception and continues to expand at a relatively rapid rate until the early third trimester, when the rate slows and then ceases altogether. Although it was previously believed that the plasma volume actually declines in late pregnancy, it now appears that the terminal "fall" is actually an artifact due to measurement in the supine position with attendant vena caval obstruction by the pregnant uterus. Thus, maximal plasma volume is reached at 34–36 weeks, at which point the incremental increase amounts to an average of 1350 ml above the nonpregnant mean of 2600 ml (34), an increase of 50%. Erythrocyte volume also increases during pregnancy, but both the pattern and magnitude differ from that of plasma. The pattern is much more nearly linear, beginning at early pregnancy and increasing progressively to term. Erythrocyte volumes rise an average total of 250 ml over nonpregnant values of 1400 ml, a factor of less than 20%. However, in patients taking supplemental iron throughout pregnancy, erythrocyte volume increases by 400 ml.

Figure 26–2 illustrates the relative increases in plasma and erythrocyte volumes. Early in pregnancy more plasma than erythrocytes is being added to the circulation; late in pregnancy the opposite is true. From a consideration of these relationships, it would be predicted that erythrocyte count, hemoglobin concentration, and hematocrit will all decline progressively during pregnancy to a nadir in the late second or early third trimester and thereafter increase slightly. Exactly these changes (see Fig. 26–2) have been described in a number of studies.

REQUIREMENTS

The amount of iron necessary for the augmented erythropoiesis of pregnancy varies with the degree of augmentation, which in part depends on the amount of iron available. Without supple-

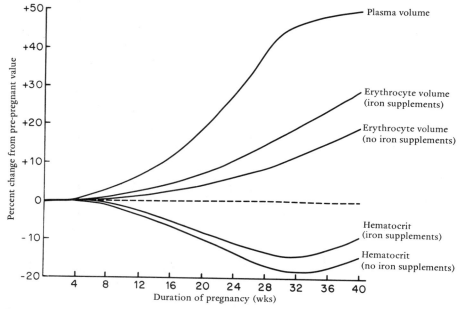

Fig. 26–2. Changes in maternal blood during pregnancy.

mental iron, erythrocyte volume increases by 250 ml, but if iron supplements are given, red cell mass increases by an average of 400 ml (44). Therefore, if adequate iron is available to the bone marrow, an average of 500 mg elemental iron will be utilized in the augmented maternal erythropoiesis during pregnancy. To this must be added the amount of iron present in the fetus and placenta—200–400 mg. Blood loss with parturition is another mechanism of iron loss, but this may be disregarded in calculating the iron requirements of pregnancy since the augmented blood volume more than compensates for it. In the interests of accuracy, the amount of iron "saved" by the amenorrhea of pregnancy, estimated at 120 mg (32), should be subtracted. Thus, the total iron requirements of pregnancy amount to 600–800 mg elemental iron.

Dietary surveys indicate that the usual American diet provides 10–15 mg elemental iron daily. Absorption in healthy subjects amounts to approximately 10% of dietary iron. Although some evidence indicates a somewhat enhanced degree of absorption at times of physiologic need, including pregnancy (25), it is unlikely that diet can provide more than 2–3 mg elemental iron daily, an amount little more than that lost in sweat, urine, and feces. Quite clearly, dietary iron is generally inadequate to meet the requirements of pregnancy.

Iron stored in the reticuloendothelial cells of the bone marrow is potentially available for meeting pregnancy demands. Using histochemical evaluation of marrow stores during quantitative phlebotomy, Scott and Pritchard (63) calculated that the storage iron of presumably healthy nulligravid American women averages 300 mg. Moreover, approximately a third of these subjects had no demonstrable storage iron. These observations suggest that iron stores are inadequate for the demands of pregnancy.

Considerations such as these suggest that during her reproductive years a woman is in a precarious state with respect to iron sufficiency. For whatever reasons—repetitive menstrual blood loss, previous pregnancies, or a relative lack of androgenic hormones—her iron stores are minimal. When she conceives, the marked increase in plasma volume coupled with fetal parasitism results in a falling hemoglobin concentration.

The fetus appears to be an effective parasite in extracting iron from its mother regardless of the state of maternal iron sufficiency. Thus, the hemoglobin level of infants born to pregnant women with iron deficiency anemia is usually normal, although some evidence shows that iron stores of such infants may be low, increasing the likelihood of anemia later in infancy.

SUPPLEMENTATION

Because of the iron demands of pregnancy, routine iron supplementation for all pregnant women is widely advocated. Consistent with this

view is the observation noted above that the augmented erythrocyte volume is nearly twice as great in patients given supplemental iron as in unsupplemented patients. Moreover, numerous studies have demonstrated that the decline in hemoglobin concentration and hematocrit in pregnancy may be ameliorated, though not entirely prevented, by iron supplementation. In several studies of pregnant women at or near term, mean hemoglobin concentrations were 12.3 g/100 ml with supplementation (78–200 mg/day during at least the last trimester) and 11.1 g/100 ml without; Hemoglobin levels below 11 g/100 ml were virtually eliminated by iron supplements (55). Similarly, the fall in serum iron concentration in pregnancy is minimized by iron prophylaxis.

The reasoning that a declining hemoglobin concentration during pregnancy without iron supplementation represents iron deficiency anemia is not universally accepted. A contrary view, particularly prevalent in Britain, questions the use of nonpregnant standards to define normality during pregnancy and suggests that the maintenance of hemoglobin concentration and total hemoglobin mass with iron supplementation is a "pharmacologic" effect (52), as opposed to the presumably "physiologic" decline exhibited by unsupplemented patients. An obvious implication of this controversy is the practical question of whether patients should routinely receive iron supplements during pregnancy. It is perhaps, as Hytten and Leitch (33) suggest, more a matter of philosophy than of science. In any event, the preponderance of opinion, particularly among clinicians and particularly in the United States, favors routine supplementation (46, 54). Levels of supplementation as low as 12 mg/day fail to affect the fall in hemoglobin concentration and hematocrit (52), but those of 30 mg/day or more result in normal values at term (55). Somewhat larger amounts may be necessary to protect maternal stores (19). Therefore, the recommended amount of supplementation is 30–60 mg elemental iron daily (46, 54).

Elemental iron contents of common supplemental preparations are listed in Table 26–2.

FOLATE

REQUIREMENTS

Considerable evidence reviewed in detail by Kitay (38) indicates that folate requirements are substantially increased during pregnancy. Among the factors potentially responsible are impaired absorption, defective utilization, and

TABLE 26–2. Elemental Iron Content of Supplements

Preparation	Iron (%)
Ferrous fumarate	32.5
Ferrous sulfate (exsiccated)	30.0
Ferrous sulfate (nonexsiccated)	20.0
Ferrous gluconate	11.0

increased demand. Impaired absorption may be a factor in some patients (12), particularly those with recurrent megaloblastic anemia in repetitive pregnancies, but a pregnancy-specific characteristic interferring with folate absorption does not seem likely. Defects in utilization or metabolism of folacin may be related to the greatly increased levels of steroid or gonadotrophic hormones, as suggested by an apparent increase in incidence of megaloblastic anemia in patients taking oral contraceptives (68). However, it appears that increased demands represent the most important factor. Of and by itself, the augmented maternal erythropoiesis of pregnancy requires additional amounts of folate. Moreover, because folacin is intimately involved in DNA synthesis, requirements are particularly high in rapidly growing cells, such as fetal and placental tissues. Serum folate levels decline progressively during normal pregnancy, whereas the incidence of megaloblastic marrow in pregnant women follows a pattern essentially parallel to the fetal growth curve. Megaloblastic anemia is much more frequent in multiple pregnancy and in conditions associated with abnormally high rates of erythropoiesis, *e.g.*, hemolytic anemias.

The current RDA for folate in pregnancy is 800 μg daily, which represents a doubling of the nonpregnant allowance.

EFFECT OF DEFICIENCY

The biochemical and morphologic sequelae of experimental folate deficiency are listed in Table 26–3. The developmental sequence is probably unaltered during pregnancy, but some evidence suggests that temporal relationships may be accelerated.

The incidence of folate deficiency varies widely throughout the world, presumably as a result of varying dietary intake. Moreover, the incidence depends directly on the diagnostic criteria employed. In its most severe form—anemia—it is relatively uncommon in contemporary American practice. At the opposite extreme, low serum folate (less than 3 ng/ml) is observed in 20%–25% of otherwise normal pregnancies (69).

TABLE 26–3. Morphologic and Biochemical Effects of Folate Deprivation*

Time (weeks)	Event
3	Low serum folate ($<$ 3 ng/ml)
7	Neutrophil hypersegmentation
14	Elevated foriminoglutamic acid excretion
18	Low erythrocyte folate ($<$ 20 ng/ml)
19	Megaloblastic marrow
20	Anemia

*Data from Herbert V: Trans Assoc Phys 75:307, 1962

Although the relationship between folate deficiency and megaloblastic anemia is clearly established, the clinical significance of preanemic folate deficiency remains problematic. Several reports involving mainly retrospective studies have correlated various parameters (elevated foriminoglutamic acid excretion after a test dose of histidine, megaloblastic erythropoiesis, and low serum or erythrocyte folate levels) in nonanemic patients with a variety of pregnancy complications including *abruptio placentae* and other antepartum bleeding (27, 69), spontaneous abortion (27), fetal malformation (28), and preeclampsia (67). Other studies, however, have failed to indicate a relationship between folate deficiency and any of these complications of reproduction (2, 56). Thus, the role of folate deficiency in the causation of pregnancy wastage is controversial. However, the preponderance of opinion appears to be that folate deficiency is unlikely to be associated with any complication other than maternal anemia. Infants born to women with megaloblastic anemia of pregnancy typically have normal hemoglobin levels.

SUPPLEMENTATION

In view of evidence indicating increased folate needs during pregnancy and dietary survey data suggesting that the usual American diet is marginal in folate content, some authorities have advised routine folacin supplementation of all pregnant women. As pointed out by Pritchard (55), questions regarding the advisability of routine supplementation require clear delineation of goals. If the aim is elimination of megaloblastic anemia, the important consideration becomes that of cost–benefit ratio. If, on the other hand, the goal is maintenance of the serum folate in the normal nonpregnant range, the clinical significance of indices of preanemic folate deficiency comes into question and this, as noted above, is a controversial topic.

Thus, although a case can be made for routine supplementation of all patients, one of at least equal strength can be made for supplementation of only selected patients, such as those in whom dietary history reveals the likelihood of inadequate intake, those with multiple pregnancy or chronic hemolytic anemia, or those taking anticonvulsant drugs. Certainly if vitamins are to be given at all, there is more reason to supplement folate than any other. However, it should be kept in mind that prescription of folacin, or for that matter of any other vitamin supplement, is but a minor part of efforts to improve maternal nutrition. It is more important to recognize inappropriate dietary habits and assist the patient in correcting them.

If folacin supplements are given, daily doses of 200–400 μg appear appropriate (46, 54).

CALCIUM AND VITAMIN D

REQUIREMENTS

Calcium metabolism during pregnancy and the perinatal period has recently been reviewed in detail (53). Almost all of the additional calcium required during pregnancy is utilized by the fetus. The term fetus contains an average of 27.4 g calcium, the placenta variable amounts up to 1 g, and the augmented maternal tissue and fluids approximately 1 g, so the total pregnancy requirement, in round numbers, is 30 g. Since most of this need occurs in late pregnancy coincident with calcification of the fetal skeleton, the daily increment averages 300 mg during the third trimester. Attempts to estimate requirements by calcium balance studies have yielded somewhat higher levels of retention than would be anticipated on the basis of a total accumulation of 30 g. This discrepancy may simply reflect the notorious difficulties in performing precise balance studies, or it may result from storage in the maternal skeleton. The evidence from animal experiments regarding maternal calcium storage during pregnancy is conflicting but seems to favor the hypothesis that some storage in excess of fetal needs occurs, an event reasonable teleologically in anticipation of the greatly increased requirements of lactation.

The current RDA for calcium in pregnancy is 1200 mg, an increase of 400 mg over the allowance for the nonpregnant adult. This would seem to provide adequate amounts, particularly considering the adaptive ability to increase absorption and decrease excretion at times of need, as during pregnancy. Since it is virtually impossible to meet these requirements with natural foods other than dairy products (see Table

A–4), milk is considered by many to be practically essential for the pregnant woman. The allowance for pregnancy—1200 mg—is precisely that contained in 1 quart of milk. Individuals who do not consume milk or milk products will require calcium supplementation.

The importance of vitamin D in calcium metabolism has long been recognized. It promotes calcium absorption and also has a regulatory role in bone mineralization. Balance studies have documented its role in promoting positive calcium balance in the pregnant woman. However, vitamin D requirements do not seem to particularly increase during pregnancy, and in fact, there is evidence suggesting that markedly excessive intake may actually predispose the fetus to development of the severe form of infantile hypercalcemia. The RDA for vitamin D is 400 IU/day for both pregnant and nonpregnant individuals.

METABOLISM

Calcium absorption and turnover of bone mineral both increase during pregnancy, whereas calcium excretion falls. Serum total calcium levels decline, related to the physiologic hypoalbuminemia of pregnancy, but ionic calcium levels remain constant because of increasing output of maternal parathyroid hormone. Calcium ions are transported across the placenta against a concentration gradient and the relative hypercalcemia induced in the fetus suppresses fetal parathyroid hormone and stimulates fetal calcitonin, producing a situation favorable for fetal bone growth.

CLINICAL CORRELATES

A possible relationship between calcium and leg cramps in pregnancy aroused considerable interest several years ago when Page and Page (51) presented the hypothesis that cramps result from a relative hypocalcemia due to dietary phosphate ingestion. According to this theory, leg cramps could be prevented or relieved by several measures, singly or in combination, including curtailment of milk intake (since milk contains relatively large amounts of phosphate), supplementation with nonphosphate salts of calcium, and regular ingestion of aluminum hydroxide antacids (to form insoluble aluminum phosphate salts in the gut). Although some studies appeared to confirm this theory, others failed to find a correlation between leg cramps and

ingestion of dairy products or any type of calcium supplement. Thus, the relationship between milk, calcium, phosphate, and leg cramps remains controversial.

Several recent studies have suggested a possible relationship between maternal deficiency of calcium and/or (particularly) vitamin D intake and the complication of early neonatal hypocalcemia. Lower serum calcium levels during the first two days of life have been found in association with deficient maternal milk and vitamin D intake and lack of exposure to sunlight (76). A seasonal distribution of neonatal hypocalcemia, with peak incidence when late pregnancy coincides with times of least sunlight (58), has been described. Vitamin D and at least one of its active metabolites (25-hydroxycholecalciferol) apparently cross the placenta freely, producing similar levels in mother and fetus (31, 62), and low levels are found in at least some hypocalcemic infants (62). An implication of these observations is that maternal vitamin D deficiency may be a pathogenic mechanism in neonatal hypocalcemia.

VITAMIN B$_6$

METABOLISM IN PREGNANCY

It has long been recognized that pregnancy is associated with laboratory findings that, at least in the nonpregnant individual, are considered evidence of vitamin B$_6$ deficiency. Urinary xanthurenic acid excretion following a test dose of tryptophan—the classic laboratory test for B$_6$ deficiency—increases progressively throughout gestation and by term is 15 times that in nonpregnant women (75). Similarly, blood levels of the vitamin fall progressively during pregnancy (24). Supplementation with pyridoxine in amounts of 6–10 mg daily is associated with normalization of both blood levels (17, 24) and xanthurenic acid excretion (11).

Whether these changes actually reflect a deficiency state or merely represent normal physiologic adjustments is controversial. From a review of published data, Rose and Braidman (61) suggest that the modification of tryptophan metabolism with pregnancy is due to estrogenic stimulation of corticosteroid production with resultant increased levels of tryptophan oxygenase. Late in pregnancy, however, these same authors feel that a true deficiency state is superimposed, presumably due to fetal uptake of the vitamin.

CLINICAL IMPLICATIONS

An association between vitamin B_6 deficiency and preeclampsia has been suggested. Xanthurenic acid excretion after tryptophan has been reported to be higher (66) and placental pyridoxine levels and pyridoxal kinase activity lower (39) in preeclamptic patients than in those with normal pregnancy. In one report the incidence of preeclampsia–eclampsia was significantly lower in patients receiving pyridoxine supplements compared with retrospectively determined controls (74). On the other hand, a double-blind study failed to demonstrate any clinical differences with pyridoxine supplementation (30).

The clinical significance of these observations regarding vitamin B_6 metabolism in pregnancy (both normal and abnormal) is far from clear. Although the laboratory data suggest a deficiency state, it is rather difficult on intuitive grounds alone to accept that dietary inadequacy of any nutrient could be both so widespread and yet lacking in clear-cut clinical correlations. Current dietary allowances appear to reflect this uncertainty. For example, the RDA for vitamin B_6 is 2 mg daily for adults and 0.5 mg additionally for pregnancy, an amount far below that necessary to "normalize" biochemical studies in the pregnant woman. Presumably this means that the biochemical "abberations" are viewed as normal physiology rather than indicators of deficiency. In view of evidence that vitamin B_6 requirements seem to be increased with high-protein diets (5), there is probably some reason for a modest increase in B_6 intake in pregnancy.

SODIUM

METABOLISM

Sodium metabolism in pregnancy has recently been reviewed by Lindheimer and Katz (41). Glomerular filtration increases by as much as 50% in early pregnancy and is maintained at this level until term, resulting in an additional filtered sodium load of 5,000–10,000 mEq daily. Additional natriuretic effects result from progesterone and posture. Changes of this magnitude quite clearly require a compensatory mechanism to promote tubular reabsorption and preserve maternal homeostasis. The nature of these compensatory mechanisms is not entirely clear, but a major one appears to be increased activity of the renin–angiotensin–aldosterone system. Plasma renin activity is substantially elevated during normal pregnancy, as is renin substrate. As a result, large amounts of angiotensin are formed. However, the pressor effect of angiotensin in normal pregnancy is markedly attenuated, apparently because of inactivation in the maternal plasma, and its principal physiologic effect appears to be stimulation of aldosterone, which in turn promotes sodium reabsorption to prevent sodium loss.

EDEMA

Edema is one of the signs of preeclampsia, and abundant evidence indicates that the preeclamptic patient retains sodium abnormally. It is also seen in a large proportion of otherwise normal patients (59). This "benign edema of normal pregnancy" usually occurs late in gestation and may be either generalized or dependent in distribution. The cause of the generalized form is obscure, but among the possibilities are alterations in ground substance under estrogen influence, decrease in plasma osmotic pressure due to hypoalbuminemia, and an over-compensation of the physiologic mechanisms promoting sodium retention. Dependent edema, on the other hand, is most likely due to mechanical causes, e.g., obstruction of the pelvic veins by the enlarged uterus.

CLINICAL IMPLICATIONS

Few topics in obstetrics excite as much interest and controversy as that of the relationship between sodium and toxemia. According to the older and more traditional view, pregnancy is characterized by insidious sodium retention, which increases vascular reactivity and may lead to arteriolar vasospasm with resultant development of preeclampsia. An obvious implication of this reasoning is that sodium intake should be restricted and diuretics used freely to promote sodium excretion. The more modern theory, based on evidence that pregnancy is a salt-wasting state (41), holds that inadequate sodium intake in the face of excessive losses leads to hypovolemia and in turn to compensatory vasospasm. According to this theory, sodium intake should be increased in pregnancy.

Which of the two views is correct cannot be determined with certainty. However, it does seem clear that no convincing rationale supports a compelling indication for sodium restriction in normal pregnancy. On the other hand, it must be acknowledged that sodium restriction has been practiced widely and there is no overwhelming clinical evidence of its harm. In view

of this uncertainty, the reasonable course at present seems to be to neither restrict nor increase sodium intake—to advise patients to salt their foods to taste—and to rely on the physiologic mechanisms at the renal tubular level to ensure that sodium balance is maintained.

With respect to agents that promote sodium excretion, the evidence is considerably clearer. Thiazide diuretics, in spite of early suggestions to the contrary, are of no benefit in prevention of preeclampsia (22). Maternal complications with thiazide treatment include electrolyte imbalance, hyperglycemia, hyperuricemia, and pancreatitis, and perinatal complications include hyponatremia and thrombocytopenia. Therefore, since they do no good and may do harm, they have no place in normal pregnancy.

OTHER NUTRIENTS

Blood levels of most vitamins are lower in pregnancy than in the nonpregnant state. Therefore, the proportion of pregnant women with low or deficient values judged by nonpregnant standards exceeds that of the general population. These relationships have been noted in a number of studies of individual vitamins, including vitamins A (57), C (45), and B_{12} (6) and pantothenic acid (16). Similarly, results of urinary excretion of pantothenic acid (16), riboflavin (9), and thiamin (42) suggest deficiency states. Although such findings have been interpreted as indicating deficiency, presumably on the basis of fetal parasitism, it is at least equally plausible that they represent normal maternal physiologic adjustments, such as dilution by the expanded plasma volume (18). In support of this latter hypothesis is the observation in a recent comprehensive study (36) that supplementation with multiple vitamins altered the proportion of only folate and thiamin among the 11 vitamins measured.

The clinical significance of these data is even more problematic. Ascorbic acid levels have been reported to be low in patients with preeclampsia (15) and premature spontaneous rupture of the membranes (78). As mentioned above, vitamin B_6 has also been incriminated in toxemia. In general, however, efforts to correlate low vitamin levels with abnormalities of pregnancy have yielded negative results. Nevertheless, vitamins readily traverse the placenta, and many, particularly water-soluble vitamins, appear to be concentrated in the fetus. Moreover, requirements for certain vitamins (*e.g.*, niacin and riboflavin) seem to be related to caloric intake and are therefore needed in increased amounts when energy is increased. For these reasons, it is probably advisable to increase the allowance for these agents during pregnancy.

Overdosage of certain nutrients, particularly fat-soluble vitamins, appears to be teratogenic in animal studies. Congenital renal anomalies have recently been reported in a human infant associated with maternal hypervitaminosis A (8).

Trace metals are involved in a large number of biochemical processes, and animal studies suggest that a number of them, particularly zinc, chromium, and copper, are important in reproduction. However, virtually nothing is known of their significance in human pregnancy.

SUMMARY

Pregnancy is characterized by increased needs for nearly all nutrients. Energy requirements increase by approximately 300 cal/day, representing an addition of 15% to nonpregnant needs. Caloric intake should be sufficient to support a weight gain of 0.35–0.4 kg/week through the last two-thirds of pregnancy. An additional 30 g protein daily appears advisable. Iron is a unique nutrient in that the amounts required during pregnancy are greater than those that can be provided by diet. Thus, for practical purposes every pregnant woman should receive iron supplements. Folate supplementation is considered optional, and supplementation of other vitamins and minerals is probably neither helpful nor harmful. Sodium represents an essential nutrient, and there is no valid reason for its restriction in normal pregnancy.

NUTRITIONAL SUPPORT DURING LACTATION

Throughout most of history, nutrition of the human infant has depended entirely on breast feeding, a situation still true in much of the world. Moreover, recent data suggest that the trend of the past half century in developed countries away from breast feeding may be slowing. Thus, lactation and its support continue to be important concerns. Maternal nutrition in lactation is the subject of a current review (21).

ENERGY

The additional energy requirements of lactation are proportional to the quantity of milk produced. Since human breast milk has a caloric content of approximately 70 cal/100 ml and the

efficiency of conversion of maternal energy to milk energy is at least 80% (72), approximately 90 kcal is required for production of 100 ml milk. Thus, 850 ml milk, a reasonable approximation of the average amount produced each day during established lactation, requires nearly 800 kcal.

The current RDA for energy in the lactating reference woman is 500 Cal in addition to the basic amount. During pregnancy, some 2–4 kg body fat are stored, and this may be mobilized to provide an additional 200–300 Cal/day for 3 months. Energy intake should be increased above 500 Cal/day if lactation continues beyond 3 months, if maternal weight is below the ideal weight for height, or if more than one infant is being nursed.

The amount and source of energy intake have some influence on milk composition. With caloric restriction, the fatty acid composition of human milk resembles that of depot fat, indicating mobilization of fat stores. Increased energy intake as carbohydrate results in increased levels of lauric and myristic acids, whereas a diet high in polyunsaturated fat content yields milk with increased levels of polyunsaturated fats.

PROTEIN

The protein content of human milk averages 1.2%, with a slight tendency to decrease during the course of lactation. Thus, an average daily production of 850 ml milk contains 10 g and a high level of production (1200 ml) 15 g. Assuming an efficiency of conversion of dietary protein to milk protein of 70%, the higher value accounts for the current RDA of 20 g daily additional protein for the nursing mother.

Protein levels in milk do not appear to be reduced by a maternal diet low in protein or poor in biologic quality. However, recent data suggest that the content of two essential amino acids, lysine and methionine, are lower in milk from women with protein deficient diets (40), which may imply a reduction in nutritional quality.

CALCIUM

Calcium output in milk amounts to an average of 250–300 mg daily. The current RDA for calcium in lactation is 1200 mg/day, which represents an increase of 400 mg over the nonpregnant nonlactating allowance. Considering the adaptive ability to increase absorption and decrease urinary excretion at times of need, this should represent an adequate amount unless milk production is extraordinarily high.

The calcium content of milk appears to be maintained in spite of markedly deficient intake, a phenomenon probably related to the availability of a relatively huge reservoir of calcium stored in the skeleton. Recent studies using the technique of scanning transmission suggest that lactating women mobilize approximately 2% of skeletal calcium over 100 days of nursing (4).

OTHER NUTRIENTS

The sodium content of human milk is related to maternal dietary sodium intake. However, milk concentrations of iron, copper, and fluoride are not affected by administration of these elements to nursing mothers. For this reason, iron deficiency is relatively common in breast-fed babies, and many pediatricians advise iron supplements for the nursing infant. Iron supplementation of the nursing mother, although not affecting milk levels, is advisable to replace maternal stores depleted by pregnancy.

Maternal administration of the fat-soluble vitamins A, D, and E does not raise the levels of these nutrients in milk. Although vitamins A and E are present in appreciable levels in human milk, the amount of vitamin D is low, and rickets has been found in breast-fed infants. Therefore, some authorities recommend vitamin D supplementation for the nursing baby.

By contrast, levels of water-soluble vitamins in milk reflect maternal dietary intake. Oral ingestion of large doses produces transient but marked increases in milk levels. Moreover, deficient maternal intake can produce deficiency in the infant, as evidenced by reports of beriberi in infants nursed by women with beriberi.

SUMMARY

Certain parameters of lactation, such as quantity and protein and calcium content, appear to be relatively independent of maternal nutritional status, but others, such as amino acid, fatty acid, and water-soluble vitamin composition, vary with maternal intake. Compared with the nonpregnant woman, the nursing mother should have substantially more energy, protein, and calcium, as well as modest increases of most other nutrients. The breast-fed infant should receive supplemental iron, vitamin D, and perhaps fluoride.

NUTRITIONAL SUPPORT DURING HORMONAL THERAPY

Considerable recent interest has centered on the nutritional implications of treatment with sex steroid hormones. This interest is based on the widespread usage of oral contraceptives coupled with evidence, principally of a biochemical nature, suggesting that needs for certain nutrients appear to be altered by ingestion of these agents. Oral contraceptives typically consist of a combination of a synthetic estrogen (ethinyl estradiol or mestranol) and any of several synthetic progestogens. Generally, metabolism in women taking oral contraceptives is similar in many respects to that in pregnant women. There are, however, some differences in both degree and kind of change observed.

The effects of oral contraceptives on vitamin and mineral needs and on laboratory tests have recently been reviewed (47,70). Almost all published observations relate to oral contraceptives, and the extent to which they apply to natural hormones (such as natural estrogen treatment of the menopausal woman) is conjectural.

VITAMIN B_6

Increased urinary xanthurenic acid excretion after a test dose of tryptophan, the classic laboratory finding of vitamin B_6 deficiency, is consistently observed in women taking oral contraceptives, an effect apparently related to the estrogenic component since it is also observed in men taking estrogen (60). As noted previously, similar effects are found in normal pregnancy, but the level of B_6 supplementation required to "normalize" the results is greater in oral contraceptive users than in gravid women. For example, supplements of 30 mg pyridoxine hydrochloride (25 mg vitamin B_6) are necessary to consistently suppress xanthurenic acid excretion in patients taking oral contraceptives (43) compared with 10 mg pyridoxine hydrochloride (8.2 mg vitamin B_6) in pregnancy (75). These values represent 12 and 4 times, respectively, the RDA for vitamin B_6 in the nonpregnant adult female.

The principal clinical condition suggested as a correlate of this apparent alteration in tryptophan metabolism is depression. In a recent report of 22 depressed women taking oral contraceptives, half exhibited biochemical evidence of B_6 deficiency, and all of these responded to supplemental pyridoxine given in a double-blind, crossover study design (1).

Although a number of authorities advocate routine pyridoxine supplementation of oral contraceptives users, the question remains controversial. At the present time, however, it at least seems reasonable to consider B_6 deficiency in the differential diagnosis of patients taking estrogen who exhibit depression.

FOLATE

A number of investigations have found low serum or erythrocyte folate levels, or both, in up to 50% of oral contraceptive users, but at least an equal number of studies have not found any such association. Folate-responsive megaloblastic anemia has been reported in occasional patients taking oral contraceptives, but the incidence appears to be quite low. Again, the question of routine supplementation is controversial, with some authorities advocating it (68) and others regarding it as unnecessary (56).

The basis for any change in folate metabolism during oral contraceptive administration is thought to be reduced absorption by interference with absorption of polyglutamate, the principal food source of folate (68). However, the concept of folate malabsorption is not accepted by all authorities (64).

OTHER NUTRIENTS

Several observations suggest that vitamin C needs may be higher in oral contraceptive users. Estrogen appears to increase the rate of ascorbic acid breakdown, apparently by raising levels of ceruloplasmin, a known catalyst of ascorbic acid oxidation. Plasma, platelet, and leukocyte levels of ascorbic acid are lower in patients taking oral contraceptives than in normal pregnant and nonpregnant women (10).

Low serum vitamin B_{12} levels, without alteration in binding protein or tissue B_{12} levels, have been found in approximately half of women taking oral contraceptives (77). Although such observations cannot at present be taken to indicate a deficiency state, they do indicate the importance of interpreting serum B_{12} levels in oral contraceptive users with caution.

Serum iron levels and iron-binding capacity are increased moderately in oral contraceptive users, effects apparently related to the progestational component. Menstrual bleeding is reduced in both duration and quantity with oral contraceptives, suggesting that iron requirements may be somewhat lower than in normal nonpregnant women.

Data suggesting the possibility of increased requirements for riboflavin and zinc have been reported. On the other hand, less niacin, vitamin K, copper, and calcium may be needed in users of oral contraceptives.

SUMMARY

Treatment with sex steroid hormones induces metabolic changes suggesting increased needs for several nutrients, particularly vitamin B_6 and folate. The significance of these observations is unclear at present. Hopefully, the situation will be clarified with further study.

REFERENCES

1. Adams PW, Rose DP, Folkard J, Wynn V, Seed M, Strong R: Effect of pyridoxine hydrochloride (vitamin B_6) upon depression associated with oral contraception. Lancet 1:897, 1973

2. Alperin JB, Haggard ME, McGanity WJ: Folic acid, pregnancy, and abruptio placentae. Am J Clin Nutr 22:1354, 1969

3. Antonor AN: Children born during the siege of Leningrad in 1942. J Pediatr 30:250, 1947

4. Atkinson PJ, West RR: Loss of skeletal calcium in lactating women. J Obstet Gynaecol Br Commonw 77:555, 1970

5. Baker EM, Canham JE, Nunes WT, Sauberlich HE, McDowell ME: Vitamin B_6 requirement for adult men. Am J Clin Nutr 15:59, 1964

6. Ball EW, Giles C: Folic acid and vitamin B_{12} levels in pregnancy and their relationship to megaloblastic anemia. J Clin Pathol 17:165, 1964

7. Bergner L, Susser MW: Low birth weight and prenatal nutrition: an interpretive review. Pediatrics 46:946, 1970

8. Bernhardt IR, Dorsey DJ: Hypervitaminosis A and congenital renal anomalies in a human infant. Obstet Gynecol 43:750, 1974

9. Brezezinski A, Bomberg YM, Braun K: Riboflavin excretion during pregnancy and early lactation. J Lab Clin Med 39:84, 1952

10. Briggs M, Briggs M: Vitamin C requirements and oral contraceptives. Nature 238:277, 1972

11. Brown RR, Thornton MJ, Price JM: The effect of vitamin supplementation on the urinary excretion of tryptophan metabolites by pregnant women. J Clin Invest 40:617, 1961

12. Chanarin I, MacGibbon BM, O'Sullivan WJ, Mollin DL: Folic acid deficiency in pregnancy. The pathogenesis of megaloblastic anaemia of pregnancy. Lancet II:634, 1959

13. Chesley LC: Weight changes and water balance in normal and toxic pregnancy. Am J Obstet Gynecol 48:565, 1944

14. Churchill JA, Berendes HW: Intelligence of children whose mothers had acetonuria during pregnancy. In Perinatal Factors Affecting Human Development. Washington DC, Pan Am Health Org, 1969, 185:30–35

15. Clemetson CAB, Andersen L: Ascorbic acid metabolism in preeclampsia. Obstet Gynecol 24:774, 1964

16. Cohenour SH, Calloway DH: Blood, urine, and dietary pantothenic acid levels of pregnant teenagers. Am J Clin Nutr 25:512, 1972

17. Coursin DB, Brown VC: Changes in vitamin B_6 during pregnancy. Am J Obstet Gynecol 82:1307, 1961

18. Dawson EB, Clark RR, McGanity WJ: Plasma vitamins and trace metal changes during teen-age pregnancy. Am J Obstet Gynecol 104:953, 1969

19. DeLeeuw NKM, Lowenstein L, Hsieh Y: Iron deficiency and hydremia in normal pregnancy. Medicine 45:291, 1966

20. Eastman NJ, Jackson E: Weight relationships in pregnancy. Obstet Gynecol Survey 23:1003, 1968

21. Filer, LJ: Maternal nutrition in lactation. Clinics in Perinatology. 2:353, 1975

22. Gray MJ: Use and abuse of thiazides in pregnancy. Clin Obstet Gynecol 11:568, 1968

23. Habicht JP, Yarbrough C, Lechtig A, Klein RE: Relation of maternal supplementary feeding during pregnancy to birth weight and other sociobiological factors. In Winick M (ed): Nutrition and Fetal Development. New York, John Wiley and Sons, 1974, p 127–145

24. Hamfelt A, Tuvemo T: Pyridoxal phosphate and folic acid concentration in blood and erythrocyte aspartate aminotransferase activity during pregnancy. Clin Chim Acta 41:287, 1972

25. Heinrich HC, Bartels H, Heinisch B, Hansmann K, Kuse R, Humke W, Mauss HJ: Intestinale⁵⁹ Fe-resorption und prälatenter Eisenmangel während der Gravidität des Menschen. Klin Wochenschr 46:199, 1968

26. Herbert V: Experimental nutritional folate deficiency in man. Trans Assoc Am Physicians 75:307, 1962

27. Hibbard BM: The role of folic acid in pregnancy with particular reference to anaemia, abruption, and abortion. J Obstet Gynaecol Br Commonw 71:529, 1964

28. Hibbard ED, Smithells RW: Folic acid metabolism and human embryopathy. Lancet 1:1254, 1965

29. Higgins AC, Crampton EW, Moxley JE: Nutrition and the outcome of pregnancy. Int Cong Series No. 273. Proc Washington DC, IV Int Congr Endocrinol, 1972. Washington DC, Excerpta Medica pp 1071–1077

30. Hillman RW, Cabaud PG, Nilsson DE, Arpin PD, Tufano RJ: Pyridoxine supplementation during pregnancy: clinical and laboratory observations. Am J Clin Nutr 12:427, 1963

31. Hillman LS, Haddad JG: Human perinatal vitamin D metabolism. I. 25-Hydroxyvitamin D in maternal and cord blood. J Pediatrics 84:742, 1974

32. Hytten FE, Cheyne GH, Klopper AI: Iron loss at menstruation. J Obstet Gynaecol Br Commonw 71:255, 1964

33. Hytten FE, Leitch I: The Physiology of Human Pregnancy, 2nd ed. Oxford, Blackwell Scientific, 1971

34. Hytten FE, Paintin DB: Increase in plasma volume during normal pregnancy. J Obstet Gynaecol Br Commonw 70:402, 1963

35. Joint FAO/WHO Ad Hoc Expert Committee: Energy and Protein Requirements. Geneva, WHO, 1973

36. Kaminetzky HA, Langer A, Baker H, Frank O, Thomson AD, Munves E, Opper A, Behre FC, Glista B: The effect of nutrition in teen-age gravidas on pregnancy and status of the neonate. I. A nutritional profile. Am J Obstet Gynecol 115:639, 1973

37. King JC, Calloway DH, Margen S: Nitrogen retention, total body ^{40}K and weight gain in teenage pregnant girls. J Nutr 103:772, 1973

38. Kitay DZ: Folic acid deficiency in pregnancy. Am J Obstet Gynecol 104:1067, 1969

39. Klieger JA, Evrard JR, Pierce R: Abnormal pyridoxine metabolism in toxemia of pregnancy. Am J Obstet Gynecol 94:316, 1966

40. Lindblad BS, Rahimtoola RJ: A pilot study of the quality of human milk in a lower socio-economic group in Karachi, Pakistan. Acta Paediatr Scand 63:125, 1974

41. Lindheimer MD, Katz AI: Sodium and diuretics in pregnancy. N Engl J Med 288:891, 1973

42. Lockhart HS, Kirkwood S, Harris RS: The effect of pregnancy and puerperium on the thiamine status of women. Am J Obstet Gynecol 46:358, 1943

43. Luhby AL, Brin M, Gordon M, Davis P, Murphy M, Spiegel H: Vitamin B_6 metabolism in users of oral contraceptive agents. I. Abnormal urinary xanthurenic acid excretion and its correction by pyridoxine. Am J Clin Nutr 24:684, 1971

44. Lund CJ, Donovan JC: Blood volume during pregnancy: significance of plasma and red cell volumes. Am J Obstet Gynecol 98:393, 1967

45. Mason M, Rivers JM: Plasma ascorbic acid levels in pregnancy. Am J Obstet Gynecol 109:960, 1971

46. Maternal Nutrition and the Course of Pregnancy: Summary Report. Committee on Maternal Nutrition, Food and Nutrition Board, National Academy of Sciences. Washington DC, 1970

47. Miale JB, Kent JW: The effects of oral contraceptives on the results of laboratory tests. Am J Obstet Gynecol 120:264, 1974

48. Musa BU, Doe RP, Seal US: Serum protein alterations produced in women taking synthetic estrogens. J Clin Endocrinol 27:1463, 1967

49. Niswander K, Jackson EC: Physical characteristics of the gravida and their association with birth weight and perinatal death. Am J Obstet Gynecol 119:306, 1974

50. Oldham H, Sheft BB: Effect of caloric intake on nitrogen utilization during pregnancy. J Am Diet Assoc 27:847, 1951

51. Page EW, Page EP: Leg cramps in pregnancy: etiology and treatment. Obstet Gynecol 1:94, 1953

52. Paintin DB, Thomson AM, Hytten FE: Iron and the haemoglobin level in pregnancy. J Obstet Gynaecol Br Commonw 73:181, 1966

53. Pitkin RM: Calcium metabolism in pregnancy: a review. Am J Obstet Gynecol 2:221, 1975

54. Pitkin RM, Kaminetzky HA, Newton M, Pritchard JA: Maternal nutrition: a selective review of clinical topics. Obstet Gynecol 40:773, 1972

55. Pritchard JA: Anemias complicating pregnancy and the puerperium. In Maternal Nutrition and the Course of Pregnancy. Committee on Maternal Nutrition, Food and Nutrition Board, National Academy of Sciences. Washington DC, 1970, pp 74–109

56. Pritchard JA, Scott DE, Whalley PJ: Maternal folate deficiency and pregnancy wastage. IV. Effects of folic acid supplements, anticonvulsants, and oral contraceptives. Am J Obstet Gynecol 109:341, 1971

57. Pullman RP, Dannenburg WN, Burt RL, Leake NH: Carotene and vitamin A in pregnancy and the early puerperium. Proc Soc Exp Biol Med 109:913, 1962

58. Roberts SA, Cohen MD, Forfar JO: Antenatal factors associated with neonatal hypocalcaemic convulsions. Lancet 2:809, 1973

59. Robertson EG: The natural history of oedema during pregnancy. J Obstet Gynaecol Br Commonw 78:520, 1971

60. Rose DP: The influence of oestrogens in tryptophan metabolism in man. Clin Sci 31:265, 1966

61. Rose DP, Braidman IP: Excretion of tryptophan metabolites as affected by pregnancy, contraceptive steroids, and steroid hormones. Am J Clin Nutr 24:673, 1971

62. Rosen JF, Roginsky M, Nathenson G, Finberg L: 25–hydroxyvitamin D: Plasma levels in mothers and their premature infants with neonatal hypocalcemia. Am J Dis Child 127:220, 1974

63. Scott DE, Pritchard JA: Iron deficiency in healthy young college women. JAMA 199:897, 1967

64. Shojania AM, Hornaday GJ: Oral contraceptives and folate metabolism. J Lab Clin Med 82:869, 1973

65. Smith CA: Effects of maternal undernutrition upon newborn infants in Holland (1944–1945). J Pediatr 30:229, 1947

66. Spince H, Lowry RS, Folsome CE, Behrman JS: Studies on the urinary excretion of "xanthurenic acid" during normal and abnormal pregnancy: a survey of the excretion of "xanthurenic acid" in normal nonpregnant, normal pregnant, preeclamptic, and eclamptic women. Am J Obstet Gynecol 62:84, 1951

67. Stone ML, Luhby AL, Feldman R, Gordon M, Cooperman JM: Folic acid metabolism in pregnancy. Am J Obstet Gynecol 99:638, 1967

68. Streiff RR: Folate deficiency and oral contraceptives. JAMA 214:105, 1970

69. Streiff RR, Little AB: Folic acid deficiency in pregnancy. N Engl J Med 276:776, 1967

70. Theurer RC: Effect of oral contraceptive agents on vitamin and mineral needs: a review. J Reprod Med 8:13, 1972

71. Thomson AM, Billewicz WZ: Clinical significance of weight trends during pregnancy. Br Med J 1:243, 1957

72. Thomson AM, Hytten FE, Billewicz WZ: The energy cost of human lactation. Br J Nutr 24:565, 1970

73. Tracy TA, Miller GL: Obstetric problems of the massively obese. Obstet Gynecol 33:204, 1969

74. Wachstein M, Graffeo LW: Influence of vitamin B_6 on the incidence of pre-eclampsia. Obstet Gynecol 8:177, 1956

75. Wachstein M, Gudaitis A: Disturbance of vitamin B_6 metabolism in pregnancy. J Lab Clin Med 40:550, 1952

76. Watney PJM, Chance GW, Scott P, Thompson JM: Maternal factors in neonatal hypocalcemia: a study in 3 ethnic groups. Br Med J 2:432, 1971

77. Wertalik LF, Metz EN, LoBuglio AF, Balcerzak SP: Decreased serum B_{12} levels with oral contraceptive use. JAMA 221:1371, 1972

78. Wideman GL, Baird GH, Bolding OT: Ascorbic acid deficiency and premature rupture of fetal membrane. Am J Obstet Gynecol 88:592, 1964

27 Ophthalmology

Steven J. Faigenbaum, Irving H. Leopold

This discussion of the nutritional support of ophthalmologic practice will include the deficiency states with ocular manifestations as well as the therapeutic use of vitamins and dietary substances. For obvious reasons, few controlled studies are available in humans. Much of the available information comes from studies involving generalized dietary deficiency rather than the lack of one element, *e.g.,* from the observation of prisoners of war. For these reasons, there is still some uncertainty as to the specific manifestations of deficiencies of the essential dietary elements. Animal studies are necessary; however, one must be cautious in their interpretation.

The localized ocular changes due to deficiency states may be summarized as follows:

1. Conjunctiva
 Vitamin A—Xerosis—loss of goblet cells, Bitot's spots, and pigmentary changes
 Pyridoxine—"Conjunctivitis"
 Vitamin C—Subconjunctival hemorrhages
2. Cornea
 Vitamin A—Localized changes due to drying
 Riboflavin—Circumcorneal vascularization
 Vitamin D—Band keratopathy in hypercalcemia
3. Vitreous
 Vitamin C—Vitreous hemorrhages
4. Retina
 Vitamin A—Punctate changes and nyctalopia
 Thiamin—Maculopathy
 Niacin, nicotinic acid, and nicotinamide—Maculopathy
 B$_{12}$—Nerve fiber hemorrhages and nerve fiber infarets
 Vitamin E—Maculopathy
5. Optic nerve
 Thiamin—Optic neuropathy
 Niacin, nicotinic acid, and nicotinamide—

Optic neuropathy
B$_{12}$—Optic neuropathy

Severe hypotony (60) and refractive changes (34, 77) have been found in malnourished children. In India, (77) 116 malnourished children were found to have a definite myopia of up to two diopters. Improvement in diet did not bring the children fully to emmetropia.

VITAMIN DEFICIENT STATES

VITAMIN A

Vitamin A deficiency has probably been the most studied nutritional state from an ophthalmologic standpoint. In general, it is known that deficiency causes a substitution of keratized cells for other types of epithelial cells (see Ch. 16). Also, vitamin A is used directly in the synthesis of the visual pigments and is said to play a role in stabilization of lysosomal membranes.

Biochemically, much has been learned recently of its action in the visual process. Basically rhodopsin is composed of vitamin A in the form of "eleven"-*cis*-retinal bound to a protein moiety (opsin). Light acts by changing the "eleven"-*cis*-retinal to an all-*trans*-retinal configuration (Fig. 27–1), which then is released from the protein structure after a series of intermediate steps. This reaction is associated with the initiation of the visual impulse (Fig. 27–2). Light causes an isomerization of vitamin A to an unstable form, and after several intermediate steps, rhodopsin splits into an opsin and vitamin A. During this reaction a nerve impulse is generated.

The ocular clinical features of vitamin A deficiency are generally felt to include night blindness (nyctalopia), dry eyes (xerophthalmia), hyperkeratosis of hair follicles, and pigmentary changes of the conjunctiva.

NYCTALOPIA

Nyctalopia is a frequent manifestation of vitamin A deficiency said to be more frequent in males and more common below the age of 20 years. The electroretinogram has been found to be completely extinguished as soon as the deficiency leads to the clinical manifestations of nyctalopia. It must be remembered that night blindness may be a manifestation of a congenital or hereditary predecess or seen in the pigmentary degenerative diseases. Dietary deficiencies and liver and intestinal diseases may all be associated with a form of night blindness. Diseases of the pancreas and hyperparathyroidism may also account for the relative vitamin A deficiency in retinal receptors. Night blindness has been described (23) in the third trimester of pregnancy; this disappeared post partum. Patients with GI problems, *e.g.*, sprue, liver disease, and cystic fibrosis (69) of the pancreas, have been described with nyctalopia, probably secondary to poor vitamin A absorption.

Night blindness is seen usually as a late symptom of vitamin A deficiency. Frequently vitamin A levels must be quite low for some time before any visual symptoms are noted. Structural as well as functional changes can be found in the posterior pole. Rods are affected more than cones, and in severe deficiencies, disruption of the rod outer segments can be seen. Multiple

Fig. 27–1. Structures of ll-*cis*-retinal and all-*trans*-retinal.

11-*cis*-retinal

All-*trans*-retinal

retinal lesions appearing as white dots have also been described in vitamin A deficiency.

Since primarily the rods are affected, night acuity is lost. Photopic, or cone vision, needed for central vision is essentially normal.

ELECTRORETINOGRAPHIC CHANGES

The electroretinogram (ERG) is a technique for studying retinal changes in electrical potential in response to a light stimulus (Fig. 27–3). In the dark-adapted tracing (scotopic ERG) this represents rod functioning. As in other conditions that cause rod dysfunction, *e.g.*, retinitis pigmentosa, there is a dampening or extinction of the ERG tracing. In early cases this symptom has been reported to respond quite well to oral doses of vitamin A, whereas advanced cases may remain refractory to treatment.

Recent studies have shown that vitamin A therapy may be useful in some of the hereditary diseases. The electroretinographic changes in patients with abetalipoproteinemia may be reversed with high doses of vitamin A (32, 78). Few encouraging studies are available on the therapy of retinitis pigmentosa (13). Chatznoff *et al.* (15) report no benefit from therapy with eleven-*cis*-retinal vitamin A after a double blind study. The role of vitamin A in retinal diseases, especially retinitis pigmentosa, is certainly confusing, but it is well known that vitamin A deficiency causes retinal outer segment dysfunction due, possibly, to a decrease in visual pigments. Recent animal studies have shown anatomic disruption of outer segments in the macular and peripheral retina in monkeys after vitamin A (and E) deficient diets.

ANTERIOR SEGMENT CHANGES

Deficiency of vitamin A is said to affect pigmentation of the skin and conjunctiva. Xerophthalmia and Bitot's spots have long been considered almost pathognomonic of decreased vitamin A, and studies (1, 67, 84) have shown that xerosis can occur in association with nyctalopia as a manifestation of the deficiency state, but the symptom of nutritional xerosis is more frequently a manifestation of multiple factors.

Sullivan *et al.* (79) demonstrated return of the conjunctival goblet cells in alcoholics with dry eye syndrome after treatment with oral vitamin A. Although Bitot's spots (67, 71, 72) have similarly been found to be a manifestation of a "poor nutritional state" that may have little relation-

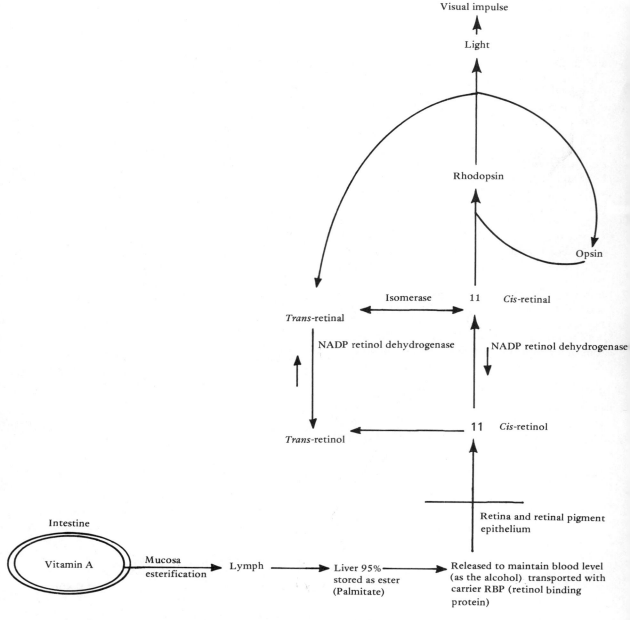

Fig. 27-2. Pathway of vitamin A utilization in production of visual impulse.

ship to vitamin A levels, some investigators feel that in infants the presence of the foamy white conjunctival change is quite diagnostic of vitamin A deficiency.

Vitamin A deficiency during the neonatal period has been found to be associated with choroidal colobomata, retinal folds, and vitreous fibroplasia in rabbits. Lamba (47) reports a case of congenital microphthalmos and colobomata as-

sociated with maternal vitamin A deficiency in humans.

THERAPEUTIC USES

The systemic as well as topical use of vitamin A has been advocated for certain skin and anterior segment diseases. Skin lesions such as ichthyosiform erythoderma, psoriasis, and acne can

Fig. 27–3. Electroretinograms. **A.** Normal. **B.** Nearly extinguished.

The four traces in each set show averaged responses to four different stimulus conditions: *Upper trace*— white stimuli, photopic adaptation state; *second trace*— white stimuli, scotopic adaptation state; *third trace*— red stimuli, scotopic adaptation state; and *bottom trace* —blue stimuli, scotopic adaptation state. Duration of each trace is 128 msec.

The traces in B are shown at 16 times higher amplification than those in A. Amplitudes of β-waves were normal in A, ranging between 150 and 350 μ v.; These amplitudes in B were between 2 and 10 μ v.; the photopic response *(upper traces)* was about 10% of normal, and the scotopic responses *(other traces)* were about 1% of normal.

be treated locally. Some of the European literature suggests the use of topical vitamin A for basal cell carcinomas, but few controlled studies are available. Prutkin (70) reports a complete regression rate of more than 85% with keratoacanthoma using 0.3% vitamin A acid and 5% 5-FU topically. Abboud *et al.* (2) report a decreased recurrence rate of chalazia after systemic therapy with large doses of vitamin A.

The role of vitamin A on the integrity of epi-

thelial cells is well known. Many "glowing" uncontrolled studies and case reports are available on the topical use of vitamin A for superficial corneal diseases. Agarwal *et al.* (5) state that vitamin A speeds healing time and helps reduce scar density. Clarkson (16) reports beneficial effects on healing of corneal abrasions after removal of superficial foreign bodies. Kentgens (41) reports "beneficial" results in the treatment of herpetic lesions of the cornea. Schmidtke (73), however, reports that therapy with topical vitamin A is of doubtful value.

Nelkin and Nelkin (62) report a significant degree of inhibition of corneal neovascularization in a controlled experiment using vitamin A palmitate in rabbits.

Increased intracranial pressure and papilledema has been reported after ingestion of large doses of vitamin A (29). A similar acute reaction is thought to occur from eating shark or polar bear liver which contains large amounts of vitamin A (64).

B VITAMINS

The B complex vitamins are a group of watersoluble factors, many of which have been shown to have clinical significance. As noted above, it is difficult to sort out a single agent as the cause for a clinical state, and there appears to be a great many interrelations among the B complex factors. For example, administration of one component of the B complex tends to deplete the supply of the other B factors. In their discussion of nutritional diseases, Walsh and Hoyt (87) make the point that since the etiology of many deficiency states is uncertain, *e.g.,* some authors believe peripheral neuritis is due to thiamin deficiency whereas others favor riboflavin as the major cause, in the majority of instances, therapy with all of the B complex factors will give the most satisfactory results.

Nutritional amblyopia, or more specifically, nutritional retrobulbar neuritis, has been described as noted above in multiple studies of deprived individuals. The classic syndrome shows blurred visual acuity with a central or centrocecal scotoma. The exact cause is not known. The B complex factors have each been implicated, especially thiamin and riboflavin, and B_{12}. (69). McLaren and Halasa's (55) claim that the best results are frequently obtained with multi-B complex therapy is reasonable since these vitamins frequently occur together in nature. The somewhat controversial etiology of tobacco–alcohol amblyopia and the visual

changes in pernicious anemia are felt by some to be forms of the "nutritional retrobulbar neuritis syndrome." Foulds and Chrisholm *et al.* (27, 28) in 1969 stated that the optic neuropathy of tobacco–alcohol amblyopia is the same as that of pernicious anemia. The present theories on etiology includes the detoxification of cyanide in the optic nerve tissue. Foulds *et al.* (28) also described two cases of pernicious anemia who developed optic neuropathy while undergoing therapy with cyanocobalamin and did not improve until placed on hydroxycobalamin therapy. Present-day therapy of this syndrome should be with the hydroxycobalamin form of vitamin B_{12}.

The B complex factors have been suggested as therapy for some of the toxic ambylopias, but few studies are available on the therapy of these conditions. Leinfelder (49) found that thiamin was of no value in altering the severity of tryparsamide reactions.

THIAMIN DEFICIENCY

BERIBERI. Walsh and Hoyt (87) divide the ocular symptoms of beriberi into three categories: 1) conjunctival and corneal changes, 2) optic nerve involvement, and 3) ocular muscle paresis.

The conjunctival change of dryness and anemia have been described in animals. Few references are found to corneal epithelial changes in humans. In a description of nutritional amblyopia in American prisoners of war during World War II, Bloom *et al.* (12) describe a syndrome of defective vision associated with central or centrocecal scotomata and, later, with pallor of the nerve head. Maculae were normal in the majority of cases. Bloom felt the condition to be due to a lack of thiamin since the visual syndrome frequently occurred with the symptoms of beriberi and because the syndrome was relieved by thiamin when administered in the early stages.

WERNICKE'S ENCEPHALOPATHY. Wernicke's syndrome includes delirium, stupor, ataxia, and external ophthalmoplegia. This condition is seen not only in the severely deprived but in alcoholics as well (see Ch. 13). In the latter, this is felt not to be a toxic manifestation, but rather a manifestation of poor dietary intake. Pathologic focal areas of hemorrhage and gliosis can be found in the brain stem. Nystagmus may be a presenting symptom. Dramatic improvement

(17) in ocular motility can be seen hours after a small dose of thiamin. Less-dramatic improvement is usually seen with ataxia and mental changes.

RETINOPATHY. The usual pathologic findings in beriberi are effusions of the pericardium, pleura, and peritoneum. It has been suggested that a central retinitis with serous changes could also be caused by thiamin deficiency. Therapy of serous retinopathy (90) has been suggested, but controlled studies are lacking.

NIACIN DEFICIENCY

PELLAGRA. Classically, the symptoms of pellagra include diarrhea, dermatitis, and dementia. However, it is not absolutely clear, in humans, whether the pellagra syndrome is due to a single deficiency or to a combination of factors.

Pellagra is not an extremely rare condition and many of the cases are alcoholics. Fine and Lachman (25) report less ocular involvement than has been reported in the past.

Reports of ocular involvement with retrobulbar neuritis sound quite similar to other nutritional retrobulbar neuritis cases (14, 25, 42, 55, 85).

Mather (53) studied 61 cases of pellagra and described a maculopathy with loss of normal yellow reflex in about 50% and frank pigment migration in 32%. Some improvement was seen in early cases after therapy.

NICOTINIC ACID AND NICOTINAMIDE. Nicotinic acid and nicotinamide are necessary for the formation of several coenzymes used in tissue metabolism. These cofactors are vital to many enzyme systems. One of these, the alcohol dehydrogenase system, is required in the early steps of rhodopsin synthesis, and therefore a deficiency of these substances could, theoretically, be expected to give symptoms of nyctalopia. Nicotinic acid in large doses is known to lower serum cholesterol levels. Harris (35) reports a case of development of a paracentral scotoma in an individual taking 6000 mg nicotinic acid/day. The scotoma disappeared on discontinuing the drug.

Argarwal *et al.* (6) report that systemic nicotinic acid will "accelerate the rate of corneal healing and will decrease corneal scar density."

Nicotinic acid will cause a vasodilatation of certain blood vessels of the skin associated with flushing and a burning sensation. As a

vasodilatator, its use has been advocated (88) by some in central retinal vascular occlusion due from spasm. Balucco-Gabriel (9) reports "noticeable" retinal vascular dilatation using a combination of nicotinic acid, m-inositol, and callicrein systemically.

Macular degenerative changes from a variety of causes have been treated with as varied a number of vitamin (10, 32, 48, 89) and vasodilating agent combinations. Very few of the studies on these agents are controlled and interpretation of the results is difficult.

RIBOFLAVIN

Riboflavin deficiency is felt to be relatively common in humans (see Ch. 7). Classically, a cheilosis or fissuring of the skin of the angle of the mouth is seen. Ocular manifestations of the deficiency state include conjunctival irritation with the development of circumcorneal vascularization. Abnormal pigmentation of the iris may also be seen. Rosacea keratitis appears to be clinically quite similar to riboflavin deficiency (50). Conflicting reports are available as to the efficacy of therapy of rosacea keratitis with riboflavin. There are reports that suggest regression of corneal neovascularization from nutritional deficiency with B complex therapy (85).

PYRIDOXINE B$_6$

The signs of pyridoxine deficiency include a *seborrheic dermatitis* (63), conjunctivitis, a *pellagra-like dermatitis,* and a *polyneuritis.* In adults, deficiencies are not spontaneous but the result of ingestion of such drugs as Hydralazine isoniazide and penicillamine. Tu *et al.* (80) suggest that the optic neuritis seen in a patient with Wilson's disease was secondary to administered penicillamine with subsequent antagonism to pyridoxine.

Irinoda and Mikami (39) raised experimental animals on a B$_6$-deficient diet and noted a high incidence of angular blepharoconjunctivitis that was responsive to therapy with pyridoxine.

Barber and Spaeth (11) have shown that treatment with large doses of vitamin B$_6$ can chemically correct patients with homocystinuria due to cystathione synthetase deficiency. Pyridoxal phosphate is a cofactor for the enzyme that couples serine with homocystine to produce cystathione. The biochemical defect is apparently corrected, but clinical effects have been disappointing (61).

Komi *et al.* (44) have given pyridoxine phosphate solution topically and report favorable results on viral keratitis.

VITAMIN B$_{12}$

Pale conjunctiva is a general manifestation of an anemic state. Severe anemia *per se* can present with the interesting ophthalmic finding of papilledema, which can be seen after acute blood loss and in microcystic anemias. It is felt that the severe anemia causes anoxia with edema sufficient to raise intracranial pressure (74).

The megaloblastic anemia associated with vitamin B$_{12}$ deficiency has several inconstant ocular findings. Flame-shaped hemorrhages are often seen in the nerve fiber layer in the posterior pole. These have also been described with white centers, the so-called Roth's spots. Their etiology is uncertain but may be related to the decreased number of defective platelets. The severe anemic states that develop can also produce a mild chronic retinal edema. This disc may appear pale, but this may be due to the anemia *per se.*

If hypotension is present, or if the anemia is severe enough, retinal anoxia can manifest itself as fluffy white, superficial, retinal exudates, the so-called cotton–wool spots. These are actually infarcts in the nerve fiber layer.

Vitamin B$_{12}$ deficiency can cause retrobulbar neuritis (18, 27, 28) that is virtually identical in clinical manifestation to that of tobacco–alcohol amblyopia (60). The prognosis for visual recovery is said to be good if treatment is started early and optic atrophy is not present. As noted above, the best treatment of this condition is probably with hydroxycobalamin.

Suggestions have been made for the use of vitamin B$_{12}$ in the treatment of retinoblastomas. These suggestions are based on reports of the use of vitamin B$_{12}$ in the therapy of neuroblastomas (38, 75). Support has not been found for the use of B$_{12}$ in either condition.

FOLIC ACID—FOLINIC ACID

The therapy of ocular toxoplasmosis includes the use of the folic acid antagonist Daraprim. Oral doses of 10–15 mg folinic acid (30) can be given every several days to prevent the symptoms of folic acid deficiency. The rationale for this therapy is that humans can utilize the folinic acid whereas the Toxoplasma organisms cannot.

VITAMIN C

Scurvy is a disease characterized predominantly by hemorrhagic manifestations, *e.g.,* perifollicular hemorrhages, petechiae, ecchymoses, bleeding gums, and bone pain with subperiosteal hemorrhages. The ocular changes are similarly centered about hemorrhagic changes. Lid ecchymoses, subconjunctival, vitreous, and retinal hemorrhages, proptosis secondary to orbital bleeding, and gaze palsies with subdural hematomas are findings seen with vitamin C deficiency. Scurvy frequently appears with anemia and a mild degree of scleral icterus. The anemia may be due to a frequently associated folate deficiency or to the blood loss *per se.*

Nyctalopia has, as well, been associated with scurvy. This is probably secondary to an accompanying vitamin A deficiency.

Vitamin C has been suggested as playing a role in such conditions as recurrent vitreous hemorrhages, retinal hemorrhages in diabetes, and cataracts. Little support has been found for these suggestions.

In normal individuals the vitamin C content of the aqueous humor is about 10 times that of serum. It is felt that the ciliary body is the source of this ascorbate level (58). The exact pharmacologic role of vitamin C in the eye has yet to be elucidated.

Attempts have been made to treat glaucoma with vitamin C. It has been given by IV infusion (37), by itself in the form of 20% sodium ascorbate, and in combination with other osmotic agents (82). It has been found to be an effective osmotic agent for decreasing intraocular pressure. Vitamin C has been given orally as 20% solution (83) in heroic doses, 0.5 g/kg body weight in one dose, and indeed, a significant decrease in intraocular pressure was recorded. Most of the patients were reported to easily tolerate the dose after the first several days of diarrhea, nausea, and vomiting had passed.

Linner (51, 52) obtained an average decrease of 2 mm Hg in ocular pressure after daily administration of 2 g vitamin C orally. There was no change in the outflow facility, and the decrease in pressure was attributed to a decrease in the rate of aqueous formation. Fishbein and Goodstein (26) showed that oral doses of 4.5–5 g vitamin C daily did not significantly alter the control of the intraocular pressure in patients already on maximal medical glaucoma therapy.

Gnadinger *et al.* (31) topically applied a 10% solution of ascorbic acid over 3 days, and noted no significant change in ocular outflow or tension. Esila *et al.* (24) noted no change in pressure in normal rabbit eyes after subconjunctival ascorbate.

It has been stated that scurvy causes poor wound healing due to defective collagen formation. Controlled data is not available as to the effect of vitamin C on ocular wound healing, but it has been suggested that oral administration will enhance the rate of corneal epithelial formation.

An additional possible therapeutic use of vitamin C is suggested by JL Smith (76), who recommends 3 g three times daily to acidify the urine and increase the rate of excretion of such drugs as Chloroquine after retinal toxic doses.

VITAMIN D

A discussion of the pathophysiology of vitamin D can be found in other sections (see Ch. 7).

Knapp's investigation (43) suggests some improvement in keratoconus with vitamin D therapy.

Calcification of Bruch's membrane of the cornea, the so-called band keratopathy (Fig. 27–4), has been noted with most conditions associated with an increase in serum calcium, including hypervitaminosis D.

VITAMIN E

The therapeutic uses, as well as the clinical manifestations of the deficiency state, of vitamin E have long been in question. Animal deprivation studies have shown neurologic and macular changes. Demole and Knapp's study (20) showed multiple ocular changes in rats. Adult rats were observed to develop keratoconus, paralysis, progressive exophthalmos, opacification, and neovascularization of the cornea, iridocyclitis with formation of secondary cataracts.

Owens and Owens (65) suggest that alpha tocopheral acetate will decrease the incidence of retrolental fibroplasia.

Recently, Hayes (36) showed that in monkeys a deficiency of vitamin E can result in retinal damage having some similarities to that caused by vitamin A deprivation. The hypothesis is forwarded that vitamin E may protect the retina from peroxidase destruction.

Devi *et al.* (22) studied the metabolism of nucleic acid and protein in cataracts of rabbits on vitamin E–deficient diets and demonstrated that DNA polymerase activity is increased.

Vitamin E has been used in the treatment of a variety of fundus lesions. Adayeva *et al.* (3) in

Fig. 27-4. Band keratopathy. The dense white near the limbus represents calcium deposition in Bowman's layer of the cornea.

an uncontrolled study suggest benefits after vitamin E in a variety of macular degenerative conditions.

DeHoff *et al.* (19) found no effect on the progression of diabetic retinopathy using oral alpha tocopherol acetate.

Ayres *et al.* (8) found that post-herpes zoster neuralgia responded favorably to topical and oral vitamin E doses.

CALORIES, PROTEIN AND MINERALS

CARBOHYDRATES AND FATS

Much has been written in recent years on the etiology, natural history, and therapy of diabetic retinopathy (see Ch. 17). Van Eck's study (81) in 1959 suggested that a decrease in serum lipids in the diabetic patient was associated with a decrease in retinal exudates. Meyerson and Schneider (57) followed 13 patients with diabetic retinopathy who were treated with low-fat diets; no definite trends were noted in the course of the diabetic retinopathy. Adnitt *et al.* (4) in a prospective study, showed that the progression of retinopathy appeared to be unrelated to mean blood sugar levels.

Albrink *et al.* (7) report that there is no evidence that serum lipids are abnormal in patients with senile macular diseases; no good studies are available as to the therapy of low-fat and low-lipid diets on macular disease.

Lid xanthelasma (66) has been reported to regress on modified fat diets.

Galactosemia is a disease caused by deficiency of galactose-1-phosphate uridyl transferase. The accumulation of dulcitol in the lens can cause cataracts. A quite similar picture can arise from a galactokinase deficiency. Monteleone (59) reports that early dietary galactose control has prevented the appearance of cataracts in a newborn galactokinase-deficient homozygote.

MINERALS

Few definite relationships have been shown between mineral metabolism and ocular findings. A zonular cataract has been reported with the hypocalcemia of tetany. Waldblott (86) reports optic neuritis associated with possible fluoride toxicity. DeRosa (21) reports trophic changes associated with a deep and superficial vascularization in magnesium-deficient rats.

PROTEINS

As mentioned throughout the text, vitamin deficiency can be the result of poor absorption or transport as reflections of protein deficiency. McLaren (54) states that ocular involvement is one of the most common and serious complications of protein-calorie malnutrition in young children. These are largely due to vitamin A deficiency. Several inborn errors of metabolism with aminoaciduria related diseases, have ocular features as part of the symptomology. In cystinosis, crystals of cystine may be found in the conjunctiva and sometimes the cornea. Cataracts have been recorded in nearly half of the cases of Toni–Fanconi syndrome.

REFERENCES

1. Abboud IA, Osman HG, Massoud WH: Vitamin A and xerosis. Exp Eye Res 7:388–393, 1968
2. Abboud IA, Osman HG, Massoud WH: Vitamin A and chalazia. Exp Eye Res 7:383–387, 1968
3. Adayeva YF, Laikhter BG, Lev RA, Neiman VN, Poletayeva GP: Vitamin E treatment in macula lutea. Dystrophy Vestnoftalm 2:75–76, 1963
4. Adnitt PI, Taylor E: Progression of diabetic retinopathy, relationship to blood sugar. Lancet 1:652–654, 1970
5. Agarwal LP, Adhaulia HN: Role of vitamin A in healing corneal ulcers. Am J Ophthalmol 38:810–816, 1954
6. Agarwal LP, Datt L: Role of nicotinic acid in healing of corneal ulcers. Am J Ophthalmol 37:764–767, 1954
7. Albrink MJ, Fasanella RM: Serum lipids in patients with senile macular degeneration. Am J Ophthalmol 55:709–713, 1963

8. Ayres S Jr, Mihan R: Post-herpes zoster neuralgia response to vitamin E therapy. Arch Dermatol 108:855–856, 1973

9. Balacco–Gabriel C: Preliminary note on the action of nicotinic acid, M-inositol, and callicrein on retinal vessels of normal young people. Arch Ottal 68:385–388, 1964

10. Balacco-Gabriel C: Preliminary tests of therapeutic activity of nicotinic acid with M-inositol and callicrein on angiosclerotic angiospastic retinopathy. Arch Ottal 68:603–639, 1964

11. Barber GW, Spaeth GL: The successful treatment of homocystinuria with pyridoxine. J Pediatr 75:463–478, 1969

12. Bloom SM, Merz EH, Taylor WW: Nutritional amblyopia in American prisoners of war liberated from the Japanese. Am J Ophthalmol 29:1248–1257, 1946

13. Campbell DA, Harrison R, Tonks EL: Retinitis pigmentosa: vitamin A serum levels in relation to clinical findings. Exp Eye Res 3:412–426, 1964

14. Carroll FD: Nutritional amblyopia. Arch Opthalmol 76:406–411, 1966

15. Chatzinoff A, Nelson E, Stahl N et al.: Eleven-CIS vitamin A in treatment of retinitis pigmentosa. Arch Opthalmol 80:417–419, 1968

16. Clarkson AK: Experiences in vitamin A: corneal incidents in relation to vitamin A. Industrial Welfare 25:69–70, 1943

17. Cole M, Turner A, Frank O et al.: Extraocular palsy and thiamine therapy in Wernicke's encephalopathy. Am J Clin Nutr 22:44–51, 1969

18. Crousaz G de: Symptomes et signes oculaires dans les carences en vitamin B₁₂. Remarques sur les neuropathies optiques biermeriennes. Ophthalmologica 159:295–306, 1969

19. DeHoff JB, Ozazewski J: Alpha Tocopherol to treat diabetic retinopathy. Am J Ophthalmol 37:581–582, 1954

20. Demole V, Knapp P: Augenerankungen bei einigen vitamin-E-frei ernährten Ratten. Opthalmologica 101:65–73, 1941

21. DeRosa L, DeConcilius U: Ocular changes during the course of magnesium-free diet. Arch Ottal 67:313–317, 1963

22. Devi A, Raina PL, Singh A: Abnormal protein and nucleic acid metabolism as a cause of cataract formation induced by nutritional deficiency in rabbits. Br J Ophthalmol 49:271–275, 1965

23. Dixit DT: Night blindness in third trimester of pregnancy. Indian J Med Res 54:791–795, 1966

24. Esila R, Tenhunen T, Tuovenen E: The effect of ascorbic acid on the intraocular pressure and the aqueous humor of the rabbit eye. Acta Ophthalmol (Kbh), 44:631–636, 1966

25. Fine M, Lachman GS: Retrobulbar neuritis in pellagra. Am J Ophthalmol 20:708–714, 1937

26. Fishbein SL, Goodstein S: The pressure lowering effect of ascorbic acid. Ann Ophthalmol 4:487–491, 1972

27. Foulds W, Chisholm IA, Bronte–Steward J et al.: Vitamin B₁₂ absorption in tobacco amblyopia. Br J Ophthalmol 53:393–397, 1969

28. Foulds WS, Chisholm IA, Stewart JB et al.: The optic neuropathy of pernicious anemia. Arch Ophthalmol 82:427–432, 1969

29. Gelpke PM: Vitamin A intoxication. Can Med Assoc J 104:533, 1971

30. Giles CL: The treatment of toxoplasma uveitis. Am J Ophthalmol 58:611–616, 1964

31. Gnadinger M, Willome J: The influence of topically applied ascorbic acid on the normal intraocular tension. Klin Monatsbl Augenhielkd 153:352–356, 1968

32. Goswami AP: Complamina in macular degeneration. A blind study on central fields. Ophthalmologica 164:219–227, 1972

33. Gouras P, Carr RE, Gunkel RD: Retinitis pigmentosa in abetalipoproteinemia: effect of vitamin A. Invest Ophthalmol 10:784–793, 1972

34. Halasa AH, McLaren DS: The refractive state of malnourished children. Arch Ophthalmol 71:827–831, 1964

35. Harris JL: Toxic amblyopia associated with administration of nicotinic acid. Am J Ophthalmol 55:133–134, 1963

36. Hayes KC: Retinal degeneration in monkeys induced by deficiencies of vitamin E or A. Invest Ophthalmol 13:499–510, 1974

37. Hilsdorf C: About the decrease of intraocular pressure intravenous drop infusion of 20% sodium ascorbinate. Klin Monatsbl Augenheilkd 150:352–358, 1967

38. Horns JW: Rationale for vitamin B₁₂ treatment of retinoblastoma. Am J Ophthalmol 61:910–911, 1966

39. Irinoda K, Mikami H: Angular blepharoconjunctivitis and pyridoxine deficiency. Arch Ophthalmol 60:303–311, 1958

40. Johnson LV, Eckhardt RE: Rosacea keratitis and conditions with vascularization of cornea treated with riboflavin. Arch Ophthalmol 23:899–907, 1940

41. Kentgens SK: Ueber Vitamin-A-Therapie bei hornhauterkrankungen. Ophthalmologica 96:3–14, 1938

42. King JH, Passmore JW: Nutritional amblyopia. Am J Ophthalmol 39:173–186, 1955

43. Kanpp AA: Results of vitamin-D-complex treatment of keratoconus: preliminary study. Am J Ophthalmol 22:289–292, 1939

44. Komi T, Shimoide K, Yasuda H: Effect of pyridoxal phosphate eye drops upon viral keratitis. Acta Soc Ophthalmol Jap 70:103–104, 1966

45. Kommerell G: Tobacco amblyopia. Klin Monatsbl Augenheilkd 153:551–562, 1968

46. Kuming BS, Politzer WM: Xeropthalmia and protein malnutrition in Bantu children. Br J Ophthalmol 51:649–666, 1967

47. Lamba PA, Sood NN: Congenital microphthalmos and colobomata in maternal vitamin A deficiency. J Pediatr Ophthalmol 5:115–117, 1968

48. Laws HW: Peripheral vasodilators in the treatment of macular degenerative changes in the eye. Can Med Assoc J 91:325–330, 1964

49. Leinfelder PJ, Stump RB: Thiamine hydrochloride in the treatment of tryparsamide amblyopia. Arch Ophthalmol 26:613–618, 1941

50. Levy NS, Krill AE, Beutler E: Galactokinase deficiency and cataracts. Am J Ophthalmol 74:41–48, 1972

51. Linner E: Corticosteroid hormones, ascorbic acid and intraocular pressure. Acta Ophthalmal (Kbh) 42:932–933, 1964

52. Linner E: The pressure lowering effect of ascorbic acid in ocular hypertension. Acta Ophthalmal (Kbh) 47: 685–689, 1969

53. Mather SP: Maculopathy in pellagra. Br J Ophthalmol 53:350–351, 1969

54. McLaren DS: Involvement of the eye in protein malnutrition. Bull WHO 19:303–314, 1958

55. McLaren DS, Halasa A: The ocular manifestations of nutritional disease. Postgrad Med J 40:711–716, 1964

56. McLaren DS, Oomen HA, Escapini H: Ocular manifestations of vitamin-A deficiency in man. Bull WHO 34:357–361, 1966

57. Meyerson L, Schneider T: Diabetic retinopathy: its treatment with a low fat diet; a classification. Med Proc 9:452–459, 1963

58. Mitsukama K: Studies on the function of iris and ciliary body. IV. Mechanism of vitamin C production viewed from the findings in plasmoid aqueons humous. Acta Soc Ophthalmol Jap 67(8): 839–845, 1963

59. Monteleone JA, Beutler E, Monteleone DL: Cataracts, galactosuria, and hypergalactosemia due to galactokinase deficiency in a child. Am J Med 50:403–405, 1971

60. Moreau PG, Cornibert and Mugneret: Serious hypotony in malnutrition. Bull Soc Ophthalmol Fr 63: 243–245, 1963

61. Morrow G III, Barness LA: Combined vitamin responsiveness in homocystinuria. J Pediatr 81:946–954, 1972

62. Nelken E, Nelken D: Inhibition of corneal neovascularization by vitamin A palmitate. Isr J Med Sci 1:243, 1965

63. Nisenson A, Barness LA: Treatment of seborrhic dermatitis with biotin and vitamin B complex. J Pediatr 81:630–631, 1972

64. Oliver TK, Havener WH: Eye manifestations of chronic vitamin A intoxication. Arch Ophthalmol 60: 19–22, 1958

65. Owens WC, Owens EI: Retrolental fibroplasia in premature infants: studies on the prophylaxis of the disease: the use of alpha tocpherol acetate. In Wiener M et al. (eds): Progress in Ophthalmology and Otolaryngology. Ped I–Ophthalmology. New York, Grune & Stratton, 1953, pp 143–149

66. Palmer AJ, Blacket R: Regression of xanthomata of the eyelids with modified fat diet. Lancet 1:67–68, 1972

67. Paton D, McLaren DS: Bitot spots. Am J Ophthalmol 50:568–574, 1960

68. Petersen RA, Petersen VS, Robb RM: Vitamin A deficiency with xerophthalmia and night blindness in cystic fibrosis. Am J Dis Child 116:662–665, 1968

69. Philipsen WM, Hommes OR: Atrophy of the optic nerve and vitamin B_6 deficiency. Ophthalmologica 160:103–104, 1970

70. Prutkin L: Antitumor activity of vitamin A acid and fluorouracil used in combination on the skin tumor, keratoacanthoma. Cancer Res 33:128–133, 1973

71. Rodger FC: The ocular effects of vitamin deficiency in man in the tropics. Exp Eye Res 3:367–372, 1964

72. Rodger FC, Saiduzzafar H, Grover AD et al.: Nutritional lesions of the external eye and their relationship to plasma levels of vitamin A and the light thresholds. Acta Ophthalmol (Kbh) 42:1–24, 1964

73. Schmidtke RL: Hypovitaminosis A in ophthalmology. Arch Ophthalmol 37:653–667, 1947

74. Schwaber JR, Blumberg AG: Papilledema associated with blood loss anemia. Ann Intern Med 55:1004–1007, 1961

75. Sinks LF, Woodruff MW: Chemotherapy of neuroblastoma. JAMA 205:161–162, 1968

76. Smith JL: Neuro-ophthalmology tapes

77. Sood NN, Gupta S: Refractive changes in malnourished children. Orient Arch Ophthalmol 4:264–269, 1966

78. Sperling MA, Hiles DA, Kennerdell JS: Electro-retinographic responses following vitamin A therapy in A-beta-lipoproteinemia. Am J Ophthalmol 73:342–351, 1972

79. Sullivan WR, McCulley JP, Dohlman CH: Return of goblet cells after vitamin A therapy in xerosis of the conjunctiva. Am J Ophthalmol 75:720–725, 1973

80. Tu J, Blackwell RQ, Lee PF: DL–Penicillamine as a cause of optic axial neuritis. JAMA 185:83–86, 1963

81. Van Eck WF: The effect of low fat diet on serum lipids in diabetes and its significance in diabetic retinopathy. Am J Med 27:196–211, 1959

82. Virno M, Bucci MG, Pecori–Giraldi J et al.: Intravenous glycerol-vitamin C (sodium salt) as osmotic agents to reduce intraocular pressure. Am J Ophthalmol 62: 824–833, 1966

83. Virno M, Bucci MG, Pecori–Giraldi J et al.: Oral treatment of glaucoma with vitamin C. Eye Ear Nose Throat Mon 46:1502–1508, 1967

84. Venkataswamy G: Ocular manifestations of vitamin A deficiency. Br J Ophthalmol 51:854–859, 1967

85. Venkataswamy G: Ocular manifestations of vitamin B complex deficiency. Br J Ophthalmol 51:749–754, 1967

86. Waldbott GL: Fluoride and optic neuritis. Br Med J 5414:945, 1964

87. Walsh FB, Hoyt WF: Clinical Neuro-Ophthalmology, 3rd ed. Baltimore, Md. Williams & Wilkins, 1969, pp 1200–1241

88. Weerekoon LM: Treatment of retinal artery occulsion. Am J Ophthalmol 43:947–951, 1957

89. Williamson J: Lipotriad therapy in senile macular degeneration. Trans Ophthalmol Soc UK 84:713–724, 1964

90. Yamaji R, Kakiuchi J, Koyama K: Study of the effect of massive o-benzoylthiamine disulfide (vitamin B_1) therapy of central retinitis and optic neuritis. Jap J Clin Ophthalmol 18:753–764, 1964

28

Oral problems

Abraham E. Nizel

A few generations back, about 75 years ago, one of the first and most important areas of clinical examination was the mouth and throat. The practice of medicine was then mostly an art, and from this oropharyngeal examination, particularly from the color and appearance of the tongue, our medical grandfathers arrived at very shrewd clinical deductions and—sometimes—very accurate systemic diagnoses. Of course, this approach had serious shortcomings and was inevitably supplanted by the sophisticated clinical and laboratory procedures of modern medicine. Nevertheless, the fact remains that abnormalities seen in the very sensitive tissues and structures of the oral cavity can indeed mirror (and therefore suggest) the presence of metabolic disturbances in other parts of the body. For example, glossodynia can be an oral syndrome of pernicious anemia with its attending hematologic and neurologic problems; or, periodontal disease unresponsive to the usual local treatment and home care can suggest an uncontrolled diabetic state. Therefore, the appearance or function of oral tissues and structures can serve as an important clue to an underlying systemic problem, including those associated with nutritional deficiencies.

The purpose of this chapter is to provide the physician with some understanding of the oral health–nutrition interrelationships that he may encounter in his medical practice by discussing the following three topics:

1. The histologic and chemical nature of the oral tissues and structures, in health
2. The effect of nutritional aberrations on the anatomy and function of the oral tissues and structures
3. The role of nutrition in the management of acute gingivitis and stomatitis, chronic periodontitis and dental caries, the major problems that affect these oral structures

ORAL TISSUES AND STRUCTURES

The oral cavity is fundamentally made up of the same type of epithelium, connective tissue, bone, muscle, nerve, and vascular supply as any other structure. However, it is also characterized by a number of unique tissues and structures, *i.e.,* the tongue, the lips, the buccal mucosa, the teeth, the salivary glands, and the periodontium.

ORAL MUCOSA

The oral mucosa covers the inner aspects of the cheeks and lips, the tongue, the palate, and the ginvia. In general, the oral mucosa consists of stratified squamous epithelium and an underlying connective tissue corium. However, the environment and function influence the type of oral mucosa in the different areas of the mouth.

The first type is the functioning thick keratinized masticatory mucosa that is firmly adherent to the bone and covers the gingiva and hard palate.

The second type is the nonfunctioning thin epithelial lining that covers the lips, floor of the mouth, ventral surface of the tongue, and buccal region. This mucous membrane has much less keratinized epithelium than the first type and covers comparatively loose, vascular underlying connective tissue.

The third type of oral mucosa is a specialized papillary epithelium covering the dorsum of the tongue.

PERIODONTIUM

The periodontium consists of those tissues which surround, support, and hold the teeth firmly in the jaws, *i.e.,* the gingiva, periodontal ligament, alveolar bone, and cementum.

The alveolar bone, which consists of cancellous bone enclosed within dense cortical plates, forms the tooth sockets. The bone is connected to the cementum on the root surface of the tooth

by the periodontal ligament, which is made up of horizontal and obliquely oriented collagenous fibers. The gingiva covers the alveolar bone and is attached to the neck of the tooth by an epithelial attachment.

TONGUE

The tongue is a highly specialized complex muscular organ. It is covered by a mucosa consisting of a large number of minute lingual papillae, giving the tongue a rough, filelike texture and appearance. The major group of the lingual papillae are of the pink filliform variety, which are extremely slender and threadlike in appearance. Scattered among these are several single larger fungiform papillae, which appear as knoblike projections and are a deeper red. At the posterior end of the lingual dorsum, the large mushroom-shaped circumvallate papillae are arranged in a V-shaped configuration with the point facing toward the oropharynx (Fig. 28–1).

TEETH

Teeth consist of three calcified tissues: 1) enamel, 2) dentin, and 3) cementum and of noncalcified centrally located tissue, the pulp. Enamel, which forms the outer portion of the crown of the tooth, consists of a series of prisms or rods composed of apatite crystallites surrounded by very small amounts of water and a protein matrix. Enamel, like bone, is a hydroxyapatite $[Ca_{10}(PO_4)_6(OH)_2]$ that can be readily

Fig. 28–1. Surface of normal tongue.

decalcified by organic acids even though it is the hardest and densest structure of the body. It is 96% inorganic, 1% organic, and 3% water and is metabolically inert after the tooth has erupted. Dentin, which is 70% inorganic, 20% organic, and 10% water and forms the inner portion of the crown and roots, consists of a calcified matrix with numerous closely arranged dentinal tubules and cells that have some limited self-reparative properties. The high percentage of collagen in dentin makes it readily susceptible to disintegration by the proteolytic activity of bacteria. Cementum forms the outer covering of the roots and is the most bonelike of the dental tissues (46% inorganic, 22% organic, and 32% water).

SALIVARY GLANDS

The parotid (serous type), the submaxillary (mixed, mainly serous type), and the sublingual (mixed, mainly mucous type) are the major salivary glands. Together with numerous small minor glands, these are responsible for the formation of saliva, which acts to keep the oral mucosa moist and pliable and exerts an important food clearance function. Saliva has both a buffering and a remineralizing capacity. Saliva also exerts a solvent action on many foods and plays a very minor role in digestion through the action of its starch-reducing enzyme, amylase.

ORAL EFFECTS OF NUTRITIONAL ABERRATIONS

The oral tissues are composed of cells that turn over and grow rapidly. Therefore, the resistance and integrity of these tissues depend on a continuous, adequate supply of essential nutrients to overcome their vulnerability to hostile bacterial, thermal, chemical, and mechanical irritants. When the oral tissues are denied adequate nourishment, they succumb readily to infection. One of the first indications of a nutrient deficit is the complaint of burning and tingling sensations in the tongue. This is followed by clinical changes in color and topography of the dorsum of the tongue if proper nutrition continues to be denied these tissues.

Oral indicator symptoms or signs of a nutritional aberration are usually considered manifestations of similar metabolic difficulties or abnormalities going on in other cells of the body. For example, redness of the tongue or a crack at the corner of the mouth might indicate that the available vitamin B complex is insufficient for the cellular oxidative functions

not only of the oral mucosa, but of intestinal epithelium as well. We always think of the total metabolic picture. No single clinical indicator is of any significance by itself since at least two or three different signs and symptoms all pointing in the same direction are required before a diagnosis of the clinical aspect of a nutritional deficiency can be made.

When conditioned by a nutritional deficiency, the tongue or lips will very likely change from the normal color, texture, and function if they are simultaneously aggravated by mechanical or microbial irritants. One of the more common functional changes in the mouth is a burning sensation (glossodynia) thought to be caused by a nerve irritation. Usually this functional change can be reversed quickly by administering therapeutic doses of the proper nutrient. On the other hand, anatomic changes which occur as a smooth shiny tongue (glossitis) will take longer for recovery.

Color changes that occur in the tongue or oral mucous membranes can be the result of several different factors. The color of the mucous membranes of the mouth depends on the thickness of the surface epithelial tissue and the amount of vascularity below the epithelium. The depth of color depends on variations in light transmission through the epithelium. If the surface epithelium becomes keratinized or thickened, then the color will appear pale, not because there has been a change in the underlying vascular bed, but merely because there has been blockage of red color transmission from the underlying blood vessels. On the other hand, if there has been a denudation or exfoliation of the surface epithelial tissues, the color will appear deep red, not because of any change in the vascular bed, but because a loss of surface opacity allows the underlying red color to be readily perceptible. As stated previously, other reasons for the color changes in the tongue are increased or decreased vascularity. Assuming that the thickness of surface epithelium remains constant, a systemic condition causing a vasodilatory hyperemia will make the tongue appear deep red; with a vasoconstriction, the tongue will appear pale pink. Thus, even though there are four variations producing essentially the same results, the mechanisms responsible for these variations can be quite different. The mechanism of the change rather than the visible change is the clue to the underlying metabolic condition.

CHEILOSIS, CHELITIS, OR ANGULAR STOMATITIS

Usually patients develop lip lesions in a predictable ordered pattern (2). The lesions begin with a pallor of the mucosa of the labial commissures. Erythema, maceration, and fissuring of the corner of the lips follow, and eventually the moist white membranous exudate of the macerated lesions dries. A secondary staphylococcal infection often follows, extending to the surrounding skin and producing a yellow crust (Fig. 28–2). After proper nutritional therapy, the macerated crusty corners of the mouth heal, leaving sometimes a slight scar.

The inflammatory changes seen in the mucosa of the lips, particularly at the labial commissures, may be a manifestation of a deficiency of one or more of the following nutrients: riboflavin, niacin, pyridoxine, folic acid, vitamin B_{12}, protein, and iron.

It must be pointed out that a differential diagnosis as to several etiologic factors possibly responsible for the angular cheilitis needs to be made. Nonnutritional as well as nutritional factors should be considered. For example, a loss of vertical dimension so that there is overclosure of the jaws can cause a folding of the skin and mucosa at the angles of the lips, thus producing a cheilitis. This type of angular cheilitis is seen in edentulous patients, in those who wear ill-fitting or poorly constructed dentures, and in elderly people with marked attrition of the incisal and occlusal surfaces of their teeth. Other

Fig. 28–2. Angular cheilosis due to vitamin B-complex deficiency.

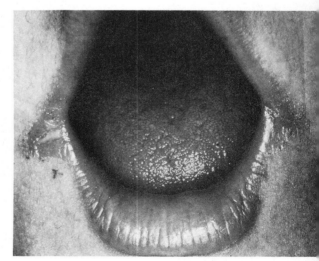

possible causes of angular cheilitis are monilial infection, excessive salivation with drooling, and the neurotic habit of licking the corners of the lips (la perlèche).

Besides the angular lesions, the lips may show an abnormal horizontal redness along the line of closure. Also, a notable increase in vertical fissuring might result from a superficial denudation of the mucosa. This is usually more apparent on the lower lip.

INFLAMMATION OF THE ORAL MUCOSA OR STOMATITIS

A patient with an acute niacin and tryptophan deficiency as seen in alcoholism will develop markedly inflamed oral mucosa sometimes having a red patchy appearance caused by isolated spots of grayish green pseudomembrane. The epithelial layer very often becomes detached from the underlying tissue, leaving raw, red, readily infected patches. This might reflect the mucosal patchy appearance that extends over the entire length of the alimentary tract.

Deficiencies of folic acid or vitamin B_{12} will show eruption of crops of whitish, painful ulcers with fiery red borders on the oral mucosa.

GLOSSITIS

The tongue undergoes a range of color, size, topographic and sensitivity changes. The tongue is sensitive to nutritional aberrations because the rapid growth of the epithelial cells covering the dorsum requires high amounts of nutrients. A nutritional deficiency may actually reduce the thickness of the epithelial protection of the tongue. Color or topographic changes in the dorsum can be confined to a single or to many localized well-demarcated areas.

Color changes may be diffused following a sequential pattern starting at the anterior border and gradually proceeding posteriorly. Changes in color range from a pink pallor through deep red to bluish purple. Pallor may be associated with a decreased hemoglobin content of the blood, as in iron deficiency anemia, or it may be the result of keratinized epithelium due to a vitamin A deficiency. On the other hand, abnormal redness results from either increased vascularity or atrophy of the papillary epithelium. A reddening of the tongue at the tip and lateral margins may be associated with sprue or Vitamin B complex— especially niacin—deficiency. A purple or magenta color is probably due to a slowing of

circulation and stagnation of blood flow, often seen in a riboflavin deficiency.

Topographically, the papillae may undergo the following sequential morphologic changes: hypertrophy, flattening, atrophy, and complete loss. Usually there is some enlargement of fungiform papillae and some atrophy of filliform papillae so that the surface of the tongue appears reddened and smooth, with prominent spots representing the fungiform papillae. The surface of the tongue may have patchy atrophic ulcerated areas and deep fissures. The fissures are usually a developmental anomaly of the tongue, whereas the ulcerated lesions may be due to some vitamin deficiency or to infection superimposed upon the normally fissured tongue, or to both. In ariboflavinosis, the dorsum of the tongue takes on a pebbly or granular appearance. However, in most chronic cases of vitamin B complex, iron, or protein deficiency, the main feature is an atrophy of both fungiform and filliform papillae so that the dorsum of the tongue is very slick, shiny, and red (Fig. 28–3).

The size of the tongue is influenced by edema or dehydration. With edema, from excessive sodium intake, for example, the tongue becomes swollen (macroglossia) (Fig. 28–4) and the sides have a scalloped appearance from indentations from the pressure of the teeth. In contrast, during dehydration the tongue appears dry and shrunken with smooth borders.

Sensitivity changes, e.g., lingual burning and soreness, can be early symptoms of folic acid or vitamin B_{12} deficiency. Diminution of taste sensation is not unusual in an elderly person, particularly one who is malnourished.

GINGIVITIS

Gingivitis is an inflammation of the gingival collar around the neck of the tooth which is initiated by local irritants, such as dental plaque, and which may be intensified by various systemic factors, such as nutritional deficiencies (3, 8). For instance, a niacin deficiency can predispose the gingiva to fusospirochetal bacterial infection, which results in characteristic wedge-shaped, punched-out ulcers in the interdental papilla of the marginal gingiva called Vincent's infection or acute ulcerative necrotic gingivitis. The lesions, which are necrotic, exudative, foul smelling, and extremely painful, are covered by a grayish white pseudomembrane, which when peeled off leaves a raw bleeding tissue surface (Fig. 28–5).

An acute vitamin C tissue deficiency in the

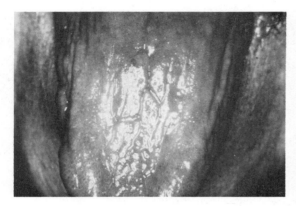

Fig. 28–3. Depapillation of tongue due to vitamin B-complex deficiency.

Fig. 28–4. Macroglossia.

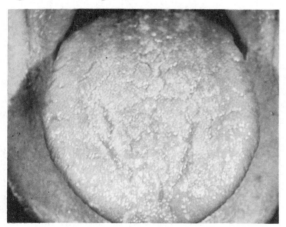

Fig. 28–5. Acute necrotizing gingivitis.

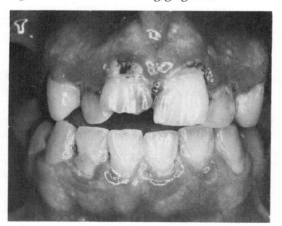

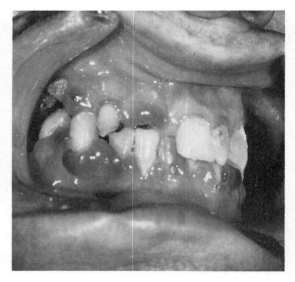

Fig. 28–6. Scorbutic gingivitis.

presence of local gingival irritants, *e.g.,* plaque and calculus, will cause the gum to become inflamed. Vitamin C deficiency contributes to the gingivitis because of defects in capillary walls produced by a failure in collagen formation. The engorgement of the blood vessels of the gingiva can produce a swollen gingiva that is fiery red, smooth and glazed in appearance, and devoid of stippling (Fig. 28–6). The congested gingiva may become infected and undergo ulceration, necrosis, and sloughing. Histologically, the gingiva show hyperemia, diminution of fibroblasts, and deficiency of collagen fibrils. Gingival manifestations of scurvy will not develop in the absence of teeth because the initiating local factor must be an irritant on the gingival third of the teeth.

PERIODONTITIS

Periodontitis is an inflammatory breakdown of the supporting structures of the tooth (gingiva and periodontal ligament) with a resultant loss of the alveolar bone. As in the case of gingivitis, systemic nutrition might play a passive, regulatory role in controlling the degree of periodontitis. In fact, one group of investigators believes that a calcium deficiency or phosphorus excess will accelerate alveolar as well as other types of bone resorption by inducing a secondary hyperparathyroidism. They postulate that hyperparathyroidism and hypocalcemia may increase the release of parathormone, which in turn may cause osteoporosis and bone resorption (4).

These investigators suggest that—since periodontitis is a chemical expression of bone loss—a dietary supplement consisting of a mixture of calcium, magnesium, and zinc may prevent periodontal disease. It is important to stress that there is no valid evidence to prove this hypothesis and that the use of such supplements has not been acknowledged by periodontists as an acceptable method of managing patients with periodontal disease.

Some population groups found to be deficient in vitamin A and protein seem to be prone to periodontal disease. However, a direct causal relationship between any of these nutritional aberrations and periodontal disease without an initiating local irritating factor has never been adequately demonstrated.

In short, on the basis of our present knowledge all we can say is that, although nutrient deficiencies might condition the periodontium to more-rapid breakdown, they are not the primary causative agents. Therefore, the major role of adequate nutrition in preventing periodontal disease should be considered to be a supportive one for enhancing the resistance of these dynamic labile sensitive tissues against infection.

DENTAL CARIES

Dental caries (from the Latin, *carius,* meaning "rotten") is a localized progressive loss of tooth substance initiated by demineralization of the tooth surface by organic acids. These acids are produced locally by bacterial enzymes that ferment deposits of simple sugars entrapped in a tooth-adherent bacterial film called dental plaque. Specifically, caries results from colonization of cariogenic bacteria (strep mutans) whose enzymes ferment simple carbohydrates (both mono- and disaccharides) *in situ* principally to lactic acid, which demineralizes the tooth hydroxyapatite and allows for bacterial proteolysis of tooth collagen. Thus, the development of caries requires a susceptible tooth (host), cariogenic acidogenic bacteria (parasite), and a diet substrate of fermentable carbohydrate (environment). The amount of tooth decalcification and decay progresses in proportion to the length of time that the decay-producing microorganisms are in intimate contact with tooth surface. The logical approach, then, for maximizing the prevention and control of this disease process, is to alter all three risk factors in this host-parasite-environment complex. (7).

CARIOGENIC NUTRIENTS

The dental decay process is dependent on the topical adhesion of simple dietary saccharides—particularly sucrose, fructose, and glucose—to the tooth surface (4). The physical nature of the sugar is exceedingly important because, as has been clearly demonstrated, the greater its retentivity, the longer the contact of acid with the enamel surface, and therefore the greater the caries potential. A second important factor contributing to prolonged demineralization is the frequency of snacking, even though small amounts of sugar are eaten each time. Therefore, from a decay-producing potential standpoint, the amount of sucrose is not nearly as important as how often sucrose comes in contact with the plaque.

CARIES-INHIBITORY NUTRIENTS

On the other hand, a few nutrients, *e.g.,* fluorides, phosphates, protein, and fats, have been shown to have some anticaries properties. The most effective caries-inhibitory nutrient is fluoride (1). When fluorides are available in community water supplies and are consumed daily, or are provided on a prescription basis in a liquid or lozenge form to infants and children from day 1 until about 13 years of age, a significant 40%–60% reduction in the incidence of caries can be anticipated. Fluoride ions ingested via this systemic route replace some of the hydroxyl ions in the tooth hydroxyapatite to form a relatively acid-insoluble fluorhydroxyapatite. Once fluoride is incorporated into the body of the apatite crystal, it remains fixed for the lifetime of the tooth. Postulated mechanisms whereby fluorides act to reduce dental caries are as follows:

1. Stabilization of enamel apatite
2. Reduction of acid solubility of the enamel
3. Promotion of recrystallization of carious lesions
4. Lessening of bacterial acid formation

Two significant systemic safety factors against toxicity when only 1 ppm of fluoride is ingested daily are: 1) rapid elimination of fluorides from the kidney because fluorides, in contrast to chlorides, are not resorbed efficiently by the tubules and 2) the affinity of calcified structures for fluorides. Thus, very insignificant amounts of fluoride are found in the circulating body fluids as a result of systemic ingestion of fluorides.

A phosphate additive to chewing gum has been shown to exert some significant caries-

reducing effects. The mechanism for this action has been postulated as being a local tooth surface remineralization and cleansing (7).

It is postulated that a high-protein diet increases the salivary urea and ammonia level, which will help neutralize some of the acids produced in the dental plaque and may thus reduce the likelihood of caries development.

Fats are generally considered to have anticaries properties because they produce a protective oily film on the surface of the teeth which does not allow the ready penetration of acids into the enamel.

NUTRITIONAL MANAGEMENT OF ORAL PROBLEMS

ACUTE GINGIVITIS AND STOMATITIS

A typical case history of a patient with an acute gingivitis usually begins with the chief complaint of a recent experience of easily bleeding gums accompanied by bad taste and fetid breath. Loss of appetite, fever, and malaise are general clinical symptoms that frequently accompany these oral complaints.

The present history will probably reveal recent illness, *e.g.,* an acute viral infection or an emotional stress, such as tensions and anxieties arising from a school examination or a marital engagement period or unemployment.

The personal history is elicited in order to establish the patient's daily routine, life style, likes and dislikes, and health habits. Ascertaining these factors assists the physician or dentist in determining the reasons for the patient's food selection and thus provides a basis for designing and recommending a realistic and acceptable therapeutic regimen.

A brief history of any medical problems (*e.g.,* diabetes, anemia, osteoporosis, or pregnancy) must be elicited in order to evaluate any conditioning factors that may increase the patient's oral mucosal susceptibility to a reaction from local dental bacterial or mechanical irritants.

To expedite the management of malnutrition responsible for acute oral problems, a dietary pattern is ascertained by asking the patient to recall his previous 24-hour food intake. In order to make it easy for him to remember, he begins recording in household measures the foods of the meal he ate just prior to his office visit and then works back recording the foods from each meal and between meal snacks during the previous 24-hour period. If this 1-day intake is not typical of his recent diet, the patient is asked to provide a typical day's intake, and an average of the two is then used as a reasonable reflection of the patient's current dietary regimen.

Sugar-rich snack foods such as cake, pie, soft drinks, and candy are circled in red to separate them from desirable protective foods. Then the adequacy of the diet is determined by comparing the average number of servings of nutritious foods with the minimum recommended daily intake from each of the four food groups, *i.e.,* 2 servings of milk, 2 meat, 4 fruit and vegetables, and 4 bread and cereals.

Clinical and oral examination will probably reveal an apprehensive patient who looks pale and sick. The corners of his lips may have some yellow-encrusted lacerations, and his tongue may have isolated, well-demarcated, smooth red areas. The gingiva are usually red, swollen, and tender; the interdental gingival papillae have a punched-out ulcerated appearance. There will be a fetid odor to the breath.

Unless there are some suspected medical problems, no routine laboratory tests are done.

Since appetite in general is usually poor, the doctor may recommend several small meals rather than the customary three full-course meals. Because of the general oral discomfort, the patient should rinse his mouth with a pain-relieving mouth wash, such as Dyclone solution, prior to eating. He might use a straw, when possible, to drink a nutritious liquified diet consisting of eggnogs, milkshakes, fruit juices, instant breakfast preparations, soups, and regular foods liquified in blenders. He must avoid the irritation of spicy or sharp-tasting foods. Puddings, custards, ice cream, and gruels are other bland nutritious foods that he can include. The obvious purpose of this full liquified diet is to satisfy the nutritional needs of the patient during this initial period of illness when he cannot chew comfortably. Usually this liquid diet is only necessary for the first 24-hour period. The patient should then change to a soft type diet consisting of a variety of foods from the four food groups:

1. Milk group, *e.g.,* cottage cheese and other soft cheeses
2. Meat group, *e.g.,* hamburger, boiled or ground chicken, cooked fish, and legumes
3. Vegetable-fruit group, *e.g.,* cooked or canned fruits, cooked or mashed vegetables
4. Bread-cereal group, *e.g.,* pastas, rice, cooked cereals

It should be added that a patient with acute necrotizing ulcerative gingivitis is often febrile.

This does not preclude prescribing a full diet. In fact, the nutrient requirements are increased during this febrile stress period, and the patient should eat enough food to overcome the negative nitrogen balance that might take place if underfed. Underfeeding will interfere with the normal defense mechanisms of the body and delay healing and convalescence.

On the basis of the increased nutrient requirements during the period of stress, and because the patient has probably already used up some of his vitamin reserve, vitamin supplementation is desirable and indicated. Therapeutic doses of a multivitamin preparation consisting of vitamin B complex and vitamin C are recommended.

Peroxide oral rinses and systemic antibiotics must be prescribed and gingival curettage done. A similar dietary regimen is recommended for patients who suffer with acute stomatitis, cheilitis, or glossitis. If there are isolated painful mucosal lesions that need to be obtunded, a topical application of a corticosteroid gel, such as Kenalog in Orabase, will be found to be most helpful.

CHRONIC PERIODONTITIS

The local exciting factors must first be eliminated by scaling, currettage, or surgical measures. The clinician must then concern himself with the following nutritional objectives: 1) identifying any systemic nutritional conditioning factors; 2) reducing the intake of those foods that contribute to plaque formation, especially the sugar-rich variety; 3) increasing the adequacy, balance, and variety of the protective foods, particularly those rich in protein, vitamin C, calcium, vitamin A, folic acid, and iron; and 4) emphasizing the desirability of consuming foods that have a firm chewy texture, rather than a soft sticky consistency, to increase the tone and vigor of the periodontium.

The assessment of the nutritional status of this type of patient involves consideration of his medical history; daily activities and life style; food habits (and their evaluation for nutrient adequacy); clinical appearance, particularly of his oral tissues; and any medical laboratory tests that have any bearing on his nutritional status.

As a result of the findings of the nutritional assessment, the clinician proceeds as follows. He deals with eliminating any uncontrolled systemic factors, such as diabetes. On the basis of an analysis of the diet, those foods needed to improve the quality, balance, and consistency of the existing diet (*e.g.,* raw fruits and vegetables rich in

vitamins A, C, and folic acid, as well as milk and cheese) are emphasized and recommended for inclusion. The patient is encouraged to eliminate the plaque-forming, sticky, sugar-rich foods and to substitute non-plaque-forming, nonretentive, firm chewy foods that can stimulate and exercise the periodontal tissues. Cutting down on between-meal snacks is an excellent way of reducing the amount of plaque formation. Starting with the patient's usual diet as a point of reference, the physician should allow the patient to write his own diet, encouraging him to select foods that he likes which will satisfy the objectives of an adequate non-plaque-forming diet, devoid of sweets, rich in fiber, vitamins, minerals and protein, which can stimulate as well as nourish the periodontal tissues.

HIGH CARIES SUSCEPTIBILITY

As a rule, the teenager usually eats the poorest quality foods and is the most caries susceptible. The basic nutritional objective, here, is a diet that will provide enough calories for his energy needs with the source of calories being of high-nutrient quality, *i.e.,* nonfermentable carbohydrates (starches rather than sugars), fats, and proteins. Another basic tenet is that enough food should be given at each of the three meals to satisfy his appetite and minimize or eliminate the need for between-meal snacking.

The procedure for nutritional management of this type of patient is: 1) obtain a representative food intake pattern by having the patient complete a 5-day food diary, 2) elicit the "why" of the adolescent's diet or life style in order to understand the reasons for his or her food selection, 3) count up the number of sugar-rich foods in the diary which were probably fermented to organic acids that demineralized the tooth enamel for about 30 min during each sugar exposure, 4) note the form and frequency of the sweets, 5) evaluate the adequacy of the wholesome nutritious food in his diet by comparing it with recommended amounts of the four food groups, and 6) note how much fluoridated water he drinks every day.

On the basis of this information, the patient usually can select for himself a much-improved diet, accepting whenever necessary more-nutritious snacks. A great number of alternative snack foods have a low caries potential and are usually as acceptable to the patient as the sugar-rich type. It is just a matter of providing a list from which to choose. Acceptable snacks from the four food groups are

Milk group: milk, cheese—hard or soft varieties

Meat group: luncheon meats, nuts of all kinds, smoked sausage

Fruit and vegetable group: raw fruits, *e.g.,* oranges, grapes, grapefruit, peaches, pears, raw vegetables, *e.g.,* carrots, celery, cucumbers, lettuce, salad greens, and tomatoes, unsweetened fruit juices, tomato or vegetable juices

Bread and cereal group: crackers, toast, pretzels

Snacks to include are

pretzels
corn chips
corn curls
cheese curls
popcorn, pizza
cheese dips
submarine sandwiches

Snacks to avoid are

candy, mints
cake, cookies
pie, pastry
ice cream sundaes
carmel popcorn
candy apples
candy-coated gum

If the communal water is fluoridated, the patient should be encouraged to drink at least 4 glasses everyday. If fluorides are not available in the public water supply, daily intake of a 1-mg fluoride lozenge should be prescribed plus fluoride oral rinses.

CONCLUSION

The oral health status of a patient is an important clue to his general health status because the cells and tissues of the lips, tongue, buccal mucosa, periodontium, and teeth are extremely sensitive to functional and anatomic changes produced by nutritional as well as other metabolic aberrations. Careful examination of the oral structures will enable the physician to diagnose metabolic problems early in the pathogenesis of the disease and thus produce a rapid reversal or cure.

The nutritional managements of stomatitis, gingivitis, periodontitis, and dental caries are essentially concerned with prescribing a balanced and varied diet by improving the general nutrient quality of the diet and avoiding sugar-rich foods. In addition, each of these oral problems stresses some unique nutritional considerations. In caries control, one should drink an adequate amount of fluoridated water and eliminate between-meal sugar-rich snacks. In periodontitis, the foods should be fibrous and of firm consistency to stimulate the tooth-supporting tissues and should be rich in protein, calcium, iron, vitamins A, C, and folic acid. In stomatitis and gingivitis, a therapeutic dose of vitamin B complex and vitamin C multivitamin capsule might be a helpful dietary supplement to deal with the initial acute dietary deficiency that these diseases produce.

By eliciting a case history that deals with the "why" as well as the "what" of the diet, a personalized acceptable diet change can be readily affected. The non–directive counseling approach, in which the patient writes his own diet prescription under the guidance of the health professional, will foster patient motivation and cooperation and therefore provide long-term beneficial and rewarding oral health results.

In conclusion, the diagnosis and management of oral health problems will be improved considerably if the nutritional component is recognized, appreciated, and dealt with in the same substantive, objective manner as is done in the nutritional management of such general health problems as anemia, diabetes, and alcoholism.

REFERENCES

1. Boudevold F: Fluoride therapy. In Bernier J, Muhler JC (eds): Improving Dental Practice Through Preventive Measures. ST Louis, CV Mosby, 1975, pp 77–103

2. Dreizen S: Oral indications of the deficiency states. Post grad Med 49:97–102, 1971

3. Glickman I: Nutritional Influence in the Etiology of Periodontal Disease in Clinical Periodontology. Philadelphia, WB Saunders, 1972, pp 365–382

4. Krook L, et al.: Human periodontal disease: morphology and response to calcium therapy. Cornell Vet 62:32, 1972

5. Mandel JD: Effects of dietary modifications on caries in humans. J Dent Res 49:1201–1211, 1970

6. Nizel AE: Nutrition in Preventive Dentistry: Science and Practice. Philadelphia, WB Saunders, 1972, pp 356–395

7. Nizel AE: Nutrition and oral problems. World Rev Nutr Diet 16:226–252, 1973

8. Stahl SS: Nutritional influences on periodontal disease. World Rev Nutr Diet 13:277, 1971

29 Pediatrics

Lewis A. Barness

Good nutrition of infants and children is an investment in the future. Poor nutrition at this developmental stage can be devastating, sometimes leading to permanent damage. Studies on brain development suggest that the earlier the deficiency, the longer-lasting the effects (19). Reserves of the young child, particularly those of calories and vitamins, are smaller per unit weight than in the non-growing adult. Some of the degenerative diseases may be imprinted or prevented by early nutritional habits (6).

NORMAL FEEDINGS

THE NORMAL TERM INFANT

Although infants have been successfully nourished with human milk, attempts to develop breast milk substitutes have included the use of milk of easily available mammals as well as of broths of some cereals. With early attempts at formula feedings, as many as 95% of infants fed animal milks died in the first two weeks of life. Not until the major constituents of milk were chemically analyzed in the late nineteenth century was it recognized that the milk of other species contained too much protein for the human infant. Protein intoxication caused diarrhea, fever, severe dehydration, hyperelectrolytemia, and death.

Animal milks, whose caloric densities are similar to that of human milk, were diluted with water and sugar was added in sufficient quantity to make the formula isocaloric with that of human milk (Table 29–1). Infants grew when fed these formulas and mortality was lowered to approximately 50%, which is similar to the present mortality of artifically fed infants in developing countries and is related to bacterial contamination or incorrect preparation of formulas.

With the development of electric refrigeration and less-contaminated water, death from "summer diarrhea" decreased and infant mortality decreased to a level similar to that of breast-fed infants. Formulas are now fortified with vitamins D and C, iron, and other nutrients, decreasing the incidence of rickets, scurvy, and iron-deficiency anemia.

Although statistical advantages of breast feeding persist, including a lower incidence of tetany, infection, dehydration, and allergy, formulas have been modified to even more closely approximate human milk, at least in major constituents, and at present, little distinction can be observed between individual breast-fed and formula-fed infants. Breast feeding remains the preferred food for human infants, but mothers who choose to feed their infants with formulas should not be made to feel guilty. Those formulas which most closely simulate human milk (Table 29–2) should be used.

Investigators and formula manufacturers are continually trying to more closely duplicate human milk. Some of the alterations in formula composition require sophisticated technology (Table 29–3). Some are termed "simulated human milk." Protein content is approximately 1% in human milk and has been lowered to approximately 1.5% in "simulated human milk" formulas. Numerous clinical and balance studies (14) have indicated the adequacy or superiority of this quantity of protein for infants. In several commercial formulas, the lactoprotein:casein ratio, approximately 2:9 in cow's milk, has been altered to approach that of human milk, *i.e.,* 6:4. The higher cystine content of lactoproteins may be beneficial to the infant.

Infants fed lactose, the major carbohydrate in human milk, develop a stool flora similar to those fed human milk and apparently absorb calcium from the formula better and excrete less phenolic substances in the urine than those fed formulas containing mixed sugars (3). Lactose is the sole sugar added to many infant formulas.

Whereas the fat of human milk contains approximately 8% polyunsaturated fatty acids, mainly linoleate, cow's milk fat contains approxi-

TABLE 29—1. Representative Evaporated Milk Formulas*

	1—3 days	Cal	4—10 days	Cal	10 days	Cal
Evaporated milk	6 oz	240	7 oz	280	13 oz	520
Sugar	1 tbsp	60	1 oz	60	3 tbsp	180
Water	14 oz		14 oz		17 oz	
	21 oz	300	21 oz	340	30 oz	700
Cal/oz		14		16		22
Cal		47		56		70

*Formula is fed every 4 hours. Total volume is divided into six bottles. Total volume is regulated by infant

mately 1% linoleate. The simulated human milks have thus included polyunsaturated fatty acids obtained from mixtures of vegetable oils, which are more easily absorbed by the infant. In addition, some consider the polyunsaturated fats given to infants a deterrent to later atherosclerosis (2).

Since the mineral content of human milk is considerably lower than that of other mammalian milks, cow's milk is diluted to lower the mineral content. In certain formulas, the mineral content has been further lowered to approach that of human milk. A theoretic advantage of the dilution of minerals is that the infant may be imprinted so that in later life he will not ingest high salt—containing foods. Although evidence is tenuous that high salt intake may be related to the development of hypertension in humans, voluntary low salt intake appears harmless and may prove to be beneficial. A more easily observed difference is that in hot climates, infants are less likely to become dehydrated when consuming formulas with lowered mineral content.

During the first few days, the infant begun on breast feeding receives colostrum, which contains slightly fewer calories, more protein, and more ash than mature human milk. Colostrum also contains antibodies that may be significant to the infant. Since infants are not believed to absorb antibodies through the intestinal wall, these antibodies may be important in inactivating bacteria or viruses in the intestinal tract so that they cannot proliferate and cause disease. Mature milk contains antibodies that may function in a similar manner.

For the first week, the breast-fed infant should be nursed on both breasts at each feeding and should not be offered supplements. After the first week, the infant should be nursed on alternate breasts at each feeding. He may then be offered 30–60 ml water twice daily, and supplements of vitamins A, C, and D should begin. Some breast-fed infants develop jaundice, possibly due to insufficient ingestion of water (which

is corrected by water supplementation) or to factors believed to be progesterone derivatives. Substituting formula for breast for 1–2 days followed by resumption of nursing usually suffices to obviate the hyperbilirubinemia.

Infants fed simulated human milk formulas can be fed directly on undiluted formula, 67 Cal/100 ml. Water may be offered between feedings. These formulas usually contain sufficient vitamins to meet daily needs when the infant consumes 800–1000 ml daily.

Infants begun on an evaporated or whole milk formula should be given a more-dilute formula containing approximately 40 Cal/100 ml the first week to avoid protein intoxication and water insufficiency. These infants should also receive vitamin supplements if not included in the formula.

From observations of breast-fed and formula-fed infants, the following standards for infant nutrition have been developed. The growing full-term infant requires approximately 100–120 Cal/kg/day to grow during most of the first year. Beginning at about 6 months, this requirement probably decreases to 80–100 Cal. Infants less than 1 year require 150–200 ml water/kg/day. This satisfies insensible water loss, growth, and waste through urine and stools. For the first 6 weeks to 5 months of life, these requirements are completely met by breast feeding or formula feeding, or a combination of these. Infants appear to be satisfied and to grow and gain well on an approximate 4-hour feeding schedule. The infant is fed approximately six times in 24 hours for the first month of life. The very early morning feeding can be eliminated at about 1 month of age. The infant can be fed four times daily beginning at about 5 months of age. The requirements for vitamins and minerals should be satisfied by either formula or breast feeding supplemented with additional vitamins, following the general recommendation listed in Appendix Table 1. Mineral intake which provides adequate growth is calculated in Table 29–4. Nei-

TABLE 29—2. Approximate Composition of Colostrum, Human, and Cow's Milk*

Constituent	Human	Colostrum	Cow
Water (g/100 g)	88	87	88
Protein (g/100 g)	1.1	2.7	3.3
Casein	0.4	1.2	2.7
Lactalbumin	0.4		0.4
Lactoglobulin	0.2	1.5	0.2
Fat (g/100 g)	3.8	2.9	3.8
% polyunsaturated	8.0	7.0	2.0
Lactose (g/100 g)	7.0	5.3	4.8
Ash	0.2	0.5	0.8
Calcium mg/100 g	34	30	117
Phosphorus mg/100 g	15	15	92
Sodium mEq/liter	7	18	22
Potassium mEq/liter	13	74	35
Chloride mEq/liter	11	80	29
Magnesium mg/100 g	4	4	12
Sulfur mg/100 g	14	22	30
Chromium μg/liter	0	0	10
Manganese μg/liter	10	tr	30
Copper μg/liter	400	600	300
Zinc mg/liter	4	6	4
Iodine μg/liter	30	120	47
Selenium μg/liter	30		30
Iron mg/liter	0.5	0.1	0.5
Amino acids (mg/100 ml)			
Histidine	22	—	95
Leucine	68	—	228
Isoleucine	100	—	350
Lysine	73	—	277
Methionine	25	—	88
Phenylalanine	48	—	172
Threonine	50	—	164
Tryptophan	18	—	49
Valine	70	—	245
Arginine	45	—	129
Alanine	35	—	75
Aspartic acid	116	—	166
Cystine	22	—	32
Glutamic acid	230	—	680
Glycine	0	—	11
Proline	80	—	250
Serine	69	—	160
Tyrosine	61	—	179
Vitamins (liter)			
Vitamin A IU	1898	—	1025
Thiamin (μg)	160	—	440
Riboflavin (μg)	360	—	1750
Niacin (μg)	1470	—	940
Pyridoxine (μg)	100	—	640
Pantothenate (mg)	2	—	3
Folacin (μg)	52	—	55
B_{12} (μg)	0.3	—	4
Vitamin C (mg)	43	—	11
Vitamin D (IU)	22	—	14
Vitamin E (mg)	2	—	0.4
Vitamin K (μg)	15	—	60

*Adapted from Fomon SJ: Infant Nutrition, 2nd ed. Philadelphia, WB Saunders, 1974; Macy IG, Kelly HJ, Sloan RE: The Composition of Milks. 1953, NAS-NRC publ 254

TABLE 29—3. Approximate Composition of Some Commercially Prepared "Simulated Human Milk" Formulas

Components	Enfamil* Similac†	SMA‡	PM 60/40*
Protein	Nonfat cow milk	Demineralized whey and nonfat cow milk	Demineralized whey and nonfat cow milk
Fat	Vegetable oils	Vegetable oils and oleo oil	Vegetable oils
Added carbohydrate	Lactose or corn syrup solids	Lactose	Lactose
Major Constituents (g/100 ml)			
Protein	1.5—1.6	1.5	1.6
Lactoproteins %	18	60	60
Casein %	82	40	40
Fat	3.6—3.7	3.6	3.5
Linoleic acid %	24—43	13	35
Lactose	7.0—7.1	0.3	0.2
Minerals	0.3—0.4		
Minerals (per liter)			
Calcium (mg)	550—600	445	350
Phosphorus (mg)	440—455	330	180
Sodium (mEq)	11—17	7	160
Potassium (mEq)	16—28	14	580
Chloride (mEq)	12—24	10	460
Magnesium (mg)	40—48	53	42
Sulfur (mg)	130—160	145	—
Copper (mg)	0.4—0.6	0.4	0.4
Zinc (mg)	2.0—4.2	3.2	—
Iodine (μg)	40—69	69	0.04
Iron (mg)	trace—1.5	12.7	2.6
Vitamins (per liter)			
Vitamin A (IU)	1700—2500	2650	2500
Thiamin (μg)	400—650	710	650
Riboflavin (μg)	600—1000	1060	1000
Niacin (mg)	7—8.5	7	7
Pyridoxine (μg)	320—400	423	300
Pantothenate (mg)	2.1—3.2	2.1	3
Folacin (μg)	50—100	32	50
Vitamin B_{12} (μg)	1.5—2.0	1.1	1.5
Vitamin C (mg)	55	58	55
Vitamin D (IU)	400—423	423	400
Vitamin E (IU)	8.5—12.7	9.5	9

*Mead Johnson
†Ross laboratories
‡Wyeth laboratories

TABLE 29—4. Required Mineral Intake for Adequate Growth*

Mineral	Normal intake	
	(per liter milk/day)	(per kg body weight/day)
Sodium (mEq)	7	1.1
Potassium (mEq)	13	2.1
Chloride (mEq)	11	1.9
Calcium (mg)	340	58
Phosphorus (mg)	140	23
Magnesium (mg)	40	7

*Calculated by assuming ingestion of 1000 ml milk by normal growing 6-kg infant (166 ml/kg)

ther type of feeding alone contains sufficient iron or fluoride. Requirements for iron are listed in Table A-1; 0.5 mg fluoride should be given daily in those areas where the water is not fluoridated.

More iron than that recommended, 10–15 mg/day, should be avoided as excess iron intake is associated with hemosiderosis. More important for the young child, excess iron may also saturate the iron-carrying proteins, such as transferrin. Iron deficiency anemia is associated with decreased resistance, and iron excess, with decreased free transferrin, is also associated with decreased resistance to bacterial and viral infections (18) (see Ch. 22).

Other trace minerals, particularly zinc and copper, may be important in the development of the nervous system. Chromium, manganese, silicon, and even aluminum have been reported to influence beneficially coronary heart disease whereas cadmium, cobalt, and lead may be toxic to the heart, blood vessels, and kidneys (12). Iodine is necessary for proper thyroid function in the growing child but is apparently present in necessary quantities in most areas (see Ch. 19).

The protein requirement of growing infants is approximately 1.5–2.5 g/kg/day and the protein, carbohydrate, and fat distribution of calories is satisfied with the approximation of 10% protein, 45% carbohydrate, and 45% fat, a distribution similar to that found in human milk (see Table 29–2).

THE OLDER CHILD

Beginning at about 6 weeks to 3 months of age, solid foods may be introduced into the diet. Earlier addition of solid foods is not generally recommended. The extrusion reflex, which causes the infant to spit when solids are placed on the anterior third of the tongue, diminishes and disappears at 6 weeks to 3 months. Intestinal amylase, necessary for the digestion of starches, may not reach adequate levels until several weeks after birth. Furthermore, some mothers mix solids with milk or formula, providing a relatively high-caloric density food. A sample feeding regimen for the first year is as follows:

1st month: Nurse approximately every 4 hours

10 days: Add multivitamins

1 month: Eliminate 2 AM feeding

2 months: Add 1–2 tbsp rice cereal, 10 AM, 6 PM

3 months: Add fruit, 1–2 oz jar, 2 PM (e.g., apples, pears, peaches)

4 months: Add meats, 1–2 oz jar, 2 PM (e.g., beef, lamb, liver)

5 months: Add vegetables, 1–2 oz jar, 2 PM (e.g., peas, beans, carrots) Also, omit 10 PM feeding

6 months: Add egg yolks

7 months: Add cottage cheese, Zweibach

9 months: Wean to cup. Change infant foods to chopped foods.

1 year: Table foods

Ordinarily, the least allergenic foods should be introduced first. The first food given is usually a cereal; rice cereal, which is probably the least allergenic of the cereals, is offered twice daily, usually in the morning and the evening. A month later, other foods are introduced. Foods such as apples, pears, and peaches in a mashed form are given, followed at 4 months by meats, such as beef, lamb, and liver; at 5 months by vegetables, such as peas, beans, and carrots; and at 6 months by egg yolk. Early ingestion of these foods tends to prevent complete reliance on either human milk or formula, which are less fortified with iron and can lead to overingestion of milk and subsequent iron deficiency. Prolonged excessive milk ingestion or delayed weaning or both may be responsible for increased caries. Chewy foods can be introduced at about 7 months of age. The child should be weaned from the breast or the bottle beginning at about 9–12 months, and at this time the child can be given table foods rather than specially prepared baby foods.

As the child ages, the caloric requirements increase (see Table A-1). A convenient formula for the caloric requirements between the ages of 1 and 10 is:

Cal required = 1000 + 100 × age in years

Distribution of foods eaten for a balanced diet should consist of the four major food groups. These include two or more servings from the meat group, four or more servings from the vegetable group, four or more of the bread and cereal, and two of the milk group. The meat group consists of meats, fish, poultry, or eggs, with dried beans, peas, and nuts as alternates. The vegetable and fruit group includes dark green or yellow vegetables, citrus fruits, and tomatoes. The bread and cereal group includes enriched or whole grain cereals. The milk group includes cheese, ice cream, and other milk-made

foods. Such a diet when given to provide sufficient calories also provides a suitable distribution of calories as protein, carbohydrate, and fat, and further provides adequate minerals and vitamins. Additional water must be provided. After the age of 1 year water requirements can be estimated by the child's thirst.

During adolescence, there may be an increase both of caloric and nutrient needs similar to that listed in the recommended dietary daily allowance table (see Table A-1). These needs are met by selecting from the four basic food groups. The increased nitrogen requirement of the pubertal growth spurt is proportional to the increased caloric requirement. Children consuming less than 0.5 g protein/kg/day during the phase of increased pubertal growth may develop decreased resistance to infection.

In general, nutritional needs of vitamins, minerals, water, protein, carbohydrate, and fat are met if caloric needs can be met. Certain children become food faddists or go on food binges. As long as these are short-lived, or if the child does not restrict himself to one food, deficiencies do not develop. However, children should be encouraged to take a varied diet. Even such common foods as milk should not be used as a major single source of calories at any age except during the first 5 months of life. Restriction of milk intake to approximately 500 ml/day (350 Cal) usually suffices to encourage a child to take a varied diet.

SPECIAL FEEDINGS

Certain states in infants and children require special dietary considerations.

THE LOW-BIRTH-WEIGHT INFANT

Proper nutrition of the low-birth-weight infant requires excellent nursing arts as well as attention to nutritional principles since the proper feeding of these rapidly growing patients must be considered in flux. The high morbidity and mortality presently attributed to anoxia and birth trauma may be reduced by earlier and more-adequate nutrition. The water requirement is more variable than that of the term infant. The amino acids leucine, isoleucine, valine, lysine, phenylalanine, methionine, threonine, and tryptophan are essential for all infants, but histidine, tyrosine, and perhaps cystine are also required by the premature infant (17). Glucose metabolism is complex; premature infants develop hypoglycemia easily and when treated develop hyperglycemia and glucose intolerance. Premature infants absorb fat poorly.

Several principles seem reasonably sound. Low-birth-weight infants should not have liquid or food withheld longer than necessary. Early glucose-containing feedings decrease the incidence of hypoglycemia in low-birth-weight infants and also decrease the incidence of what is presumed to be physiologic jaundice.

Infants less than 1500 g can be fed by gavage with a nasogastric tube as soon as the baby's temperature and respiratory rate become normal, usually within 3–6 hours. Larger infants can be started directly on nipple feedings. Volume of initial feedings should be regulated to the infant's ability to empty his stomach. The first feeding should consist of distilled water since glucose and water is injurious to the lungs if aspirated. After the first feeding, 2–4 ml 5% glucose and water can be put down the tube and slowly increased in volume over 3 to 24-hour intervals. The volume of subsequent feedings is largely regulated by the infant. The complications of aspiration make it extremely important not to overfeed the baby. For the small infant, feedings given every three or four hours seem adequate. If the baby is sluggish, takes little at one feeding, and becomes active and alert shortly after eating, he may be refed at shorter intervals.

With the attainment of caloric intakes of 110–130 Cal/kg/day, most low-birth-weight infants will achieve a satisfactory rate of growth (Table 29–5). If gain is unsatisfactory, a higher caloric intake may be offered, but at the present time, no major advantage seems to accrue to the baby from feeding formulas containing more than 67 Cal/100 ml. In some nurseries, it has become commonplace to feed formulas of 81–91 Cal/100 ml. These formulas produce infants who gain faster than those fed the more-dilute formula, but they may decrease water reserves and may be otherwise harmful. These formulas contain a higher osmotic load, a possible cause of necrotizing enterocolitis of sick premature infants.

The protein requirement of rapidly growing

TABLE 29–5. Energy Expenditures of Premature Infants

Item	Caloric requirements (Cal/kg/day)
Resting	50
Intermittent activity	15
Occasional cold stress	10
Specific dynamic action	8
Fecal loss of calories	12
Growth allowance	25
Total	120

infants is not precisely defined, but 3 g protein/kg/day supports growth at rates similar to that of higher protein intake, and intakes greater than 6 g/kg/day are associated with increased morbidity and mortality of premature infants (14).

The carbohydrate of choice for premature infants cannot be specified with certainty, but seems to be similar to that of full-term infants, both in quality and quantity.

Fat absorption of low-birth-weight infants is relatively poor, perhaps due to inadequate bile formation or anatomically decreased villi. Unsaturated fats have been found to be absorbed more easily than saturated fats. Formulas containing medium-chain triglycerides have been found to be absorbed even better than other formulas, especially in those infants with obvious steatorrhea. Fats serve to lower the osmolar load of the formula, and formulas containing 40%–50% of the calories as fat seem satisfactory (5).

Although linoleic acid is absorbed more easily than saturated fatty acids by the premature infant and therefore leads to less steatorrhea and more-efficient calorie utilization, administration of formulas containing linoleic acid and iron have been associated with the development of a vitamin E–responsive anemia in the premature infant (13, 15).

The optimal mineral content of the formula is not established. Because of the rapid growth and deposition of minerals in the low-birth-weight infant, the mineral allowance suggested for the term infant is considered the minimum.

Daily oral supplements of vitamin A, C, D, all of the B vitamins, and perhaps vitamin E are recommended. A single injection of vitamin K, 1 mg, at birth suffices to prevent hemorrhagic disease of the newborn.

The water requirement of the low-birth-weight infant has been estimated to be approximately 150–200 ml/kg/day. This is similar to that of the term infant. Premature infants should consume this volume of formula by approximately the 6th–7th day of life. This requirement is usually reached if the formula is diluted to 67 Cal/100 ml.

Some low-birth-weight infants gain poorly or not at all when taking oral feedings. Some have anatomic anomalies that restrict oral or tube feedings, and total or partial parenteral nutrition (see Ch. 12) should be offered these infants, but total parenteral nutrition or gastrostomy feedings should not be adopted as a routine feeding mode.

COLIC

"Colic" describes a symptom complex. The infant is irritable, draws up his legs, appears to have abdominal pain, cries, and develops a distended abdomen. Many causes have been suggested, including underfeeding, overfeeding, parental overconcern or underconcern, abnormal hormones, and food allergy. Symptoms usually begin before 3 months of age and disappear within 2–3 months.

Careful estimate of food intake and correction of feeding volume and density may relieve symptoms. If the baby is formula-fed, one must ascertain that the formula is constituted properly. If the baby is constipated, suitable measures should be taken for correction. Physical examination may reveal rectal fissure, hernia, glaucoma, hair in the eye, or other abnormalities that may cause similar symptoms. Feeding technique should be observed while the mother feeds the infant.

If no cause is found, the formula may be changed to a soybean or meat-base formula. Drugs, including sedatives, are ineffective.

CONSTIPATION

Constipation consists of hard stools. The normal number of stools may vary from one every 2–3 days to eight stools daily without being either constipation or diarrhea. Breast-fed infants are rarely constipated.

Constipation early in life may be due to inadequate water, carbohydrate, or caloric intake; vomiting; excess water loss; GI anomalies, such as megacolon, rectal fissure, or tight anal sphincter; or metabolic abnormalities, such as hypothyroidism. A history of food and water intake should be obtained. Physical examination should include examination of the rectum and rectal sphincter.

Anomalies should be corrected. Diet should be corrected for water and caloric intake. Increasing carbohydrate and water may correct the condition. Suppositories and enemas should be used only rarely and then not more than one or two times.

In the older infant, increasing bulk or fiber in the diet may aid in correcting constipation. Fruit juice, e.g., prune juice, may help temporarily. Chronic constipation may be a sign of a behavioral disorder and may be associated with fecal soiling, abdominal pain, and enuresis. Treatment of the bowel disorder with mineral oil, 10 ml twice daily for up to 6 months, may correct both the behavior problem and the constipation.

VOMITING AND DIARRHEA

Vomiting may be due to overfeeding, improper feeding, gastroenteritis, or anatomic or metabolic abnormalities. Vomiting should be distinguished from regurgitation (a normal phenomenon of infants) and rumination (an abnormal psychological manifestation). Quantity and quality of food intake should be ascertained. Physical examination and urinalysis, especially for the presence of infections and anomalies, should be performed. Gastrointestinal x rays may be necessary.

Infants up to the age of 1–2 years who vomit should be restricted to very simple feedings, usually clear liquids. These feedings should not be offered more than once or twice. If the vomiting persists, danger of dehydration exists, and the infant should be placed on parenteral fluids.

Diarrhea and vomiting may have similar causes. If the infant has both and is not severely dehydrated, an attempt should be made to feed the child at the same time one treats his diarrhea. This is accomplished by making the diet of the infant as simple as possible by eliminating those foods that had been added most recently to his feeding regimen. Thus, if the child has recently had solid foods, such as meats and vegetables, added to his feeding regimen, these should be eliminated. The least diarrhea-producing foods are breast milk, or formula, and fruits with low fiber. If the child still has diarrhea on this simple diet, he should be fed only clear liquids, but these should not be offered for more than 24 hours. The child is likely to become very irritable if he is given few calories for longer than this time.

If the diarrhea persists in spite of this simplified food intake, he should be given parenteral fluids to satisfy his water needs. His caloric needs can be met later as the diarrhea ceases. Parenteral fluids consisting of ¼ physiologic salt solution and ¾ 5% glucose in water provide approximately 80% free water. In the presence of severe diarrhea, dehydration or vomiting, decreased blood pressure may necessitate use of a solution containing half physiologic saline and half 5% glucose in water. Serum electrolytes should be monitored at least daily during the use of IV infusions.

Adding Kaopectate or similar bulk-producing agents to the oral intake can only be recommended if the child is not severely dehydrated when first seen. These agents serve to solidify the stool and make the observer think that the diarrhea is getting better. In addition, they decrease diaper rash and irritation and may absorb certain toxins from the GI tract. These agents should not be used in dehydrated infants or in infants with persistent severe diarrhea as they will increase the dehydration. Agents that decrease peristalsis, e.g., paregoric, should not be used in infants with diarrhea since they may be absorbed and depress the respiration, or they may increase absorption of toxic intestinal contents.

Once a child has been placed on parenteral fluids, realimentation must proceed slowly. Not only may the bowel still be irritable with persistent hyperperistalsis, it may also have developed decreased enzymes, particularly lactase, so that adding any feeding may be accompanied by recurrence of diarrhea.

The child should be slowly returned to his full feedings. This can be accomplished by first giving clear liquids on the day that the IV fluids are stopped. The next day one or two feedings of a diluted formula can be offered. The third day all of the feedings can be dilute formula. The fourth day the child can return to a full formula, and then daily thereafter each of the foods that he has previously been taking can be added back to his intake. If diarrhea recurs, the physician should return to those feedings that were not associated with diarrhea. It may be necessary in some infants who have had diarrhea for 3 days or longer to introduce lactose-free formulas for several weeks. Infants who have had nonspecific diarrhea for several days develop altered stool flora and may develop vitamin K deficiency. These infants should be given 1–2 mg vitamin K twice weekly while the diarrhea persists.

ANEMIA

Anemia, a lower than normal concentration of hemoglobin, red cell volume, or number of red cells per mm^3, is found in children with specific nutritional deficiencies or disorders. The most frequent nutritional causes are

Iron
Copper
Pica (lead)
Folic Acid
Vitamin B_{12}
Ascorbic Acid
Vitamin B_6
Vitamin K
Vitamin E
Protein

Metabolic diseases, such as hypothyroidism, drug toxicity, and allergic states, may cause nutritional deficiencies that may result in anemia. Many children with anemia have multiple deficiencies, all of which must be corrected.

Anemia results in decreased oxygen-carrying capacity of the blood (4). Children with severe anemia develop tachycardia, heart enlargement, pallor, decreased exercise tolerance, and possibly decreased resistance to infection. Because anemic children are lethargic, they may learn less well than infants who are not anemic. Some may be irritable and hyperactive. A physiologic response to the anemia is an increase in red cell 2, 3-diphosphoglycerate (2,3-DPG), which results in more-complete transfer of oxygen from red cells to the tissues. With iron deficiency, anemia is manifest by a low hemoglobin concentration, and the red cells are small and hypochromic. Serum iron-binding proteins are elevated, and bone marrow iron is decreased. Hemoglobin levels as low as 11 g or hemotocrit levels as low as 33% are considered normal in children.

Microcytic anemias with high serum iron include the thalassemias, the hemoglobinopathies, and sideroblastic anemia. Anemia with chronic infection may be associated with a low serum iron. Anemias of these causes must be distinguished from anemias due to nutritional causes.

IRON DEFICIENCY

Iron deficiency is the most frequent cause of anemia in childhood. In some surveys 5%–25% of children under 6 years have been found to be iron-deficient. The newborn infant has about 0.5 g iron, the adult 5.0 g. The prematurely born infant with lower iron stores is more likely to develop iron deficiency. Large intake of cow's milk or iron-poor foods is associated with this common deficiency. In addition, iron deficiency may be a cause of GI blood loss, further aggravating the deficiency.

The infant must absorb about 1 mg of iron daily. Iron-fortified formulas and baby cereals provide absorbable iron and are apparently responsible for a decreasing incidence of iron deficiency. When the infant is old enough to discontinue formula or baby cereals, the foods then introduced should contain absorbable iron.

Treatment consists of decreasing the intake of cow's milk and giving 6 mg elemental iron/kg daily. The iron-deficient infant or child will respond with an increased reticulocyte count and

hemoglobin, and this response may be used as a diagnostic test. Medicinal iron may cause diarrhea, constipation, or vomiting. Staining of the teeth has been reported. Chronic excess ingestion of iron results in hemosiderosis with deposition of iron in many tissues. Acute toxicity from ingestion of large amounts of medicinal iron causes GI bleeding, liver failure, and death.

COPPER DEFICIENCY

Copper deficiency anemia resembles iron deficiency in that it is hypochromic and microcytic with a low serum iron. Copper is a part of ceruloplasmin, the enzyme necessary for the conversion of ferrous to ferric iron, which is the form of iron transported as transferrin. Serum copper and white blood count are low. Serum albumin may be decreased and edema present.

Anemia due to copper deficiency is very rare. The usual childhood diet contains about 0.1 mg copper and is sufficient to prevent deficiency. High milk intake, particularly powdered milk, may result in low copper levels. Some children with intestinal diseases, particularly intestinal lymphangiectasia, demonstrate copper deficiency.

Therapeutically, 0.2 mg 0.5% copper sulfate/kg/day given orally results in prompt correction.

LEAD POISONING

Lead poisoning causes hematologic and central nervous system abnormalities in children. One of the earliest signs of lead poisoning is anemia, usually hypochromic and microcytic. It occurs more frequently in those children living in older houses and in those exposed to lead-containing paints or lead fumes.

Most lead poisoning in this country occurs in those children with pica. Such a craving for unusual foods occurs in many malnourished children, but any child may develop a perverted appetite and eat bizarre foods. Most normal children under 3 years put objects in their mouth as part of the normal sucking and mouthing response, and irritable and mentally defective children are especially prone to this habit. Since lead-poisoned children usually have low serum iron, and iron-deficient children are apparently more prone to lead poisoning, it has been suggested that iron-deficient children crave abnormal foods and thus eat lead-containing materials. Diagnosis is made by finding increased blood

lead or serum prophyrins and decreased serum aminolevulinic acid dehydrase.

Treatment consists in removing lead from the environment and in using chemicals to remove body lead, *e.g.,* with ethylene diamine tetraacetic acid (EDTA). Treatment of the behavioral disorder may be necessary.

FOLIC ACID DEFICIENCY

Folic acid deficiency occurs in some children as a result of decreased intake or absorption and may cause megaloblastic anemia. The megaloblastic cells contain nuclear material due to a lack of maturation of red cells. White cells and platelets may be decreased. Serum folate is low, and the urine contains formiminoglutamic acid; serum lactic acid dehydrogenase is elevated. The bone marrow is hypercellular.

Daily requirement of folic acid is 20–50 μg. Human and cow's milk contain sufficient folate for the normal infant, but goat's milk is deficient. Rapid growth, infection, and hemolysis of red cells increase the need for folic acid, and GI diseases causing malabsorption result in folate deficiency. Congenital malabsorption of folate is associated with severe neurologic signs and normal serum vitamin B_{12} levels.

Treatment with 0.5–1.0 mg folic acid/day results in a rapid hematologic response and should be continued for about 1 month. Toxicity is rare, providing vitamin B_{12} deficiency is not present, but when both deficiencies are present, folic acid produces a hematologic response without correcting the neurologic abnormalities associated with vitamin B_{12} deficiency.

VITAMIN B_{12} DEFICIENCY

Vitamin B_{12} deficiency is rare in children in this country. Vitamin B_{12} is the extrinsic factor and requires the presence of intrinsic factor found in normal gastric mucosa to be absorbed. The metabolic functions of vitamin B_{12} concerned with blood formation are closely related to folic acid metabolism, and the type of anemia is indistinguishable from that of folic acid deficiency. In patients with vitamin B_{12} deficiency, vitamin B_{12} is low in the serum and red cells, and urinary excretion of methylmalonic acid is increased. In those with suspected malabsorption of vitamin B_{12}, the Schilling test will indicate lack of intrinsic factor or other causes of malabsorption.

The daily requirement of vitamin B_{12} for the infant is about 0.1 μg, much less than that contained in most infant diets except those of strict vegetarians (vegans). Deficiency occurs in infants whose mothers have pernicious anemia or are taking a vitamin B_{12}–deficient diet. Congenital lack of intrinsic factor causes infantile pernicious anemia even though the gastric mucosa structure and function are normal. Juvenile pernicious anemia is similar to that in adults, children with the juvenile form having gastric atrophy and decreased secretion of gastric acid and pepsin with serum antibodies to intrinsic factor and parietal cells. Endocrinopathies and evidence of immune deficiencies may be present. Both congenital and juvenile pernicious anemia may be inherited as autosomal recessive disorders.

Absorption occurs in the ileum, and children with surgical conditions requiring removal of the ileum or those children infested with the fish tapeworm do not properly absorb vitamin B_{12}. Some bacterial infections, regional enteritis, or congenital malformations may be responsible for malabsorption of vitamin B_{12}.

Transport and utilization of vitamin B_{12} are deficient in the rare autosomal recessive disorder, transcobalamin II deficiency, in which methylmalonate is not increased in the urine.

Treatment of vitamin B_{12} deficiency in children is successful with 1 mg vitamin B_{12} IM. This dose should be repeated in 1 month with simultaneous correction of dietary deficiencies. With disorders of transport or absorption, 1 mg/month is given indefinitely.

Orotic aciduria, an autosomal recessive disorder of pyrimidine biosynthesis, results in a megaloblastic anemia similar to that of folate or vitamin B_{12} deficiency. Children with this inborn metabolic error excrete large amounts of orotic acid in the urine and do not respond to folate or vitamin B_{12} administration, but they may improve with dietary supplements of yeast extract containing uridylic and cytidylic acid.

ASCORBIC ACID DEFICIENCY

Ascorbic acid deficiency, rare now in the United States, may cause anemia. In children with scurvy, chronic blood loss results in a microcytic hypochromic anemia with decreased serum iron, increased iron-binding proteins, and characteristic x-ray changes. Ascorbic acid may also participate in the metabolic activity and absorption of folic acid, and ascorbic acid deficiency may be accompanied by hematologic signs of folic acid deficiency.

The daily requirement of vitamin C in infancy is about 30 mg. Prematurely born infants fed high-protein diets develop increased serum levels of tyrosine and phenylalanine, as well as increased urinary excretion of phenyllactic and phenylacetic acids. These amino acid levels become more nearly normal with increased ascorbic acid intake. Blood levels of tyrosine and phenylalanine remain more nearly normal in those prematurely born infants whose protein intake is 2.5–6 g/kg/day, but even in some of these hypertyrosinemia and hyperphenylalanemia occur. The latter may respond to increased vitamin C intake.

Children with infections, severe injuries, e.g., burns, or those illnesses requiring increased adrenocortical response benefit from increased ascorbic acid intake during the illness.

In children with scurvy, white cell counts and platelet ascorbate are low, and tests for increased capillary fragility are positive. Treatment with 200–1000 mg ascorbic acid over a period of 3–4 days results in rapid improvement.

VITAMIN B$_6$ DEFICIENCY

Vitamin B$_6$ deficiency is a rare cause of microcytic hypochromic anemia in children. Such children may have increased serum iron and increased iron stores in the bone marrow. The diagnosis of vitamin B$_6$ deficiency or dependency is usually made after the child is found not to be losing blood and is not responsive to oral medicinal iron in adequate doses. Treatment consists of daily supplementation of vitamin B$_6$ 10–100 mg orally. Response occurs in several days if the child is vitamin B$_6$ deficient. Children with vitamin B$_6$ dependency require daily vitamin B$_6$ supplements indefinitely.

VITAMIN K DEFICIENCY

Vitamin K deficiency results in anemia secondary to decreased prothrombin and increased bleeding. Prothrombin time is increased, and especially in the neonate serious bleeding into the skin, the head, or the GI tract can result in a severe microcytic hypochromic anemia, so-called hemorrhagic disease of the newborn. Coagulation factors II, VII, IX, and X are decreased in the blood of these infants.

Because sufficient vitamin K is produced by the intestinal flora after the neonatal period, recommended allowance is not established, but 1 mg given at the time of birth prevents hemor-rhagic disease. Increased requirements occur in those children receiving diets that change the intestinal flora, in those with diarrhea, or in those receiving antibiotics; 1 mg given intramuscularly once weekly suffices. In those with liver disease, vitamin K is not converted to prothrombin. Administration intramuscularly of 1–5 mg vitamin K weekly may decrease the prothrombin time to normal in these children.

VITAMIN E DEFICIENCY

Vitamin E deficiency is rare in term infants, children, or adults. Infants of low birth weight, particularly those fed formulas containing over 20% of the fat as linoleic acid, develop a hemolytic anemia at about 6–10 weeks of age. The anemia is associated with an elevated blood reticulocyte count and an increase in circulating platelets. Seborrheic dermatitis and generalized edema have been seen in some of these children. Hemolysis is more common in children receiving formulas that also contain iron; serum tocopherol levels are less than 0.5 mg/100 ml, and red cells hemolyse in the presence of hydrogen peroxide *in vitro*. This syndrome has not been seen in those receiving very low fat-containing formulas.

Infants with low serum tocopherol respond within 10 days to daily supplementation of α-tocopherol 200 mg until a total dose of 400–1000 mg is given. Serum tocopherol increases to normal, *in vitro* peroxide hemolysis decreases, platelets and reticulocytes decrease to normal, and seborrhea and edema decrease or disappear. Without treatment, signs and symptoms may disappear spontaneously within 3–6 weeks.

MARASMUS AND KWASHIORKOR

Kwashiorkor and marasmus cause multiple signs of malnutrition, including anemia. The anemia may be macrocytic or microcytic, and may be related to specific nutritional factors other than protein or calories. Iron-binding proteins are low in the serum. Partial amelioration of the anemia occurs with specific nutritional additives, such as vitamins or iron. Total correction is not achieved until the general state of the child is improved with protein and calories; intercurrent infections and infestations must also be treated.

Marasmus is the clinical state caused by severe malnutrition in infancy which results in inanition, starvation, and atrophy of the muscles and

subcutaneous tissues. Weight gain is poor, and emaciation is common. The skin is wrinkled and loose: fat is lost from the buttocks and over the body, and finally from the sucking pads of the cheeks. Malnutrition of this extent is rare in the United States but is associated with the high mortality rate of infants and children in the developing countries of Africa, Asia, and Central and South America.

When the deficiency is mainly that of protein and intake of calories is nearly sufficient for the age and size of the child, the children may develop a different appearance. This protein undernutrition state is termed kwashiorkor (16). Worldwide, this is the most common form of malnutrition. Growth retardation becomes most apparent in such children between 1–5 years of age, when the infant is weaned from the breast and the food consumed by the child is high in carbohydrate and very low in protein content and quality.

Gains in height and weight are below those of normal children but are not nearly as deficient as in those with marasmus. The weight deficit is usually greater than the deficit in height. First, second, and third degree protein–calorie malnutrition (PCM) levels are sometimes classified on the 50th percentile of standard height-weight-age charts. Children with heights and weights 75%–90% of the 50th percentile are said to have first degree PCM; 60%–75% is second degree and less than 60% third degree PCM. Fat is mobilized early in deficiency states and adipose tissue diminishes. Physical activity decreases.

The infant becomes irritable and anorexic and loses muscle tone. There is no known tissue storage of protein in contrast to that of fat, carbohydrate, vitamins, or minerals. Thus, lack of protein in the diet is accompanied by muscle breakdown to provide those amino acids necessary for essential enzymes and hormones. The liver may become enlarged. Immunity is reduced, and multiple infections occur. Edema is common, particularly in those who develop infections and diarrhea. Dermatitis, including dyspigmentation and discoloration, are common. The hair may be sparse, thin, and streaky red. The hair is fragile and its texture coarse. Central nervous system changes, particularly irritability and apathy, are common.

Pancreatic enzymes are deficient. Serum amylase, lipase, cholinesterase, transaminase, and other enzymes are reduced. The serum cholesterol level is low. Anemia is common and may be normocytic, macrocytic, or microcytic. Multiple vitamin and mineral deficiencies usually accompany severe malnutrition.

Laboratory tests of PCM are significant in the more severe degrees of malnutrition. These include decreased serum albumin, decreased blood hemoglobin, decreased serum transferrin and decreased ratio of essential to nonessential serum amino acids. Hair fragility is increased.

Treatment includes the treatment of the diarrhea, which is common. Electrolyte imbalance is corrected by parenteral infusion. Calories are provided parenterally until the anorexia improves. Mineral imbalances at onset of treatment or those which occur during treatment are corrected as expeditiously as possible. Magnesium deficiency may occur, requiring measurements of this ion as well as the usual serum electrolytes (see Ch. 12). Oral alimentation is begun slowly, noting the tolerance of the infant to oral feedings and the recurrence of diarrhea.

A diet consisting of 10%–15% of the calories as good quality protein, 35%–45% as simple carbohydrates and 40%–55% fat supplemented with all vitamins and with one dose of 100,000 IU vitamin A are recommended. Carbohydrate should not include lactose since many of these children are lactase deficient. Fat containing medium-chain triglycerides is absorbed better than longer-chain fatty acids (8). Feedings containing larger percentages of protein have been noted to cause enlargement of the liver without hastening recovery from the disease. Infections caused by the decreased body proteins aggravate the malnutrition and must be treated to stop excess protein and calorie losses. Dietary correction hastens recovery in the acute phase and must be supplemented with psychological support, attention to the child's wants and needs, and stimulation and challenge.

Even with recovery, these children do not usually regain normal height and weight, and many may be permanently retarded (see Ch. 30). Extensive studies on mental development related to severe malnutrition appear to indicate that the earlier and more severe the insult, the more likely is permanent retardation. Even when these children are identified late in the disease, intensive realimentation should be attempted before retardation is considered irreversible (1).

ADVERSE REACTIONS TO FOOD

Allergic reactions to foods are expressed by reactions in the GI tract, respiratory tract, skin, central nervous system, and vascular system.

The mechanisms of adverse reactions include hereditary enzyme deficiencies and immunologic and psychologic factors. The intestinal mucosa contains antibody-forming cells that may cause local reactions. Protein molecules may be absorbed intact through the intestinal wall, especially in the young or following intestinal wall injury, such as follows severe diarrhea. Antibodies formed against these antigens produce a series of reactions resulting in clinical signs and symptoms. This explanation of symptoms is, however, inadequate as antibodies to some proteins are found in patients who do not develop symptoms when challenged. Likewise, positive skin test reactions to food, and serum immunoglobulin levels of all classes correspond poorly to clinical signs.

Clinical tests for food allergy consist in removing the food and noting prompt improvement of symptoms. This improvement is followed by return of symptoms with reintroduction of the suspect foods.

MILK ALLERGY

In the young infant, adverse reactions occur most frequently to milk, wheat, and egg white, three of the foods introduced early. Many signs and symptoms of milk allergy have been described. A diagnosis of milk allergy may be made with supporting evidence limited to poor food intake. Milk allergy has been diagnosed in children whose only symptoms are vomiting or diarrhea due to overfeeding, irritability due to improper handling of the infant, or multiple nonrelated causes. Although true milk allergy is less common than diagnosed, a number of different forms of adverse reactions to milk are known.

Milk allergy is associated with bleeding from the GI tract. On feeding the infant small amounts of milk, he becomes anemic with blood loss which may be gross or microscopic in the stool. When such children are prohibited from ingesting milk, the blood loss ceases. If they are later given small amounts of milk, they may develop anaphylactic shock.

A more-insidious and less-severe blood loss occurs in infants fed casein-containing foods. These children continuously lose small amounts of blood with excessive milk ingestion. This is less common if the milk is boiled; it is worse if iron deficiency has occurred before the excess casein ingestion.

One syndrome consists of frequent episodes of bronchiolitis, sinusitis, otitis, and rhinorrhea.

Children with this acute respiratory syndrome are usually about 4 months to 1 year of age and may appear to have seasonal allergies. Food allergy is rarely suspected as the cause of these symptoms, but when milk is removed from the diet, chest and nasal symptoms disappear (9).

A syndrome occurs in older children with signs and symptoms suggesting ulcerative colitis or spastic colon. These children may have abdominal pain, diarrhea, and weight loss. Stools may contain excess mucus and fat and may be frequent or infrequent. Constipation may alternate with diarrhea. When milk is removed from the diet, symptoms disappear. This has been related to the lactose in milk as it occurs in children who develop alactasia at about 2 years of age.

As with other food allergies, children allergic to milk may also develop dark circles under the eyes, hyperkinesia, irritability, and lack of attention. They sometimes seem tense and fatigue easily. These symptoms also disappear after cessation of milk ingestion.

Except for anemia and blood loss in stools (melena), no child should be labeled "allergic to milk" or "milk intolerant" unless the symptoms disappear within 2–6 weeks after the cessation of milk ingestion and recur with the reinstitution of milk.

Milk-free formulas with protein derived from soy flour are available (Table 29–6). Other milk-free formulas are made with meat base.

WHEAT ALLERGY

Reactions to wheat and other foods similar to those described as due to milk have been reported. These reactions disappear with the removal of the offending substance. One more-specific syndrome is commonly associated with wheat ingestion, celiac disease, or sprue. The child with celiac disease is asymptomatic until 6 months to 1 year, at which time he becomes irritable, refuses to eat or eats little, vomits, fails to gain weight or height, and develops a distended abdomen. Constant whining and crampy abdominal pain, rectal prolapse, constipation, and anemia are seen in those whose symptoms are mild or begin after 2 years of age. Puberty may be delayed. Easy bruising, clubbing of the fingers, and generalized edema may occur. Stools are frequent and foul-smelling, greasy, and float on water. Tests of fat absorption during these symptoms indicate that little fat is absorbed and that the stools contain excessive fat. If untreated, these children remain irritable and fail

TABLE 29–6. Formulas for Special Nutritional Use

Formula	Protein Source	Protein g/100 ml	Fat Source	Fat g/100 ml	Carbohydrate Source	Carbohydrate g/100 ml	Minerals (g/100 ml)
Milk-Free formulas, *e.g.* Prosobee*, Isomil[T], Nursoy[‡] Neo-Mull-Soy[§]	Soy isolate	1.8–2.5	Vegetable oils	3.0–3.6	Corn syrup or sucrose	6.4–6.8	0.4–0.5
Protein hydrolysate Nutramigen*	Hydrolysed casein	2.2	Vegetable oils	2.6	Sucrose	8.6	.6
Pregestimil*	Hydrolysed casein	2.2	15% MCT	2.6	Starch and glucose	8.6	.6
Very-low-protein formulas[‡], *e.g.* S–14 (1.1%), S–29 (1.7%), S–44 (1.55%) (For leucine-sensitive hyperglycemia, renal disease, and hypercalcemia)	Dialysed whey	—	—	—	—	—	—

*Mead Johnson
[T]Ross laboratories
[‡]Wyeth laboratories
[§]Syntex

to grow. Signs of fat-soluble vitamin deficiencies and tetany develop.

Characteristic changes are demonstrable in the duodenal–jejunal mucosa obtained by per-oral biopsy. The mucosa is flattened with elongated crypts, and surface epithelial cells appear damaged. Lactose intolerance may be present, with alactasia demonstrated by enzyme analysis of the mucosa.

Treatment consists in the removal of gluten from the diet. Foods that contain gluten are wheat, barley, rye, and oats. Many baby foods contain vegetable-protein additives, including cereal proteins, and these must be meticulously avoided in children diagnosed as having celiac disease.

Irritability, diarrhea, and abdominal distension decrease within 2–6 weeks of exclusion of gluten. Intestinal mucosal biopsy after this time cannot be distinguished from normal. Growth improves and returns to normal after about 2 years. After several years, gluten may be slowly introduced. If symptoms recur, full diet should not be attempted for several years longer.

CYSTIC FIBROSIS

Some signs and symptoms of cystic fibrosis, an autosomal recessively inherited disorder, are similar to those of celiac disease. Cystic fibrosis occurs in approximately 1 in 600 Caucasian live births and may be somewhat less frequent in other races. These children may have diarrhea, steatorrhea, and rectal prolapse, and they fail to thrive. Early in life, they may develop edema and signs of vitamin deficiencies. Other signs are dissimilar from those with celiac disease.

The newborn infant with cystic fibrosis presents with signs of intestinal obstruction and meconium ileus, or he may be born with evidence of intestinal perforation or meconium peritonitis. In contrast to the 6-month-old infant with celiac disease, at a few months of age he appears to have a voracious appetite. He has a happy disposition unless infected. Pulmonary infections (frequently due to Staphylococcus aureus), nasal polyps, peripheral edema, chronic cough, and respiratory distress are common. Rickets, eye changes consistent with vitamin A deficiency, and muscle weakness and wasting relate to the severity of the disease. Males are usually sterile.

Diagnosis is made by determining the absence of trypsin and other pancreatic enzymes in the small intestine. Determination of electrolytes in the sweat reveals an elevated concentration of sodium and chloride, over 60 mEq/liter, and is used as an accurate screening test for the disease. At autopsy, secretions of many glands are viscid and the pancreas is fibrotic.

Treatment is complex. For those with intestinal symptoms, a high-calorie diet with hydrolysed proteins (see Table 29–6), low fat, and pancreatic enzymes orally help control the diarrhea and improve serum albumin levels. Fat-soluble vitamins at two or three times the recom-

mended daily allowances (see Table A-1) should be given in a water-miscible base. Vitamin E should be included and may lessen muscle weakness. Soybean milks should not be used because of difficult digestion. Medium-chain triglycerides are absorbed better than other fats. Supplementary sodium chloride is needed in hot weather.

Therapy related to the pulmonary complications is difficult and less successful than that related to the GI symptoms. Antibiotics, high humidity, vapor, and physical drainage of the lung are necessary. Patients with good and constant pulmonary care may reach the fourth decade.

ABETALIPOPROTEINEMIA AND ACRODERMATITIS

Abetalipoproteinemia and acrodermatitis are sometimes confused with celiac disease or cystic fibrosis. Abetalipoproteinemia is a rare autosomal recessively inherited disorder with decreased serum levels of fat-transporting proteins. Diarrhea, steatorrhea, acanthocytosis and very low serum vitamin E levels are associated with failure to thrive in infancy. Later, ataxia, scoliosis, and retinitis pigmentosa further disable the child. Some improvement occurs with low-fat or medium-chain triglyceride–containing diets (see Table 29–6).

Acrodermatitis enteropathica is a disease of infancy characterized by diarrhea and dermatitis of the extremities. Improvement has been noted when infants are fed solely breast milk. Diarrhea is lessened if ingested fat contains a high percentage of linoleic acid or medium-chain triglycerides. Treatment with zinc-containing salts has resulted in improvement; further studies with this treatment are necessary.

LACTOSE INTOLERANCE

Lactose intolerance occurs in three forms (10): 1) congenital lactose intolerance is rare and inherited as an autosomal recessive characteristic; 2) acquired lactose intolerance occurs following diarrhea of any cause, including viral gastroenteritis as well as other malabsorption syndromes; and 3) developmental lactose intolerance occurs in 30%–70% of Blacks and Orientals and about 15% of Caucasians, usually beginning at about 2–3 years of age.

Intolerance is due not to allergy but to the absence of intestinal lactase. When fed lactose-containing foods, the children fail to thrive.

Symptoms include vomiting, diarrhea, and abdominal distension. Later symptoms may be limited to abdominal pain and mild diarrhea after drinking milk. Stool pH is below 6 and contains reducing substances, excess fat, and mucus.

Elimination of all lactose-containing foods from the diet (see Table 29–6) improves symptoms. Symptoms may lessen spontaneously with age even though milk ingestion continues.

Sucrase–isomaltase deficiency and glucose–galactose and fructose malabsorption may cause similar symptoms. Elimination of these substances from the diet ameliorates symptoms.

ANOREXIA NERVOSA

Anorexia nervosa is a syndrome of self-starvation more common in adolescent girls than boys. Patients may be obese or may have the self-image that they are obese. They limit their food intake and lose weight but do not stop the limited food intake. In addition to weight loss and failure to eat, adolescent girls may develop amenorrhea. Their appearance must be distinguished from the similar appearance of children with brain tumor or metabolic disease. Children with anorexia nervosa usually have severe psychological problems, though in some, encouragement and psychological support may reverse the process.

Treatment is difficult. Electrolyte imbalance is first corrected, and this may require emergency administration of parenteral fluids. Weight gain following rehydration may lead to false encouragement. Total parenteral nutrition, behaviour modification, or intensive psychotherapy may reverse the process (see Ch. 30).

METABOLIC DISEASES

A number of metabolic diseases are best treated by dietary means or are partially treated by changes in the diet. Diabetes is discussed in detail in Chapter 17.

RENAL DISEASE

Children with renal disease must be carefully monitored. Those children with pyelonephritis require extra fluids but maintain their customary diet. They present no nutritional problems unless the disease becomes chronic, when nutritional needs become similar to those of children with degenerative renal disease.

Children with the nephrotic syndrome present with edema, hypoalbuminemia, proteinuria, and hypercholesterolemia. The course is variable. In spite of the low serum proteins, a high-protein diet may be followed by anorexia and destruction of tissue proteins. Allowing the child to choose his diet provides calories and may prevent tissue destruction while other measures are taken to ameliorate the underlying disease. In the presence of hypertension sodium chloride intake should be restricted.

Children with degenerative renal disease of any cause are a challenge in management. These children may have growth failure, hypertension, elevated serum urea nitrogen, oliguria, hyposthenuria or isosthenuria, and formed elements and protein in the urine. Nutritional management is directed to the symptoms. Caloric intake is maintained at a high level but short of inducing vomiting or diarrhea. Sodium chloride is restricted in the presence of hypertension. The diet is high in carbohydrate and fat to limit the accumulation of nitrogenous metabolites in the blood. Fluid balance is meticulously maintained to prevent both over hydration and dehydration. Increased phosphate is given if phosphate is being excreted in excess, and a low-phosphate diet with Amphogel or similar phosphate binders is used for those with phosphate retention. Calcium is given those with hypocalcemia. When associated with vitamin D resistance, 1,25-dihydroxycholecalciferol administration may be helpful.

LIVER DISEASE

Children with chronic liver disease likewise do well on a low-protein diet. In acute liver disease, *e.g.,* acute viral hepatitis, they should be fed foods that do not cause vomiting. Hepatitis in children generally is a milder disease than that in the adult, and dietary changes are not necessary and even undesirable. High-protein diets given to such children have resulted in decreased mental responses and neurologic abnormalities.

HEART DISEASE

Children with heart disease usually do not require any dietary change and can be managed by the usual pharmacologic treatment for heart disease. However, in those children who develop persistent failure, low-sodium diets are advantageous.

CONGENITAL METABOLIC DISORDERS

Children with certain autosomal recessive disorders of amino acid metabolism have been improved with special diets. Diets are not readily available from natural foods and must be prepared by such techniques as chromatographic separation of the implicated amino acids (Table 29–7). Children with phenylketonuria, maple syrup urine disease, oxaluria, cystinuria, and diseases of methionine metabolism have been moderately successfully treated. When children with these diagnoses are identified, dietary information from the Academy of Pediatrics or similar agencies should be obtained. A number of vitamin-dependent states have been identified. Such children require true megavitamin therapy (Table 29–8). Whenever one of these vitamin-dependent states is suspected, specific diagnosis must be made before megavitamin therapy is begun. Not all apparently vitamin-dependent states respond to large doses of vitamins because the underlying enzyme error may involve multiple proteins.

HYPERCHOLESTEROLEMIA

Because increased cholesterol levels are considered a risk factor in the development of coronary artery disease, lowering cholesterol by dietary means has been suggested, beginning in childhood. Blood cholesterol can usually be lowered by restricting dietary cholesterol. After examining presently available evidence, the Academy of Pediatrics Committee on Nutrition (5) recommends no such severe restriction of cholesterol intake in normal infants and children. Among the considerations is the possible poor development of enzyme systems, *e.g.,* lecithin cholesterol acyltransferase, necessary for the metabolism of cholesterol.

In those children heterozygous for type II hyperbetalipoproteinemia, early cholesterol restriction may be advantageous. Cholestyramine or similar pharmaceutical agents may be required in addition to dietary restriction of cholesterol. Limited effect is achieved by substituting unsaturated for saturated fatty acids in the diets of these children; lowering total dietary fat has been more effective. Substituting complex carbohydrates and starches for refined sugar may also be effective. It has been suggested that in such children circulating cholesterol does not shut off the production of endogenous cholesterol due to a congenital lack of feedback mechanism with 3-hydroxy-3-methylglutaryl-CoA reductase (7). Restriction of dietary cholesterol

TABLE 29–7. Approximate Nutritive Composition of Special Dietary Products (per 100 g powder)

	Lofenalac (A 1)	Albumaid-XP (A 2)	Aminogram (A 3)	3229–A (A 4)	3200–AB (C 4)	MSUD-Aid (B 2)	Metinaid (D 5)	3200–K (D 1)	Histidine (Low 2)	80056 (E 1)
Calories	454	370	400	406	460	393	384	464	360	486
Protein (equivalent)	15	40	100	20.3	15	98.2	40	14	40	0
Fat (g)	18	1	0	6.8	18	0	0	19	0	22.5
Carbohydrate (g)	60	47	0	66	60	0	56.1	60	50	73.5
L-amino acids (g)										
Essential										
Isoleucine	0.75	1.1	8.5	1.08	0.86	0	0.8	0.67	1.2	—
Leucine	1.41	3.5	9.9	1.70	1.76	0	1.8	1.16	2.0	—
Lysine	1.57	3.4	(7.3)†	1.85	1.91	10.4	3.7	0.87	3.0	—
Methionine	0.45	0.5	2.9	0.62	0.56	2.2	0	0.16	0.8	—
Phenylalanine	0.08	0	0	0	<0.08	4.3	2.4	0.76	1.2	—
Threonine	0.77	2.8	5.7	0.93	0.65	4.3	1.8	0.52	1.6	—
Tryptophan	0.19	0.4	1.5	0.28	0.20	1.6	0.4	0.16	0.6	—
Valine	1.20	2.5	7.0	1.24	1.38	0	1.9	0.71	1.6	—
Histidine	0.39	0.9	3.8	0.46	0.40	3.2	1.6	0.34	NL	—
Nonessential										
Arginine	0.34	1.7	(4.3)†	0.68	0.39	6.5	2.4	0.96	2.4	—
Alanine	0.64	2.3	2.4	NL	0.76	8.8	3.2	0.60	3.2	—
Aspartate	1.34	4.4	6.1	5.15	1.60	15.3	5.3	1.72	5.6	—
Cystine	0.025	1.7	1.5	0.34	0.042	5.4	2.0	0.107	2.0	—
Glutamate	3.78	5.1	(12.9)‡	1.85	4.31	17.5	6.0	2.76	6.4	—
Glycine	0.35	1.7	6.1	3.30	0.40	8.8	2.4	0.59	3.2	—
Proline	1.13	2.1	4.3	NL	1.13	2.8	0.9	0.68	1.0	—
Serine	1.02	2.8	8.4	NL	1.09	2.8	1.0	0.72	1.0	—
Tyrosine	0.81	3.1	6.4	0.93	<0.04	4.3	2.4	0.49	2.4	—
Glutamine	NL	NL	NL	4.75	NL	NL	NL	NL	NL	—
Vitamins										
Vitamin A (IU)	1160	0	0	2030	1160	0	0	1450	0	1440
Vitamin D (IU)	284	0	0	406	284	0	0	290	0	360
Vitamin E (IU)	7.1	0	0	10	7.1	0	0	7.2	0	9
Vitamin C (mg)	37	0	0	53	37	0	0	38	0	45
Thiamin (µg)	428	2000	0	609	438	5000	2000	440	2000	450
Riboflavin (µg)	714	2000	0	1015	714	5000	2000	720	2000	540
Vitamin B$_6$ (µg)	290	1000	0	508	290	2500	1000	360	1000	360
Vitamin B$_{12}$ (µg)	1.4	20	0	2.5	1.4	50	20	1.8	20	1.8
Niacin (µg)	5714	10,000	0	8122	5714	25,000	10,000	5800	10,000	7200
Folic acid (µg)	72	200	0	51	72	500	200	30	0	90
Pantothenic Acid (µg)	2142	4000	0	3046	2142	10,000	4000	2200	4000	2700
Choline (mg)	61	0	0	86	61	0	0	62	0	76
Biotin (µg)	36	49	0	30	36	130	50	22	50	45
Vitamin K (µg)	72	0	0	102	72	0	0	71	00	90
Inositol (mg)	72	0	0	102	72	250	100	73	100	90

(continued)

TABLE 29–7. Approximate Nutritive Composition of Special Dietary Products (per 100 g powder) (continued)

	Lofenalac (A 1)	Albumaid-XP (A 2)	Aminogram (A 3)	3229–A (A 4)	3200–AB (C 4)	MSUD-Aid (B 2)	Metinaid (D 5)	3200–K (D 1)	Histidine (Low 2)	80056 (E 1)
Minerals										
Calcium (mg)	435	1000	8200*	634	435	0	700	650	700	540
Phosphorus (mg)	326	637	3837*	508	326	254	1500	450	1500	300
Magnesium (mg)	51	148	970*	76	51	200	80	54	80	63
Iron (mg)	8.6	20	50*	12	8.6	10	4	8.7	4	11
Iodine (μg)	32	77	700*	66	32	150	60	47	60	41
Copper (μg)	429	2000	6300*	609	429	1250	500	430	500	540
Manganese (mg)	0.7	1.2	5.7*	2	0.7	1250	500	1.4	0.5	0.9
Zinc (mg)	2.9	2.2	10.5*	4.1	2.9	2.5	0.9	2.9	0.9	3.6
Sodium (mEq)	9	43	172*	10	9	NL	33	10	34	3
Potassium (mEq)	12	23	213*	18	12	NL	19	15	19	9
Chloride (mEq)	9	114	NL*	14	9	NL	NL	NL	NL	4

Collated by Academy of Pediatrics, Committee on Nutrition, 1975

*Composition may vary between batches of individual product, separate mineral package

NL = not listed

†offered as glutamate salt

‡includes glutamate from lysine and arginine salts

A. Low phenylalanine
B. Low branched-chain amino acids
C. Low tyrosine, phenylalanine, methionine
D. Low methione
E. Protein-free calorie-mineral-vitamin mix

1. Commercially available from Mead Johnson Company, Evansville
2. Milner Scientific and Medical Research, Liverpool. (Supplement with carbohydrate, fat, vitamins, and minerals)
3. Glaxo Allsenburg, Ltd. London. (Feed only as a supplement)
4. Mead Johnson Company, Evansville
5. Commercially available from Scientific Hospital Supplies
6. An additional low branched-chain amino acid mixture is available from Grand Islands Biological Company

TABLE 29–8. Vitamin Dependency States

Disease	Untreated clinical state	Vitamin	Recommended daily dose		Defect
			Normal	Disease	
Darier's disease	Hyperkeratosis follicularis	A	2500 IU	25,000 IU	?
Maple syrup urine disease	Hypotonia, seizures, death	B$_1$	1.4 mg	10 mg	Branched-chain keto-acid Decarboxylase activity
Hyperpyruvic acidemia hyperalanemia hyperlacticacidosis	Ataxia, retardation	B$_1$	1.4 mg	600 mg	Pyruvate decarboxylase activity?
Thiamin-responsive anemia	Megaloblastic anemia	B$_1$	1.4 mg	20 mg	DNA synthesis
Cystathioninuria	None?	B$_6$	2.0 mg	200–400 ml	Cystathionase activity
Homocystinuria	Retardation, thrombi, dislocated lens, osteoporosis	B$_6$	2.0 mg	25–500 mg	Cystathionine synthetase activity
Pyridoxine-responsive anemia	Microcytic, hypochromic anemia	B$_6$	2.0 mg	10 mg	δ amino levulinic acid synthesis
Pyridoxine-responsive seizures	Seizures	B$_6$	2.0 mg	10–25 mg	Glutamic decarboxylase activity
Xanthurenic aciduria	Retardation	B$_6$	2.0 mg	5–10 mg	Kynureninase activity
Formininotransferase deficiency	Mental deficiency	Folate	50 μg	? 5 mg	
Folic acid reductase deficiency	Megaloblastic anemia	Folate	50 μg	? 5 mg	
Methylmalonic acidemia	Acidosis, failure to grow, retardation, osteoporosis	B$_{12}$	1 μg	200–1000 μg	B$_{12}$ coenzyme synthesis
Propionic acidemia	Acidosis	Biotin	300 μg	10,000 μg	Propionyl CoA carboxylase activity
Vitamin D dependency (rickets)	Rickets, short stature	D	400 IU	4000 IU	Calcium absorption, phosphate utilization
Familial hypophosphatemic rickets	Rickets, short stature	D	400 IU	50,000 – 200,000 IU	Absorption of calcium
Hartnup's disease	Ataxia, retardation?, dermatitis	Niacin	10 mg	40–200 mg	Absorption of tryptophan

before the age of 3–4 years should be attempted with caution.

Decrease in dietary fiber, the undigestible part of plants, may be more responsible for the increase of blood cholesterol levels and atherosclerosis than dietary cholesterol. Increase in dietary fiber may aid in lowering serum cholesterol in affected children.

FAILURE TO THRIVE

Failure to thrive physically is an ill-defined term, indicating that the child is below the 3rd percentile of standard growth charts for height, weight, or both. The term encompasses almost all of the illnesses or abnormalities of pediatrics, but the most common cause is lack of calories. Some mothers fail to give their children sufficient calories for psychological reasons, because of ignorance of requirements, or for economic or sociologic reasons. Accurate diagnosis is essential for proper management of such children.

First, a good dietary history must be obtained and from this the intake of calories estimated. If the caloric intake seems sufficient or excessive, the informant may be fabricating. If the caloric intake is deficient, the physician must seek causes for the deficiency. Next, an attempt should be made to obtain a sequential growth record. Sudden weight changes are indicative of sudden changes in the metabolic–nutritional state of the child. The heights and weights of the parents and grandparents should be known since small forebears are more likely to have small progeny. The parental attitude to the child should be observed since lack of proper affect or good relationship may equal lack of calories in causing failure to thrive.

Except in mild cases it is probably most expeditious to admit the child to a hospital and attempt to feed him. Few laboratory studies should be done initially until the physician obtains an accurate estimate of caloric intake. If the child begins to consume calories and increase his

weight, few further studies are necessary. If, however, the child consumes sufficient or excessive calories and does not gain weight, the physician must pursue the diagnosis further, looking particularly for GI losses or hypermetabolic states. Simple tests on the stool for protein, carbohydrate, and fat; tests of the urine for chronic urinary tract disease; and tests for bone and endocrine diseases, *e.g.,* hypothyroidism should be considered. A good physical examination should be sufficient to rule out diseases in the major systems which can cause failure to thrive, but if all of these tests are within normal limits, the physician must consider some of the rarer causes of failure to thrive, *e.g.,* disorders of amino acid metabolism and growth hormone deficiencies (Table 29–9).

OBESITY

Children whose weight is more than 10% greater than the 97th percentile for weight are prone to some complications of the obese. Skinfold measurements are useful in determining excess fat, but the diagnosis of obesity itself is a judgmental one and includes the prejudices, desires, and evaluation of body image of the child himself, his peers, parents, and other observers (see Ch. 25).

The causes of obesity in children are multiple and are not well understood. When caloric intake is greater than caloric utilization plus waste, the child can respond only with either vomiting and diarrhea or the development of obesity. Infections and sedation which result in keeping the child at rest frequently herald the onset of obesity. Early feeding of high-calorie foods during infancy may result in habitual excessive appetite or in the development of fat cells (11), and increased numbers of fat cells may presage the later development of permanent obesity. Regardless of etiology, obese parents tend to have obese children, and as many as 80% of obese children become obese adults.

Obese infants are prone to respond poorly to respiratory infections, particularly croup. Obesity can cause serious psychological problems in both the pre-teen and teen-ager. Older obese children develop respiratory insufficiency (*e.g.,* the Pickwickian syndrome—which includes hypoxemia and lethargy) and also dislocated hips and degenerative diseases.

TABLE 29–9. Determine Representative Causes of Failure to Thrive

History
 Genetic
 Height of parents and grandparents
 Birth Weight
 Small for gestational age
 Sequential growth record
 Acute or chronic illness
 Intake
 Losses
 Stool
 Metabolic

Physical Examination
 Abnormalities in any system

Suitable History, Physical Examination and Laboratory Tests

Disorder	Tests
Infections	Urinalysis, blood and stool culture, erythrocyte sedimentation rate
Anemias: hemoglobinopathies, hemolysis, deficiency	Complete blood count and smear
Kidney disease	BUN; urine: pH, specific gravity (SG) prot., reducing substance, $FeCl_3$, amino acids, blood pressure
Diabetes	Glucose tolerance
Liver disease	SGOT, alkaline phosphatase, bilirubin
Heart disease	EKG, chest film
Food intolerance	Stool pH, reducing substances, fat, mucus, protein, ova, parasites, bacteria, blood. X rays of GI tract, proctosigmoidoscopy. Jejunal biopsy
Cystic fibrosis	Sweat test, chest film
Endocrine (thyroid, adrenal, pituitary)	Bone age, height age, T4, serum electrolytes, fasting blood sugar, growth hormone
Immune disorders	Immunoelectrophoresis, CBC, complement, skin tests for hypersensitivity
Other metabolic	Urine as for kidney disease, stool as for food intolerance
Unusual appearance	Buccal smear, chromosomes

TABLE 29–10. Levels of Nutritional Assessment for Infants and Children*

Birth to 24 Months

Level of Approach†	History		Clinical evaluation	Laboratory evaluation
	Dietary	Medical and socioeconomic		
Minimal	Source of iron Vitamin supplement Milk intake (type and amount)	Birth weight Length of gestation Serious or chronic illness Use of medicines	Body weight and length Gross defects	Hematocrit Hemoglobin
Mid-level	Semiquantitative Iron-cereal, meat, egg yolks, supplement Energy nutrients Micronutrients — calcium, niacin, riboflavin, vitamin C Protein Food intolerances Baby foods — processed commercially; home cooked	Family history: diabetes, tuberculosis Maternal: height, prenatal care Infant: immunizations, tuberculin test	Head circumference Skin color, pallor, turgor Subcutaneous tissue paucity, excess	RBC morphology Serum iron Total iron-binding capacity Sickle cell testing
In-depth level	Quantitative 24-hour recall Dietary history	Prenatal details Complications of delivery Regular health supervision	Cranial bossing Epiphyseal enlargement Costochondral beading Ecchymoses	Same as above, plus vitamins and appropriate enzyme assays, protein and amino acids, hydroxyproline, etc. should be available
For Ages 2 to 5 Years				
	Determine amount of intake	Probe about pica; Medications	Add height at all levels; Add arm circumference at all levels; Add triceps skinfolds at in-depth level	Add serum lead at midlevel; Add serum micronutrients (e.g., vitamins A, C, folate) at in-depth level
For Ages 6 to 12 Years				
	Probe about snack foods; Determine whether salt intake is excessive	Ask about medications taken; drug abuse	Add blood pressure at midlevel; Add description of changes in tongue, skin, eyes for in-depth level	All of above plus BUN

*Cristakis G (ed): Am J Public Health Supplement, Vol. 63, November, 1973
†It is understood that what is included at a minimal level would also be included or represented at successively more-sophisticated levels of approach. However, it may be entirely appropriate to use a minimal level of approach to clinical evaluations and a maximal approach to laboratory evaluations

Skin infections in skin folds, menstrual irregularities, and impaired glucose tolerance occur in adolescents.

In childhood, obesity is best controlled by advising an increase in activity with little change in the diet. If dietary change is required, it is essential in the young that the diet contains adequate protein, carbohydrate, and fat and that the caloric density and thus the caloric intake be reduced. This can be accomplished most simply by diluting the formula or milk with water or by increasing the intake of low-calorie foods. The practice of feeding obese infants skim milk is not recommended since skim milk is a very high-protein food that may be associated with an excessively high protein intake. In the older child caloric restriction may be limited to the desired level by eliminating snacks and extra meals. It is desirable to avoid stringent dietary restrictions until after the pubertal growth spurt since such diets are accompanied by increased protein catabolism, which may interfere with normal growth and hormonal development. Diets similar to those prescribed for adults may be used in the massively obese child.

EVALUATION OF NUTRITIONAL STATUS

Single tools for evaluation of nutritional status are inexact. However, a combination of careful history, physical examination, and laboratory studies leads to a reasonable evaluation of individuals and can be used in the evaluation of large groups. A convenient outline has been developed by Christakis *et al.* (Table 29–10).

Such an evaluation includes many of the historic aspects useful in diagnosing the multiple causes of failure to thrive, the development of obesity, and the causes of adverse reactions to food. When obtaining such a record, inference can be drawn of family relationships, the significance of food to the family, and the medical and nutritional care received by the infant or child.

REFERENCES

1. Chavez A, Martinex C, Yashine T: Nutriton, behavioral development, and mother-child interaction in young rural children. Fed Proc 34: 1574–1582, 1975

2. Committee on Nutrition, American Academy of Pediatrics: Childhood diet and coronary heart disease. Pediatrics 49:305, 1972

3. Cornely DA, Barness LA, Gyorgy P: Effect of lactose on nitrogen metabolism and phenol excretion in infants. Pediat 51:40–45, 1957

4. Dallman PR: The nutritonal anemias In Nathan DG, Oski FA(eds): Hematology of Infancy and Childhood. Philadelphia, WB Saunders, 1974

5. Fomon SJ: Infant Nutriton 2nd ed. Philadelphia, WB Saunders, 1974

6. Goldman HT, Goldman JS, Kaufman I, Liebman OB: Late effects of early dietary protein intake on low-birth-weight infants. Pediatr 85: 764, 1974

7. Goldstein JL, Brown MS: Familial hypercholesterolemia: identification of a defect in the regulation of a3-hydroxy 3-methyl glutaryl CoA reductase activity associated with overproduction of cholesterol. Proc Natl Acad Sci USA 70:2804–2808, 1973

8. Graham GG, Baertl JM, Cordano A, Morales E: Lactose-free, medium-chain triglyceride formulas in severe malnutrition. Am J Dis Child 126:330–335, 1973

9. Heiner DC, Sears JW, Kniker WT: Multiple precipitus to cow's milk in chronic respiratory disease. Am J Dis Child 103:634, 1962

10. Johnson JD, Kretchmer N, Simoons FJ: Lactose malabsorption; its biology and history. In Shulman I (ed): Advances in Pediatric 21. Chicago, Year Book Medical, 1974

11. Knittle JL, Ginsberg–Fellmer F: The effect of weight reduction on in vitro adipose tissue lipolysis and cellularity in obese adolescents and adults. Diabetes 21: 745, 1972

12. Masirani R: Trace elements and cardiovascular diseases. Bull WHO 40: 305–312, 1959

13. Melhorn DK, Gross S: Vitamin E-dependent anemia in the premature infant. II. Effects of large doses of medicinal iron. J Pediat 79:581, 1971

14. Omans WB, Barness LA, Rose CA, Gyorgy P: Prolonged feeding studies in premature infants. J Pediatr 59: 951, 1961

15, Oski FA, Barness LA: Vitamin E deficiency: a previously unrecognized cause of hemolytic anemia in the premature infant. J Pediatr 70:211–220, 1966

16. Payne PR: Safe protein-calorie ration in diets. The relative importance of protein and energy intake as causal factors in malnutrition. Am J Clin Nutr 28:281–286, 1975

17. Synderman SE: The protein and amino acid requirements of the premature infant. In Jouxis JHP, Visser HKA, Troclstra JA (eds): Nutricia Symposium: Metabolic Processes in the Foetus and Newborn Infant. Leiden, Stenfert Korese, 1971

18. Weinberg ED: Nutritional immunity: host's attempt to withhold iron from microbial invaders. JAMA 231:39, 1975

19. Winick M, Brasel JA, Rosso P: Nutrition and cell growth. In Winick M (ed): Nutrition and Development. New York, John Wiley, 1972, p 49

30 Psychiatry

Morris A. Lipton, Francis J. Kane, Jr.

HISTORICAL PERSPECTIVE

Less than 50 years ago there were more than 200,000 cases of pellagra annually in the United States. Mortality for this illness averaged 33%, and about 10% of the beds in insane asylums throughout the country were occupied by patients with pellagra. In the South, the figure was even higher; from a third to a half of the state hospital beds were so occupied (23). Of these many thousand cases, some entered the hospital with symptoms of mental illness, a not uncommon finding in pellagra, whereas others developed pellagra, superimposed upon whatever other illness might have caused admission to the hospital, because of poor nutrition within the institution. Pellagra was also common in prisons, orphanages, and other institutions.

Although pellagra had been recognized as an illness in the United States and Europe for more than three centuries, its etiology remained obscure until the classic studies of Goldberger (29) in the 1920s demonstrated that it was not a consequence of infection, intoxication, or genetic taint, but rather a specific nutritional deficiency disease that could be prevented or remedied by yeast, liver, or high-quality protein diets. Goldberger's finding of an animal model, black tongue in dogs, led to the discovery by Elvehjem in 1937, that nicotinic acid (niacin) or nicotinamide was the specific antipellagra vitamin. Within a few years, a national policy of fortifying bread and other cereal products with this water-soluble vitamin was established. This, in conjunction with alterations in the food-growing patterns and dietary customs of rural populations and in institutions, permitted the eradication of pellagra in this country and most of Europe. Today this illness is found very rarely in the United States and then only among debilitated chronic alcoholics, food faddists, or those with Hartnup's disease (a rare genetic disorder in the absorption of tryptophan, the amino acid precursor of niacin).*

The discovery of the cause of pellagra and its subsequent cure and prevention surely must rate among the greatest medical and public health advances. Yet before the cause of pellagra was known, it was for many years considered to be a psychiatric illness because of the high frequency of associated mental and behavioral disturbances. By definition, this means an illness treated by psychiatrists (physicians of the mind). After its etiology was discovered, it was removed from this category, and it is now clearly a nutritional illness. In the same fashion, general paresis, which manifested itself most frequently with symptoms of disordered thinking and feeling, was for many years considered to be a psychiatric illness, but with the discovery of its syphilitic origins and its cure with antibiotics, it too has virtually disappeared and is no longer within the province of responsibility of the psychiatrist.

Psychiatry as a medical discipline deals with illnesses whose signs and symptoms are manifest in disorders of emotion, thinking, and behavior (7). Psychiatrists are professionally concerned with disorders of mood, cognition, and behavior, including the affective illnesses, *e.g.,* depression and mania; cognitive disorders, *e.g.,* mental retardation and organic brain syndromes; personality and behavior disorders ranging from drug and alcohol abuse to the neuroses; and the psychoses, *e.g.,* schizophrenia, which are called functional because no underlying structural pathology has been discovered. With the exception of some forms of mental retardation and organic brain disease, the etiology of these manifold disorders is not clearly established. Current thinking favors psychological influences as dominant in the genesis of the neuroses and personal-

*Pellagra remains an endemic problem of great magnitude in parts of Africa, India and Central America where extreme poverty makes corn (maize) the staple diet (23).

ity disorders. With schizophrenia and the depressive psychoses there is accumulating evidence for a genetic predisposition, but environmental influences that convert the genotype to the phenotype are also invoked. For most psychiatric illnesses it seems likely that univalent casuality will not be found. Instead, most recent research points toward the view that there is an interplay between genetics, the antenatal and perinatal physical–chemical environment, and psychological influences in early childhood development, all of which converge to create mental illness (22).

In this chapter we shall be concerned with nutrition as a branch of biology and shall deal with psychological elements only insofar as they reflect nutritional disorders or interact with the intake of nutrients to alter the mental state.

STRATEGIES OF PSYCHIATRIC RESEARCH

Typically in studying the biology of mental illness or retardation the research psychiatrist employs two major strategies (16). One is to seek metabolic defects in individuals or groups of patients who manifest similar spectra of illness. This strategy is based on the model of "inborn errors of metabolism." The second is based on the premise that when the mechanism of action of effective psychotomimetic or psychotropic drugs is understood, we will be closer to the understanding of the pathophysiology of the illness they may generate or treat.

On the whole, the search for metabolic abnormalities in mental illness has been disappointing (16). In mental retardation this strategy has been more fruitful. Tizard (3) has pointed out that although many inborn errors of metabolism resulting in mental retardation have been found, 50% of the population of retardates has no known cause (3). In todays "state of the art" there are no chemical or physiological laboratory findings that are unequivocally found in most forms of mental illness. Diagnoses are made on the basis of manifest behavior or psychological tests rather than clinical laboratory findings. Animal models are hardly used with the first strategy because "mental illness" in animals, if it exists, is difficult to define or measure. On the other hand, such models are used extensively in the study of the mode of action of drugs because only with animals can drug effects on the brain be studied directly.

NUTRITIONAL RESEARCH

The strategy of those concerned with the investigation of nutritional disorders resembles that of research psychiatrists in some regards but differs in two fundamental ways: the research psychiatrist does not have 1) animal models nor 2) chemical assays. Major advances in the discovery of nutritional disorders have come initially from experimental therapeutics. Foods that would prevent or treat nutritional deficiencies, e.g., beriberi, scurvy, and pellagra, were discovered. From these, active concentrates were made, and ultimately vitamins were isolated, chemically characterized, and synthesized. Later, diets specifically lacking vitamins, essential amino acids, or minerals were created and tested in animals to permit further knowledge of the pathobiology of the deficiency state as well as the metabolic role of the nutrients. Nutritional research has been aided considerably by the discovery of animal models of the deficiency state. It has also depended on the availability of chemical or bioassays for vitamins or other nutrients. Unfortunately, neither animal models nor chemical assays are available for the major mental illnesses.

NUTRITIONALLY INDUCED PSYCHIATRIC SYMPTOMS

From nutritional research has come the realization that severe nutritional deficiencies usually manifest themselves in a combination of somatic and psychiatric symptoms and signs. Typically the psychiatric symptoms associated with vitamin deficiencies do not show a high degree of specificity (5). Thus in pellagra, mild and prodromal symptoms may include insomnia, anxiety, vertigo, burning sensations, fatigue, palpitations, numbness, backache, distractability, and headache. Some students of pellagra noted a breakdown in the personality, with robust men becoming weary, apprehensive, and pessimistic. More-severe cases often became severely melancholic with occasional hallucinations, confusion, disorientation, and loss of memory. Some cases resembling catatonic schizophrenia have been described. Very severe cases became lethargic, stuperous, and comatose. Those advancing to this stage often died. In early cases, "pellagra sine pellagra" may be seen, with psychiatric symptoms appearing in the absence of the typical skin lesions or diarrhea. In severe cases the triad of symptoms invariably appeared. Treatment with niacin is almost always dramatic: beginning

clinical recovery can be seen in 24 hours and is usually complete within a few weeks.

The psychiatric symptoms of thiamin, riboflavin, or pyridoxine deficiency in adults resemble those of niacin deficiency, but the somatic symptoms differ considerably. Diagnosis of specific deficiency states requires a history, somatic manifestations specific for the vitamin, and laboratory tests for circulating vitamin levels or for the metabolic derangements caused by the deficiency state (27).

Thus it is difficult to discriminate between the psychiatric symptoms caused by a clinical deficiency of any single vitamin of the B complex from any other. In part this may be due to the likelihood that poor nutrition in man is usually associated with multiple rather than single dietary deficiencies. For example, in clinical pellagra there is often a riboflavin deficiency as well as the niacin deficiency. Similarly in alcoholism, where so many calories are derived from alcohol that intake of protein and other nutrients is diminished, there are probably combined deficiencies of thiamine and other water-soluble vitamins. More likely, however, the lack of specificity may be attributed to the multiple enzymatic reactions in which each of the water-soluble vitamins participate as cofactors. For thiamin there are at least 2 such reactions, for pyridoxine the number is about 50. A specific vitamin deficiency would therefore likely involve several metabolic derangements, and these would lead to multiple somatic and psychiatric symptoms.

The wide spectrum of psychiatric symptoms in nutritional deficiencies is probably also associated with the severity and duration of the disorder. Vitamins are usually precursors of coenzymes, and the dissociation constants for a given coenzyme and its many apoenzymes vary considerably. Hence, a mild deficiency would probably not affect all metabolic reactions equally. Furthermore, the metabolic rate of tissues varies with age and endocrine state. Different organs have different metabolic rates and different capacities for recovery or regeneration after injury. Hence, vitamin deficiencies are likely to be more damaging in infants than in adults, and the rapidly growing brain of the child is particularly sensitive. Acute deficiencies treated rapidly can lead to full recovery. Chronic deficiencies or repeated episodes of acute deficiency may lead to permanent brain damage.

In general, there is no substantive evidence that the common major psychiatric illnesses of adults, in this country, are caused by nutritional deficiencies or that they may be effectively treated by dietary correction. Yet there is good evidence that inadequate nutrition plays a significant role in the mental retardation and the behavioral disturbances found in children in those nations where the food supply is inadequate. It also plays a role in the rare genetic vitamin dependency illnesses, where extraordinarily large quantities of specific vitamins are required to prevent and treat both the somatic and behavioral disturbances which occur on a "normal" diet (25). Nutritional inadequacy, especially of vitamins may also occur following the chronic ingestion of drugs administered by the physician for the treatment of other conditions. Each of these will be discussed.

Finally, a group of psychiatrists, who call themselves megavitamin therapists or orthomolecular psychiatrists, advocate the use of huge quantities of vitamins for the treatment of chronic alcoholism, learning disabilities and hyperkinesis in children, and schizophrenia. The evidence supporting and denying the use of vitamins for these conditions will be critically reviewed.

PROTEIN CALORIE MALNUTRITION AND MENTAL RETARDATION

It is estimated that several hundred million people throughout the world suffer from malnutrition. Given continued population growth and the concurrent energy shortages, famine or at least chronic malnutrition will almost certainly worsen in many underdeveloped countries (6).

Many studies in impoverished societies have shown that severe, prolonged protein–calorie malnutrition is especially devastating to infants and children and that the consequences are prolonged and perhaps irreversible. The results of such studies have been summarized in several excellent monographs derived from international conferences on this subject (3,27). One exception (28) to these findings is a recent epidemiologic follow-up study of the long-term consequences of a year-long famine in Western Holland during the Nazi occupation in 1944–1945 showing no permanent effects on the physical or mental development of the children born during that period. The Holland study is interesting in its own right, but the results of a brief interlude of malnutrition in an otherwise well-endowed nation cannot be generalized to nations whose moderate malnutrition is endemic and where periodic famine is superimposed upon the chronic malnutrition.

Studies of the growth of the human brain and of the effects of malnutrition on the growth and development are more limited than those with subhuman subjects. Nonetheless Winick (30) has shown that in the human the number of brain cells increases linearly from gestation till birth, then increases more slowly till about 10 months of age, and then virtually stops. Cell size, in contrast to cell number, continues to increase for several years. Myelination occurs rapidly at birth and is still occuring at 2 years of age. The weight of the brain increases rapidly through gestation and the first 2 years of life. Its rate of growth diminishes thereafter, but adult weight is not reached until adolescence.

A few studies have been conducted on the brains of children who have died from malnutrition. The available data show that children dying from marasmus have 15%–60% fewer brain cells than normal children of comparable age. The 60% reduction is found in infants who weighed less than 5 pounds at birth; the 15% reduction is found in children with normal birth weights. It is not certain whether the child with 60% reduction was a premature infant who was more susceptible to malnutrition after birth, or whether this represents a clinical counterpart to the rat who is malnourished during gestation as well as immediately after birth.

Children with kwashiorkor who become malnourished after being taken off the breast in the second or third year of life have a normal number of cells, but the size of the cells is diminished (21).

Behavioral studies of children who survive early severe malnutrition have been reported by several groups of workers to show that these children have profound disturbances in the acquisition of language, motor skills, interpersonal relationships, and adaptive and motivational behavior. Memory defects have also been found (3).

Most of these studies have been limited to only a few years after recovery from malnutrition, but an on-going longitudinal study by Cravioto and DeLicardie should ultimately give an answer to the question of whether or not the damaging consequences of early malnutrition are truly irreversible and lead to a vicious cycle in which malnutrition during infancy results in a large pool of poorly functioning people who, because of their poor functioning, rear their children under conditions destined to produce a new generation of malnourished people.

ANIMAL STUDIES

The mechanisms by which malnutrition results in structural and functional deficits of the brain has been examined more thoroughly in animals than in humans. In malnourished infant rats there is lower brain weight, fewer neurons, abnormal neurons, and less DNA, RNA, lipid, cholesterol, phospholipid, and protein. Myelination is retarded and the pituitaries are smaller with a diminished concentration of growth hormone. In the rat, DNA synthesis and cell division stops at 17–21 days after birth, but the net protein content (indicating growth in cell size) increases until 99 days. Rats malnourished for the first 17 days of life show a permanent diminution in the number of brain cells, with different areas of the brain showing greater sensitivity than others. Malnutrition during pregnancy causes an even greater diminution in brain cell number of the pups and the brain is apparently sensitized so that additional malnutrition immediately after birth can result in a reduction of cell number by 60%. Rats malnourished after day 21, when brain cell number is no longer increasing, have a diminished cell size, but this is reversible if adequate nutrition is instituted by the 42nd day. Myelination in the rat occurs most rapidly during the 10th–21st day. Malnutrition during the first 3 weeks of life causes a deficit in total brain cholesterol and in myelination which persists for a long period of time even when the animals are nutritionally rehabilitated. Acetylcholinesterase activity is persistently elevated after neonatal malnutrition, and norepinephrine and serotonin levels are transiently reduced (3).

The chemical changes have behavioral correlates. Turkewitz (29a) has shown that rats malnourished from infancy show increased spontaneous fighting and increased passive avoidance following foot shock. Adult rats malnourished from infancy show a 50% decrease in biogenic amines following major stress. This suggests a more-limited capacity to tolerate stress than is shown by normal adults or by rats malnourished as adults. Rats malnourished during development also show a greater susceptibility than normals to electroconvulsive shock. This is only partially reversed by nutritional rehabilitation. Rats malnourished early in life show a motivational deficit in learning situations, but even when motivation is controlled for, there remains a deficit in learning tasks involving discrimination. Rats that are the progeny of six to eight generations of malnourishment and are themselves malnour-

ished show a deficit in learning of tasks that involve discrimination between correct and incorrect stimuli (27).

The monkey, who is capable of much more complex learning and social interaction than the rat, has been used by Zimmerman *et al.* (27) to study the behavioral consequences of malnutrition. In general, monkeys that are made protein deficient at 4 months of age show less play, less sexual behavior, less grooming, and more aggressive behavior than animals with adequate protein. Such low-protein monkeys show a striking avoidance of novel stimuli (neophobia), whereas high-protein animals show consistent approach responses. In learning situations low-protein animals show no deficit in learning set performance or long-term memory, and they are able to perform tasks that do not require detailed attention. On the other hand they show deficits in tasks requiring attentional or observing behavior. Whether or not this attentional deficit will persist after recovery from malnutrition remains to be determined.

Many of the behavioral changes noted in malnourished animals have been shown to actually be a product of both malnourishment and stimulus deprivation. This is particularly striking in ingenious experiments reported by Frankova (6a), who measured exploratory activity in rats. Protein-deficient rats raised with their mothers and litter mates show about a 20% decrement in exploratory activity. They also show abnormal behavior, *e.g.,* freezing, trembling, and stereotype. Rats on a normal diet, who have restricted optical and acoustic stimuli and little contact with the experimenters, show about a 30% decrement in exploratory activity. Rats deprived of both protein and stimuli show a 90% decrement. The effects of both types of deprivation simultaneously are thus more than additive, they are synergistic. The introduction of an "aunt," a nonpregnant virgin female, into the cages of protein-deprived infant rats, elevated their performance to that of normal rats. Such a "mother's helper," though she cannot offer food, tends to normalize the behavior of the rat mother and the pups.

NUTRITIONAL AND PSYCHOSOCIAL INTERACTION

Prior to the past decade research in the field of undernutrition of children focused on the somatic effects of malnourishment. More recently it has emphasized the effects on mental functions. Most studies have shown that survivors of early severe malnutrition differ from normal children in a great variety of functional aspects, ranging from psychomotor behavior to intersensory organization (3). Deficits have been found in children up to 7 years of age, but the long-term studies required to determine whether these deficits are permanently irreversible have not yet been done. Recent studies of the behavioral effects of early malnutrition have focused on the predisposing ecological conditions since many of the factors that either cause or accompany malnutrition are themselves capable of retarding mental and behavioral development.

Cravioto and DeLicardie (3) studied the ecological factors that determined which of the children in a cohort of 300 (born in 1 year in a primarily agricultural community in Central America, where literacy is low) developed marasmus or kwashiorkor. In this population, 83% of the children showed no clinical signs of malnutrition, 11.2% showed mild-to-moderate malnutrition, and 5% showed severe malnutrition. Severe malnutrition peaked to 9% after the first year of life, when breast feeding stopped. To determine the ecological correlates of the severe malnutrition, the authors measured biologic, social, economic, and psychological variables of the environment of those children. No correlations were found with per capita income, family size, sanitary facilities, age of mother, education, literacy, or the mother's personal hygiene. Curiously, mothers who listened to the radio had fewer children with severe malnutrition. On the other hand, positive correlations were found with the microenvironment of the children. Psychologists studying this cohort of children, who were unaware of the nutritional antecedents of the children, found that the degree of psychological stimulation offered at age 6 months to those children who later developed severe malnutrition was significantly lower than that of controls matched by age and birth weight. Similarly, at age 4 years, children who were medically treated and who had recovered from severe malnutrition continued to live in homes where psychosocial stimulation was significantly below that of the control group. Measurement of psychologic stimulation in these ecological studies involved the assessment of: 1) frequency and stability of adult contact, 2) vocal stimulation, 3) need gratification, 4) emotional climate, 5) avoidance of restriction, 6) breadth of experience, 7) aspects of the physical environment, and 8) available play materials.

The findings of Cravioto and DeLicardie ap-

pear to answer the question of why it is that in a relatively homogeneous socioeconomic and cultural macroenvironment, in which many children show mild-to-moderate malnutrition, only a few develop severe malnutrition. These few seem to suffer simultaneously from protein–calorie undernutrition and psychosocial deprivation. The combination seems to be synergistic and leads to devastating developmental consequences. Critical periods in early development exist for adequate nutrition and for adequate psychological input. Psychosocial deprivation seems to predispose children whose diets are marginal nutritionally to severe malnutrition. Malnutrition in turn, diminishes motivation, exploratory behavior, and those complex signals that ordinarily elicit a stimulating and gratifying response from adult parents. A vicious cycle is set up in which the effects of malnutrition synergize with those of environmental deprivation, and the consequences may well lead to irreversible emotional and mental development. It is interesting that the need for both adequate nourishment and environmental stimulation is not limited to man but has been demonstrated in every mammalian species that has been studied. Frankova (6a) has summarized the work of many investigators who have shown in animal studies that infant stimulation causes increased brain weight and a denser cortex, more-rapid myelination, accelerated development of an adult EEG, earlier development of the hypothalamopituitary system, and increased exploratory activity when they become adults. Behaviorally stimulated infants show less emotionality in novel situations and greater tolerance to stress (3). It is quite remarkable that the effects of infant animal stimulation produce so many positive anatomic, chemical, and behavioral changes that are dramatically opposite to the negative effects produced by malnutrition. There is no reason to believe that similar effects do not occur in man.

VITAMIN DEFICIENCY STATES

IATROGENIC-INDUCED VITAMIN DEFICIENCIES

Lasagna has coined the term "disease of medical progress" for those illnesses that come about as a result of the use of pharmacologic agents prescribed by a physician for the treatment of illness. The Boston Drug Surveillance Program (10) has reported that: 1) 30% of hospitalized medical patients suffer at least one drug-related adverse reaction, affecting up to 3,000,000 pa-

tients per year nationally; 2) 3% of all admissions are the result of drug reactions; and 3) deaths in the nation from these causes approximate 29,000 per year. Older patients are more at risk for all kinds of illness and use a disproportionate number of pharmacologic agents, so they are also at greater risk than other populations for the development of such illness. This section will briefly review the acquired vitamin deficiencies as they occur, usually secondary to the use of pharmacologic agents. These most commonly follow the long-term use of antituberculosis drugs, anticonvulsants, and oral contraceptives. A more-comprehensive review of this topic is available (15).

VITAMIN B_6—PYRIDOXINE

The role of this vitamin in neurobiology has recently been reviewed (4). Adults with proved vitamin B_6 deficiency show a microcytic anemia that fails to respond to iron but improves dramatically following treatment with small doses of the vitamin. Psychological symptoms may include lassitude, weakness, anorexia, depression, and mental confusion. In mild deficiency states the mental symptoms may precede the somatic ones.

Two drugs commonly used in the treatment of tuberculosis can cause vitamin B_6 deficiency. Isoniazid and cycloserine form carboxyl addition compounds with pyridoxal or pyridoxal phosphate and thus inactivate several of the enzymes for which pyridoxal is a coenzyme. Reported complications associated with the use of these drugs usually involve the central nervous system. Neurologic symptoms may include somnolence, headache, tremor, dysarthria, abnormal EEG, and convulsions. Psychiatric symptoms that have been reported include both euphoria and depression, loss of self-control, and acute psychotic episodes in which loss of reality testing is apparent. The administration of vitamin B_6 supplements along with antituberculosis medication is recommended because several reports indicate that neurologic symptoms disappear when the vitamin is given in appropriate quantities. Curiously, the psychiatric symptoms associated with cycloserine administration are less responsive than the neurologic ones. Sodium glutamate administered with pyridoxine has been reported to abolish cycloserine-induced psychoses.

The dietary precursors of norepinephrine and dopamine are tyrosine and phenylalanine; for serotonin, it is tryptophan. The conversion of

these amino acids to the neurotransmitters involves hydroxylation and decarboxylation. The amino acid decarboxylases require pyridoxal phosphate as a cofactor. It has been suggested that estrogens compete with the cofactor for binding sites on the apoenzymes. Levels of serotonin and catecholamines might therefore be expected to be diminished by oral contraceptives containing these agents. Unfortunately, these measurements are difficult to make reliably on ambulatory patients, and conflicting results have been obtained. In therapeutic trials on women receiving oral contraceptives, it has been shown that vitamin B_6 supplements improve mood and that the abnormal excretion of tryptophane metabolites in the urine of women using steroid hormones are corrected.

Since vitamin B_6 is a cofactor for about 50 decarboxylase and transaminase enzymes, it is unlikely that only one clinical symptom, *i.e.,* depression, would be associated with a pyridoxine deficiency. Consideration must therefore be given to the possibility of functional pyridoxine deficiency being contributory to other types of reported side effects. Oral contraceptives manufactured in Spain contain 25 mg pyridoxine and are reported to produce fewer side effects.

VITAMIN B_{12}

Vitamin B_{12} is involved with a wide variety of metabolic processes, including transmethylation reactions and synthesis of amino acids, purines, and pyrimidines. This vitamin is vital for blood formation and the maintenance of neuronal integrity in man.

A vitamin B_{12} deficiency due to failure to absorb this vitamin (because of the absence of the gastric intrinsic factor) results in pernicious anemia. Similar absorption failures may result from tropical sprue, ileitis, bowel operations, and some pharmacologic agents.

A number of studies have shown that 25%–30% of patients with pernicious anemia have either major or minor psychiatric problems, or both. These include depression and apathy, irritability, difficulties in concentration, confusion, and paranoid states. Neurologic symptoms result from demyelination of the dorsal columns and the pyramidal tracts and constitute a syndrome known as "combined system disease." As many as 60% of the pernicious anemia patients have been found to have an abnormal EEG.

Patients with pernicious anemia and low serum B_{12} excrete increased amounts of methylmalonic acid. Treatment with amounts of B_{12} that correct the hematologic abnormality may be inadequate to correct the metabolic abnormality, which disappears slowly with large doses. This may be one reason why mental changes may persist for some time after hematologic remission. Another reason may be that the patchy demyelination which sometimes occurs in the cerebral cortex may be irreversible.

Acquired vitamin B_{12} deficiency may follow the chronic ingestion of alcohol or may result from folic acid deficiency because folate is required for absorption of B_{12}. A deficiency may also follow the administration of neomycin, paraminosalicylic acid or colchicine. There is also an increased requirement for vitamin B_{12} during pregnancy.

The incidence of vitamin B_{12} deficiency in routinely admitted psychiatric patients has been reported to be 2%–20%. Many of these patients fail to show clinical anemia or megaloblastic bone marrow. Populations especially at risk include elderly patients and any patients receiving tranquilizers, antidepressants or antituberculosis drugs. Since the chemical assay of vitamin B_{12} blood levels in the preanemic state is neither simple nor routine, patients at risk may be most economically screened by blood smears and observations of cell morphology. Therapeutic trials with large doses of B_{12} may be worthwhile, but results with preanemic psychiatric patients are inconsistent, both excellent results and failures having been reported.

FOLIC ACID

Folic acid (Pteroylglutamic acid) is required in a large number of metabolic reactions in which 1-carbon fragments are involved. In deficiency states there is impairment in synthesis of serine from glycine and in the synthesis of purines and pyrimidines needed for DNA synthesis. Folic acid is also involved in transmethylation reactions and is thus required for the synthesis of methionine from homocysteine. Methionine in the form of *S*-adenosylmethionine is active in the transmethylation of many compounds. Since transmethylation reactions are involved in the metabolic inactivation of norepinephrine, and since aberrant transmethylation has been suggested as a source of endogenous hallucinogens (which might be implicated in schizophrenia), the role of folic acid in the pathogenesis of schizophrenia has received serious attention. Three lines of evidence suggest such a relation-

ship: 1) methionine, at a level of 20 g/day, exacerbates the symptoms of about 20% of stabilized schizophrenics; 2) large doses of folic acid have been reported to act like methionine on schizophrenics; and 3) *in vitro* brain preparations using a folate cofactor have been shown to synthesize dimethyltryptamine and other hallucinogens.

The search for abnormalities in folic acid metabolism in most psychiatric patients has not thus far been rewarding. However, in geriatric studies it has been found that 67%–80% of admissions to an old age home or to a geriatric mental ward were folate deficient. The mental symptoms most often seen were apathy, withdrawal, lack of motivation, and depression. Another report (15) suggests that chronic schizophrenics, endogenous depressives, and patients with organic psychoses who are treated with folic acid and vitamin B_{12} in addition to their usual medication have shorter hospital stays and leave the hospital in better condition than do patients treated by conventional methods alone.

Another population at risk is those receiving medication for epilepsy. A number of recent reviews (22a) related to the prevalence of folic acid deficiency in patients receiving anticonvulsant medications have implicated diphenylhydantoin, but phenobarbital alone produced microcytosis in 34% of one group of patients. Apathy and slowing of the mental processes was prominent in this population, but Reynolds (22a) has reported that most of 26 treated epileptic patients given folic acid supplements improved in drive, alertness, concentration, sociability, and speed of thinking after 1–3 months of treatment.

In a recent study, Hunter and Barnes (13) gave pharmacologic doses of folic acid to 14 healthy volunteers and had to abandon the study after 1 month because of disturbing behavioral effects in most of the subjects. Malaise and irritability were most common. Five subjects became overactive and excitable, several had insomnia, two became depressed, and several had episodes of confusion and difficulty in concentration. Whether or not this is related to the formation of abnormal metabolites derived from neurotransmitters is not known.

VITAMIN DEPENDENCY ILLNESSES

The term vitamin dependency illness refers to a group of rare, autosomal recessive genetic illnesses in which the daily requirement for specific vitamins may be 10–1000 times the estimated daily requirement of normal subjects.

This topic has been extensively reviewed in the recent literature (21, 25, 27)

The first of these illnesses was discovered in 1954, when the sibling of a child that had died from an undiagnosed and untreatable disorder was found to be having convulsions that responded to 3.0 mg pyridoxine daily (10 times the estimated daily requirement for infants). This child was treated too late to prevent mental retardation, but several years later it was demonstrated that early diagnosis and treatment of this condition with large doses of pyridoxine throughout the entire period of childhood is compatible with normal mental development. Later it was demonstrated that this disorder is genetic in origin, and in 1971 it was shown that reduction of glutamic acid decarboxylase activity occurs in the kidney of a child with pyridoxine-dependent seizure disease. Normal enzyme activity can be restored with the addition of high concentrations of the coenzyme pyridoxal phosphate *in vitro*. Children with this disorder are unable to convert glutamic acid to the inhibitory neurotransmitter, γ-aminobutyric acid (GABA), and this deficiency is apparently responsible for the seizures.

By 1970, 14 vitamin-responsive inherited metabolic diseases had been discovered; by 1974, the number had grown to 25. These genetic illnesses manifest themselves as disorders of many organ systems, and the associated clinical symptomatology may vary from none to death. Of these vitamin-responsive disorders 14, involving six of the water-soluble vitamins of the B complex, have been found to produce neurologic abnormalities. At least 6 vitamin-dependency disorders result in treatable mental retardation. One case of childhood schizophrenia responsive to folic acid has been reported (8).

The nature of the chemical abnormality and the manifest clinical symptoms of each of these illnesses depends not only on the specific vitamin whose quantity is inadequate when ingested in the usual physiologic dose, but also on the single enzyme and defective metabolic reaction. It will be recalled that each vitamin of the B complex functions as a coenzyme for multiple enzymatic reactions and that the protein apoenzyme determines the specificity of the metabolic reaction associated with the coenzyme (see Ch. 3). Pyridoxine is involved as a coenzyme for more than 50 enzymatic reactions. If any one of the protein apoenzymes is a genetic mutant, that single reaction will be affected. For pyridoxine, for example, if the enzymatic defect is in the glutamic acid decarboxylase, the clinical consequence will be

seizures; if it is in the cystathionine synthetase, the consequences will be mental retardation, cerebral vascular accidents, or psychoses; if it is in the kynurinenase, the consequence will be mental retardation. Vitamin dependency illnesses involving thiamin, pyridoxine, vitamin B_{12}, folic acid, and biotin have been demonstrated to involve mental retardation. A single case of homocystinuria presenting with schizophrenic symptoms and responding to large doses of folic acid has been described (8).

The vitamin dependency illnesses are rare because they are autosomal recessives and therefore express themselves clinically only in the homozygotic state. Diagnosis requires not only the demonstration of clinical symptoms and signs but also an abnormal aminoaciduria or some other distinctive biochemical finding (25). These illnesses are of interest for several reasons. First, they respond therapeutically to a single specific vitamin in doses 10–1000 times the usual estimated daily requirement. Such doses would be pharmacologic in the normal subject, but they are physiologic in the subjects with a vitamin dependency illness. If the metabolic abnormality is detected early in life and adequate quantities of the specific vitamin are given throughout life, the subject can live and grow with no systemic or mental abnormalities. Late detection and treatment may leave the patient with permanent residual neurologic and mental defects. Second, it seems safe to assume that with improvement in technology more vitamin dependent–inherited disorders affecting the central nervous system will be discovered in the near future. Indeed, in principle, there is no reason why similar disorders involving essential minerals might not be discovered. Third, although the incidence of these illnesses is very rare, since they are caused by autosomal recessive genes that become clinically manifest only in the homozygotic state, the incidence of heterozygosity is not nearly so rare. Thus a homozygotic condition appearing once in 40,000 births would be present in the heterozygotic condition once in 200 births. Since 25 conditions are already known and a rapid rate of discovery of new ones can be anticipated, it seems plausible that a significant portion of the population might be heterozygotic carriers. Techniques for the detection of heterozygotes require a complex technology involving either tissue culture or enzyme assays *in vitro*. Undoubtedly such techniques will become more-readily available, and once this advance is made it will become possible to determine whether heterozygotes have a normal requirement for nutrients or whether the requirement is somewhere intermediate between that of normals and that of homozygotes for the vitamin dependency illnesses.

Rosenberg (25) comments that with the present state of knowledge vitamin dependency illnesses must be considered in the differential diagnoses of patients with a wide variety of neurologic and mental deficits because early recognition leads to effective long-term treatment that may prevent lethal or disabling sequelae. This does not imply, however, that all schizophrenic illness or mental retardation will respond to a particular vitamin. Rosenberg feels that a short course of vitamins in large amounts may represent a valuable therapeutic trial in young patients with neurologic or psychiatric problems of unknown nature, but he is opposed to the use of vitamins in pharmacologic doses over long periods of time for the treatment of illnesses of unknown etiology and without demonstrable laboratory abnormalities.

MEGAVITAMIN AND ORTHOMOLECULAR THERAPY IN PSYCHIATRY

It is now generally accepted that schizophrenia is a syndrome or collection of associated symptoms with diverse and complex causes. A genetic diathesis for this condition has been demonstrated from twin and family studies (16, 18). An interaction of genetics and environment is inferred from these studies on identical twins which fail to reveal more than 40% concordance for the manifest illness. Although there seems little doubt that there is some biologic defect in schizophrenia, the nature of the biochemical defect is not known. Diminished monoamine oxidase in platelets and dopamine β-hydroxylase in brain has been reported in schizophrenic populations. Aberrant transmethylation with the formation of endogenous hallucinogens has also been proposed (18). It is also generally agreed that the phenothiazines and haloperidol do more than merely attenuate schizophrenic symptoms; rather, they seem to act on the biologic substrates of the psychotic state. The fact that most antipsychotic drugs have dopamine receptor-blocking properties has led to the suggestion that in schizophrenia there is excessive dopaminergic activity (16).

The nature of the environmental contributions to schizophrenia is also unclear. The pathogenic environment may be toxic or deficient; it

may be physical, chemical, or psychosocial. Environmental hazards may be greatest during the antenatal or perinatal period, or they may continue to act throughout childhood and even early adulthood. Research in the area of the etiology of the schizophrenias and in their treatment is very active, but crucial questions remain unanswered (24).

Almost 20 years ago, when the hypothesis of psychogenesis of schizophrenia was dominant, a biologic hypothesis was formulated which attempted to integrate the psychological, biochemical, and clinical findings in schizophrenia. From this was derived a method of treatment that employed massive doses of vitamin B_3 (niacin) added to other existing forms of treatment, such as electroconvulsive therapy and barbiturates. Over the past 20 years there has been increasing acceptance of pharmacotherapy with the phenothiazines and butyrophenones as crucial, though perhaps not sufficient, in the treatment of this illness (17). Originators of megavitamin treatment have gradually accepted the new forms of pharmacotherapy, but they always add on water-soluble vitamins in huge quantities and claim better results.

Megavitamin therapy is today a concept that is loosly defined. Initially, the term dealt with the use of 3g or more daily of nicotinic acid or nicotinamide for the treatment of schizophrenia. Later, it came to include the use of nicotinamide adenine dinucleotide (NAD), the coenzyme derived from niacin. Over the years, additional water-soluble vitamins (*e.g.,* ascorbic acid, pyridoxine, folic acid, and vitamin B_{12}) minerals, hormones, diets, and drugs have been added. The name has also been changed; it is now called orthomolecular therapy (9, 18).

The theoretic base for the use of vitamins in "mega" doses has shifted over the years. The original hypothesis was that aberrant transmethylation caused schizophrenia. Vitamin B_3 was proposed to act as a methyl group acceptor that reduced the formation of endogenous psychotogens (adrenochrome and adrenolutein). In the initial publication (11a), 20 years ago, which proposed the hypothesis and treatment, the possibility that schizophrenia was an incipient form of cerebral pellagra was considered to be very remote. Today the same proponents argue that schizophrenia is a vitamin dependency illness, resulting in cerebral pellagra and requiring exceptionally high quantities of niacin because of a postulated block between the substrate vitamin B_3 and its synthesis into the coenzyme NAD (11, 12).

In 1968, Pauling (19) published a theoretic paper supporting the possibility that some forms of mental illness might resemble the vitamin dependency illnesses. Treatment was aimed at correcting the molecular defect with appropriate nutrients. This concept was called orthomolecular psychiatry. Pauling defined orthomolecular therapy as the "treatment of mental disease by the provision of the optimum molecular environment for the mind, especially the optimum concentration of substances normally present in the human body." Advocates of megavitamin therapy quickly accepted the Pauling concept and changed the name of their treatment approach to orthomolecular psychiatry. They now employ a combination approach that still frequently uses electroconvulsive therapy, the phenothiazines, tranquilizers, and antidepressants but which also adds on very high doses of the water-soluble vitamins as well as some hormones, chelating agents, and special diets (9, 11). Orthomolecular psychiatrists state that the schizophrenias are a group of illnesses with different biochemical aberrations and that the nutritional needs of each patient must be discovered and corrected. However, in marked contrast to the research of the geneticists who continue to discover and treat new vitamin dependency illnesses, orthomolecular psychiatrists say nothing about how the biochemical irregularities are demonstrated or corrected. Furthermore, although in the recognized genetic vitamin dependency illnesses of children the addition of a specific vitamin alone results in a rapid cure with no other pharmacotherapy being needed, in the common psychiatric conditions for which therapeutic utility is claimed for massive doses of vitamins, additional pharmacologic and somatic treatments are always employed, and these are not "orthomolecular."

Orthomolecular psychiatry has been reported to be useful, not only in schizophrenia but in the treatment of hyperactive children, childhood autism, alcoholism, adverse reactions to psychomimetic drugs, arthritis, hyperlipidemia, geriatric problems, and even some forms of neuroses and depression (11). But the methods and claims of orthomolecular psychiatrists have not been generally accepted by the psychiatric community. Among the many reasons, one has been that no unequivocal biochemical defect has been found either in schizophrenia or in the other psychiatric illnesses for which its use is proposed. The differences between schizophrenia and the true vitamin dependency illnesses has been emphasized by Rosenberg, a pioneer in the discovery

of these latter illnesses (27). Furthermore, in the past decade, orthomolecular psychiatrists have used questionable diagnostic procedures and have not performed carefully controlled clinical trials.

Since the claims of therapeutic efficacy became more vigorous over the years and because the psychiatric profession was castigated for not using these inexpensive forms of treatment, a task force was established by the American Psychiatric Association (APA) to critically examine the evidence for the theory and practice of orthomolecular psychiatry. The APA Task Force (18) found no evidence to support the theory and practice of the orthomolecular psychiatrists. The theory was found to be superficial and inconsistent. For example, a single molecule of nicotinamide cannot simultaneously function as a methyl acceptor and as a precursor for the coenzyme, because once it has been methylated it cannot be synthesized into the coenzyme. Similarly the coenzyme cannot be methylated and hence cannot be a methyl acceptor. The transmethylation hypothesis and the vitamin dependency hypothesis are therefore incompatible. Yet orthomolecular psychiatrists continue to adhere to both. No evidence could be found to support the contention that adrenochrome is present in the blood or urine of schizophrenics. No evidence could be found to support the view that schizophrenia is associated with an absolute or relative deficiency of niacin. The clinical symptoms of pellagra differ vastly, psychiatrically, and somatically, from that of schizophrenia. Successful treatment of pellagra with niacin takes place rapidly, but according to orthomolecular psychiatrists, therapeutic efficacy of niacin in schizophrenia requires months or years of treatment with massive doses of the vitamin.

Nonetheless, since it seemed possible that despite the absence of evidence to support the theory the practice might still be beneficial, carefully controlled empirical trials were conducted. The very dramatic claim (18) that the coenzyme NAD made chronic schizophrenics well within a few days could not be replicated by five independent groups of investigators. The claims that niacin addition to conventional procedures enhances the treatment of schizophrenia could also not be substantiated by three separate investigators in carefully controlled studies. The vitamin in doses of 3–6 g/day was found not to diminish the requirement for chlorpromazine nor to diminish the duration of hospitalization. The possibility that a small subgroup of schizophrenics

might represent a niacin-dependent disease was rendered highly unlikely because during three studies in which several hundred patients were tested none were found to respond dramatically to niacin.

The APA Task Force Report has not remained unchallenged (12,20). The advocates of orthomolecular psychiatry have argued that the replications cited in the APA Task Force Report involved antiquated procedures using only niacin whereas now they use multiple vitamins. They have also argued that they frequently use electroconvulsive therapy along with the vitamins in the types of patients studied by the three groups that obtained negative results and that if this had been used positive results would have been obtained. However, a recent report found that electroconvulsive therapy is not a crucial variable because patients receiving this treatment along with massive doses of niacin fare no better than those who do not receive the vitamins.

The need for improved treatment of schizophrenia is so great that the authors of the APA Task Force reached their negative conclusions reluctantly. They wondered whether the wrong vitamin might have been used in the replication studies. Niacin was selected because it is, historically, the foundation around which all later claims of therapeutic efficacy were made. It was therefore felt that if the initial findings could not be confirmed, the credibility of the orthomolecular psychiatrists would be too low to warrant the expensive and time-consumming trials with other vitamins. Nonetheless, a study is now in progress at McGill University testing multiple vitamins in megadoses. Unfortunately the code has not been broken at the time of this writing.

In summary, there is no evidence at present that adult schizophrenics differ from the population at large in their nutritional requirements for niacin. A recent study suggests that the ascorbic acid requirement for schizophrenics does not differ from that of normals. The nutritional requirements for the other water-soluble vitamins or trace mineral elements has not been carefully investigated in schizophrenics, but the absence of significant somatic symptoms or biochemical findings in schizophrenia does not favor the suspicion that nutritional requirements for these differ markedly from normal. Although the toxicity of the water-soluble vitamins is not high, ingestion of massive doses of niacin and ascorbic acid over long periods of time has been reported to be damaging. Under similar circumstances

the other water-soluble vitamins may also be damaging. Since there is no evidence of benefit and there is some potential for harm, the treatment of common mental illness with doses of ten to several hundred times the usual daily requirement is not warranted.

ANOREXIA NERVOSA

The metabolic and psychiatric aspects of anorexia nervosa have been reviewed recently (14, 2). Anorexia nervosa was first defined as a clinical entity by Gull, 100 years ago (2). It is a relatively rare condition about which only a few definitive statements can be made. About 90% of the reported cases occur in adolescent girls, usually within a few years after menarche, and about 10% occur in boys, these being invariably prepubertal. Anorexia nervosa is characterized by a relentless pursuit of thinness that leads to emaciation and occasionally death. A few of the patients are schizophrenic, but most are very immature, dependent neurotics who are unable to cope with family, social, or sexual pressure except by overeating or by ceasing to eat adequately. Commonly these patients are exceptionally energetic and active even when severely underweight. They appear to treat food phobically, seeming to fear that if they submit to the temptation of food they will be unable to moderate their intake. Occasionally this happens, and one finds an alternating bulemia and anorexia.

A dramatic case (observed by the writer) involved a 13-year-old boy who achieved a maximum weight of 230 pounds. Teased by his schoolmates, he determined to lose weight. Unable to control his appetite, he would gorge himself and then secretly induce vomiting. When this was discovered by his parents, who attempted to control his food intake, he stopped eating almost entirely and presented at the hospital about 15 months later weighing 85 pounds. Initially in the hospital he cheerfully resumed his pattern of eating publicly and vomiting privately. When this was prevented he maneuvered in every conceivable way to avoid eating while giving the appearance that he was enjoying his meals. Medically and endocrinologically this boy was within normal limits. Psychologically he was intact except for a substantial conflict with his family which had always been deeply invested in food. His mother believed that fat babies were the healthiest, but that young men should be vigorous and lean. Typically he was given huge meals, told to empty his plate, and then criticized for being fat. Treatment involved several months of hospitalization with firm control and clear messages. At one point tube feeding was necessary, later he required company while eating and for several hours thereafter to prevent self-induced vomiting. He developed a good relationship with both his physician and nurses and was able to change his self-image to be more free about his choices of food, books, and hobbies. His parents changed in allowing him greater freedom to be himself. When last seen he was 16, somewhat overweight, but otherwise doing well socially and in school.

This case, though it occurred in a boy, illustrates several of the features of the syndrome. There is a markedly distorted self-image. In girls, breasts and buttucks are abhorred, and they find themselves most attractive when they are emaciated. Years later, when they are well and see a photo of themselves taken when they were ill, they will be able to recognize their lack of attractiveness, but while they are still sick they will look at themselves admiringly. Amenorrhea, which is very common, may precede or be concommitant with the weight loss, but it usually follows the weight loss and is welcomed by the patient.

Recent developments in endocrinology have eliminated some misconceptions and illuminated others. For example, the concept that it resembles Simmonds' disease or pan hypopituitaris is incorrect (14). Although the basal metabolic rate (BMR) is frequently low, direct tests of thyroid function fail to reveal deficient function. Levels of triiodothyronine (T3), thyroxin (T4), protein-bound iodine, and butanol-extractable iodine have been found to be within normal limits in severely ill patients. The low BMR is therefore probably an attempt to compensate for the extreme emaciation. At autopsy the thyroid glands appear normal (14).

Plasma 17-OHCS are normal, as is the response to adrenocorticotrophic hormone even though 24-hour urinary 17-OHCS is low. Probably there is decreased catabolism of cortisol. Growth hormone levels tend to be high and do not increase with hypoglycemia. Gonadal function in girls is clearly disturbed since amenorrhea is universal. Urinary estrogens are low, and this is manifested by atrophic vaginal epethelium. Similarly, in cases coming to autopsy, the gonads are small. The ovarian deficiency is not primary, for if it were one would find elevated gonadotrophins in response to diminished estrogen, and in anorexia nervosa this is not found. Instead urinary gonadotrophins are low. Luteinizing hormone (LH) is extremely low,

and follicle-stimulating hormone (FSH) is also low in about 50% of patients. Recent studies in which plasma LH is sampled frequently show a plasma LH pattern resembling that of pubertal girls rather than adult women (14).

Despite this impressive evidence with respect to gonadal activity, selective pituitary malfunction does not seem to be primary. Thus, the administration of hypothalamic luteinizing hormone–releasing factor (LHRF) to five young women patients led to elevation of LH and FSH in four of them. This led to the conclusion that the primary difficulty is impaired function in the hypothalamus, which is probably due to disorders of cortical function expressed as psychologic conflict. The clinical impression of disordered hypothalamic function is supported by the animal studies, which show gluco receptors in the hypothalamus which can influence eating behavior (14).

TREATMENT

There are two major issues in the treatment of anorexia nervosa: 1) nutritional deficiencies and 2) psychiatric disorders. Patients who present with severe cachexia are in a life-threatening situation and must be treated accordingly. No special deficiencies in vitamins, minerals, or protein exist, and hence no special diet is needed. The object is to increase the food intake of such patients to the 2000–3000 Cal needed in a well-balanced diet. This should be done over a period of weeks. The patients may require gastric tube feeding with liquid semisynthetic diets or even IV feeding, but the latter should be a last resort because of the many hazards involved. Physical restraints or phenothiazines in the doses employed with psychotic patients, may be needed to control them while the forced alimentation goes on. Once the patient is over the most-critical stage, feeding of solid foods in a high-protein, high-calorie diet should be resumed. Here the primary problem has been to get the patient to take the food. Some success in this has been achieved with authoritative procedures and especially with the techniques of behavior modification (2). For example, patients are permitted to make or receive phone calls only after eating. Or they may be put on enforced bed rest and allowed to get up only after they have achieved a daily specified weight gain.

Once the life-threatening crisis is over, psychological treatment should not focus on the eating problem but rather on the nature of the interpersonal relationships and stresses that underlie the eating disorder. The family should be treated simultaneously, focusing on the youngster's attempts to individuate himself. An excellent view of the types of treatment that have been useful is offered by Bruch (2), who points out that unless changes occur in the social and family structure in which the child lives, recurrences are likely. The patient must be encouraged and assisted in increasing his capacity to psychologically separate himself from his family. Although the illness is self-limiting in terms of threatening weight loss, individuals who have not changed psychologically fail to mature and usually end with other severe phobias, compulsions, or character disorders. Psychological treatment over the long run is difficult, but it is the best treatment currently available and in more than half the cases leads to disappearance of both the eating problems and the underlying conflicts so that an effective and productive life can be achieved (2).

REFERENCES

1. Bondy PK, Rosenberg LE (eds): Duncan's Diseases of Metabolism, 7th ed. Philadelphia, WB Saunders, 1974
2. Bruch H: Eating Disorders, Obesity, Anorexia Nervosa and the Person Within. New York, Basic Books, 1973
3. Cravioto J, Hambraeus L, Vahlquist B (eds): Early malnutrition and mental development. Swedish Nutrition Foundation XII. Uppsala, Almqvist & Wiksell, 1974
4. Ebadi M, Costa E (eds): Role of Vitamin B_6 in Neurobiology, Vol 4. New York, Raven Press, 1972
5. Eddy WH, Dalldorf G: The Avitaminoses—The Chemical, Clinical and Pathological Aspects of the Vitamin Deficiency Diseases. Baltimore, Williams & Wilkins, 1944
6. Ehrlich P: The End of Affluence. New York, Ballantine Books, 1974
6a. Frankova S: Interaction between early malnutrition and stimulation in animals. In Cravioto J, Hambraeus L, Vahlquist B (eds): Early Malnutrition and Mental Development. Swedish Nutrition Foundation XII. Uppsala, Almqvist and Wiksell, 1974, pp 202–209
7. Freedman AM, Kaplan HI, Sadock BJ (eds): Comprehensive Textbook of Psychiatry, 2nd ed. Baltimore, Williams & Wilkins, 1975
8. Freeman JM, Finkelstein JD, Mudd HS: Folate-responsive homocystinuria and schizophrenia. N Engl J Med 292(10):491–496, 1975
9. Hawkins D, Pauling L (eds): Orthomolecular Psychiatry—Treatment of Schizophrenia. San Francisco, WH Freeman, 1973
10. Hershel J: Drugs—remarkably non-toxic. N Engl J Med 291:824–828, 1974
11. Hoffer A: Orthomolecular treatment of schizophrenia. Can J Psychiatr Nurse 14(2): 11–14, 1973

11a. Hoffer A, Osmond H, Smythies J: Schizophrenia: a new approach. II Result of a year's research. J Ment Sci 100:29–54, 1954

12. Hoffer J: Orthomolecular Therapy—An Examination of the Issues. Saskatchewan, Canadian Schizophrenia Foundation, 1974

13. Hunter R, Barnes J, Oakeley HF, Matthews DM: Toxicity of folic acid given in pharmacological doses to healthy volunteers. Lancet i:61–63, 1970

14. Katz JL: Psychoendocrine considerations in anorexia nervosa. In Sachar EJ (ed): Topics in Psychoendocrinology. New York, Grune & Stratton, 1975, pp 121–132

15. Lipton MA, Kane FJ, Jr: The use of vitamins as therapeutic agents in psychiatry. In Shader RI (ed): Psychiatric Complications of Medical Drugs. New York, Raven Press, 1972, pp 333–368

16. Matthysse S, Lipinski J: Biochemical aspects of schizophrenia. Ann Rev Med 551–565, 1975

17. May PRA: Treatment of Schizophrenia: A Comparative Study of Five Treatment Methods. New York, Science House, 1968

18. Megavitamin and Orthomolecular Therapy in Psychiatry. Washington DC, Task Force Report #7 of the American Psychiatric Association, 1973

19. Pauling L: Orthomolecular psychiatry. Science 160: 254–271, 1968

20. Pauling L: On the orthomolecular environment of the mind: orthomolecular theory. Am J Psychiatry 131(11): 1251–1257, 1974

21. Plum F (ed): Brain Dysfunction in Metabolic Disorders. New York, Raven Press, 1974

22. Pollin W: The pathogenesis of schizophrenia-possible relationships between genetic, biochemical and experiential factors. Arch Gen Psychiatry 27:29–37, 1972

22a. Reynolds EH, Milner G, Matthews DM, Chanarin I: Anticonvulsant therapy, megaboblastic haemopoiesis and folic acid metabolism. QJ Med 35:521–537, 1966

23. Roe DA: A Plague of Corn—The Social History of Pellagra. Ithaca, Cornell University Press, 1973

24. Schizophrenia Bulletin. The Center for Studies of Schizophrenia. Washington DC, National Institute of Mental Health, 1973–1974

25. Scriver CR, Rosenberg LE: Amino Acid Metabolism and Its Disorders. Philadelphia, WB Saunders, 1973

26. Sebrell WH, Harris RS: The Vitamins. New York, Academic Press, 1968

27. Serban G (ed): Nutrition and Mental Functions. New York, Plenum Press, 1975

28. Stein Z, Susser M, Gerhart S, Marolla F: The Dutch Hunger Winter of 1944–45. New York, Oxford University Press, 1975

29. Terris M (ed): Goldberger on Pellagra. Baton Rouge, Louisiana State University Press, 1964

29a. Turkewitz G: Learning in chronically protein-deprived rats. In Serban G (ed): Nutrition and Mental Functions. New York, Plenum Press, 1975, pp 113–120

30. Winick M: Malnutrition and the developing brain. In Plum F (ed): Brain Dysfunction in Metabolic Disorders. New York, Raven Press, 1974 pp 253–261

31 Pulmonary medicine

Daniel B. Menzel

Respiratory diseases are frequently encountered in all social and economic groups. Local environmental problems may be evidenced in specific respiratory problems generally associated with occupational exposures, *e.g.,* byssinosis of the cotton worker, pneumoconiosis of the coal worker, or organic solvent intoxication of the chemical worker. More-widespread respiratory diseases, especially chronic asthma, chronic bronchitis, and emphysema, are influenced by the degree of air pollution in local urban areas but are also present in rural populations. The pulmonary manifestations of cystic fibrosis appear to be independent of locality. Since respiratory disease is diverse and is often present with other chronic diseases, the prognosis for patients afflicted with respiratory diseases is highly variable.

Nutritional approaches to the treatment of respiratory diseases are controversial. Definitive long-term studies using double-blind test protocols have not been conducted on all studies. Consequently, most of the material discussed here is based on clinical reports and extrapolated from animal experiments.

ASTHMA, BRONCHITIS, AND ATOPIC SYNDROME

True allergic responses of the atopic patient are likely to manifest in either dermal or pulmonary reactivity. Considerable progress has been made in understanding the basic mechanism of the allergic response. It is now apparent that mast cells of all tissues respond in the same manner through the same receptors and mediators. Immunoglobulin of the E series (IgE) may be fixed on a number of cell membranes and may react with antigens to cause the release of inflammatory hormones. The clinical manifestation of such a release depends on the extent of involvement of the tissues exposed to the antigen. Since the lung possesses a relatively large number of mast cells and is the recipient of highly potent airborne antigens or allergens, bronchoconstriction and the resulting respiratory distress are common manifestations of the allergic response in man.

Austen (3) has reviewed the present knowledge and examined the hypothesis of allergic components of asthma. Clearly not all of the symptoms of the disease can be explained as the result of the IgE-mediated release of vasoactive hormones. The relatively uniform response to pharmacologic agents, especially β-adrenergic agonists (isoproterenol), supports the concept that a dysfunction of the IgE-mediated release of vasoactive hormones is a central cause of this disease. Current therapy is based on the use of β-adrenergic agonists or inhibitors of the cyclic nucleotide phosphodiesterase.

PHARMACOLOGIC BASIS FOR THERAPY

Austin has proposed the scheme shown in Figure 31–1 for the pharmacologic basis of the modulation of the release of vasoactive hormones. Briefly, the agonists, isoproterenol and epinephrine, act on the β-adrenergic receptor to activate an intracellular adenylcyclase raising intracellular levels of cyclic 3′,5′-adenosine monophosphate (c-AMP). The methylxanthines similarly raise intracellular levels of c-AMP by inhibiting phosphodiesterases that degrade c-AMP. Phenylephrine or norepinephrine in the presence of propranolol act on the α-adrenergic receptor to lower intracellular c-AMP levels. The release of histamine, slow-reacting substance of anaphylaxis, and eosinophil chemotactic factor by IgE-mediated degranulation reactions is inversely proportional to the intracellular c-AMP concentration. Drugs acting to increase c-AMP concentrations provide relief from the symptoms of asthma, whereas those decreasing c-AMP concentrations exacerbate the symp-

toms. Similarly, acetylcholine or carbicol stimulate the cholinergic receptor of the mast cell to increase the intracellular levels of cyclic 3', 5'-guanosine phosphate (c-GMP). Increasing the level of c-GMP increases the release of vasoactive hormones by IgE. The treatment of choice then is to augment the β-adrenergic system. Isoproterenol is particularly useful as an aerosol inhaled directly by the patient during asthmatic attacks. Because of the rapid relief afforded by isoproterenol (Isoprel inhalers), the drug has become abused. Epinephrine continues to be useful. Long-term therapy is afforded by aminophylline and theophylline; these methylxanthines are particularly useful with children. Some therapeutic failures reported with the methylxanthines may be the result of errors in prescription due to variable concentrations in different proprietary preparations or to variable metabolism by the patients. Atropine is a classic drug providing cholinergic blockade but is less useful than adrenergic agents in chronic therapy. Obviously, cholinomimetic and α-adrenomimetic drugs as well as β-adrenergic antagonists are counterindicated in the treatment of atopic disease syndromes.

Sodium chromoglycate (Chromalyn) is rapidly becoming one of the prime means of chronic and preventative treatment. Chromoglycate acts on the mast cell by means other than the adrenergic system to decrease the magnitude of the IgE-mediated degranulation reaction. The interaction of antigen with cell-bound IgE is, however, not prevented. Because of the rapid destruction of the drug, chromoglycate must be given directly by inhalation of a respirable powder.

Steroids are useful for suppression of the immune response in extreme cases, but their use may increase the hazard of infection and unwanted actions. It is generally agreed that steroid therapy is useful only on an intermittent basis under very careful supervision.

IDENTIFICATION OF ALLERGENS IN ASTHMA

An alternative approach to asthma is the identification of offending antigens. Radioallergosorbent tests (RAST) have been developed to detect the presence of immunologically specific IgE for certain antigens (1). The RAST is virtually as reliable as the conventional dermal and sublingual challenge tests. The RAST is conducted *in vitro* and has the advantage of offering little or no hazard to the patient from the exposure to a highly potent antigen. The identification of the offending antigen likely to provoke an attack allows two additional methods of treatment which have met with variable success. Avoidance is an obvious choice that can not always be accomplished. A second choice is the injection of the purified allergen in hopes of raising immunologically specific IgG. Such an IgG could compete with the fixed IgE to decrease circulating levels of the antigen. Multiple problems arise in this method of treatment, especially in the immunologic specificity of the IgG produced from isolated antigens.

Fig. 31–1. Pharmacologic approaches to IgE-mediated release of vasoactive hormones. (Austen KF, Lichtenstein LM (eds): Asthma, Physiology, Immunopharmacology and Treatment. New York, Academic Press, 1973, pp 109–119)

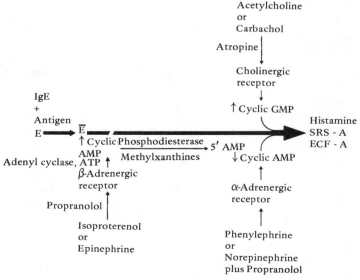

Because of the potency and ease of access to the bronchial epithelium, most clinical attention has focused on the airborne allergens of pollen, molds, and plant and animal materials. Positive challenge tests have been demonstrated in numerous cases, and RAST specific for these allergens have also been demonstrated, illustrating the presence of circulating immunologically specific IgE. One might ask whether food antigens are also likely to provoke respiratory distress. Two opposing schools have developed.

FOOD ALLERGENS AS A BASIS FOR AIRWAY DISEASE

An extensive literature exists on the association between milk sensitivity and asthma, chronic rhinitis, and chronic bronchitis. Cook (4) has recently reviewed the evidence for such an association. Familial recurrent rhinorrhea and bronchitis have been reported to be due to sensitivity to cow's milk antigens, and complete elimination of cow's milk and dairy products are reported to relieve the symptoms. Immunologically specific IgE to cow's milk antigens have been detected in both symptomatic and asymptomatic patients. Urticaria and angioedema due to food allergens are also reported associated in extreme cases with life-threatening upper respiratory obstruction, hypotension, or both (15). Chocolate, nuts, soy products, rice, corn oil, oranges, and oats have also been suspect. The most difficult situation is the expression of milk sensitivity by infants as an upper airway obstruction. Such cases are often associated with diarrhea and failure to thrive. The method of treatment is breast milk, or lacking that, commercial soy protein–based infant formulas.

The second school of thought is evidenced by Patterson (12), who proposes that food allergens are not likely to reach the mast cells of the nasal mucosa or the bronchial smooth muscle because of the barriers excluding foreign proteins from the circulation. In Patterson's view, IgE-mediated rhinitis is the direct contact of the allergen with the nasal mucosa. Because of their presence in normal patients, cow's milk antibodies are taken to have no clinical significance. An exception, according to Patterson, is the sensitivity of hayfever patients to cucumbers and melons during the hayfever season.

Controlled experiments have not been undertaken to support the role of food allergy in upper airway diseases. Food has not been concealed in opaque capsules and presented to the patient. A test of the food allergy hypothesis by the use of Rowe's cereal elimination diets has brought negative results (16).

SALICYLATE SENSITIVITY IN ASTHMA

Agreement does exist on the sensitivity of a small fraction of asthmatics to salicylates, but such sensitivity is not universal. Salicylates and salicylate metabolites are suspect. An approved food color, FDC No. 5, tartrazine, produces urticaria and angioedema in aspirin-sensitive patients. Asthmatics are often supposed to be sensitive to aspirin, but the general sensitivity may be more due to the known pharmacologic actions of aspirin to inhibit irreversibly the cyclooxygenase of the prostaglandin and thromboxane system. In contrast, the tartrazine–aspirin sensitivity extends to benzoic acid, which does not inhibit cyclooxygenase (nor does tartrazine). Benzoic acid is a common food preservative; tartrazine is found in many foods and medicaments. Perhaps the greatest hazard to the aspirin-sensitive patient lies in over-the-counter drugs that contain aspirin, but which are not recognized as such by the patient.

RECOMMENDATIONS

In allergic rhinitis, allergic bronchitis, asthma, and patients having urticaria or angioedema, or both, associated with respiratory distress, a competent search for potentially offending food allergens can be undertaken. Cow's milk, chocolate, nuts, fish, rice, corn oil, soy products, oranges, and oats are most commonly reported as associated with these syndromes. Elimination diets can be used, but their success depends on the adherence of the patient to the diet and the attention given by the physician. Equivocal results may occur. Sensitivity of the patient to aspirin suggests that the patient be directed to avoid medications containing aspirin and tartrazine. The patient should be warned of the existence of tartrazine in foodstuffs and that benzoic acid and oil of wintergreen are likely to be offending compounds. None of the nutritional approaches to eliminate allergens will supplant the pharmacologic treatment, nor will they modify the response of the patient to drug therapy. There is little doubt that a strong psychologic component influences the course of atopic diseases, especially asthma, rhinitis, and bronchitis. Thus although clear-cut evidence that a food antigen is the basis of asthma or other allergic upper airway diseases has yet to appear, the assurance and rapport likely to result from a nutritional approach may be the principle benefit.

VITAMIN C AND THE COMMON COLD

The common cold is so often used to describe respiratory diseases that its true incidence is probably grossly inflated. The public has come to use "colds" to encompass a wide spectrum of upper respiratory symptoms, and a clear differentiation between colds and allergic rhinitis is not generally made. Still, in the double-blind studies of vitamin C at the National Institutes of Health, there were about 1.6–1.9 episodes per person per year lasting from about 6 days. If these statistics are representative of the population of the United States at large, then the number of man–days lost to colds represents a considerable loss of productive effort. This premise has initiated massive studies designed to test the efficacy of vitamin C in preventing or reducing the symptoms of the common cold.

The mechanism by which vitamin C may affect rhinovirus infection is not known, if indeed one does exist. Pauling (13) revived much of the controversy surrounding the effect of the vitamin on colds and has presented the evidence concisely in favor of a prophylactic and therapeutic effect. The best scientific summary of the large-scale studies on vitamin C in man are presented in the proceedings of the Second Conference on vitamin C (2, 5, 7, 17).

Most investigators state a prior bias against any prophylactic or therapeutic effect of the vitamin as the main factor for initiating their studies. Such a statement seems odd in a supposedly unbiased double-blind study and, of course, would not be tolerated in a therapeutic trial of a drug. Placing this complication aside, the presently completed trials fall into two categories: 1) a small effect on symptoms, but no effect on incidence, or 2) a large effect on both symptoms and incidence of episodes of colds. Unfortunately, there is no uniformity in the protocols of the studies nor in the statistical analysis. All of the studies have been on "free-living" subjects and subsequently are dependent on the uniformity of the nutritional background, exposure to the infectious agent, uniformity of susceptibility, and unknown supplementation with the vitamin.

LARGE-SCALE TESTS OF VITAMIN C

Anderson and his colleagues (2) have conducted three trials on adults in Toronto. In their first study, a 30% decrease was found in the number of days indoors due to colds when the subjects received 1 g/day for maintenance and 4 g/day during the first 3 days of illness. The mean number of episodes of colds decreased by 7% with vitamin C treatment, but this was not statistically significant. A larger study was undertaken to repeat these results and to separate potential therapeutic from prophylactic effects. In an attempt to detect a dose–response relationship, vitamin C was given in graded doses from 0.25 to 2 g/day. No positive correlation could be found between the increasing dose of the vitamin and the prophylactic or therapeutic effect. Assuming that tissue saturation with the vitamin might be a limiting factor in the achievement of a significant effect, a third study was undertaken using a sustained release preparation of either 0.5 or 1 g/day. This preparation gave significant symptomatic relief of chest discomfort, feeling feverish, and number of days of shivering. On the short term, 2–4 days of duration of the episode, the number of days spent indoors because of cold also decreased.

Lewis et al. (7) reported a supposedly double-blind study of National Institutes of Health personnel in which either 0 or 3 g/day were given for prophylaxis or therapy. The study failed after 9 months when the number of patients dropping out of the placebo group became disproportionately large. The authors admit that the blindness of the study was probably lost earlier when it was discovered that the patients were tasting the capsules and identifying the vitamin C–containing capsules. Despite these complications, the placebo groups had a higher incidence of symptom–days than did the treated groups. The placebo group receiving no vitamin C had 7.14 symptom–days, whereas the 3 g/day groups had 6.59 and the 6 g/day group 5.92 symptom–days. Overall, the vitamin C–treated subjects had milder symptoms in 18 of the 20 symptoms scored.

Three studies have been conducted in school children. Coulehan et al. (5) have studied Navaho children using 1 or 2 g/day for a 14-week exposure period. During this study the treated children had 28%–34% fewer days of symptoms than the placebo group. No prophylaxis was detected. A second study using the same methodology and schools but 1 g/day failed to substantiate any effect. Major observer bias was detected, and the authors plan to reevaluate their conclusion on the basis of blood vitamin C levels when the analyses become available.

Wilson (17) studied a group of Irish school children using either 200 or 500-mg doses and found a significant reduction in the incidence, severity, duration, and total symptoms of colds. This group of workers used a completely differ-

ent statistical method of symptom interaction and proposed that the cold is composed of two classes of symptoms: 1) toxic and 2) catarrhal. Toxic symptoms include sore throat, headache, feverishness, and feeling "out of sorts." Catarrhal symptoms are cold in the head, cough, nasal obstruction, and nasal discharge. Toxic symptoms were suppressed at 200 mg, but catarrhal symptoms were not. Further, there was a definite sex difference. A dose of 500 mg provided a calculated protection of 30%–40% in girls but none in boys.

METABOLISM OF VITAMIN C DURING COLDS

In a subsequent study, Wilson *et al.* (18) found a very marked difference in the metabolism of vitamin C both during a cold and between the sexes. The vitamin C levels of leukocytes drop dramatically during infection, and large doses of vitamin C are required to raise the leukocyte level back to the precold or postcold values. The most striking aspect of this report is that even 2 g vitamin C was inadequate to restore leukocyte levels to their normal level in males. The subjects of this study were drawn from the university student population and were presumably adults. Thus the sex differences found in children persist into adulthood.

Wilson suggests that 500-mg doses will increase both plasma and leukocyte levels in females, whereas up to 2 g will give only plasma increases in males. Such data suggest marked differences in the pharmacokinetics of vitamin C both during colds and between the sexes. Wilson's group suggests that the ratio of the plasma to leukocyte levels is an index of tissue saturation. To be therapeutically active in their view, any trial dosage of vitamin C must be sufficient to maintain the precold plasma to leukocyte level during a cold. In support of this concept, Wilson *et al.* claim a positive correlation between prevention or reduction of the severity of the cold and maintenance of "tissue saturation." Males were also observed to have colds of greater severity.

It is discouraging that the present studies on the efficacy of vitamin C have not been undertaken without adequate precautions to prevent patient recognition of the dosage regimen. The most critical error in the studies is the lack of recognition of the pharmacokinetic data presented by Wilson *et al.* These data clearly show that most of the regimens tested were without any consideration of the potentially attainable plasma and tissue levels of vitamin C. Aside from

Wilson's group, plasma levels either were not measured or were taken so late after the last dose of vitamin C as to be predictably too low to show any differences. That no sex differences were reported by others raises serious conflicts with the data of Wilson's group and the other investigators. If these studies were to have been undertaken with a potential drug instead of a vitamin, adequate pharmacokinetic experiments would have been completed in a Phase I Preclinical study prior to any Phase III Clinical study, such as that reported here.

SAFETY OF VITAMIN C

Little or no toxic effect has been reported from the ingestion of up to 5 g/day. Acidosis has not been observed with 3–6 g/day given to produce urinary acidity in conjunction with methenamine mandelate (Mandelamine) therapy. Since about 50% of the excreted oxalic acid is derived from vitamin C, oxaluria or oxalosis has been feared. Patients with oxalosis should avoid excessive amounts, but no evidence of oxalate stones have appeared in normal subjects. Similarly, the urinary acidification resulting from vitamin C supplementation has not produced nephrocalcinosis as suggested. The hyperglycemia and glycosuria reported with vitamin C are due to analytic errors produced by the reduction of colorimetric agents for glucose by ascorbate and the activation of glucose oxidase by ascorbate. No physiologic effects have been detected. Nausea, abdominal cramps, and diarrhea may occur on occasion and may be due to allergic reactions that are not as yet clearly documented. Most likely these effects are really due to the acidity of vitamin C and can be prevented by buffered preparations or by taking the dosage after meals. Some suggestion has appeared that increasing the extradietary vitamin C can result in "conditioning" the body to higher levels of vitamin C. Abrupt removal can precipitate scurvy in the patient. Scurvy has been reported in two infants whose mothers took large doses of vitamin C during pregnancy, but who were maintained only on normal vitamin supplements postpartum. Vitamin C may antagonize dicumarol, but this can be compensated for with appropriate prothrombin time assay and adjustment of dicumarol dosage. Serum cholesterol may be elevated by vitamin C and therefore may be counterindicated in arteriosclerotic patients. In sum, the normal patient should be warned not to discontinue supplemental vitamin C abruptly and the physician should be alert for signs of scurvy in

patients who have done so. Otherwise the toxic effects of vitamin C are minimal.

RECOMMENDATIONS

To the practitioner, the present studies on the effects of vitamin C on the common cold come down to two choices. One can ignore the claims and recommend that the patient eat a normal varied diet sufficient to provide the recommended daily allowance of the vitamin. Certainly, no toxic or other adverse effects are likely to result from the middle road of 100–200 mg/day additional vitamin C. Alternatively, one can accept the claims and follow the aggressive recommendations of Wilson. A 2-g load dose appears essential to provide even a modest elevation in plasma levels of vitamin C during a cold. A therapeutic regimen would be 2 g/day for 4 days during a cold. A prophylactic dose would be 500 mg/day. Mild scorbutic signs may occur in infants born to mothers taking such a dose.

VITAMIN E AND OBSTRUCTIVE LUNG DISEASE

Emphysema and other obstructive respiratory diseases represent the cause of a growing number of permanent disabilities. Respiratory cripples are unable to function in productive work and probably succumb earlier as a result of their disease. The incidence of chronic obstructive lung diseases had been positively correlated with the level of oxidant pollution in urban areas. Exposure of rats and mice to higher than ambient levels of the oxidizing air pollutants, nitrogen dioxide and ozone, leads to an emphysemalike pathologic condition. The pathology of nitrogen dioxide and ozone differ only slightly from each other. The propensity toward emphysema in man may be genetically predetermined through the α_1-antitrypsin levels in the serum and tissue. Patients having low levels of or genetically altered α_1-antitrypsin often have emphysema, but the correlation is not absolute. Defects in the α_1-antitrypsin system may be a major predisposing factor. Similarly, air pollution may represent an initiating factor of lung damage that results in emphysema.

AIR POLLUTANTS CAUSING LUNG DISEASE

Oxidizing air pollutants are formed by photochemical reactions in the air as a result of the burning of hydrocarbon fuels. Auto emissions represent the major source of these toxicants. Ozone is the more toxic pollutant, being about 30 times more toxic on a weight basis than nitrogen dioxide. Rural populations may be exposed to nitrogen dioxide and ozone as photochemical smog drifts over the continental United States or is swept from urban areas out to sea and then returns to urban areas by cyclonic air movements. Ozone also is produced naturally in the air from electric storms, from incursions of ozone from the stratosphere into the troposphere (where we live), and from photochemical reactions catalyzed by hydrocarbons released naturally from pine forests and other plants. Unfortunately these sources of ozone and nitrogen dioxide are sufficiently widespread and of large enough scale to expose the majority of our population to levels having biologic effects. Some concern has also been raised over the potential mutagenic effects of these gases, but no clinically demonstrable effects have been shown in man.

A major dilemma is whether or not a threshold or no effect dose exists for nitrogen dioxide and ozone. Experiments measuring the resistance of the mice to subsequent challenge by infectious agents suggest that a true threshold does not exist for nitrogen dioxide. Toxicity appears better correlated with the maximum concentration to which the animals are exposed than with the product of the concentration and the time of exposure, as has generally been assumed. Man is exposed to brief, but high, levels of these air pollutants due to the photochemical nature of the production and the diurnal cycle of human activity. Should the sensitivity of mice to nitrogen dioxide prove similar to that of man, then the present levels are likely to produce greater damage than originally supposed.

PROTECTIVE MECHANISM OF VITAMIN E IN AIR POLLUTION

Ozone and nitrogen dioxide probably exert their toxic action through the oxidation of unsaturated fatty acids, either in the blood or in cell membranes (8). Once ozone or nitrogen dioxide attacks the unsaturated fatty acid, highly chemically reactive species are produced which either are free radicals or which subsequently generate free radicals. Free radicals mediate peroxidation of cellular unsaturated fatty acids in a manner already known for the oxidative rancidity of unsaturated fats and oils. Addition of phenolic antioxidants to unsaturated fatty acids retards the oxidative rancidity. Vitamin E is a naturally occurring phenolic antioxidant which is effective in the ozone and nitrogen di-

oxide–catalyzed oxidation (14). Alterations occur in the lung tissue fatty acid composition of animals exposed to nitrogen dioxide and ozone suggestive of peroxidation *in vivo*. Feeding high levels of vitamin E in the diet retards these oxidations and increases the survival time of mice and rats exposed to lethal concentrations of both ozone and nitrogen dioxide (10).

Using an indirect test of the susceptibility of human erythrocytes to peroxidation, vitamin E was found to prevent oxidative damage by a putative chemical mediator of ozone intoxication, unsaturated fatty acid ozonides (11). Unsaturated fatty acid ozonides are formed on the ozonolysis of lipids and probably occur in plasma exposed to ozone. Volunteers were given 0, 100 IU, or 200 IU vitamin E acetate per day in addition to their normal intake of about 8 mg total tocopherol. Protection of the erythrocytes of these volunteers against Heinz bodies formed by oxidation of the erythrocyte membrane by ozonides was greatest with 200 IU per day but not significantly greater with higher doses.

Preliminary reports suggest that vitamin E is mobilized when volunteers inhale ozone at concentrations slightly above current air pollution levels. The physiologic consequences of such a mobilization are not clear.

ALTERNATIVE REGIMENS OF VITAMIN E

The biologic activity of vitamin E is ascribed by current theories to stabilization of the physical properties of the membrane, scavenging of free radicals generated by lipid peroxidation and recently as a modulator of the prostaglandin system (9). All of these theories are predicated on the observed membrane effects of vitamin E since it is the membrane concentration which is therapeutically important. Like vitamin C, controversy swirls around the appropriate dose of vitamin E likely to provide the greatest prophylactic effect. Since the symptoms taken as indications for the use of vitamin E vary widely, it is not surprising that the recommendations for doses also vary by 1000-fold. The occurrence of frank classic deficiency signs in man (creatinuria, muscular dystrophy, anemia, and liver necrosis) at the present intake of an average of 9 mg total tocopherols is so rare as to be undetectable. Premature infants may evidence classic signs of deficiency, especially sensitivity of their erythrocytes to oxidative hemolysis from vitamin K injections or dietary iron. These effects can well be prevented by the current recommended levels of 10–15 IU. Vasodilation as observed in the prevention of intermittent claudication requires 200 IU/day for an extended period of at least several months. Protection of erythrocytes against peroxidative agents, including ozone and nitrogen dioxide, requires 200 IU/day and can be achieved after a few days of intake, certainly no more than 7 days. These levels are analogous to the dietary levels found to be protective in rats and mice exposed to high concentrations of ozone and nitrogen dioxide. There is no information on the level of vitamin E in the lung with prolonged intake of the vitamin at these levels. Hopefully, the erythrocyte membrane is representative of the cell membranes in general, and similar protective effects will occur in the human lung at 200 IU/day.

No direct experiments have been conducted in man on the protective effects of 200 IU/day. The rate of conversion of ozone to chemical mediators, such as fatty acid ozonides, is difficult to predict from animal experiments. Direct experiments in man are planned for the very near future.

SAFETY OF VITAMIN E

Large doses of vitamin E have been consumed in double-blind experiments for the prevention of intermittent claudication. Gastric upset occurred in a few cases. No other pathophysiologic signs could be detected with several years of ingestion of 200–500 IU/day. Doses of 1000 IU/day have been reported without any adverse reactions. An allergic dermatitis has been reported from the topical application of vitamin E preparations. Most of these reports were with natural oils that had been enriched in their tocopherol content by partial vacuum distillation of the oil. The mixture contains not only vitamin E (D-α-tocopherol) but other tocopherols, tocotrienols, and plant steroids. One can not be sure that the carrier or other materials might not be responsible for the dermatitis. No deficiency syndromes have been reported on the abrupt discontinuation of vitamin E supplementation. From animal experiments, high vitamin E may stimulate the storage of arachidonic acid in the tissues. Potentiation of dicumerol therapy has been reported for high vitamin E supplementation in one case. Patients on dicumerol should be monitored for changes in prothrombin time. Considering the millions of IU vitamin E self-administered daily in the United States, the paucity of adverse reports assures a relatively safe preparation.

RECOMMENDATIONS

Since no one knows the toxic effects of air pollutants to which everyone is exposed everyday, it seems prudent to provide a supplemental dose that has little or no potential toxicity until direct experiments are completed. The recommended dosage of 200 IU/day seems to fit these criteria. Such a dose may provide an added benefit in reduction of platelet aggregation.

CYSTIC FIBROSIS

Cystic fibrosis may manifest pulmonary involvement, but it is not necessarily fatal, and with care patients may survive into the fourth decade or longer. A more-detailed description of the nutritional approaches to cystic fibrosis is presented in Chapter 29. The impaired absorption of fat-soluble vitamins may result in marginal squamous metaplasia of the respiratory epithelium. There is little doubt that although cystic fibrosis is not an organ disease it does influence all tissues, including the lung. Provision of increased vitamins A and E can prevent these marginal signs of deficiency. Since this disease is associated with electrolyte transport dysfunction, trace elements such as zinc may become more important in the nutritional support of such patients. Zinc also functions in the transport of vitamin A via its stimulation of the release of retinol-binding protein. The question is under active clinical investigation and hopefully will be resolved shortly.

NEONATAL CHYLOTHORAX

Neonatal chylothorax is relatively rare, and the spontaneous course is unpredictable. The etiology of chylothorax is unknown, but chylous plural effusions are likely to make up a major fraction of such exudates during the neonatal period. Chylothorax occurs also at times following thoracic surgery. Repeated thoracentesis or continuous drainage are present methods of treatment. These procedures increase the chances of infection, pneumothorax, and repeated loss of both fat and lipid, potentially compromising the nutritional status of the patient. An alternative is the administration of medium-chain triglycerides that pass directly into the portal system bypassing the lymphatic system. Gershanik *et al.* (6) present an interesting application of this method to neonatal chylothorax, but their method has more-general value as a method to treat other conditions of impaired lymphatic drainage. A commercially prepared medium-chain diet (Portagen) is available for use.

REFERENCES

1. Aas K, Johansson SGO: The radioallergosorbent test in the in vitro diagnosis of multiple reaginic allergy. Clin Immunol 48:134–142, 1971
2. Anderson TW: Large scale trials of vitamin C. Ann NY Acad Sci 258:498–503, 1975
3. Austen KF: A review of immunological, biochemical and pharmacological factors in the release of chemical mediators from human lung. In Austen KF, Lichtenstein LM (eds): Asthma, Physiology, Immunopharmacology and Treatment. New York, Academic Press, 1973, pp 111–120
4. Cook WG: Food allergy—the great masquerader. Pediatr Clin North Am 22:227–238, 1975
5. Coulehan JL, Kapner L, Eberhard S, Taylor FH, Rogers KD: Vitamin C and upper respiratory illness in Navaho children: preliminary observations (1974). Ann NY Acad Sci 258:513–521, 1975
6. Gershanik JJ, Jonsson HT Jr, Riopel DA, Packer RM: Dietary management of neonatal chylothorax. Pediatrics 53:400–403, 1974
7. Lewis TL, Karlowski TR, Kapikian AZ, Lynch JM, Shaffer GW, George DA: A controlled clinical trial of ascorbic acid for the common cold. Ann NY Acad Sci 258:505–512, 1975
8. Menzel DB: Toxicity of ozone, oxygen and radiation. Annu Rev Pharmacol 10:379–394, 1970
9. Menzel DB, Anderson WG: Modulation of prostaglandin synthesis and sensitivity by vitamin E and other antioxidants. Fed Proc 34:912, 1975
10. Menzel DB, Roehm JN, Lee SD: Vitamin E: the environmental and biological antioxidant. J Agric Food Chem 20:481–486, 1972
11. Menzel DB, Slaughter RJ, Bryant AM, Jauregui HO: Prevention of ozonide-induced heinz bodies in human erythrocytes by vitamin E. Arch Environ Health 30:234–236, 1975
12. Patterson R: Rhinitis. Med Clin North Am 58:43–54, 1974
13. Pauling L: Vitamin C and the common cold. San Francisco, WH Freeman, 1970
14. Roehm JN, Hadley JG, Menzel DB: Oxidation of unsaturated fatty acids by ozone and nitrogen dioxide: a common mechanism of action. Arch Environ Health 23:142–148, 1971
15. Sheffer AL: Urticaria and angioedema. Pediatr Clin North Am 22:193–201, 1975
16. Van Metre TE Jr, Anderson AS, Barnard JH, Bernstein IL, Chafee FH, Crawford LV, Wittig HJ: A controlled study of the effects on manifestations of chronic asthma of a rigid elimination diet based on Rowe's cereal free diets 1, 2, 3. J Allergy 41:208, 1968
17. Wilson CWM: Ascorbic acid function and metabolism during colds. Ann NY Acad Sci 258:529–538, 1975
18. Wilson CWM, Greene M, Loh HS: The metabolism of supplementary vitamin C during the common cold. J Clin Pharmacol 16:19–29, 1976

32 Surgery

Bruce V. MacFadyen, Jr., Edward M. Copeland, III, Stanley J. Dudrick

PRINCIPLES OF SURGICAL NUTRITION

CAUSES OF MALNUTRITION

Malnutrition has often gone unrecognized or been inadequately treated when discovered in surgical patients. Since the relatively recent innovation of intravenous hyperalimentation, malnutrition has been diagnosed and treated more frequently and effectively than in previous years (15). Catabolism is a usual consequence of surgical diseases and operations and frequently leads to weight loss even after such seemingly small procedures such as inguinal herniorrhaphy and cholecystectomy. This weight loss usually results from protein–calorie malnutrition. In the past, malnutrition was usually regarded as a vitamin, electrolyte, or trace element deficiency, and the consequences of protein–calorie deficiencies were often overlooked. Even today, major operations are carried out on patients who are not adequately prepared nutritionally, and this practice is likely to lead to an increased morbidity and mortality. In a recent review of hospitalized patients (4), significant protein–calorie malnutrition (PCM) was observed in 25%–50% of medical and surgical patients who were in the hospital for two weeks or longer. These patients, therefore, were more vulnerable to concurrent illnesses and had a greater susceptibility to infection and other complications. An increased risk of complications can be expected in: 1) patients who are grossly overweight; 2) patients who are grossly underweight; 3) patients who have pancreatic insufficiency, celiac disease, Crohn's disease, or patients who have had massive bowel resections; 4) patients with chronic alcoholism; 5) patients who have been on IV solutions containing only 5% dextrose and electrolytes for two weeks or longer; 6) patients with increased metabolic requirements secondary to fever, trauma, hyperthyroidism, pregnancy, burns, and infancy; 7) patients with protein–calorie losses from enterocutaneous fistulas or abscesses; and 8) patients who are unable to eat at least 1500 Cal and 80 g protein/day after 10 days of relative starvation.

EVALUATION OF NUTRITIONAL STATE

In order to determine the nutritional status of the patient, the most useful measurements have been the patient's height and weight. Rapid weight loss, especially in a hospitalized patient, is a signal of hypercatabolism which should be treated as judiciously as chronic weight loss occurring over a period of months. Edema is frequently seen in patients with PCM and usually occurs when the serum albumin level is less than 3 g %. Since height is rarely altered by PCM, weight–height ratios may provide valuable data concerning the level of malnutrition. Other indices that can be used for nutritional evaluation include triceps skin fold measurements, upper arm circumference, serum albumin and prealbumin levels, height–creatinine ratios, total serum lymphocyte counts, serum transferrin levels, hair and nail growth, serum carotene levels, and nitrogen balance (3). Using these measurements, the patient's level of nutrition can be classified and monitored as discussed in Dr. Blackburn's chapter in this textbook (see Ch. 10). Vigorous nutritional therapy is indicated in all patients with malnutrition, especially when the body weight has decreased 20%–30% below normal. A routine oral diet is usually not sufficient for correction of such severe degrees of malnutrition, and a high-calorie, high-protein diet with supplemental IV feedings is often necessary. With such nutrient management, the physician can provide aggressive and complete nutritional replacement.

EFFECTS OF HYPERMETABOLISM ON NUTRITIONAL STATUS

The mechanism of weight loss in the surgical patient is often a prolonged increase in the basal rate of metabolism superimposed on inadequate nutrient intake and assimilation. The magnitude of such loss of weight depends in part on the degree and duration of hypermetabolism. Thus the longer and more severe the stress, the greater the weight loss. Body composition studies during hypermetabolism have demonstrated that fat and lean body mass each contribute approximately 50% of the cellular loss (29), but fat contributes 80%–85% of the calories. A decrease in total body water may also add to the weight loss, and this factor must be considered in the nutritional evaluation. However, loss of lean body mass is not obligatory and can be prevented or reversed with the provision of adequate calories and protein during most stressful periods.

Various factors that govern the level of hypermetabolism in the surgical patient include: 1) anabolic and catabolic hormones, *i.e.,* catecholamines, glucagon, insulin, corticosteroids, growth hormone, and thyroid hormones; 2) cold stress; 3) systemic infection; 4) central nervous system lesions that affect the function of the pituitary gland; and 5) significant tissue destruction that results from a surgical operation, crush injury, long-bone fracture, or a major full thickness cutaneous burn (38). All of these factors induce starvation to a significant degree, and if these stimuli are not diminished and the nutritional deficiencies corrected with adequate metabolic and nutritional support, the patient may die from malnutrition and its complications rather than from the primary disease or injury. The hypothalamus is the primary organ that governs metabolic activity via the action of the sympathetic and parasympathetic nervous systems and thus regulates substrate flux and body heat production. Indeed, the response to stress can be obliterated by removal of the anterior pituitary gland. During acute stress, sympathetic impulses travel from the ventral medial nucleus of the hypothalamus and eventually to the autonomic nerves supplying the liver, pancreas, and adrenal glands with resultant release of the catabolic hormones (catecholamines, glucagon, and corticosteroids) which produce glycogenolysis and increased serum glucose levels. The parasympathetic fibers seem to originate in the ventral lateral nucleus of the hypothalamus and cause an increase in liver glycogen synthetase activity which favors glucose storage. Alterations in body temperature can affect food intake and substrate availability. The autonomic nervous system maintains the body temperature within very narrow limits by its action on the blood vessels, respiratory rate, metabolic rate, and various endocrine and exocrine glands. Fever, pyrogens, drugs, and various hormones such as the neurohormones, norepinephrine, and 5-hydroxytryptamine can alter the body temperature and thus increase or decrease the metabolic rate. Ionic changes in the posterior hypothalamus may alter the body temperature as well and thus affect the metabolic rate.

Recently, Wilmore *et al.* (39) have demonstrated increased urinary catecholamines in patients with thermal injuries, and this was correlated positively with increased heat production and severity of the stress. The catecholamines stimulated heat production by a direct effect on cellular calorigenic activity. Although the other catabolic hormones contributed to increased metabolism and heat production, catecholamines appeared to be the primary regulators. As the stress decreased in severity, sympathetic activity decreased to normal levels, and the anabolic hormones (insulin and growth hormones) increased in activity, causing the deposition of nutrient substrates in the tissues. The use of high-calorie oral or IV feedings did not decrease the metabolic response to stress but rather provided the necessary biochemical moieties for energy production. Thus body reserves were spared and weight loss was minimized or prevented. Without high-calorie, high-nitrogen intake, large urinary losses of nitrogen occur after moderate-to-severe stress, particularly in injuries to the skin which can result in significant nitrogen losses from the body surface accounting for 20%–25% of the daily nitrogen deficit. In addition, 15%–20% of the energy consumption during acute distress can be accounted for by the increased loss of nitrogen primarily derived from skeletal muscle. Other factors that produce an increase in urinary nitrogen, muscle wasting, and decreased muscle strength include bed rest, previous poor nutrition, inadequate nutritional intake, decrease in skeletal muscle activity, an ambient temperature below 25° C, and general anesthesia. Therefore, increased gluconeogenesis and ureagenesis characterize protein catabolism in the body during surgical stress, infection, prolonged inactivity, and exposure to cold.

Urinary nitrogen retention or excretion is regulated by the interaction of insulin, gluca-

gon, and catecholamines (39). When insulin activity is increased in relation to glucagon, anabolism is stimulated, whereas catabolism is stimulated by hypoglycemia, increased sympathetic activity, and certain amino acids. Additionally, catecholamines cause suppression of insulin release, accounting for the low insulin levels and hyperglycemia which occur after severe trauma. In addition, fat is mobilized during acute stress primarily in the form of free fatty acids and to a lesser degree as cholesterol, neutral fat, and phospholipids. Growth hormone, on the other hand, resets the insulin response to glucose, stimulates free fatty acid release and utilization in the periphery and augments nitrogen retention. In a fasting patient, nitrogen excretion and muscle wasting during a systemic infection are not secondary to increased secretion of corticosteroids alone, but rather to a combination of increased serum levels of corticosteroids and catecholamines. Thyroid hormone is produced and released in increased amounts during acute stress, and its effect is similar to that of the catecholamines. Therefore, anabolism occurs when insulin is elevated relative to glucagon, and the synthesis of glycogen and protein is increased. Conversely, gluconeogenesis and urinary nitrogen excretion are decreased. Catabolism, on the other hand, results when glucagon is increased relative to insulin, and glycogenolysis, gluconeogenesis, and ureagenesis are increased at the expense of endogenous protein breakdown. Thus, in surgical patients, stress produces excessive nitrogen loss, and the provision of adequate exogenous calories and protein is mandatory to prevent body wasting.

NUTRITIONAL ALTERNATIVES IN THE SURGICAL PATIENT

Since acute and chronic stress produce increased catabolic demands on the body tissue, nutritional and metabolic support are of utmost importance to minimize or reverse weight loss and excretion of nitrogen secondary to muscle wasting. The endogenous fuel composition of normal man is listed in Table 32–1 (5). Although fat is utilized for energy production during periods of starvation and semistarvation, the provision of adequate exogenous calories and protein either by mouth or by vein can prevent this catabolic response to stress. The various therapeutic nutritional options that the physician can use include: 1) a normal oral diet, 2) nasogastric tube feedings, 3) gastrostomy feedings, (4) jejunostomy feedings, 5) chemically defined (elemen-

tal) diets, and 6) intravenous hyperalimentation (IVH). Whenever the GI tract is utilized for feeding, certain criteria must be met. The diet should contain at least 80–120 g protein, and 2000–3000 Cal should be supplied as dextrose or fat. Malabsorption, rapid transit time, loss or absence of pancreatic enzymes, decreased biliary secretions, and GI diseases that alter mucosal function and cause persistent diarrhea should not be present. Moreover, chronic bowel obstruction and radiation injury to the intestine can produce a relative malabsorption in the GI tract, whereas the short bowel syndrome can induce malnutrition due to inadequate length of effective bowel. If these conditions are present, GI feedings will not be very effective, and the use of IVH should be utilized as supplemental or total parenteral nutrition.

TUBE FEEDINGS

Occasionally, patients may be resistant to oral intake of food and yet have an intact and functional GI tract. Such patients include those with neurologic diseases that prevent normal swallowing; those with head and neck tumors that impair oral ingestion because of pain on deglutition or obstruction of the mouth, pharynx, or esophagus; and those who refuse to eat because of psychological factors, general weakness, or debilitation. Patients with these conditions may benefit from the use of a feeding tube that can be inserted through the nose, hypopharynx, or esophagus. Normal oral diets that have been blenderized into liquid form may be given through a #8 or #10 French feeding tube either intermittently or continuously over 24 hr using a Barron pump. The advantages of such feedings are that they avoid the necessity for operative insertion of a gastrostomy or jejunostomy tube, and that inexpensive foodstuffs are readily avail-

TABLE 32–1. Endogenous Fuel Composition of Normal Man

Fuel	Kg	Cal
Tissues		
Fat (adipose triglyceride)	15	141,000
Protein (mainly muscle)	6	24,000
Glycogen (muscle)	0.150	600
Glycogen (liver)	0.075	300
Total		165,900
Circulating Fuels		
Glucose (extracellular fluids)	0.020	80
Free fatty acids (plasma)	0.0003	3
Triglycerides (plasma)	0.003	30
Total		113

able and are digested and absorbed in the normal sequence. When infusing these diets, the initial concentration should be ¼–½ Cal/ml, with this eventually increased to 1 Cal/ml over 3–4 days of administration, thus allowing the GI tract to adapt gradually to the osmolality, which may be 400–1000 mOsm/liter. Side-effects such as gastric retention, esophageal regurgitation, and aspiration pneumonia can be minimized by slow infusion of dilute solutions initially and with the patient's head elevated 45°. After the GI tract has adapted to these concentrations and volumes (200 ml/feeding initially), the concentration and volume can be increased to tolerated or desired effectiveness. If intermittent feedings are to be utilized, the initial volume and frequency is usually 200 ml of a ½ Cal/ml diet administered over 45 min every 4–6 hr, advancing the concentration, volume, and frequency as tolerated. Continuous feedings are best regulated with a Barron pump, the initial volume per 24 hr usually being 1500 ml with a concentration of ½ Cal/ml. The incidence of gastric retention and vomiting is less with this method.

Some of the disadvantages of this type of feeding include pressure necrosis along the nasopharynx, partial pharyngeal and esophageal obstruction, esophagitis, eustachitis, esophageal stricture, gastric dilatation, dumping, aspiration pneumonia, and asphyxia. Generally, however, this is a safe and relatively easy, economic, and effective technique for administering nutrients with a low incidence of complications.

GASTROSTOMY FEEDINGS

Feeding via a gastrostomy is similar to feeding through a nasogastric tube, but a surgical procedure is necessary to insert the tube through the anterior abdominal wall directly into the stomach. Nasogastric tube feedings are contraindicated in comatose patients because of the increased risk of regurgitation, and the primary advantage of gastrostomy feeding is that the cardioesophageal sphincter is intact, and regurgitation is less likely to occur. The concentration and frequency of feedings are similar to nasogastric tube feedings. Occasionally, it is necessary to create a permanent gastrostomy in which a mucosa-lined tube is constructed from the stomach to the skin. Sometimes a loop of jejunum may be interposed between the stomach and skin as a convenient route of nutrient administration (17).

JEJUNOSTOMY FEEDINGS

Various clinical conditions such as coma, obstruction of the stomach by tumor, and total gastrectomy will obviate nasogastric or gastrostomy feedings. Therefore, long-term nutritional requirements in these patients can be better supplied through a jejunostomy feeding tube. The most common jejunostomy feeding tube is a Witzel-type, which is a serosa-lined tunnel fashioned over a #22 French catheter inserted through the antimesenteric border of the jejunum. If necessary, this tube can be removed, and the tract will generally close, but reinsertion of a tube into the jejunum requires verification of its position with radiopaque dye. If this is not done, extravasation of nutrient solutions into the peritoneal cavity may occur with subsequent peritonitis. A typical jejunostomy feeding regimen is outlined in Table 32–2 (34). Due to the hyperosmolality of these solutions, diarrhea may initially occur, but by starting slowly and gradually increasing the volume and concentration of the diet, satisfactory results can be obtained in 85% of the patients. It should be mentioned that reflux may occur in the jejunum for 50 cm proximally, and therefore, these diets should be administered well below an anastomosis or fistula. Although these types of diets can be used in patients with a high GI fistula, total bowel rest and IV hyperalimentation are generally most effective.

On rare occasions, a permanent Roux-en-Y loop of jejunum measuring at least 50 cm may be used for feeding from the skin to the small bowel when the upper alimentary tract is chronically or permanently disabled. The primary advantage is that this provides a mucosa-lined tube that will permit easy access into the bowel lumen and decrease the incidence of stricture at the tube entrance site. With these feedings, gastric secretion can be decreased and the possibility of gastroesophageal reflux can be minimized. However, in the authors' experience, only 1500–2000 Cal can be supplied daily to these patients, and this amount is usually inadequate for the hypermetabolic patient, who may require 3000–5000 Cal/day.

CHEMICALLY DEFINED (ELEMENTAL) DIETS

The development of pure L-amino acids has allowed the formulation of diets containing these amino acids and an energy source of dextrose or oligosaccharides with a minimal amount of fat.

TABLE 32—2. Jejunostomy Feeding Regimen*

	Total volume (1)	Total calories (Cal)	Total protein (g)
12—18 hr postjejunostomy	0	0	0
1 day: 50 ml 5% dextrose/water/hr X 20	1.0	200	0
2 day: 100 ml 5% dextrose/water/hr X 20	2.0	400	0
3 day: 50 ml homogenized milk/hr X 20	1.0	700	35
4 day: 100 ml homogenized milk/2 hr X 10	1.0	700	35
5 day: 180 ml homogenized milk/2 hr X 10	1.8	1260	63
6 day: 240 ml homogenized milk/2 hr X 10	2.4	1680	84

Continue same regimen as on 6 day but add an additional half cup of powdered milk to each quart of homogenized milk daily until 1.5 cups/quart homogenized milk is being used as a feeding formula. Thereafter, give 240 ml of this mixture q.2 h X 10 daily. Feedings should begin at 6 a.m. and continue through 12 midnight. Additional water may be given between feedings when indicated

Components for mixing
1. Powdered milk 1.5 cups
2. Homogenized milk 1.0 quart
3. Tween 40 (emulsifying agent) 1.0 ml
4. Polyvisol 0.6 ml
5. Fer-in-sol 0.6 ml

*Adapted from Shires GT, Canizaro PC: Fluid, electrolyte and nutritional management of the surgical patient. In Schwartz SI et al.: Principles of Surgery. Copyright 1974, New York. Used with permission of McGraw-Hill Book Company, p 65

TABLE 32—3. Composition of Current Chemically Defined Diets*

	Vivonex 100	Vivonex high nitrogen	W—T low residue food	Flexical
Carbohydrates (g)	226	210	226	155
	Glucose, glucose oligosaccharides	Glucose oligosaccharides	Dextrin	Sucrose
Nitrogen (g)	3.27	6.67	3.0	3.5
	Amino acids	Amino acids	Amino acids	Protein hydrolysate and added amino acids
Protein (g)	20.4	41.7	18.8	21.9
Fat (g)	0.74	0.44	0.74	34.0
	Safflower oil and linoleic acid	Safflower oil	Safflower oil	
Sodium (mEq)	57.6	35.5	55.7	15.7
Potassium (mEq)	29.9	17.9	30.0	38.9
Calcium (mEq)	22.1	13.3	27.8	26.0
Magnesium (mEq)	7.11	9.6	18.4	14.6
Iron (mEq)	0.19	0.11	0.34	0.02
Chloride (mEq)	71.2	52.2	85.0	34.3
Osmolarity (mOs/liter)	1175	844	649	805

*Adapted from Nutrition Gap, Eaton Laboratories, Norwich, N.Y.; W—T Low Residue Food, Warren-Teed Pharmaceuticals, Inc, Columbus, Ohio; Flexical, Low Residue Elemental Diet, Mead-Johnson Laboratories, Evansville, Indiana

Such diets can provide sufficient calories and protein for normal growth and development and wound healing. Their advantages include: 1) there is ultra-low residue, 2) minimal absorption and digestion is required, and 3) the potential exists for prolonged maintenance of body weight (36). However, the osmolality of these diets is 840–2200 mOsm/liter, and this can produce significant gastric retention or diarrhea, or both. Additionally, they have an organic taste that is not well tolerated by sick patients. However, elemental diets can be administered intermittently or continuously through a nasogastric or gastrostomy tube, thus minimizing the taste problem. Although these diets may decrease pancreatic, biliary, and GI secretions, the myoelectric activity of the bowel remains unchanged (30). The basic formulations of these diets are listed in Table 32–3 (12).

Recently, a chemically defined diet has been formulated primarily from short-chain peptides rather than free amino acids. Since with these diets the unpleasant organic flavor is more easily masked, they may be of great benefit to patients who cannot receive IVH, or they may be used after IVH has been discontinued and before a normal oral diet is restarted.

Recently, there has been interest in the preoperative use of elemental diets in preparation for bowel surgery (18). Although these studies have shown decreases in some of the bacterial flora and bulk content of the colon, there have not been any significant alterations in the concentration of bacteroides species in the large bowel. Therefore, the value of elemental diets for primary bowel preparation is somewhat questionable, although they certainly may improve the patient's preoperative nutrition.

INTRAVENOUS HYPERALIMENTATION

Whenever the GI tract does not function normally, IVH can be utilized to provide sufficient quantities of nutrients to prevent the ravages of prolonged catabolism. With this technique, bowel rest can be achieved and the energy of the bowel can be directed toward healing rather than toward absorption and assimilation of nutrients. With this method, 2000–5000 dextrose Cal and 80–200 g amino acids can be infused each 24 hr, and weight gain, positive nitrogen balance, and normal growth and development can be induced even during periods of severe hypercatabolism.

Because of the hypertonicity of these solutions (1800–2200 mOsm/liter), they must be infused continuously at a constant rate into a large-diameter vein, such as the superior vena cava. If these solutions are delivered via peripheral veins, thrombophlebitis will occur within 4–6 hr. Accordingly, central venous infusion is mandatory. Routes for insertion of superior vena cava feeding catheters are as follows:

1. Perferred insertion site: subclavian vein—infraclavicular
2. Acceptable insertion sites: subclavian vein—supraclavicular, internal jugular vein, external jugular vein, or cephalic vein
3. Contraindicated insertion sites: femoral vein, saphenous vein, and brachial vein

The preferred catheterization technique in the authors' experience has been via the infraclavicular approach to the subclavian vein, in which the catheter is advanced into the midportion of the superior vena cava. Absolute sterility is extremely important during catheter insertion, daily catheter care, and preparation of IV solutions. If meticulous aseptic technique is used, individual catheters can remain in place without sepsis for periods of 30–60 days with an infection rate of less than 2.2% (7). An 8–10 inch long polyvinyl catheter is usually used; silastic, polyethylene and teflon catheters have been used, but these have not offered any demonstrable advantage over the polyvinyl catheters. The actual technique of parenteral hyperalimentation and insertion of the central venous catheter in adults has been described in Dr. Meng's chapter (see Ch. 11), and its application in pediatric patients has been discussed comprehensively in Dr. Heird's chapter (see Ch. 12).

However, certain advantages of IVH should be emphasized. The first distinct advantage is that it allows delivery of large quantities of calories and amino acids directly into the bloodstream and thus eliminates the necessity for absorption and assimilation by the GI tract. All of the infused nutrients are ordinarily utilized, whereas only partial absorption of oral nutrients can be achieved by a disordered alimentary tract. A second unique advantage of IV nutrition is that the bowel can be put at complete rest except for very basal metabolic functions, thus allowing energy in the GI tract to be directed toward healing rather than toward absorption and assimilation of nutrients. In addition, myoelectric activity of the bowel is decreased to a resting state compared with the hyperactivity

that occurs following ingestion of normal foods and even of elemental diets (30). A third advantage is the purity of the nutrients and their high rate of incorporation within the tissues. Moreover, appropriate combinations of amino acids can be administered in different ratios to correct various specific nutritional deficiencies. A fourth advantage is the low rate of complications that can occur relative to the potential nutritional benefits if the physician is careful and meticulous in preparing and administering solutions, in inserting and maintaining aseptic catheters, and in managing fluid and electrolyte balances (14). Thus with conscientious care, IVH solutions can be administered safely and effectively, thereby providing a satisfactory nutritional alternative to the enteral route.

THE CLINICAL APPLICATION OF NUTRITION IN SURGERY

There are several categories of surgical patients who are particularly susceptible to developing metabolic and nutritional deficiencies. These include patients with obstruction of the GI tract, with neurologic disorders that decrease the patient's ability to eat or impair the motility of the stomach, or with small or large bowel tumors of the GI tract which not only produce partial or complete obstruction but may cause hypermetabolism, decreased absorption of available nutrients, and weight loss. A second group of patients includes those with diseases of the liver, gallbladder, or pancreas which alter digestive enzymatic secretions and hence impair absorption. A third category of patients are those who do not adequately metabolize available nutrients after absorption has occurred, such as in acute and chronic renal failure and in liver failure. Carcinoma outside the GI tract, major trauma, cutaneous burns, endocrine tumors (*i.e.,* hypo or hyperfunction of the pituitary, thyroid, ovary, pancreas, parathyroids, adrenal glands or extraadrenal pheochromocytoma) can lead to hypermetabolism, increased muscle degradation and weight loss. Neonates with congenital anomalies are particularly susceptible to malnutrition because of inadequate reserves and therefore need early and intensive nutritional support. Adequate nutritional support in all of these categories is necessary if optimal results are to be obtained, and if enteral nutrient administration is not sufficient, IVH should be instituted to provide nutrition exclusively or in combination with enteral feedings. The nutri-

tional management of some of these clinical problems will be discussed in detail along with examples of results of treatment.

GASTROINTESTINAL DISEASES

INFLAMMATORY BOWEL DISEASE

Acute and chronic GI diseases can produce significant malnutrition due to increased tissue catabolism and inability to digest and absorb adequate amounts of essential oral nutrients, thus increasing the overall morbidity and mortality of the primary process. Disorders such as inflammatory bowel disease, short bowel syndrome, and GI fistulas particularly are associated with malnutrition. In addition to the ravages of the basic pathologic process, therapeutic endeavors such as surgery, chemotherapy, and radiotherapy often lead to further deterioration of the patient's nutritional status. In patients with inflammatory bowel disease, for example, the clinical presentation is usually characterized by hypoproteinemia, edema, muscle weakness, hypokalemia, osteomalacia, and deficiencies of vitamins A, D, E, K, folic acid, and vitamin B_{12}; a 10–15% weight loss is not uncommon. Moreover, 50–60% of the patients will have further metabolic and nutritional problems as the disease progresses. Major features of granulomatous enteritis are the frequent recurrences and exacerbations of disease activity which often lead to operation. Surgical intervention, on the other hand, can result in bowel resections, internal or external GI fistulas, and the short bowel syndrome, which can produce further nutritional deterioration. The use of corticosteroids only magnifies the nutritional problems. The most common metabolic and nutritional side-effects of corticosteroid therapy are

Negative nitrogen balance
Impaired wound healing
Decreased resistance to infection
Increased capillary permeability
Growth retardation in children
Moon facies and striae
Buffalo hump
Osteoporosis

Low-residue, low-fat oral diets have been used to counteract these nutritional problems, but significant diarrhea frequently occurs secondary to fat and carbohydrate malabsorption and lactase deficiency in the small bowel. Some investiga-

tors have utilized elemental diets because of their ultralow residue, rapid GI absorption, and ability to partially decrease the motor activity of the bowel. However, complete bowel rest is usually not produced, and these patients often remain anorectic and unable to ingest sufficient foodstuffs. The added stress of progressive inability to tolerate oral feedings of any kind leads to progressive debilitation.

Recently, the use of IV hyperalimentation and bowel rest has been evaluated in a series of 52 patients with inflammatory bowel disease (13). Most of these patients were treated initially with corticosteroids, immunosuppressive drugs, and sulfur compounds without remission. They then received dextrose IVH supplying 2000–5000 Cal and 80–200 g amino acid/24 hr (Table 32–4). The first group consisted of 41 patients (78.8%) who had a favorable nutritional response and whose disease became clinically inactive. Within this group, 28 patients (53.8%) were able to resume a low-residue oral diet without exacerbation of their disease within an average duration of IVH of 36.3 days; 13 patients required operations for complications such as intestinal obstruction, intraabdominal abscesses, or chronic GI fistulas. A third category of 11 patients (21.2%) had an average of 15 days IVH and total bowel rest before definitive surgery was undertaken for persistently active disease. Although it was quite obvious after only 7–10 days that disease activity would not subside on this regimen, IVH was continued in order to nutritionally replete the patients and thus decrease the overall morbidity and mortality subsequent to the surgical procedures.

What is the mechanism of action of bowel rest and IVH in patients with inflammatory bowel disease? One possible explanation may be that the provision of large quantities of nutrients allows a reversal of impaired immunocompetence and decreases the susceptibility to infections that frequently occur in malnourished patients with inflammatory bowel disease. By the provision of adequate nutrition, normal defense mechanisms may be restored and a normal intestinal flora maintained. Chronic incomplete bowel obstruction often results in a very low serum protein concentration, particularly the albumin fraction. However, serum albumin levels can be restored to normal with IVH, which thus leads to a decrease in edema and inflammation and to resolution of intestinal obstruction if significant fibrosis has not occurred. Another possible beneficial effect of bowel rest is the resultant minimal mechanical, physical, and chemical activity of the bowel, which can improve the rate of the healing process. The elimination of roughage and food particles from the lumen of the inflamed gut minimizes surface trauma and decreases peristaltic activity. Furthermore, reduced hormonal and autonomic stimulation of GI secretions decreases the caustic effects of digestive enzymes on the inflamed bowel. It should be emphasized that bowel rest can be maximally advantageous only when adequate IV nutrition is provided simultaneously. Moreover, oral nutrients can be restarted when the bowel mucosa has had adequate time and nutrient substrates to heal and regain normal function.

GASTROINTESTINAL FISTULAS

In the past the treatment of patients with GI fistulas has been associated with morbidity and mortality rates as high as 30%–60%. Frequently, significant malnutrition resulted from hypercatabolism secondary to sepsis, surgical stress, and open wounds. Although oral diets have been utilized in the past, adequate nutrition could dependably be supplied only by a regimen of IVH and bowel rest. In a recent series of 62 patients with 78 GI fistulas, bowel rest and IVH constituted the major mode of therapy (27). Antibiotics and appropriate surgical drainage of abscesses and resections of fistulas were employed

TABLE 32—4. Intravenous Hyperalimentation in Inflammatory Bowel Disease

Patients	Results	Duration IVH (days)
Group I		
41 (78.8%)	Marked nutritional improvement	
	Clinical remission of disease	
A. 28	Resumed oral diet without exacerbation of disease	36.3
B. 13	Surgery necessary for a complication such as fistula, abscess, or bowel obstruction	26.8
Group II		
11 (21.2%)	Marked nutritional improvement	15.0
	Operation for severe activity of primary disease	

TABLE 32—5. Gastrointestinal Fistulas in Inflammatory Bowel Disease

	Patients/Fistulas	Spontaneous closure (%)	Duration IVH (days)
Small bowel disease	13/16	75	42
Large bowel disease	10/15	30	40

when indicated. All of the patients lost 10–50 pounds while being fed orally or with IV 5% dextrose and water, but they regained their normal weight on IVH. The results of this series demonstrated a spontaneous fistula closure rate of 70.5% and an overall mortality of only 6.45%. Successful operative closure of 21.8% of the fistulas produced an overall fistula closure rate of 92.3%. All of the remaining patients whose fistulas did not close, died. When patients required operation, the mortality was 6.5%. The average period of time between the initiation of IVH and bowel rest and the spontaneous closure of a fistula was 34.9 days. Sepsis and renal failure were the most common causes of death. Elemental diets have been used in the treatment of GI fistulas with some success, but these diets seem to be most beneficial in very low GI tract fistulas, i.e., in the distal ileum or colon.

Other types of alimentary tract fistulas respond favorably to the bowel rest–IVH regimen. Pancreatic and esophageal fistulas usually close spontaneously if abscesses are drained and sepsis is controlled. Long et al. (23) report a series of eight esophageal fistulas that healed spontaneously without a mortality, thus emphasizing the need for nutritional support in patients with this ordinarily catastrophic surgical complication.

A unique problem arises in patients with GI fistulas arising in areas of active inflammatory bowel disease. Although various investigators have stated that these fistulas will not close spontaneously, others have maintained that nonoperative closure will occur if the active disease becomes quiescent. A series of 23 patients were treated for granulomatous disease (Crohn's) and associated GI fistulas (Table 32–5) (24). As the disease became quiescent, malnutrition was reversed and spontaneous fistula closure was obtained for an average period of 9 months. Thirteen patients with small bowel disease had 16 fistulas that closed spontaneously (75% of the cases). Ten patients with large bowel disease had 15 fistulas, but the overall spontaneous closure rate was only 30%. The average duration of IVH and total bowel rest in the two groups of

patients was 42 and 40 days, respectively. Thus, it is concluded that the prognosis of GI fistulas arising from areas of granulomatous enteritis is not dismal as long as the patient is provided with adequate nutrient substrates for healing.

The nutritional management of patients with radiation injury to the small bowel can be extremely difficult and complex. Although intestinal length may be normal, the mucosa is usually permanently damaged and malabsorption is frequent. Dissacharidase enzymes are usually depleted and gut hypermotility is common. Those oral diets which are readily absorbed, which have low residue, and which do not contain milk components or long-chain fatty acids may be used; however, if oral diets do not maintain the patient's nutrition, further progression in villus atrophy of the mucosa will result. In these cases, IVH should be given to reverse the malnutrition and improve mucosal absorption to maximal levels under these adverse conditions. When GI fistulas arise from irradiated intestine, surgical resection or bypass is usually required, and even with optimum nutritional repletion, a 40%–50% failure rate can be expected. Frequently, the course of management of radiation injury of the small bowel includes repeated operations, bowel resections, and eventually the short bowel syndrome.

In the treatment of GI fistulas, the provision of optimum IV nutrition has greatly improved morbidity and mortality. Only with IVH can these nutrients be supplied in large enough quantities to produce optimal wound healing, positive nitrogen balance, and weight gain. Although jejunostomy feedings can be used in gastric and duodenal fistulas and elemental diets can be used effectively in low intestinal fistulas, it is of utmost importance that optimum calories and protein be supplied and that stimulation of GI activity be decreased to a minimum to provide the proper milieu for healing.

SHORT BOWEL SYNDROME

The short bowel syndrome is a life-threatening complication that often results from massive intestinal resections for vascular occlusion of the

superior and/or inferior mesenteric arteries, or of both, extensive inflammatory bowel disease, multiple GI fistulas, retroperitoneal tumors, and radiation enteritis. Malabsorption is the most significant characteristic of this syndrome secondary to loss of intestinal length. This occurs to a significant extent if 50% of the small intestine is resected, and severe nutritional and metabolic complications may result when only 3–4 feet of the small intestine remain. Other factors that influence the overall survival of patients with this syndrome include: 1) the nutritional status of the patient prior to the onset of his intestinal catastrophe; 2) the etiology of the syndrome; and 3) the length, specific segment, and histologic status of the remaining intestine. Patients who have residual ileum and an ileocecal valve have a better chance of normal absorption compared with those who have only jejunum and colon remaining. It has been observed that the ileum will adapt to the functions of the jejunum better than the jejunum will adapt to ileal functions.

Initially, total bowel rest should be utilized, and all nutrients including water should be supplied exclusively intravenously. At this stage, oral intake of any type usually produces significant and protracted diarrhea that is difficult to control even with antiperistaltic drugs, *e.g.,* Lomotil and codeine, and anticholinergic drugs, *e.g.,* Probanthine. The regimen of IVH and total bowel rest is continued for 1 month, thus minimizing the effects of intestinal chyme on mucosal adaptation. Levin (22) and Cameron (6) report that total bowel rest and IVH decreases gut weight and protein content and results in atrophy of the mucosal villi, a 40% decrease in maltase activity, and an 80% decrease in sucrase activity per centimeter of intestine. However, Schanbacher *et al.* (33) note a two-fold increase in glucose absorption and metabolism per unit length of intestine in rats on IVH when compared with orally fed controls. They concluded that although enzyme concentrations in intravenously fed animals were lower than those in orally fed controls, the absorptive and metabolic efficiency per unit length of gut was twice normal. Johnson, *et al.* (20) have corroborated these data and found additionally that the concentration of intestinal brush border enzymes returned to normal in rats on IVH and total bowel rest when pentagastrin was concomitantly administered parenterally. Therefore, it was concluded that either antral/or intestinal gastrin, or both, might be the essential hormone necessary to achieve maximal bowel adaptation and that although IVH and total bowel rest induced some intestinal hypotrophy, absorption per unit length actually was increased. It should be noted, however, that these data were derived from animals having normal intestinal length and not from animals who had undergone massive intestinal resections.

After 1 month of total bowel rest, oral nutrients can be started and slowly increased both in quantity and variety. Long-chain fatty acids and lactose should be eliminated initially because of their tendency to cause diarrhea, and antiperistaltic agents should be used as indicated to control the diarrhea. It may be necessary to use IVH intermittently over a period of months after resection to allow maximum GI adaptation and weight maintenance. This usually requires 2 years and is evidenced by increased intestinal weight and length, dilatation, and thickening of the residual intestine, especially of the mucosa. The reinstitution of oral feeding after 1 month causes increased release of GI hormones particularly gastrin, which enhances intestinal growth and adaptation. Patients who have very short intestinal lengths may require the use of home or ambulatory hyperalimentation for a prolonged period of time or even for life. Recently, in a series of 12 patients with the short bowel syndrome in whom the technique of IVH was utilized for 1 month, followed by 2–3 months of IVH and oral feedings, sufficient intestinal adaptation occurred to allow oral diets to be instituted in order to maintain the patient's nutrition (25). In selected patients elemental diets can provide adequate nutrition, but significant diarrhea may produce further deterioration of some patients. It is of utmost importance that these patients receive adequate nutrition, especially during the early postresection period of bowel adaptation. If the residual bowel length is too short to compensate sufficiently to sustain the patient, home hyperalimentation may be life-saving.

MORBID OBESITY

Occasionally, patients who have morbid obesity may require a surgical procedure in order to lose weight. However, frequently these patients are relatively deficient in total body protein and have fatty infiltration of the liver with excessive triglyceride deposition. The type of operation usually performed is a small bowel bypass with anastomosis of 12 in. of proximal jejunum to 4–8 in. of distal ileum. The long bypassed segment is then vented to the cecum, transverse or sigmoid colon. A major complication following operation is liver failure, which results from the

excessive accumulation of triglycerides in the liver which most commonly occurs secondary to the continued ingestion of a high-carbohydrate, low-protein diet postoperatively. When liver failure becomes severe, the best therapeutic management is the administration of large amounts of amino acids and protein intravenously or orally. This regimen has been successfully used at the University of Texas Medical School at Houston in 25 patients with a broad spectrum of liver failure to decrease the fatty infiltration of the liver and improve overall liver function studies as evidenced by decreases in serum concentrations of bilirubin, SGOT, SGPT, and alkaline phosphatase.

Besides high-carbohydrate, low-protein ingestion as an etiology of fatty liver, other etiologic possibilities exist, *e.g.,* the absorption of lithocholic acid, fatty acid deficiency, absorption of bacterial toxins from the bypassed segment, and deficiencies of various lipotrophic factors such as choline and methionine. Some authors have suggested the use of IVH to decrease fatty infiltration in the liver (2), but unless the patient is critically ill, it appears that the most appropriate type of nutritional therapy is the administration of peripheral or oral amino acids with basal quantities of glucose and no fat. In addition, some patients who receive the usual commercially available IVH, *i.e.,* 25% dextrose and 5% amino acids, can develop a fatty liver if the calorie–nitrogen ratio exceeds 150 Cal/g nitrogen for prolonged periods of time. In most patients who are not hypermetabolic, 100–150 Cal/g nitrogen may be sufficient for substrate deposition and thus prevent excess carbohydrate conversion to lipid and its deposition in the liver. However in the hypermetabolic state, a high calorie–nitrogen ratio greater than 150/1 is necessary because of increased nitrogen and caloric utilization and wastage. It has been suggested that the use of cyclic hyperalimentation will lower the infusion of carbohydrates and fat and thus decrease the calorie–nitrogen ratio (28). This theory is based on the fact that high insulin levels secondary to glucose infusion contribute to fatty infiltration in the liver. Thus, adjustments in the calorie–nitrogen ratio may be necessary on a daily or weekly basis in order to provide optimum nutrition without causing untoward metabolic and morphologic changes in the liver.

PANCREATITIS

Another clinical problem that may be helped by the use of IVH and total bowel rest is acute pancreatitis. This disorder is characterized by severe inflammation of the pancreas with swelling of the acinar cells and decreased pancreatic enzyme secretion. The most common etiology is idiopathic, although pancreatitis secondary to alcoholism and biliary tract disease is increasing in frequency. Although the usual treatment of this disease includes IV fluids, antibiotics, nasogastric suction, and occasionally parasympatholytic drugs, the use of IVH can decrease the acinar cell count and size as well as pancreatic enzyme production (31). Some investigators (32) have also shown that elemental diets can decrease pancreatic exocrine secretions, but in the authors' experience IVH has demonstrated its superior effectiveness in providing optimum nutrition as well as maximally decreasing the exocrine work of the pancreas.

CANCER

Patients with various malignant diseases have demonstrated increased metabolic rates, usually secondary to increased tissue destruction by the tumor. Weight loss and malnutrition are common when the patient is seen initially by the physician. Various therapeutic modalities such as chemotherapy, radiotherapy, and surgical therapy further increase caloric demands and cause additional malnutrition. Loss of body weight may be the initial presenting sign in malignancies such as leukemia, lymphoma, and oat cell carcinoma of the lung, as well as in many types of GI malignancies. In contradistinction, malignant melanoma, breast cancer, and soft tissue sarcomas produce early symptoms, *e.g.,* a palpable mass or bleeding, and thus the patient usually is seen by the physician before significant malnutrition has occurred. Lymphoma of the small intestine and certain GI hormone–secreting tumors such as carcinoma of the pancreatic islet cells can produce malnutrition secondary to malabsorption. Moreover, oncologic therapy ordinarily will continue to compound and increase the nutritional deficit.

CHEMOTHERAPY

It must be emphasized that, if possible, the GI tract should be utilized for delivery, absorption, and assimilation of nutrients in preference to the IV route. The use of a nasogastric feeding tube, particularly in patients with head and neck malignancies, can supply large quantities of enteral nutrients for adequate assimilation and utilization. However, if malnutrition is present, the GI tract mucosal villi may be somewhat atro-

phied and unable to absorb normally, and elemental diets may be more effective than a normal oral diet. Recently, three categories of cancer patients who received nutritional support for surgery, chemotherapy, and radiotherapy were evaluated at the M. D. Anderson Hospital and Tumor Institute. In 58 patients who received chemotherapy, nutrition was maintained initially by the oral route, but subsequently IVH was necessary because of persistent nausea, vomiting, and diarrhea (8). In this group, IVH was given for 25–30 days, and the patients gained an average of 6.8 pounds during therapy. Gastrointestinal side-effects, particularly from 5-fluorouracil, were greatly reduced. Leukocyte depression below 2500 cells/mm³ occurred in 48% of the patients and lasted for approximately 7–8 days. Moreover, all of the patients gained weight during the period of IVH and treatment with antineoplastic agents, and all were in positive nitrogen balance. Even though significant leukocyte depression occurred, the infection rate from a contaminated central venous catheter was zero in this group of high-risk patients. In addition, 36% of these patients had at least a 50% reduction in measurable malignant disease when treated with chemotherapy and IVH.

Another group of 30 patients with non–oat cell carcinoma of the lung were treated with bleomycin, cyclophosphamide, vincristine, methotrexate, and 5-fluorouracil (21). Of this group, 33% received concomitant IVH while the remainder received oral nutrition. The conclusion of this study was that only those patients who maintained their nutrition either orally or with IVH responded favorably to chemotherapy and that pretreatment weight loss less than 6% had no effect on ultimate response. It appears that the response rate for the IVH patients was equal to that of the nutritionally intact group, and the data imply that response is improved in previously malnourished patients who are adequately repleted nutritionally prior to the beginning of chemotherapy.

The effect of IVH in 10 patients receiving 5-fluorouracil for metastatic colon carcinoma was evaluated in respect to tumor response and GI toxicity (35). The patients were treated with IVH for 7 days prior to the initiation of chemotherapy, 15 mg/kg/day administered intravenously over a 1-hr period. In each instance, drug toxicity was initially manifested by mild stomatitis, nausea, or diarrhea, but all of these symptoms cleared within 24 hr after discontinuing the drug. Four of the patients (40%) responded with a measurable reduction of tumor size

greater than 50%, either in perineal, sacral, intraabdominal, or pulmonary metastases. Responding patients received an average of 8.1 g 5-fluorouracil for an average period of 10 days. Nonresponding patients tolerated only 6 g drug in 7.3 days, whereas oral control patients received only 3.8 g 5-fluorouracil in 4.4 days. Although 5-fluorouracil may not be the best single chemotherapeutic agent for GI malignancies, this drug can be given in higher dosages more frequently when patients are also treated with IVH and bowel rest than when oral nutrition is used alone.

SURGERY

Heatley *et al.* (19) in England have emphasized preoperative nutritional repletion in a study of patients with esophageal and GI tract malignancies. In a prospective randomized study of preoperative malnourished patients with these problems, IVH was given to one group for 10 days prior to operation in order to decrease operative and postoperative morbidity and mortality. Anastomotic problems, wound infection and dehiscence, and postoperative pneumonia were significantly less in the group receiving preoperative IVH, and those patients on preoperative IVH had a shorter total hospital stay than the control group. At the M. D. Anderson Hospital and Tumor Institute, 48 malnourished patients who were to have a general or thoracic surgical procedure were evaluated, and nutritional repletion was accomplished by IVH (9). Of these patients, 60% underwent curative operations, which included total esophagectomy, total gastrectomy, and abdominal perineal resection, and the remaining 40% underwent major palliative procedures. The average age of the patients was 54.8 years, and they received IVH for 20–22 days with an average weight gain of 5.8 pounds. Only 2 patients expired postoperatively, and catheter-related sepsis occurred in only 1 patient. In this study 24 patients received IVH for average periods of 11.5 days preoperatively and 12.8 days postoperatively; an additional 15 patients received IVH only preoperatively for a period of 18 days, whereas 9 patients received IVH only postoperatively for an average of 19 days. It was concluded that if nutrition can be returned to normal preoperatively, the overall surgical morbidity and mortality can be greatly decreased, whereas the number of postoperative complications greatly increases when existing preoperative malnutrition is allowed to persist.

These findings were reemphasized recently in a series of 10 patients with obstructing carcinomas of the esophagus who were treated by either radiation therapy, esophagectomy combined with colon interposition, or both modalities. Only 1 patient expired postoperatively, and no anastomotic disruptions were recorded in this extremely high-risk group.

Patients with oropharyngeal malignancies have painful deglutition, and oral feedings often cannot be tolerated well. In a series of 23 patients with head and neck malignancies, nasogastric feedings supplying 3000 Cal/day were given (10). Frequently, however, diarrhea and malabsorption occurred because of malnutrition, and hence malabsorption, due to mucosal atrophy. In these patients, IVH had to be used first to improve nutritional status, after which tube feedings could be better tolerated and absorbed by the GI tract. The average age of the patients was 64.3 years, and IVH was used for an average treatment period of 44.2 days. Of the patients, 12 required major head and neck surgery during the course of IVH therapy but still gained 12–15 pounds. These data emphasize that patients with head and neck malignancies can be maintained adequately on tube feedings as long as the GI tract is capable of normal absorption, but when severe malabsorption occurs, IVH should be used alone or as a supplement to enteral nutrition until normal GI function has been restored.

RADIATION THERAPY

Patients who receive radiation therapy often develop mucositis with resultant painful deglutition, nausea, vomiting, abdominal pain, and diarrhea. Therefore they often ingest suboptimal quantities of food, and in addition, the ability of the GI tract to absorb ingested nutrients is decreased. The reparative phase of mucosal injury is therefore delayed, and prolonged mucositis may result in fibrosis and stricture in different parts of the GI tract. These complications may occur in as many as 10%–15% of patients treated. Moreover, an additional 20% of patients may have severe nutritional deficiencies as well. In a recent study at the M. D. Anderson Hospital and Tumor Institute (11), 14 patients were treated adjunctively with bowel rest and IVH, and nausea and vomiting disappeared unless oral feedings were restarted. Intravenous hyperalimentation was given for an average period of 34 days, and the average weight gain was

5.4 pounds. Of these patients, 8 had a good tumor response and maintained normal nutrition orally after radiotherapy.

Although patients sometimes develop complications secondary to their cancer treatments, they can usually overcome them with adequate nutritional support. More-complicated and radical surgical, chemotherapeutic, and radiation treatments can be performed not only in the presence of complications, but with decreased morbidity and mortality should problems develop.

ESSENTIAL FATTY ACID DEFICIENCY

Surgical patients with malnutrition may show chemical and clinical evidence of essential fatty acid deficiency, especially when they are maintained on glucose–amino acid solutions for longer than 2–3 months. Chemically, this deficiency is manifest in the serum phospholipid fraction by an elevation in the level of 5,8,11-eicosatrienoic acid and reciprocal depressions of linoleic and archidonic acid levels. These changes have been found in approximately 50% of long-term IVH patients who have had prolonged periods of preexisting starvation (26). Clinical manifestations of this syndrome are extremely uncommon; there have only been two or three cases at the M.D. Anderson Hospital and Tumor Institute. Signs and symptoms of essential fatty acid deficiency include: 1) anemia, 2) thrombocytopenia, 3) hair loss and sparse hair growth, 4) increased capillary permeability, 5) dry scaly skin, 6) desquamating dermatitis, and 7) a shift of the oxygen dissociation curve to the left. The administration of oral or IV essential fat may be necessary to correct these deficiencies. The average adult patient requires 10 g linoleic acid/day. An IV fat emulsion (Intralipid) which is now commercially available in this country supplies 20 g linoleic acid in 500 ml of a 10% emulsion. This emulsion can be administered over a 4-hr period twice a week in order to maintain adequate serum and tissue levels of linoleic acid and thereby prevent or correct essential fatty acid deficiencies.

ACUTE RENAL FAILURE

Renal failure is not an uncommon problem in patients with surgical diseases, and the associated morbidity and mortality may be as high as 60%. A significant but correctable complication of renal failure is malnutrition, which often produces decreased immunocompetence and in-

TABLE 32—6. Intravenous Hyperalimentation Formulas

Normal formula	Renal failure formula	Modified renal failure formula
500 ml 50% dextrose	750—1000 ml 50%—70% dextrose	500—750 ml 50%—70% dextrose
500 ml 8% amino acids (essential & nonessential amino acids)	100—200 ml 5% essential amino acid mixture	250 ml 8% amino acids (essential and nonessential amino acids)
6.4 g nitrogen	1—1.5 g essential nitrogen	3.2 g nitrogen
Electrolytes	Electrolytes	Electrolytes
Vitamins	Vitamins	Vitamins

creased susceptibility to infection. Frequently a special oral diet (Giordano–Giovannetti diet) can be used which primarily limits protein intake and supplies 20–40 g essential amino acids. However, nausea and vomiting frequently occur in such patients, and thus adequate oral nutrition is difficult to maintain. Therefore, the IV infusion of essential amino acids in combination with a large ration of carbohydrate calories can promote positive nitrogen balance and normal wound healing. In the usual parenteral renal failure formula, 1000 ml solution contains 1500–2500 dextrose calories plus 1–1.5 g essential amino acid nitrogen. This mixture can be infused over a 24-hr period, and additional nitrogen can be added if the patient tolerates this regimen well. Besides achievement of positive nitrogen balance, decreases in serum phosphate, sulfate, and potassium concentrations usually occur, as well as a decrease in the frequency of dialysis. Abel *et al.* (1) report decreased morbidity and improved mortality rates in renal failure patients receiving the essential amino acids and hypertonic glucose in contrast to those receiving hypertonic glucose alone. Essential amino acid solutions are not currently commercially available, however, modified IVH solutions can be used during renal failure (Table 32–6). Hemodialysis must be done more frequently than when only the essential amino acids are infused, but the nutrition of the patient can be better maintained or improved, and the overall morbidity and mortality can be decreased.

CONCLUSION

It is obvious that patients with surgical diseases and their complications require large quantities of high-quality nutrients to maintain homeostasis. Preferably, adequate nutrition should be provided orally or through a nasogastric tube, but if digestion, absorption, or assimilation are impaired or impossible, IVH should be utilized. The ravages of malnutrition interfere with every type of treatment in surgical patients and certainly result in increased morbidity and mortal-

ity. The recognition of protein–calorie malnutrition in patients whose diseases or treatments may produce this complication is essential if they are to benefit from preventive or corrective nutritional therapy. In this day of modern medicine, protein–calorie malnutrition in surgical patients should never occur, and if it has occurred, it should not be tolerated, but should be treated as promptly and as vigorously as possible.

REFERENCES

1. Abel RM, Shih VE, Abbott W, Beck CH, Fischer JE: Amino acid metabolism acute renal failure: influence of intravenous essential L–amino acid hyperalimentation therapy. Ann Surg 180:350–355, 1974
2. Ames FC, Copeland EM, Leeb DC, Moore DL, Dudrick SJ: Fatty metamorphosis of the liver complicating small bowel bypass for obesity. Nonoperative treatment with parenteral hyperalimentation. JAMA 235:1249–1252, 1976
3. Bistrian BR, Blackburn GL, Sherman M, Scrimshaw NS: Therapeutic index of nutritional depletion in hospitalized patients. Surg Gynecol Obstet 141:512–516, 1975
4. Butterworth CE, Blackburn GL: Hospital malnutrition. Nutr Today 10(2):8–18, 1975
5. Cahill GF Jr: Starvation in man. N Engl J Med 282:668–675, 1970
6. Cameron IC, Pavlat BA, Urban E: Adaptive responses to total intravenous feedings. J Surg Res 17:45–52, 1974
7. Copeland EM, MacFadyen BV Jr, Dudrick SJ: The use of hyperalimentation in patients with potential sepsis. Surg Gynecol Obstet 138:377–380, 1974
8. Copeland EM, MacFadyen BV Jr, Lanzotti VJ, Dudrick SJ: Intravenous hyperalimentation as an adjunct to cancer chemotherapy. Am J Surg 129:166–173, 1975
9. Copeland EM, MacFadyen BV Jr, Lanzotti VJ, Dudrick SJ: The nutritional care of the cancer patient. In Howe CC (ed): Cancer Patient Care at M.D. Anderson Hospital and Tumor Institute. Chicago, Yearbook Medical, 1977 (in press)
10. Copeland EM, MacFadyen BV Jr, MacComb WS, Guillamondegui O, Jesse RH, Dudrick SJ: Intravenous hyperalimentation in patients with head and neck cancer. Cancer 35:606–611, 1975
11. Copeland EM, Souchon EA, MacFadyen BV Jr, Rapp MA, Dudrick SJ: Intravenous hyperalimentation as an adjunct to radiation therapy. Cancer 39:609–619, 1977
12. Dudrick SJ, Duke JH Jr: Nutritional complications in the surgical patient. In Artz CP, Hardy JD (eds): Com-

plications in Surgery and Their Management, 3rd ed. Philadelphia, WB Saunders, 1974

13. Dudrick SJ, MacFadyen BV Jr, Daly JM: Management of inflammatory bowel disease with parenteral hyperalimentation. In Clearfield HR, Denoso VP Jr (eds): Gastrointestinal Emergencies. New York, Grune & Stratton, 1976

14. Dudrick SJ, MacFadyen BV Jr, Van Buren CT, Ruberg RL, Maynard AT: Metabolic problems and solutions. Ann Surg 176:249–264, 1972

15. Dudrick SJ, Wilmore DW, Vars HM, Rhoades JE: Long-term total parenteral nutrition with growth, development and positive nitrogen balance. Surgery 64: 134–142, 1968

16. Duke JH Jr, Jorgensen SB, Broell JR, Long CL, Kinney JM: Contribution of protein to caloric expenditure following injury. Surgery 68:168, 1970

17. Gibbon JH Jr, Nealon TF, Greco VF: A modification of Glassman's gastrostomy with results in 18 patients. Ann Surg 143:838, 1956

18. Glotzer DJ, Boyle PL, Silen W: Preoperative preparation of the colon with an elemental diet. Surgery 74: 703, 1973

19. Heatly RV, Hughes LE: Preoperative intravenous nutrition in cancer patients (abstr). Proc XI Int Cancer Congr 4:874, 1975

20. Johnson LR, Lictenberger LM, Copeland EM, Dudrick SJ, Castro GA: Action of gastrin on gastrointestinal structure and function. Gastroenterology 68:1181–1192, 1975

21. Lanzotti VJ, Copeland EM, George SL, Dudrick SJ, Samuels ML: Cancer chemotherapeutic response and intravenous hyperalimentation. Cancer Chemother Rep 59:437–439, 1975

22. Levin GM, Deren JJ, Steiger E, Zinno R: Role of oral intake in maintenance of gut mass and disaccharidase activity. Gastroenterology 67:975–982, 1974

23. Long JM, Steiger E, Dudrick SJ, Berkowitz HD, Allen TR, Ruberg RL: Total parenteral nutrition in the management of esophagocutaneous fistulas. Fed Proc 30: 300, 1971

24. MacFadyen BV Jr, Dudrick SJ: The management of fistulas in inflammatory bowel disease. Montpellier, Pro Int Soc Parenteral Nutr, 1974

25. MacFadyen BV Jr, Dudrick SJ: Unpublished data

26. MacFadyen BV Jr, Dudrick SJ, Gum EP: The use of ten percent soybean oil emulsion in adult patients. AMA Proc on Fat Emulsions in Parenteral Nutr, Chicago, Illinois, December 1977 (in press)

27. MacFadyen BV Jr, Dudrick SJ, Ruberg RL: Management of gastrointestinal fistulas with parenteral hyperalimentation. Surgery 74: 100–105, 1974

28. Maini B, Blackburn GC, Bristrian BR, Flatt JP, Page JG, Bothe A, Benotti P, Rienhoff HY: Cyclic hyperalimentation: an optimal technique for preservation of visceral protein. J Surg Res 20:515–525, 1976

29. Moore FD: Metabolic Care of the Surgical Patient. Philadelphia, WB Saunders, 1959, pp 409–456

30. Moore E, Copeland EM, Dudrick SJ, Weisbrodt NW: Effect of an elemental diet on the electrical activity of the small intestine in dogs. J Surg Res 20:533–537, 1976

31. Pavlat WA, Rogers W, Cameron IL: Morphometric analysis of pancreatic cancer cells from orally fed and intravenously fed rats. J Surg Res 19:267–276, 1975

32. Ragins H, Levenson SM, Signer R, Stamford W, Seifter E: Intrajejunal administration of an elemental diet at neutral pH avoids pancreatic secretion. Am J Surg 126: 606–614, 1973

33. Schanbacker LM, Copeland EM, Dudrick SJ, Johnson LR, Castro GA: Glucose transport across the small intestine of parenterally nourished rats. Fed Proc 34:917, 1975

34. Shires GT, Canizaro PC: Fluid, electrolyte and nutritional management of the surgical patient. In Schwartz SI, Lillehei RC, Shires GT, Spencer FL, Storer EH: Principles of Surgery. New York, McGraw–Hill, 1974, p 65

35. Souchon EA, Copeland EM, Watson P, Dudrick SJ: Intravenous hyperalimentation as an adjunct to cancer chemotherapy with 5–fluorouracil. J Surg Res 18:451–454, 1975

36. Stephens RV, Randall HT: Use of a concentrated balanced, liquid elemental diet for nutritional management of catabolic states. Ann Surg 170:642, 1969

37. Wilmore DW, Dudrick SJ, Daly JM, Vars HM: The role of nutrition in the adaptation of the small intestine after mass resection. Surg Gynecol Obstet 132:673–780, 1971

38. Wilmore DW, Long JM, Mason AD, Pruitt BA Jr: Stress in surgical patients as a neurophysiologic reflex response. Surg Gynecol Obstet 142:257–269, 1976

39. Wilmore DW, Long JM, Mason AD, Skreen RW, Pruitt BA Jr: Catecholamines: mediator of the hypermetabolic response to thermal injury. Ann Surg 180:653–669, 1974

Appendix

TABLE A–1. Food and Nutrition Board, National Academy of Sciences–National Research Council Recommended Daily Dietary Allowances,[a] Revised 1974*

Designed for the maintenance of good nutrition of practically all healthy people in the USA

	Age	Weight		Height		Energy	Protein	Fat-soluble vitamins				Water-soluble vitamins							Minerals					
								Vitamin A activity (RE)[c]	Vitamin A activity (IU)	Vitamin D (IU)	Vitamin E activity[e] (IU)	Ascorbic acid (mg)	Folacin[f] (μg)	Niacin[g] (mg)	Riboflavin (mg)	Thiamin (mg)	Vitamin B_6 (mg)	Vitamin B_{12} (μg)	Calcium (mg)	Phosphorus (mg)	Iodine (μg)	Iron (mg)	Magnesium (mg)	Zinc (mg)
	(yrs)	(kg)	(lbs)	(cm)	(in.)	(Cal)[b]	(g)																	
Infants	0.0–0.5	6	14	60	24	kg X 117	kg X 2.2	420[d]	1400	400	4	35	50	5	0.4	0.3	0.3	0.3	360	240	35	10	60	3
	0.5–1.0	9	20	71	28	kg X 108	kg X 2.0	400	2000	400	5	35	50	8	0.6	0.5	0.4	0.3	540	400	45	15	70	5
Children	1–3	13	28	86	34	1300	23	400	2000	400	7	40	100	9	0.8	0.7	0.6	1.0	800	800	60	15	150	10
	4–6	20	44	110	44	1800	30	500	2500	400	9	40	200	12	1.1	0.9	0.9	1.5	800	800	80	10	200	10
	7–10	30	66	135	54	2400	36	700	3300	400	10	40	300	16	1.2	1.2	1.2	2.0	800	800	110	10	250	10
Males	11–14	44	97	158	63	2800	44	1000	5000	400	12	45	400	18	1.5	1.4	1.6	3.0	1200	1200	130	18	350	15
	15–18	61	134	172	69	3000	54	1000	5000	400	15	45	400	20	1.8	1.5	2.0	3.0	1200	1200	150	18	400	15
	19–22	67	147	172	69	3000	54	1000	5000	400	15	45	400	20	1.8	1.5	2.0	3.0	800	800	140	10	350	15
	23–50	70	154	172	69	2700	56	1000	5000		15	45	400	18	1.6	1.4	2.0	3.0	800	800	130	10	350	15
	51+	70	154	172	69	2400	56	1000	5000		15	45	400	16	1.5	1.2	2.0	3.0	800	800	110	10	350	15
Females	11–14	44	97	155	62	2400	44	800	4000	400	12	45	400	16	1.3	1.2	1.6	3.0	1200	1200	115	18	300	15
	15–18	54	119	162	65	2100	48	800	4000	400	12	45	400	14	1.4	1.1	2.0	3.0	1200	1200	115	18	300	15
	19–22	58	128	162	65	2100	46	800	4000	400	12	45	400	14	1.4	1.1	2.0	3.0	800	800	100	18	300	15
	23–50	58	128	162	65	2000	46	800	4000		12	45	400	13	1.2	1.0	2.0	3.0	800	800	100	18	300	15
	51+	58	128	162	65	1800	46	800	4000		12	45	400	12	1.1	1.0	2.0	3.0	800	800	80	10	300	15
Pregnant						+300	+30	1000	5000	400	15	60	800	+2	+0.3	+0.3	2.5	4.0	1200	1200	125	18+	450	20
Lactating						+500	+20	1200	6000	400	15	80	600	+4	+0.5	+0.3	2.5	4.0	1200	1200	150	18	450	25

*Recommended Dietary Allowances, 8th ed. National Academy of Sciences, 1974, p 128. Reproduced with permission of the National Academy of Sciences

[a]The allowances are intended to provide for individual variations among most normal persons as they live in the United States under usual environmental stresses. Diets should be based on a variety of common foods in order to provide other nutrients for which human requirements have been less well defined. See text for more detailed discussion of allowances and of nutrients not tabulated

[b]Kilojoules (kJ) = 4.2 X Cal

[c]Retinol equivalents

[d]Assumed to be all as retinol in milk during the first 6 months of life. All subsequent intakes are assumed to be half as retinol and half as β-carotene when calculated from international units. As retinol equivalents, three-fourths are as retinol and one-fourth as β-carotene

[e]Total vitamin E activity, estimated to be 80% as α-tocopherol and 20% other tocopherols

[f]The folacin allowances refer to dietary sources as determined by *Lactobacillus casei* assay. Pure forms of folacin may be effective in doses less than one-fourth of the recommended dietary allowance

[g]Although allowances are expressed as niacin, it is recognized that on the average 1 mg niacin is derived from each 60 mg dietary tryptophan

[h]This increased requirement cannot be met by ordinary diets; therefore, the use of supplemental iron is recommended

TABLE A—2. Nutrients Required by Man*

Amino acids	Elements	Vitamins

Established as Essential

Amino acids	Elements	Vitamins
Isoleucine	Calcium	Ascorbic acid
Leucine	Chlorine	Choline‡
Lysine	Copper	Folic acid
Methionine	Iodine	Niacin §
Phenylalanine	Iron	Pyridoxine
Threonine	Magnesium	Riboflavin
Tryptophan	Manganese	Thiamin
Valine	Phosphorus	Vitamin B$_{12}$
	Potassium	Vitamins A, −D**, E, and K
	Sodium	
	Zinc	

Probably Essential

Amino acids	Elements	Vitamins
Arginine†	Fluorine	Biotin
Histidine†	Molybdenum	Pantothenic acid
	Selenium	Polyunsaturated fatty acids

*White A, Handler P, Smith EL: Principles of Biochemistry, 5th ed. Copyright 1973, New York, McGraw-Hill, p 1136. Used with permission of McGraw-Hill Book Company

†Indicated to be unnecessary for maintenance of nitrogen equilibrium in adults in short-term studies but probably necessary for normal growth of children

‡Requirement met under circumstances of adequate dietary methionine

§ Requirement may be provided by synthesis from dietary tryptophan

**Requirement may be met by exposure of children to sunlight. No evidence for a requirement in adults

TABLE A—3. Fatty Acid and Cholesterol Content of Foods*

Food	Approximate amount	Weight (g)	Total fat (g)	Saturated fat (g)	Unsaturated fatty acids Oleic (g)	Linoleic (g)	Cholesterol (mg)
Meat Group							
Beef	1 oz	30	7.5	3.6	3.3	Trace	27
Veal	1 oz	30	3.6	1.8	1.5	Trace	27
Lamb	1 oz	30	6.3	3.6	2.4	Trace	27
Pork, ham	1 oz	30	7.8	3.0	3.3	Trace	27
Liver	1 zo	30	1.5	0.4	Trace	Trace	75
Beef, dried	2 slices	20	1.2	0.6	0.6	—	18
Pork sausage	2 links	40	17.6	6.4	7.6	1.6	45
Cold cuts	1 slice	45	9.7	2.4	2.7	0.6	30
Frankfurters	1	50	17.4	9.0	8.0	0.4	50
Fowl	1 oz	30	3.6	1.2	1.2	0.6	23
Eggs	1	50	6.0	2.0	2.5	0.5	253
Fish	1 oz	30	2.7	0.5	1.7	0.5	21
Salmon and tuna	¼ cup	30	5.1	1.4	1.5	1.2	—
Shellfish	1 oz	30	1.9	0.6	1.0	0.3	45
Cheese	1 oz	30	9.0	5.1	3.0	—	45
Cottage cheese	¼ cup	50	2.1	1.0	0.5	—	5
Peanut butter	2 tbsp	30	15.9	2.7	7.5	4.2	—
Peanuts	25	25	12.0	2.5	5.0	3.2	—

(continued)

TABLE A—3. Fatty Acid and Cholesterol Content of Foods* (continued)

Food	Approximate amount	Weight (g)	Total fat (g)	Saturated fat (g)	Unsaturated fatty acids Oleic (g)	Linoleic (g)	Cholesterol (mg)
Fat Group							
Avocado	1/8	30	5.1	0.9	2.4	0.6	—
Bacon	1 strip	5	2.6	0.9	1.0	0.3	5
Butter	1 tsp	5	4.0	2.3	1.2	—	12
Margarine	1 tsp	5	4.0	1.1	2.5	0.4	—
Special margarine	1 tsp	5	4.0	0.6	2.3	1.1	—
Coconut oil	1 tsp	5	5.0	4.4	0.5	0.1	—
Corn oil	1 tsp	5	5.0	0.5	1.8	2.7	—
Cottonseed oil	1 tsp	5	5.0	1.3	1.2	2.5	—
Olive oil	1 tsp	5	5.0	0.6	4.0	0.4	—
Peanut oil	1 tsp	5	5.0	0.9	1.6	1.5	—
Safflower oil	1 tsp	5	5.0	0.4	1.0	3.6	—
Sesame oil	1 tsp	5	5.0	0.9	1.0	2.1	—
Soybean oil	1 tsp	5	5.0	0.8	1.6	2.6	—
Vegetable fat	1 tsp	5	5.0	1.0	2.6	0.4	—
Half and half	2 tbsp	30	3.6	1.8	1.8	—	12
Cream substitute, dried	1 tbsp	2	0.5	0.3	0.2	—	—
Whipping cream	1 tbsp	15	5.6	3.2	2.2	0.2	18
Cream cheese	1 tbsp	15	5.3	3.0	2.2	0.1	18
Mayonnaise	1 tsp	5	4.0	0.7	1.3	2.0	8
French dressing	1 tbsp	15	5.0	1.1	1.1	3.0	—
Nuts							
Almonds	5	6	3.5	0.3	2.5	0.7	—
Pecans	4	5	3.6	0.3	2.6	0.7	—
Walnuts	5	10	6.5	0.4	2.0	4.0	—
Olives	3	30	4.2	0.6	3.0	0.3	—
Milk Group							
Milk, whole	1 cup	240	8.5	4.9	3.6	—	27
2% milk	1 cup	240	4.9	2.4	2.5	—	15
Skim milk	1 cup	240	—	—	—	—	7
Cocoa (skim milk)	1 cup	240	1.9	0.7	1.2	—	—
Chocolate milk	1 cup	240	8.5	2.5	6.0	—	—
Bread Group							
Bread	1 slice	25	0.8	0.3	0.5	—	—
Biscuit	1	35	6.5	2.3	3.4	0.8	17
Muffin	1	35	3.5	0.7	2.4	0.4	16
Cornbread	1 (1 ½ in. cube)	35	4.0	1.4	2.1	0.4	16
Roll	1	28	1.3	0.3	0.7	0.3	—
Pancake	1 (4 in. diam)	45	3.2	0.9	1.9	0.4	38
Waffle	1	35	3.4	1.0	2.1	0.4	28
Sweet roll	1	35	8.2	2.4	5.1	0.7	25
French toast	1 slice	65	8.1	3.9	3.4	0.8	130
Doughnut	1	30	6.0	1.3	4.4	0.3	27
Cereal, cooked	2/3 cup	140	1.4	—	1.4	0.3	—
Crackers (saltines)	6	20	2.4	0.6	1.4	—	—
Popcorn (unbuttered)	1 cup	15	0.7	0.1	0.2	0.4	—
Potatoes							
Potato chips	1-oz bag	30	12.0	3.0	4.0	6.0	—
French fried							
In corn oil	10	50	6.2	0.4	2.3	3.5	—
In hydrogenated fat	10	50	6.2	1.6	4.0	0.6	—
Mashed potato	½ cup	100	4.3	2.0	2.3	—	—
Soup, cream	½ cup	100	4.2	1.0	2.2	1.0	9
Dessert							
Ice milk	½ cup	75	2.5	1.5	—	—	5
Ice cream	½ cup	75	9.0	5.0	3.9	—	43
Sherbet	1/3 cup	50	0.6	0.4	0.2	—	—
Low fat cookies	5	15	1.8	0.3	—	—	—
Cake	1 piece	50	14.0	2.0	—	0.5	45
Fruit pie	1/6 of 9 in. pie	160	15.0	4.0	9.5	1.4	11
Miscellaneous							
Gravy	1/4 cup	60	13.8	6.8	6.6	0.4	18
White sauce	1/4 cup	60	8.2	4.6	3.6	—	29
Coconut	1 oz	28	10.9	9.5	1.4	—	—
Chocolate sauce	1 oz	30	3.8	2.0	1.8	—	—

*The committee on dietetics of the Mayo Clinic: Mayo Clinic Diet Manual. Philadelphia, WB Saunders, 1971, pp 138—139

TABLE A—4. Foods Hign in Calcium*
(More Than 25 mg Calcium/Serving)

Food	Approximate amount	Weight (g)	Calcium (mg)
Meat Group			
Egg	1	50	27
Fish			
Salmon (with bones)	1 oz	30	51
Sardines	1 oz	30	115
Clams	1 oz	30	29
Oysters	1 oz	30	31
Shrimp	1 oz	30	35
Cheese			
Cheddar	1 oz	30	218
Cheese foods	1 oz	30	160
Cheese spread	1 oz	30	158
Cottage cheese	1/4 cup	50	53
Fat			
Cream			
Half and half	2 tbsp	30	32
Sour	2 tbsp	30	31
Bread Group			
Bread			
Biscuit	2 in. diameter	35	42
Muffin	2 in. diameter	35	36
Cornbread	1 ½ in. cube	35	36
Pancake	4 in. diameter	45	45
Waffle	1/2 square	35	39
Beans, dry (canned or cooked)	1/2 cup	90	45
Lima beans	1/2 cup	100	42
Parsnips	2/3 cup	100	45
Milk			
Whole	1 cup	240	288
Evaporated whole milk	1/2 cup	120	302
Powdered whole milk	1/2 cup	30	252
Buttermilk	1 cup	240	296
Skim milk	1 cup	240	298
Powdered skim milk, dry	1/4 cup	30	367
Fruit			
Blackberries	3/4 cup	100	32
Orange	1 medium	100	41
Raspberries	3/4 cup	100	30
Rhubarb	1 cup	100	96
Tangerine	2 small	100	40
Vegetable A, cooked			
Beans, green or wax	1/2 cup	100	50
Beet greens	1/2 cup	100	99
Broccoli	1/2 cup	100	88
Cabbage	1/2 cup	100	49
Cabbage, Chinese	1/2 cup	100	43
Celery	1/2 cup	100	39
Chard	1/2 cup	100	73
Collards	1/2 cup	100	188
Cress	1/2 cup	100	81
Dandelion greens	1/2 cup	100	140
Mustard greens	1/2 cup	100	138
Sauerkraut	1/2 cup	100	36
Spinach	1/2 cup	100	93

(continued)

TABLE A—4. Foods High in Calcium* *(continued)*

Food	Approximate amount	Weight (g)	Calcium (mg)
Vegetable A, cooked (continued)			
Squash, summer	1/2 cup	100	25
Turnip greens	1/2 cup	100	184
Turnips	1/2 cup	100	35
Vegetable B, cooked			
Artichokes	1/2 cup	100	51
Brussels sprouts	1/2 cup	100	32
Carrots	1/2 cup	100	33
Kale	1/2 cup	100	187
Kohlrabi	1/2 cup	100	33
Leeks, raw	3—4	100	52
Okra	1/2 cup	100	92
Pumpkin	1/2 cup	100	25
Rutabagas	1/2 cup	100	59
Squash, winter	1/2 cup	100	28
Dessert			
Cake, white	1 piece	50	32
Custard, baked	1/3 cup	100	112
Ice cream	1/2 cup	75	110
Ice milk	1/2 cup	75	118
Pie, cream	1/6 of 9 in. pie	160	120
Pudding	1/2 cup	100	117
Sherbet	1/3 cup	50	25

*The committee on dietetics of the Mayo Clinic; Mayo Clinic Diet Manual.
Philadelphia, WB Saunders, 1971, p 142

TABLE A—5. Sodium and Potassium Content of Foods*

Food	Approximate amount	Weight (g)	Sodium (mEq)	Potassium (mEq)
Meat				
Meat (cooked)				
Beef	1 oz	30	0.8	2.8
Ham	1 oz	30	14.3	2.6
Lamb	1 oz	30	0.9	2.2
Pork	1 oz	30	1.0	3.0
Veal	1 oz	30	1.0	3.8
Liver	1 oz	30	2.4	3.2
Sausage, pork	2 links	40	16.5	2.8
Beef, dried	2 slices	20	37.0	1.0
Cold cuts	1 slice	45	25.0	2.7
Frankfurters	1	50	24.0	3.0
Fowl				
Chicken	1 oz	30	1.0	3.0
Goose	1 oz	30	1.6	4.6
Duck	1 oz	30	1.0	2.2
Turkey	1 oz	30	1.2	2.8
Egg	1	50	2.7	1.8
Fish	1 oz	30	1.0	2.5
Salmon				
Fresh	1/4 cup	30	0.6	2.3
Canned	1/4 cup	30	4.6	2.6
Tuna				
Fresh	1/4 cup	30	0.5	2.2
Canned	1/4 cup	30	10.4	2.3
Sardines	3 medium	35	12.5	4.5
Shellfish				
Clams	5 small	50	2.6	2.3
Lobster	1 small tail	40	3.7	1.8
Oysters	5 small	70	2.1	1.5
Scallops	1 large	50	5.7	6.0
Shrimp	5 small	30	1.8	1.7

(continued)

TABLE A—5. Sodium and Potassium Content of Foods* *(continued)*

Food	Approximate amount	Weight (g)	Sodium (mEq)	Potassium (mEq)
Cheese				
Cheese, American or Cheddar type	1 slice	30	9.1	0.6
Cheese foods	1 slice	30	15.0	0.8
Cheese spreads	2 tbsp	30	15.0	0.8
Cottage cheese	1/4 cup	50	5.0	1.1
Peanut butter	2 tbsp	30	7.8	5.0
Peanuts, unsalted	25	25	—	4.5
Fat				
Avocado	1/8	30	—	4.6
Bacon	1 slice	5	2.2	0.6
Butter or margarine	1 tsp	5	2.2	—
Cooking fat	1 tsp	5	—	—
Cream				
Half and half	2 tbsp	30	0.6	1.0
Sour	2 tbsp	30	0.4	—
Whipped	1 tbsp	15	0.3	1.0
Cream cheese	1 tbsp	15	1.7	—
Mayonnaise	1 tsp	5	1.3	—
Nuts				
Almonds, slivered	5 (2 tsp)	6	—	0.8
Pecans	4 halves	5	—	0.8
Walnuts	5 halves	10	—	1.0
Oil, salad	1 tsp	5	—	—
Olives, green	3 medium	30	31.3	0.4
Bread				
Bread	1 slice	25	5.5	0.7
Biscuit	1 (2 in. diam)	35	9.6	0.7
Muffin	1 (2 in. diam)	35	7.3	1.2
Cornbread	1 (1/2 in. cube)	35	11.3	1.7
Roll	1 (2 in. diam)	25	5.5	0.6
Bun	1	30	6.6	0.7
Pancake	1 (4 in. diam)	45	8.8	1.1
Waffle	1/2 square	35	8.5	1.0
Cereals				
Cooked	2/3 cup	140	8.7	2.0
Dry, flake	2/3 cup	20	8.7	0.6
Dry, puffed	1 1/2 cups	20	—	1.5
Shredded wheat	1 biscuit	20	—	2.2
Crackers				
Graham	3	20	5.8	2.0
Melba toast	4	20	5.5	0.7
Oyster	20	20	9.6	0.6
Ritz	6	20	9.5	0.5
Rye-Krisp	3	30	11.5	3.0
Saltines	6	20	9.6	0.6
Soda	3	20	9.6	0.6
Dessert				
Commercial gelatin	1/2 cup	100	2.2	—
Ice cream	1/2 cup	75	2.0	3.0
Sherbet	1/3 cup	50	—	—
Angel food cake	1 1/2 in X 1 1/2 in.	25	3.0	0.6
Sponge cake	1 1/2 in. X 1 1/2 in.	25	1.8	0.6
Vanilla wafers	5	15	1.7	—
Flour products†				
Cornstarch	2 tbsp	15	—	—
Macaroni	1/4 cup	50	—	0.8
Noodles	1/4 cup	50	—	0.6
Rice	1/4 cup	50	—	0.9
Spaghetti	1/4 cup	50	—	0.8
Tapioca	2 tbsp	15	—	—

(continued)

TABLE A−5. Sodium and Potassium Content of Foods* *(continued)*

Food	Approximate amount	Weight (g)	Sodium (mEq)	Potassium (mEq)
Vegetable *				
Beans, dried (cooked)	1/2 cup	90	—	10.0
Beans, lima	1/2 cup	90	—	9.5
Corn				
Canned‡	1/3 cup	80	8.0	2.0
Fresh	1/2 ear	100	—	2.0
Frozen	1/3 cup	80	—	3.7
Hominy (dry)	1/4 cup	36	4.1	—
Parsnips	2/3 cup	100	0.3	9.7
Peas				
Canned†	1/2 cup	100	10.0	1.2
Dried	1/2 cup	90	1.5	6.8
Fresh	1/2 cup	100	—	2.5
Frozen	1/2 cup	100	2.5	1.7
Popcorn	1 cup	15	—	—
Potato				
Potato chips	1 oz	30	13.0	3.7
White, baked	1/2 cup	100	—	13.0
White, boiled	1/2 cup	100	—	7.3
Sweet, baked	1/4 cup	50	0.4	4.0
Milk				
Whole milk	1 cup	240	5.2	8.8
Evaporated whole milk	1/2 cup	120	6.0	9.2
Powdered whole milk	1/4 cup	30	5.2	10.0
Buttermilk	1 cup	240	13.6	8.5
Skim milk	1 cup	240	5.2	8.8
Powdered skim milk	1/4 cup	30	6.9	13.5
Vegetable A†				
Asparagus				
Cooked	1/2 cup	100	—	4.7
Canned‡	1/2 cup	100	10.0	3.6
Frozen	1/2 cup	100	—	5.5
Bean sprouts	1/2 cup	100	—	4.0
Beans, green or wax				
Fresh or frozen	1/2 cup	100	—	4.0
Canned‡	1/2 cup	100	10.0	2.5
Beet greens	1/2 cup	100	3.0	8.5
Broccoli	1/2 cup	100	—	7.0
Cabbage, cooked	1/2 cup	100	0.6	4.2
Raw	1 cup	100	0.9	6.0
Cauliflower, cooked	1 cup	100	0.4	5.2
Celery, raw	1 cup	100	5.4	9.0
Chard, Swiss	3/5 cup	100	3.7	8.0
Collards	1/2 cup	100	0.8	6.0
Cress, garden (cooked)	1/2 cup	100	0.5	7.2
Cucumber	1 med	100	0.3	4.0
Eggplant	1/2 cup	100	—	3.8
Lettuce	Varies	100	0.4	4.5
Mushrooms, raw	4 large	100	0.7	10.6
Mustard greens	1/2 cup	100	0.8	5.5
Pepper, green or red				
Cooked	1/2 cup	100	—	5.5
Raw	1	100	0.5	4.0
Radishes	10	100	0.8	8.0
Sauerkraut	2/3 cup	100	32.0	3.5
Spinach	1/2 cup	100	2.2	8.5
Squash	1/2 cup	100	—	3.5
Tomatoes	1/2 cup	100	—	6.5
Tomato juice‡	1/2 cup	100	9.0	5.8
Turnip greens	1/2 cup	100	0.7	3.8
Turnips	1/2 cup	100	1.5	4.8

(continued)

TABLE A–5. Sodium and Potassium Content of Foods* (continued)

Food	Approximate amount	Weight (g)	Sodium (mEq)	Potassium (mEq)
Vegetable B†				
Artichokes	1 large bud	100	1.3	7.7
Beets	1/2 cup	100	1.8	5.0
Brussels sprouts	2/3 cup	100	—	7.6
Carrots, cooked	1/2 cup	100	1.4	5.7
Raw	1 large	100	2.0	8.8
Dandelion greens	1/2 cup	100	2.0	6.0
Kale, cooked	3/4 cup	100	2.0	5.6
Frozen	1/2 cup	100	1.0	5.0
Kohlrabi	2/3 cup	100	—	6.6
Leeks, raw	3–4	100	—	9.0
Okra	1/2 cup	100	—	4.4
Onions, cooked	1/2 cup	100	—	2.8
Pumpkin	1/2 cup	100	—	6.3
Rutabagas	1/2 cup	100	—	4.4
Squash, winter				
Baked	1/2 cup	100	—	12.0
Boiled	1/2 cup	100	—	6.5
Fruit				
Apple				
Fresh	1 small	80	—	2.3
Sauce	1/2 cup	120	—	2.5
Juice	1/2 cup	120	—	3.1
Apricots				
Canned	1/2 cup	120	—	6.0
Dried	4 halves	20	—	5.0
Fresh	3 small	120	—	8.0
Nectar	1/3 cup	80	—	3.0
Banana	1/2 small	60	—	4.8
Berries, fresh				
Blackberries	3/4 cup	100	—	3.0
Blueberries	1/2 cup	80	—	1.5
Boysenberries	1 cup	120	—	3.2
Gooseberries	3/4 cup	120	—	4.0
Loganberries	3/4 cup	100	—	4.4
Raspberries	3/4 cup	100	—	4.5
Strawberries	1 cup	150	—	6.3
Cherries				
Canned	1/2 cup	120	—	4.0
Fresh	15 small	80	—	2.7
Dates				
Pitted	2	15	—	2.5
Figs				
Canned	1/2 cup	120	—	4.6
Dried	1 small	15	—	2.5
Fresh	1 large	60	—	3.0
Fruit cocktail	1/2 cup	120	—	5.0
Grapes				
Canned	1/3 cup	80	—	2.2
Fresh	15	80	—	3.2
Juice				
Bottled	1/4 cup	60	—	2.8
Frozen	1/3 cup	80	—	2.4
Grapefruit				
Fresh	1/2 med	120	—	3.6
Juice	1/2 cup	120	—	4.1
Sections	3/4 cup	150	—	5.1
Mandarin orange	3/4 cup	200	—	6.5
Mango	1/2 small	70	—	3.4

(continued)

TABLE A—5. Sodium and Potassium Content of Foods* *(continued)*

Food	Approximate amount	Weight (g)	Sodium (mEq)	Potassium (mEq)
Fruit (continued)				
Melon				
Cantaloupe	1/2 small	200	—	13.0
Honeydew	1/4 med	200	—	13.0
Watermelon	1/2 slice	200	—	5.0
Nectarine	1 med	80	—	6.0
Orange				
Fresh	1 med	100	—	5.1
Juice	1/2 cup	120	—	5.7
Sections	1/2 cup	100	—	5.1
Papaya	1/2 cup	120	—	7.0
Peach				
Canned	1/2 cup	120	—	4.0
Dried	2 halves	20	—	5.0
Fresh	1 med	120	—	6.2
Nectar	1/2 cup	120	—	2.4
Pear				
Canned	1/2 cup	120	—	2.5
Dried	2 halves	20	—	3.0
Fresh	1 med	80	—	6.2
Nectar	1/3 cup	80	—	0.9
Pineapple				
Canned	1/2 cup	120	—	3.0
Fresh	1/2 cup	80	—	3.0
Juice	1/3 cup	80	—	3.0
Plums				
Canned	1/2 cup	120	—	4.5
Fresh	2 med	80	—	4.1
Prunes	2 med	15	—	2.6
Juice	1/4 cup	60	—	3.6
Raisins	1 tbsp	15	—	2.9
Rhubarb	1/2 cup	100	—	6.5
Tangerines				
Fresh	2 small	100	—	3.2
Juice	1/2 cup	120	—	5.5
Sections	1/2 cup	100	—	3.2

(continued)

Conversion Table

To convert mg to meq

1. Divide mg by atomic weight

Example: 1000 mg sodium = $\dfrac{1000}{23}$ = 43.5 mEq sodium

Mineral	Atomic weight
Sodium	23
Potassium	39

To convert specific weight of sodium to sodium chloride

1. Multiply by 2.54

Example: 1000 mg sodium = 1000 X 2.54 = 2540 mg sodium chloride (2.5 g)

To convert specific weight of sodium chloride to sodium

1. Multiply by 0.393

Example: 2.5 g sodium chloride = 2.5 X 0.393 = 1000 mg sodium

Sodium (mg)	Sodium Values (mEq)	Sodium Chloride (g)
500	21.8	1.3
1000	43.5	2.5
1500	75.3	3.8
2000	87.0	5.0

*The committee on dietetic of the Mayo Clinic: Mayo Clinic Diet Manual. Philadelphia, WB Saunders, 1971, pp 144—149
†Value for products without added salt
‡Estimated average based on addition of salt, approximately 0.6% of the finished product

TABLE A—6. Acid-Base Reaction of Foods*

Potentially acid or acid-ash foods	Potentially basic or alkaline-ash foods	Neutral foods
Meat	*Milk, Cream, and Buttermilk*	*Fats*
Meat, fish, fowl, shellfish	*Nuts*	Butter or margarine
Eggs	Almonds, chestnuts, coconut	Cooking fats and oils
Cheese, all types	*Vegetable*	*Sweets*
Peanut butter	All types (except corn and lentils)	Candy, plain
Fat	*Fruit*	Sugar and syrup
Bacon	All types (except cranberries, prunes, plums)	*Starch*
Nuts: Brazil, filberts, peanuts, walnuts		Arrowroot, corn, tapioca
Bread		
Breads, all types; crackers		
Macaroni, spaghetti, noodles		
Vegetable		
Corn and lentils		
Fruit		
Cranberries, plums, prunes		
Dessert		
Cakes and cookies, plain		

*The committee on dietetics of the Mayo Clinic: Mayo Clinic Diet Manual. Philadelphia, WB Saunders, 1971, p 137

TABLE A—7. Physiologic Values*

Blood Values

1. Energy (per 10 ml blood)
 Carbohydrates
 Fasting sugar 65—90 mg
 Lipids (per 100 ml plasma)
 Cholesterol, total 150—300 mg
 Cholesterol, esters 105—210 mg
 Phospholipids, total 180—320 mg
 Triglycerides <150—150 mg
2. Protein (per 100 ml serum)
 Protein electrophoresis
 Albumin 3.3—4.3 g
 α-1-globulin 0.3—0.4 g
 α-2-globulin 0.5—0.8 g
 β-globulin 0.6—1.1 g
 γ-globulin 0.8—1.6 g
 Urea (per 100 ml blood) Male 17—51 mg
 Female 13—45 mg
 Uric acid (per 100 ml serum) Male 4.3—8.0 mg
 Female 2.3—6.0 mg
 Phenylalanine (per 100 ml plasma) 0.7—2.8 mg
3. Vitamins (per 100 ml serum)
 Ascorbic acid 0.4—1.0 mg
 Carotene 48 μg
 Folic acid 0.59—1.6 mg
 Vitamin A 125—150 IU
4. Mineral elements (per 100 ml serum)
 Calcium 8.9—10.1 mg
 Phosphorus 2.5—4.5 mg
 Copper 75—145 μg
 Protein-bound iodine 3.5—7.5 μg
 Iron 75—175 μg
 Magnesium 1.9—2.6 mg
 Zinc 70—140 μg
5. Electrolytes and water
 Carbon dioxide 25—29 mEq/liter plasma
 Chloride 97—106 mEq/liter plasma
 Potassium 4.0—5.0 mEq/liter serum
 Sodium 135—145 mEq/liter serum
 Osmolality 270—285 mOsm/liter blood
6. Hematology
 Erythrocyte count Male: $4,500,000—6,200,000/mm^3$
 Female: $4,200,000—5,400,000/mm^3$
 Hematocrit reading Male: 42%—54%
 Female: 38%—46%
 Hemaglobin Male: 14—17 g/100 ml blood
 Female: 12—15 g/100 ml blood
 Bleeding time Duke: 1—5 min
 Ivy: 1—6 min

Stool

Fat, quantitative <7g/24 hr
Nitrogen <2.5 g/100 ml

Urine

Creatinine clearance 120—130 ml/min
Potassium 40—65 mEq/24 hr
Total protein excretion <30 mg/24 hr
Sodium 130—200 mEq/24 hr
Urea clearance 40—60 ml/min
Uric acid 250—750 mg/24 hr

Miscellaneous

Basal metabolism rate —10% to +10%
Schilling test >8% excretion

*The committee on dietetics of the Mayo Clinic: Mayo Clinic Diet Manual. Philadelphia, WB Saunders, 1971, pp 150—151

TABLE A—8. Percentiles for Weight and Height*
 A. For Boys from Birth to 18 Years

	Percentiles						
Age	3	10	25	50	75	90	97
Birth							
Weight (lb)	5.8	6.3	6.9	7.5	8.3	9.1	10.1
Height (in.)	18.2	18.9	19.4	19.9	20.5	21.0	21.5
3 mo							
Weight (lb)	10.6	11.1	11.8	12.6	13.6	14.5	16.4
Height (in.)	22.4	22.8	23.3	23.8	24.3	24.7	25.1
6 mo							
Weight (lb)	14.0	14.8	15.6	16.7	18.0	19.2	20.8
Height (in.)	24.8	25.2	25.7	26.1	26.7	27.3	27.7
9 mo							
Weight (lb)	16.6	17.8	18.7	20.0	21.5	22.9	24.4
Height (in.)	26.6	27.0	27.5	28.0	28.7	29.2	29.9
12 mo							
Weight (lb)	18.5	19.6	20.9	22.2	23.8	25.4	27.3
Height (in.)	28.1	28.5	29.0	29.6	30.3	30.7	31.6
15 mo							
Weight (lb)	19.8	21.0	22.4	23.7	25.4	27.2	29.4
Height (in.)	29.3	29.8	30.3	30.9	31.6	32.1	33.1
18 mo							
Weight (lb)	21.1	22.3	23.8	25.2	26.9	29.0	31.5
Height (in.)	30.5	31.0	31.6	32.2	32.9	33.5	34.7
2 yr							
Weight (lb)	23.3	24.7	26.3	27.7	29.7	31.9	34.9
Height (in.)	32.6	33.1	33.8	34.4	35.2	35.9	37.2
2½ yr							
Weight (lb)	25.2	26.6	28.4	30.0	32.2	34.5	37.0
Height (in.)	34.2	34.8	35.5	36.3	37.0	37.9	39.2
3 yr							
Weight (lb)	27.0	28.7	30.3	32.2	34.5	36.8	39.2
Height (in.)	35.7	36.3	37.0	37.9	38.8	39.6	40.5
3½ yr							
Weight (lb)	28.5	30.4	32.3	34.3	36.7	39.1	41.5
Height (in.)	37.1	37.8	38.4	39.3	40.3	41.1	41.9
4 yr							
Weight (lb)	30.1	32.1	34.0	36.4	39.0	41.4	44.3
Height (in.)	38.4	39.1	39.7	40.7	41.9	42.7	43.5
4½ yr							
Weight (lb)	31.6	33.8	35.7	38.4	41.4	43.9	47.4
Height (in.)	39.6	40.3	40.9	42.0	43.3	44.2	45.0
5 yr							
Weight (lb)	33.6	35.5	37.5	40.5	44.1	46.7	50.4
Height (in.)	40.2	40.8	41.7	42.8	44.2	45.2	46.1
5½ yr							
Weight (lb)		38.8	42.0	45.6	49.3	53.1	
Height (in.)		42.6	43.8	45.0	46.3	47.3	
6 yr							
Weight (lb)	38.5	40.9	44.4	48.3	52.1	56.4	61.1
Height (in.)	42.7	43.8	44.9	46.3	47.6	48.6	49.7
6½ yr							
Weight (lb)		43.4	47.1	51.2	55.4	60.4	
Height (in.)		44.9	46.1	47.6	48.9	50.0	
7 yr							
Weight (lb)	43.0	45.8	49.7	54.1	58.7	64.4	69.9
Height (in.)	44.9	46.0	47.4	48.9	50.2	51.4	52.5
7½ yr							
Weight (lb)		48.5	52.6	57.1	62.1	68.7	
Height (in.)		47.2	48.6	50.0	51.5	52.7	

(continued)

Age	\multicolumn{7}{c}{Percentiles}						
	3	10	25	50	75	90	97
8 yr							
Weight (lb)	48.0	51.2	55.5	60.1	65.5	73.0	79.4
Height (in.)	47.1	48.5	49.8	51.2	52.8	54.0	55.2
8½ yr							
Weight (lb)		53.8	58.3	63.1	68.9	77.0	
Height (in.)		49.5	50.8	52.3	53.9	55.1	
9 yr							
Weight (lb)	52.5	56.3	61.1	66.0	72.3	81.0	89.8
Height (in.)	48.9	50.5	51.8	53.3	55.0	56.1	57.2
9½ yr							
Weight (lb)		58.7	63.7	69.0	76.0	85.5	
Height (in.)		51.4	52.7	54.3	55.9	57.1	
10 yr							
Weight (lb)	56.8	61.1	66.3	71.9	79.6	89.9	100.0
Height (in.)	50.7	52.3	53.7	55.2	56.8	58.1	59.2
10½ yr							
Weight (lb)		63.7	69.0	74.8	83.4	94.6	
Height (in.)		53.2	54.5	56.0	57.8	58.9	
11 yr							
Weight (lb)	61.8	66.3	71.6	77.6	87.2	99.3	111.7
Height (in.)	52.5	54.0	55.3	56.8	58.7	59.8	60.8
11½ yr							
Weight (lb)		69.2	74.6	81.0	91.6	104.5	
Height (in.)		55.0	56.3	57.8	59.6	60.9	
12 yr							
Weight (lb)	67.2	72.0	77.5	84.4	96.0	109.6	124.2
Height (in.)	54.4	56.1	57.2	58.9	60.4	62.2	63.7
12½ yr							
Weight (lb)		74.6	80.6	88.7	102.0	116.4	
Height (in.)		56.9	58.1	60.0	61.9	63.6	
13 yr							
Weight (lb)	72.0	77.1	83.7	93.0	107.9	123.2	138.0
Height (in.)	56.0	57.7	58.9	61.0	63.3	65.1	66.7
13½ yr							
Weight (lb)		82.2	89.6	100.3	115.5	130.1	
Height (in.)		58.8	60.3	62.6	64.8	66.5	
14 yr							
Weight (lb)	79.8	87.2	95.5	107.6	123.1	136.9	150.6
Height (in.)	57.6	59.9	61.6	64.0	66.3	67.9	69.7
14½ yr							
Weight (lb)		93.3	101.9	113.9	129.1	142.4	
Height (in.)		61.0	62.7	65.1	67.2	68.7	
15 yr							
Weight (lb)	91.3	99.4	108.2	120.1	135.0	147.8	161.6
Height (in.)	59.7	62.1	63.9	66.1	68.1	69.6	71.6
15½ yr							
Weight (lb)		105.2	113.5	124.9	139.7	152.6	
Height (in.)		63.1	64.8	66.8	68.8	70.2	
16 yr							
Weight (lb)	103.4	111.0	118.7	129.7	144.4	157.3	170.5
Height (in.)	61.6	64.1	65.8	67.8	69.5	70.7	73.1
16½ yr							
Weight (lb)		114.3	121.6	133.0	147.9	161.0	
Height (in.)		64.6	66.3	68.0	69.8	71.1	
17 yr							
Weight (lb)	110.5	117.5	124.5	136.2	151.4	164.6	175.6
Height (in.)	62.6	65.2	66.8	68.4	70.1	71.5	73.5
17½ yr							
Weight (lb)		118.8	125.8	137.6	153.6	166.8	
Height (in.)		65.3	67.0	68.5	70.3	71.6	
18 yr							
Weight (lb)	113.0	120.0	127.1	139.0	155.7	169.0	179.0
Height (in.)	62.8	65.5	67.0	68.7	70.4	71.8	73.9

(*continued*)

TABLE A—8. Percentiles for Weight and Height* *(continued)*
B. For Girls from Birth to 18 Years

Age	3	10	25	50	75	90	97
				Percentiles			
Birth							
Weight (lb)	5.8	6.2	6.9	7.4	8.1	8.6	9.4
Height (in.)	18.5	18.8	19.3	19.8	20.1	20.4	21.1
3 mo							
Weight (lb)	9.8	10.7	11.4	12.4	13.2	14.0	14.9
Height (in.)	22.0	22.4	22.8	23.4	23.9	24.3	24.8
6 mo							
Weight (lb)	12.7	14.1	15.0	16.0	17.5	18.6	20.0
Height (in.)	24.0	24.6	25.1	25.7	26.2	26.7	27.1
9 mo							
Weight (lb)	15.1	16.6	17.8	19.2	20.8	22.4	24.2
Height (in.)	25.7	26.4	26.9	27.6	28.2	28.7	29.2
12 mo							
Weight (lb)	16.8	18.4	19.8	21.5	23.0	24.8	27.1
Height (in.)	27.1	27.8	28.5	29.2	29.9	30.3	31.0
15 mo							
Weight (lb)	18.1	19.8	21.3	23.0	24.6	26.6	29.0
Height (in.)	28.3	29.0	29.8	30.5	31.3	31.8	32.6
18 mo							
Weight (lb)	19.4	21.2	22.7	24.5	26.2	28.3	30.9
Height (in.)	29.5	30.2	31.1	31.8	32.6	33.3	34.1
2 yr							
Weight (lb)	21.6	23.5	25.3	27.1	29.2	31.7	34.4
Height (in.)	31.5	32.3	33.3	34.1	35.0	35.8	36.7
2½ yr							
Weight (lb)	23.6	25.5	27.4	29.6	31.9	34.6	38.2
Height (in.)	33.3	34.0	35.2	36.0	36.9	37.9	38.9
3 yr							
Weight (lb)	25.6	27.6	29.6	31.8	34.6	37.4	41.8
Height (in.)	34.8	35.6	36.8	37.7	38.6	39.8	40.7
3½ yr							
Weight (lb)	27.5	29.5	31.5	33.9	37.0	40.4	45.3
Height (in.)	36.2	37.1	38.1	39.2	40.2	41.5	42.5
4 yr							
Weight (lb)	29.2	31.2	33.5	36.2	39.6	43.5	48.2
Height (in.)	37.5	38.4	39.5	40.6	41.6	43.1	44.2
4½ yr							
Weight (lb)	30.7	32.9	35.3	38.5	42.1	46.7	50.9
Height (in.)	38.6	39.7	40.8	42.0	43.0	44.7	45.7
5 yr							
Weight (lb)	32.1	34.8	37.4	40.5	44.8	49.2	52.8
Height (in.)	39.4	40.5	41.6	42.9	44.0	45.4	46.8
5½ yr							
Weight (lb)		38.0	40.8	44.0	47.2	51.2	
Height (in.)		42.4	43.4	44.4	45.7	46.8	
6 yr							
Weight (lb)	37.2	39.6	42.9	46.5	50.2	54.2	58.7
Height (in.)	42.5	43.5	44.6	45.6	47.0	48.1	49.4
6½ yr							
Weight (lb)		42.2	45.5	49.4	53.3	57.7	
Height (in.)		44.8	45.7	46.9	48.3	49.4	
7 yr							
Weight (lb)	41.3	44.5	48.1	52.2	56.3	61.2	67.3
Height (in.)	44.9	46.0	46.9	48.1	49.6	50.7	51.9
7½ yr							
Weight (lb)		46.6	50.6	55.2	59.8	65.6	
Height (in.)		47.0	48.0	49.3	50.7	51.9	

(continued)

TABLE A—8. Percentiles for Weight and Height*
B. For Girls from Birth to 18 Years (*continued*)

Age	Percentiles						
	3	10	25	50	75	90	97
8 yr							
Weight (lb)	45.3	48.6	53.1	58.1	63.3	69.9	78.9
Height (in.)	46.9	48.1	49.1	50.4	51.8	53.0	54.1
8½ yr							
Weight (lb)		50.6	55.5	61.0	66.9	74.5	
Height (in.)		49.0	50.1	51.4	52.9	54.1	
9 yr							
Weight (lb)	49.1	52.6	57.9	63.8	70.5	79.1	89.9
Height (in.)	48.7	50.0	51.1	52.3	54.0	55.3	56.5
9½ yr							
Weight (lb)		54.9	60.4	67.1	74.8	84.4	
Height (in.)		50.9	52.0	53.5	55.1	56.4	
10 yr							
Weight (lb)	53.2	57.1	62.8	70.3	79.1	89.7	101.9
Height (in.)	50.3	51.8	53.0	54.6	56.1	57.5	58.8
10½ yr							
Weight (lb)		59.9	66.4	74.6	84.1	95.1	
Height (in.)		52.9	54.1	55.8	57.4	58.9	
11 yr							
Weight (lb)	57.9	62.6	69.9	78.8	89.1	100.4	112.9
Height (in.)	52.1	53.9	55.2	57.0	58.7	60.4	62.0
11½ yr							
Weight (lb)		66.1	74.0	83.2	94.0	106.0	
Height (in.)		55.0	56.3	58.3	60.2	61.8	
12 yr							
Weight (lb)	63.6	69.5	78.0	87.6	98.8	111.5	127.7
Height (in.)	54.3	56.1	57.4	59.8	61.6	63.2	64.8
12½ yr							
Weight (lb)		74.7	83.7	93.4	104.9	118.0	
Height (in.)		57.4	58.8	60.7	62.6	64.0	
13 yr							
Weight (lb)	72.2	79.9	89.4	99.1	111.0	124.5	142.3
Height (in.)	56.6	58.7	660.1	61.8	63.6	64.9	66.3
13½ yr							
Weight (lb)		85.5	94.6	103.7	115.4	128.9	
Height (in.)		59.5	60.8	62.4	64.0	65.3	
14 yr							
Weight (lb)	83.1	91.0	99.8	108.4	119.7	133.3	150.8
Height (in.)	58.3	60.2	61.5	62.8	64.4	65.7	67.2
14½ yr							
Weight (lb)		94.2	102.5	111.0	121.8	135.7	
Height (in.)		60.7	61.8	63.1	64.7	66.0	
15 yr							
Weight (lb)	89.0	97.4	105.1	113.5	123.9	138.1	155.2
Height (in.)	59.1	61.1	62.1	63.4	64.9	66.2	67.6
15½ yr							
Weight (lb)		99.2	106.8	115.3	125.6	139.6	
Height (in.)		61.3	62.3	63.7	65.1	66.4	
16 yr							
Weight (lb)	91.8	100.9	108.4	117.0	127.2	141.1	157.7
Height (in.)	59.4	61.5	62.4	63.9	65.2	66.5	67.7
16½ yr							
Weight (lb)		101.9	109.4	118.1	128.4	142.2	
Height (in.)		61.5	62.5	63.9	65.3	66.6	
17 yr							
Weight (lb)	93.9	102.8	110.4	119.1	129.6	143.3	159.5
Height (in.)	59.4	61.5	62.6	64.0	65.4	66.7	67.8
17½ yr							
Weight (lb)		103.2	110.8	119.5	130.2	143.9	
Height (in.)		61.5	62.6	64.0	65.4	66.7	
18 yr							
Weight (lb)	94.5	103.5	111.2	119.9	130.8	144.5	160.7
Height (in.)	59.4	61.5	62.6	64.0	65.4	66.7	67.8

*From Studies of Child Health and Development, Dept. of Maternal and Child Health, Harvard School of Public Health, and from Studies of Howard V. Meredith, Iowa Child Welfare Research Station, State University of Iowa

TABLE A—9. Average Weights of Men (top) and Women (bottom)*

Age groups	Graduated weights (indoor clothing — lb)							
	15—16	*17—19*	*20—24*	*25—29*	*30—39*	*40—49*	*50—59*	*60—69*
Height								
5' 0"	98	113	122	128	131	134	136	133
1"	102	116	125	131	134	137	139	136
2"	107	119	128	134	137	140	142	139
3"	112	123	132	138	141	144	145	142
4"	117	127	136	141	145	148	149	146
5"	122	131	139	144	149	152	153	150
6"	127	135	142	148	153	156	157	154
7"	132	139	145	151	157	161	162	159
8"	137	143	149	155	161	165	166	163
9"	142	147	153	159	165	169	170	168
10"	146	151	157	163	170	174	175	173
11"	150	155	161	167	174	178	180	178
6' 0"	154	160	166	172	179	183	185	183
1"	159	164	170	177	183	187	189	188
2"	164	168	174	182	188	192	194	193
3"	169	172	178	186	193	197	199	198
4"	†	176	181	190	199	203	205	204
4' 10"	97	99	102	107	115	122	125	127
11"	100	102	105	110	117	124	127	129
5' 0"	103	105	108	113	120	127	130	131
1"	107	109	112	116	123	130	133	134
2"	111	113	115	119	126	133	136	137
3"	114	116	118	122	129	136	140	141
4"	117	120	121	125	132	140	144	145
5"	121	124	125	129	135	143	148	149
6"	125	127	129	133	139	147	152	153
7"	128	130	132	136	142	151	156	157
8"	132	134	136	140	146	155	160	161
9"	136	138	140	144	150	159	164	165
10"	†	142	144	148	154	164	169	†
11"	†	147	149	153	159	169	174	†
6' 0"	†	152	154	158	164	174	180	†

*Build and Blood Pressure Study, Society of Actuaries, October 1959. And Bogert LJ, Briggs GM, Calloway DH: Nutrition and Physical Fitness, 9th ed. Philadelphia, WB Saunders, 1973, p 579

†Average weights omitted in classes having too few cases

TABLE A—10. Average Height-Weight Tables for Boys (top) and Girls (bottom)*

Height (in.) — Boys

Age (yr)	5	6	7	8	9	10	11	12	13	14	15	16	17	18	19
38	34	34													
39	35	35													
40	36	36													
41	38	38	38												
42	39	39	39	39											
43	41	41	41	41											
44	44	44	44	44											
45	46	46	46	46	46										
46	47	48	48	48	48										
47	49	50	50	50	50	50									
48		52	53	53	53	53									
49		55	55	55	55	55	55								
50		57	58	58	58	58	58	58							
51			61	61	61	61	61	61							
52			63	64	64	64	64	64	64						
53			66	67	67	67	67	68	68						
54				70	70	70	70	71	71	72					
55				72	72	73	73	74	74	74					
56				75	76	77	77	77	78	78	80				
57					79	80	81	81	82	83	83				
58					83	84	84	85	85	86	87				
59						87	88	89	89	90	90	90			
60						91	92	92	93	94	95	96			
61							95	96	97	99	100	103	106		
62							100	101	102	103	104	107	111	116	
63							105	106	107	108	110	113	118	123	127
64								109	111	113	115	117	121	126	130
65								114	117	118	120	122	127	131	134
67									119	122	125	128	132	136	139
68									124	128	130	134	136	139	142
69										134	134	137	141	143	147
70										137	139	143	146	149	152
71										143	144	145	148	151	155
72										148	150	151	152	154	159
73											153	155	156	158	163
74											157	160	162	164	167
											160	164	168	170	171

Height (in.) — Girls

Age (yr)	5	6	7	8	9	10	11	12	13	14	15	16	17	18	19
38	33	33													
39	34	34													
40	36	36	36												
41	37	37	37												
42	39	39	39												
43	41	41	41	41											
44	42	42	42	42											
45	45	45	45	45	45										
46	47	47	47	48	48										
47	49	50	50	50	50	50									
48		52	52	52	52	53	53								
49			54	55	55	56	56								
50			56	57	58	59	61	62							
51			59	60	61	61	63	65							
52			63	64	64	64	65	67							
53			66	67	67	68	68	69	71						
54				69	70	70	71	71	73						
55				72	74	74	74	75	77	78					
56					76	78	78	79	81	83					
57					80	82	82	82	84	88	92				
58						84	85	86	88	93	96	101			
59						87	90	90	92	96	100	103	104		
60						91	95	95	97	101	105	108	109	111	
61							99	100	101	105	108	112	113	116	
62							104	105	106	109	113	115	117	118	
63								110	110	112	116	117	119	120	
64								114	115	117	119	120	122	123	
65								118	120	121	122	123	125	126	
66									124	124	125	128	129	130	
67									128	130	131	133	133	135	
68									131	133	135	136	138	138	
69										135	137	138	140	142	
70										136	138	140	142	144	
71										138	140	142	144	145	

*Prepared by Bird T. Baldwin, Ph.D., and Thomas D. Wood, M.D. Published originally by American Child Health Association.

TABLE A—11. Desirable Weights for Men and Women (indoor clothing — lb)*

Men (aged 25 and over)				Women (aged 25 and over)					
Height (with shoes, 1" heels)† Feet Inches		Small frame	Medium frame	Large frame	Height (with shoes, 2" heels)† Feet Inches		Small frame	Medium frame	Large frame

Feet	Inches	Small frame	Medium frame	Large frame	Feet	Inches	Small frame	Medium frame	Large frame
5	2	112—120	118—129	126—141	4	10	92—98	96—107	104—119
5	3	115—123	121—133	129—144	4	11	94—101	98—110	106—122
5	4	118—126	124—136	132—148	5	0	96—104	101—113	109—125
5	5	121—129	127—139	135—152	5	1	99—107	104—116	112—128
5	6	124—133	130—143	138—156	5	2	102—110	107—119	115—131
5	7	128—137	134—147	142—161	5	3	105—113	110—122	118—134
5	8	132—141	138—152	147—166	5	4	108—116	113—126	121—138
5	9	136—145	142—156	151—170	5	5	111—119	116—130	125—142
5	10	140—150	146—160	155—174	5	6	114—123	120—135	129—146
5	11	144—154	150—165	159—179	5	7	118—127	124—139	133—150
6	0	148—158	154—170	164—184	5	8	122—131	128—143	137—154
6	1	152—162	158—175	168—189	5	9	126—135	132—147	141—158
6	2	156—167	162—180	173—194	5	10	130—140	136—151	145—163
6	3	160—171	167—185	178—199	5	11	134—144	140—155	149—168
6	4	164—175	172—190	182—204	6	0	138—148	144—159	153—173

*Prepared by Metropolitan Life Insurance Company, 1960. Derived primarily from data of the Build and Blood Pressure Study, 1959

†For nude weight, deduct 5—7 pounds (male) and 2—4 pounds (female)

TABLE A—12. Structure and Melting Points of Some Common Fatty Acids*

No. of carbon atoms	Fatty acids		Melting point in °C.
Saturated			
4	Butyric	C_3H_7COOH	-7.9
6	Caproic	$C_5H_{11}COOH$	-3.4
10	Capric	$C_9H_{19}COOH$	31.6
16	Palmitic	$C_{15}H_{31}COOH$	62.9
18	Stearic	$C_{17}H_{37}COOH$	69.6
Unsaturated			
18	Oleic	$CH_3(CH_2)_7CH=CH(CH_2)_7COOH$	16.3
18	Linoleic[†]	$CH_3(CH_2)_4CH=CHCH_2CH=CH(CH_2)_7COOH$	-5.0
18	Linolenic[†]	$CH_3CH_2CH=CHCH_2CH=CHCH_2CH=CH(CH_2)_7COOH$	-11.0
20	Arachidonic[†]	$CH_3[CH=CHCH_2CH_2]_4CH_2CH_2COOH$	-49.5

*Bogert LJ, Briggs GM, Calloway DH: Nutrition and Physical Fitness, 9th ed. Philadelphia, WB Saunders, 1973, p 580

[†]Essential fatty acids

With two amino groups (one carboxyl)

Lysine

$$\text{(E)} \quad (NH_2)\ CH_2\ (CH_2)_3\ CH \underset{COOH}{\overset{NH_2!}{<}}$$

Arginine

$$H_2N - \overset{\overset{\displaystyle NH}{\|}}{C} \quad NH\ (CH_2)_3\ CH \underset{COOH}{\overset{NH_2}{<}} \quad \text{(E)}$$

With two carboxyl groups (one amino)

Aspartic acid

$$HOOC - CH_2\ CH \underset{COOH}{\overset{NH_2}{<}}$$

Glutamic acid

$$HOOC - CH_2\ CH_2\ CH \underset{COOH}{\overset{NH_2}{<}}$$

With benzene ring[†]

Phenylalanine

$$\text{(E)} \quad \bigcirc - CH_2\ CH \underset{COOH}{\overset{NH_2}{<}}$$

Tyrosine

$$OH \bigcirc - CH_2\ CH \underset{COOH}{\overset{NH_2}{<}}$$

*Bogert LJ, Briggs GM, Calloway DH: Nutrition and Physical Fitness, 9th ed. Philadelphia, WB Saunders, 1973, p 580
Each of the essential amino acids is indicated by an (E). Histidine and perhaps arginine are needed only by growing children, not by adults

[†]For simplification, the benzene ring is often represented by a hexagon. It should be understood that there is a carbon atom (C) at each of the six points of the hexagon with hydrogen atoms attached, except where the valence bond is attached to the remainder of the molecule. The benzyl radical may also be represented as:

$$C_6H_5 - \text{ or } HC \overset{\overset{\displaystyle H \quad\quad H}{\underset{\displaystyle}{C = C}}}{\underset{\underset{\displaystyle H \quad\quad H}{C - C}}{}} C -$$

In the heterocyclic groups, simplified representations of which are used in formulas on the following page, there are also carbon atoms at each point unless otherwise indicated (*e.g.*, N), with hydrogen atoms attached as needed to satisfy valences.

TABLE A–13. Structural Formulas of the Most Common Amino Acids*

With one amino and one carboxyl group

Glycine

$$CH_2 \Big\langle \begin{array}{l} NH_2 \\ COOH \end{array}$$

Alanine

$$CH_3CH \Big\langle \begin{array}{l} NH_2 \\ COOH \end{array}$$

Valine

$$\begin{array}{l} CH_3 \\ CH_3 \end{array} \Big\rangle CH\, CH \Big\langle \begin{array}{l} NH_2 \\ COOH \end{array} \quad Ⓔ$$

Leucine

$$\begin{array}{l} CH_3 \\ CH_2 \end{array} \Big\rangle CH\, CH_2\, CH \Big\langle \begin{array}{l} NH_2 \\ COOH \end{array} \quad Ⓔ$$

Serine

$$HO - CH_2\, CH \Big\langle \begin{array}{l} NH_2 \\ COOH \end{array}$$

Isoleucine

$$\begin{array}{l} C_2H_5 \\ CH_2 \end{array} \Big\rangle CH\, CH \Big\langle \begin{array}{l} NH_2 \\ COOH \end{array} \quad Ⓔ$$

Threonine

$$\begin{array}{l} CH_2 \\ HO \end{array} \Big\rangle CH\, CH \Big\langle \begin{array}{l} NH_2 \\ COOH \end{array} \quad Ⓔ$$

Methionine

$$CH_3 - S - CH_2\, CH_2\, CH \Big\langle \begin{array}{l} NH_2 \\ COOH \end{array} \quad Ⓔ$$

Cysteine

$$(SH)CH_2\, CH \Big\langle \begin{array}{l} NH_2 \\ COOH \end{array}$$

Cystine

$$\begin{array}{l} H_2N \\ HOOC \end{array} \Big\rangle CH\, CH_2 - S - S - CH_2\, CH \Big\langle \begin{array}{l} NH_2 \\ COOH \end{array}$$

With heterocyclic group

Tryptophan

$$CH_2\, CH \Big\langle \begin{array}{l} NH_2 \\ COOH \end{array}$$

Histidine

$$\begin{array}{l} N - CH \\ HC \quad\quad C - CH_2\, CH \Big\langle \begin{array}{l} NH_2 \\ COOH \end{array} \quad Ⓔ \\ \quad N \\ \quad H \end{array}$$

Proline

$$\begin{array}{c} H_2C - CH_2 \\ | \quad\quad | \quad H \\ H_2C \quad C \Big\langle \\ \quad N \quad COOH \\ \quad H \end{array}$$

Hydroxyproline

$$\begin{array}{c} (OH)HC - CH_2 \\ | \quad\quad | \quad H \\ H_2C \quad C \Big\langle \\ \quad N \quad COOH \\ \quad H \end{array}$$

Ascorbic acid: Vitamin C

Riboflavin: Vitamin B$_2$

Thiamin: Vitamin B-1

Niacin group

Nicotinic acid

Nicotinamide

Vitamin B-6 group

Pyridoxine

Pyridoxal

Pyridoxamine

Pantothenic acid

Folacin
(represented by monopteroylglutamic acid)

$$HOOC-\underset{\underset{H-C-H}{|}}{\overset{\overset{H}{|}}{C}}-\underset{\overset{H}{|}}{N}-\overset{\overset{O}{\|}}{C}-C=C ... C-N-\overset{H}{C}-C ... N=C-NH_2$$

HOOC—CH₂

Vitamin B-12
(represented by cyanocobalamin)

CH₂·CONH₂
CH₂
CH₃ CH₃
CH₂·CONH₂
NH₂CO·CH₂
A
B
CH₂·CH₂·CONH₂
CH₃
CH₃
CN
N N
Co⁺
N N
CH₃
CH₃
NH₂CO·CH₂
D C
CH₃
CH₂·CH₂·CONH₂
CO·CH₂·CH₂ CH₃ CH₃ CH₂·CH₂·CONH₂
NH
CH₂
CH·CH₃
O O
P
⁻O O OH
C—C
H H H
N CH₃
N CH₃
H
C C
HO·CH₂ O H

Choline

CH₃ CH₂CH₂OH
CH₃—N
CH₃ OH

Biotin

$$\underset{\underset{\underset{S}{\diagdown\diagup}}{H_2C-\underset{|}{C}}}{HN\overset{\overset{O}{\|}}{\underset{|}{C}}NH} \qquad H-C-C-H$$

CH₂—CH₂—CH₂·CH₂·COOH

*Bogert LJ, Briggs GM, Calloway DH: Nutrition and Physical Fitness, 9th ed. Philadelphia, WB Saunders, 1973, p 583

TABLE A—15. Structures of Fat-Soluble Vitamins*

Vitamin A (represented by retinol)

$$H_3C \quad CH_3 \qquad CH_3 \qquad CH_3$$

$$H_2-C \qquad C \qquad C \qquad CH_2OH$$

$$H_2-C \qquad C-CH_3$$

$$H_2$$

Vitamin D (represented by cholecalciferol, vitamin D_3)[†]

Cholecalciferol

$$CH_3 \quad C_{H_2} \quad C_{H_2} \quad CH_3$$
$$CH$$
$$CH_3 \qquad CH_3$$

$$H_2C \qquad CH_2$$
$$H_2C \qquad CH_2$$
$$C$$
$$CH$$
$$HC$$
$$C \qquad CH_2$$
$$H_2-C \qquad C$$
$$C \qquad C$$
$$HO \qquad C \qquad H_2$$
$$H_2$$

1,25-dihydroxycholecalciferol

$$CH_3 \quad C_{H_2} \quad C_{H_2} \quad CH_3$$
$$CH \qquad C-OH$$
$$CH_3 \qquad 25 \quad CH_3$$

$$H_2C \qquad CH_2$$
$$H_2C \qquad CH_2$$
$$C$$
$$HC$$
$$HC$$
$$C \qquad CH_2$$
$$H_2C \qquad C$$
$$C \qquad C$$
$$HO \qquad C \qquad 1 \qquad OH$$
$$H_2$$

Vitamin E (represented by alpha tocopherol)

$$CH_3$$
$$C$$
$$O \qquad CH_3 \qquad H \qquad H \qquad CH_3$$
$$H_3C-C \qquad C \qquad C-(CH_2)_3-C-(CH_2)_3-C-(CH_2)_3-C-H$$
$$HO-C \qquad C \qquad CH_2 \qquad CH_3 \qquad CH_3 \qquad CH_3$$
$$C \qquad C$$
$$H_2$$
$$CH_3$$

R

TABLE A—15. Structures of Fat-Soluble Vitamins* *(continued)*

Vitamin K (represented by phytylmenaquinone, vitamin K_1)

*Bogert LJ, Briggs GM, Calloway DH: Nutrition and Physical Fitness, 9th ed. Philadelphia, WB
Saunders, 1973, p 585

†Cholecalciferol (vitamin D_3) is converted into 25-hydroxycholecalciferol in the liver and then in the
kidney to 1,25-dihydroxycholecalciferol, the active form

TABLE A—16. Weights and Measures*

	Weights	Approximate equivalents of metric
1 ounce (oz)	=28.35 g	30 g
1 pound (lb)	=453.6 g	
1 stone	=6.35 kg	
1 gram (g)	=0.0353 oz	
1 kilogram (kg)	=2.205 lb	2.2 lb
	Fluid measures	
1 fluid ounce (fl oz)	=28.41 ml	30 ml
1 pint	=568.2 ml	600 ml
1 (English) gallon	=4.546 liter	
	=1.2 USA gallons	
1 teaspoonful	=1/8 fl oz	4 ml
1 dessertspoonful	= 1/4 fl oz	8 ml
1 tablespoonful	=1/2 fl oz	15 ml
1 millilitre (ml)	=0.0352 fl oz	
1 litre (l)	=1.760 pints	2 pints
	Measures of length	
1 inch (in.)	=2.54 cm	
1 foot	=30.48 cm	30 cm
1 mile	=1.609 km	
1 centimetre (cm)	=0.394 in	
1 kilometre (km)	=0.6214 mile	

*Davidson S, Passmore R, Brock JF: Human Nutrition, 5th ed.
Edinburgh, Churchill Livingstone, 1973, p 566

TABLE A—17. Conversion Factors for Weights and Measures*

To change	To	Multiply by
Inches	Centimeters	2.54
Feet	Meters	.305
Miles	Kilometers	1.609
Meters	Inches	39.37
Kilometers	Miles	.621
Fluid ounces	Cubic centimeters	29.57
Quarts	Liters	.946
Cubic centimeters	Fluid ounces	.034
Liters	Quarts	1.057
Grains	Milligrams	64.799
Ounces (av.)	Grams	28.35
Pounds (av.)	Kilograms	.454
Ounces (troy)	Grams	31.103
Pounds (troy)	Kilograms	.373
Grams	Grains	15.432
Kilograms	Pounds	2.205
Kilocalories	KiloJoules	4.184
Kilocalories	MegaJoules	.004

*Bogert LJ, Briggs GM, Calloway DH: Nutrition and Physical Fitness, 9th ed. Philadelphia, WB Saunders, 1973, p 576

TABLE A—18. Equivalent Weights and Measures*

	Milligram	Gram	Kilogram	Grain	Ounce	Pound
Weight equivalents						
1 microgram (μg)	.001	.000001				
1 milligram (mg)	1.	.001		.0154		
1 gram (g)	1000.	1.	.001	15.4	.035	.0022
1 kilogram (kg)	1,000,000.	1000.	1.	15,400.	35.2	2.2
1 grain (gr)	64.8	.065		1.		
1 ounce (oz)		28.3		437.5	1.	.063
1 pound (lb)		453.6	.454		16.0	1.

	Cubic millimeter	Cubic centimeter	Liter	Fluid ounce	Pint	Quart
Volume equivalents						
1 cubic millimeter (mm^3)	1.	.001				
1 cubic centimeter (cc)	1000.	1.	.001			
1 liter (l)	1,000,000.	1000.	1.	33.8	2.1	1.05
1 fluid ounce		30.(29.57)	.03	1.		
1 pint (pt)		473.	.473	16.	1.	
1 quart (qt)		946.	.946	32.	2.	1.

	Millimeter	Centimeter	Meter	Inch	Foot	Yard
Linear equivalents						
1 millimeter (mm)	1.	.1	.001	.039	.00325	.0011
1 centimeter (cm)	10.	1.		.39	.0325	.011
1 meter (m)	1000.	100.	1.	39.37	3.25	1.08
1 inch (in.)	25.4	2.54	.025	1.	.083	.028
1 foot (ft)	304.8	30.48	.305	12.	1.	.33
1 yard (yd)	914.4	91.44	.914	36.	3.	1.

*Cooper LF, Barber EM, Mitchell HS, Rymbergen HJ: Nutrition in Health and Disease, 12th ed. Philadelphia, JB Lippincott Co, 1953, p 712

Index

The letters t and f following a page number indicate table and figure respectively.

Abdomen, glycogen storage disease and, 16
Abetalipoprotenemia, in infants and children, 455
ABI. See Atherothrombotic brain infarction
Absolute losses of nutrients. See also Negative body balances definition of, 348
Absorption. See also Digestion; Malabsorption syndromes
of ascorbic acid, 38
of calcium, 59
cancer and, 171
of carbohydrates, 14–15
of folacin, 33
of iodine, 68
of iron, 65
of magnesium, 63
and oral feedings in infants, 98
phosphorus and, 60–61
of pyridoxine, 36
of radioactive vitamin B_{12}, 113
of riboflavin, 29
of sodium, 63
of sulfur, 64
of thiamin, 27
of vitamin A, 41, 102
of vitamin B_{12}, 34
of vitamin E, 49
of vitamin K, 52
of zinc, 67
Acetate, in parenteral nutrition, 161
Acetoacetic acid, 20
Acetone bodies. See Ketone bodies
Acetyl choline formation, pantothenic acid and, 29–30
Achlorhydria, pellagra and, 109
Acid-base balance
in infectious illness, 358
and low-carbohydrate reducing diets, 135
phosphorus and, 61
Acid chyme, intestinal digestion and, 18–19
Acne vulgaris, nutritional therapy for, 275
Acrodermatitis
in infants and children, 455
zinc deficiency and, 271–272
Acrodynia, pyridoxine deficiency and, 35
ACTH
in anorexia nervosa, 323

ACTH (continued)
eosinopenic response to, pantothenic acid deficiency and, 115
malnutrition and, 322
Acute bacterial endocarditis, definition of, 260
Acute myocardial infarction, nutritional therapy for, 247–249
Acute nephritic syndrome
definition of, 377
nutritional management of, 377
Acute renal failure, nutrition and, 497–498
Acute tubular necrosis, 375–377
definition of, 375
Adaptive phase of illness, metabolism during, 81
Addison's disease, 326
Additives. See Food additives
Adenosine diphosphate (ADP), 11
Adenosine triphosphate (ATP), 11
depletion, fructose and, 157
energy release and, 60
lipid metabolism and, 19
phosphorylation of blood glucose and, 15–16
Adiposity. See also Obesity
diabetes prevalence and, 280
diabetic diet and, 284
Adolescents
energy requirements of, 12
obesity treatment for, 403
ADP. See Adenosine diphosphate
Adrenal cortex. See also Adrenal cortical hormones
nutritional effects of, 325–326
obesity and, 318–319
vitamin C content of, 38
Adrenal cortical hormones
cholesterol as precursor of, 18
and negative body balances, 351–352
Adult-onset obesity, treatment of, 403–404
Aged. See also Aging
alcohol in parenteral nutrition for, 158
gastrointestinal disease in, 339
and hyponatremia, 360
protein requirements of, 153–154
Aging. See also Aged
bone calcium phosphate and, 58–59

Aging (continued)
chromium levels and, 69
folacin deficiency and, 110
weight loss and, 77
Agricultural revolution, 4–5
Air Force diet, 398
Air pollutants, lung disease caused by, 482
Airway disease. See Asthma, bronchitis, atopic syndrome
Albumin-transferrin, in nutritional assessment, 147f
Albuminuria, vitamin K toxicity and, 122
Alcohol. See also Alcoholism
angina and, 247
coronary atherosclerotic heart disease and, 247
diabetes development and, 280
in diabetic diet, 285, 288
energy requirements and, 10
hepatic fat clearance and, 205
lipid metabolism and, 210, 211f, 212
nutritional value of, 202, 203f, 204
in parenteral nutrition, 158
peptic ulcer and, 338
toxicity, 202, 205
vitamin and mineral deficiencies and, 300–301
Alcoholic cardiomyopathy, 217
Alcoholic cerebellar degeneration. See Cerebellar cortical degeneration
Alcoholism, 202–218. See also Alcohol
and beriberi, 26
and beriberi heart disease, 213
bile salts and, 208
carbohydrate metabolism and, 209
fat-soluble vitamins and, 214–215
folacin deficiency and, 111
gastrointestinal tract and, 207–209
hepatic encephalopathy and, 216–217
interactions with drugs and disease states, 217–218
iron metabolism and, 215
kidney function and, 216
liver injury and, 204–207
magnesium deficiency and, 63
malabsorption syndromes and, 208–209